F4

THE OXFORD HANDBOOK OF

ADAPTATION STUDIES

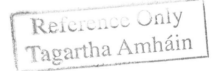

THE OXFORD HANDBOOK OF

ADAPTATION STUDIES

Edited by

THOMAS LEITCH

OXFORD

UNIVERSITY PRESS

OXFORD
UNIVERSITY PRESS

Oxford University Press is a department of the University of Oxford. It furthers
the University's objective of excellence in research, scholarship, and education
by publishing worldwide. Oxford is a registered trade mark of Oxford University
Press in the UK and certain other countries.

Published in the United States of America by Oxford University Press
198 Madison Avenue, New York, NY 10016, United States of America.

Library of Congress Cataloging-in-Publication Data
Names: Leitch, Thomas M., editor.
Title: The Oxford handbook of adaptation studies / edited by Thomas Leitch.
Description: New York : Oxford University Press, [2017] | Includes
bibliographical references. | Description based on print version record
and CIP data provided by publisher; resource not viewed.
Identifiers: LCCN 2016019662 (print) | LCCN 2016011065 (ebook) |
ISBN 9780199331017 (updf) | ISBN 9780199331000 (cloth)
Subjects: LCSH: Literature—Adaptations—History and criticism. | Film
adaptations—History and criticism. | Intertextuality.
Classification: LCC PN171.A33 (print) | LCC PN171.A33 O94 2017 (ebook) |
DDC 809—dc23
LC record available at https://lccn.loc.gov/2016019662

1 3 5 7 9 8 6 4 2
Printed by Sheridan Books, Inc., United States of America

CONTENTS

PART V ADAPTATION
AND INTERTEXTUALITY

Contributors

Fien Adriaens is a postdoctoral researcher at the Department of Communication Sciences at Ghent University, Belgium. Her research focuses on media audiences, diversity, television formats, and everyday life. She is currently working as a social policy advisor at the socialist trade union (ABVV).

Mieke Bal is a cultural theorist and video artist based at the Amsterdam School for Cultural Analysis, University of Amsterdam. Her areas of interest range from biblical and classical antiquity to seventeenth-century and contemporary art and modern literature, feminism, and migratory culture. Her many publications include *A Mieke Bal Reader* (2006) and *Narratology* (3rd edition, 2009). Her internationally exhibited documentaries on migration include *Separations, State of Suspension,* and *Becoming Vera.* She is currently completing a feature film and five-screen installation on René Descartes and his friendship with Queen Kristina of Sweden.

Daniël Biltereyst is Senior Professor of Communication Sciences at Ghent University, Belgium, where he is director of the Centre for Cinema and Media Studies. His areas of research and publication include international communication, media controversy, and censorship.

Jack Boozer is a professor in the graduate Moving Image Studies program at Georgia State University. His interests are in film genre, the adaptation of literature to film, and screenwriting. In addition to publishing many academic articles in journals and anthologies, he has written *Career Movies: American Business and the Success Mystique* (2003) and edited *Authorship in Film Adaptation* (2008).

Brian Boyd, University Distinguished Professor of English, University of Auckland, has written widely on fiction, verse, drama, comics, translation, and literary and narrative theory; on art, literature and evolution (*On the Origin of Stories,* 2009; *Why Lyrics Last,* 2012; and the co-edited *Evolution, Literature, and Film: A Reader,* 2010); and on writers from Homer and Shakespeare to Art Spiegelman and Carol Ann Duffy. He is especially known as a biographer, critic, and editor of Vladimir Nabokov. His work has won awards on four continents and has been translated into eighteen languages. He is currently writing a biography of philosopher Karl Popper.

Petr Bubeníček is an Assistant Professor in the Department of Czech Literature at Masaryk University, Brno, specializing in the history of modern Czech literature, literary interpretation, film adaptation, and intermediality. He has published several essays

on these topics and has edited three issues on film adaptation for the journals *Česká literatura*, *Iluminace*, and *Pandora*. In 2013, he was awarded an Alfried Krupp Fellowship and began his work on the forthcoming monograph *Subversive Adaptations*. In the same year he organized the conference Film Adaptation: A Dialogue among Approaches, which brought together many significant scholars of adaptation studies.

Claus Clüver, an Indiana University Professor Emeritus of Comparative Literature, has also taught at New York University and the University of California–Berkeley, and in Brazil, Portugal, Germany, Sweden, and Denmark. His publications include a book in German on twentieth-century epic theater, over forty essays on the history, theory, and practice of intermedial and interarts studies, and six co-edited volumes, from *The Pictured Word* (1998) to *The Imaginary: Word and Image/L'Imaginaire: texte et image* (2015).

Timothy Corrigan is a Professor of English and Cinema Studies at the University of Pennsylvania. His books include *Film and Literature* and *The Essay Film: From Montaigne, After Marker*, winner of the 2012 Katherine Singer Kovacs Award for the outstanding book in film studies. In 2014 he received the SCMS Award for Outstanding Pedagogical Achievement and the Abrams Memorial Award for Distinguished Teaching at the University of Pennsylvania. He is currently on the editorial boards of *Adaptation* and *Film Criticism*.

Dennis Cutchins is Associate Professor of English at Brigham Young University, where he regularly teaches courses in adaptation, American literature, and Western American literature. He has published on a wide range of topics and has co-edited three collections on adaptation. In 2000 he won the Carl Bode award for the best article published in the *Journal of American Culture* for an essay on Leslie Silko's *Ceremony*, and in 2004 received the Charles Redd Center's Mollie and Karl Butler Young Scholar Award in Western Studies. His current projects explore the application of "big data" to adaptation studies.

Nico Dicecco recently received his doctorate in English from Simon Fraser University for his dissertation, "The Ends of Adaptation: Comparative Media, Digital Culture, and Performance." He has published on issues of adaptation across a range of media, including articles in *Games and Culture, Journal of Graphic Novels and Comics*, and *Adaptation*. His current research extends his work on performative models of adaptation to investigate digital media and the cultural politics of fidelity.

Lars Ellestrom is Professor of Comparative Literature at Linnæus University, Sweden. He presides over the Linnæus University Centre for Intermedial and Multimodal Studies and chairs the board of the International Society for Intermedial Studies. He has written and edited several books and also has published numerous articles on poetry, intermediality, semiotics, gender, and irony. His recent publications, starting with the article "The Modalities of Media: A Model for Understanding Intermedial Relations" (2010), have explored and developed basic semiotic, multimodal, and intermedial concepts aiming at a theoretical model for understanding and analyzing interrelations among dissimilar media.

Kamilla Elliott is Professor of Literature and Media in the Department of English and Creative Writing at Lancaster University. Her principal teaching and research interests lie in British literature of the long nineteenth century and literature's relations with other media generally. Author of *Rethinking the Novel/Film Debate* (2003) and *Portraiture and British Gothic Fiction: The Rise of Picture Identification, 1764–1835* (2012), she is currently working on sequels to both: *Rethinking the Adaptation/Theorization Debate* and *British Literature and the Rise of Picture Identification, 1836–1918*.

Kevin M. Flanagan is Visiting Lecturer in English/Film Studies at the University of Pittsburgh. His dissertation is on war discourse in British cinema and television from 1939 to 1980. He has edited *Ken Russell: Re-Viewing England's Last Mannerist* (2009) and has contributed to *Framework*, the *Journal of British Cinema and Television*, and *Media Fields Journal*. He is currently editing a special issue of *Widescreen Journal* on video-game adaptation for release in 2016.

Marty Gould is Associate Professor of English at the University of South Florida, where he teaches courses on Victorian literature, empire, and literary adaptation. In *Nineteenth-Century Theatre and the Imperial Encounter* (2011), he traces the interplay among global politics, imperial ideology, and the popular stage in the nineteenth century. As the director of a series of NEH Summer Seminars on Charles Dickens, he has helped K–12 teachers explore some of the ways in which adaptations can be used to teach literary texts and assess student learning. His current research involves dramatizations as readings of nineteenth-century fiction.

Richard J. Hand is Professor of Theatre and Media Drama at the University of South Wales, UK. He is the founding co-editor of the *Journal of Adaptation in Film and Performance*. His interests include interdisciplinarity in performance (with a particular interest in historical forms of popular culture, including horror) using critical and practical research methodologies. He is the author and editor of books on radio and audio drama, Grand-Guignol theater, horror films, Joseph Conrad, and Graham Greene, and he has published translations of plays by Victor Hugo and Octave Mirbeau.

Eirik Frisvold Hanssen is Head of the Film and Broadcasting Section in the Department of Research and Dissemination at the National Library of Norway. He has published on such topics as adaptation, intermediality, classical film theory, and color and cinema in numerous edited volumes and journals, including *Film History*, *Visual Anthropology Review*, and *Montage AV*. With Jørgen Bruhn and Anne Gjelsvik, he is co-editor of *Adaptation Studies: New Challenges, New Directions* (2013). He is currently editing an anthology on Norwegian expedition films.

Dan Hassler-Forest is Assistant Professor of Media Studies at Utrecht University. He has published books on superhero movies, comics, adaptation studies, and transmedia storytelling, and enjoys writing about critical theory, popular culture, and zombies. His most recent book, *Science Fiction, Fantasy and Politics* (2016), focuses on fantastic world-building and radical political theory.

Álvaro Hattnher is Associate Professor at São Paulo State University, Brazil, where he teaches courses in American Studies, American Literature, and Literary Translation Practice. The many translations he has published include works by Nathanael West, Chester Himes, Peter Burke, David Remnick, and Truman Capote. His research focuses on theories of adaptation and American popular culture, especially zombie texts, graphic novels, and videogames as narratives. He has co-edited *Pelas veredas do fatástico, do mítico e do maravilhoso* (2013). He is also a musician, acting as producer and bass player of the rock band Luigi and the Pirandellos.

I. Q. Hunter is Professor of Film Studies at De Montfort University, Leicester, UK. He is the author of *British Trash Cinema* (2013) and *Cult Film as a Guide to Life* (2016) and editor or co-editor of numerous books, most recently *British Comedy Cinema* (2012) and *Science Fiction across Media* (2013).

Linda Hutcheon is University Professor Emeritus in the Department of English and the Centre for Comparative Literature at the University of Toronto. She is author of nine books on contemporary postmodern culture in Canada and around the world. She has edited five other books on cultural topics, and is associate editor of the *University of Toronto Quarterly*.

Michael Hutcheon is Professor of Medicine at the University of Toronto. A pulmonologist specializing in lung transplantation, his extensive scientific research publications include work in pulmonary physiology, bone marrow transplantation, and AIDS. He has also published in the fields of medical education and the semiotics of both cigarette and pharmaceutical advertising.

The Hutcheons have collaborated on interdisciplinary work on the cultural construction of sexuality, gender, and disease in opera (*Opera: Desire, Disease, Death*, 1996), both the real and the represented operatic body (*Bodily Charm: Living Opera*, 2000), the lessons opera teaches about mortality (*Opera: The Art of Dying*, 2004), and the later creative life and "late style" of opera composers (*Four Last Songs: Aging and Creativity in Verdi, Strauss, Messiaen, and Britten*, 2015).

Mike Ingham is Professor of English Studies at Lingnan University, Hong Kong. A founding member of Theatre Action drama company in Hong Kong, he has written on Shakespearean adaptation, performance studies, and stylistics, and has had numerous publications in adaptation studies and cinema studies, as well as Hong Kong creative writing in English (*City Voices*, 2003; *City Stage*, 2005; and *Hong Kong: A Cultural and Literary History*, 2007). His contribution on Shakespeare and jazz is included in the forthcoming *Cambridge World Shakespeare Encyclopedia*, and his Routledge monograph on Intermediality in Film and Theatre will be published in 2016.

Glenn Jellenik is Lecturer in English at the University of Central Arkansas. His research explores adaptation, the productive intersections between mass culture and literature, and the cross-pollination between texts and the cultures that produce and consume them. He is co-editor of *Ten Years after Katrina: Critical Perspectives of the Storm's Effect*

on American Culture and Identity (2014), co-editor of the scholarly edition of Helen Maria Williams's *Peru and Peruvian Tales* (2014), and volume advisor for the *Nineteenth-Century Literature Criticism* cumulative index on George Colman the Younger (2015).

David T. Johnson is Associate Professor of English at Salisbury University in Salisbury, Maryland, where he teaches courses in cinema studies and adaptation. He is the author of *Richard Linklater* (2012) and the co-editor, with Rashna Wadia Richards, of a forthcoming volume on cinephilia and teaching. He has published essays in the journal *Adaptation*, among others, and co-edited *Literature/Film Quarterly* from 2005 to 2016.

William B. Jones, Jr. is the author of *Classics Illustrated: A Cultural History* (2nd ed., 2011) and the editor of *Robert Louis Stevenson Reconsidered* (2003). He has written introductions for more than 100 reissued *Classics Illustrated* titles and articles for the *Journal of Stevenson Studies* and *Verniana*. Jones has spoken on *Classics Illustrated* at the Library of Congress and various literary conferences. He is also the author of a novella, *Petit Jean: A Wilderness Adventure* (2016).

Stijn Joye is Assistant Professor of Communication Sciences at Ghent University, Belgium, where he is a member of the Centre for Cinema and Media Studies and the Center for Journalism Studies. His areas of research and publication include international news, the representation of distant suffering, and artistic imitation in film.

Lucia Krämer is Professor for British Culture and Media at the University of Passau, Germany. Her PhD thesis about biofictional representations of Oscar Wilde in novels, dramas, and films was published in 2003. Her current research focuses on adaptation and related phenomena like remaking and transmedial storytelling, as well as on Hindi cinema. She has co-edited volumes on the construction of authenticity (2011) and *Remakes and Remaking* (2015) and has written *Bollywood in Britain* (2016). With Rainer Emig, she is co-editing a German handbook, *Adaption* (2017).

Thomas Leitch is Professor of English at the University of Delaware. His most recent books are *A Companion to Alfred Hitchcock*, co-edited with Leland Poague (2011), and *Wikipedia U: Knowledge, Authority, and Liberal Education in the Digital Age* (2014). He is currently working on *The History of American Literature on Film*.

Peter Lev is Professor Emeritus at the Department of Electronic Media and Film, Towson University, Towson, Maryland. He is the author of five books of film history, most recently *Twentieth Century-Fox, The Zanuck–Skouras Years: 1935–1965* (2013), which was supported by an Academy Scholars grant from the Academy of Motion Picture Arts and Sciences. In adaptation studies he is the co-editor, with James M. Welsh, of *The Literature/Film Reader: Issues of Adaptation* (2007). He is a longtime member of the Editorial Board of *Literature/Film Quarterly*.

Kyle Meikle recently completed his doctorate at the University of Delaware. His work has appeared in *Adaptation, Literature/Film Quarterly*, and the *Journal of Adaptation in Film and Performance*. He is co-author of the Oxford Bibliographies Online guide to adaptation.

Renata Kobetts Miller is Associate Professor and Chair of English at City College of New York. She is the author of *Recent Reinterpretations of Stevenson's* Dr. Jekyll and Mr. Hyde: *Why and How This Novel Continues to Affect Us* (2005), and her work on the Victorian novel, theater, and culture has appeared in *MLQ* and *BRANCH*, among other publications. She is currently completing *Playing Her Part: The Victorian Novel, Theater, and the Actress*. Her work on the theater of the 1890s includes mentoring students developing an online archive of materials pertaining to London's Independent Theatre Society.

Kate Newell teaches courses in literature and adaptation at the Savannah College of Art and Design. Her research interests include adaptation and other modes of intermediality. She has published essays on illustration and adaptation and is currently writing on novelization, cartography, illustration, and other print-based modes of adaptation.

Dennis R. Perry is Associate Professor of English at Brigham Young University, where he teaches and writes on nineteenth-century American literature and film adaptation. He has published articles on Poe, Hawthorne, Melville, Whitman, and various early American writers. His books include *Hitchcock and Poe: The Legacy of Delight and Terror* (2004) and, with Carl H. Sederholm, *Adapting Poe: Re-Imaginings in Popular Culture* (2012).

Laurence Raw, who teaches in the Department of English at Baskent University, Ankara, Turkey, is the author of several books on film and adaptation. His latest publications are *Six Turkish Filmmakers* (2016) and *Value in Adaptation*, coauthored with Berkem Gurenci Saglam (2016). He runs a blog on translation and adaptation at laurenceraw.blogspot.com.

Marie-Laure Ryan is an independent scholar based in Colorado. She has been Scholar in Residence at the University of Colorado and Johannes Gutenberg Fellow at the University of Mainz. Her work in narratology, possible worlds theory, media theory, and digital culture has earned her the Prize for Independent Scholars and the Jeanne and Aldo Scaglione Prize for Comparative Literature, both from the Modern Language Association, and she has been the recipient of Guggenheim and NEA fellowships. Her most recent books are *Narrating Space/Spatializing Narrative* (2016, co-authored with Ken Foote and Maoz Azaryahu) and *Storyworlds across Media* (2014, co-edited with Jan-Noël Ton).

Mary H. Snyder is an independent scholar and writer living in the San Francisco Bay Area. Her book, *Analyzing Literature-to-Film Adaptations: A Novelist's Exploration and Guide*, was published in 2011. She continues to research women and gender issues related to adaptation studies. She also writes fiction and creative nonfiction.

Robert Stam is University Professor at New York University. He has written and edited eighteen volumes on film and cultural theory, national and transnational cinema, comparative race, and postcolonial studies. His recent books include *Keywords in Subversive Film/Media Aesthetics* (2015) and, with Ella Shohat, *Race in Translation: Culture Wars*

Around the Postcolonial Atlantic (2012). His work has been translated into some fifteen languages.

Defne Ersin Tutan is Assistant Professor in American Culture and Literature at Başkent University, Ankara, Turkey. She has worked extensively on the intersection of postmodern and postcolonial discourses, with a special interest in their impact on the representation of alternative histories. Her recent research has focused on historical adaptations and on history as adaptation. She is the co-editor of *The Adaptation of History: Essays on Ways of Telling the Past* (2013).

Constantine Verevis is Associate Professor in the School of Media, Film and Journalism at Monash University, Melbourne. He is author of *Film Remakes* (2006), co-author of *Australian Film Theory and Criticism, Volume 1: Critical Positions* (2013), and co-editor, most recently, of *US Independent Film after 1989: Possible Films* (2015).

Eckart Voigts is Professor of English Literature at TU Braunschweig, Germany. He has written, edited, and co-edited numerous books and articles, including most recently *Reflecting on Darwin* (2014), *Dystopia, Science Fiction, Post-Apocalypse. Classics—New Tendencies—Model Interpretations* (2015), and the special issue of *Adaptation* (2013) on transmedia storytelling and participatory culture.

Keith Wilhite is Associate Professor of English at Siena College. His research focuses primarily on the modern and contemporary American novel, especially regionalism and the literature of place. His essays have appeared in *American Literature, Arizona Quarterly, ELH, MFS, Midwestern Miscellany, Prose Studies, Studies in American Fiction,* and *Studies in the Novel.* He is the editor of the forthcoming collection *The City since 9/11: Literature, Film, Television.*

Wendy Siuyi Wong is Associate Professor of Design and Graduate Program Director at the Department of Design, York University, Canada. An expert in Chinese graphic design history and Chinese comic art history, she is the author of *Hong Kong Comics: A History of Manhua* (2002) and numerous articles in academic journals. In 2009 and 2010, she was a visiting research fellow at the Department of Design History, Royal College of Art, and she served as a scholar-in-residence at the Kyoto International Manga Museum.

Wendy Zierler is Sigmund Falk Professor of Modern Jewish Literature and Feminist Studies at HUC-JIR in New York. She is the author of *And Rachel Stole the Idols: The Emergence of Modern Hebrew Women's Writing* (2004) and *Reel Theology: Popular Film and Jewish Religious Conversation* (forthcoming) and the co-editor of *To Tread on New Ground: Selected Writings of Hava Shapiro* (2014). A finalist in the 2012 Moment Magazine Karma Foundation fiction contest, she will receive her MFA in fiction writing from Sarah Lawrence in 2016.

THE OXFORD HANDBOOK OF

ADAPTATION
STUDIES

INTRODUCTION

THOMAS LEITCH

COLLECTIONS of scholarly essays on topics in the humanities tend to fall into three categories, depending on their temporal orientation. One kind of collection looks backward, aiming to explain how the field under consideration arrived at its current position by examining its history to date. The best representative of this position in adaptation studies is Timothy Corrigan's *Film and Literature: An Introduction and Reader*, which reprints a representative sample of essays on adaptation from Vachel Lindsay and Hugo Münsterberg to the present. A second kind of collection aims to give a snapshot of the field in the present by presenting all new essays that emphasize its current status and showcase its leading methodologies at work, like Mireia Aragay's *Books in Motion: Adaptation, Intertextuality, Authorship*, James M. Welsh and Peter Lev's *The Literature/Film Reader: Issues of Adaptation*, Rachel Carroll's *Adaptation in Contemporary Culture: Textual Infidelities*, Deborah Cartmell's *Companion to Literature, Film, and Adaptation*, and *Pockets of Change: Adaptation and Cultural Transition*, edited by Tricia Hopton, Adam Atkinson, Jane Stadler, and Peta Mitchell. The third kind of collection, oriented more tendentiously toward the future, lays out directive paths the field should take and makes a case for choosing them rather than the alternatives. In adaptation studies, this prescriptive tendency is clearest in Deborah Cartmell and Imelda Whelehan's *Adaptation: From Text to Screen, Screen to Text*, Robert Stam and Alessandra Raengo's *Literature and Film: A Guide to the Theory and Practice of Film Adaptation* and *A Companion to Literature and Film*, Jillian Saint Jacques's *Adaptation Theories*, and *Adaptation Studies: New Challenges, New Directions*, edited by Jørgen Bruhn, Anne Gjelsvik, and Eirik Frissvold Hanssen.

The present collection rather immodestly attempts to combine all three of these tendencies, reflecting on adaptation studies' past, surveying its present, and proposing new directions for its future. Some of the contributors, especially to Part I, reflect on the history of adaptation and adaptation studies; others report on current problems and positions in the field; still others imply or explicitly advise new directions. Since the questions all scholarly essays raise and the methodologies they use to address them are historically sanctioned, it's fair to say that every essay, whatever its historical

orientation, is rooted in its field's past. It's even more obvious that whatever their orientation, all essays are inevitably rooted in the here and now, choosing problems that seem more urgent now than they did twenty years ago, or perhaps twenty years after. And of course every essay, here and elsewhere, aims to present conclusions that will redirect its field in large ways or small, if only by clarifying or redefining the historical past that informs it. Nonetheless, it makes sense to distinguish these three tendencies and to say that in the present collection, the second and third of them predominate, largely subordinating the history of adaptation and adaptation studies to the requirements of its present and the hopes for its future. For this reason, it seems reasonable to begin this introduction with a brief historical sketch of adaptation studies, though here again the history is intended ultimately to contextualize the present and to motivate recommendations for the field's future.

I leave to contributors like Timothy Corrigan (in Chapter 1) the debate over whether adaptation is as old as the production of texts or whether it emerges relatively recently as a distinctive practice of textual production and reception. But there is no question that adaptation studies, as distinct from adaptation, has a prehistoric period. It is not clear when this period begins—perhaps, as Glenn Jellenik argues in his contribution (Chapter 2) to this volume, at the dawn of the nineteenth century, perhaps fifty years later, with the rise and spread of the kinds of novel-based plays considered here by Renata Kobetts Miller (Chapter 3), who cites Charles Dickens's diatribe against adaptations in *Nicholas Nickleby* with a very different force from Jellenik's citation, perhaps with the arrival of cinema at the beginning of the twentieth century—but it clearly ends in 1957 with the publication of George Bluestone's *Novels to Film*. What makes this first period prehistoric rather than historic is that it does not deal directly with specific adaptations at all, but rather focuses on generalizations about literature and film as such. The leading figures in Adaptation Studies 0.0, as we may call it, often argue passionately—but always in general terms—about the possibility and advisability of turning novels or plays into movies. Vachel Lindsay, writing in 1915, emphasizes the differences between stage and screen productions; Virginia Woolf, in her 1927 essay "The Cinema," decries the folly of attempting to film any novel as ambitious and penetrating as *Anna Karenina*; Sergei Eisenstein's landmark 1944 essay "Dickens, Griffith, and the Film Today" establishes cinema as the logical successor to the nineteenth-century novel by describing the wide range of apparently cinematic techniques already employed in Dickens; Alexandre Astruc's 1948 polemic "The Birth of a New Avant-Garde: La Caméra-Stylo" argues that just as novelists use a pen to write, filmmakers, who should be considered their artistic counterparts and equals, use a camera. Whatever their disagreements with each other, the goal of all these commentators is to support general conclusions about the relations between literature and film, rather than analyses of or judgments about any particular adaptations.

This period comes to an end with the rise of Adaptation Studies 1.0, the period that establishes adaptation studies as a methodology and a field. Bluestone's widely influential monograph takes the form of a series of case studies designed to illustrate and illuminate general principles of adaptation. These principles are medium-specific,

emphasizing the fundamental differences between prose fiction and film as representational modes that pose challenges to anyone seeking to adapt a novel into a film. So profound are these differences, contends Bluestone, that the two modes are impossible to compare and adaptation a futile endeavor. But this conviction does not prevent him from devoting a seventy-page introduction to a general comparison of prose fiction and the cinema as storytelling modes and proceeding to six chapters comparing significant Hollywood films to their literary sources. Most adaptation scholars who follow over the next forty years do not share Bluestone's belief that novels and movies are categorically different representational modes. One tendency of adaptation theory during this period, marked by the continuing impulse to compare prose fiction and film as such, is to consider the impact of film on modern fiction and the relations between fiction and film as distinctively modernist approaches to representation. Over the past thirty years, this project, most explicit in the work of Keith Cohen and Bruce Morrissette but relatively neglected by Anglo-American adaptation scholars since, has continued to serve as the focal point for European intermedialists who have broadened its scope beyond novels and films to consider a much wider array of media and a more comprehensive set of possible relations among them. Another contemporaneous tendency has been far more influential in adaptation scholarship: the attempt to distinguish between different possible approaches to adaptation and different ways to describe these approaches—Geoffrey Wagner's transposition, commentary, and analogy, for instance, or Dudley Andrew's borrowing, intersecting, and transforming—that acknowledge some adaptations' attempts to remain faithful to their source texts and other adaptations' determination to rewrite them or use them as inspiration for new texts.

However divergent their beliefs on other subjects, the theorists of Adaptation Studies 1.0 share Bluestone's sense that, as Siegfried Kracauer trenchantly puts it, "each medium has a specific nature which invites certain kinds of communications while obstructing others" (3)—or, to use the language of Seymour Chatman's celebrated essay, that novels can do things films can't, and vice versa—and that the fundamental challenge of adapters is to find equivalents in one signifying system for signs that might seem to be unique to another system. This second period reaches a climax with Brian McFarlane's 1996 *Novels into Film*, which joins Bluestone both in deploring fidelity criticism—the belief that adaptations should be judged on the basis of how faithful they are to the texts they adapt—in its opening pages and in proceeding to a close comparison of a series of film adaptations with the novels they have adapted.

If medium specificity was the lodestar of Adaptation Studies 1.0, intertextuality was the leading principle of Adaptation Studies 2.0. Although Donald F. Larssen had attacked medium-specific assumptions as early as 1982, this new period was heralded more influentially by Deborah Cartmell and Imelda Whelehan's 1999 collection *Adaptation: From Text to Screen, Screen to Text*, which supplemented Bluestone and McFarlane's medium-specific analysis by pressing three new claims: that popular culture could be just as profitably mined as the literary canon by adapters and adaptation scholars, that the adaptations of texts that had been adapted repeatedly were particularly worthy of study, and that the vector from novel to film, as Álvaro Hattnher calls it in his

contribution to this volume (Chapter 21), could readily be inverted in novelizations like the *Star Wars* books and in films like *The Piano* that felt somehow literary even though they had not been adapted from any particular novel. The result was to cast adaptation in far more generous terms as something that happened not only when novels became films but when films became novels, when comic books became films or films became comic books, or when films were interpreted and consumed as if they had been based on novels. In *Adaptation Revisited*, Sarah Cardwell added television to this mix and deftly sketched the theoretical consequences of expanding the canon of adaptations, and in *Rethinking the Novel/Film Debate*, Kamilla Elliott took on the ostensibly absolute distinction between novels and films as allegedly verbal and visual texts by indicating how deeply implicated each of them was in the signifying system long associated with the other; she posited in place of media-specific dualities a reciprocal model in which both adapting and adapted texts held looking glasses up to each other.

The central text for Adaptation Studies 2.0 arrived in the form of three volumes, two of them—*Literature and Film* and *A Companion to Literature and Film*—edited by Robert Stam and Alessandra Raengo and the third, *Literature through Film*, a monograph by Stam alone. Together these three volumes reoriented adaptation studies along the lines of the intertextuality theorized by Mikhail Bakhtin, Julia Kristeva, and Gérard Genette, none of whom had written directly about adaptation. For Stam and Raengo, adaptation was no longer an isolated, exceptional phenomenon; it was merely one particular instance of the intertextual impulse at the heart of every text that sprang from and in turn generated other texts, so that, as Genette put it, "every successive state of a written text functions like a hypertext in relation to the state that precedes it and like a hypotext in relation to the one that follows" (395). Under the aegis of intertextuality, scholars from Linda Hutcheon to Cartmell and Whelehan, in *Screen Adaptation: Impure Cinema*, were freed to reconsider adaptation as a dynamic process that raised a wide range of questions, which Hutcheon memorably summarized as "What? Who? Why? How? Where? When?" (1), that earlier case studies had simply overlooked because they were preoccupied with questions of how to translate medium-specific signs and cues from one presentational mode to another.

Hutcheon's synoptic view of adaptation and the range of the questions she pursued made her 2006 overview, *A Theory of Adaptation*, the indispensable guide to Adaptation Studies 2.0, to which it offered a concise but thorough and systematic methodological overview. In particular, Hutcheon dramatized the way adaptation studies had moved from one phase to the next: not by resolving its central debates and moving on, but by bracketing or rejecting old paradigms. Instead of embracing new models of inquiry, the field made its critique of earlier models, and indeed prevalent models still highly influential in popular and journalistic writing about adaptation, central to its new inquiries. Scholars who practiced Adaptation Studies 1.0 did not approach literature and cinema as monolithic entities marked by absolute distinctions. Even if they began by assuming that the two presentational modes were distinct and incommensurable, they presented case studies that constantly called this assumption into question. Apart from Gordon E. Slethaug, whose *Adaptation Theory and Criticism* explicitly returns to the

foundational texts and tenets of post-structuralism in its analysis of "postmodern tex-
tuality" (5), participants in Adaptation Studies 2.0 have been more emphatic in their
rejection of fidelity criticism and medium specificity than in their embrace of Bakhtin
and Kristeva, whose intertextuality they absorbed mostly in Stam's version, but with-
out Stam's ideological commitments to the politically liberating powers of adaptation.
Complaints about the ritual flogging of fidelity discourse or medium specificity or case
studies rightly spread throughout the field because those criticisms persisted as founda-
tional moves for new interventions and new theories whose disavowals became consti-
tutive of Adaptation Studies 2.0.

In the same way, hints of Adaptation Studies 3.0 have taken two forms. One is an
embrace of digital technologies whose invitation to what Lawrence Lessig has called a
Read/Write Literacy, as opposed to the Read/Only Literacy that Lessig ascribes to print
technologies, poses a further challenge rather than any resolution to the questions liter-
ary scholars had been pursuing before the rise of the Internet. The other is an increas-
ingly pervasive suspicion of the limits of intertextuality as a methodological framework
because it makes it difficult to distinguish adaptations from other intertexts and threat-
ens to dissolve adaptation studies into intertextual studies. If assertions that what Henry
Jenkins has influentially called convergence culture and critiques of Adaptation Studies
2.0's uncritical adoption of intertextuality have so far produced more discontent with the
old paradigm than consensual allegiance to any new paradigm, that is par for the course.

These inquiries into the state of the discipline already assume that adaptation stud-
ies is a discipline. Having already considered some ways adaptation studies might
seek to escape its status as "a poor relation of both literary studies and film studies"
("Is Adaptation Studies a Discipline?" 20), I'd ask now simply what might be gained
and lost by thinking of adaptation studies as a discipline. The gains would be obvi-
ous: greater respect from other established disciplines like literary studies and cinema
studies; greater likelihood of institutional support from universities and foundations;
greater ability to direct professional conversations about the making and marketing and
analysis and consumption of texts; and perhaps even greater influence on nonprofes-
sional discussions of adaptation (though this last seems utopian). The probable losses,
however, are equally likely: the headaches of administering adaptation programs and
dovetailing them with other disciplinary offerings in universities; the institutional pres-
sures to subscribe to a single set of beliefs about what adaptation is and what adaptation
studies ought to be; and the inevitable proprietary defensiveness and turf battles as pro-
grams in adaptation studies, geared toward the production of critical knowledge rather
than toward the inculcation of readily marketable skills, faced the budgetary axes that
already threaten more established programs in the humanities. This is not the ideal time
for adaptation studies to declare its disciplinary independence.

That is ironic, since adaptation studies already has the hallmarks of several kindred dis-
ciplines. What Simone Murray calls the "insider-outsider status" that has led "medium-
specific disciplinary rivals" (186) like literary and cinema studies to marginalize the field
should remind us that cinema studies was an insurgent discipline as recently as the 1970s,
American literature as recently as the 1940s, and English literature as recently as the 1880s.

It is true that to the extent that it focuses on processes rather than products, emphasizing *adapt* as a verb over *adaptations* as a series of texts, adaptation studies abandons the possibility of a canon of the sort that has held literary studies, and to a surprising extent cinema studies, together for so long. In light of a long series of attacks on what continues to be called the Western literary canon—calls for its supplementation by once non-canonical works, fears that enlarging the canon might dilute its prescriptive force, accusations of its irrelevance to the needs of the modern world—and the gradual revelation that literary studies, lacking a consensual methodology, can ill afford to lose the canon that has provided its raison d'être for generations, adaptation studies' stance, more anti-canonical than non-canonical, looks downright prophetic. Certainly the discipline, if it is a discipline, has developed a canon of questions and concerns parallel to the central questions of literary theory. Patrick Cattrysse and a number of European intermedialists have sought to use these questions to configure the field more systematically along scientific principles.

For the moment, however, adaptation studies, continuing to resist calls to both scientific organization and the study of a canon, alternates between deploring and valorizing its marginal status. It lacks certain marks of institutional support—most notably, teachers and staff members dedicated to adaptation studies—though it maintains others, especially three journals (*Literature/Film Quarterly, Adaptation,* and the *Journal of Adaptation in Film and Performance*) and two associations (the Literature/Film Association and the Association of Adaptation Studies) that sponsor annual conferences. The field lacks a progressive disciplinary narrative history and a consensus on whether it is a disciplinary field or a range of interdisciplinary practices. Despite welcome exceptions like Robert Stam's contribution to this volume (Chapter 13), the scope of adaptation studies remains largely Anglo-American rather than international; indeed, many adaptation scholars outside the English-speaking world prefer to focus on Hollywood adaptations.

Even my reference here to Hollywood indicates another fault line over whether or not "the literary/screen nexus" is or should be "the heart of adaptation studies," as Cartmell and Whelehan argue (*Screen Adaptation* 12). In theory, most scholars currently working the field would probably disagree with Cartmell and Whelehan. Yet studies of literature-to-film adaptations continue to dominate both the field and its theorization, even in the hands of so ambitious a theorist as Cattrysse. There are many reasons why: the abiding cultural capital of the novel, the theater, and the cinema; the impetus of Hollywood adaptations in provoking increasingly wide-ranging debates about the nature of adaptation; the background of so many adaptation scholars in literary or cinema studies; the greater readiness of academic publishers to accept and commission monographs on novel-to-film adaptations. The present volume offers one additional reminder of this privilege. Because it is much easier to prepare illustrations from movies than to secure reprint permission for other kinds of images, practically all the illustrations in this volume—despite its aim to include a wide range of adaptations—are screen grabs from films based on novels or plays. The difficulties in obtaining permission to reprint images outside the cinema has prevented even Kate Newell's essay on adaptation and illustration (Chapter 27) from including any illustrations.

Whether they are celebrated or deplored, the foundational debates of adaptation studies are clear. The first of them, appropriately, is the question of what counts as an adaptation—or, if the expansive view of adaptation advanced by Stam and other commentators who root adaptation in the intertextual theories of Bakhtin and Kristeva is adopted, of what does not. If all texts are intertexts, as adaptation scholars have increasingly been inclined to agree, then which intertexts should be called adaptations, and why? Several further questions follow logically from this one. Can, and should, adaptation be defined as a particular group of texts? If so, what distinguishes the species of adaptation from other members of its genus? If not, should it be defined in terms of a particular impulse or practice? Is it more properly defined by its makers or its consumers? Dennis Cutchins and Nico Dicecco both wrestle with these problems in their contributions to this collection (Chapters 4 and 35, respectively). Since they reach very different conclusions about whether and how adaptation is to be defined, however, they can hardly be said to have exhausted the topic.

Another foundational question concerns the notion of fidelity, the responsibility of adaptations to communicate or evoke some essential features associated with the texts they are adapting. Fidelity has become something of an undead spirit in adaptation studies—attacked by scholars as far back as Bluestone, who began his study of novels and films by announcing, "It is as fruitless to say that film A is better or worse than novel B as it is to pronounce Wright's Johnson's Wax Building better or worse than Tchaikowsky's *Swan Lake*" (5–6)—regularly castigated by later generations of adaptation scholars as a chimera and a red herring, yet repeatedly arising from the grave in collections like *True to the Spirit: Film Adaptation and the Question of Fidelity* and explicitly acknowledged as a powerful force even by Stam, whose intertextual orientation would seem to render it moot. In fact, adaptation scholars' repeated attacks on fidelity as a criterion of a given adaptation's value is an apt measure of the field's estrangement from both the public discourse on adaptation (especially from film reviews of adaptations, which typically consider their faithfulness or unfaithfulness an unproblematic evaluative touchstone) and other disciplines in the humanities (for example, Victorian studies, whose practitioners, writing on websites like the Victoria listserv and Streaky Bacon, routinely assess film adaptations as teaching aids whose value is largely a function of their fidelity). Fidelity, widely execrated within the field as a criterion for the success or failure of an adaptation, is just as widely adopted as a criterion outside the field. Indeed, Glenn Jellenik argues in his contribution to this volume (Chapter 2) that it has been a defining criterion of adaptation for as long as adaptations have been recognized as such. In his own contribution, David T. Johnson (Chapter 5) acutely notes that the attack on fidelity has been a much more important move within the field than the embrace of fidelity. It may well be true, as he argues, that attacks on fidelity studies come disproportionately from outside adaptation studies, but it is at least equally true that both defenses of fidelity studies, like those in *True to the Spirit*, and the much more common assumption that fidelity can be reflexively and unquestioningly used to evaluate the success or failure of a given adaptation also come disproportionately from outside adaptation studies—from reviewers, journalists, and literary scholars in fields like Victorian studies. No one inside or outside the

field has yet provided definitive answers to the pointed questions Mary H. Snyder asks in her contribution (Chapter 6): "Is it necessary for screenwriters to honor their source texts? And who decides whether they're being honored?"

A third foundational debate turns on the question of whether adaptation study should be fundamentally analytical or fundamentally evaluative. My own arguments in favor of the analytical basis of adaptation studies have been countered by James Naremore, Fredric Jameson, and several other contributors to *True to the Spirit*. But these commentators represent only the tip of the iceberg, for almost every essay on adaptation makes assumptions about the role of evaluation in adaptation studies, whether those assumptions are made explicit or merely come out through particular keywords or a particular tone. No one seriously proposes that we stop evaluating adaptations; the debate is over what place evaluation ought to play in the field. The answer to this question depends largely on whether adaptation studies is conceived in the fundamentally aesthetic terms associated with Anglo-American scholarship through journals like *Adaptation*, departments of English and literary studies in the United Kingdom and the United States, and the liberal arts generally, or in the alternative terms—analytical, theoretical, ideological, sociological, categorical—associated with the Birmingham school of cultural studies in England, the sociological analysis called for by Dudley Andrew and James Naremore (themselves both largely aesthetic in their own orientations) and pioneered by Simone Murray's economic account of the adaptation industry, and the rigorously categorical analyses provided by Patrick Cattrysse and intermedial scholars in Germany, Scandinavia, and other intellectual centers of Continental Europe. The evidence presently available shows that both approaches, the aesthetic and the analytical, can flourish among sizable cohorts; the question, as Eckart Voigts-Virchow raises it in "*Metadaptation*: Adaptation and Intermediality," is how to get them to talk to each other in common terms. Despite all the conferences, papers, and informal dialogues between adaptationists and intermedialists since Voigts-Virchow wrote in 2009, this problem remains as urgent as ever.

Still another foundational question concerns the value of the case study—most frequently, the analysis of how one particular film adapts one particular novel—for adaptation studies generally. The most influential attack on the case study is Robert Ray's 2000 essay "The Field of 'Literature and Film,'" which dismisses one-to-one comparisons of novels and films as servile, parochial, limited in their theoretical implications, confined to specialized journals with limited impact, and dictated only by the economics of academic publishing, which encourage researchers to publish as many articles as possible in the race to beat the tenure clock, ensuring that each article requires as little research in pursuit of a goal of minimal scope and consequence. I joined this attack myself in *Film Adaptation and Its Discontents*, well aware that that volume itself was a collection of case studies, though most of them dealt with more than a single novel and a single film. Although few scholars have risen to an explicit defense of the case study as a methodology, it is not hard to imagine such a defense, based for example on the analogy with the experiments scientists devise to test their working hypotheses. Ray's assumption that the vast majority of case studies have no hypothesis in mind to test—they are merely conducting the kind of compare-and-contrast exercises so beloved of undergraduate students—would surely not apply to most contemporary case studies. And there are

many such examples, for the model continues to proliferate, often without a word of self-justification, in conference presentations. It could hardly be otherwise, for the serious constraints on the length of such presentations—about three thousand words for a twenty-minute presentation—makes it distinctly challenging to analyze more than a single case in any detail and leads to a fracture between two kinds of presentations: the case study offered frankly as a microcosm or representative anecdote illustrating a particular hypothesis, and the theoretically driven argument that plucks much briefer examples, illustrated in passing by PowerPoint slides of pull-quotes or frame grabs, from a wider range of texts. Every issue of *Literature/Film Quarterly* or *Adaptation* or the *Journal of Adaptation in Film and Performance* is inevitably another collection of case studies. So are edited collections of essays on adaptation studies like the present volume, which continue to dominate book-length publications in the field.

The place of case studies in the field raises the larger question of whether adaptation scholarship is more usefully advanced by the close readings Simone Murray deplores or by more general, synthetic, holistic approaches. Clearly any humanistic field, like any science, advances—assuming of course that advancement is what it seeks—through a combination of categorical, top-down approaches driven by theoretical hypotheses and empirical, bottom-up approaches driven, in the case of adaptation studies, by textual analysis. The question is how to integrate the two. The work of Continentally trained intermedialists like Patrick Cattrysse, Eckart Voigts, Marie-Laure Ryan, and Lars Elleström abounds in maps and diagrams that show, for example, exactly what room adaptation is assigned in the larger mansion of intermedial practices. Elleström's recent work has increasingly focused on defining the place of adaptation and adaptation studies within intermediality and intermedial studies, and he naturally uses spatial models to show how that place can best be imagined. But since every map is in a no-holds-barred competition with other maps, which it dismisses as inaccurate or incomplete, it also makes sense to consider other models whose orientation is temporal rather than spatial. Instead of maps of adaptation and intermediality, scholars often present histories and other narratives about adaptation, whether or not they include intermediality. The advantage of temporal narratives over spatial maps is that they are not mutually exclusive; as every historian knows, multiple narratives can flourish at the same time. But this pluralism comes at a price that Robert Gorham Davis has labeled "the professors' lie" (6): humanistic scholars who hold mutually incompatible positions and make no attempt to test their positions against each other because they simply assume that pluralism is the order of the day do an insidious disservice to their students and the field they ought to be advancing. Even so, it would be unnecessarily scrupulous for adaptation to shun the paradigm of competing narratives given the monumental investment in this strategy that the academy has already made, from classrooms to conferences to collections like this one.

I have already indicated some of the ways in which different contributors to this volume address these foundational problems. Before reviewing its contents in greater detail and turning to debates more specific to them, I'd like to offer the general assurance that this work does not pretend or aspire to be definitive. If it did, it would already face stiff competition from recent collections edited by James Naremore, Robert Stam and Alessandra Raengo, and Deborah Cartmell, and it would be swiftly superseded by

competitors forthcoming from Routledge, edited by Dennis Cutcheon, Katja Krebs, and Eckart Voigts, and from Palgrave Macmillan, edited by Julie Grossman and R. Barton Palmer. Unlike the Palgrave collection, and even more the Routledge collection, its genesis and organization are top-down rather than bottom-up. Instead of linking an open call for submissions to a series of topics or recruiting the leading adaptation scholars and turning them loose to write whatever they wanted, I developed the table of contents myself, revised it in response to suggestions from three helpful outside readers enlisted by the Press, and then sought out the particular scholars I thought best qualified to write on the topics I had chosen. Some of the scholars I approached declined my invitation—not surprisingly, since I aimed as high as I could. Others accepted but then had to drop out because of illness, life changes, or other commitments. Still others wrote quite different essays from the ones I'd had in mind. Along the way, correspondence with friends and acquaintances on other subjects made me resolve to propose topics they might consider that my original outline had not included. So this volume, conceived in terms of a single top-down design, is better thought of as a series of compromises between the contributors and me and between me and my editor and readers—generated, as Keith Wilhite puts it in his contribution to this volume (Chapter 37), through a continuous process of mutual adaptation—or a fresh round of debates generated by the contributors, only a few of whom invoke each other by name.

The organization of the volume's seven parts roughly follows the development and spread of adaptation studies as I have outlined it here. But these parts, everywhere informed by implicit debates, should not be construed as constituting a history of adaptation studies, much less of adaptation itself. The six essays in the Part I, "Foundations of Adaptation Study," are united not by their focus on the earliest adaptations or methods for studying adaptation but by their concern with first principles. Following Timothy Corrigan's overview of attempts to define adaptation (Chapter 1), which situates the practices of contemporary theorists in a much older discourse, Glenn Jellenik in Chapter 2 provides a sharply divergent view that traces the birth of "adaptation, as such," to a single day, 12 March 1796. Renata Kobetts Miller, countering the tendency to privilege page-to-screen adaptations, examines in Chapter 3 two page-to-stage sets of adaptations that bookend the history of adaptation in nineteenth-century England. A quite different approach to the foundations of adaptation is represented in Chapter 4 by Dennis Cutchins's discussion of Mikhail Bakhtin, who is frequently invoked but rarely discussed in detail as the founding spirit of the intertextual approach characteristic of Adaptation Studies 2.0, and David T. Johnson's review in Chapter 5 of the persistence of fidelity as a touchstone for the analysis and evaluation of individual adaptations and a primary impetus for adaptation in general. Mary H. Snyder (Chapter 6) concludes this opening part with a plea to practitioners and theorists of adaptation to search for common ground.

Part II, "Adapting the Classics," focuses on adaptations of canonical works of literature. But the contributors to this part all distance themselves in different ways from the generally devotional tone of the essays in canonical adaptation so characteristic of Adaptation Studies 1.0. Instead supplying obligatory chapters on adaptations of

Shakespeare, Austen, and Dickens, they consider what might be called alternative canonical adaptations that offer new ways of thinking about the whole project of canonical adaptation. Wendy Zierler's tour (Chapter 7) of adaptations of the biblical figure of Moses develops a model of adaptation based on the exegetical practice of midrash, a practice that has invitingly broad implications for theories of adaptation. Dennis Perry's survey (Chapter 7) of movies based on Mary Shelley's *Frankenstein* emphasizes both the exemplary status of Baron Frankenstein's monster as a figure for adaptation and the wide range of uses to which the cinema has put the monster. Eirik Frisvold Hanssen, Mieke Bal, and Jack Boozer (Chapters 9, 10, and 11) explore the ambivalence of specific adaptations to writers—Henrik Ibsen, Gustave Flaubert, and Philip Roth—whose adapters both acknowledge them as classics and consider it imperative to distance themselves from them. Hanssen describes the ways silent filmmakers and their audiences regarded Ibsen as both daring and dated, a classic who had to be soft-pedaled, updated, and Americanized. Bal recounts the strategies she and Michelle Williams Gamaker adopted in recasting *Madame Bovary*, the adamantine rock on which so many adaptations have foundered, as a deliberately anachronistic "intership," a film and video installation that seeks a conceptual alternative to fidelity. And Boozer discusses the tricky business of adapting the work of a living novelist you love while resolving to declare your independence from his interference. This second part concludes with William B. Jones's overview (Chapter 12) of the different strategies the comic book series *Classics Illustrated* took toward the novels and plays and histories and poems that different volumes adapted—strategies that to a surprising extent reflect the attitudes scholars have taken toward the project of adaptation generally.

Unlike the adaptations that are the focus of Part II, those under consideration in the Part III, "Adapting the Commons," use the materials they adapt, typically drawn from what Robert Stam here calls the aesthetic commons, as raw material rather than inspiration. Indeed a more precise title for this section might have been "Adapting the Literary Commons in the Age of Translationalism," since both Stam and Lucia Krämer deal with cinematic adaptations that often treat literary classics as if they were no more than another part of the commons freely available to all. Stam's brisk traversal of culturally revisionist adaptations (Chapter 13) provides the keynote for this part in its examination of the different kinds of "performative infidelities" open to adapters whose attitude toward their sources ranges from reverent to defiant. Focusing on the adaptive practices of Bollywood cinema, Krämer (Chapter 14) reveals a commercial culture in which adaptation of variously canonical sources that the industry considers the aesthetic commons is as rampant as it is unacknowledged, providing a challenge to Hutcheon's dictum that "adaptation *as adaptation* is unavoidably a kind of intertextuality *if the receiver is acquainted with the adapted text*" (21) and a powerful alternative to Hollywood's adaptation industry. Constantine Verevis (Chapter 15) examines the relationship between adaptations and its discursive cousins—remakes, sequels, and prequels—which some scholars consider adaptations and others do not. Eckart Voigts (Chapter 16) brings this part to a close by his survey of recombinant adaptations, digital creations that draw on the commons in ways that may extend the frontiers of adaptation or mark a brave new world beyond it.

Part IV, "Adaptation and Genre," is the longest in the volume, but it is not nearly long enough, for it would have had to be extended indefinitely if it were to cover all the ways adaptations shift their tactics when they operate within different presentational genres. It begins with Linda and Michael Hutcheon's comprehensive survey (Chapter 17) of the adaptive strategies at play in opera, perhaps the representational mode that depends most clearly at every stage of its composition on earlier texts. Mike Ingham (Chapter 18) adds a complementary view of the pervasive role of adaptation in popular songs that set earlier texts to music. Richard J. Hand in Chapter 19 makes a case for the importance of radio adaptation, which scholars have generally neglected in favor of cinema and television adaptations, even though the presentational limitations it embraces make it in some ways a far more suggestive model. Stijn Joye, Daniël Biltereyst, and Fien Adriaens (Chapter 20) explore the paradoxes of telenovela adaptations, which repeatedly transplant a model designed to attract audiences in one specific culture to foreign cultures. Álvaro Hattnher in Chapter 21 examines the many lives of zombies in adaptations that take their cue from heroes defined by their afterlives, drawing out the possibility that adaptation itself is not so much an act of creation or recreation as a plague. Wendy Siuyi Wong (Chapter 22) traces the development of Hong Kong manhua from comic books to the films that introduced them to a still wider audience, and Dan Hassler-Forest, taking the opposite tack in Chapter 23, considers the reasons three much-heralded comic book adaptations failed to set new patterns for Hollywood. In Chapter 24, I. Q. Hunter examines the surprising intimacy between pornographic movies and adaptation, and Kevin M. Flanagan (Chapter 25) concludes this part with a suggestive look at the strategies that videogames follow in adapting both their ostensible sources and their own earlier generations.

The essays in Part V, "Adaptation and Intertextuality," focus more narrowly on two topics: the relations between the specific case of adaptation and more general instances of the intertextuality that provides the keynote for Adaptation Studies 2.0, and the implications of defining adaptation as an intertextual mode. Claus Clüver in Chapter 26 considers the affinities and differences between adaptation and ekphrasis, the venerable "genre of verbal representations of configurations in visual media" ranging from Achilles' shield to John Hollander's poem "Edward Hopper's Seven A.M. (1948)." Kate Newell (Chapter 27) focuses more narrowly on the relation between adaptation and the visual illustration of verbal texts. Laurence Raw (Chapter 28) summarizes the fraught relationship between adaptation and translation scholars and proposes ways of bringing their views of intertextuality into closer harmony. Lars Elleström in Chapter 29 proposes a series of topics for adaptation scholars to engage in order to situate their field more coherently within the larger field of intermedial studies. Marie-Laure Ryan (Chapter 30) analyzes the implication of contemporary intermedial storytelling for theories of adaptation, and Kyle Meikle (Chapter 31) rounds out this part by asking how new the interactivity widely perceived as licensed by digital media actually is and what lessons convergence culture offers adaptation scholars.

Part VI samples the forbiddingly vast subject of the relationship between textual adaptation and other disciplines. Petr Bubeníček in Chapter 32 examines postwar Czech film adaptations of the reformist cleric Jan Hus to probe questions about adaptation and political ideology. Defne Ersin Tutan (Chapter 33) supports her argument about

adaptation and history by considering the very different reception that greeted the popular television program *The Tudors* in the United Kingdom and Turkey. Brian Boyd (Chapter 34) urges adaptation scholars to attend more closely to the biological metaphor from which their field takes its name, situating the practice of textual adaptation within a much wider array of adaptive strategies common to human beings and other species. Nico Dicecco (Chapter 35) closes this part with a bold redefinition of adaptation as a performative and receptive practice rather than an assembly of texts.

"Professing Adaptation," the seventh and final part, is the one most frankly oriented toward prescriptions for the future. Marty Gould in Chapter 36 lays down fundamental principles for teaching adaptation within the humanities in general and the institutional context of the American Common Core Standards in particular. Keith Wilhite (Chapter 37) examines the surprisingly neglected relationship between the formal procedures of adaptation and the incessant process of revision that teachers across the disciplines urge on their students because it plays such a vital role in all textual production. The final essays are the most prescriptive of all. Peter Lev (Chapter 38) advises scholars seeking to write adaptation history to base their arguments more firmly on archival research. Kamilla Elliott (Chapter 39) provides a bracing critique of adaptation scholars' enduring embrace of high theory and urges a radical consideration of the relationship between adaptations and theories. My own essay (Chapter 40) closes this part and the entire volume with a call, not for new and better theories of adaptation, but for a different attitude toward theories in general.

None of these essays resolves the foundational debates I have enumerated. Although I have been mindful of Elliott's critique of the naïve assumption that "if we use all the theories, then we will arrive at a comprehensive picture of adaptation" ("Rethinking" 583), my leading purpose in bringing so wide a range of essays together has been to encourage new debates. Some of these involve differences in emphasis or terminology in addressing long-standing questions, rather than substantive disagreements. Álvaro Hattnher and Marty Gould, in their very different essays, agree that the battle over whether adaptation studies should be broadened beyond the novel-to-film paradigm has essentially ended; even adaptation scholars, here and elsewhere, who narrow their focus to novels and films—or to comic books or manhua, or videogames or popular songs or opera— do so for the sake of convenience and salience, not out of a conviction that the field should be limited to their own particular area of expertise. Indeed, a salutary effect of the broadening of adaptation studies' purview has been to absolve any one practitioner for responsibility for the whole field, freeing scholars to work as members of teams or as friendly competitors. Claus Clüver, Lars Elleström, and Kate Newell take very different approaches to the question of how adaptation is related to such different modes of intermediality as visual ekphrasis, but their approaches, for all those differences, are better seen as complementary than as mutually exclusive. In similar ways, Marie-Laure Ryan's careful taxonomy of transmedial approaches to storytelling and Kyle Meikle's attack on the distinction between adaptation and the self-proclaimed interactive or participatory tendencies of transmedia storytelling are instructively read in connection with each other, since their very different conclusions could well drive further debate about the relation between transmediation and adaptation. And if, instead of asking whether

adaptation studies ought to be conceived as a discipline, we adopt, or adapt, John Bryant's question—"Who are the agents of adaptation and for whom do they speak?" (109), Elleström, Laurence Raw, and Timothy Corrigan offer material for provocatively different answers to the question of who owns adaptation studies, who gets to decide what counts as an adaptation, and for what purposes.

Several substantive debates arise between different contributors, whether or not they are aware of them. Timothy Corrigan, Glenn Jellenik, and Renata Kobetts Miller all offer different takes on the questions of when adaptation begins, what its relation to its forebears is, and whether these forebears constitute what might be called a prehistory of adaptation as such or a series of intertextual practices that are either so similar to adaptation that they should share its name or so different that they constitute an entirely different chapter in the history of textual production and consumption. How much does an audience need to know to experience an adaptation, in Linda Hutcheon's terms, "as an adaptation" (6)? Dennis Cutchins supplies an answer to this question that is sharply, albeit implicitly, at odds with both Hutcheon's *Theory of Adaptation* and the answers of several other contributors. Are distortions of history in adaptations aberrant, and therefore noteworthy and subject to correction, or built into the process of adaptation itself? Petr Bubeníček, following most professional historians, spends most of his essay arguing for the first of these positions, though he acknowledges the force of the second in his closing paragraphs; Defne Ersin Tutan assumes the second throughout.

Other debates that seem to involve only terminological preferences end up involving much more. For many years, the texts that adaptations adapted were called "source texts," a loaded term whose hidden agenda Bakhtin and Kristeva revealed. Hutcheon has called them "adapted texts," Gérard Genette "hypotexts." Among the contributors to this volume, Marty Gould calls them "originary texts"; Lucia Krämer calls them "pretexts"; Laurence Raw continues to prefer "source texts." Each of these terms is freighted with its own baggage, but there is no point in looking for a term that is not; even the most neutral-sounding term, assuming that every practitioner were willing to embrace it, ends up implicated in associations of one sort or another. Instead of seeking the most precise terms possible, we might ask instead what is at stake in the choice of any particular term. Given the frequent confusion and self-absorption arising from competing terms, is it better to work toward the goal of committing practitioners in the field to a single term, or of preserving the nuances and debates that different terms suggest?

More generally, contributors have very different ideas about how to organize the field of adaptation studies and resolve its terminological discrepancies. When Elliott, writing fifteen years ago, proposed "looking glass analogies" (*Rethinking* 209) as a more precise and illuminating model for adaptation than any of the six models she surveyed in an earlier chapter, her term did not catch on widely. But much of her analysis has been broadly influential, even among scholars who have poured her new wine into older terminological bottles. Elleström and Clüver propose what amount to maps or rationales designed to organize the field more systematically. Brian Boyd's essay, by contrast, implicitly raises the question of whether, considering its heavy metaphorical baggage, we ought to be using the word "adaptation" at all, and Mieke Bal proposes a new term, *intership*, to replace *adaptation*.

Still another unresolved problem lurks in the table of contents itself. From the inception of this project, I have been at pains to make it interdisciplinary. Indeed, its interdisciplinary impetus seems to me the feature that most clearly distinguishes it from competing collections. Like most interdisciplinary projects, however, this one is more precisely described as undertaken in a spirit of interdisciplinary outreach, with a single orientation—here, adaptation studies—serving as the center for a wide array of investigations into areas that all have methodological centers of their own, centers that are inevitably decentered or ignored for the purposes of this project. Despite my best efforts, the enterprise retains an irreducibly evangelical impulse, as adaptation reaches out to what operate here as satellite areas, announces the good news to them, and considers how adopting the problems and terms and methods of adaptation studies can improve them. Despite contributions by experts in other fields—Renata Kobetts Miller's essay in theatrical history, Wendy Zierler's in midrash, Brian Boyd's in biological adaptation, Keith Wilhite's in rhetorical revision—this collection remains focused on what Hutcheon has called "adaptation proper" (171) and adaptation studies as the field is currently understood, its essays on outlier areas seeking to enlarge the field at the implicit expense of other approaches and other fields. Individual readers must weigh the virtues of this imperialistic project—most notably, its success in making adaptation studies more resourceful by bringing a broader, more flexible set of methods and materials within its purview—against its real dangers: the possibility that enlarging adaptation studies will not only decenter it but dilute or dissolve it, and the opposite danger of proposing an all too plausible center for a field that by its very nature subordinates centers of any kind to the ongoing process of adaptation. It is particularly illuminating in this connection to read Wendy Siuyi Wong's cultural history of modern Hong Kong through manhua adaptations against Dan Hassler-Forest's essay on roads not taken in Hollywood's adaptation of comic books. These two contributions are equally historical in their orientation, but they conceive adaptation's relation to history, and indeed the nature of history, very differently.

Other problems that arise here are less explicit debates than open questions to be continued in later discussions. Dennis Cutchins and Laurence Raw both emphasize the relations between adaptation studies and translation studies, but their very different views of those relations is less likely to provoke synthesis than further rumination. Lucia Krämer's observation that "the [Bollywood] adaptation is a secondary genre, and a given adaptation's marketing can offer the potential viewer different entry points, the film's status as an adaptation being only one of them" offers an invitation to rethink the Euro-American assumptions that prevail in most of the contributions here about the practices of the adaptation industry and the question of whether a given adaptation needs to be identified, perceived, and acknowledged as an adaptation in order to count as an adaptation. Investigating the implications of this insight for Hollywood adaptations is beyond the scope of Krämer's essay; interested readers are invited to pursue it on their own.

Another area explored but not resolved here is the status of different fictionalized figures as tropes for adaptation. Dennis Perry considers Frankenstein's monster, cobbled together from bits and pieces of diverse corpses, as a paradigmatic figure for adaptation;

Álvaro Hattnher nominates zombies, which maintain their lives by feeding on the flesh of humans, who then become zombies themselves. In their essay on telenovelas, Stijn Joye, Daniël Biltereyst, and Fien Adriaens briefly consider the peculiar status of melodrama in general and telenovelas like *Ugly Betty* in particular as both products and sources of essentially opposed adaptive impulses, at once formulaic and adaptable, nationalistic and universal (that is, "glocal"), open and closed. Their analysis suggests that the very features that make texts most likely to appeal to very specific audiences also make them most likely to be adapted or indigenized for very different audiences— a proposition that throws new light on Brian Boyd's arguments about the need for all texts, like all organisms, to adapt or die. As if enlarging on Dan Hassler-Forest's "roads not taken" approach, Linda and Michael Hutcheon, Richard Hand, and Mike Ingham provide material for reflections about how adaptation theory might be different if it were rooted in opera or radio or song instead of in novels and films.

Several indications of subjects for further investigation seem especially urgent. Implicitly or explicitly, Constantine Verevis, Eckart Voigts, and Kyle Meikle all consider the question that Hutcheon and Siobhan O'Flynn advance in the second edition of *A Theory of Adaptation*: "For adaptation studies, is ours a transitional time or are we facing a totally new world" (xix) shaped by the dramatic rise of digital media? Hutcheon and O'Flynn see digital media and the participatory culture they enable as game changers. Verevis's analysis of the resulting mediascape is evenhanded and noncommittal; Voigts reports skeptically on the "not just" rhetoric of contemporary storytellers and theorists who rejoice in anointing transmedial texts as not just adaptations but something more; and Meikle vigorously dissents from the whole narrative in which digital media bring participatory culture to birth. But all three of them, together with most of this volume's contributors, would probably concur with Voigts's admonition: "Adaptation studies must focus on what people do with texts, rather than how they process or interpret texts." I. Q. Hunter's examination of the pornographic adaptations whose heyday preceded that of the digital revolution suggests some of the ways X-rated video adaptations designed to produce specific physiological reactions offer a fascinating, albeit implicit, prefiguration of participatory culture and inflect Hutcheon's question and Voigts's admonition in provocative new ways.

Whatever attitude adaptation scholars take toward the digital revolution, it has only intensified debates concerning the foundational questions in the field. How consistently and categorically can and should adaptation be theorized? Laurence Raw, taking issue with Patrick Cattrysse, throws new light on this question without attempting to settle it for good. Should adaptation studies be driven by deductive (top-down) theory or empirical, inductive (bottom-up) analysis? Continental intermedialists continue to prefer the former approach, Anglo-American adaptations the latter. Here at least a rapprochement should be possible, since both approaches are so clearly essential to the development of any field that it would be calamitous if either party convinced the other to give up its research. But such a rapprochement continues to hinge on a search for a common language that would foster productive dialogue between the two approaches, and this language continues to be maddeningly elusive. Finally, is adaptation study a science?

Should adaptation scholars follow scientists in their attempts to resolve debates? Should we welcome and foster debates as the material of a discipline that is and should remain immitigably aesthetic or humanistic? Or should we simply seek to get beyond them or periodically change the subject, if only to escape the tedium of reinventing the wheel, thrashing the same straw men, or recycling the same disciplinary clichés over and over?

The present volume, like this introduction, makes no attempt to resolve most of these questions. But it's not Olympian or objective either. Through its original design and a group of congenial contributors' interpretations of that design, their own contributions to it, and the field in general, it weighs in on many of them. If I may presume to speak for most, if not all, the contributors, this volume takes several positions no less significant for being unofficial and often unsought. It assumes, to begin with a position that has achieved something like consensus, that it is better for adaptation studies to risk flinging its doors too wide than to ignore the ever-growing volume of adaptations that are not films based on novels. As readers of recent issues of *Literature/Film Quarterly* can attest, that particular genie isn't going back into the bottle, even in a journal whose title hearkens back to a more restricted corpus. The very presence of so many different viewpoints, methodologies, and kinds of adaptations in this volume attests to the belief that it is healthier for the field to be riven by debates than to produce methodological consensus. More pointedly, adaptation studies can and should be informed by both aesthetic and sociological approaches. Not only is there room for both Simone Murray and the close readings she deplores; each of them provides an indispensable framework for interpreting the other. Recent developments in literary and cinema studies suggest that these kindred fields have consistently been healthier when they teach their foundational conflicts instead of seeking consensus and banishing the heretics who reject it. For all the complaints they have provoked about navel-gazing, metaphysics and ethics and aesthetics have flourished for thousands of years because, instead of resolving debates about the nature of existence or the path to the good life or the status of art, they have continually folded new twists on these age-old questions into the corpus and the practice of their own disciplines.

Despite the forbidding bulk of this volume, its status as only one among many such volumes offers compelling evidence that it would be not only arrogant but unnecessary for any one person or any one volume to attempt to cover the field. Multiple perspectives can be complementary and mutually illuminating, even (or especially) through the conflicts among them. Adaptation studies can profit greatly from closer attention to the sciences, but the field should not try to become a science itself. Debates within the field, as in so many others, should be neither resolved in the interests of progress and clarity nor simply celebrated as evidence of intellectual ferment but rather *managed* in the manner exemplified by Kenneth Burke's prescription of "comic ambivalence" (93) that allows observers at once to debunk and to transcend the "acceptance frames" (92) that make life meaningful.

As the essays by contributors like Mieke Bal, Wendy Siuyi Wong, Claus Clüver, and Brian Boyd demonstrate, adaptation study can reap rich benefits from dialogue with scholars in other fields. This volume, not so much a museum as a laboratory and a

provocation, actively seeks to promote further dialogue along these lines, and through its example to promote new lines of dialogue its contributors cannot yet imagine. Over and above the problems of self-placement that essay collections of this sort typically raise (who is the target audience, what do they already know, what are they looking for?), dialogue between adaptation scholars and their counterparts in other fields presents a new problem: how should the dialogue between an insurgent field like adaptation studies and more established fields that are less central to the volume be balanced? The volume neither seeks a definitive answer to this question nor endorses the prospect of one. Instead of balancing this dialogue, it can only suggest some different ways of managing it. In his contribution, David T. Johnson points out the implications of the assumptions Kenneth Rothwell does and does not make about his audience in discussing Roman Polanski's 1971 film adaptation of *Macbeth* in the first volume of *Literature/Film Quarterly.* We could extend his analysis to Marty Gould's acknowledgment at the outset of his essay on teaching adaptation that he does not assume an audience familiar with the fundamental issues at stake, or the expository focus of Dennis Cutchins's essay on Bakhtin—a figure whose writings are apparently little read by adaptation scholars despite his enormous impact on the field—or the even more emphatic focus on first principles in Mary H. Snyder's essay on the roles of adapters and adaptation scholars in the adaptation industry. At the other end of the deictic spectrum, we could consider the rhetorical paradox implicit in Kamilla Elliott's essay on adaptation scholarship, which assumes an audience already familiar with that body of work even as it exposes example after example of adaptation scholars' pervasive and debilitating unfamiliarity with their own field.

Although scientific approaches to adaptation studies commendably urge scholars to quit fighting yesterday's battles and beating dead horses, this volume's strongest position is once again a negative one: its resistance to the dream of settling the fundamental questions in adaptation studies. Instead, its enabling proposition is that the seeds of Adaptation 3.0 are most likely found in the questions its contributors raise and the debates they seek to clarify without necessarily settling them, or perhaps even aspiring to resolve them. Instead of closing with a summary, therefore, it seems more appropriate to end this introduction with a series of interrelated injunctions. So make way for the main event, here presented in forty segments. Join me in thanking Brendan O'Neill, who commissioned this volume for Oxford University Press and readied it for review; Norman Hirschy, the OUP editor who carried it successfully to publication; Alexa Marcon, the indispensable OUP staffer who answered my every call with helpful information and reassurance; Prabhu Chinnasamy, who supervised the volume's production; Dorothy Bauhoff, whose copyediting elicited praise and gratitude from all concerned; and, most importantly, all the contributors, who have done everything in their power to make this the best collection they could. Consider well what to make of what these contributors have to say. Then, enlightened or provoked like the readers of *A Christmas Carol* or *Joy of Cooking,* prepare your own attitudes, works, and dishes, as the study of adaptation constantly invites everyone to do. To adapt an ancient injunction: go and do likewise—or not.

Works Cited

Andrew, Dudley. "Adaptation." *Concepts in Film Theory*. New York: Oxford UP, 1984. 96–106. Print.

Aragay, Mireia, ed. *Books in Motion: Adaptation, Intertextuality, Authorship*. Amsterdam: Rodopi, 2005. Print.

Astruc, Alexandre. "The Birth of a New Avant-Garde: La Caméra-Stylo." 1948. Rpt. in Corrigan 181–84. Print.

Bluestone, George. *Novels into Film*. Baltimore: Johns Hopkins UP, 1957. Print.

Bruhn, Jørgen, Anne Gjelsvik, and Eirik Frissvold Hanssen, eds. *Adaptation Studies: New Challenges, New Directions*. London: Bloomsbury, 2013. Print.

Bryant, John. *The Fluid Text: A Theory of Revision and Editing for Book and Screen*. Ann Arbor: U of Michigan P, 2002. Print.

Burke, Kenneth. *Attitudes toward History*. 3rd ed. Berkeley: U of California P, 1984.

Cardwell, Sarah. *Adaptation Revisited: Television and the Classic Novel*. Manchester: Manchester UP, 2002. Print.

Carroll, Rachel, ed. *Adaptation in Contemporary Culture: Textual Infidelities*. London: Continuum, 2009. Print.

Cartmell, Deborah, ed. *A Companion to Literature, Film, and Adaptation*. Chichester: Wiley Blackwell, 2012. Print.

Cartmell, Deborah, and Imelda Whelehan, eds. *Adaptation: From Text to Screen, Screen to Text*. New York: Routledge, 1999. Print.

Cartmell, Deborah, and Imelda Whelehan. *Screen Adaptation: Impure Cinema*. Basingstoke: Palgrave Macmillan, 2011. Print.

Cattrysse, Patrick. *Descriptive Adaptation Studies: Epistemological and Methodological Issues*. Antwerp: Garant, 2014. Print.

Chatman, Seymour. "What Novels Can Do That Films Can't (and Vice Versa)." *Critical Inquiry* 7.1 (1980): 121–40. Print.

Cohen, Keith. *Film and Fiction: The Dynamics of Exchange*. New Haven: Yale UP, 1979. Print.

Corrigan, Timothy, ed. *Film and Literature: An Introduction and Reader*. 2nd ed. London: Routledge, 2011. Print.

Davis, Robert Gorham. "The Professors' Lie." *Columbia Forum*. New series 1.4 (Fall 1972): 6–15. Print.

Eisenstein, Sergei. "Dickens, Griffith, and the Film Today." *Film Form: Essays in Film Theory*. Ed. and trans. Jay Leyda. New York: Harcourt, 1949. 195–255. Print.

Elleström, Lars. "The Modalities of Media: A Model for Understanding Intermedial Relations." *Media Borders, Multimodality and Intermediality*. Ed. Lars Elleström. Basingstoke: Palgrave Macmillan, 2010. 11–48. Print.

Elliott, Kamilla. "Rethinking Formal-Cultural and Textual-Contextual Divides in Adaptation Studies." *Literature/Film Quarterly* 42.4 (2014): 576–93. Print.

——. *Rethinking the Novel/Film Debate*. Cambridge: Cambridge UP, 2003. Print.

Genette, Gérard. *Palimpsests: Literature in the Second Degree*. Trans. Channa Newman and Claude Doubinsky. Lincoln: U of Nebraska P, 1997. Print.

Hopton, Tricia, Adam Atkinson, Jane Stadler, and Peta Mitchell, eds. *Pockets of Change: Adaptation and Cultural Transition*. Plymouth: Lexington, 2011. Print.

Hutcheon, Linda, with Siobhan O'Flynn. *A Theory of Adaptation*. 2nd ed. New York: Routledge, 2013. Print.

Jameson, Fredric. "Afterword: Adaptation as a Philosophical Problem." MacCabe, Murray, and Warner 215–33.

Jenkins, Henry. *Convergence Culture: Where Old and New Media Collide.* New York: New York UP, 2006. Print.

Kracauer, Siegfried. *Theory of Film: The Redemption of Physical Reality.* London: Oxford UP, 1960. Print.

Larssen, Donald F. "Novel into Film: Some Preliminary Considerations." *Transformations in Literature and Film.* Ed. Leon Golden. Tallahassee: UP of Florida, 1982. 69–83. Print.

Leitch, Thomas. *Film Adaptation and Its Discontents: From* Gone with the Wind *to* The Passion of the Christ. Baltimore: Johns Hopkins UP, 2007. Print.

———. "Is Adaptation Studies a Discipline?" *Germanistik in Ireland* 7 (2012): 13–26.

Lessig, Lawrence. *Remix: Making Art and Commerce Thrive in the Hybrid Economy.* New York: Penguin, 2008. Print.

Lindsay, Vachel. *The Art of the Moving Picture.* 1915. Rpt. New York: Liveright, 1970. Print.

Macbeth. Dir. Roman Polanski. Perf. Jon Finch, Francesca Annis. Columbia, 1971. Film.

MacCabe, Colin, Kathleen Murray, and Rick Warner, eds. *True to the Spirit: Film Adaptation and the Question of Fidelity.* Oxford: Oxford UP, 2011. Print.

McFarlane, Brian. *Novel to Film: An Introduction to the Theory of Adaptation.* Oxford: Clarendon P, 1996. Print.

Morrissette, Bruce. *Novel and Film: Essays in Two Genres.* Chicago: U of Chicago P, 1985. Print.

Münsterberg, Hugo. *The Photoplay: A Psychological Study.* New York: Appleton, 1916. Print.

Murray, Simone. *The Adaptation Industry: The Cultural Economy of Contemporary Literary Adaptation.* New York: Routledge, 2012. Print.

Naremore, James, ed. *Film Adaptation.* New Brunswick: Rutgers UP, 2000. Print.

The Piano. Dir. Jane Campion. Perf. Holly Hunter, Harvey Keitel. Miramax, 1993. Film.

Ray, Robert. "The Field of 'Literature and Film.'" Naremore 38–53. Print.

Rothwell, Kenneth. "Roman Polanski's *Macbeth*: Golgotha Triumphant." *Literature/Film Quarterly* 1.4 (1973): 71–75. Print.

Saint Jacques, Jillian, ed. *Adaptation Theories.* Maastricht: Jan Van Eyck Academie, 2011. Print.

Slethaug, Gordon E. *Adaptation Theory and Criticism: Postmodern Literature and Cinema in the USA.* New York: Bloomsbury, 2014. Print.

Stam, Robert. *Literature through Film: Realism, Magic, and the Art of Adaptation.* Malden: Blackwell, 2004. Print.

Stam, Robert, and Alessandra Raengo, eds. *A Companion to Literature and Film.* Malden: Blackwell, 2004. Print.

———, eds. *Literature and Film: A Guide to the Theory and Practice of Film Adaptation.* Malden: Blackwell, 2005. Print.

Streaky Bacon: A Guide to Victorian Adaptations. Web. 29 Dec. 2015.

VICTORIA listserv. Web. 29 Dec. 2015.

Voigts-Virchow, Eckart. "*Metadaptation*: Adaptation and Intermediality—Cock and Bull." *Journal of Adaptation in Film and Performance* 2.2 (2009): 137–52.

Wagner, Geoffrey. *The Novel and the Cinema.* Madison: Fairleigh Dickinson UP, 1975. Print.

Welsh, James M., and Peter Lev, eds. *The Literature/Film Reader: Issues of Adaptation.* Lanham: Scarecrow, 2007.

Woolf, Virginia. "The Cinema." 1927. *Woolf Online.* Web. 30 Dec. 2015.

PART I

FOUNDATIONS OF ADAPTATION STUDY

DEFINING ADAPTATION

TIMOTHY CORRIGAN

THE LAYERS AND MOVEMENTS OF ADAPTATION

DEFINITIONS of adaptation tend to move between or concentrate on three perspectives. As a process, adaptation often describes how one or more entities are reconfigured or adjusted through their engagement with or relationship to one or more other texts or objects. As a product, an adaptation can designate the entity that results from that engagement or the synthesized result of a relationship between two or more activities. With the first, an adaptation might refer to the omissions and additions made in representing, for instance, a particular historical event in a novel, or the adjustments necessary for an individual to move from one culture to another. With the second, an adaptation would describe the product produced by that process, such as the compositional blend of historical and fictional elements in a novel, or the modified habits or personal traits and identity resulting from an individual's changed environment. More recent definitions have offered a third perspective: adaptation as an act of reception in which the reading or viewing of that work is actively adapted as a specific form of enjoyment and understanding. From this angle, readers may understand that different works operate differently for different readers depending on their background, while a community may assimilate or not assimilate a new member of that culture in different ways. Within this tripartite framework, more specific and concrete practices and theories have shaped the traditional and contemporary fabric of adaptation where, as throughout history, definitions of adaptation are invariably about readapting other definitions.

A ready-made and common touchstone for the many movements defining adaptation today is Spike Jonze's 2002 film *Adaptation*. In this tongue-in-cheek tale, successful screenwriter Charlie Kaufman suffers profound writer's block as he struggles to script a completely faithful adaptation of Susan Orlean's *New Yorker* essay, "The Orchid Thief." Meanwhile, his twin brother Donald, an untested and aspiring screenwriter, manages

to write an absurd potboiler script that immediately attracts an agent who sees it as a potential blockbuster. Across this plot, the two brothers represent both an aesthetic and a biological image of adaptation, two figures whose struggle to define and differentiate themselves madly expands and redirects a tortured character study. With a rapidly transformative pace, *Adaptation.* becomes a mystery story about drugs and death, an action film with car crashes and man-eating alligators, and ultimately a parable about the triumph of commerce and industry as Charlie forsakes his quest for a pure adaptation of the *New Yorker* story.

Fidelity and infidelity, those cornerstones of definitions of adaptation, permeate other parts of the plot, most obviously in Orlean's affair with her orchid-thief lover. A commitment to singularity and fidelity here becomes a dangerous kind of psychological and textual trap, and the film follows that danger along a Darwinian path that moves from a romantic and solipsistic individualism to its commercial transformation, from passionless fidelity to passionate infidelity. In the end, fidelity itself is reconstituted, not as a commitment to a source, but as a personal and textual commitment to faithful change, personal passion, and continual transformation. If Charlie's ultimate lesson is that "change is not a choice," it is a lesson that allows him to overcome his paralytic insistence on authorial expression and textual integrity and to give way to the demands of a social and industrial environment as the evolving prism of both. The horror of mere duplication embodied in twins thus evolves into the triumph of continual environmental adaptation, so that to survive is to follow your changing passions about what you love, and not, as Donald puts it, "what loves you." As the bizarrely grotesque climax of the film suggests, you can adapt to the world or be eaten by an alligator.

With its shifting ironies and reflexivities, *Adaptation.* accordingly weaves many of the key trajectories that overlap across the definitions and practices of adaptation. It dramatizes the difficult, if not tortuous, process of adaptation in Charlie's catatonic state, the textual and imagistic transformations that turn an artistic vision into a commercial product, and the determining role of an audience's predictable and unpredictable expectations (both within the film and of the film) as a third adaptive frame. At the same time, the film aligns those three dimensions of adaptation specifically with prominent models found in science and biology, literature and writing, commerce and art, and technology and representation, pointing toward the main motifs in the history of adaptation: evolution, fidelity, and intertextuality.

IN HISTORY

Although the foundational terminologies and meanings of adaptation have regularly shifted and have acquired different connotations through many centuries, the conceptual bases for definitions of adaptation have followed certain movements and emphases through this history. Here, through an admittedly selective process of trends and individuals, I intend to highlight some of these historical currents in order to point to their

cultural archaeology and to anticipate their modern and contemporary shapes: as socio-logical and scientific forms of adaptation, as theological and mythological activities, and as textual and representational movements.

In the broadest sense, adaptation has described the capacities for human, cultural, and biological adjustments as a way of surviving, advancing, or simply changing. In this sense, adaptation has been a frequently recognizable and assumed process in cultural sociology, political economies, and evolutionary science through much of human his-tory. Early and advanced societies have been characterized by their ability to adapt to environmental and social conditions, whether that has meant adapting to physical con-ditions, such as climate changes or the need for different natural resources, or to social shifts, such as population growth or political turmoil. The most widespread version of these models of adaptation is the Darwinian scheme that since the nineteenth century has often dominated discussions of adaptation, described as a process by which different biological forms succeed each other as part of an evolutionary narrative of physical sur-vival and advancement. While that model has been subject to both criticism and refine-ment, its scientific heritage and vestiges remain common even today. In their recent discussions of adaptation, both Robert Stam and Linda Hutcheon note with reference to the film *Adaptation.* that hybrids and mutations remain suggestive forms and metaphors for discussing adaptation within a scientific model. As Hutcheon points out, Richard Dawkins further explores this scientific connection in his discussions of "memes" as a suggestive analogue for the adaptation process. For Dawkins, memes describe units of cultural imitation and transmission that are analogous to genetic transmissions and evolutions.

This socio-scientific framework has in turn partially informed adaptation as myth-ological and theological activities—activities attuned especially to the adaptation of narratives and images. In the first quarter of the eighteenth century, Giambattista Vico famously describes in his *New Science* the emergence of poetry in human history as originating in early human attempts to imitate the spiritual sounds associated with the natural world through human language and signs. For Vico, a primitive linguistic abil-ity generates an adaptive performance that connects the supernatural mysteries of the universe to the intellectual evolution of mankind. At their base, other mythologies can also be seen as forms and methods for adapting natural and human crises and mysteries to comprehensible imagistic and narrative forms, while concomitantly illustrating the way different mythologies have been transposed across various cultures and historical periods. Thus, the differences between ancient Greek and Roman mythologies might be considered adapted variations on both primary gods and heroes, such as the Greek god Zeus and the Roman god Jupiter, while East Asian and South Asian mythologies often share and transpose their own figures and stories, such as creation myths or myths of order battling chaos. Clearly, this long tradition of mythological adaptations and trans-formations continues into modern times as canonized narratives, from *The Odyssey* to the tale of the Minotaur, become recirculated as imagistic and narrative variations on archetypes or myths in, for instance, James Joyce's *Ulysses* and the drawings of Pablo Picasso.

Throughout the course of history, theological and scriptural adaptations involve similar transpositions, accumulations, and adaptations of religious stories, parables, and people. More significant, however, is a new direction in adaptation practices in the sixteenth-century textual shift in biblical hermeneutics from commentary to criticism. Before this historical juncture, the relation of theological or scriptural texts to their readers has been described as an authorized reader's commentaries or glosses on those sacred writings. The resulting commentary primarily summarizes or rehearses the meaning of the scripture. During the early modern period, however, a more active and critical engagement by scholarly and often secular readers amounts to a sea change in which a more productive interpretation of scripture and other texts appears not as commentary but as a kind of criticism, a more subjective textual and intellectual adaptation of a primary work. This shift represents, as Michel Foucault has noted in his *Order of Things*, a significant change in the historical relation of readers to authorized texts, and, by extension, it signals a major and continuing redefinition of adaptation as a more productive critique or more subjective interpretation that still resonates in the twentieth and twenty-first centuries.

This historical shift in textual reading and interpretive practices leads in turn to the multiple linguistic paths and forms that have become most commonly associated with adaptation, the small and large ways, that is, that one rhetorical or representational frame adapts another. These linguistic, visual, or audio adaptations include a long list of syntactical and grammatical tactics, including adaptation as quotation, as allusion, as embedding, as appropriation, and as palimpsest. Each of these rhetorical moves denotes a specific structural adaptation of one expression, text, or representation by another along a continuum in which the source becomes increasingly less prominent or authoritative. Recognizing the authority of the adapted material, quotations visibly foreground a source or original expression as it is adapted within another text, such as the direct quotation of a line from Shakespeare within a Dickens novel. An indirect allusion less visibly adapts another representation as an oblique reference that may or may not be recognized, such as the allusion to *The Night of the Hunter* (1955) by Radio Raheem's brass knuckles in *Do the Right Thing* (1989). In adaptations conceived as embeddings, the adapting representation incorporates another structure or the source, allowing its independent status but giving it a more marginal or secondary relation to the adapting form, as when mathematical sets embed subsets or when a journalist is embedded within an army platoon. Appropriations are transformative adaptations that remove parts of one form or text (or even the whole) from their original context and insert them in a different context that dramatically reshapes their meaning. An extreme and ironic example of appropriation is Jorge Luis Borges's 1939 story "Pierre Menard, Author of the *Quixote*," in which a writer proposes to rewrite the entire Cervantes novel word for word. Originating in the ancient practices of writing over one manuscript page with another, a palimpsest suggests a form of adaptation in which an original work may exist only as a trace or as an unseen foundation, including not only certain manuscripts that have different material layers buried beneath new surfaces (and more metaphorically layered texts), but also architectural sites adapted for different buildings over the centuries.

As that rhetorical domain usurps those scientific and theological traditions of adaptation, connections and variations proliferate across a spectrum of even larger rhetorical and textual strategies and structures. In *Adaptation and Appropriation*, Julie Sanders lists many of these literary and artistic generic variations on adaptation, which indicate often slight but significantly different meanings. According to Sanders, these include a version, a variation, an interpretation, a continuation, a transformation, an imitation, a pastiche, a parody, a forgery, a travesty, a revaluation, a revision, and a rewriting (18). Each of these can suggest a different rhetorical or textual mode as a form of adaptation. A version, for instance, becomes a variation on an adapted source, while a continuation suggests adaptation as a developmental process. A parody or travesty debunks the adapted material, and a forgery removes the aura of authenticity from the original. Finally, with different nuances, revisions, revaluations, and rewritings could suggest adaptation as an improvement of its source in a variety of ways.

Within this historical sketch, modernity itself might be considered the gateway to the emerging centrality of adaptation as a cultural and epistemological perspective. As both a break from and a continuation of modernism, postmodernism continues and expands this central relationship, underlining and foregrounding adaptation as a principal form of contemporary representation and knowledge. Among the various large tenets associated with modernity, several stand out as buttressing definitions of adaptation since the sixteenth century. First, modernism and modernity began to question textual objectivity and the authorities associated with that objectivity so that, as with the shift from commentary to criticism, subjective interpretation went hand in hand with the open adaptation of one source through another. Second, as modernity evolved over the last four centuries, a widespread shift occurred, whereby cultural differentiations replaced global universals and so laid the groundwork for numerous adaptive migrations across those cultural differences. And third, temporal change and development became the measure of progressive adaptations (of civilizations, knowledge, and so forth) as an implicit and sometimes explicit modern historiography.

When models of postmodernism succeeded those modernist assumptions in the latter half of the twentieth century, more fluid and pronounced versions of adaptation began to appear in architecture, literature, the visual arts, historiography, politics, and the social sciences. In the latter half of the twentieth and the early years of the twenty-first centuries, in short, postmodern strategies of pastiche, bricolage, and collage dramatically adapted and reassembled fragments as increasingly ubiquitous activities. Following Roland Barthes's arguments, literary and aesthetic engagements began to highlight and celebrate how a "writerly" text can produce an engagement—beyond traditional and passive "readerly" relations—that encourages an active "adapting" of it by a reader or viewer. For many, cultural identities and nations around the world now seem better understood as hybrids, or as part of a transnational fluidity in which those identities and nations are configured as adapted mixtures across permeable borders. Indeed, within a postmodern perspective, history itself becomes characterized as a malleable field that can be adapted and shaped in numerous ways, as for example what Fredric Jameson has called the reconstruction of past events as nostalgic images and fabrications.

FILM AND MEDIA ADAPTATION

While a historical survey demonstrates the scope of adaptation as different practices and evolving definitions, the most prominent and common understandings of adaptations today usually refer to film, media, and related artistic practices. Over the last century, definitions and debates about adaptation have figured especially in media studies, focusing on, for instance, the specificity of technological, textual, and other media as differentiated appropriations of so-called source texts, the differences and similarities of writing and filmmaking as modes of expression, and viewing and reading positions as distinctive activities that adapt works to new contexts.

Throughout the twentieth and twenty-first centuries, definitions of adaptation within media studies have themselves been actively (and sometimes contentiously) adaptive processes involving industrial, academic, cultural, and historical maneuvers. During the first quarter of the twentieth century, the movies and the critical and social discourses that described them were distinctly interdisciplinary, often clearly presenting films as processes that adapt and transform other artistic practices and social fields. In these early years, cinematic adaptation became a version of what would later be termed "intertextuality," according to which a film assimilates and coordinates other artistic or social forms. One of the first serious books about the movies, Vachel Lindsay's 1915 *The Art of the Moving Picture,* is thus a passionate argument for how film adapts a range of sister arts, including poetry, sculpture, theater, and music, to create its own form. Lindsay prophetically envisions movies in the future adapting academic and pedagogical discourses as a way of communicating and teaching ideas and arguments. About this same time, Hugo Münsterberg in 1916 redirected the debates about the new art of film from its interdisciplinary assimilation of different arts to its specific adaptation of a psychology of perception. In *The Film: A Psychological Study*, Münsterberg endows film with the singular power of recreating and intensifying the interior workings of human perception as a unique new form of perception.

During the 1920s and 1930s, adaptation extended those intertextual exchanges with the other arts and refocused those psychological exchanges as a decidedly social and political activity. On the one hand, artists and poets like Ferdinand Leger and Vsevolod Meyerhold enthusiastically explored the conjunction of the cinema and avant-garde movements in painting and theater as radically modernist ways of generating new ways of seeing. For filmmakers like Sergei Eisenstein and philosophers like Walter Benjamin, on the other hand, the cinema provided crucial conceptual and formal structures for adapting new and sometimes more radical politics as a medium for mass communication. In his 1944 essay "Dickens, Griffith, and the Film Today," Eisenstein returns to the novels of Charles Dickens to trace and expand a theory of montage that would underpin an adaptation of Marxist dialectics to the political potential of film editing. In a very different manner, Benjamin's celebrated "The Work of Art in the Age of Its Technological Reproducibility" (1936) finds in a certain type of cinematic practice a technological and

social experience that can engage and respond to the political debates associated with the Frankfurt School, adapting and transforming deeply rooted aesthetic traditions to the political expediencies of the 1930s. For him, film can potentially shatter a long artistic tradition of auratic distance and authenticity in an aesthetic experience, and instead mobilize its mass audience to test and measure their own social experiences through their encounter with film.

Meanwhile, in the Hollywood of the 1930s, the industrial dimensions of adaptation propelled it in quite different political directions with the proliferation of adaptations of classic novels like *Becky Sharp* (1935), based on Thackeray's *Vanity Fair*, and topical contemporary fiction like *The Grapes of Wrath* (1940). Following and building upon the recent coming of synchronized sound, these classical adaptations created often complex plots, characters, and dialogue that firmly established the global domination of the classical Hollywood narrative. In many cases, moreover, they also allowed movie studios to evade—through the adaptation of respected literature—the censorial pressure of the Production Code (established in 1930 and enforced in 1934), suggesting one of the more subtle relations between adaptation, technology, and politics.

After World War II, issues about and definitions of adaptation moved even more visibly into the centers of movie culture, redirecting debates about adaptation toward questions of authorial agency and cinematic specificity. In 1948 Alexandre Astruc famously coined the term "camera-stylo" ("camera pen") in order to argue that filmmaking offers the same expressive and creative freedom as writing (made possible by the introduction in the 1940s of new lightweight cameras). According to Astruc, film was now able to express a filmmaker's ideas and thoughts "exactly as . . . in the contemporary essay or novel" (18). While this influential shift in a critical perspective on cinematic practice might appear tangentially connected to the practices of adaptation, it clearly added an important extra-textual dimension to adaptation studies that would evolve continually through the rest of the twentieth century. By the mid-1950s, various voices in the French New Wave and the *Cahiers du cinéma* (most prominently, François Truffaut) followed Astruc's lead and hailed that potential for an authorial agency in the cinema as a vehicle for cinematic "auteurism," a significant conceptual swerve from what these writers and filmmakers characterized as the bromidic adaptations of classic literature as mere illustrations in French "boulevard cinema." George Bluestone's 1957 *Novels into Film* extended this move toward an equivalency in the relation of film and literature and marked the beginning of a new wave of academic scholarship concerned with the complexities of adaptation. In his rigorous study of such adaptations as William Wyler's *Wuthering Heights* (1939), he focuses on the distinctions and specificities that allow literature and film to represent different "modes of consciousness" and representational strategies.

No critical work during this period, however, considers and measures adaptation with more subtlety, sophistication, and insight than that of André Bazin. Of his numerous reflections on adaptation, three stand out as most resonant: his discussions of adaptation as transformation, of adaptation as digest, and of adaptation as refraction. Most notably in his essay on "Theater and Cinema," Bazin provides a parallel and counterpoint

to Bluestone's argument by defending the specificity of differences between theater and film, a specificity that does not suggest, as Bluestone sometimes does, that one form might be more developed or sophisticated than the other. He targets particularly the trend to produce in the postwar years what he calls "canned theater," and insists that a cinematic adaptation of drama—as with adaptations of novels or paintings—should be fully informed by the formal and representational distinctions of the adapting medium. In "Adaptation, or the Cinema as Digest," Bazin proposes the more radical and heretical idea that adaptations have little investment in fidelity to an original text or story and that the valorization of authorship may not be a particularly useful idea. Instead, adaptations should be considered as extended and multiple variations on core myths, stories, or compact "digests" that accumulate meanings through the history of their numerous social and material incarnations. As Bazin notes in another essay, "In Defense of Mixed Cinema," adaptations "do not derive from the cinema as an art form but as a sociological and industrial fact" (65).

Bazin introduces his notion of adaptation as refraction most fully in his analysis of Robert Bresson's *Diary of a Country Priest* (1951), describing it as a "dialectic between cinema and literature" that includes "all that the novel has to offer plus . . . its refraction into the cinema" (143). He insists that there "is no question here of translation. Still less is it a question of free inspiration with the intention of building a duplicate. It is a question of building a secondary work with the novel as foundation. . . . It is a new aesthetic creation, the novel so to speak multiplied by the cinema" (142). Refraction becomes, in short, a symbiotic multiplication of forms, putting into play a productive interaction of different kinds of what Bazin calls "aesthetic biologies" (142). While this last phrase obliquely suggests the physical and material terms of adaptation and the evolutionary pressures that dog it, Bazin's sense of adaptation as refraction anticipates more importantly a contemporary climate in which hierarchies and precedents lose their privileges as texts as they create a prismatic environment of intersections, overlappings, and misdirections.

In the 1960s and 1970s, film and media studies tended to relegate adaptation to the margin. Yet those theoretical movements that marginalized adaptation studies— post-structuralist models that emphasized semiotic, psychoanalytic, and ideological positions—also served as future gateways to new developments and definitions of adaptation in terms of semantic codes and sign systems. Signaling a widespread move away from questions of fidelity and infidelity, definitions and models of adaptation in the 1980s built specifically on semiotic perspectives, refining and exploring those theoretical foundations popularized in the preceding decades. Dudley Andrew's landmark 1980 essay "Adaptation," for instance, is based in semiotics but draws significant attention to the "sociological contexts missing from many studies" (104). The majority of the essay distinguishes between three kinds of adaptations: (1) "borrowing," in which an artist "employs . . . the material, idea, or form" of an earlier text; (2) "intersecting," in which "the uniqueness of the original text is preserved . . . and left unassimilated in adaptation"; and (3) "transforming," in which faithful or unfaithful adaptations measure "the reproduction . . . of something essential about an original text." Andrew's concluding

remarks on "the sociology and aesthetics of adaptation" may, however, be the most forward-looking part of his argument. In a similar manner, Deborah Cartmell offers three categories of adaptation that suggest different semantic and ideological openings and reflections on adaptation: as transpositions, adaptations move from one semiotic system to another; as commentaries, they dramatize the encounter between two texts or contexts as a way to draw out specific meanings and ideas inherent in the source text; and as analogues, adaptations suggest certain homologous relations or connections between two different works.

Robert Stam's arguments are perhaps the most influential and pronounced attempts to move contemporary definitions of adaptation "beyond fidelity" and into fields of "intertextuality" and "transtextuality," where the key terms are "translation," "transposition," and "transformation." Identifying at the start the moralistic assumptions that have bolstered conventional definitions of fidelity and have dogged previous adaptation studies, he develops a dialogic scheme extrapolated from the work of Mikhail Bakhtin and Gérard Genette. Emphasizing the multiple and material textualities that create an "intertextual dialogism," especially in adapted works, Stam's argument situates adaptation in historical and cultural fields that invariably call attention to the social and ideological implications of any adaptation.

REVALUATIONS AND EXPANSIONS

Since the beginning of the twenty-first century, adaptation studies and definitions of adaptation have grown more numerous, more elaborate, and sometimes more combative, now identifying adaptation as one of the most dynamic fields in textual and cultural studies of all sorts. These more contemporary definitions of adaptation have opened up the field in a variety of ways, extending its scope well beyond the case-study interactions that link a literary and a cinematic text to include, for example, adaptations of music, television programs, videogames, and the Internet, and concentrating, for instance, on the pressures of different historical periods and different cultural geographies as they shape these new adaptive practices. These recent perspectives have additionally investigated the layering of different adapted textualities as intermedialities, the use of more flexible models of adaptation as translation, and the elaboration of reading and viewing as adapting activities in themselves—all indications of the increasing relevancy and energy in the field.

Thomas Leitch's 2003 essay "Twelve Fallacies in Contemporary Adaptation Theory," a crisp and succinct barometer of this renewed energy, confronts worn-out truisms that no longer provide viable definitions of cinematic adaptations of literature. Among Leitch's targets are those traditional specificity arguments that have relegated different media to different isolated corners, the woeful lack of a coherent theoretical framework for adaptation studies at a time when both its methodologies and its critical practices have become more varied and often more nuanced, the still-lurking hierarchies and

valuations that champion literature over film, the no longer meaningful distinctions between active readers and passive viewers, the seemingly common claim that original source texts have an integrity that can only be weakly imitated by the parallel intertextuality of an adaptation, and, most to the point perhaps, the now clearly archaic assumption that adaptation is "a marginal enterprise" (168).

Other contemporary positions have similarly worked to break down borders and assumptions not only about literature-to-film adaptations, but also across a spectrum of other cultural forms and materials. These contemporary expansions of the borders and terms of adaptation have encouraged a remapping of the ideological fabrics of adaptation, as well as a closer consideration of its broadly commercial and industrial dimensions. Simone Murray's *The Adaptation Industry: The Cultural Economy of Contemporary Literary Adaptation* proposes an alternative model that *materializes* adaptation theory within the larger framework of the adaptation industry. While acknowledging key contributions to the field, Murray criticizes the tendency toward uncritical adherence to textual analysis as the field's primary methodology at the expense of production contexts. Murray calls for a rethinking of the adaptation as a material phenomenon by moving beyond aesthetic evaluation to understand adaptation within its social and cultural contexts. Murray's own model for studying the adaptation industry innovatively seeks to create alternative methodologies by looking to contemporary research in the fields of political economy, cultural theory, and the history of the book.

"Intermediality" and "transmediality" have also become key terms in defining adaptation today, opening up adaptation studies more visibly than ever to its impact and influence in performance studies, music, political activity, and numerous other social and cultural platforms. With these new directions, adaptation studies has emphasized the material differences and compromises that shape both the movement of texts between various media (as those texts move between books, computers, videogames, iPads, and other devices) and the movement of ideas, social positions, and identities between cultures, across geographical borders, and through different epistemological and philosophical traditions. In one sense, these kinds of adaptive movements tend to stress the manipulation, appropriation, and transformation of source materials as they become converted as "samplings," "remixes," "reboots," and "mashups," terms that are now a central part of the lexicon of adaptation. In another sense, adaptation here focuses especially on the interval, or the "in between" that adaptations dramatize as process, product, and reception.

Intermediality and transmediality often align in turn with scholarship and criticism attuned to fan cultures and so suggest how both conservative and radical appropriations of sources act out a significantly different version of adaptation. As a product of those intermedial contexts and industrial transformations, adaptation studies has dramatically expanded its borders to emphasize the appropriation of texts and images by readers and viewers who inhabit the intervals between materials and texts and act as the agents of their transformations and adaptations. Lawrence Lessig's *Remix* offers an important angle on this dimension of adaptation in his discussion of the technological shift from RO to RW activities, the first describing the more conventional relation of text

that elicit "reading only," the second describing the possibilities inherent in new digital technologies to promote "reading as (re)writing." A crucial part of Lessig's argument is the extent to which these new writerly engagements make obsolete old-fashioned claims for copyright protection of source texts, reminding us that ever since the lawsuit over the 1907 film adaptation of Lew Wallace's 1880 novel *Ben-Hur*, copyright laws have been the elephant in the room of adaptation practices.

Elaborating on these new reader/writer activities as fan cultures blurring the spaces between texts and platforms, Henry Jenkins's *Convergence Culture* has become a contemporary touchstone for these mobile and adaptive audiences and fan communities. Exploring what he terms "transmedia storytelling," Jenkins examines the process of telling stories across various media platforms, all of which serve as self-contained stories that also contribute to an overall whole. This process of storytelling serves to create, on the one hand, potentially lucrative media franchises and, on the other, immersive story worlds for the pleasure (and sometimes confusion) of the contemporary audiences that create and inhabit them. Using the multiple layers of intertextual media—from movies to video games to comic books to the Internet—that absorb television shows like *Survivor* or *American Idol* and blockbuster novels like *Harry Potter* and *The Matrix* as case studies, Jenkins traces the contours and complexities of adaptive storytelling in an age of media convergence in which narrative worlds have become too large to be contained within a single medium. More than just a clever business model to increase profits, transmedia storytelling becomes for Jenkins a prominent sign of an active participatory popular culture and thus serves to define entertainment and adaptation in an era of "collective intelligence."

In her *Theory of Adaptation*, Linda Hutcheon has synthesized many of these contemporary dimensions of adaptation. She begins her extended definition of adaptation as situated between product and process. Across her large overview of adaptation, she creates a blueprint foregrounding the questions "What? Who? Why? How? Where? When?" This blueprint allows her to address different forms and media of adaptation, its various motivations and legal or economic constraints, the different "modes of engagement" with the audiences and consumers elicited by adaptation, and the cultural and historical determinants of adaptation. In the process, she also unravels "the pleasures of adaptation," the differences between "knowing and unknowing" audiences, and the various "degrees of immersion," according to which audiences respond to adaptation and its expansion into new media (114, 120, 133).

As an indication that definitions of adaptation tend to survive as they are continually readapted, some of its earlier terms and perspectives have resurfaced within contemporary debates and changing directions. Two stand out: the focus on authorship and auteurs as agents of adaptation, and the notion of fidelity as an illuminating touchstone. While the celebration of authorship and auteurism appeared most notably in the 1950s and later in Peter Wollen's structuralist revision of the terms in 1969, today auteurism has, like much within adaptation studies, expanded to measure this concept and activity in discussions of screenwriters as auteurs, the commercial and industrial use of authorship as a economic and hermeneutical tool, and the specific contours of television or new

media auteurs. At the same time, after decades of being dismissed as a useful concept in adaptation studies, fidelity too has been resurrected by scholars like Colin MacCabe. In his collection *True to the Spirit: Adaptation and the Question of Fidelity*, a broad group of critics investigates how and why the barometer of fidelity can still provide insights into the production process and the critical assessment of adaptations today.

If definitions of adaptation have, at least since the nineteenth century, tended to concentrate on the relationships, exchanges, and connections between literature and other media, what the recent trends in adaptation studies emphatically underline is how adaptation can be found throughout culture—not only in the arts, but in fields and practices such as history, technology, translation practices, politics, pedagogy, and economics. Likewise, these contemporary perspectives have significantly layered the dimensions and definitions of adaptation beyond textualities to include industrial, commercial, and technological imperatives, economic and sociological pressures, and the psychological and physical construction of subjectivities and identities. Because its activities and perspectives continue to evolve rapidly, there cannot be any single or stable definition of adaptation. Within this climate, scholars and practitioners accordingly need to change and refocus regularly, or risk being lost in an alligator-infested past.

WORKS CITED

Adaptation. Dir. Spike Jonze. Perf. Nicolas Cage, Meryl Streep. Columbia, 2002. Film.

Andrew, Dudley. "Adaptation." *Concepts in Film Theory*. New York: Oxford UP, 1984. 96–106. Print.

Astruc, Alexandre. "The Birth of a New Avant-Garde: La Camera-Stylo." 1948. Rpt. in *The New Wave*. Ed. Peter Graham. New York: Doubleday, 1968. 17–23. Print.

Barthes, Roland. *S/Z*. Trans. Richard Miller. New York: Hill and Wang, 1974. Print.

Bazin, André. "Adaptation, or The Cinema as Digest." 1948. Trans. Alain Piette and Bert Cardullo, 1997. Rpt. Naremore 19–27. Print.

———. "In Defense of Mixed Cinema." *What Is Cinema?* Vol. 1. Berkeley: U of California P, 1967. 53–75. Print.

———. "*Le Journal d'un Curé de Campagne* and the Stylistics of Robert Bresson." *What Is Cinema?* Vol. 1. Berkeley: U of California P, 1967. 125–43. Print.

———. "Theater and Cinema." *What Is Cinema?* Trans. Hugh Gray. Berkeley: U of California P. 95–112. Print.

Becky Sharp. Dir. Rouben Mamoulian. Perf. Miriam Hopkins, Frances Dee. Pioneer, 1935. Film.

Ben-Hur. Dir. Harry T. Morey, Sidney Olcutt, Frank Rose. Perf. Herman Rottger, William S. Hart. Kalem, 1907. Film.

Benjamin, Walter. "The Work of Art in the Age of Its Technological Reproducibility: Second Version." *Selected Writings, Vol. 3, 1935–1938*. Cambridge: Belknap, 2008. 21–34. Print.

Bluestone, George. *Novels into Film*. Baltimore: Johns Hopkins UP, 1957. Print.

Borges, Jorge Luis. "Pierre Menard, Author of the *Quixote*." Trans. James E. Irby. In Borges, *Labyrinths: Selected Stories and Other Writings*. Ed. Donald A. Yates and James E. Irby. Augmented edition. New York: New Directions, 1964. 36–44. Print.

Cartmell, Deborah, and Imelda Whelehan, eds. *Adaptations: From Text to Screen, Screen to Text*. London: Routledge, 1999. Print.

Dawkins, Richard. *The Selfish Gene*. New York: Oxford UP, 1989. Print.

Diary of a Country Priest. Dir. Robert Bresson. Perf. Claude Laydu, Jean Riveyre. UGC, 1951. Film.

Do the Right Thing. Dir. Spike Lee. Perf. Spike Lee, Danny Aiello. Universal, 1989. Film.

Eisenstein, Sergei. "Dickens, Griffith, and the Film Today." *Film Form*. Trans. Jay Leyda. New York: Harcourt Brace, 1949. 195–233. Print.

Foucault, Michel. *The Order of Things: An Archeology of the Human Sciences*. Trans. Alan Sheridan. New York: Random House, 1970. Print.

The Grapes of Wrath. Dir. John Ford. Perf. Henry Fonda, Jane Darwell. Twentieth Century-Fox, 1940. Film.

Hutcheon, Linda, with Siobhan O'Flynn. *A Theory of Adaptation*. 2nd ed. London: Routledge, 2013. Print.

Jameson, Fredric. "Nostalgia for the Present." *South Atlantic Quarterly* 88.2 (1989): 53–64. Print.

Jenkins, Henry: *Convergence Culture: Where Old and New Media Collide*. New York: New York UP, 2005. Print.

Leitch, Thomas. "Twelve Fallacies in Contemporary Adaptation Theory." *Criticism* 45.2 (2003): 149–71. Print.

Lessig, Lawrence. *Remix: Making Art and Commerce Thrive in the Hybrid Economy*. New York: Penguin, 2009. Print.

Lindsay, Vachel. *The Art of the Moving Picture*, 1915. Rpt. New York: Liveright, 1970. Print.

MacCabe, Colin, Kathleen Murray, and Rick Warner, eds. *True to the Spirit: Film Adaptation and the Question of Fidelity*. New York: Oxford UP, 2011. Print.

Münsterberg, Hugo. *The Film: A Psychological Study*, 1916. Rpt. New York: Dover, 1970. Print.

Murray, Simone. *The Adaptation Industry: The Cultural Economy of Contemporary Literary Adaptation*. New York: Routledge, 2013. Print.

The Night of the Hunter. Dir. Charles Laughton. Perf. Robert Mitchum, Shelley Winters. United Artists, 1955. Film.

Sanders, Julie. *Adaptation and Appropriation*. London: Routledge, 2006. Print.

Stam, Robert. "Beyond Fidelity: The Dialogics of Adaptation." *Film Adaptation*. Ed. James Naremore. New Brunswick: Rutgers UP, 2000. 54–76. Print.

———. "Introduction: The Theory and Practice of Adaptation." *Literature and Film: A Guide to the Theory and Practice of Film Adaptation*. Ed. Robert Stam and Alessandra Raengo. Malden: Blackwell, 2005. 1–52. Print.

Vico, Giambattista. *The New Science*. New York: Penguin, 2000. Print.

Wallace, Lew. *Ben-Hur: A Tale of the Christ*. Harper, 1880. Print.

Wuthering Heights. Dir. William Wyler. Perf. Laurence Olivier, Merle Oberon. Goldwyn, 1939. Film.

ON THE ORIGINS
OF ADAPTATION, AS SUCH

The Birth of a Simple Abstraction

GLENN JELLENIK

ENGAGING HISTORY

IT has become a trope in the field of adaptation studies to suggest rather than explore the roots of adaptation. In place of a thorough excavation and processing, scholars make abbreviated nods to a long and vague history of adaptation. Philip Cox begins his study of Romantic-period stage adaptations by announcing, "The adaptation of a narrative text from one medium into another has a long history in western culture" (1). Linda Hutcheon borrows or steals or shares Cox's idea: "Western culture [has a] long and happy history of borrowing and stealing, or, more accurately, sharing stories" (4). Both authors locate the roots of adaptation in an expansively generalized place and time: in the West—long ago. Colin MacCabe stretches the act of adaptation back as far as possible, granting it "a history as old as narration" (5). Read in the most positive and productive light, these amorphous historical long views function to de-marginalize and legitimize adaptation by establishing its venerable status. The infusion of the act with a measure of primacy and authority defends against (relatively recent) positionings of it as debased and secondary. MacCabe's historical formula collapses telling and retelling, rendering attempts to marginalize adaptation absurd. Yet that expanded scope also renders theorizing adaptation almost impossible. Such stretching thins the act beyond critical utility; it loses all elasticity and becomes too broad to speak of in specific and productive terms. In a Barthesian sense, all texts are adaptations, bound up in the intertextual fabric of an all-encompassing "tissue of quotations, drawn from innumerable centres of culture" (Barthes 146). But is it even possible to theorize such a universal act?

The opening section of MacCabe's Introduction, subtitled "Historical Perspectives," anticipates this objection and works toward specificity. After opening the act of

adaptation even wider than the history of narrative by evoking Darwinian uses of the term, he zooms in sharply to argue that, beyond the act of adaptation as a generally essential human function, a new form of adaptation emerged, one "in which the relation to the source text is part of the appeal and the attraction" (5). Indeed, his massive expansion of the history of the act of adaptation quoted in the preceding paragraph is only half of a crucial and contextualizing sentence: "In a history as old as narration, this form of [cinematic] adaptation constitutes a new chapter" (5). Essentially, MacCabe urges the importance of recognizing the birth of adaptation as a simple abstraction. And I agree. But while MacCabe is correct to foreground the need to point out the rise of a new simple abstraction, his historical location of adaptation's "new chapter" is simply wrong.

MacCabe asserts that the cinema "produces a completely new kind of adaptation that claims that the source material is being faithfully translated into a new medium. It is important to stress that this relation between source and adaptation is effectively unknown to previous cultural eras, although it has a prehistory in nineteenth century theatre" (5). MacCabe's arguments are problematic on several fronts. While a new relationship between adaptation and source might seem to emerge, transferring that shift to the construction of adaptation runs afoul of the intentional fallacy. There is no Manifesto of Adaptation that claims "faithful translation" (whatever that is) into a new medium as the act's raison d'être. Beyond that, MacCabe misuses the term "prehistory." Labeling the theatrical adaptations of nineteenth century—which I'll locate specifically in the early Romantic period, or the late eighteenth century—as "prehistory" implies that such adaptations and their reading or viewing audiences unconsciously engaged with a series of issues that self-consciously emerge only in twentieth-century film adaptations. Here MacCabe invokes the source/copy and original/derivative binaries. In fact, those issues were very much activated in both adaptation and the cultural consciousness of the eighteenth century. Indeed, the moment that MacCabe offhandedly identifies as "prehistory" produced an explosion of texts that evidence the dynamic between source and adaptation that he claims originated with cinematic adaptation.

Thus, even as MacCabe works to supply a vital missing piece in adaptation studies—a historical understanding of the origins of adaptation, as such—his construction of that history misses the mark completely and serves to obscure modern adaptation's true roots. It was not the moment of the high modernists and New Critics that fashioned the shifting foundation for adaptation as a simple abstraction. It was the moment of the Romantics. Even more interestingly, that "new kind of adaptation" emerged at the same moment and in response to the same cultural pressures as Romanticism's aesthetic. Indeed, the case could be made that the ethos of Romanticism set in motion by William Wordsworth's 1800 Preface to *Lyrical Ballads* was a reaction to this new kind of adaptation. Acknowledging and exploring these origins offers an opportunity to contextualize and critically process adaptation. Such an engagement helps to unwind the ethos of Romanticism that has so often been used to marginalize adaptation.

An unpacking of this alternate history suggests that adaptation functions as a vital cultural reaction, a movement that actually helped to develop and shape Romanticism's critical shifting and redefining of notions of originality. Dismissing early Romantic-period

adaptation as prehistory ignores the development of the very reading strategies that underpin some of MacCabe's more objectionable theories. In effacing those origins, MacCabe misses an opportunity to understand more fully the cultural construction of and relationship to adaptation shaped by those reading strategies. Engaging with the root of this new type of adaptation reveals the genesis of the cultural reading strategies that have shaped mainstream and critical opinions of adaptation.

So MacCabe is right and wrong. He is right in his plan to offer a more specific historical perspective, and also right in his claim that out of a long, vague, and general history of what can be termed "adaptation," a new type of adaptation emerged. But he is wrong about the where and when of that rise. Twentieth-century cinema did not create a new form of adaptation in which the relation to the source text is an integral part of the appeal and attraction; rather, it continued to develop a mode of spectacular adaptation that emerged in the late eighteenth century. What MacCabe offers as a footnote to adaptation history actually functions as the rise of a simple abstraction, the birth of adaptation, as such.[1]

Locating the origin of that new adaptation in the late eighteenth century provides a critical opportunity to link the history of adaptation with a whole set of culturally determining contingencies and emergences, such as the Licensing Act of 1737 and the Donaldson Act of 1774; the explosion of literacy, literary texts, and marketplaces; the development of Romanticism's ethos; the differentiation of high and low culture and the emergence of a concept of literature; and the rise of the novel as a dominant cultural form. These developments and others intersect to create the conditions for adaptation's rise as a simple abstraction.

Adaptation and Romanticism were both vital eighteenth-century literary reactions, born of divergent responses to the same cultural conditions, different approaches to processing a changing world. I define adaptation as the frank appropriation of a text that taps into a new (and usually broader) audience or commercial market. Adaptation functions as a specific set of practices, a contained system, in which the boundaries between cultural and literary genres dissolve or become permeable, a system that commodifies intergeneric curiosity and enables a productive intertextual play that can both reflect and drive the culture that produces and consumes it. With regard to the birth of such adaptation, Romantic-period culture was undergoing a radical destabilization, or at least an anxious questioning, of its own socioeconomic hierarchies. And in that moment, it became fascinated with a set of texts that rehearse similar boundary-collapses with regard to literary genre.

So to get the full story of the rise of adaptation as such, we need to go back to London in the early Romantic period, and all that place and time imply and enact. When I say that adaptation rose as a simple abstraction in the early Romantic period, I mean that it is possible to trace adaptation's emergence as such to that moment, and in doing so, to tether it to the matrix of material, cultural, and social changes that arose there. When that is done, we can pinpoint the history of the first adaptation and begin to process fidelity criticism's role in launching adaptation as we know it.

In the Moment

The late eighteenth century was a moment of intense conceptual innovation. Many crucial ideas and terms crystallize and pivot there—the individual, originality, and genius, to name just a few. "Adaptation" belongs on the list as well. The first uses of the term as a noun that refers to a text (an adaptation) appeared in Romantic-period newspaper advertisements; these ads highlighted the works' twice-told status in order to identify the material for potential consumers. In keeping with the paradoxical nature of such a revolutionary moment, the word "adaptation" underwent a radical transformation in the late eighteenth century. As with literary texts and genres, language derives from and drives culture. So it is not surprising that, in a moment of intense cultural flux, the use of a word like "adaptation" pivots, from passively implying suitability to actively signaling mutability.

The *Oxford English Dictionary* dates the oldest usage of the term to its adjective form, "adapted," which in 1425 signified "well suited or fitted to a particular purpose or use; suitable, fitting" (*OED*, def. 1). In its noun form, "adaptation," the term came to mean "[t]he condition or state of being adapted; adaptedness, suitableness" (*OED*, def 3). Such usage refers directly to the concept of a thing's intrinsic and static essence: "He is adapted to it by nature." The term originally connoted innate suitability to a condition. However, at the end of the eighteenth century, usage took a remarkable 180-degree turn to generate a new definition, "the process of modifying a thing so as to suit new conditions . . . to alter or modify so as to fit for a new use" (*OED*, def. 2a). In 1790, William Paley writes of St. Paul, "His adaptation will be the result of counsel, scheme, and industry" (*OED*, def. 2a). Clearly, the term refers to Paul's active transformation to a new condition, not a passive revelation of characteristics already existing inside him. Paul's "adaptation" signals change: he who was Saul *becomes* Paul; born one thing, he has the capacity to transform into another. Adaptation, then, no longer stands for Saul's fundamental condition, but for the fundamental *alteration* of a condition. The shift in "adaptation" reflects emerging Enlightenment concepts of the self-determining possibilities of the individual: "Man has unrivalled powers of self-adaptation" (*OED*, def. 2a). According to pre-Romantic usage, the very phrase "self-adaptation" would be impossible: man cannot logically change his essential self to better suit his essential self.

In accord with that shift, the late eighteenth century marks the initial use of the term to describe our modern concept of textual adaptation: "An altered or amended version of a text, musical composition, etc., (now *esp.*) one adapted for filming, broadcasting, or production on the stage from a novel or similar literary source" (*OED*, def. 4).[2] The first direct reference to textual adaptation provides another illustration of the simultaneous birth of adaptation as a simple abstraction and the marginalization of the act: "It is very well known that such adaptations are the easiest efforts of genius; and may often be made successfully by those who have none" (*OED*, def. 4). I argue that the new noun (adaptation-as-text) and the shifted verb (adaptation-as-mutability/modification)

function as part of the same cultural movement. In adaptation-as-text, the concept of change ("modification" or "alteration") is built in, just as in the shifted usage of the verb. Thus, in the early Romantic period, "adaptation" came to signify mutability, the possibility of fundamental alteration according to changed circumstances. The term shifted, from evoking stasis and a natural-birth state (he *was adapted* to his world), to signifying the productive possibility of change (he *adapted to* his world), from passive to active verb.

Those lexical changes were driven by a series of cultural and political changes occurring on the ground in the eighteenth century. Obviously, such Enlightenment-aligned shifts had potential radical and revolutionary political implications. The specific historical contingencies of the moment mark the adaptation that occurs there as distinct from previous systems of literary recycling in key ways. The shifting of social, cultural, and economic structures, the expansion and splintering of audiences and literary markets, and the massive influx of literary texts occasioned the rise of the productive and systematic recycling, reworking, and repurposing of texts. Those conditions, combined with the dialectical tension from literary and political counter-movements, came together to form adaptation as a simple abstraction.

Viewed from a traditional literary historical perspective, Romantic-period adaptation is the cultural detritus jettisoned by the rising tides of the emergent ethos of Romanticism and the novel. Viewed from a cultural historical perspective, however, it is a productive driving force that emerged at the same moment. And it must be recognized that adaptation held a significant and prominent place in the center of British culture. The Romantic theater fed a British public in flux, a public with complexly conflicted tastes and a hunger for new texts. Allardyce Nicoll touches on adaptation's specific role in the shifting literary and dramatic economies: "[The novel] was rapidly becoming a dominant form of literature, and the minor dramatists found here in plenty that for which they were seeking—plots, characters and dialogues ready formed, the *scenario* (and more than the *scenario*) on which they could base their hastily written plays" (91).[3] Nicoll's description of the moment's adaptations as "hastily written" reveals his critical bias, but while minimizing the texts' literary quality, he never denies their cultural centrality. Philip Cox concurs, though he probes a bit deeper: "[A]daptation was popular [in the Romantic period]—what need to be explored are the possible reasons for this popularity" (2). What made the moment an ideal culture for the rise of adaptation as such?

That the Romantic period (roughly 1780–1832) was marked by tensions in language, culture, economics, and politics is far from a new insight. Charles Dickens's binary summary of "The Period" in *A Tale of Two Cities* (1859) is one of the most recognizable openings in literature: "It was the best of times, it was the worst of times, it was the age of wisdom, it was the age of foolishness, it was the epoch of belief, it was the epoch of incredulity, it was the season of Light, it was the season of Darkness, it was the spring of hope, it was the winter of despair" (1). In retrospect, dramatic shifts overtook a series of cultural concepts and forms, among them genius, originality, art and the artist, and literature. Yet at the moment, those concepts and forms were fluid, their very formation

subject to the age's bipolar mood swings. It was the age of originality, it was the age of derivation and adaptation, it was the epoch of the lyric, it was the epoch of the musical comedy, it was the season of poetic innovation, it was the season of theatrical formula, it was the spring of the genius, it was the summer of the middleman.

Cultural assumptions surrounding originality, adaptation, invention, derivation, art, mass culture, genre, purity, and genius emerged or shifted decisively during the Romantic period. The literary criticism of Romanticism has done a thorough job of systematically exploring the implications of about half of these swirling concepts; in doing so, it has all but obscured the production of the other half. That production represents an alternate spirit of the age, a parallel processing of the moment's shifting social, political, and economic conditions, a different reaction to the same historical factors and conditions to which Romanticism responded.

For example, in a phenomenon that touched on all these aspects, late eighteenth-century London experienced an explosion of literary texts and an accompanying expansion and blurring of the audience that signaled one aspect of encroaching modernity as it concerned issues of market capitalism and print culture. The British legal ruling in *Donaldson v. Beckett* (1774), which denied common-law or perpetual copyright and broke the booksellers' monopoly on intellectual property, acted as a catalyst for that explosion, expansion, and blurring. Michael Gamer reads the resulting cultural reaction to the ruling as bringing "permanent changes in the economic practices and cultural politics of British publishing. . . . [T]he decades that followed Donaldson v. Beckett constitute . . . a span of years in which venture publicists, aided by two revolutions and over two decades of world conflict, became canon-builders by reprinting British authors on an unprecedented scale" (155–56). That ruling changed not only the culture and economics of publishing but British culture itself. In short, Donaldson v. Beckett released a massive flood of texts into the culture, and the culture reacted in a variety of ways: new audiences emerged; new narrative systems and genres arose to engage, meet with, and react to those audiences; the publishing and theater industry developed to deliver those emerging genres to those audiences, flooding more texts into the culture in a productive feedback loop.

The literary movement that came to be called Romanticism functions to a large extent as an artistic response to that flood. Wordsworth processed that influx into a mass-culture phobia, a severe contamination anxiety. The poet attaches his call for a poetic revolution to the conditions produced in Britain by encroaching industrial capitalism. "[A] multitude of causes, unknown to former times, are now acting with a combined force to blunt the discriminating powers of the mind, and, unfitting it for all voluntary exertion, to reduce it to a state of almost savage torpor. The most effective of these causes [is] . . . the increasing accumulation of men in cities, where the uniformity of their occupations produces a craving for extraordinary incident, which the rapid communication of intelligence hourly gratifies. . . . The invaluable works of our elder writers . . . are driven into neglect by frantic novels, sickly and stupid German Tragedies, and deluges of idle and extravagant stories in verse" that pander to the "craving for extraordinary incident" (xvi). The rise of industrial capitalism led to mass urbanization, and the jobs

it produced uprooted men from the diversity of what the poet saw as their natural state. Adrift in the city, they compensated for their profound cultural losses by seeking sensational spectacle and virtual thrills as the simulacra of actual existence became a palliative for modern monotony.[4]

Wordsworth's poetry and poetic philosophy sought to enact a vital shift. His system posits the mainstream current as a contaminant or a disease, and he offers his work as an artistically pure cultural antidote. In doing so, he drives a wedge between high and mass culture. His reaction to encroaching modernity represents the core tenets of Romanticism: a fervent guarding of solitary genius, a paranoid distrust of popularity, a concern for literary purity, and a mania for innovation and originality. Subsequent critics would install that ethos as the spirit of the age; from the perspective of literary history, it has become the default mind-set of Romantic culture. In the moment, however, newly emerging consumer audiences, not at all distrustful of popularity, did not share Wordsworth's fear and disdain of the culture flood. They eagerly consumed products driven by other concerns: collaboration, intertextual play, an engagement with literary formula. Adaptation's emergence represents an alternate negotiation of the flood, an embrace of it rather than a retreat from it. That embrace's divergent artistic reaction recognizes a market demand for recycled texts. And that demand represents the market's recognition of something culturally reflective in the performance of such texts.

Adaptation's subsequent marginalization, its exile from the realm of literature, which shaped our cultural reading strategies of the act going forward, functions as a vital aspect of the critical crystallization of Romanticism and the novel. Important elements of both came to be defined in direct contrast to the act of adaptation. It is not surprising, then, that adaptation becomes specifically recognizable as a simple abstraction with the advent of that marginalization. Indeed, that marginalization is an integral part of the story and history of adaptation. This becomes apparent through an exploration of and engagement with the first adaptation as such, which appeared at London's Drury Lane on 12 March 1796.

WRITING ADAPTATIONS, OR THE BIRTH OF ADAPTATION, AS SUCH

By all accounts, the opening night of *The Iron Chest* was a disaster. The play ran over four hours and was often incoherent; the players forgot lines and alternately argued with and apologized to a jeering audience. In addition, the debacle occasioned a messy public feud between the play's author and its star. *The Iron Chest* had been a highly anticipated production for a host of reasons. It was financed by Richard Sheridan, the biggest name in British theater; its author, George Colman the Younger, was the moment's most popular playwright; John Kemble, the director and star, was the most acclaimed actor of the day; and the play was adapted from the popular philosophical novel *Things As They Are,*

or The Adventures of Caleb Williams, by William Godwin, the leading philosopher of the time.

Godwin's novel is itself an adaptation, a 1794 novelization of his radical philosophical treatise *An Enquiry Concerning Political Justice* (1793). The novel enacts perhaps the first self-reflexive example of what Deborah Cartmell has recently referred to as "adaptation as the art of Democracy" (3). Godwin's generic shift from philosophy to fiction consciously reworks a prior text in order to make it available to a new audience. The author explicitly announces this adaptive intention in his Preface to *Caleb Williams*: "The following narrative is intended to answer a purpose more general and important than immediately appears on the face of it. . . . It is now known to philosophers, that the spirit and character of the government intrudes itself into every rank of society. But this is a truth highly worthy to be communicated to persons whom books of philosophy and science are never likely to reach" (3). The generic shift represented an attempt to recontextualize and deliver Godwin's ideas to a new and broader audience. It simultaneously testifies to the rise of the novel in the culture and the author's optimism at the potential capacity of adaptation in that historical moment. Godwin aimed to mix high-culture political ideas with a mass-culture narrative delivery system. And the viewing public was intrigued and excited by the idea that *The Iron Chest* might do similar work. As it turned out, Colman's play and adaptation, as a cultural act, moved in quite another direction.

Given such topical urgency and interesting generic implications, anticipation of the play was strong. Upon its release, all agreed that it was a spectacular flop, but there was far less agreement about who deserved the blame. Early critics pointed to the author for delivering such an untamed script, but Colman pointed to Kemble, his director and star, who he claimed made revision impossible by spending the weeks leading up to the train-wreck premiere on an opium bender. Thanks to the extremely public feud between Colman and Kemble, *The Iron Chest* became great theater only after it closed. Incensed by Kemble's performance, Colman penned a thirty-page anti-Kemble screed that he affixed as a preface to the published version of the play.

Out of the ashes of that scathing preface (mingled with the emergent winds of Romanticism's aesthetic priorities) rose the first adaptation, as such, because Colman's public hatchet job occasioned a response from the Kemble camp that took the form of the very first piece of fidelity criticism. That is, the cultural and historical circumstances surrounding the composition, production, and reception of *The Iron Chest* combined to make it the first adaptation *as such*, the first adaptation that fits the description of what we consider an adaptation today. This distinction is not due to Colman's technical act of adapting Godwin's novel for the stage. The borrowing and recycling of plots was nothing new in the theater, or, as MacCabe asserts, in narrative as a whole. What marks *The Iron Chest* as the birth of a simple abstraction was the public and critical reception of Colman's work. In other words, the modern concept of adaptation is a critical rather than artistic construction. The adaptation's existence as such depends not on the artist's production, but rather on the audience's reception.

Here it is helpful to refer to Linda Hutcheon's assertion in the opening of *A Theory of Adaptation* that adaptation critics and other knowing audiences "deal with adaptations

as adaptations" (6). This seemingly simple observation is complicated, according to Hutcheon, by the fact "that we use the same word—adaptation—to refer to the process and the product" (7). The process of adaptation—the general narrative repurposing of plot, characters, setting, themes, and so on—stretches as far back in literary history as you care to look. But the product of that process, specifically, the cultural and critical reception of that product, changes over time. To read adaptations *as adaptations*, critics must first acknowledge the prevailing cultural/critical reception of adaptation, since these contingencies define both act and product for the culture that produces and consumes them. The existence of adaptation *as adaptation* has more to do with the critical act of reading than it does with the creative act of writing. Adaptation, like Romanticism, is a critical construction.

It was therefore inevitable that the birth of the first adaptation would be preceded by the first adaptation critic. It was not Colman's play, his act of recycling the material of Godwin's novel, as much as his furious preface-attack on Kemble that prompted Kemble's friend John Litchfield to write "Remarks on Mr. Colman's Preface: Also a Summary Comparison of the Play of *The Iron Chest* with the Novel of *Caleb Williams*." Litchfield published his piece in the *Monthly Mirror* on 1 September 1796, installing himself as the first fidelity critic. And adaptation as such was born.

The assertion of a twin birth of adaptation and fidelity criticism has deep critical implications. First and foremost, it means that fidelity criticism is not driven by the straw-man fallacy, as many scholars have argued. For example, Robert Stam asserts, "The question of fidelity ignores the wider question: Fidelity to what?" (57), and Thomas Leitch argues, "Fidelity to its source text . . . is a hopelessly fallacious measure of a given adaptation's value because it is unattainable, undesirable, and theoretically possible only in a trivial sense" (161). Both critics posit fidelity as a chimerical straw man. Clearly, fidelity is unattainable in the ways outlined by Stam, Leitch, and many others. This makes the fact that fidelity criticism refuses to die particularly perplexing. My historical contextualization offers an explanation, though certainly not an endorsement, of the continued survival of the misbegotten urge to valorize fidelity. Fidelity is primarily driven by the fallacy of the begged question: our modern notion of adaptation actually enters the culture via fidelity criticism. Thus our cultural definition of adaptation is shaped by and emerges out of a central notion of and desire for fidelity, making it difficult to conceive of adaptation criticism without it.

LOCKING *CALEB WILLIAMS* (AND ADAPTATION) IN *THE IRON CHEST*

There was no way to dramatize Godwin's *Caleb Williams* faithfully on London's legitimate stage in 1796. The Licensing Act of 1737 had set forth strong censorship laws designed to stem political criticism of the Walpole government on stage. The Act, aimed

at political satirists like Henry Fielding, made the production of all new plays subject to the approval of the Lord Chamberlain's Examiner and so helped push politically minded satirists like Fielding toward the novel. That Examiner purged virtually any and all overt political references and implications. By the end of the eighteenth century, playwrights and theater managers had internalized this systematic censorship, leaving the stage devoid of overt politics.

Godwin, advocating radical social change, constructed *Caleb Williams* as a politically subversive novel, a gothic processing of the nightmarish implications of the aristocratic system, a call for the democratization of British society. Colman's dramatization conspicuously avoids overt political commitments. In his Advertisement to the publication of *The Iron Chest*, Colman anticipates his future as Examiner of Plays by striking a pose of utter political ignorance with regard to his adaptation: "I have cautiously avoided all tendency to that which, vulgarly (and wrongly, in many instances,) is termed Politicks; with which, many have told me, *Caleb Williams* teems. The stage has, now, no business with Politicks; and, should a Dramatick Author endeavour to dabble in them, it is the Lord Chamberlain's office to check his attempts, before they meet the eye of the Publick" (xxi). Here, the playwright removes "politics" so completely from the discussion that he reduces the novel's obvious political investments to hearsay; while he sees no politics in the book, people have told him that some resides there.

There is no way to know if Colman's political naïveté was a product of the Romantic theater's internalization of the Licensing Act's censorship or a cunning and necessary adaptive strategy. Certainly, however, any attempt to approximate the democratic leanings of Godwin's novel would have run afoul of the Examiner. Colman steadfastly refuses to engage with both his source's Jacobin aspects and the tragic consequences that spin out of those elements. In their place, the playwright inserts healthy doses of melodrama, domestic romance, musical numbers, and comedy that have little in common with the novel's tone and concerns. In his Advertisement, Colman offers a blanket defense of his adaptive choices: "All this I did that I might fit it, in the best of my judgment, to the stage" (xx). However simply stated, Colman's defense opens up a wide-ranging series of interpretive possibilities. By "fitting" Godwin's material to the stage, does he refer to purging the novel's radical politics, transforming complex characters into stock figures, domesticating the novel's public themes, or shoehorning its philosophical tensions into a rote love story? The multiple potential interpretations activated by Colman's use of the term "fit" make it impossible to know for sure. One thing is certain, though: *The Iron Chest* opened disastrously. Colman published a preface defending his play and blaming Kemble, and Litchfield published an article defending Kemble and attacking Colman. Out of the petty labor of all that critical bickering, adaptation was born.

Litchfield's essay unfolds in two parts. As indicated by his title, "Remarks on Mr. Colman's Preface," part one directly challenges Colman's assertions. Litchfield's central thesis is simple: *The Iron Chest*'s spectacular failure was the fault of the playwright's pen. Colman wrote such an inept play—flat characters, dull dialogue, plodding plot— that no performance could have salvaged it. But Litchfield goes much further in answering in detail what he considered a personal attack on Kemble, at one point making the

odd assertion that opium "makes a man *cheerful,* excites him to enterprize" (10). In his view, Kemble's delivery of such a sluggish performance testified not to Kemble's opium use but to the ponderous nature of the material with which Colman had forced him to work. Later, Litchfield answers Colman's anti-Semitic barb that Kemble looked like "the son of Kish, that lofty Jew" (14) by bouncing the barb right back: "[Colman] is known to be a little priggish, dusky man . . . that looks, at all events, as much like a *son of Kish* as Kemble, excepting that his stature is very *low*" (15). If Kemble looks like a Jew, Colman looks like a short Jew. Tobias Smollett described "Remarks" as "[a]n angry man answering an angry man" (103). Had Litchfield stopped there, his article would amount to little more than a bizarre and deliciously squirm-inducing I-am-rubber-you-are-glue counterattack. But Litchfield affixes an addendum to his response, and that addendum functions as the opening salvo in the invasion of fidelity criticism.

The title of the second part of Litchfield's essay, "Summary Comparison of the Play of *The Iron Chest* with the Novel of *Caleb Williams*," turns away from answering Colman's Preface and veers into an extended literary critical engagement with the play and its source. It begins with a now all-too-familiar lament: "To a dramatic author who knows not how to select with taste and arrange with judgment, a *novel* is a dangerous resource" (20). From there, Litchfield proceeds to develop a compare/contrast adaptation study, beginning, "I shall not attempt to ascertain how far Mr. Colman has fallen short of the design of Mr. Godwin, but in what particular instances he has failed in explaining it" (20). In the end, Litchfield's reading is designed to support his summary judgment: "There was never a *copy* perhaps so miserably varied from its *original* as this" (23). Note the precise parallels with the classic critical adaptation study of the twentieth century, as described by Robert Ray, which "persists in asking about individual movies the same unproductive laymen's questions (how does the film compare to the book) and getting the same unproductive answer (the book was better)" (126). Litchfield consciously lays out the source/copy binary that would dominate adaptation studies throughout the twentieth century and into the twenty-first, clearly coding the copy as inherently inferior.

In order to flesh out the critical dynamic of that binary, he develops a structure, language, and vocabulary for the fidelity reading. This begins with an announcement that the adaptation's fatal flaw arises with the misreading of the source text: "Mr. Colman has mistaken the source of the compunction of Falkland" [the villain in Godwin's novel, renamed Mortimer in Colman's play] (21). From there, Litchfield toggles back and forth between texts in a basic compare/contrast fashion: "Mr. Godwin's Falkland. . . . The Sir Edward Mortimer of Colman" (21–22); "In the novel. . . . In the play" (22); "Godwin artfully prepares us for certain events. . . . Colman thinks of producing the effects without the trouble of *preparation*" (26). A specific and familiar coding underpins that he-said/he-said structure. Godwin's novel-construction is "artful . . . minute . . . subtle . . . philosophical . . . ratiocinating and refining" (22). Colman's play inspires quite different adjectives: "ludicrous . . . ignorant . . . corrupted . . . perverted" (22–23). Finally, the language of fidelity criticism will develop around the coding enacted by such vocabulary, approximating not just critical but moral judgment; adaptations are deemed not merely

artistically lacking but ethically corrupt. This anticipates Wordsworth's cultural polemi-
cizing, when he refers to mass culture as a "general evil" and preaches that "the time is
approaching when the evil will be systematically opposed" (xvi). Stam's groundbreak-
ing essay "Beyond Fidelity" argues that this kind of critical morality produces largely
unproductive criticism "awash in terms such as *infidelity, betrayal, defamation, viola-
tion, defamation, vulgarization*, and *desecration*, each accusation carrying its specific
charge of outraged negativity" (54). In the end, it is not enough that Colman's *Iron Chest*
fails to rise to the level of *Caleb Williams*. The language of the criticism suggests that the
play has violated its source; the linguistic implication of violence codes adaptation as an
immoral act.

Above all, Litchfield's study inaugurates the backward or rearview reading strategy
for adaptation studies that endures as the heart of fidelity criticism. Rather than look
forward to consider how the specific changes made by the playwright speak to the audi-
ence, conditions, and industrial context into which the adaptation is being introduced,
Litchfield insists that the best way to read the text is by reflecting all changes backward,
to reconsider the source. At that point, the adaptation can exist as nothing more than
what Litchfield calls a *copy*. Leitch engages the critical impasse occasioned by positing
adaptations as such, arguing that, viewed through the lens of fidelity, "adaptations will
always reveal their sources' superiority because whatever their faults, the source texts
will always be better at being themselves" (161).

This is not to make the case that *The Iron Chest* is a good adaptation of Godwin's novel,
or even a good play. This essay is not designed to evaluate Colman's adaptation, but rather
to point out the specific and historically significant way that Litchfield evaluated it and
the significant cultural results of his method. Litchfield was the first commentator to
practice fidelity criticism. To return to MacCabe's twenty-first-century iteration of the
formula, the method arose when the relation to a source came to function as a vital part
of the appeal and the attraction of an adaptation, engendering the expectation, in readers
and viewers, that the source material was being faithfully translated into a new medium.

At the moment of Litchfield's assessment, the concept of a direct comparison and
contrast between two versions of a story was unlikely. In *Conjectures on Original
Composition* (1759), Edward Young treats the issue of literary influence: "Imitate [literary
predecessors] by all means; but imitate aright" (20). Young never specifies what it means
to "imitate aright," but his injunction seems to have been result-oriented. Originality
was defined by the ability to produce a good text. There was no anxiety of influence,
no responsibility to source material in the eighteenth century, only the responsibility
for writing an effective novel, play, or poem. Writing a generation before the Romantic
period, Young uses Shakespeare as his paradigm of originality: "Shakespeare mingled
no water with his wine, lower'd his genius with no vapid Imitation" (78). In *Nicholas
Nickleby* (1839), Dickens readily identifies Shakespeare as an adapter: "Shakespeare dra-
matized stories which had previously appeared in print" (478). Writing on the other side
of the Romantic period, Dickens develops a now-familiar adaptation reading strategy,
defining what it means to "imitate aright": "[Shakespeare] brought within the magic
circle of his genius traditions, peculiarly adapted for his purpose, and turned familiar

things into constellations which should enlighten the world for ages" (478). The novelist then directly contrasts Shakespeare's adaptation with his concept of the contemporary adapter as bastardizer: "[Y]ou drag within the magic circle of your dullness, subjects not at all adapted to the purposes of the stage, and debase as he exalted. For instance, you take the uncompleted books from living authors, fresh from their hands, wet from the press, cut, hack, and carve them to the powers and capacities of your actors, and the capability of your theatres" (478). Here Dickens constructs a neat binary opposition between the novelist, whom he refers to as the "original projector," and the crude and parasitic adapter, whom he compares to a pickpocket.

Back on the other side of the Romantic period, Tobias Smollett's contemporary review of Colman's play identifies a fidelity problem in both the play and the act of adaptation that has nothing to do with the anxiety of influence. Rather than complain about Colman's lack of fidelity to his source, Smollett suggests that adaptation's "original sin" lies in the other direction: "We know not whether it was well-judged to take the story of a play from a novel so recent and so much read as the Caleb Williams of Mr. Godwin, because it is impossible to produce a lively interest where the denouement is previously known" (102). For Smollett in 1796, the problem with adaptation has nothing to do with an inability to find sufficient dramatic equivalents for Godwin's novel. Rather, its twice-told status precludes suspense. Clearly, Smollett would have been a failure as a Hollywood studio executive. In fact, he was out of step with the realities of his own moment's hunger for adaptations. Still, his observation underscores the fact that, unlike our moment's book-was-better cultural reading strategy, no cultural consensus had yet emerged as to what adaptations could or should do in and with the culture.

But that cultural consensus was fast approaching, and *The Iron Chest* serves as a critical signpost. The critical marginalization of adaptation, as fully expressed by Dickens in 1839, coincides with the historical rise of Romanticism's critical repositioning of definitions of literature and the related composition of literary canons. Elizabeth Inchbald's 1808 *British Theatre* functions as the earliest canonization of British drama. The collection represents her attempt to clear a space for the drama's potential as literature. That potential relies on changes in the ways plays were composed, changes that comport with Romanticism's shifting of the concepts of literature. When Inchbald turns her attention to the topic of dramatic adaptation, she finds reason for concern. Her 1808 reading of *The Iron Chest* points to its status as an adaptation as a fatal flaw: "to follow an author, in a work of such powerful effect, what hope could be cherished of arriving at the goal which he had reached, or of approaching him nearer than as one of his admiring train?" (3). Such logic trickles down from Wordsworth: adaptation forfeits originality, and a text that is not the "legitimate offspring of his own mind" (Inchbald 3) cannot be literature; it must be a bastard.

William Hazlitt's 1816 consideration of *The Iron Chest* also touches on issues of adaptation. His critique focuses on the central workings of the novel and its adaptation: "The interest in the novel chiefly arises from two things: the gradual working up of the curiosity of Caleb Williams with respect to the murder . . . and then from the systematic

persecution which he undergoes from his master" (107). As Colman's adaptation cannot express the "gradual" or the "systematic," "[t]he great beauty of *Caleb Williams* is lost in the play" (107). Again, such readings are offered in retrospect, thirteen and twenty-one years after the play's premiere, and practice the backward reading strategy that would come to define adaptation studies: Colman's play functions as an invitation to look back at Godwin's novel. And the copy is found wanting. The overall shape of Inchbald's and Hazlitt's adaptation studies, which mirrors Litchfield's, would go on to serve as the template for adaptation studies through the twentieth century.

Conclusion: Developing a Better Understanding of the Act of Adaptation

Perhaps the constitutive construction of an adaptation tempts its audience, and critics in particular, to read it backward. The text's announced existence as a recycled narrative immediately invites a focus on where it comes from, rather than where it is going. The dated concept of adaptation as simple—and by definition insufficient—repetition inevitably leads critics to read backward, privileging the question: what does the adaptation do to its source? Only with such postmodern concepts of adaptation as Hutcheon's formula—adaptation as "repetition without replication" (7)—are critics left with more potentially productive openings. Within that shifted critical economy, adaptation can no longer be understood adequately as a structuralist generic translation along the lines of George Bluestone's *Novels into Film* or Brian McFarlane's *Novel to Film*. Accounting for the adaptive shift demands that critics consider not only the narrative capacities of the shift from one genre to another, but also the changed contexts and new sets of constraints imposed on new genres by new audiences. At that point, processing the *act* of adaptation becomes key to understanding not merely the structure of that genre but the concerns of that audience.

By recontextualizing texts, adaptation allows them to meet their beholder halfway. In "The Work of Art in the Age of Mechanical Reproduction," an essay that examines the results of the clash of tradition and modernity, Walter Benjamin points out that "technical reproduction can put a copy of the original into situations which would be out of reach for the original itself. ... to meet the beholder or listener in his own particular situation" (793, 794). Such an original/copy binary transfers (adapts) smoothly to the critical consideration of adaptations. Adaptations follow a dynamic and perform a function similar to those of Benjamin's mechanical reproduction: they allow an audience to encounter "originals" in new spaces and under new conditions. Benjamin argues that such shifted conditions of production and consumption imbue the text with a "reactivated" life: "Instead of being based on ritual, it begins to be based on another practice—politics" (796). I argue that adaptation, as inaugurated in the early Romantic period,

reactivates texts in new contexts and so functions not as a polemical but as a dialectical intervention. In the case of *The Iron Chest*, that reactivation engages adaptation's progressive democratic possibility of textual/generic mobility as a reflection of the audience's emerging social mobility. Paradoxically, it simultaneously normalizes the conservative containment and effacement of its source's democratic questioning of "things as they are" and buries Godwin's radical political arguments in a conventional clichéd love story. A rearview reading strategy focusing on fidelity would miss all this work of adaptation.

Many critics have pointed out fidelity criticism's debt to the critical aesthetics developed by Romanticism. Approaching the issue from a historical perspective both endorses and sheds new light on that observation. Fixing the rise of adaptation as a simple abstraction at the outset of the Romantic period—essentially coeval with the rise of the concepts that would compose the critical aesthetics of Romanticism—makes it clear that the cultural concept of the act of adaptation is a critical construction that developed along with the fidelity urge. In the end, adaptation as such functions more as a strategy for reading than for constructing texts. And that reading strategy is driven by fidelity. The fidelity urge has proven so difficult for the field of adaptation studies to shake because our very definition of what an adaptation is emerged from reading adaptations through a fidelity lens. We recognize an adaptation as an adaptation only through the act of comparing it with its source (and finding it wanting). The game is rigged; the question of fidelity is begged.

The frustrating part—and the part with which, hopefully, history can help—comes when we realize that, to quote the orchid thief John Laroche in *Adaptation.* (2002), "adaptation is a profound process." For critics looking to shift the focus away from the limitations imposed by Romanticism's hidebound concepts of originality and toward a more postmodern aesthetic that engages with the cultural and critical possibilities of retelling, reiterating, and recycling, it may be liberating to know that the concept of fidelity, along with the corresponding rearview reading strategy, was encoded from the beginning in nineteenth- and twentieth-century definitions of adaptation. Only by unwinding and understanding that history can we fully reach that point where we can move and read forward.

Notes

1. I borrow the term "simple abstraction" from Michael McKeon, who adapts it from Karl Marx. Simple abstraction signals a stabilization of terminology, the point at which a term becomes a portable, reliable signifier in a culture, cohesively recognizable as such. It is, for McKeon, "a deceptively monolithic category that encloses a complex historical process" (20). As such, it covers up and simplifies a long history of more diverse, less unified usage.
2. For example, Thomas Southerne's play *Oroonoko* (1695), now easily recognizable as an adaptation of Aphra Behn's 1689 novel, was not referred to as an adaptation until the nineteenth century. Southerne did not hide his debt to Behn; the term "adaptation" as a signifier for the repurposing of a source was simply not yet in use.

3. A similar explosion of adaptation occurs in cinema with the introduction of sound. When dialogue suddenly became necessary in the late 1920s, filmmakers turned to the raw material of the theater and began adapting plays. It is this moment to which MacCabe refers as the dawn of modern adaptation.

4. Interestingly, Tom Gunning reads Maxim Gorky's "Boredom" (1907), about the attractions of Coney Island, as a strikingly similar assessment of early twentieth-century America, extending Gorky's reading to the specific conditions that fostered the rise of early cinema: "Gorky also provides insight into the needs for thrills in an industrialized consumer-oriented society. The peculiar pleasure of screaming before the suddenly animated locomotive indicates . . . a spectator whose daily experience has lost the coherence and immediacy traditionally attributed to reality. This loss of experience creates a consumer hungry for thrills" (Gunning 873). Like Wordsworth, Gorky and Gunning see the conditions of industrial capitalism as systematically producing a hunger for spectacle. In order to compensate for the numbing narrowness and compartmentalization of urban experience, the modern consumer craves astonishment.

WORKS CITED

"Adaptation." *Oxford English Dictionary.* 2nd ed. Oxford: Oxford UP, 1989. Print.

Adaptation. Dir. Spike Jonze. Perf. Nicholas Cage, Meryl Streep. Columbia, 2002. Film.

Barthes, Roland. *Image—Music—Text.* Trans. Richard Miller. New York: Hill and Wang, 1978. Print.

Benjamin, Walter. "The Work of Art in the Age of Mechanical Reproduction." 1936. Braudy and Cohen 791–811. Print.

Bluestone, George. *Novels into Film.* Berkeley: U of California P, 1957. Print.

Braudy, Leo, and Marshall Cohen, eds. *Film Theory and Criticism.* 6th ed. New York: Oxford UP, 2004. Print.

Cartmell, Deborah. "100+ Years of Adaptations, or, Adaptation as the Art of Democracy." *A Companion to Literature, Film, and Adaptation.* Ed. Deborah Cartmell. Malden: Blackwell, 2012. 1–13. Print.

Colman, George the Younger. *The Iron Chest. The Plays of George Colman the Younger.* Vol. 1. Ed. Peter Tasch. New York: Garland, 1981. Print.

Cox, Philip. *Reading Adaptations: Novels and Verse Narratives on the Stage, 1790–1840.* Manchester: Manchester UP, 2000. Print.

Dickens, Charles. *Nicholas Nickleby.* 1839. New York: Oxford UP, 2009. Print.

———. *A Tale of Two Cities.* 1859. New York: Oxford UP, 2008. Print.

Gamer, Michael. "A Select Collection: Barbauld, Scott, and the Rise of the (Reprinted) Novel." *Recognizing the Romantic Novel: New Histories of British Fiction, 1780–1830.* Ed. Jillian Heydt-Stevenson and Charlotte Sussman. Liverpool: Liverpool UP, 2008. 214–35. Print.

Godwin, William. *Things as They Are, or The Adventures of Caleb Williams.* Ed. Maurice Hindle. New York: Penguin, 2005. Print.

Gorky, Maxim. "Boredom." *The Independent* 63 (8 Aug. 1907): 311–12. Print.

Gunning, Tom. "An Aesthetics of Astonishment: Early Film and the (In)Credulous Spectator." 1989. Braudy and Cohen 862–76. Print.

Hazlitt, William. Rev. of *The Iron Chest.* 1816. *Hazlitt On Theatre.* New York: Hill and Wang, 1957. Print.

Hutcheon, Linda, with Siobhan O'Flynn. *A Theory of Adaptation*. 2nd ed. New York: Routledge, 2013. Print.

Inchbald, Elizabeth, ed. *The British Theatre: A Collection of Plays Acted at the Theatres Royal, with Biographical and Critical Remarks*. Vol. 21. London: Longman, 1808. Print.

Leitch, Thomas. "Twelve Fallacies in Contemporary Adaptation Theory." *Criticism* 45.2 (2003): 149–71. Print.

Litchfield, John. "Remarks on Mr. Colman's Preface: Also a Summary Comparison of the Play of *The Iron Chest* with the Novel of *Caleb Williams*." *Monthly Mirror*, 1 Sept. 1796. Print.

MacCabe, Colin. "Introduction: Bazinian Adaptation: *The Butcher Boy* as Example." *True to the Spirit: Film Adaptation and the Question of Fidelity*. Ed. Colin MacCabe, Kathleen Murray, and Rick Warner. Oxford: Oxford UP, 2011. 3–25. Print.

McFarlane, Brian. *Novel to Film: An Introduction to the Theory of Adaptation*. Oxford: Clarendon, 1996. Print.

McKeon, Michael. *Origins of the English Novel, 1600–1740*. Baltimore: Johns Hopkins UP, 2002. Print.

Naremore, James, ed. *Film Adaptation*. New Brunswick: Rutgers UP, 2000. Print.

Nicoll, Allardyce. *The History of English Drama, 1660–1900*. Cambridge: Cambridge UP, 1955. Print.

Ray, Robert. "The Field of 'Film and Literature.'" Naremore 38–53. Print.

Smollett, Tobias. Rev. of *The Iron Chest*. *The Critical Review, or, Annals of Literature*. London: Hamilton, 1797. Print.

Stam, Robert. "Beyond Fidelity: The Dialogics of Adaptation." Naremore 54–76. Print.

Wordsworth, William. *Lyrical Ballads with Pastoral and Other Poems*. London: Longman, 1800. Print.

Young, Edward. *Conjectures on Original Composition*. London: Millar, 1759. Print.

CHAPTER 3

NINETEENTH-CENTURY THEATRICAL ADAPTATIONS OF NOVELS

The Paradox of Ephemerality

RENATA KOBETTS MILLER

MANY of London's theaters are said to be haunted by those who once trod their boards. While such stories manifest a broader field of theatrical superstition, they also speak to the fleeting presence of the work of actors, directors, and managers. These ghost stories represent an impulse to give these figures afterlives. Specific actors, for example, are said to dwell in the theaters in which they became famous, replaying their most successful roles. In a sense, to write an essay about Victorian stage adaptations is to trace the ghostly presences of vanished works and to acknowledge the ways in which they continue to haunt the literary canon through their cultural influence.

Adaptation studies places value and importance on works that have traditionally been devalued as secondary or derivative. When dealing with film adaptations, the claim that such works are worthy of study represents a movement to study popular culture. The adaptations, in this case, may occupy a devalued cultural status but still have a material and cultural presence that can be as strong as or stronger than that of the adapted works. The film still exists for the researcher as it did for its original viewing audience, and it may still continue to attract a following. In contrast, stage performances, particularly those that predate video, have left behind no complete material work but only the traces of scripts, promptbooks, images, and descriptions of performances. This suggests that both the study of these works and the mechanism through which they have exerted cultural influence are different from those adaptations that have stable, lasting material existence. To study Victorian stage adaptations is to study works that have disappeared but whose influence remains, though often in unexpected ways.

In addition to lacking enduring material embodiment, Victorian stage adaptations are doubly, even triply erased from cultural memory. As adaptations they are regarded

as derivative; as Victorian dramas they are tarred with the generalization that they lack artistic merit. Apart from those of Wilde and Shaw, Victorian dramas have not survived in the theatrical repertoire. Drama is the neglected stepchild of Victorian studies, attracting interest from theater historians but eclipsed in literary and cultural study by fiction and poetry. Jacky Bratton argues that this current underrated status has its roots in the Victorian debate surrounding the condition of the British stage. Emily Allen, J. Jeffrey Franklin, and Joseph Litvak have all examined how the theater was employed by novelists and poets as an abjected other onto which they displaced their own concerns about writing for popular audiences as they defined their own writing in contrast to the theater.

Central to the devaluing of drama in the Victorian period was the view that the stage was a form of popular entertainment that was financially obligated to cater to the tastes of the working classes. In his 1850 essay "The Amusements of the People," Charles Dickens describes a theater full of working-class spectators, discusses the theatrical tastes of a fictional "common" man, Joe Whelks, and expounds on the dependence of the stage on a non-reading audience: "Heavily taxed, wholly unassisted by the State, deserted by the gentry, and quite unrecognized as a means of public instruction, the higher English Drama has declined. Those who would live to please Mr. Whelks, must please Mr. Whelks to live" (13). Similarly, in an 1858 *Household Words* article, Wilkie Collins suggested that theater managers, in contrast to publishers of novels, catered to the lowest tastes in the audience: "The publisher can understand that there are people among his customers who possess cultivated tastes, and can cater for them accordingly, when they ask for something new. The manager, in the same case, recognises no difference between me and my servant" (266). Collins's argument that theater managers make no attempt to bring those with "cultivated tastes" back into the theater because "the increase of wealth and population, and the railway connection between London and the country, more than supply in quantity what audiences have lost in quality" has become the received history of how Victorian theater was shaped by rapid demographic and technological change (269; compare, for example, Rowell). Collins goes on to execrate the lack of discrimination in this broad-based, working-class audience. According to Collins, theater managers cater to a "vast nightly majority . . . whose ignorant sensibility nothing can shock. Let him cast what garbage he pleases before them, the unquestioning mouths of his audience open, and snap at it" (269).

Such scathing criticisms of the theater and its audience, however, were not limited to mid-Victorian novelists. Writing as one of the foremost theater critics of the fin de siècle, William Archer deplored the state of British theater in terms that echoed those of Collins: "Here we have not a single theatre that is even nominally exempt from the dictation of the crowd" ("The Free Stage and the New Drama" 666). This essay and another by Archer that addressed England's lack of a "literary drama" led the *Pall Mall Gazette* in 1892 to pose the question: "Why is it that in modern England . . . scarcely any of the popular novelists are known as writers for the stage?" (Archer, "The Stage" 219; "Why"). A recurrent theme in the novelists' responses was the qualitative difference between a reading audience and a theater audience.

George Gissing decried the unintellectual taste of theater audiences in extreme terms. His rhetoric provides a good example of the vitriol that motivated novelists' attacks on the stage:

> The acted drama is essentially a popular entertainment; author and player live alike upon the applause of crowds. When the drama flourished in England, it was by virtue of popular interests, for in those days the paying public was the intellectual public. . . .
>
> Nowadays, the paying public are the unintelligent multitude. The people who make a manager's fortune represent a class intellectually beneath the groundlings of Shakespeare's time. . . . When Johnson, or when Lamb, sat in the pit, they had no such fellow playgoers about them as now crush together at the unopened doors, but a majority of men who with us would merit the style of gentle. Our democratic populace, rich and poor, did not exist. What class of readers made the vogue of the Waverley Novels? Those books were never *popular*, as the word is now understood; price alone proves that. Nor was Sheridan popular in this sense. The spiritual mates of those who now pay for a stall at Drury Lane or the Adelphi sat then in stalls of another kind—cobbler's or huckster's—and recked not of dramatic literature.

Gissing's rhetoric exaggerates the numbers of theatergoers as he evokes the notion of "popularity" to denote an appeal to a crowd that is large, working-class, and uneducated, reflecting the anxiety that Patrick Brantlinger has argued nineteenth-century novelists had about mob-like reading audiences. This projection may account for their magnified notion of the masses that attended London theaters. Indeed, just as Gissing resented the "democratic" theatrical audience, Harold Frederic's central thrust against the drama was that it was subject to majority rule. In Frederic's view, for a play, "nobody cares about its merit *qua* merit. The only question is whether a theatre-going public will like it." The novelist, on the other hand,

> writes for just the audience that he feels in touch with, and need not think of the others. If, on a given day, of 500 people reading his book there are 50 who like it and are glad it was written, the fact that the other 450 yawn affects nothing. The book was not written for them, that is all; and it will go on finding its way to those for whom it was written. . . .
>
> The work of the novelists is never wasted or lost. The hostile majority I have assumed above cannot prevent the appreciative minority from enjoying the work written for them. In the playhouse absolutely the reverse is true. There the hostile majority can, and does, decree that the play it does not like shall be seen no more of men.

Most novelists writing in the *Pall Mall Gazette* agreed that the theater's "democratic" audience was less exclusive than the novel-reading public. Mary Elizabeth Braddon specifically described the heterogeneous audience of the theater in contrasting "the kindly public of the circulating library" with "that triple-headed monster of the stalls, pit, and gallery whom the playwright has to please." Braddon used the theater's ticket levels to stand metonymically for the economic strata its audience comprised.

Even as most novelists did not write plays, and even as many of them contrasted the conditions of their work with those of the stage, many of them wrote indirectly for the stage, for contemporary novels were commonly used as source texts for Victorian drama. Allardyce Nicoll attributes this phenomenon to the novel "becoming a dominant form of literature"—an ascendance that J. Jeffrey Franklin has argued contributed directly to the decline of drama (1: 91). Nicoll slights the dramatists and their adaptations: "the minor dramatists found here in plenty that for which they were seeking—plots, characters and dialogues ready formed, the *scenario* (and more than the *scenario*) on which they could base their hastily written plays" (1: 91). In Nicoll's view, adaptations were not only without merit; they were a direct cause of the theater's stagnation. According to Nicoll, adaptations of novels were particularly insidious examples of poor Victorian drama that infected the theater with poor dramatic techniques:

> Dickens' novels helped, like Scott's, in still further developing the melodramatic tradition, and, besides this, ... they contributed in preventing the development of a new and truer dramatic technique. Careless adaptation of narrative fiction can lead towards nothing but the stringing together of episodes, and it is this episodical treatment which, more than anything else, mars the workmanship of the plays of the half century.... Finer dramatic technique was lost, characterization was not sought for; incidents alone could make a direct and a popular appeal. (1: 99)

Stage adaptations of Victorian novels have thus been themselves devalued both in the Victorian period and in contemporary criticism, subjected to a more general devaluing of Victorian drama, and even identified as a cause of the decline of the theater.

Yet the devalued, impermanent, and immaterial theatrical performance can have enduring effects in a paradox of ephemerality. According to a Google NGram viewer, the term "ephemera" peaked in print usage around 1858, reflecting an era marked by the inexpensive production of consumer goods and the acceleration of lived experience brought about through urban life and technologies of transportation and communication like the railroad and telegraph. Ephemeral items are popular and common, but impermanent and short-lived. In the economy of material collecting, such items often become valuable precisely because their disposable nature means that very few survive, and their scarcity drives up their price in the marketplace. The value of such items depends not only on scarcity of supply but also on intensity of demand, and this demand is often driven by the fact that, while the material items themselves were prone to disappear, their cultural impact, like that of vanished individual advertisements from influential ad campaigns, endures.

The theatrical production is fleeting. Although George Henry Lewes and William Archer, writing about acting in the Victorian period, went to great lengths to assert that actors' techniques are based on real emotions channeled in such a way that produced performances that could be replicated, such anxious assurances work against the underlying understanding of theatrical performances as unfixed, impermanent, and

potentially unstable, in contrast to the immutable, enduring printed text (see Lewes; Archer, *Masks*). This ephemerality was associated with their devaluation as popular.

Yet the image of the stage as popular relative to the novel is a myth that is contradicted by readership and attendance statistics, a fact that the novelist Margaret L. Woods, in her essay for the *Pall Mall Gazette*, reflected when she wrote that "the novelist in England has the advantage of appealing to an audience not only larger than the dramatist's but somewhat more discriminating," and imagined an intelligent, far-reaching, novel-reading public. The proposition that novels might have a larger audience than plays might seem counterintuitive to a reader in the twenty-first-century, when "a best-selling book may reach a million readers; a successful Broadway play will be seen by 1 to 8 million people; [and] a movie or television adaptation will find an audience of many million more" (Hutcheon 5). A best-selling nineteenth-century novel certainly reached much more than a million readers. Dickens's *Pickwick Papers* (1836–37) had sold 800,000 copies by 1879, and Harriet Beecher Stowe's blockbuster import *Uncle Tom's Cabin* (1852) sold 1,500,000 copies in the British empire in its first year alone. Neither of these statistics accounts for the prominence of the circulating libraries in the distribution of novels: each copy purchased by a circulating library would have had numerous users (Altick 383–84). In contrast, Archer suggested "by his 'Law of the Hundred Thousand' that the mark of a play's success was a run of at least one hundred nights. At a theatre seating 1,000 this means a minimum of 100,000 needed to see a play, yet 'it is absurd to imagine that there are in London, at any one time, 100,000 playgoers of keen intelligence and delicate perception—capable, in short, of appreciating the highest order of drama'" (Archer and Granville Barker, qtd. in Davis, "The Show Business Economy" 39–40). Although the need to attract an audience of 100,000 was considered the reason that the stage needed to pander to unsophisticated audiences, the stage was not prima facie more popular than the novel. At the same time that the "long run" became, increasingly over the course of the nineteenth century, the dominant business model for theaters, making it more likely that a single production could be seen by many more than 100,000 people, the Victorian reading public was also expanding (Davis, *Economics* 212–14; Rose).

Thus the influence of stage adaptations cannot be attributed to their putting a story into significantly more extensive circulation. There is evidence that plays allowed the original story to reach an audience that was distinct from that of the novel's readership. In a letter to the *Athenaeum*, Charles Reade explained why he adapted the play *Masks and Faces* (1852), which he had written with Tom Taylor, into his novel *Peg Woffington* (1853): "First, I was unwilling to lose altogether some matter which we had condemned as unfit for our dramatic purpose; secondly, the exigencies of the stage had, in my opinion, somewhat disturbed the natural current of our story; thirdly, it is my fate to love this dead heroine, and I wished to make her known in literature, and to persons who do not frequent the theatres" (82). In addition to hinting at the desire to give Peg Woffington a lasting tribute in the novel—one that the play in its ephemerality could not offer—Reade suggests that Peg's story, as he relates it in his novel, could not be told in a play, and also notes that the novel and the theater attracted different audiences.

Although theatrical productions were fleeting and devalued, and although individual theatrical productions were unlikely to bring the story of a novel to a substantially larger audience, such productions were nevertheless influential because they were the first step toward abstracting from the original novel what Paul Davis has called a "culture-text." Davis writes that Dickens's "*A Christmas Carol* could be said to have two texts, the one that Dickens wrote in 1843 and the one that we collectively remember. . . . The text of *A Christmas Carol* is fixed in Dickens' words, but the culture-text, the Carol as it has been re-created in the century and a half since it first appeared, changes as the reasons for its retelling change. We are still creating the culture-text of the Carol" (4). The emergence of a culture-text creates a frequently renewed audience for the originating text, and the Victorian practice of adapting novels to the stage was a key element in the creation of a culture-text. Beyond extending the audience, there were several aspects of theater production that contributed to the culture-text, namely the repertoire and revival system, the association of roles with particular actors who helped to perpetuate the text, and the particular ways in which the original novel's characters were embodied. When a novel was first adapted to the stage, that theatrical production encouraged the formation of a culture-text, beginning a process that it could help to shape long after the theatrical production itself had been forgotten.

The Victorian period is bookended by two novels that were famously, persistently, competitively, and controversially adapted to the stage and attained "culture text" status, continuing to live on in film and stage adaptations. Both Dickens's *Nicholas Nickleby* (1838–39) and Robert Louis Stevenson's *Strange Case of Dr. Jekyll and Mr. Hyde* (1886) were dramatized either during or shortly after their publication, and were dramatized in multiple adaptations simultaneously.[1] In both cases, these early adaptations shaped a history of subsequent adaptations.

EMBODIMENT AND THE SERIAL
PUBLICATION OF *NICHOLAS NICKLEBY*

"Every writer of fiction, though he may not adopt the dramatic form, writes in effect for the stage," said Dickens in a toast to William Makepeace Thackeray. Dickens himself wrote about and for the theater, his enthusiastic participation in semi-public theatricals led to his affair with the actress Ellen Ternan, and he famously staged public readings of passages from his novels. While his statement gestures metaphorically toward how novelists wrote for a popular audience, it also suggests that the novelistic imagination— his own in particular—was shaped by a theatrical view and, perhaps, was even shaped by envisioning how novels would be staged. Given his statement, it is no surprise that Dickens's novels were popular source texts for stage productions (see Nicoll 1: 96, 97). *A Christmas Carol* (1843) is undoubtedly the strongest culture-text yielded by Dickens's works, as Paul Davis has explored; in fact, it is one of the strongest culture-texts to

emerge from the Victorian period. It was in *Nicholas Nickleby*, however, that Dickens explicitly confronted the phenomenon of the stage adaptations of novels.

Following on *Pickwick Papers* (1837) and *Oliver Twist* (1838), which were both heavily adapted immediately following their publication, *Nicholas Nickleby* was Dickens's third novel. Its publication in monthly numbers from March 1838 through September 1839 is central to its adaptation history. Even before the novel had been concluded, Edward Stirling's play *Nicholas Nickelby* opened at the Adelphi Theatre on 19 November 1838, George Dibdin Pitt's *Nicholas Nickleby Or, the Schoolmaster at Home and Abroad* opened at the City of London Theatre on 19 November 1838, and W. T. Moncrieff's *Nicholas Nickleby and Poor Smike or The Victim of the Yorkshire School* opened at the Strand Theatre on 20 May 1839. In response to the last, the number of *Nicholas Nickleby* that appeared on 1 June 1839 introduces "a literary gentleman ... who had dramatised in his time two hundred and forty-seven novels as fast as they had come out—some of them faster than they had come out—and *was* a literary gentleman in consequence" (726). Speaking through his title character, Dickens holds the playwright, as well as the-atrical business structures, culpable for the state of the drama. In this stab at Moncrieff, Nicholas describes how adapters

> take the uncompleted books of living authors, fresh from their hands, wet from the press, cut, hack, and carve them to the powers and capacities of your actors, and the capability of your theatres, finish unfinished works, hastily and crudely vamp up ideas not yet worked out by their original projector, but which have doubtless cost him many thoughtful days and sleepless nights; by a comparison of incidents and dialogue, down to the very last word he may have written a fortnight before, do your utmost to anticipate his plot—all this without his permission, and against his will; and then, to crown the whole proceeding, publish in some mean pamphlet, an unmeaning farrago of garbled extracts from his work, to which you put your name as author, with the honourable distinction annexed, of having perpetrated a hundred other outrages of the same description. (727–28)

Cox accounts for such intensity by arguing that as Dickens determined that he would pursue a "career as a serious literary novelist," "it became ... important for him to distinguish his literary productions from less serious, ephemeral publications of the kind that he was originally asked to write for Chapman and Hall and from the equally ephemeral and yet more populist adaptations of his novels in the minor theatres" (124). Dickens aspired to permanence rather than ephemerality, and serial publication inclined toward the latter. Despite his association of the theater with "the common people" in "The Amusements of the People," it appears that ephemerality rather than populism was the key target of his animosity toward Moncrieff's version (237). The Adelphi and Strand Theatres stood within a few blocks of each other in the West End. Jim Davis and Victor Emeljanow describe how, in 1841, West End theaters were not yet "in a position to exclude less affluent patrons such as the local working commu-nity. Yet the process of commercialization and exclusiveness that would isolate the West End was becoming evident" (186). The Adelphi Theatre, in which Stirling's play

was produced, was described by *Cruchley's Guide* in 1841 as "a favorite resort of the laughter-loving gentry ... [and] one of the most fashionably attended of the minor theatres" (qtd. in Davis and Emeljanow 186). In contrast, the City of London Theatre, where Pitt's play appeared, was an East End theater that attracted a local working-class audience and would have been more like the theater that Dickens characterized in "The Amusements of the People." That essay, moreover, suggests that Dickens would not have eschewed a popular crowd. He ultimately argues for the value of the theater as an edifying influence, identifying literature, and the theater as its non-print surrogate, as important imaginative engagements, in contrast to polytechnic institutes.

Putting class status aside, Dickens's attack on Moncrieff and Moncrieff's response reveal both Dickens's recognition that the drama helped to make his fame, giving permanency to his own accomplishment, and Moncrieff's recognition of the ephemerality of his own adaptations. Dickens's Nicholas tells the adapter-playwright in the novel: "if I were a writer of books, and you a thirsty dramatist, I would rather pay your tavern score for six months—large as it might be—than have a niche in the Temple of Fame with you for the humblest corner of my pedestal, through six hundred generations" (728). Moncrieff responded to that very line: "I can assure him that I have never anticipated that any credit I might have derived from dramatising 'Nicholas Nickleby' would more than endure beyond as many days" (125). Indeed, while *Nicholas Nickleby* remains in print the world over, the text of Moncrieff's drama exists only in the manuscript submitted to the Lord Chamberlain for approval and held in the British Library, and in the microfiche series that includes the Lord Chamberlain's Plays.

The Stirling and Moncrieff adaptations capitalized on the novel and contributed to its success. In dedicating his play to Dickens, Stirling cites the novel's "exceeding popularity" as the reason he adapted it. Stirling's adaptation was performed on a double bill with an adaptation of *Oliver Twist*. It is clear from the structure of both the Stirling and Moncrieff adaptations that their ideal audiences are the readers of the serialized books. The plays make no attempt to provide a coherent narrative, but instead present a series of scenes without interstitial connections. In the Moncrieff version, the action begins with Nicholas's arrival at the Yorkshire school. Later, we witness Nicholas discussing Clara Bray with the Cheerybles in their counting house without learning how Nicholas came to work for them, and his first meeting with Clara is only narrated. In this sense, the play seems designed to provide a series of favorite scenes from the novel, realizing them in three-dimensional animation, fulfilling some of the same desires as a tableau vivant. The scenes freely recycle dialogue from the novel.

The plays, in turn, likely contributed to the sales of the novel-in-progress. In fact, Nicoll provides evidence that for later novels Dickens provided dramatists with proofsheets or even sold a dramatist his manuscript (1: 98–99). John Rieder has pointed out how the performance of melodramatic stage adaptations of Mary Shelley's *Frankenstein* (1818) may have boosted the novel's long-term sales, preventing it from being forgotten (19), and Kate Mattacks has chronicled how Colin H. Hazlewood's 1863 dramatic adaptation of Mary Elizabeth Braddon's *Lady Audley's Secret* (1862–63), and a series of dramas that followed it, remained readily available in acting editions

long before the novel came back into print (11, 21 n.38). The theatrical repertoire—the culture of revival in the theater and during the careers of actors and actresses—fosters a novel's longevity as its story is brought back into stage production, generating additional novel sales. Reade's novel *Peg Woffington* enjoyed this effect. Squire and Marie Bancroft's repeated revivals of *Masks and Faces* into the 1880s probably account for the republication of *Peg Woffington* several times in the last decades of the nineteenth century.

Indeed, particular scenes of *Nicholas Nickleby* that appeared in the Stirling and Moncrieff plays have been echoed in modern adaptations, including Alberto Cavalcanti's 1947 film, David Edgar's 1980 play, and Douglas McGrath's 2002 film. These include Nicholas turning Squeers's abuse of Smike against the schoolmaster himself, Ralph Nickleby's debasing of Kate as bait for his clients, and Nicholas hearing Ralph's clients taking the liberty of toasting Kate. The first stage adaptations also served to embody the characters in ways that made them memorable. Dickens wrote to Frederick Yates, who played Mantalini in the Stirling version: "My general objection to the adaptation of any unfinished work of mine simply is that being badly done and worse acted, it tends to vulgarise the characters, to destroy or weaken the minds of those who see the impressions I have endeavoured to create, and consequently to lessen the after-interest in their progress. No such objections can exist where the thing is so admirably done in every respect as you have done it in this instance" (qtd. in Fitz-gerald 129–30). Dickens's praise suggests how seeing a novel's characters embodied on stage creates a market for the text that originated them.

Although Dickens's characters are vividly realized in the text of the novel, their embodiment in adaptation also served, paradoxically, to make them immortal. The influence that performance had in shaping understandings of characters in *Nicholas Nickleby* and in establishing a culture-text is evident in the fact that, when H. Horncastle's *The Infant Phenomenon; or, a Rehearsal Rehearsed*, which opened at the Strand Theatre in July 1838, was revised and played at the Surrey Theatre under the title of *Nicholas Nickleby*, several members of the Adelphi company who had played in Stirling's first adaptation reprised their roles (Fitz-gerald 128–31). Similarly, as adapting *Nicholas Nickleby* evolved into something resembling a franchise when Stirling's *The Fortunes of Smike; or, A Sequel to Nicholas Nickleby: A Drama in Two Acts* opened on 2 March 1840 at the Adelphi, it also included a handful of actors in their original roles. Stirling even dedicated the published version of the sequel to Mary Ann Keeley, stating that her "personation" of Smike, in all of the versions, "shed new luster on the magic pen of Boz" (qtd. in Fitz-gerald 132) (Figure 3.1).

It is notable that Keeley, an actress, helped shape the character of Smike in the early formation of the *Nickleby* culture-text. On the one hand, this casting used visual titillation to appeal to audiences. The Victorian breeches roles, in which male characters were played by actresses, allowed for the display of more leg than was visible in long skirts. The casting of a woman as Smike also makes Smike central to the action, both by highlighting Smike's status as the only cross-dressed role and by allowing a greater onstage sexual tension and attraction in the bond between Nicholas and Smike. In the novel,

SCENE FROM "NICHOLAS NICKLEBY," AT THE ADELPHI THEATRE, 1838. O. SMITH
AS NEWMAN NOGGS, MRS. KEELEY AS SMIKE, AND J. WEBSTER AS NICHOLAS.

[*To face p.* 128.

FIGURE 3.1 Self-captioned image of Newman Noggs, Smike, and Nicholas Nickleby.

Source: S. J. Adair Fitz-gerald, *Dickens and the Drama.*

Smike's devotion to Nicholas is transferred to a romantic but unspoken love for his sister Kate, whose attachment to another man contributes to Smike's pathos as he dies. In these plays, the male-male relationship is made more visually acceptable by casting Smike as a woman, thereby downplaying implications of homoerotic intimacy through heterosexual pairing on the level of casting. Accordingly, in the Moncrieff and Stirling plays that cast Smike as a woman, the Clara Bray romantic interest for Nicholas is displaced. Nicholas does not marry Clara Bray, nor does Smike die.

Nicholas Nickleby appeared in new adaptations or in revival several times over the course of the nineteenth century, with Smike consistently played by a woman (Fitz-gerald 139; Bolton). In 1875, a benefit played for Nelly Farren at the Gaiety Theatre, with Farren in the role of Smike, drew the praise of Keeley, who had originated the breeches role (Fitz-gerald 137). This theatrical emphasis on generations of performers in the repertoire and revival system shows how theatrical traditions helped to perpetuate a culture-text, even as individual dramas failed to gain permanence.

CULTURE-TEXT ECLIPSING TEXT
IN *JEKYLL AND HYDE*

Robert Louis Stevenson's *Strange Case of Dr. Jekyll and Mr. Hyde* (1886) is one of the most powerful culture-texts of the Victorian period and in the history of English literature. No other literary work has entered the vernacular as the concept of Jekyll and Hyde has, irrespective of any direct familiarity with Stevenson's novella. It has taken hundreds of new forms on stage, in film, on television, and in sequels and rewritings. As such, it offers an excellent example of a culture-text whose cultural afterlife has so eclipsed its source text that the original story bears little resemblance to the details of its cultural afterlife.

In Stevenson's novella, a third-person narrative traces Gabriel Utterson's experiences as he explores the relationship between his friend, the successful physician Henry Jekyll, and the mysterious ruffian Edward Hyde, and it incorporates fragments told to Utterson by other men in the novel's entirely male community. Utterson's friend and relative Richard Enfield tells him how, late one night in the streets, he witnessed Hyde trample a young girl, disappear behind a door Utterson knows is the back door to Jekyll's laboratory, and produce a check signed by Jekyll. Suspicious of Jekyll's will, which stipulates that, in case of his death or disappearance, Hyde will be his sole beneficiary, Utterson vows to investigate. When Utterson's clerk, Stephen Guest, reveals that the handwriting on the note left by Hyde after the murder of Member of Parliament Danvers Carew is an opposite-slant version of Jekyll's, Utterson suspects that Jekyll is aiding a murderer. Jekyll's colleague Hastie Lanyon becomes ill, dissociates himself from Jekyll and, before dying, leaves a note for Utterson to read after Jekyll's death or disappearance. Finally, suspecting foul play, Jekyll's butler Poole and Utterson break down the door to Jekyll's laboratory to find Hyde's dying body in Jekyll's clothes and a note addressed to Utterson telling him to read "Dr. Lanyon's Narrative" and "Henry Jekyll's Full Statement of the Case." Lanyon's letter recounts his experience of witnessing Hyde transform into Jekyll and relates Jekyll's account of how he lost control of his transformations. Jekyll's statement explains that he began his experiments in order to indulge in pleasures without social constraints while maintaining a blameless reputation. Jekyll loses control because Hyde is completely unconstrained. Even Jekyll's "Full Statement" fails to define and contain Hyde, who lives in narrative silences and represents unspoken evils. The subjective fragments of narrative provided by individuals create gaps within Utterson's knowledge of Hyde.

The first adaptations of Stevenson's novella, staged shortly after its publication in 1886, immediately made extensive changes to this textually complex story. Thomas Sullivan's play *The Strange Case of Dr. Jekyll and Mr. Hyde*, with Richard Mansfield in the title role of both Jekyll and Hyde (Figure 3.2), opened at London's Royal Lyceum Theatre on 4 August 1888 after touring American theaters.

FIGURE 3.2 Richard Mansfield as Dr. Jekyll and Mr. Hyde.

Source: Library of Congress.

Sullivan's play billed itself the "Sole Authorized Version," in contrast with another adaptation by John McKinney that opened at the Opera Comique two days later with Daniel Bandmann in the double lead role, and a third version that was canceled at the Theatre Royal, Croydon, because it violated copyright laws (Rev. in *Graphic*; rev. in *Sunday Times*). The McKinney version employed a cast of twenty-three to tell a story in which Jekyll is in love with the much younger Sybil Howard, the daughter of Rev. William Howell [*sic*]. Hyde kills Howell, and the play identifies Hyde's vice as sexual desire. Much of the action takes place in the garden between the vicarage and the neighboring church, and religion, as well as romance, mitigates the novel's sense of pervasive corruption. Eliminating man-about-town Enfield, who in the novel inexplicably wanders the streets of London by night, in the play it is the Vicar who describes how he encountered Hyde while returning from a sick parishioner. Thus, just as an actress playing Smike downplayed homosocial desire while introducing heterosexual attraction, one of the plays that initiated the culture-text for *Jekyll and Hyde* reframes a novel rich with homosocial relationships as a problem of hetero-sexual desire.

Upon receiving negative reviews, McKinney's version was canceled in London after its second performance, but was performed later in the United States (rev. in *The*

Theatre 1 Sept. 1888, rpt. in Geduld 167–68). Several additional versions appeared in the United States and England while Mansfield continued to perform Sullivan's script, which also introduces a romantic interest for Jekyll but maintains a stronger sense of widespread social problems. It dramatizes the problematic competitiveness among men in showing Carew's habit of upsetting the chessboard when Utterson is winning. It retains Enfield and his habit of "pushing his way down by-streets at dead of night after adventure" (7). It even uses many phrases from the novel, including Jekyll's punning accusation that Lanyon is a "hide-bound pedant" (11) and Jekyll's reference to "the cross roads" (14), both of which suggest weaknesses in the fabric of male society—one by emphasizing the Hyde in men other than Jekyll, the other by alluding to Oedipal rivalries. This fidelity to the spirit of the novel may be why Stevenson publicly pledged support for this play in a letter to the New York *Sun* on 12 March 1888 (*Four Letters*, letter 3, 5). Stevenson received royalty checks directly from Mansfield and on 18 June 1886 wrote to Sullivan: "I am sure . . . that *Jekyll* will be in good hands; and I have no doubt (as you say) that the venture can do me only good" (*Four Letters*, letter 1, 3). Stevenson seemed aware of the power that dramatic adaptation could have on his story's endurance, and of how it would shape its afterlife.

The changes the play makes to the story all narrow the threat posed by Hyde. By providing a younger Jekyll with a fiancée and Carew with a daughter, Sullivan's drama eliminates the novel's exploration of intimacy among men and removes the suggestion of homosexuality implied by the novel's silence regarding Hyde's transgressions. It further accomplishes this exclusion by introducing a Mrs. Lanyon and by eliminating the character of Stephen Guest, Utterson's trusted clerk. William Winter describes how the play was acted in a way that gave no indication of evil in Jekyll before the split, thereby containing evil within Hyde (165). Finally, like McKinney, Sullivan introduced the character of Inspector Newcomen, a police detective who recurs in later versions of the story and who symbolizes social control and order.

A *New York Times* review indicated that at this early stage, "[t]he theme of the story and the play needs no description now. Everybody has read the book. It was inevitable that Dr. Jekyll and his alter ego, Mr. Hyde, should be put on the stage, and it was equally certain beforehand, that in the effort to make a play out of Mr. Stevenson's narrative much of the psychological quality of that Gautier-like romance would be lost." It proceeds to describe how "Mr. Sullivan has, of course, conventionalized the story. A love interest is introduced. The victim of Hyde's brutal rage, Gen. Danvers Carew, becomes an active instead of merely passive personage, and he is provided with a daughter, to whom Dr. Jekyll is betrothed" (5). Clearly such additions of heterosexual romance plots were typical of stage adaptations, and later versions would follow in introducing Carew's daughter as a romantic interest for a young Jekyll.

The Untold Sequel of the Strange Case of Dr. Jekyll and Mr. Hyde, a novel published in 1890 by "N. A.," slyly comments on the relationship between opportunistic stage adapters and the capaciousness of Stevenson's original text, as Utterson finds the "Confession" of Edward Hyde, an American actor who abused Dr. Jekyll's generosity (27). According to the sequel, Jekyll was researching a potion that would transform him into another

person and had willed his estate to the actor Hyde so that Hyde could return the prop-
erty to Jekyll in his new form. Although Jekyll concealed Hyde for the murder of Carew,
Hyde killed Jekyll and, using his acting skills, assumed his place. Hyde ends up over-
taken by opium addiction and unable to maintain "the upright carriage of Jekyll" (40).
One can read this sequel as an allegory commenting on how the mercenary theater sub-
sumes the place of the novel while lacking the novel's nobility.

The changes that the earliest plays make to the story reveal the cultural influence of
theatrical adaptation, as it is the theatrical version of the story that was perpetuated in
later adaptations. Luella Forepaugh and George F. Fish's *Dr. Jekyll and Mr. Hyde or a
Mis-Spent Life: A Drama in Four Acts*, performed at Forepaugh's Theatre, Philadelphia,
in 1897, was arguably the strongest link between the very first theater adaptations and
the cinematic adaptations of *Jekyll and Hyde* that would follow. The play's first filming
in Chicago in 1908 converts Stevenson's novel into a detective mystery dominated by
Sullivan's invention, Inspector Newcomen, who represents the law and stops the vice
embodied in Hyde. Like the McKinney version, the play strengthens the moral tone of
the story by replacing Carew with the Vicar Rev. Edward Leigh, whose daughter, Alice, is
engaged to Jekyll. There is no Enfield, and heterosexual romance abounds among minor
characters. Implications of intimacy are also removed from the relationship between
Utterson and his clerk, Stephen Guest, who never shares a bottle of wine with Utterson,
as he does in Stevenson. The play clearly defines Jekyll's vice as heterosexual desire and
Hyde's vice as sadism: when Jekyll changes into Hyde, he assaults Alice before killing her
father. Alice demands justice for the murder of her father, continuing the play's moral
tone. The Forepaugh and Fish play was followed by theater productions that included
Henry B. Irving's production, written by J. Comyns Carr, which opened in April 1910 at
Queen's Theatre in London. This version gave Jekyll a wife and continued the theatrical
trend toward creating a thriving society of brightly lit dining and drawing rooms peo-
pled with men in full dress and women in ball gowns who are threatened by an isolated
madman.

The 1920 films by Louis Meyer for the Pioneer Film Corporation with Sheldon Lewis
as Jekyll, and by Clara S. Beranger for the Famous Players–Lasky Corporation with John
Barrymore as Jekyll and Hyde, provided two love interests for Jekyll: a fiancée in the
person of Carew's daughter, and a music hall dancer named Gina. The heroine, as in the
earlier theatrical adaptations, calls for justice against Hyde.

The extensive history of adaptations of Jekyll and Hyde over the course of the twenti-
eth and into the twenty-first century has been shaped more by the early theater adapta-
tions than by Stevenson's novella. David Edgar described how his 1991 play produced by
the Royal Shakespeare Company emerged from this culture-text:

> The play is an attempt to reread the novel, and therefore it absolutely related, not only
> to the novel as being an independent text, but also to other readings of the novel.
> I am aware, and I hope addressing the fact, that most people's knowledge of *Jekyll
> and Hyde* is actually knowledge of the [1941] Spencer Tracy film. And those who have
> knowledge of the Spencer Tracy film are probably unaware that the Spencer Tracy

film is a model which actually doesn't result from the novel but is a variant on the [1932] Mamoulian film, which is a variant on the John Barrymore film, which is a variant on the play that Richard Mansfield [performed in 1888]. (Edgar interview in Miller 191–92)

Most of the twentieth-century adaptations portray a secure heterosexual patriarchy, and *Jekyll and Hyde* develops into a culture-text about a personality split between upstanding virtue and selfish hedonism. Jekyll is civilization, Hyde savagery. Even though many of the more recent adaptations of *Jekyll and Hyde* reconstitute elements of the original novel in suggesting widespread corruption and not containing it, they remain heavily influenced by the early stage adaptations and this history that followed it. Leslie Bricusse and Frank Wildhorn's musical, which first opened in Houston in 1990 before undergoing revision and playing on Broadway, implicated much of society in Hyde's corruption, depicting even a bishop as a client of the brothel that Hyde patronizes. But it also retained the fiancée/prostitute plot of the Mamoulian and Fleming films, which was a development of the heterosexual love interest present in the first stage adaptations. In fact, the 1995 film *Dr. Jekyll and Ms. Hyde* features a perfume chemist named Richard Jacks who works at a company called "Omage," an echo of "homage," and the movie includes explicit echoes of earlier versions, including a segment showing John Barrymore as Hyde. The chemist, who is the Jekyll/Hyde figure, finds among his great-grandfather's things an autographed edition of Stevenson's novel, and he learns that his great-grandfather and Stevenson were "drinking budd[ies] in Glasgow." Just as Jacks had been unaware of his relationship to Stevenson, the movie emphasizes that the original Jekyll and Hyde story is often a far-removed ancestor of contemporary reinterpretations.

Even as culture-texts depart from their originary novels, the novels are supported and remain more popular because of the existence of the culture-texts. Although recent film versions of *Nicholas Nickleby* and *Jekyll and Hyde* define those works for the present generation, the novels still exist for those who want to read them. The earliest Victorian stage adaptations, in contrast, remain hard to access, out of print, and out of performance. Initiating a tradition of reinterpretation, the first adaptations did not necessarily popularize Victorian novels in their own time but perpetuated them. The ephemeral theatrical performance thus exercises an important degree of often unacknowledged control over the collective consciousness.

NOTE

1. I am indebted to David Edgar for the idea of pairing these novels. Edgar himself adapted both *Nicholas Nickleby* and *The Strange Case of Dr. Jekyll and Mr. Hyde* to the stage and pointed out in an interview with me that "in many ways ... *Nickleby* and *Jekyll* in their original forms stand in relation to the great mid-Victorian era of economic success that my *Nickleby* and *Jekyll* stand to the Thatcher period. They are at either ends of a period of great economic growth and perceived success" (Miller 224).

WORKS CITED

Allen, Emily. *Theater Figures: The Production of the Nineteenth-Century British Novel.* Columbus: Ohio State UP, 2003. Print.

Altick, Richard D. *The English Common Reader: A Social History of the Mass Reading Public 1800–1900.* Chicago: U of Chicago P, 1957. Print.

Archer, William. "The Free Stage and the New Drama." *Fortnightly Review* n.s. 50 (1891): 663–72. Print.

———. *Masks or Faces? A Study in the Psychology of Acting.* London: Longmans, Green, 1888. *Google Books.* Web. 1 Dec. 2013.

———. "The Stage and Literature." *Fortnightly Review* n.s. 51 (1892): 219–32. Print.

———. "Why I Don't Write Plays." *Pall Mall Gazette* 31 Aug. 1892. *19th Century British Library Newspapers.* Farmington Hills: Gale/Cengage. Database. 21 July 2008.

Archer, William, and H. Granville Barker. *A National Theatre: Scheme and Estimates.* Rev. ed. New York: Duffield, 1908.

Bolton, H. Philip. *Dickens Dramatized.* Boston: G. K. Hall, 1987. Print.

Braddon, Miss [Mary Elizabeth]. "Why I Don't Write Plays." *Pall Mall Gazette* 5 Sept. 1892. *19th Century British Library Newspapers.* Farmington Hills: Gale/Cengage. Database. 21 July 2008.

Brantlinger, Patrick. *The Reading Lesson: The Threat of Mass Literacy in Nineteenth-Century British Fiction.* Bloomington: Indiana UP, 1998. Print.

Bratton, Jacky. *New Readings in Theatre History.* Cambridge: Cambridge UP, 2003. Print.

[Collins, Wilkie.] "Dramatic Grub Street: Explored in Two Letters." *Household Words* 17 (1858): 265–70. Print.

Cox, Philip. *Reading Adaptations: Novels and Verse Narratives on the Stage, 1790–1840.* Manchester: Manchester UP, 2000. Print.

Davis, Jim, and Victor Emeljanow. *Reflecting the Audience: London Theatregoing, 1840–1880.* Hatfield: U of Hertfordshire P, 2001. Print.

Davis, Paul. *The Life and Times of Ebenezer Scrooge.* New Haven: Yale UP, 1990. Print.

Davis, Tracy C. *The Economics of the British Stage: 1800–1914.* Cambridge: Cambridge UP, 2000. Print.

———. "The Show Business Economy, and Its Discontents." *The Cambridge Companion to Victorian and Edwardian Theatre.* Ed. Kerry Powell. Cambridge: Cambridge UP, 2004. 36–51. Print.

Dickens, Charles. "The Amusements of the People." *Household Words* 1 (1850): 13–15, 57–60. Print.

———. Toast to William Makepeace Thackeray at the Royal General Theatrical Fund. 29 March 1858. Web. 12 Sept. 2014.

———. *Nicholas Nickleby.* 1839. Ed. Michael Slater. Harmondsworth: Penguin, 1982. Print.

Dr. Jekyll and Mr. Hyde. Dir. Otis Turner. Perf. Hobart Bosworth, Betty Harte. Selig, 1908. Film.

Dr. Jekyll and Mr. Hyde. Dir. John S. Robertson. Perf. John Barrymore, Martha Mansfield. Famous Players–Lasky, 1920. Film.

Dr. Jekyll and Mr. Hyde. Dir. J. Charles Haydon. Perf. Sheldon Lewis, Alexander Shannon. Pioneer, 1920. Film.

Dr. Jekyll and Mr. Hyde. Dir. Rouben Mamoulian. Perf. Fredric March, Miriam Hopkins. Paramount, 1931. Film.

Dr. Jekyll and Mr. Hyde. Dir. Victor Fleming. Perf. Spencer Tracy, Ingrid Bergman. MGM, 1941. Film.

Dr. Jekyll and Ms. Hyde. Dir. David Price. Perf. Sean Young, Tim Daly. Hammer, 1995. Film.

Fitz-gerald, S. J. Adair. *Dickens and the Drama.* London: Chapman and Hall, 1910. Print.

Franklin, J. Jeffrey. *Serious Play: The Cultural Form of the Nineteenth-Century Realist Novel.* Philadelphia: U of Pennsylvania P, 1999. Print.

Frederic, Harold. "Why I Don't Write Plays." *Pall Mall Gazette* 12 Sept. 1892. *19th Century British Library Newspapers.* Farmington Hills: Gale/Cengage. Database. 21 July 2008.

Geduld, Harry M. *The Definitive Dr. Jekyll and Mr. Hyde Companion.* New York: Garland, 1983. Print.

Gissing, George. "Why I Don't Write Plays." *Pall Mall Gazette* 10 Sept. 1892. *19th Century British Library Newspapers.* Farmington Hills: Gale/Cengage. Database. 21 July 2008.

"Ephemera." Google N-gram viewer. Web. 11 Nov. 2014.

Hutcheon, Linda. *A Theory of Adaptation.* New York: Routledge, 2006. Print.

Jekyll and Hyde. By Leslie Bricusse. Music by Frank Wildhorn. Lyrics by Frank Wildhorn, Leslie Bricusse, and Steve Cuden. 1990. Musical play.

Lewes, George Henry. *On Actors and the Art of Acting.* London: Smith, Elder, 1875. Print.

Litvak, Joseph. *Caught in the Act: Theatricality in the Nineteenth-Century English Novel.* Berkeley: U of California P, 1992. Print.

Mattacks, Kate. "Regulatory Bodies: Dramatic Creativity, Control, and the Commodity of *Lady Audley's Secret,*" *Interdisciplinary Studies in the Long Nineteenth Century* 8 (2009). Web. 20 Mar. 2015.

McKinney, John. *Dr. Jekyll and Mr. Hyde.* Lord Chamberlain's Playscripts, British Library. July 1888, 53408 (K). Print.

Miller, Renata Kobetts. *Recent Reinterpretations of Stevenson's Dr. Jekyll and Mr. Hyde: Why and How This Novel Continues to Affect Us.* Lewiston: Edwin Mellen, 2005. Print.

Moncrieff, W. T. *Nicholas Nickleby.* Plays Submitted to the Lord Chamberlain, British Library. Add. Mss. 42951 (26). *Nineteenth-Century British and American Plays.* Ed. Joseph Donohue, George Freedley, and Allardyce Nicoll. El Paso: Readex. Print.

Moncrieff, W. T. "To the Public." Rpt. in Fitz-Gerald 121–26. Print.

N. A. *The Untold Sequel of The Strange Case of Dr. Jekyll and Mr. Hyde.* Boston: Pinckney, c. 1890. Print.

Nicoll, Allardyce. *A History of Early Nineteenth Century Drama 1800–1850.* 2 vols. Cambridge: Cambridge UP, 1930. Print.

Reade, Charles. Letter. *Athenaeum.* 15 Jan. 1853: 82. Print.

Rev. of *The Strange Case of Dr. Jekyll and Mr. Hyde. Graphic* 4 Aug. 1888. Print.

Rev. of *The Strange Case of Dr. Jekyll and Mr. Hyde. Sunday Times* 19 July 1888. Print.

Rev. of *The Strange Case of Dr. Jekyll and Mr. Hyde. New York Times* 10 May 1887: 5; rpt. in *The New York Times Theater Reviews.* Vol. 2. New York: Times/Garland, 1971–2000. Print.

Rieder, John. *Early Classics of Science Fiction: Colonialism and the Emergence of Science Fiction.* Middletown: Wesleyan UP, 2008. Print.

Rose, Jonathan. "Education, Literacy, and the Victorian Reader." *A Companion to the Victorian Novel.* Ed. Patrick Brantlinger and William B. Thesing. Malden: Blackwell. 31–47.

Rowell, George. *The Victorian Theater 1792–1914.* 2nd ed. Cambridge: Cambridge UP, 1978. Print.

Stevenson, Robert Louis. *Four Letters from Robert Louis Stevenson Concerning the Dramatization of Dr. Jekyll and Mr. Hyde* (Pretoria, Printed for Private Circulation, 1923). Parrish Collection, Princeton University Library. Print.

———. *Strange Case of Dr. Jekyll and Mr. Hyde.* 1886. Rpt. in *Dr. Jekyll and Mr. Hyde and Other Stories.* Ed. Jenni Calder. New York: Penguin, 1990. Print.

Stirling, Edward. *Nicholas Nickelby: A Farce—In Two Acts.* New York: Samuel French, n.d. Print.

Sullivan, Thomas. *Strange Case of Dr. Jekyll and Mr. Hyde.* Lord Chamberlain's Playscripts, British Library. Add. Manuscripts 53409B. Print.

Winter, William. "The First Adaptation of *Jekyll and Hyde*." Rpt. in Geduld 162–65.

Woods, Margaret L. "Why I Don't Write Plays." *Pall Mall Gazette* 2 Sept. 1892. *19th Century British Library Newspapers.* Farmington Hills: Gale/Cengage. Database. 21 July 2008.

CHAPTER 4

..

BAKHTIN, INTERTEXTUALITY, AND ADAPTATION

..

DENNIS CUTCHINS

ONE of the questions faced by scholars and students of adaptation is what "adaptation" means in the light of intertextuality. Because an adaptation approach requires that we focus attention on the relationships every text has with other texts, it is in some ways the ideal application of the concepts of intertextuality. Mikhail Bakhtin, one of the first scholars to theorize intertextuality, never concerned himself directly with adaptation. Nevertheless, his ideas about texts, translations, literary language, and the ways meaning is generated offer some important answers for this question and some useful concepts for adaptation studies. In fact, Bakhtin may have unwittingly helped answer some of the most vexing questions faced by scholars of adaptation. That fact has long been recognized by adaptation scholars. Robert Stam, a scholar deeply influenced by Bakhtin, argues in *Subversive Pleasures* that Bakhtin's insistence on the ubiquitous nature of texts justifies the application of "Bakhtin's ideas to media that he himself never discussed" (18), and Stam largely based his influential *Literature through Film* on Bakhtinian concepts that "cast suspicion on ideas of purity and essence and origin, and thus indirectly impacted on the discussion of adaptation" (4). This essay outlines a few of Bakhtin's ideas and briefly sketches their application to adaptation studies. Bakhtin's way of looking at the world, which may be labeled dialogic thought, can help define what adaptations are, explain why they intrigue us, and suggest how they may be studied. Perhaps most important, dialogic thought suggests that the study of adaptations, broadly understood, is not peripheral to the study of literature, films, plays, or other kinds of texts, but is foundational to all textual studies.

Why Is Bakhtin Important
to Adaptation Studies?

One of the ideas to which Bakhtin was constantly drawn over his long career is the notion of simultaneity, or the recognition that something can be one thing and another thing at the same time. That helps explain why Bakhtin was fascinated with translation. He loved the fact that translation required a simultaneity of thought on the part of the translator, who must imagine two words, in two different languages, at once. Indeed, the possibility of translation formed the heart of much of what he thought about literature generally. Bakhtin saw translation not simply as the transfer of information from one language to another, but as the profoundly destabilizing event that actually defines literary thought. He argued that any act of translation forces the translator to recognize the relational, rather than absolute, status of one language to another. In other words, Bakhtin believed that translation forever separates what we say from how we say it. This is important because, he argued, translation allows people to imagine the possibility of *literary* language, as opposed to absolute language. Literary language is quite different from the languages of personal experience, scripture, myth, or epic. These genres imply a kind of absolute truth for both the listener or reader and the teller or writer. If your neighbor, for instance, tells you, "I saw a ghost last night," you'll be inclined to treat his statement as either true or false. If, on the other hand, your neighbor says, "I wrote a story, and the first line of the story is, 'I saw a ghost last night,'" then your reaction will probably be quite different. You are much more likely to *interpret* the second statement, rather than simply to judge its truth or falsity. That is one of the defining characteristics of literary language.

For Bakhtin, literary language—language open to interpretation—requires "a complete rupture between language and its material" (*Dialogic* 378). This rupture creates the very idea of literature by allowing a story to exist not as an absolute truth, but "as a rejoinder in a given dialogue, whose style is determined by its interrelationships with other rejoinders in the same dialogue" (*Dialogic* 274). Literature, in short, is always understood as relative, rather than absolute, and thus always generates multiple readings or possible interpretations. It is also always in dialogue with other language. For Bakhtin, once something had been translated, the content or meaning of the now literary text and the language used to define the text could no longer be imagined as a "seamless whole (as they were for the creators of the epic), but were rather fragmented, separated from each other, had to seek each other out" (*Dialogic* 377).

That phrase, "seek each other out" is intriguing for adaptation scholars because it may suggest what is taking place in our minds when we perceive an adaptation. When we see a play or a film titled *Sense and Sensibility*, for example, one of the things that happens is that our memories of Austen's novel, if we have read it, are triggered. We become what Linda Hutcheon calls a "knowing" participant in the text (120), or what Lawrence Venuti describes as an "elite" viewer ("Adaptation" 38). The actions and dialogue on the

stage or screen exist for us, at least fleetingly, simultaneously with our memories of the novel. And these simultaneous memories and perceptions "seek each other out" (there may not be a better way to describe this process) in our minds. If we have not read the novel, the play may still remind us of other plays or films we have seen, but the sense of perceptions and memories seeking each other out will likely be much less intense, as well as less focused.

These Bakhtinian ideas are powerful. They help to unlock the prophetic chains placed on adaptation studies more than two thousand years ago when Socrates declared that art could never hope to be anything more than a copy of a copy. Not surprisingly, Bakhtin defined himself as an "anti-Aristotelian," in part, perhaps, because he created a space in which literary art, and adaptations in particular, could be more than mimesis, more than an always inferior copy (Holquist xx). Moreover, Bakhtin's definition of literary language as language that implies multiple possible meanings denies the existence of any "absolute" *Sense and Sensibility*, and acknowledges only relative and multiple understandings of the text. Your *Sense and Sensibility* is not likely to be the same as mine, though they may have things in common. This understanding of literature specifically and texts generally seems potentially productive and empowering for adaptation studies because it places adaptation not at the edges of textual study, but at its center.

WHY IS DIALOGIC THOUGHT IMPORTANT TO ADAPTATION STUDIES?

The gap Bakhtin imagined between language and expressive material, what we might call a gap between language and content, is not only central to Bakhtin's definition of literature but also suggests what may be the most valuable concept he offers to adaptation studies. Because of the gap between language and content, Bakhtin believed that words (or any other texts) can never mean exactly what a speaker intends. As soon as words are uttered, they enter into a negotiation or a dialogue both with listeners and with other words. Hence "[d]ialogue is more comprehensively conceived as the extensive set of conditions that are immediately modeled in any actual exchange between two persons but are not exhausted in such an exchange. Ultimately, dialogue means communication between simultaneous differences" (Clark and Holquist 9). Bakhtin believed that contemporary linguistic theory was insufficient to explain how meanings are created at the level of individual words: "As treated by traditional stylistic thought, the word acknowledges only itself (that is, its own context), its own object, its own direct expression and its own unitary and singular language" (*Dialogic* 276). He argued, however, that this is not sufficient, since "between the word and its object," and "between the word and the speaking subject, there exists an elastic environment of other, alien words about the same object" through which the word is always forced to pass (*Dialogic* 276). Thus

no word can relate solely to its object. Any utterance about the object in question must be understood "by the 'light' of alien words that have already been spoken about it. It is entangled, shot through with shared thoughts, points of view, alien value judgments and accents" (*Dialogic* 276). Utterances of any sort, in other words, are always influenced. Harold Bloom concluded as much in his *The Anxiety of Influence* when he wrote, "there is no end to influence" (xi).

This concept provides a potential keystone for adaptation studies. Imagine two people tossing a beach ball to each other on a windy day. Once the ball leaves the thrower's hands, it is subject to the winds and likely to end up someplace different than the thrower intends. This is not to say that the thrower does not have intentions; it simply acknowledges that those intentions are not the only factors in the ball's eventual landing spot. The catcher must adjust, perhaps more than once, to the thrower's intentions, as well as to the effects of the wind. Perhaps the thrower too adjusts her aim to anticipate the wind. Bakhtin understood these adjustments as "dialogues." In a similar way, he believed, a speaker must negotiate with the listener or listeners, as well as with the language itself, which is never "clear" or unbiased, but always colored by other conversations. We may also imagine a lump of clay spinning on a potter's wheel and recognize that the shape of the pot that is eventually created has something to do with the potter's intentions, but also depends on the consistency of the clay, the speed of the wheel, and the hand of the potter. Bakhtin finds the interactions of these kinds of elements endlessly intriguing. He argues that all texts are more or less constantly in dialogue, adjusting themselves to the other texts around them, as well as to multiple intentions. "The artistic act," he writes, "lives and moves not in a vacuum but in an intense axiological atmosphere of responsible interdetermination" (*Art* 275). "Interdetermination" aptly suggests that the influences between texts move in every direction simultaneously. Bakhtin believed that these often unintended and complicated webs of meaning, these interdeterminations, surround every word we utter or hear, along with every image we see. Every utterance is already in play:

> The living utterance, having taken meaning and shape at a particular historical moment in a socially specific environment, cannot fail to brush up against thousands of living dialogic threads, woven by socio-ideological consciousness and around the given object of an utterance; it cannot fail to become an active participant in social dialogue. After all, the utterance arises out of this dialogue as a continuation of it and as a rejoinder to it—it does not approach the object from the sidelines. (*Dialogic* 276–77)

Lawrence Venuti echoes this idea when he argues that translations, like all Bakhtinian utterances, are constantly buffeted by cultural and linguistic winds: "Both the foreign text and translation are derivative: both consist of diverse linguistic and cultural materials that neither the foreign writer nor the translator originates, and that destabilize the work of signification, inevitably exceeding and possibly conflicting with their intentions" (*Translator's* 13). The implications for the application of dialogic thought to

adaptation studies are far-reaching. Dialogic thought would suggest that all meanings, including those generated by adaptations, are negotiated in complex webs of intended and unintended meanings and dialogues, and that when we label a text an adaptation we are simply acknowledging one of the particular relationships that we perceive between texts. This suggests that adaptation occupies a place, or perhaps several places, along the intertextual spectrum—or the "transtextual" spectrum, if you prefer Gérard Genette's term (83–84).

One of the implications of this logic is that a simplistic idea of influence, the notion that an earlier text can affect a later text, is likely not an accurate picture of what happens in an adaptation. The word "influence" suggests a one-way street along which William Shakespeare might influence Leonard Bernstein, Arthur Laurents, and Stephen Sondheim, but denies that these men could ever influence Shakespeare. The notion of interdetermination, on the other hand, and the recognition that all texts, even those written four hundred years ago, are constantly in dialogue with other texts, suggests that *West Side Story* can have an effect on the meaning of *Romeo and Juliet*, at least for the person who has experienced both texts. In his article "Dialogizing Adaptation Studies: From One-Way Transport to a Dialogic Two-Way Process," Jørgen Bruhn makes exactly this argument. He writes, "Any rewriting or adaptation of a text is always influencing the original work," and suggests that "[a]fter the publication of James Joyce's *Ulysses*, the meaning of Homer's *Odyssey* changed, if ever so slightly, and its position in literary history has been altered" (69). This certainly describes my own practical experiences. The meaning of Mary Shelley's Gothic novel *Frankenstein* is always colored in my mind by the fact that my first memorable experience with Frankenstein and his monster came not with the novel, but with a 1973 television adaptation, *Frankenstein: The True Story*. The lack of an absolute *Frankenstein* means that for all practical purposes the novel, which I read ten years later, was influenced by the TV show, at least for me. Frances Bonner and Jason Jacobs make a similar point, stressing the order of encounter, in their discussion of readers' experience of stories about Alice in Wonderland (38).

Textual interdetermination may be more or less ubiquitous, but I don't think Bakhtin would argue that the "influence" of two texts on each other is always equal. These influences are always reciprocal, but there's no question that some texts are weightier than others, and thus their influence is more easily felt. It might be useful in this context to imagine this co-influence or interdetermination as a question of gravity or mass. The Earth pulls on the moon and keeps it in orbit, but the moon also pulls on the earth, causing tides and shifts in the Earth's crust. The "mass" of any given text is not absolute, however, but rather determined by personal experience, by priority, and likely by the text's cultural pervasiveness. It's doubtful that *Frankenstein: The True Story* influenced many people, but James Whale's 1931 *Frankenstein*, with its near-universal cultural saturation, has influenced millions. Likewise, Bernstein's influence on Shakespeare might be subtle, but no one who has seen the Sharks and the Jets rumble (Figure 4.1) can ever look at the Capulets and the Montagues fencing in the street the same way again. How different are their actions, *West Side Story* forces us to ask, from contemporary gang violence?

FIGURE 4.1 The Sharks and the Jets square off against each other in *West Side Story* (1961).

And to carry that a step further, there is no question in my mind that the scenes of gang violence in *William Shakespeare's Romeo + Juliet* (1996) were in turn influenced by *West Side Story*.

If the meanings of a text as venerable as Shakespeare's *Romeo and Juliet* are constantly being negotiated, then a traditional understanding of fidelity to the text becomes largely a non sequitur. Because texts are always in dialogue with readers and with other texts, these negotiations constantly shift their meanings. Fidelity, in this model, is an illusion. Venuti suggests that translations, and I would add adaptations, should be read "not to assess the 'freedom' or 'fidelity' of a translation, but rather to uncover" the various dialogues with other texts that created the translation, or what he calls "the canons of accuracy by which the translator produced and judged it" (*Translator's* 30). Thus the most someone experiencing an adaptation can hope to find are points of intersection at which their own, sometimes very personal, understanding of the earlier text coincides with that of the adaptation as the two "seek each other out." And as the earlier analogy of the game of catch suggests, readers and viewers are anything but passive in this process. Bakhtin, in fact, suggests that the reader must "become active in the form" of the text (*Art* 306). The need for active readers and viewers becomes clear if you imagine yourself in the crowd at an unfamiliar sporting event. Someone who didn't understand the rules and strategies of hockey, for instance, would likely fail to notice exceptional plays and misunderstand fouls, and would quickly lose interest in what must appear to the untrained eye to be chaotic action on the ice. The most strenuous effort of the players, in this case, would leave only an impression of frenetic activity, not of purpose, teamwork, or achievement. Even the best plays would be indistinguishable from poor ones. A very basic knowledge of the game, on the other hand—what Venuti would call a canon of

accuracy—would allow the action on the ice to establish a dialogue with the viewer and make meaning possible.

Bakhtin uses an odd phrase to describe this active relationship with the text. He suggests that the reader must "encompass it, give it form, and consummate it" (*Art* 306). In an uncommonly exact prophecy of Lawrence Venuti's recent work on translation, Rainer Maria Rilke uses similar language to describe both the process a poet goes through when writing a poem and the process in which a translator participates when translating a poem. He suggests that as we encounter either a phenomenon about which we would like to write a poem, or a poem that we would like to translate, "we must comprehend, must grasp these phenomena, these things, more affectionately, more intimately, and transform them. Transform? Yes, our commission is to impress the transitory, frail world upon ourselves, that its very being is invisibly resurrected in us" (Norris viii).

The process, variously described here as encompassing, comprehending, consummating, intimately grasping, transforming, and resurrecting, both dismisses fidelity and at the same time explains our sometimes emotional reactions to adaptations that we feel are unfaithful. If we have read a book, perhaps as teenagers, and if we have comprehended it, or encompassed and consummated it, then we are likely to have established a very close relationship indeed with the text. In fact, both Bakhtin and Rilke suggest that the texts we experience become a part of us, a part of who we imagine ourselves to be. Our personalities are formed and transformed by what we have comprehended. Imagine, then, our disappointment with an adaptation that fails to evoke these same feelings and experiences. In a case like this, the adapter is not simply adapting a text. He or she may be undermining elements of our personalities, implicitly criticizing who we have become, and treading on the sacred ground of our selves.

I suspect that we have all experienced this moment as we witnessed a stage or film adaptation of a favorite text, or perhaps even as we read a review of a novel or film that touched us deeply. My own moment came near the end of Peter Jackson's 2003 adaptation of *The Return of the King*, the third volume of J. R. R. Tolkien's *Lord of the Rings* trilogy (1954). Jackson chose to omit the "Scouring of the Shire" section from his film. His decision is not surprising. The miniature battle in the Shire is a far cry from the epic battle scenes that readers have just experienced. And yet I did not know how much this section of the novel meant to me until I saw the film and realized that it had not been included in the adaptation. I don't know if my childhood experiences witnessing veterans returning home from Vietnam had made "The Scouring of the Shire" important to me. But I do know that I was deeply disappointed that Jackson had not chosen to adapt that part of the novel. The adaptation scholar in me dismissed my disappointment as clinging to fidelity, but emotionally I was not able to let it go. It was as if Jackson had said, "that part of your life is not important."

Of course, an appeal to fidelity at this point, however tempting, would have been silly. And my reaction to Jackson's film was not based on my ideas about fidelity in any case. It was, instead, the result of the fact that as a teenager I had comprehended and consummated Tolkien's text, and it had become a permanent part of me, a part of who I am. Recognizing this consequence of the way we comprehend texts, Bakhtin suggests that

there is a strong ethical component to this relationship. "What guarantees the inner connection of the constituent elements of a person?" he asks. "Only the unity of answerability. I have to answer with my own life for what I have experienced and understood in art, so that everything I have experienced and understood would not remain ineffectual in my life" (*Art* 1). And this answerability is reciprocal; art must also be answerable for the lives it influences. So, Bakhtin suggests, while we must discount the idea of fidelity, we should never ignore the answerability between art and those who consummate it.

WHAT DO ADAPTATIONS ADAPT?

This is an important question, but it begs what may appear to be the more basic question, "What is an adaptation?" If I may set that second question aside for a moment, I hope that by the time I address it, the answer will be self-evident.

The simple answer to "What is being adapted?" is that texts are being adapted in all adaptations. That, of course, means that we need to understand what a text is. Bakhtin's answer to this question is found in his definition of an "artistic text," which he sees as a subset of "cultural domains"—surfaces or boundaries in contact with the surfaces or boundaries around them. These surfaces or boundaries actually form the entire text. In other words, there is no "inside" to a work of art, or to any text. They are containers with no contents. These cultural domains, he writes, "should not be thought of as some kind of spatial whole, possessing not only boundaries but an inner territory. A cultural domain has no inner territory. It is located entirely upon boundaries, boundaries intersect it everywhere, passing through each of its constituent features," thus defining and enlivening it (*Art* 274). Stam recognizes this concept, as well as its implications for notions of fidelity, when he writes, "The notion of 'fidelity' is essentialist in relation to both media involved. First, it assumes that a novel 'contains' an extractable 'essence,' a kind of 'heart of the artichoke' hidden 'underneath' the surface details of style . . . but in fact there is no such transferable core" ("Beyond Fidelity" 57). Bakhtin's definition of texts is a logical extension of the insight that meaning is always established in a dialogue. We have only to imagine asking for directions in a place where no one speaks our language to know that the meaning of what we say is not "inside," or inherent in the words, but only created in dialogue at its boundaries. A work of art is special, though, since, by definition, it is always open to interpretation. One of the problems we may encounter when studying artistic adaptations is that we expect dialogue when we ask for directions, but often accept artistic works at face value, as it were.

When I teach this concept to my students, I sometimes use a balloon as an illustration. The things that make a balloon *a balloon*—its color, form, size, and printed words or images—exist only on its surface. Thus any meaning or significance that a balloon has lies entirely on that surface. Stam expresses this idea by noting that "the concept of intertextual dialogism suggests that every text forms an intersection of textual surfaces" ("Beyond Fidelity" 64). If we were to open a balloon to access its "contents," as

I have seen my dog do on more than one occasion, we would be sorely disappointed. Bakhtin describes the attempt to remove a text from its surface of contexts or interrelations and to access its imagined "essence" in this way: "Every cultural act lives essentially on the boundaries, and it derives its seriousness and significance from this fact. Separated by abstraction from these boundaries, it loses the ground of its being and becomes vacuous, arrogant; it degenerates and dies" (*Art* 274). Bakhtin suggests that all texts, and indeed all cultural domains, function in this same manner. The meaning of any text, from *Romeo and Juliet* to Michelangelo's *David*, lies exclusively on its surface. Meaning, in this model, is not generated by the contents or essence of a text, since these things don't exist, but by the ways the surface of the text interacts with other surfaces.

The balloon analogy, however, breaks down as we understand the complexity of the surfaces Bakhtin is describing. The simple surface of a balloon cannot hope to represent surfaces in which "boundaries intersect it everywhere, passing through each of its constituent features" (*Art* 274). Perhaps a sponge is a more accurate metaphor. Despite its complexity and the appearance of having both an inside and an outside, a sponge is literally all surface. If we were to cut a sponge in half we would find no heart or brain, but only more surface, exactly like the surface we already see. Stam suggests this point when he writes, "The barrier between text and context, between 'inside' and 'outside,' for Bakhtin is an artificial one, for in fact there is an easy permeability between the two" (*Subversive* 20).

Bakhtin makes another important point in the preceding passage. There are innumerable ways, he notes, that a text can be "separated by abstraction" from the contexts that make it meaningful. When in a review or in conversation with a friend we attempt to reduce a play to a brief plot summary, we risk making the play seem vacuous. We have all experienced the disappointment of trying to explain why a work of art moved us, only to conclude, "I guess you had to be there." That experience is what Bakhtin is conceptualizing when he suggests that "every cultural act lives essentially on the boundaries, and it derives its seriousness and significance from this fact" (*Art* 274). Meaning, for Bakhtin, is always contextual, always dependent on the interdetermination of the texts we have experienced. A wildlife biologist friend of mine recently described an experiment he performed to measure the effectiveness of hikers' "bear bells" in limiting the number of dangerous encounters between humans and bears. What he discovered is that the sound of a bell has absolutely no significance to a bear who has never heard a bell. Bears, in fact, seem unable even to hear the sound of a tinkling bell, even though they respond immediately and dramatically to the sound of a snapping twig fifty yards away (Smith). Meaning, even for bears, seems utterly dependent on the ways the text—in this case a very small sound—interdetermines with other known texts.

For adaptation studies, this model suggests that what is being adapted in any particular case cannot be the text alone, nor the essence of the text, but rather a particular understanding of the text that is dialogized, or constantly negotiated along its boundaries. In a situation analogous to adaptation, Venuti suggests that the prime mover in this negotiation process in terms of translation is what he calls an "interpretant." He

believes that any act of translation "inscribes an interpretation by applying a category that mediates between the source language and culture, on the one hand, and the translating language and culture, on the other, a method of transforming the source text into the translation. This category consists of *interpretants*" (*Translation Changes* 181). These "interpretants are fundamentally intertextual and interdiscursive," and "it is the translator's application of interpretants that recontextualizes the source text, replacing relations to the source culture with a receiving intertext" (*Translation Changes* 181).

If this is true, then a film adapter working with a literary text, for example, can't simply extract an "essence," since none exists, but, instead, must first interpret the text, simultaneously negotiating a dialogue with dozens of factors, including particular readings of the text that the adapter or other creative colleagues might have, the conventions of literature and cinema, the expectations of both audiences who have read the original and audiences who have not, and, in the case of culture texts like *Hamlet, Pride and Prejudice,* the Sherlock Holmes tales, or *Frankenstein,* scholarly or popular readings that have become so common that they may be perceived as correct or inherent meanings. All these boundaries help to create the thoroughly dialogized reading that is eventually adapted. This understanding implicitly defines the adaptation scholar's job as defining and tracing these multiple, interrelated boundaries or "canons of accuracy," and the "interpretants" that have created the contact at those boundaries.

WHAT IS AN ADAPTATION?

The simplest way to answer this question is that an adaptation is primarily not a *kind of text,* but *a way of looking at texts.* I don't mean this answer to be phenomenological double-talk. Adaptations really are a way of thinking about texts, and any structural definition of an adaptation is likely to be problematic. But that doesn't make the answer any more satisfying. It's tempting here to fall back on the logic of Justice Potter Stewart when he defined pornography by declaring, "I know it when I see it." Most of us would agree that we know an adaptation when we see one, but what exactly makes us recognize an adaptation? Dialogic thought, as we have defined it, suggests a radical answer to this question. Bakhtin would likely argue that all texts are adaptations to one degree or another. In the context of dialogic thought, the more pertinent question becomes, "What makes us perceive or treat only some texts as adaptations?" That's a very different way of thinking about this question. It implies that when we say that something is an adaptation, what we are really doing is identifying a specific kind of intertextuality (or transtextuality). Certainly an understanding of intertextuality should be included in any Bakhtinian theory of adaptation, but "adaptation" implies that the influence of one word upon another, or one text upon another, is both intentional on the part of the speaker or performer or writer, as well as acknowledged by the listener or observer or reader. Although suggesting that something is an adaptation does not rule out either

the intentional or unintentional interplay of texts in general (intertextuality), it does indicate that at least some of the interplay is by design and with a specific predecessor text (adaptation), for, as Linda Hutcheon says, "Adaptations have an overt and defining relationship to prior texts" (3). A significant degree of the meaning and even some of the pleasure we derive from any adaptation is the result of seeking out and recognizing this interplay between texts.

Now we have finally worked our way toward a practical dialogic or Bakhtinian definition of adaptation. First, adaptation is most often a way of looking at texts, rather than a specific kind of text, because all texts interdetermine (they function intertextually) and thus may be potentially recognized as adaptations. Second, we recognize adaptations by their particular degree of interdeterminations, and by a perceived intentionality. Like all texts, adaptations are artistic works that share a significant number of boundaries and interrelationships with other, previously known, texts. But the more that meaning is generated for a perceiver by contact with these earlier texts, the more likely he or she is to identify it as an adaptation. This is usually experienced as a kind of simultaneity, a perception of two or more things at once. Several scholars have called this kind of perception "palimpsestuous" (Hutcheon 6) and have labeled adaptations as palimpsests. The most fitting image of this idea for me derives from a child's anatomy book I found endlessly fascinating when I was in elementary school. One section of the book consisted of a color plate of a skeleton, over which I could fold transparent pages that each represented a different system: one transparent page for the muscles, another page for the digestive system, and so on. The final page laid skin over the whole image. Although the content of each transparent page was quite different, the shape, size, and style, and most important, the fact that the images "fit" each other when properly folded suggested that they belonged together, and created a somewhat uncomfortable moment of simultaneity as I realized that all of these systems were operating together not just on the pages of the book, but under my own skin. It might do to keep this image in mind in the following discussion of the grotesque body.

HOW AND WHY ARE TEXTS ADAPTED?

It might be argued that recognizing all texts as intertextual and thus potential adaptations may weaken the whole idea of adaptation studies. If adaptation really is a way of thinking about texts more than a particular kind of text, then why don't we consider more things to be adaptations? We recognize literally hundreds of adaptations of *Frankenstein* or the Sherlock Holmes stories, for instance, but relatively few for most texts. Once again, Bakhtin provides an answer to this question in his conception of the "grotesque body." Stam explores Bakhtin's concept of the grotesque body in *Subversive Pleasures*, and his explanations are useful, but they remain fixed in a rather literal understanding of the term. He discusses the grotesque, for instance, almost

completely in terms of pornography (159–60). Bakhtin's notion of the grotesque, more broadly applicable and more metaphorical, suggests why we perceive some texts as adaptations more readily, and why some texts seem to invite adaptation more often than others.

Bakhtin's basic notion is that some bodies or texts lend themselves to adaptation, while others tend to close themselves off from it. This idea is part of his larger conversation about the carnivalesque, and he finds a strong correlation between the image of the carnival, with its emphasis on parody and the temporary overturning of social norms, and his description of the grotesque body. In *Rabelais and His World*, however, Bakhtin argues that "the carnival is far distant from the negative and formal parody of modern times. Folk humor denies, but it revives and renews at the same time. Bare negation," he notes, "is completely alien to folk culture" (11).

Using the term "canonical" to refer not to any canon of literature, but to "the canon of polite speech" that he believes emerged in the sixteenth century (*Rabelais* 320), Bakhtin distinguishes "canonical" texts from "grotesque" texts. Equating both kinds of texts with bodies, he suggests that canonical texts or bodies are "entirely finished, completed," and "strictly limited" (*Rabelais* 320). They present a smooth surface to other texts and to those who experience them. Bakhtin calls their surface an "impenetrable façade" that "does not merge with other bodies and with the world" (*Rabelais* 320). The "opaque surface and the body's 'valleys,'" in a canonical text, "acquire an essential meaning as the border of a closed individuality" (*Rabelais* 320). The implication here that canonical texts are not intertextual may seem to fly in the face of the notion of interpenetrating texts discussed earlier. There's a catch, though. According to Bakhtin's logic, texts that lose contact with other texts—or in other words, lose their intertextuality—also lose their *textuality*, or their literariness. Canonical texts, in short, lose their ability to generate symbolic or broader meanings, since those functions always require some degree of interpenetration. In a canonical text, "all that happens within it concerns it alone, that is, only the individual, closed sphere" (321). In short, canonical texts, as Bakhtin defines them, don't open themselves to interpenetration or even to interpretation. Their insistence on remaining closed off means that these texts no longer have literary value. They become something closer to the non-literary texts mentioned at the beginning of this essay—texts that we tend to judge as either true or false. Bakhtin is making an important distinction here, but we must remember that what he is describing is less an inherent quality of the text itself than a matter of the way we treat the text.

Grotesque bodies or texts, on the other hand, are quite different from canonical texts. Grotesque texts constantly invite the reader or viewer to perceive interconnections. Bakhtin describes the "grotesque body" as "a body in the act of becoming. It is never finished, never completed; it is continually built, created, and builds and creates another body" (*Rabelais* 317). The "logic of the grotesque image," he suggests, "ignores the closed, smooth, and impenetrable surface of the body and retains only its excrescences (sprouts, buds) and orifices, only that which leads beyond the body's limited space or into the body's depths" (318). In this way the grotesque body or text reminds us of the sponge, which is all holes. Bakhtin uses images of birth and copulation,

images in which bodies literally interpenetrate, to describe the grotesque body. Far from being smooth or finished, the grotesque text remains under construction, a work in progress.

Carrying the image of the unfinished body to its logical end, Bakhtin notes that "if we consider the grotesque image in its extreme aspect, it never presents an individual body; the image consists of orifices and convexities that present another, newly conceived body. It is a point of transition in a life eternally renewed, the inexhaustible vessel of death and conception" (*Rabelais* 318). He goes on to call this a "double body," and part of "the endless chain of bodily life," where "one link joins the other, in which the life of one body is born from the death of the preceding, older one" (318). This revolutionary image suggests that grotesque texts create their own co-texts, and in the case of adaptation, generate their own adaptations.

Once again, this abstract idea is well-grounded in practical experience, as we can see if we consider adaptation from the perspective of the adapter. In 2014 I had the chance to interview Joseph Hanreddy, a stage director and playwright who adapted *Pride and Prejudice* a few years ago and who had recently completed a new adaptation of *Sense and Sensibility*. When I asked him how he approaches a text like one of Austen's novels, he said that it was intimidating, "because *Pride and Prejudice*, to a certain extent, and *Persuasion*, both are masterpieces. I mean, they're pretty perfect as literature, so anything that you do is going to make it less perfect." He then went on to suggest that *Sense and Sensibility* is different in terms of adaptation. That novel, he believes, "sprawls a little bit in kind of an interesting way, in a way that's kind of attractive, is difficult to categorize, and that is, in some ways, very positive." He went on to suggest, "I see the author actually changing her mind and where she was going with some of the characters throughout the book." This sprawl, which Hanreddy perceives as a narrative flaw, gives him, at least in his own mind, permission to adapt the text. In fact, he says, the text seems almost to demand rewriting: "There are some things that for drama probably do need to be corrected." This perceived chink in the novel's armor provides the "sprouts, buds ... and orifices" that allow the playwright entrance to the text. Hanreddy certainly seems to believe that the flaws in the novel, even if they are imaginary, are important to the adaptation process.

How Should We Study Adaptations?

A Bakhtinian understanding of adaptation has promising implications for both the methodology and the subject matter of adaptation studies. Adaptation scholars are interested in the boundaries of any text, and the ways texts interdetermine at those boundaries. We recognize adaptations as those texts that share significant boundaries with specific antecedent texts. Perhaps that defines, as succinctly as possible, the way scholars of adaptation approach texts. We strive to understand neither the text nor the context, but the ways in which interrelated texts and contexts work together or against each other at their boundaries.

Bakhtin called this kind of study "architectonics," or the study of the relationships between things. In an effort to get at the heart of Bakhtin's way of thinking about the world, his translator Michael Holquist observes:

> Bakhtin's obsession with simultaneity of various kinds can all too easily be misread as (yet another example of) a mechanical concern for binary oppositions. But what is essential for Bakhtin is not only the categories as such that get paired in author/hero, space/time, self/other, and so forth, *but in addition the architectonics governing relations between them.* What counts is the simultaneity that makes it logical to treat these concepts *together.* The point is that Bakhtin honors *both* things and the relations between them—one cannot be understood without the other. The resulting simultaneity is not a private *either/or*, but an inclusive *also/and.* In other words, the logic of Bakhtin's simultaneity is—dialogic. (xxiii, emphasis in original)

Holquist's observations bring us back to the notion of simultaneity. That's fitting, since the experience of adaptation seems to be, in its simplest terms, a moment of simultaneity—a recognition of two things at once.

I have largely dodged the question of *why* we sometimes experience this doubled perception. The answer to this question, if there is one, is for Bakhtin neither structural nor theoretical but ethical. Earlier, I mentioned Bakhtin's notion of "answerability," his demand that art be "answerable" to life, and life to art (*Art* 2). Bakhtin suggests that "a work is alive and possesses artistic validity in its intense and active interdetermination with a reality that has been identified and evaluated by a performed action" (*Art* 275). In other words, works of art, or any texts, for that matter, create their own artistic validity, their own weight, meaning, value, or power, only through the kinds of intertextuality I have been describing. A distinctive feature of adaptations is that, in addition to their relationship with reality, they also tap a source of great power as they maintain an "intense and active interdetermination" with the texts on their boundaries. Much of the power of an adaptation, in other words, derives from its relationships with source texts and other texts on its boundaries, even if those texts are created hundreds of years later.

In all of this, we need to recognize that Bakhtin's "reality," against which art is to be measured, is always mediated. He insists "once and for all that no reality *in itself*, no *neutral* reality, can be placed in opposition to art: by the very fact that we speak of it and oppose it to something, we determine it and evaluate it in some way" (*Art* 276, emphasis in original). For the study of adaptations, this determined reality includes perceived source texts that are also always mediated or interpreted. Bakhtin acknowledges the role of the mediator, the perceiver/interpreter in all of this, when he suggests that "one must simply come to see oneself clearly and understand the actual direction of one's evaluation" (276).

Thus Bakhtin recognizes that the relationships between texts, including the relationships surrounding adaptations, are primarily in the eye of the beholder. We must all operate within our own perceptions. So where some perceive an adaptation, others don't. I was surprised this past summer, as I attended the production of Joseph Hanreddy's new stage adaptation of *Sense and Sensibility*, to overhear some theatergoers

during intermission animatedly discussing whether Elinor and Marianne would marry Edward and Willoughby. Clearly their experience that evening was quite different from my own. Bakhtin, nevertheless, did not despair over the perceptual isolation we all face. Indeed, this idea led him directly to his most enduring trope—the dialogue. The need for constant dialogue becomes one of the humanizing elements of Bakhtin's work. It constantly prevents him, and us, from thinking reductively. The text, he writes, "never appears as a dead thing," with a meaning that may be assumed, because "beginning with any text—and sometimes passing through a lengthy series of mediating links— we always arrive, in the final analysis, at the human voice, which is to say we come up against the human being" (*Dialogic* 252–53). The inevitable dialogue, the fact that no work of art is able to stand alone in its meaning, is for Bakhtin the best, the most human part of any work of art. All texts, finally, depend upon us.

Works Cited

Bakhtin, Mikhail. *Art and Answerability: Early Philosophical Essays*. Trans. Vadim Liapunov. Ed. Michael Holquist and Vadim Liapunov. Austin: U of Texas P, 1990. Print.

——. *The Dialogic Imagination*. Trans. Caryl Emerson and Michael Holquist. Ed. Michael Holquist. Austin: U of Texas P, 1981. Print.

——. *Rabelais and His World*. Trans. Hélène Iswolsky. Bloomington: Indiana UP, 1984. Print.

Bloom, Harold. *The Anxiety of Influence: A Theory of Poetry*. 2nd ed. New York: Oxford UP, 1997. Print.

Bonner, Frances, and Jason Jacobs. "The First Encounter: Observations on the Chronology of Encounter with Some Adaptations of Lewis Carroll's Alice Books." *Convergence* 17.1 (2011): 37–48. *Sage Publications*. Web. 22 May 2015.

Bruhn, Jørgen. "Dialogizing Adaptation Studies: From One-Way Transport to a Dialogic Two-Way Process." *Adaptation Studies: New Challenges, New Directions*. Ed. Jørgen Bruhn, Anne Gjelsvik, and Eirik Frisvold Hanssen. London: Bloomsbury, 2013. 69–88. Print.

Clark, Katerina, and Michael Holquist. *Mikhail Bakhtin*. Cambridge: Harvard UP, 1984. Print.

Frankenstein. Dir. James Whale. Perf. Colin Clive, Boris Karloff. Universal, 1931. Film.

Frankenstein: The True Story. Dir. Jack Smight. Perf. James Mason, Leonard Whiting. Universal, 1973. Television.

Genette, Gérard. *The Architext: An Introduction*. Trans. Jane E. Lewin. Berkeley: U of California P, 1992. Print.

Hanreddy, Joseph. Personal interview. 19 June 2014.

Holquist, Michael. "Introduction: The Architechtonics of Answerability." Bakhtin, *Art and Answerability*. ix–xlix. Print.

Hutcheon, Linda, with Siobhan O'Flynn. *A Theory of Adaptation*. 2nd ed. New York: Routledge, 2013. Print.

Lord of the Rings: The Return of the King. Dir. Peter Jackson. Perf. Elijah Wood, Viggo Mortenson. New Line, 2003. Film.

Norris, Leslie, and Alan Keele. "Foreword." Rainer Maria Rilke, *The Duino Elegies*. Trans. Leslie Norris and Alan Keele. Columbia: Camden House, 1993. v–ix. Print.

Shelley, Mary. *Frankenstein*. Ed. Johanna M. Smith. 2nd ed. New York: Bedford/St. Martin's, 2000. Print.

Smith, Tom. "Do Bear Bells Really Work?" *Backpacker.* 18 Aug. 2010. Web. 21 Aug. 2015.

Stam, Robert. "Beyond Fidelity: The Dialogics of Adaptation." *Film Adaptation.* Ed. James Naremore. New Brunswick: Rutgers UP, 2000. 54–76. Print.

———. *Literature through Film.* Malden: Blackwell, 2005. Print.

———. *Subversive Pleasures: Bakhtin, Cultural Criticism, and Film.* Baltimore: Johns Hopkins UP, 1989. Print.

Tolkien, J. R. R. *The Return of the King.* 1954. New York: Ballantine, 1965. Print.

Venuti, Lawrence. "Adaptation, Translation, Critique." *Journal of Visual Culture* 6.1 (2007): 25–43. *Sage Publications.* Web. 5 June 2015.

———. *Translation Changes Everything: Theory and Practice.* Independence: Routledge, 2012. *Proquest.* Web. 22 May 2015.

———. *The Translator's Invisibility.* 2nd ed. New York: Routledge, 2008. Print.

West Side Story. Dir. Robert Wise and Jerome Robbins. Music by Leonard Bernstein. Lyrics by Stephen Sondheim. Based on a book by Arthur Laurents. Perf. Natalie Wood, George Chakiris. United Artists, 1961. Film.

William Shakespeare's Romeo + Juliet. Dir Baz Luhrmann. Perf. Leonardo DiCaprio, Claire Danes. Twentieth Century Fox, 1996. Film.

CHAPTER 5

··

ADAPTATION AND FIDELITY

··

DAVID T. JOHNSON

THIS essay focuses on the most important concept in the brief history of adaptation studies to date: *fidelity*, a word that has been almost impossible to displace from our discourse. Put simply, fidelity refers to the extent to which a given aesthetic object—traditionally, in adaptation studies, a film—reflects a *faithful* understanding of its source—traditionally, a literary text, especially a novel, play, or short story. That this small idea should inspire such vitriol over the years may surprise the scholar new to the study of adaptation, particularly since the most common reaction to any film based on a source with which the viewer is familiar is to compare both experiences precisely along these lines. Yet the explicit rejection of this impulse has so often characterized adaptation scholars' approach to the concept that the critical move guiding almost any recent study in the discipline has been, at some point in the opening, to distance one's current work from the approaches of the past—specifically, that of fidelity (or what has commonly become known as *fidelity studies*). The sources of this scholarly anxiety can be difficult to unravel, even for someone familiar with the history of the field. This essay seeks to give some basic sense of how the concept has been discussed in the past; to explain why it has inspired praise and, more commonly, abhorrence; and to suggest what, if any, future it may have in our discourse.

One of the most surprising revelations is just how few straightforward endorsements of fidelity exist in our collective history—that is, statements that do not in some way hedge their bets with acknowledgments of exceptions, complications, or acceptable alternatives. David L. Kranz and Nancy C. Mellerski begin their 2008 collection *In/Fidelity: Essays on Film Adaptation* by noting the centrality of fidelity for responding to adaptation. They would seem to be a perfect example of fidelity-studies advocates. By the end of their introduction, however, they are arguing not for a return to fidelity but for a "plurality of perspectives" that they hope "will contribute to the ongoing theoretical debate over the function and value of comparing film adaptations to their sources while also taking into account a plethora of relevant textual and contextual issues" (9). Thus, even those sympathetic with fidelity's aims, at least in more recent years, end up presenting something more complex and nuanced in practice. A similarly straightforward and recent call for fidelity's

return can be found in Colin MacCabe, Kathleen Murray, and Rick Warner's volume *True to the Spirit: Film Adaptation and the Question of Fidelity*. In his introduction, MacCabe asserts, "This volume goes against the academic grain in that it considers the question of 'truth to the spirit' to capture something important but, further, it also implicitly raises questions of value that are routinely dismissed by adaptation studies" (8). Again, MacCabe and his fellow writers suggest that we should return to fidelity, but what they demonstrate, by way of this return, is something far more complex than the position implied by the typical fidelity critique. Neither Kranz and Mellerski nor MacCabe et al. are rejecting fidelity, as has become the standard response for adaptation scholars, but they are not practicing fidelity in a way that the standard response would immediately recognize.

Earlier examples provide little guidance. In fact, even in older adaptation research, fidelity, more often than not, serves as a counterexample, something held up as the opposite of a more sophisticated model that the critic intends to use. Our discourse thus often has a reactive ring to it, an insistence that *this time* we will get it right, contra our predecessors, when it is never quite clear that in the last case, whenever that was, we were getting it wrong. Deborah Cartmell and Imelda Whelehan make this point in the opening of *Screen Adaptation: Impure Cinema* when they write, "Since the late 1990s, there has been a tendency among scholars of screen adaptation to announce their own perspectives on the field as some kind of corrective to what has gone before" (10), and Kamilla Elliott, in a breathtaking recent assessment of adaptation studies, has shown conclusively just how repetitive our discourse has been, whether in its rejections or in its proposals for new ways of working. One can trace the rejection of fidelity—or what J. D. Connor, in his own excellent history of fidelity studies, calls "the persistent call for it to end"—to the book most cited as the origin of the field: George Bluestone's *Novels into Film*. (For a thoughtful recent evaluation of some of Bluestone's central tenets, see de Zwaan.) Here, at the headwater of so much that follows, Bluestone rejects an idea of fidelity that he finds articulated by no less esteemed an intellectual than Jean-Paul Sartre: "But when Jean Paul Sartre suggests that for many of these readers, the book appears 'as a more or less faithful commentary' on the film, he is striking off a typically cogent distinction" (4–5). Bluestone uses Sartre's misappropriation of fidelity to launch a critique of typical clichés that he finds limiting, such as "the film is true to the spirit of the book" or "it's incredible how they butchered the novel," in order to set up his own study of the "mutational process" (5), which he sees as inevitable but insufficiently studied, and to tease out the ways the two media represent narrative. Yet Sartre himself had no interest in making the case for fidelity studies. The passage in question comes from a longer discussion in which Sartre is arguing that even with the greater publicity brought on by movie adaptations, a literary author cannot expect to have a greater reading public, much less a greater influence over that public, since readers who come to the novel after seeing the film, Sartre believes, will read the novel in a more facile way. Drawing on the example of Jean Delannoy's *La symphonie pastorale* (1946), based on a novel by André Gide and starring Michele Morgan, Sartre reflects, "The name of Gide recently entered certain heads by invasion, but I am sure that it is curiously married there with the beautiful face of Michele Morgan. It is true that the film has caused a few thousand copies of

the work to be sold, but in the eyes of its new readers the latter appears as *a more or less faithful commentary* on the former" (245, emphasis mine). Sartre is bemoaning the state of the literary author's potential readership and influence in the mid-twentieth century, not making any grand claims about adaptation studies—and certainly making no claims for the study of fidelity.

Bluestone's work is thoughtful and careful, and this misreading is uncharacteristic of the whole. Unfortunately, however, our discussion of fidelity must begin here, with a scholar who, with the best of intentions, misinterpreted a famous postwar philosopher. We have been trying to recover ever since.

Let us leap ahead on the timeline. In 1996, one of the key texts in the development of the field was published, a book that echoed Bluestone's in its title: Brian McFarlane's *Novel to Film: An Introduction to the Theory of Adaptation*. (Note that the subtitle includes the word *Theory*, indicating the field's growing seriousness of purpose.) McFarlane's book was probably the most important intellectual statement until that point to make explicit the desire to reject fidelity, even if, as the example of Bluestone shows, such rejections had been part of adaptation discourse for years. In many ways, the rejection has often been twofold, since fidelity frequently serves a dual function: it reflects a one-to-one *comparative* model of investigation, but it very often *evaluates* the aesthetic worth of the adaptation, based on its adherence to the source. In terms of the first idea, fidelity studies was somewhat rutted, according to its critics, since it was so focused on the one-to-one relationship that it in effect discounted multiple other possible sources, contexts, and concerns. As Robert B. Ray would later aptly note, it resembled "that undergraduate staple, the comparison-contrast paper" (47). As such, implicitly, it did not represent a stretch for the scholar or the reader. But the comparative model on its own perhaps did not present so many problems for the field as the second aspect of fidelity—the idea of evaluating the aesthetic worth of an adaptation, or any aesthetic object, period. Adaptation studies had the misfortune to come of age in the very era that would reject the desire to evaluate art, given that those standards would come to be regarded as serving the interests of the dominant hegemony. Replacing that impulse would be what Paul Schrader has elsewhere called "the rise of the nonjudgmentals" (40): a movement toward scholarship that would study aspects of culture that did not rely upon judging the value of the object. Historicization in particular became a useful discourse in this respect, since the historian's job was not so much to judge the object as to study it and place it within a larger context within which it might be understood.

Thus McFarlane had to reject both impulses at once, and this he did. He begins by identifying fidelity's widespread use: "At every level from newspaper reviews to longer essays in critical anthologies and journals, the adducing of fidelity to the original novel as a major criterion for judging the film adaptation is pervasive" (8). Here McFarlane's prose assumes a reader so familiar with such work that examples are unnecessary—and, as later passages will reveal, a reader likely to share the writer's sense of exasperation over this state. In fact, if Bluestone's book is the wellspring of our field more generally, we might credit McFarlane not just with popularizing the critical move to reject fidelity at

the outset of a work, but equally with accompanying that move by expressing a feeling of immense frustration, a sense that the critic is at his or her wit's end with the concept and that the rejection is years overdue. We find an analogous derision, if not exactly exasperation, over a decade earlier, in Dudley Andrew's *Concepts in Film Theory*, published in 1984, where he calls fidelity "[u]nquestionably the most frequent and most tiresome discussion of adaptation" (100) in a chapter that had first appeared four years earlier. Christopher Orr, reviewing *Narrative Strategies* along with three other titles, expresses a similar attitude in a book review cited by McFarlane himself: "Given the problematic nature of the discourse of fidelity, one is tempted to call for a moratorium on adaptation studies" (72). McFarlane's sentiments match Andrew's and Orr's—at least when it comes to fidelity. "Discussion of adaptation has been bedevilled by the fidelity issue," McFarlane writes, offering James Agee as a more positive example of someone arguing that "the cinema [should] make its own art and to hell with tasteful allegiance" (8). As he continues, an implicit frustration begins to surface: "Fidelity criticism depends on a notion of the text as having and rendering up to the (intelligent) reader a single, correct 'meaning' which the filmmaker has either adhered to or in some sense violated or tampered with" (9)—the scholar's frustration evident in the parentheses surrounding *intelligent* and the quotation marks surrounding *meaning*. McFarlane also notes the "distinction" in fidelity criticism "between being faithful to the 'letter,' an approach which the more sophisticated writer may suggest is no way to ensure a 'successful' adaptation, and to the 'spirit' or 'essence' of the work" (9). This spirit-based model for fidelity investigation does indeed drive much of the critical work that precedes and follows McFarlane, yielding either rich or poor returns, depending on the writer's and the reader's overall receptiveness to fidelity. My conceding some value to spirit-based fidelity criticism should not be confused with McFarlane's own attitude, however, since he is explicitly and wholly negative, concluding after his reflections on spirit models that "the fidelity approach seems a doomed enterprise and fidelity criticism unilluminating" (9).

That McFarlane's book would go on to be cited so often over the years indicates its importance in the ever-unfolding movement away from fidelity. Still, as is often the case in adaptation studies, some of those later texts that cite McFarlane will take him to task for being too *close* to fidelity, setting yet another precedent: however much a given scholar distances his or her work from the earlier embrace of fidelity, it becomes common for the next scholar to emphasize the relative proximity of the previous work to fidelity studies. Part of this is because the term itself is so ambiguous, as McFarlane indicates in his critique of "spirit"-based inquiry. And this ambiguity becomes its problem, one that sets up the repeated gesture of characterizing past work as not nearly distant enough from fidelity's aims. For if we can never quite identify exactly what we mean by fidelity studies, always gesturing toward some impulse we cannot describe with certainty, how are we to be sure that we ourselves are not practicing it? This is what James Naremore's introduction to the collection *Film Adaptation*, published four years later, would assert about McFarlane. Naremore initially places McFarlane in line with Bluestone's own "adaptation as translation" approach, tracing out the narrative's movement through an emphasis on media specificity. (For a fuller consideration of this adaptation metaphor, see Laurence

Raw's essay "Aligning Adaptation Studies with Translation Studies," Chapter 28 in this volume.) But he also notes how McFarlane's book circles back, inevitably, to fidelity, "and necessarily so, because the major purpose of his book is to demonstrate how the 'cardinal features' of narrative, most of them exemplified by canonical, nineteenth-century novels from British and American authors, can be transposed intact to movies" (9). To demonstrate that, the scholar *must* engage in some form of comparative analysis—and hence must engage with fidelity. Naremore's proposal, in his highly influential volume, is that "[w]riting about adaptation ought to provide a more flexible, animating discourse in film studies, if only because it can address such a wide variety of things" (9). He anticipates more recent scholarship when he notes, "I would suggest that what we need instead is a broader definition of adaptation and a sociology that takes into account the commercial apparatus, the audience, and the academic culture industry" (10). Yet as the collection unfolds—and likely to the surprise of a contemporary reader—fidelity asserts itself in small but important ways. Robert Stam, for instance, frequently cited in studies that explicitly seek to reject fidelity, concedes "the partial persuasiveness of 'fidelity'" in arguing that it "should not lead us to endorse it as an exclusive methodological principle" (55), a phrasing that does not imply a full-scale rejection so much as an openness to other methodologies *in addition to* fidelity. The end of his essay calls for the field "to be less concerned with inchoate notions of 'fidelity'" (75–76)—*less* concerned, not *unconcerned*. Other writers, too, sometimes just in passing, make reference to fidelity, but do so in ways that are wholly positive. Jonathan Rosenbaum calls the film *Housekeeping* a "passionate, faithful film adaptation" (206), even if his essay is not straightforward fidelity criticism. Likewise, Lesley Stern begins her study on the *Emma* adaptation *Clueless* by remarking that "there is something uncanny in the way Cher reprises the role that Emma Woodhouse vacated in 1816" (221), an observation that invites engagement along the lines of fidelity, even if here too there is something more complex at work.

The palimpsest metaphor has become a common one in humanities study, and its ubiquity has perhaps led to a certain imprecision with regard to the vehicle of the figure. In a palimpsest, one can detect traces of the original writing underneath the newer writing; many critics today seem to take it to mean something closer to pastiche, or hybrid, or collage, which are altogether different comparisons. But I think here the palimpsest metaphor really does apply, since the language of fidelity often lies beneath the more explicit scholarly text, even one seemingly hostile to fidelity; one wonders, at times, if we *could* read newer scholarship without the faded language of fidelity hovering behind it. What is my insistence that we be accurate about the correct meaning of *palimpsest* in relation to its metaphorical use, after all, than its own appeal to fidelity?

Having examined some of the rejection impulse with more specificity, let us return now to the practice of fidelity studies, for as the opening of this essay suggests, clear endorsements of the approach are remarkably rare, both now and in the past. And, going further, if Bluestone was not practicing fidelity studies, and if Andrew and Orr were already rejecting it in 1984, along with McFarlane, Naremore, Stam, in part or in full, along with so many others, years later (and notwithstanding more recent attempts at a recovery),

then, to appropriate Raymond Williams's famous query about Modernism, when was fidelity studies? Did it ever, in fact, exist? Or did we invent it in order to have something to reject? Simone Murray makes some compelling arguments about how fidelity has functioned, more often than not, as counterexample to the critic's preferred methodology. Although she does not imply that fidelity criticism *never* existed, since surely it has and continues to do so, she underscores its far greater importance as a critical target:

> In reading over several decades of adaptation criticism, the suspicion grows that, while fidelity models may remain prevalent in film and television reviewing, in broader journalistic discourse, and in everyday evaluations by the film-going public, in academic circles the ritual slaying of fidelity criticism at the outset of a work has ossified into a habitual gesture, devoid of any real intellectual challenge. After all, if no one in academe is actually advocating the antiquated notion of fidelity, what is there to overturn? It appears more likely that the standardized routing of fidelity criticism has come to function as a smokescreen, lending the guise of methodological and theoretical innovation to studies that routinely reproduce the set model of comparative textual analysis. (6)

While Murray is making this point in order to advocate for new directions in adaptation studies—specifically, studying the adaptation *industry*—I want to seize on her passing reference to those places where "fidelity models may remain prevalent," since they may shed some light on how academics have engaged with fidelity over the development of the field.

To consider where and how fidelity discourse has existed, we might first bear in mind the history of adaptation studies, much of which has been detailed already, including Thomas Leitch's marvelous history of the Literature/Film Association, "Where Are We Going, Where Have We Been?" as well as Robert Ray's essay on the field cited earlier. Both scholars see the late 1960s and early 1970s as key moments in the development of literary studies, cinema studies, and adaptation studies, when the two former disciplines were gravitating increasingly toward working in light of the extraordinary insights being yielded largely by continental philosophy—and what became known simply as *theory*—just as adaptation studies was in large part moving *away* from those insights, toward defending what Leitch identifies, borrowing a phrase from James Naremore, as "a mixture of Kantian aesthetics and Arnoldian ideas about society" (328). Because adaptation studies lacked the clear institutional identity of literary studies, under the banner of English, and because it also lacked the sheer number of cinema-studies scholars, as Leitch points out, fidelity's early days in academic criticism, as a discourse within adaptation studies more generally, tended to be dispersed. It did not find its way into print within most of the higher-profile academic journals or university presses. This is very likely why those who took up fidelity did so from smaller institutions, where publications could serve a scholar's professional progress but would not do so primarily or exclusively, as in research-oriented posts. One could reverse this, too, and say that scholars who were interested in fidelity were not being hired at more research-oriented posts *because* their interests did not jibe with the current interests of the fields. One reason

that the true practice of fidelity studies is so difficult to identify is because of this institutional history. Since scholars practicing fidelity studies were often at teaching institutions, their work was more widely diffused, among multiple voices, rather than centered within a few key practitioners around whose work other writers might have rallied. For this reason, I believe, the practice of fidelity studies, however common it may have been at one time (and that is still probably much less common than the reader would believe, given the frequency of fidelity's rejection), has always felt less centered than the rejection of it does—a rejection that has, by and large, come from research institutions, and from prominently established scholars (and, as in the case of many contributors to Naremore's volume, often from scholars not primarily associated with adaptation studies).

One potential locus, however, that might in part qualify these remarks regarding fidelity's dispersal is *Literature/Film Quarterly*, a journal founded at a teaching school, Salisbury University (then Salisbury State College), in Maryland, in the United States (an institution where I now work and a publication I co-edited from 2005 to 2016). Dispersal is of course relative, for even if the discourse was at times centered in this journal, it can be difficult to know who was reading it, and how often—or if, much as academic journals are used today, readers were less likely to peruse an entire issue than to find essays that dealt specifically with their own research interests, meaning that fidelity might seem to be a robust or meager discourse, depending upon the individual reader. In the pages of *Literature/Film Quarterly*, readers could find fidelity as a part of a larger set of interests, whether directly engaged with or indirectly alluded to among a larger evaluative mode of writing that could be playful, sensuous, and expressive. Kenneth S. Rothwell's review-essay of Roman Polanski's 1971 adaptation of *Macbeth* published in the first volume of the journal in 1973 provides a good example of the journal's early sensibility. Rothwell's opening paragraph remarks, for instance, "As though cocksure of the license granted him to indulge in Senecan horrors (after all did not the Elizabethans have their strange tastes?), Polanski fills up the technicolor screen with a banquet of cruelty" (71). Most film reviews in standard journalism would eschew references to Seneca and to the larger context of Elizabethan drama with which the average lay reader would be unfamiliar, thus indicating the essay's address to scholarly readers. Yet Rothwell clearly draws from a more informal, essayistic mode of address associated with journalism: the comic tone of "cocksure," the rhetorical question about Elizabethan taste, the evocative "banquet" metaphor. And while the style becomes even looser as the review-essay continues, with Rothwell reflecting on the theater where he first saw the film in a passage that recalls William Hazlitt's immersive essay "The Fight"—"The young people there, by no means all dull groundlings I hasten to add, nevertheless, I felt, identified less with Shakespeare, whom they thought of only as someone jammed down their throats in school, than with the bizarre ambiance from whence the film was generated" (71)— the essay equally assumes a reader familiar with, if not fully realized scholarly debates within Shakespeare scholarship, clear understandings of the play and other adaptations of it. In other words, this sort of writing is and is not journalistic; it is and is not scholarly. Although there is a whole range of writing styles in fidelity studies' earlier days (to be fair, some quite scholarly, in almost any way one would define that word), and although

fidelity criticism is often more nuanced and complex in practice, those who wrote with this set of concerns in mind tended to do so with a blend of scholarly and journalistic interests, with the advantage that fidelity could enter the discussion with relatively little resistance from theoretical vocabularies found solely within scholarship and ultimately incompatible with fidelity's values—the very vocabularies quickly becoming entrenched in literary and cinema studies.

Contrary to prevailing ideas about where fidelity discourse thrives, it would be unfair to writers who identify with journalism to suggest that they are primarily responsible for keeping that discourse alive. Although reviewers often acknowledge a source and speak of fidelity—even, at times, to a great degree—they are not exclusively interested in the interchange between sources and adaptations, and to the extent that their writing is evaluative (and it is that), such appraisal is less often based on fidelity than on the quality of the film as the reviewer sees it. Otis Ferguson, reviewing *Of Human Bondage* in 1934, acknowledges the source text, in a very traditional fidelity-studies mode, as being "a finer thing" than the film, but only so that he can recommend that the viewer forget the source and enjoy "a very fine thing in its own right" (41). Surely, Ferguson's comparison here, where he contextualizes an adaptation in light of its source and only then acknowledges its worth, would seem to bear out the common complaint that Murray and others have made about journalistic inquiries into fidelity. Nonetheless, his phrase "a very fine thing in its own right" indicates where the journalist typically lands (or its opposite, in the case of a negative review)—that is, on an assessment of the film as an experience in and of itself, even if fidelity comes to bear on that assessment. In a much more recent example, reviewing *Harry Potter and the Deathly Hallows: Part 2* in 2011, Manohla Dargis acknowledges the importance of fidelity but, like Ferguson, is much more at pains to make the case for the beauty—even the art—of the film, one she regards through the prism of nostalgia, both for the actors who have aged and also for the aging of cinema itself, her sentiments perhaps inflected by the "death of cinema" arguments in the air at the beginning of the twenty-first century. "It isn't often in the summer that you enjoy the intense pleasure of a certain kind of old-fashioned cinema experience," she reflects, "the sort that sweeps you up in sheer spectacle with bigger-than-life images and yet holds you close with intimately observed characters and the details that keep your eyes and mind busy." Elsewhere Dargis speaks to fidelity, but not exclusively, nor with the vigor and breadth one might expect to find, if journalism were the mode of writing that had kept fidelity alive all these years. For her as much as for Ferguson, fidelity is not the sole issue and often drops away entirely from the reviewer's immediate concerns. Other examples might qualify my characterization, but I would argue that the overall contribution journalism has made to keeping fidelity alive has been much smaller than has always been imagined. Fidelity thus may have entered our field through an evaluative and essayistic mode associated in part with journalism, but journalists do not regularly practice fidelity evaluation, nor can they be held responsible for the field's inability to reject it fully.

And so fidelity began within adaptation studies, as literary studies and cinema studies were gravitating toward theoretical models that scholars of adaptation were not interested in pursuing. It grew instead within the work of scholars dispersed in various

institutions and smaller publications, and when scholars from literary studies and cinema studies, respectively, did weigh in on what adaptation studies was up to, it was most likely to say that adaptation scholars were not practicing good scholarship, given that fidelity embodied all of those older ways of working that humanities scholars were rejecting in a much broader way. And after a time, adaptation scholars began to realize that to be taken seriously, they too would have to abandon these impulses. For scholars like me from teaching institutions who wanted to join their aspirational peers, rejecting fidelity became an act of camaraderie whereby lesser known voices could join those who were more well established. It also became a real moment of advocacy for the field, a way of reclaiming and reconfirming intellectual worth within a discipline that continues to struggle for recognition. This is why I do not find it to be a disingenuous gesture, nor a Freudian one, when a scholar enacts yet another rejection of fidelity, but an earnest expression of a desire for coherence within a still emergent field. Unfortunately, the insistence on fidelity's rejection, coupled with a sense that previous rejections were, in their own way, too close to fidelity, has meant that we are always traveling further and further out on some asymptotic line we will never fully complete, in an eradication of fidelity from our language *in toto*. A true rejection of fidelity will occur, by contrast, when scholars simply neglect to address it at all. Fidelity's final disappearance will be complete, in fact, when we are all looking elsewhere, so that, when we turn our gaze back to where it once was, we will have forgotten what was there in the first place, and what all of the frustration and anxiety had been about, all of those years, for those of us who once talked about it, that aged concept, that museum piece—that word, in letter or spirit, that we may then be hard-pressed even to remember.

Yet that moment seems unlikely from our current vantage, does it not? After all, almost every book on adaptation studies published thus far in the twenty-first century has, at some point in its opening, characterized fidelity studies as belonging to the past, and if this is a "ritual slaying," as Murray puts it, perhaps such ritual persists because the old gods do as well. Rather than join those voices at this point, however, since the reader can easily find examples of the rejection of fidelity—many, I should hasten to add, quite cogent and compelling—this essay will instead consider what possible futures might exist for fidelity in our field. I am not suggesting that these are the best possible avenues for the future study of adaptation, and they may seem so pointedly obvious as not to constitute a real break of any kind. Indeed they do not. But I hope the reader will not confuse simplicity for ineffectiveness, since the first two approaches may offer us good, thorough, and rich intellectual engagement with adaptation. These two paths derive from the two twenty-first-century critical defenses of the concept mentioned earlier: *In/Fidelity: Essays on Film Adaptation* (2008), edited by David L. Kranz and Nancy C. Mellerski, and *True to the Spirit: Film Adaptation and the Question of Fidelity* (2011), edited by Colin MacCabe, Kathleen Murray, and Rick Warner. In the first case, I want to focus on Kranz's approach to fidelity elaborated upon in his contribution to *The Literature/Film Reader: Issues of Adaptation*; in the second, I will focus on MacCabe's introduction, as well as Kathleen Murray's contribution. Kranz proposes to emphasize

the comparative impulse over the evaluative one; MacCabe and Murray propose the opposite. Truly separating them, or giving one primacy without any residue of the other, is probably impossible. Still, these two solutions, to which I will add a third, may yet cultivate good scholarship devoted to the study of adaptation.

In "Trying Harder: Probability, Objectivity, and Rationality in Adaptation Studies," Kranz asserts that "there's no necessary or inherent reason why fidelity criticism must include an evaluation of the relative quality of an adaptation with respect to its source," adding, in a sentiment that alludes to the journalistic history outlined earlier, "Why evaluate at all? We're not reviewers" (85). Kranz is quite expansive in the way he envisions this comparative approach; for him, contra the sense of one-to-one models with which fidelity studies is often associated, "[c]omparative criticism of adaptations should include analysis of cinematic, intertextual, and contextual elements relevant to interpretive arguments emerging from analyses of narrative and other traditionally favored data" (86). He also makes clear the sense that comparative approaches, when divorced from evaluative counterparts, might be mobilized through any number of theoretical frameworks, even and especially those that would reject the evaluative impulse. The only problem with the comparative approach, as Kranz outlines it, is his distrust of the theoretical traditions that he locates within postmodernism, those which, he admits, can be mobilized by the comparative/fidelity approach, but those whose "relativistic excesses" (88), he argues strongly, should be curtailed or "filter[ed] out" (88). This is the point at which I would depart from Kranz, since ostensibly, once one takes the comparative/fidelity approach away from its evaluative counterpart, one might employ nearly any possible theoretical framework, including those that might have "relativistic excesses" (some that might be productive, too, in the right critical context). Close reading has been successfully wrested from its exclusive association with New Criticism in literary studies, so that its methodology is available to any number of other hermeneutic traditions that might be suspicious of, if not outright hostile toward, New Criticism's desires. In the same way, the comparative model might equally serve a fidelity studies drawing upon multiple different theoretical and historiographic traditions. This possible future for the scholarly study of fidelity is probably the most common form that it currently takes, and I suspect it will continue to yield rich results in the right hands.

Another future for fidelity might be found in *True to the Spirit*, where Colin MacCabe and other writers make clear their desire to foreground the possibilities of evaluative, fidelity-based adaptation scholarship. Although the essays often take distinct approaches to their various case studies, they begin with the assumption not only that evaluation can be critically productive, but also that adaptation might create a kind of surplus value, with source and adaptation having value on their own *as well as* a combined value, as part of a *system*—an important word for this collection—that then reveals the individual values as well. (André Bazin's work on adaptation, which posits something similar, is an explicit touchstone for the collection.) There is thus a model of active circulation at work here, as well as a sense of a more synchronic, less diachronic way of evaluating adaptation, one explained particularly well in Kathleen Murray's reading of *To Have and Have Not*'s various incarnations. She reflects that what we need to study adaptation is "a more flexible

model": "[*To Have and Have Not*] needs to be thought of as a Warners picture, a Hawks film, a Hemingway adaptation, a Faulkner screenplay, a response to *Casablanca*, and a Bogart/Bacall vehicle simultaneously" (111). Elaborating further, she concludes, "[i]t is only through holding all of these in our heads at once, juggling them around to see how they fit, thinking of them as a *system*, that the true richness of the text emerges" (111, my emphasis; note as well that the subtitle to her essay is "An Adaptive System"). Part of the appeal of this approach is that it destabilizes the causality apparently implicit in chronological succession while taking a broader, more system-oriented approach to history, and no one, least of all MacCabe, assumes that the terms of evaluation will themselves remain stable. He is quick to point out, for instance, that "[e]valuation is a complex and collaborative effort, and individual judgments can only enter into a vast and continuous exchange"—a wording that also invokes a circulatory system rather than an apparently fixed lineage from sources to adaptations (9). Surely there are advantages to returning at least part of our discipline to evaluation, a mode of engagement that, as MacCabe asserts, we need not all take part in, given the importance of other kinds of scholarly inquiry in which evaluation is not necessary. Still, the idea of entering an "adaptive system" evaluatively, locating both individual and combined worth within those varying forms that the discourse might usefully destabilize, and finding a surplus value, not a diminished one, in the process, is a second future for fidelity, which, like Kranz's proposal, is likely to yield rich forms of scholarly engagement in the years ahead.

Finally, a third, admittedly speculative, possibility for fidelity's future may lie within an essay that hinges on a mistranslation. In his contribution to the collection *Opening Bazin: Postwar Theory and Its Afterlife*, Philip Rosen points out that one of the key terms in Bazin's writings, in French, is *croyance*, which Hugh Gray translates as "faith" in the primary volumes in which most English-speaking readers have encountered Bazin over the years. Yet as Rosen explains, this is not exactly the French meaning of the word, which he suggests might be better understood as "belief"—a word that offers an advantage to us in English, since "it seems connotatively easier to tilt 'faith' toward a religious attitude," whereas "belief," even if it "can apply to religious commitment," also "can signify more epistemological generality and less subjective valance" (107). Rendering *croyance* as "belief" allows Rosen to move laterally among Bazin's writing, suggesting a quite convincing connection between Bazin's explorations of reality and cinema and Bazin's interest in adaptation and cinema, and his provocative essay surely has significant implications for Bazin scholars. I wonder if we might draw upon it in adaptation studies, especially in fidelity studies. If we appropriated Rosen's new translation for our own purposes, what would it mean for an adaptation to evince *belief* in a source, rather than *faith*? What would it mean, in other words, to practice *belief studies*? Among other benefits, *belief studies* would likely force us to emphasize fidelity "as part of the reception process" (3), in the words of Christine Geraghty, describing Catherine Grant's work on adaptation and reception. Grant notes that "the most important act that films and their surrounding discourses need to perform in order to communicate unequivocally their status as adaptations is to (make their audiences) *recall* the adapted work, or the cultural memory of it" (Grant 57; qtd. in Geraghty 3). Studying fidelity—or belief—in this way

might provide a new dimension to the study of adaptation, but would do so through a concept we thought we had exhausted. But we might be even more expansive. For if part of the larger project of the humanities has been, and continues to be, learning how to become conscious of, and critical of, one's own beliefs, and where those beliefs come from, and where they are likely to lead, and in what ways they may be static or capable of change—and how one's own beliefs meet the beliefs of others, and what happens when they do, and what the implications for that are on the political, economic, and social realities we inhabit and those we want to envision—then adaptation studies and *belief studies* might be particularly well poised to provide some guidance to these larger, complicated, always unfolding questions.

Whether or not *belief studies* becomes part of our discourse, however, these three possibilities at least point toward ways that fidelity might continue to inform what we do. But let us take the many, many rejections at face value and assume that the field, as a whole, does not want to continue practicing fidelity studies. Given that, we are faced with a real dilemma. For if fidelity studies is to be rejected, but if our discourse inevitably retains the residue of fidelity, a concept that is anathema to its very identity, then what is to become of the field?

We might do well here to take comfort in that most comforting of genres, the graduation speech. In 2013, film and television director Joss Whedon, coming off two successful, albeit very different, adaptations—the blockbuster *The Avengers* and the more modestly budgeted *Much Ado about Nothing*—gave the commencement address to the graduating class of his alma mater, Wesleyan University. Whedon acknowledged the pitfalls of clichés that plague most graduation speeches when he opened with, "Two roads diverged in a wood, and . . . no, I'm not that lazy." One could hardly imagine a less inspired beginning than going to Frost's poem, and the joke might have been enough, on its own, before Whedon proceeded into the "real" speech. But Whedon, an expert on genre in his own right, recovered the cliché, for the duration of his speech, and (as my poetry colleagues would be quick to note) gave a more accurate reading of the poem than the popular interpretation of its celebration of self-fashioning in contrast to a more conventional mode of living. Whedon reflected that, no matter what road the students took, the "other road" would not just always look better, or at least undeniably appealing, but would always be with them in some fundamental way. This "duality" was, as Whedon explained to the graduates, part of one's identity formation, not a fixed state but "something that you are constantly earning. It is not just who you are. It is a process that you must be active in." As he elaborated, "for your entire life, you will be doing, on some level, the opposite—not only of what you were doing—but of what you think you are. That is just going to go on. What you do with all your heart, you will do the opposite of. And what you need to do is to honor that, to understand it, to unearth it, to listen to this other voice."

We might use Whedon's musings on Frost's famous poem to speculate on our own future as a field. Because whether or not we practice fidelity studies in that future—and most of us, in all probability, will not—it is likely to remain part of what we do, informing

in its own way every statement we make, a presence confirmed by its constant negation. Yet what if we were to treat it as an "other voice," to adopt Whedon's language, and rather than attempt to silence it once again, delay that impulse, and let it speak? What would it say? Would it demand a certain attention to older questions that we thought we had answered? Might it ask us to think about the study of adaptation in ways we never have? Maybe such speculations are better left alone; maybe we would do well to heed the rejections, to add some of our own, and move on. But if this old, outmoded, far too unsophisticated, repeatedly discarded idea might still have a few lessons to impart, then perhaps we should for a time listen.

Works Cited

Andrew, Dudley. "Adaptation." *Concepts in Film Theory*. New York: Oxford UP, 1984. 96–106. [First published as "The Well-Worn Muse: Adaptation in Film History and Theory." *Narrative Strategies: Original Essays in Film and Prose Fiction*. Ed. Syndy M. Conger and Janet R. Welsch. Macomb: Western Illinois UP, 1980. 9–17.] Print.

Bluestone, George. *Novels into Film*. 1957. Berkeley: U of California P, 1971. Print.

Cartmell, Deborah, and Imelda Whelehan. *Screen Adaptation: Impure Cinema*. New York: Palgrave Macmillan, 2010. Print.

Connor, J. D. "The Persistence of Fidelity: Adaptation Theory Today." *M/C Journal* 10.2 (2007). Web. 7 Sept. 2015.

Dargis, Manohla. "Class Dismissed." *New York Times* 13 July 2011. Web. 19 June 2014.

de Zwaan, Victoria. "Experimental Fiction, Film Adaptation, and the Case of *Midnight's Children*: In Defense of Fidelity." *Literature/Film Quarterly* 43.4 (2015): 246–62. Print.

Elliott, Kamilla. "Theorizing Adaptations/Adapting Theories." *Adaptation Studies: New Challenges, New Directions*. Ed. Jørgen Bruhn, Anne Gjelsvik, and Eirik Frisvold Hanssen. London: Bloomsbury, 2013. 19–45. Print.

Ferguson, Otis. *The Film Criticism of Otis Ferguson*. Ed. Robert Wilson. Philadelphia: Temple UP, 1971. Print.

Geraghty, Christine. *Now a Major Motion Picture: Film Adaptations of Literature and Drama*. Lanham: Rowman and Littlefield, 2008. Print.

Grant, Catherine. "Recognising Billy Budd in *Beau Travail*: Epistemology and Hermeneutics of Auteurist 'Free' Adaptation." *Screen* 43.1 (Spring 2002): 57–73. Print.

Harry Potter and the Deathly Hallows: Part 2. Dir. David Yates. Perf. Daniel Radcliffe, Emma Watson. Warner Bros., 2011. Film.

Kranz, David L. "Trying Harder: Probability, Objectivity, and Rationality in Adaptation Studies." Welsh and Lev 77–102. Print.

Kranz, David L., and Nancy C. Mellerski, eds. *In/Fidelity: Essays on Film Adaptation*. Newcastle: Cambridge Scholars P, 2008. Print.

Leitch, Thomas. "Where Are We Going, Where Have We Been?" Welsh and Lev 327–33. Print.

Macbeth. Dir. Roman Polanski. Perf. Jon Finch, Francesca Annis. Columbia, 1971. Film.

MacCabe, Colin, Kathleen Murray, and Rick Warner, eds. *True to the Spirit: Film Adaptation and the Question of Fidelity*. Oxford: Oxford UP, 2011. Print.

MacFarlane, Brian. *Novel to Film: An Introduction to the Theory of Adaptation*. Oxford: Clarendon, 1996. Print.

Murray, Simone. "Materializing Adaptation Theory: The Adaptation Industry." *Literature/Film Quarterly* 36.1 (2008): 4–20. Print.

Naremore, James, ed. *Film Adaptation.* New Brunswick: Rutgers UP, 2000. Print.

Of Human Bondage. Dir. John Cromwell. Perf. Leslie Howard, Bette Davis. RKO, 1934. Film.

Orr, Christopher. "The Discourse on Adaptation." *Wide Angle* 6.2 (1984): 72–76. Print.

Ray, Robert B. "The Field of 'Literature and Film.'" Naremore 38–53.

Rosen, Philip. "Belief in Bazin." *Opening Bazin: Postwar Film Theory and Its Afterlife.* Ed. Dudley Andrew, with Hervé Joubert-Laurencin. Oxford: Oxford UP, 2011. Print.

Rosenbaum, Jonathan. "Two Forms of Adaptation: *Housekeeping* and *Naked Lunch*." Naremore 206–20.

Rothwell, Kenneth. "Roman Polanski's *Macbeth*: Golgotha Triumphant." *Literature/Film Quarterly* 1.4 (1973): 71–75. Print.

Sartre, Jean-Paul. *What Is Literature?* Trans. Bernard Frechtman. New York: Philosophical Library, 1949. Print.

Schrader, Paul. "Canon Fodder." *Film Comment* 42.5 (Sept./Oct. 2006): 33–49. Print.

Stam, Robert. "Beyond Fidelity: The Dialogics of Adaptation." Naremore 54–76.

Stern, Lesley. "*Emma* in Los Angeles: Remaking the Book and the City." Naremore 221–38.

Welsh, James M., and Peter Lev, eds. *The Literature/Film Reader: Issues of Adaptation.* Lanham: Scarecrow, 2007. Print.

Whedon, Joss. "Joss Whedon '87—2013 Wesleyan University Commencement Speech—Official." Online video clip. YouTube, 28 May 2013. Web. 13 Jan. 2014.

CHAPTER 6

ADAPTATION IN THEORY AND PRACTICE

Mending the Imaginary Fence

MARY H. SNYDER

WHEN I was in graduate school, my friend Kim and I learned of a workshop at which we could have our poems critiqued by a panel of academic critics. Kim said that if I went, she'd go. Kim aspired to be respected for her work. She aimed for critical feedback from experts who would transform her into what she desired to be: a published poet. I chose a poem of my own and brought enough copies for the academic critics and my fellow poets to read and critique. I sighed my relief when Kim volunteered to go first. I felt intimidated by the row of scholars sitting in front of me as the copies of my pitiful poem sat lifeless in my hands.

Kim's poem resonated with me. It exuded a simple beauty. It was a short poem about a couple who had lost their baby girl a short time before Christmas. On Christmas Day, the mother of the dead child shot and killed herself, a pink rocking horse ornament on the Christmas tree presented as a backdrop to the woman's husband entering the room, unable to stop her, as she was in the act of ending her life.

When the professors attacked Kim's poem in what felt like an irrational manner, I at first kept quiet, since they knew more about poetry than I. Then they said two things that infuriated me, and experienced or not, I refused to stay silent. They said that because the poem took place at Christmas time, a pink rocking horse ornament didn't make sense. A blue rocking horse would be more symbolic, signifying a boy and the birth of Christ. They also expressed consternation that the poem depicted a suicide at Christmas, which represented a joyful time of year.

Stunned by their responses, I was reluctant to voice my horror at their ignorance, but I did speak up. I tried to keep my emotions controlled. Having worked with victims of trauma, I knew that the suicide rate at Christmas time spiked to one of the highest of the year. When I explained that to the professors, they were dismissive, and I suppressed my

remaining thoughts, particularly that the pink rocking horse seemed a shining example of irony, rife with meaning.

Kim was devastated by the critique. As we walked to our cars together, she told me the situation her poem described had happened to someone close to her. She had been trying to capture the dire incident in a poem. I'd felt the poem's intensity. The senselessness of the suicide at the end of the poem, during what is supposed to be a joyful time of year, weighed me down. Kim's poem stayed with me. I still remember the emotion it stirred in me that day and the scene the poem evoked in my imagination.

Kim revised the poem and used the newer version in her M.A. thesis. She changed the pink ornament to blue. I didn't respond to the revised poem as deeply as to the initial version I'd read. I tried to hold on to that first one physically, but it got lost in a sea of miscellaneous paperwork that piled up as I moved from graduate school into teaching. A massive search for it absorbed an entire weekend, but it was gone. I still yearn to feel what I did when I first read it. That poem was powerful. Kim never published either version, and she and I lost touch years ago.

This anecdote may seem a strange way to begin an essay about the distance between adaptation in theory, put forth by academic scholars, and adaptation in practice, put forth by professional screenwriters, yet it seems fitting that I begin by considering the two types of readers who approached Kim's poem.

Screenwriter as Reader

Some readers feel the intensity of a text, in this case a poem, and simply enjoy it but do not demand it be rife with meaning. When Kim presented her poem, I was this sort of reader, struck by the emotional vigor of the text. The image it inspired in me proved vivid and enduring. Some texts provoke such intense responses in some readers that they feel driven to recreate it in different terms—to adapt it—as screenwriters read a literary text and re-envision the scene or scenes of that text for a cinematic version. My perception of screenwriters approaching source texts, novels or plays or short stories, and growing so enamored of them that they want to bring them into the medium of film, may well be idealized. Although screenwriters who adapt texts begin as readers of those texts, they don't necessarily choose to adapt them because of their emotional response. Professional screenwriters rarely have the luxury of acting on behalf of such impulses because of the monetary demands the profession places on individuals, their work, and the project it fuels.

Horton Foote attests to the internal conflict that can arise when asked to adapt a novel with which one is unfamiliar. In his essay "Writing for Film," Foote explains how Alan Pakula calls to ask him to read "a novel he had recently purchased called *To Kill a Mockingbird*" (7). Foote remembers Pakula telling him "that Harper Lee did not want to dramatize the film and that I was the choice of all of them to do it. I read it and liked

it, and I consented to the task" (7). However, Foote remembers after agreeing to write the adaptation "feeling very depressed," reading the novel over and over again, unable to start writing the screenplay. Finally, he read a review of the novel that helped him see it in a new way, and he "began to feel at home in the material" (7). Although Foote then proceeded with more caution than wild abandon, he describes the experience as having "changed my notion of the writer and his relation to films forever—or rather, made me understand the possibilities for creative work for the writer of films" (7).

Writers adapting screenplays from source texts become readers of those texts and perform interpretations of them. In Mary Sollosi's Film Independent blog, professional screenwriters describe themselves as readers interpreting texts. Gina Prince-Bythewood, a writer and director of film who adapted *The Secret Life of Bees*, believes that "one of the biggest pitfalls she's encountered is expecting [writing an adapted screenplay] to be easier than writing an original screenplay" (Sollosi 3) because the structure is already established. Instead, she says, "[y]ou have to do the same work that you do for something in your head" (3). Perhaps the work is not the same, but it is equally challenging in a different way. A reading of the source text (or texts) must be carried out. An interpretation of that text must be developed before a screenwriter can begin. Jane Anderson, who wrote the screenplay for the 2014 television miniseries *Olive Kitteridge* (Figure 6.1) based on Elizabeth Strout's novel, emphasizes how necessary her interpretation of the text became as she tangled with the producers. When she began to work on *Olive Kitteridge*, she felt heavy expectations from the producers that led to a terrible first draft: "HBO wants you to be hip and edgy," she explained, "and the book *Olive Kitteridge* is very quiet. . . . It's about a miserable woman in Maine who's just a pain in the ass." She attempted to reorganize the novel's chronology to make this ornery New England woman as hip and edgy as premium cable requires.

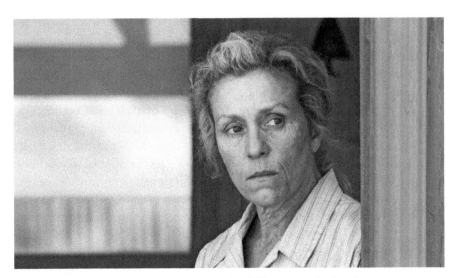

FIGURE 6.1 Frances McDormand in the title role of *Olive Kitteridge* (2014).

"Finally I begged my executive producer, 'can I just tell the story?' . . . I wasted a good four months" (2).

Another issue that arises for screenwriters adapting a source text is whether or not they are doing right by that text. In praising the example of *Seabiscuit*, a book published in 2001 by Laura Hillenbrand and adapted to the screen two years later by Gary Ross, Syd Field writes, "As a screenplay adapted from a book, it honored the original source material both in terms of spirit and integrity" (258), then poses the questions he believes crucial to screenwriters creating adaptations: "What makes this adapted screenplay so good? And what's the best way to go about adapting a novel, play, magazine article, or newspaper story into a screenplay?" (258). Field claims that the screenwriter's role is difficult and that few "can do adaptations well" (259). Prince-Bythewood concurs. When the producers of *The Secret Life of Bees* (2008) "wanted her to make a major plot point—essentially the novel's premise—into a shocking revelation later in the film," she fought it because she "wanted to honor the book" (Sollosi 3). Honoring the book or source text for a screenwriter seems to be a problematic endeavor, one that adaptation scholars discuss at length and refer to as a question of fidelity. Is it necessary for screenwriters to honor their source texts? And who decides whether they're being honored?

ADAPTATION SCHOLAR AS READER

The screenwriter carries out a very different role from that of the scholar who writes about adaptation. Although I have likened the screenwriter's reaction to my own reaction in the critique of Kim's poem—enjoying the poem and becoming emotionally attached to the text—screenwriters play a much more complex role as they perform readings of the texts they plan to adapt. Just as complex is the role of the scholarly reader. In the anecdote involving Kim's poem, that reader is the perspicacious reader who requires a text, like Kim's poem, to embody a coherent meaning and excavates the text in order to interpret it, or eschews it if such an effort proves fruitless. This reader can have two roles: to create a new text based on the source text that builds from an attempt to understand and interpret that source text, or to offer his or her wisdom on how to make the text more universally meaningful. When Kim presented her poem, I experienced the academicians playing this latter role, desiring more depth from it, critiquing what they believed to be the poem's deficiencies, and encouraging more universal connections. My discomfort with these readers at the time and ever since signals my mistrust of scholars writing from a theoretical perspective—the very perspective from which I myself now write. However, my specific mistrust of adaptation scholars comes from another perspective from which I write, that of fiction and creative nonfiction writer.

It is imperative to explore one's biases when entering a discourse on a subject that is fraught with tension and misconceptions, and possibly misinformation. Navigating the distance between screenwriters' and scholars' perspectives on adaptation is such a subject. As a fiction writer, I realize that it is unreasonable to imagine a romanticized

version of a screenwriter who reads my story and gets exactly what I want him or her to get from the story, visualizing it exactly as I do. My mistrust of adaptation scholars also has no firm ground upon which to rest. Perhaps it stems from my fear of rejection as an artist insisting upon the value of my work and its right to be interpreted the way I intend. Yet it may be similarly delimiting views of screenwriters and scholars of adaptation— perhaps even of each other, if they consider each other much at all—that have prevented the two groups from crossing paths.

Whether they are aware of it or not, however, their paths do cross, or at least run parallel. A screenwriter must read a text to adapt it. Similarly, scholars writing on adaptation, drawing from their readings of specific adaptations, also engage in a process of adaptation in their own writing. Ann Dobie, in the introduction to *Theory into Practice: An Introduction to Literary Criticism*, suggests that a reader of a text is "required to assume the role of coparticipant in the making of [that] text" (xvi). She aptly suggests that as the reader, "you cannot remain a silent partner in the conversation about a text, because what you have to say about it helps to create it" (xvi). Looking at criticism from this perspective narrows the gap between scholars and screenwriters of adaptation. Both the scholar and the screenwriter contribute to the making of the text in question. Both readers approach the text from the perspective they determine the source text requires and create a text out of their interpretation. And both groups of writers create a text by relying on their imagination, experience, and expertise around a specific source text. The two factions are conjoined in creating new texts, even though the processes are conducted differently. To view each group's overarching approach when thinking about adaptation brings the scholar and practitioner closer in alliance, bridging a gap that may be more imagined than actual, since both are drawing directly from one or more texts to create an additional text.

Robert Stam discusses this position as he describes the impact of structuralism and post-structuralism on the study of adaptation. He claims that the "structuralist semiotics of the 1960s and 1970s treated all signifying practices as shared sign systems productive of 'texts' worthy of the same careful scrutiny as literary texts, thus abolishing hierarchy between novel and film" (8). Thus not only literary texts but other media as well, including film, became worthy of interpretation. Stam's reference to Roland Barthes's "provocative leveling of the hierarchy between literary criticism and literature" (8) establishes literary criticism as a text built upon the literature it interprets. By analogy, Stam contends, Barthes rescued "the film adaptation as a form of criticism or 'reading' of the novel, one not necessarily subordinate to or parasitic on its source" (8). Establishing literary criticism as a text built upon other texts indicates that scholars and screenwriters perform similar tasks.

Linda Hutcheon's discussion of the character of Carmen as it resonates through myriad adaptations illustrates the ways in which adaptation criticism creates new texts built on other texts. Developing her analysis of Carmen from the work of others, Hutcheon produces an adaptation as well. What Hutcheon has to say about the adaptations of Carmen helps to create those adaptations by rethinking them, and she herself produces an adaptation in the form of criticism formed from the work of

others to establish her own work. Hutcheon expands her reader's understanding of the multifaceted adaptations of Carmen and its many implications as she writes of "The Carmen Story—and Stereotype," and develops her argument further by discussing "Indigenizing Carmen" (158), "Historicizings/Dehistoricizings" (158), "Racializings/ Deracializings" (160), and "Embodyings/Disembodyings" (164), each stage of her argument focusing on the adaptations of Carmen, adding to the discourse and creating a new text with that addition.

This essay aims to bridge the gap between practitioners who write adaptations and scholars who write about adaptation from a theoretical perspective. Although scholars tend to gravitate toward a more analytical approach to adapted texts, more as outsiders who are comfortable with that status, the practitioners are deeply enmeshed in the process of creating their own adapted texts. I detect problems inherent in both perspectives and recognize what each group could learn from the other. The chasm between the two camps is not so wide as either group might think, and may well be reimagined amid countless misconceptions and overlaps.

Kamilla Elliott observes that "there is often no clear demarcation between theorists, academic critics, novelists, filmmakers, reviewers, and reader-viewers" (6), and further specifies:

> Sergei Eisenstein, who mainstreamed both the analogy of the cinematic novel and of film "language," was theorist, critic, and filmmaker. Novelists like Joseph Conrad, F. Scott Fitzgerald, and William Faulkner became screenwriters. Novelists like Fitzgerald, Leo Tolstoy, and Virginia Woolf have written about the novel's relationship to cinema. Other novelists are academics: semiotician Umberto Eco wrote a novel, *The Name of the Rose,* and later critiqued its film adaptation; Anthony Burgess has been professor, novelist, screenwriter, film reviewer, and adapter of literature to theater and film—he even composed music for a theatrical adaptation of one of his novels. (6)

Despite known intersections involving individuals who work in various and sometimes conflicting mediums, it is important to emphasize that theorizing adaptation is in itself a form of adaptation. Thus scholars and practitioners of adaptation already are not so clearly delineated or separate. At the heart of the involvement with adaptation for both scholars and screenwriters is at least one source text. Those discussing adaptation commonly refer to previous scholarship (one type of source text), the "original" text (another type of source text), and the adapted text (also a source text if it is the subject of written discourse).

Although no literary text is created from scratch, and all texts invariably come from previous texts, authors having been influenced by texts before and around them, some useful distinctions can be made. A literary text can be seen as an adaptation in the sense that it springs from other texts that have influenced its creation. However, a story already created in literary form adapted to cinematic form constitutes a purposeful adaptation. A story created out of several external influences is an inevitable adaptation of the world around the creator that he or she includes in his or her text. That being

said, distinguishing between conscious and unconscious adaptations can easily become muddled, and the rest of my discussion will focus on conscious adaptations alone.

Middle Ground

John Keats was keenly aware of oppositional practices for reading a text. Keats himself was not averse to receiving criticism. He appreciated both Percy Shelley's encomiums on his work and his criticism when the two writers encouraged and critiqued each other's poems. Keats writes to Shelley in a letter dated 16 August 1820: "A modern work it is said must have a purpose, which may be the God—*an artist* must have 'self concentration' selfishness perhaps. You I am sure will forgive me for sincerely remarking that you might curb your magnanimity and be more of an artist, and 'load every rift' of your subject with ore" (Mellor and Matlack 1309). Keats prioritizes the goal of one's writing here, but he remains concerned with the art in writing. In that same letter, he takes pains to separate his imagination from his person: "My imagination is a Monastery and I am its Monk" (1310).

Keats's poem "Lamia" contrasts the reading of a text for pleasure without a critical eye, simply absorbing it and thinking it pleasurable, with the reading of a text in order to judge it. The poem's critique of both ways of reading a text implies a middle ground of interpretation that involves finding meaning through readings that combine analysis with pleasure. Screenwriters and adaptation scholars could gain from what Keats says about critical reading and might find guidance in establishing a common ground for their writing of or about adaptations.

Lamia, who first appears as an iridescent, magnificent serpent/woman, can readily be seen as representing one's imagination. In the shape of a snake, she is ornate, fantastical, and "of a dazzling hue / Vermillion-spotted, golden, green, and blue; / Striped like a zebra, freckled like a pard, / Eyed like a peacock, and all crimson barr'd" (1299). Yet she is still a beautiful snake. Lamenting her fate, she strikes a bargain with Hermes: she will lead him to the wood-nymph he desires if he returns her to her "woman's shape" (1300). He agrees.

Lamia's transformation into a woman seems discomforting, even painful. Like the labor of transforming the imagination into a work of art, it is not a pleasant process. When the transformation is complete, "Nothing but pain and ugliness were left" (1301). Lamia is still beautiful, but this beauty has been tamed from her serpentine magnificence into the form of a maiden.

The audience Lamia has chosen for her newly controlled form is Lycius. She is a text ready to be consumed by her viewer, and she knows how to give pleasure. She also knows that she can manipulate Lycius by enticing him. As Lycius spends more time with Lamia, consuming her, he becomes increasingly enthralled with her until "every word she spake enticed him on / To unperplexed delight and pleasure known" (1303). Lycius is the consumer who drinks in the text and never once doubts its beauty or

pleasure. He is the gullible, innocent, naïve reader who becomes so enthralled with the text that he begins to become it. He is no longer Lycius; he is intertwined with and dominated by Lamia. When the reader begins to identify too much with a text and becomes influenced by it, however, the text has gained too much control over the reader. The reader or viewer has lost perspective and cannot learn from the experience, but simply gorges on it. A reader who loses the critical or analytical perspective and can see only pleasurable attributes of the text refuses to consider the work's negatives, its problems, its contradictions.

Apollonius, the cold philosopher "[w]ith curl'd gray beard, sharp eyes, and smooth bald crown / Slow-stepped, and robed in philosophic gown" (1303), reads a given text not to experience its pleasure or beauty but only its function and truth, its meaning. He is outside the work, refusing to enter it in any way. Instead, he waits to critique the text, dissect it with his sharp eyes, until he sees only truth, and not any of its beauty. He does not want to "feel" the text, but only look at it from a position outside it. Lycius wants to stay within the text, never viewing it from a critical perspective.

The end of the poem shows how the two opposing ways of reading a text, pleasure-seeking versus analytical criticism, can be equally damaging and ineffective. When Apollonius sees Lamia, he pierces through her with "his demon eyes" (1307). Lycius appears "heart-struck and lost" (1307) as Apollonius delivers his final crushing blow, revealing that Lamia was once a serpent. As Lycius recoils from her, Lamia returns to her earlier form, showing perhaps that Apollonius has too much power as a critical reader, reducing the text into what he "knows" it to be, but what it may not actually be. When Lamia vanishes, destroyed by Apollonius, Lycius dies, destroyed in turn by her disappearance. Without her, he does not exist. Having relinquished his independent identity, he cannot live without her presence to define him.

The story of Lamia reminds me of the critique of Kim's poem by a panel of academics. The Apolloniuses in the workshop insisted that Kim's poem had to convey truth, or a clear message, through the proper use of the techniques at her disposal as a poet. They did not take into account the way the poem had been derived. To remain too far outside the poem undercut its value, neglecting the inspiration from which it had come, the emotion it evoked. At the same time, a reader of her poem who did not demand complexity or investigate its contradictions, who thought it fine just the way it was, also was not the ideal reader. There is a middle ground. Keats does not identify this middle ground in "Lamia," but he strongly endorses the search for it.

In *The Pleasure of the Text*, Roland Barthes discusses the pleasure in reading a text, but he is careful not to encourage readers to become controlled by the texts they read. Despite Barthes's pleasure in reading, he retains his critical eye. He believes that working with a text involves action from both ends of the spectrum. The text is acted upon by the writer; the writer, drawing from his imagination, creates the text; the reader reads the text. In adaptation, the reader can be the screenwriter. However, the reader also can be the scholar viewing or reading the adaptation.

Barthes might well disapprove of Lycius as a reader. Lycius does not interact with the text; he becomes the text. Barthes distinguishes between texts of pleasure and texts of

bliss. Texts of pleasure are those that are comfortable to read, texts that do not break with the culture that produces them. A text of bliss, on the other hand, is "the text that imposes a state of loss, the text that discomforts (perhaps to the point of a certain boredom), unsettles the reader's historical, cultural, psychological assumptions, the consistency of his tastes, values, memories, brings to a crisis his relation with language" (14). Readers engaging with this latter text might be akin to Lycius, since such a text inspires communion between reader and writer, a conjoining of minds that is experienced as sensual. Barthes himself seems to struggle with this closeness in reading a text: "To be with the one I love and to think of something else: this is how I have my best ideas, how I best invent what is necessary to my work" (24). He places similar demands on a text, for it produces the greatest pleasure "if it manages to make itself heard indirectly" (24). Although he prefers texts of bliss to texts of pleasure, he seems to encourage reading that does not involve immersing oneself in the text.

Barthes requires readers to be active in their readings, for "there is not, behind the text, someone active (the writer) and out front someone passive (the reader); there is not a subject and an object" (16). Lycius could gain from trying to understand and interpret Lamia, rather than simply obeying and succumbing to her. Lamia could benefit from Lycius's attempt to see her truth as well as her beauty. Both are doomed to disappointment.

Readers like Apollonius, however, cannot live outside the text and be effective interpreters. Apollonius views Lamia from the outside, penetrating her with his eyes, trying to see into her, but not trying to get inside her and move around. The reader must experience the text from the inside without becoming the text. Barthes writes: "Which is what the inter-text is: the impossibility of living outside the infinite text—whether this text be Proust or the daily newspaper or the television screen: the book creates the meaning, the meaning creates life" (36). Looking only for meaning, Apollonius dismisses Lamia as a serpent. He does not try to see her in terms of her desire or her longing to be released from what she regards as a prison. And the reader of "Lamia" never has the opportunity to find out more about Lamia and her history, because Apollonius chases her away with a single simplified meaning.

Barthes suggests a middle ground by distinguishing between individuality and subjectivity: "Whenever I attempt to 'analyze' a text which has given me pleasure, it is not my 'subjectivity' I encounter but my 'individuality', the given which makes my body separate from other bodies and appropriates its suffering or its pleasure: it is my body of bliss that I encounter" (62).

Barthes focuses on the individual, not the personal. Lycius loses sight of his individuality when he becomes involved with Lamia. He becomes enmeshed within her. Apollonius stays removed, preventing his individuality from affecting his reading of Lamia. Neither one ever truly reads her.

Screenwriters cannot be so immersed in the source text that they become enmeshed within their reading of the text and sacrifice any objectivity. Conversely, adaptation scholars cannot be so removed as they study an adaptation that they overlook the process by which the adaptation came to be.

In "The Critic as Host," J. Hillis Miller addresses the possibility of entering a text without destroying it, as Apollonius destroys Lamia. Miller notes that the reader of a text is often seen as penetrating it and becoming a parasite within it, sucking the life out of it: "The host feeds the parasite and makes its life possible, but at the same time is killed by it, as criticism is often said to kill literature" (217). Miller asks: "[C]an host and parasite live happily together, in the domicile of the same text, feeding each other or sharing the food?" (217).

Miller provides an argument for a reader who can position himself or herself between Lycius and Apollonius. Lycius is the reader who enters the text and resides there, offering nothing in return. Apollonius is the reader who stamps a univocal meaning onto a text without entering the text, from the outside, reducing the text to much less than it can be. The ideal reader is not the parasite, but the reader who enters the text and coexists with the text, sharing its space. For Miller, this ideal reader is the deconstructive reader. And a deconstructive reading, Miller contends, can coexist with a univocal meaning: "On the one hand, the 'obvious or univocal reading' always contains the 'deconstructive reading' as a parasite encrypted within itself as part of itself. On the other hand, the 'deconstructive' reading can by no means free itself from the metaphysical reading it means to contest" (224–25).

Both adaptation scholars and screenwriters would function best in their work if they approached their tasks from a deconstructive perspective. Since both the scholar and the practitioner are performing the art of interpretation, deconstruction offers avenues to each that allow them to expand their scope, as is required of adaptation. Deconstruction requires the reader to enter the text and move around within it. Deconstruction is mobile; it's active. It allows for change. Although it cannot escape the limits of language, it allows the reader more mobility within the text and allows the text more room to breathe. The text is not restricted to one fixed meaning but can be interpreted in many different ways. The possibilities are infinite. Deconstruction traverses the realm between Lycius and Apollonius, yet includes them as oppositional readers.

Some commentators consider deconstruction dangerous because it allows the reader too much freedom to penetrate the text, to go into it and move things around. Deconstruction can seem frightening, but it also can be intensely liberating. That the reader is simultaneously host and parasite to the text implies that text and reader can work together instead of against each other. The reader does not master the text. Deconstructive criticism is often viewed as a takeover of the text from the outside, like an Apollonian style of criticism, "something a bit too external, a bit too masterful and muscular" (251). But Miller shapes deconstruction into a less intimidating form of criticism:

> This form of criticism is not outside but within. It is of the same nature as what it works against. Far from reducing the text back to its detached fragments, it inevitably constructs again in a different form what it deconstructs. It does again as it undoes. It recrosses in one place what it uncrosses in another. Rather than surveying the text with sovereign command from outside, it remains caught within the activity in the

text it retraces. To the action of deconstruction with its implication of an irresistible power of the critic over the text must always be added, as a description of what happens in interpretation, the experience of exercising that power. The dismantler dismantles himself. (251–52)

Readers who move around within the text become involved with the text so that it changes them, but not so much that it consumes them. These readers benefit from their experience. Mastering the text involves trying to reduce it to one simplified meaning. But as Barthes suggests, the text creates the meaning, and the meaning creates life. For a reader to reduce a text to one meaning, as Apollonius does, is to ignore the inherent multiplicity in that text.

Writers seeking to adapt texts and writers seeking to open up adaptations in order to investigate their contradictions, complexities, even their ruptures, would both benefit from establishing common ground. What can each group learn from the other? The most obvious difference between the two actually represents something they both share. A screenwriter reads a source text to re-create it. A scholar reads an adaptation to explore it and identify its multiplicities. Yet both writers are performing an adaptation, and in so doing, are creating their own work, drawing from other work to make a work that is their own.

In his chapter on adaptation in *Screenplay: The Foundations of Screenwriting*, Syd Field discusses the process of beginning a screenplay based on a source text:

Every screenwriter approaches the craft of adaptation differently. Alvin Sargent, the Academy Award–winning screenwriter of *Ordinary People*, *Spider-Man 2*, and *Julia*, among other films, reads the source material as many times as it takes to 'make it his own,' until it's his story. Then he writes individual scenes in a random fashion, lays them all together on the floor, and shapes a story line out of those individual scenes. (259)

"Making it his own" might seem problematic, yet Sargent's process seems very similar to the process scholars engage in when developing a critical interpretation of a film adaptation based on a source text, perhaps reading both the source text and the adaptation several times. Yet "making it one's own" seems to be a struggle for some screenwriters. The goal of honoring or respecting the source text and the question of how best to achieve that goal are fundamental to the work of many screenwriters. Interestingly, this goal echoes the issue of fidelity in film adaptation, a contentious issue among adaptation scholars. A discourse between scholars and screenwriters concerning fidelity in adaptation might prove fruitful, as it pervades the thinking behind the work they do.

Many adaptation scholars have expressed their frustration with the expectation of fidelity in film adaptation as well as with the practice of fidelity criticism. One of Thomas Leitch's "Twelve Fallacies in Contemporary Adaptation Theory" reads, "*Fidelity is the most appropriate criterion to use in analyzing adaptations*" (161; emphasis in original). Leitch contends, "Fidelity to its source text . . . is a hopelessly fallacious measure of a given adaptation's value because it is unattainable, undesirable, and theoretically

possible only in a trivial sense" (161). Robert Stam claims that an adaptation can't win, since a "'faithful' film is seen as uncreative, but an 'unfaithful' film is a shameful betrayal of the original" (8). And Gordon Slethaug responds to Stam's list of the various "moralistic" metaphors that adaptation has been saddled with, from "infidelity" to "violation" to "bastardization" (Stam 3) by adding that these are "based on binary gender conceptions as well" (19). Slethaug observes that the metaphors such as faithfulness and fidelity "suggest that film is gendered as a weak female against the strong male work of art from which it draws its sustenance" (19). Linda Hutcheon contends that an "adaptation's double nature does not mean, however, that proximity or fidelity to the adapted text should be the criterion of judgment or the focus of analysis" (6).

Screenwriters encounter the conundrum of fidelity at the other end of the adaptation process, or the beginning. According to Syd Field, "you can't adapt a novel literally and have it work, as Francis Ford Coppola learned when he adapted F. Scott Fitzgerald's *The Great Gatsby* [for Jack Clayton's 1974 film] . . . a visually magnificent failure; dramatically, it didn't work at all" (258–59). When Baz Luhrmann ventures to adapt the classic novel more creatively in 2013, however, A. O. Scott calls the result "less a conventional movie adaptation than a splashy, trashy opera" (2). When Horton Foote was writing the screenplay of *To Kill A Mockingbird*, he was encouraged by Alan Pakula, one of the film's producers, to change the time span of the screenplay, a tactic that helped him "rethink the original structure in a creative way" (7), but was a difficult decision for him to make. Foote explains his aversion to adapting the work of others as trying "to get inside the world of another writer . . . [and being] under constant tension not to violate this other person's vision" (7). As Mary Sollosi notes in her Film Independent blog entry, "Top Screenwriters Reveal How to Avoid the Pitfalls of Film Adaptation," a group of professional screenwriters convened to discuss the topic of adapting novels to film agreed that "[g]etting to the core of what a book is truly about is the key to adaptation" (3). These screenwriters talk about knowing the theme and the character you're "meant to follow"; from there it's easy to choose what to leave out and what to develop. As Jane Anderson puts it, "You have to decide as a dramatist—how do I want to tell this story?" (3).

Gordon Slethaug has recently applied a postmodern perspective to film adaptation, extending the conversation beyond fidelity and faithfulness to intertextuality. In discussing scholars' movement away from fidelity as a criterion for adaptation, Slethaug draws from Jacques Derrida, who "perceives that there is no center, no master narrative for everything is, of necessity, hybrid, intertextual, and nontotalized, and, by that measure, so are so-called original and adapted texts" (24). Derrida encourages a shift from anticipating a center or origin when reading a text. Texts are too slippery to be reduced to one meaning. All of them, including adapted texts, can carry a wide range of meanings: "The only real point is whether adaptation is interesting and artistically inspired or whether it is dull and pedestrian, not whether it is original, part of a center or master narrative, or some kind of copy" (Slethaug 24).

The 2006 film *Children of Men* (Figure 6.2) represents one such interesting adaptation. The narrative of the film deviates significantly from the novel on which it is based. Yet the film remains introspective as well as inventive, depicting a not-so-distant future

FIGURE 6.2 Clive Owen in *Children of Men* (2006), a film adaptation that adds the concept of "The Human Project" to P. D. James's 1993 novel.

after universal infertility has ravaged the world. Writing in the 1990s, novelist P. D. James had addressed the same concept quite differently. Alfonso Cuarón, Timothy J. Sexton, and Clive Owen crafted the screenplay after 9/11. In an interview with Jason Guerrasio for *Filmmaker*, Cuarón acknowledged that 9/11 was a motivating factor for wanting to do the film. When Guerrassio asked Cuarón how he had approached the source material, he responded:

> Once we decided to do this exploration on the state of things—and you don't have to go very far to realize that the environment and immigration are pretty much on the top of the list—then we had to craft a story. I had the story I wanted to tell so clear in my head that I was very afraid of reading the book and getting completely confused. I read an abridged version of the book and Timothy J. Sexton, my writing partner, read the [entire] book. But our whole idea was let's find out what elements are relevant to what we're doing and let's disregard what we think is irrelevant. (2)

In another interview, with Kim Voynar for *Cinematical*, Cuarón stated that he wasn't going to use the concept of infertility, the premise of James's novel, because he didn't want to do a science fiction film. Yet when that premise continued to haunt him, he realized that universal infertility "could serve as a metaphor for the fading sense of hope, that it could be a point of departure for an exploration of the state of things that we're living in now" (2). Although the James novel put forth an interesting concept and a study of how the world might react, Cuarón chose to present that same premise in a different manner. He decided to explore his own vision of a post–9/11 world devastated by the added scourge of universal infertility. The film presents a dark and disturbing vision of such a world, though not without the sliver of hope James's novel offered. Cuarón's focus

wasn't on honoring the source text but on creating a film that would express his vision and challenge his viewers.

Perhaps adaptation scholars pushing beyond the concept of faithfulness in film adaptations based on a literary narrative, and opening up adaptations to examine their multiplicitous meanings, will nudge screenwriters into feeling less encumbered and freer to be more creative as they embark on a reading of the source text they intend to adapt. They can open up the source text and mine it for its infinite meanings, choosing the direction of the screenplay on the basis of what seems most captivating and not necessarily most respectful. Horton Foote writes, "To be really successful adapting one must like the original work. I don't have to always understand it, but I have to like it and be willing to try to understand it and go through the painful process of entering someone else's creative world" (7). Thus, to encourage the inventive aspects of adaptation and establish emphasis far from fidelity criticism, as adaptation scholars have been advancing, it might be best if screenwriters did not have a passionate affinity for the source text, so they wouldn't be held back by their reverence for the text and might harvest their own creative force at its ripest.

Works Cited

Barthes, Roland. *The Pleasure of the Text*. 1975. Trans. Richard Miller. New York: Hill and Wang, 1998. Print.

Children of Men. Dir. Alfonso Cuarón. Perf. Clive Owen, Julianne Moore. Universal, 2006. Film.

Derrida, Jacques. "Structure, Sign and Play in the Discourse of the Human Sciences." *Writing and Difference*. Chicago: U of Chicago P, 1978. 278–93. Print.

Dobie, Ann B. *Theory Into Practice: An Introduction to Literary Criticism*. 2nd ed. Boston: Wadsworth Cengage, 2009. Print.

Elliott, Kamilla. *Rethinking the Novel/Film Debate*. Cambridge: Cambridge UP, 2003. Print.

Field, Syd. *Screenplay: The Foundations of Screenwriting*. Rev. ed. New York: Delta, 2005. Print.

Foote, Horton. "Writing for Film." *Film And Literature: A Comparative Approach to Adaptation*. Ed. Wendell Aycock and Michael Schoenecke. Lubbock: Texas Tech UP, 1988.

Guerrasio, Jason. "A New Humanity." *Filmmaker*. 22 Dec. 2006. Web. 15 Sept. 2015.

The Great Gatsby. Dir. Jack Clayton. Perf. Robert Redford, Mia Farrow. Paramount, 1974. Film.

The Great Gatsby. Dir. Baz Luhrmann. Perf. Leonardo DiCaprio, Carey Mulligan. Warner Bros., 2013. Film.

Hillenbrand, Laura. *Seabiscuit: An American Legend*. New York: Random House, 2001. Print.

Hutcheon, Linda. *A Theory of Adaptation*. New York: Routledge, 2006. Print.

James, P. D. *The Children of Men*. 1992. New York: Vintage, 2006. Print.

Kidd, Sue Monk. *The Secret Life of Bees*. Viking, 2002. Print.

Lee, Harper. *To Kill a Mockingbird*. New York: Perennial, 2002. Print.

Leitch, Thomas. "Twelve Fallacies in Contemporary Adaptation Theory." *Criticism*. 45.2 (2003): 149–71. Web. 20 Aug. 2015.

Mellor, Anne K., and Richard E. Matlack, eds. *British Literature 1780–1830*. New York: Harcourt Brace, 1996. Print.

Miller, J. Hillis. "The Critic as Host." *Deconstruction and Criticism*. Ed. Harold Bloom. New York: Seabury, 1979. 217–53. Print.

Olive Kitteridge. Dir. Lisa Cholodenko. Perf. Frances McDormand, Richard Jenkins. HBO, 2014. Television.

Scott, A. O. "Shimmying Off the Literary Mantle: 'The Great Gatsby,' Interpreted by Baz Luhrmann." *New York Times* 9 May 2013. Web. 5 Sept. 2015.

Seabiscuit. Dir. Gary Ross. Perf. Tobey Maguire, Jeff Bridges. Universal, 2003. Film.

The Secret Life of Bees. Dir. Gina Prince-Bythewood. Perf. Dakota Fanning, Jennifer Hudson. Fox Searchlight, 2008. Film.

Slethaug, Gordon. *Adaptation Theory and Criticism: Postmodern Literature and Cinema in the USA*. New York: Bloomsbury, 2014. Print.

Sollosi, Mary. "Top Screenwriters Reveal How to Avoid the Pitfalls of Film Adaptation." *Film Independent*. 3 Nov. 2014. Web. 15 Aug. 2015.

Voynar, Kim. "Interview: *Children of Men* Director Alfonso Cuarón." *Cinematical*. 25 Dec. 2006. Web. 15 Sep. 2010.

Stam, Robert, and Alessandra Raengo, eds. *Literature and Film: A Guide to the Theory and Practice of Film Adaptation*. Malden: Blackwell, 2005. Print.

Strout, Elizabeth. *Olive Kitteridge*. New York: Random House, 2008.

To Kill a Mockingbird. Dir. Robert Mulligan. Perf. Gregory Peck, Brock Peters. Universal, 1962. Film.

PART II

ADAPTING THE CLASSICS

MIDRASHIC ADAPTATION

The Ever-Growing Torah of Moses

WENDY ZIERLER

ADAPTATION AS MIDRASH

IT is a curious fact that the ever-growing field of adaptation studies boasts little material on the adaptation of the Bible. Scholars of religion, Bible, and theology have written much about screening scripture and the nexus between religion and film (see Aichele and Walsh; Forshey; Reinharz; Walsh; Wright.) But apart from essays by Gavriel Moses, Ella Shohat, and Thomas Leitch, this work has had little impact on the field of adaptation studies, which has mainly focused on the adaptation of novels and on adaptation theory. Timothy Corrigan's widely used collection *Film and Literature: An Introduction and Reader* does not include a single essay about biblical adaptation. It is equally curious that this inattention to questions of biblical adaptation comes in the context of a field that was long characterized by a "near-fixation with the issue of fidelity" (McFarlane 194). Given this focus on fidelity, one might have expected more scholars to look to the Bible as way of investigating fidelity or dispelling its importance. After all, the project of adapting the words, form, and message of the Bible, with its claims to divine inspiration and instruction, offers perhaps the most extreme test case of fidelity or betrayal. As Shohat asks, "how do we begin to account for adaptation when it is not of a book, but rather of *The Book*, and one that virtually decrees that it *not* be adapted?" (24).

Shohat is referring here to the Bible's prohibition against producing graven images and therefore what would seem to be a biblical aversion to transforming word into visual form:

> Judaic culture is thoroughly predicated upon concepts having to do with "word" and "hearing." Central to the "covenant" (*brith* in Hebrew) between God and the Jewish people, for example, is the duty of male circumcision known as *brith milah*, or the covenant of the word. The linguistic genealogy of the Ten Commandments, or *aseret*

ha-dibrot, similarly derives from the root "d.b.r," signifying "speak," while the Torah's imperative phrase "*na'ase ve-nishma*" (we shall do and we shall listen), along with the daily [*Shema*, Hear O Israel] prayer . . . places words, written and spoken, at the center of the believer's act. (Shohat 25)

On the face of it, Shohat's observation about the word-centeredness and by extension, image-phobic nature of the Hebrew Bible seems well-founded. Yet all the examples she adduces—*milah* (circumcision), the *Shema* prayer (Deut. 6:4–9) and the Ten Commandments—include salient visual elements. Circumcision visualizes the covenant. The *Shema* prayer employs visual markers—the *mezuzot* placed on doorposts, the *totafot* (phylacteries) placed on one's arms and between one's eyes. Although the Bible prohibits the creation of idolatrous graven objects, the tablets of the law themselves happen to be "idolic," graven with the words of the Ten Commandments (Shell 126).

All this is to say that the Bible's take on the visual is hardly cut and dried. In contrast to this ambiguity is the unqualified premium the Bible places on retelling and reinterpreting core narratives in both narrative and ritual form. In addition, the Bible abounds in intratextual allusions to and inner-biblical exegesis of other biblical texts, providing a precedent for textual re-engagement with the text that develops further in the rabbinic era in the enterprise of midrash (Fishbane 3–18).

In midrash, gaps or textual anomalies in the biblical text provide an occasion for rabbinic readers and interpreters to amplify and adapt biblical narratives, in some cases inventing new materials out of whole cloth: "Classical midrash furnishes the details missing from the biblical narratives; explains apparent contradictions and resolves confusions; supplies rationales for God's behavior or that of individuals; teaches values; aligns the Bible's ancient traditions with the reader's contemporary reality; and provides the opportunity for speculation and theology" (Myers 120). In short, the Hebrew biblical tradition invites rather than proscribes adaptation. The distinctive narrative form of the Bible—"fraught with background," in Erich Auerbach's famous formulation (15)—demands *midrash*, a word that derives from the Hebrew verb *lidrosh*, meaning to demand, seek, or inquire. As a mode of retelling and interpretation, midrash can also be adopted as a model for the study of biblical adaptation, as well as adaptation writ large. This approach is source-centered, always emphasizing the relationship of the new text to the original text. At the same time, the midrashic approach allows for considerable creativity on the part of the re-teller, including a radical reshaping of the materials to fit contemporary concerns.

RABBINIC REVISIONS OF MOSES

Nowhere is this seen more clearly than in the many rabbinic and modern revisions of the biblical Moses. In Hebraic tradition, Moses is not merely a character in a story: he is *the* speaker, writer, and transmitter of the Torah. Adaptations of Moses thus do not

merely function as discrete re-enactments or interpretations, but also provide commentary on the very idea of biblical adaptability and the unfolding nature of Torah.

In Exodus 24, Moses, Aaron, and the elders are commanded to come up to the Lord, but "Moses alone shall come near unto the Lord" (Ex. 24:2). A Talmudic story that recalls this primary moment, however, challenges Moses's unique status as lawgiver and interpreter of God's word:

> Rabbi Yehuda said in the name of Rav: When Moses ascended on high, he found the Holy Blessed One sitting and tying crowns [*ketarim*] on the Holy letters. He said to the Holy One: "Master of the Universe, who stays Your hand?" He answered: "There will arise a man at the end of many generations, named Akiva the son of Joseph, who will expound on every jot [*kotz*] heaps and heaps of laws." "Master of the Universe," said Moses, "permit me to see him." He replied, "Turn around!" Moses sat down behind eight rows [and listened to discourses on the law] and did not know what they were saying. His strength ebbed until they came to a certain subject and the disciples said to the master, "Where do you derive this from?" And he replied, "It is a law given to Moses at Sinai," and Moses was comforted. Thereupon he returned to the Holy Blessed One and said, "Master of the universe, you have a man like this and you give the Torah by my hand?" He said, "Be silent, for such is my decree." Then said Moses, "Master of the Universe, you have shown me his Torah/teaching, now show me his reward." "Turn around!" said He. And Moses turned around and saw them weighing out Akiva's flesh in the market stalls. "Master of the Universe!" cried out Moses, "Such Torah and such a reward!" He replied, "Be silent, for such is my decree!" (B Talmud Menuhot 29b)

The image of God as a scribe with a writing hand seems scandalously anthropomorphic and contradicts the biblical account specifying that Moses himself "wrote all the words of the LORD" (Ex. 24:4)—just one indication of the imaginative liberties the rabbis take in this retelling of the giving of the Torah.

The language Moses uses to query God about the crowns, "*mi me'akev al yadekha*" [who is staying your hand?], directly recalls a previous Talmudic passage in which Rabbi Yehudah specifies the kinds of missing sections of a *mezuzah* scroll that are "*me'akvot zo et zo*"—that stay or invalidate the text as a whole. Is there something incomplete or invalid about the Torah without these calligraphic crowns? God explains to Moses that the crowns will enable a great sage named Akiva to do later, revelatory, interpretive work, deriving piles of laws from each and every textual *kotz*. Even before Moses receives the Torah, he is already learning about how others, not he, will carry on its message.

There is an almost cinematic quality to this story. In one brief tale, Moses ascends on high, turns around and turns back, and time travels to the future, where he sits eight rows back in Akiva's study hall, a symbolic representation of Moses's sense of being backward and behind in the rabbinic world. In the same way that Moses wants to behold God's glory (Ex. 33:20), he wants to glimpse his successor. But here, too, there is a limit to what he can see and comprehend. Moses is consoled in his befuddlement when he hears Akiva attributing a ruling to a Mosaic/Sinaitic tradition, a notion that shores up Mosaic

authority but also usurps it for the rabbis. Moses continues to find himself at a loss to understand God's choices. Why give the Torah to Moses when he could give it to Akiva? And why should Akiva suffer so?

This story is significant because it juxtaposes "two important theological questions: the expansion of Torah and the problem of theodicy.... The greatest Torah scholar ever, perhaps even greater than Moses, suffers the cruelest death, and yet God gives no explanation. God takes great care for his Torah, meticulously adding crowns to each individual letter, but apparently cares less about those who dedicate their lives to it" (Rubinstein 215, 216). Most remarkable about this story is its combination of conservative and radical elements. On the one hand, the story encloses Akiva's innovation within the textual space of Moses's initial giving of the Torah and God the King's inscription of the crowns. On the other, it suggests that Moses's revelation has been exceeded, even superseded, by the rabbis. The dual metaphor of crowns and thorns suggests here both the beauty and the aggressive incisiveness of rabbinic interpretation—a fitting description for a beautiful but troubling story that culminates with Roman persecution, divine silence, and failed theodicy. Embodied by Akiva's martyrdom, Torah itself here seems to wear a crown of thorns.

I've taken all this time to read this story, calling attention to its traversal of time periods, its simultaneous fidelity to and betrayal of the original biblical story of Mosaic revelation, as well as its contemporary theological message, because I believe it presents an intriguing model for modern biblical adaptation. Some might say that it is anachronistic and disingenuous to adduce rabbinic stories or midrash in the context of contemporary adaptation studies. Erich Auerbach indeed says as much when he refers to the special interpretive demands placed on the reader of the Bible "to fit our life into its world" (15). Granted, there is a marked difference between the theological stance of most modern writers, filmmakers, and readers and that of the ancient rabbis. And yet a chasm also yawned between biblical and rabbinic times. These stories were devised precisely to close gaps in understanding and faith:

> Writing from the second century, in exile after the destruction of the Temple that marked the center of their religion, the rabbis felt a loss of connection between their world and the world of their sacred texts. Thus, they wrote midrash, a form of exegesis that simultaneously stressed the ongoing value of the Bible even as the rabbis themselves understood that many of its texts no longer had an immediately evident application for contemporary life. (Stahlberg 11)

How different really is this from what Bible scholar Brian Britt describes in his book-length study of modern literary and cinematic "rewritings" of Moses? "Again and again," Britt observes, "Moses is mobilized to address fierce controversies of the day, bearing traces and complexities of biblical tradition in diverse, subtle and even hidden ways" (2). In comparing *The Ten Commandments* and *The Prince of Egypt* with the original biblical story, Alicia Ostriker notes, "As with screen adaptations of novels one has loved, it is easy to be shocked, shocked, at omissions and deviations in Biblical epics from the

original sacred text." But this sense that the sacred has been tampered with or violated through adaptation falls away, Ostriker maintains, if one considers these films "in terms of a Jewish genre whose essence is sacred play with sacred text for the sake of communal need—the genre of midrash."

A fruitful way to view the kinds of adaptation examined by Britt, even if it is not entirely Jewish or Hebraic in orientation, is as forms of modern midrash. The diversity of midrash makes this argument easier to make. A modern revision need not strictly conform to all aspects of midrash to profit from this reading strategy; rather, it can evince one or another salient element or form. Classical midrash takes several forms:

> *Exegetical* midrash consists of discreet, short comments on scriptural passages. *Homiletic* midrash takes the form of sermons anchored together by interpretations of scripture. *Narrative* midrash is the body of stories and legends about heroes and events from biblical or postbiblical times In contrast is a genre that first appears in the High Middle Ages, the *running commentary*. This type of midrash represents an individual's idiosyncratic perspective on the biblical text, and it invariably incorporates earlier midrashic material reworked for the author's purposes. (Myers 120)

In some instances, rabbinic and medieval midrashists make no exegetical claims, engaging instead in a process of "figuration, in which character types from the past are transformed into new types that reflect the values and experiences of the present" (Jacobson 4). Viewing an adaptation as exegetical, homiletic, narrative, figurative, or running commentary can refocus analysis on innovations in form, as well as interpretive needs served by the adaptation.

Exegetical/Homiletic Midrash: The Levite Cloth

Exegetical midrash takes the form of a comment on a particular biblical verse, supplying missing information where necessary, in some cases also projecting a contemporary concern. In Exodus 2:3, the Bible relates that when Moses's mother "could not longer hide him, she took for him an ark of bulrushes, and daubed it with slime and with pitch; and she put the child therein, and laid it in the flags by the river's brink." Is it possible that she placed the child entirely naked into this slime and pitch-daubed basket? Did she not cover him in some sort of cloth? If so, what might that cloth have looked like?

In *The Ten Commandments* (1956), Cecil B. DeMille provides exegesis of the verse and answers these very questions by choosing to wrap the baby in red, white, and black or navy-colored cloth, a visual marker that assumes layers of significance over the course of the film. In *Moses and Egypt*, the volume released to provide scholarly documentation on the making of the film, the idea of the tri-colored Levite cloth is attributed to a midrashic gloss on Numbers 2:2 (Noerdlinger 142), which describes the Israelites as encamped,

"every man with his own standard, according to the ensigns." Midrash Numbers Rabbah 2:7 explains: "There were distinguishing signs for each [tribal] prince . . . each had a flag and a different color for every flag . . . the color of Levi's flag was a third white, a third black, and a third red" (Numbers Rabbah 29–30).

Over the course of the film, the Levite cloth becomes "the sign and evidence of Moses's Hebrew identity: it is produced in the scene where Moses learns with certainty who he is, and he wears it with pride as the leader of the Hebrews" (Britt 50). Women control the secret of the cloth, hence of Moses's identity (Britt 50). That Moses's fate lies in the hands of women, however, is a notion that arises not from the cloth specifically but from the central role played by women in Exodus 2. In this essay, it is three women—Moses's mother, his sister, and Pharaoh's daughter, all unnamed in this essay—who act to ensure the baby's safety. Unlike the biblical text, in which two out of three of these women (Moses's mother Yocheved and Pharaoh's daughter) disappear from the text after ensuring Moses's safety, the 1956 film extends both their roles considerably. DeMille also expands the role of the handmaid who fetches the baby from the water in Exodus 2:5, turning her into the spiteful Menmet, a chauvinistic Egyptian who despises the Hebrews and thus divulges Moses's Hebrew identity to thwart his rise to power.

Beyond serving as a mere marker of Hebrew identity, Levite cloth also links Moses and his inner circle with a mid-twentieth-century Cold War American ethos. Indeed, the recurrence of the tri-colored Levite cloth bearing the colors and stripes of the American flag results in a cinematic homily on freedom. Toward the end of the film, when Moses is about to ascend Mount Nebo to die, the wearing of striped cloth signals fidelity to the American ideals of freedom and democracy. Moses's wife Sephora, wearing a head scarf of red, white, and blue stripes, looks down at the people assembled to enter the Promised Land and says to Moses: "You are God's torch that lights the way to freedom." Immediately following this, Moses robes Joshua in the Levite cloth, symbolizing the orderly (democratic) transfer of power. Everyone else present in this scene wears some combination of these same three colors, the black now decidedly transformed into blue. As Moses ascends Nebo, he commands: "Go, proclaim liberty throughout the lands and all the inhabitants thereof," a verse taken from Leviticus 25:10, referring to the Jubilee year. Ascending the mountain, Moses raises his hand up in the air, mimicking the very pose of the Statue of Liberty (Babington and Evans 55). The fusion of Hebrew Moses with American liberty completes the homily on American democratic ideals.

Because of its appearance in *The Ten Commandments*, the Levite cloth becomes a canonical artifact, appearing in later filmic revisions of the Moses story as well. In the parodic Old Testament section of Mel Brooks's *History of the World: Part I* (1981), for example, Moses is pictured, like Charlton Heston in *The Ten Commandments,* with a full white beard and wearing the Levite cloth. God calls out to Moses, commanding him, "Obey my law. Do you hear me?" "I hear you, I hear you. A deaf man could hear you," says Brooks as Moses. God commands Moses to give "these laws" to the People, lightning strikes in the background, and Moses says "Wow." Moses is then shown coming down from Sinai carrying three stone tablets. "The Lord Jehovah has given unto you

these fifteen—" he announces, at which point he accidentally drops and shatters one of the three tablets. "Oy . . . ten! *TEN Commandments!* For all to obey!"

Much of the humor of this scene hinges on the schlemiel-like affect and incompetence of Moses. The accidental breaking of the tablets contrasts comically with the earnest representation of this same event in DeMille's film, where Moses hurls the tablets, like lightning, at the Golden Calf, breaking and burning the idol and sending the idol worshippers to a fiery death. In *History of the World: Part I*, Brooks clearly aims to shatter the air of solemnity surrounding the Golden Calf. If the Levite cloth functions in DeMille's film as a marker of American freedom and Cold War anti-communism (see Wright and Forshey), Brooks's scene expands the notion of freedom to include the right to laugh at anything you want to, even the Bible. It's a free country, isn't it?

NARRATIVE MIDRASH: DAVID FRISCHMANN'S *BAMIDBAR*

According to Myers's taxonomy, narrative midrash need not be connected to a particular biblical verse or exegetical problem. Rather, it can relate more broadly to the biblical source, forging a link between the biblical story and contemporary life or theology. The Talmudic story of Moses watching God inscribe crowns on the letters of the Torah might be categorized as a narrative midrash insofar as it neither begins with nor cites a biblical verse as a pretext for the story. Nevertheless, this story sheds important light on the idea of Mosaic revelation writ large.

Early twentieth-century Warsaw-based critic, poet, and fiction writer David Frischmann presents several works of modern narrative midrash in his 1922 story collection *Bamidbar* (In the Wilderness). In these stories, Frischmann imaginatively revises the stories of Moses and the Israelites by projecting contemporary, Enlightenment values and European literary ideals onto invented side characters who inhabit the Exodus milieu but whose experiences sharply diverge from the biblical model. The first story in the series begins with a description of an imagined matriarchal storytelling tradition: "My mother received these words from her mother, and her mother from her mother, and her grandmother from her grandmother, generation from the mouth of generation—and my mother relayed the words to me" (Frischmann 9). The presentation of these stories "as part of an oral tradition that has been maintained and transmitted by women since biblical times" renders them an alternative both "to the written Torah of Moses and the oral Torah of the rabbis" (Jacobson 68)

This idea of an alternative Mosaic tradition is especially apparent in the story "Behar Sinai" ("At Mount Sinai," originally published in 1919). The life story of its protagonist Moushi, like his name, closely approximates that of the biblical Moshe/Moses, yet departs from the Mosaic model in crucial ways. Like Moses, Moushi is cast as a baby into the Nile. Saved, like the Levite baby in Exodus 2, he too is given a new

name, in this case "Peli," meaning wondrous, a word associated in the Exodus story with signs and wonders of God, "*oseh feleh*" (Doer of Wonders; Ex. 15:11). Moushi/Peli's story unfolds wondrously, but without divine intercession. In marked contrast to Prince Moses, Moushi works as a slave building the walls of the city of Ramses. One day he sees Puah, a girl whose name recalls that of the Hebrew midwife Puah from Exodus 1, and falls in love with her at first sight. For thirteen days Moushi and Puah seek each other out, until finally, on the fourteenth day—the second Sabbath, as it were—they find each other and run off together, not needing permission from Pharaoh or divine intervention to be released from their work. For days they walk together in a love trance, unwittingly mimicking the travels of the biblical Israelites in the wilderness. They wander for so long that they miss the whole national experience of the exodus from Egyptian slavery. In the biblical account, the desert functions as a site where one can serve God rather than Pharaoh. In Frischmann's story, however, the desert serves as an emotional and cultural *tabula rasa*, allowing Moushi and Puah to make love without restraint.

Continuing to wander, Moushi and Puah reach as far as Sinai, where they wake up one morning to witness the arrival of the Israelites for the giving of the Torah. They have no idea what any of it means: the torches, lightning and thunder, the voice of God. In the Bible, the giving of the Torah marks the culmination of the Exodus. For Frischmann's lovers, however, the giving of the Torah, with all its regulations and injunctions, means the end of their youthful, innocent love.

In keeping with the anti-authoritarian message of the other stories in this collection, "Behar Sinai" offers a critique of the way in which traditional Jewish religious norms stifle individualism, passion, and emotional maturity. The only way these young lovers are able to be together is by separating themselves entirely from their community.

It is interesting to consider the post–World War I, post–Russian Civil War context of the story as influencing, perhaps, its anti-establishment message. It is equally interesting to consider the message of this story alongside some of the popular film or television adaptations of the Moses story, especially the Golden Calf scene, which occurs when the people are separated from Moses. In both the 1956 *The Ten Commandments* and De Bosio's *Moses the Lawgiver* (1975), the Golden Calf scene is a depraved orgy, a yielding to passions associated with idolatry, fornication, even human sacrifice. Both films uphold a norm of chaste piety even as they revel, Hollywood style, in showing bodies undulating with desire: "Biblical film orgies offer Hollywood semi-respectable opportunities for flesh exposure in scenes justified historically and morally as images of decadence and corruption of civilized law" (Babington and Evans 65). In this sense, these films conform to Siegfried Kracauer's notion of the "confirmative" or "corroborative" image, rather than one that opens up issues and prods viewers to think differently (360). In Frischmann's story, however, civilization and the rule of law—sowers of war, conflict, and carnage in Frischmann's own day—become the target of criticism insofar as they snuff out Moushi and Puah's innocent, guileless love. In this sense, Frischmann's early-twentieth-century Hebrew narrative proves far more provocative and midrashically innovative and transgressive than these popular Bible films.

Exegetical Midrash/Figuration:
The Stuttering King

According to Walter Benjamin, "storytelling is always the art of repeating stories" (367). Linda Hutcheon adds that Western culture includes so many adaptations because of the "pleasure" that comes from "repetition with variation, from the comfort of ritual combined with the piquancy of surprise. Recognition and remembrance are part of the pleasure (and risk) of experiencing an adaptation; so too is change" (4). A midrashic approach to adaptation, however, requires an explanation that goes beyond notions of entertainment or pleasure, one that accounts for the urgency that attends such re-encounters with the biblical text. According to midrash scholar David Stern,

> the object of midrash was not so much to find the meaning of Scripture as it was liter-
> ally to engage its text. Midrash became a kind of conversation the Rabbis invented in
> order to enable God to speak to them from between the lines of Scripture, in the tex-
> tual fissures and discontinuities that exegesis discovers. The multiplication of inter-
> pretations in midrash was one way, as it were, to prolong that conversation. (Stern 31)

The theological underpinnings of literary and cinematic biblical adaptations vary widely, depending on the writer and the context. Even those texts and films that assail traditional theology, however, are typically informed by a sense of Ultimate Concern, to borrow Paul Tillich's term, a desire not simply to present a novel, entertaining rereading but to engage in a long-standing cultural and theological conversation.

This notion of midrashic adaptation as vital creative/interpretive conversation becomes especially relevant to adaptations that specifically engage and problematize the biblical Moses as speaker. When God speaks to Moses from the burning bush and asks him to return to Egypt to take the Israelites out of slavery (Ex. 3:10), Moses repeatedly demurs, claiming that he cannot speak: "Oh Lord, I am not and have never been a man of words, neither yesterday, nor the day before, nor since You spoke to your servant; for I am heavy of mouth, and heavy of tongue" (Ex. 4:10). Later, Moses repeats this concern about his inability to speak effectively both before the people and Pharaoh, claiming that he is of "uncircumcised lips" (Ex. 6:12, 30).

What does Moses mean when he says that he is "heavy of mouth and heavy of tongue" or that he has foreskinned lips? Most commentators, ancient and modern, assume that Moses had some form of speech impediment (Tigay 57–67). Some, however, such as Rashbam (Rabbi Samuel ben Meir, 1085–1158), categorically reject the idea that a prophet and leader of Moses's stature could have been a stammerer. Instead, they insist that Moses simply lacked proficiency in the Egyptian language, having fled Egypt as a young man (Rashbam Exodus 4:11). With the notable exception of the 1995 television movie *Moses*, virtually every film adaptation of the Moses story echoes the Rashbam's disinclination to view Moses as someone with a speech impediment. In the interest of

presenting a charismatic, heroic leader, the 1956 *The Ten Commandments*, De Bosio's *Moses the Lawgiver*, Steven Spielberg's *The Prince of Egypt* (1998), and Ridley Scott's *Exodus: God and Kings* (2014) all bypass the issue of Moses's heaviness of mouth entirely, choosing instead to depict Moses as an articulate and fluent speaker.

The film that best addresses and interprets Moses's unwillingness to take up the leadership of the people because of a speech impediment is not any of these Moses films, but *The King's Speech* (2010; Figure 7.1), a work that I would categorize either as a biblical figuration, according to Jacobson's formulation, or as appropriation—a work that appropriates key elements of the source story, but transposes them to a different context and historical setting (see Sanders 26). *The King's Speech* examines a time in British history marked by new technologies of speech communication (the radio) and rising tyranny (the ascent of Hitler). At stake in the film are the continuity and the adaptability of the monarchy, as one king abdicates for the sake of love and another assumes the throne and the responsibility of speaking for the people despite a debilitating stammer. Read as a figuration or appropriation of the often unacknowledged story of Moses the stammerer, *The King's Speech* opens up a reciprocal conversation about the continuity and the disruption of tradition, and about the social and theological significance of Moses's distinctive speech. Reading the biblical story in relation to the film helps shed new light on the desirability of Moses and Bertie as leaders, not just despite but also because of their stuttering. At the same time, reading the film in relation to the biblical text situates the concern raised in the film about continuity and tradition within a long-standing conversation.

The parallels between Bertie, the Duke of York, and Moses are striking. Both are royal princes with older brothers. Both have speech impediments and a tendency to anger easily. (Recall Moses's smiting of the Egyptian overseer in Exodus 2:12 and his striking of the rock in Numbers 20:11.) Both speak fluently when singing or listening to music; Moses sings poetically after the parting of the Red Sea (Ex. 15), and Bertie demonstrates

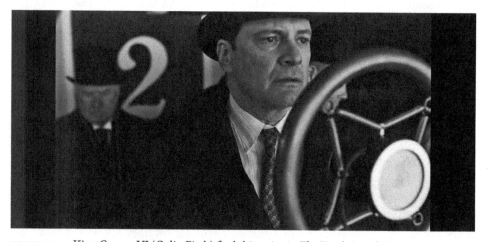

FIGURE 7.1 King George VI (Colin Firth) finds his voice in *The King's Speech* (2010).

his ability to speak while listening to music in his very first meeting with Lionel Logue. Finally, both are reluctant to assume leadership because of a general sense of unworthiness, especially because of their speech impediments.

In the biblical text, however, God specifically chooses Moses to plead the cause of Israel's liberation before Pharaoh, even though he cannot speak. What is it about Moses's encumbered speech that recommends itself for this errand? Similarly, what is it about speech-impeded Bertie, Duke of York, that ultimately makes him a more fitting leader than his older brother David?

It is worth noting here the recurrence of the Hebrew verb *kvd* (heavy) in the early chapters of Exodus. This verb first appears in Moses's self-description in Exodus 4 ("I am heavy of mouth and heavy of tongue," Ex. 4:10), but thereafter proliferates throughout the account of the Exodus from Egypt. In Exodus 6, we learn that Moses's mother's name is Yokheved, meaning "YHVH is weighty" (Buber 50). As the story progresses, the same verb *k.v.d.* appears alternately in relation to Pharaoh and God, as Pharaoh increases the weight of slavery on the people (Ex. 5:9) and hardens his heart in response to Moses's demand for deliverance (Ex. 7:14; 8:28), and God strikes back heavily (Ex. 10:14; 14:18; 14:25).

Read in conjunction with other uses of the word *kvd*, Moses's heaviness of mouth functions as part of a plan to reveal God's honor (*kavod*) to Pharaoh and the world. Translated into the context of *The King's Speech*, heaviness of tongue is associated with a certain royal gravitas and sense of responsibility that the lovestruck, bullying, irresponsible King David/Edward entirely lacks. There is a tragic element to the fact that "[i]t is laid upon the stammering to bring the voice of Heaven to Earth" (Buber 59), insofar as it raises a barrier between Moses and rest of the people and the world. And yet both the Exodus story and *The King's Speech* suggest that there is something of value in labored, heavy speech.

Note that in the burning bush scene, God is also depicted as a stutterer. When Moses asks for God's name, God replies, "*Eheyeh asher eheyeh*," "I am that I am," or "I shall be what I shall be" (Ex. 3:14; Shell 106). In Exodus, then, stuttering serves as a metaphor both for the closeness of God and Moses, and for the eternal, necessary gap between divine and human speech. Moses's stutter, with its halts and repetitions, reminds us that there is no way to communicate God's complex, sublime, eternal message in a fluent, straightforward way. Conjoined with God's own stutter, which presents itself as "*Eheyeh asher eheyeh*," a name-state of eternality or ever-becoming, stuttering also becomes a figure for ongoing invention, substitution, improvisation, and interpretation—in a sense, for adaptation itself.

Stammered speech (and by extension, midrashic invention or adaptation) also serves as a representation of and response to trauma. Scholars of rabbinic midrash consistently call attention to the traumatic upheaval that gave rise to the development of midrash, which

> represents an attempt to develop new methods of exegesis designed to yield new understandings of Scripture for a time of crisis and a period of conflict, with foreign

cultural influence pressing from without and sectarian agitation from within. . . . To achieve this, it was necessary that the Torah remain dynamic and open to varying interpretation in order to meet the challenges of drastically varying circumstances. (Heinemann 42)

Moses's speech develops against a backdrop of exile, identity confusion, and the oppression of slavery. His stutter, a form of speech struggling its way into being, reflects the condition of the Israelites as they struggle to throw off the yoke of slavery and to be born as a people against the backdrop of an Egyptian culture of stasis and death. Sholem Asch makes this observation in his novelistic adaptation of Moses's life, where he contrasts the Egyptian obsession with death with the Hebrew notion of God "as eternal being, of creation, of becoming, of life, of all that there was, of all presentness" (42). Part of the burgeoning of Moses's consciousness in the novel involves a developing hatred of Egyptian culture, in which "the living work for the dead" (29).

To be sure, the post-Holocaust context is crucial. According to Martin Buber, who wrote his own study of Moses in 1944 against the backdrop of Hitler's Reich, Pharaonic Egypt was a sinister, impersonal bureaucracy, characterized by fixed, immovable routines and forms. In contrast, God and Moses as stutterers present a view of life, interaction, and speech that remains open, dynamic, and unresolved.

All this brings to mind the scene in *The King's Speech* in which Bertie and his family watch Hitler's speech at Nuremburg. In this scene, halting Bertie, like Buber's Moses, is presented as the antithesis to maniacally fluent Hitler. In contrast to Hitler, Bertie stands for self-conscious, deliberate, and moral speech. It is these qualities that enable Moses, despite his earlier protestations, to become an "*ish devarim*," a divinely inspired man of words. The same enables Bertie to assume the throne and to be remembered for his wartime speeches to the British people. Viewing *The King's Speech* as an adaptation of the biblical story of Moses the stutterer thus helps shed new interpretive light on the biblical text, highlighting those details of Moses's character and story previously eclipsed by interpreters who were eager to view Moses as classical orator or larger-than-life hero. By the same token, viewing the film in light of the biblical narrative expands the scope of the film, situating Bertie's story within an ancient conversation about the power and burden of speech as a means to oppose tyranny.

FEMINIST RE-VISIONARY RUNNING COMMENTARY: RIVKA MIRIAM'S *MOSHE*

In "When We Dead Awaken: Writing as Revision" (1972), Adrienne Rich counters the tyranny of tradition through a feminist form of adaptation she terms "re-vision": "Re-vision—that act of looking back, of seeing with fresh eyes, of entering an old text from a new critical direction—is for us more than a chapter in cultural history: it is an act of survival" (18). Responding to T. S. Eliot's injunction in "Tradition and Individual Talent"

that no poet who wishes to be remembered can write without a "historical sense"—the perception not just "of the pastness of the past, but of its presence" (4), Rich insists that feminist writers need to know "the writers of the past, [but] know it differently than we have ever known it: not to pass on a tradition but to break its hold on us" (19). Rich's essay has by now become part of canonical feminist tradition, and feminist re-vision is an acknowledged feminist literary strategy. In the enterprise of feminist midrash, re-vision serves a means of reshaping the past in light of the social, spiritual, and ethical needs of the present.

One can detect elements of feminist re-vision in such film adaptations of the Moses story as *The Prince of Egypt*, which gives major speaking and singing roles to Yocheved, Miriam, and Zippora, greatly expanding their roles beyond the limited representation they are afforded in the biblical text. Spielberg's Yocheved sings to the baby Moses, the voice of Israeli pop star Ofra Haza lending a distinctive Israeli tone to the film. And whereas Miriam's song in the Bible occupies only one verse (Ex. 15:21), Spielberg's film places Miriam and Zippora in the choral forefront, thereby echoing the aspirations of modern feminist biblical scholarship to recuperate the lost voices of biblical women.

An even bolder, feminist re-visionary adaptation of the Moses, one that both radically reshapes and conserves the present-ness of the past, can be seen in contemporary Israeli poet Rivka Miriam's *Moshe* (2011), a book-length series of Hebrew poems based on the Moses story that features poems about nearly all the figures featured in the Exodus and wilderness stories, together with occasional appearances by the poet herself as well as her father, a Yiddish poet and Holocaust survivor. Each poem focuses on a particular moment or aspect of the story. As such, the book can be read as a kind of feminist, midrashic running commentary on the Exodus story.

The series begins with a poem speculating on the origins of "Mosesness":

Before Moses was born, was he already?
From the dawn of creation, was there already some hidden Mosesness
Concealed within, a stammering granule in the growing bloom, in the falling foliage
Was it hidden in the shadow of Adam the first, as he clumsily measured the image
 against his body
Or in Noah, who, with a nail in his mouth and with ruler and saw in his hand
Built the firebrand of the ark with precision and silence
Was the Mosesness hinted at in Abraham, so that he could pass it on to Isaac
Or was it concealed in an anonymous shepherd boy, or even in an unknown girl
Was Moses, before he was born, a letter among other letters, a hint, an ending, a point
 or a crown
Or did he arise and come into being, embodied,
Only when Yokheved, tired of the past, and sealed off from the future, brought Amram
 to the present [tense] of her body? (Miriam 5, my translation)[1]

In this overture poem, Rivka Miriam considers many possible origin points for "*moshiyut*" (Mosesness), a pun on the Hebrew word "moshiyah" (savior). Perhaps the idea

of Moshiyut was encoded in the original foliage of the Garden of Eden, or foreshadowed by Adam's efforts to measure his own self-image against the notion of being created in the image of God. Perhaps Moses's Mosesness was anticipated by the deeds of Noah and Abraham or by some anonymous shepherd(ess). By conjecturing so, Miriam points to the long-standing tendency of readers, viewers, and interpreters of the Moses story to view Moses, not just as a human, but as the prototypical prophet and voice of God, a figure whose legacy spans and influences the ages and takes on mythic proportions. Referring to letters and crowns, the poem clearly recalls the Talmudic story from BT Menahot 29b and the idea of expanding Mosaic revelation. The closing idea of the poem, however—that Mosesness came into being not in some ahistorical, superhuman way, but when his hopeless mother had the courage to bring her husband to the present-ness of her body—returns Moses to the realm of the real and acknowledges his mother's role in bringing about salvation.

The notion of Moses originating from a "stuttering granule" also indicates the significance that Moses's stutter will play in the poetic running commentary. Indeed, in another early poem about Moses's origins, Miriam refers to and counters a well-known midrash from Exodus Rabbah 1:26 that attributes Moses's speech impediment to a test his Egyptian masters made him undergo as a toddler to prove that he was not the feared future savior of the Hebrews. Gold and burning coal were placed before Moses. If Moses reached for the gold, he would prove himself a threat to Pharaoh and would be put to death; if he reached for the coal, however, he would be deemed no threat at all, and thus would be saved. According to the midrash, Moses initially reaches for the gold, but the angel Gabriel pushes his hand away and compels him to take the coal instead, which he then places it in his mouth, resulting in a permanent "heaviness of tongue."

Miriam's poem rejects this midrashic account outright:

> *No, It Isn't So. Moses Never Attempted to Grab the Gold*
> No, it isn't so. Moses never attempted to grab the gold and the angel never pushed
> him to the coal
> and his tongue was heavy—for already in his mother's womb he was stuttering
> and before he was born, broken tablets were in his mouth. . . . (Miriam 13,
> my translation)

According to this poem, Moses never tried to reach the gold, and was never maimed in the mouth by angelic intercession. Instead, Miriam connects Moses's stutter in utero with the idea of the broken tablets, as if to suggest from the beginning the impossibility of bearing and transmitting God's word intact. The end of the poem also assigns his sister Miriam a role alongside Moses as the bearer of these broken words. Traditionally, it is Aaron who speaks on behalf of Moses the stutterer. In this poem, however, Moses's stutter calls out to Miriam from the womb, compelling her to erupt in poetic song. The poem brings new attention to Miriam's role as a speaker and singer alongside Moses.

In another poem Rivka Miriam similarly expands and deepens Moses's sister's role as the guardian of the basket as it floats down the river to Pharaoh's palace (Ex. 2:4), noting the similarity in the biblical text between the Hebrew word used for basket (*teivah*) and that used for the "ark" in the story of Noah:

> Noah's ark [teivah] slid down the mountains of Ararat into the small hands
> of Miriam
> And she placed Moses on the padded mat of the ark
> A mat made out of the fallen-off hairs of the animals, that was once soft and downy
> But which the weight of the years had now made rough—
> How it floated, Noah's ark, traverser of mountain and desert,
> Crawler on the beds of the sea, to arrive, wrinkled from years, scarred like Jacob's
> thigh tendon,
> To this Nile, and to the little hands of Miriam, who now mumbles "alive and well"
> As she places Moses inside. (Miriam 24, my translation)

Like the Talmudic story from Menahot 29b, here too there is an element of time travel: Noah's ark survives, travels through space and time, and slides in miniature form into Miriam's hands. The same vessel used in Genesis 6 to save Noah, his family, and the animal species is retrieved and repurposed to save Moses and by extension the people of Israel. Insofar as the word *teivah* also means "letter," Moses's *teivah* becomes a metaphor for linguistic, literary, and artistic adaptation, with Miriam serving as the catalyst for the process. The words that Miriam mumbles here, "*hai vekayam*," are themselves recycled or adapted from a Talmudic passage in which R. Judah the Prince instructs his disciples to say *David melekh yisrael hai vekayam* (David the King of Israel is alive and well) when sending a message that it is time to sanctify the new month, the waxing moon serving as a symbol for the future redemption of Israel. In modern times, this same expression has furnished the lyrics to a popular Hebrew folk song about the national survival of the Jews. Miriam's intoning of these words thus adds a woman's voice to this chorus of Jewish redemption and adaptation.

Perhaps the most notable feminist midrashic adaptation in this series is the poet's insertion of herself into the story and her visceral identification with the biblical characters. Even her sense of estrangement or emptiness in relation to the distant biblical story becomes an occasion for her to generate neo-midrashic poetry. Not just that: in a later poem in the cycle, she and the biblical Moses engage in parallel writing of each other's biography:

> And Moses told me, "I too, at the same time, am writing your biography"
> And the biography of your mother and father, and your children's too.
> And that of your lovers.
> Even though you seem to be the *b'al peh* [the oral mode], you too are written
> in a book,
> And I am flipping through your pages and looking for an answer. (Miriam 144, my
> translation)

What we have here is a kind of meta-reflection on the idea of midrashic adaptation as reciprocal interpretation and invention. In revising and adapting Moses's story, the contemporary poet has also invited Moses to write and adapt her own, as if in accord with Kamilla Elliott's notion of a "reciprocally transformative model of adaptation, in which the film is not a translation or copy, but rather metamorphoses the novel and is, in turn, metamorphosed by it" (229). In undertaking this midrashic adaptive project, Rivka Miriam's poetic speaker reattaches to and transforms the past, and by extension is transformed by it.

INTERPRETIVE AUDACITY: RIDLEY SCOTT'S *EXODUS: GOD AND KINGS*

As a whole, *Moshe* is a work that argues eloquently for the ongoing relevance of Moses adaptations and for the possibility that with each new engagement with the text, something pressingly new, vital, and transformative will emerge. Mainstream movie critics do not necessarily agree. One reviewer of Ridley Scott's recently released *Exodus: God and Kings* suggests that Scott's film "suffers from a sense of superfluousness, a near-constant, niggling feeling that we don't really *need* another retelling of Moses and the Israelites' flight from Egypt" (Lawson 2014). But although Scott's film does reprise many aspects of previous popular Moses adaptations, including the rivalry of young Moses and Ramses, the film nevertheless offers an entirely new approach to the representation of the biblical God, in this case as a ten-year-old boy.

At first blush, this appears to be an outrageous choice. Yet the choice to render God as a boy is not entirely without textual anchor. Exodus 3:2 specifies that an "angel of the Lord appeared to Moses" from the burning bush, while Exodus 3:4, dropping the reference to the angel, refers to God speaking directly to Moses. Which one is it? Scott's choice to embody God as a boy can be seen as an exegetical response to this textual contradiction, one that dispenses with the clichéd representation of angels with wings and of God as a booming, disembodied voice. Admittedly, the God-boy's identification of himself as "I am" presents a disturbing association of godliness with eternal (masculine) youth. But this is no idealized portrait. The scenes of Moses speaking and arguing with this petulant boy-God hardly suggest ready devotion. Moses adamantly opposes the boy-God's dark, murderous plan to kill the firstborn Egyptian children. At best, he is a reluctant follower of this war-mongering child deity, indicative of the filmmaker's own skepticism about the childish religious underpinnings of so many contemporary wars.

At the same time, this boy-God calls attention to the conspicuous absence of any account of Moses's boyhood both in the film and in the biblical text. Scott's God can be seen as speaking for the lost Hebrew boys. In a certain sense, "I am" proves to be an apt adversary for the Pharaoh who would be God and who has sought to consolidate power over the Hebrew slaves by throwing their boys into the Nile. Perhaps most important, the sheer audacity and novelty of this depiction underscores the ongoing allure of midrashic adaptation and its

power to provoke ongoing, compelling conversation around our central, canonical texts, especially those that claim an authority not just to entertain but also to instruct. Although we may not need another Moses story, novel, poem, cartoon, or film, we still need new ways of re-encountering this core story—its central protagonist, its people, its God—in relation to our contemporary *condition*. Even if some efforts prove less than inspiring or instructive than others, this kind of retelling somehow never seems superfluous.

NOTE

1. © All rights to the poems of Rivka Miriam are reserved by the author and ACUM.

WORKS CITED

Aichele, George, and Richard Walsh, eds. *Screening Scripture: Intertextual Connections Between Scripture and Film*. Harrisburg: Trinity, 2002. Print.

Asch, Sholem. *Moses*. Trans. Maurice Samuel. New York: Putnam, 1951. Print.

Auerbach, Erich. *Mimesis: The Representation of Reality in Western Literature*. Trans. Willard R. Trask. Princeton: Princeton UP, 1953. Print.

Babington, Bruce, and Peter William Evans. *Biblical Epics: Sacred Narrative in the Hollywood Cinema*. Manchester: Manchester UP, 1993. Print.

Babylonian Talmud, Tractate Menahoth. The Soncino Talmud. Ed. Isadore Epstein. London: Soncino, 1989. Print.

Benjamin, Walter. "The Storyteller." 1936. Rpt. in *The Novel: An Anthology of Criticism and Theory 1900–2000*. Ed. Dorothy J. Hale. Malden: Blackwell, 2006. Print.

Britt, Brian. *Rewriting Moses: The Narrative Eclipse of the Text*. London: Clark, 2004. Print.

Buber, Martin. *Moses: The Revelation and the Covenant*. New York: Harper Torchbooks, 1946. Print.

Corrigan, Timothy, ed. *Film and Literature: An Introduction and Reader*. 2nd ed. New York: Routledge, 2011. Print.

Eliot, T. S. "Tradition and Individual Talent." 1919. *Selected Essays*. New ed. Harcourt, Brace and World, 1964. 3–11. Print.

Elliot, Kamilla. *Rethinking the Novel/Film Debate*. Cambridge: Cambridge UP, 2003. Print.

Exodus: God and Kings. Dir. Ridley Scott. Perf. Christian Bale, Joel Edgerton. Twentieth Century Fox, 2014. Film.

Fishbane, Michael. *The Garments of Torah*. Bloomington: Indiana UP, 1992. Print.

Forshey, Gerald E. *American Religious and Biblical Spectaculars*. Westport: Praeger, 1992. Print.

Frischmann, David. *Bamidbar*. 1922; rpt. Tel Aviv: Dvir, 1990. Print.

Heinemann, Joseph. "The Nature of the Aggadah." *Midrash and Literature*. Ed. Geoffrey H. Hartman and Sanford Budick. New Haven: Yale UP, 1986. 41–56. Print.

History of the World: Part I. Dir. Mel Brooks. Perf. Mel Brooks, Dom DeLuise. Twentieth Century–Fox, USA, 1981.

Hutcheon, Linda. *A Theory of Adaptation*. New York: Routledge, 2006. Print.

Jacobson, David. *Modern Midrash: The Retelling of Traditional Jewish Narratives by Twentieth-Century Hebrew Writers*. Albany: State U of New York P, 1987. Print.

The King's Speech. Dir. Tom Hooper. Perf. Colin Firth, Geoffrey Rush. Weinstein, 2010. Film.

Kracauer, Siegfried. *Theory of Film: The Redemption of Physical Reality.* New York: Oxford UP, 1960. Print.

Lawson, Richard. "*Exodus: God and Kings* Is a Persuasive Retelling of a Really Old Story." *Vanity Fair*, 14 Dec. 2014. Web. 4 Aug. 2015.

Leitch, Thomas. *Film Adaptation and Its Discontents: From* Gone with the Wind *to* The Passion of the Christ. Baltimore: Johns Hopkins UP, 2007. Print.

McFarlane, Brian. *Novel to Film: An Introduction to the Theory of Adaptation.* Oxford: Clarendon, 1996. Print.

Miriam, Rivka. *Moshe.* Jerusalem: Carmel, 2011. Print.

Moses. Dir. Roger Young. Perf. Ben Kingsley, Frank Langella. Turner, 1995. Television.

Moses, Gavriel. "The Bible as Cultural Object(s) in Cinema." Stam and Raengo 399–422. Print.

Moses the Lawgiver. Dir. Gianfranco De Bosio. Perf. Burt Lancaster, Anthony Quayle. ATV, 1975. Television.

Myers, Jody. "The Midrashic Enterprise of Contemporary Jewish Women." *Jews and Gender: The Challenge to Hierarchy.* Ed. Jonathan Frankel. Oxford: Oxford UP, 2001. 119–141. Print.

Noerdlinger, Henry S. *Moses and Egypt: The Documentation to the Motion Picture* The Ten Commandments. Los Angeles: U of Southern California P, 1956. Print.

Ostriker, Alicia. "Whither Exodus? Movies as Midrash." *Michigan Quarterly Review* 42.1 (Winter 2003). Web.

The Prince of Egypt. Dir. Steven Spielberg. Perf. Val Kilmer, Ralph Fiennes. Dreamworks, 1998. Film.

Rashbam (Rabbi Simon Ben Meir). Commentary on the Bible. *Torat Hayim: Shemot vol. 1.* Jerusalem: Mossad HaRav Kook, 1993. Print.

Reinharz, Adele. *Scripture on the Silver Screen.* Louisville: Westminster John Knox P, 2003. Print.

Rich, Adrienne. "When We Dead Awaken: Writing as Re-Vision." *College English* 34.1 (Oct. 1972): 18–30. Print.

Rubinstein, Jeffrey. *Rabbinic Stories.* Mahwah: Paulist, 2002. Print.

Midrash Rabbah V. Trans. Judah J. Slotki. London: Soncino, 1939. Print.

Sanders, Julie. *Adaptation and Appropriation.* London: Routledge, 2006. Print.

Shell, Marc. *Stutter.* Cambridge: Harvard UP, 2006. Print.

Shohat, Ella. "Sacred Word, Profane Image: Theologies of Adaptation." Stam and Raengo 23–45. Print.

Stahlberg, Lesleigh Cushing. *Sustaining Fictions: Intertextuality, Midrash, Translation, and the Literary Afterlife of the Bible.* New York: Clark, 2008. Print.

Stam, Robert, and Alessandra Raengo, eds. *A Companion to Literature and Film.* Malden: Blackwell, 2004. Print.

Stern, David. *Midrash and Theory: Ancient Jewish Exegesis and Contemporary Literary Studies.* Evanston: Northwestern UP, 1996. Print.

The Ten Commandments. Dir. Cecil B. DeMille. Perf. Charlton Heston, Yul Brynner. Paramount, 1956. Film.

Tigay, Jeffrey. "'Heavy of Mouth' and 'Heavy of Tongue': On Moses' Speech Difficulty." *BASOR* 231 (1978): 57–67. Print.

Tillich, Paul. *The Dynamics of Faith.* New York: HarperCollins, 1957. Print.

Walsh, Richard. "Bible Movies." *The Continuum Companion to Religion and Film.* Ed. William Blizek. London: Continuum, 2009. 222–30. Print.

Wright, Melanie. *Moses in America.* New York: Oxford UP, 2003.

THE RECOMBINANT MYSTERY OF FRANKENSTEIN

Experiments in Film Adaptation

DENNIS R. PERRY

> You must excuse this trifling deviation from Mrs. Shelley's marvelous narration.
>
> —Richard Henry, *Frankenstein; or, The Vampire's Victim*, 1849

PREAMBLE

A study of adaptations of *Frankenstein*, acknowledging the nearly infinite variations in every conceivable popular and highbrow medium, begs the question of our persistent fascination with Mary Shelley's story, particularly her "creature," which continues to be reimagined in the twenty-first century in every conceivable sublime and absurd incarnation. What is the overwhelming appeal of this Halloween icon? Novelist Marilynne Robinson notes that we "weep over the fates of people who don't exist because for some reason or other they're paradigmatic for us" (Handley 21). But what makes us weep over Frankenstein's patchwork monster when he shouldn't be paradigmatic for us? Perhaps he represents all of our inadequacies, fears, and social anxieties—the embodiment of what Jung calls our "shadow," or all that is weak and inadequate about us. An interesting Jack Davis drawing of the monster as a scarecrow stuck in a cornfield perhaps epitomizes us all. Besides reminding one of the monster strung up by the Pharisaical villagers as a Christian visual jest in James Whale's *Bride of Frankenstein,* Davis's drawing simultaneously emphasizes two of the monster's central functions in popular culture—as a figure of horror and as a figure of humor. In other words, as an audience of the monster we can perhaps see through him the two sides of our own shadows, as both horrifically dark and humorously pathetic (as suggested by the subtitle of Picart's *Remaking the Frankenstein Myth: Between Laughter and Horror*). On the other hand, or at the same

time, the monster is nothing like us, embodying what Martin Tropp calls a "total otherness" (14). This complex and ambiguous doubleness has spawned hundreds of adaptations in every conceivable medium, style, and tone. This hyperadaptability may be central to the Frankenstein monster's role as a matrix figure, a chameleon that can fit any kind of story, enabling him to become a dominant figure in every medium. Why he has been more broadly adaptable largely goes back to Karloff's sympathetic portrayal in three early films, together with the iconic makeup that has conclusively defined Shelley's character visually for popular culture. We are not merely fascinated by the creature but sympathize and identify with him; hence our need to give him the love that Frankenstein withheld, on some level, is also the more complete love we ourselves need.

Intertextual Monster

Intertextuality is the very seed of Mary Shelley's novel. Like Frankenstein, she is an adapter sewing together parts from older texts like the Prometheus myth, *Paradise Lost*, *The Rime of the Ancient Mariner, Faust,* and *Caleb Williams* to create a monster that made conservative reviewers indignant enough to call the novel "a tissue of horrible and disgusting absurdity" (Anon.). Like Frankenstein himself, Shelley reflects the monster of the book she makes. Also like Frankenstein, she has a horrifying vision and longs to do what none has done before, in her case to create an uncanny vision that will terrify readers in new ways. In creating her monster, she borrows from materials around her, making Frankenstein an overwrought idealist like Percy Shelley, who perhaps did not always think through the consequences of his ideas or behaviors. Mary herself, having run away from her family, and from the mores of conservative society, becomes the monster as outcast to a displeased father/creator. At a structural level, adaptation shapes Shelley's characters. Jerrold Hogle notes that Walton, Frankenstein, and the Creature, the novel's three principal narrators, root their stories in previous texts. Walton's description of his quest "for the source of magnetism is spawned by a 'history of all the voyages made for the purpose of discovery'"; Victor Frankenstein's "lust for the 'causes of life'" is based on the alchemists he encountered in his youth; and the Creature's search for meaning and selfhood is inspired by his reading of "Plutarch's *Lives*, Goethe's *Werther*, Milton's *Paradise Lost*, and Frankenstein's journal" (Hogle 207). In a sense, each of these narrators' lives is an intertextual adaptation from the parts of other lives, books, and ideas.

The patchwork creation of Frankenstein's monster, of course, is a perfect analogy for the underlying intertextual processes of artistic creation itself. Because intertextual theory posits that all texts are the result of a conscious or unconscious synthesis of previous texts, all authors, in drawing on preexisting plot lines, characters, and themes, reflect Frankenstein himself, who made his creature by suturing together parts from different corpses. Taking the intertextual creation trope further for this study, a movie itself is, as Alfred Hitchcock pointed out, made of "bits of film" (Truffaut 61) sewn, or

edited, together. Certainly among the over one hundred Frankenstein films there has been much borrowing of ideas and images, mixing and matching, creating "new" films out of the parts of previous ones. Taking the intertextual metaphor to yet another level, Fred Botting relates it to criticism: "Different critical discourses which assemble their own monsters form the partial and dead signifiers that make up the narrative bodies of *Frankenstein*. Critics suture these fragments into their own commentary to produce new and hideous progenies that have lives of their own" (3).

Robert Stam notes that Spike Jonze's adaptation of Susan Orlean's book *The Orchid Thief* is "one of those rare feature films that not only **is** an adaptation, but is also **about** adaptation, and that is also actually **entitled** *Adaptation*" (1; bold in original). I would argue that all Frankenstein films, because of their inherent intertextuality, are implicitly about adaptation as well. Their focus on gathering body parts and suturing them together to create an artificial human makes them *about* the process of adapting—in their case, adapting humankind. Hence Stam's fleshing out of the various ways adaptation functions in *The Orchid Thief* is easily translatable into the language of Frankenstein films. First, just as Charlie Kaufman makes himself the main character of his adaptation—that is, he adapts himself—so Victor Frankenstein, in creating his creature, seems to adapt himself as well. An important postmodern aspect of Shelley's novel is its treatment of simulacra. Victor's problem with accepting his creation is that he sees it as a poor copy of a human being, rather than what Baudrillard would call a "truth in its own right," or the "hyperreal." In the process of creating his creature over years of "frantic," "resistless toil," sacrificing the "delicacy of his feelings," Frankenstein recreates himself into a being very unlike the well-bred young man who had arrived in Ingolstadt some years earlier. In the process of the "horrors of my secret toil" he changes physically, becoming pale and emaciated, though he continues in a "resistless, and almost frantic impulse," losing "all soul or sensation but for this one pursuit" (33). The creation process takes such a toll on Victor that it changes his very nature, his looks, and his sensibilities. When Shelley's Creature is finally animated, like Victor he is emaciated. His features are acceptable except for his "dull yellow" eyes, which seem to be the source of the uncanny horror Frankenstein perceives within himself. What Victor sees and what terrifies him, in truth, is the very weird likeness of his own self as a groping, lost, and nervous being who has no idea what he is. Because Frankenstein and his monster are simulacra of each other, through years of antagonism and tragedy they become two beings whose hatred of each other evolves into hatred of themselves, leading to their joint unstated suicide pact, ultimately enacted in their journey north. Years later, film adaptations follow suit in linking creator and creation. Whale's neurotic and changeable Henry creates a lost and stumbling monster in his *Frankenstein*; in *The Curse of Frankenstein* Baron Frankenstein creates a monster as relentless and heartless as himself; and in *Young Frankenstein* the repentant and self-sacrificing Frankenstein finally succeeds in producing a well-adjusted, functioning, and married artificial human, so normal that he reads the paper in bed. Stam notes that *The Orchid Thief* creates "a complex Pirandellian maze of doubles" (2) who, like Frankenstein himself, seem inseparable from the self-reflecting characters they are adapting.

More than most novels, Mary Shelley's *Frankenstein* begs for a visual treatment to complete itself. Her radically innovative and intertextual novel is postmodern in highlighting its own constructedness, referencing *Prometheus* and *Paradise Lost* on the title page and invoking her father by mentioning his novel *Caleb Williams*. Such overt intertextuality also signals the pastiche in the novel's various narrators and interpolated stories, together with the juxtaposition of radically different types of narratives. For example, the novel contrasts Frankenstein's desperate, guilty musings with his sunny travelogue of his and Clerval's tour of Europe. The novel also contrasts the familiar stories of eighteenth-century sensibility, represented by the way Elizabeth and Justine are charitably brought into the Frankenstein family, with the Creature's heretofore unprecedented experiences, problems, and feelings. Just as postmodernism questions master narratives and conventional wisdom, so Shelley's novel questions the master narrative of all master narratives—birth, life, and death.

Thinking about Shelley's novel in postmodern terms also suggests an alternative to the conventional view held since the 1980s of seeing its adaptations as mythos. Certainly the novel's mythic sources invite such a perspective. Each adaptation reinterprets and adds new dimensions to the original text, drawing on the cultural anxieties of the time (see Botting; Baldick; Hand; Picart). In the context of postmodern intertextuality, however, Dennis Cutchins and I in *Adapting Frankenstein* have proposed another model, a "Frankenstein Complex," that locates an adaptation's meaning not in a preconceived mythos, but in the minds of the individual audience members. Both approaches have their place: the Frankenstein *mythos* accounts for the public collection of adaptations, while the Frankenstein *complex* accounts for the very different ways individual viewers have responded to those adaptations. For example, in the context of the broad field of Frankenstein adaptations and their audiences, a commentator's analysis of the mythic dimensions of a Frankenstein videogame like *Dr. Franken II* might be cogent, despite having little to do with its reception by the players themselves. In fact, the videogame players are receiving this adaptation in the context of their own previous encounters with the Frankenstein myth and their unique frames of reference—whether from their young experiences with the comical *Scooby Doo* or from some more dramatically intense film. The game's meaning for them grows largely out of its relationship to other Frankenstein texts they have previously encountered. This intertextual approach to analyzing Frankenstein adaptations defines a methodology that mirrors postmodernism's vision of an infinity of signs and significations wherein all meaning lies. Since there are more adaptations of Frankenstein than can be thoroughly accounted for, the field comprises nearly endless signs with limitless possible significations and meanings, or frames of reference.

Given the plethora of subsequent Frankenstein adaptations in a given adaptor's consciousness, the process of intertextual accumulation begins when old, dead adaptations, along with newer sources, are gathered and recombined. A striking example of this process is *Frankenstein: The True Story*, in which screenwriter Christopher Isherwood, familiar with many previous adaptations, stitches together what he judges to be the most promising parts of the Frankenstein myth. His manner of appropriation, in fact, is so

profuse that the film is virtually a postmodern collage of Isherwood's own Frankenstein complex. Like *The Bride of Frankenstein*, the miniseries begins in a world of English Regency glamour whose title explicitly invokes Mary Shelley. A tattooed arm that Dr. Clerval amputates is visually emphasized throughout in the manner of the tattooed arm that Cushing's Frankenstein amputates and finally uses on himself in *The Revenge of Frankenstein*. Clerval, like Whale's Frankenstein, is so critical of the scientific conservatism of university scientists that he strikes out on his own. Frankenstein and Clerval's enthusiasm over the "fine young bodies" they acquire is reminiscent of the more modern Dr. Frankenstein of *I Was a Teenage Frankenstein*. Clerval, whose hands have been injured in a fire, needs Frankenstein to perform the surgery on the assemblage of the creature, just as the injured Baron Frankenstein depends on a younger assistant to operate vicariously for him in *Frankenstein and the Monster from Hell*. The monster's physical degeneration over time is also drawn from *The Revenge of Frankenstein*, even to the detail of his initial decomposition starting behind the ear. The lab explosion after the creation scene harkens back to the end of *The Bride of Frankenstein*, which also supplies the motif of the creature clapping to the blind man's violin playing. Isherwood's screenplay is virtually a "greatest hits" of Frankenstein adaptations. Thus, in a creative-technological act that embodies the cinematic cutting and editing of celluloid, this new Frankenstein adaptation, like many others, can said to be assembled intertextually from various body parts of its predecessors.

As Robert Weimann notes, there is a "reproductive dimension of appropriation" (qtd. in Sanders 1). Specifically, ideas are being reborn and reproduced: "The inherent intertextuality of literature [and film] encourages the ongoing, evolving production of meaning, and an ever-expanding network of textual relations" (Sanders 3). Film adaptations of Shelley's novel from Edison's *Frankenstein* to *I, Frankenstein* have all engaged, however unknowingly, in the postmodern enterprise of recomposing memory to encompass new or previously excluded stories. This postmodern game of infinite possible narratives is invited by the Frankenstein monster and the story he inhabits, becoming a *what if* game commonly played out in television and comic books. Fans of *X-Files*, for example, enjoy the various extreme situations that challenge Mulder and Scully. At different times one character or the other is abducted by aliens, dies and is brought back to life, contracts alien diseases, falls in love, goes into hiding, contacts a sister's spirit, is imprisoned and escapes, is pursued by the FBI, and becomes the subject of a campy movie starring Garry Shandling. These variations provide fans the pleasure of seeing their heroes in extreme circumstances and glimpsing unplumbed depths of their personalities.

Similar playful *what if* questions are explored in various adaptations of Mary Shelley's hero. What if the monster couldn't talk and captured Frankenstein in the end (Whale's *Frankenstein*)? What if he were bald, had a zipper on his neck, and read the newspaper in bed (*Young Frankenstein*)? What if the monster joined a military unit (*Nick Fury's Howling Commandos*)? What if he joined with gargoyles to fight demons (*I, Frankenstein*)? What if he earned a PhD and fought for liberal causes, prompting fundamentalist groups to seek his life (*Doc Frankenstein*)? Such questions get at the heart of adaptations in general, as various adapters take the monster apart and put

him back together again. As Linda Hutcheon has noted, one of the pleasures audiences derive from adaptations is experiencing a beloved text (character, setting, romance, storyline, etc.) again with variations, enabling a viewing process of comparing and contrasting (21). The most basic pre-adaptation adaptation questions might have included these: What if we could see what Frankenstein's monster looked like? What if we could see him created (Peake)? What if Frankenstein had actually created a mate (Whale)? More recently, we might ask casting questions. What if Daniel Radcliffe played Igor (*Victor Frankenstein*)? What if Benedict Cumberbatch played both Frankenstein and his monster (the 2011 *Frankenstein* adapted by Nick Dear)—as did Ian Holm before him in Voytek's 1968 television *Frankenstein*? Such questions, even if never literally asked except at Hollywood power luncheons, help explain why Frankenstein adaptations have entertained so many audiences for so long. Paul Ricoeur's definition of appropriation as a fundamentally "playful" process captures an important dimension of adaptation itself, as well as the processes that occur within the minds of audience members (87). Going further, Jacques Ehrmann argues that any theory of communication—and hence of literature—must necessarily imply a "theory of play . . . and a game theory" (De Ley 33).

From Stage to Screen

This grand complex begins on stage at English Opera House on 28 July 1823, when Richard Brinsley Peake entertains several *what if* questions about the sensational novel published just five years before. His play, and others the same year, immediately anticipate the conventions of serious and playful adapting of the story. Major changes include removing the monster's speech, adding characters, parodying Shelley's novel, giving more emphasis to the creation scene, and adding a strong religious moral. Because the British stage was conservatively monitored to ensure healthy and moral content—much as Hollywood was policed by the Motion Picture Production Code in the United States from 1930 to 1968—plays were carefully reviewed and needed approval from the Examiner of Plays and the Lord Chamberlain. Such strictures on British stage productions would set the tone for the early Frankenstein films that were still over eighty years away. Early on, despite the censorial care lavished on the play, the theater still drew protestors before the mostly approving reviews hit the streets.

The first major stage adaptation, Peake's *Presumption; or, The Fate of Frankenstein*, was such a great hit—even Shelley herself admitted to being "much amused" with it—that it encouraged countless other stage versions throughout the nineteenth and twentieth centuries, and continued to be produced regularly itself. Peake's major changes to the novel forever radically altered perceptions of the story and of the monster, giving him a place next to Shelley and Whale as a major definer of what we understand as the Frankenstein complex. In addition to the changes noted earlier, some of the characters are also mixed and matched. Agatha de Lacey becomes Victor's fiancée, who is later killed by the monster, and Clerval and Elizabeth (here Victor's sister) live on after Victor and his creation

die together under an avalanche. Despite the influence of Peake's individual innovations, his more influential contribution may be the revelation that the novel is not sacred and can be profitably altered. While many similarly serious and moral versions of the play continued to be produced, parodies were also common during the 1820s and beyond. In the same year as Peake's *Presumption*, three comic adaptations were produced. Later in the century came Richard Henry's *Frankenstein; or, The Vampire's Victim* (1887), featuring a scene that would show up in *Young Frankenstein*, in which Frankenstein brings his creation on stage to perform before a scientific audience dressed as a dandy. Another element in Henry's and Peake's stage productions that would often be exploited is that of the monster's weakness for music, first expressed in his description of Mr. De Lacey's violin music: "Sound sweeter than the voice of the thrush or the nightingale" (74). *The Bride of Frankenstein* shows the creature drawn to the old man's hut by his violin playing, and *Young Frankenstein* uses music to lure the creature back to the castle.

Historically, there is a close relationship between the stage and screen adaptations of *Frankenstein*, although the pattern of simplifying the tale often becomes conventional in films. Whale's iconic film adaptation cuts Walton and Justine and adds the lab assistant and creation scene. Whale's film is based most directly on Peggy Webling's 1927 play, whose most influential innovation is making Frankenstein more sympathetic to his creation. Another Webling scene, the monster's kidnapping of Elizabeth, is not filmed until *The Bride of Frankenstein* and *Young Frankenstein*. Taking perhaps more liberties than any Frankenstein play before or since is The Living Theater's 1965 *Frankenstein*. Sometimes as long as six hours, this surrealistic, semi-improvised stage version seems both serious and parody at once. Performed on a large frame structure, the play includes love scenes and bizarre antics that anticipate *The Rocky Horror Picture Show*, the 1975 cult film that in turn is also often adapted for the stage.

The contemporary stage has often found its sources in the cinema. *Young Frankenstein* was reworked as a Broadway stage musical in 2007. Danny Boyle's *Frankenstein* was simultaneously performed on stage and broadcast to cinemas internationally. Finally, a BBC Three television/stage event, *Frankenstein's Wedding*, broadcast from Leeds, was produced in 2011. The BBC version included much of Shelley's story, some of which had been previously filmed and shown between the live stage parts, and it included songs as well. Stage and screen have been interdependent in developing and innovating mixed media adaptations, creating yet another metaphor of intertextual *Frankensteinian suturing*.

WEIRD SQUARED: THE SURREALIST STRAIN

Whale's *Frankenstein* and *Bride of Frankenstein* are among the most important and influential adaptations in cinematic history. As either homages to or as responses against them, the steady stream of Frankenstein adaptations that continues in their wake is an unparalleled phenomenon. As is widely acknowledged, Whale's films comprise joint

Frankenstein source texts even more influential than Shelley's novel as sources of imagery for subsequent films. These two films not only established the iconic look of the monster but were largely responsible for the mise-en-scene of later gothic horror films in general. Drawing on important 1920s German expressionist film precedents, Whale, greatly aided by Jack Pierce's makeup of Karloff, focused on expressionist sets, dark wit, and the genius of Frankenstein himself to bring new life to the dead. Baldick puts the immortal power of the film in perspective: "Myths are also susceptible to 'closure,' or to adaptations which constrain their further development into fixed channels. In the case of the Frankenstein myth, this moment of closure arrived in 1931 in the shape of William Henry Pratt (better known as Boris Karloff), whose rectangular face and bolt-adorned neck have fixed our idea of the monster into a universally-known image from which it is hard to see further revisions breaking free" (4–5).

The astronomical number of subsequent filmmakers who have drawn from his imagery puts Whale in the elite company of style setters like Griffith, Eisenstein, and Hitchcock. Given the originality of these films and their famous departures from Shelley, similarities between the two are not always obvious. In fact, however, Whale's *Frankenstein* is not as completely removed from Shelley's novel as is usually assumed, particularly when we compare their similar cultural contexts to the deep structures of the films. The unparalleled impact and longevity of Whale's classic adaptations involve a number of elements, most of which support the hub of the film: the superbly made-up Boris Karloff. However, a significant aspect of his makeup, usually taking a backseat to the flat head and neck bolt, is the heavily-lidded eyes, lending him what David J. Skal calls "a dimension of pathos and incomprehension" (133). Just as important is the living-death quality the eyes suggest. When Karloff's monster turns around slowly during his famous first appearance and the camera jump cuts closer to fill the screen with his face, the film audience is primed to react as Victor reacts to Shelley's creature's horrific "watery eyes." Interestingly, during early screenings of Whale's film, horrified audience members would get up and leave the auditorium, return, and then leave again. In Frankenstein's "waking dream," Shelley describes the exhausted and horrified creator awaking to see "the horrid thing stand[ing] at his bedside, opening his curtains, and looking on him with yellow, watery, but speculative eyes" (168).

While "watery" and "speculative" suggest life for Shelley's creature, Karloff's dead eyes take the uncanniness a step further by presenting a walking corpse. The importance of the joint emphasis on the eyes by Shelley and Whale suggests that he may have been drawing on Shelley's text as well as on Webling's play. The opening credits of the 1931 film initiate the eye imagery with an intense pair of eyes literally shining their rays down on something—perhaps a reference to the novel's depiction of the newborn creature looking down through the bed curtains at Victor. The credits then introduce a weirdly exotic figure with many individual eyes circling his face (Figure 8.1). Indeed, what the audience is going to see in the film may send them reeling. Slavoj Žižek notes that the monster's depthless eyes become a horrific subject that cannot be "subjectivized." The eyes are what prevent the creature from seeming human, an ever-present

FIGURE 8.1 The surreal credit sequence from *Frankenstein* (1931) foreshadows the visually uncanny horror to follow.

reminder of what it is or what it seems—depthless, therefore soulless, and the source of its uncanniness (cited in Gigante 571).

The idea of horrifying eyes has precedents in both Shelley's time and Whale's, importantly linking them in their separate creations. During the fateful summer of 1816 in Switzerland, as Byron read Coleridge's "Christabel" aloud, Percy Shelley ran out of the room, shrieking as he remembered an uncanny image of a woman with eyes for nipples on her breasts. His panic attack seems a likely model for Victor's own mad flight after seeing his creature's horrific eyes. The image that frightened Shelley was a precursor to what the Surrealists would call an "interpreted found object," something that is slightly changed to create a bizarre effect, many of which involve eyes. Man Ray's famous metronome with an eye on the pendulum ("Destroyed Object") is just one example of the surrealist obsession with eyes. Another notable and disturbing surrealist image is the slicing of the woman's eye in *Un chien andalou*, a scene perhaps suggesting that cutting the physical eye—the audience's—will enable them to see with their subconscious eyes. In fact, according to André Breton's 1924 Manifesto, photographs of surrealists with their eyes closed are about recognizing "the omnipotence of the dream" (19).

Surrealism plays an important role in the Whale films. In supervising the creation of the monster's makeup, as well as the Bride's, Whale helps fashion these creatures into timeless surrealistic objects made of contradictory parts—alive and dead, human and machine, sympathetic and horrific, playful and destructive. The monster is likewise a freak of science and of art, like so many surrealist images of grotesque bodies melting, hatching, growing drawers or picture frames for abdomens, being stretched to impossible lengths, being tortured and becoming mannequins made from various objects. In fact, surrealism and horror are often stylistically linked in their similar use of grotesque imagery. Unsurprisingly, as Skal notes, "terror films were much admired by the surrealists, who loved their disorienting effect" (54). Like surreal art, Whale's films look dreamlike, set in a Hollywood Neverland that combines nineteenth-century Germanic village life with twentieth-century electricity (Figure 8.2). Commentators link these films to surrealism, noting elements like emotional shock and psychological chaos, as well as surrealism's strange conceptions of the body. Equally of interest is the claim that "surrealists paved the way for the horror film" (Jones). Jonathan Jones cites *Un chien andalou* and *L'age d'or* as two films that have influenced cinema more than most, with extreme non-narrative violence, macabre imagery, and rotting corpses. Both Shelley's and Whale's versions of *Frankenstein* grow out of strange new worlds, exploring cultures characterized by the weird. Both Shelley and Whale experienced the art of horror. For Shelley it included Fuseli and Blake; for Whale, Dalí and Picasso. Theirs were worlds of bizarre visions, lifestyles, and the imperative to create something new and daring.

Whale is not alone in his cinematic surreal vision. Universal's *Son of Frankenstein* is characterized by its surreal architectural expressionism, including a cockeyed castle and an outdoor lab that looks like a giant brain with a hole in it. *The Ghost of Frankenstein*

FIGURE 8.2 This multi-angled, shadow-laden image shows the surrealist and expressionist influences that shape the mise-en-scene of *Frankenstein* (1931).

creates a surreal effect when the hitherto silent monster speaks in Ygor's voice following a brain transplant, an effect duplicated in Hammer's *Frankenstein Created Woman* when Hans's brain, transplanted into his girlfriend Christina's body, causes her to speak in his voice as she takes revenge on his murderers. More recently, *Edward Scissorhands* epitomizes the irrational juxtapositions of surrealism with a classic gothic castle overlooking a garish suburban neighborhood. Edward himself, in fact, is another surrealist/expressionist object with scissors for hands. Finally, *The Rocky Horror Picture Show* creates a mad/camp horror musical out of Frankensteinian imagery, featuring Tim Curry as a shocking (at the time) transsexual surrealist object, Dr. Frank N. Furter, who cross-dresses in high heels and mesh stockings when creating his stud monster.

THE UNIVERSAL SERIES

The eight films in the Universal Frankenstein series (1931–48) constitute a fascinating case study in the unimagined sources of the afterlives of some film adaptations. Becoming, from the second film on, the second banana to other characters, the monster mostly lies on a slab, like a patient in a hospital waiting for his "operation" to take place. While he is nominally the motivating force behind the action in these films, he has little to do. Ironically, then, the monster is absent from most of the action as Universal paints itself into an adaptation corner, desperately grafting additional body parts—the Wolf Man, Dracula, hunchbacks, and a comedy team—to its Frankenstein monster movies. Of their dilemma, Albert J. LaValley asks, after *Abbott and Costello Meet Frankenstein*, "where was there to go?" (274). Seemingly itself endowed with eternal life, Universal could not be kept down. While the Universal Frankenstein series apparently ends here, it merely passes the baton from Karloff, Lugosi, Chaney, and company to the comedy team as they go on to meet Dr. Jekyll and Mr. Hyde, the Mummy, the Killer, and the Invisible Man. By following the pattern of "meet Frankenstein," these films, in fact, become indirect Frankenstein adaptations, with the other monsters standing in for *the* monster. Hence the monster never dies but only evolves as new parts get sewn onto his undying cinematic body.

Another and unprecedented new life came to the monster when the Screen Gems *Shock Theater* (1957) and *Son of Shock* (1958) horror packages were made available for television, introducing these classic horror films to a generation of young viewers who did not regard the monster rallies as diminished art compared to Whale's "serious" films. To them these films were at once scary and fun when seen through the lens of their appearances in *Abbott and Costello Meet Frankenstein*, the horror-comedy antics of the many horror show hosts filling the airwaves, and the publication of *Famous Monsters of Filmland* magazine (1958–83), with Forrest J. Ackerman's pun-filled descriptions of the classic films and glorification of Karloff, Lugosi, and the other reborn stars. This phenomenon of reanimating these seemingly dead films, in fact, occurs as the "monster movies" are repositioned through various new media. Even the new young fans

themselves participated in adapting Frankenstein's monster by assembling models, sometimes including entire laboratory set designs made available in various accessory kits, enabling these young fans to become aspirational Dr. Frankensteins. The cultural importance of the horror craze of the 1950s and 1960s is an object lesson in how one adaptation (*Abbott and Costello Meet Frankenstein*) can become a lens through which to see and adapt anew. The later audiences were able to re-view these Universal B pictures as sublime dark rides that create both fear and delight, hearkening back to Jack Davis's drawing of the monster as scarecrow. This new synthesis finds its perfect embodiment in a 1962 Halloween tribute to the popular monsters on *Route 66*'s "Lizard's Leg and Owlet's Wing" episode, guest starring Boris Karloff and Lon Chaney in their classic makeups as the Frankenstein monster and the Wolf Man. It ends as Buzz shakes hands with the Wolf Man, who gets in his face and startles him with a snarling growl, immediately followed by a hearty laugh. A more fitting tribute to the evolution—and adaptation legacy—of the Universal series would be hard to find.

The Hammer Series, Irony, and Nostalgia

In the nine years between *Abbott and Costello Meet Frankenstein* and *The Curse of Frankenstein*, the post–World War II science fiction film craze had become the new custodian of Shelley's themes, spawning endless indirect appropriations of Frankensteinian disasters by the post–atomic bomb mad scientists of the period. Their creations include id monsters, teenage werewolves, talking heads, giant mutated insects, and resurrected dinosaurs, all wreaking havoc on the cities or neighborhoods of the world. Even a few unmentionable low-budget Frankensteins make token appearances. Hence Frankenstein is both explicitly and implicitly everywhere in 1950s science fiction. From this setting rises the beginning of the six Peter Cushing Frankenstein films (1957–74), which reflect darker variations on the past, sewn together from parts of its Frankenstein, gothic horror, and 1950s science fiction predecessors. In a new adaptation synthesis, these films bring out the more lurid aspects of the gothic tradition unthinkable in the Universal series, including frank sexuality and rape, graphic violence, and a disturbing psychological underside, all in blood-red Technicolor.

Threatened from its inception with a lawsuit from Universal, the Hammer series was necessarily conceived as contrary in every possible way to the earlier series. Much of the power of the series lies in the boldness and originality of Cushing's Frankenstein character. He is at once charming and brutal, compassionate and homicidal, admirably persistent and ruthlessly manipulative. Stylistically, Cushing's Baron Frankenstein is as much the offspring of Professor Henry Jarrod from the Technicolor *House of Wax* as he is of Shelley's Victor or Universal's Henry Frankenstein. Like Cushing, Jarrod is a driven, homicidal, and manipulative figure who kills to create his new wax people. As

Baron Frankenstein does in several of the films, he must rely on the hands of others to do his creating. Like Jarrod, the Baron, not his creations, becomes the horrific center of the films. Making the connection between the two madmen explicit, the mask Cushing wears at the beginning of the darkest film in the series, *Frankenstein Must Be Destroyed*, looks too much like Jarrod's fire-deformed face to be a coincidence. Both scenes, in fact, involve stalking someone through dark streets. *House of Wax*'s 3-D effects bring the horror closer to the audience, becoming the template for the further, darker adventures of Frankenstein.

The fact that through all this Cushing's characterization of the mad scientist remains beloved by fans suggests the ironic reduction of some aspects of the horror implicit in Shelley's blueprint. More a postmodern anti-hero than a gothic scientist, the Baron has grisly and cynical adventures that become dark fun in a quite different way than the horror-light Universal films. There is little here of the nostalgia evident in Wolfe and Ludwig's desire to complete their father's work, or on other occasions as would-be Frankensteins return to his castle laboratory in awe and wonder, seeking his formula for creating life. In *Frankenstein and the Monster from Hell*, Frankenstein creates a bizarre amalgamation of a creature that looks like an apish Quasimodo. This creation is so horrifically ugly that it seems to function, like the portrait of Dorian Gray, as a physical embodiment of Baron Frankenstein's soul after a lifetime of evil deeds. As Karloff's performance has become the chief and irreplaceable embodiment of Frankenstein's creature, so Cushing, along with Colin Clive, has become an iconic image of Frankenstein himself.

Together with the Universal franchise, the Hammer film series became a major touchstone for subsequent adaptations. In the 1960s sex, violence, and more palpable horror brought Frankenstein back into cinematic consciousness and encouraged a wave of more adult-oriented Frankenstein films, from *Flesh for Frankenstein* to *The Rocky Horror Picture Show*, both ironic and pornographic camp adaptations of the tradition. Displaying virtually no nostalgia for the past, they are iconoclastic deconstructions of the well-known characters and events. While somewhat laughable in its hyper-seriousness, *Mary Shelley's Frankenstein* pumps Shelley's novel full of enough amphetamines to make an MTV horror video punctuated by disturbingly graphic surgeries. Meanwhile, though the film is neither nostalgic nor ironic, Robert De Niro's monster looks, as Janet Maslin deftly notes, like a "post–blood bath Travis Bickle crossed with a baseball."

However, by the 1970s, when the Hammer series ends, another major evolutionary shift in Frankenstein adaptations occurs as some filmmakers create more personal adaptations through the lens of their early viewings of the Universal Frankenstein films. Just as digging up dead bodies to construct new ones is itself a kind of ironic scientific nostalgia, so these Universal-inflected adaptations by Mel Brooks and Tim Burton are made from parts of old films to become cinematic nostalgia. Perhaps inevitably, after the iconoclastic, anti-nostalgia of Hammer's Frankenstein and its naughty successors, the pendulum had to swing back for a sentimental return to Universal's now quaint black-and-white gothic legacy. Nostalgic attitudes, however, can range from memorializing

the past into precious moments "selected by memory, but also forgetting," to a more critical awareness of the "risks and lures of nostalgia" (Hutcheon, "Irony"). In *Young Frankenstein*, Brooks combines some of both, playfully adapting the old tropes with hilarious reminders that we no longer live in the 1930s ("Woof!"). On the other hand, the film is about learning to embrace the past. Just as Brooks incorporates the black-and-white expressionism of the Universal films, so Victor "Fronkensteen" learns to reclaim his family past, evolving from a cynical and snobbish medical professor to an enthusiastically boyish mad scientist. The film takes the characters even further back into their childhoods as they play games like charades and "roll in der hay." Brooks further invokes nostalgia by having the tender-hearted monster become emotionally touched by beautiful music. While Brooks displays the inherent absurdities and comic potential in Universal's gothic mythology, even that is a nostalgic gesture, since he only slightly exaggerates Whale's own comic irreverence in *Bride* and the slapstick tone of Abbott and Costello's approach. In short, his adaptation of the tradition becomes a projection of his nostalgic and ironic double-mindedness.

More openly and complexly nostalgic, Tim Burton seems the filmmaker of his generation most personally invested in the imagery and pathos of the Frankenstein story and its Universal imagery. His adaptations of Shelley's hideous offspring reflect an intricately nostalgic project to combine the world of his youth with the glorious black-and-white horror films to which he retreated. Many of Burton's films are a mix of sad and gently humorous nostalgia that are personal projections of his outsider status as a youth. *Edward Scissorhands*, for example, brings together a tender Frankenstein fairy tale that is informed by a sympathetically monstrous outcast in a German expressionist leather outfit. Burton amplifies the monster's innocence here by making the conventional characters the real monsters. Like Fritz, in fact, Kim's mean boyfriend Jim cannot resist tormenting Edward, and in the end receives the same reward. Burton's other major Frankenstein adaptation, *Frankenweenie*, is a remake of his 1984 live-action short involving a young boy who resurrects his dead dog Sparky using the Galvini methods he learns in science class. The weird, James Whale–like New Holland setting reveals a uniquely nostalgic approach to adaptation, with Burton mashing up the setting of his suburban childhood with the gothic visions he saw on television to make *Frankenweenie* the most accurate possible depiction of his own wish-fulfilling nostalgia. From such a perspective, the addition of Japan's giant monster Gamera and the demonized sea monkeys advertised in *Famous Monsters* magazine could hardly be more appropriate.

NEW BEGINNINGS AND CONCLUSIONS

The two most recent Hollywood Frankenstein films target younger audiences of the macho Marvel superheroes and the magical worlds of Harry Potter. *I, Frankenstein*, based on a popular graphic novel in which the monster joins a legion of gargoyles to

save the world from marauding demons, emphasizes gothic settings, CGI (computer-generated imagery) spectacle, and action. *Victor Frankenstein*, on the other hand, takes its cue from the popular trend of telling the backstories of famous characters as in the recent live-action adaptations of Disney's classic fairy-tale characters. Daniel Radcliffe stars as Igor, whose youthful friendship with Victor Frankenstein is recounted. Meanwhile, on television Frankenstein and his monster further demonstrate their longevity and versatility in two ongoing television mashups: in *Once Upon a Time* as part of a fairy-tale plot wherein Frankenstein is brought into the story by the evil queen because he alone can bring the dead back to life; and in *Penny Dreadful*, which features a vampire-hunting collection of famous fantastic British literary figures that include Victor and two of his monsters.

If *Frankenstein* is the "most important minor novel in English" (Levine 3), its status must stem at least partly from its being one of the most often adapted. As this essay has noted, Frankenstein's creature has become a trope for the adaptation process itself. But what makes the monster of particular fascination is that, like ourselves, he is a complex amalgamation of many divergent parts, at once funny and tragic, kind and cruel, mundane and miraculous. Because Frankenstein's hideous creation is a combination of the recognizable and inexplicable, the history of Frankenstein adaptations has been marked by the effort to probe and understand what that *thing* half of the monster is, to tame it, and make it something we can define and embrace. The monster represents a complex combination that is at once human and other, good and evil, sympathetic and repulsive. In *Frankenstein* Mary Shelley early on defined the irresolvable, open narrative—both the story itself and the creature at its center. In short, filmmakers and critics adapt, profit from, and analyze Shelley's and Whale's monster, but by its very nature he, or it, is a narrative conundrum that seems as impossible to fathom as our own dark side.

Works Cited

Adaptation. Dir. Spike Jonze. Perf. Nicolas Cage, Meryl Streep. Columbia, 2002. Film.

L'age d'or. Dir. Luis Buñuel. Perf. Gaston Modet, Lya Lys. Vicomte de Noailles, 1929. Film.

Anon. Review of *Frankenstein; or the Modern Prometheus*, 3 vols. London (1818). *Quarterly Review* 18 (Jan. 1818): 379–85. Print.

Baldick, Chris. *In Frankenstein's Shadow: Myth, Monstrosity, and Nineteenth-Century Writing*. Oxford: Clarendon, 1987. Print.

Baudrillard, Jean. *Simulacra and Simulation*. Trans. Sheila Faria Glaser. Ann Arbor: U of Michigan P, 1994. Print.

Botting, Fred. *Making Monstrous: Frankenstein, Criticism, Theory*. Manchester: Manchester UP, 1991. Print.

Breton, André. "Le manifeste du surréalisme." 1924. Rpt. *Manifestos of Surrealism*. Trans. Richard Seaver and Helen R. Lane. Ann Arbor: U of Michigan P, 1969. 5–34. Print.

The Bride of Frankenstein. Dir. James Whale. Perf. Boris Karloff, Colin Clive. Universal, 1935. Film.

The Curse of Frankenstein. Dir. Terence Fisher. Perf. Peter Cushing, Hazel Court. Hammer, 1958. Film.

Cutchins, Dennis, and Dennis R. Perry, eds. *Adapting Frankenstein: The Monster's Eternal Lives in Popular Culture*. Manchester: Manchester UP, forthcoming.

De Ley, Herbert. "The Name of the Game: Applying Game Theory to Literature." *SubStance* 17.1 (1988): 33–46. Print.

Doc Frankenstein. 2004–7. Written by the Wachowskis. Illus. Steve Skroce. Burlyman. Print.

Dr. Franken II. Elite Systems, 1997. Videogame.

Edward Scissorhands. Dir. Tim Burton. Perf. Johnny Depp, Winona Ryder. Twentieth Century Fox, 1990. Film.

Famous Monsters of Filmland. Ed. Forrest J. Ackerman. Pub. James Warren. 1958–1983. Print.

Flesh for Frankenstein. Dir. Paul Morrissey, Antonio Margherti. Perf. Joe Dallesandro, Dalila Di Lazzaro. Braunsberg, 1974. Film.

Frankenstein. Dir. Danny Boyle. Perf. Benedict Cumberbatch, Jonny Lee Miller. *National Theatre Live*, 2011. Television.

Frankenstein. Dir. J. Searle Dawley. Perf. Charles Ogle. Edison, 1910. Film.

Frankenstein. Dir. James Whale. Perf. Colin Clive, Boris Karloff. Universal, 1931. Film.

Frankenstein. Dir. Judith and Julian Beck. Living Theater, 1965. Drama.

"Frankenstein." Dir. Voytek. Perf. Ian Holm, Richard Vernon. *Mystery and Imagination*, 11 Nov. 1968. Television.

Frankenstein and the Monster from Hell. Dir. Terence Fisher. Perf. Peter Cushing, Shane Briant. Hammer, 1974. Film.

Frankenstein Created Woman. Dir. Terence Fisher. Perf. Peter Cushing, Susan Denberg. Hammer, 1967. Film.

Frankenstein Must Be Destroyed. Dir. Terence Fisher. Perf. Peter Cushing, Veronica Carlson. Hammer, 1969. Film.

Frankenstein: The True Story. Dir. Jack Smight. Perf. James Mason, Leonard Whiting. Universal, 1973. Television.

Frankenstein's Wedding . . . Live in Leeds. Dir. Colin Teague. Perf. Andrew Gower. BBC3, 2011. Television.

Frankenweenie. Dir. Tim Burton. Perf. Winona Ryder, Catherine O'Hara. Disney, 2012. Film.

Gigante, Denise. "Facing the Ugly: The Case of "Frankenstein." *ELH* 67.2 (Summer 2000): 565–87. Print.

Hand, Richard J., and Jay McRoy, eds. *Monstrous Adaptations: Generic and Thematic Mutations in Horror Film*. Manchester: Manchester UP, 2007. Print.

Handley, George. "The Mystery of Us: An Interview with Marilynne Robinson." *Humanities at BYU* (Spring 2014): 20–21. Print.

Henry, Richard. *Frankenstein, or The Vampire's Victim*. West End, 1887. Drama.

Hogle, Jerrold E. "Otherness in Frankenstein: The Confinement/Autonomy of Fabrication." *Frankenstein: Contemporary Critical Essays*. Ed. Fred Botting. London: Macmillan, 1995: 206–34. Print.

House of Wax. Dir. André de Toth. Perf. Vincent Price, Frank Lovejoy. Warner Bros., 1953. Film.

Hutcheon, Linda, with Siobhan O'Flynn. *A Theory of Adaptation*. 2nd ed. London: Routledge, 2013. Print.

———. "Irony, Nostalgia, and the Postmodern." University of Toronto English Department Conference Paper, 1997. Web.

I, Frankenstein. Dir. Stuart Beattie. Perf. Aaron Eckart, Yvonne Strahovski. Lionsgate, 2014. Film.

I Was a Teenage Frankenstein. Dir. Herbert L. Strock. Perf. Whit Bissell, Phyllis Coates. American International, 1957. Film.

Jones, Jonathan. "The Joy of Gore." *Guardian.* 7 Feb. 2004. Web. 7 Dec. 2015.

LaValley, Albert J. "The Stage and Film Children of Frankenstein: A Survey." *The Endurance of Frankenstein: Essays on Mary Shelley's Novel.* Ed. George Levine and U. C. Knoepflmacher. Berkeley: U of California P, 1979: 243–89. Print.

"Lizard's Leg and Owlet's Wing." *Route 66.* CBS, 26 Oct. 1962. Television.

Mary Shelley's Frankenstein. Dir. Kenneth Branagh. Perf. Robert De Niro, Kenneth Branagh. Columbia TriStar, 1994. Film.

Maslin, Janet. Rev. of *Mary Shelley's Frankenstein. New York Times* 4 Nov. 1994. Web. 7 Dec. 2015.

Nick Fury's Howling Commandos. Dec. 2005–May 2006. Written by Keith Griffen. Illustrated by Eduardo Francisco. Marvel. Print.

Once Upon a Time. Created by Edward Kitsis and Adam Horowitz. Perf. Jennifer Morrison, Robert Carlyle. ABC, 2011–. Television.

Orlean, Susan. *The Orchid Thief: A True Story of Beauty and Obsession.* New York: Random House, 1998. Print.

Peake, Richard Brinsley. *Presumption: or, the Fate of Frankenstein.* 1823. Drama.

Penny Dreadful. Created by John Logan. Perf. Timothy Dalton, Eva Green. Showtime, 2014–. Television.

Picart, Joan S. *The Cinematic Rebirths of Frankenstein: Universal, Hammer, and Beyond.* Westport: Praeger, 2002. Print.

———. *Remaking the Frankenstein Myth on Film: Between Laughter and Horror.* Albany: State U of New York P, 2003. Print.

The Revenge of Frankenstein. Dir. Terence Fisher. Perf. Peter Cushing, Francis Matthews. Hammer, 1958. Film.

Ricoeur, Paul. "Appropriation." *A Ricoeur Reader.* Ed. Mario Valdés. London: Harvester Wheatsheaf, 1991. Print.

The Rocky Horror Picture Show. Dir. Jim Sharman. Perf. Tim Curry, Susan Sarandon. Twentieth Century–Fox, 1975. Film.

Sanders, Julie. *Adaptation and Appropriation.* London: Routledge, 2006. Print.

Shelley, Mary. *Frankenstein.* Ed. J. Paul Hunter. New York: Norton, 1996. Print.

Skal, David J. *The Monster Show: A Cultural History of Horror.* New York: Norton, 1993. Print.

Son of Frankenstein. Dir. Rowland V. Lee. Perf. Basil Rathbone, Boris Karloff. Universal, 1939. Film.

Stam, Robert, and Alessandra Raengo, eds. *Literature and Film: A Guide to the Theory and Practice of Film Adaptation.* Malden: Blackwell, 2005. Print.

Truffaut, François, with Helen G. Scott. *Hitchcock.* Rev. ed. New York: Simon and Schuster, 1984. Print.

Tropp, Martin. "The Monster." *Mary Shelley's Frankenstein.* Ed. Harold Bloom. New York: Chelsea House, 2007. Print.

Un chien andalou. Dir. Luis Buñuel. Perf. Pierre Batcheff, Simone Mareuil. 1929. Film.

Victor Frankenstein. Dir. Paul McGuigan. Perf. Daniel Radcliffe, James McAvoy. Twentieth Century Fox, 2015. Film.

Webling, Peggy. *Frankenstein.* 1927. Drama.

Young Frankenstein. Dir. Mel Brooks. Perf. Gene Wilder, Teri Garr. Twentieth Century–Fox, 1974. Film.

SILENT GHOSTS ON THE SCREEN

Adapting Ibsen in the 1910s

EIRIK FRISVOLD HANSSEN

DURING the 1910s and early 1920s, some thirty known film adaptations of works by Henrik Ibsen were produced in a number of countries. The most famous of these films is probably Victor Sjöström's 1917 Swedish production, *Terje Vigen*, based on Ibsen's 1862 poem. Other silent film adaptations of Ibsen were produced in Germany, Italy, Great Britain, Spain, Russia, and the United States (Hansen).

The majority of US silent Ibsen adaptations are assumed to be lost—for example, four versions of *A Doll's House*, based on *Et dukkehjem* (1879), that were produced between 1911 and 1922 (Hanssen, "Doll's"). This essay will consider the four US silent film adaptations of stage plays by Ibsen that are still known to exist: *The Pillars of Society* (1911), based on *Samfundets støtter* (1877); *Peer Gynt* (1915), based on the 1867 play; *Ghosts* (1915), based on *Gengangere* (1881); and a second adaptation of *Pillars of Society* (1916).[1]

Drawing on extant film material, contemporary film reviews, and trade press articles, this essay will demonstrate how these particular films, through their various adaptation strategies and their trade press reception, might be understood in terms of broader discourses on what is often characterized as the transitional period in US film history. In particular, I will focus on discussions throughout the 1910s concerning medium specificity and media borders. Because all the US films were adaptations of stage plays, their reception in contemporary reviews and film debate often involved general arguments about the differences between cinema, theater, and literature. In addition, the films studied in this essay represent what Linda Hutcheon, emphasizing the importance of production and reception contexts, characterizes as transcultural adaptations (145). The transcultural nature of the Ibsen adaptations—US films produced in the period 1911–15, based on Norwegian literary works published in the period 1867–81—makes them not only indicative of medium specificities in a general sense, but also reminders of the need to consider adaptations as both historically and culturally specific phenomena.

I will consider the United States as a specific cultural context for film production and reception. The US setting is fundamentally different from, for example, the contemporary Swedish context that produced *Terje Vigen*, where Ibsen was an integrated part of Scandinavian culture and filmmakers could assume the audience's intimate knowledge of a poem such as "Terje Vigen." In Scandinavia in the 1910s, adapting Ibsen for the screen meant taking part in contemporary strategies for emphasizing the "local," or Scandinavian, in the establishment of a national cinema (Florin). Likewise, US films also differ from, for example, contemporary Italian cinema; the Ibsen adaptations produced there must be viewed in relation to specific national theater traditions, acting styles, and cinematic conventions like those of the "diva" picture (Alovisio).

I will begin this essay by briefly outlining the ways in which Ibsen has been discussed with regard to the film medium in terms of both historically specific and broadly ahistorical contexts. Then I will identify certain specific stylistic and narrative strategies in the four films, in particular those connected to space, narrative, and performance. Finally, I will consider several ethical and moral considerations associated with the Ibsen films, including both elements within the films and elements in their contemporaneous reception and discussion, contextualized in a specific period of US film history.

IBSEN, FILM HISTORY, AND CINEMA STUDIES

As a literary figure, Henrik Ibsen has not been particularly central in scholarly discussions on film. The most important exception might be the prominent role that *A Doll's House* (1879) plays in Stanley Cavell's analysis of the theme of "remarriage" and "the unknown woman" in classical Hollywood comedy and melodrama, respectively, in *Pursuits of Happiness* (20–24) and *Contesting Tears* (11, 85–87). Ibsen is often associated with values that have been central to norms in discourses on film, such as naturalism, characterization, and dramaturgy. He has not, however, been associated with modernity or visual media culture to the same degree as many of his contemporaries, most notably his Swedish rival, August Strindberg (Hockenjos). There are, nevertheless, some overt references to modern visual media in his plays: the role of photography in the exploration of truth and lies in *The Wild Duck* (1884), or *Peer Gynt*'s linking of the coexistence of a negative and positive image in the *daguerreotype* to the protagonist's waste of potential through his life choices (see Lien; Larsen). The suggestive images in much of Ibsen's work, in particular in his later plays, often invoking the gothic and the uncanny, have usually been read as symbols containing meanings that can be unlocked, rather than in terms of their power of visual suggestion, although there have also been arguments that these plays contain a kind of visual imagination, sometimes described as "cinematic" (Alnæs).

Scholarly discussions of Ibsen and cinema continually return to two pivotal observations. One is that although Ibsen was one of the most frequently staged dramatists of the world throughout the twentieth century, there have been few film adaptations from his works, compared to the wealth of Shakespearean adaptations and adaptations of

other theatrical and literary sources. The other is that most Ibsen adaptations have been artistic failures—with Sjöström's *Terje Vigen*, based on a poem, an important exception. These points also initiate most of the very limited discussions of Ibsen adaptations, which commonly take the form of attempts to explain why there are so few of them and why these few films are so unsuccessful (Engelstad; Ferguson).

The explanations, usually rooted in notions of medium specificity, point out how the established conventions of classical cinema are fundamentally different from those of Ibsen's stagebound drama. It is important to note, however, that most moving image Ibsen adaptations do not belong to what is often described as "classical cinema"—which in the most influential study on the topic (Bordwell, Staiger, and Thompson) is located in the period between 1917 and 1960—but rather to the transitional period directly preceding the classical era in US cinema. The period with the greatest number of film adaptations of his plays is the 1910s, followed by a revival in the genre of television theater during the 1950s and 1960s (Törnqvist). Between the mid-1920s and the 1970s, the period that constitutes the height of the classical era, there were practically no adaptations of Ibsen in Hollywood cinema, even though literary adaptations as such continued to be widespread.

This does not, of course, preclude an argument that might accentuate the difference between Ibsen and the conventions of classical cinema. One might in fact argue that this hiatus confirms such a thesis. Both the transitional cinema of the 1910s and television theater, however, are fundamentally dissimilar from classical cinema and are characterized by other sets of conventions, a more explicit affinity with the theater, distinctive and unstable forms of narration and audience address, and different ways of highlighting their intertextuality. Fluctuations in the interest in adapting Ibsen throughout the history of moving images remind us that exchanges between media must be understood through a framework of specific historical conditions, aesthetic ideals, and even partly specific social and cultural norms. Most discussions of early cinema are in fact precisely attempts to trace the origins of the new medium in the theatrical conventions that early cinema follows, transforms, or rejects.

The transitional period of US film history, generally defined as the period between 1907–8 and 1917, is characterized by fundamental changes in the industrial and economic structures of film production, distribution, and exhibition, as well the gradual and irregular transition from an attractions-based aesthetic to the narrative-based classical cinema (Bowser; Keil; Keil and Stamp). During this period, highbrow culture is often exploited for the sake of the cinema's artistic uplift and cultural prestige (Uricchio and Pearson; Buchanan 74–104). Cinema's relation to theater changes during this period. Sources for adaptations become more culturally ambitious, replacing what Tom Gunning has characterized as the "promiscuous intertextuality" of early cinema (130). There is an increase in the use of actors from the theater in the 1910s, especially in D. W. Griffith's Biograph films and pictures in the European Film d'Art tradition. Acting styles influenced by pantomime are gradually supplanted by a style associated with the psychological realism and naturalistic acting style of the "new drama." Ben Brewster and Lea Jacobs have argued that the influence of naturalistic acting techniques was not

as pronounced in this period as some researchers have asserted, in particular with regard to the restraining of "pictorial effects" in silent film acting: "Naturalist theatre was famously wordy, and to some extent the emphasis on the language compensated for the opacity of gesture and action typical of the acting style. It required considerable sophistication to adapt it to the new medium" (96). Many of the films from this period, including the four examined here, combine elements from a number of different acting styles. The most significant development of the transitional period is perhaps the transition from one-reel films to multi-reel films around 1913, resulting in longer films, more streamlined and less elliptical or condensed narratives, and greater affinity with the storytelling conventions of the theater and the novel (Frykholm). The profound changes in filmmaking within this relatively short period create huge differences among the four surviving US Ibsen films, all produced in the period of 1911–16. The multi-reel films from 1915–16 not only are considerably longer, but also have a much more complex editing structure than what Thomas Leitch calls the "one-reel epics" (22) typical of 1911. Different stylistic registers coexist in all four films, however, along with different indications of an intermedial impurity in the ways they convey the theatrical origins of the stories they tell and the different ways of marking intermedial negotiations between their literary or theatrical sources and the relatively new medium of cinema. Finally, when we talk about "cinema," it is less appropriate to refer to it in terms of what cinema is now than to what cinema was about to become in that historical moment.

Trade press and film discourses during the 1910s reveal that Ibsen was a recurring cultural reference, but also an ambivalent and paradoxical one. His realist aesthetic, his use of social themes, and his intricate and precise dramaturgy and plot construction are often noted as important sources of inspiration. At the same time, he is also considered old-fashioned. In several essays and reviews in *The Moving Picture World*, Louis Reeves Harrison associates Ibsen's plays with antiquated themes belonging to the nineteenth century. The gender politics of *A Doll's House* are outdated, a view Harrison shares with several contemporary film critics (see Hanssen, "*Doll's*"), and the handling of heredity in *Ghosts* is unscientific compared to early twentieth-century studies that accentuate the importance of the environment (Harrison, "*Ghosts*" 1439). Ibsen is consequently perceived as representing an aesthetic that should be avoided in cinema, as well as a set of social themes belonging to a distant past. His plays are widely understood as both a model and an antithesis of cinema's assumed medium specificity.

Harrison associates Ibsen with a specifically Scandinavian "gloominess," opposed to the American optimism that should characterize the new medium ("Creative Method" 1804). He finds Ibsen sometimes insularly Scandinavian in his themes, as when he calls the plot of *Pillars of Society* "intensely local" ("*Pillars of Society*" 1099). "Ibsenesque" is a recurring epithet in reviews of films during this period, especially if they feature a depressing atmosphere or a serious social theme. In these discourses, Ibsen is usually defined as an institutional figure and a general concept, rather than as the author of specific poems or plays.

Even so, Ibsen is associated throughout the period with highbrow culture, revealing one of the main objectives for making film adaptations in the 1910s: the opportunity to

attract new and more refined audiences to the cinema. In some of the films, the authorial figure is explicitly made visible. The 1915 *Ghosts* starts with the image of an actor posing as Ibsen (Figure 9.1), presented in an accompanying intertitle as a "life-like representation of the great poet and dramatist."

This emphasis on the visible presence of the author echoes similar practices in other cinematic adaptations of literary works. Most notably, Jack London personally appears in prologues to several adaptations of his novels during the 1910s, providing "a kind of guarantee of authenticity" (Bowser 206). Although it does not present a similar physical manifestation of the author, the 1916 version of *Pillars of Society* also begins with a title card introducing Ibsen, "considered by many the greatest modern playwright," and explaining how the play's idealist exploration of notions of truth is emblematic of his larger oeuvre.

The Swedish adaptation of *Terje Vigen* is famous for using direct quotations from the literary work, presented in fragments, in its intertitles, and self-consciously playing on this explicit fidelity to the original text (Hanssen and Rossholm). The US adaptation of *Ghosts,* on the other hand, takes great liberties with Ibsen's narrative and does not reproduce any of the original dialogue, with one exception: at the end of the film, one piece of dialogue, the most famous line from the play—"Mother, give me the sun!" [Gi meg solen, mor!"] is presented in an intertitle. Here the reference to the original literary text is undoubtedly more significant than the function of the intertitle within the narrative of the film's diegesis or fictional reality.

Ibsen adaptations often generate essentialist arguments on the differences between cinema and theater in contemporary reviews and film debate. In Vachel Lindsay's 1915 treatise, *The Art of the Motion Picture,* the chapter entitled "Thirty Differences between the Photoplay and the Stage" (108–17) uses the adaptation of *Ghosts* as its point of departure. Here, Lindsay emphasizes that Ibsen should be read aloud, that he

FIGURE 9.1 Ibsen impersonated at the opening of *Ghosts* (1915).

Frame enlargement from print held at the Library of Congress, Washington, DC.

primarily represents the spoken word, and that at the close of every act of his plays "one might inscribe on the curtain 'This the magnificent motion picture cannot achieve'" just as after every successful film "could be inscribed 'This the trenchant Ibsen cannot do.'" Elliott (27) has pointed out that the claims made by Lindsay in 1915 on adaptation between theater, literature, and cinema have been continually repeated in scholarly works on the topic, and are still often presented as new insights. Lindsay's opposition between Ibsen's theatrical aesthetics and the cinema is consequently typical not only of discourses on cinema in the 1910s, but also of attitudes enduring a century later.

CINEMATIC AND THEATRICAL
SPACE: NARRATIVE, LOCATION,
PERFORMANCE

Referring to Susan Sontag's contrasting of the logical, continuous space of theater and the illogical, discontinuous space of cinema (29), the Norwegian literary scholar Asbjørn Aarseth has argued that the use of what he terms the "narrow room" in Ibsen's drama functions as an obstacle for successful cinematic adaptations (40–45). Aarseth cites *Pillars of Society* specifically as an example of a play that it is troublesome to adapt, referring to what he calls Ibsen's "double stage." Here the field of action for the characters is limited, but a space outside is always implied. We hear that the protagonist has a spacious garden, but all the action takes place in a confined room, constraining the action. Here, according to Aarseth, Ibsen's critique of bourgeois ideals is represented spatially. *Pillars of Society* is in fact one of the plays most often adapted for the screen during the silent era,[2] and two of the four remaining US films are adaptations of this particular work: the earliest of the group, from 1911, and the latest, from 1916.

Aarseth's conception of Ibsen's double space and the emphasis on offscreen space in his plot construction and dialogue provide a useful point of departure for examining the negotiation and exchange between Ibsen's works and the cinematic conventions developed during the 1910s. The emphasis on offscreen space may also be understood as following the spatial logic often ascribed to cinema. André Bazin famously suggested that while the theater emphasizes the boundaries of the action, cinema denies these boundaries. According to Bazin, the cinema screen is based on the notion that something always exists outside the frame, a mask that hides more than it reveals. The energy of a film image is always directed outward, beyond the frame (193–95).

Like many films from the same time period, the one-reel 1911 adaptation of *Pillars of Society* is characterized by a visual organization in depth, an interplay between foreground and background action. Each scene is represented as a static take, and the position belonging to the camera and the audience functions as a stable fourth wall. This highly cinematic way of staging has obvious affinities with theatrical traditions that are underlined by the blocking of actors, who are often positioned

frontally toward the audience. The lack of dialogue allows parallel actions to take place simultaneously but also includes theatrical gestures that directly or indirectly acknowledge the presence of the audience in the terms of what André Gaudreault has characterized as the "monstration" of early cinema, an aesthetic of showing and presenting (81–89). During a long farewell scene toward the end of the film, Olaf, the son of Bernick, the protagonist of the play, has the idea of leaving home and hiding on a ship. We clearly see the boy, placed frontally, having the idea, even as his father is shown deep in thought and his wife and brother-in-law are saying goodbye (Figure 9.2). Later in the same scene, and the same take, we see the boy leaving, employing the theatrical gesture of shushing the audience (Figure 9.3). Finally, we view him further back in deep space, waving and blowing kisses, primarily to his parents, who do not see him, but also to the audience (Figure 9.4).

Similarly, the mental illness of Osvald in the *Ghosts* adaptation is displayed through an extensive display of dramatic and grotesque gestures, with the actor, Henry B. Walthall, who also had the leading role in *Pillars of Society* the following year, facing the fourth wall and the audience frontally the whole time (Figure 9.5).

Another even more obvious way of dealing with the "double stage" of Ibsen is to open the space up, folding it out, changing the nature of the narration to emphasize not the unity of time and space, with a backstory revealed through Ibsen's retrospective

FIGURE 9.2 Frontal positioning of actors addressing the audience in *Pillars of Society* (1911).
Frame enlargement from print held at the George Eastman Museum, Rochester, NY.

FIGURE 9.3 Actor shushing the audience in *Pillars of Society* (1911).

Frame enlargement from print held at the George Eastman Museum, Rochester, NY.

FIGURE 9.4 Actor waving to the audience in *Pillars of Society* (1911).

Frame enlargement from print held at the George Eastman Museum, Rochester, NY.

FIGURE 9.5 Oswald (Henry B. Walthall) breaking the fourth wall in *Ghosts* (1915).
Frame enlargement from print held at the Library of Congress, Washington, DC.

narrative technique, but the direct dramatic portrayal of events that were explained but never shown on stage. The backstory is folded out in both the one-reel 1911 version and the four-reel 1916 version of *Pillars of Society*. In fact, the majority of the action in both films consists of scenes that take place before the stage play begins. The deathbed scene of the actress, Lona, for example, is dramatized in both of the films, even though it is only mentioned in the play (Figures 9.6 and 9.7).

As is typical of the one-reel epic, the 1911 film features a fragmented narrative, a series of tableaux presenting dramatic highlights *in medias res* (the first intertitle of the film characteristically reads, "Bernick calls to break off an old love affair").

The narrative strategy of folding out the narrative also has very different implications in the one-reel film of 1911 and the four-reel adaptation of the same play five years later. As Leitch has shown (23–30), normalizing the chronology of the plot in favor of the Aristotelian unity of the play was also a widespread practice in early one-reel Shakespearean adaptations. The limited format of the one-reel film also entailed an aesthetic of the tableau, an elliptical narrative composed of a selection of singular moments. According to Leitch, the one-reel adaptation thus could function as a kind of illustration whose purpose was to "embellish the existing text rather than replace it" (29). Such a strategy relied on the audience's knowledge of the original work and their ability to supply a sense of narrative continuity to the fragmented plot presented in the film. Ibsen's status as "highbrow" culture, however, was in part associated with his works not being very well-known among general audiences, as illustrated by this passage from a 1911 review of the Thanhouser production:

> Ibsen is the typical representative of the ultra high-browed drama. An Ibsen play advertised for performance in a legitimate theater is enough to send orthodox play-goers running in the opposite direction. To find an Ibsen drama under the guise of

FIGURE 9.6 The death of Lona in *Pillars of Society* (1911).
Frame enlargement from print held at the George Eastman Museum, Rochester, NY.

FIGURE 9.7 The death of Lona in *Pillars of Society* (Walsh, 1916).
Frame enlargement from print held at the Library of Congress, Washington, DC.

a photoplay circulating freely and cordially among the theaters of the presumably "low-browed," is surely a piquant situation. In this case the ignorance of the low-browed seems to consist simply in an ignorance of the conventional attitude toward Ibsen; being unaware of the Ibsen bug-bear, they accept his drama without prejudice and enjoy it according to its merits. A low-browed attitude, indeed! (Crippen 131)

Later Ibsen adaptations, benefiting from longer running times, also became less elliptical but continued the tradition of folding out the narrative. In the 1916 *Pillars of Society* we get more than halfway into the third of the four reels before the film picks up where the play begins, fifteen years after the first scene in the film takes place. Ibsen adaptations of the mid–1910s were consequently often criticized for being overly plotted; a review of the 1916 adaptation described the film as having "seven fathoms of plot and about half an inch of characterization" (Johnson 86).

In addition to the reorganization of plot elements, several cinematic devices for representing simultaneity typical of the period are integrated into Ibsen's stories. In the 1915 film version of *Peer Gynt*, the well-established convention of 1910s cinema, the split screen, shows us the aging protagonist in the desert dreaming of his love Solveig, along with the image of his love interest waiting for him in Norway (Figure 9.8).

FIGURE 9.8 Split-screen connecting Peer in the American desert and Solveig at home in Norway in *Peer Gynt* (1915).

Frame enlargement from print held at the Library of Congress, Washington, DC.

In the 1916 *Pillars of Society*, two spaces are similarly linked through the telephone, the editing being structured by communication media, following a widespread trope of the period (Olsson). The plot in *Ghosts* is also constructed in order to integrate the mid-1910s convention of the last-minute rescue scene using parallel editing into the film. The family doctor who has replaced Ibsen's character of Pastor Manders learns that Oswald is going to marry a girl that only the doctor knows is his half-sister. He finds out from a telegram while he is away on a fishing trip and hurries home. What follows is a typical gradually accelerating alternation between images of the doctor on his way back home and the preparations for the wedding—until the doctor at the last minute is able to stop the wedding ceremony (Figures 9.9 and 9.10).

Another distinctive spatial feature of the cinema in the 1910s that is integrated into the Ibsen adaptation is the increasing emphasis on location shooting in fiction films. This is particularly evident in the adaptation of *Peer Gynt*. Ibsen's verse play had been notoriously difficult to stage, moving freely from one location to the other, and the trade press frequently contrasted the expansive possibilities of screen space with the limitations of stage space. During the production of the film, several news articles reported on location shooting in Catalina Island, Imperial Valley, Sierra Madre, and the San Bernardino mountains. What was described as "the world wanderings of a poet-souled adventurer" played by Cyril Maude, another famous stage actor, apparently gave the moving picture

FIGURE 9.9 The family doctor on his way to church in *Ghosts* (1915).

Frame enlargement from print held at the Library of Congress, Washington, DC.

FIGURE 9.10 The family doctor stopping the wedding at the last minute in *Ghosts* (1915).

Frame enlargement from print held at the Library of Congress, Washington, DC.

an opportunity to present "typical scenes of clime and people" ("'Peer Gynt' with Cyril Maude in Films" 310).

The attraction of including exotic locations in the film thus also gives way to ethnic and gender stereotypes. Paramount's advertisement in *Moving Picture World* announced that the film presented "Ibsen's most human hero in a series of dramatic love episodes with five different types of the world's most beautiful women." The exoticization of land-scapes and female beauty renders problematic the film's display of ethnicities, which includes stereotypical depictions of Native Americans, Arabs (Bedouins), and African Americans (Figure 9.11).

The first kind of exotic location and female type depends on the highlighting of Norwegian whiteness. The beginning of the film emphasizes Norwegian folklore and cultural tradition in terms similar to those of Norwegian silent cinema (Myrstad, "*Fante-Anne*"), through the emphasis on traditional clothing and cultural rituals, such as a folk dance during the wedding scene (Figure 9.12).

In Paramount's four-page advertisement for the film, the depiction of folklore takes part in a broader discourse of authenticity in the promotional material for the film through the claim that the dress worn by Myrtle Steadman, who played Solveig, was made by a Norwegian woman. Ibsen's play is a highly intertextual work, a drama about storytelling, a fragmented, proto-modernist text packed with quotations from and

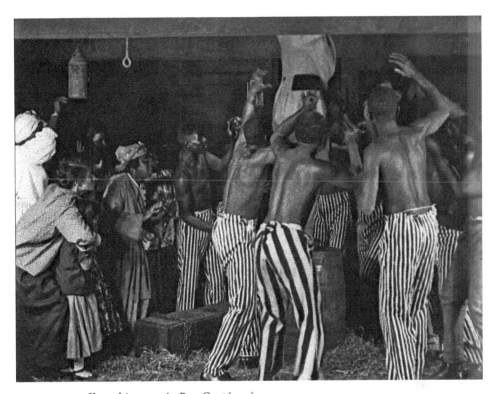

FIGURE 9.11 Slave ship scene in *Peer Gynt* (1915).

Frame enlargement from print held at the Library of Congress, Washington, DC.

FIGURE 9.12 Wedding scene in *Peer Gynt* (1915).

Frame enlargement from print held at the Library of Congress, Washington, DC.

references to, among others, Norwegian folk tales, Goethe's *Faust*, contemporary philosophy, and the Bible. Appropriately, the first image of the film shows a book page illustration featuring Norwegian trolls, emphasizing the influence of Norwegian folk tales on both the protagonist and Ibsen himself (Figure 9.13). The protagonist is described in the intertitles as a "lazy dreamer" who "has become the jest of the community by his tales of supernatural adventure, induced by constant reading of Norwegian folk lore."

The prominence of location shooting highlights the film's status as a specifically US adaptation. Hutcheon has argued that in the case of Hollywood adaptations, "transculturating usually means Americanizing a work" (146), and this is also pertinent to the early example of *Peer Gynt*. Instead of traveling to Morocco, as in the play, Peer travels to North America, and the film becomes a display of US locations, US historical conditions, cultural traditions, and ethnic relations. This also gives the film an opportunity to introduce traditional cinematic genre elements to the story.

At this point in the film, a number of storylines and characters are invented without any particular source in Ibsen's play. Peer becomes a hunter and fur dealer in the United States and is courted by Notanah, a "half-breed," and then is introduced to her Native American tribe before the film reveals that she is a fur thief (Figure 9.14), a complication that eventually leads to a dramatic canoe chase scene.

FIGURE 9.13 The first image of *Peer Gynt* (1915): a book page illustration of Norwegian trolls.
Frame enlargement from print held at the Library of Congress, Washington, DC.

FIGURE 9.14 Peer learns that the Native American "half-breed," Notanah, is a fur thief in *Peer Gynt* (1915).

Frame enlargement from print held at the Library of Congress, Washington, DC.

In the play, Peer's career as a slave trader is only mentioned, but in the film it is drama-tized and set in the southern United States (five years after the sequence showing his life as a hunter, according to an intertitle). Here the protagonist falls in love with a wealthy plantation owner's daughter, a traditional costume drama about rivalry is established, and a duel ensues. Then he is exposed as a slave trader by a woman who has pretended to flirt with him but who reveals herself as undercover agent Annabelle Lee of the Secret Service (Figure 9.15). Hired to shadow Peer, she tricks him into disclosing his occupa-tion aboard one of his ships, leading to another dramatic action sequence in which Peer manages to escape by jumping off the vessel.

Thus the film presents a burlesque of Ibsen's story adapted to US locations, histori-cal events, ethnic diversity, and conflict typical of many other instances of contempo-rary popular US cinema: the treatment of native Americans, the slave trade, and the system of law enforcement. The liberties taken with the plot in this film in particular illustrate the conflict arising from the attempt to combining highbrow cultural tradi-tions with a popular cultural medium. This conflict is noted humorously in the trade press when it observes that exhibitors have advertised the 1918 adaptation of *A Doll's House* as a "treat for kiddies" or reports under the heading "Syncopating a Viking" that

FIGURE 9.15 Peer and undercover Secret Service agent Annabelle Lee in *Peer Gynt* (1915).

Frame enlargement from print held at the Library of Congress, Washington, DC.

some screenings of the 1917 adaptation of the same play are accompanied by a local jazz band ("Close-Ups" 54).

The main challenge for the Ibsen adaptation, however, seems not to be linked to formal or stylistic choices. The debate on film adaptations of sources from more established art forms in the 1910s is not only preoccupied with cultural and aesthetic ideals, but also certain moral ideals, and here Ibsen, with the inherent moral ambiguity in several of his plays, becomes problematic.

Uplift, Censorship, and Moral Ambiguities

Ibsen may have been considered high art, but he was also a highly controversial author. *Ghosts* was censored in several countries, and an alternative ending to *A Doll's House* in which Nora returns to her husband was written for the first German performances of the play.

In addition, these particular films take part in a specific institutional discourse. The ambition to increase cinema's cultural status and attract more refined audiences during the transitional period is, among other things, a response to a broad discussion about cinema and censorship, the need to control and police the new medium, and the consequent emergence of different state laws as a method for dealing with the prevalent conception of movie theaters as "recruiting stations of vice" (Bowser 37–52).

Again, trade press discourse situates the film medium in a specifically American tradition, based on values of optimism and freedom, in contrast to the more dubious values espoused by certain European authors. In a piece called "Avoid Crime and Carrion," W. Stephen Bush writes:

> The modern American stage is comparatively free from crime and the successful playwright of the day is the one who scrupulously eschews crime in the preparation of his plot. We might learn from these men. Even where they paint the darker sides of life and seek to illustrate its sinister forces it is almost always against an optimistic background. The few exceptions like Zola, Ibsen, Nietzsche, prove the prevailing rule of modern dramatic endeavor. It is unfortunate that such highly gifted minds suffer from such obliqueness of vision seeing nothing but the evil, the abnormal, the degenerate and the repellant in life. However, philosophic pessimism is not among the faults of the motion picture and we may well be thankful for that. It is one of the instances where intellectual limitation is a distinct blessing without any disguise whatever. (25)

The benefits of the "intellectual limitation" Bush identifies—cinema's limited interest in exploring dark and problematic aspects of individuals or society—are here explicitly contrasted with Ibsen, whose status as a literary classic was based to a large extent on controversy and moral ambiguity, distinctive characteristics that film adapters during this period were attempting to avoid, even actively resist.

Pillars of Society (Figure 9.16) is not merely the Ibsen play that is most often adapted in US silent cinema. It is also the play in which the author himself most explicitly addresses ideas about America. As in many other European literary texts from the nineteenth century, the New World is associated with new beginnings, hard work, and greater tolerance, an escape from oppressive Scandinavian and European moralism and puritanism. Ironically, when US cinema adapts this story and other plays with similar themes, they are largely transformed into cautionary tales of European decadence, Bohemian lifestyles, unhealthy alcohol consumption, and the morbidity and tragic consequences of such a lifestyle. This turn gives the filmmakers the opportunity for vivid depictions of Bohemian life, especially lavish and titillating party scenes, followed by portrayals of the misfortune that inevitably ensues.

In Britain, the 1915 US adaptation of *Ghosts* was retitled *The Inherited Burden*, further accentuating the film's narrative as a cautionary tale about alcoholism. An advertisement in the British fan magazine *Pictures and the Picturegoer* even refers to a "Private Screening to the Medical Profession," listing the names of seven of the doctors or

FIGURE 9.16 Decadent Paris lifestyles in *Pillars of Society* (1916).

Frame enlargement from print held at the Library of Congress, Washington, DC.

"eminent gentlemen" present who, according to the advertisement, were "unanimous in their praises" of the film (Dominion 379).

While the majority of the performers in the 1911 film are anonymous, the adaptations from 1915–16 are characterized by the emergence of the star system. *Ghosts* (1915) and *Pillars of Society* (1916) were marketed not only as Ibsen adaptations but as star vehicles for Henry B. Walthall, an actor associated with the grotesque and macabre, in particular because of the 1914 Poe adaptation *The Avenging Conscience*. An interview, with Walthall ironically describing *Ghosts* as "Ibsen's sweet little pastoral" (Cohn 30), seems to link the play to a similar aesthetic. The presence of Walthall serves as an intertextual link between *Ghosts* and *Pillars of Society*. In the former, he plays both Osvald and Osvald's father, serving alcohol to his young son (Figure 9.17).

Walthall's characterization of Bernick's personality is revealed equally early on in *Pillars of Society* when we see him reading Frank Berkeley Smith's 1903 book *How Paris Amuses Itself*, featuring images of half-dressed women, and packing the volume in his bag on the way to the French capital. When his mother gives him another book, which in close-up is revealed as *The Holy Bible*, he reluctantly brings that with him as well.

Ibsen's characters have often carried out illegal or immoral acts (forgery in *A Doll's House*, false testimony in *Pillars of Society*, adultery in *Ghosts*) whose revelation

FIGURE 9.17 Oswald's father (Henry B. Walthall) serving alcohol to his young son in *Ghosts* (1915).

Frame enlargement from print held at the Library of Congress, Washington, DC.

sometimes prepares for redemption. In the last scene of *Pillars of Society*, Bernick reveals his dark secret. In Ibsen this scene is depicted as a kind of salvation in which the truth sets him free. In the incomplete surviving print of the 1911 film version, this revelation evidently emphasizes instead Bernick's humiliation, shame, and loss of social status. As in the play, the crowd leaves in disappointment after Bernick "confesses his life's lie" (here the intertitle alludes to *The Wild Duck*), and Bernick sits down, covering his face. The final images of the film are apparently lost, and while a trade press synopsis suggests that the film ends with Bernick being forgiven by his wife, "in the fullness of her love" ("Manufacturers" 15), a "film chart" for distributors, valuing the "educational track" of the film, simply lists the "moral" of the film as "Let the guilty take their blame" ("Film Charts" 19).

Similarly, the Christian motifs in *Peer Gynt* (Figures 9.18 and 9.19) are highlighted in the film adaptation. The last act's theme of being true to oneself and fulfilling one's potential is reduced to a problematic opposition of good and bad moral conduct. The Button Moulder's Christlike affinities are made explicit in the film, which gives him a visual appearance modeled on the iconography of Jesus and presents several scenes displaying the character in a celestial space, even including a scene in Heaven with the Button Moulder and Saint Peter scrutinizing Peer's good and bad deeds in a big

FIGURE 9.18 The Button Moulder as Christ-like figure in *Peer Gynt* (1915).

Frame enlargement from print held at the Library of Congress, Washington, DC.

FIGURE 9.19 Saint Peter and the Button Moulder in Heaven in *Peer Gynt* (1915).

Frame enlargement from print held at the Library of Congress, Washington, DC.

book (Figure 9.19). It turns out that he has only done one good deed in his life: "He went to church . . . once," the book tells us.

These changes are not the result of differences in any essential properties between theater and film, in a formal or stylistic sense. They are more likely the result of specific cultural conditions, contemporary film debate—and the actual purpose of making adaptations of highbrow sources in the first place. It is also here that the problem of the Ibsen adaptations become evident: the status of Ibsen's works as classic was achieved through means that to some degree stand in opposition to one of the main purposes of film adaptations: the cultural uplift of the medium.

The strategies described earlier were harshly criticized in contemporary debate. William Marion Reedy's 1915 review of *Ghosts* argued that adapting the play to the well-established moral and aesthetic conventions of contemporary cinema demanded that "the whole *motif* of the work of art is destroyed" and "its moral inexcusably twisted":

> The movie makes the piece a gob of antidrink propaganda. The Ibsen drama makes the mother poison her son to save him. The movie makes the son wriggle and crawl all over the place to get the poison from the top of the ice-box, while the mother and the physician race to the house to save him, but arrive too late. All the meaning there is in "Ghosts" is utterly killed in its movie form. It is debased to the most sensational kind of yellow drama. The thing is an egregious sin against the art of Ibsen, and it is utterly disgusting to any one who has seen or read the great play. (591)

Reedy goes on to distinguish between the censorship carried out by the film industry, which "passes the most execrable rubbish and sends it out under the name of some play that won favor because of its intellectual or spiritual content," adding cinema's need for "an esthetic censorship" (592).

Similarly, in a satirical piece titled "Emasculating Ibsen," Margaret Anderson mocks the way the film version of *Ghosts* associates Ibsen with a Prohibitionist agenda through a letter written by a fictional audience member, telling the author her plan to establish the "West Side Ibsen Prohibition Club." In a footnote to the letter, the author remarks: "The wet nurses who minister to the mob have put our old friend Ibsen into diapers and give him to their patients to play with. The cherubic little fellow is kicking up his dimpled heels and thriving well in all the movie houses" (36). Attempts to adapt Ibsen into US cinema of the 1910s faced many challenges: a lack of familiarity with general audiences, difficulties in negotiating with the aesthetics of the theater, and texts brimming with unwelcome moral transgressions and ambiguities. Ibsen adaptations in the silent period in many cases also seem to have been perceived as an uneasy mix of social realism and Film d'Art.

Looking back twenty years later, Erwin Panofsky claims that the tradition of so-called quality films represented the first conscious attempt to transplant films from the "folk art level to that of real art," but adds that "they also bear witness to the fact that this commendable goal could not be reached in so simple a manner" (71). It is no wonder that, as Rob King has pointed out (115), these adaptations were to a large extent commercial failures. Highbrow elements did not change cinema or the taste of cinema audiences;

instead, the mass medium of cinema, and consumer culture in general, took part in changing the tastes and aesthetic and moral ideals of the middle and upper classes. Similarly, attempts to define cinema as an art form emerging in the avant-garde discourses of the late 1910s and throughout the 1920s placed the realist theater and literature associated with Ibsen in direct opposition to the cinematic, relegating borrowings from such sources to a middlebrow aesthetic with which film adaptations of classical literature are still associated (Naremore 6).

Even though they might be characterized as unsuccessful either as artworks or as strategies for the uplift of cinema, what remains fascinating about the Ibsen adaptations of this crucial period is how they make visible cinema's negotiation with other more established media and cultural and social norms at a time when the notion of what a film is and should be is constantly contested and redefined.

Notes

1. A print of *The Pillars of Society* (1911) is held at the George Eastman House in Rochester, NY, as well as the National Library of Norway, Mo i Rana. Prints of *Ghosts* (1915), *Pillars of Society* (1916), and *Peer Gynt* (1915), the latter incomplete and partly deteriorated, are held at the Library of Congress in Washington, DC.
2. A British adaptation of the play from 1920, directed by Rex Wilson, and produced by the R. W. Syndicate, was filmed in the Norwegian town of Grimstad, where Ibsen lived and worked as an apprentice pharmacist from 1843 to 1847. Detlef Sierck, later more well-known as Douglas Sirk, directed a 1935 German film adaptation of the play, *Stützen der Gesellschaft*.

Works Cited

Aarseth, Asbjørn. "Drama in the Narrow Room: Teichoscopy as a Constitutional Difficulty in the Ibsen Film." *Ibsen on Screen*. Ed. Jan Erik Holst and Astrid Sæther. Oslo: Norsk filminstitutt, 2000. Print.

Alnæs, Karsten. "Footlights to Film." *Scandinavian Review* 66.4 (1978): 67–71. Print.

Alovisio, Silvio. "Another Hedda. Pastrone Interprets Ibsen. *Hedda Gabler:* A Cinematographic Fragment of 1920." *NorthWest Passage*, no. 4 (2007): 189–211. Print.

Anderson, Margaret. "Emasculating Ibsen." *Little Review* 2.5 (1915): 36. Print.

The Avenging Conscience: or "Thou Shalt Not Kill." Dir. D. W. Griffith. Perf. Henry B. Walthall, Spottiswood Aitken. Majestic, 1914. Film.

Bazin, André. "Theatre and Cinema (2)." 1951. *What Is Cinema?* Ed. and trans. Timothy Barnard. Montreal: Caboose, 2009. Print.

Bordwell, David, Janet Staiger, and Kristin Thompson. *The Classical Hollywood Cinema: Film Style and Mode of Production to 1960.* London: Routledge, 1985. Print.

Bowser, Eileen. *The Transformation of Cinema, 1907–1915.* Berkeley: U of California P, 1990. Print.

Brewster, Ben, and Lea Jacobs. *Theatre to Cinema: Stage Pictorialism and the Early Feature Film.* Oxford: Oxford UP, 1997. Print.

Buchanan, Judith. *Shakespeare on Silent Film: An Excellent Dumb Discourse.* Cambridge: Cambridge UP, 2009. Print.

Bush, W. Stephen. "Avoid Crime and Carrion." *Moving Picture World* 15 (4 Jan. 1913): 24–25. Print.

Cavell, Stanley. *Contesting Tears: The Hollywood Melodrama of the Unknown Woman*. Chicago: U of Chicago P, 1996. Print.

———. *Pursuits of Happiness: The Hollywood Comedy of Remarriage*. Cambridge: Harvard UP, 1981. Print.

"Close-Ups: Editorial Expression and Timely Comment." *Photoplay* 12 (Sept. 1917): 54. Print.

Cohn, Alfred A. "The Reformation of 'Wally'" [interview with Henry B. Walthall]. *Photoplay* 13 (Dec. 1917): 31. Print.

Crippen, James B. "Progress among the Independents." *Motography* 5 (June 1911): 131. Print.

Dominion Exclusives Co. Advertisement for *The Inherited Burden* [*Ghosts*, 1915]. *Pictures and the Picturegoer* 9 (14 Aug. 1915): 379. Print.

Elliott, Kamilla. "Theorizing Adaptation Studies/Adapting Theories." *Adaptation Studies: New Challenges, New Directions*. Ed. Jørgen Bruhn, Anne Gjelsvik, and Eirik Frisvold Hanssen. London: Bloomsbury, 2013. Print.

Engelstad, Audun. "Hedda Gabler i Hollywood." *Rushprint* 41.1 (2006): 36–39. Print.

Ferguson, Robert. *Ibsen på film*. Oslo: Norsk Filminstitutt, 2006. Print.

"Film Charts." *Moving Picture News* 4 (6 May 1911): 19. Print.

Florin, Bo. *Den nationella stilen: studier i den svenska filmens guldålder*. Stockholm: Aura förlag, 1997. Print.

Frykholm, Joel. *Framing the Feature Film: Multi-Reel Feature Film and American Film Culture in the 1910s*. Diss., Stockholm U. 2009. Print.

Gaudreault, André. *From Plato to Lumière: Narration and Monstration in Literature and Cinema*. Toronto: U of Toronto P, 2009. Print.

Ghosts. Dir. George Nichols and John Emerson. Perf. Henry B. Walthall, Mary Alden. Majestic, 1915. Film.

Gunning, Tom. "The Intertextuality of Early Cinema: A Prologue to *Fantômas*." *A Companion to Literature and Film*. Ed. Robert Stam and Alessandra Raengo. Malden: Blackwell, 2004. 127–43. Print.

Hansen, Karin Synnøve, ed. *Henrik Ibsen, 1828–1992: En filmografi*. Oslo: Norsk Filminstitutt, 1992. Print.

Hanssen, Eirik Frisvold. "*A Doll's House* and the Performance of Gender in American Silent Cinema." *Screening the Past*, special dossier: "Women and the Silent Screen: Performance and the Emotions." Ed. Victoria Duckett and Susan Potter, 2015. Web. 3 Aug. 2015.

Hanssen, Eirik Frisvold, and Anna Sofia Rossholm. "The Paradoxes of Textual Fidelity: Translation and Intertitles in Victor Sjöström's Silent Film Adaptation of Henrik Ibsen's *Terje Vigen*." *Translation, Adaptation and Transformation*. Ed. Laurence Raw. London: Continuum: 2014. 145–61. Print.

Harrison, Louis Reeves. "Creative Method—Ibsen." *Moving Picture World* 29 (16 Sept. 1916): 1804. Print.

———. "*Ghosts*" [film review]. *Moving Picture World* 24 (29 May 1915): 1439. Print.

———. "*Pillars of Society*" [film review]. *Moving Picture World* 29 (12 Aug. 1916): 1099. Print.

Hockenjos, Vreni. *Picturing Dissolving Views: August Strindberg and the Visual Media of His Age*. Diss., Stockholm U, 2007. Print.

Hutcheon, Linda, with Siobhan O'Flynn. *A Theory of Adaptation*. 2nd ed. London: Routledge, 2013. Print.

Johnson, Julian. "The Shadow Stage." *Photoplay* 11 (Nov. 1916): 79–87. Print.

Keil, Charlie. *Early American Cinema in Transition: Story, Style, and Filmmaking, 1907–1913*. Madison: U of Wisconsin P, 2001. Print.

Keil, Charlie, and Shelley Stamp, eds. *American Cinema's Transitional Era: Audiences, Institutions, Practices*. Berkeley: U of California P, 2004. Print.

King, Rob. "1914: Movies and Cultural Hierarchy." *American Cinema of the 1910s: Themes and Variations*. Ed. Charlie Keil and Ben Singer. New Brunswick: Rutgers UP, 2009. 115–38. Print.

Larsen, Peter. *Ibsen og fotografene: 1800-tallets visuelle kultur*. Oslo: Universitetsforlaget, 2013. Print.

Leitch, Thomas. *Film Adaptation and Its Discontents: From* Gone with the Wind *to* The Passion of the Christ. Baltimore: Johns Hopkins UP, 2007. Print.

Lien, Sigrid. "*The Wild Duck* and Other Stories: The Discourse of Photography in Nineteenth Century Norway." *Konsthistorisk tidskrift/Journal of Art History* 74.2 (2005): 82–95. Print.

Lindsay, Vachel. *The Art of the Moving Picture*. 1915; rpt. London: Random House, 2000. Print.

"Manufacturers' Synopses of Films." *Moving Picture News* 4 (22 Apr. 1911): 15. Print.

Myrstad, Anne Marit. "*Fante-Anne*: Det nasjonale gjennombrudd i norsk film." *Nærbilder: Artikler om norsk filmhistorie*. Ed. Gunnar Iversen and Ove Solum. Oslo: Universitetsforlaget, 1997. Print.

Naremore, James, ed. *Film Adaptation*. New Brunswick: Rutgers UP, 2000. Print.

Olsson, Jan. "Framing Silent Calls: Coming to Cinematographic Terms with Telephony." *Allegories of Communication: Intermedial Concerns from Cinema to the Digital*. Ed. John Fullerton and Jan Olsson. Bloomington: Indiana UP, 2004, 157–92. Print.

Panofsky, Erwin. "Style and Medium in the Motion Pictures." 1934, rev. 1947; rpt. in *The Visual Turn: Classical Film Theory and Art History*. Ed. Angela Dalle Vacche. New Brunswick: Rutgers UP, 2003. 69–84. Print.

Paramount Pictures advertisement for *Peer Gynt*. *Moving Picture World* 25 (11 Sept. 1915): 1780. Print.

Paramount Pictures four-page advertisement for *Peer Gynt*. Samson de Brier collection, Margaret Herrick Library, AMPAS Library, Los Angeles. 1915. Print.

Peer Gynt. Dir. Oscar Apfel. Perf. Cyril Maude, Myrtle Stedman. Oliver Morosco, 1915. Film.

"'Peer Gynt' with Cyril Maude in Films." *Moving Picture World* 25 (10 July 1915): 310. Print.

Pillars of Society. Prod. Edwin Thanhouser. Perf. Martin Faust, Julia M. Taylor. Thanhouser. 1911. Film.

Pillars of Society. Dir. Raoul Walsh. Perf. Henry B. Walthall, Mary Alden. Fine Arts, 1916. Film.

Reedy, William Marion. "Movie Crimes against Good Taste." *Literary Digest*, 18 Sept. 1915: 591–92. Print.

Sontag, Susan. "Film and Theatre." *Tulane Drama Review* 11.1 (1966): 24–37. Print.

Terje Vigen. Dir. Victor Sjöström. Perf. Victor Sjöström, August Falck. Svenska Biografteatern AB, 1917. Film.

Törnqvist, Egil. *Ibsen, Strindberg and the Intimate Theater: Studies in TV Presentation*. Amsterdam: Amsterdam UP, 1999. Print.

Uricchio, William, and Roberta Pearson. *Reframing Culture: The Case of the Vitagraph Quality Films*. Princeton: Princeton UP, 1993. Print.

INTERSHIP

Anachronism between Loyalty and the Case

MIEKE BAL

INTRODUCTION: TWO PROBLEMS, TWO SOLUTIONS, AND A CASE

IN a book conceived as a guide, the introduction guides (-*duction*) inside (*intro-*); each article is a guide to a specific aspect of the problematics of adaptation. So let me guide you inside the problem and my proposal. For this article (only), I propose to suspend the term "adaptation" and replace it with "intership." That noun brings together all activities qualified with the preposition *inter-*, from interdisciplinary to intertextual, international, intermedial, intercultural, to interdiscursive. *Inter-* means between. It denotes a willingness to exchange on an equal basis.

The well-known problem with "adaptation" is that the word is fraught with normative assumptions. Even if many of these have been critiqued and dismissed, I am not sure the word best indicates the relationships between texts in an interdiscursive, intermedial, international, and intertemporal perspective. While agreeing with objections mounted against some assumptions, I contend there may be valid reasons for their resilience. Take fidelity and the single-case comparative analysis. Both have to do with temporality.

After Thomas Leitch's 2003 decisive article, "Twelve Fallacies in Contemporary Adaptation Theory," it should no longer be necessary to beat the dead horse of fidelity. Yet adaptation implies comparison, and comparison implies standards, grounds of comparison. Nor is the one-to-one comparison of novel and film the only model for adaptation studies, as Linda Hutcheon and many others have argued. Yet, the one-to-one is still a strong part of it, because of the renewed, productive interest in case studies and close reading. Hence, I'd say to those who just wish to dismiss these starting points and the assumptions they harbor: "not so fast."

Rather than dismiss these tenacious assumptions, I look for solutions in a rephrasing and reorientation of the problematic notions. This entails a cautious generalization concerning intership that, in turn, serves as a frame for my plea for anachronism as a guide for assessing the loyalty, or friendship, between an adaptation and its source. But after pleading for singularization so that the artworks can participate in the relationship, I will go back and forth between general considerations and a single case. My case concerns a film based on a classic novel. I was one of two makers of this film. But Michelle Williams Gamaker and I, as makers of *Madame B*—a film and video installation project based on Flaubert's novel—have resisted calling this an adaptation to avoid the misunderstandings the term entails.

The 96-minute film extracts the unhappy story of Emma B from its historical setting, where it had been safely ensconced for so long. Thus we perpetuate the sin of anachronism. This is necessary out of loyalty to the novel. Anachronism—going against chronology—is a historical error. Chronology is sacred in the study of art. Especially in art history, anachronism is heresy.

Historians think of anachronism as the worst mistake; they are not wrong. Anachronism as unreflective impulse projects a contemporary vision on a past for which that vision could not exist, and hence cannot be relevant. This problem of unreflected anachronism is gauged in relation to an expectation that a reconstruction of the past with its own values and meanings is possible—a dubious assumption. Nevertheless, such projections are historically naïve and hamper insight into the past one seeks to understand. Anachronism flattens time, makes everything resemble the present, and thus clouds the original texts with irrelevant considerations. Often, such criticisms are justified. Not always.

A curator once said that a self-portrait by Rembrandt was "not consistent with Rembrandt's concept of self" and therefore de-attributed it. Here, anachronism clouds judgment. The anachronism lies in the assumed psychological and philosophical unity of Rembrandt's self-portraiture. Rembrandt depicted his face in idealization, caricature, and play-acting, and in different media, from elaborate paintings to quick sketches and etchings. As he foregrounded the mirror effect of self-portraiture and thus the fictional, deceptive nature of it as a depiction, he cannot be assumed to have limited the portraiture of which he was the model to a single "concept of self." In addition to his taste for experimentation, such a notion was not around in his time.[1]

Loyalty and the Case Study

Here is another instance of an anachronism committed out of fidelity, this time in an adaptation. I compare and judge. Claude Chabrol's legendary fidelity to Flaubert in his 1991 *Madame Bovary* leads to at least one mistake that goes against the grain of the text. To deal with the writer's reluctance to use dialogue, he introduces a narrator, a Flaubert look-alike. This is a primary mistake: narrator and author cannot

be confused, especially given a narrator who moves so fast between irony and empathy. A desire for fidelity makes Chabrol reluctant to let go of the famous narratorial sentence "La conversation de Charles était plate comme un trottoir de rue" [Charles's conversation was flat like a sidewalk]. True, the narrative sentence is superb. So he makes Charles say something silly, like "It's going to rain. . . ." Since Flaubert doesn't quote Charles, any platitude is as good as any other. Then the narrator, who has no business being present at the scene, pronounces the famous comparison, and Charles continues: " . . . I think." Ridiculing Charles is one thing, even if it is already a misreading, but making the narrator overrule the character in this intrusive way is another. Interrupting Charles's boring remark, thus making it ironic, obliterates Flaubert's relentless, continuous reiteration of clichés, to the point of exasperation. The fidelity here leads to gross infidelity.

Most of the novel's many film adaptations are unsuccessful, even those made by such brilliant directors as Jean Renoir (1933), who had to shorten to the point of incoherence; Vincente Minelli (1949), subject to postwar censorship in the United States, obliterating what Flaubert included in his wish to scandalize by saying what, rather than adulterous sex, was really sordid; Alexander Sokurov, whose *Save and Protect* (1989) seems too long and slow, too loyal to a kind of writing that is not an equivalent of film; and Chabrol, whose film suffers from a misconstrued historical fidelity and didactic casting. It is implausible that Emma would fall for any of the three men, an unattractive bore, a fool, and an empty-headed, featureless *coquet*. Arturo Ripstein's 2011 black-and-white film *Las razones del Corazón* develops a post-story set in a working-class environment. This is no longer an adaptation but a sequel. Sophie Barthes' 2014 film is yet another Hollywood costume drama, beautifully crafted. The costumes are so gorgeous that the element "costume" in the film distracts from the element "drama." As a result, there is no enticement for viewers to empathize nor to criticize, let alone to do both at the same time. These films disappoint because they adhere more closely to the story—events, characters—than to the storytelling and its specific dynamic. Chabrol *illustrates* the famous sentence, and illustration is not intership.[2]

Confusing visuality with concrete images, the most spectacular scenes are elaborated in these films—the Ball at the Vaubyessard Castle and its *Vicomte*; Emma's wedding dress caught in thistles; the ride with Léon in the fiacre; Emma's agony—but not the way these images are being visually told. Most deplorably, the acute contemporaneity of Flaubert's novel is erased. The genre of the historical costume drama makes the films anachronistic in the more traditional, negative sense. For, paradoxically, the attempt to avoid anachronism by turning "historical" makes the films anachronistic in an unavowed, hence pernicious way. Projecting on the past our conception of what today we assume it was is an inevitable and unreflective lie.

In contrast, a dialogue with a past we know was there but cannot be "restored" is a productive deployment of anachronism as a figure of intertemporal thought: an "intership." Flaubert wrote his novel in a strong and critical contemporaneity. The historicity of the cinematic images of the *Madame Bovary* films thus obliterates from the novel its

own historicity, substituting for it a theatrical mask that puts everything at a distance. Flaubert did the opposite. The confusion of language that makes the question "who speaks" unanswerable was also a way of staying close to the words perceived, understood, and perhaps even heard by the reader in the aftermath. This is the paradox of anachronism: inevitable, necessary; damaging, productive; treacherous, loyal.

Any explanation of why judging adaptations in terms of fidelity is untenable demands an alternative that preserves the aspects of fidelity that make sense while discarding what is irrelevant, or blinding in the concept. Fidelity's drawbacks are its connotations of exclusivity and sexual privilege and its implied hierarchy. As a thought experiment, for this concept we can substitute the neighboring concept of *loyalty*. A different focus emerges. Now there is no exclusive relationship; metaphorically, we can say that we shift from love to friendship.

This is what Lorraine Code has proposed in her search for a feminist epistemology, revising the Platonic teacher-student-as-lover model for teaching and learning, hence, knowledge. The conceptual persona of the friend for the teacher-student relationship—analogous to the relationship between the "original" and the "adaptation"—takes knowledge as provisional. Her task is to facilitate ongoing and *inter*active reflection. Moreover, knowledge is not to learn something *about* but to learn something *from* (Shoshana Felman). The artifact of a case study must therefore be transformed into a theoretical object. Within the framework of the present Handbook and Felman's description of teaching as facilitating the condition of knowledge (31), Code's shift from lover to friend guides us, provisionally, to exiting the adaptation-fidelity obsession.

The point of such a shift is the watershed between Adaptation Studies 2.0 and 3.0. This somewhat hyperbolic claim is justified once we accept that old—or ancient, going back to Plato—metaphors and analogies cannot so easily be eliminated; the case of fidelity shows it. Plato proposed the conceptual persona of the lover and beloved—in an unequal relationship—for the teacher-student relationship. Take the sex out, and everything changes, beginning with the departure of domination, subjection, and other such power inequalities. Friendship is a model for knowledge-production, the traditional task of the humanities, but as interminable process, not as preface to a product; as dialogue in mutual respect and acceptance, not domination of one (the "original") over the other (the "adaptation").

Code lists these features of friendship, in contrast to the lover's passion, as productive analogies for learning and knowledge production:

- Such knowledge is not achieved at once, rather it develops.
- It is open to interpretation at different levels.
- It admits degrees.
- It changes in the course of time.
- Subject and object positions are reversible.
- It is a constant, never-completed process.
- The "more-or-lessness" of this knowledge affirms the need to reserve and revise judgment. (37–38)

This list helps us understand the humanities as a field rhizomatically organized in a dynamic interdisciplinary practice that allows us to suspend the dilemma of whether adaptation studies is a discipline or an interdisciplinary field. The field could use friendship as a conceptualization of its many branches. It also helps to see the relationship between the later and the earlier text as friends, with loyalty but without exclusivity, with affection but not blinding passion. This list, then, will be my guide in the argument for anachronism.

I treat the problem of the one-to-one comparison just as critically while shifting it from love to friendship. To this effect I modify the case study to bring the field in line with other disciplines and interdisciplinary fields in the humanities. The case study has had a turbulent history. After a few decades of glory, when it was the successful way of overcoming the late nineteenth-century "race, milieu, moment" approach of historical dogma, it was discredited when the autonomy of art became obsolete in favor of contextualism. In our time, autonomy is again taken seriously, not to disconnect the artwork from the social world, but against an overdose of "relational art" speak. The case study is a tool for exchanging the critical arrogance of theory "applied" to objects kept mute for an intership between critic and artwork in which the object, thanks to the close attention paid to it, can "speak back." An intership between an adaptation and its source—this speaking back—will be a three-way conversation between the two artworks and the scholar.

The case study has mitigated sweeping historical overviews and theoretical statements, which tend to overrule the cultural objects that motivate the humanities in the first place. To cast out the case study would be throwing away the baby with the bathwater. Crucial to our field of study is the relationship between the singular and the general, the basis for any analysis beyond anecdotalism. It contributes knowledge beyond its moment and foregrounds the singularity of the object through its wider relevance. In its long history from seventeenth-century Jesuit casuistry through case law and psychoanalytic case histories, however, the method has acquired a dubious reputation as a facile entrance into theoretical generalization and speculation, as well as judgment, especially for adaptation studies. This is an improper use of the method, not a flaw of the method itself.

As Lauren Berlant wrote, the genre is "a problem-event that has animated some kind of judgment" ("On the Case" 663). Later she elaborates, arguing that, when something becomes *a case of something*, this becoming a case is itself an event; it becomes exemplary of something else. Note that the concept of "event" implies temporality, historical positioning, and agency. That event, moreover, verifies something in a system or series. This has consequences for the formation of systems or series, which is why the "becoming a case of" constitutes an event. When symptoms are named, this event can lead to a diagnosis, as it does in medicine. Alternatively, it can reframe a cluster of objects or activities. The new case may solidify the cluster or series, or transform them. They may also be explained through the new case (see Berlant, "Introduction").

The major problem the case study poses, Berlant suggests, is the temptation to generalize on the basis of a single case in an over-extended induction. Rather

than over-generalizing, however, an analysis of an adaptation is, if anything, over-singularizing—except for the tenacious judgmental ground of comparison, which necessarily involves other cases, either overtly or silently. This poses a dilemma. The study of adaptation depends on in-depth case studies. But instead of inviting generalization on the basis of a singular case, each case study oscillates between one special view and another. In terms of the logic of reasoning, this movement is neither deductive nor inductive, but what the American philosopher Charles Sanders Peirce called "abductive." This concept can help avoid unwarranted generalization.

Abduction is important for the creative and innovative potential of the arts under scrutiny, as well as for my view of the virtues of anachronism. Jan van der Lubbe and Aart van Zoest define it as follows: "In general abduction is considered as that type of inference which leads to hypothetical explanations for observed facts. In this sense it is the opposite of deduction" (805). Abduction goes from consequence to possible cause, from later to earlier; anachronism is already a form of abduction. As van der Lubbe and van Zoest write, this logic is "diagnostic" (806). Rather than thinking of illness when hearing the word "diagnostic," I take *dia-* as a variation on *inter-* and *gnostic* as knowledge. Translated from Greek to Latin, it means inter-knowing. Deduction, in contrast, reasons from cause to consequence; it is prognostic. Abduction makes new ideas possible. It leaps creatively from the singular as its starting point. It thrives on uncertainty and speculation, but originates in observable fact. And those observable facts are the features of the two artifacts compared, the observation of which is needed to anchor the abductive speculation.

Abduction is a paradoxical form of logical inference. "Peirce holds both that hypotheses are the product of a wonderful imaginative faculty in man and that they are products of a certain sort of logical inference" (Frankfurt 594). Harry G. Frankfurt resolves this paradox by reformulating abduction not as the formation but as the provisional adoption of hypotheses, as working hypotheses. Although this makes abduction logically unproblematic, what Frankfurt considers a paradox is a description of the case study redefined according to the multiple meanings of "the case." The case, in casuistry, is also a dispute or discussion, and in law it is a quite precise form of abduction. In line with the opening sentence of Wittgenstein's *Tractatus*, the real existence in the world of the thing that is the case—here, literature and art, as the "wonderful imaginative faculty in man"—is a condition I gladly adopt. For the objects we study, fictional or not, are "the case"—they exist in the world and function in it. Conversely, Wittgenstein's simple sentence, "The world is everything that is the case," makes the case study something other than an opportunity for unwarranted generalization.

For now, then, I advocate intership as methodological starting point; friendship, hence loyalty, as its model; and the multi-semic case study as the method itself. The first offers ways of cleaning up the tenacious judgmentalism, the second helps map the steps that can lead to balanced analyses between generalization and singularization, and the third demonstrates how this works. My case for these three principles will be based on the *Madame B* project.

WHY WE MUST ANACHRONIZE

While a primary issue of fidelity is historical correctness, loyalty concerns time. To be loyal rather than faithful to Flaubert's novel, what matters most is the novel's own relationship to history and the present. This involves two issues. One is the present tense in relation to images in general, the other the way this novel is set in terms of history. I start from the premise that anachronism is indispensable if we want to understand how storytelling works. The reasoning is simple and well-known. Reading or hearing or seeing stories is itself anachronistic. One reads for oneself, and in the present. It is like memory: one performs an "act of memory" in the present, even if the content of the memory took place in the past. Ordinary as this idea is, it matters for the possibility of helping traumatized people or people otherwise affected by the past to rejoin the present of their lives. In other words, to help overcome past ills, anachronism is necessary.[3]

I first reacted to Flaubert's character Emma Bovary by thinking. "If only she had gotten a life!" Starting myself to work while taking care of a family, I thought she was too passive. One can think that and cry hot tears simultaneously. No one withstands the pernicious attraction of the clichés Flaubert called *idées reçues*. But encouraging an unhappy woman to take a job is a gesture of today, not of the mid-nineteenth century. This was an anachronism—projecting aspects from the present onto the past without realizing it.

Many critical texts about the novel consider Emma a flawed character, insufferably romantic, passive, and of course "unfaithful," guilty of adultery. These judgments come from unreflected anachronism that implies the superiority of the reader in his or her present time. Instead, identifying with characters, even unbearably fraught ones, one can share their adventures, emotions, hopes, and disappointments, partake of the events, even adopt the words that describe those. Identification does not depend on the merit of the character. At one time, we were able to engage with them; now, in the present, we can recognize the sentiment, relive it, because it is lodged somewhere inside us and continues to be overdetermined, layer by layer, by other memories.[4]

In particular, in the present we can *see* Emma and the others: her little daughter, the men in her life. The image, remade every time someone sees it, is in constant transformation and stands outside standard time. It unfolds in the tempo of those who see it. One tends to underestimate the part that images play, not only in visual art and culture, but in reading, in memory, in any cultural activity. It is through this anachronistic bond and the images it forges that literature's relevance continues. This is a banal view, yet it is crucial to recognize its claims. The cultural function of narrative depends on it. A successful film that attempts to be loyal to its precedent novel would need to consider how that precedent artwork sits in its time.[5]

Anachronism is inevitable and productive, but also the only way the past can stay or even become alive. Burying the nameless dead of past violence, for example, gives them names and allows survivors to mourn them. Anachronism is also the only way to

understand what art from the past offers the present. Even if such anachronistic visions would be unrecognizable to the past artist, their work lends itself to such "remaking," a recharging with energy generated by the encounter between present and past. I must grasp Flaubert's novel's relation to history before deciding how loyal it makes sense to be.

Flaubert's novel, a product of the second half of the nineteenth century steeped in late-Victorian European culture, makes a series with *Effie Briest* (Germany), *Anna Karenina* (Russia), *La Regenta* (Spain), and other novels written in European countries as novels of adultery. Written by male authors, they tell about unhappy female characters, often deemed hysterical, who end badly. The genre was fashionable at the time, and given fashion's transience, one would think that only its status as a "classic" would save Flaubert's novel from oblivion. But what made these novels remarkable was their engagement with their own time. Any attempt to make an adaptation should logically endorse that contemporaneity by placing the story in the adaptation's time. This already requires anachronism instead of historicizing.

Yet these novels also worked in relation to their future. They prepared for the emergence of Freudian psychoanalysis: they gave a glimmer of women's desire and the horror it inspired in men. The question "What does woman want?" was in the air; Freud became its spokesman, but he did not invent it. Hence futurality is inherent in their imagining something that did not yet exist: the idea of the hysterical housewife. Only the second feminist wave of the 1970s made this housewife melancholia speakable. Strictly speaking, then, only imaginative futuralities can remain loyal to the novel. In our film, the scene of the reception of the fictive association of pharmaceutical companies PharmaFrance—the contemporary equivalent of the Ball at the Vaubyessard Castle—ends with Emma appearing as a ghost, predicting her own death. Earlier in the scene, after she has danced briefly with a handsome man, a traveling salesman substituting for the Vicomte, she turns to food, sprinkling white powdered sugar onto her dessert. Formally, the sugar anticipates Emma's poisoning by arsenic. Flaubert also foregrounds white sugar, but the goal of this motif is not fidelity to any metaphorical import of white sugar but the expression of futurality as such.[6]

In an earlier article I linked description, in this case—and the metaphors and metonymies of which it consists—to the politics of the piece. I argued that the description of Rouen, presented during the routine of the affair with Léon, Emma's last attempt at happiness, was predictive. This futurality was created by verb tense. The description is introduced by one of those apparently ungrammatical past tenses (the *imparfait* of routine) Flaubert invented. Because of the combination of that particular tense with an adverbial phrase expressing suddenness ("tout à coup, la ville apparaissait"), it predicted Emma's failure to find the elusive happiness she so obstinately sought.[7]

This is difficult to render cinematically. The image—in this case, the description, with its contradiction—requires the act of watching, of seeing, and of visual processing that can only take place in the present. This is why the passage speaks directly to us, its second person, who can only see it *now*. What becomes visible in ways that historical ("faithful") readings obscure is that Flaubert not only played with grammar at the limit of acceptability and thereby kept language vital, but also demonstrated what we

call today a feminist view. When Michelle and I reread the novel, anachronistically, for the purpose of our film project, we realized that the novel is more than proto-feminist. It is prophetic, radical, of a progressive vision that even today is hard to understand and, if we must believe the criticism, hard to accept. Is this an anachronistic reading? Of course. It is both necessary and inevitable.

We wanted to make an audiovisual work that would both actualize the novel and be loyal to it in the manner of its actualizing. Loyalty to such a novel compelled us to explore the ways the image does its own storytelling. The question of the image in movement is that it is a priori visual, while the audio is essential. This question can be addressed by the examination of some features generally attributed to Flaubert's novel: its visuality, noticeable in the predominance of description and its narratively arbitrary appearances; the sparing use of dialogue and the author's avowed aversion to that mode of direct discourse; and the replacement of dialogue by not only narration but also that ambiguous mode, *free indirect discourse* (henceforth FID). This mode confuses the categories of "who speaks?" with that of "who perceives?"—voice with focalization, the orientation and subjectivity of perception that some call "perspective" or "point of view." Focalization includes not only seeing but also hearing. And this pre-cinematic filmic novel has a soundtrack, too. Because it facilitates a multiplication of subjectivities, FID fosters an identification between the protagonist and the storyteller or "imager." Flaubert's text moves from narration to FID without warning, transition, or clear indication.[8]

These modes tend to narrate through images, allowing a dynamic between the proclaimed objectivity and a fundamental subjectivity—solidarity with the latter by means of the former. This subjectivity is not only the character's but, more complexly, that of the meeting of character and reader-viewer. This has consequences that for us pertain to the political. We are not making a case for a feminist Flaubert, or for the author as socially committed. Whether he was the "idiot of the family," as Sartre called him, or the sympathizing but apocryphal "Madame Bovary, c'est moi," does not concern us. For any projection of intention onto the author would obscure or even prohibit anachronism, a mode of thought we found indispensable in making sense of the artistic heritage of the past by throwing into relief its actuality.[9]

THE CASE AS THEORETICAL OBJECT

One novel, one film: such a case is already much too large if the power of the case study depends on its attention to detail. The one-to-one comparative model makes sense only when we reconsider the case study. Detailed attention to a single case has the value of foregrounding the art of the artwork, the reasons why it is worth fussing about. Beyond that interest lies another one. If artworks still have so much to say to us, it is not because of some concept of beauty, since such concepts, and the taste that sustains them, change with time. Nor can coherence, plausibility, or depth of character be considered

transhistorical or universal criteria. If there ever was an unreflected anachronism, it is such judgments presented as universal. They are temporal selfies. Instead, small-scale elements of either the novel or the film can help understand something of the intership between them.

The deployment of the audio image helps explain the paradox of anachronistic loyalty. In our film, the sounds—murmuring, bells tolling, sheep bleating and cows mooing, Emma pleading, love-talking, and screaming—constitute a network that can narrate anachronistically and loyally. Digging deeper into the effects of the sounds can make us aware of how the novel presents a network of sounds characterized by *indistinction*. This goes well with the indistinction of Flaubertian FID. The sounds are all reiterative, durable, routine. My example is a direct discourse creating an image that is itself in FID. Outside of story time, that sonic image becomes the source of narration in its own imagistic manner.

Among the thousands of Flaubert's narrative sentences, some stand out as unforgettable, precisely as Chabrol implied through his mistakenly excessive fidelity, and we have taken some of these as motors for a different kind of narration. Our conception, resulting in a script that limits most dialogue to literal quotations, also includes the opposite of this constraining method. Sometimes we gave our actors not a quotation to pronounce but a sentence to run with—a phrase, an expression, a thought—asking them to use it for improvisation. That method yielded sonic images, developments whose importance resides in how they constitute a sense-based expression of narrative content that is not illustrative, but rather finds its place in a story without having a textual location.

My example is an "imaging" rather than a quotation of the famous sentence "Charles's conversation was flat like a sidewalk." In order for an artistic object, such as this sentence, to become a "theoretical object" (Bois et al. 8) that nourishes thought and thereby encourages intership, the content of the sentence matters less than its narrativity. It is famous for its economy of means, its comparison, and its power to image routine. It is devastating for Charles in Emma's eyes if we consider the sentence a case of FID. But, as Jonathan Culler has argued, nothing is less definite than that free-floating discourse. According to Culler, Flaubert's project is unmooring discourse and thus precluding facile judgments. How he does that makes it possible for us as filmmakers in the twenty-first century to decide how, and to what extent, ours as well (see Prendergast).

The shortness of the sentence is telling as a characterization of the narrative aesthetic. The use of the generic noun "conversation," accompanied by a verb in the imperfect, which here simply expresses the reiteration of routine, implies many words—an infinite number of words that end up, like a load of stones, bludgeoning one to death. This sentence cried out for inclusion not only as a narrative expression of a non-event—what Gérard Genette called "Flaubert's silences"—but also as a trigger of the boredom that will kill Emma. But this could not be done, we felt, by the intrusion of a Chabrolian narrator. Once it is understood in its narratological implications, it causes a reversal in the narrative economy and its dynamic between narration and description—for us, between literary and cinematic—a reversal that must be retained in order to be loyal to the novel by apparently betraying it.

The iterative character of the flat conversation implies that the sentence, the perception Emma has of its content, and the slide toward what follows—none of that can easily be audiovisualized, not with Flaubertian concision. Most films based on novels fail when they try hardest to do just this. To make film a laboratory where we explore what storytelling is and can do, rather than provide ready-made answers, we only talked with the actors, then took up the camera without any rehearsal or further direction. For the quality of improvised acting ("jeu d'atelier") depends on the spontaneous, the first time—the opposite of what the sentence conveys. We owed this opportunity to our good fortune in working with brilliant actors.

Once we had deployed the sentence as a theoretical object about storytelling of routine, our goal became turning the short narrative sentence and the iterative indirect discourse into an audio image in FID of the Flaubertian, indistinct kind in order to allow the audience to experience, on an intuitive, sensate level, a double, conflicted perception. This had to include the over-the-top and bizarre *comparant*. We sought a similar audiovisual FID to convey the annihilating tedium of another sentence: "C'était surtout aux heures des repas qu'elle n'en pouvait plus" (especially during mealtimes she couldn't stand it anymore). A narrative summing up, again in a comparison, follows this sentence: "toute l'amertume de son existence lui semblait servie sur son assiette" (it seemed to her that the entire bitterness of her existence was served to her on her plate). Writing seventy years ago, Erich Auerbach described this sentence as "the climax of the portrayal of her despair" (483). We hoped that conflating the two short passages into a rather extensive audio(visual) image would do justice to the dialogic failure of Charles's monologic conversations.[10]

Thomas Germaine, the French actor playing Charles, announced that he wanted to hold these iterative conversations on four subjects, spread out over four evening dinners, marked by different outfits: the weather, the project to build a shed in the garden, a patient, and the tasteless quality of the raspberries this year. One sees the boredom coming. Marja Skaffari, the Finnish actress who played Emma, needed only to sit tight and keep her mouth shut, showing in her face the visual echo of Charles's discourse. The auditory image created by these two characters functioned like a visual performative image.[11]

This was our form of loyalty, not to follow Flaubert but to learn about cinema from his prose. We filmed the scene with two fixed cameras, each focusing on one of the two faces. But we decided to edit it favoring Emma's face almost exclusively. That is where the boredom inscribed itself with more and more exasperation, and where FID can take shape, precisely because Charles is the one who is talking. Instead of his face, we see his blurred shoulder in what is called a "dirty close-up," looming over Emma like a dark shadow. Like the contact that has emerged from two socially dubious looks in the first piece, the two characters together produce the boredom, ending in horror.

Barely seeing him, his talk constitutes a sonic image. In the textual story, Emma focalizes, even if the anonymous narrator takes over. It is that narrator who makes the short sentence ambiguous. Hence we had to show Emma as the prisoner of the flat conversation—flat, like a sidewalk, and crushing, like the heavy stones of which such a flat sidewalk is made. And, according to the performative conception of the look, the

spectator enables her to show her boredom and, when boredom changes into horror, to scream. For it is the spectator who, seeing and feeling the horror, reads the face, allowing the boredom visibility.

Our project comprises video installations for an immersive exhibition and a feature film. Two issues emerged when the theatrical film diverged from the gallery film. There, the conversation is on one of four screens in a single scene. The gallery film depends on its viewers to complete its narrative potential. Viewers who become impatient may not be there when Emma screams. This freedom to stay or leave is the essential reason we needed to rely on anachronism.

In addition, we wanted to withdraw Charles from the contempt with which criticism surrounds him, a reception that makes his character ineffective. The actor saves the character by his acting. Speaking of boring topics, he nevertheless talks in a nervous rhythm, sometimes almost feverish, and progressively more so, speaking quickly but also leaving silences and sighing. Once he pleads: "Say something!" Thus he shapes the anxiety of the character, who is also a prisoner of this marriage. He suffers from his own clichés, and in the same move, incites us to interrogate the interpretation that renders Flaubert's irony a bit too systematic. Sensing his wife's boredom, he speaks more and more nervously, filling beforehand the silences he knows to be inevitable, and accumulating further stupidities. Thus *bêtise* is shared. As Emma says when she lies dying, no one is to blame. We wished to take this work out of the moralism that, suggesting judgment, allows the audience who feel superior to escape the work's demands. Flaubertian *bêtise* is here situated less in the iteration of clichés than in the need to fill the profound void the clichés generate. This need gives Charles more depth. The sonic image that holds on Emma's face as its visual counterpart is the product of his rambling. In this scene, Charles and Emma are more united than ever by their boredom, nervousness, and anxiety. Their infernal union says everything Flaubert merely implied. When Emma finally screams, the astonished Charles asks: "Ça va?" (But what's the matter?), as if this country doctor thought that, if only he could transform boredom into an illness, he could save his marriage. Not so much later, a Viennese doctor invented a way of considering such boredom an illness indeed. That is why Germaine's superb acting includes a slight rise of hysteria, why Flaubert's novel demands futurality, and why the (sonic) image is anachronistic by definition. This is just one example that made us decide that loyalty is more productive than a judgmental fidelity. And this insight was possible thanks to the case as a theoretical object—a case study.

Such sonic images demonstrate another side of the performativity of the image. This visual image is not the result of the look of the other. Instead, it is the product of the voice, of words, of the conversation with only one speaker, that Flaubert, also assigning it to a single speaker ("la conversation *de Charles*") has characterized so perfectly—but hyperbolically, in a proto-postmodernist vein. Nevertheless, Charles almost kills Emma in this scene. He is the generator, the character who brings about an invisible event: the one that transforms Emma, barely awoken to life, into a living cadaver, entering an agony that takes up the remainder of the story.

Her husband (and fellow victim) only facilitates this agony. The veritable cause is the expectation, the passivity, of Emma, captured by a system she fails to understand, but

that she has internalized from an early age. This system, where capitalism and romantic love trade places, where commodities are invested with emotion and love is for sale, is what kills her, like so many others. And where emotions are staged, manipulated, and foregrounded, identification is at stake. Here lies the politics involved.

IDENTIFICATION?

The importance of anachronism and the revised case study also has political implications. When we talk casually about adaptations, the tacit but crucial standard of judgment is frequently the question of whether we can identify with the characters in the adaptation as easily and strongly as in the original. Identification is such a pervasive aspect of cinema that it seems almost convincing as a standard. These judgments are important, both because the latter are so often unreflectively based on the former and because the public making such judgments are the people whose culture we study. Although the same qualifications regarding historicity hold here, more is at stake. Not only is an appeal to identification avoided by means of the same FID that also encourages it, but the novel skirts that temptation in order to dismiss it more forcefully. Here lies the meaning of the Flaubertian, wavering FID as a theoretical object that helps establish loyalty as critical friendship.

Jill Bennett has argued that sentimentalism encourages forms of identification based on emotional appropriation, absorption of otherness within the self, and vicarious suffering. These three movements encourage neither reflection nor action within the political present-with-past, but rather its evasion. The first movement is the problem of sentimentality: an identification that either appropriates someone else's pain, or exploits it in order to feel oneself feeling and thus feel good about oneself. The joy is in feeling that one has regained the capability of feeling. The emotional realm in which such identification may occur most easily is that of suffering. The identifying viewer may appropriate the suffering of others, in a more bearable form, and feel good about it. This entails the second trap, frequently discussed within trauma studies, which involves a cannibalizing form of identification. The viewer identifying with other people's (represented) suffering appropriates the suffering, cancels out the difference between self and other, and diminishes the suffering. Vicarious suffering, finally, is obviously an extremely lightened form, and if this lightening comes with the annulling of difference, in the end the suffering all but disappears from sight, eaten up by the commiserating viewer.

To remedy this triple danger, Dominick LaCapra proposes what he calls "empathic unsettlement" (41). Through this concept he attempts to articulate an aesthetic based on both *feeling for* another and "becoming aware of a distinction between one's own perceptions and the experience of the other" (Bennett 8). With all these qualifications in mind, I read Emma's face, accompanied by the sonic image of Charles's droning voice, as an affection-image that steers away from these traps. Gilles Deleuze seems to share this reluctance to endorse the centrality of the face in the humanistic sense—the

sense that is seducing us to sentimental identification. Instead, as Mark Hansen argues, the philosopher identifies the affection-image (210)—which, in order to avoid conflating Deleuzian affection with the realm of the emotions, I call the "affect-image"—that the philosopher spotted in the close-ups of classical cinema not only *with* but *as* the face. As Deleuze says, "There is no close-up of the face. The close-up is the face, but the face precisely in so far as it has destroyed its triple function [individuation, socialization, communication]. . . . [T]he close-up turns the face into a phantom. . . . The face is the vampire" (99; cf. 66). The view of the close-up image *qua* face, standing in as face instead of the human face, becomes increasingly relevant, as no image other than this face is forthcoming. This unique face is a close-up of and to the viewer that collapses subject and object.

Emma's face in the sonic image is a close-up, just as Flaubert's focus on his protagonist privileges her with attention and affect. But his muddling FID and our shift from close-up to a medium shot inhibits sentimental identification. The audience's greater distance from Emma provides the space for what James Tully has called a "critical freedom" (202). Such a freedom is critical because it stimulates the imagination. Critical freedom is the practice of seeing the specificity of one's own world as one among others. Inter-temporally, this freedom sees the present as fully engaged with a past that, insofar as it is part of the present, we can rewrite a little more freely.

Conclusion

My twinned plea for anachronism as a form of loyalty and the modified case study as an access to theorizing through artwork may seem to stay a bit too close to the old traps of adaptation studies. But in two ways it does not, and I have chosen to modify rather than reject the old concepts because I believe in that old bathwater saying. The difference between loyalty and fidelity, seen through the metaphor of friendship, is the different critical attitudes they foster. Instead of judging one work, usually the adaptation, on the basis of a slavish subjection to its precedent or "source" with a normative posture that obscures its own standards, I consider the two-way intership between the two works a more productive source of insight because a detailed analysis can bring to light aspects of both source and adaptation that can converse with each other.

If I call the case study in this modified sense a relation to the text as theoretical object, it is not to suggest that artifacts do the thinking for us. Instead, I recommend a more committed relationship in which loyalty does not preclude criticism but encourages it. Only your best friends can be critical of you and remain loyal. Their criticism is useful and constructive, bringing things to your awareness you didn't realize. And if appreciated for what it is, such criticism accepts mutuality. Mathieu Montanier, the actor who played our Homais, found Flaubert's pharmacist too much of a caricature. Flaubert may have predicted the fashionable topos of the hysterical woman, but the principle of indistinction did not extend to male hysteria. Montanier, to render his character complex

and give him more depth, opened up something that the novel does not provide. Yet a planned alternative ending to the novel, unknown to us at the time of filming, confirms the actor's intuition:

> Doute de lui—regarde les bocaux—doute de son existence. [délire, effets fantastiques, la croix répété dans les glaces, pluie foudre du ruban rouge],—"ne suis-je qu'un personnage de roman, le fruit d'une imagination en délire, l'invention d'un petit paltoquet que j'ai vu naître et qui m'a inventé pour me faire croire que je n'existe pas." (Self-doubt—looks at the jars—doubts his existence. (delirium, phantasmatic effects, the cross repeated in the mirrors, a rain storm of the red ribbon),—"am I just a character in a novel, the fruit of a delirious imagination, the invention of a little scribbler whom I have seen be born and who has invented me to make me believe I don't exist"). (*Oeuvres complètes* 549–50 [my translation]; compare Flaubert, *Nouvelle version* 129, quoted in Culler, "Realism" 686)

This passage also confirms that Flaubert was as postmodern in sensibility as they come.

The idea I have developed here is not new. A return of the past in the present has been discussed in at least three different areas. First, there has been a recent flow of responses to Aby Warburg's surviving or resurfacing figures from the past in unequal reappearances in modern art (see Carreri; Michaud). Second, in his volume *The Fiction of Narrative*, Hayden White discusses Kierkegaard's conception of repetition as the fulfillment of a pre-figuration, by way of Northrop Frye, echoing Deleuze's view of repetition and Michael Holly's consistent interest in the way artworks predict the kind of criticism they will encounter. Hence my insistence on futurality. Third, productive anachronism has been put forward in the wake of renewed interest in Warburg and other contexts. I would like to end by proposing a notion of preposterous history that is different from these three approaches to the possibility that time is neither linear nor singular.

I see in Warburg's survival a desire for permanence, as if everything goes underground until the time is ripe, whereas preposterousness is a new emergence connected to an older one, not the latter's reappearance. The idea of fulfillment, which suggests a permanence of something still undisclosed but already there, sounds a bit too much like redemption. Anachronism is a less religiously inflected concept that begs the question of who performs the activity that makes the connection. To answer that question, we need anachronism, detailed analysis with a theoretical desire, and empathic unsettlement.

NOTES

1. Because this was a private conversation, the speaker remains anonymous. For a discussion of this instance and its connection to portraiture, see Bal, "Allo-Portraits."
2. Mary Donaldson-Evans's study of film adaptations of Flaubert's novel analyzes the Renoir, Minelli, and Chabrol films, among others. Because adaptation is another form of repetition, Robert Stam and other recent adaptation scholars have argued that seeking fidelity is the worst advice to give to the aspiring filmmaker. According to Donaldson-Evans, Chabrol's

Madame Bovary was threatened by the director's near-fanatical attempt at fidelity and saved by the inevitable anachronism—in his case, his feminist inclination (101–36). Yet paradoxically, in making the feminist judgment that Emma is doomed not by her personal stupidity but by the patriarchal culture that framed her, Chabrol only repeated what Flaubert, prophetically and without having the words for it, had already, in his forward-anachronism, pointed out. Any repetition without this prophetic anachronism fails in loyalty.

3. For this conception of memory, see Bal, Crewe, and Spitzer. On anachronism's necessity, see Bal, *Quoting Caravaggio*, and Bal, *Of What One Cannot Speak*. We have examined the possibility of helping traumatized people through psychoanalysis in our previous project, on which a website is available at http://www.crazymothermovie.com/. This project was based on Davoine, *Mother Folly*.

4. Girard demonstrates an embarrassingly severe judgmental attitude. In his eagerness to judge, which also includes critical texts (e.g., Jonathan Culler's book), he overlooks key aspects of Flaubert's text.

5. On this role of narrative, see Bal, *Narratology*.

6. On Freud's question of women's desire, see Shoshana Felman. Felman adds an indefinite article. Thus she turns the question into "what does a woman want?"—a productive anachronism.

7. I wrote this earlier article in the wake of a seminar directed by Françoise Van Rossum-Guyon. It was also inspired by work by Philippe Hamon on description. I thank Françoise and Philippe for decades of inspiration and friendship.

8. I ignore the technical differences between analogue and digital images. See Rodowick. Sara Pinheiro composed the soundtrack for the project.

9. Not his biography, but the writing suggests a commitment. González, who has meticulously studied Flaubert's notorious "mistakes," explains the generative "nous" that opens the novel. Adducing an article by Italo Calvino in which the latter suggests that "le véritable thème de cet homme apparemment si renfermé avait été l'identification avec l'Autre" [the real theme of this man who seemed so withdrawn had been an identification with the Other] (Calvino 160; González 221), he argues that Flaubert's strange opening scene is an originary scene from which the rest of the novel emerges . For an argumentation against "intentionalism," see Bal, *Travelling*, Chapter 7.

10. See also Collas's psychoanalytic commentary on the role of food and poison, eating and eating disorders in the novel.

11. The situation during filming was hilarious. Marja Skaffari burst into laughter; Germaine's performance was outrageously convincing. As directors, actors, assistants, makeup artist, we all burst out with her. Aside from those interruptions, the takes are long, and edited with a minimum of intervention. The long takes contrast with the nervous talk.

Works Cited

Auerbach, Erich. *Mimesis: The Representation of Reality in Western Literature*. Trans. Willard R. Trask. Princeton: Princeton UP, 1956. Print.

Bal, Mieke. "Allo-Portraits." *Mirror or Mask: Self-Representation in the Modern Age* (Berliner Theaterwissenschaft 11). Ed. David Blostein and Pia Kleber. Berlin: VISTAS Verlag, 2003. 11–43. Print.

———. "Fonction de la description romanesque." *Revue des langues vivantes* 40.2 (1974): 132–149. Print.

———. *Narratology: Introduction to the Theory of Narrative.* 4th ed. 2 vols. Toronto: U of Toronto P, forthcoming. Print.

———. *Of What One Cannot Speak: Doris Salcedo's Political Art.* Chicago: U of Chicago P, 2010. Print.

———. *Quoting Caravaggio: Contemporary Art, Preposterous History.* Chicago: U of Chicago P, 1999. Print.

———. *Travelling Concepts in the Humanities: A Rough Guide.* Toronto: U of Toronto P, 2002. Print.

Bal, Mieke, Jonathan Crewe, and Leo Spitzer, eds. *Acts of Memory: Cultural Recall in the Present.* Hanover: UP of New England, 1998. Print.

Bennett, Jill. *Empathic Vision: Affect, Trauma, and Contemporary Art.* Stanford: Stanford UP, 2005. Print.

Berlant, Lauren. "Introduction: What Does It Matter Who One Is?" *On the Case: Missing Persons.* Special issue, *Critical Inquiry* 34.1 (2007): 1–5. Print.

———. "On the Case." *Critical Inquiry* 33.4 (2007): 663–72. Print.

Berlant, Lauren, ed. *On the Case: Making the Case.* Special issue, *Critical Inquiry* 33.4 (2007). Print.

Bois, Yve-Alain, Denis Hollier, Rosalind Krauss, Hubert Damisch. "A Conversation with Hubert Damisch." *October* 85 (Summer 1998): 3–17. Print.

Calvino, Italo. *Por qué leer los clásicos.* Barcelona: Tusquets Editores, 1993. Print.

Carreri, Giovanni. *Gestes d'amour et de guerre. L'image-affect. Poésie, peinture, théâtre et danse dans l'Europe du Tasse.* Paris: Éditions de l'EHESS, 2005. Print.

Code, Lorraine. *What Can She Know? Feminist Epistemology and the Construction of Knowledge.* Ithaca: Cornell UP, 1991. Print.

Collas, Ion K. *Madame Bovary: A Psychoanalytic Reading.* Genève: Droz, 1985. Print.

Culler, Jonathan. *Flaubert: The Uses of Uncertainty.* Aurora: Davies, 1974. Print.

———. "The Realism of *Madame Bovary.*" *Modern Language Notes* 122 (2007): 683–96. Print.

Davoine, Françoise. *Mother Folly: A Tale.* Trans. Judith G. Miller. Stanford: Stanford UP, 2014 (1998). Print.

Deleuze, Gilles. *Cinema 1: The Movement-Image.* Trans. Hugh Tomlinson and Barbara Habberjam. Minneapolis: U of Minnesota P, 1986. Print.

Donaldson-Evans, Mary. *Madame Bovary at the Movies: Adaptation, Ideology, Context.* Amsterdam: Rodopi, 2007. Print.

Felman, Shoshana. "Psychoanalysis and Education: Teaching Terminable and Interminable." *Yale French Studies* 63 (1982): 21–44. Print.

Flaubert, Gustave. *Madame Bovary.* 1857. Paris: Gallimard, 2004. Print.

———. *Madame Bovary.* Nouvelle Version. Ed. Jean Pommier and Gabrielle Lelen. Paris: Corti, 1949. Print.

———. *Madame Bovary. Oeuvres complètes* I. Paris: Club de l'Honnête Homme, 1971. Print.

Frankfurt, Harry G. "Peirce's Notion of Abduction." *Journal of Philosophy* 55.14 (1958): 593–97. Print.

Genette, Gérard. "Silences de Flaubert." *Figures.* Paris: Seuil, 1966. Print.

Girard, Marc. *La passion de Charles Bovary.* Paris: Imago, 1995. Print.

Hansen, Mark B. N. "Affect as Medium, or the 'Digital-Facial-Image.'" *Journal of Visual Culture* 2.2 (2003): 205–28. Print.

Hutcheon, Linda. *A Theory of Adaptation*. New York: Routledge, 2006. Print.

LaCapra, Dominick. *Writing History, Writing Trauma*. Baltimore: Johns Hopkins UP, 2001. Print.

Leitch, Thomas. "Twelve Fallacies in Contemporary Adaptation Theory." *Criticism* 45.2 (2003): 149–71. Print.

Lubbe, Jan C. A. van der, and Aart J. A. van Zoest. "Subtypes of Inference and Their Relevance for Artificial Intelligence." *Semiotics around the World: Synthesis in Diversity*. Eds. Irmengard Rauch and Gerald F. Carr. Berlin: Walter de Gruyter, 1997. 805–8. Print.

Madame B. Dir. Mieke Bal and Michelle Williams Gamaker. Perf. Marja Skaffari, Thomas Germaine, Mathieu Montanier. Cinema Suitcase, 2014. Film/video.

Madame Bovary. Dir. Jean Renoir. Perf. Max Dearly, Valentine Tessier. NSF, 1934. Film.

Madame Bovary. Dir. Vincente Minelli. Perf. Jennifer Jones, Van Heflin. MGM, 1949. Film.

Madame Bovary. Dir. Claude Chabrol. Perf. Isabelle Huppert, Jean-François Balmer. MK2, 1991. Film.

Madame Bovary. Dir. Sophie Barthes. Perf. Ezra Miller, Mia Masikowska. Occupant/Alchemy, 2014. Film.

Michaud, Philippe-Alan. *Aby Warburg and the Image in Motion*. Cambridge: MIT P, 2004. Print.

Prendergast, Christopher. "Flaubert and the Cretan Liar Paradox." *French Studies* 35.3 (1981): 261–77. Print.

Las razones del Corazón. Dir. Arturo Ripstein. Perf. Arcelia Ramírez, Vladimir Cruz. FIDECINE, 2011. Film.

Rodowick, David N. *The Virtual Life of Film*. Cambridge: Harvard UP, 2007. Print.

Save and Protect. Dir. Alexander Sokurov. Perf. Robert Vaap, Cécile Zervudacki. Lenfilm, 1989. Film.

Stam, Robert, and Alessandra Raengo, eds. *Literature and Film: A Guide to the Theory and Practice of Film Adaptation*. Malden: Blackwell, 2005. Print.

Tully, James. *Strange Multiplicity: Constitutionalism in an Age of Diversity*. Cambridge: Cambridge UP, 1995. Print.

Wittgenstein, Ludwig. *Tractatus Logico-Philosophicus*. Trans. David Francis Pears and Brian McGuinness. New York: Routledge, 2001. Print.

CHAPTER 11

..

THE INTRATEXTUALITY
OF FILM ADAPTATION

From The Dying Animal *to* Elegy

..

JACK BOOZER

THE challenges that literature-to-film adaptation presents for film theory have led me back to a further consideration of the on-the-ground authorship issues tied to the specific developmental stages of the adaptation process. This essay urges an analysis of the three arenas of authorial intent on the part of novelists, screenwriters, and directors. These can be supplemented where relevant by a consideration of significant contributions by above-the-line talents in film, including producers and leading performers. What we might call serial authorship in film adaptation begins with a consideration of the published source and its author as a basis for an interpretation of intention, of apparent strategies and orientations toward meanings in a given fictional narrative. While this text might be influenced by a variety of sources and approached through a variety of critical methods, I will restrict my focus here to the novelist and the text at hand as the initiating stage for adaptation. Source authorship also helps to illuminate the central stage of adaptation, which involves a producer's purchase of literary rights, the hiring of a screenwriter, and the composition of a screenplay. A close investigation of the process of adaptation—beginning with an interpretation of an author's published source, and the further interpretation and media transformation by the adapting screenwriter(s)—becomes the primary but not entirely determinative prescription for everything that happens thereafter. Whether or not they take screenwriting credit, modern directors usually play a role in the final development of a screenplay prior to shooting, which may or may not include collaboration with the screenwriter, but which remains a part of this central preproduction process of script development. Although the final film production and post-production stages supervised by the director are shaped primarily by their relation to the unpublished screenplay (post-film transcripts not included) rather than the literary source, adaptation study has usually viewed the completed film only in relation to the published source. This overlooks the critical, interpretive screenwriting stage

that most nearly conceives what the organization, direction, and intent of the adaptation is to be. A consideration of the screenplay/shooting script with which a film begins, therefore, can help to distinguish the screenwriter's from the director's contribution in the evolution of the completed film.

The final, directorial stage of authorship is of course further tied to very specific financial, casting, and performance issues; the extended and complex processes of cinematography, sound/score mixing, and visual editing; and all the other technical, staffing, and personal aspects of film production. The collaborative burden of production and post-production in the post-classical era makes any determination of a director's driving intentions a challenge to decipher in process, if not in the finished product. Novelists at times also script their own work, and pure screenwriters at times may also direct their own scripts, but this does not change the function of these positions or necessarily produce a consistency of intent even where such overlaps exist. Unlike the isolated function of writing a novel, the relatively pre-inscribed and itinerant aspect of adaptive screenwriting, not to mention the collaborative aspects of film production, can also veil significant contributions to the final product by others, including leading cast members who may serve in either one or both of these credited authoring roles, or who may assert critical insider influence at certain stages of their performative work. A comprehensive analysis of authorship in any given film adaptation must therefore consider not only which participating creator is making key decisions in whatever immediate context, but also how key personal and thematic intentions at each stage of media specificity impact the chain of collaboration and finished product. In any case, serial authorship study can capture the multivariate creative interaction of intentions characteristic of film adaptations, in which the screenplay holds the pivotal site of media conversion.

Apart from a producer's marketing and profit motivations for translating literary and best-selling fiction to film, modern cinematic adaptations are usually constructed the way that they are because certain individual producers, screenwriters, directors, and/or performers who make them have recognized something in the source or screenplay transformation that speaks to their own orientations, skills, and desires. Assuming a dedication beyond a mere paycheck and career window dressing, compelling film adaptations typically originate—as do novels, short stories, plays, autobiographies, biographies, and memoirs—with those who are personally driven to create them. Linda Hutcheon aptly observes that "adapters' deeply personal as well as culturally and historically conditioned reasons for selecting a certain work to adapt and the particular way to do so should be considered seriously by adaptation theory, even if this means rethinking the role of intentionality in our critical thinking about art in general" (95).

To say that a film adaptation is an intertextual product of its time in cultural and industrial ways beyond the personal input of its makers is a valid point, but this should not rule out considering the ways that a film's key creative team chooses to respond to these kinds of forces. The essence of intertextuality in adapted cinema resides first in the multistage collaborative process of adaptation itself, which may be recognized as specifically intratextual work. Although locating authorial intent is hardly a new goal in book-to-film studies, I hope to show how tracking the apparent goals and developmental

processes within a specific adaptation project can be a useful alternative or supplement to more broadly intertextual (dialogic) critical approaches. This is not to say that producers, screenwriters, and directors are impervious to current cultural and industrial forces, but rather that the adaptive transformation or refraction, whatever its chosen relationship to its source, still has to work finally as a consolidated dramatic performance in the language of cinema. This is what Dudley Andrew implies, given a desire for some level of source allegiance in adaptation, when he writes, "Genuine fidelity, then, needs creativity as well as good will" (140). Any effort toward "genuine" fidelity to the characters, plot, and spirit of the original will still require media transformational creativity, which can include some exteriorization of thought into dialogue or images, changes in characters and point of view, narrative relocation in story flow and changes in time and settings, compression in characters and events, and the overall invention of multiple audiovisual equivalences or even expanded audiovisual motifs for dramatic, cinematic affect. Such an intratextual approach should finally focus, however, not so much on exactly what is borrowed or not in film adaptation, or even how, but on why—to what purpose and end?

LAKESHORE ENTERTAINMENT PRODUCES PHILIP ROTH

The concern for reading primary authorial intentions at each stage in the greater adaptation process is particularly useful when considering the transformation of a work such as Philip Roth's 2001 novella *The Dying Animal* into what became the film *Elegy*, although the backdrop for this project needs elaboration. Roth's prodigious output of highly acclaimed literary fiction had not been adapted to theatrical features since the days of *Goodbye, Columbus* (1969) and *Portnoy's Complaint* (1972). Hence, the head of Lakeshore Entertainment, Tom Rosenberg, was taking a significant risk in his purchase of two Roth novels: *The Human Stain*, published in 2000, and *The Dying Animal*, published in 2001. The backing of executive producers Bob and Harvey Weinstein at Miramax helped to raise the ultimate production costs of the first of these adaptations to some $30 million. Lakeshore's head of production, Gary Luchesi, who had been a former agent of award-winning screenwriter Nicholas Meyer, prompted the hiring of Meyer to write the adaptation for *The Human Stain*. Meyer initially wanted to also direct his screenplay of this film and to change its title to "American Skin," but when these initiatives were not approved, he did support the well-established director Robert Benton for the job. Meyer came to feel, however, that the production of *The Human Stain* "jettisoned whole sections" of his original screenplay draft. He called the film "a misguided effort which I don't think is where he [Roth] is coming from." This film broke Meyer's "first rule in adapting": "What do you owe the novel?" (personal interview, hereafter PI). The film was released in 2003 to a lukewarm critical reception and a weak box office.

Many who were familiar with the novel considered this sweeping, near-lifetime account by Roth's recurring observer/narrator Nathan Zuckerman (Gary Sinise) of racial passing and a violent Vietnam War backlash to be virtually unfilmable, not least because of the need for two actors of different ages for the lead role of protagonist. Reviewers also noted a lack of convincing chemistry between this closely observed and supposedly Caucasian senior academic figure, Coleman Silk (Anthony Hopkins), and a far younger, baggage-laden white woman, Faunia Farley (Nicole Kidman).

The leading couple in *The Dying Animal* is similarly separated by age, although this novella presents a far narrower time frame and omits the race and class complications of the central pairing found in the earlier novel, as well as that novel's many other detailed characterizations and extended plotting. Lakeshore's low-budget production of this second Roth adaptation project for only $13 million proceeded without the Weinsteins' participation. Lakeshore was nevertheless sufficiently satisfied with Meyer's work on that earlier script to hire him immediately in 2003 to write the screenplay for this more tightly focused character study. Both of "those movies," as Meyer reported, "were made because this man, Tom Rosenberg, was in love with these books, and he also knew what an uphill struggle it would be" (PI). While Rosenberg expressed a personal motivation in these two productions that was not ruled predominantly by financial interests, his continuing desire to see Roth presented credibly on the screen clearly influenced his choices of scriptwriter, cast, and director for both projects. Once Rosenberg and his producing team purchased the rights to *The Dying Animal* as well as Meyer's screenplay, the hiring of a director and cast remained, although no casting director was employed (PI).

The Dying Animal

Philip Roth's goals in his novella are revealed not only through the story and characters, but also in his privileging of narrative supplements. The imposing title, *The Dying Animal*, is borrowed from three lines in William Butler Yeats's poem, "Sailing to Byzantium," which relate to the heart of the "dying animal" that is ever still "sick with desire" (Yeats 96). Roth also provides as an epigraph a quotation from Edna O'Brien: "The body contains the life story as much as the brain." This foreshadows Roth's candid focus on the sex life of his protagonist, David Kepesh, and four other main characters. The novella further presents a dedication to "N. M.," presumably in homage to Norman Mailer's insistence on male independence and sexual freedom, which Roth has largely shared and projected here through Kepesh's position on sexual emancipation. Early on, Kepesh reveals his prevailing concerns: "Should a man of seventy still be involved in the carnal aspects of the human comedy?" (36) To this question Meyer's script adds, "Because in my head, nothing has changed" ("Elegy" screenplay 5). Indeed the story Kepesh weaves, in a bold and critically self-reflexive way, is that of a learned, self-aware man whose lust for women burns ever bright in his aging corpus.

Kepesh's first-person narration is also presented in the past tense in full recognition of the chasm that has developed between his belief in sexual and emotional independence,

which he has maintained in his affair with Carolyn, a businesswoman and former student now in her late forties, and his newly realized jealous obsession at the age of sixty-two with Consuela Castillo, a fresh sexual partner and recent student of twenty-four. Kepesh has had faith in his emotionally restrained attitude in his relationships with women. He asserts to his assumed reader, "emancipated manhood never has had a social spokesperson . . . people don't want it to have social status" (112). Since the thirty-eight-year gap between his and Consuela's ages does not square with convention, he argues that she is ennobled by his cultural status, even as he recognizes that his sexual dominance is on the decline, and that his resulting lack of confidence and increased jealousy have become debilitating. Poet George O'Hearn, Kepesh's university colleague and friend of fifty-two, had reminded him of their agreement that "attachment is the enemy" (100). George is married and has sexual flings, but he suddenly keels over from a heart attack just as he is about to give a public reading of his work. He soon dies at his home with Kepesh in attendance, but not before George grasps for his estranged wife's breast and gives her a final embrace and kiss. This gesture gives his friend momentary pause, as Kepesh recalls how his position on independence developed from his own past experience with a life-draining marriage and divorce. He had concluded bluntly, "Marriage at its best is a sure-fire stimulant to the thrills of licentious subterfuge" (111). Halfway through the novella and after more than a year into his relationship with Consuela, however, his conviction finally meets its greatest test. She challenges him with a simple request that he join her family's celebration for the completion of her M. A. degree, as he eventually promises but ultimately fails to do. In response, Consuela sends him a letter in words of pained fury condemning the disconnect between his public role as "arrogant intellectual critic" and his private cowardice concerning any emotional commitment to her.

Consuela's termination of their affair sends Kepesh into bouts of depression long afterward, even after he has repeatedly brought other women to his bed. After six and a half years, he suddenly receives a call from Consuela, now thirty-two, whose revelation of her breast cancer and pending surgery reverberates for a now seventy-year-old man facing his own corporeal comeuppance with age. His previous objectification of Consuela's body as "a great work of art" (37) and his glorification of uncommitted sexuality as an older man's "revenge on death" (69) are now further tested by Consuela's pending surgery and possible death from breast cancer. As she lies in the hospital at the conclusion of Roth's novella, Kepesh, still at home, speaks to himself in quoted words: "'She's in terror. I'm going.'" But his final statement is also a quoted rejoinder that seems to come from his alter ego: "'Think about it. Think. Because if you go [to Consuela], you're finished'" (156). Roth has Kepesh's story end without revealing Kepesh's final decision and position on independence, and thus Roth's discomfort with a fixed conclusion. Consuela's helpless condition nevertheless elevates reader sympathy and seems a final blow against the protagonist's lack of commitment. Moreover, Roth has hinted throughout this novella at larger issues beyond Kepesh's personal dilemma and even his cultural perspective.

The anxiety pervading this work and one of Roth's earlier novels involving Kepesh, *The Professor of Desire* (1977), both seem to be preoccupied with the main character's

sexual independence. This anxiety reflects Roth's own experience with beautiful part-
ners and his creation of similar types in his fiction generally. The thirty-five-year-old
David Kepesh in *The Professor of Desire* is much the same self-critical intellectual. The
notable difference here is that the younger version of Kepesh is also a devoted novel-
ist. A few years after this younger protagonist's disastrous marriage to a woman named
Helen, and his associated nervous breakdown and very gradual recovery (imitating
Roth's own experience resulting from a drug he was given to accompany knee surgery),
Kepesh eventually settles in with a near "perfect woman," Claire, only seven years his
junior. He is not jealously possessive of Claire (who shares her first name with Roth's
former wife, Claire Bloom), but his fears about the limited nature of the sexual gratifica-
tion possible in their domestic pastoral life soon drive him to end the relationship. The
limitations he fears, which continue even with the perfect Claire under ideal conditions,
are associated with Kepesh's struggles as a novelist and the artistic fulfillment he longs
for. Roth insinuates that the physical beauty of the women Kepesh desires and would
sexually possess in these two novels is as ephemeral as the creative spark that he seeks
to guide and control in the production of his own fiction. This is further confirmed by
what Kepesh says about his work in *The Professor of Desire*: "In order to achieve any-
thing lasting, I am going to have to restrain a side of myself strongly susceptible to . . . a
debilitating sort of temptation that . . . long ago . . . I already recognized as inimical to
my interests" (51). His concern about sexual temptation is equally paradoxical for Roth,
since he continued to mine his own desire for, and sexual experience with, women for
fictional material in both this novel and *The Dying Animal*. Claire, in the earlier novel,
and Carolyn and Consuela, in the latter, are all described as Kepesh's near-ideal partners
who along the way become insufficient to his ultimate greater "interests."

Many readers have noted the similarities between Kepesh and Roth, who shares his
character's age, Jewish ethnicity, sexual energy, intellectual status, social criticism, and
family history. A dominant characteristic of Roth's other work, in fact, including par-
ticularly *The Facts: A Novelist's Autobiography* (1988), and *Deception: A Novel* (1999),
is his tendency to efface the distinctions between factual autobiography, particularly
regarding his intimate relationships, and his fiction. This ambiguity is of a piece with
Roth's intimate concern with the relationship between a writer's personal experience
and cultural moment. In these two novels, the blending of the author's own heterosex-
ual attitudes and practices with those displayed in the partly fictive autobiography and
the partly autobiographical novel confuses genre status, begs the question of authorial
sources, and so produces a postmodern hyper-narrative, a dialogue with narrative that
raises larger questions of truth in fiction and autobiography. Implying in addition an
assault on American cultural myths and propriety, Roth told interviewer Jeffrey Brown,
"As a writer you have to be shameless, you have to have a good ear." Clearly, the elder
Roth is fully conscious of his literary and cultural/political heritage and of their con-
temporary manifestations, which he often provides as context in his fiction. But he
seldom strays far from the individual experience of his narrators, and indeed from his
frequent reliance on certain aspects of his own most intimate physical and emotional
realities. The combination of these personal, social, ethical, and aesthetic sources, in

whatever manner he chooses to draw upon them, is the basis and guide for the bulk of his acclaimed creative work.

In the novella, then, it is long after the breakup with Consuela that Kepesh, as literary scholar, is reminded of the three lines from "Sailing to Byzantium": " 'Consume my heart away; sick with desire / And fastened to a dying animal / It knows not what it is' " (Yeats 96). While Kepesh recognizes his own "sick[ness] with desire," he must also recognize Yeats's sense of heartfelt longing that exceeds lust. Kepesh does not cite the rest of the third line or the fourth, which completes this stanza of the poem: "and gather me / Into the artifice of eternity." His selective quotation leaves out what is surely Roth's more comprehensive understanding of Yeats's poem. The complete poem offers an imagined release of the poet from the dying body through transformation into a golden bird, a kind of "artifice of eternity" that sings of what is "passed, or passing, or to come" (Yeats 96). Yeats dreams toward the greatest insights and the release of art itself, which is for him a modern focus of consciousness, redeemed through its very expression from endless physical desire and social struggle. How does a bird crafted in gold sing, after all, but through the inner awareness the artist ascribes to it? Byzantium is a space of creative consciousness, of deeper truth, that exceeds cultural delusions while yet speaking of this world and not of some heavenly afterlife. Thus does the enunciating totality of the novella and its place at the conclusion of the Kepesh characterizations seemingly look to surpass, like Yeats, all the "sensual music" of coupling in which David seems trapped. This may well be the larger intended meaning of the final question and closing line posed by the disembodied voice, which seems to speak beyond Kepesh and his story at the end: "Think. Because if you go, you're finished." While Kepesh struggles with the shortcomings of his aging body and the intimidating power of his unexpected longing for Consuela, Roth also sings a truth of material existence that he formulates as a dimension of his own voyage, a subtle impetus toward a higher aesthetic achievement, like Byzantium, where he will never live. That disembodied voice's final word, "finished," intimates that his character Kepesh has probably reached a limit to his personal self-absorption. The final irony is that Roth needs the sensual music of his life for his narrative material, and that the sexual drive, limited as it may finally be by the dying body, is nevertheless tied up with his energy and inspiration as a writer. Nor is his need only some aesthetic abstraction. In a recent interview, Roth told Jeffrey Brown, "When I'm not writing, I'm empty and not very happy."

THE SCREENPLAY ADAPTATION

Meyer completed his screenplay adaptation of *The Dying Animal* late in 2003 and handed it over to Lakeshore. He retitled his script *Elegy*, not because he had missed Roth's literary allusions or wanted to distance the script or film from the novella, but simply for reasons of audience appeal (PI). In his second attempt to script Roth for Rosenberg, Meyer did have the advantage of a more concentrated story, although David Kepesh as the acting

narrator also created problems for adaptation because of his dominating subjectivity, facile intellect, and restricted point of view. The more exteriorized dramatization of this complex and intimately exposed character provided in the script would further require very sensitive casting and direction for the film. Locating an American star willing to take on the central male role again became problematic. Lakeshore opened negotiations with Al Pacino, who wanted an Italian director, who along with Pacino wanted changes to the screenplay. The back-and-forth around this package dragged on until 2007, when the producers finally rejected it. Rosenberg was apparently not happy with alterations that would take the story a greater distance from the content and tone of Roth's novella and Meyer's script (PI).

More than four years after Meyer had submitted the *Elegy* script to Lakeshore in 2003, Penélope Cruz entered the picture. Long a Roth fan, Cruz had read Roth's novella soon after its 2001 publication and saw herself as Consuela Castillo, the immigrant Cuban with a convenient Spanish accent. She wanted to go forward with Meyer's script, which she liked very much, and she strongly urged bringing in her Spanish compatriot, Isabel Coixet, to direct (PI). Coixet mentioned later that she, too, had read the novella as early as 2002 and thought that it would make a great film. Hence the contributions of the star, Penélope Cruz, to the eventual critical success of this project became central to what happened on both sides of the camera. The actor who came on board for the difficult role of David Kepesh was Ben Kingsley. Like Anthony Hopkins, who plays the central role in *The Human Stain*, Kingsley didn't want to compromise his acting by straining for an American accent, so this script also came to include mention of a partly Anglo background to accommodate him. Meyer found the casting of British performers (Hopkins and Kingsley) to play the roles of the protagonists, and Australian and Spanish performers (Nicole Kidman and Penélope Cruz) to play the roles of their paramours in these two adaptations (also helmed in the latter case by a Spanish director) an interesting commentary on the disinclination of career-oriented American stars to take risks (PI). Was it primarily the controversial racial passing or class differences in *The Human Stain*, or the sexual behavior and countercultural stance of the elderly intellectuals in both films that made them difficult to cast at home?

Nicholas Meyer shifts some of David Kepesh's many references in the novella to his own aging and loss of independence over to the ongoing judgments made by Kepesh's foil, George O'Hearn, whose untimely death in the novel and script leaves Kepesh bereft of his closest friend. Meyer also compresses the novella by changing Kepesh's son Kenny from a man who works in an art restoration business with his mother to an oncologist at the hospital where Consuela eventually becomes a patient. Father and son have a modest reconciliation toward the end of the screenplay and film that is not present in the novella. In the DVD release of *Elegy*, with a commentary track interestingly provided by Meyer rather than Coixet, Meyer defines the role of the screenwriter as that of a dramatist who must find a way to create an organic "blueprint" appropriate to cinema, since the ideas and feelings in the novella "are already a matter of interpretation." He also notes here that "the better the idea [and its expression in the source], the harder to live up to it." He asks, "Are we mainly to preserve as much of Philip Roth as possible, or

also to make something accessible in a different medium?" Others have attributed his success in living up to Roth's novella and its emotional charge in part at least to Meyer's shocking loss of his thirty-six-year-old wife Lauren to cancer, an experience he recalls in his memoir *The View from the Bridge* (237). Whatever the source of Meyer's inspiration while scripting, he was apparently happy with what he deemed his obligation to the novella in his comment on *Elegy*: "We let Roth be Roth" (PI).

Meyer invents ways beyond the novella to accentuate Kepesh's creative side in direct relation to his appeal to Consuela. He is shown more than once playing his piano for her (rather than when he is alone), being a culture critic on TV as she observes him, and enjoying a theater performance with her. Most notably, he becomes an active photographic hobbyist, complete with darkroom, and with Consuela as his main subject. His photography becomes a motif in the script that is visually expanded even further in the film to reveal his gradually changing attitude toward Consuela, beginning with his early close-up photos of her on the beach (Figure 11.1).

This change will finally reach a climax in the haunting scene of picture-taking toward the end of all three versions. Earlier, his lying to Carolyn, his hardness toward the son and former wife he deserted, and his insecure jealousy over Consuela also appear in all three texts, although his multifaceted creativity shown on screen softens him and further endears him to Consuela. The script and film adaptation stand together as an illuminating reflection of the novella's conflict between Kepesh's effort to maintain lustful male independence and the compelling pressure from the lovely and fair-minded Consuela for lasting commitment. And the dice, already loaded in Consuela's favor in the novella and script, are even more loaded in the film. Meyer's DVD commentary notes that he wanted his script to capture "a certain spectacle of [confessional] comedy in Roth to mute the misogyny," which he accomplishes in the opening interview scene

FIGURE 11.1 Photographing Consuela Castillo (Penélope Cruz) makes David Kepesh (Ben Kingsley) challenge his bachelor code of mere sexual involvement.

with the real Charlie Rose, in which Kepesh mocks the confining nature of the Puritan tradition. Meanwhile, the screenplay and film omit most of Kepesh's description in the novella of his extended sexual history with women, as well as certain depictions of his most extreme sexual behavior with Consuela.

THE DIRECTOR

Catalonian Isabel Coixet, the first woman to direct an adaptation of Roth, was already familiar enough with other works by Roth to say at the time of filming, "I think he's never apologetic about being a male, and that's one of the things that really attracts me to his writing. . . . He's never apologetic for what's human" (Walters D5). But she had more than the novella and Meyer's screenplay to contend with. Roth tried in two phone discussions with Coixet to direct her choices in filming *The Dying Animal*: "He read me his book page by page and he talked about every single detail. . . . I know that for him this is a very, very personal story. But I told him, 'This is a film and a film has its own laws.'" She notes that some of the most extreme sexual scenes were rendered more problematic by the graphic nature of film and its shaping of characters for audiences. She does not mitigate the sexual focus of the story as Meyer adapted it, but after considering an early episode in the novella in which Kepesh tries to break Consuela's sexual neutrality toward him by roughly fucking her in the mouth, and she responds by snapping her teeth back at him, she cut the scene. When Roth earlier read that passage to her, Coixet recalls, "he said, 'THAT, we have to have in the movie!' And I said, 'No, over my dead body!' 'But why?' he asked. 'This is a very powerful scene.' So I said, 'Philip, you know what? . . . I don't have any problem doing whatever's right for the film, but people don't want to hear the sound of those teeth. If I show that at the beginning of the film, I think it will make it hard for the audience to sympathize with these characters. I'm not saying you have to like them, but you have to care'" (Walters D5).

The snapping of teeth is not precisely the point, as Coixet certainly knew, for she finds verbal and visual equivalences to demonstrate Consuela's growing resistance to Kepesh's demeaning ideas of sexual tutelage and control as his failing pretense of emotional superiority becomes apparent. His self-conscious "pornographic jealousy" is also explored on screen in two scenes taken from his daydreams in the novella. The film accompanies Kepesh's voiceover with fantasy visualizations of her embracing some younger man. The self-lacerating monologues Roth assigns to Kepesh are also translated into other scenes in the script and film, first with his friend George (Dennis Hopper), who criticizes Kepesh's growing emotional vulnerability, and then with his grown son Kenny (Peter Sarsgaard). Kenny complains about his father's continuing emotional distance and hostility to conventional family life, even as Kenny confesses the problems his own adultery is causing. Consuela's growth as a self-assured woman emerges more strongly in the script and film than in the novella, where the narrative dominance of Kepesh overshadows her and the other characters. The novella, the script, and particularly the film all

clearly represent his growing emotional attachment to Consuela despite himself, since he is looking back fully cognizant of his senescence.

While Coixet carefully constructs the central couple's sexual and emotional intimacy, she also avoids any mawkish representation of their romance. Her realistic style, as in her two previous films, produces tightly focused character studies that favor spare environments over crowded scenes. Serving as her own camera operator and art director throughout, she favors close, interactive two-shots and shot reversals over wider framings that might distance her characters. In her adapted film, *My Life Without Me* (2002), which follows a mother of two children who is secretly preparing for her death from cancer, she emphasizes the mother's interior life. Similarly, in one dinner scene in *Elegy* just before Consuela's request that Kepesh attend her family celebration, she simply asks him in the film, though not in the novel or script, "What do you want from me?" Kepesh's failed promise to attend her graduation event causes not only her misery and their breakup (Figure 11.2), but also his own period of depression, which is more prominent and extended in the novella than in Meyer's and Coixet's compressed versions.

Following the novella and the script after the death of George and the breakup with Consuela, Kepesh explains, "I recovered my equilibrium—and my independence." To this assertion, Coixet adds his voiceover rejoinder to himself: "Who am I kidding?" Coixet does generally follow the script as Lakeshore wished, but her subtle inventions, including her selections for the film's score, build an elegiac tone that is expanded into

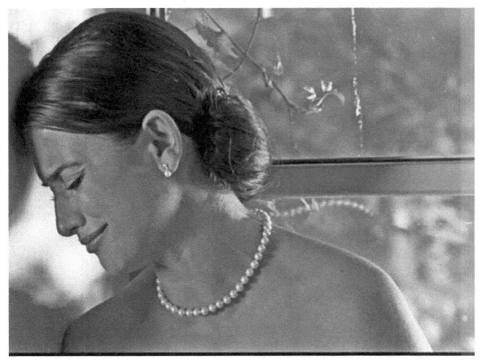

FIGURE 11.2 Consuela's reaction when Kepesh doesn't show up at her graduation party.

her own altered conclusion to the film. Coixet explains, " 'When you're making a film of a story, you add your experiences, your gender, all the stories of your life. Being really respectful of Philip Roth's work, I bring all the things I live' " (Garcia).

The screenplay and film compress the interim period of Consuela's absence from seven to two years and thus move quickly to Consuela's sudden call and consequent visit to announce her breast cancer to a stunned Kepesh (Figure 11.3).

She wants him to photograph her breasts and thus retain the image of her natural beauty beyond the surgery to come. Coixet's constant handheld camera operation (even as she generously credits Jean-Claude Larrieu as the cinematographer) succeeds here, too, in avoiding any sense of voyeurism in virtually static long takes of Consuela's toplessness (versus near nudity in the novella) as it is quietly photographed by the distraught Kepesh's still camera (Figure 11.4).

As she looks sadly and directly at him and at the audience, it is clear that he, too, finally sees beyond her body, an insight that leads to the film's concluding section. Coixet observed that "the novel has a beautiful ending because it leaves us not knowing what's going to happen. . . . But I felt the characters in my film needed some kind of redemption, some kind of hope. But this is not, 'Wow, he discovers he loves her. Everything is fine.' No, I hate that. Life's not going to be the same for them; that has to be clear" (Walters D5).

Coixet's film continues the storyline in a way that departs from the novella, and also from Meyer's script, which offers two more pages that describe Kepesh imagining Consuela already back at his apartment as he cooks for her, and then running toward him in the park as he continues in voiceover, "And it's not supposed to happen like . . . this," just before the closing scene at the hospital with his words, "not if I can help it" (116–17). In the film, Coixet simply has Consuela tell Kepesh, when he visits her after the surgical removal of a breast, "I didn't think you would come . . . I'm no longer beautiful."

FIGURE 11.3 Consuela's return marks a crisis for both her and Kepesh.

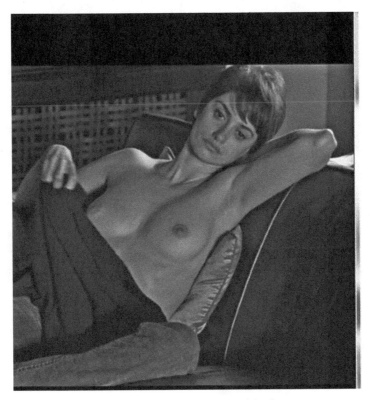

FIGURE 11.4 Kepesh's photography memorializes Consuela's body.

When he climbs onto her hospital bed, she leans into him and continues, "I'm going to miss you." Kepesh draws her close and says, "I'm here," as he slowly kisses her entire face (Figure 11.5).

Coixet's scene thus develops the implication of Kepesh's possible commitment to Consuela beyond the novella's concluding either-or interrogative, as well as the screenplay's focus on Kepesh's dialogue. Coixet not only allows Consuela to speak her fears but goes one step further. The film's closing wide shot, just before the credits are superimposed, shows an earlier moment, now virtually bleached of color, when the couple walked on a foggy beach together, a shot that continues as they walk out of the frame (Figure 11.6). Life will not be the same for them indeed, for they have both been forced to a greater acceptance of the wiles of fate in the human condition. Whether this will result in loving commitment is not finally confirmed here either, and even if so, the desolate gray beach suggests that it certainly will not be grounded in idealized romance.

Earlier in the screenplay, Meyer invented the lines that George addresses to Kepesh in the film about men's blindness to what lies behind a beautiful woman's surface. George wants to alert Kepesh to the dangers of caving in emotionally to mere physical attraction, the so-called "beauty barrier," which is accented earlier when he compares her eyes to those of a woman in a Goya painting. Kepesh's later fashion magazine–style cover

FIGURE 11.5 Kepesh's body "speaks" along with his words.

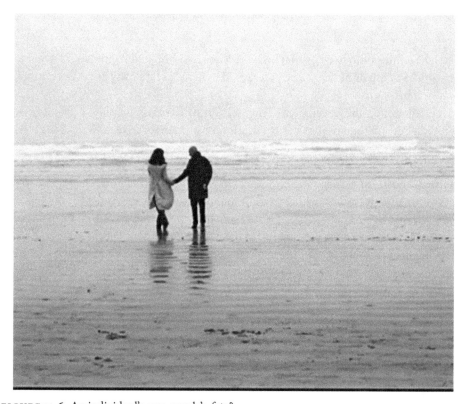

FIGURE 11.6 An individual's, or a couple's, fate?

shots of Consuela's wind-blown face out on the beach also occur at the apparent onset of his feared emotional involvement with her. And even these happy, romanticized photos taken earlier leave out the storm fence Coixet briefly foregrounds in a wide shot of the couple walking along the shore. Most telling is the grim atmosphere around the photos George takes much later of Consuela's bare breasts and staring brown eyes. We understand that the beautiful eroticism of the woman's body has now turned against itself. Consuela's exposed breasts now signify her victimization by disease, and thus the label of "dying animal" applies to both genders, beyond physical attributes. Coixet shows Kepesh afterward clutching these sad photos in a manila envelope to his chest while standing frozen in a moving crowd on the street, still shocked at the possibility of her death. Coixet's multiplied visual variations on issues of surface and depth for Kepesh thus drag him inexorably from an aesthetic-erotic form of desire toward a fuller emotional engagement with her, and indeed as Coixet's film here seems to suggest, the greater human condition.

The film adaptation does extend the jealousy and depression that overrule Kepesh's reasoning in the novella by having George admit before his stroke that he has had a recent rapprochement with his own wife—news that rattles Kepesh. After George's death and long after Consuela's departure, Kepesh receives a phone message, rather than a letter, from her that leads to her sudden visit and the revelation of her cancer, and a direct challenge to Kepesh and revelation of the hindsight of his extended self-criticism in the novella. As Coixet remarks on Roth and this work: "I think there is a void in the center of his infatuation with women. And I really think that *The Dying Animal* is him." But she continues that while [Kepesh] knows all about culture and art, "he doesn't know the most basic things in life: how to love, how to be loved. He doesn't even know how to talk to his kid. So there is a gap. David Kepesh doesn't really know human nature. Philip Roth knows more, a whole lot more" (Coixet).

While Meyer's script and Coixet's film lighten Kepesh and his obsessive sexual preoccupations, their interpretation and transcoding of the novella do not convey the larger theme of longing that is subtly underlined in this last of Roth's Kepesh novels. This theme, as noted, invokes the author's overriding struggle with the complex dualities of his erotic impulses and his lasting aesthetic desires as a writer. The novella's story material and peripheral references to beloved writers also show Roth's expressed kinship with Kafka's state of guilt and creative alienation, and Yeats's demanding vision of an art beyond the "manifold illusion[s]" of passing civilizations (Yeats 157). George's earlier criticism of Kepesh's behavior with Consuela is addressed to him as a literary critic: "You sentimentalized the aesthetic experience with this girl—you personalized it . . . you lost the sense of separation essential to your enjoyment" (99). Simply replacing the word "girl" with the word "character" turns his phrasing into a statement about the writer's lack of distance from characters with whom he dare not become too enamored. But how can one put this implied level of the novelist's struggle, hinted in the novella, into the dramatic body of the film, especially since the character Kepesh is more of a publicly active scholarly observer than a novelist like Roth, who works thematically at an intense level of self-interrogation and aesthetic longing? To the extent that the film challenges romantic love, it does let Roth be Roth, as the final cinematic thrust suggests Kepesh's

movement toward a deeper emotional rather than simply romantic commitment. This can also be observed in the ways the director highlights Kepesh's isolation from Consuela as he looks out from his apartment at the rain, or later dashes through a downpour to reach her after her surgery at the hospital. Meyer explains in his DVD commentary that filming his screenplay ultimately depended on the chemistry between the film's stars as a potential couple, especially since he did not know who would be cast when he wrote it: "Part of a film can't be written but must be acted. There is something ineffable that actors bring to it. . . . And Coixet's elegant and eloquent compositions add to the blueprint of the script. She stays very close to people." The visual intensity of Coixet's focus on the experience of Consuela seems confirmed by the decision to place Penélope Cruz's name first among the cast credits. It is the strong and constrained performance of Penélope Cruz on screen that gives the dominant life to the film, as she and her director were already determined to create together a story of a woman's as well as a man's fate.

The film also presents the difficult performative interplay of sexuality and emotional connection in a way that arguably overshadows the couple's thirty-eight-year age difference in the novel, as well as the thirty-one-year difference between Ben Kinglsey (at sixty-five) and Penélope Cruz (at thirty-four) on screen. Their convincing relationship makes Kepesh's belief that heterosexual coupling necessarily turns into dutiful drudgery and disillusionment in marital convention less central to the film. Roth's concerns, like those of Kafka and Yeats, clearly transcend these social questions. In Roth's intimations in these two Kepesh novels of the final longing and aesthetic challenges for the artist, it is clear that physical and emotional devotion to another person will never satisfy the artist's compulsion to create perfect work. And this applies most anxiously in the face of looming death, where one's written legacy may be given birth through the tumultuous experience of the flesh, but more lastingly in the spirit that lives through the work. This is the voice that speaks through and beyond David Kepesh in the novella.

Focusing on authorial intention enables us to see that Roth is using Kepesh to explore the implications of the erotic-leaning world of the body in Roth's own growing shadow of mortality and his place in literary history. The novel is closer to the dying animal that speaks of Roth and the artist's ultimate longing; Meyer's script and Coixet's film are directed more toward the education of the erotic male beyond the fetishized female body of sexuality. Through careful tonal control, the filmmakers of *Elegy* also place the arc of the highly cultured but self-serving intellectual into the context of a shared gender struggle. The experience of loss and sadness in physical mortality is the elegy of existence that all three authors have sought at some level to call forth. Coixet's wide-angle conclusion, showing the isolated couple walking in the distance along the beach, manages to imply a subtle subordination of the questions of gender and sexual authority to the larger question of what can be possible in their sharing of the greater human problem of meaningful human life. Coixet, like Meyer and particularly Roth, looks toward a wider ascension of consciousness, one that she orchestrates in cinema through her choice of music and art direction, and most convincingly in her handling of the camera and close engagement with the performers.

Artistic intention is not entirely conscious or controlled, particularly with a writer as autobiographical with his character Kepesh as is Roth. As he told Jeffrey Brown about being a novelist, "You don't know what you have done." This lesson can also be applied to the outcome of collaborative authorship in adaptation, where some level of good or ill fortune, even beyond all the best efforts of intention, can come into play. Locating authorial intent is certainly not a complete critical method, but it does offer a fuller understanding of what the essential process of film adaptation is and can mean. The intratextual approach to authorship has the potential to bring us closer to the authenticity of expressive lives as lived in the body, the heart, and the imagination, and as these personal dimensions are projected into each stage of the adaptive process.

WORKS CITED

Andrew, Dudley. *What Cinema Is!* West Sussex: Wiley-Blackwell, 2010. Print.

Coixet, Isabel. Interview by Maria Garcia. *Film Journal International* 111.8 (Aug 2008): 18. Print.

———. Interview by Karl Rozemeyer. 28 Dec. 2009. Web. 18 Apr. 2015.

Elegy. Dir. Isabel Coixet. Perf. Ben Kingsley, Penélope Cruz. Samuel Goldwyn, 2008. Film.

The Human Stain. Dir. Robert Benton. Perf. Anthony Hopkins, Nicole Kidman. Miramax, 2003. Film.

Hutcheon, Linda. *A Theory of Adaptation.* New York: Routledge, 2006. Print.

Meyer, Nicholas. Commentary. *Elegy.* Sony, 2009. DVD.

———. "Elegy." Screenplay. 117 pages. 13 Nov. 2003. Print.

———. "The Human Stain." Screenplay. 119 pages. 2001. Print.

———. Personal Interview. 30 Apr. 2010.

———. *The View from the Bridge.* New York: Viking, 2009. Print.

My Life Without Me. Dir. Isabel Coixet. Perf. Sarah Polley, Mark Ruffalo. Sony Pictures Classics, 2002. Film.

Roth, Philip. *The Breast.* New York: Farrar, Straus and Giroux, 1972. Print.

———. *Deception: A Novel.* New York: Houghton Mifflin, 1999. Print.

———. *The Dying Animal.* New York: Houghton Mifflin, 2001. Print.

———. *The Facts: A Novelist's Autobiography.* New York: Farrar, Straus and Giroux, 1988. Print.

———. *The Human Stain.* New York: Houghton Mifflin, 2000. Print.

———. "Interview with Jeffrey Brown." *PBS Newshour.* 10 Nov. 2004. Web. 18 Apr. 2015.

———. *The Professor of Desire.* New York: Farrar, Straus and Giroux, 1977. Print.

Walters, Ben. "If You're Looking for Isabel Coixet, Squint." *Gazette* [Montreal]. Arts and Life. D5. 18 Aug. 2014. Print.

Yeats, William Butler. *Selected Poems and Two Plays of William Butler Yeats.* Ed. M. L. Rosenthal. New York: Collier, 1968. Print.

CLASSICS ILLUSTRATED AND THE EVOLVING ART OF COMIC-BOOK LITERARY ADAPTATION

WILLIAM B. JONES, JR.

"FEATURING STORIES BY THE WORLD'S GREATEST AUTHORS"

THE *Classics Illustrated* (*CI*) comic-book series of adaptations of works of literature, nonfiction, and biography or autobiography presents a richly varied and rewarding field for adaptation studies. This essay will focus on the main US series (Gilberton Company, 1941–67, Frawley Corporation, 1967–71), which began its long life as *Classic Comics* in October 1941, when New York entrepreneur Albert Lewis Kanter issued a 62-page comic-book adaptation of *The Three Musketeers* by Alexandre Dumas, along with a two-page biography of the author. A similar treatment of Sir Walter Scott's *Ivanhoe* was published in December 1941 as No. 2. Kanter's intention was to offer more filling fare to a generation of young readers mesmerized by the exploits of Superman, Batman, and Captain America through the means of the same culturally disfavored medium (Jones, *Classics* 6). Each cover bore the proud declaration beneath the logo's yellow banner: "Featuring Stories by the World's Greatest Authors." As with all comic books, the art and scripts in *Classic Comics* were mutually supportive and dependent.

Although *Classics Illustrated*—so renamed in March 1947—was the most successful enterprise to date in the field of comic-book literary adaptation and the prototype of the graphic novel, it was not the first effort made in the comics realm to bring "classic" stories to sequential-art form. In 1926–27, George Storm produced for the McClure Syndicate a twenty-two-week adaptation of *Swiss Family Robinson* with brisk comic-strip pacing (Goulart, *Encyclopedia* 40–41; Jones, *Classics* 11). Serialized versions of

Treasure Island and an abandoned *Ivanhoe* appeared in 1935 in Major Malcolm Wheeler-Nicholson's *New Fun* comic-book series, followed in 1936 by serialized adaptations of *Gulliver's Travels, A Tale of Two Cities*, and *She* (Goulart, *History* 56, 58, 66; Jones, *Classics* 11). But it was Kanter's insight that self-contained comic-book adaptations of literary masterpieces would find a niche in the Golden Age market (Jones, *Classics* 11).

Textual Fidelity and Comic-Book Storytelling: A Handmaid's Tale

In a letter addressed "To Our Readers" on the inside front cover of *Classics Comics* No. 1, Kanter trumpeted the goals for the new publication:

> It is not our intent to replace the old established classics with these editions of the "CLASSIC COMICS LIBRARY," but rather we aim to create an active interest in those great masterpieces and to instill a desire to read the original text. It is also our aim to present these editions to include all the action that is bound to stimulate greater enjoyment for its readers. It is our sincere belief that men and women, as well as junior men and women have attained a finer taste in literature, and they will welcome these highly interesting, concise editions of the established works of the masters. (*CC* No. 1)

From the beginning, then, the literary adaptations provided by *Classic Comics/Classics Illustrated* were intended to occupy a subservient role—a handmaid's function—in relation to the source material; they were meant to serve as an inducement for "junior men and women" to encounter "the original text." This initial statement of intent was reiterated in April 1950, on the last page of *Classics Illustrated* No. 70, *The Pilot*, in language that was repeated at story's end in almost every issue published thereafter in the series and that became a mantra for many young readers for the next twenty-one years: "Now that you have read the CLASSICS *Illustrated* edition, don't miss the enjoyment of reading the original, obtainable at your school or public library."

Yet despite stated intentions, *Classics Illustrated* became an independent and identifiable art form in its own right, reflecting different approaches to textual adaptation and recapitulating the stylistic shifts in comic-book illustration, moving from exuberant primitivism through pulp-influenced realism to mid-century minimalism. The graphic-novel heirs of the original *CI* series of literary adaptations, including the Berkley/First Publishing *Classics Illustrated* second series (1990–91), which featured artwork by Peter Kuper, Bill Sienkiewicz, Jill Thompson, and other significant contemporary figures, as well as the unrelated Neon Lit and Puffin Graphics series (Versaci 199), went further in terms of responding to source texts through layout and design. Within the original series, however, the essential elements of the history of literary adaptation are already present.

Between 1941 and 1971, 169 titles appeared in the original US *Classics Illustrated* series. Unlike other comic-book lines that featured mostly one-shot offerings, the publishers reprinted issues and maintained back-cover reorder lists that showed available titles

as new numbers were added and less successful ones dropped. Business manager O. B. (Bernie) Stiskin flatly declared that *CI* titles were "discontinued when they performed poorly on newsstands," citing as an example Charles Kingsley's *Westward Ho* (Stiskin, 8 Aug. 2002). Beginning in 1953, earlier *Classics* editions were replaced with what was believed to be improved artwork and scripts. Most pre-1951 titles received new painted covers to replace the comics-style line-drawing art between 1953 and 1962. A total of thirty scripts were completely rewritten in the same period (one of which, for Herman Melville's *Typee*, was not included in the North American line until 2013). A fresh cover and new interior art were introduced in *The Jungle Book* in 1968, but the 1951 script remained intact. Thus the student of *Classics Illustrated* has available for examination approximately 200 different adaptations in the US series alone.

Maintaining a catalogue that comprised overlapping old and new titles created a kind of historical-present tense for *Classics Illustrated* readers. As late as 1971, a prospective purchaser could find on spinner racks reprints of the 1945 adaptation of Mary Shelley's *Frankenstein*, which "straightened the novel's circular story line" and "added details where Shelley's prose left questions unanswered" (Hitchcock 217); the 1952 adaptation of Shakespeare's *Hamlet*, with dialogue and soliloquies intact in speech balloons and context provided by added narrative boxes; and the socially conscious 1960 adaptation of Frank Norris's *The Octopus*, with the author's language scrupulously unchanged, as late as 1971. So different were the approaches of the artists and adapters that, apart from the instantly recognizable yellow rectangle on the front covers, the books might have seemed to belong to different publications. All of which is to say that generalizations about *Classics Illustrated* are of limited use in attempting to understand the dynamics of this complex publication.

That, of course, has not stopped some critics from making broad assumptions about the series, treating every one of the 169 titles as contemporaneous and interchangeable, with no distinctions drawn among publication dates or changing editorial principles, art styles, and approaches to scriptwriting. And thereby hangs a tale, for most of the objections to—and, for that matter, defenses of—*Classics Illustrated* are framed in terms of debates regarding fidelity to source material that are familiar to students of adaptation theory as applied to literature and film. Indeed, the principle of textual fidelity came to be central to the Gilberton Company's mission in producing the *CI* series.

In May 1940, two years after the first appearance of Superman and one year after Batman's debut, children's author Sterling North declared comic books a "poisonous mushroom growth" in a *Chicago Daily News* editorial (Beaty, *Fredric Wertham* 113) and urged parents to introduce their charges to such adventure stories as Charles Kingsley's *Westward Ho!* and Robert Louis Stevenson's *Treasure Island* (both of which were later adapted for *Classics Illustrated*). The following year, *Parents' Magazine* introduced *True Comics*; the first issue in its nine-year run included educational features on Winston Churchill, the Marathon run, and Simón Bolívar (Jones, *Classics* 10–11). It was within this cultural context that Albert Kanter launched *Classic Comics*, in a sense seeking a form of redemption for a disfavored medium, or at least changing the terms of the argument.

Endorsements of the publication from parents, teachers, and young readers began arriving within the first year and were occasionally published as inside-front-cover

testimonials (*CC* No. 8). The Gilberton Company, responding not only to readers but also to the mounting anti-comics crusade of the late 1940s, made the most significant marketing decision in the history of the series when it changed its name, as announced in the February 1947 *Classic Comics* issue: "Starting in March, with issue number 35, the new name will be 'Classics *Illustrated*.' Why the change? Well, ever since our first issues, you have said that they really aren't 'comics.' We agree with you and so we're changing the name to 'Classics *Illustrated*'" (*CC* No. 34).

Publisher Albert Kanter actively courted the educational market, running a number of *Classics Illustrated* ads in *The Instructor* during the late 1940s and early 1950s (Jones, *Classics* 92–93; Munson 4–7). An advertisement made its case for the series on the basis of the appeal of the comic book and the textual fidelity of the adaptations: "The comic-strip technique, so popular among youngsters, is utilized to bring to life the heroes of great literature. Authentically illustrated in full color and maintaining the original text, each title is a complete adaptation of the original. The grandeur and high language level of the original is retained throughout" (Classics Illustrated, *Instructor* 1). Indeed, while some educators viewed the comic books merely as book-report fodder for unmotivated students, many teachers distributed *CI* adaptations of assigned novels to encourage reluctant readers. It is estimated that tens of thousands of schools worldwide eventually adopted Gilberton publications as supplementary instructional aids (Crawford 205; Jones, *Classics* 111–12).

CRITIQUES OF THE *CLASSICS*

Despite the accolades *Classics Illustrated* received in certain quarters by the 1950s, it was caught up in the anti-comics crusade that peaked in the early years of the decade, as well as the postwar highbrow-middlebrow cultural debate. Poet-critic Delmore Schwartz delivered the highbrow critique of *Classics Illustrated*. In his analysis of three titles—*CI* No. 89, *Crime and Punishment* (November 1951); *CI* No. 87, *A Midsummer Night's Dream* (September 1951); and *CI* No. 16, *Gulliver's Travels* (December 1943)—Schwartz sounded the cultural alarm as he took issue with different aspects of the three adaptations, reserving his strongest objections for the Dostoevsky comic.

Regarding *Crime and Punishment*, most likely adapted by Kenneth W. Fitch, Schwartz noted the "sentences of bold apology and excellent advice" (Schwartz 462) appearing at the end of the forty-four page adaptation (Figure 12.1); they formed a variation on the usual concluding *CI* exhortation: "BECAUSE OF SPACE LIMITATIONS, WE REGRETFULLY OMITTED SOME OF THE ORIGINAL CHARACTERS AND SUBPLOTS OF THIS BRILLIANTLY WRITTEN NOVEL. NEVERTHELESS, WE HAVE RETAINED ITS MAIN THEME AND MOOD. WE STRONGLY URGE YOU TO READ THE ORIGINAL."

Schwartz points to the omission of the character of Sonia: "She may have been omitted because of space limitations but it is just as likely that her prostitution had something to do with her absence from the literary version. What remains after the deletion of some of the original characters [Marmeladov, Raskolnikov's mother and sister, Luzhin, and

FIGURE 12.1 *Classics Illustrated* No. 89, *Crime and Punishment*, Palais art, unidentified script-writer, 1951 (44). Raskolnikov (and the editors) fess up.

Svidrigailov, among others] and sub-plots is the thin line of a detective story in which a murderer is tracked down" (462).

The cultural climate of 1951 would have made Sonia a prime candidate for exclusion from the *Classics Illustrated* script, although she might have figured in the adaptation with no reference to her means of support. In his essay, Schwartz is essentially stating the case for faithfulness and not contemplating how contorted a forty-four-page adaptation would be if it were to encompass every character and plotline in Dostoevsky's novel. His condescending tone shows that he views "cartoons" as an inherently inferior medium and sees any attempt to adapt a hallowed text as an act of cultural presumption, if not outright vandalism. Schwartz presents himself as part of a mandarin class of postwar critics who insisted on a particular way to read literature and detested middle-brow efforts at diluting the proper response—that is to say, their response—to canonical authors (Beaty, "Middlebrow" 122).

Without ceding any merit to the scriptwriter's ability to reveal in a different medium something of the thematic concerns of the novel, Schwartz declares,

> The miracle, or perhaps one should say the triumph of Dostoevsky's genius, is that despite all the cuts and mutilations of the original, there are gleams and glitters throughout the illustrated version of the psychological insight which Dostoevsky possessed.... The brilliance and the originality of Dostoevsky's psychologizing comes through mainly in the exchanges between Raskolnikov and Porfiry the detective.... There are also numerous moments in the illustrated edition which are unknowingly comic and probably the expression of deep unconscious attitudes upon the part of the illustrator and the editor. For example, Raskolnikov at times looks very much like a Russian delegate to the UN who is afraid that the NKVD is after him. At other times Raskolnikov has an unquestionable resemblance to Peter Lorre, the film star who has so often been a villain. At other moments the illustrations—but not the text—suggest a detestation of all intellectuals, not only Raskolnikov, and in general there is the sharp implication throughout that most Russians are either criminals or police agents, and all Russians are somehow fundamentally evil. (Schwartz 462–63)

This passage says more about the writer than the adaptation. Whatever good Schwartz finds in the *Classics Illustrated* adaptation of *Crime and Punishment* is attributable to "Dostoevsky's genius," which transcends the "cuts and mutilations of the original." In his comments, however bizarre, on artist Rudolph Palais's illustrations, the critic at least shows an apprehension of the relation of art and text in a comic-book adaptation, even though he attempts to segregate the elements, in the process defending the very script he has been deriding. Schwartz, like other readers, recognized Palais's Lorre-influenced Raskolnikov. Before entering the comics field in the 1940s, Rudy Palais had spent seven years in the 1930s producing color movie posters for Warner Bros. and Columbia Pictures (Jones, *Classics* 105); the latter studio had released a film adaptation of *Crime and Punishment* starring Lorre in 1935.

In December 1951, one month after the publication of the Dostoevsky adaptation, Gilberton managing editor Meyer A. Kaplan found himself defending *Classics*

Illustrated before the New York Legislature's Joint Legislative Committee to Study the Publication of Comics. Among the authorities who had been invited to appear was the distinguished New York psychiatrist Dr. Fredric Wertham, a leader in the mid-century anti-comics campaign. Kaplan, responding to Wertham's attack on *Classics Illustrated* that had appeared in a 29 May 1948 article in *The Saturday Review*, delivered a defense of the series and a justification for literary adaptation:

> The taste for good literature . . . must be cultivated in a child slowly. He must be made to understand it before he can like it. . . . [A] pictorial rendering of the great stories of the world which can be easily understood and therefore more readily liked would tend to cultivate that interest. Then, when he grows older, if he has any appetite for these things. He will want to know more fully those bookish treasures merely suggested in this, his first acquaintance with them. . . . The names of d'Artagnan, Ivanhoe, Jean Valjean and other famous characters in the world of literature will be no strangers to him. (New York State 860–62; Jones, *Classics* 167)

Again, the debate is couched in terms of *Classics Illustrated* serving a larger literary purpose—or, from the perspective of the critics, subverting that purpose by the very act of adaptation.

Fredric Wertham renewed his attack on the series in his well-publicized 1954 jeremiad, *Seduction of the Innocent*, which impelled the comics industry to establish a new self-policing code (Nyberg 98). While the book's principal targets were crime and horror comics, Wertham took special aim at *Classics Illustrated*, inveighing in broad terms against the presumption of adapting literary masterpieces in the first place:

> Comic books adapted from classical literature are reportedly used in 25,000 schools in the United States. If this is true, then I have never heard a more serious indictment of American education, for they emasculate the classics, condense them (leaving out everything that makes the book great), are just as badly printed and inartistically drawn as other comic books and, as I have often found, do *not* reveal to children the world of good literature which has at all times been the mainstay of liberal and humanistic education. They conceal it. (Wertham 36)

This broad-brush condemnation persists among some present-day critics who make essentially the same point: "[C]omics adaptations of prose books are almost uniformly terrible, from the old *Classics Illustrated* pamphlets to the contemporary versions of *Black Beauty* and *The Hunchback of Notre Dame*; they don't run on the same current, basically, and they end up gutting the original work of a lot of its significant content" (Wolk 13). Wertham and Wolk share the assumption that the very act of literary adaptation in the comics medium is at best a compromised endeavor.

In essence, these arguments are variants on the fidelity critique, the fallback position in most considerations of the merits or failings of a specific *CI* adaptation, despite recent attacks on this position by Thomas Leitch (161) and others. Indeed, the debates concerning the merits of *Classics Illustrated* were often conducted in a kind of theoretical vacuum by participants who assumed the inherent superiority of the literature adapted

and who had little acquaintance with or understanding of the structure of sequential-art narrative within and between the panels or its potential as an art form in its own right.

THREE ERAS OF *CLASSICS ILLUSTRATED* ADAPTATION

Three eras in the thirty-year evolution of *CI* adaptation can be roughly outlined. Approaches by individual scriptwriters varied considerably within those periods, so nothing can be fitted neatly into well-defined boundaries, but the issue of textual fidelity informs them all. Gilberton scriptwriter Alfred Sundel, who adapted some thirty titles for the US *Classics Illustrated* series and many more for the series' British and European licensees, summed up three methods of comic-book adaptation of classic fiction or nonfiction that were used at different times between 1941 and 1962, when US new-title production ceased: "As for adaptations, I suspect there are 3 kinds. 1. Faithful. 2. Interpretive. 3. A hybrid of the first two. . . . I deeply respected the author's rights and did not change anything. I didn't want to let the author down in any way, since I was working away on my own writings" (Sundel, Email, 29 Oct. 2014). Sundel's commitment to the principle of textual fidelity is entirely consonant with the declared pedagogical purposes and cultural aspirations that *Classics Illustrated* demonstrated under the editorial supervision of Roberta Strauss Feuerlicht (Jones, *Classics* 197). But this approach triumphed fully only in the final period of the publication's history, when Feuerlicht and Sundel exercised nearly complete editorial control.

Using the categories outlined by Sundel, the three eras in *CI* adaptation might be loosely defined as Interpretive (1941–1944), Hybrid (1945–1956), and Faithful (1957–1962). These periods roughly correspond to the mode of production. What follows are accounts of different adaptation strategies employed by Gilberton scriptwriters in those three stages of *Classics Illustrated* history, with principal emphasis given to four representative figures: Evelyn Goodman ("Interpretive"); George D. Lipscomb and Kenneth W. Fitch ("Hybrid"); and Alfred Sundel ("Faithful").

INTERPRETIVE EVELYN GOODMAN AND HER REWRITES

During the war years, Albert Kanter initially worked with artists affiliated with Lloyd Jacquet's Funnies, Inc., shop, such as Malcolm Kildale (*CC* No. 1, *The Three Musketeers*) and Ray Ramsey (*CC* No. 4, *The Last of the Mohicans*). Beginning with *CC* No. 5, *Moby-Dick*, and continuing through *CC* No. 22, *The Pathfinder* (October 1944), the Gilberton Company employed freelance artists such as Rolland H. Livingstone (*Les misérables*, *Uncle Tom's Cabin*), Lillian Chestney (*Arabian Nights*, *Gulliver's Travels*), and Louis

Zansky (*Don Quixote, Huckleberry Finn*), who doubled as de facto art director until he departed for overseas service. The artwork ranged from briskly fluid (Zansky) to stolidly competent (Kildale) to charmingly fanciful (Chestney) to willfully antiquated (Livingstone) to occasionally wooden (Ramsey).

Evelyn Goodman, one of several female scriptwriters, editors, and artists whom the Gilberton Company employed, was in charge of "Story Adaptation" from 1942 to 1944, sharing scriptwriting duties with several freelancers. Among the titles Goodman adapted were *CC* No. 6, *A Tale of Two Cities* (October 1942); *CC* No. 13, *Dr. Jekyll and Mr. Hyde* (August 1943); and *CC* No. 18, *The Hunchback of Notre Dame* (March 1944). The scriptwriter understood the comic book as a medium separate from the literary works she was called upon to adapt and never seemed intimidated by the canonical status of the masterpieces on the Gilberton publication schedule (Jones, *Classics* 35). *A Tale of Two Cities*, despite such unintentionally comical interpolations as "Put your head on the block, Evremonde!" (Goodman, *Tale* 63), shows Goodman working in the hybrid mode, which she adopted in her treatments of *CC* No. 9, *Les misérables* (March 1943), and *CC* No. 15, *Uncle Tom's Cabin* (November 1943), while the Stevenson and Hugo adaptations are models of how loosely adapted *Classic Comics* could be.

Goodman's script for *The Hunchback of Notre Dame* is more interpretive than any other adaptation to appear under Gilberton's yellow banner. In rewriting Victor Hugo's *Notre-Dame de Paris*, Goodman turns the villainous archdeacon Claude Frollo into a stern yet caring protector of Quasimodo and removes any trace of his libidinous interest in the gypsy Esmeralda; presents Captain Phoebus de Châteaupers as Esmeralda's devoted lover, who is attacked by a random ruffian rather than the jealous churchman Frollo, and lives to save the girl and win her in the end; spares Esmeralda her unhappy fate; and sends Quasimodo plunging to his doom from one of his beloved bells (Figure 12.2).

The scriptwriter's free hand was complemented by Allen Simon's woodcut-style drawings, which evoked 17th-century broadsheets and offered a certain primitive charm (Jones, *Classics* 23). Goodman inclined at times in her retelling of Hugo's tale to the sentimental. The Frollo stand-in adds a "Lord have mercy on his soul" unknown to Hugo (Goodman, *Hunchback* 48). "Esmeralda! My lovely Esmeralda!" the miraculously revived Phoebus exclaims in a heart-shaped panel at the end (Goodman, *Hunchback* 50). Simon's natural bent, by contrast, was toward the grotesque. The anarchic energy of his illustrations alternately subverts and supports Goodman's script, providing a rewarding example of "the space of disjunction between texts and media" (Albrecht-Crane and Cutchins 20).

Elsewhere, both scriptwriter and artist showed a certain relish for horror scenes, as when Esmeralda is subjected to the wooden boot: "Stop the torture. . . . I confess! Take it off!" (Goodman, *Hunchback* 28). The tone was set in Simon's line-drawing cover, which depicted an oversized Quasimodo wreaking havoc on soldiers attacking the Cathedral. This Grand Guignol cover was suppressed in 1949 and was replaced with a tamer illustration by Henry C. Kiefer showing Esmeralda and her goat, with Quasimodo's shadow looming ominously in the background. This revised edition otherwise retained Simon's original illustrations, though the page count was cut from fifty-six to Gilberton's postwar standard forty-eight.

FIGURE 12.2 *CC* No. 18, *The Hunchback of Notre Dame*, Simon art, Goodman script, 1944 (47). Quasimodo meets his fate at the hands of artist and adapter.

FIGURE 12.3 *CI* No. 18, *The Hunchback of Notre Dame*, Evans and Crandall art, Sundel script, 1961 (45). Note the absence of speech balloons and the text-only final panel.

In the fall of 1960, Feuerlicht assigned Gilberton scriptwriter Alfred Sundel the task of providing a new script that would more faithfully reflect the content of Hugo's novel. Two of the most highly regarded artists associated with *Classics Illustrated*, EC veterans George Evans and Reed Crandall, supplied the new interior artwork. Both versions devoted space to competitors vying for the title of pope of fools. In the 1944 comic book, however, Simon slips a caricature of Adolf Hitler into the sequence and emphasizes the bizarre appearance of the hunchback (Goodman, *Hunchback* 6–7), while Evans and Crandall focus on the pathos of Quasimodo's plight, supplying visual context for Sundel's script information about the bell ringer's employment and consequent deafness. Sundel, in a final narrative box following two pages devoted to the hanging of Esmeralda and the death of Frollo, restores Hugo's unsettling postscript in abridged form (Figure 12.3) (Sundel, *Hunchback* 45).

George D. Lipscomb, Kenneth W. Fitch, and the Hybrid Era

Fiction House (Iger Shop) scriptwriter Ruth A. Roche presided over the first two years of the second stage of Gilberton adaptations, producing, either alone or with her frequent collaborator Tom Scott, several key *Classic Comics* adaptations, including *CC* No. 29, *The Prince and the Pauper* (July 1946), and *CC* No. 32, *Lorna Doone* (December 1946) (Jones, *Classics* 321–22). As Jerry Iger's assistant editor, she also supervised other scriptwriters like Harry G. Miller and George D. Lipscomb during the transition from *Classic Comics* to *Classics Illustrated* in 1947 and through the end of the decade (Jones, *Classics* 323–25). A formidable figure in the industry from 1940 to 1961, Roche "probably wrote more comics during the 1940s than any other woman who was not also drawing her own strip" (Robbins 76).

George Lipscomb's script for James Fenimore Cooper's *The Spy* was written for a Gilberton–*New York Post* newspaper supplement (a short-lived experiment by Albert Kanter in producing a syndicated weekly series in 1947–48), and a year after its publication as a four-part, sixty-four-page "Illustrated Classic" serial from 20 July to 10 August 1947 (Malan 1), it was trimmed and issued as a forty-eight-page *Classics Illustrated* edition, No. 51, in September 1948. The adaptation was thus itself further adapted by Gilberton editor Harry M. Adler, who had already made deletions and changes in Lipscomb's script before it was translated into a grid of sequential images for newspaper pages.

Adler cut as redundant a "thought" line Lipscomb gave the protagonist, Harvey Birch, a double agent in the American War of Independence: "They do not know that I am an American spy in the personal service of General Washington" (Lipscomb 9; *NY Post* 6). The disguised George Washington, "Mr. Harper," had sent up in the same panel a thought balloon with the words: "Ah, one of my most faithful soldiers stands before me" (Lipscomb 9; *NY Post* 6), but the entire page was deleted for the 1948 *Classics Illustrated* edition, and Birch's connection to Washington was revealed more organically through four existing

panels of secret conversation between the two men (*NY Post* 8; *CI Spy* 7). Lipscomb's newspaper adaptation includes the hanging of the renegade Skinners (actually a single Skinner in Cooper's novel) (Figure 12.4), the death of the dashing Captain Lawton in battle, and the discovery of Washington's exculpatory letter on the body of Harvey Birch in an epilogue set during the War of 1812. These episodes filled four pages in the 1947 "Illustrated Classic" version, but all were cut from the 1948 *Classics Illustrated* No. 51 in the interests of space restrictions, narrative economy, and reducing violent content.

For each panel, Lipscomb offered veteran *CI* artist Arnold L. Hicks a "Scene" statement, as in this scenario for the most famous panel in the comic book: "The Skinners with their backs naked are tied up to limbs of trees; dragoons have switches and are beating them" (Lipscomb script 40). Lipscomb also supplied subtext for the illustrator: "The Skinners have the peddler, who is carrying his heavy sack, and are driving him along at the points of their bayonets. This is a picture that seems to indicate that Cooper wishes to suggest the Christ in the character of the peddler" (Lipscomb script 37). Lipscomb's hybrid approach to Cooper's novel is evident throughout in his treatment of the author's characteristically opaque language, as when he changes "A large proportion of [Westchester's] inhabitants . . . affected a neutrality" (Cooper 10) to "Others were neutral" (Lipscomb script 1). Nothing is substantively changed, yet the scriptwriter never feels bound to reproduce the author's words verbatim.

Another exemplar of the hybrid model was Kenneth W. Fitch, the chief scriptwriter for Gilberton in the early 1950s, who supplied at least twenty adaptations for *Classics Illustrated* between July 1950 and September 1953, when the publication released new titles on a monthly basis. Fitch's practice was to read not only the book to be adapted but also related reference works. Before creating a script for the comic book, the scriptwriter took extensive notes on the plot, characters, and historical milieu of the work at hand. This background work, such as an overview of seventeenth-century Paris street life for *CI* No. 79, *Cyrano de Bergerac* (January 1951), invariably found its way into the finished adaptations as comments directed to the editorial staff and assigned artist, but not intended for publication (Jones, *Classics* 115). For *CI* No. 96, *Daniel Boone: Master of the Wilderness* (June 1952), the scriptwriter corresponded with Boone biographer John Bakeless (Jones, *Classics* 115).

A remarkably complete Kenneth Fitch adaptation file exists for Robert Louis Stevenson's *The Master of Ballantrae, CI* No. 82 (April 1951), a title selected with an eye to capitalizing on the connection to the forthcoming Warner Bros. swashbuckler starring Errol Flynn (Jones, "Mackellar" 253). The papers contain not only the forty-four-page script and a two-page biography of the author for the comic book but also a letter from the adapter to Gilberton editor Harry M. Adler; a three-page legal-sized plot synopsis; a sixteen-page, legal-sized handwritten series of notes detailing characters, plot points, multiple narrative perspectives, and historical references (e.g., Culloden); and a single-page, legal-sized list of "Descriptions of Characters," such as this one of the titular hero-villain:

> *James Durie, The Master of Ballantrae and Durrisdeer:* The eldest son and next in line
> to the right of the title of Lord Durrisdeer when the father should die. He is a dashing

FIGURE 12.4 *Illustrated Classic, The Spy*, Hicks art, Lipscomb script, 1947 (58). This newspaper-supplement page was deleted in the 1948 *CI* comic book.

handsome man in appearance. About 22 or 23 at the time of the opening of the story. He has an arrogant graceful bearing. Make his face if possible one that can be pleasing when he is in the mood and vicious when he is angry. He is tall, erect, well proportioned. He has a very intelligent look about him. (Fitch, *Ballantrae* script xx)

The artist to whom Fitch addressed these comments was Lawrence Dresser, a children's book illustrator who took the scriptwriter's observations to heart and produced a well-researched costume piece, basing two of his drawings on illustrations by William Hole for the initial publication of the novel in *Scribner's Magazine* (November 1888–October 1889) (Jones, "Mackellar" 254; Swearingen 119). Although Fitch and Dresser clearly had one of Hole's *Ballantrae* illustrations in mind for the title-page splash (Figure 12.5), the detail embedded in the scriptwriter's note, which fills an entire legal-sized typescript page, illuminates Fitch's conception of his responsibility to the principle of fidelity:

The splash is a picture set in the center of the page, the background taking up as much as the artist considers necessary for getting over the spirit of the scene. Drop the splash picture to bottom of page, but leave space for some caption panels that can give a short synopsis of the historical events that set the time and locale of the story.

The scene itself is a duel between James Durie, the Master of Ballantrae, and his brother, Henry. James is older than Henry, being at the time of the duel about 32 or 33, while Henry's age is just short of 30 according to the story. In this scene, James, the Master shows terror and fear in his face, and he is avoiding the thrust of Henry's sword by grasping it in his free hand. Show Henry at the moment of the thrust, with his own free hand behind his back where it should be according to the rules of duelling.

The time of the duel is February, 1757, so the dress of these gentlemen is according to the period. They are dressed in satin breeches to the knees, silk stockings and buckled pumps. Their shirts are of linen with lace collars and cuffs, and they wear vests that are sleeveless and drape down below the waist. Kneeling on the ground nearby is Ephraim Mackellar, steward of the estate who appears much frightened at what he is witnessing. The scene is lighted by two flickering candles that cast shadows and lights that accentuate the background. (Fitch, *Ballantrae* script 1)

The rest of Fitch's script shows similar attention to detail, but also a willingness to take liberties in service of the scriptwriter's own storytelling instincts. Most boldly, on the last page of the comic book he alters Stevenson's ambiguity, expressed through the narrator Mackellar in the following words concerning the unearthed James Durie: "I thought I could myself perceive a change upon that icy countenance of the unburied. The next moment I beheld his eyelids flutter; the next they rose entirely, and the week-old corpse looked me for a moment in the face. So much display of life I can myself swear to. I have heard from others that he visibly strove to speak, that his teeth showed in his beard, and that his brow was contorted as with an agony of pain and effort" (Stevenson, *Master* 330). In Fitch's rendering of the scene, Mackellar notes in a caption: "The lids flickered for a moment." Then follows a line entirely the invention of the scriptwriter. James looks at the narrator and says, "Hello, Mackellar" (Fitch, *Ballantrae* comic 44), thereby transforming the author's Hawthornesque ambiguity into a moment of high melodramatic certainty.

FIGURE 12.5 *CI* No. 82, *The Master of Ballantrae*, Dresser art, Fitch script, 1951 (1). The artist heeds the adapter's prompts.

ALFRED SUNDEL AND FEUERLICHT-
ERA FIDELITY

In 1953, *Classics Illustrated* and the Iger shop, its longtime art supplier, ended their business relationship on friendly terms, and freelancers were thereafter employed. That same year, William E. Kanter, a son of Albert Kanter and the person most responsible for the day-to-day operations of the Gilberton Company, hired recent Hunter College graduate Roberta Strauss (later Feuerlicht) as an editorial assistant. It proved to be a momentous move for the publisher. Without a formal title or masthead appearance until July 1957, when she was listed as "Editor," the young perfectionist reviewed artwork and scripts for accuracy and continuity, inquiring of the British National Maritime Museum about seventeenth-century naval court-martial procedure for *CI* No. 132, *The Dark Frigate* (May 1956), or counting buttons on soldiers' uniforms from panel to panel on Graham Ingels's Bristol boards for *CI* No. 135, *Waterloo* (December 1956) (Jones, *Classics* 198).

Gilberton, along with Dell Comics, refused in 1954 to adopt the restrictive content guidelines of the industry-sponsored Comics Code Authority, itself a product of the decade's anti-comics hysteria. The Kanters insisted that the inherent quality of *Classics Illustrated* required no Code seal of approval on front covers. Further, while such Code-compliant publishers as DC and Timely (Marvel) hesitated to hire or effectively blackballed artists associated with EC comics like *Tales from the Crypt* and *Crime SuspenStories*, *Classics Illustrated* welcomed them to a new home at 101 Fifth Avenue. Beginning with *CI* No. 130, *Caesar's Conquests* (January 1956), Gilberton employed some of the finest comics artists of the era, such as Joe Orlando, George Evans, Reed Crandall, Graham Ingels, and George Woodbridge, all refugees from William Gaines's abruptly folded comics lines (Jones, *Classics* 168).

Around the same time, Strauss assigned several scripts to an admired and controversial friend and mentor, Annette T. Rubinstein, a Marxist writer and teacher who had been the subject of scrutiny by the FBI (Jones, *Classics* 180). Rubinstein adapted *Caesar's Conquests; CI* No. 131, *The Covered Wagon* (March 1956); *CI* No. 6 (revised), *A Tale of Two Cities* (May 1956); and *CI* No. 132, *The Dark Frigate* (May 1956). For her adaptation of Caesar's *Commentaries on the Gallic War*, Rubinstein tackled the first seven of the eight books and made structural abridgments emphasizing sections of the original work likely to be encountered by second-year Latin students. Caesar had most often reported speech indirectly; the scriptwriter, for the sake of pacing, turned it into direct dialogue in speech balloons. Rubinstein also eliminated a number of individual names (e.g., Orgetorix, Divico, Acco) in order to keep the focus on primary characters like Caesar and Vercingetorix. At the end, she included a detail Caesar omitted from Book VII about the execution of the defeated leader of the Gauls (Rubinstein, *Conquests* 44).

While Rubinstein and other scriptwriters of the late 1950s moved ever closer to Roberta Strauss Feuerlicht's goal of textual fidelity, the arrival of Alfred Sundel as resident adapter at the end of the decade brought about a unified new approach to the art of

adaptation in the Gilberton offices. As he put it, explaining the three different forms of adaptation (Faithful, Interpretive, Hybrid):

> I would only take the job, and Roberta would only give it to me, if I was in the No. 1 [i.e., "Faithful"] category. That compatibility made us a good team.
>
> When you are in Faithful, the author does all the work. Intro, characters, drama, ending. Sometimes, I took a declarative sentence and transposed it into dialogue. Essentially, it was following the storyline. . . .
>
> As for method, in Step 1, I penciled the areas in the margin that looked like storyline on my first read through. . . . In Step 2, I penciled a 2-sided script by hand. Step 3: I revised the ms in the typing phase. . . . Toward the end, I sometimes did a script in one single go at a typed draft, skipping Step 2, xxxing out parts I edited after writing the full script on the typewriter, and got it out in a hurry, which they liked (Sundel, Email, 29 October 2014).

Sundel, an expert in pre-Columbian history and culture who would later write books on Columbus and the Aztecs and Mayas, was ideally suited to script *CI* No. 156, *The Conquest of Mexico* (May 1960), an adaptation of *La historia verdadera de la conquista de la Nueva España* by Bernal Díaz del Castillo, who served under Hernando Cortés ("Cortez" in Sundel's text) in the expedition that resulted in the destruction of the Aztec Empire. The book, beautifully illustrated in exacting historical detail by Italian-born Argentine artist Bruno Premiani, with some guidance from Sundel, is one of the showpieces of the *CI* line. Both the script and the artwork, which incorporates drawings from Aztec codices on the title page, depict the Aztecs with dignity and respect, while not diminishing the horrors of human sacrifice.

Díaz, in his preface to the *Historia*, had declared himself "no Latin scholar" and promised to "describe quite simply, as a fair eyewitness without twisting events one way or another" (Carrasco xxviii), the events in which he had participated as a soldier. The memoir is written in a plain, direct style, the author praising Cortés's military leadership and psychological insight, yet criticizing his cupidity and duplicity. In the *Classics Illustrated* adaptation, that balanced authorial attitude is present from the first page, which reproduces part of the preface.

The key to Sundel's approach to faithfulness to the original is his decision to approximate the author's voice in narrative boxes without the imposition of editorial comment or a strained attempt at exactitude. Sundel's adaptation follows that strategy throughout the forty-five pages, perhaps most strikingly in a sequence that deals with the appropriation and distribution of Montezuma's gold, a complex two-page passage depicting Cortés as a master of manipulation (Carrasco 203, 204), which Sundel condenses into three compact panels (Figure 12.6). These are faithful to Díaz's intent and simultaneously are an independent act of literary creation, reflective as they are of the scriptwriter's own choices with respect to necessary emphasis, economies of scale, and dramatic momentum.

The most esteemed adaptation in the history of *Classics Illustrated* was No. 167, *Faust* (August 1962), the last of the series' regularly scheduled new titles. (Two new titles, *CI*

FIGURE 12.6 *CI* No. 156, *The Conquest of Mexico*, Premiani art, Sundel script, 1960 (25). Two panels above set up the conflict, while the three panels below resolve it.

No. 168, *In Freedom's Cause*—scheduled for publication in 1962 and issued in the British series but delayed in the parent line—and *CI* No. 169, *Negro Americans—The Early Years*, were published in 1969 under new ownership.) Except perhaps for the five Shakespeare titles, this epic-scale drama by Goethe was arguably the most ambitious project in the history of the series, and it earned William Kanter's wry comment: "We make Cadillacs and market them as Chevrolets" (Jones, *Classics* 160). Sundel recalled that the inclusion of the title in the *CI* series was "done at my insistence to impress the [American Library Association] and booksellers' and educational conventions. I wrote *Faust* in a blaze on a weekend and in a few evenings, quickly, while I was on staff. It may have been one of the toughest scripts ever for me" (Letter 21 Aug. 1994).

Roberta Strauss Feuerlicht assigned the cover and interior artwork of what Sundel would later call a "very elite comic book" (Email, 29 Oct. 2014) to the ever-reliable realist Norman Nodel, who, as the dominant *Classics* artist of the late 1950s and early 1960s, had been entrusted with such major projects as *Moby-Dick, Ivanhoe, Rip Van Winkle*, and *Les misérables*. By the time *Faust* came along, the artist and scriptwriter had worked closely together for two or three years. With a booksellers' convention looming, the two pushed against a tight deadline to make the book the centerpiece for a Gilberton display (Jones, *Classics* 160, 162). Nodel employed a scratchboard, woodcut style that had yielded good results in the past (Jones, *Classics* 162). The result was an illustrated book with speech balloons, rather than a newsstand comic.

The Gilberton *Faust* is an adaptation that simultaneously hits the marks of textual fidelity and asserts its presence as an imaginative collaboration of scriptwriter and artist. Sundel used the public-domain Bayard Taylor translation and retained the essential cast of the language but dispensed with the nineteenth-century "thees" and "thous." Mephistopheles states the bottom line of his deal with the doctor thus in Taylor: "*Here*, an unwearied slave, I'll wear thy tether, / And to thine every nod obedient be: / When *There* again we come together, / Then shalt thou do the same for me" (Taylor 51). Sundel comes more directly to the point: "*Here*, I'll be your slave. When we meet *there*, you will do the same for me" (Sundel, *Faust* 13). Yet where possible, the speech remains strictly Goethe's by way of Taylor, even in the elliptical joining of the words of Homunculus (called "an artificial dwarf" by the scriptwriter): "How goes it, Daddy? What's to be done?" (Sundel, *Faust* 41; Taylor 221, 222).

Sundel devotes thirty-seven pages to Part I, ending with the "voice from above" saying of the imprisoned Margaret, "She is saved!" (Sundel, *Faust* 37; Taylor 150). Along the way, most of the principal scenes are explored, including "Prologue in Heaven," "The Study" (Figure 12.7), "Auerbach's Cellar," "The Witches' Kitchen," "Martha's Garden," "Walpurgis-Night," and "Dungeon."

The more challenging Part II is condensed to an impressively proportioned ten pages, with Acts I through V rapidly but coherently treated. Omitting Goethe's closing scene, Sundel chooses instead to end with the Chorus of Angels "bearing away the immortal part of Faust" (Taylor 380; Sundel, *Faust* 47, "bore" replacing "bearing"). The scriptwriter offered his own interpretive words in the last narrative box, "For his striving, which Mephistopheles had never quelled, and for his love of Margaret, Faust was saved"

FIGURE 12.7 *CI* No. 167, *Faust*, Nodel art, Sundel script, 1962 (15). Mephistopheles and Faust strike their bargain in the study.

(Sundel, *Faust* 47), in a nod to the final affirmation of the Chorus Mysticus in Scene VII: "The Woman-Soul leadeth us / Upward and on!" (Taylor 389).

Although Sundel modestly presents himself as one who simply got out of the author's way in his "Faithful" *Classics Illustrated* adaptations, his own gifts as a published author transformed the adaptations he produced into independent, self-sustaining works of art. Indeed, whatever the method of those who reinterpreted literary works for the Gilberton Company between 1941 and 1962, they created their own canon that in some ways has outlasted the canon they believed they were enshrining. Or, to put it in Delmore Schwartz's words: "[I]t is certainly not fanciful to suppose that the day is swiftly approaching when one human being says to another: 'Have you read *Hamlet*?' and is answered: 'No, but I seen the comic book edition'" (465).

WORKS CITED

Albrecht-Crane, Christa, and Dennis Cutchins, eds. *Adaptation Studies: New Approaches*. Madison: Farleigh Dickinson UP, 2010. Print.

Beaty, Bart. "Featuring Stories by the World's Greatest Authors: *Classics Illustrated* and the 'Middlebrow Problem' in the Postwar Era." *International Journal of Comic Art* 1.1 (1999): 122–39. Print.

———. *Fredric Wertham and the Critique of Mass Culture*. Jackson: UP of Mississippi, 2005.

Burke, Janet, and Ted Humphrey, trans. and ed. *The True History of the Conquest of New Spain*. By Bernal Díaz del Castillo. Indianapolis: Hackett, 2012. Print.

Carrasco, Davíd, ed. *The History of the Conquest of New Spain*. By Bernal Díaz del Castillo. Albuquerque: U of New Mexico P, 2008. Print.

Classics Illustrated. Advertisement. *The Instructor* 62.4 (Dec. 1952): 1. Print.

Cooper, James Fenimore. *The Spy: A Tale of the Neutral Ground*. Ed. Wayne Franklin. New York: Penguin, 1997. Print.

Crawford, Hubert H. *Crawford's Encyclopedia of Comic Books*. Middle Village: Jonathan David, 1978. Print.

Fitch, Kenneth William, adapt. *Crime and Punishment*. By Fyodor Dostoevsky. Illus. Rudolph Palais. New York: Gilberton, 1951. Print.

———, adapt. *Cyrano de Bergerac*. By Edmond Rostand. 1950. TS. Private collection.

———, adapt. *Cyrano de Bergerac*. By Edmond Rostand. Illus. Alex A. Blum. New York: Gilberton, 1950. Print. Classics Illustrated No. 79.

———, adapt. *The Master of Ballantrae*. By Robert Louis Stevenson. 1950. TS. Collection of William B. Jones, Jr.

———, adapt., *The Master of Ballantrae*. By Robert Louis Stevenson. Illus. Lawrence Dresser. New York: Gilberton, 1951. Print. Classics Illustrated No. 82.

Goodman, Evelyn, adapt. *The Hunchback of Notre Dame*. By Victor Hugo. Illus. Allen Simon. New York: Gilberton, 1944. Print. Classic Comics No. 18.

———, adapt. *A Tale of Two Cities*. By Charles Dickens. Illus. Stanley Maxwell Zuckerberg. New York: Gilberton, 1942. Print. Classic Comics No. 6.

Goulart, Ron, ed. *The Encyclopedia of American Comics: From 1897 to the Present*. New York: Facts On File, 1990. Print.

———. *Ron Goulart's Great History of American Comic Books*. Chicago: Contemporary, 1986. Print.

Hitchcock, Susan Tyler. *Frankenstein: A Cultural History*. New York: Norton, 2007. Print.

Jones, William B., Jr. *Classics Illustrated: A Cultural History*. 2nd ed. Jefferson: McFarland, 2011. Print.

———. "'Hello, Mackellar': *Classics Illustrated* Meets *The Master of Ballantrae*." *Journal of Stevenson Studies* 4 (2007): 247–69. Print.

Leitch, Thomas. "Twelve Fallacies in Contemporary Adaptation Theory." *Criticism* 45.2 (Spring 2003): 149–71. Print.

Lipscomb, George D., adapt. *The Spy*. By James Fenimore Cooper. 1947. TS. Collection of Michael Sawyer.

———, adapt. *The Spy*. By James Fenimore Cooper. Illus. Arnold L. Hicks. Comic strip. *New York Post* 20 Jul.–10 Aug. 1947. Print. Illustrated Classic serial.

———, adapt. *The Spy*. By James Fenimore Cooper. Illus. Arnold L. Hicks. New York: Gilberton, 1948. Print. Classics Illustrated No. 51.

Malan, Dan, ed. *Newspaper Classics: Full-Size, Full-Color Facsimile Reproductions of 14 Illustrated Classics Titles, Published in the Sunday Funnies from 3/30/47–3/21/48*. St. Louis: Malan Classical Enterprises, 1992. Print.

Munson, Wayne. *A Review and Update of Classics Ads in Teacher Magazines*. Calgary: Privately published, no imprint, 2015. TS.

New York State. Joint Legislative Committee to Study the Publication of Comics. Minutes. Albany: State of New York, 1951. Print.

Nyberg, Amy Kiste. *Seal of Approval: The History of the Comics Code*. Jackson: UP of Mississippi, 1998. Print.

Robbins, Trina. *The Great Women Cartoonists*. New York: Watson-Guptill, 2001. Print.

Rubinstein, Annette T., adapt. *Caesar's Conquests*. By Julius Caesar. Illus. Joe Orlando. New York: Gilberton, 1956. Print. Classics Illustrated No. 130.

———, adapt. *A Tale of Two Cities*. By Charles Dickens. Illus. Joe Orlando. New York: Gilberton, 1956. Print. Classics Illustrated No. 6.

Schwartz, Delmore. "Masterpieces as Cartoons." *Partisan Review* 19.4 (Jul.–Aug. 1952): 461–71. Print.

Stevenson, Robert Louis. *The Master of Ballantrae: A Winter's Tale*. London: Cassell, 1889. Print.

Stiskin, O. B. (Bernie). Telephone interview. 8 Aug. 2002.

Sundel, Al, adapt. *The Conquest of Mexico*. By Bernal Díaz del Castillo. Illus. Bruno Premiani. New York: Gilberton, 1960. Print. Classics Illustrated No. 156.

———, adapt. *Faust*. By Johann Wolfgang von Goethe. Illus. Norman Nodel. New York: Gilberton, 1962. Print. Classics Illustrated No. 167.

———, adapt. *The Hunchback of Notre Dame*. By Victor Hugo. Illus. George Evans and Reed Crandall. New York: Gilberton, 1960. Print. Classics Illustrated No. 18.

———. Letter to the author. 21 Aug. 1994. TS.

———. Message to the author. 29 Oct. 2014. Email.

Taylor, Bayard, trans. *Faust: A Tragedy in Two Parts*. By Johann Wolfgang von Goethe. London: Oxford UP, 1932. Print.

Versaci, Rocco. *This Book Contains Graphic Language: Comics as Literature*. New York: Continuum, 2007. Print.

Wertham, Fredric. *Seduction of the Innocent*. New York: Rinehart, 1954. Print.

Wolk, Douglas. *Reading Comics: How Graphic Novels Work and What They Mean*. Cambridge: Da Capo, 2008. Print.

PART III

ADAPTING THE COMMONS

REVISIONIST ADAPTATION

Transtextuality, Cross-Cultural Dialogism, and Performative Infidelities

ROBERT STAM

THIS essay deals with adaptations that dramatically transform and revitalize their source texts through provocative changes in locale, epoch, casting, genre, perspective, performance modes, or production processes. The endlessly protean adaptations of Shakespeare's plays, both in the theater and in the cinema, offer vivid examples of innovative remediation. In his paradigm-shattering *Voodoo Macbeth*, Orson Welles, for example, revitalized Shakespeare through changes in locale, epoch, casting, and cultural reference. Performed in Harlem's Lafayette Theatre in 1936, the Welles version transformed the racial affect of Shakespeare's play through an all-black cast, which supplemented its cast of professional actors Canada Lee, Maurice Ellis, and Edna Thomas with a host of Harlem-based amateurs. This casting was in itself a highly radical gesture. Unlike "all-black musicals" like *Hallelujah* (1929), Welles deployed black performance to completely re-envision a canonical masterpiece. At the very height of white supremacy, Welles entrusted the play to black actors, not in the name of some primordial "natural talent," but rather in the name of what he saw as black actors' keen understanding of iambic pentameter.

But quite apart from what might be considered the "gimmick" of an all-black cast, Welles radically reinterpreted Shakespeare by transposing the location and time of the play from eleventh-century Scotland to eighteenth-century Haiti. The Welles version generally respected the literal text of *Macbeth* but deployed costumes, sets, and performance to evoke the most radical of the Republican revolutions—the Haitian revolution, which was at once political, social, and racial. Instead of Shakespeare's "Hail the King of Scotland," Welles substituted the phrase "Hail King" in order to evoke the reign of another king, Haiti's Henri Christophe. (Scotland's "Red King" became Haiti's "Black King.") Generally, Welles amplified elements familiar from European history—witches, charms, magical thinking—and concretely present in the Shakespeare play, but

reimagined in terms of their Afro-diasporic equivalents. Thus Welles turned Hecate, the witch goddess, into a male Vodun priest, associated in the Yoruba tradition with Exu-legba, the spirit of crossways and entrances, and, for Henry Louis Gates, with translation, semiosis, and adaptation (15). Hecate's role is enhanced in the Welles version, in which he is the one who declares "security" to be the "mortals' chief enemy," revealing that Macbeth was "not of woman born" and thus vulnerable.

Voodoo Macbeth reveals the subversive possibilities of revisionist adaptation. Apart from casting black actors, Welles imbued the play with African spiritual values. Rather than serving as mere decoration, the vodun rituals, performed as in Haiti in circular formation, structured the entire performance. Welles achieved this cultural transvalorization not only through his own genial intuition, but also through substantive collaboration with African artists like Asadata Dafora, the play's musical director. Originally from Sierra Leone, Dafora studied opera in Italy and Germany before coming to New York in 1929, where he founded the dance company Shogola Olaba. The group introduced into the New York art scene African music and dance as choreographed and performed by Africans themselves. The goal, for Dafora as for Welles, was not only to create a popular spectacle, but also to show African culture as complex and sophisticated, rather than merely primitive or exotic. Indeed, Welles might have borrowed the idea of turning the weird sisters into Vodun priestesses from Dafora's 1934 play *Kykunkor, or the Witch Woman*, which had been a huge success in New York just two years earlier. *Voodoo Macbeth* similarly electrified New York and generally received rave reviews, except for one by Percy Hammond in the *Herald-Tribune*. A staunch Republican, Hammond denounced the play partially because he detested the very idea of federal funding for the arts. In the wake of the negative review, theater manager John Houseman noted that there was more drumming than usual in the basement of the Lafayette Theatre, and that it sounded to his untutored ears like a different *kind* of drumming. Percy Hammond soon fell ill and died a few days later, testimony for the faithful of the power of the religion.

Voodoo Macbeth opened the way for an endless pageant of revisionist adaptations. In the wake of *West Side Story* (1957), which set *Romeo and Juliet* in a stylized Manhattan Latin "slum," Lúcia Murat's 2008 film *Maré, Nossa História de Amor* (*Maré, Another Love Story*) locates *Romeo and Juliet* in the eponymous Rio de Janeiro slum. Revisionist readings have emphasized the latent critique of anti-Semitism in *The Merchant of Venice*, the potential racism in *Othello*, and so forth. Tim Blake Nelson's *O* (2001) turns Othello into a black basketball star in an American high school who dates the Dean's daughter. As part of a critique of global capitalism, Michael Almereyda's 2000 *Hamlet* turns the Castle of Elsinore into the headquarters of the "Denmark Corporation."

A non-Eurocentric theory of cross-cultural adaptation appears in the manifestos of the Brazilian modernist "anthropophagy" movement in the 1920s. The *modernistas* proposed a new form of anti-colonial art based on the cannibalistic devouring of the European historical avant-gardes as a way of absorbing their power without being dominated by them, just as the Tupinamba Indians devoured European warriors to appropriate their strength. This aesthetic was captured in the modernist slogan: "Tupi

or not Tupi: That is the Question"—whether to be proudly Indian (anti-colonial) or to be colonized mimic men aping metropolitan trends. This cannibalistic twist on the most famous phrase from *Hamlet* was enacted in a six-hour 2009 version of Shakespeare's play by Brazilian *dramaturg* (and direct heir of modernist anthropophagy) Jose Celso Martinez Correa and his Oficina Theatre Company. If Welles Afro-diasporized *Macbeth*, Jose Celso Indianized *Hamlet*. The Oficina version of the play begins with the performers and the audience singing a musical version of the Tupi or not Tupi slogan. Further amplifying the carnivalesque hybridities already present in the play itself, the performance turns the play into an anthropophagic musical by interspersing it with original musical numbers in a variety of styles and genres related to the themes and characters of the play: "Ophelia's *Fado*," "Polonius Blues," "Guildenstern's Ballad," "Canticle of the Furies," and so forth. In an anti-canonical treatment of what is perhaps the ultimate canonical work, the play begins with the word "Merda," perhaps an allusion to the opening "merdre" of Alfred Jarry's *Ubu Roi* (1896). Tupinizing Shakespeare, the lyrics celebrate the rebel Indian, the one who uses his bows and arrows against the colonizer. Oficina re-energized and Brazilianized *Hamlet*, in sum, through the trope of the gregarious communalism of the Tupi Indians.

Although Gérard Genette takes a narrowly taxonomic, almost technocratic view of transtextuality, his categories can be "communalized" so as to illuminate a text's relation to what I call the aesthetic commons. All five categories of Genette's transtextuality—(1) "intertextuality," or the "effective co-presence of two texts" in the form of quotation, plagiarism, and allusion; (2) "paratextuality," or the relation, within the totality of a literary work, between the text proper and its "paratext" (titles, prefaces, postfaces, epigraphs, dedications, illustrations; in short, all the accessory messages and commentaries that come to surround the text and which at times become virtually indistinguishable from it); (3) "metatextuality," or the critical relation between one text and another, whether the commented text is explicitly cited or only silently evoked; (4) "architextuality," or the generic taxonomies suggested or refused by the titles or subtitles of a text; and (5) "hypertextuality," or the relation between one text, which Genette calls "hypertext," and an anterior text or "hypotext," which the former transforms, modifies, elaborates or extends (1–5)—favor the communalization of textual transmission by transcending the fetishism of the single text and the sacralization of the solitary author-genius and appealing to a broad relationality between texts and other texts (the *intertext*), between texts and surrounding discourses (*paratext*), and between genres of discourse (*architext*), while also extending the concept to refer to the critique of anterior texts (*metatext*) and to the posterior revisionist adaptation of texts (*hypertext*). As a feature common to all artistic practices, from oral epic to Harlequin romances to news shows and TV commercials, transtextuality is not inherently revolutionary. But the concept does carry the theoretical potential of socializing art by recasting it as transindividual and collective, emanating not from the individual artist's demiurgic brain, but rather from larger networks of socially shared meanings.

A high proportion of feature films consists of adaptations drawn from the literary commons of classic texts, some of them in the public domain and therefore not requiring

copyright. Henry Fielding, interestingly, referred to the commons in *Tom Jones* when speaking of his own debts to classical writers: "The ancients may be considered as a rich Common, where every Person who hath the smallest tenement in Parnassus hath a free right to fatten his muse" (qtd. in Hyde 46). Adaptations borrow from literature but also draw on all the other arts integral to the cinematic medium, resulting in a multiplication and amplification of intertexts, a stretching of the verbal text in keeping with the rich potentialities of a multi-artistic medium.

The obligation of fidelity to a source text is sometimes based on a proprietary assumption that the source text belongs to the author. Although we often assume that directors adapt novels out of sincere affection for them, Sergio Giral's adaptation of Cuba's first anti-slavery novel, *El otro Francisco* (1974), practices strategic infidelity, its revisionism steeped in a visceral-ideological aversion to the original. Based on Anselmo Suarez y Romero's abolitionist novel *Francisco*, the film constitutes a brilliant example of metatextual adaptation. Often called the Cuban *Uncle Tom's Cabin* (although it was written in 1838–39, years before the Stowe novel), the novel was a sentimental historical romance about a young slave who commits suicide when his fiancée reveals that she has been raped by her master. The original novel already formed part of the intertextual corpus of abolitionist novels sponsored by the liberal literary circle of Domingo del Monte. While the anti-slavery literature of the mid-nineteenth century focalized the relatively privileged figure of docile house slaves like Francisco, twentieth-century postrevolutionary literature about slavery focalizes the more rebellious figure of the field slave. And while *Francisco* was written by a white Cuban for a largely white elite audience, *El otro Francisco* was filmed by a black Cuban filmmaker aiming at a multiracial and transnational audience.

Made roughly a century after the wave of anti-slavery novels, the Giral film forms part of the very different context and intertext of the revolutionary 1960s and 1970s, a period in which Cuban novels, biographies, and films developed revisionist versions of the history of slavery. This intertext includes films like Giral's trilogy on slavery (*El otro Francisco*, *Malula*, 1979, and *Rancheador*, 1979); Alea's *La última cena* (1976); and literary writings by Miguel Barnet, Cesar Leante, Alejo Carpentier, and Reinaldo Arenas, whose *Graveyard of the Angels* (1987) rewrites Cirilo Villaverde's *Cecilia Valdés*, the classic nineteenth-century novel about slavery. Like many revisionist rewritings, the Giral film practices what Mikhail Bakhtin calls "novelization" (5), the pluralization of voices and styles within artistic representation, by dialectically counterpointing and mutually relativizing diverse generic styles. While the source novel is fundamentally a melodrama, the Giral adaptation promotes a critical orchestration of generic modes: a parodically melodramatic approach, sarcastically "faithful" to the novel's sentimental spirit; a staged (anachronistically vérité) documentary about the novel's production context; and a realistic reconstruction of the historical life of the enslaved. Taken together, the three modes bring out what was suppressed in the novel: the crass material motives undergirding official British abolitionism, the author's status as himself a slaveholder, the catalytic role of black rebellion, and the artistic mediation of the story itself.

The Giral film self-reflexively deploys a series of activist metatextual opera-
tions: (1) parody, for example the opening pre-credit sequence's hyperbolization of the
novel's melodramatic conventions through their filmic equivalents of overwrought act-
ing, haloed backlighting, soft-focus visuals, and bathetic music; (2) contextualization,
by revealing the upper-class liberal del Monte salon as the social/artistic milieu out of
which the novel was generated; (3) historicization, by including other contemporane-
ous historical figures like the British free-trade agent Richard Madden, whose books
depict Cuban slavery as a thoroughly modern system of production; (4) amplification,
through historical research that reveals what is elided in the novel, informing us that
the author, although himself the owner of slaves and aware of the slave rebellions, chose
not to include them; (5) character transformation, whereby the novel's docile Francisco
becomes the "other" revolutionary Francisco of the title. While the novel offers the puta-
tively positive image of a meek and self-sacrificing saintly figure, the film portrays a
rebel's refusal to be meek, an inspirational exemplum of spiritual marooning. Indeed,
the film's finale has Francisco participate in the very slave uprisings so carefully excised
from the novel. As the maroon leader Crispin, in traditional attire, ritualistically inspires
the slaves to revolt, the film orchestrates a musical power reversal: European symphonic
music gives way to Afro-Cuban drums. In the adaptational equivalent to a slave revolt,
everything in the film becomes "other" to the novel: another medium, another style,
another ideology, another Francisco.

We find transtextual subversion when a recombinant text challenges the socially
retrograde premises of preexisting hypotexts or genres, or calls attention to repressed
but potentially subversive features of preexisting texts. Some revisionist adaptations
practice epidermal subversion by casting actors of color in roles usually assumed to be
white, thus triggering subtle changes in reception and affect. Films, in this sense, can
take advantage of a signal difference between the nature and status of characters in nov-
els and films. While novels have only those verbal constructs called characters, film
adaptations offer a complex amalgam of character and performer, which allows for rich
possibilities of interplay and contradiction. *Karmen Gei* (2002), by Senegalese director
Joseph Gai Ramaka, both queers and Africanizes the story of Carmen. The film takes the
Carmen story from Prosper Mérimée's 1845 novella (subsequently restaged in Georges
Bizet's 1875 opera), a story that has been adapted to the screen scores of times, from Cecil
B. DeMille through Otto Preminger's black-cast *Carmen Jones* (1954), Carlos Saura's
flamenco *Carmen* (1983), and Jean-Luc Godard's noirish *Prenom Carmen* (1983). The
Ramaka film unceremoniously discards the Bizet score in favor of Afro avant-gardist
jazz, as if to say that the African music of Julien Jouga's choir and Hadj Ndiaye's Sons
is more than an adequate substitute for Bizet. The film Africanizes the original story, a
product of France's quasi-Orientalist fascination with Spain. Taking the story out of the
exoticizing frame of *Espanholisme*, *Karmen Gei* is "gay" in both senses of that word. As
played by the vibrant Djeinaba Diop Gai, Carmen becomes an irresistible *femme fatale*
trickster figure who incarnates a spirit of anarchic rebellion against bourgeois propriety
and social hierarchy. Against the grain of the "aesthetics of whiteness," the statuesque

beauty of the film's dark-skinned Carmen embodies the resilient courage of the African woman, Africanizing the traditionally European mode of opera.

As an exemplar of queer postcoloniality, the opening production number plunges us into a world of social inversion, against the backdrop of what is apparently some sort of all-female concert space that turns out to be a woman's prison where Karmen is an inmate. Karmen dances exuberantly in order to seduce Angelique, the uniformed warden in a prison on Goree Island, a site redolent of transatlantic slavery. Karmen successively tantalizes and then humiliates representatives of official power: first Angelique, then the young police officer Lamine. Now the setting shifts to an upper-class wedding celebration—the juxtaposition of the two scenes suggests that marriage, too, might be seen as a prison—where Karmen shocks the bourgeois dignitaries attending the wedding with a cannibalistic threat and accusation: "You are all evil! You've swallowed up the country, but we'll eat your guts!" The rebellion is spoken as well as danced, as Karmen mocks and enchants Lamine, challenging his bride to a dance-off that culminates when Karmen throws her rival to the ground. In this lesbi-indigenization of the Carmen story, the forces of corruption struggle against the people as embodied by the inexhaustibly kinetic Karmen. More abstractly, the Law confronts Desire, as dance, music, and ridicule become the weapons of the weak. The subversive dimension of the film did not go unnoticed; the Mouride Sect of the Islamic Brotherhood in Senegal, armed with clubs, threatened to set fire to the movie theater screening the film.

Every cross-cultural adaptation of a novel, even those that are far less aggressively provocative than *Karmen Gei,* filters its source text through both a national culture and a specific reconfiguration of a set of genres. Ketan Mehta's *Maya Memsaab,* a 1993 Indian rewriting of *Madame Bovary,* offers an example of cultural indigenization, whereby the French culture of the source novel is mediated and transformed by the adapting Indian culture. The double-edged effect, in *Maya,* is both to universalize and to provincialize Europe. Mehta juxtaposes Bollywood-style production sequences, set against sublime scenic backdrops that recall Emma's languorous reveries about Swiss chalets, with a more realistic style. Romanticism, as in Flaubert's text, lands with a thud in the banal everyday world, in an equivalent to Flaubert's ionic deflation of romantic metaphors. At times, Mehta stages the same scene twice, first from Maya's poetic-romantic perspective, then from her husband's more prosaic point of view. As she stages her own suicide in order to elicit what she thinks will be her husband's passionate declarations of love, Mehta presents us first with her fantasy of the husband's reaction, then with his actual reaction, which is not to praise her for her imagination but rather to reprimand her for what he considers a very bad joke. Indigenization, in sum, can be both respectful and inventive.

In *Bride and Prejudice* (2004), Gurinder Chadha adapts Jane Austen's novel by updating the story to the present and relocating it to India and America, with short visits to England. The Bennets become the Bakshis from Amritsar. Such cross-cultural updates create a kind of hermeneutic puzzle for the spectator familiar with the source novel. While Darcy appears under his original name, other characters do not. Since the characters no longer look or dress like Austen's characters or the actors in most adaptations

of her novel, the spectator is challenged to a game of decipherment. Could that handsome dark-skinned friend of Darcy dressed in Indian attire be a new version of the rich, handsome, charming Bingley? And could that assimilated Indian accountant from Los Angeles who proposes to Lalita, with his gauche manners, outdated American slang, and borrowed ethnocentric attitudes, be a new version of the obsequious clergyman Collins?

The update of the novel is obliged to discard historically obsolete laws, such as the entailment that prevented women from inheriting estates. A technological upgrade, meanwhile, turns Austen's letters into the daughters' emails. Language, too, is updated. The famous first sentence of the novel—"It is a truth universally acknowledged, that a single man in possession of a good fortune, must be in want of a wife"—becomes more contemporary, colloquial, and consumerist: "A guy with a lot of bucks must be shopping for a wife." Lalita compares contemporary arranged marriages, including the one sought by Darcy's mother, to a "global dating service." The formal balls of the novel transmute into rave sequences set on the beaches of Goa and Bollywood-meets-Hollywood production numbers.

At the same time, the film practices cross-cultural *mise-en-equivalence* by suggesting certain subterranean affinities between Austen's England and Chadha's India: the similar sexual modesty and subtle indirection; the strategic role of dance balls in charting the trajectories of romance; the family resemblances in the role of wealth in marriage, whether in the form of Western marriages for financial convenience or of Indian arranged marriages. The infra-national class differences that mark the Austen novel are transmuted into the transnational cultural differences of the adaptation, so that the romance between the American Darcy and the Indian Lalita seems to homologize the geopolitical romance of India and the United States in the period of the film. In a perhaps unduly reciprocal portrayal, both the American and the Indian have to abandon some of their prejudices.

Bride and Prejudice blends, as Sandra Ponzanesi puts it, "successful commercial strategies with mildly subversive narratives" (175). The film subversively decenters Europe by making the English family deeply Indian and placing them on Indian soil. (One can imagine the anti-immigrant backlash: "First they come here and take our jobs, and now they go back there and take our canon!") In addition, it absorbs postcolonial critique by making Lizzie/Lalita the voice, if not of the subaltern, at least of a Global South perspective on the North. If the Elizabeth of the novel voices a proto-feminist critique of patriarchy, the Lalita of the film voices a critique of neoliberal globalization. She accuses the new American Darcy of wanting to turn India into a theme park for spoiled rich tourists in search of exoticism, experienced only from within their bubble of "five-star comfort." The aristocratic prejudice of the novel's Darcy gives way to the tendentious ignorance of the new aristocrats, the masters of the universe who mouth the nostrums of trade and investment of neoliberalism and the Washington consensus. The class and gender entitlements of Jane Austen's world are now supplemented by the geopolitical entitlements of the wealthy of the Global North, as the landed gentry from Austen's novel cede place to the forces of transnational capitalism.

Lalita becomes the national allegorist in the film, a spokeswoman for some of the Indian *ressentiment* about the abuses of globalization, while the "green-card holder" Kohli, Chadha's version of Austen's Mr. Collins, comes to incarnate the alienated Indian overly enamored of the West, even if he is ultimately much more *simpatico* than Austen's clergyman. But of course these verbal attacks on global capitalism end up getting co-opted by the conservative conventions of Austen's novels and Bollywood musicals in what Linda Hutcheon has called "complicitous critique" (24). All the master of the universe has to do to win over the recalcitrant Lalita is prove his honesty and his love, wear some version of Indian clothes, defend India in conversations, do some Indian drumming, and marry in Amritsar.

In films like *Bhaji at the Beach* (1993) and *What's Cooking?* (2000), Chadha had revealed herself to be the poet laureate of transnational hybridity. The hybridity in *Bhaji*, for example, is at once musical, sartorial, linguistic, culinary, genetic, and broad. *Bride and Prejudice*, in this sense, is hybrid in its funding, its locations, its production personnel, and its themes. The film reveals the problems with the discourse of loss that only sees what has been lost in adaptation and not what has been gained. Instead of the monolingual world of Austen, we find a multilingual world that speaks English, Hindi, and Punjabi. Instead of Austen's monocultural world, we find a multicultural world whose music includes banghra, ska, reggae, rap, gospel and mariachi, where the East, to recite a postcolonial truism, is in the West and vice versa, and where Hollywood has been Asianized and Asia has been Hollywoodized.

A number of other revisionist adaptations perform actualization/relocalization as critique, whereby a change in period and setting generates revelatory differences between the source text and the film. Abdellatif Kechiche's *L'esquive* (English title: *Games of Love and Chance*, 2004) stages a modern-day adaptation of Marivaux's *Les jeux de l'amour et du hasard* as a springboard for exposing the social fractures of contemporary French society. In a reflexive move, Kechiche does not adapt the play, but rather stages the process of adapting the play. He stages that process in a surprising location: a present-day high school in the marginalized *banlieues* of Paris, literally "suburbs," but more accurately low-income housing ("projects") inhabited by immigrants and their children. The French expression "Marivaudage" suggests highly articulate flirtation and disguises against the backdrop of class relations between noble rich and servant poor, where the rich pretend to be poor and the poor pretend to be rich. Within the drama teacher's class-essentialist interpretation, the point of the play is that the rich should fall in love with the rich and the poor with the poor, without any pointless cross-class masquerade. But while flirtation has existed from time immemorial, the restaging of Marivaux's dialogue by *banlieue* adolescents dramatically transforms the meaning and affect of the play. Since the students are all relatively poor, the class contrasts central to the play become less pertinent, while other issues like religion (Muslim, Christian, Jewish), nationality, color, ethnicity, and police harassment come to the fore.

The film's *banlieue* context and the casting of local youths raises a question not operative in the play: is Krimo partially in love with the blonde Lydia because, unlike his Maghrebi girlfriend, she is Franco-Francaise—that is, white? Inarticulate in life and

not given to flowery amorous declarations—a taboo among the macho adolescents, for whom they are an index of homosexuality—Krimo tries to express his love under the cover of theater. Here the gap in centuries between the source play and its adaptation is transmuted into an ethnic-cultural gap: the all-white French of the play have become the multiracial children of a postcolonial France transformed by massive immigration. The play retains its contemporary relevance because the amorous emotions of the young students resemble those of the characters of the play, but class difference is now displaced. The contrast now is between the class structures relayed by the play, whose nobles and servants share a common world structured by clear class hierarchies, and those of the film, where the most salient differences reflect the social divisions of the postcolonial city between the wealthy French center and the impoverished *banlieue*, or what Mehdi Belhaj Kacem has punningly called "the place of the banned" (qtd. in Stam and Shohat 173).

Given the fact that cinematic adaptations are often based on novels written decades or even centuries earlier, adaptations become ideological barometers that register the shifts in the social/discursive atmosphere. But these shifts in social/discursive atmosphere are never univocal; rather, they are polyvocal and dissensual. Already in the late 1920s, Bakhtin and Pavel Medvedev offered a major corrective to antecedent conceptualizations of mimesis as a faithful mimicry of the "real world" of phenomenal appearance by proposing what might be called a second-degree discursive realism in which the role of the artistic text is not to represent real-life "existents" in a verisimilar manner, but rather to stage the competitions of languages and discourses (14). For Bakhtin, human consciousness and artistic practice do not come into contact with the real directly, but rather through the medium of the surrounding discursive-ideological world. The audiovisual media, in this sense, not only register the sounds and images of the world; they also chronotopically stage, through images, dialogue, and movement, the competing languages and discourses that refract and interpret the world.

Within a double refractionism, then, art does not so much reflect or even refract the real as much as it refracts a refraction of the stuff of life, offering a mediated version of an already textualized, discursivized, and ideologized socio-ideological sphere. Adaptations, in this sense, inevitably translate the competing languages and discourses typical of the past of the source text into the competing languages and discourses typical of the present of the adaptation. Adaptations give voice to a kind of social Unconscious, reflecting the mutations triggered by changing genres, formats, technologies, discourses, and modes of authorship. But this process does not have a predetermined political valence. On the one hand, as Julie Sanders puts it, adaptations can "respond or write back to an informing original from a new or revised political and cultural position, and . . . highlight troubling gaps, absences, and silences within the canonical texts to which they refer" (98). On the other hand, adaptations can reinscribe nostalgia for empire and patriarchy. What is certain is that stasis is impossible; no adaptation can step into the same transtextual river twice, or for that matter once.

In the final class of my 2015 fall course on adaptation, I evoked the possibility of presenting thousands of years of literature through the theory and practice of transtextual

adaptation and remix, beginning with the three sacred texts of the Abrahamic religions as transtextual variations on the Jewish Bible. That is to say, the Jewish Bible, already a collage of genres and preexisting texts and oral traditions, forms the hypotext for the Christian Bible, which reconfigures the Jewish Bible as Christian allegory as it presents the Jewish sacrificial lamb as a prefiguration of Jesus. The Jewish and Christian sacred texts then form hypotexts for the Quran, where both Moses and Jesus appear as prophets within the remixed Islamic tradition. In terms of secular literature, the *Odyssey* remixed a preexisting corpus of oral-traditional stories, which is then written down and refined by Homer, spawning in turn a well-known series of hypertextual spin-offs ranging from Virgil's *Aeneid* to Guy Maddin's *Keyhole* (2011), much as Aristophanes' *Lysistrata* becomes remediated through Spike Lee's *Chi-Raq* (2015).

I offered the class a whirlwind tour of the History of World Literature (Part One) through a series of remediations of canonical texts in the form of parodic trailers and sketches (DeMille's *Ten Commandments* as a *Grease*-style high school film); Mel Brooks's shattered tablet of Fifteen Commandments in *History of the World: Part I*; *parodia sacra* variations on Christ's Last Supper in films by Luis Buñuel, Monty Python, Mel Brooks, and Tomás Gutiérrez Alea; clips of the spectacular carnage in *Maqbool*, the Indian *Macbeth*; the translocalization of Marivaux's *Games of Love and Chance* in the Parisian banlieue in *L'esquive*; the Indianization and Bollywood musicalization of Jane Austen in *Bride and Prejudice*; the romanticism of the Native American in *Indianerfilme*, German adaptations of Karl May novels; the cartoonization of *Heart of Darkness* (and *Apocalypse Now*) in the mashup *Apocalypse Pooh*; and any number of Internet fan music video tributes to *The Grapes of Wrath* via Bruce Springsteen's "Ghost of Tom Joad." I also evoked the web series version of *Pride and Prejudice* in the form of *The Lizzie Bennet Diaries*, whose episodes are filmed as video blogs from Lizzie to her followers, and whose producers maintained social media accounts for the characters, where they interacted and produced Facebook posts about their lives.

I concluded by offering my suggestions for a new covert adaptation of *Madame Bovary*. In the wake of Woody Allen, who replaced Flaubert's romantic literature with Depression-era escapist movies in *The Purple Rose of Cairo*, I proposed a more contemporary variation. To disguise the French origins of the plot, I suggested giving the characters a motley series of names drawn from multiple ethnic origins, as would be more typical of the United States today. In my version, a farmer's daughter from upstate New York, an adolescent girl shaped by her binge television watching and vivid online fantasy life, would marry a male nurse from Long Island but soon become bored. After moving to Brooklyn, she would successively fall in love, thanks to Internet dating, with an artsy accountant from Williamsburg and a suave Don Juan who managed a hedge fund on Wall Street. Disillusioned with both lovers, she would become obsessed with Tinder, culminating in a disastrous series of dates and in a vertiginous montage—reminiscent of the ball sequence in the Vincente Minnelli film—of rightward swipes on images of handsome men. Subsequently disillusioned with Tinder masculinity, she would move to interactive games and fall in love with an Avatar on Second Life. In a nod to contemporary political realities, she would die less from frustrated love than from

credit card debt and the brutal foreclosure of her home triggered by the 2008 financial crisis. If any of the students were to subsequently make a successful film based on my ideas, I told them, I would not ask for a cut of the profits but only for a modest acknowledgment in the credits.

WORKS CITED

Apocalypse Now. Dir. Francis Coppola. Perf. Martin Sheen, Marlon Brando. United Artists, 1979. Film.

Apocalypse Pooh. Dir. Todd Webb. 1987. *YouTube.* Web. 31 Dec. 2015.

Arenas, Reinaldo. *Graveyard of the Angels.* Trans. Alfred J. MacAdam. New York: Avon, 1987. Print.

Austen, Jane. *Pride and Prejudice.* 1813. Oxford: Oxford World's Classics, 2008. Print.

Bakhtin, Mikhail. *The Dialogic Imagination: Four Essays.* Ed. Michael Holquist. Trans. Caryl Emerson and Michael Holquist. Austin: U of Texas P, 1981. Print.

Bakhtin, M. M., and P. M. Medvedev. *The Formal Method in Literary Scholarship: A Critical Introduction to Sociological Poetics.* Trans. Albert J. Wehrle. Revised ed. Cambridge: Harvard UP, 1985. Print.

Bhaji at the Beach. Dir. Gurinder Chadha. Perf. Kim Vithana, Jimmi Harkishin. First Look International, 1993. Film.

Bride and Prejudice. Dir. Gurinder Chadha. Perf. Aishwarya Rai, Martin Henderson. Pathé, 2004. Film.

Carmen. Dir. Carlos Saura. Perf. Antonio Gades, Laura del Sol. C.B. Films S.A., 1983. Film.

Carmen Jones. Dir. Otto Preminger. Perf. Harry Belafonte, Dorothy Dandrige. Twentieth Century–Fox, 1954. Film.

Chi-Raq. Dir. Spike Lee. Perf. Nick Cannon, Teyonah Parris. Lionsgate, 2015. Film.

Conrad, Joseph. *Heart of Darkness.* 1899. New York: Penguin Classics, 2012. Print.

El otro Francisco. Dir. Sergio Giral. Perf. Margarita Balboa, Miguel Benavides. ICAIC, 1974. Film.

Flaubert, Gustave. *Madame Bovary.* 1857. Trans. Geoffrey Wall. New York: Penguin Classics, 2002. Print.

Gates, Henry Louis, Jr. *The Signifying Monkey: A Theory of African-American Literary Criticism.* London: Oxford UP, 1988. Print.

Genette, Gérard. *Palimpsests: Literature in the Second Degree.* Trans. Channa Newman and Claude Doubinsky. Lincoln: U of Nebraska P, 1997. Print.

The Grapes of Wrath. Dir. John Ford. Perf. Henry Fonda, Jane Darwell. Twentieth Century–Fox, 1940. Film.

Grease. Dir. Randal Kleiser. Perf. John Travolta, Olivia Newton-John. Paramount, 1978. Film.

Hallelujah. Dir. King Vidor. Perf. Daniel L. Haynes, Nina Mae McKinney. MGM, 1929. Film.

Hamlet. Dir. Michael Almereyda. Perf. Ethan Hawke, Kyle MacLachlan. Miramax, 2000. Film.

Hamlet. Dir. Jose Celso Martinez Correa. Oficina Theatre Company, 2009. Play.

History of the World: Part I. Dir. Mel Brooks. Perf. Mel Brooks, Gregory Hines. Twentieth Century–Fox, 1981. Film.

Hyde, Lewis. *Common as Air.* New York: Farrar, Strauss and Giroux, 2010. Print.

Karmen Gei. Dir. Joseph Gai Ramaka. Perf. Djeinaba Diop Gai, Magaye Niang. Arte France, 2002. Film.

Keyhole. Dir. Guy Maddin. Perf. Jason Patric, Isabella Rossellini. Monterey Media, 2011. Film.

Kykunkor, or the Witch Woman. By Asadata Dafora. Perf. Asadata Dafora. Unity Theatre, 1934. Play.

La última cena. Dir. Tomás Guttiérez Alea. Perf. Nelson Villagra, Silvano Rey. ICAIC, 1976. Film.

L'esquive [Games of Love and Chance]. Dir. Abdellatif Kechiche. Perf. Osman Elkharraz, Sara Forestier. Lola/Noé, 2004. Film.

The Lizzie Bennet Diaries. Created by Hank Green and Bernie Su. *YouTube*. Web. 31 Dec. 2015.

Madame Bovary. Dir. Vincente Minnelli. Perf. Jennifer Jones, Van Heflin. MGM, 1949. Film.

Malula. Dir. Sergio Giral. Perf. Samuel Claxton, Miguel Gutiérrez. ICAIC, 1979. Film.

Maqbool. Dir. Vishal Bhardwaj. Perf. Irrfan Khan, Tabu. Yash Raj, 2003. Film.

Maré, Nossa História de Amor [Maré, Another Love Story]. Dir. Lúcia Murat. Perf. Vinícius D'Black, Monique Soares. Taiga, 2008. Film.

Maya Memsaab. Dir. Ketan Mehta. Perf. Deepa Sahi, Farooq Shaikh. Forum, 1993. Film.

O. Dir. Tim Blake Nelson. Perf. Mekhi Phifer, Julia Stiles. Lionsgate, 2001. Film.

Ponzanesi, Sandra. "Postcolonial Adaptations: Gained and Lost in Translation." *Postcolonial Cinema Studies*. Ed. Sandra Ponzanesi and Marguerite Waller. London: Routledge, 2011. 172–88. Print.

Prenom Carmen. Dir. Jean-Luc Godard. Perf. Maruschka Detmers, Jacques Bonaffé. Parafrance, 1983. Film.

The Purple Rose of Cairo. Dir. Woody Allen. Perf. Mia Farrow, Jeff Daniels. Orion, 1985. Film.

Rancheador. Dir. Sergio Giral. Perf. Olivia Belizaires, Samuel Claxton. ICAIC, 1979. Film.

Sanders, Julie. *Adaptation and Appropriation*. London: Routledge, 2006. Print.

Stam, Robert, and Ella Shohat. *Race in Translation: Culture Wars around the Postcolonial Atlantic*. New York UP, 2012. Print.

Suárez y Romero, Anselmo. *Francisco*. Havana: N. Ponce de Leon, 1880. Print.

The Ten Commandments. Dir. Cecil B. DeMille. Perf. Charlton Heston, Yul Brynner. Paramount, 1956. Film.

Villaverde, Cirilo. *Cecilia Valdés, or El angel hill*. 1882. Trans. Helen Lane. Ed. Sibylle Fischer. New York: Oxford UP, 2005. Print.

Voodoo Macbeth. By William Shakespeare. Dir. Orson Welles. Perf. Canada Lee, Maurice Ellis. Lafayette Theatre, 1936. Play.

West Side Story. Book by Arthur Laurents. Music by Leonard Bernstein. Lyrics by Stephen Sondheim. Winter Garden Theatre, 1957. Play.

What's Cooking? Dir. Gurinder Chadha. Perf. Joan Chen, Julianna Margulies. Trimark, 2000. Film.

CHAPTER 14

ADAPTATION IN BOLLYWOOD

LUCIA KRÄMER

SOME readers may consider the inclusion of a chapter relating to Bollywood in this Oxford Handbook as surrender to an academic fad or, even worse, a fig leaf intended to ward off accusations of Eurocentrism. Yet an article about adaptation in what may currently be the most conspicuous non-Western film industry is indispensable for other, much sounder reasons. An examination of the practices, procedures, and forms of adaptation in today's popular Hindi cinema, together with reflections on the status of adaptation as an industrial category in the Hindi film industry, shows crucial differences from the hegemonic Hollywood model and therefore underlines the importance of always taking into account the specific industrial, cultural, and artistic contexts in which adaptation occurs. On a more theoretical level, an examination of adaptation in Bollywood can help us reconsider established notions and categories of adaptation developed by predominantly Western scholars on the basis of examples deriving from predominantly Western production contexts.

Such an examination challenges the widespread notion that, in contrast to Hollywood's long-standing and well-known dependence on outside sources, there is a relative paucity of adaptations in Bollywood. As this essay will elaborate, it is true that the Hindi film industry shows much less inclination toward that which the genre label "adaptation," if used in marketing, still primarily implies today in the Hollywood context: the adaptation of high-profile literary works, usually novels. In the Hindi film industry, adaptation *as a genre* has a different status because of the different relative commercial values ascribed to literature and film. Yet if we take into account other sources for Hindi films and include intramedial as well as intermedial transpositions in our concept of adaptation, adaptation *as a practice* emerges as ubiquitous in popular Hindi cinema. At the same time, the specific manifestations of literary adaptation and remaking in the Hindi film industry and the industry's prevalent policies concerning whether the status of films as adaptations or remakes is openly acknowledged add new nuances to the theorization of the adaptation as a genre and industrial practice.

First, however, a word about nomenclature. This essay uses "Bollywood" to denote mainstream Hindi cinema since the mid-1990s and the industry, centered in Mumbai,

that produces it. Despite its nationwide appeal (Vasudev 115), Bollywood is not to be equated with all of Indian cinema. Nor should the term, *pace* Joshi and others, be used to refer to earlier Hindi films, other regional Indian cinemas, or the so-called Indian art cinema or parallel cinema, a form of filmmaking following more realist protocols, which started to develop as an alternative to the all-India films of mainstream cinema in the 1950s. "Middle cinema," whose aesthetics and thematic focus situate it between mainstream and art cinema, is another growing sector of Indian cinema that today finds its most visible form in the so-called multiplex films—niche films that do not attract the mass audience necessary to make a film profitable in a traditional single-screen cinema but seek an audience through smaller cinemas in the multiplexes, which also cater to a more sophisticated audience than the traditional single-screen venues.[1]

So far, there have been relatively few attempts to theorize adaptation in Bollywood cinema in terms of genre and industrial practice (see especially Ganti, "And Yet"; Krämer, "End"; Wright, "Tom Cruise" and *Postmodernism*). Moreover, with few exceptions, adaptation in Indian cinema generally, and in Bollywood more specifically, has only recently become the subject of academic interest, mainly as a consequence of what one might call the academic Bollywood boom. As the visibility of Hindi films started to grow in Western film markets from the late 1990s onward, there was also a marked increase of scholarly interest in and publications about Hindi cinema. Few of these publications, however, dealt with the topic of adaptation. In the introduction to her seminal 2007 volume *Indian Literature and Popular Cinema*, Heidi Pauwels thus rightly lamented the absence of studies on Indian film adaptations of literature (5), a sentiment echoed in Blair Orfall's dissertation on adaptation in Hindi cinema two years later (13).

Since then, several other books and many articles on literary adaptation in Indian cinema have followed. Yet the development toward more theoretical and methodological sophistication in the field of adaptation studies, which started around the same time as the Bollywood boom, has unfortunately left relatively few marks on most of these books and articles, which follow the dominant practices of more traditional literature/film studies and deal with subjects that are relatively safe bets in terms of attracting an international publisher. There is a strong focus on adaptations of classic canonical literature, both Indian (Asaduddin and Ghosh, *Filming Fiction*; Creekmur; Pauwels) and international (Donaldson-Evans; Lawrence), as well as a focus on adaptations of individual canonical authors, with Shakespeare a particular favorite because of his international appeal (Biswas; Chaudhuri; Dionne and Kapadia; Huang; Trivedi, "Filmi Shakespeare"; Verma, "Hamlet" and "Shakespeare"). "Bollywood Shakespeare" criticism (Thakur 22) has flourished ever since Vishal Bhardwaj's films *Maqbool* (2003) and *Omkara* (2006), two acknowledged film adaptations of *Macbeth* and *Othello*, respectively, garnered international attention. The growing interest in Bollywood in the academy at the time when these films were released, as well as the familiar literary sources, obviously encouraged scholars to discuss the films, and Bollywood Shakespeare was thus seamlessly fitted into the academic Shakespeare industry's niche for transcultural adaptations. Other critical texts have concentrated on the figure of an auteur director.

Since Satyajit Ray, the most renowned representative of Indian art cinema, remains to this day the only truly canonical Indian film director in international film studies, it is hardly surprising that he has been singled out for adaptation criticism of this kind (see especially Asaduddin and Ghosh, *Filming Fiction*).

Methodologically, the greater part of criticism about Indian film adaptations of literature has been unsurprising. Apart from some of the newest texts (e.g., Dionne and Kapadia; Orfall), the default mode of criticism has been the individual case study that presents a reading (and frequently an evaluation) of the adaptation in relation to its source text from a specific theoretical angle, such as gender, transnationalism, postcoloniality, or the global/local dynamic. While readings of individual films like those Simran Chadha has recently collected are by no means without interest, they nonetheless rarely provide wider-reaching glimpses of the status or role of adaptation for filmmaking practices in India or the Hindi film industry.

A broader focus of this kind, however, is evident in several recent critical texts that interpret current practices of adaptation in the Hindi film industry as expressive of its status, which is often regarded as precarious, within globalized world cinema (see Krämer, "End"; Orfall 18; Richards; Smith; Wright, "Tom Cruise" and *Postmodernism*). While this broader focus is a welcome change from the classic case studies predominant in the field, one can still argue that it is ultimately just as problematic because of a "Hollywoodcentric" (Shohat and Stam 2) tendency to posit Bollywood, at least implicitly, as Hollywood's Other.[2] Moreover, just as Shakespeare adaptations are unduly overrepresented in the critical literature on Bollywood adaptations (Orfall 57; Trivedi, "Shakespeare and Bollywood" 196), the texts that contextualize Bollywood in relation to global cinema tend to concentrate on the role of transcultural adaptations in Bollywood while largely neglecting adaptations based on Indian material. Hence the prolific genre of the Hindi remake of South Indian films remains underexplored in comparison to Bollywood's adaptations of Hollywood films.[3] Nonetheless, these critical texts have done a great deal to illuminate adaptation as an industrial practice in Bollywood. Moreover, they remind us that Hindi cinema has, since its very beginnings, been positioned at the interface of multifold national and international influences, which it has incorporated and adapted in various ways. In fact, looking back at the beginnings of Hindi cinema, one already discovers features that exemplify several specifically Indian trends in cinematic adaptation, many of which continue in some variation in Bollywood to this day. Based on selected references to adaptation practices from the history of Hindi cinema, the essay will discuss some of the prevalent features of adaptation in Bollywood today, focusing first on literary adaptations, then on film remakes and their typical strategies of Indianization and copyright. After outlining the hybrid and transnational nature of the Bollywood film, it closes with a look at the specificities of adaptation in Bollywood in terms of both practice and genre and considers how they might be theorized.

A good starting point is *Raja Harishchandra* (1913), directed by Dhundiraj Govind Phalke, who is widely considered the father of Indian cinema. Even though *Pundalik* (1912), about the eponymous Hindu saint, preceded *Raja Harishchandra* (Rajadhyaksha

and Willemen 243; Thoraval 5), it is Phalke's film that has become widely known as the first Indian feature film. Moreover, the anecdote, as recorded by Phalke himself, about the film's inception has, through constant repetition, become something of an origin myth of Indian cinema that illustrates paradigmatically how Indian cinema "has been both transnational and rooted in adaptation since its inception" (Orfall 10).

The story goes as follows: Watching the early silent film *The Life of Christ* (1906) in a Bombay theater around Christmas 1910,[4] Phalke was so excited by the magic and possibilities of the new technology that he decided to obtain and use it himself in order to bring Indian mythology to life, just as he had seen it done with Jesus' story. By putting "Indian images on the screen" (Phalke, qtd. in Orfall 8), he would attempt to create specifically Indian films for Indian audiences (see also Rajadhyaksha and Willemen 177; Thoraval 6). The immediate result was *Raja Harishchandra*, which presented the story of Harishchandra, legendary king of Ayodhya, whose story can be found in the *Mahabharata*, the *Aitareya-brahmana*, and the *Markandeya Purana*.

In this sense, *Raja Harishchandra* is the first Indian film adaptation of literature, and it set a highly influential tone. As Asaduddin and Ghosh have pointed out, "In Hindi, Urdu as well as in other Indian languages, cinema in its first phase borrowed unashamedly from legends, mythologies, as well as literature" ("Filming Fiction" xix), often by way of adaptations in Parsi theater. The great epics *Mahabharata* and *Ramayana* emerged as particularly popular sources. The films based on their stories form a central genre of Indian cinema: the mythological. Even in contemporary films set in modern India, intertextual references to their characters, legends, and motifs abound, comprehension ensured by the fact that they are widely known among large parts of the Indian population, quite independent of educational level, not least through ritual performance. *Raja Harishchandra* is thus also representative of an important kind of adaptation in Hindi cinema history that relies not on one specific source, but looks back at several versions and presentations of a story and hence adapts a myth, rather than a single text. There have been several examples of this process in Indian film beyond the legends from the great epics, such as the story of the slave girl Anarkali, which inspired many plays and several films, including one of the most sumptuous Hindi films ever, *Mughal-e-Azam* (1960). In a similar way, by the time Sanjay Leela Bhansali made his screen version of *Devdas* (2002), both its eponymous hero and story had, through earlier adaptations in various languages, become quite independent of Sharat Chandra Chattopadhyay's novel.

This predilection for myths is one reason why adaptation in Hindi cinema appears on the whole to have been less book-centric, and especially less novel-centric, than in Hollywood. In her screen guide to a hundred key Hindi films, Rachel Dwyer observes that only "a handful of Hindi films [have been] adapted from a novel" (103). Given the three *Devdas* adaptations in Hindi alone that had already been released when Dwyer's guide was published—Anurag Kashyap's *Dev.D* (2009) has been added since—this is clearly a deliberate exaggeration. In fact, Dwyer herself points to the novels behind Hindi film classics such as *Guide* (1965), *Duniya Na Mane* (1937), *Sahib Bibi Aur Ghulam* (1961), *Umrao Jaan* (1981), and the various *Devdas* films (1935, 1955, 2002). Yet her

seemingly offhand remark underlines the fact that novels have, especially in comparison to Hollywood, played a decidedly minor role as source texts for films in Hindi cinema.

This is also true for Bollywood cinema more specifically. None of the films that are generally regarded as having triggered or as being particularly representative of the Bollywoodization, as Rajadhyaksha calls it, of Hindi cinema—films like *Hum Aapke Hain Kaun . . . !* (1994), *Dilwale Dulhania Le Jayenge* (1995), *Dil To Pagal Hai* (1997), *Taal* (1999), *Pardes* (1997), *Kuch Kuch Hota Hai* (1998), *Kabhi Khushi Kabhi Gham* (2001), and *Lagaan* (2001)—was based on a book, even though many of them abound in intertextual references to sources from Indian mythology to MTV, or were inspired by other films. There have of course been Bollywood films that have carried their derivation from literary sources openly on their sleeves, mostly through their titles. Often, however, as in the cases of *Devdas* (2002) and *Parineeta* (2005), they also look back to earlier screen versions and therefore lend themselves better to interpretation as film remakes or re-adaptations (see Leitch, "Twice-Told Tales"; Verevis 12–17) rather than straight adaptations. Given the fact that Hindi popular cinema has, since the 1960s, aimed to appeal to as large an audience as possible, and given the long-time dominance of film as a medium in India, the film will, in such a case, be the more widely known source text. When Indian mainstream filmmakers create adaptations to exploit the popularity or cultural status of specific source texts, they can safely assume that their audiences will be more likely to know an earlier film than an earlier book, particularly when the literary source is not Indian (Verma, "Shakespeare" 270).

Perhaps for this reason, adaptations of literary classics in Bollywood cinema are rarely marketed as such. Adaptations are never only adaptations but also, for example, comedies, melodramas, tragedies, musicals, fantasy, or masala films. In this sense, the adaptation is a secondary genre, and a given adaptation's marketing can offer the potential viewer different entry points, the film's status as an adaptation being only one of them. Hollywood often deploys this strategy. Labeling them as adaptations allows the marketing for films based on classic literature or modern prize winners to evoke the prestige of the source text and tap into the higher education market. Adaptations of modern bestsellers can exploit the book's readership or use the book's fans as multipliers. References to the authors of literary texts on which adaptations are based can help to brand films, whether they are canonical authors like Shakespeare, popular favorites like Nicholas Sparks, Stephen King, or Patricia Highsmith, or critical darlings like Dennis Lehane. All of these strategies are standard procedure in Hollywood. Not in Bollywood, however. Neither *Devdas* (2002) nor *Umrao Jaan* (2006), for example, was marketed explicitly via its source. Although both evoked a literary text in their titles, their immediate, and in terms of their intended audience more prestigious, pre-texts were, respectively, the Devdas myth and the first *Umrao Jaan* film (1981). The films were accordingly marketed not as literary adaptations but as star vehicles, and by showcasing their high production values, which reflected their pre-texts' reputations.

One reason for this strategy can be found in Rajiva Verma's analysis of the poster campaign for *Angoor* (1982), an adaptation of *The Comedy of Errors*. According to Verma, the film's producers seem to have regarded its Shakespearean connection "as a

liability at the box office rather than an asset; a rich source to be mined but not revealed, at least not prematurely, for that could send wrong signals to the prospective audience to the effect that this was a forbiddingly high-brow film" ("Shakespeare" 285). In the case of adaptations of canonical literary texts, many Indian filmmakers who aim at the mainstream market adopt the strategy of not signaling the film's literary connection in order to protect their film's mass appeal. In contrast to most Western film markets, "adaptation" is for them a genre label that is likely to repel, rather than attract, potential viewers.

In this context, it is remarkable that Vishal Bhardwaj's Shakespeare films were acknowledged Shakespeare adaptations, and that Chattopadhyay's name appeared on some posters as the author of the source of *Parineeta* (2005). If a Bollywood film announces its status as an adaptation in this way, it probably aspires toward the international art house market, where its reference to literature is likely to be an asset rather than a liability. Suddhaseel Sen reports that "Bhardwaj himself . . . stated in an interview that he aimed to go beyond Indian audiences" with *Maqbool* and *Omkara*. Alternatively, the reference to literature signals a film's affinity for the non-mainstream multiplex film market. For several years now, the multiplex revolution in India has made "risk-taking commercially viable" for filmmakers (Ganti, *Bollywood* 49) by providing exhibition spaces for films whose content or technique is unconventional and by blurring the distinction between mainstream and middle cinema. Because filmmakers can now signal that their films can be read as more than entertainment, acknowledged literary adaptations will probably become more frequent in the future.

Moreover, as strong content has become more important, more filmmakers have turned to contemporary literature as a possible source for stories.[5] Although film producers in Hollywood have long cultivated close contacts to the publishing industry in order to option the film rights for promising new books before they are even published, no pervasive connection between the publishing and film industries of this kind yet exists in India. Even so, the Bollywood blockbuster *3 Idiots* (2009), which was based on Chetan Bhagat's 2004 novel *Five Point Someone*, as well as the 2008 success of *Slumdog Millionaire*, which was observed with great interest by Bollywood, showed the enormous economic potential in adaptations of contemporary Indian literature. At the moment, we therefore see a trend toward more Bollywood adaptations of best-selling novels and non-fiction books like *Hello* (2008), *Kai Po Che* (2013), *Shootout at Wadala* (2013), and *2 States* (2014). Articles announcing that Bollywood production houses have acquired adaptation rights of best-selling novels that keep popping up in the Indian press (Salvadore; Basu) further indicate that publishers, authors, and filmmakers regard this link as potentially useful publicity for their respective works. Amish Tripathi, author of the best-selling Shiva trilogy, whose Indian-language adaptation rights have been acquired by Karan Johar's Dharma Productions, has expressed his confidence that the Bollywood movie adaptations will boost his book sales (DNA), while Johar has emphasized the cinematic potential of Tripathi's storyworld (Basu).

In addition to highlighting the economic potential of best-seller adaptations, *3 Idiots* also became notorious for a controversy between Chetan Bhagat, the author of the

novel, and the filmmakers when Bhagat complained that his input had been insuffi-
ciently acknowledged and even deliberately played down in the marketing of the film in
order to create the impression that *3 Idiots* was an original work (Asaduddin and Ghosh,
"Filming Fiction" xxviii). This treatment of the literary source fits into established indus-
try practices of not advertising a film's indebtedness to other texts, even illicitly hiding
it. The *3 Idiots* controversy was so widely reported that it created a new awareness of
the adaptation process and questions of copyright. Still, while literary adaptations may
be on the rise, the remake remains the mode of choice for reworking tested material in
Hindi films.

Remaking, a widely practiced risk-avoidance strategy in Hindi cinema (Ganti,
Bollywood 89), has in the new millennium developed "from something previously occa-
sional and cursory, to a now much larger-scale investment and cultural trend that is
being recognised by the Indian film media and embraced by the industry and its audi-
ences as never before" (Wright, *Postmodernism* 133). Filmmakers regularly rework older
Hindi films—recent examples include the infamous *Sholay* (1975) remake *Ram Gopal
Varma Ki Aag* (2007) as well as *Don* (2006, originally 1978), *Agneepath* (2012, originally
1990) and *Khoobsurat* (2014, originally 1980)—but remaking recent successful motion
pictures from other regional Indian film centers, especially the South Indian Tamil and
Telugu cinemas, is even more common. As Ganti has pointed out, several of these films,
such as *Ghajini* (2008), *Bodyguard* (2011), and *Rowdy Rathore* (2012), have been among
the biggest hits of the past few years (*Bollywood* 89). Foreign movies, too, whether from
North America, Europe, or other Asian cinemas, have long been a welcome source of
inspiration. Abundant examples rework originals of all imaginable genres and styles.
The list seems inexhaustible, from the *Reservoir Dogs* (1992) remake *Kaante* (2002) to
the *Oldboy* (2003) remake *Zinda* (2006), from the *Kramer vs. Kramer* (1979) remake
Akele Hum Akele Tum (1995) to the *Mrs. Doubtfire* (1993) remake *Chachi 420* (1997),
from the *When Harry Met Sally . . .* (1989) remake *Hum Tum* (2004) to other movies that
borrow from several films, like *Ghulam* (1998), which mixes elements from *The Wild
One* (1953), *On the Waterfront* (1954), *Raging Bull* (1980), and *Rebel Without a Cause*
(1955), and *Life in a Metro* (2007), which remixes *The Apartment* (1960), *Brief Encounter*
(1945), and *Unfaithful* (2002).[6]

Again, *Raja Harishchandra* anticipates this practice, as Phalke reworked a Western
film to create what would become the first example of a genuinely Indian form of cin-
ematic expression, the mythological.[7] This approach to existing material has a long-
established cultural tradition. Poonam Trivedi has pointed out that in indigenous Indian
literary tradition, "translation, adaptation, rewriting and transformation have been
sanctioned practices of literary creation" and "legitimate modes of alterity." Adaptation,
she observes, is perceived as "neither parasitic nor transgressive," since in Sanskrit lit-
erary theory, the acts of literary creation (*anukriti*), representation (*anukaran*), and
translation (*anuvada*) all share the notion (contained in the word root *anu* = "to come
after") of following after something else, so that already "the very act of literary creation
is a re-scription, an imitation" ("Reading" 60). The Hindi film industry makes similar
assumptions about the practice of reworking material. "Hindi filmmakers are quite

open about their sources of inspiration," Ganti explains, and there is a prevalent view that the originality of the treatment and presentation of a film's story are more important than the originality of the story itself, since there are a limited number of stories that can be varied (*Bollywood* 87). Combining this belief with the assumption that a story is in the public domain once a given book has been published or a given film released—a dramatic contrast with dominant Western ideas of copyright—produces the conclusion that "an individual can copy another's idea and not violate copyright as long as the idea is expressed in a different manner" (*Bollywood* 88). As a consequence, Bollywood remakes of foreign films usually make considerable changes to their source material: "While remakes from other Indian languages resemble the original screenplay, adaptations of Hollywood films barely do" (*Bollywood* 89). They are not "cultural copies" (Khan 356), but are more usefully conceived of as adaptations or reworkings. At the same time, the filmmakers' frequent failure to acknowledge their indebtedness to (especially foreign) copyrighted material has given the Hindi film industry a reputation of being "notoriously appropriative" (Ganti, "And Yet My Heart" 440).

Like early Indian Shakespeare adaptations for the Parsi theater, which were highly selective and adapted individual scenes almost literally while introducing substantial changes to the rest of the plays (Verma, "Shakespeare" 84), Bollywood follows a pick-and-mix approach in its use of features from foreign films and then adapts and adds to them to create a film that fits the conventions of Hindi cinema. *Chori Chori Chupke Chupke* (2001), for example, replicates entire scenes from *Pretty Woman* (1990). In the Indian film, however, the story of the loud-mouthed hooker with a heart of gold who falls in love with the man who pays for her sexual services is changed considerably and becomes merely one plot strand among many. The prostitute is sought out by the man because he and his wife want children but cannot have them, and therefore look for a surrogate mother to bear his child. A love triangle and conflicts of love and duty ensue and are resolved. All in all, there are so many alterations and additions to *Pretty Woman* that despite the striking similarities, *Chori Chori Chupke Chupke* is also clearly different. It may be more fitting to call films like this remixes or reinventions, rather than remakes (Prasad 14–15; Wright, *Postmodernism* 183; see also Nayar 74), or to focus on their adaptation strategies rather than their textual status as remakes.

Adaptational strategies in Bollywood remakes of foreign films include the addition of emotion and sensation, "a need to transfer what is literal into the figural," and the necessity "to accommodate Indian ethics and censorship" (Wright, "Tom Cruise" 204, 205). Ganti identifies three key strategies of "Indianization." One is the inclusion of songs, another the addition of emotion, not only through aesthetic choices (especially concerning music and acting styles) that exteriorize the characters' emotions, but also through greater emphasis on interpersonal relationships and their emotional conflicts and dynamics than their Western models, stressing the moral aspects of the narrative in the process. The third strategy is the expansion of the narrative of the original film. After all, in contrast to what Indian filmmakers call the "single-track" narrative of Hollywood films, Hindi films tend to be considerably longer and to contain several parallel tracks and subplots ("And Yet My Heart"). Where Ganti speaks of Indianization, Nayar uses

the term "chutneyfication" to describe the narrative changes that are made to render Hollywood films "acceptably Indian" (73). Focusing on film endings and resolutions, Nayar identifies love triangle scenarios, the treatment of parents and family themes, and denouements of sacrifice whose underlying principle is the fulfillment of dharma, one's sacred duty, as key adaptation strategies in transcultural Bollywood remakes. To this list might be added Indian settings, references to Indian institutions and politics, and the fact that Bollywood remakes often draw on multiple films because of the multistrand plot structure of most Hindi films (Krämer, "Hollywood"). By Indianizing a foreign film in this way, Bollywood remaking creates a new version of the story that competes with the earlier film commercially and culturally. Wright accordingly considers the phenomenon an example of "reverse colonialism" (*Postmodernism* 135). The remake may also efface its source, not least because the original, as in literary adaptations, is rarely acknowledged.

Unacknowledged or unofficial remaking is in fact so widespread in the Hindi film industry that it deserves to be considered a fully institutionalized industrial category. It is encouraged by the fact that the Indian domestic film market is geared almost exclusively toward Indian product. Dubbed versions of foreign films have never truly caught on; nor have subtitles, partly because of still comparatively high illiteracy rates. Moreover, Indian audiences like their domestic stars, often to the point of adoration. These factors combine to favor films with Indian soundtracks and actors and with stories that are set in a fictional world whose cultural practices and values are readily recognizable to Indian spectators. Excepting individual success movies such as *Spider-Man* (2002) or *Avatar* (2010), which were released in dubbed versions, Hollywood has therefore found it difficult to penetrate this market.

Given the hegemonic role of domestic film productions in India, filmmakers there can readily assume that, with the possible exception of international blockbusters and award-winning films, most foreign films will be unfamiliar to their Indian audiences, and they have used this circumstance to rework copyrighted material without first acquiring the rights to it. At least potentially, this practice holds an oppositional impetus, as Bollywood filmmakers have refused to play by international copyright rules. As standard practice in the Hindi film industry, the unacknowledged remake constitutes an important counterweight to the international copyright system—a system that ultimately upholds the existing discrepancies of wealth and power between Bollywood and Hollywood (see Krämer, "End"). More frequently, however, Bollywood's practice of remaking is interpreted as indicating a lack of creative energy and international respectability. Orfall, rightly and critically observing that Bollywood's unacknowledged remaking has been framed discursively in entirely negative terms, notes that "borrowing *any* element of filmmaking in content, style, marketing, etc from Hollywood film is simultaneously linked to copyright issues rather than a director's personal interests as say, Tarantino is discussed[.] The language used to discuss *any* film adaptation generally (an adaptation's fidelity or infidelity, betrayal, justice, etc to a source text) and unacknowledged adaptation specifically (rip-off, theft, copycat) implies censure" (92).

This pejorative notion of remaking has apparently been internalized by several film producers, especially those striving for greater respectability and better relations with actual or potential international partners. For several years now, there has therefore been a trend, which may also be a reaction to Hollywood's increasing tendency to litigate against copyright infringement by Bollywood filmmakers, to acquire the necessary rights before copyrighted material is reworked. The first widely publicized official remake of this kind was *We Are Family* (2010), a co-production between Sony and Karan Johar's company Dharma Productions, which was adapted from Chris Columbus's film *Stepmom* (1998). Since then, Bollywood has seen official remakes of several more films, including *The Italian Job* (1969; *Players* 2012), *Après vous* (2003; *Nautanki Saala!* 2013), and *Knight and Day* (2010; *Bang Bang* 2014).

The transcultural Bollywood remake is a perfect example of the hybrid nature of Hindi cinema, a quality that already marked the earliest days of Indian film. As in the West, India's early films drew on theatrical traditions combining influences from classical Sanskrit theater, various folk theaters, and the Parsi theater, which itself combined Eastern and Western theater forms (Dionne and Kapadia 8; Gokulsing and Dissanayake, *Indian Popular Cinema*). In addition to the great epics, further important influences were saints' lives, history, tales of romance, melodrama, Indian calendar art, and devotional practices (Orfall 10; Verma, "Shakespeare" 85). Throughout its history, Hindi cinema, moreover, has incorporated foreign films and film styles, from German Expressionism and Italian Neorealism via 1950s Hollywood musicals and melodramas (Orfall 10) and 1970s Spaghetti Westerns to Hollywood's superhero extravaganzas of the twenty-first century. Hindi cinema thus emerges as a site where many national and international intertexts continue to converge (Orfall 17).

Today more than ever, Bollywood functions "as a hybrid cinema, borrowing and adapting foreign elements while asserting local sensibilities" (Richards 345). It offers a prime example of the impact of cross-cultural and transcultural as well as intermedial and transmedial relationships that are typical of cinemas in the current age of globalization. Transcultural adaptations and remakes by Bollywood can no longer simply be viewed as Indianizations, but are better interpreted as "glocal masala films" (Richards 349). Iain Robert Smith, for example, discusses *Zinda*, the Indian version of South Korean film *Oldboy*, as an example of cultural exchange in the context of global media and geo-cultural flows (195) by underlining the way the film engages "with the common stylistic and narrative tropes of the global horror genre" (193) in order to reach an audience beyond India. In a similar vein, Wright has interpreted what she regards as a boom of various forms of remaking in Hindi cinema in the new millennium as "the prime example of the current identity-collapse of Bollywood cinema," given that Bollywood has to cater to its traditional audiences while "being recast and remoulded to fit the international market" ("Tom Cruise" 206; see also Prasad 16–17).

Just as *Zinda* tries to tap into this international market through the global horror genre, films like *Krrish* (2006) and *Ra.One* (2011) have done the same through the superhero genre. Unlike *Zinda*, they do not acknowledge or remake any recognizable individual pre-text, but they can still be interpreted as adaptations, this time of the generic

conventions of a specific and globally very successful Hollywood film genre that tends to rework comic-book story elements itself. In the case of *Ra.One*, the level structure of games is a further pre-text. *Krrish* and *Ra.One* do not primarily derive from a particular "postliterary" pre-text, but from the Hollywood film adaptations of such texts, and so resemble what Leitch has called secondary, tertiary, or quaternary imitations (*Film Adaptation* 257, 120). This phenomenon is not new in principle. It is clearly at work in Hindi films that rework other film adaptations of literary texts rather than their literary source texts, like *Maqbool*, which reworks Kurosawa's *Throne of Blood* (1957) as much as *Macbeth*, or *Masoom* (1982), which reworks the American film *Man, Woman and Child* (1982) rather than the 1980 Erich Segal novel on which it was based (Dwyer, *100 Bollywood Films* 158; Orfall 59–87). The difference between these examples and contemporary films like *Krrish* and *Ra.One* is that the growth of Bollywood's overseas markets in the past fifteen years, the growing international visibility of Hindi cinema, and the increasing translocality of the global mediascape have combined to produce films that have a better chance of both exploiting and feeding back into global cinema by adapting genres that have been particularly successful internationally.

The conclusions to be drawn about adaptation in Bollywood are manifold. Most fundamentally, perhaps, the hybrid nature of Bollywood films suggests that adaptation in Bollywood should be best approached in terms of a rhizomatic interrelation of disparate Indian and non-Indian texts and practices. Linear notions of adaptation have of course long been problematized in favor of weblike, non-hierarchical concepts of adaptation inspired by poststructuralist approaches. Such an approach is ideally suited to Hindi cinema generally, and Bollywood cinema more specifically, given their films' manifold interrelations to other media, filmmaking styles, and film texts.

While the rhizome is a compelling model for adaptation in Bollywood on a general level, the industry's predilection for remaking, especially for unacknowledged transcultural remaking, indicates that some of the basic notions developed around official remakes do not apply or must be modified to fit the Indian context. When Verevis speaks of remaking as an industrial category and posits the remake as a category that establishes and is based on a contract between filmmakers and audience (3–4), this contract obviously does not apply to unacknowledged remakes. Nonetheless, although some filmmakers have recently begun to produce official remakes, thus subscribing to Western copyright practices (Krämer, "End"), unacknowledged remaking of foreign material remains the norm in Bollywood and thus conforms to David Wills's description of the remake as "a precise institutional form of the structure of repetition" (148). The unacknowledged Bollywood remake can therefore be interpreted as a specific regional variety of the remake as industrial category.

The remake, moreover, functions in Bollywood as an established category to minimize risk and as a genre in the sense that the label "remake" establishes a contract between film producers and viewers (Altman 14) that encourages the comparative mode of reception typical of viewing an adaptation "as an adaptation" (Hutcheon 6). The status of the literary adaptation as a genre appears more precarious. The tendency to downplay or conceal literary sources of adaptations and therefore not to label literary adaptations

as adaptations indicates that the adaptation as a genre is in a far weaker position than either the adaptation in Western film industries or the remake in the Hindi film industry. Moreover, the discourses of authenticity, which in the marketing of Western literary adaptations often emphasize the fidelity of the adaptation to some essence of the literary text or to the intentions of its authors, are usually neglected or downplayed in the case of Bollywood adaptations in favor of discourses that foreground the originality and vision of the filmmakers. Like the predominance of remakes over literary adaptations in Hindi cinema, this phenomenon ultimately derives from the fact that film production in the Hindi film industry is guided by an implicit media hierarchy in which film is more powerful than literature, which is exploited for its stories rather than its supposed cultural capital—or, if it is overtly acknowledged, for its relative familiarity. Given the fact that the multiplex boom and the growing international orientation of Bollywood have, in recent years, already led to more adaptations of contemporary Indian best-sellers, more official remakes, and more films that deliberately exploit global genres such as horror or fantasy, it remains to be seen where both adaptation as a practice and adaptation as a genre in Bollywood will be heading in the immediate and the medium-term future.

For now, investigating adaptation in Bollywood holds various corrective implications for Euro-American adaptation scholars who take the Hollywood model as the unmarked case. Adaptation studies draws on the culture industries for the subjects it investigates and the texts it analyzes and is therefore always already linked to these industries on a basic level. When the industry creates new strategies, academics follow in theorizing them. Too many non-Western film industries, however, remain underexplored, and simply comparing them to Hollywood on the basis of concepts developed in Western film industries, such as the "adaptation" film genre, can be misleading by submerging existing practices and ideas under foreign ones. When Euro-American adaptation scholars wish to adapt their work to different artistic and industrial contexts, they must therefore be ready to engage with the cultural traditions, aesthetic, ideological, and industrial practices and ideas, texts, and languages of the cultural sphere they are considering. They should especially avoid moralistic frameworks of investigation in favor of more descriptive and analytic approaches. The alleged rip-offs in Bollywood remakes, for example, can be more productively placed in the context of traditional local assumptions of adaptation or discussions of copyright law.

The scarcity of literary adaptations and the fact that the adaptation label is rarely deployed as a selling point in Bollywood should warn us against the long-established practice in Western adaptation criticism of privileging literary over other types of film adaptations. The Bollywood example shows that even when a film industry produces few literary adaptations and the status of the adaptation as a film genre in the sense of a contract between producer and spectators is weak, adaptation can be a pervasive cultural and industrial practice. The specificities of this practice—in the case of Bollywood, especially intramedial adaptations and the phenomenon of secondary adaptation—deserve our special attention. Going beyond its traditional focus on film adaptations in Hollywood, adaptation studies will find different industrial and conceptual models of

adaptation in other film industries, which in today's increasingly globalized and trans-cultural film culture are more and more likely to talk back to Hollywood.

NOTES

1. For the conceptualization of Bollywood in this essay and an elaboration on the governmental policies, changes in organizational structures, industrial strategies, and national and international medial contexts that have shaped the development of Bollywood since the mid-1990s, see Rajadhyaksha; Ganti, *Producing Bollywood*; Punathambekar.
2. See, however, chapter 1 in Gehlawat's *Twenty-First Century Bollywood*, where he analyzes some recent remakes of older Hindi films in order to test whether, as other scholars have suggested, there are clearly discernible categorical "difference(s) between earlier and later Bollywood films" (14).
3. Ganti, for example, explicitly identifies remakes of successful South Indian films "as part of the Hindi film industry's standard repertoire of risk management" (*Producing Bollywood* 246). Yet she does not pursue this topic further. The critical neglect of these remakes is most likely due mainly to scholars' unfamiliarity with South Indian cinema and South Indian languages, although in some cases, it may also simply be a matter of priorities.
4. This is probably a mistake in Phalke's memory. As Rajadhyaksha and Willemen point out, contemporary film notices suggest that an Easter 1911 date is more likely (177).
5. The recent production trend of biopics, which has included films such as *Bhaag Milka Bhaag* (2013), *Paan Singh Tomar* (2013), *Rang Rasia* (2008), and *Gandhi, My Father* (2007), can also be interpreted as a result of this development.
6. See Wright, *Postmodernism* for a list of reasons for the recent boom in cross-cultural Bollywood remakes (183–84).
7. *Pundalik* arguably achieved the same results for the mythological's sister genre, the devotional film, which presents the lives of Hindu saints (see Dwyer, *Filming the Gods* 15).

WORKS CITED

Altman, Rick. *Film/Genre*. London: British Film Institute, 1999. Print.

Asaduddin, Mohd, and Anuradha Ghosh, eds. *Filming Fiction: Tagore, Premchand, and Ray*. New Delhi: Oxford UP, 2012. Print.

Asaduddin, Mohd, and Anuradha Ghosh. "Filming Fiction: Some Reflections and a Brief History." Asaduddin and Ghosh xiii–xxxii. Print.

——, eds. *Filming Fiction: Tagore, Premchand, and Ray*. New Delhi: Oxford UP, 2012. Print.

Basu, Upala K. "Karan Johar Brings Meluha to Life." *Times of India* 4 Jan. 2012. Web. 17 Oct. 2014.

Biswas, Moinak. "Mourning and Blood-Ties: Macbeth in Mumbai." *Journal of the Moving Image*. 2006. Web. 17 Oct. 2014.

Chadha, Simran, ed. *Bollywoodising Literature Forging Cinema: Adaptation and Hindi Cinema*. New Delhi: Research India Press, 2015. Print.

Chaudhuri, Sukanta, ed. *The Shakespearean International Yearbook* 12: *Special Section, Shakespeare in India*. Farnham: Ashgate, 2012. Print.

Chori Chori Chupke Chupke. Dir. Abbas Alibhai Burmawalla and Mastan Alibhai Burmawalla. Perf. Salman Khan, Preity Zinta. Nazim Hassan Rizvi, 2001. Film.

Creekmur, Corey K. "The Devdas Phenomenon." *Philip'sfil-ums: Notes on Indian Popular Cinema by Philip Lutgendorf*. Web. 17 Oct. 2014.

Devdas. Dir. Sanjay Leela Bhansali. Perf. Shah Rukh Khan, Aishwarya Rai. Mega Bollywood, 2002. Film.

Dionne, Craig, and Parmita Kapadia, eds. *Bollywood Shakespeares*. New York: Palgrave Macmillan, 2014. Print.

DNA. "Bollywood Movie Adaptation Will Boost My Books' Sale Says Amish Tripathi." 20 Jan. 2014. Web. 17 Oct. 2014.

Donaldson-Evans, Mary. "The Colonization of *Madame Bovary*: Hindi Cinema's *Maya Memsaab*." *Adaptation* 3.1 (2010): 21–35. Print.

Dwyer, Rachel. *100 Bollywood Films*. London: BFI, 2005. Print.

——. *Filming the Gods: Religion and Indian Cinema*. London: Routledge, 2006. Print.

Ganti, Tejaswini. "'And Yet My Heart Is Still Indian': The Bombay Film Industry and the (H) Indianization of Hollywood." *Genre, Gender, Race, and World Cinema*. Ed. Julie F. Codell. Malden: Blackwell, 2007. 439–57. Print.

——. *Bollywood: A Guidebook to Popular Hindi Cinema*. 2nd ed. London: Routledge, 2013. Print.

——. *Producing Bollywood: Inside the Contemporary Hindi Film Industry*. Durham: Duke UP, 2012. Print.

Gehlawat, Ajay. *Twenty-First Century Bollywood*. London: Routledge, 2015. Print.

Gokulsing, K. Moti, and Wimal Dissanayake. *Indian Popular Cinema: A Narrative of Cultural Change*. New rev. ed. Stoke on Trent: Trentham, 2004. Print.

Gokulsing, K. Moti, and Wimal Dissanayake, eds. *Routledge Handbook of Indian Cinemas*. London: Routledge, 2013. Print.

Huang, Alexa, ed. *Asian Shakespeares on Screen: Two Films in Perspective*, special issue of *Borrowers and Lenders: The Journal of Shakespeare and Appropriation* 4.2 (Spring/Summer 2009). Web. 17 Oct. 2014.

Hutcheon, Linda, with Siobhan O'Flynn. *A Theory of Adaptation*. 2nd ed. London: Routledge, 2013. Print.

Joshi, Priya. *Bollywood's India: A Public Fantasy*. New York: Columbia UP, 2015. Print.

Khan, Amir Ullah. "Indian Cinemas: Acknowledging Property Rights." Gokulsing and Dissanayake, *Routledge Handbook* 351–59. Print.

Krämer, Lucia. "The End of the Hollywood 'Rip-Off'?: Changes in the Bollywood Politics of Copyright." *The Politics of Adaptation: Media Convergence and Ideology*. Ed. Dan Hassler-Forest and Pascal Nicklas. Houndmills: Palgrave Macmillan, 2015. 143–57. Print.

——. "Hollywood Remade: New Approaches to Indian Remakes of Western Films." *Remakes and Remaking: Concepts—Media—Practices*. Ed. Rüdiger Heinze and Lucia Krämer. Bielefeld: transcript, 2015. 81–96. Print.

Lawrence, Michael. "Hindianizing *Heidi*: Working Children in Abdul Rashid Kardar's *Do Phool*." *Adaptation* 5.1 (2012): 102–18. Print.

Leitch, Thomas. *Film Adaptation and Its Discontents: From* Gone with the Wind *to* The Passion of the Christ. Baltimore: Johns Hopkins UP, 2007. Print.

——. "Twice-Told Tales: Disavowal and the Rhetoric of the Remake." *Dead Ringers: The Remake in Theory and Practice*. Ed. Jennifer Forrest and Leonard R. Koos. Albany: State U of New York P, 2002. 37–62. Print.

Nayar, Sheila J. "'Dreams, Dharma and Mrs. Doubtfire': Exploring Hindi Popular Cinema via Its 'Chutneyed' Western Scripts." *Journal of Popular Film and Television* 31.2 (2003): 73–82. Print.

Orfall, Blair. "Bollywood Retakes: Literary Adaptation and Appropriation in Contemporary Hindi Cinema." Diss. University of Oregon, 2009. Print.

Parineeta. Dir. Pradeep Sarkar. Perf. Saif Ali Khan, Vidya Balan. Vinod Chopra, 2005. Film.

Pauwels, Heidi R. M., ed. *Indian Literature and Popular Cinema: Recasting Classics.* London: Routledge, 2007. Print.

Prasad, Madhava M. "From Cultural Backwardness to the Age of Imitation: An Essay in Film History." Gokulsing and Dissanayake, *Routledge Handbook* 7–18. Print.

Punathambekar, Aswin. *From Bombay to Bollywood: The Making of a Global Media Industry.* New York: New York UP, 2013. Print.

Raja Harishchandra. Dir. Dhundiraj Govind Phalke. Perf. D.D. Dabke, P.G. Sane. Phalke, 1913. Film.

Rajadhyaksha, Ashish. "The 'Bollywoodization' of the Indian Cinema: Cultural Nationalism in a Global Arena." *Inter-Asia Cultural Studies* 4.1 (2003): 25–39. Print.

Rajadhyaksha, Ashish, and Paul Willemen. *Encyclopaedia of Indian Cinema.* New rev. ed. London: BFI, 1999. Print.

Ra.One. Dir. Anubhav Sinha. Perf. Shah Rukh Khan, Kareena Kapoor. Red Chillies Entertainment et al., 2011. Film.

Richards, Rashna Wadia. "(Not) Kramer vs. Kumar: The Contemporary Bollywood Remake as Glocal Masala Film." *Quarterly Review of Film and Video* 28 (2011): 342–52. Print.

Salvadore, Sarah. "'Chanakya's Chant' to Be Adapted into Film." *Times of India* 13 Jan. 2012. Web. 17 Oct. 2014.

Sen, Suddhaseel. "Indigenizing *Macbeth*: Vishal Bhardwaj's *Maqbool*." Huang, *Asian Shakespeares.* Web. 17 Oct. 2014.

Shohat, Ella, and Robert Stam. Introduction. *Multiculturalism, Postcoloniality, and Transnational Media.* Ed. Ella Shohat and Robert Stam. New Brunswick: Rutgers UP, 2003. 1–17. Print.

Smith, Iain Robert. "*Oldboy* Goes to Bollywood: *Zinda* and the Transnational Appropriation of South Korean 'Extreme' Cinema." *Korean Horror Cinema.* Ed. Alison Peirse and Daniel Martin. Edinburgh: Edinburgh UP, 2013. 187–98. Print.

Thakur, Vikram Singh. "Parsi Shakespeare: The Precursor to 'Bollywood Shakespeare.'" Dionne and Kapadia 21–43. Print.

3 Idiots. Dir. Rajkumar Hirani. Perf. Aamir Khan, Kareena Kapoor. Vinod Chopra, 2009. Film.

Thoraval, Yves. *The Cinemas of India.* Delhi: Macmillan India, 2000. Print.

Trivedi, Poonam. "Afterword: Shakespeare and Bollywood." Dionne and Kapadia 193–97. Print.

———. "'Filmi' Shakespeare." *Literature/Film Quarterly* 35.2 (2007): 148–58. Print.

———. "Reading 'Other Shakespeares.'" *Remaking Shakespeare: Performance across Media, Genres and Cultures.* Ed. Pascale Aebischer, Edward J. Esche, and Nigel Wheale. Houndmills: Palgrave Macmillan, 2003. 56–73. Print.

Umrao Jaan. Dir. Jyoti Prakash Dutta. Perf. Aishwarya Rai, Abhishek Bachchan. J.P. Films, 2006. Film.

Vasudev, Aruna. *Liberty and Licence in the Indian Cinema.* New Delhi: Vikas, 1978. Print.

Verevis, Constantine. *Film Remakes.* Edinburgh: Edinburgh UP, 2006. Print.

Verma, Rajiva. "Hamlet on the Hindi Screen." *Hamlet Studies* 24 (2002): 81–93. Print.

———. "Shakespeare in Hindi Cinema." *India's Shakespeare: Translation, Interpretation and Performance*. Ed. Poonam Trivedi and Dennis Bartholomeusz. Newark: U of Delaware P, 2005. 269–290. Print.

Wills, David. "The French Remark: *Breathless* and Cinematic Citationality." *Play It Again, Sam: Retakes on Remakes*. Ed. Andrew Horton and Stuart Y. McDougal. Berkeley: U of California P, 1998. 147–61. Print.

Wright, Neelam Sidhar. "'Tom Cruise? Tarantino? E.T.? . . . Indian!': Innovation through Imitation in the Cross-cultural Bollywood Remake." *Cultural Borrowings: Appropriation, Reworking, Transformation*. Ed Iain Robert Smith. Special issue of *Scope: An Online Journal of Film and TV Studies* (2009): 194–210. Web. 17 Oct. 2014.

Wright, Neelam Sidhar. *Bollywood and Postmodernism: Popular Indian Cienma in the 21st Century*. Edinburgh: Edinburgh UP, 2015. Print.

Zinda. Dir. Sanjay Gupta. Perf. Sanjay Dutt, John Abraham. White Feather, 2006. Film.

CHAPTER 15

···

REMAKES, SEQUELS, PREQUELS

···

CONSTANTINE VEREVIS

FILM remakes, along with related media types—sequels and prequels—are often understood as forms of adaptation: that is, modes of cinematic remaking characterized by strategies of repetition, variation, and expansion (see Hutcheon 16, 170). This essay seeks to examine the circumstances in which these modes of serialization have been taken up in the new millennium. Like my earlier work in *Film Remakes*, which sought to understand cinematic remaking as an industrial, textual, and critical category, it is less concerned with legal-industrial definitions than with the place of adaptation and remaking in a wider cultural landscape of re-production. Rather than condemn remake formats as evidence of the commoditized relations of contemporary media culture, this essay seeks to examine the historically specific circumstances in which these serial modes are registered and negotiated. That is, it seeks to widen and deepen an understanding of adaptation and remaking, moving beyond objections around the commercial debasement of film, to examine the inscription of remake formats across a range of institutional and cultural sites. It analyzes the practice, aesthetics, and politics of cinematic remaking to build up an inventory of contexts, descriptions, and knowledges that contribute to the cultural and economic currency of serial forms. It seeks to demonstrate that, instead of analyzing the transformations of particular adaptations or remakes, it is more productive to examine adaptation and remaking as historically variable practices. Specifically, this essay interrogates a new millennial context that has mobilized a set of discourses around intermediality, transnationalism, and a logic of convergence to determine how these factors have been worked in and through the concepts of adaptation and remaking.

Recent accounts of Hollywood cinema—notably, Thomas Schatz's "New Hollywood, New Millennium," Thomas Elsaesser's *The Persistence of Hollywood*, and Tino Balio's *Hollywood in the New Millennium*—tell a similar story: namely, that since the turn of the century a combination of forces—conglomeration, globalization, and digitization—has contributed to a new historical period of "post-production," as Nicolas Bourriaud

calls it. For these writers, post-production not only signals the way in which production practices have changed significantly over the past two decades, but also heralds a transformed media culture, one characterized by a proliferation of viewing screens and new communicative technologies (iPhones, Twitter, Instagram), a rapid increase in digital distribution (downloading, streaming), and an intensification of interest in moving image content (iTunes, Netflix, YouTube) (see Corrigan, "Introduction" 10). Reversing the direction of these discussions, in which new media provide templates for new ways of thinking about adaptation, Anna Stenport and Garrett Traylor claim that contemporary remakes/adaptations exemplify conceptual frameworks for digital information organization. In Bourriaud's terms, post-production, and the art of post-production—that is, the proclivity of filmmakers to interpret, reproduce, remake, and make use of available cultural products—is a response to the "proliferating chaos of global culture in the information age, . . . [one] characterized by an increase in the supply of works . . . [and an associated] eradication of the traditional distinction between production and consumption, creation and copy, readymade and original work" (13).

Costas Constandinides' recent work on adaptation—a term that he also uses to describe practices of cinematic remaking—further develops this account of post-production through the argument that the shift of all culture to digitized forms of production, distribution, and communication—along with the capacity of digital modes to remake and remodel—at once undermines oppositions between original and copy and demands a theory of "post-celluloid adaptation" (19–26). In such an account, the (new millennial) remake is not, as in earlier definitions, described as a film based upon another film (or films), but is defined from an intermedial perspective as the translation of narrative units and popular characters from a preexisting (celluloid) medium to a new (digital) one:

> Post-celluloid adaptation [cinematic remaking] can be . . . defined as the transition of familiar media content from a traditional medium—print, film and television—to a new media object or a set of new media objects that embrace the concept of the main end-product. . . . [Furthermore,] post-celluloid adaptation is not restricted to the interconnectedness of two texts, but a multiplicity of texts that function across collaborative media. . . . [It] does not simply describe the transition of familiar images from an older medium to a new [one], but a process that is a symptom of the cultural logic of convergence culture. (24–25)

Constandinides' account of post-celluloid adaptation at once signals new media transformations of replica practices and frustrates those approaches that seek to differentiate processes of adaptation and remaking by appealing to the relationship between a new version (an adaptation or remake) and the medium of the original artifact. One of the principal arguments of adaptation theory has been around questions of remediation: adaptations involve *intersemiotic translation* or "recoding" (most often from literature to film: see Andrew 32–34; Ray 121–23), but remakes are generally understood as versions of another film, that is, as a process of *intralingual translation* or "rewording"

(Dusi 120). This distinction is, however, already problematic for the many literary adaptations of works that have been previously adapted to film, like the several versions of F. Scott Fitzgerald's *The Great Gatsby* (Baz Luhrmann, 2013; Jack Clayton, 1974; Elliott Nugent, 1949; Herbert Brenon, 1926). As Lesley Stern points out, a chain of adaptations often makes the more recent film version "by default a remake, and particularly in a case in which the source is not a classic [literary] text, the reference point will be the earlier film" (226). Accordingly, Pam Cook describes the recent Todd Haynes–directed television miniseries remake of *Mildred Pierce* (HBO, 2011)—a version of James M. Cain's 1941 novel and Michael Curtiz's textbook 1945 melodramatic film noir—as a "multidimensional cultural event that has no single [point of] origin": "The [*Mildred Pierce*] miniseries is decidedly *transmedia*—announced as a film on the credits, made for television, based on a book—signalling the *convergences* characteristic of contemporary media and the variety of . . . [ways it opens up to] potential consumer experiences" (379, emphasis added).

The suggestion that cinematic remakes are bound up in questions of translation (and intermediality) is not a new one (see Cattrysse; Mazdon; Evans), but the intermedial relationship between old and new (millennial) media is perhaps more urgently focused on examples like Peter Jackson's 2005 blockbuster remake of *King Kong* (Merian C. Cooper and Ernest B. Schoedsack, 1933). The original story's mythic dimension, its inherent spectacularity, and its openness to new interpretations have made it a site of ongoing industrial and cultural remaking, with theatrical reissues (1938, 1942, 1946, 1952, 1956), sequels (*Son of Kong*, Ernest B. Schoedsack, 1933), spin-offs (*Mighty Joe Young*, Ernest B. Schoedsack, 1949), cross-cultural adaptations (*King Kong vs. Godzilla*, Ishiro Honda, 1962), and—following the massive commercial success of *Jaws* (Steven Spielberg, 1975)—Dino De Laurentiis's epic remake, *King Kong* (John Guillermin, 1976), an overt parable of third-world exploitation that ends, in hubristic swagger, with Kong ascending the recently completed twin towers of the World Trade Center. Riding the crest of a wave of fan enthusiasm for his *Lord of the Rings* trilogy (2001, 2002, 2003), Jackson revisited the story of *King Kong* with solemn respect (and an estimated $200 million budget), treating his remake to impressive, state-of-the-art digital effects. More significantly, Jackson employed new media strategies to engage fans (or "viewer/users") and rendered the film's official "website a powerful paratext of the main text, or created a 'database as non-linear narrative'" (Constandinides 24; see Gray 216). As Cynthia Erb points out in her extended study of the historical reception of the multiple versions of *King Kong*, Jackson established a relationship between the 1933 film and the 2005 remake by way of a collection of video-blog entries, initially shown on a (Jackson-approved) independent fan website before being released on DVD as *King Kong: Peter Jackson's Production Diaries* (Michael Pellerin, 2005). The video diaries not only demonstrate Jackson's personal investment in, and creative transformation of, a pioneering special effects classic, but also underline the significance of establishing an *intermedial* approach to post-celluloid adaptations (and remakes) that attends to the transformation of popular serial forms in and through new media platforms.

The *remediation* that characterizes the example of *King Kong*—and the way this extends into the immersion of the viewer/user through the interactive pleasures of game play and IMAX-3D technologies—is further evident in the more recent example of *RoboCop* (José Padilha, 2014), a new millennial reboot in which the film—or "main end-product"—clearly draws upon previous versions of the phenomenon and its global reputation as (non-hierarchical) film and television series and set of video games, beginning with the award-winning, cabinet arcade game from 1988. The cross-platform example of *RoboCop* demonstrates some of the ways in which a digitally networked culture organizes and manages information, with Sony Pictures setting up the film's official website—as the homepage for the fictional OmniCorp, creator of the RC2000, or RoboCop, project—to embrace the new millennial potential of the Web and so engage a "multiplicity of textual relationships that function across collaborative media . . . for [textual and] commercial purposes" (Constandinides 24). Online features, such as OmniCorp's 2027 Keynote announcement of the RC2000 project, resist any simple reduction of the site to its promotional function, and of the remake to any direct or singular relationship between itself and *RoboCop* (1987). Instead, *RoboCop* 2014 adopts a non-linear and non-hierarchical database logic, inserting the new millennial *RoboCop* into a collection of artifacts—*RoboCop, RoboCop 2* (1990), *RoboCop 3* (1993), the *RoboCop* television series (1994), the *RoboCop: Prime Directive* mini-series (2000), the *RoboCop vs. Terminator* video game (2006)—and extending its content across new aesthetic and media forms, most evidently the website's hyperlinks to social media and online game platforms. In this respect, *RoboCop* 2014 accords with Clare Parody's account of the "franchise adaptation," wherein the new installment inevitably appeals to *RoboCop* (1987) as its principal source, but is also "unavoidably structured in relation to the entire *franchise multitext*, because any instalment chosen is constantly speaking to the others, extending them, completing them, reframing them, and drawing on them for meaning and effect" (212, emphasis added). Despite some withering review comments—for instance, the perceived anomaly of a "PG-rated reboot" of Verhoeven's vicious, R-certificate critique of Reaganomics (Nayman 82)—*RoboCop*, like *King Kong* before it, demonstrates that in the new millennium one can no longer claim an absolute distinction between feature film and other media forms (see James 35).

A digitally networked communications context transforms the way in which films are made, distributed, and consumed and generates new commercial and textual configurations of adaptations and remakes (see Hutcheon xxi). Participatory and social media cultures precipitate unauthorized new versions of recognizable properties and proprietary characters for immediate dissemination on the Internet, as, for example, the non-commercial productions—fan-films, mashups, and recut trailers—described in Barbara Klinger's *Beyond the Multiplex* (191–238; see also Loock and Verevis 177–247). These appropriations have become a part of a remix culture (for instance, the *Our RoboCop Remake* online spoof), but official adaptations and remakes just as clearly support and maintain commercial interests, including the negotiation of intellectual property rights and payments, and the conglomerate Hollywood development of "local-language

productions" (Donoghue 3–27). Such authorized forms of cultural transfer are, however, not restricted to Hollywood investment in, or remakes of, foreign or non-English-language films (Graser 6–7), nor to the relentless pursuit of synergy and brand extension characteristic of so-called "total film" (Elsaesser, *Persistence* 283–85). Tim Bergfelder, for instance, has proposed a *transnational* history of European cinema that focuses on the practice and processes of cultural translation precisely to challenge unidirectional accounts of global media traffic, focus on the interrelationship between cultural and geographical centers and margins, and trace the migratory movements between these poles (320). Recently, trade journals like *Variety* have reported that "remakes are ringing up box office gold in Europe, prompting a proliferation of local hits being redone for neighboring markets and causing some curious cases of cross-pollination" (Vivarelli 6). European investment in remake rights is consistent with the logic behind the selling of formats for television—in a prominent example, the Danish/Swedish crime series *Broen/Bron* (2011), remade on the US-Mexico border as *The Bridge* (USA, 2013), and again as the Canal Plus–Sky Atlantic TV series *The Tunnel* (UK/France, 2013)—and co-production deals where even large companies seek to limit their budgets and cover a broader audience right from the outset. Stigmatized by Vivarelli as "an American cheap trick" (6), remakes of film (and television) properties that have been substantial commercial successes in single European markets increasingly provide suitable themes and subject matter for cross-border adaptation and translation.

In the case of one high-profile European export, *The Girl with the Dragon Tattoo* (Figures 15.1 and 15.2), Yellow Bird, the production company behind the Swedish-Danish film version (*Män som hatar kvinnor*, 2009), bought the rights to Stieg Larsson's 2005 novel, the first of the so-called *Millennium* trilogy, shortly after its release and

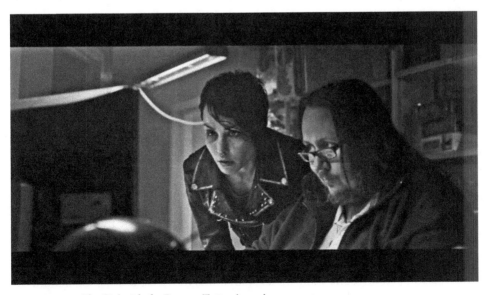

FIGURE 15.1 *The Girl with the Dragon Tattoo* (2009).

FIGURE 15.2 *The Girl with the Dragon Tattoo* (2011).

consequently earned a main production credit in the Hollywood version, *The Girl with the Dragon Tattoo* (2011).

Neil Archer, citing a 2011 production report, notes that for Yellow Bird "'cross border thinking and higher budgets' are key to the company's success, which in itself underlines the already transnational, genre [oriented] and property-conscious nature of the company and its output" (5). The transatlantic collaboration yielded a much-anticipated remake directed by David Fincher and starring Daniel Craig and Rooney Mara. Although the remake performed financially "below expectation" (Gant), Fincher's authorial interests, established in such psycho-thrillers as *Se7en* (1995) and *Zodiac* (2007), transformed the classical mise-en-scene of Niels Arden Oplev's 2009 adaptation, originally made for television, into state-of-the-art genre filmmaking. In a more complex way, Fincher's "mood-based aesthetic of surface attention and obsessive detail" simultaneously resisted "the conspiracy thriller's sense of 'totality' or the 'global'" (Archer 12–13; see Newman, "Icegirl" 16–18). Examples like this one complicate earlier suggestions that cross-cultural remakes are simply evidence of American "cultural imperialism" (Vincendeau 23–25). Indeed, concerns around moves to lift exemptions (originating in 1990s General Agreement on Tariffs and Trade talks) that treat European films differently from other products under international free trade rules in the European Union were recently reversed by Wim Wenders, who argued that abandoning the EU cultural exemption would in fact hurt Hollywood just as badly as Europe because EU films would not be there as a counterpart to enrich and inform Hollywood, especially through the US practice of remaking European feature films and television formats (Macnab 19).

In Elsaesser's account of new millennial Hollywood, the forces of conglomeration, globalization, and digitization not only require that blockbuster films perform equally well both in the US domestic market and internationally, but also on multiple platforms: "the

film's internet site, the movie trailer, the video game and the DVD as both textual and promotional entities" (*Persistence* 284). If one accepts Elsaesser's suggestion that global Hollywood has entered a digital or franchise era of post-production, then a blockbuster like Steven Spielberg's 2005 version of *War of the Worlds* (previously adapted as *The War of the Worlds* in 1953) can be understood as a "signature product," an instance in which a preexisting film or property no longer provides a closed narrative model, but rather functions as a blueprint for "remediation," and the blockbuster remake ideally becomes a prototype and basis for the generation of serial forms (sequels, series, and cycles), the production of tangible objects (DVDs, soundtracks, and books), and the occasion for commodity experiences (games, rides, and theme park attractions) (Elsaesser, *Persistence* 283–85). Extending this line of argument, one can describe the way in which new millennial filmmakers—not only "new Hollywood" auteurs like Spielberg, but also *post*-auteurs like David Fincher, Christopher Nolan, and Steven Soderbergh—seek to insert themselves into the innumerable flows of global film and media production, not by setting out to create something that is new and original, but rather by adapting that which exists: revising it, inhabiting it, and *putting it to use* (Bourriaud 13–20). In a global marketplace, available forms are remade and remodeled, then "serialized" and "multiplied"—in sequels, prequels, and series—across expanding territories and media platforms (see Lewis 66; Elsaesser, "Fantasy Island" 143–58).

The paucity of critical approaches to the film remake over a long period has been attributed to the concept's "anti-authorship quality" (Quaresima 75). In the new millennium, the authorial agency and "brand-name vision" of the post-auteur becomes a key element in the remake's promotion and reception (Corrigan, "Auteurs" 40). The notion of "brand Hollywood" is evident in the case of Soderbergh's franchise text, *Ocean's Eleven* (2001), and its two knowing sequels, *Ocean's Twelve* (2004) and *Ocean's Thirteen* (2007), a case that seems to exemplify Paul Grainge's identification of a shift in emphasis from a regime of rights based on authorship and originality toward one centered on trademark and reproducibility (11). In a perhaps more conventionally "personal" example, Soderbergh created a 2002 film version of *Solaris* (Figures 15.3 and 15.4) that directly invoked Andrei Tarkovsky's 1972 film and Stanislaw Lem's 1961 novel, but reviewers noted that Soderbergh had transformed the source material (even more than Tarkovsky before him), abandoning its broad philosophical questions to focus primarily on the love story: the relationship between Kris (Chris in the remake) and his wife Rheya, and—in a reprise of Alfred Hitchcock's *Vertigo* (1958)—their opportunity for a "second chance." Although Soderbergh claimed that *Solaris* was a new adaptation, driven by the ideas at the center of the book—"[the novel] just seemed to be about everything I [was] interested in personally"—reviewers drew attention to the thematic and stylistic similarities between *Solaris* and Soderbergh's other film work, describing the remake as an authorial *re*-vision: a property transformed, according to auteur predilections, into "an intimate two-hander between a man and a woman" (Romney 14). In a further comment, one that underlines the way in which cinematic remaking can be understood in terms of a filmmaker's desire to repeatedly express and modify a particular aesthetic sensibility and worldview, Amy Taubin calls *Solaris* "the most personal, interiorized narrative of [Soderbergh's] career, [a film that] could be his *Pierrot le fou* [1965] or *Vertigo*" (78).

FIGURE 15.3 *Solaris* (1972).

FIGURE 15.4 *Solaris* (2002).

In a more recent example, the press kit for *Passion*, Brian De Palma's 2012 remake of Alain Corneau's psychodrama *Crime d'amour/Love Crime* (2010), announces: "Brian De Palma returns to the sleek, sly, seductive territory of *Dressed To Kill* [1980] with an erotic corporate thriller fueled by sex, ambition, image, envy and the dark, murderous side of PASSION," before going on to note that "the screenplay is written by De Palma

with additional dialogue by Nathalie Carter [and is] based on the French film *Crime D'amour*." Separated by only a few years from (and initiated by the same Paris-based production company as) Corneau's original, *Passion*—a film characterized by its use of hi-tech, glass and polished-steel interiors—"presents [itself as] a model of production and distribution strongly influenced by [the] contemporary audiovisual landscape": the principal characters, Christine (Rachel McAdams) and Isabelle (Noomi Rapace), "shoot on their mobile, edit on their laptop, project it at the staff meeting, and stick it on YouTube" (Álvarez and Martin). In and through this distinctively reflective mise-en-scene, De Palma engages not only his signature preoccupations—doubling and artifice, including an elegant, extended split screen sequence that ends with a violent murder—but also a further crucial innovation: a "knotty, triangular construction [that] rotates through Christine, Isabelle and Dani [Karoline Herfurth]," transforming the two-sided conflict of the original players—Christine (Kristin Scott Thomas) and Isabelle (Ludivine Sagnier)—into a "disturbing, *serial chain* [in which] the competitiveness never ends, but [in an eloquent metaphor for the remake itself] only ever perpetuates itself, *expanding and renewing* with each new turn of the screw" (Álvarez and Martin, emphasis added).

In a less obvious example, Nathan Lee mounts an inspired post-auteur defense of Rod Zombie's 2007 remake of John Carpenter's *Halloween* (1978), one of a cycle of contemporary treatments of an era of American low-budget horror films bracketed by George A. Romero's *Night of the Living Dead* (1968) and the Romero-backed *Night of the Living Dead* remake (Tom Savini, 1990). As described by Kim Newman, the tone for the cycle was set by films like *The Texas Chainsaw Massacre* (2003; 1974) and *Dawn of the Dead* (2004; 1978), but ten years on "the cycle has yielded too many unmemorable redos of the likes of *When a Stranger Calls* [2006; 1979] and *Prom Night* [2008; 1980] plus genuinely disastrous takes on *Halloween* and *It's Alive* [2008; 1974]" (*Evil Dead* 91). Contra Newman, Lee's assessment not only recognizes the way in which the *Halloween* remake is repurposed within a new discursive field, but also how it is re-envisioned in/as genuine authorial innovation:

> Given the hallowed status of the original, [and] the prejudice and blind spots of critical orthodoxy . . . *Halloween* (07) has not been seen for what it is: *the remake as legitimate parallel creation*. An independent feat of imagination that extends, amplifies, and in certain regards improves on the source material, this most original and morally complex of the current [horror] remake cycle properly belongs to a discussion of the distinctly remade: Schrader's *Cat People* [1982], Carpenter's *The Thing* [1982], *Invasion of the Body Snatchers* per Kaufman [1978] and Ferrara [*Body Snatchers*, 1993]. (26, emphasis added)

The new millennium is characterized by an exponential increase in content and availability of not only recycled properties (adaptations and remakes), but also films on video/DVD and more immediately films (and fragments of films) through video on demand (VOD) and on the Internet. If the new millennium is distinguished by unprecedented access, then the issue becomes one of selection: not how to see films, but how

to choose between them (Cousins 41). One expression of this shift is found in Paul Schrader's comments on his recent film *The Canyons* (2013), a work he calls an example of "post-Empire" independent filmmaking. Schrader borrows the term from *The Canyons*'s co-writer, Bret Easton Ellis, who says that American film has come into a late *post*-imperial period: the US film empire was characteristic of the twentieth century, but the country has now entered a period in which it is making films out of the remains of the empire, "the junk that's left over" (Gross 26). Ellis's comment is perversely realized in the recent *Transformers: Age of Extinction* (2014) when Cade Yeager (Mark Wahlberg), a Texas inventor always on the lookout for scrap he can recycle, encounters an old timer in a derelict cinema who tells him that "sequels and remakes [are] a bunch of crap." *The Canyons* similarly plays out the end of cinema over its opening titles through the motif of abandoned movie theaters. However, for Schrader, the number-one fact of the new low-budget (digital) cinema is that it is no longer impossible to get a film financed; instead, because of the sheer volume of work that gets made, it is increasingly difficult to get anyone to see it. In the case of *The Canyons*, Schrader says that he "got lucky" with the "noise factor" surrounding the film. He says that he and Ellis—along with *The Canyons*'s lead actors, Lindsay Lohan and porn star James Deen—had "some cachet" with interest groups:

> We were in with four different sub-groups of interested people. . . . Lindsay has four million (Twitter) followers, and James has half a million. Bret has 250,000. . . . We got lucky with the noise factor. When you're pitching a movie, that's the question they ask: is it going to make noise? Are you going to hear this above the din of the avalanche of film productions? And if the idea has noise, then they are interested in it. . . . And this idea [*The Canyons*] had noise. Some of it by design, some of it by luck. (Gross 27)

As the volume of films—and versions of films and other properties—increases and accelerates across media and delivery platforms, pre-sold titles and propriety characters sparked by conglomeration, globalization, and digitization contribute not only to the noise factor (especially for genre films, as exemplified by the series of *Transformers* adaptations of Hasbro's line of toys), but to a fascination among both audiences and practitioners for recycled properties, or what Simon Reynolds calls a "retromania" for revivals, reissues, and remakes (ix–xxxvi). Although it may be the case that remakes were once understood to compete economically and culturally with their previous versions, contemporary remakes typically enjoy a more symbiotic relationship with their originals, with publicity and reviews often drawing attention to earlier versions that are increasingly available and so appear more closely connected in time. As recently as 2011, *Video Ezy* magazine ran a promotion ("[Not] Lost in Translation") which not only used the line "laughter is an international language, something proven by the fact that this month's hilarious comedy *Dinner for Schmucks* [Jay Roach, 2010] actually comes from a hugely successful French film titled *The Dinner Game* [Francis Veber, 1998]" to promote a new release, but also to draw attention to a back catalogue of double (or *doubled*)

features including *The Departed* (2006) and *Infernal Affairs* (2002); *Let Me In* (2010) and *Let the Right One In* (2008); *The Ring* (2002) and *Ringu* (1998); *Vanilla Sky* (2001) and *Open Your Eyes/Abre los Ojos* (1997) (10–11).

The significance of the noise factor is plainly evident in authorized "non-remakes" like *Ocean's Eleven* and *The Italian Job* (2003) that retain little more than the title from a previous version, but employ this recognizable, marketable signature to invest a new film with an image and brand, ideally in order to add aesthetic and commercial value. The 2003 version of *The Italian Job* might have been seen as one more generic heist movie and star vehicle for Mark Wahlberg and Charlize Theron if its pre-sold title (and iconic Mini-Cooper tunnel chase sequence) did not function both as a marker of distinction and an opportunity for remodeling—literally in the case of film's tie-in with the 2001 new generation Mini-Cooper S series. To this end, Paramount Pictures' website for the film included comments by director F. Gary Gray: "I liked a lot of things about the [1969] original. It had great style and unforgettable performances. But the film that we've made is for modern audiences, with updated technology." Executive producer James Dyer similarly noted that the earlier version was a point of departure, not replication: "This movie is a little different. It's not a remake . . . but it does use similar tools to tell the story: heist, armored truck, gold, Mini-Coopers." Following the 2003 theatrical run of *The Italian Job*, both versions were simultaneously released to DVD, with extras on the remake DVD not only drawing attention to the original but featuring scenes from it. The subsequent release of Paramount Home Video's "*The Italian Job* Gift Set" DVD edition, which included both 1969 and 2003 versions, demonstrates that, just as adaptations of literary properties often lead viewers back to source novels for a first reading, remakes encourage viewers to seek out original or parallel film properties (Corrigan, "Which Shakespeare" 164).

Just as remakes provide an illustration of some of the operations of new millennial film culture, so do reboots. In the 1980s and 1990s, filmmakers and their production companies had been forced to defend serial filmmaking—specifically, film remakes, sequels, and prequels—against accusations that aesthetically inferior remakes (and commercially timid sequel-prequels) were evidence that Hollywood had exhausted its creative potential. Sven Lütticken, for instance, opens his essay "Planet of the Remakes" with an account of the "widespread critical and popular aversion to remakes of classic—and even not-so-classic—films." By the beginning of the new millennium—perhaps in part a reaction to the bemused and often hostile response to Gus Van Sant's 1998 remake of *Psycho* (1960)—there was, however, evidence of a discursive shift, with subsequent industry discourses more positively framing a new film's "remake" status by ascribing value to an earlier version and then identifying various filters—technological, cultural, authorial—through which it had been transformed (or "value-added"). In the first instance, this move can be seen as a commercial strategy (as, in the *Video Ezy* example, a way to sell a back catalogue), but it also identifies a serial practice in which the remake does not simply follow an original, but recognizes new versions as free adaptations or variations that actualize an implicit potentiality at the source. This trend, which has increasingly led to (authorized) remakes that bear only a generic resemblance to their

precursors, seems to have found its apotheosis in the reboot: a legally sanctioned version that attempts to dissociate itself textually from previous iterations while at the same time having to concede that it does not replace but adds new associations to an existing serial property. In other words, it marks out a critical-historical moment in which remakes no longer linearly follow and supersede their originals, but a digitalized, globalized one in which multiple versions proliferate and coexist.

Taken from its original context in computer technology, "rebooting" describes the process of restarting, remaking, or re-commercializing a film property or film franchise by denying or nullifying earlier iterations in order to "begin again" without requiring any knowledge of those previous versions. Citing examples such as *Man of Steel* (2013), *The Amazing Spider-Man* (2012), *Star Trek* (2009), and—"the quintessential reboot"— Christopher Nolan's *Batman Begins* (2005), William Proctor argues that the reboot differs conceptually from the remake insofar as it is a franchise-specific concept: "A remake is a singular text bound within a self-contained narrative schema; whereas a reboot attempts to forge a series of films, to begin a franchise anew from the ashes of an old or [critically or commercially] failed property. In other words, a remake is a reinterpretation of one film; a reboot 're-starts' a *series* of films that seek [*sic*] to disavow and render inert its predecessors' validity" ("Regeneration and Rebirth"). In making this distinction, part of Proctor's endeavor is to delimit the concept of the reboot in the face of opportunistic advertising that seeks to promote mere sequels—*Tron Legacy* (2010), *Terminator Salvation* (2009), and *The Mummy: Tomb of the Dragon Emperor* (2008)—by assigning them a reboot label and thus aligning the films with the critical and commercial success of Nolan's Dark Knight trilogy: *Batman Begins, The Dark Knight* (2008), and *The Dark Knight Rises* (2012) (Proctor, "Regeneration and Rebirth").

In recent years, the term *reboot*, along with a string of remake euphemisms—*encore, reworking, refitting, retooling, retread, redo, makeover*—has gained cultural currency in film industry and press reports. *Sight and Sound* reports of three recent examples: "most of the industry's recent reboots have been expensive disasters ... as with this [2011] reconstitution of John Carpenter's *The Thing* [1982]" (Atkinson 76); "Danny Cannon's *Judge Dredd* (1995) is likely to be remembered as the version that got it wrong.... However, a generation on, the flop has got its reboot [*Dredd*, 2012]" (Newman, "A Sense of Dredd" 34); "there is a memorable scene in the 1982 film of *Conan* [*the Barbarian*, in which Conan is harnessed to a massive millstone that he must turn in perpetuity] but there is no equivalent scene in Marcus Nispel's [2011] relaunched or remade or rebooted *Conan*" (Pinkerton 57). Moreover, and in a move that recognizes that popular genres and characters have often been realized as quasi-independent—or "hybrid"—adaptations, rather than as a linear succession of remakes (Leitch 208), the term *reboot* has been used to retrospectively designate serial properties from earlier decades. For instance, in an account of the serial saga of Edgar Rice Burroughs's *Tarzan the Ape Man*, Tim Lucas attends to a set of eleven post–Johnny Weissmuller film titles—five films starring Lex Barker (1949–53) and another six with Gordon Scott (1955–60)—to assert: "*Tarzan's Greatest Adventure* (1959) reboots the franchise in the same way that *Casino Royale* [Martin Campbell, 2006] did with the Bond films.... Scott rises admirably to the

occasion . . . and carries the film to the most exciting climax of the entire series" (88). Lucas's example supports the notion of franchise rebooting and underscores an affinity between comic book and film reboots, but the idea that a new version somehow erases or overwrites previous iterations is at odds with a digitally networked culture in which new media do not displace the old, but rather add layers and associations to them. Hence Proctor concludes that "a reboot is a brand-new product; yet it is already old. . . . All texts are adaptations. There is no blank slate" ("Beginning Again").

The force of multiple, parallel versions—which coexist rather than erase or overwrite—is evident in *Planet of the Apes*, Tim Burton's 2001 "remake/reboot" (Newman, "Dawn" 85) of Franklin J. Schaffner's 1968 film adaptation of Pierre Boulle's novel *Monkey Planet* (1963). Poised at the beginning of the new millennium, Burton's version, with an estimated budget of $110 million, was seen by some as a "jittery catalogue of millennial anxieties" (O'Hehir 12), but more typically as a film that had transformed the B-movie aesthetic of the *Planet of the Apes* film (and television) series into a B-movie blockbuster, "a wild concept coated in incongruous corporate gloss" (Brooks 56). Despite its differences, the reimagined *Planet of the Apes* was a film that owed much to Schaffner's version: its reputation, its progeny, and especially its well-remembered ending, in which astronaut Taylor (Charlton Heston) realizes through his discovery of a bomb-blasted Statue of Liberty that the ape planet is actually a post-apocalyptic Earth. Indeed, reviews of *Planet of the Apes* consistently focused on Burton's transformed ending—in which astronaut Davidson (Mark Wahlberg) crash-lands on the steps of the Lincoln Memorial, only to find that the chiseled features of Abraham Lincoln have been replaced by those of gorilla General Thade—describing it as "spectacularly befuddling" (Paatsch 38) and a "monkey-puzzle of an ending" (Brooks 56). As disingenuous as the Burton ending might have been, these reviews missed a more obvious point: that the *Planet of the Apes* remake had a twist ending because the original one famously did. That is, it may well be the case that the "crazed final coda . . . makes little in the way of logical sense, and clashes conspicuously against the pedestrian narrative that precedes it" (Brooks 56), but the ending makes perfect remake sense because it displays a remake logic that builds upon the memory of the cult original to adapt and extend rather than erase it.

Vivian Sobchack finds something similar in the case of Ridley Scott's *Prometheus* (2012), a reboot of the *Alien* franchise that is impressively attended to and extended through its (fictional) Weyland Industries website (administered by *Alien*'s parent company, Twentieth Century Fox). As described by Sobchack, the estimated $130 million *Prometheus* is a work that gets caught literally between a rock, the planet LV-233, and a hard place, the spaceship Prometheus. More precisely, the difficulty some viewers found with *Prometheus* was that it presented itself as both a type of remake, a prequel to *Alien* (1979), and a completely original film, a reboot of the *Alien* franchise, only to fall apart because, like Burton's *Planet of the Apes*, it obeys a remake logic incompatible with the narrative logic of the discrete rebooted episode, thus leading to confusing, illogical, and disjointed plotting. In Sobchack's metaphor, the bedrock in this case is the industry franchise and mythic universe initiated by Ridley Scott's sci-fi horror hybrid *Alien*, then serialized in *Aliens* (James Cameron, 1986), *Alien 3* (David Fincher, 1992), and

Alien Resurrection (Jean-Pierre Jeunet, 1997), and multiplied in the Alien vs. Predator video games (1999, 2001) and films, *AVP: Alien vs. Predator* (2004) and *AVP-R Alien vs. Predator: Requiem* (2007). The tension between remake and reboot logic is evident in Fox's own promotional material, which presents *Prometheus* as a film that "started out as a prequel to *Alien*" but wants to function as a "stand-alone film . . . that tips its hat to elements of the original *Alien*" (Sobchack 33). Ultimately, the film leads back to the future, with the planet's various (xenomorphic) life forms transforming at the end into "the old alien we've come to love—a kind of annunciation of a hoped-for sequel to the prequel" (33). However, the key question for Sobchack, as for the reboot, remains: "how to get out of this double bind between [a remake logic of] origins and [questions of] originality?" (34). She concludes that "while [*Prometheus* has been] rightly criticized for its unforthcoming and ultimately incoherent narrative, and its often arbitrary character motivation and editorial (il)logic, *Prometheus* is indeed coherent as an allegory of its own struggle with and resistance to its origins. . . . That is, not able to escape that old mythology completely and unable to integrate it with a new one, the film instead signifies the resistance brought to bear against both" (34).

When asked what appealed about "rebooting a series that had already been interpreted," Nolan replied that when he undertook *Batman Begins*, "there was no such thing conceptually as a 'reboot.' That idea didn't exist" (Foundas 7). This understanding of the reboot—the notion that it is as much a discursive category as an industrial one—has most recently been advanced by Joe Tompkins, who writes that "rebooting does not necessarily entail a process of aesthetic negation or an intertextual break with the 'aura' of an original brand" but operates instead "as a critical industrial practice, . . . a means of activating and sustaining the discourses of aesthetic value and distinction . . . to bolster consumer ties and brand loyalty" (3–4). In and through the example of Zombie's 2007 *Halloween*, Tompkins describes the way industrial and critical discourses not only communicate the new "film's cultural status as artistic 're-imagining' (as opposed to a [disreputable] remake)," but also invoke intertextual frameworks—specifically those of (post) authorship and canonicity—to revive the character of Michael Myers and reboot the *Halloween* franchise (4–5). In this respect, Tompkins's essay aligns itself with key critical discussions around franchise adaptation and with those inquiries into the nature of remaking that do not limit it to industrial and textual strategies, but understand it in relation to a more complex set of general and cinematic discursive fields. The loose set of theses advanced in this essay around remediation and convergence, proliferation and simultaneity, seek to advance a similar understanding of adaptation and serialization, with the additional aim of sketching a provisional map, or at least some significant lines and contours, for a "media-historic profile" of new millennial remakes (Kelleter and Loock). While it may be too early in the millennium to draw conclusions about the nature of the present historical period, the preceding notes should at least demonstrate that the present and future of cinema—especially in the new millennium—is a re-vision of its past, and that aesthetic and economic evaluations of film adaptations and remakes are less interesting than the cultural and historical significance of new millennial remake practice.

WORKS CITED

Alien. Dir. Ridley Scott. Perf. Sigourney Weaver, Tom Skerritt. Twentieth Century–Fox, 1979. Film.

Álvarez López, Cristina, and Adrian Martin. "To the Passion." *Lola* 4 (Sept. 2013). Web. 6 Apr. 2014.

Andrew, Dudley. "Adaptation." 1980. Rpt. Naremore 28–37. Print.

Archer, Neil. "*The Girl with the Dragon Tattoo* (2009/2011) and the New 'European Cinema.'" *Film Criticism* 37.2 (Winter 2012–13): 2–21. Print.

Atkinson, Michael. Rev. of *The Thing*. *Sight and Sound* 22.1 (Jan. 2012): 76–78. Print.

Balio, Tino. *Hollywood in the New Millennium*. Basingstoke: Palgrave Macmillan, 2013. Print.

Bergfelder, Tim. "National, Transnational or Supranational Cinema? Rethinking European Film Studies." *Media, Culture and Society* 27.3 (2005): 315–31. Print.

Bourriaud, Nicolas. *Postproduction: Culture as Screenplay: How Art Reprograms the World*. New York: Lukas and Sternberg, 2002. Print.

Brooks, Xan. Rev. of *Planet of the Apes*. *Sight and Sound* 11.10 (Oct. 2001): 54–56. Print.

The Canyons. Dir. Paul Schrader. Perf. Lindsay Lohan, James Deen. Prettybird, 2013. Film.

Cattrysse, Patrick. "Media Translation: Plea for an Interdisciplinary Approach." *Quaderni di studi semiotici, Sulla traduzione intersemiotica*. Ed. Nicola Dusi and Suri Nergaard. *Versus* 85–86–87 (Jan.–Dec. 2000): 251–70. Print.

Constandinides, Costas. *From Film Adaptation to Post-Celluloid Adaptation: Rethinking the Transition of Popular Narratives and Characters across Old and New Media*. New York: Continuum, 2010. Print.

Cook, Pam. "Beyond Adaptation: Memory, Mirrors, and Melodrama in Todd Haynes's *Mildred Pierce*." *Screen* 54.3 (Autumn 2013): 378–87. Print.

Corrigan, Timothy. "Auteurs and the New Hollywood." *The New American Cinema*. Ed. Jon Lewis. Durham: Duke UP, 1998. 38–63. Print.

———. "Introduction: Movies and the 2000s." *American Cinema of the 2000s*. Ed. Timothy Corrigan. New Brunswick: Rutgers UP, 2012. 1–18. Print.

———. "Which Shakespeare to Love? Film, Fidelity, and the Performance of Literature." *High-Pop: Making Culture into Popular Entertainment*. Ed. Jim Collins. Oxford: Blackwell, 2002. 155–81. Print.

Cousins, Mark. "Overwhelmed by Options." *Sight and Sound* 20.2 (Feb. 2010): 41. Print.

Crime d'amour (Love Crime). Dir. Alain Corneau. Perf. Ludivine Sagnier, Kristin Scott Thomas. SBS/France 2/Divali, 2010. Film.

Donoghue, Courtney Brannon. "Sony and Local-Language Productions: Conglomerate Hollywood's Strategy of Flexible Localization for the Global Film Market." *Cinema Journal* 53.4 (Summer 2014): 3–27. Print.

Dusi, Nicola. "Remaking as Practice: Some Problems of Transmediality." *Cinéma and Cie* 12.18 (2012): 115–27. Print.

Elsaesser, Thomas. "Fantasy Island: Dream Logic as Production Logic." *Cinema Futures: Cain, Abel or Cable?* Ed. Thomas Elsaesser and Kay Hoffmann. Amsterdam: Amsterdam UP, 1998. 143–58. Print.

———. *The Persistence of Hollywood*. London: Routledge, 2012. Print.

Erb, Cynthia. *Tracking King Kong: A Hollywood Icon in World Culture*. 2nd ed. Detroit: Wayne State UP, 2009. Print.

Evans, Jonathan. "Film Remakes, The Black Sheep of Translation." *Translation Studies*. 30 Jan. 2014. Web. 6 Apr. 2014.

Foundas, Scott. "Cinematic Faith. Interview with Christopher Nolan." *Film Comment*, Special Supplement (Winter 2012–13): 7–11. Print.

Gant, Charles. "Is the Hollywood Remake Dead?" *The Guardian*. 30 Mar. 2012. Web. 6 Apr. 2014.

The Girl with the Dragon Tattoo [Män som hatar kvinnor]. Dir. Niels Arden Oplev. Perf. Michael Nykvist, Noomi Rapace. Yellow Bird, 2009. Film.

The Girl with the Dragon Tattoo. Dir. David Fincher. Perf. Daniel Craig, Rooney Mara. MGM/Columbia, 2011. Film.

Grainge, Paul. *Brand Hollywood: Selling Entertainment in a Global Media Age*. London: Routledge, 2008. Print.

Graser, Marc. "H'wood Mines Europe's New Wave for Remakes." *Variety*, 16–22 Mar. 2009, 6–7. Print.

Gray, Jonathan. *Show Sold Separately: Promos, Spoilers, and Other Media Paratexts*. New York: New York UP, 2010. Print.

Gross, Larry. "The Canyons." *Film Comment* 49.4 (Jul.–Aug. 2013): 22–29. Print.

Halloween. Dir. John Carpenter. Perf. Donald Pleasence, Jamie Lee Curtis. Compass International/Falcon International, 1978. Film.

Halloween. Dir. Rod Zombie. Perf. Scout Taylor-Compton, Malcolm McDowell. Dimension, 2007. Film.

Hutcheon, Linda, with Siobhan O'Flynn. *A Theory of Adaptation*. 2nd ed. London: Routledge, 2013. Print.

The Italian Job. Dir. Peter Collinson. Perf. Michael Caine, Noël Coward. Oakhurst, 1969. Film.

The Italian Job. Dir. F. Gary Gray. Perf. Donald Sutherland, Mark Wahlberg. Paramount, 2003. Film.

The Italian Job. Official Website. Web. 28 May 2004.

James, Nick. "Syndromes of a New Century." *Sight and Sound* 20.2 (Feb. 2010): 34–38. Print.

Kelleter, Frank, and Kathleen Loock. "Retrospective Serialization: Remaking as a Method of Cinematic Self-Historicizing." 13 Mar. 2014. Web. 6 Apr. 2014.

King Kong. Dir. Merian C. Cooper and Ernest B. Schoedsack. Perf. Fay Wray, Robert Armstrong. RKO, 1933. Film.

King Kong. Dir. Peter Jackson. Perf. Naomi Watts, Jack Black. Universal, 2005. Film.

Klinger, Barbara. *Beyond the Multiplex: Cinema, New Technologies, and the Home*. Berkeley: U of California P, 2006. Print.

Lee, Nathan. "Horror Remakes." *Film Comment* 44.2 (Mar.–Apr. 2008): 24–28. Print.

Leitch, Thomas. *Film Adaptation and Its Discontents: From* Gone with the Wind *to* The Passion of the Christ. Baltimore: Johns Hopkins UP, 2007. Print.

Lewis, Jon. "Following the Money in America's Sunniest Company Town: Some Notes on the Political Economy of the Hollywood Blockbuster." *Movie Blockbusters*. Ed. Julian Stringer. London: Routledge, 2001. 61–71. Print.

Loock, Kathleen, and Constantine Verevis. *Film Remakes, Adaptations, and Fan Productions: Remake/Remodel*. Basingstoke: Palgrave Macmillan, 2012. Print.

Lucas, Tim. "Them Tarzan." *Sight and Sound* 20.2 (Feb. 2010): 88. Print.

Lütticken, Sven. "Planet of the Remakes." *New Left Review* 25 (Jan.–Feb. 2004). Web. 6 Apr. 2014.

Macnab, Geoffrey. "Protect and Survive." *Sight and Sound* 23.7 (Jul. 2013): 19. Print.

Mazdon, Lucy. "Rewriting and Remakes: Questions of Originality and Authenticity." *On Translating French Literature and Film*. Ed. Geoffrey T. Harris. Amsterdam: Rodopi, 1996. 47–63. Print.

Mildred Pierce. Dir. Michael Curtiz. Perf. Joan Crawford, Zachary Scott. Warner Bros., 1945. Film.

Mildred Pierce. Dir. Todd Haynes. Perf. Kate Winslet, Guy Pearce. HBO, 2011. Television.

Naremore, James, ed. *Film Adaptation*. London: Athlone, 2000. Print.

Nayman, Adam. Rev. of *Robocop*. *Sight and Sound* 24.4 (Apr. 2014): 82. Print.

Newman, Kim. Rev. of *Dawn of the Planet of the Apes*. *Sight and Sound* 24.9 (Sept. 2014): 85. Print.

———. Rev. of *Evil Dead*. *Sight and Sound* 23.5 (May 2013): 91. Print.

———. "The Icegirl Cometh." *Sight and Sound* 22.2 (Feb. 2012): 16–18. Print.

———. "A Sense of Dredd." *Sight and Sound* 22.10 (Oct. 2012): 32–34. Print.

"(Not) Lost in Translation." *Video Ezy Magazine* (Jan. 2011): 10–11. Print.

O'Hehir, Andrew. "Gorilla Warfare." *Sight and Sound* 11.9 (Sep. 2001): 12–15. Print.

Paatsch, Leigh. "A-Grade Apes." *Herald Sun* (9 Aug. 2001): 38. Print.

Parody, Clare. "Franchising/Adaptation." *Adaptation* 4.2 (2011): 210–18. Print.

Passion. Dir. Brian De Palma. Perf. Rachel McAdams, Noomi Rapace. ARP Sélection, 2012. Film.

Passion. Official Website. Web. 6 Apr. 2014.

Pinkerton, Nick. Rev. of *Conan the Barbarian*. *Sight and Sound* 21.10 (Oct. 2011): 57. Print.

Planet of the Apes. Dir. Franklin J. Schaffner. Perf. Charlton Heston, Roddy McDowell. Twentieth Century–Fox, 1968. Film.

Planet of the Apes. Dir. Tim Burton. Perf. Mark Wahlberg, Helena Bonham Carter. Twentieth Century Fox, 2001. Film.

Proctor, William. "Beginning Again: The Reboot Phenomenon in Comic Books and Film." *Scan* 9.1 (June 2012). Web. 6 Apr. 2014.

———. "Regeneration and Rebirth: Anatomy of the Franchise Reboot." *Scope* 22 (Feb. 2012). Web. 6 Apr. 2014.

Prometheus. Dir. Ridley Scott. Perf. Noomi Rapace, Logan Marshall-Green. Twentieth Century Fox, 2012. Film.

Prometheus. Official Website. Web. 6 Apr. 2014.

Quaresima, Leonardo. "Loving Texts Two at a Time: The Film Remake." *CiNéMAS* 12.3 (2002): 73–84. Print.

Ray, Robert B. "Film and Literature." *How a Film Theory Got Lost and Other Mysteries in Cultural Studies*. Bloomington: Indiana UP, 2001. 120–31. Print.

Reynolds, Simon. *Retromania: Pop Culture's Addiction to Its Own Past*. London: Faber and Faber, 2011. Print.

RoboCop. Dir. Paul Verhoeven. Perf. Peter Weller, Nancy Allen. Orion, 1987. Film.

RoboCop. Dir. José Padilha. Perf. Joel Kinnaman, Gary Oldman. MGM/Columbia, 2014. Film.

RoboCop. Official Website. Web. 6 Apr. 2014.

Romney, Jonathan. "Future Soul." *Sight and Sound* 13.2 (Feb. 2003): 14–17. Print.

Schatz, Thomas. "New Hollywood, New Millennium." *Film Theory and Contemporary Hollywood Movies*. Ed. Warren Buckland. London: Routledge, 2009. 19–46. Print.

Sobchack, Vivian. "*Prometheus*." *Film Comment* 48.4 (Jul.–Aug. 2012): 30–34. Print.

Solaris. Dir. Andrei Tarkovsky. Perf. Natalya Bondarchuk, Donatas Banionis. Mosfilm, 1972. Film.

Solaris. Dir. Steven Soderbergh. Perf. George Clooney, Natascha McElhone. Twentieth Century Fox, 2002. Film.

Stenport, Anna Westerstahl, and Garrett N. Traylor. "The Eradication of Memory: Film Adaptations and Algorithms of the Digital." *Cinema Journal* 55.1 (2015): 74–94. Print.

Stern, Lesley. "*Emma* in Los Angeles: Remaking the Book and the City." Naremore 221–38. Print.

Taubin, Amy. "Back to the Future." *Filmmaker* 10.4 (Summer 2002): 78–85. Print.

Tompkins, Joe. "'Re-imagining' the Canon: Examining the Discourses of Contemporary Horror Film Reboots." *New Review of Film and Television Studies* (Aug. 2014). Web. 17 Aug. 2014.

Verevis, Constantine. *Film Remakes*. Edinburgh: Edinburgh UP, 2006. Print.

Vincendeau, Ginette. "Hijacked." *Sight and Sound* 3.7 (Jul. 1993): 23–25. Print.

Vivarelli, Nick. "Remake Mania Strikes Europe." *Variety,* 21–27 Feb. 2011, 6. Print.

..

MEMES AND RECOMBINANT APPROPRIATION

Remix, Mashup, Parody

..

ECKART VOIGTS

THIS essay considers the ways in which new intertextual forms engendered by emerging technologies—mashups, remixes, reboots, samplings, remodelings, transformations—further develop the impulse to adapt and appropriate, and the ways in which they challenge the theory and practice of adaptation and appropriation. It argues that broad notions of adaptation in adaptation studies and the concept of media protocols are useful for the analysis of recombinant appropriations and adaptations/appropriations in general. It explores the political and aesthetic dimensions of participatory mashups and viewer engagements with, and appropriations of, transmedia franchises, taking a variety of Internet memes and the BBC franchise *Sherlock* as case studies and focusing on the politically, ethically, and aesthetically transgressive potential of recombinant adaptations.

THE PROTOCOLS OF RECOMBINANT APPROPRIATION: COMING TO TERMS WITH TRANSGRESSION

..

The Internet is a site of endless textual variation: short texts and clips are uploaded and removed, hyped and forgotten under the ceaseless pressures and incentives of capitalist identity formation as identities of all kinds are illimitably solidifying, constantly liquefying. The web as anti-essentialist (Cutchins and Albrecht-Crane 17–18; Voigts-Virchow)

adaptation and remix machine has generated a rich range of the recombinant appropriations—compiled videos, samplings, remixes, reboots, mashups, short clips, and other material involving text, sound, vision—typically found (and lost) on web-based video databases. Can these remix clips be described as adaptations or appropriations? What do they tell us about theories of intermediality, transmediality, and remediation? How do they relate to transmedia storytelling? What do they tell us about participatory culture and mashup textualities? My key arguments are that adaptations are best thought of structurally in terms of varying a protocol or script and that the prevalence of recombinant mashups signals a shift from hermeneutic to performative modes of adaptation.

As remix and mashup vids and clips tend to refunction and remodel existing material, they are better called "appropriations" than "adaptations." The qualifier "recombinant"—a term adapted from recombinant DNA or recombinant organism in genetics—suggests that these texts and practices conjoin all sorts of material from multiple sources, much in the way that recombinant DNA—that is, two strands of DNA combined—is a key factor in transforming genetic material and organisms. Richard Dawkins notoriously initiated the adoption of biogenetic models into cultural studies, analogizing genetic and cultural reproduction. Adaptation studies have picked up the biological analogy. Gary R. Bortolotti and Linda Hutcheon argue that stories, "in a manner parallel to genes, replicate; the adaptations of both evolve with changing environments" (445). Critics, however, quickly pointed out that the term "meme" as "a unit of cultural inheritance," "a unit of cultural transmission, or a unit of *imitation*" (Dawkins 192), applied to "tunes, ideas, catchphrases, clothes, fashions, ways of making pots or of building arches" (192) that propagate themselves in a hypothesized meme pool, cannot be regarded as any more than an analogy or metaphor. The same criticism may apply to the term "recombinant appropriation," but it usefully invokes broadly target- and reception-oriented notions of adaptation and appropriation beyond the established literature-to-film model. As genetic recombination occurs during meiosis, the term also invokes the idea of cell division and thus of cultural reproduction. It suggests the fundamental perpetuity and infinitude of recombining cultural materials. This is clearly a cultural struggle: either one can transform existing codes, recombining and appropriating found discourses and texts, or one is shaped by established, normalized texts and discourses. It is interesting to note that parts (a) and (b) in Limor Shifman's definition of Internet memes also apply to adaptation and appropriation in general: "(a) a group of digital items sharing common characteristics of content, form, and/or stance; (b) that were created with awareness of each other; and (c) were circulated, imitated, and/or transformed via the Internet by many users" (*Memes* 41). Indeed, Shifman makes the degree of change, manipulation, and participation the key criterion for her differentiation between virals, founder based memes, and egalitarian memes, evident in the categories "user involvement" and "derivatives" (*Memes* 82, 83).

Deborah Cartmell and Imelda Whelehan have modeled the expansion of adaptation studies beyond literature-to-film in a "flower" diagram, with petals like "new contexts of consumption," "reception," and "intertextuality," and they require of texts counted as adaptations merely "a sustained recognition where the adaptation utilizes the text it adapts or appropriates with a purpose" (15, 18). For the purposes of this essay, "adaptation" is the recombination of cultural material and the operation at work in intertextual remodeling. Broad notions of adaptation and appropriation inform, for instance, the perspective of Kathleen Loock and Constantine Verevis, who never explain whether they see a fundamental difference between adapting and remodeling, but invoke James Naremore in their bid to link adaptation studies to other forms of recycling, remaking, and retelling (3–4). Some contributors to Loock and Verevis, such as Robin Anne Reid, tendentiously describe the object of their studies as "fan" productions or "fan" adaptations, even though their cultural impact clearly transcends fan studies (179). Recombinant and remodeled texts on the web are important aesthetically, because they transform the textuality of cultural production, and politically, because they transform the praxis of cultural production, seeking to replace the power imbalance between cultural producers and audience by models of circulation. For critics like Eli Horwatt, recombinant memes are appropriation art. Lawrence Lessig and Eduardo Navas have praised remixes for their read-write creativity and reflexive potential, and the 2014 publication of the *Routledge Companion to Remix Culture* has signaled the integration of the field into mainstream academic discussion. As terms like "shredding" (adding inept synchronized soundtracks to concert video footage) and "trashing" suggest, remixes can initiate aggressive and destructive counter-discourses, can produce Dadaist or surrealist cut-ups in the vein of William S. Burroughs, or can interrogate cultural and artistic systems à la Marcel Duchamp, often involving theft, violence, and scandal. Seen in this way, recombinant or remodeling vids on the web constitute an avant-garde that has left the art museum to perform on a readily available playing field of everyday cultural reproduction and circulation, encouraging transformation and rejuvenation.

Kevin Kelly, the former editor of *Wired*, has suggested a set of conditions that supports the spread of this kind of recombinant cultural data: immediacy (the reason people still pay for hardcover books or films in movie theaters), personalization (the stickiness of a product tailored to one's needs), interpretation (contextual information), authenticity (for example, of signed copies), accessibility (as in cloud computing, which alleviates the burden of ownership), embodiment (in live performances or book readings by authors), patronage (as in crowdfunding), and, most important in attention and gift economies, findability.

This following list, though not as exhaustive, amorphous, and up-to-date as the Wikipedia entry "List of Internet phenomena," is intended to provide an overview of platforms, "genres," and significant instantiations.

Platforms:
Imageboards (4chan); microblogs (Tumblr); video-sharing platforms (YouTube, Vimeo, MyVideo); Internet news media, magazines, and news aggregators (HuffPost, Slate, Screen Junkies, BuzzFeed, Reddit, Mashable); social networking services (Twitter, Facebook, Pinterest), blogging services, social bookmarking sites (etc.)

Genres	Significant Examples
Listicles	If Women's Roles in Movies Were Played by Men
Animated GIFs	Dancing Baby
Image Macros	Lolcats
Supercuts	Star Wars Uncut; Previously on Lost; Hello?: Lionel Richie Supercut, Woody Allen Stammer Supercut
Literal Videos	Total Eclipse of the Heart
Redubbing/Fandubs	Sinnlos im Weltraum
Gag Sub/Fansubs	Downfall Parodies
Fan Edits	The Phantom Edit
Lip Dubbing	Furtwangen: What Do You Do after Studying?
Animutation	French Erotic Film
Hyperlink Bait and Switches	Rickrolling
Response videos	Ten Hours of Walking . . . , Leave Britney Alone
Web Comics	PHD comics, rage face, Obama not bad
Charity Videos/Challenges	Ice Bucket Challenge
Trailer Mashup/Trailer Parodies	Honest Trailers, Ten Things I Hate about Commandments
Shredding	Kiss shred, Creed shred, Revolverheld shred

I will use these platform-circulated short clips and vids—frequently produced by fans in voluntary affiliation with transmedia franchises—to address questions that have long haunted adaptation studies.

Several examples show how far this kind of engagement is from the reading of fiction on pages or screens: the Ice Bucket Challenge that swept the web in July 2014 with a view to boost donations for the disease amyotrophic lateral sclerosis (ALS); the Internet meme Ten Hours Walking; the parodies of *Downfall* (2004), hundreds of subtitled variations on a scene in which Hitler (Bruno Ganz) has a violent outburst in the Führerbunker on learning that promised troops will fail to arrive in the final stages of World War II; The UNfappening meme, in which Amsterdam-based advertisers and artists covered up the stolen photos of female celebrities in August 2014; and scarlettjohanssoning, which involves posting nude selfies online.

Recently, models adapted from digital media studies have made inroads into adaptation studies. In 2011, Julie Sanders viewed Shakespeare's texts as a kind of Linux, a software kernel or open source code, for Shakespeare adaptations ("Introduction" xii). Following Lisa Gitelman, Michael Ryan Moore has usefully applied the term "protocol" to account for media-related adaptive changes (180). He takes his cues from Gitelman's definition of media as "socially realized structures of communication, where structures include both technological forms and their associated protocols, and where

communication is a cultural practice, a ritualized collocation of different people on the same mental map, sharing or engaged with popular ontologies of representation" (Gitelman 7).

Moore joins Lev Manovich in showing how the protocols or scripts of modular and malleable new media have resulted in a personalization—or, in the words of Mirko Tobias Schäfer, how a "bastard culture" facilitates the "integration of user activities into new business models" (107). Viral videos or memes like the Ice Bucket Challenge, The UNfappening, 10 Hours Walking . . . , and the *Downfall* parodies are shared by friends and colleagues via software mashups. Both friends and algorithms therefore offer cultural material designed to appeal directly to the participating consumers' (or prosumers') predilections. They appear embedded in a specific media configuration or apparatus via APIs (application programming interfaces) that enable connections "between various applications and sources" (Schäfer 106)—as, for instance, in Google Maps or the embedded YouTube video on a Facebook wall.

It is this media configuration, the protocols and scripts of YouTube and Facebook, that mandates, for instance, short duration. The protocols must quickly introduce recognizable signals that generically shape the clips or photos, but the best instances of these clips also vary or adapt content according to the given scripts and rules. The principle can be observed in most viral videos, such as Chris Crocker's classic "Leave Britney Alone!" meme, first uploaded on YouTube on 9 September 2007, which resulted in endless parodies by satirist Seth Green and others, all clearly signposting the protocols of "Leave Britney Alone!": effeminate gay melodrama (flawed masculinity, overacting?), simplicity (neutral backdrop, direct address), repetetiveness, short duration (recurrent pleas in two-minute rant; see Shifman, *Memes* 77–82).

The Ice Bucket Challenge meme is based on a short video of an individual or group dumping ice water on their heads, framed by a declaration of the good cause supported by the action and the nomination of at least three further candidates who are challenged to douse themselves with cold water within twenty-four hours. The phenomenon has since resulted in variations in which the charity context is replaced, for instance, by a political message. The "Rubble Bucket Challenge" initiated by Palestinian university student Maysam Yusef and popularized by journalist Ayman Aloul sought to raise awareness of the destruction in Gaza during the Israeli campaign against Hamas in the summer of 2014. Clearly, Yusef and Aloul adapted or appropriated the Ice Bucket Challenge, observing the protocols but repositioning the cultural contexts and intentionalities.

Recombinant appropriations have been both hailed as the subversive replenishment of an everyday avant-garde and dismissed as signs of an exhausted, hyper-reflexive culture that lacks innovative and progressive potential. They fulfill all or most of the following criteria:

- They are viral memes, both commercial and non-commercial, made popular through sharing in an attention economy and a relational "bastard culture."

- They are ephemeral vignettes, short-lived, marginal, and non-functional.
- They tend to be hybrid, derivative, parasitic, critical, comic, playful, transgressive, humorous, parodic, carnivalesque, performative, illegitimate, celebrating discontinuity and undermining textual authority and integrity by appropriating existing texts.
- They tend toward montage, collage (art, two-dimensional), or assemblage (art, three-dimensional).
- They tend to use *objets trouvés* and damage the integrity of (popular) artworks or texts.
- They complicate meanings, precluding a seamless, unilinear meaning-making.
- They celebrate the monteur's art of ephemeral meme creation.

Another more recent case is the "Street Harassment Video" produced by the anti–street harassment organization Hollaback! and planted as a viral video by the marketing agency Rob Bliss Creative. In this social experiment video, entitled "10 Hours Walking in NYC as a Woman" (Bliss), twenty-four-year-old Shoshana B. Roberts walks down a New York street, stone-faced and clad in an apparently unobtrusive T-shirt and jeans. The edited video shows men catcalling, walking alongside her, and otherwise harassing her. The video spread virally and received almost 33 million views within a week (as of 18 September 2016 the YouTube counter was at 43 million+). It quickly resulted not just in rape threats against Roberts and a discussion of the racial implications and the ethics of the editing (some viewers alleged that white men had been cut to produce a pattern of racial bias in the sexist comments), but also in a deluge of parody videos, remakes, and appropriations observing the protocols of the original video. Significantly driven by commercial concerns, corporate response videos have also appeared (such as a commercial for TGI Friday's) and legal battles have ensued (Roberts has sued Bliss over her participation in the video).

Almost invariably, response videos are entitled "10 Hours Walking . . ." to ensure findability. They frequently begin with the adjustment of the secret camera, followed by a subtitled, edited version of the street experience. One anti-feminist response video ("3 Hours of 'Harassment' in NYC!", currently at 11.4+ million views) strays from the "10 Hour" protocol. The video might be remade in a different city, for instance Rome, Berlin, Delhi, Mumbai, or Auckland, with different styles of clothing (and with varying degrees of harassment) or displaying a different identity (gender, race, class, disability), as in "3 Hours Walking in NYC as a Homosexual" (4.6 million+ views). "10 Hours Walking in New York as a Woman in Hijab" (12.8 million+) suggests that the hijab protects women from harassment. Some, however, would have to be described as appropriative spoofs. "10 Hours of Walking in NYC as a Man" (538k+) portrays excessive accolades offered to a young white male, who ends up being carried on a throne in royal regalia to chants of "King! King! King!" The final caption exhorts the viewer: "If you want to help, please do nothing. Keep the patriarchy in place." Soon afterward, a Jewish version, "10 Hours of Walking in NYC as a Jew" (849k+), showed a bearded white male miraculously discovered to be a Jew by passersby in Orthodox Jewish garb who fling Jewish culture at him. This parody video provoked a more serious

response from conservative Jewish news outlet NRG, this time designed to expose anti-Semitism ("Ten Hours of Walking in Paris as a Jew," 4.9 million+). The protocols remain intact, in both spoofs and responses, that adapt the structure of the original video, from the approximate two-minute length to an extended mid-video of silent accompaniment (a silent high-five sequence in the first parody, an extended prayer in the Jewish parody). In fact, Bliss deliberately cut many scenes of harassment to produce a shorter video "because some of the scenes were repetitive and he wanted the length to be around two minutes, in order to help it go viral" (qtd. in Palmer). More than forty further parodies followed, such as "Ten Hours of Walking in Berlin as a Man PARODY" (659k+), "10 Hours of Walking in Dublin as a Woman" (352k+), "Ten Hours of Walking in Battlefield 4 as a Soldier" (a game walk-through, 724k+), "10 Hours of Walking in LA as a Drag Queen" (916k+), "10 Hours of Walking in Hollywood as a Man" (1.7 million+), "10 Hours of Walking in Austin as a Hipster" (872k+), etc. The spoof "10 Hours of Princess Leia Walking in NYC" (3.6 million+) is representative of a number of pop-cultural parodies. Humorously remixing the protocols of "10 Hours Walking . . ." and the *Star Wars* franchise, it includes a variety of *Star Wars* characters on the streets of New York. The parody "10 Hours Walking in Skyrim as a Woman in Skimpy Armor" (2.3 million+) recalls the equally recent "Gamergate" controversy on videogame misogyny and sexism, attacking critics like Leigh Alexander and Anita Sarkeesian (Feminist Frequency). In fact, Alexander is moved to an attack on game culture that might also be leveled at the culture of recombinant appropriation: it's not even culture: "It's buying things, spackling over memes and in-jokes repeatedly, and it's getting mad on the internet."

Recombinant Appropriation and Transgression

The UNfappening meme raises similar concerns about the gendered ethics of recombinant appropriation, its portmanteau title punning on "happening" and "to fap" (to masturbate). The UNfappening (Artbox/Redurban) provides a recipe for cultural recombination: take the celebrity nudes hacked from private cloud storage and leaked into the public sphere and refit them with aesthetically striking clothing, resulting in a cultural appropriation that re-transgresses the original intentionalities and textualities. Unlike the hackers' violation of the celebrities' privacy by leaking the photos into the public sphere, The UNfappening strategically covers the nude photos, which become material for an art project that supposedly reinstalls the dignity of the bodies on display and ironizes the corrupt appropriation of celebrity nudity in the public web sphere. Whether this art project really transgresses this criminal infiltration of privacy or rather extends the original transgression in order to raise attention for the advertising agency might be the focus of a different essay. The same question could also be asked of the

website scarlettjohanssoning.com, which since 2011 has published appropriations of the leaked selfie of Scarlett Johansson posing nude in front of a mirror. This recombinant appropriation of the stolen images testifies both to the publicity value of (particularly female) celebrity nudity under conditions of a sex-obsessed patriarchal capitalism and to the ways in which a group of avowed artists can exploit this situation in order to redirect web attention to their own appropriations.

The examples of The UNfappening and scarlettjohanssoning illustrate the logic of transgression as "a dynamic force in cultural reproduction" that feeds recombinant appropriation: "it prevents stagnation by breaking the rule and it ensures stability by reaffirming the rule" (Jencks 7). The transgressions of cultural recombination force audiences to re-examine existing norms—in this case, for instance, making it clear that male celebrity nudes seem to be less attractive for digital theft.

Maybe this parasitical intrusion of intimacy and privacy—by declaring the appropriated, covered-up celebrity nudes art—can be legitimized by its parodic creativity. But maybe not, as transgression may not merely violate cultural and social norms, but also attack and destroy inalienable individual rights. And lower thresholds to participation, like the promise of anonymity, also imply lower thresholds to narcissism, abuse, violation, and harassment.

RECOMBINANT APPROPRIATION VERSUS TRANSMEDIA STORYTELLING

Since 2007, participatory communities—so-called Untergangers, from the movie *Downfall*'s original German title, *Der Untergang*—have prepared hundreds of subtitled Hitler rants based on a scene in Oliver Hirschbiegel's film. In the *Downfall* parodies, one of the web's most productive and durable meme fields, mashers and vidders recombine elements of a given text, in this case the subtitle track of a historical film.

The mashed-up subtitles in the clip from *Der Untergang*, in which a character who has become a worldwide symbol of evil cracks up in emotional excess, involve not so much interpretation as cultural appropriation and transformation. The case signals a shift from an adaptational mode dominated by hermeneutic concerns (rereading texts) to a performative, appropriative attitude toward text as material to be transformed or "versioned." The vidders are not driven by a hermeneutic impetus. Instead of reading or interpreting Hitler or *Der Untergang*, they mine the movie for clips that can be transformed as material for remixes and mashups. Hitler's speech (and, more specifically, the English subtitles) are not so much lacunae to be filled with interpretative meaning, according to the model suggested by Wolfgang Iser and the Constance School of reception aesthetics and reader-response criticism, but transformable, mashable content. We may, as Eli Horwatt suggests, object to Hitler becoming an avatar of *vox populi*, but to

debate whether the clips satirize Hitler or not is to miss an important point: the Hitler rant is merely material in the media protocol that shapes the re-performance.

The creative jazz of collective intelligence does not merely receive cultural products to be assessed on a vertical axis of cultural value but generates its very own canonizations and subversions. In 2009, the online *Daily Telegraph* published an overview of twenty-five *Downfall* parodies "worth watching" and developed a typology that indicated the cultural priorities of the meme creators (meta-parodies, technology and gaming, sport, Internet, miscellaneous). Ever since the first parodically subtitled mashup appeared on YouTube in 2007, the Untergangers have maintained a presence, for instance on the HitlerRantsParodies channel (Blackmon), and discussions on the political stance, implications, and impact of these parodies have erupted. A Hitler parody wiki lists more than 2,800 memes and sub-memes. One sub-meme is an interview with Bruno Ganz captioned with fake subtitles, in which he observes that the millions of views of the *Downfall* parodies have changed his career as an actor. On the *Downfall* parody wiki, all the characters in *Downfall* and its vernacular incarnations receive a detailed character analysis both within and outside the Parody Universe. Currently, "Der Untergang: The Parody" is running, the Untergangers' second attempt to collaborate on a spoof version of the entire film.

Interestingly, Untergangers are not necessarily fans of Hirschbiegel's film (or Ganz or Hitler). More often than not, the concept of fandom does not do justice to participatory communities seeking an outlet for their messages. In 2012, the *Downfall* parody was controversially mashed with the Gangnam-style video. Increasingly, these parodies have included meta-parodies in which Hitler rants about fidelity criticism in adaptation studies or about the massive presence of *Downfall* parodies or about the lameness of *Downfall* parodies or about how to make a *Downfall* parody.

Academics have taken *Downfall* parodies very seriously. Limor Shifman calls the scene a "memetic video," which, in contrast to the stable viral video, "lures extensive creative user engagement in the form of parody, pastiche, mash-ups or other derivative work" ("Anatomy" 190). Andrew Clay, discussing copyright issues related to the meme, recounts how nineteen-year-old computer student Chris Bowley prepared and uploaded the parody meme "Hitler Gets Banned From Xbox Live." Within an hour, Bowley was threatened with legal action by copyright owner Constantin Film, probably following a cue from Sony, the copyright owners of Xbox (228). Constantin first reacted to the appropriation of its content with blanket takedowns of *Downfall* parody videos on YouTube (Clay) but has now reversed this policy.

The case of the Untergangers makes it clear that recombinant appropriations are neither adaptations nor transmedia storytelling in the narrow sense of these terms. Henry Jenkins developed his theory of transmedia storytelling to account for globally circulated media narratives like *The Matrix*. As Elizabeth Evans has pointed out, the term "transmedia storytelling" was first used by Marsha Kinder and Mary Celeste Kearney to refer to a promotional practice involving merchandising, adaptations, sequels, and franchising (20–21). When transmedia storytelling is contrasted with adaptation, the rhetoric is often evaluative. Transmedia storytelling, the argument goes, can tell stories more effectively

because it reflects the differences between media. The franchise is the undisputed model of transmedia storytelling, organizing what Jenkins calls the "flow of content across multiple media platforms" (282) and Evans the "coherent matrix of texts distributed on a range of media technologies" (24). As Jenkins argues in an oft-quoted passage,

> In a perfect transmedia storytelling world, each medium does what it does best, so that a story might be introduced in a film, expanded through television, novels, and comics, and its world might be explored and experienced through game play. Each franchise entry needs to be self-contained enough to enable autonomous consumption. That is, you don't need to have seen the film to enjoy the game, and vice versa. ("Transmedia")

Here Jenkins deliberately excludes the knowing joys of recognizing adaptations, although his delineation of transmedia storytelling clearly also applies to adaptations and appropriations that are not part of transmedia franchises. Scholars of transmedia storytelling, however, tend to dismiss or disregard adaptations. A "not just" mode pervades their euphoric populist rhetoric. Carlos Alberto Scolari, for instance, argues that transmedia storytelling "is not just an adaptation from one medium to another" (587). In the vein of Jenkins, transmedia scholars view traditional adaptations as marked by the problematic processes of cross-platform compromise and the clumsy semiotic or textual rearrangements of texts, whereas transmedia story-worlds create a sustained and intensified experience of fictional worlds. Indeed, as new approaches to adaptation studies indicate, the reconceptualization of adaptation as an umbrella term for cultural borrowing or cultural appropriation has helped overcome the strictures of the novel-to-film model that used to be the core of adaptation studies (Loock and Verevis; Nicklas and Lindner; Smith; Voigts and Nicklas).

The term "transmedia storytelling" is too narrow to describe transmedia worlds crucially marked by multimodal "polyprocesses" (Voigts-Virchow 65), including mashups and remixes that play with, but are clearly outside, the franchise. Low thresholds to more active audience participation are increasingly turning cultural reception by individual readers or passive viewers into networked cultural performance. Audiences are thus transformed into partners in textuality, even if they are junior partners. User-generated texts may not meet aesthetic standards, may not be visible, and may be transient rather than permanent. Frequently, they are supportive of the meanings circulated in franchise products, rather than transgressive or subversive. The viral videos or memes shared by friends and colleagues via platforms and user-generated interfaces embedded in a specific media configuration or apparatus are currently changing the status of the literary and cultural artifact, which turns from an object of perusal and interpretation (under the old adaptation studies) into material to be played with (under the new adaptation studies).

The implications of these developments are clear. Adaptation studies must focus on what people do with texts, rather than how they process or interpret texts. A reinvigorated adaptation studies will renew the focus on issues of distribution, circulation, and performance that were superseded by the comparative textual readings that have given

adaptation studies a bad name for so long. Under this wide notion of adaptation, there is no fundamental difference between current transmedia discourse and the processes of cultural adaptation, appropriation, and borrowing. While frequently deploying aggregate texts that unfold in the long-term narrative coordination that producers undertake in pursuit of long-term revenues, recombinant appropriations still carry the potential to challenge, undermine, and transgress the semantic limits of corporate transmedia storytelling. These limits become evident, for instance, in the one-dimensional gender politics rightly attacked by feminist critics of contemporary computer games. As the praxis of recombinant appropriation shows, one can do much more in these platforms than serve as a sustained consumer of transmedia narratives.

The Politics of Recombinant Appropriation

As the preceding paragraph shows, it is easy to cull grand claims about contemporary remix culture from examples like the Unterganger videos. One of the key political arguments about recombinant appropriations addresses the question of whether they change established capitalist modes of production and consumption.

In spite of all the anthill rhetorics, crowdfunding multitudes, and swarm intelligence, the dominant framework of production in popular culture is currently the franchise. Take the example of the BBC series *Sherlock* (2010–). To date, four seasons have been produced, each featuring Benedict Cumberbatch as Holmes, Martin Freeman as Watson, and a growing network of supporting actors that create a recurring character constellation, varying the Holmes canon in a striking case of "heretical fidelity" (Hills 34). Cliffhangers, most notably in the final episode of the second series, seek to keep fan interest alive after a series hiatus necessitated by increasing problems in accommodating production schedules to celebrity performers. The franchise aims to retain a coherent audience across media boundaries.

The fan culture and recombinant appropriations emerging from *Sherlock* cast doubt on the liberating aspects of fan engagement. *Sherlock* presents an excellent example of fan engagement that has been thoroughly investigated (Stein and Busse). First, its heretical fidelity toward the Holmes canon replicates typical fan engagement. Second, the history of Holmes fans, which helped resurrect the character in 1903 after Arthur Conan Doyle had killed him off in "The Final Problem" (1893), shows that fan power and transgressive reading are by no means new phenomena restricted to digital media. Third, authors Steven Moffat and Mark Gatiss increasingly write fandom into their products, providing an excellent example of the polyprocesses of adaptation. In the third season, a sequence culminating in a kiss between Holmes and his archenemy Moriarty is revealed as a fan-produced version showing how Sherlock faked his death in the final episode of the second season. Early in January 2014, at an advance screening of the third series of

Sherlock, the producers, represented by actors Freeman and Cumberbatch and creators Moffat and Gatiss, encountered "racy" fan fiction and, after reading extracts, dismissed it as ridiculous. In an article for *Wired*, Kevin Maloney took this episode as indicative of the producers' condescending attitude toward their fans. He quotes a critical view on producer-audience engagement by academics and fans Lynn Zubernis and Katherine Larsen, who argue that fans' impact on products is frequently overestimated, even as fans increasingly become more critical of franchise makers:

> [The relationship] seems a lot more reciprocal and closer than it is, which is an artifact of the way social media, especially Twitter, makes fans feel.... I always stay on Twitter when a *Supernatural* episode is airing, and the actors and the writers and directors are usually on [Twitter], and I see what it does to fans when somebody answers their tweet. There's a need, I think, to feel like, "They're listening to me; I'm important." That's a normal psychological response, but it's not actually true; it's wishful thinking. It's a constructed intimacy that's not really intimate at all. (qtd. in Maloney)

"Oklahomo" and "Mind Phallus," two *Sherlock* parodies on YouTube, produced by the comedians Vidar Magnussen and Bjarte Tjøstheim for the Norwegian TV show *Underholdningsavdelingen*, exhibit a transgressive awareness of the program's knowing homophobia and misogyny, focusing on its quirky implausibilities, mannerist mise-en-scene, pseudo-intellectual dialogue, techno-glorification, and sexualized subtexts. The possibility of a homoerotic relationship between Holmes and Watson has been a long-standing undercurrent in readings of Conan Doyle's stories. In view of fan activities around the Holmes stories and their current actualizations via various franchises, however, its homoeroticism seems blatant. Like Claire Monk, who has found fan responses to E. M. Forster's *Maurice* "by turns emotionally engaged and highly irreverent, sexually frank and politicized" (39), we may conclude that the wild intertextualities of recombinant appropriations available online have had a decisive effect in teasing out the latently liberatory gender politics of Doyle's text. Maloney's *Wired* report on the clash between fan readings and the *Sherlock* franchise's covert homophobia and conservative gender politics highlights this rift. In fact, the unease the producers express toward their fans' creation is to be cherished.

Media producers increasingly incorporate fan-made recombinant appropriations into their products as a marketing strategy. The "I don't shave for Sherlock" passage in the first episode of *Sherlock*'s third season is another case in point. When the resurrected Holmes comments in an amused and condescending way on the beard Watson has grown, Watson decides to shave it off, but responds to the teasing of his fiancée Mary Morstan (Amanda Abbington) that "I don't shave for Sherlock." Mary's ironic comment that he should "put that on a T-shirt"—repeated in the season finale when the villain Magnussen (Lars Mikkelsen) tells Watson to put "I don't understand" on the front of a T-shirt and "I still don't understand" on the back—cues the offer of official BBC merchandise, as well as numerous fan-created variants. The case illustrates Katherine

Larsen's criticism of franchises that reference viewer engagement only to turn it into "this big selling festival of consumerism: 'Come buy our products, we'll give you sneak peeks, things to take home with you.' It's not because they're so into the fans. They're into the fans' buying power" (qtd. in Maloney).

The pros and cons of this debate are best illustrated by Henry Jenkins, on the one hand, and Trebor Scholz and Christian Fuchs, on the other. In the work of Jenkins, the focus is less on criticizing than on affirming the technological, industrial, cultural, and social contexts of these processes. Praising the import of participatory culture and collective intelligence on contemporary cultural practices, which often involve the processes of adaptation and appropriation, Jenkins engages with the industries of social media. Highlighting the surprisingly uncontrolled way in which audiences rework and appropriate source material, Jenkins pleads for more intelligent marketing that takes participatory culture seriously. Writing in 2013, Jenkins, Ford, and Green do not engage in processing, reading, or interpreting texts; they have even less interest in subverting the underlying economic systems of capitalist text production. What is at stake in their paradigm is a participating consumer, redefined as active and authoritative, rather than a reader or a rebel. In this model, what else is to be hoped for than a replenishment of the exhausted aesthetics or politics of popular culture—a replenishment one may find in the Norwegian *Sherlock* parodies?

Scholz and Fuchs have cast doubt on the transgressive potential of participatory culture on more fundamental grounds than Zubernis and Larsen. In the Marxist view, the free and creative variations of "cultural jazz" remixes are merely a playground fostered by Big Bad Media to situate and flog the products of corporate intertextuality more effectively. Social media provide both a playground and a factory in which fans are duped to supply their labor for free to capitalists like Mark Zuckerberg (Scholz 8). In Scholz's classical model of economic base and ideological superstructure, recombinant appropriation is creative labor donated freely by victims of the entertainment industries:

> Social life on the Internet has become the "standing reserve," the site for the creation of value through ever more inscrutable channels of commercial surveillance.... Harry Potter fans produce fan fiction and give their creative work away for free in exchange for being ignored by the corporation that owns the original content. Such unpaid labor practices also include "game modding" and the submission of "captchas." ... [T]ime spent on Facebook stops us from giving love and affection to others or from furthering projects that undermine capitalism. (1)

Fuchs has argued that Jenkins's primarily culturalist understanding of participation is flawed because it excludes participation in economic decision-making and the web as a site of control and exploitation: "Media and Communication Studies should forget about the vulgar and reductionist notion of participation (simply meaning that users create, curate, circulate or critique content) and focus on rediscovering the political notion of participation by engaging with participatory democracy theory" (65).

The plethora of recombinant appropriations focused on President Obama illustrate some ways of responding to this challenge. One of the most frequently shared recent

memes is a supercut of Obama singing Carly Mae Jepsen's hit "Call Me Maybe," which has been viewed over 48 million times on YouTube. The clip was created by Sadi Faleh, a nineteen-year-old biochemistry student at the University of Tennessee, who hosts the baracksdubs channel on YouTube. Faleh, who has since then formed his own company, was initially projected as an amateur, supposedly free of commercial interests when posting his remix. The German-language blog netzpolitik.org currently has a list of forty-five key remixers, some of whom have meanwhile gained recognition as authors/editors. A case in point is remix artist Mathijs Vlot, renowned for his remix of Lance Armstrong's confessional interview with Oprah Winfrey and Radiohead's "Creep" (1992) and his "Hollywood karaoke" supercut of Lionel Richie's "Hello" (1984), uploaded on the video-sharing platform Vimeo on 14 January 2012, which has since spread through other platforms and software mashups.

According to supercut.org, the fan supercut is a "fast-paced montage of short video clips that obsessively isolates a single element from its source, usually a word, phrase, or cliché from film and TV." The circulation of the video is an act of social community building, as sharing generates affinity and social connectivity. The community created by this sharing, however, is temporary and dispersed, as these short videos continuously compete with other videos and other forms of mashup culture. The short duration of the clips ensures undivided short-term attention. The clip assemblage is therefore clearly at home in the fragmentary and short-term world of the Internet meme.

These recombinant mashups of participatory culture are oppositional in the sense that they degrade a given text as merely an *objet trouvé*, material to be transformed at the hands of its audience. Hence "[m]ashups are transgressive because passionate users are willing to trespass into media territories that have traditionally been off limits to them for cultural, political, technological or legal reasons" (Edwards 40).

It does not follow, however, that re-contextualization is politically oppositional. While clearly supportive of President Obama's image as a cool, entertainment-friendly leader, the supercut of Obama singing Pharrell Williams's "Happy" rather depoliticizes discourses, since it is clearly Obama's (and Williams's) celebrity status and entertainment value (rather than any political agenda or attitude) that prompt their use in this way. It is thus an example of what Jim McGuigan and others call the celebrification of politics. *Star Wars Uncut*, an amateur fan montage of 473 fifteen-second clips that re-enact the first-released *Star Wars* movie, even gained the support of Lucasfilm. Thus, by definition, such recontextualization is neither oppositional nor transgressive, but rather participatory. Although it can be put to political uses, the playful hedonism of cultural jazz is primarily and essentially recreational and apolitical. Obama is here a globally recognizable celebrity and little else, but *pace* Trebor Scholz, playing with Obama does not preclude audiences from fighting capitalism or giving love and affection to others. Appropriating Obama clips for baracksdubs, Shepard Fairey's iconic Obama "Hope" poster, or an Obama Rage Face and sharing them on media platforms may, in fact, express love and affection, and may even undermine capitalism in a subtle, incremental way.

Recombinant Appropriations
and/as Parody

Kirby Ferguson, who currently has a set of crowdfunded video clips on the issue online, is clearly the contemporary analogue of Julia Kristeva (significantly, we have come a long way from a French 1970s intellectual to a speaker and videomaker available for hire). Ferguson's "Everything is a Remix" varies the strong position on intertextuality articulated by Kristeva, who, adapting Bakhtin's notions of dialogism, claimed that every text is an intertext. The contemporary relationship of mashup or remix culture to adaptation studies clearly replicates the problems raised by the relationship of intertextuality, intermediality, and remediation to adaptation studies. These problems require a broader notion of adaptation (Bruhn, Gjelsvik, and Hanssen; Cattrysse 23–25; Della Coletta; Kranz and Mellerski; Loock and Verevis). Phyllis Frus and Christy Williams have suggested the umbrella term "transformation" for textual "permutation" that is not "based on" but "inspired by" (3, 5).

Clearly, the viral web is frequently a polyphonic carnival, a Bakhtinian parody machine, generating texts and recording practices ranging from the imitative, uncritical pastiche to the critical refunctioning we associate with appropriative parody. Parody, which etymologically combines *para* (counter, beside) with *ode* (song), is an "imitation with critical distance," a "repetition with difference" (Hutcheon, *A Theory of Parody* 26, 32) or "the comic refunctioning of preformed linguistic or artistic material" (Rose 52). As Frus and Williams have argued, the exclusion of parody from the field of adaptation is not necessary if we consider this wide definition of parody as imitation with difference and refunctioning—with the addendum of comic intentionality (8).

Scholars of parody have complained about the lack of attention adaptation studies seems to have paid to parody, even though many adaptations are parodic (Chambers 116). Parody comes close to Sanders's definition of appropriation: a recontextualization of a text that "frequently affects a more decisive journey away from the informing source into a wholly new cultural product and domain" (*Appropriation* 26). Again, definitions of "parody," a term Sanders largely skirts, tend to specify this "journey away from," for instance by highlighting the difference as polemical allusion: "any cultural practice which provides a relatively polemical allusive imitation of another cultural production or practice" (Dentith 20). The existing terminologies concerning parody are frequently more useful than simply calling texts "adaptations" or "appropriations" because studies of parody and irony are clearer about the specifics of the "complexified meaning" (Hutcheon, *Irony's Edge* 13) generated by the ironic mode in parodies. Having discussed parody and pastiche as part of the continuum between adaptation and allusion (*Film* 116–19), Leitch points out that Hutcheon has used "adaptation" in passages in which "parody" could unexceptionably be substituted ("Adaptation" 102). One could make the same point with her work on irony, which might be described as an attitude specific to certain cases of

appropriation. As Hutcheon writes, irony is "the making or inferring of meaning in addition to and different from what is stated, together with an attitude toward both the said and the unsaid. The [interpretive and intentionally ironic] move is triggered by conflictual textual evidence or by markers which are socially agreed upon" (*Irony's Edge* 11). It is fairly easy to judge along these lines whether a video simply presents a ten-hour-walk in a different city, albeit with a different cultural agenda, or whether it appropriates its protocols with parodic or ironic intentions. It is much harder to assess the conflicting messages of these texts, taking into account the intentionality of the producers, their paratexts, contexts, and media environments, and the varying modes and conditions of reception of users who might or might not activate these texts as parodies. Even if Simone Murray's attack on her bête noire, "textual analysis" (4), throws the baby of intriguing textual engagements out with the bathwater of dematerialized formalism, I can still agree with a textual taxonomist like Patrick Cattrysse, who argues that terms like "paratext" or "parody" are too locked in the logocentric terminology of textuality to do justice to the practices of recombinant appropriation (311). These terms suggest that the engagement with these texts is still a semiotic reading process, when in fact mashers and vidders are on the hunt for material to rework and appropriate for their relational community. Adaptation and appropriation are always text and praxis. Recombinant appropriations perform existing material according to a set of media protocols. The emerging appropriations and remodelings are adaptations only if we accept the wide notion of the term as an umbrella of intertextual practices. Recombinant appropriations on the web invite sociological and ethnographic as well as intertextual and intermedial readings, focusing on the many ways texts emerge in sites of cultural participation.

Works Cited

Alexander, Leigh. "'Gamers' Don't Have to be Your Audience. 'Gamers' Are Over." *Gamasutra.* 28 Aug. 2014. Web. 1 Dec. 2014.

Aloul, Ayman. "Rubble Bucket Challenge." *YouTube.* 23 Aug. 2014. Web. 5 Aug. 2015.

Artbox/Redurban. "The UNfappening." Web. 5 Aug. 2015.

Blackmon, Stacy Lee. "HitlerRantsParodies." *YouTube.* 30 Apr. 2009. Web. 5 Aug. 2015.

Bliss, Rob. "Ten Hours Walking in NYC as a Woman." *YouTube.* 28 Feb. 2014. Web. 5 Aug. 2015.

Bortolotti, Gary R., and Linda Hutcheon. "On the Origin of Adaptations: Rethinking Fidelity Discourse and Success—Biologically." *New Literary History* 38.3 (2007): 443–58. Print.

Bruhn, Jørgen, Anne Gjelsvik, and Eirik Frisvold Hanssen, eds. *Adaptation Studies: New Challenges, New Directions.* London: Bloomsbury, 2013. Print.

Cartmell, Deborah, and Imelda Whelehan. *Screen Adaptation: Impure Cinema.* London: Palgrave Macmillan, 2010. Print.

Chambers, Robert. *Parody: The Art That Plays with Art.* New York: Lang, 2010. Print.

Cattrysse, Patrick. *Descriptive Adaptation Studies: Epistemological and Methodological Issues.* Antwerp: Garant, 2014. Print.

Clay, Andrew. "Blocking, Tracking, and Monetizing: YouTube Copyright Control and the Downfall Parodies." *Video Vortex Reader II: Moving Images Beyond YouTube.* Ed. Geert Lovink and Rachel Somers Miles. Amsterdam: Institute of Network Cultures, 2011. 219–33. Print.

Cutchins, Dennis, and Christa Albrecht-Crane, eds. *Adaptation Studies: New Approaches.* Rutherford: Fairleigh Dickinson UP, 2010. Print.

Dawkins, Richard. *The Selfish Gene.* 2nd ed. Oxford: Oxford UP, 1989. Print.

Della Coletta, Cristina. *When Stories Travel: Cross-Cultural Encounters between Fiction and Film.* Baltimore: Johns Hopkins UP, 2012. Print.

Dentith, Simon. *Parody.* London: Routledge, 2000. Print.

Edwards, Richard L. "Flip the Script: Political Mashups as Transgressive Texts." *Transgression 2.0.* Ed. David J. Gunkel and Ted Gournelos. London: Continuum, 2012. 26–41. Print.

Evans, Elizabeth. *Transmedia Television: Audiences, New Media and Daily Life.* New York: Routledge, 2011. Print.

Ferguson, Kirby. *Everything Is a Remix.* Web. 1 Dec. 2014.

Frus, Phyllis, and Christy Williams, eds. *Beyond Adaptation: Essays on Radical Transformations of Original Works.* Jefferson: McFarland, 2010. Print.

Fuchs, Christian. *Social Media: A Critical Introduction.* London: Sage, 2014. Print.

Gitelman, Lisa. *Always Already New.* Cambridge: MIT P, 2006. Print.

Hills, Matt. "Sherlock's Epistemological Economy and the Value of 'Fan' Knowledge: How Producer-Fans Play the (Great) Game of Fandom." *Sherlock and Transmedia Fandom.* Ed. Louisa E. Stein and Kristina Busse. Jefferson: McFarland, 2012. 27–40. Print.

Horwatt, Eli. "A Taxonomy of Digital Video Remixing: Contemporary Found Footage Practice on the Internet Cultural Borrowings." Smith 76–91. Web. 20 June 2013.

Hutcheon, Linda. *Irony's Edge.* London: Routledge, 1994. Print.

———. *A Theory of Parody.* London: Routledge, 2000. Print.

Hutcheon, Linda, with Siobhan O'Flynn. *A Theory of Adaptation.* 2nd ed. London: Routledge, 2013. Print.

Kranz, David L., and Nancy Mellerski, eds. *In/Fidelity: Essays on Film Adaptation.* Cambridge: Cambridge Scholars P, 2008. Print.

Jencks, Chris. *Transgression.* London: Routledge, 2003. Print.

Jenkins, Henry. *Convergence Culture: Where Old and New Media Collide.* New York: New York UP, 2006. Print.

———. "Transmedia Storytelling." *MIT Technology Review* 15.1 (2003). Web. 31 May 2012.

Jenkins, Henry, Sam Ford, and Joshua Green. *Spreadable Media: Creating Value and Meaning in a Networked Culture.* New York: New York UP, 2006. Print.

Kelly, Kevin. "Better than Free." Edge Foundation. 5 Feb. 2008. Web. 20 Jun. 2014.

Leitch, Thomas. "Adaptation and Intertextuality, or, What Isn't an Adaptation, and What Does it Matter?" *A Companion to Literature, Film, and Adaptation.* Ed. Deborah Cartmell. Chichester: Wiley-Blackwell, 2012. 87–104. Print.

———. *Film Adaptation and Its Discontents: From* Gone with the Wind *to* The Passion of the Christ. Baltimore: Johns Hopkins UP, 2007. Print.

Lessig, Lawrence. *Remix: Making Art and Commerce Thrive in the Hybrid Economy.* London: Bloomsbury Academic, 2008. Print.

Loock, Kathleen, and Constantine Verevis. "Introduction: Remake/Remodel." Loock and Verevis 1–15.

Loock, Kathleen, and Constantine Verevis, eds. *Film Remakes, Adaptations and Fan Productions: Remake/Remodel.* London: Palgrave Macmillan, 2012. Print.

Maloney, Kevin. "Sherlock Isn't the Fan-Friendly Show You Think It Is." *Wired* (2014). Web. 15 June 2014.

McGuigan, Jim. "The Coolness of Capitalism Today." *tripleC* 10.2 (2012): 425–38. Web. 1 Dec. 2014.

Monk, Claire. "Heritage Film Audiences 2.0: Period Film Audiences and Online Fan Cultures." *Participations* 8.2 (2011): 1–47. Print.

Moore, Michael Ryan. "Adaptation and New Media." *Adaptation* 3.2 (2010): 179–92. Print.

Murray, Simone. *The Adaptation Industry: The Cultural Economy of Contemporary Adaptation.* New York: Routledge, 2012. Print.

Naremore, James, ed. *Film Adaptation.* New Brunswick: Rutgers UP, 2000. Print.

Navas, Eduardo. *Remix Theory: The Aesthetics of Sampling.* Wien: Springer, 2012.

Navas, Eduardo, Owen Gallagher, and Xtine Burrough, eds. *The Routledge Companion to Remix Studies.* London: Routledge, 2014.

Nicklas, Pascal, and Oliver Lindner, eds. *Adaptation and Cultural Appropriation.* Berlin: Walter de Gruyter, 2012. Print.

Palmer, Ewan. "Director of New York Catcalling Video 'Would Have Loved' More White Men to Be in It." *International Business Times.* 31 Oct. 2014. Web. 1 Dec. 2014.

Parody Universe. Web. 1 Dec. 2014.

Reid, Robin Anne. "Remaking Texts, Remodeling Scholarship." Loock and Verevis 179–96. Print.

Rose, Margaret A. *Parody: Ancient, Modern, and Post-Modern.* Cambridge: Cambridge UP, 1993. Print.

Sanders, Julie. *Adaptation and Appropriation.* London: Routledge, 2006. Print.

——. "Introduction: Evolving the Field: Adaptation Studies in Transition." *Pockets of Change: Adaptation and Cultural Transition.* Ed. Tricia Hopton, Jane Stadler, Peta Mitchell, and Adam Atkinson. Lanham: Lexington, 2011. xv–xviii. Print.

Sarkeesian, Anita. "Damsels in Distress: Part 1—Tropes vs Women in Video Games." Feminist Frequency. *YouTube.* 7 Mar. 2013.

Schäfer, Mirko T. *Bastard Culture! How User Participation Transforms Cultural Production.* Amsterdam: Amsterdam UP, 2011. Print.

Scholz, Trebor. *Digital Labor: The Internet as Playground and Factory.* New York: Routledge, 2013. Print.

Scolari, Carlos Alberto. "Transmedia Storytelling: Implicit Consumers, Narrative Worlds and Branding in Contemporary Media Production." *International Journal of Communication* 3 (2009): 586–606. Web. 7 Oct. 2011.

Shifman, Limor. "An Anatomy of a YouTube Meme." *New Media and Society* 14.2 (2012): 187–203. Print.

——. *Memes in Digital Culture.* Cambridge; MA: MIT P, 2014. Print.

Smith, Iain Robert. *Cultural Borrowings: Appropriation, Reworking, Transformation.* Special issue of *Scope: An Online Journal of Film and Television Studies* 15 (2009). Web. 20 June 2013.

Stein, Louisa E., and Kristina Busse, eds. *Sherlock and Transmedia Fandom.* Jefferson: McFarland, 2012. Print.

Supercut. Web. 18 June 2014.

Voigts, Eckart, and Pascal Nicklas. "Introduction: Adaptation, Transmedia Storytelling and Participatory Culture." Special Issue of *Adaptation: Adaptation and Participatory Culture.* 6.2 (2013): 139–42. Print.

Voigts-Virchow, Eckart. "Anti-Essentialist Versions of Aggregate Alice: A Grin Without a Cat." *Translation and Adaptation in Theatre and Film.* Ed. Katja Krebs. New York: Routledge, 2013. 63–77. Print.

PART IV

ADAPTATION
AND GENRE

ADAPTATION AND OPERA

LINDA AND MICHAEL HUTCHEON

ADAPTATION is "the lifeblood of opera" (Blake 187) and has been so since that art form's inception in Italy in the late sixteenth century: the tried and tested, not the new and original, is the norm in this expensive art form. With this long history, opera can arguably lay claim to being the Ur-adaptive art. Given its historical and systemic identity as a musico-dramatic hybrid (Campana 204), opera brings together into one simultaneous integrated event the textual, the musical, and the theatrical—with each mutually influencing the others (Baest 19). Emerging at the same time as print culture, opera was always a textual practice: elaborate presentation volumes ensured that courtly operas survived; operas for public theaters, performed with handwritten parts, were often lost. Later, both libretti and scores were printed. But because opera is transmitted orally and staged theatrically, in performance it has never been reducible to its texts (Campana 219–20). Unlike an oil painting, for example, which is the direct product of the originating artist ("autographic," in Nelson Goodman's terms), opera is an "allographic" art form (Goodman 113), requiring not a single artist but a phalanx of creators, performers, and producers to interpret and thus bring its libretto and score, its two "dramatic texts," to musical and theatrical life on stage in a "performance text" (Elam 3). Perhaps, then, because it is not only an ontologically complex hybrid (see Goehr 2–3 and *passim*), but also the collaborative medium par excellence (Halliwell 32), opera has occasioned less theorizing of its adaptation process than has film, for example. This is despite the groundbreaking work on individual adaptations by scholars like Nassim Balestrini, Michael Halliwell, Irene Morra, Marcia Citron, and Suddhaseel Sen.

The other reason for the relative paucity of operatic adaptation theory is the persistence of an operatic version of that familiar, limiting focus on fidelity that has gone out of fashion in recent years in other areas. Opera's tradition of *Werktreue* is invested in "serving and authentically realizing the operatic work bequeathed to us by notation and authenticated by tradition" (Morris 102). While in earlier centuries operatic texts were supplemented and substituted—in short, altered constantly—over time they have become repeated and standardized, and thus respected as if inviolate. This has made the critical acceptance of adaptations *of* opera to film, for instance, a challenge. Here

we will theorize not only adaptation *into* opera but also adaptation *of* operas to old and new media. The first, opera as adaptation, is the more complex, for it involves a series of steps: text adapted to libretto; libretto set to musical score; both libretto and score realized in performance. A further complication comes with the changes that occur in the 400-year history of the art form in the West. While adaptation is a constant over the centuries, its sources, ideology, and aesthetics change with time and place.

OPERA AS ADAPTATION

With its origins in sixteenth-century Italian courtly genres such as the *intermedi* and pastorals, opera began as a hybrid of music, poetry, and spectacle. While, in France, Jean-Baptiste Lully and Philippe Quinault would later superimpose existing French stage conventions onto Italian opera (Gallo 140), in the beginning, in Italy, opera did not develop out of spoken theater and thus was free of the demands of the Aristotelian unities (Baest 55–56). This is why Italian opera could bring music and drama together with spectacle and multiple scene and time changes (Ferrero 1–2). It turned to adaptations of classical myth and tragedy for its subject matter in part because of these origins, but also because of a conscious desire on the part of a group of Florentine composers, poets, and artists to recreate the form and power of ancient Greek drama. Assuming that the classical dramatic texts that had been rediscovered in the Renaissance had been performed to music (now lost), the Camerata Fiorentina engaged in a three-part adaptation process. First, they adapted the familiar stories told in those ancient (and now available) textual materials. Second, they found they had to jettison the complex polyphonic musical tradition of their time and adopt a new and simpler monophonic style. This would allow the words to which the music was set to be much more easily comprehended by the courtly audiences when performed—the third stage of their adaptation process. Soon the Camerata's view of the primacy of words in opera would be challenged in Venice and Rome by more emphasis on both music and spectacle (Smith xvii–xviii). From then on, the history of opera is infamously one of a constant and combative realigning of the relationships among the creators of the words, music, and dramatic performance—including singers and, today, directors.

As opera moved over time from the courts to public theaters, those small homogeneous and educated aristocratic audiences were replaced by a wider and more disparate public. Creation and reception are always inseparable in a costly art form like opera, where audience expectations inevitably condition what is offered in the theater. Therefore composers and librettists have always had an eye to adapting stories that their audiences would know and enjoy. Along with the addition of historical figures and familiar comic elements from classical comedy (Halliwell 21), the myths and legends of antiquity continued to offer narrative materials into the eighteenth century. The story of Orpheus, the singing poet, provided a particularly apt as well as familiar subject, inspiring multiple settings. Certain free-standing published libretti, especially

those of Pietro Metastasio, were set by many composers: his *Artaserse* saw over forty different adaptations. With the rise of a literate middle class and a growing European literary culture (Groos 8) came the adaptation of literary romances like Ludovico Ariosto's *Orlando Furioso*, as well as popular novels. Later, melodramas and stage plays by Friedrich Schiller, Victor Hugo, and others would be added, and by the late nineteenth and early twentieth centuries, an even larger range of genres, from dramatic poems to accounts of historical events, would also be adapted for the operatic stage, often driven by the nationalism of newly formed European states. Certain writers of drama and fiction remained particularly in fashion, Shakespeare and Walter Scott among them. Not all works adapted for the stage were canonical ones; popular melodramatic potboilers like Victorien Sardou's *La Tosca* (1887) often provided more powerful dramatic material that would guarantee the large audiences that composers like Giacomo Puccini desired.

Through the twentieth and twenty-first centuries in both Europe and the Americas, the range of operatically adapted narrative materials broadened immensely. Canonical works in traditional literary genres (epics, novels, short stories, plays, poems) continued to be used. The familiarity of their stories and the cultural capital of their status provided both box-office appeal and artistic legitimacy (Kramer 68). Other art forms also provided stories: William Hogarth's eighteenth-century series of narrative paintings and engravings gave rise to Igor Stravinsky/W. H. Auden and Chester Kallman's *The Rake's Progress* in 1951. The advent of popular culture brought with it other materials, from serialized comic strips (Leoš Janáček's *The Cunning Little Vixen* [*Příhody lišky Bystroušky*], 1924) to television shows (Richard Thomas/Stewart Lee's *Jerry Springer: The Opera*, 2003). Not surprisingly, even popular films were remediated into operas: Robert Altman's 1978 *A Wedding* became William Bolcom/Arnold Weinstein's 2004 opera of the same name. More directly, Philip Glass took the screenplay of Jean Cocteau's 1949 film, *Orphée,* as the libretto text for his 1993 opera, *Orphée.* The stories of celebrity culture provided adaptive fodder as well, with subjects ranging in notoriety from Jacqueline Onassis (*Jackie O*, 1997, by Michael Daugherty and Wayne Koestenbaum) to Anna Nicole Smith (*Anna Nicole*, 2011, by Mark-Anthony Turnage and Richard Thomas). News events were also transformed into what were dubbed "CNN operas." For the libretto of *Nixon in China* (1987), Alice Goodman took the press coverage of Richard Nixon's historic 1972 visit to Mao's China for the basic structure of the stage drama that was set to music by John Adams. Director Peter Sellars then adapted these dramatic texts to the stage in such a way as to echo in certain poses the earlier televised images that audiences would have remembered (Kamuf 99).

The audience's memory and experience, in other words, remain central to opera as adaptation, as they always have. As with all adaptations, operatic ones produce in the audience members who are familiar with what is being adapted a doubled response, as they oscillate between what they remember and what they are experiencing on stage (Hutcheon xvii). The operatic performance becomes a kind of palimpsest, with these doubled layers of what is recalled and what is being experienced at that moment creating both intellectual and aesthetic pleasure (Hutcheon 117). If members of that audience

do not know the adapted material, they will experience that performance differently, that is, not as an adaptation but as they would any other work. No matter the prospective audience members and their knowledge, the writer of the libretto will always have them in mind. Misjudging one's audience can be financially disastrous. The librettists for Bizet's *Carmen* had to contend with the fact that their Parisian audience at the Opéra Comique was going to consist of "families seeking light-hearted entertainment and young ladies on the look out for potential husbands" (Rosmarin 95). Therefore Prosper Mérimée's murderous, cynical, and rather unsavory Carmen had to be tamed considerably for the operatic stage. Whether the libretto offers an original story (a relatively rare occurrence) or a familiar and popular story adapted from another work (the norm), the audience's expectations and the social context of reception are central to the creation of opera.

Opera as Adaptation, Step 1: Adapted Text to Libretto

The first of three steps in an operatic adaptation, the move from adapted text to the creation of a libretto, has been carried out in diverse manners over the centuries. In this collaborative art form, librettists are obviously the composers' enabling co-creators, for without the libretto there would be nothing to set to music. Their status in the collaboration has changed over time, however. They have gone from being recognized poets and dramatists (Apostolo Zeno and Pietro Metastasio, in the early years) to being "demoted and ghettoized" (Gross 7), and by the nineteenth century even having their roles taken over by composers (Richard Wagner, Hector Berlioz, and so on) who were seeking "authorial control" (Till, "The Operatic Work" 234). That said, in the nineteenth century it was also common for two librettists to work together, with one writing the scenario and another the poetic lines (e.g., Giuseppe Giacosa and Luigi Illica, working with composer Giacomo Puccini). By the end of the century, many a composer chose to set a preexisting literary text almost verbatim, preempting the librettist completely, in what is called *Literaturoper*. But in recent years, especially in Britain, major writers, including E. M. Forster, Ted Hughes, and Ian McEwan, have brought new prestige to the libretto form (Morra, *Twentieth-Century*) and the librettist is now granted "authorial integrity" (Morra, "Outstaring" 122). Ideally, composer and librettist today are "two complete artists in their respective fields intent upon the creation of a synergic unity that neither could create alone" (Smith xxi). Composers of opera are always adapters of libretti; unless they are inventing an original story, librettists are adapters as well.

Every adapter is both an interpreter of a previous work and a creator of a new one from it (Hutcheon 8). Librettists interpret through the lenses of their knowledge and opinion of the text and its author, as well as with an eye to audience expectations and social custom (concerning the conventions of both the theater and the general society). In moving from interpretation to creation, however, librettists may treat the adapted text's words more as a reservoir of dramatic possibilities, for they must look now as well to opera's specific generic conventions. While these have always been flexible, they have

varied according to the historical period. Conventions came into being early in opera's history, as a way to make the new art form easier for creators to write and for audiences to understand (Abbate and Parker 21–22). They originated "as answers to the contingent, practical needs of making opera recognizable, communicable, viable and enjoyable" (Campana 203). In some periods, librettists had to conform to specific conventions of poetic structure (meter, rhyme, stanza form), for these determined the "rhythmic and harmonic structures of the music" (Zeiss 181). But with time there were also musical and dramatic forms to which librettists, even famous ones, had to write. As Metastasio complained, "The length of the performance, the number of scene-changes, the arias, everything, is laid down by immutable decree" (qtd. in Stendhal 235). And in the eighteenth century, for example, *opera seria* had very formalized conventions regarding the apportioning of arias to characters and their positioning in the drama. The largest (and carefully defined) number of arias would go to the *prima donna* and *primo uomo*; the *seconda donna* and *secondo uomo* had fewer. Helpers and villains in the plot would have only two each. Arias were to appear at the end of scenes, so that the character whose aria revealed his or her affective response to the situation could then leave the stage.

For much of the genre's later history, the dominant musico-dramatic form was the "number" opera—with its regulated succession and alternations of recitatives and soliloquy-like arias with ensembles (duets, trios, and so on)—which allowed the adapting librettist to engage two simultaneous temporal scales: one "naturalistic," in which events unfold and characters converse (in recitative); and the other, more "psychological," as characters stop and reflect on their states of mind "utilizing the expansiveness of aria and ensemble" (Halliwell 28; see also Baest 57).

No matter the period and its conventions, there is one obvious and constant challenge for all adapting opera librettists. How are they to adapt, for instance, a long work that might take many hours to read into an opera that will take only a few hours to experience? Given that music is, in addition, a "retarding agent" (Rosmarin 49), slowing down narrative time, they also have to take into account the crucial fact that it takes much longer to sing a line than to read or even speak it. Thus their first major task becomes one of drastic selection and compression, but again always within the limits of the operatic conventions of the time. Lorenzo da Ponte, Mozart's librettist for *Le nozze di Figaro* (1786), summarized the task well: "I did not make a translation of this excellent comedy [Beaumarchais's *Le mariage de Figaro*] but rather an adaptation or, let us say, an extract. To this end, I was obliged to reduce the sixteen characters of which it consists to eleven . . . and I had to omit, apart from an entire act, many a very charming scene and a number of good jests and sallies with which it is strewn, in place of which I had to substitute canzonettas, arias, choruses, and other forms and words susceptible to music" (qtd. in Carter 180).

As da Ponte suggests, this step in the process of adaptation has many dimensions, from satisfying specific formal conventions to seriously pruning the narrative. Because he was adapting a dramatic work, da Ponte did not have to think about dramatizing the story, but he did have to change it radically nonetheless. In adapting a narrative from a non-dramatic text, all of opera's various creators move in effect from a "telling" mode to

a "showing" mode (Hutcheon 38–46), thereby shifting from just one sign system (words) to adding opera's other sign systems. Librettists begin their work with the knowledge that the composers and eventually the performers and the production teams will be collaborating in this adaptive process of transcoding the narrative and its various elements. Therefore they must take the future collaboration into account, even in this first step. In other words, things like rhythm and pacing, visual and even emotional impact are not the sole task of the librettist.

The narrative to be adapted is an arrangement of events constituting a story (in time) and a plot (in their causal linkage), involving characters (and their motivations and responses) in a particular setting. In the adapted work, it will have been presented from a certain perspective: either a straightforward point of view (first- or third-person) or an implied focalization (see Rimmon-Kenan 1–5). From all this, librettists must make a selection in order to create a tightly focused dramatic text, full yet concise enough to allow for the slowing effect of the music to which it will be set. They must choose a sequence of the narrative events, which may or may not retain the specific temporal and causal relations of the adapted text, but which, even with rearrangement, is recognizably the same narrative. They have to choose which characters to include, and so may end up jettisoning subplot characters (and even entire subplots) or adding them. The task of librettists is then to render what they select from the adapted text into equivalences in order to dramatize rather than narrate, and to do so concisely and with maximal dramatic impact. Events and characters can be shown (materialized and dramatized), or "talked" about and described in dialogue (often in recitative). Actions can be delineated in stage directions, and the setting can be established with stage set descriptions or by what characters say/sing about it. Economy and concision must never be at the cost of emotional impact, however, for librettists cannot leave all of the affective work to the composers, performers, and production teams.

When adapting prose fiction, librettists must decide whether (and how) to adapt the point of view or focalization of the narrative. The most straightforward way is to introduce scenes of narration by a character on stage. First-person diegetic narrators' perspectives can be presented through staged soliloquies or by having them present on stage for all the action, and thus constantly in the audience's interpreting eyes, if not ears. This was the perhaps unconventional choice of Myfanwy Piper in adapting Thomas Mann's third-person narrative in *Der Tod in Venedig* (1912) for Benjamin Britten's opera *Death in Venice* (1973). The intimacy of focus that results from this shift to a narrating protagonist increases the audience's sympathy for the character, but loses the irony and distance of the third-person narrator of the novella. By way of contrast, when the same librettist adapted the part of the story told by Henry James's first-person narrator, the governess, in *The Turn of the Screw* for Britten's opera of that name, the central ambiguity of the novella for the reader (are the ghosts real or imagined by her?) had to be disambiguated. As (perhaps unreliable) narrating gave way to staging, the ghosts were made to appear on stage.

As this example suggests, some things, like ambiguity, can be lost in the move from telling to showing. Irony can suffer a similar fate. In Pyotr Ilyich Chaikovsky and Konstantin Shilovsky's 1879 adaptation of Alexander Pushkin's cynically ironic novel

in verse, *Yevgeniy Onegin* (1837), the opera texts' "lush, dreamily sentimental romanticism" (Schmidgall, *Literature* 219) took the place of Pushkin's irony. Since texts set to music often lack not only the speed but also the density and dexterity of literary language, their creators must use fewer words and must choose them carefully. Verbal complexity and rhetorical flourish may have to be replaced by lyric simplicity of expression, with perhaps predictable consequences. In early nineteenth-century *bel canto* opera, librettists would focus on moments in the adapted text that seemed to call for "lyrical explosion into aria" (Schmidgall, *Literature* 122) rather than extended moral, political, or philosophical debates. The result was that adaptations of Walter Scott novels, for example, ended up "almost completely innocent of ideas" (Schmidgall, *Literature* 135). The other obvious elements that can be lost in the move to a showing mode range from long, detailed descriptions of places and events to an extended sense of the psychology of characters. Symbols and metaphors in the adapted text might have to be sacrificed in the libretto, but they might also either be present as part of a sung text or materialized in iconic form on stage.

In other words, though some things are lost, others are not—and there are even gains in the move from telling to showing in an opera libretto. The clear and recognized convention of the aria allows for the expression of the inner life of a character in opera in a manner much stronger than even the dramatic soliloquy. In addition, the use of ensembles—duets, trios, quartets, and so on—permits a simultaneity of character perspectives only possible in an opera libretto and its score. And, as we shall see in the next section, since the libretto is written to be adapted to music, its version of the narrative knowingly creates the room for the addition of the emotional impact of such musical features as orchestral color or vocal expressivity.

When an adapted text is in this way condensed, rearranged, simplified, dramatized, and made to conform to operatic conventions, the resulting libretto is not just a reinvention in a different medium—what Halliwell calls "metaphrasis" (1)—it is also unavoidably recontextualized in a different social and political (as well as artistic) arena. Opera, like all theater, has always worried authorities: gathering people in one place and providing them with a strong emotional experience can be a threat. The late impresario Gérard Mortier believed that opera is and was dangerous: "Art is provocative. . . . By reflecting and questioning life, it breaks the routine of daily life. Accordingly, democracy exists because of art. Revolution is made in theatre, not in literature or the museum" (Nicholas Payne, qtd. in Neef 21). This explains why libretti, as early as the seventeenth century in France, had to be approved by the authorities before being set to music (Gallo 140). Antonio Somma's libretto for what would become Verdi's *Un ballo in maschera* (1859) went through many names and versions in an attempt to satisfy the different and increasingly stringent censors in various Italian cities. Beginning as an adaptation of Eugène Scribe's 1833 *Gustave III* about the assassination of a European monarch, the opera's narrative had to be rewritten several times. It was finally renamed and reset in safely non-monarchical colonial Boston—after the 1858 attempt by three Italians to assassinate Emperor Napoleon III. Whether the new social context be aristocratic, bourgeois, or politically controlling, it will have an impact on the form as well as reception of the libretto as an adaptation.

Though tempting, it would not be totally accurate to make an analogy between an opera libretto and a film screenplay. At times during its long history the libretto has been a free-standing published literary work (in the Baroque period), while at other times it has been published along with the musical score, though again as a separate book, to be read by audience members before or during a performance. Nevertheless, there are those who have argued that the libretto provides "only" an inspiration and that the real dramatist is the composer (Kerman). As one literary scholar of opera has noted: "Libretto-bashing has a distinguished tradition in the blood sport of opera" (Groos 2). Paul Robinson offers a fine example of this tradition in his claim that "an opera cannot be read from its libretto" (328) because "an operatic text really has no meaning worth talking about except as it is transformed into music" (341–42). But an opera cannot be studied *without* its libretto text, for that was precisely what the music was written to and for. Operatic music, like that of the art song, is an adaptation of a text (itself often an adaptation).

Opera as Adaptation, Step 2: From Libretto to Musical Score

Composer Hector Berlioz somewhat ironically called the act of adapting a literary work to music "ce travail profanateur" (this profaning task) (331). The "profaning" music written for an opera is never "absolute" music; as "texted" music, it always has an extra-musical dimension because it is written to give voice, literally, to a dramatic text in words. Thus there is both a vocal line and its orchestral music, and the relationship between the two can be one of doubling, supporting, or even ironizing or contradicting. Orchestral passages that do not set words also have extra-musical associations from their very context within an opera, but in addition they also accrue meaning as the opera progresses. The form and function of all these kinds of operatic music are dependent on the specific historical time and place. Clearly, however, all composers must dramatize through their music the libretto's events, characters, actions, as well as dramatic world and its atmosphere. Through their musical decisions, they must also give to all of these a rhythm and a pace, not to mention a certain emotional temperature.

The music is what adapts—that is, creates or reinforces sonically—the libretto text's material and atmospheric stageworld, and the range of possibilities open to composers is large. Carl Maria von Weber famously used key structures (an ominous C Minor) and harmonic devices (diminished sevenths) to create the demonic soundworld of the gruesome Wolf's Glen scene in his 1821 *Der Freischütz* (Brown 298). Nicolai Rimsky-Korsakov, on the other hand, deployed the contrast between octatonic and diatonic scales to create the sonic differences between the fantasy and the human worlds in *Sadko* (1897) (Taruskin 4: 117–19).

Obviously, these are not the only elements of the libretto to be adapted to music. The characters' personalities and, especially, their inner lives, require adaptation to the stage, and music provides the bridge between the literary text and the performance.

For composers as adapters, then, there is an important distinction between the "plot-character" of the libretto, which exists in words, and the "voice-character," which is "constructed by means of an amalgam of the music assigned to the plot-character and the feats of performance that music elicits from the singer" (Abbate and Parker 17–18). To adapt plot-characters into voice-characters, composers have at their disposal everything from choice of vocal distribution (particular voice categories elicit different connotations) to an entire tool kit of musical devices—dynamics, pitch, timbre, inflection, melody, harmony, rhythm, tempi (Halliwell 39). In *Die Zauberflöte* (1791), the scheming plot-character of the Queen of the Night in Emanuel Shickaneder's libretto becomes a terrifying voice-character largely through Mozart's music heralding her arrival on stage and the extremely high tessitura of her vocalization.

This musical characterization occurs in both the vocal and orchestral lines. In Britten's *Death in Venice* (1973), the repressed and anxious protagonist, Gustav von Aschenbach, sings in "dry recitative"—in the rhythms of everyday speech to piano accompaniment—while the object of his affections, the mysterious, silent Tadzio (cast as a dancer), is presented through exoticizing gamelan-inspired music in the orchestra, allowing the audience to perceive him through the "sonic gaze" of Aschenbach's attraction (Rupprecht 268). The expressive orchestra, in fact, is often seen as acting like an omniscient narrator, offering the audience access to the mind or even the subconscious of the characters. As strange as it may seem, this is possible because only the audience hears the music in opera: the characters are deaf to the "music that is the ambient fluid of their music-drowned world" (Abbate 119), except in the case of actual songs—toasts, serenades—sung by them. What the audience hears in the music, therefore, may not necessarily support the words being sung, which represent the conscious intentions of the characters, but rather may well contradict or comment upon them. What is heard is what the characters cannot verbalize, but can only feel. Music, in this way, can express even the silence of a character.

While the complexity of this adaptation process has been a constant for composers, their means of dealing with it have varied over the centuries, with the differing conventions and customs. In the early years of the art form, the voice—singing melodiously in recitative-like arioso—carried the dramatic and emotional weight, and the setting of the music was meant to reflect the rhythm of speech (Gallo 17). It was not long, however, before virtuosic vocal display and its supporting music, as well as spectacle, challenged the primacy of the words in opera. The aria—with its rhyming verse, sustained vocal line, and emotional expansiveness—evolved to become dominant in carrying the drama. In the Baroque period, music was considered a language that communicated emotions, and did so to moral ends for the listener; voice, in particular, was believed to move the soul (Gallo 79). Theorized through rhetoric and the "doctrine of the affects," different musical tropes expressed and then engaged different emotions, and these took pride of place in the tool kit of the composer adapting a libretto to music. As one eighteenth-century theorist of the affects explained: "Hope is an **elevation** of the soul or spirits; but despair is a **depression** of this: all of which are things which can very naturally be represented with sound, especially when the other

circumstances (tempo in particular) contribute their part. And in this way one can form a sensitive concept of the emotions and compose accordingly" (Mattheson 105, bold in original). Key structures, for example, had specific cultural connotations: D major was the key of "triumph . . . , of war-cries, of victory-rejoicing"; E-flat minor was the key of "brooding despair, of blackest depression, of the most gloomy condition of the soul" (Christian Schubart, *Ideen zu einer Aesthetik der Tonkunst*, qtd. in Steblin 124–25). Dissonant harmonies were believed to heighten the drama and move listeners. Tempo and pacing also contributed to meaning: speeding up for agitation, slowing down for despair or tranquility, with a normal pace for contrast (Gallo 18).

By the nineteenth century, the orchestra had taken on new and greater dramaturgical and structural roles, and so composers had different adapting tools at their disposal. The larger scale and new diversity of the musical forces enabled greater mimetic possibilities of "word painting" than ever before. Particular instruments took on specific narrative and atmospheric associations. Gaetano Donizetti used the eerie-sounding glass harmonica in *Lucia di Lammermoor* (1839) to signal his protagonist's descent into madness in her final aria. In his 1762 *Orfeo ed Euridice*, Christoph Willibald Gluck had already created a soundworld for the heavenly Elysium "by employing the four musical categories pitch, duration, loudness and timbre in such a way that there can be no misunderstanding with regard to the mood the orchestra is to convey" (Baest 109).

It was around this time, first in Germany and then elsewhere, that the number opera, structured dramatically through separate conventional set pieces, gave way to non-repetitive, continuous "through-composed" music, intended to sustain and even intensify the dramatic momentum of the libretto. In addition, the repeated melodic device of the motive or "reminiscence motive" provided the adapter with a useful kind of quasi-mimetic musical means to associate a particular melody with a character or emotion. With Wagner came the rich elaboration of what were called *Leitmotiven*, motives that changed and developed throughout an opera, gaining both meaning and significance en route. Adapting composers now faced their difficult task with the most effective tools ever—even to the point of being liberated by Wagner's revolutionary *Tristan und Isolde* (1859) from "tonality as defined by standard linear and harmonic progression" (Latham 9).

Over the last century, other new adaptive avenues have opened for composers: "the breaking-up of the nineteenth-century musical conventions—including the logic and decorum of the diatonic system—has in effect expanded the possibilities of expressiveness. Sounds that would have seemed meaningless a century ago are now potent with significance and dramatic consequence" (Sutcliffe, *Believing* 416). Though composers still had to think about their audiences, the advent of musical modernity meant that the audience's ears were no longer necessarily to be soothed, but might be assaulted. In setting Hugo von Hofmannsthal's adaptation of Sophocles, Richard Strauss found musical means in his *Elektra* (1909) for describing "psychological abnormality, fragmentary experience, existential horror, and ennui" (Schmidgall, *Literature* 303): distorted instrumental sounds, dissonances, overt word-painting. So, too, did Alban Berg, but through different musical means, in his hallucinatory, nightmarish 1925 adaptation of

Georg Büchner's *Woyzeck*. Into *Wozzeck*'s atonal score—representing the opera's world of "physical or psychological abnormality . . . stress, aberration, horror"—the composer inserted tonal moments to "summon pity" for his protagonist (Taruskin 4: 520–22). Berg wrote that, in adapting the libretto, he sought to ensure that the "music could force out of itself everything that the drama needed in order to be transformed into the reality of the stage, a task that demands from the composer all the essential duties of a stage director" (125). For the theater is the next site of adaptation in opera.

Opera as Adaptation, Step 3: From Libretto and Score to Performance

Over the nineteenth and into the twentieth centuries, there was a convergence of operatic forces that together emphasized opera as drama, that is, "conceived as a unitary creation" (Guccini 126) everything from the costumes (which became opera-specific, rather than generic) to the overture (which became part of the drama, rather than a separate add-on). New theatrical dynamics resulted from the collaboration of all the many adapters of the dramatic texts to the performance text—not only the conductor, orchestra, and performers, but also the large and complex production team that conceptualized the staging: the designers (and then the creators) of the lighting, sets, costumes, makeup, and wigs, all with the assistance of the stage manager and stagehands who made it all work smoothly in performance. Today we would add to this next step in the adaptation process figures such as the dramaturge, the stage director, the technical director, the chorus master, the repetiteurs, the surtitlist, and others who act as both interpreting and creative agents.

We accept today that the conductor and the director together take overall charge of the musical and the dramatic elements, but historically both are relatively new positions and even roles. Before the nineteenth century, more often than not, in performance the first violinist would lead the musical ensemble, while the harpsichordist cued the recitative. And although stage directions appear in libretti and scores from as early as 1608 (Guccini 130), in earlier periods there was no one to ensure that they were followed, since no one person was ever in charge of the many independent professional specialists, from singers to set painters, who would work on an opera production. Various figures would manage stage movement, from the courtier in charge of the entertainment to the librettist, and possibly the composer. With the nineteenth-century shift to performing already existing repertory, rather than always offering new works, came the perceived need to stabilize, indeed fix, performance practices (musical and dramatic) at the premiere, and so guide future productions. This coincided with the increased cultural status of the composer of opera. Wagner's goal of the grand totality of the *Gesamtkunstwerk* demanded that all the expressive dimensions of opera—visual, verbal, and musical—work together. Therefore, as the composer and librettist, he also sought to determine the staged production process as well. Equally passionate about the dramatic dimensions of his operas, Giuseppe Verdi, Wagner's exact contemporary and

another consummate man of the theater, went a step further, adapting the Parisian stage manual or codification of a production, the *livret de mise-en-scène*, into the detailed descriptive *disposizione scenica*. This text would, now by contract, determine exactly (in terms of elements like blocking and gestures) how his operas would be performed on stage thereafter. By conducting the premiere himself, Verdi also sought to fix the musical performance by example.

The exact opposite of this desire to *control* interpretation is the defining role of the conductor and director as adapters today. Like the performing singers and musicians, both understand themselves to be interpreters of the dramatic texts of the opera, as a means to creating a live experience for an audience by adapting the page to the stage. Conductors had assumed this agential role somewhat earlier. For the stage director, however, it was a twentieth-century notion to appoint a creative artist to act as the formative mind behind the production of an opera. Though this role began with such early figures as Max Reinhardt in Germany, it was not until after World War II that it was entrenched in opera. Productions came to be designed to stimulate not only the eye and ear, but also the imagination and intellect of audiences—in other words, not simply to entertain a complacent bourgeoisie with familiar "performances of yesteryear" (Sutcliffe, "Technology" 321) that risked condemning opera to being "a branch of heritage" (Payne 319). In order to combat the perceived stagnation of operatic stagings—with their prescribed, static postures for singers, their predictable naturalistic stage sets and costumes (Baker 253)—directors moved from being coaches and coordinators to being adapting interpretive artists, often with the aid of a dramaturge (Williams 147). Demanding longer rehearsal times, directors encouraged singers to become, even more obviously than before, active adapters of the dramatic texts themselves. Interpreting both libretto and score, they would communicate that interpretation to their audiences through their singing bodies as the "site of dramatic interpretation" (Rutherford 124).

In some cases, the creative intervention of directors in this process turned out to be more challenging, or at least more surprising, than audiences were initially prepared for. What more conservative North Americans audiences have dubbed "Eurotrash," directors' opera has thrived in Europe, where audiences have seen (perhaps too) many of the traditional productions of canonical operas. It is no accident that it is usually referred to by the German term *Regietheater*. Less judgmentally called interventionist stagings, these more radical adaptations of the libretto (and traditional performance practices) of popular operas of the past come in many varied forms. Some are more or less straightforward updatings of the action to fit the current Zeitgeist; others are more drastic deconstructions. These may have a Brechtian political message, but sometimes appear to be seeking new ways to engage a contemporary audience with defamiliarizing novelty, adapting into a more fresh and living stage idiom. But in each case, as David Levin has argued, these new adaptations not only can "unsettle" (1), but also can tell us much about opera as a genre, as well as about the particular operas. Nevertheless, the resulting changes in the visual stage world have often disconcerted audiences expecting a more traditional staging, perhaps closer to the libretto's stated setting.

Whatever the novelty of the staging, the adaptation of the musical score today is usually less radical. Conductors choose which edition of the printed (and now fixed) score to use (Gossett 203–40), and while they may make either cuts or restorations (in what was historically a much more flexible and changing text), there is less extensive adaptation involved than there is in the directorial task. Since the advent of the original instruments movement, the notion of fidelity to the original score has perhaps become even stronger (Gossett 413–14). Obviously, however, the conductor and the musicians do interpret the notes of the score, and they too adapt from page to (sonic) stage. The theatrical side of the production team requires more and different tools in order to adapt the characters, action, atmosphere, and so on, from the two dramatic texts. Taking the words and stage directions, and working with all the musical possibilities from rhythm to melody, the team must realize all the aspects of the drama in live performance. As Constantin Stanislavski articulated this task, "The objective of the director of an opera is to sift out the *action inherent in the musical picture* and restate this composition of sounds in terms of the dramatic, that is to say, the visual" (qtd. in Latham 44, italics in original).

As we have seen, characters are created, on the one hand, by the music associated with them, and on the other, by what they sing/say and by what others sing/say about them; but they also are incarnated on stage through their appearance, sound, and actions. For the production team, this kind of adaptation therefore involves everything from who (sometimes literally) has center stage in relation to the other characters (blocking) to their individual gestures and postures. In recent years, the physical size and even age of the singer have become points of contention, pitting the demands of audiences accustomed to cinematic naturalism against opera's traditional artifice. More controllable elements, such as costumes, makeup, and wigs, are also crucial in defining the character on stage. The representation of the character's inner life, whether expressed in a sung aria or in an orchestral commentary, can be signaled on stage by lighting, as well as physical isolation. The singing actors corporeally embody the plot action through their physical presence, appearance, and gestures, as well as in the blocking. But other elements, like their manner of vocal production, are also relevant. In what turned out to be an operatically revolutionary demand, Verdi wanted his diabolical Lady Macbeth (in *Macbeth*, 1847) to be "brutish and ugly," with a "harsh, suffocated, veiled voice" (qtd. in Schmidgall, *Literature* 183), so that she could convincingly effect the psychological domination of her husband that the opera's libretto and music demanded. In addition to characters and action, the stage world and its atmosphere, adapted from both the libretto's words and the score's music, can be created through lighting, sets, and costuming. With today's computerized stage machinery and video projection possibilities, there are almost no technical constraints on this step of the adaptation process (Baker 375).

The production team must also deal with the specific opportunities or limitations of the theatrical (and musical) performance space in which their adaptation is to take place. Though site-specific chamber operas, using smaller musical and dramatic forces, have become common today, the traditional larger opera house, with its varying size and its acoustic and visual challenges, makes its own demands on both performers and

audience members. The Canadian Opera Company's 1984 introduction of surtitles—partial translations projected above the stage—revolutionized the audience's comprehension of the words of the opera and added the act of reading to its theatrical experience (Morris 108). The surtitlist constitutes yet another adapter who not only must decide what part of the libretto text is crucial to understanding, but also must work to coordinate the actual appearance of the translated words with the music and, most crucially in comic operas, with the timing of the dramatic action on stage. Some directors, like Peter Sellars, have experimented with different coloring for surtitles, or colloquial updatings of the language of the translations to suit the dramatic world being brought to life on stage (Morris 115). Through all these multiple complexities of the mise-en-scene, the members of the adapting team both direct audience response and control it.

They are not, however, the only ones to play this role, for the creators of the paratexts—everything from media interviews with the production team to directorial program notes—contribute as well. While not always perceived as part of the adaptation process involved in opera creation, these paratexts, or their absence, do frame the response and understanding of the audience. Beyond being familiar with these paratexts, the audience members at an opera performance may well know the adapted text from which the libretto is derived, or may have seen another production (another performance text) of the opera. They may also have a broader cultural knowledge of operatic conventions or of the composer's other works. All of this forms the horizon of expectation (Hans Robert Jauss, as adapted by Bennett 48–49) that the audience brings with it into the theater, where it experiences the performance text as the last step in the operatic adaptation.

ADAPTATIONS OF OPERA

Audiences today are exposed to opera in commercials, film soundtracks (see Joe), and recorded ambient music everywhere. In the broadest sense of the word, these practices are adaptations, although thinking of them more as intertextual appropriations by popular culture might be more accurate. Nevertheless, it is also true that writers like Thomas Mann have often used operatic plots as structuring devices; visual artists have painted scenes and "portraits" of operatic characters; and comic books and graphic novel adaptations of operas have proliferated recently. European operas have been adapted into American musicals, as in *Carmen Jones* (stage version 1943; film adaptation 1954). Ballets and other dance works have been created from operas to rearranged music and a simplified narrative to be communicated by wordless dancing bodies. *Carmen* and *Eugene Onegin* are among the operas that have attracted choreographers as adapters for over a century. Arrangements like this, which may alter the order or even rescore operas for smaller (or larger) musical forces, are indeed adaptations, as are piano reductions of entire operas or single arias. So, too, are operas presented live "in concert"—that is, without the dramatic enactment of the story with its costumes, sets, and action.

However, here we will focus on the kind of remediation of entire operas that began with gramophone recordings: the capturing of the live, fleeting, evanescent, unique performance in a physical medium that renders it repeatable, manipulable, portable, salable, and collectable (Katz 5). Between the live and the recorded lies an intermediate ground: the live simulcast or relay—on television, in webcasts, in High Definition (HD) on the movie screen. Both a document of a creative act—a "reportage of a performance" (Götz Friedrich, qtd. in Senici 64)—and a creative artifact in itself (Morris 111), the live broadcast is an adaptation as a remediation: it has its own visual language and conventions (including close-ups) into which the live opera is adapted. This is the case whether in a relatively straightforward streaming of a performance at the Metropolitan Opera or in a more complex form, such as the 1992 Italian television *Tosca*, performed on location in Rome (at the precise site where each act takes place) and at the actual time of day indicated in the libretto (see White). Confronted with live broadcasts, it is difficult not to agree with Philip Auslander, who argues in *Liveness: Performance in a Mediatized Culture* that there is no clear-cut distinction between the live and the mediatized today (7). Worldwide, live opera has long been relayed, first on radio, then television, and now broadcast to cinemas (see Fawkes 157–70). And the subsequent fixing of these live relays on video recordings raises the question of whether the production team should gear its work toward the audience viewing the performance in the opera house or the larger one seeing it on the screen (Baker 377). Either way, we have now moved from the intermediate zone of live broadcast into the more clear-cut realm of adaptations of opera. With that move comes the inevitable and problematic issue of stage theatricality versus mediated realism.

The visual idiom of television and of film, each in its different way, is one of naturalism. That of opera is not, not only because of its sung artifice but also because of the brute corporeality of the work of the singing body. The history of operas actually written for television, from Gian Carlo Menotti's 1951 *Amahl and the Night Visitors* to the present, reveals the difficulties posed by the camera's demands of absolute realism for everyone from the singers to the set and costume designers (see Baines). The pitiless close-ups of wide-open singing mouths and sweating faces proved disconcerting to early television viewers and critics faced with the "intrusive physicality" (Esse 81) of operatic sound production. Add to this the difference in scale between opera's customary grand spectacle and television's domestic intimacy, and the difficulties of adaptation to the new medium increase (Barnes 34–41). Nevertheless, television adaptations have used the medium to their advantage to produce effects that are impossible on the stage. Crosscutting between characters can annihilate space, while fadeouts between scenes can alter time (Warrack 373–74). Close-ups can isolate characters in an ensemble; indeed, different shot angles can alter the spectators' focus and attention with ease. The point of view of the camera in television, as in film, can direct the audience's collective eyes in a much more controlling way than can all the efforts of the production team of live opera.

It has been in the cinema, rather than on television, that the most (and the most popular) operatic adaptations have taken place. Even silent film operas were popular, in part because they lent prestige to the new art form (Cooke 267). In fact, opera and

film have a long history of mutual influence in everything from music to acting style. As Jeremy Tambling once quipped, "film has wanted to be like opera, and opera has not been above learning from film" (*Opera* 1). In the mid-1970s and 1980s, a boom in film adaptations of operas gave new audiences a taste of the art form as reimagined by such well-known cinema directors as Ingmar Bergman (*Trollflöjten* [*The Magic Flute*], 1975), Joseph Losey (*Don Giovanni*, 1979), Franco Zeffirelli (*La Traviata*, 1983), and most provocatively, Hans-Jürgen Syberberg (*Parsifal*, 1982). The various versions of Bizet's *Carmen* show the range of transculturations possible in adaptations across languages and cultures: from Francesco Rosi's naturalistic, on-location filming (1984) to Carlos Saura's self-reflexive, flamenco-infused rewriting (1983) to Robert Townsend's rap-singing, MTV version called *Carmen: A Hip-Hopera* (2001). Engaging even greater cross-cultural adaptation, Mark Dornford-May's *U-CARMEN eKHAYELITSHA* (2005) was sung and spoken in Xhosa, a South African language, and Joseph Gaï Ramaka's *Karmen Geï* (2001) used indigenous Senegalese music to replace Bizet's familiar score (see Hutcheon 153–64).

In technological terms, film, like television, has had much to offer opera adapters. Because the score can be recorded in the studio separately from the visual enactment of the story, arias can be presented as interior monologues: singers do not move their lips, but audiences hear (and recognize) their voices as inner and private ones. For audiences accustomed to the conventions of cinema, then, there will be a greater sense of realism in filmed opera, thanks to the possible effects achieved by the use of everything from split screens to slow- or fast-motion shots. These are among the potential ways to overcome the problem, for example, that the pace of opera is radically slower than that of both film and television. The advent of new electronic media, in turn, has meant new possibilities both for adaptations *of* opera (YouTube videos) and for adaptations *to* opera (using Google Glass as the site of surtitle projection).

Each new technology will change the options for creation, production, and consumption, further expanding and diversifying opera as an adaptive art form. As early as 1989, director Peter Sellars captured this energizing possibility: "The new technologies suggest new vocabularies; the new societies demand them. Is there an art form which is various and organic and subtle enough to comprehend the social imperatives and questions of identity that confront the next generation? Maybe it's film. Probably it's video. But if the issue finally arrives as the point of living people in a room together all at once, include film, press on with video, and let's make an opera" (24).

Works Cited

Abbate, Carolyn. *Unsung Voices: Opera and Musical Narrative in the Nineteenth Century.* Princeton: Princeton UP, 1991. Print.

Abbate, Carolyn, and Roger Parker. *A History of Opera: The Last Four Hundred Years.* London: Allen Lane, 2012. Print.

Albright, Daniel, ed. *Modernism and Music: An Anthology of Sources.* Chicago: U of Chicago P, 2004. Print.

Aspden, Susan. "Opera and National Identity." Till, *Cambridge Companion* 276–97. Print.

Auslander, Philip. *Liveness: Performance in a Mediatized Culture*. London: Routledge, 1999. Print.

Baest, Arjan van. *A Semiotics of Opera*. Delft: Eburon, 2000. Print.

Baines, Jennifer. "Television Opera: A Non History." Tambling, *A Night* 25–51. Print.

Baker, Evan. *From the Score to the Stage: An Illustrated History of Continental Opera Production and Staging*. Chicago: U of Chicago P, 2013. Print.

Balestrini, Nassim Winnie. *From Fiction to Libretto: Irving, Hawthorne, and James as Opera*. Frankfurt am Main: Peter Lang, 2005. Print.

Barnes, Jennifer. *Television Opera: The Fall of Opera Commissioned for Television*. Woodbridge: Boydell P, 2003. Print.

Bennett, Susan. *Theatre Audiences: A Theory of Production and Reception*. 2nd ed. London: Routledge, 1997. Print.

Berg, Alban. "The Problem of Opera." Albright 124–26. Print.

Berlioz, Hector. *A travers chants: Études musicales, adorations, boutades, et critiques*. Paris: Michel Lévy Frères, 1872. Print.

Bianconi, Lorenzo, and Giorgio Pestelli, eds. *Opera on Stage*. Trans. Kate Singleton. Chicago: U of Chicago P, 2002. Print.

Blake, Andrew. "'Wort oder Ton'? Reading the Libretto in Contemporary Opera." *Contemporary Music Review* 29.2 (2010): 187–99. Print.

Brown, Clive. "*Der Freischütz*." *The New Grove Dictionary of Opera*. Ed. Stanley Sadie. Vol. 2. London: Macmillan, 1992. 296–99. Print.

Campana, Alessandra. "Genre and Poetics." Till, *Cambridge Companion* 202–24. Print.

Carter, Tim. *W. A. Mozart*: Le nozze di Figaro. Cambridge: Cambridge UP, 1978. Print.

Citron, Marcia. *When Opera Meets Film*. Cambridge: Cambridge UP, 2010. Print.

Cooke, Mervyn, ed. *The Cambridge Companion to Twentieth-Century Opera*. Cambridge: Cambridge UP, 2005. Print.

———. "Opera and Film." Cooke 267–90. Print.

Elam, Kier. *The Semiotics of Theatre and Drama*. London: Routledge, 1980. Print.

Esse, Melina. "Don't Look Now: Opera, Liveness, and the Televisual." *Opera Quarterly* 26.1 (2010): 81–95. Print.

Fawkes, Richard. *Opera on Film*. London: Duckworth, 2000. Print.

Ferrero, Mercedes Viale. "Stage and Set." Bianconi and Pestelli 1–123. Print.

Gallo, Denise. *Opera: The Basics*. New York: Routledge, 2006. Print.

Goehr, Lydia. *The Imaginary Museum of Musical Works: An Essay on the Philosophy of Music*. New York: Oxford UP, 1992. Print.

Goodman, Nelson. *Languages of Art: An Approach to a Theory of Symbols*. Indianapolis: Bobbs-Merrill, 1968. Print.

Gossett, Philip. *Divas and Scholars: Performing Italian Opera*. Chicago: U of Chicago P, 2006. Print.

Groos, Arthur. Introduction. Groos and Parker 1–11. Print.

Groos, Arthur, and Roger Parker, eds. *Reading Opera*. Princeton: Princeton UP, 1988. Print.

Guccini, Gerardo. "Directing Opera." Bianconi and Pestelli 125–76. Print.

Halliwell, Michael. *Opera and the Novel: The Case of Henry James*. Amsterdam: Rodopi, 2005. Print.

Hutcheon, Linda, with Siobhan O'Flynn. *A Theory of Adaptation*. 2nd ed. New York: Routledge, 2013. Print.

Joe, Jeongwon. *Opera as Soundtrack*. Aldershot: Ashgate, 2013. Print.

Kamuf, Peggy. "The Replay's the Thing." *Opera through Other Eyes*. Ed. David J. Levin. Stanford: Stanford UP, 1994. 79–106. Print.

Katz, Mark. *Capturing Sound: How Technology Has Changed Music*. Berkeley: U of California P, 2004. Print.

Kerman, Joseph. *Opera as Drama*. Berkeley: U of California P, 1988. Print.

Kramer, Lawrence. "The Great American Opera: *Klinghoffer, Streetcar* and the Exception." *Opera Quarterly* 23.1 (2007): 66–80. Print.

Latham, Edward. *Tonality as Drama: Closure and Interpretation in Four Twentieth-Century Operas*. Denton: U of North Texas P, 2008. Print.

Levin, David J. *Unsettling Opera: Staging Mozart, Verdi, Wagner, and Zemlinsky*. Chicago: U of Chicago P, 2007. Print.

Mattheson, Johann. *Der vollkommene Capellmeister: A Revised Translation with Critical Commentary*. Trans. Ernest C. Harriss. Ann Arbor: UMI Research P, 1980. Print.

Morra, Irene. *Twentieth-Century British Authors and the Rise of Opera in Britain*. Aldershot: Ashgate, 2007. Print.

———. "Outstaring the Sun: Contemporary Opera and the Literary Librettist." *Contemporary Music Review* 29.2 (2010): 121–35. Print.

Morris, Christopher. "'Too much music': The Media of Opera." Till, *Cambridge Companion* 95–116. Print.

Neef, Alexander. "Remembering Gérard Mortier." *Opera Canada* 55 (Summer 2014): 19–22. Print.

Payne, Nicholas. "The Business of Opera." Till, *Cambridge Companion* 53–69. Print.

Rimmon-Kenan, Shlomith. *Narrative Fiction*. 2nd ed. London: Routledge, 2002. Print.

Robinson, Paul. "A Deconstructive Postscript: Reading Libretti and Misreading Opera." Groos and Parker 328–46. Print.

Rosmarin, Leonard. *When Literature Becomes Opera: Study of a Transformational Process*. Ed. Michael Bishop. Amsterdam: Rodopi, 1999. Print.

Rupprecht, Philip. *Britten's Musical Language*. Cambridge: Cambridge UP, 2001. Print.

Rutherford, Susan. "Voices and Singers." Till, *Cambridge Companion* 117–38. Print.

Schmidgall, Gary. *Literature as Opera*. New York: Oxford UP, 1977. Print.

Sellars, Peter. "Exits and Entrances: On Opera." *Artforum* 26.4 (1989): 23–24. Print.

Sen, Suddhaseel. "The Afterlife of Shakespeare's Plays: A Study of Cross-Cultural Adaptations into Opera and Film." Diss. U of Toronto, 2010. Print.

Senici, Emanuele. "Porn Style? Space and Time in Live Opera Videos." *Opera Quarterly* 26.1 (2010): 63–80. Print.

Smith, Patrick J. *The Tenth Muse: A Historical Study of the Opera Libretto*. London: Victor Gollancz, 1971. Print.

Steblin, Rita. *A History of Key Characteristics in the Eighteenth and Early Nineteenth Centuries*. Ann Arbor: UMI Research P, 1983. Print.

Stendhal. *Lives of Haydn, Mozart and Metastasio*. Trans. Richard Coe. London: Calder and Boyars, 1972. Print.

Sutcliffe, Tom. *Believing in Opera*. London: Faber and Faber, 1996. Print.

———. "Technology and Interpretation: Aspects of 'Modernism.'" Cooke 321–40. Print.

Tambling, Jeremy, ed. *A Night in at the Opera: Media Representations of Opera*. London: John Libbey, 1994. Print.

———. *Opera, Ideology and Film*. Manchester: Manchester UP, 1987. Print.

Taruskin, Richard. *The Oxford History of Western Music.* 6 vols. New York: Oxford UP, 2005. Print.

Till, Nicholas, ed. *The Cambridge Companion to Opera Studies.* Cambridge: Cambridge UP, 2012. Print.

———. "The Operatic Work: Texts, Performances, Receptions and Repertories." Till, *Cambridge Companion* 225–53. Print.

Warrack, John. "Britten's Television Opera." *Opera* 22.5 (May 1971): 371–78. Print.

White, Jonathan. "Opera, Politics and Television: Bel Canto by Satellite." Tambling, *A Night* 267–94. Print.

Williams, Simon. "Opera and Modes of Theatrical Production." Till, *Cambridge Companion* 139–58. Print.

Zeiss, Laurel E. "The Dramaturgy of Opera." Till, *Cambridge Companion* 179–201. Print.

CHAPTER 18

POPULAR SONG
AND ADAPTATION

MIKE INGHAM

A song is a bastard. It is uniting two art forms that did not ask to be forced
together.... It is a question of taking a pre-existing lyric, often a lyric
masterpiece, and then assuming that you can add something to it.

—Ned Rorem, 1998 interview

INTRODUCTION

OF all forms and media of creative expression, the song form is one of the most natu-
rally adaptive to significant variation, even if the intrinsically protean, iterative quality
of song has caused it to be rather neglected in the context of adaptation studies dis-
course. Anthony May's recent research on the marketing of 1940s and 1950s pop music
reveals the extent to which adaptation has played a significant role in the exploitation of
the genre's commercial potential and growth. In his study of popular music concepts,
Roy Shuker has defined the tendency toward adaptation in popular music in terms of
"appropriation" more specifically than adaptation—"an umbrella term, a synonym for
'use,' which includes related concepts such as transculturation, hybridization, indi-
genization and syncretism. Collectively these refer broadly to the process of borrowing,
reworking and combining from other sources to form new cultural forms and spaces"
(11). Shuker's "umbrella term," whether we employ the term "adaptation" or "appropria-
tion" to designate the practice, is a useful starting point for any discussion of the cultural
recycling that pervades the history not only of popular song, but of song in general, as a
manifestation of the human creative and communicative impulse.

Song categories across a broad spectrum from high-culture art songs to more popu-
list and lightweight, chart-oriented material share the tendency, as Shuker's overview
suggests, to metamorphose over time in the contexts of different performances and,
in some cases, a wide range of styles and interpretations. One problem that inevitably

arises in any discussion of song adaptation, therefore, is how to distinguish between the myriad possible ways in which a particular song may evolve over the *longue durée* of its life in any given culture.

Popular film-musical melodies, for example, can be appropriated from the context of children's entertainment and cross over into the realm of more highbrow instrumental jazz art in the hands of interpreters like Miles Davis ("Some Day My Prince Will Come," 1961) and John Coltrane ("My Favorite Things," 1961). The original melodies are recognizable only when the refrain or theme is explicitly stated, and are much less so when soloists embark on complex embellishment and free improvisation. This kind of transposition practice, involving the freely creative interflow of musical material and influences, is a commonplace in popular culture. Such intramedial reworking certainly needs to be recognized under a broader rubric as a type of adaptation. At the same time, however, if the present study is to align itself with other adaptation discourses across the full spectrum, a critical distinction has to be made.

We can begin by distinguishing intermedial forms of adaptation, where another art form, medium, or genre interacts with a certain song or set of songs to create a fresh artistic entity, from intramedial transformations, variations, transcriptions, transpositions, restylings, and so on, where the song evolves without being recontextualized by its relationship with another art form. In such cases it may often be radically transformed in the process, but typically not as the result of fusion with a different aesthetic form. I propose to discuss intramedial and intermedial forms and consider pertinent examples of both, although my emphasis in this essay regarding creative adaptation will be on the intermedial type, in which adaptation is the result of contact between the coalescence of two art forms, one of which is song. Other contingent art forms that can generate inter-semiotic hybrids in which sign systems, codification, and conventions commingle include poetry, drama, fiction, and cinema. One way of conceiving this inter-semiotic relationship as both dynamic and organic is by analogy to the field of contact linguistics, which explores areas of integration and influence across language varieties.

Such a contact aesthetics model would imply an unprejudiced appraisal of the synthesis of two or more expressive elements, offering a construct more descriptive than prescriptive. A useful established framework for general inter-semiotic analysis and taxonomy exists in more theoretically developed areas of adaptation studies such as film adaptation. For example, Geoffrey Wagner, citing the influence of Béla Balázs's theorization of film adaptation (222), proposes a three-level descriptive categorization of what he describes as "adaptive modes." According to Wagner's schema, adapted from Balázs, the three modes are *transposition, commentary,* and *analogy,* representing a continuum of formal and aesthetic approaches to adaptation, from closer alignment between source and target text in transposition, "with the minimum of apparent interference," to commentary, "where an original is either purposely or inadvertently altered in some respect . . . a re-emphasis or re-structure" (223), to analogy, which Wagner sees as representing "a fairly considerable departure for the sake of making *another* work of art" (227). Invoking this model from film adaptation theory, I shall present the case for complementing the broadly descriptive categories of intramedial and intermedial adaptation

with the more arguable but more insightful formal-aesthetic modes, following Wagner's taxonomy. The application of these criteria to the diverse approaches to song adaptation involving the amalgamation of words and music naturally necessitates an adaptation in itself, but one that offers a more sophisticated taxonomy. At the same time, we should bear in mind that such generalized models are more abstract than concrete—for example, the notion of "minimal interference" in respect of the transposition mode.

The integration of the verbal with the nonverbal in the meeting of lyrics and musical melody epitomizes the dichotomous quality in songs. Art song composer Ned Rorem has argued that the relationship between words and music in the production of song tends to be a bastardized one, implying as it does a sense of illegitimacy in the coupling; conversely, this essay will suggest that the syncretic or alchemical metaphor referenced by Shuker is more apt, since it emphasizes the target or outcome of the fusion, rather than any sense of incompatibility in the source material.

The process of mutation and transformation in the material is endemic both to popular music as an institution and, crucially, to performance artists who are conscious of the need to adapt a prior recorded performance of a characteristic song, when performing live or on television, for the sake of both the particular song's afterlife and for their own artistic development. Moreover, the context and synchronicity of performance changes everything. For example, during the 1974 tour by Bob Dylan and The Band, one line from Dylan's 1965 song "It's All Right, Ma, I'm Only Bleeding" took on a completely fresh meaning in the charged political atmosphere of the developing Watergate scandal. When Dylan sang the line "Even the President of the United States sometimes must have to stand naked," there were rousing cheers from the audience, all of whom were aware, as the performers were, of Richard Nixon's likely impeachment over the break-in and illicit activities of his subordinates. The decision by Dylan—one of the most inveterate song adapters (both of his own works and those of others) in modern culture—to include this particular song in his performance set suggests his canny ability, shared by many other popular music icons, to inflect older songs with newer meanings.

Equally, the critical factor of contextual receptivity indicates how a song can take on a life of its own depending on the circumstances. The afterlife of Bruce Springsteen's coruscating 1984 anthem "Born in the USA" illustrates this phenomenon, as Linda Hutcheon has pointed out. After the song was appropriated and reconceived as a flag-waving jingoistic vehicle by Reaganite right-wingers, who presumably had never bothered to look beyond the lyrics of the refrain at the indictment of those values contained in the song's verses, a disgusted Springsteen "chose to record it alone on a dark stage with only an acoustic guitar. His self-cover became an adaptation in that the new context of protest transformed the piece into a somber dirge. Time too changes meaning and always has" (145). The brooding, downbeat song that it was transformed into provides an implicit meta-commentary on the misinterpretation associated with the rock version; the instance shows that the original artist—even a performer of Springsteen's status—cannot control the afterlife and subsequent use of his song material. He can, however, respond using the artist's weapons of choice by reappropriating his own song

and implicitly repudiating the travesty of its appropriation, precisely as the left-leaning Springsteen did. The various permutations of "Born in the USA" in live performance have also added to the song's checkered history, and live performances, as well as studio recordings, add the further dimension of context, namely the other songs in the performance set or on the album recording, which all affirm Springsteen's blue-collar, anti-imperialist sympathies.

In such contexts, the cover version, or reinterpretation, functions as a hypertext (to employ Gérard Genette's terminology), a re-presentation that is in some cases intended to invoke the original version, but in others is intended literally to cover the underlying hypotext. Stephen Greenblatt has referred to this process of mutation and fluidity in an artwork as "cultural mobility" in his recent collaborative study and manifesto. However, as he astutely points out, there can be a counter-reaction to the type of free adaptation that enhanced cultural mobility promotes, resulting in "anxious, defensive, and on occasion violent policing of the boundaries" (7). Nonetheless, the concept has been valuable in facilitating a more dynamic model for adaptation than the common yardstick of fidelity alone and helps to raise the cultural status of adaptation.

Richard Dawkins in *The Selfish Gene* proposes the concept of a cultural meme as counterpart to the human gene complex. Interestingly, he begins his argument by citing anthropological observations on birdsong variations as exemplification of the way memes work in human "cultural mutation" (190). Following Dawkins's stimulating thesis, commentators like Susan Blackmore have developed hypotheses concerning memetic replication and modification that resonate with evolutionary adaptation theory. According to the theory, a meme spreads and, like a gene, it replicates. Also like a gene, a meme, whose habitat is the human brain, transforms itself in accordance with the conditions of each new habitat in order to survive. In *The Meme Machine*, Blackmore discusses its fundamental characteristics: "What then makes for a good quality replicator? Dawkins sums it up in three words—fidelity, fecundity and longevity. This means that a replicator has to be copied accurately, many copies must be made, and the copies must last a long time—although there may be trade-offs between the three" (58). The degree of fidelity necessary is a moot point, but the essential requirement is that the variant on the original be to some extent recognizable as an adaptation. In this connection Dawkins's more recent postulation of an Internet meme or creative memetic impulse, which epitomizes the sociocultural applications of his concept, brings to mind viral Internet hit songs like those by Justin Bieber, as well as the South Korean viral phenomenon "Gangnam Style" (2012) by K-Pop artiste Psy, the latter adapting to new audiences and new cultures by prompting imitations and pastiches in its turn.

Despite the generally accepted view among those who support meme theory that a meme constitutes a single self-replicating unit of cultural imitation and transmission, it has been notoriously difficult to establish an empirical scientific basis for the theory. Dawkins's reference in his chapter "Memes: The New Replicators" to musical melody and song as a good illustration of his idea harmonizes with broader cultural adaptation studies. Julie Sanders explores this scenario of dynamic cultural replication in her 2006 study of literary adaptation and appropriation across art forms in general. Sanders sees

a necessary link, rather than a loose metaphorical analogy, between biological and cultural adaptation phenomena:

> What already begins to emerge is the more kinetic account of adaptation and appropriation . . . these texts often rework texts that often themselves reworked texts. The process of adaptation is constant and ongoing.
>
> It is not entirely unconnected that the disciplinary domains in which the term adaptation has proved most resonant are biology and ecology. . . . Adaptation proves in these examples [of adaptive variations in biological species] to be a far from neutral, indeed highly active, mode of being, far removed from the unimaginative act of imitation, copying, or repetition that it is sometimes presented as being by literature and film critics obsessed with claims to "originality." (23–24)

Perhaps one reason for the popular song's aptness for iterability, for cultural replication and transmission, is that the popularity and transferability of song style, theme, and interpretation are hard to predict, and the criteria for commercial success are less formulaic than they may seem. The song melody or the chorus hook, the rhythm or beat, the instrumentation and arrangement, the interaction of lyrics and music, may all play a part in this process of propagation and popularity. Moreover, tastes, styles, and fashions continue to evolve in such a way that established song genres such as blues, folk, soul, and rhythm and blues are no longer easily recognizable to previous generations.

Consequently, any kind of evolutionary narrative of popular musical styles and genres—from gospel to blues and jazz and thence to soul, rock 'n' roll, and rap—is intrinsically bound up with adaptation theory and practice. The relative unimportance of canonical sources or fidelity to a culturally acknowledged source, together with the greater license than in other creative forms and media of adaptation, are certainly factors affecting creative recycling and refashioning in contemporary music.

Cover versions by great song interpreters of non-original material, whether by specialist songwriters or by professional singer-songwriters, may not, of course, be perceived as adaptations, but as definitive original renditions in their own right. Frank Sinatra's 1968 version of the Paul Anka–Claude François song "My Way" is in its own way an adaptation, not just of the 1967 French lyrics, which Anka adapted freely, but also of the theme. Today, however, "My Way" is still Sinatra's song, as Anka perceived it would be, despite different interpretations by Anka himself, Elvis Presley, Tom Jones, Sid Vicious, and a host of others. A translation, too, such as Rod McKuen's version of Jacques Brel's classic "Le moribond" (1961) into the hit English-language song "Seasons in the Sun," can take on a life of its own quite distinct from the song that inspired it. In this case, Brel's ironic, personal, un-self-pitying original has a lachrymose and maudlin quality in the lyrically altered English versions by Terry Jacks (1974) and Westlife (1999).

In many cases, like that of Jacks's version of "Seasons in the Sun," the ubiquitous cover version becomes so commercially successful and well-known that it is often perceived as the original. This effect, sometimes dubbed "adaptation displacement," can occur in many contexts. With tribute groups, however, the situation is very different.

While contemporary culture places higher value on the original artists' versions, it is likely that the "original" tribute artists will enjoy higher cultural status than subsequent copycat performers and possibly will be seen in time as the "authentic" tribute group or performer. The proliferation of Elvis impersonators, which shows no sign of abating, is instructive in this connection; the cloned quality of such performers exemplifies a further extension of the endless tendency toward "mechanical reproduction" in modern culture, to reference Benjamin's groundbreaking critical essay. Authenticity and originality often, though not always, tend to reside in the stylistic innovators who, like Shakespeare, bring an original voice and ethos to established traditions, in the way that Raymond Williams posited in his "structure of feeling" theory. Judged by the criteria of Williams's model, Elvis was authentic and innovative, whereas the same cannot be said of his imitators, who operate in widely divergent social contexts that are usually commemorative or celebratory; hence we may recognize that the legions of Elvis imitators are of greater sociological than musical significance. Bearing this profusion of adaptation possibilities in mind, we will concentrate in the following section on various types of intramedial adaptation examples from popular source or target cultures.

Intramedial Adaptation

Widely divergent types of intramedial adaptation are to be found in song adaptation practice, all involving unapologetic appropriation and re-conceptualization of the sources. These principal areas are genre transfer and song cover, contrafactum and parody, quotation, sampling, dubbing, and mashup. In this section I will discuss them in turn and conclude by asserting that, in terms of aesthetic mode and level of dependence on or independence of their respective sources, these intramedial adaptations represent the full range of adaptation types: transposition, commentary, and analogy.

Contrafactum and the more recent phenomenon of mashup both adapt new words to an existing melody; sampling, dubbing, and remix create hybrids of existing material and represent them in different generic styles and contexts. The latter practice involves the manipulation and overlay of sounds on other sounds by splicing original song material, suppressing the vocal track and foregrounding drums and bass, and inserting echo and reverb sound effects, as in much house, hip-hop, rap, and techno. In the case of mashup, the adaptation grafts the instrumental track of one known song onto the vocal track of another to create the hybrid. This phenomenon, which is rapidly increasing in popularity, continues to be regarded as more derivative than creative in the more conservative quarters of the music industry. Whereas contrafactum is a long-standing and accepted practice, since more traditional melodies are commonly sequestered for the newly created lyrics text, there are inevitable issues of copyright surrounding the fandom-like practice of mashup and the counterculture methods of sampling, mixing, and dubbing in house music.

Although this practice, like sampling and dubbing, might seem to present a fairly open-and-shut case of copyright infringement, practitioners argue fair legal use, despite the frequent analogies they make between their activities and illegal bootleg recording, a term that some original songwriting artists like Dylan have reappropriated for their own use in series of so-called official bootlegs. Thus the boundaries have become increasingly blurred and legal definitions of fair use tested and extended. Another significant factor has been the spirit of Internet reciprocity and sharing, which has begun to undermine established copyright and dissemination practices in print culture and particularly popular music.

The very notions of original authorship, authenticity, and creative ownership in the postmodern era have been under threat ever since Roland Barthes and Michel Foucault challenged their preeminence in groundbreaking critical essays, and the intertextuality theories of Barthes and Julia Kristeva, following Mikhail Bakhtin, have conferred fashionable credibility on the appropriation of texts or extracts produced by others. Defenders of dubbing, sampling, and mashup practices claim that their quotations, pastiches, and recyclings of the work of other recording artists constitute transformative fair use and maintain it is a legitimate adaptation practice, while an older generation of critics continues to lay greater emphasis on original compositions according to more conventional definitions of the word. The occasional use of the term "bastardization" by sampling and mashup artists chimes with Ned Rorem's pithy characterization of songs in general, cited in my epigraph. It is also worth bearing in mind that at least three famous twentieth-century artists considered uniquely creative and original in their spheres, Pablo Picasso, T. S. Eliot, and Bertolt Brecht, are credited with critical aperçus to the effect that good artists borrow, while great artists steal. Eliot's view was that "immature poets imitate; mature poets steal; bad poets deface what they take and good poets make it into something better, or at least, something different" (114).

The time-honored and recognized practice of contrafactum, by sharp contrast with sampling and similar strategies, is not predicated on adaptation at the cutting edge of music technology and fashion. From time immemorial, folk melodies and ballads have been freely transferred to new sets of lyrics containing fresh thematic material. The melody of Robert Burns's celebrated "Auld Lang Syne" (1788), for example, one of the most genuinely transcultural songs on the planet, was transformed into the popular Japanese student graduation song "Hotaru No Hotari" (1877) without any apparent cultural incongruity. "England's Rose," Elton John's 1997 reworking of Bernie Taupin's 1973 lament for Marilyn Monroe in "Candle in the Wind" as a threnody for the funeral of Princess Diana, is one of the best-known pop culture examples of contrafactum. There was no question of plagiarism involved in this particular transformation, since John had composed the original melody. In sharp contrast, in the early 1960s Dylan's now classic reworking of the traditional English ballad "Lord Randal" into "A Hard Rain's A-Gonna Fall," his critique of the insanity of hawkish Cold War politics and endemic racism in the United States, was criticized in some quarters for appropriating the traditional ballad melody. In retrospect, "A Hard Rain's A-Gonna Fall" has superseded its ballad source as a cultural meme.

To take another well-known example of such usage, the secular traditional sixteenth-century melody "Greensleeves," sometimes implausibly attributed to Henry VIII, provided the melody for "What Child Is This," the nineteenth-century religious carol by William Chatterton Dix. In fact, the ballad and its variants have a long history of such contrafactum adaptations since it was first registered in the stationer's register of 1580. It has also prompted instrumental variations in a more classical vein, from Ralph Vaughan Williams's 1934 *Fantasia on Greensleeves* to Leonard Cohen's 1974 song adaptation. In the case of contrafactum adaptation, the rhythm, syllable count, accentuation, and overall prosodic features of the target version of lyrics must follow the formal characteristics of the source work quite closely. Dix's adapted version, though replete with nineteenth-century hymn-lyric commonplaces, succeeds in this respect partly by using feminine rhymes (keeping/sleeping, feeding/pleading) for the alternating rhyme pattern to achieve a similar effect to that of the original, which uses an *-ly* pattern of repetition (discourteously/company, gorgeously/ gladly). The other constraint with contrafactum is that the notation and range, or tessitura, is already established. The new lyricist-composer's job is to ensure that the accented syllables of higher pitch and longer duration occur on semantically strong words instead of grammatically functional words that are normally unstressed.

Exactly the same constraints apply to the parody song, including the various pastiches of famous pop and folk songs by humorous songwriter-comedians like Weird Al Yankovic, Billy Connolly (whose ribald 1975 hit "D.I.V.O.R.C.E." spoofed the maudlin Tammy Wynette country song that had just reached Number One in the British pop charts), and Fred Wedlock. Yankovic's numerous parodic adaptations of popular culture in song and video, especially his whimsical 1984 "Eat It" version of Michael Jackson's hit 1982 song "Beat It," the video of which followed shot-for-shot Jackson's official video, have brought him considerable recognition. His recent parody versions include a 2011 online spoof of Lady Gaga's "Born This Way" (2011), retitled "Perform This Way," adapting the female singer's penchant for extravagant and eye-catching stage personas and performances into a kind of metacommentary on the music business. Yankovic's great strength is his ability to adapt from a whole spectrum of styles and genres of source material.

In contrast to Yankovic, who always asks for original artists' permission to release his parodies, the late British folk parodist Fred Wedlock excelled in lampooning the self-conscious earnestness of certain doyens of the folk and pop scene in his satirical and unapproved adaptations. His 1973 song "The Folker" is a mordantly tongue-in-cheek parody of Paul Simon's "The Boxer" (1969) that both sends up Simon's original and mocks Wedlock's own putative lack of talent as a folk singer. A highly skilled adaptation by an accomplished folk-club entertainer, "The Folker" follows the melody and delightfully riffs on key phrases from the source song lyrics: "I'm called 'Lead Fingers Wedlock' and my story's seldom told / How I massacre folk music / With a yard of German plywood and capo / I do requests / Just the ones that got two chords in / And I disregard the rest." Simon's memorable "lie-la-lie" vocalizing chorus is wickedly travestied by Wedlock's lame and unflattering "na-na-nya." The gulf between the respective folk singers' worlds is hilariously conveyed both by the adapter's lyrics and his performing style.

One final, very recent type of parodic adaptation, or rather appropriation, that has acquired popular appeal via YouTube is the so-called "shred." This phenomenon involves a lampoon of the source song derived from "mashing" the official music video with a distorted, off-key spoof soundtrack. Typically, Lady Gaga is considered fair game for such parodic treatment, but probably the most hilarious and skillful of all online shreds to date is the virtuosic deconstruction/destruction of Michael Jackson and Lionel Richie's 1985 song "We Are the World." One culturally significant feature of the shred is that, like many pop songs from earlier centuries, it is an anonymous practice, the difference here being that anonymity is preserved in order to circumvent action by litigious music companies and unamused composers.

While the parody can certainly be classified as radical transformation of the source work, the same cannot always be said of cover versions, and particularly not references by singer-songwriters to other song titles. In rare cases, however, such as U2's 1989 song "God Part II," which responds to and syntactically imitates John Lennon's spare 1970 aporetic anthem, "God," the citation/reference functions as both independent of and tangential to the source, and thus as bona fide adaptation; it appears the song was intended as both an homage to Lennon's lyrics and a repudiation of a sensationalized account of Lennon's life by biographer Albert Goldman. Well-known Lennon lines are paraphrased and referenced in a creative pastiche of the ex-Beatle's song renouncing the shallow hype of much of the popular song business, including his earlier off-the-cuff claim that the Beatles were "bigger than Jesus." U2's direct citation of lines from Lennon's 1972 song "Instant Karma" and another completely separate song, "Lovers in a Dangerous Time" (1984), by the lesser-known but prodigiously talented Canadian Bruce Cockburn, makes this an intricately crafted intertext of a song. Rich in allusion to Lennon's life and work as well as to the pop-icon status of U2 themselves, it creates a stimulating nexus of critical, cultural, philosophical, and personal resonances. David Bowie's 2002 song "Afraid" also echoes the original patterning of Lennon's skepticism concerning his mythic status by paradoxically reaffirming the value of the Beatles as a personal influence on Bowie's own work in yet another intertextual accretion.

While adaptations are necessarily intertextual, not all intertextual allusions can be considered adaptations. There are also rare examples of song intertexts that function more like the mashup adaptation, in which one song is incorporated into another. One good example is Joni Mitchell's "Down in the Chinese Café" (1982), which seamlessly assimilates the 1955 song "Unchained Melody" into its chorus structure to emphasize the mood of deep nostalgia for the music and companionship of earlier years that the then middle-aged Mitchell wished to convey. Employing the chorus of the source song skillfully to contemplate the inexorable passage of time and the accompanying sense of loss, Mitchell provides a foretaste of the well-known source melody and aching lyrics through brief citations until she sings the full refrain in all its glory at the end of the song. Whether "Chinese Café/Unchained Melody" should be considered a cover, an adaptation, an interpolation, or merely a quotation illustrates the problems of definition and strict categorization, not only in the field of adaptation, but also in the litigious

commercial context of popular music and song, where lucrative copyright arguments usually prevail over proponents of fair use. It would be crass, however, to regard the type of creative fusion that Mitchell employs in her thought- and emotion-provoking song as plagiarism.

Here we can examine the case of intramedial transfer in which songs are re-contextualized completely, not just for the purposes of a new cover interpretation, but rather to serve a fresh sociocultural or ideological purpose. In his 1941 oratorio *A Child of Our Time*, Michael Tippett used five traditional black spirituals, including "Go Down Moses," "Steal Away to Jesus," and "Deep River." His settings enabled the oratorio to create resonances between the historical oppression experienced by the people of Judea in the songs' backstory and that experienced by black slaves in the United States while providing an allegorical framework for Tippett's contemporary Nazi-era Jewish pogrom narrative. His orchestration of the spirituals in the context of a single, longer, artistically sophisticated composition does not detract from their power, beauty, or touching relevance. Rather, the spirituals heighten and condense the emotion of the work, functioning like a typical Bach or Handel chorale.

The bizarre appropriation and reincarnation of another black American spiritual, "Swing Low, Sweet Chariot," as a rugby anthem for the England Rugby Union team, as well as Liverpool Football Club's long-term borrowing of "You'll Never Walk Alone," the signature song from the 1945 stage musical *Carousel*, are good examples of re-contexualization with markedly different applications. Anthropologically speaking, such adaptations may be described as songs, but in essence they represent more closely a collective oral expression of quasi-tribal identity. Considering the notion of adaptation as a form of "cultural re-territorialization" or "re-signification" that causes resource texts and cultural artifacts "to be used in ways that differ radically from their original meanings and functions" (Lull 161), we must accept that this type of sociocultural mutation corresponds to accepted adaptation principles, even if the chant or anthem tends to supersede the original song and inevitably assumes an independent afterlife as the source is gradually obscured.

To review the intramedial adaptation types and examples in this section and attempt to fit them into the proposed taxonomy outlined in the introduction, we can make a broad case for considering song cover and genre transfer as *transposition*, sampling, mashup, parody and interpolation/quotation as *commentary*, and contrafactum and recontextualization as *analogy*. Admittedly, covers or genre shift versions can be regarded as being altered to a degree, but that is implicit within the term "transposition," and in any case no adaptation exists that has not interfered with the source to some extent. The "re-emphasis" or "restructuring," to use Wagner's terms, are attitudinal and involve comment on the source, whether implicitly or explicitly. Contrafactum songs correspond to this model by departing from the source text while employing the musical structure, whereas re-contextualizations involve radical cultural, textual, or musical shifts. Hence both types of adaptation evidently fulfill the stated criteria for the analogy mode.

INTERMEDIAL ADAPTATION

In theory, any other art medium could interact with song or provide the source for a song adaptation. But in practice, only a few other art forms are common catalysts for inter-semiotic transformation where song is concerned. The most obvious of these external art forms is poetry, which will furnish our case studies here. Whereas poems almost always provide the adaptation hypotext, with song as hypertext, the polarities are reversed in most other intermedial transfers. Some contemporary new ballets have been choreographed to popular song, including Twyla Tharp and the Pittsburgh Ballet's "Nine Sinatra Songs" (1982), collaborations between Lady Gaga and the Bolshoi Ballet (2009) and subsequently between Sufjan Stevens and the New York Ballet (2014), as well as Nashville Ballet's hybrid ballet-and-music piece based on Johnny Cash songs (2014). Given the importance of music to the ballet form, this type of creative alchemy between two media with radically different cultural status offers exciting possibilities for similar projects to be developed. Movies, videogames, stage musicals, and other cultural source and target texts and artifacts engage with songs, if more obliquely, or even parasitically, as cultural reference points, more commonly as target adaptations than as source texts.

Stage musicals like *Buddy* (Buddy Holly, 1989), *We Will Rock You* (Queen, 2002), and *Mamma Mia* (Abba, 1999) all recycle well-known songs set to flimsy dramatic narratives, arguably exploiting the popularity of the form and the familiarity of the songs more for the benefit of commercial entertainment than from motives of creative artistic endeavor. By contrast, the practice of creating songs for stage musicals from poems or novels tends to result in fresh works, which, like "Always True to You (In My Fashion)" from Cole Porter's *Taming of the Shrew* musical *Kiss Me Kate* (1948), "Memory" from the *Old Possum's Book of Practical Cats* stage show *Cats* (1981), and "Do You Hear the People Sing?" from *Les misérables* (1985), can yield significant compositions in their own right, acquiring an afterlife that transcends the stage production. In the 2014 Hong Kong "Occupy" civil disobedience movement, for example, "Do You Hear the People Sing?" became the anthem of the protesters' choice in Cantonese translation.

Films like *I'm Not There*, *Ode to Billy Joe*, and *Alice's Restaurant* all have their genesis in song titles, while the jukebox musical *Moulin Rouge!* (2001) employs the conceptual metaphor of contemporary song performance to evoke doomed romantic love and art as nineteenth-century *fin de siècle* pastiche. Such examples merely scratch the surface of the extensive film-song interaction, including numerous examples of pop song–inspired films, many of which tend to be vehicles for the propagation of the artists' songs that fail to assert their aesthetic independence from the song medium.

The ubiquitous MTV video is another facet of the endlessly reiterative adaptation process, altering or transforming the hermeneutic range of the original song through visualization and performance. These elements inevitably affect the listener's reception and perception by limiting the song's signification and referential field to the artist's or the director's personal vision. The mind's eye of the audio version of the song is replaced

by the camera eye, generally inhibiting plural associations and closing down the song's possible alternative interpretations, while at the same time providing rich imagery to accompany the song's auditory stimulus. Hip-hop compositions by Kanye West and Dr. Dre, older rap songs like Grandmaster Flash's 1983 hit "The Message," and rock songs like Ram Jam's "Black Betty" (1977) and David Bowie's "Space Oddity" (1969) have been appropriated into popular videogame soundtracks under licensed usage.

Famous and fashionable novels and short stories have also provided inspiration for many songs. Jefferson Airplane's "White Rabbit" (1967) takes its cue from *Alice in Wonderland*. Kate Bush's "Wuthering Heights" (1978) and "The Sensual World" (1989) reference *Wuthering Heights* and *Ulysses*, respectively. Gordon Lightfoot's "Don Quixote" (1972) is inspired by the Cervantes novel. All three of these examples illustrate the impossibility of adapting more than just an element, be it a crucial scene and a single character's perspective rendered by Bush's hauntingly high-pitched vocal delivery in "Wuthering Heights" or the general impression of the source novel's theme in "Don Quixote." "White Rabbit" essentially uses the surreal situations of the Alice books as a coded but unequivocal reference to psychotropic substance use in 1960s underground culture, which marks it out as a free adaptation of the basic premise of Lewis Carroll's books, rather than of their narrative sequences. All these songs do more than simply quote from, or allude in passing to, their sources. Another fascinating example of the use of novel material is U2's setting and performance of the lyrics Salman Rushdie wrote for his rock-star character, Ormus Cama, in *The Ground Beneath Her Feet*. The eponymous fictional "song" becomes a real song, appropriately enough a rock ballad, in Bono and The Edge's sensitive 2000 adaptation of Rushdie's lyrics, which credit Rushdie officially on the recording as lyricist.

The Bible has naturally spawned well-known song adaptations, notably Leonard Cohen's frequently covered 1978 masterpiece "Hallelujah," which treats David's composition of the Psalms and his infatuation with Bathsheba. Other popular takes on Old Testament poetry include Pete Seeger's 1962 folk song "Turn, Turn, Turn (To Everything There Is a Season)," from the Book of Ecclesiastes, and The Melodians' 1970 reggae song "Rivers of Babylon," based on Psalms 19 and 137 and popularized by Boney M's irrepressible, foot-tapping cover version from 1978.

In these latter examples, poetic (as opposed to prose) text is the genuine source of lyrical inspiration. Indeed, the poem-to-song transfer is probably the most complete form of intermedial adaptation, apart from odd exceptions like the Rushdie example cited earlier, since it is a practice that is predominantly holistic rather than fragmentary. Great poetry can provide the touchstone for creative independence from the source text, generating a definitive artistic response to source material in the process of transformation.

There is no better example of this process than Beethoven's setting of Friedrich Schiller's poem "An die Freude" (commonly known as "Ode to Joy") for the final movement of his Ninth Symphony. Unlike a popular song adaptation, which is almost invariably strophic and involves reiteration of verse and chorus motifs plus an optional "middle eight," classical settings such as the "Ode to Joy," especially in the context of a larger work like a symphony, tend to be through-composed and subject to greater

melodic and harmonic variation. The emotional gamut and symphonic scope of Beethoven's setting of "Ode to Joy" is exceptional; the work transfers emphasis from the cognitive element conveyed by the poetic text to the affective end of the continuum. The setting is thus designed to convey a collective and shared emotion in performance, which enacts the poem's original message of the joy of brotherhood more intensely than the poem itself can possibly do.

Another example in a different idiom, that of jazz, is Billie Holiday's best-selling song, "Strange Fruit," originally adapted in 1937 by writer Abel Meerepol from his own poem as a song vehicle for his wife. The song has been cited as one of the greatest of the twentieth century and a rare example of a jazz protest song. Holiday's coolly understated, almost distanced, 1939 delivery turned a relatively obscure if coruscating and passionate poem into a song of great subtlety and power through her idiosyncratic phrasing and inflection, which serve to accentuate the ironic indictment in lines such as "Pastoral scene of the gallant south" and the acerbic closing line, "Here is a strange and bitter crop." Without Holiday's arresting vocal performance, the social impact of the verses would have been minimal; thanks to the adaptation, the song became a precursor of the civil rights movement.

Outstanding folk or popular song poem adaptations include Poe's popular "The Bells" (also set by Rachmaninov in Russian translation), which has been adapted to the folk song idiom in a spirited version by Phil Ochs on his 1964 journalistic protest album *All the News That's Fit to Sing*, a synthesis of voice, text, melody, and musical backing, which combine to bring out the poem's distinctive aural qualities and light but rhythmical prosody. To a considerable extent, any felicitous poem-to-song adaptation depends on the poem's preexisting musicality: its prosody and phonological features, its structural features, natural rhythms, rhymes and half-rhymes, and thematic content, although this last need not necessarily be an insurmountable problem. Much of W. B. Yeats's poetry has a natural predisposition to adaptation, precisely because he was an immensely skilled poet and songwriter as well as a unique dramatist. His attraction to lyrics and songs in his plays and the intensely lyrical quality of his writing are reflected in a number of his collections, notably *Words for Music Perhaps* (1931). The music in his poems can be heard in the reading of them. But this natural musical quality can be transformed by an accomplished composer or singer-songwriter into a very concrete musical form employing melodic and harmonic choices related to important song elements, such as genre, tempo, key, notation, vocal range, and instrumentation.

The adaptations of Yeats's poetry by the Celtic Fringe folk-rock group The Waterboys exemplify the balance of this symbiotic relationship. After the success of their initial adaptation of Yeats's fairy poem "The Stolen Child," from his first collection, *Crossways* (1889), on their 1988 *Fisherman's Blues* album—where singer Mike Scott blended his tuneful setting of the refrain, "Come away, O human child / To the waters and the wild / With a fairy hand in hand / For the world's more full of weeping than you can understand," with Irish singer Tomas McKeown's rhythmically recited verses against a dreamlike mosaic of flute, bouzouki, folk fiddle, piano, saxophone, and bells—more Yeats adaptations by Scott were always likely. A project over twenty years in the

making, The Waterboys' homage album *An Appointment with Mr. Yeats* (2011) was first conceived as a series of live concerts at the Abbey Theatre, Dublin, where Yeats's poetic dramas were originally showcased. Although "Stolen Child" and other individual adaptations are effective as separate songs, as their popularity on YouTube suggests, the concept album aims for something more ambitious, spanning the Irish poet's long career with judiciously selected texts that exploit the band's range of genres and styles and Scott's expressive vocal timbre and clarity of articulation.

A number of the songs, conspicuous for their directness, can be appreciated immediately as songs independent of their intertextual connections to Yeats. Under this rubric is the pulsating dotted/triple-rhythm rock of "The Hosting of the Shee (Sidhe)"—also adapted in 2002 by Irish heavy-metal band Primordial—the elegiac "An Irish Airman Foresees His Death," and the simple and exquisite "Sweet Dancer," Scott's imaginative amalgamation of the short late poem "Sweet Dancer" and extracts from two other poems, one taken from the early play, *The Hour Glass*. All three songs are short, lyrically powerful, and independent of any knowledge of Yeats's life and work for their effect on the listener. The stripped-down quality of the arrangement, the subtly touching melody, the arresting minor-to-major key shift, and the faintly menacing background drumming, complemented by a wistful cor anglais "outro," of "An Irish Airman Foresees His Death" all serve to underscore that poem's understated political-philosophical implications, making this the perfect popular-song blend of thought and emotion. To reflect on the final line of the poem, repeated for effect in the song, "In balance with this life, this death," one might reformulate it as: "In balance with this poem, this song." Likewise, the adaptation of "Sweet Dancer" benefits from a compelling hook phrase, set directly from Yeats's own refrain. The felicitous lightness of mood, belying the sadness of the mentally disturbed girl's situation, and the chemistry between the lyrics and the song's sweet melody capture the poignant beauty and kinetic energy of the moment. Such poem settings that transcend the literary and attain the quality of pure, almost effortless, song are relatively rare. The chemistry between music and lyrics generates a song meme that, as in the examples discussed here, can flourish in the context of popular culture.

In such cases the vocal and musical performance adds a fresh dimension to the source poem with specific inflections, emphases, and aesthetic restructuring following the initial transposition of poetry into lyrics. With reference to the Wagner-Bálazs taxonomy, we can posit the poem-derived song as a commentary-type adaptation, since the adapter initially transposes, and then in musical performance comments on or re-presents, the poetic text. By contrast, the typical film, ballet, stage musical, or videogame that re-contextualizes and imposes a narrative on a source text asserts greater creative independence, and thus corresponds to the analogy mode, whether or not the product can be regarded from a critical viewpoint as felicitous. Put simply, a good song adaptation is one that functions well as a song, not primarily as an adaptation, while a creative work based on a song or songs has the primary goal of succeeding on its own terms as a film, videogame, or stage musical. As with art song, there are many pop song settings that are less popular but still accomplished and skillful.

CONCLUSION

As Rorem's thought-provoking axiom cited earlier suggests, the history of popular song attests to the fact that an ethos of illegitimacy is intrinsic to the creative instincts of songwriters and performers. On the basis of the descriptive categories and the pertinent examples offered in this essay, the successful propagation of song memes via aesthetic symbiosis does not exclude the idea of bastardy, any more than the successful propagation of genes in any way precludes unlikely or transgressive biological couplings. Rorem's remark draws attention more to the dichotomous challenge of song composition, and by extension particularly to song adaptation, than to any implicit suggestion that one should not undertake it. His own life's work as a song composer, after all, refutes such an interpretation. Song adapters not only assume they can add to the preexisting lyric, but regularly do so, with varying degrees of cultural impact and artistic flair. It is more useful, therefore, to see the bastardization/alchemy tension discussed earlier as a dialectical relationship arising out of creative interaction, rather than as a mere opposition.

The scope and findings of this general study indicate not only that adaptation as praxis is inseparable from the cultural production of song, but that literary adaptation is congruent with the singer-songwriter tradition, whose genealogy is in folk, blues, and ballad-singing. In these contexts the adaptation creates a more equal dialogue with the original work and arguably contributes more to its afterlife. The more holistic practice involved in transpositional and commentary modes can offer a double vision that incorporates both hypotext and hypertext in the transformed work; by contrast, the more replacive mode of analogy, being a more fragmentary practice, has a greater tendency to ignore the source or to use it as basic creative inspiration and/or a commercial branding strategy.

In the commercially vibrant cut-and-thrust of the contemporary pop market, there is a greater propensity for copycat appropriation, but even here, as the history of pop music empirically demonstrates, innovative new sounds and styles develop out of a mass of more derivative material. The transformations arising out of *bricolage* and hybridization and responding to diverse cultural memories and memetic impulses do not necessarily follow predictive patterns. They may ultimately produce shape-shifting works that help to change the popular song landscape, but much depends on the interplay of convention and contemporary feeling in this alchemical process. So while it can be argued that all adaptations are intrinsically exploitative after their fashion, the intuitive counter-argument is that popular music has thrived on adaptation in all its facets.

WORKS CITED

Alice's Restaurant. Dir. Arthur Penn. Perf. Arlo Guthrie, Patricia Quinn. United Artists, 1969. Film.

Benjamin, Walter. "The Work of Art in the Age of Mechanical Reproduction." 1936. *Illuminations: Essays and Reflections.* Trans. Harry Zohn. Ed. Hannah Arendt. London: Jonathan Cape, 1970. Print.

Blackmore, Susan. *The Meme Machine*. Oxford: Oxford UP, 1999. Print.

Dawkins, Richard. *The Selfish Gene*. Oxford: Oxford UP, 1976. Print.

———. Introduction to Blackmore. vii–xvii. Print.

Eliot, T. S. "Philip Massinger." *The Sacred Wood: Essays on Poetry and Criticism*. London: Methuen. 1920. Print.

Genette, Gérard. *Palimpsests: Literature in the Second Degree*. Trans. Channa Newman and Claude Doubinsky. Lincoln: U of Nebraska P, 1997. Print.

Greenblatt, Stephen, with Ines G. Županov, Reinhard Meyer-Kalkus, Heike Paul, Pál Nyíri and Friederike Pannewick. *Cultural Mobility: A Manifesto*. New York: Cambridge UP, 2010. Print.

Hutcheon, Linda. *A Theory of Adaptation*. London: Routledge, 2006. Print.

I'm Not There. Dir. Todd Haynes. Perf. Christian Bale, Cate Blanchett. Weinstein, 2007. Film.

Lull, James. *Media, Communications, Culture: A Global Approach*. Cambridge: Polity P, 1995. Print.

May, Anthony. "'Dancin' with my Darlin'": Patti Page and Adaptation in Pop Music." *Continuum: Journal of Media and Cultural Studies* 23.2 (2009): 127–36. Print.

Moulin Rouge! Dir. Baz Luhrmann. Perf. Nicole Kidman, Ewan McGregor. Twentieth Century Fox, 2001. Film.

Ode to Billy Joe. Dir. Max Baer. Perf. Robby Benson, Glynnis O'Connor. Warner Bros., 1976. Film.

Rushdie, Salman. *The Ground Beneath Her Feet*. New York: Henry Holt, 1999. Print.

Sanders, Julie. *Adaptation and Appropriation*. New York: Routledge, 2006. Print.

Shuker, Roy. *Popular Music: The Key Concepts*. 2nd ed. Abingdon: Routledge, 2005. Print.

Wagner, Geoffrey. *The Novel and the Cinema*. Madison: Fairleigh Dickinson UP. 1975. Print.

Williams, Raymond. *Drama from Ibsen to Brecht*. London: Chatto and Windus, 1968. Print.

CHAPTER 19

RADIO ADAPTATION

RICHARD J. HAND

SOMETIMES we need to remind ourselves that although the technology of radio is older than television, it is much younger than cinema. While the Victorian spectators of the 1890s witnessed the birth of the motion picture, the technology that would lead to the invention of radio existed in theory only. It was the subsequent practical experiments of Guglielmo Marconi, Nikola Tesla, Ronald Fessenden, and others that created what is arguably the first great invention of the twentieth century: the radio. Initially, wireless communication by radio was seen as having value primarily for shipping, the military, and amateur enthusiasts. However, the large number of people who eagerly tuned in to anything they could find on self-made crystal sets and more elaborate receivers proved that there was an audience willing to *listen*. The establishment of stations in the United States and across the world—including the BBC in 1922—witnessed a phenomenal level of public engagement and support, and the expansion of radio listening happened at a rate that even television would not match. The first radio content that the public consumed was news and sports information. This subsequently extended to culture through music and book readings. This culture of the spoken word then began to feature drama. Initially these were plays read out on air or broadcast stage performances, but gradually a new form came into existence: radio drama.

Just as the study of radio has been all but eclipsed by the inventions that sandwich it—cinema and television—the form of audio drama has been similarly eclipsed by the study of visual media dramas. One key reason for this is the optical dimension. The fact that there is nothing to look at when we listen to the radio has, for some, signaled radio's limitations. The fact that radio is the invisible or, it has often been said, the "blind" medium seems to signify its deficiency, as if it were the poor relation that lacks the infinite vistas of the screen. Tim Crook is particularly persuasive in dismantling the myth of the "blind medium," a myth that creates a "sensory hierarchy" (54) that assumes that sound is always inferior to vision. Crook argues that listening to audio drama is a participatory process that is "physical, intellectual and emotional": as a medium, radio's "imaginative spectacle presents a powerful dynamic which is rarely prioritised by alternative electronic media" (66). In other words, radio is not visionless; rather, it facilitates

a particularly rich way of seeing. The current BBC guidelines for radio writing also spell out the powerful vision created by audio drama: "The pictures are better on radio. There's nothing you can't do, nowhere you can't go, and nothing that looks 'cheap.' Nobody will say that they can't afford to build that set, or the lighting's not quite right, or that the bad weather is going to delay production for days. The true 'budget' is that spent between you and the listener—the cost of two imaginations combined" ("Writers' Room").

As much as this statement emphasizes the aesthetic richness of radio drama through the limitless potential of using one's imagination in audio, it also reflects a pragmatic advantage of radio: it is a highly economical form. In an exploration of radio scriptwriting, Shaun MacLoughlin explains that "[y]ou can make the equivalent of a film like *The Lord of the Rings* for a thousandth of the cost" (14). Indeed, BBC radio did this in 1981, producing a serialized version some thirteen hours in duration compared to the eleven hours of Peter Jackson's combined "extended versions" on screen (2001–3) and at much less cost than the filmmaker's $300 million budget.

It is not just on aesthetic and economic terms that radio drama has some expedient advantages as a cultural form: there are practical benefits as well. One is that, as Crook writes, radio "persists and stays with the individual in a greater variety of physical environments compared to other media" (65). Hugh Chignell speaks of the "secondariness" whereby a "listener can easily perform some other activity (work, drive, and so on) while listening and paying attention to the radio" (70). This may conjure up a contemporary image of multitasking individuals listing to podcasts while they keep fit or travel from A to B, but we should remind ourselves that inventions such as the car radio first appeared in the 1920s and steadily grew in popularity from the 1930s onward. The iconic family gathered around the wireless, as if they were waiting for television to be invented, may not be as ubiquitous as the cliché suggests.

Despite the secondariness of radio, the art of listening is a learned skill. Writings by early scholars of radio like Filson Young (1933) are fascinating in what they reveal about the novelty of listening to the spoken word as a cultural practice. As Young explains, radio is not a passive aesthetic experience: "broadcasting has no life until the listener joins himself to it. . . . He is to broadcasting what light is to colour" (14). In order for radio to work as its producers intend, it needs, to some degree, our *active* attention. The fact that the cultural experience of listening may frequently be competing with a secondary activity places as great a challenge on production teams as audiences who risk switching off (sometimes literally). Crook considers this a particular challenge for radio writers, to whom he offers a warning: "Boredom is not listed as one of the seven deadly sins, but for most people it is something to avoid. When this happens you do not exist as a dramatist" (156).

Once mastered, however, the world of audio drama can be almost limitless in scope. Audio drama can take a listener across realms of time and space with convincing verisimilitude and minimum expenditure. This can be particularly the case in genres such as horror and science fiction. For Stephen King, radio is the ultimate form for horror because there is no "zipper" at the back of a monster that the audience can point out and laugh at (136). Even when tell-tale zippers become tacky latex, which in turn become

poorly rendered computer-generated images (CGI), the principle remains the same. In contrast, the nonvisual realm of radio has the potential to be free of these problems. This is why Jim Harmon claims that the Martians in *Mercury Theatre on the Air*'s "War of the Worlds" (1938) were "more convincing than anything the movies have ever provided" (12). Indeed, hundreds of thousands of panicking listeners evidently took the sound of a manhole cover being dragged across a CBS studio floor to signify the opening of a spacecraft as the first sounds of an apocalypse. Similarly, when it comes to the adaptation of horror fiction, radio drama can solve certain problems. Even though H. P. Lovecraft has increasingly become a giant influence and inspiration in horror culture, the screen adaptation of his fiction has not been without difficulty. Arguably, examples of neo-Lovecraftian films like *Evil Dead II* (1987) and *The Cabin in the Woods* (2012) produce more authentic Lovecraft worlds through their processes of playful appropriation than the ostensible cinematic canon of Lovecraft adaptations. In contrast, the audio adaptation of Lovecraft, beginning with "The Dunwich Horror" on *Suspense* in 1945 and including the H. P. Lovecraft Historical Society's ongoing series of dramatizations, beginning in 2007, have produced compelling audio plays that have tended to be more successful in capturing the eldritch—or more appositely suggesting the ineffable—realms of Lovecraft's universe.

More often than any other performance medium, radio drama has been compared to other art forms. Writing on this, Elke Huwiler is happy to acknowledge the "closeness of radio drama and literature in general," but stresses that "even with this closeness, radio drama should be considered as an art form in its own right, with its own intrinsic features" (130). The fact that Huwiler is obliged to emphasize this nearly a century after the first radio play was aired reminds us that audio drama is often seen as a secondary form that is assessed in relation to other forms and media. This enduring tendency is partly explained by John Drakakis's observation that the history of radio drama is "dominated from the outset by the search for material" and from its inception in the 1920s "has always, implicitly or explicitly, sought to measure its achievements against those of the theatre, and of literature generally" (1). The fact that radio drama has always searched for material and has struggled to be seen autonomously, as opposed to standing in direct comparison with other art forms, makes it no surprise that it has always had a particularly profound relationship with adaptation.

Radio drama began wholly as an adaptive medium. The first dramas broadcast on the air were stage plays, including popular stage melodramas like Eugene Walter's *The Wolf*, the first on-air drama broadcast in the United States (1922), and Shakespeare's *Twelfth Night*, the first full-length play aired by the British Broadcasting Corporation (1923). The choice of stage plays was particularly apt, not just because they were performance texts but because they matched the circumstances of broadcast drama. In the first epoch of broadcasting from the 1920s until after World War II, all radio drama in Europe and the United States was created "live." The voice actors, sound effects technicians, and musicians the listeners heard were creating the productions at the moment they were heard. In this regard, radio drama was a form of live theater, a fact that audiences must have understood without question, since pre-recording was not only largely impractical

but prohibited by major networks like NBC and CBS. Hence, the title of the program *Mercury Theatre on the Air* both reflects the fact that a critically acclaimed New York theater company had been given a radio contract and emphasizes that a live theatrical experience was being created for an audience of millions across the United States. Indeed, the CBS announcer who introduced the premiere broadcast of *Mercury Theatre on the Air* ("Dracula," in July 1938) makes this clear when he states that this new series aims to reach "the Broadways of the entire United States."

The fact that radio was entirely live placed a heavy demand on production. The repeats and reruns that so dominate the broadcast of contemporary media drama did not apply in the first epoch. A play might be re-produced with the same or different teams. Agnes Moorehead recreated her leading role in "Sorry, Wrong Number" on *Suspense* live on the air eight times between 1943 and 1960. Frank Sinatra starred in the *Suspense* thriller "To Find Help" in 1945 but was replaced by Gene Kelly in the 1949 revival. Significantly, a play would have to warrant revival and usually did so only on the back of popular audience or critical response. The vast majority of plays were produced on a one-off basis. This is one reason that soap operas and situation comedies came into being, for they permitted creative teams the opportunity to develop and consolidate a story-world that could evolve through time.

Because there were only a finite number of Shakespeare plays to broadcast on radio, as early as April 1925 the BBC produced a radio dramatization of Charles Kingsley's novel *Westward Ho!* The world of classic and popular fiction offered the radio an ocean of source texts to adapt. In the introduction to "The Waxwork," broadcast on *Suspense* in 1959, the program's producer, William M. Robeson, offers a summation of radio drama: "There is an old definition which describes the theatre as a plank on two barrels and a passion. And now we might define radio drama as a microphone, a voice, and a story."

As well as continuing to associate radio closely with theater, Robeson's pithy definition also suggests the inherent simplicity to the form of radio drama. Above all, it is a form that tells a *story*. This importance given to story is repeated in contemporary examples from the industry. Until recently, the BBC's commissioning briefs for radio drama stressed this to all would-be writers:

> We are looking for three crucial things:
>
> Story
>
> Story
>
> Story. ("Commissioning Briefs")

Adaptation facilitates the selection of good stories: tried and tested narratives can be trawled and a scriptwriter can choose and work an already successful story into the audio medium.

As with adaptation in other media, a literary source text can also provide prestige. Indeed, the aforementioned *Mercury Theatre on the Air* was commissioned by CBS "to

ward off federal investigations into radio's overcommercialization" (Hilmes 104): CBS attempted to raise its cultural profile by commissioning Orson Welles and his New York theater company to produce a season of radio plays. The Mercury Theatre met this brief by specializing in adaptation, sometimes adapting stage plays by Shakespeare and Arthur Schnitzler, but mainly giving its audience radio dramatizations of fiction by the likes of Charles Dickens, Alexandre Dumas, Robert Louis Stevenson, Charlotte Brontë, Jules Verne, Joseph Conrad, Thornton Wilder, and, most (in)famously, H. G. Wells. Other series in the same Golden Age of broadcasting would also specialize in adaptation. CBS's *Escape* (1947–54) created a repertoire of some 250 half-hour plays, mainly based on classic or popular adventure fiction. The "high adventure" format and adaptive sourcing of *Escape* would prove influential on later radio, including the CBS series *The General Mills Radio Adventure Theater* (1977–78), which specialized in adaptation, primarily for an audience of families or children. The hour-long adaptations are vividly dramatic works characterized by strong scriptwriting, dynamic voice acting, and evocative soundscapes. The series drew its sources from fairy tales, popular stories from the *Arabian Nights* and Greek legends (from Ulysses to Jason and the Argonauts), classic adventure fiction (*King Solomon's Mines, Treasure Island*, and *Twenty Thousand Leagues under the Sea*), and classics of American literature adapted into fast-paced adventure tales (*Moby Dick, The Last of the Mohicans, The Red Badge of Courage*).

Escape was in many respects the sister series to the longer-running CBS series *Suspense* (1942–62), which also used the classic half-hour, self-contained format. Although less dependent on adaptations than *Escape* and famous for masterpieces of original radio writing like "Sorry, Wrong Number," *Suspense* still featured adaptation as a creative option in its scriptwriting. In fact, the 1940 one-off pilot episode for *Suspense* was a dramatization of Marie Belloc Lowndes's *The Lodger*, directed by Alfred Hitchcock. Hitchcock's film version of the novel in 1927 is one of his early masterworks, and it is not surprising that he returned to this source text in his first venture into radio drama. *Suspense* would feature adaptations of gothic classics like Edgar Allan Poe's "The Pit and the Pendulum" (in 1947 and 1959) and Mary Shelley's "Frankenstein" (in 1952 and 1955), but usually its sources were short stories from contemporary fiction magazines. The lead writer in the opening season of *Suspense* was the crime novelist John Dickson Carr. Carr produced original plays for radio and occasionally adaptations of fiction by himself or other writers, especially Poe. Carr is synonymous with the genre of the locked-room mystery, in which seemingly impossible crimes are explained at the end of the story. Sometimes these whodunits stretch the borders of plausibility, but in many respects they are adaptations "beautifully suited to the form of the thirty-minute thriller on radio" (Hand 53).

The public demand for radio drama in the first epoch must have seemed insatiable. The frantic production schedules that were needed to keep up with the appetites of listeners have become part of the legend of the Golden Age of all-live radio. The fact that adaptation was a staple genre of radio drama and a practical solution to the hunger for output meant that a vast number of dramatizations were produced. In its prolific output, BBC radio continues to have distinct formats for drama, ranging from forty-five-minute

self-contained plays to serialized dramas in daily fifteen-minute or weekly one-hour slots. Original plays for radio are complemented by many examples of adaptation. Indeed, radio adaptation is a particular genre all its own, as evidenced in the prestigious Prix Italia broadcasting awards, which divides international radio drama awards into two categories: "Original Radio Drama" and "Adapted Drama."

Inevitably, multiple versions of canonical literary works crop up throughout the history of radio drama. The fact that the works of Shakespeare, Dickens, and Austen have become sub-generic fields of screen adaptation is equally true of audio adaptation. Moreover, the relative economic viability of radio has permitted the realization of many ambitious projects. For example, in 1977 the BBC aired *Vivat Rex,* an epic twenty-six-part account of the Wars of the Roses mixing the plays of Shakespeare (and other historical and Elizabethan-Jacobean source texts) with new writing. In a major project between 1989 and 1998, BBC radio dramatized Arthur Conan Doyle's complete Sherlock Holmes oeuvre. In 2009–10, the BBC produced a twelve-part dramatization of the complete George Smiley fiction of John Le Carré and in 2011 aired the eight-part *Classic Chandler,* which adapted the entire Philip Marlowe fiction of Raymond Chandler. The BBC continued its completist approach in 2013 with a seven-part adaptation of Evelyn Waugh's *Sword of Honour* trilogy of World War II novels. These major projects are fascinating for their dedication of purpose over the perception of appeal—after all, it is probably fair to say that some Sherlock Holmes stories are better than others. They also remind us of the economic viability of radio: while screen media might balk from undertaking the adaptation of a complete oeuvre, radio can often afford to do it.

The vast output of radio drama means that its rich repertoire of adaptations can extend beyond the standard source texts. It comes as no surprise that there are multiple adaptations of Joseph Conrad's *Lord Jim,* beginning with the BBC's first version in 1927, and *Heart of Darkness,* including two extremely different interpretations by Orson Welles in 1938 and 1945. However, radio has dramatized less familiar Conrad works, such as "The Brute" (on *Escape* in 1948)—an adaptation that in many respects redeems what is often regarded as one of his weakest short stories—and an anthology of short story dramatizations on the BBC's *Tales from the Islands* in 1997. The range of chosen source texts extends to popular genres. Usually acknowledged as the first horror radio series, *The Witch's Tale* (1931–38), created by Alonzo Deen Cole, featured an arch character-host presenting half-hour narratives of melodramatic horror. The huge repertoire of plays featured not only original dramas but also many adaptations of legends (e.g., "The Flying Dutchman" and "The Golem") and fiction. Inevitably, *The Witch's Tale* produced versions of *Frankenstein* and "Strange Case of Dr. Jekyll and Mr. Hyde." But, in a decision that may astonish us in considering what is ostensibly a formulaic program restricted to a single popular genre, it also extended its range to adapt neglected or lesser-known examples of gothic literary fiction by Frederick Marryat, Edward Bulwer-Lytton, Amelia Edwards, Friedrich Heinrich Karl de la Motte, Károly Kisfaludi, Théophile Gautier, Prosper Mérimée, and others.

Radio's need and ability to mine the rich seams of classic literature has also led to some notable examples of pedagogical output and experimentation. One example is

CBS's *Adult Education Series* (1938–57), a "landmark experiment in adult education by radio" (Dunning 6) encompassing a number of separate series, including *Living History*, which dramatized historical events and emphasized their contemporary relevance. Another is *Adventures in Research* (1943–55), an attempt to increase public engagement in science. Beginning with a lecture/discussion format, the series evolved into presenting dramatizations of discoveries and inventions from the history of science. In the area of literary adaptation, the most noteworthy pedagogical series is the *NBC University Theater* (1948–51), which was established by a number of universities in partnership with NBC. Listeners could subscribe to courses for qualifications. The series, which remains a pioneering experiment in distance learning, featured impressive adaptations of a wide range of literary works, often including an interval lecture by a prominent writer or university academic. Unsurprisingly, *NBC University Theater* featured adaptations of Charles Dickens, Jane Austen, Henry Fielding, Charlotte Brontë, and Thomas Hardy (though the choice of Hardy's "The Withered Arm" is unexpected). The series also encompassed world literature in translation, with adaptations of Stendhal, Voltaire, Flaubert, Dostoevsky, and Tolstoy. In addition, *NBC University Theater* dramatized modernist fiction by Virginia Woolf, James Joyce, Ernest Hemingway, D. H. Lawrence, Christopher Isherwood, and Graham Greene. Perhaps most interestingly, the series devoted particular attention to American novelists, including Sinclair Lewis, John Dos Passos, Booth Tarkington, Katherine Anne Porter, Thomas Wolfe, Ellen Glasgow, and Robert Penn Warren. John Dunning sums up the *NBC University Theater* as a combination of "superb drama with university credit," a series with adaptations that were "fully the equal of any commercial radio series and better than most" (482).

BBC radio's most overt adaptation forum is *The Classic Serial*, which dramatizes world literature into self-contained or serialized sixty-minute episodes. The range of its repertoire is impressive. In a single month (March 2013), for example, the series featured radio versions of Charles Kingsley's *The Water Babies*, George Moore's *Esther Waters*, Philip Larkin's novel *Jill*, and Bibhutibhushan Bandyopadhyay's *Pather Panchali*. Other works adapted on *The Classic Serial* have included Giovanni Boccaccio's *Decameron*, which Don Taylor presented in three one-hour segments in 1998. Boccaccio's fourteenth-century prose epic comprises one hundred stories. Taylor's adaptation selects fifteen of these within an overarching narrative frame of a bubonic plague outbreak. The adaptation is well-structured and vivid. The voice of Boccaccio (Roger Allam) sets the context of the Black Death and a group of travelers taking refuge in a remote villa. The travelers pass the time by recounting stories, which are themselves fully dramatized. The yarns they tell are colorful historical tales of adventure and romance, evocatively realized through effective soundscapes and music as much as spirited performances by the voice actors. Significantly, the BBC does not shy away from the bawdy content of some of Boccaccio's original tales. Despite being originally aired at three o'clock on Saturday afternoons, the series features Boccaccio's salacious nuns, roguish priests, and adulterous spouses in all the satirical and erotic glory of the source text.

The fact that the BBC *Decameron* was broadcast on weekend afternoons demonstrates that explicit material can be presented without need for the 9 p.m. "watershed"

that has nominally determined the difference between family and adult viewing for television output by the same corporation. It is as if this medium, which—in contrast to the great slogan of other performance media ("show, don't tell!")—is obliged to tell more than it can show, seems all the safer for lacking literal visuals. This is ironic, because in some respects radio drama is an exceptionally intimate form. In the production of radio drama, a starting point for the training of voice actors is that the microphone is *the ear of the listener*. This quality was recognized early in the history of radio, which was characterized by live broadcasting in the domestic space of the listener. The potential of this intimate address for drama was recognized by early critics: "One of the great properties of radio drama is the intimacy of its appeal to the listener" (Young 137).

Two comparatively early demonstrations of the intimate power of radio are Patrick Hamilton's "Money with Menaces" (1937) and Lucille Fletcher's "Sorry, Wrong Number" (1943). Both these works are pioneering radio thrillers in which the telephone is central to the narrative. Central to the plays' success in building suspense and tension is the fact that the listener is privy to the unfurling action. We are as close to the telephone receiver as if we were holding it ourselves, and we can hear the voice (and breath) of the victim and eventually the tormentor. In "Sorry, Wrong Number" (Figure 19.1), we find ourselves in the claustrophobic environment of the bedridden Mrs. Stevenson as

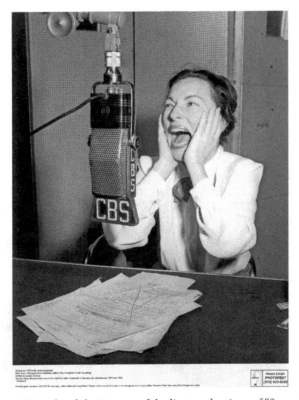

FIGURE 19.1 Agnes Moorehead during one of the live productions of "Sorry, Wrong Number," broadcast on *Suspense* between 1943 and 1960 (Photofest).

we overhear a murder plot and then the (literally) faceless world of telephone operators and emergency services as they are unable, and often apparently unwilling, to help her. The intense and intimate world of this thriller—which plays out in real time (all the action takes place in thirty minutes)—is arguably more effective than Anatole Litvak's 1948 film adaptation of it (Figure 19.2), even though Fletcher adapted the script herself.

In "Money with Menaces," we hear the protagonist, Andrew Carruthers, being blackmailed by a man who has kidnapped his daughter. Hamilton creates a taut and effective thriller by establishing a sense of a seemingly normal day in London, with Carruthers keeping a brave face to all he encounters in order to ensure that his daughter is kept alive, while we join him in hearing the voice of the kidnapper in his periodic phone calls. These plays are a powerful demonstration of the *hierarchy of sound* in audio drama, a concept that gives a sense of the technical construction of audio narrative to create effect and meaning. In "Sorry, Wrong Number," for instance, we are next to the terrified Mrs. Stevenson as the door in the corner opens and her killer approaches the bed and, more distantly, a train whistle eclipses her death screams. In "Money with Menaces," we have the hubbub of the city, Carruthers's confident air while he is at work, and the menacing voice of the kidnapper in the receiver at his ear. Successful deployment of the hierarchy of sound can put us at the heart of the action, centering (and even, for effect, de-centering) us within a dramatic narrative.

FIGURE 19.2 Barbara Stanwyck in *Sorry, Wrong Number* (1948) (screen capture).

"Money with Menaces" and "Sorry, Wrong Number" are both plays written specifi-
cally for radio, and their exploitation of the intimacy of the telephone is at the heart of
their effect. Less successful examples of radio drama are often marked by a tendency
to over-narrate. In fretting about what cannot be seen, some writers overcompensate
with the facile solution of a narrator who can spell out what we are meant to be see-
ing. Alternatively, this expository impulse often produces dialogue that amounts to
another mode of over-narration, as demonstrated in Timothy West's wonderful 1972
spoof of bad radio drama, *This Gun That I Have in My Right Hand is Loaded* (Hand and
Traynor 120–21). In fact, radio writing is at its best when it does not obsess about visuals
and strikes a balance between exposition and suggestion, constructing an ideal narra-
tive experience through the process of creative cooperation with the listener. The prob-
lems of radio writing—over-narration, over-compensation for a lack of visuals, and so
on—are no less a risk in audio adaptation, which in some cases seems to feel obliged to
force us to see. One such example of this is the 2001 BBC radio adaptation of Daphne du
Maurier's *Don't Look Now* (Hand 171–73).

In many ways, audio adaptation is at its best when it succeeds in exploiting the
intimacy of radio. A pioneer in this regard is the *Mercury Theatre on the Air*. In their
approach to radio drama, Orson Welles's theater company worked on the poten-
tial intimacy of the medium. A month after the *Mercury Theatre on the Air*'s opening
broadcast, Welles talks of the "first person singular" technique in the *New York Times*
(14 Aug. 1938), explaining that this approach can make proper use of the intimacy that is
"one of radio's richest possessions." With this device, the audience is no longer an eaves-
dropper but implicit and involved, a decision that permits the possibility of listeners as
co-creators. For Erik Barnouw, the *Mercury Theatre on the Air*'s consistent and innova-
tive deployment of the first person singular "did much to loosen up the whole structure
of radio drama" (2). For James Naremore, Welles and company created the foundation
of the "oral narrative" while acknowledging that the radio was "an intimate piece of
living-room furniture" (13).

At its best, the *Mercury Theatre on the Air* repertoire creates tremendously effec-
tive and experiential adaptations. It goes without saying how much the "War of the
Worlds" radio play fueled listeners' imaginations, creating an almost visceral experi-
ence. However, this production does not eclipse the achievement of the company's
"Dracula," which creates an enthralling intimacy by adhering to the novel's epistolary
format. The *Mercury Theatre on the Air*'s equally effective 1938 "Heart of Darkness"
casts Welles as both the shipmate listening to the story of Marlow—an equivalent to
the framing narrative technique of Conrad's original novella—and also Kurtz. The
production is absorbingly immersive, featuring an effective crafting of Conrad's prose,
atmospheric music, and haunting soundscapes. For Guerric DeBona, the achievement
of the *Mercury Theatre on the Air* involves not merely technique but genuine social sig-
nificance: the "individual, subjective style also helped Welles vitiate between highbrow
and lowbrow cultures when adapting cultural literary capital like the classics" (72). The
democratic potential of radio offers intriguing scope for adaptational interpretation and
exploitation. DeBona's observation takes us back to the airwaves' thirst for—and use

of—adaptations in *The Witch's Tale*'s remarkable repertoire of literary gothic (melo)dramatizations and the *NBC University Theater*'s literature courses.

As an adaptive medium, however, radio does not simply turn to prose fiction. A particularly rich subgenre of audio adaptation is to be found in radio's relationship with cinema. In the United States, a growing number of radio programs that capitalized on a close link between radio and cinema became popular. The most famous movie adaptation show was *Lux Radio Theatre* (1934–55). This series, presented for many years by Cecil B. DeMille, had "the biggest stars, the highest budgets, the most acclaim" (Dunning 416). When listeners tuned in to *Lux Radio Theatre*, they were participating in "the most important dramatic show in radio" (Dunning 416), a truly prolific series that offered all-live radio versions of motion pictures starring the original casts (or suitable equivalents). In 1943, Bing Crosby and Bob Hope starred in a radio version of the previous year's film *The Road to Morocco*, and in 1951 Gloria Swanson and William Holden reprised their roles from the 1950 film *Sunset Boulevard*. If the original film's stars were not available, replacements were made: in 1939 the radio version of *The Awful Truth* (1937) stars Cary Grant but replaces Irene Dunne with Claudette Colbert, and the 1950 radio version of *Rebecca* (1940) starred Laurence Olivier, with Vivien Leigh replacing Joan Fontaine. As Jeffrey Richards explains,

> Although Hollywood had superseded Broadway as a popular attraction, the show retained a theatrical structure. It was performed in three acts, the host referred to "our play," to the curtain rising, to actors coming to the footlights to take a curtain call and so forth. It indicates both that the theatrical structure retained prestige and that a three-act format allowed for commercials without compromising the flow of the dramatic action. (129)

The format is a fascinating example of the domestic consumption of cinema, decades before home video was invented. The fact that it occasionally featured interviews with the source film's costume designers or choreographers was a curious precursor to DVD extras. Crucially, it adapted cinema into theater, thereby creating an intimate relationship permitting "listeners vicarious participation in the romance and glamour of Hollywood" (Richards 129).

The theatricalized adaptations on *Lux Radio Theatre* were shorter than their cinematic sources (usually running sixty minutes) but still present impressive examples of audio dramatization. The strategies adopted in transforming a motion picture into a three-act stage version sometimes included the comparatively simple approach of *précis*: hence on Christmas Day 1950, any nostalgia-hungry listener could hear Judy Garland recreate her role of Dorothy from *The Wizard of Oz* (1939) with a streamlined narrative and all the best songs. Other radio adaptations could be more inventive. For example, in 1951 Bette Davis recreated her role as Margo Channing from *All About Eve* (1950), but a combination of the three-act structure, the economy compelled by the duration of the time slot, and the intimacy of the medium brings out the furious memoir of Margo with particular intensity.

Lux Radio Theatre offered a wide range of work in its repertoire, but as Frank Krutnik explains, "With the heyday of US radio's movie adaptation genre coinciding with what critics have identified as the 'film noir era,' it is not surprising that a large number of films subsequently labelled noir were translated to the airwaves, alongside comedies, dramas, westerns, war films, musicals and films of other genres" (298). In analyzing the *Lux Radio Theatre*'s 1945 dramatization of Otto Preminger's film noir *Laura* (1944), Krutnik finds an adaptation that "loses its [the film's] visual sophistication and its provocative subtextual implications" because of the differences of media and institutional constraints (including commercial sponsorship). Nevertheless, he notes that "[t]here remain fleeting moments . . . where the evocative orchestration of sound allows the programmes to leave their filmic sources behind by capitalizing on radio's potential to summon forth, as the clichéd but apposite phrase has it, a 'theatre of the mind' " (311).

Another critic of the radio adaptation of film noir, Jesse Schlotterbeck, analyzes the 1949 radio adaptation of *The Killers* (1946) on another cinema adaptation series, the *Screen Director's Playhouse* (1949–51). The movie was itself based on an Ernest Hemingway short story, and both the film and radio versions star Burt Lancaster. For Schlotterbeck, film noir scholarship is understandably dominated by an analysis of visual style, dense imagery, and a "catalogue of iconography" (59). Radio adaptations of film noir, however, oblige us to look at the genre's non-visual characteristics in a fulfilling way. Schlotterbeck's summation of the 1949 radio version of the Siodmak film captures the rewards of this comparative analysis:

> If the radio version of *The Killers* is not as elaborate or consistent as the original film, what it loses in fullness, it gains in expressivity. While *The Killers*, like many noir films, works with strikingly indeterminate visual compositions towards an unsettling emotional affect, the radio adaptation logically extends both qualities. It is often less clear and more suggestive than the film version, and, thus, enhances *The Killers* [*sic*] already disturbing tone. According to the men who originally grouped this genre of films, noir amounts to the evocation of strange, unsettling emotions more than anything else. In this respect, the *Screen Director's Playhouse*, in its most effective passages, produces an even darker, disquieting noir than the original. (68)

While Krutnik is acutely aware of radio adaptation's limitations, Schlotterbeck finds a medium that, if nothing else, can compel us to look at neglected aspects of a cinematic genre and at its best can surpass the original in presenting the disturbing aspects of the story.

The extant recordings of radio versions on shows like *Lux Radio Theatre* and the *Screen Director's Playhouse* offer versions that reveal interesting aspects of—and even a commentary on—source films. There is also the fascinating phenomenon of life after film. A particularly striking example concerns Harry Lime, the Mephistophelian anti-hero of *The Third Man* (1949), Graham Greene and Carol Reed's celebrated film set in postwar Vienna. The unscrupulous racketeer Lime (Orson Welles) may appear to be dead and buried at the beginning of the story, but by the end of the film he has been

unequivocally shot dead in the Viennese sewers. However, such was the popularity of the character that he would soon be resurrected on the airwaves. *Lux Radio Theatre* produced versions of *The Third Man* in 1951 and 1954. Even more intriguingly, the BBC produced *The Third Man: The Adventures of Harry Lime* (1951–52), a series of fifty-two half-hour radio plays about the exploits that preceded Lime's final misadventure in Vienna. Orson Welles recreates his film role in the series and is reinvented as a maverick hero as charismatic (albeit not as loathsomely villainous) as the original screen incarnation. Although Harry Lime is a hero, foiling Nazi plots and conning the deservingly gulled, he can still be unscrupulous, and the radio series features surprisingly disturbing and violent moments (Hand and Purssell 68–70). Even if Lime may not be as diabolical as he is in the original film, he is still as recognizably Harry Lime in character as in his literal voice.

Although it perhaps comes as no surprise that radio has adapted examples of popular film, there are also more surprising choices, including adaptations of early cinema. In 1938, the BBC broadcast a live radio adaptation of the 1920 German Expressionist film *The Cabinet of Dr. Caligari*. There is no extant recording, but a surviving production script reveals a radio play that evidently transformed the original film into a "straightforward thriller narrative, even something of a melodrama," even though the detailed notes on music and soundscape reveal an ambitious attempt to create "an aural equivalent of cinematic Expressionism" (Hand 47, 48). Decades later, the BBC returned to German Expressionism with its 2006 adaptation of *Metropolis* (1927). Although the radio version used the film's source text, a short story by Thea Gabriele von Harbou (who herself adapted it into a screenplay with Fritz Lang), the radio play is a boldly contemporary reinterpretation of the work, radically different from the film yet no less disquieting.

One of the most extraordinary landmarks of British radio drama is a compelling exploration of the world of a cinema auteur. David Rudkin's *The Lovesong of Alfred J. Hitchcock*, broadcast by BBC radio in 1993, is a startling biographical drama that takes the listener deep into the psyche of Hitchcock. The audience experiences the memories, obsessions, and creative *modus operandi* of Hitchcock from what feels like the inside of his mind. The prose Rudkin deploys to create the voice of Hitchcock is highly lyrical and reminiscent, as the title suggests, of the poetry of T. S. Eliot. The play uses the cinematic techniques of flashbacks that permit us to hear Hitchcock in the film studio, or as a crying baby, and haunting auditory montages of the voices of his leading actors and actresses. In addition, giving Hitchcock's "Camera" a voice of its own and using extracts from Bernard Herrmann's original film scores enhance this audio experience, which is as uncanny as it is edifying. As David Ian Rabey observes, "(Rudkin's) Hitchcock is . . . sufficiently unafraid to rise beyond interpolating himself between his art and his audience, and raise strange 'lovesongs,' mountainous imaginings hewn from his own personal anguish, which permit an audience to astonish themselves" (164).

Whatever the merits of the 2012 biopics *Hitchcock* or BBC television's *The Girl*, not least the impersonations of the Master of Suspense by Anthony Hopkins and Toby Jones, respectively, the films' strategies of emulation and portrayal do not have the immersive intensity of the radio play and Richard Griffiths's flawless vocalization of the subject.

Rabey concludes that this audiophonic biography resists "reductivism" and is a virtuosic treatment of radio that "opens out the process of defining meaning in an art, a life, and their confluences" (164).

The haunting quality of *The Lovesong of Alfred J. Hitchcock*'s fact-based defamiliar-ization reveals the potential of biographical drama, a subgenre of adaptation that has particular distinction in audio form. Some examples include BBC radio's collaboratively written *The Cemetery Confessions* (2004), a playful celebration of the Père Lachaise graveyard in Paris, which gives monologues to some of the famous people buried there, from Colette to Jim Morrison. Other examples have demonstrated an impressive social consciousness. The BBC's *Black Roses: The Killing of Sophie Lancaster* (2011) explores the tragic true story of the victim of a hate crime through the powerful interleaving of recordings of the victim's mother and a series of poetic monologues written by Simon Armitage that give voice to the victim. Another fact-based audio adaptation, Charlotte Williams's *Well, He Would, Wouldn't He?* (2013), explores the 1963 scandal surrounding the British government minister John Profumo through the perspective of Mandy Rice-Davies, one of the women centrally involved in the sensational affair. The play features monologues from Rice-Davies herself, as she remembers and analyzes the incidents of a half-century before, interleaved with dramatizations of Rice-Davies's life as she comes to London and is gradually embroiled in the scandal. As well as functioning like *Black Roses* in mixing authentic testimony with dramatic interpretation, Williams's play is another example of the remarkable potential of radio's intimacy. In a startling scene, Rice-Davies arrives at a club in London to audition as a dancer and is obliged to strip naked. The fact that she was under eighteen at the time would make the scene some-what disturbing and highly problematic for interpretation on television, especially at the play's original afternoon slot.

Our contemporary digital culture is a particularly rich epoch for radio drama. Streaming audio, torrents, and downloads have made archival recordings of vintage US radio more easy to obtain than ever before, sometimes in better quality than our prede-cessors could have imagined. In addition, podcast culture has permitted the creation and dissemination of new audio work on an unprecedented scale. We can, if we wish, listen to a wealth of international amateur or university audio dramatizations. At the same time, audio companies like Chatterbox Audio Theater in the United States and the Wireless Theatre Company in the United Kingdom are producing professional work that continues to raise the medium's profile and expand its audience. While these companies expand their outreach and audience, the BBC continues to broadcast and, through its web presence, to make audio drama available in a variety of ways. Although generally limited by time constraints, the BBC iPlayer allows listeners to catch up at their own convenience with audio plays after their initial broadcast. The BBC website has also facilitated audience engagement with radio drama on an unprecedented scale by host-ing supporting materials and participatory forums for perennially popular dramas such as *The Archers* and experimental listening experiences like Graham White's landmark 2010 adaptation of B. S. Johnson's *The Unfortunates*. Johnson's experimental novel was first published in 1969 as a box of loose chapters. Although the BBC radio version was

first aired in a fixed order, the subsequent web version permitted the listener to take a random approach to the dramatized chapters, in keeping with the spirit of Johnson's original text(s).

Listening to radio drama is a learned skill, not so different from reading. We sometimes have to learn how to follow an audio narrative while multitasking, as every radio writer must take into account. Nevertheless, when audio drama works well, it can combine sound, music, voice, and narrative consummately. Radio can provide us with dramatized adaptations that are conventionally impressive, innovative, or historically significant. The radio adaptation of literature has ranged as widely in its forms as in its purposes. At its best, it can immerse us in the heart of a story, even if it literally shows us nothing. Similarly, the audio dramatization of cinema throws a fascinating perspective on its source texts. The same can be said of radio drama and its relationship with historical actuality, including biography.

In discussing the function of radio drama, Tim Crook contends, "By giving the listener the opportunity to create an individual filmic narrative and experience through the imaginative spectacle the listener becomes an active participant and 'dramaturgist' in the process of communication and listening" (66). Crook's choice of the terms "filmic" and "dramaturgist" is highly significant. Although we may heed Elke Huwiler's plea to consider audio drama as "an artistic work in its own right" that creates a story world with the "intrinsic features of the auditive medium" (139), we should note the significance of Crook's deliberate borrowing of terms from other performance media. One way to understand the potential of the neglected medium of radio drama is to consider ourselves as the co-creators of unique personal cinematic or theatrical experiences in a distinctive mode of performance that restricts itself to exploiting the multiple languages of sound.

Works Cited

Barnouw, Erik, ed. *Radio Drama in Action: Twenty-Five Plays of a Changing World*. New York: Rinehart, 1945. Print.

Black Roses: The Killing of Sophie Lancaster. By Simon Armitage. Dir. Susan Roberts. BBC Radio, 24 Aug. 2011. Radio.

The Cabin in the Woods. Dir. Drew Goddard. Perf. Kristen Connolly, Chris Hemsworth. Lionsgate, 2012. Film.

Chignell, Hugh. *Key Concepts in Radio Studies*. London: Sage, 2009. Print.

"Commissioning Briefs." British Broadcasting Corporation. Web. 14 July 2010.

Crook, Tim. *Radio Drama: Theory and Practice*. London: Routledge, 1999. Print.

DeBona, Guerric. *Film Adaptation in the Hollywood Studio Era*. Urbana: U of Illinois P, 2010. Print.

Decameron. By Giovanni Boccaccio. Adapt. Don Taylor. Dir. Don Taylor. BBC Radio, 12 July 1998. Radio.

Drakakis, John. *British Radio Drama*. Cambridge: Cambridge UP, 1981. Print.

Dunning, John. *On the Air: The Encyclopedia of Old-Time Radio*. Oxford: Oxford UP, 1998. Print.

Evil Dead II. Dir. Sam Raimi. Perf. Bruce Campbell, Sarah Berry. DEG/Renaissance, 1987. Film.

Hand, Richard J. *Listen in Terror: British Horror Radio from the Advent of Broadcasting to the Digital Age.* Manchester: Manchester UP, 2014. Print.

Hand, Richard J., and Andrew Purssell. *Adapting Graham Greene.* London: Palgrave, 2015. Print.

Hand, Richard J., and Mary Traynor. *The Radio Drama Handbook: Audio Drama in Practice and Context.* New York: Continuum, 2011. Print.

Harmon, Jim. *The Great Radio Heroes.* New York: Doubleday, 1967. Print.

Hilmes, Michelle. *Radio Reader: Essays in the Cultural History of Radio.* New York: Routledge, 2002. Print.

Huwiler, Elke. "Radio Drama Adaptations: Approach Towards an Analytical Methodology." *Journal of Adaptation in Film and Performance* 3.2 (2010): 129–40. Print.

King, Stephen. *Danse Macabre.* London: Futura, 1982. Print.

Krutnik, Frank. "'Barbed Wire and Forget-Me-Not': The Radio Adventures of Laura (1944)." *Journal of Adaptation in Film and Performance* 5.3 (2012): 283–95. Print.

The Lovesong of Alfred J. Hitchcock. By David Rudkin. Dir. Philip Martin. BBC Radio, 14 Mar. 1993. Radio.

MacLoughlin, Shaun. *Writing for Radio.* Bristol: Soundplay, 2008. Print.

Money with Menaces. By Patrick Hamilton. Dir. Laurence Gilliam. BBC Radio, 4 Jan. 1937. Radio.

Naremore, James. *The Magic World of Orson Welles.* Dallas: Southern Methodist UP, 1989. Print.

Rabey, David Ian. *David Rudkin: Sacred Disobedience: An Expository Study of His Drama 1959–1994.* London: Routledge, 2013. Print.

Richards, Jeffrey. *Cinema and Radio in Britain and America 1920–60.* Manchester: Manchester UP, 2010. Print.

Schlotterbeck, Jesse. "Killing Noir?—The Adaptation of Robert Siodmak's The Killers to Radio." *Journal of Adaptation in Film and Performance* 3.1 (2010): 59–70. Print.

"Sorry, Wrong Number." By Lucille Fletcher. Dir. Ted Bliss. Suspense. CBS Radio, 25 May 1943. Radio.

The Unfortunates. By B. S. Johnson. Adapt. Graham White. Dir. Mary Peate. BBC Radio, 2 Oct. 2011. Radio.

"This Gun That I Have in My Right Hand Is Loaded." By Timothy West. Unproduced training radio script. BBC. 1972. Web. 15 July 2015.

"The War of the Worlds." By H. G. Wells. Adapt. Howard Koch. Dir. Orson Welles. *Mercury Theatre on the Air.* CBS Radio. 30 Oct. 1938. Radio.

Well, He Would, Wouldn't He? By Charlotte Williams. Dir. Kate McAll. BBC Radio, 23 Feb. 2013. Radio.

"Writers Room: Writing Radio Drama." British Broadcasting Corporation. Web. 30 Aug. 2014.

Young, Filson. *Shall I Listen: Studies in the Adventure and Technique of Broadcasting.* London: Constable, 1933. Print.

CHAPTER 20

TELENOVELAS AND/AS ADAPTATIONS

Reflections on Local Adaptations of Global Telenovelas

STIJN JOYE, DANIËL BILTEREYST,
AND FIEN ADRIAENS

INTRODUCTION

ALTHOUGH the telenovela has a long and successful history, particularly in Latin American countries, telenovela exporters have faced many difficulties in establishing and consolidating the format's international success. Despite modestly successful attempts to conquer European television markets in the 1980s, the worldwide export of the original telenovela series struggled with overcoming Western audiences' aversion for subtitled or dubbed programs, which is related to their strong preference for domestic fiction (Biltereyst and Meers 404–5). In the twenty-first century, however, telenovelas as a genre and format have experienced a renewed and larger international success, linked to the rapid global expansion of the format trade (Dhoest and Mertens 110) and, primarily, to the related rise in local adaptations of Latin American telenovelas. Spearheading the present revival is the Colombian telenovela *Yo soy Betty, la fea* (1999–2001), which was adapted in nearly twenty countries, including Belgium, Germany, India, Russia, Turkey, and the United States (Moran, *New Flows in Global TV*). In addition, the original series, unlike previous series, has also been dubbed or subtitled and successfully broadcast around the world, in Bulgaria, Brazil, China, the Czech Republic, Georgia, Hungary, Italy, Japan, Malaysia, Mexico, Poland, Spain, and many other Asian and European countries (Akass and McCabe; Moran, *New Flows in Global TV*). Albert Moran further notes the widespread existence of various unofficial copycats and spin-offs of the original show (*New Flows in Global TV*, 103). Apart from demonstrating effective corporate strategies for production, distribution, and marketing, the international success of *Yo soy Betty, la fea* is largely informed by its distinctive mix of universal themes and the format's

culturally adaptable characteristics (Adriaens and Biltereyst 556). In other words, the practice of locally adapting telenovelas manages to reconcile the well-known tensions between global and local appeal and between familiarity and novelty by embodying them in one successful media product. This media product is likewise caught in a complex connectivity (Tomlinson 26) that involves "television cultures and industries, as well as multiple discourses of identities—socio-cultural, economic and consumer, ethnic and racial, global and local" (McCabe 4). The broader societal process of cultural globalization has stirred popular and scholarly interest in the practices of adapting texts from one culture to the other (Hutcheon 145). In our take on telenovelas as adaptations, we follow Linda Hutcheon (7–8) in her definition of adaptation as a product. This product—in this case, the local adaptation of a global telenovela format—is the outcome of a shift in context within the same medium that results in a change or reformatting of the original text in terms of language, place, or narrative. Telenovelas can be seen as a form of transcultural adaptation that requires a resetting or re-contextualizing (Hutcheon 145), which often equals (extra-)textual changes in order to fit in with the prevailing values, preferences, viewing habits, and local sensibilities of the adapting culture.

In this brief essay, we will reflect further on how the worldwide spread of the telenovela format from Latin America redefines assumptions about the national and cultural specificity of its specific narrative formulas. The particular practice of local adaptations challenges adaptation studies' focus on the text by encouraging us to examine more closely the relation between the source text of the original telenovela and its locally adapted text. A number of extra-textual features and contexts (cultural context, production context, format industry, language issues, and so on) have substantial implications for the ostensibly universal narrative of the source text. In developing this argument, we draw on findings from several international inquiries into contemporary globalized and domestically adapted telenovelas by focusing on the ways they have been embedded in different geopolitical and cultural contexts. Given its widespread popularity and its key role in re-establishing the telenovela as a successful global format, the Colombian telenovela *Yo soy Betty, la fea* and its numerous local adaptations are a useful and important starting point for reflecting on the relation between telenovelas and the process of adaptation. According to Janet McCabe, the show is generally acknowledged as a modern global media phenomenon whose story "has circulated internationally through different *mediascapes* (the production and distribution of images) and *ideoscapes* (political and ideological messages) and often translated in surprising (not wholly anticipated) and inventive ways" (1–2, italics in original).

DEFINING TELENOVELAS: FORMAT, GENRE, AND NARRATIVE

Since gaining rapid popularity in Latin America during the 1950s, the telenovela has developed into a complex cultural product with generic, social, and cultural roots that

reach deep into Latin American history (La Pastina, "Telenovela Reception"). Before turning to the (Latin American) telenovela as the object of adaptation and replication, it is necessary to take a closer look at this broad category of the telenovela, a complex cultural phenomenon given its roots in divergent historical, political-economic, and cultural environments. Although telenovelas are often considered easily recognizable products on the international television market—characterized as they are by their specific (Latin American) cultural references, their highly melodramatic modes of storytelling, and their closed narrative—research into this (meta-)genre underlines how telenovelas differ noticeably in their use of themes, narrative styles, and production values (Straubhaar, *World Television* 152).

One of the reasons for overlooking these differences is that telenovelas have often been viewed from an outsider's perspective, and accordingly have been seen as another, distinctive sort of serialized television melodrama, more or less comparable to the better-known US, Australian, British, or other European soap operas. In his landmark 1995 volume *To Be Continued: Soap Operas around the World*, Robert C. Allen argues that Western soaps are characterized by narrative openness, by a lack of an "ultimate moment of resolution," and by the absence of a "central indispensable character," whereas Latin American telenovelas are "designed to end and their narratives to close— although this closure might not be achieved until after several months or 200 episodes" (18, 23). Allen claims that this closed narrative structure has many implications, including the viewer's opportunity to "look back upon the completed text and impose on it some kind of moral or ideological order" (23). Hence telenovelas' closed narratives are "inherently melodramatic in nature."

More recent research in Latin America has brought forward a much more nuanced view of the institutional, political-economic, and cultural context in which these programs are made and received. One characteristic feature of the scholarship on telenovelas is to underline their national differences. Arguing that the telenovela is the genre that facilitated the insertion of Latin American audiovisual culture into global markets, Ana M. Lopez, for instance, argues that the telenovela can be differentiated by using national characteristics: Brazilian telenovelas are considered "more realistic," often "addressing social issues," whereas Mexican examples are believed to be "more melodramatic and conservative," and Colombian examples "are best known for their use of literary and historical themes" (169). Trying to go beyond these national characteristics, other studies have looked at historical shifts within the telenovela category within one country by focusing on the changing political-economic, institutional, and cultural context. Historical work on the Brazilian telenovela, for example, has referred to the implications of wider shifts in Brazil's socio-political landscape for the production of telenovelas. Mauro Porto recalls that during the period of political opening under the military dictatorship (1974–85), telenovelas "responded to the economic crisis, the growth of the opposition and the rise of a more organized and active civil society" (65). These more critical representations of the nation were often reserved for the late-night melodramas, which had smaller audiences. The re-democratization went hand in hand with a greater

freedom for telenovela writers, who commented on contemporary social and political problems like corruption and social inequality (Porto; Ribke).

A further move away from a monolithic understanding of the telenovela format concerns the various traditions and related media outlets that lie behind the (meta-)genre, with the influence of early literary genres (e.g., the Brazilian *romance-folhetim*), *fotonovelas*, theater, circus, and *radionovelas* (Brennan 547–49). It is now accepted that, as Brennan argued, the telenovela evolved into a relatively open meta-genre that cultivated an essentially melodramatic mode, but whose hegemony is invaded by "other 'territories' of fictionality, such as a comedy, adventure, police drama, the fantastic and the erotic" (550).

Despite these internal differences, telenovelas continue to foster a melodramatic emphasis on strong pathos (Singer 7) with heightened emotionality, moral polarization, non-classical narrative mechanisms, spectacular effects, and often stylistic excess. In the specific case of telenovelas, the basic precepts include soap-opera themes and an aspirational, often Cinderella-like love story consistent with a closed-arc run and multi-episodic showings (Conway 596; Zbar 26). A defining feature of telenovelas still concerns the choice of limited-run content or end-stopped stories (120–200 episodes) and daily scheduling, "which serves to capture and maintain a steadfast and transfixed audience" (Miller 204). The stories further adopt a highly conventional narrative structure without usually identifying one specific source, since telenovelas mostly draw on values and archetypes that relate to many cultures. For instance, Kyle Conway (590) refers to typical story lines that draw heavily on such common themes as love, redemption, and the overcoming of hardship. Scholars from Veneza Ronsini to Fien Adriaens and Daniël Biltereyst (553) have identified class conflict and social mobility as major themes within the telenovela discourse. Other characteristics of traditional telenovelas that recur, often in different combinations or in dialogue with each other, include the presence of suspense and emotion, a heterosexual love story, the use of triangles, the enforced bipolarity between good and evil, the use of music to create emotional identification, the use of real-life events in the plot, naturalistic acting, and improvisation (Acosta-Alzuru; Allatson; McCabe; Tufte). For many, the (meta-)genre's success is inextricably related to an intrinsic formula that usually comprises melodramatic stories with universal appeal (such as rags-to-riches and Cinderella-like love stories) and globally resonant archetypes with which viewers can easily identify (Miller 213). Given the replication of universal stories and the genre's heavy reliance on standardized elements, telenovelas strive to balance the predictability of the familiar and well-established themes, archetypes, and narratives related to generic telenovela conventions with the vital element of surprise or novelty (Dhoest and Mertens 103), echoing Hutcheon's statement that successful adaptations depend on both repetition and variation. For the audience, the pleasure of viewing lies in recognition and remembrance, on the one hand, and the refreshing feeling of perceived change, on the other (Hutcheon 4–5).

With respect to the narrative structure, many story lines of telenovelas are further characterized by what is identified as the flexi-narrative form: "mixtures of the series

and the serial form, involving the closure of one story arc within an episode (like a series) but with other ongoing story arcs involving the regular characters (like a serial)" (Nelson 82). This particular structure allows new viewers to start watching at any time, while the continuing story line, with a clear beginning, middle, and end, keeps the viewers hooked, like soap opera addicts (Dhoest and Mertens 102). According to Antonio C. La Pastina and Joseph D. Straubhaar, the use of such well-known narrative formulas and archetypes, proven to attract a broad range of audiences, is essential in facilitating successful export to other cultures (Conway 590).

Telenovelas and Adaptation Studies: Fidelity and the Process of Replication

In its young history, the academic discipline of adaptation studies has focused on theorizing the practice and in particular the relationship between source novel and film, often restricting itself to (exclusively text-based) one-on-one comparisons between the source text and its adaptation. In recent years, scholars like James Naremore, Robert Stam ("Introduction"), Thomas Leitch (*Film Adaptation*), and Linda Hutcheon have attempted to broaden the field in terms of its scope and research objects. The widening of the range of adaptation studies to include such non-literary adaptations as television serials, videogames, and telenovelas has been complemented by a call to take into account extra-textual aspects that formerly had been largely neglected, such as the commercial apparatus of the media industry or the audience. According to Leitch, this vital redefining of adaptation studies also throws "a new light on the subject of adaptation and suggests a possible alternative to the chimerical quest for fidelity" (*Film Adaptation* 258). This issue of fidelity, which has been the object of much debate within the field of adaptation studies ever since the first scholarly work on the practice of adaptation, is highly relevant to any discussion of telenovelas as adaptations, given the (extra-)textual transformations that follow the export of the telenovela format and its local adaptation.

Although the discourse of fidelity has repeatedly been attacked within academia (Brooker 45; Leitch, "Twelve Fallacies"), Deborah Cartmell and Imelda Whelehan (12), as well as Stijn Joye and Tanneke Van de Walle, observe that it continues to dominate popular reviews, fan appreciation, and conventional criticism alike. Gary R. Bortolotti and Linda Hutcheon (444–45) have proposed an interesting way to move beyond the fidelity-related theoretical impasse in adaptation studies by conceiving adaptation as a process of replication. Drawing on Richard Dawkins's concept of the meme, a self-replicating element of culture that is passed on by imitation, they regard narratives as replicators that require a vehicle through which they become externalized and hence replicated. The adaptation, as the vehicle for the narrative idea to be replicated, should

be regarded as an independent work whose success is not determined by the adaptation's faithfulness to the original. By contrast, the factors that ensure the success of a narrative as it competes with other narratives include a measure of diversity—that is, the proliferation of forms in which the narrative is adapted and the range of different cultural environments exploited and thus audiences reached (Bortolotti and Hutcheon 450–51). The latter is clearly exemplified by the practices of the telenovela industry in exporting the format to worldwide audiences and in adapting it to local markets in order to reach as many audiences as possible. According to McCabe, choosing a format that has proven its success and aiming to replicate that success elsewhere is "one of the most significant elements in the adaptation process" (10).

Telenovelas embody Bortolotti and Hutcheon's idea of adaptation as a process of replication in other significant ways as well. Telenovelas as a genre emphasize the element of replication illustrated by the aspirational, Cinderella-like love story that is common to almost all telenovela series. Telenovelas as a widely exported format emphasize the transformations following the change in cultural environment and context (cf. Bortolotti and Hutcheon 448), even though the local adaptation also reproduces or replicates the same basic narrative premises. The degree of faithfulness to the original is further fixed by the negotiations and licensing agreements between the format exporter and the production company that purchased the rights to make a local version. Most adaptations remain quite faithful in following the closed-arc run and multi-episodic showing format, while in terms of content and narration, the dominant romantic or melodramatic tone and outlook of the plot are generally kept unaltered, along with the main characters' typology and constructed conflicts (Dhoest and Mertens 111). Changes in the adaptation process thus occur on a more micro-level of the text by introducing often seemingly superficial narrative details that localize the story, alongside changes that concern such extra-textual features as the production values, scheduling the program to fit the viewing habits of the targeted audience group, or casting local actors to give the adaptation a local touch and to create a sense of cultural credibility (Adriaens and Biltereyst 563; Dhoest and Mertens 111; Zbar 26).

Moran (*New Flows in Global TV* 46–52) identifies three broad categories of transformations that can take place in the process of adapting a global television format like the telenovela. The first involves forms of "linguistic-code" translation, which refers to the poetics of television in terms of the different specificities of form and style. The second concerns "intertextual-code" translation, which concerns practices of adaptation according to local television production and the technical or generic standard of the domestic media market. The third is "cultural-code" translation: the localization of a format involving issues such as gender relations, history, language or accents, geography, ethnicity, public behavior, and cultural values at large. Cultural-code translation thus encompasses the combination of social and cultural factors "that make for communal and national difference" (Moran, *New Flows in Global TV* 50).

We turn now to these more practical issues that are raised when locally adapting a telenovela format in television markets over the world.

Adapting Telenovelas: Mixing Global Formats with Local Contexts

According to Conway (584), a large body of scholarly work within the field of adaptation studies is preoccupied with studying "the circulation of texts across cultural and linguistic lines," but neglects the issues of power that are at play in this context. In consequence, Conway has urged adaptation scholars to pay more attention to how the industrial logics that govern the global circulation of programs also shape them as texts. This call echoes Stam's call for a meaningful sociology of adaptation "as a kind of multi-leveled negotiation of intertexts" ("Beyond Fidelity" 67) that can incorporate textual and industry analysis within the same research design. Drawing on the case of *Yo soy Betty, la fea* and its circulation in the United States as well as the local adaptation (*Ugly Betty*, 2006–10), Conway's analysis reveals a wide range of forces that can have an impact on the decision to locally adapt a text as well as its final outcome. Central to his argument is a series of economic or structural forces. Telenovelas are cost-effective to produce, both for a domestic audience and for export, because of their easy-to-localize themes. They can create a loyal fan base (Adriaens and Biltereyst 556) and attract underserved and growing markets, such as the Hispanic community in the United States. Given the US television industry's history of limited program imports (Kunz), however, marketing executives have preferred to adapt, rather than broadcast the original telenovela series, in order to appeal to the broader US market. The lack of openness of a broadcast market to international programs is thus a decisive structural factor in making a local adaptation (Conway 591).

Another prominent reason to adapt a global telenovela format locally can be found among the audience's expectations and viewing habits. The viewing habits of a domestic audience are a good example of how macro-level factors can influence or transform the text. Contrary to most Latin American telenovelas with fixed daily scheduling, local adaptations often opt for different program scheduling. In the United States, network executives programmed *Ugly Betty* as a weekly hour-long show, since such a schedule was more familiar to US viewers than the Colombian original's schedule of five nights a week (Conway 593–94). In Flanders, the Northern, Dutch-speaking part of Belgium, *Sara*, the very successful local adaptation of *Yo soy Betty, la fea*, followed a combination of both program strategies. In addition to scheduling the show on weekdays at 6:30 p.m., its distributors showed it at the end of the week in an omnibus edition in order to increase the series' popularity and advertising income, since the audience's unfamiliarity with the new genre made restricting its broadcast to weekdays too financially risky (Dhoest and Mertens 101). Furthermore, the program schedule is largely influenced by the local executives' understanding of the domestic culture (McCabe 9). It is obvious that such structural choices of scheduling also have an impact on the pacing of a story and its narrative development.

In terms of viewer expectations, telenovelas as well as their local adaptations generally thrive on a series of cultural clichés that are consciously and knowingly exploited

by the producers, mostly to confirm viewer expectations, and sometimes to contradict them, in order to introduce the desirable element of surprise in the show (Dhoest and Mertens 103). Most Western audiences, unfamiliar with the specific format of telenovelas and their generic conventions (Conway 591), have had limited knowledge of the narrative patterns and visual stylistic elements of the genre (Mikos and Perrotta 85). A local version can help to overcome this obstacle by providing the audience with a sense of familiarity: recognizable actors and localized themes to which the audience can more easily relate. The telenovela format is exemplary for this practice, as telenovelas have been successfully adapted in regions outside Latin America, particularly in Western Europe. As Biltereyst and Straubhaar ("Beyond Media Imperialism") have pointed out, a television format's commercial success is closely tied to its resonance with the audience's local and national culture. La Pastina and Straubhaar (273) argue that audiences prefer television programs that are "closest, most proximate or most directly relevant to them in cultural and linguistic terms" (Straubhaar, *World Television* 199). As domestic television programs remain the most popular among viewers, the practice of adapting an international format has become a successful way of satisfying such viewers' demands while simultaneously boosting a global format industry. Even so, local producers are not entirely free to do what they want with the original material but are bound to the so-called bible of format production (Zhang and Fung).

LOCALIZATION: INSPIRING EXTRA-TEXTUAL AND TEXTUAL TRANSFORMATIONS

A great many transformations to the telenovela narrative are driven by the central factor of localization. Moran attributes the localization tendency to a diverse set of influences, such as alterations in national television systems caused by privatization, deregulation, and the proliferation of novel distribution technologies, which have multiplied the availability of television channels within national spheres (*TV Formats*). He notes as well that protectionist policies may also encourage producers to adapt their contents to local considerations by employing domestic production personnel (*TV Formats*). The concept of localization encompasses a number of distinct processes (Waisbord and Jalfin 57). Particularly relevant to the issue of telenovelas and adaptation is a specific understanding of localization as the power that domestic media industries or local media markets hold amid the increasing intricacy of media flows and global industries of, for example, television formats (Straubhaar, *World Television*). This is what Robertson has called the power to "glocalize," or, as McCabe defines that process, to "absorb and localize foreign influences into domestically created products" (10). Significant for this take on localization is what Moran calls a wide variety of cultural proximities, such as language, ethnicity, history, religion, geography, and culture, that allow for the adaptation of the original series into a local version that takes into account communal and national differences (*TV Formats* 50).

Adriaens and Biltereyst identify gender relations and public behavior as additional areas of cultural sensitivity that must be considered when studying local adaptations of a television show (555). In the case of local adaptations of telenovelas, La Pastina and Straubhaar stress several cultural components, such as local dress codes, ethnic types, body language, humor, ideas about story pacing, music, and religious elements. The success or failure of a localized adaptation, however, lies not in the process of remaking the telenovela, but rather in the local audience's process of recognition, identification, and appreciation (Moran, *New Flows* 52). To achieve local resonance, adaptations commonly make use of national identity discourses, which reiterate national stereotypes, clichés, and myths in an endeavor to be recognizable and to create a sense of authenticity and truthfulness (Adriaens and Biltereyst 555). It is worth taking a closer look at some of these practices of localization and the extra-textual transformations that take place during the process of adaptation.

In analyzing *Ugly Wu Di* (2008–9), the Chinese version of *Ugly Betty*, Xiaoxiao Zhang and Anthony Fung (507) have concluded that the local producers differentiate ideological points of contestation and modify narratives that contradict the prevailing Chinese ideology, for instance with regard to representations and discourses of ethnicity, gender, and sexuality. In a previous study of the same show, Fung and Zhang (274) demonstrated how the modifications in the Chinese version tried to merge the demands of market forces with those of the paternalistic state, as its producers sought to embrace the global popular aesthetics of modern television dramas while simultaneously reconciling the program with the local ideological standards of an authoritarian state and a conservative society. Nevertheless, their analyses also revealed that through format localization the telenovela brought global lifestyles and typical Western values of sexuality, social norms, and political culture into China, thus acting as "a de facto cultural bridge" (Fung and Zhang 274). These findings support the claim by Conway (584) that issues of power should be integrated more in scholarly work within the field of adaptation studies. Similar socio-political shifts occurred in the adaptation of the telenovela in Russia and the Czech Republic, where "the Cinderella storyline was adapted to negotiate the transition from socialism to capitalism in a post-socialist society" (McCabe 18) and the adaptation addressed pressing local issues of class, economic, and social conflicts. In the United States, textual changes in *Ugly Betty* due to localization concerned the setting of the story (a fashion magazine instead of a fashion studio), multi-ethnic casting choices, and a reshaping of the (sub)themes in order to make them more familiar to the average American viewer (Conway 594).

Recent studies by Adriaens and Biltereyst and by Dhoest and Mertens provide a more detailed exploration of adaptation by and through localization in a Western European context. Both pairs of scholars observed *Sara* (2007–8), the Flemish adaptation of *Yo soy Betty, la fea*, which is based on the original Colombian telenovela but also inspired and influenced by other foreign adaptations of the show, particularly the successful German adaptation, *Verliebt in Berlin* (2005–7). The latter inspired the producers to create new characters that were less easily categorized morally and to increase the narrative's intricacy by adding numerous subplots and ancillary stories and providing the

characters with complex life stories to enable a better understanding of their behavior (Adriaens and Biltereyst 560; Dhoest and Mertens 104). Such changes are predicated on local viewers' acquaintance with and anticipation of more familiar modes of narration than those of the telenovela. Overall, the producers of the show enjoyed a relatively wide liberty to transform the original telenovela. Given the need to adapt the script to the local Belgian context and to generate identification and recognition among Flemish viewers (Adriaens and Biltereyst 558–59), the producers inserted into the adapted text a large number of closely interrelated proximity markers: the local language or dialect and classic Dutch-language names, including the choice of *Sara* as the title of the series (the woman's name Sara ranked as one of the most popular in Flanders); the series' location in a real Flemish city (Antwerp) with recognizable landscapes; familiar clothing styles and interior designs; numerous references to typical Flemish or Belgian services, products, and culinary specialties; and national stereotypes, such as the habit of keeping one's salary a secret or the appeal of the underdog in Flemish culture (Adriaens and Biltereyst 561; Dhoest and Mertens 104, 109). In aiming for escapism, the producers also relied heavily on strong comic types and clichés to keep the local adaptation consciously lighthearted (Dhoest and Mertens 103).

Some of the most visible or thorough transformations of the original source material thus correspond to Moran's category of cultural-code translation. But there were also obvious instances of linguistic- and intertextual-code translations. The creative process of rewriting and retelling the original story was subject to budget-related restrictions as well as specific guidelines imposed by the commercial broadcaster concerning production values, scheduling, and advertising practices. For instance, the network explicitly instructed the producers to integrate some of the factors that had contributed to the success of previous local series, such as narrative complexity, pace, and the casting of well-known local stars. For marketing and publicity reasons, the narration of the telenovela had to be structured around two large commercial breaks. Other market logics, such as product placement, further determined the development of the script (Adriaens and Biltereyst 559).

These studies all confirm the defining role of political, cultural, and commercial imperatives when replicating, recycling, or re-creating a global media product such as a telenovela in different broadcasting territories and cultures around the world. In their strategic search for credibility, authenticity, and audience success, producers of local adaptations rely on a wide range of adjustments to national contexts and identities—language, geography, gender relations, history, ethnicity, and cultural values (Adriaens and Biltereyst 562)—even as they consider market logics and local production values. Telenovelas as transcultural adaptations adjust their content, themes, and visual styles to suit the conditions of the local market, but also create hybrid formats that mingle the conventions and vocabularies of different genres (Mikos and Perrotta 92–93). Nevertheless, local adaptations remain quite faithful in incorporating and reproducing the more transnational features and themes of the original telenovela, such as the universal tale driven by a melodramatic mode and recognizable social and family values that entail numerous possibilities for identification, entertainment, and escapism. By

playing on these wider universal themes and features, telenovelas carry the potential through their format adaptations, as well as through the export of canned or subtitled versions to transgress cultural boundaries (Adriaens).

CONCLUDING REMARKS

The broader genre and format of telenovelas touch upon several problems that have been widely debated in adaptation studies, including issues of fidelity and replicated narratives, alongside notions of familiarity and novelty. Studying the practice of locally adapting a global telenovela format further invites us to move the discussion away from the (exclusively text-based) compare-and-contrast studies and fidelity criticism so prominent in early debates within the field. Since then, scholars have challenged adaptation studies to embark on a new course by incorporating the social, cultural, and particularly economic forces that, for instance, shape the actual process of locally adapting global telenovela formats. This call was embedded in a broader acknowledgement of our contemporary society as "a media-saturated environment dense with cross-references" (Naremore 12–13) and defined by "an exponential proliferation of adaptations across the whole range of performance media" (Hand and Krebs 3).

Within this new constellation and emerging tradition of adaptation research, the case of telenovelas is exemplary for a contemporary media industry that is characterized by a cross-media and cross-border exchange of narratives, but also attentive to a series of extra-textual features and contexts related to the local adaptation that have implications for the avowedly universal narrative of the source text. The adaptation of telenovelas underlines the importance of acknowledging issues of political power and economic interests and indicates some of the specific ways that adaptation requires a complex intertextual negotiation between the original telenovela, various other adaptations, other successful series, and multiple cultural codes. In the intertextual process of adaptation and circulation to different countries, elements of the original series are reworked, reinterpreted, and supplemented (McCabe 15) in various ways that complicate any one-on-one comparison between the source text of the original telenovela and its locally adapted texts. In this respect, it is best to understand telenovelas as localizable yet universally appealing cultural products that traverse a surprisingly broad range of geographical and cultural contexts through a series of commercially successful local adaptations.

In addition to the paradoxical status of telenovelas as both transcultural and culturally specific, we need to consider the very nature of the relation between telenovelas and the process of adaptation as complex and inconclusive as well. In some ways, telenovelas are clearly adaptations, for they draw on universal narratives and recycle many elements that are already very familiar to their audiences. In other ways, telenovelas are clearly not adaptations, for they are rarely based on specific sources that they identify or otherwise acknowledge. This apparent contradiction warrants further investigation.

Works Cited

Acosta-Alzuru, Carolina. "Tackling the Issues: Meaning Making in a Telenovela." *Popular Communication* 1.4 (2003): 192–215. Print.

Adriaens, Fien. "The Glocalized Telenovela as a Space for Identifications for Diaspora Girls in Flanders: An Audience Cum Content Analysis of Sara." *OBS* Observatorio* 4.4 (2010): 171–95. Print.

Adriaens, Fien, and Daniël Biltereyst. "Glocalized Telenovelas and National Identities: A 'Textual Cum Production' Analysis of the 'Telenovelle' *Sara*, the Flemish Adaptation of *Yo soy Betty, la fea*." *Television and New Media* 13.6 (2012): 551–67. Print.

Akass, Kim, and Janet McCabe. "Not So Ugly: Local Production, Global Franchise, Discursive Femininities, and the *Ugly Betty* Phenomenon." *Flow TV* 5.7 (26 Jan. 2007). Web. 27 May 2015.

Allatson, Paul. *Key Terms in Latino/a Cultural and Literacy Studies*. Oxford: Blackwell, 2007. Print.

Allen, Robert C., ed. *To Be Continued: Soap Operas around the World*. London: Routledge, 1995. Print.

Biltereyst, Daniël. "Resisting American Hegemony: A Comparative Analysis of the Reception of Domestic and US Fiction." *European Journal of Communication* 6.4 (1991): 469–97. Print.

Biltereyst, Daniël, and Philippe Meers. "The International Telenovela Debate and the Contra-Flow Argument: A Reappraisal." *Media, Culture and Society* 22.4 (2000): 392–413. Print.

Bortolotti, Gary R., and Linda Hutcheon. "On the Origin of Adaptations: Rethinking Fidelity Discourse and 'Success'—Biologically." *New Literary History* 38.3 (2007): 443–58. Print.

Brennan, Niall. "Melodrama, Modernity and the Brazilian Television Mini-Series." *Modern Drama* 55.4 (2012): 544–65. Print.

Brooker, Will. *Hunting the Dark Knight: Twenty-first Century Batman*. London: Tauris, 2012. Print.

Cartmell, Deborah, and Imelda Whelehan. *Screen Adaptation: Impure Cinema*. London: Palgrave Macmillan, 2010. Print.

Conway, Kyle. "Cultural Translation, Global Television Studies, and the Circulation of Telenovelas in the United States." *International Journal of Cultural Studies* 15.6 (2011): 583–98. Print.

Dhoest, Alexander, and Manon Mertens. "Ugly Betty, Funny Sara: Telenovela Adaptation and Generic Expectations." McCabe and Akass 99–113. Print.

Fung, Anthony, and Xiaoxiao Zhang. "The Chinese Ugly Betty: TV Cloning and Local Modernity." *International Journal of Cultural Studies* 14.3 (2011): 265–76. Print.

Hand, Richard J., and Katja Krebs. "Editorial." *Journal of Adaptation in Film and Performance* 1.1 (2007): 3–4. Print.

Hutcheon, Linda, with Siobhan O'Flynn. *A Theory of Adaptation*. 2nd ed. London: Routledge, 2013. Print.

Joye, Stijn, and Tanneke Van de Walle. "Batman Returns, Again and Again: An Explorative Inquiry into the Recent 'Batman' Film Franchise, Artistic Imitation and Fan Appreciation." *Catalan Journal of Communication and Cultural Studies* 7.1 (2015): 37–50. Print.

Kunz, William. M. "Prime-time Island: Television Program and Format Importation into the United States." *Television and New Media* 11.4 (2010): 308–24. Print.

La Pastina, Antonio C. "Telenovela Reception in Rural Brazil: Gendered Readings and Sexual Mores." *Critical Studies in Media Communication* 21.2 (2004): 162–81. Print.

La Pastina, Antonio C., and Joseph D. Straubhaar. "Multiple Proximities between Television Genres and Audiences: The Schism between Telenovelas' Global Distribution and Local Consumption." *Gazette: The International Journal of Communication Studies* 67.3 (2005): 271–88. Print.

Leitch, Thomas. *Film Adaptation and Its Discontents: From* Gone with the Wind *to* The Passion of the Christ. Baltimore: Johns Hopkins UP, 2007. Print.

———. "Twelve Fallacies in Contemporary Adaptation Theory." *Criticism* 45.2 (2003): 149–71. Print.

Lopez, Ana M. "A Train of Shadows: Early Cinema and Modernity in Latin America." *Through the Kaleidoscope: The Experience of Modernity in Latin America.* Ed. Vivian Schelling. London: Verso, 2000. 148–76. Print.

McCabe, Janet. "Introduction: 'Oh Betty, You Really Are Beautiful.'" McCabe and Akass 1–25. Print.

McCabe, Janet, and Kim Akass, eds. *TV's Betty Goes Global: From Telenovela to International Brand.* London: Tauris, 2013. Print.

Mikos, Lothar, and Marta Perrotta. "Traveling Style: Aesthetic Differences and Similarities in National Adaptations of *Yo Soy Betty, La Fea.*" *International Journal of Cultural Studies* 15.1 (2011): 81–97. Print.

Miller, Jade L. "Ugly Betty Goes Global: Global Networks of Localized Content in the Telenovela Industry." *Global Media and Communication* 6.2 (2010): 198–217. Print.

Moran, Albert. *New Flows in Global TV.* Bristol: Intellect, 2009. Print.

Moran, Albert, ed. *TV Formats Worldwide: Localizing Global Programs.* Bristol: Intellect, 2009. Print.

Naremore, James, ed. *Film Adaptation.* London: Athlone, 2000. Print.

Nelson, Robin. "Analysing TV Fiction: How to Study Television Drama." *Tele-visions: An Introduction to Studying Television.* Ed. Glen Creeber. London: Routledge, 2007. 74–86. Print.

Porto, Mauro. "Telenovelas and Representations of National Identity in Brazil." *Media, Culture and Society* 33.1 (2011): 53–69. Print.

Ribke, Nahuel. "Telenovela Writers under the Military Regime in Brazil: Beyond the Cooption and Resistance Dichotomy." *Media, Culture and Society* 33.5 (2011): 659–73. Print.

Robertson, Roland. "Glocalization: Time–Space and Homogeneity–Heterogeneity." *Global Modernities.* Ed. Mike Featherstone, Scott Lash, and Roland Robertson. London: Sage, 1995. 25–44. Print.

Ronsini, Veneza. "'Many People Are Just Dreamers': Telenovelas and the Ideology of Meritocracy." *Television and New Media* 15.6 (2014): 551–61. Print.

Sara. VTM, 2007–8. Television.

Singer, Ben. *Melodrama and Modernity.* New York: Columbia UP, 2001. Print.

Stam, Robert. "Beyond Fidelity: The Dialogics of Adaptation." Naremore 54–76. Print.

———. "Introduction: The Theory and Practice of Adaptation." *Literature and Film: A Guide to the Theory and Practice of Film Adaptation.* Ed. Robert Stam and Alessandra Raengo. London: Blackwell, 2005. 1–52. Print.

Straubhaar, Joseph. "Beyond Media Imperialism: Asymmetrical Interdependence and Cultural Proximity." *Critical Studies in Mass Communication* 8.1 (1991): 39–59. Print.

———. *World Television: From Global to Local.* Thousand Oaks: Sage, 2007. Print.

Tomlinson, John. "Globalisation and National Identity." *Contemporary World Television.* Ed. John Sinclair and Graeme Turner. London: BFI, 2004. 24–27. Print.

Tufte, Thomas. *Living with the Rubbish Queen: Telenovelas, Culture and Modernity in Brazil*. Luton: U of Luton P, 2000. Print.

Ugly Betty. ABC-TV, 2006–10. Television.

Ugly Wu Di. Hunan TV, 2008–9. Television.

Verliebt in Berlin. Sat.1, 2005–7. Television.

Waisbord, Silvio, and Sonia Jalfin. "Imagining the National: Television Gatekeepers and the Adaptation of Global Franchises in Argentina." Moran, ed., *TV Formats Worldwide* 55–78. Print.

Yo soy Betty, la fea. RCN Televisión, 1999–2001. Television.

Zbar, Jeff. "Telenovela Format Takes on a Decidedly Anglo Look." *Advertising Age* 77.19 (2006): 26. Print.

Zhang Xiaoxiao and Anthony Fung. "TV Formatting of the Chinese *Ugly Betty*: An Ethnographic Observation of the Production Community." *Television and New Media* 15.6 (2014): 507–22. Print.

ZOMBIES ARE EVERYWHERE

The Many Adaptations of a Subgenre

ÁLVARO HATTNHER

ZOMBIES are everywhere. At least for the past thirty years, we have been completely surrounded by those creatures, who have not only stormed popular culture but also attacked high culture bastions and spread throughout several textual architectures in our century, constituting a huge set of narratives dealing with one of the fictional possibilities that describe the end of the world as we know it. And if we have lost our world to the living dead, it seems the main cause for that is adaptation. The recent zombie text outbreak was not caused by any accident in a laboratory or a supernatural entity, but rather by the dissemination of different forms of adaptations in as many textual architectures as possible.

Mutating into its many possibilities of existence, adaptation here takes new forms that go beyond the once traditional vector of literature to film, adapting itself to the fact that we live in an age of media convergence, in which the integration of multiple texts creates narratives so broad that they cannot be contained in a single medium. This integration occurs through what Henry Jenkins calls "transmedia storytelling" (293), which is established by means of its expression in multiple textual architectures, and in which each new text, as in Jenkins's paradigmatic example of *The Matrix* (1999) and all the media associated with it, represents a new contribution to an ever-expanding whole. Thus a story can be presented in an original movie and expanded through graphic narratives, novelizations, videogames, and various other texts. It is this perspective that allows us to invert the conventional vectors in studies of adaptation and to propose a study in which the primary texts, or what Linda Hutcheon calls the adapted texts, are films that unfold in adaptations that create a new genre broadly characterized by intersections and recombinations of media, building textual regularities.

George A. Romero's *Night of the Living Dead* (1968) (Figure 21.1) is our patient zero, the first text to begin the contagion of modern zombies. No one questions the primacy of *Night of the Living Dead* as the first text of the zombie apocalypse.

FIGURE 21.1 The zombie apocalypse begins. *Night of the Living Dead* (1968).

Romero's first film, an independent production in black and white with a derisively small budget of $114,000, broke barriers of form and content with innovations that included an African-American actor as protagonist and the presence of violence so explicit, especially in scenes of cannibalism, that *Variety*, in reviewing the film, referred to the "pornography of violence" (quoted in Fallows and Owen 25). In fact, Romero's hexalogy of the living dead not only establishes new paradigms for the horror genre, but also represents the foundations for the development of a specific form of apocalyptic narrative in different textual architectures that has been called "zombie apocalypse" ("zompoc"). Romero's six films—*Night of the Living Dead, Dawn of the Dead* (1978), *Day of the Dead* (1985), *Land of the Dead* (2005), *Diary of the Dead* (2008), and *Survival of the Dead* (2009)—contain the formal and thematic basis to which all subsequent zompoc narratives in any media have been adapted.

The dead in these texts are transformed into creatures that feed on the living. The inability of the living to cope with the zombie outbreak leads to the total collapse of all institutions that shape civilization as we conceive it. Most narratives have as their thematic axis the survival of individuals or groups of individuals in the devastated world. The complexity of plot and social criticism increases significantly when the focus is on groups of individuals and their incapacity to handle the obstacles posed not only by the new threat but also by their newfound fear of other human beings.

Zombie apocalypse narratives represent a fascinating case of transmedia storytelling, since their characteristics as a genre are the result of a series of textual creations, adapted from the works of Romero and disseminated through novels (either avowedly original texts or novelizations), short stories, graphic narratives, videogames, apps for smartphones and tablets, and other films.

The multiplicity of narrative possibilities in so many different textual architectures corresponds to an almost insatiable narrative hunger. For audiences, the ur-text, the primordial narrative—or, to use the terminology of Gérard Genette adopted by many theorists of adaptation, the "hypotext" (5)—is not enough. Audiences crave sequels, prequels, unfoldings, reformulations, amplifications, and every new possibility of telling and retelling, showing and showing again, especially from a different angle, and participating in the narratives as a reader, a spectator, or a computer game persona, generating new narrative paths.

In this context, Julie Sanders's accounts of "appropriation" and "adaptation" (26) can be useful. For Sanders, adaptations signal a relationship with an informing source text or original, and appropriations distance themselves "from the informing source into a wholly new cultural product and domain" (26). However, it is difficult to see an expressive difference between the two terms, since "distancing from the informing text" is also a form of "relationship" with that text. And doesn't every adaptation generate a "new cultural product"? Sanders seems to use the notion of appropriation to create a comfort zone that allows us to include certain texts that otherwise we would simply call adaptations. The process of a "wholesale rethinking of the terms of the original" (28), as she calls *West Side Story*'s treatment of the story of *Romeo and Juliet*, is characteristic of an appropriation in her terms, but, to some degree, this is exactly what happens in any adaptation. Adaptations always rethink their originals and always create a new cultural product.

For the approach of zompoc texts in any medium, a merging of appropriation and adaptation seems to be more adequate. Every adaptation is an appropriation that may involve all the possibilities Sanders lists: variation, version, interpretation, imitation, proximation, supplement, increment, improvisation, prequel, sequel, continuation, addition, paratext, hypertext, palimpsest, graft, rewriting, reworking, refashioning, revision, re-evaluation. Although some of those terms overlap, the absence of "translation" from this list is noteworthy, especially when one thinks that the trope is not new in adaptation studies. For Robert Stam, translation "suggests a principled effort of intersemiotic transposition, with the inevitable losses and gains typical of any translation" (62). Adaptation is one of the many strategies employed in many translations, especially literary translations, just as translation is one of the possibilities that may be used to describe an adaptation.

The terminological kaleidoscope presented by Sanders allows us to examine several textual possibilities generated by Romero's films. One of these, relevant and still underrated, is the literary production that might be called zombie fiction: novels, short stories, and graphic narratives that reproduce, recreate, or develop—that is, adapt—the thematic constants laid out by the living dead hexalogy. Since its beginning, Romero's "dead project" has presented a continuous reciprocal dialogue that involves not only literature and film, but also graphic narratives. According to Romero, the starting point for *Night of the Living Dead* was a short story he had written entitled "Anubis," or "Night of the Anubis." Clearly inspired by Richard Matheson's 1954 novel *I Am Legend*, Romero's *Night of the Living Dead* not only adapts themes from a literary piece, but also is informed by

narrative structures and images recurrent in horror comic books, such as the triad *Tales from the Crypt, The Vault of Horror*, and *The Haunt of Fear*, published by EC Comics in the 1950s (Harvey; for a comprehensive view of zombies in comic books, see Flint).

Kyle William Bishop lists other intertextual links to *Night of the Living Dead*, most notably John W. Campbell, Jr.'s tale "Who Goes There?" (1938), Daphne du Maurier's 1952 story "The Birds," and Jack Finney's 1955 novel *The Body Snatchers*. That textual circuit allows Bishop to call Romero's film an "assemblage—a blend of preexisting texts that combines the defining features of other narratives to create something new and original" (271).

This is not the place to comment on the apparent paradox in the relation between "preexisting texts" and "something new and original," since preexistence would seem to preclude originality. But one relevant aspect in Bishop's proposition is the tendency to locate intertextuality at the core of investigations in adaptation studies, as other commentators have urged. Studies of intertextuality have shown us how cultural products that can be considered postmodern, such as zompoc texts, include as one of their fundamental features the presence of formal and thematic structures based on allusions, quotations, citations, parodies—that is, the rewriting of various types of texts—a feature that corroborates Graham Allen's affirmation: "Intertextuality reminds us that all texts are potentially plural, reversible, open to readers' own assumptions without clear boundaries or defined, and always involved in the expression or repression of the 'voices' that are dialogic within society" (209).

This position suggests the possibility of reversing the vectors to investigate the textual net composed by contemporary zombie narratives, which are organized around thematic rules created by Romero in his hexalogy. Those recurrent themes, whose identification is based partly on work by Kim Paffenroth and Kevin J. Wetmore, are summarized in the following section.

Textual Themes in Contemporary Zombie Narratives

Origin/Cause

This is one of the most intriguing and distressing aspects already present in *Night of the Living Dead*: we do not know what caused the dead to return to life. The film features a brief reference to a problem that might have occurred with a space probe sent to Venus, but this short origin narrative is not developed. The dead become the undead and we have to deal with it, period. As Paffenroth remarks, "the plausibility of an explanation is irrelevant, as the movies [and the majority of zompoc texts] are always about some small group dealing with the effects, not the causes" (3).

Autonomy

Romero's zombies are autonomous creatures who do not depend on any external control. Unlike the so-called Haitian zombie, activated by magic or voodoo, the undead in Romero's hexalogy are creatures motivated solely by hunger, the urge to feed on the living. This trait is present in most zombie narratives, with some developments associated with specific food needs, such as brains. This perspective, first introduced in *The Return of the Living Dead,* in which the zombies are only interested in the brain lobes of the living, has been deployed exhaustively by the culture industry to define zombies, especially in comedy-oriented texts like Robin Becker's novel *Brains: A Zombie Memoir,* which is presented as the testimony of Jack Barnes, professor and zombie:

> Brains. More dear to me than my wife. More precious than my intellect and education, my Volvo and credit rating—all that mattered in "life" pales in comparison to this infinite urge. Even now, as I write these words, my lips quiver and a drop of saliva—tinged crimson—falls onto the paper, resulting in a brain-shaped stain.
>
> Stain, brain, pain, brain, sustain, brain, brain, wane, brain, refrain, brain, cocaine, brain, main, brain, brain, brain, brains!
>
> Oh, how I love them. (2)

Multiplication

Zombies multiply by attacking living human beings and turning them into other zombies. A human bitten or scratched by a zombie will inevitably die of the wound and become another zombie. This transformation is the effect of a disease, a cause associated with a specific virus. This idea is present in all films of the hexalogy, although other texts, especially remakes like Zack Snyder's *Dawn of the Dead* (2004), add some exciting variations. In the television series *The Walking Dead,* an adaptation of the eponymous graphic narrative by Robert Kirkman, all human beings are carriers of the virus that turns the dead into zombies, so that all human beings, whether or not they had physical contact with a zombie, will become "walkers" after they die.

The multiplication of zombies occurs in geometric progression, following the chronological appearance of the films. In *Night of the Living Dead,* the groups of the undead are not very large and apparently can be controlled by the authorities, whereas by the time of the last movie, *Survival of the Dead,* zombies have taken over the planet, and humans are the minority—an endangered species, hunted relentlessly.

Weakness

Although zombies show an unwavering persistence in attacking humans, it is not hard to kill a zombie. Indeed, a single zombie may be relatively harmless, specially the Romero

type, which is slow. Packs, herds, or hordes are the greatest problem in most zompoc narratives. According to Romero, the undead brain is the part of the brain that has been reanimated or revived. So a gunshot or a heavy blow to the head can kill the creature for good. This rule has not changed in subsequent texts in any medium.

Survival

This is another rule that has not changed in the narratives that represent the zombie apocalypse since *Night of the Living Dead*. In a significant number of narratives, an individual or group of individuals face the consequences of a world overrun by the undead. In this sense, a recurring theme involves forms of interaction among humans. It is important to note here that often the threat of the undead remains in the background. The true enemy may be within the group, infected by the selfishness, fear, and mistrust that catalyze its disintegration, putting the survivors against each other. This perspective informs the hexalogy and many other narratives.

The issues addressed in those narratives are associated with many other features that may vary. Among them are the mobility of zombies (variable in Romero's films, but never approaching the running zombies of movies like *28 Days Later* [2002] and the remake of *Dawn of the Dead*); their fear of fire (present in Romero's *Night of the Living Dead* but variable in other texts); their interest in eating other living beings (in *Night*, they eat insects; in the remake of *Dawn of the Dead*, they ignore a dog that rushes in through a crowd of them; in *Survival of the Dead*, Romero returns to the idea that zombies eat animals, as they also do in two episodes of *The Walking Dead*); their frequent status as fools devoid of any trace of intelligence (a feature that began to be changed in *Day of the Dead* and was further developed in *Land of the Dead*).

LITERARY AND FILM ADAPTATIONS

The earliest adaptations of Romero's hexalogy were two novelizations. The first was written and published in 1974 by John Russo, who co-wrote the screenplay for the film. Although David Flint pronounced the book "a huge hit," it did not contain significant additions to the film, with Russo "opting for a fairly straight retelling of the story, with no additional effort to develop the characters for the printed page" (162). Nor does the second novelization, Romero and Susanna Sparrow's *Dawn of the Dead* (1978), offer significant variations on the film, with one notable exception: it makes more frequent use of the word "zombie," which is never used in the first movie and is used only once in the second. Also noteworthy is the intertextuality produced through the book cover, which is similar to the main film poster and includes the emblematic catchphrase, "When there's no more room in hell, the dead will walk the earth."

Later franchise entries' expansion of the basic rules Romero established for the genre can be traced to 1989, when one of the first zombie anthologies was published. Edited by John Skipp and Craig Spector, with a foreword by Romero, *Book of the Dead* contained sixteen stories by authors from Stephen King to Joe R. Lansdale and was followed by a 1992 sequel, *Book of the Dead 2: Still Dead*, with a foreword by Tom Savini, makeup master and director of the 1990 remake of *Night of the Living Dead*. What these collections have in common, besides the walking dead as their thematic core, is that both explicitly acknowledge the influence of Romero's films in the texts they offer while expanding the films' thematic possibilities, rewriting the apocalyptic landscape. The status of the short story as a laboratory or formal vehicle for exploring the thematic potentialities present in the films is confirmed by even a superficial analysis of the several anthologies published after *Book of the Dead*. Twenty-first-century zombie texts in particular range from survivalist narratives to stories told by zombies as autodiegetic narrators. In "The Things He Said," by Michael Marshall Smith, the human narrator becomes a cannibal in order to survive the zombie apocalypse. In Dale Bailey's "Death and Suffrage," zombies demand the right to vote. And humans, not to be left out, get high on all sorts of chemicals they are using to disguise their body odors and so become invisible to the zombies, or engage in romances with the living dead.

Book of the Dead is the starting point of an almost endless multiplication of zombie texts that could not be contained by film medium and that troubled the life of pop culture in the form of novels. In fact, one of the first zombie novels to cause real impact was an adaptation that reversed the vector of novel to film: Russo's novelization of *Night of the Living Dead*. Other texts further develop the possibilities established by Romero's rules, including supernatural causes for the outbreak and the acquisition of consciousness. In *The Rising*, for instance, Brian Keene presents intelligent, flesh-eating zombies who have been engendered by demonic possession, "a rare religious explanation for zombie outbreak" (Flint 166). Variations of the self-conscious zombie, which abound in zombie fiction, can be seen as extensions and adaptations of the idea that zombies could gradually develop the self-awareness that was already present in *Day of the Dead* and further enhanced in *Land of the Dead*.

One of the most important novels in the twenty-first-century outbreak of zombie narratives is Max Brooks's *World War Z*. Published in 2006, *World War Z* is presented as a collection of accounts from survivors in the aftermath of a war against zombies that has lasted ten years. Those accounts appear in the form of interviews made by a member of the United Nations' Postwar Commission, whose final report has been "edited" because of "too many opinions, too many feelings" in the original text, which worked against "clear facts and figures, unclouded by the human factor" (4). Through a unique style that mixes the question-answer structure of the interviews with almost autonomous short narratives, Brooks presents a comprehensive panorama of the zombie war, including its probable origin in a virus-infected patient "o" in China, its development in many different countries, and the viewpoints of all sorts of witnesses.

As in Romero's films, Brooks focuses on human relations, individual suffering, and the acquisition of experience through a painful process of loss and discovery. According

to Jovanka Vuckovic, "While the enemy may be complete fiction, the responses to it—from the most powerful government on the planet to the lowliest dog trainer—seem all too real. And when that reality includes firebombing mixed zombie and human crowds, or eating a neighbor to prevent starvation, the knowledge that 'zombie apocalypse' is just a metaphor for any wide-scale disaster very much within the realm of possibility today is a horrifying thought indeed" (135).

World War Z can readily be seen as an expansion of Romero's films. Brooks's zombies have the same characteristics as Romero's undead: they are slow, mindless, and hungry for human flesh. The narrative further develops specific aspects only hinted in the films. For example, in *Land of the Dead*, zombies discover that they can survive underwater, a trait first dramatized in *Zombi 2* (1979) by the Italian film director Lucio Fulci, in the now infamous sequence of a fight between a zombie and a tiger shark. In one of the interviews in *World War Z*, the narrator undergoes a small trip in a "submersible" whose pilot is "possibly the most experienced diver in the U.S. Navy's Deep Submergence Combat Corps (DSCC)" (497): "They say there are still somewhere between twenty and thirty million of them, still washing up on beaches, or getting snagged in fishermen's nets. You can't work an offshore oil rig or repair a transatlantic cable without running into a swarm. That's what this dive is about: trying to find them, track them, and predict their movements so maybe we can have some advance warning" (498).

This passage provides a good example of adaptation through expansion. Brooks develops and creates a narrative that enhances, expands, and details one of the thematic possibilities present in *Land of the Dead*. This is a prevalent strategy for the dissemination of zombie texts. They undergo all the transformations that characterize any adaptation process, explicitly incorporating elements from previous texts or developing ideas that are potentialities in the adapted texts.

The horde of literary texts inspired by *World War Z*, either as extensions or as intertextual dialogues, is getting bigger and bigger. An example of the first case is Brooks's own work directly related to the content of *World War Z*, such as the short story "Closure, Limited: The Story of World War Z," which appeared in *The New Dead* (2010). By contrast, Bret Hammond's short story "Dead Country," in *The Living Dead 2* (2010), has delighted readers familiar with Brooks's text through its intertextual dialogue with the earlier novel. Hammond's story involves an interviewer in conversation with a representative of an Amish community that tells how the group dealt with the zombie apocalypse and how the posture of extreme pacifism influenced the way these individuals faced the equally extreme (and violent) new circumstances.

In 2013, *World War Z* generated a film adaptation directed by Mark Foster with a team of screenwriters that included J. Michael Straczynski. Known and honored as a writer of graphic novels and creator of the acclaimed television series *Babylon 5* (1994–98) and the underrated post-apocalyptic TV series *Jeremiah* (2002–4), Straczynkski may have had a soothing effect on audiences waiting anxiously for the film and suffering from one of the great health disturbances of the twenty-first century, which could be called PAS, pre-adaptation syndrome—the absolute terror generated by the possibility that an adaptation might not be faithful to the adapted text. The effects of the

syndrome can be clearly seen on many comments on social networks like Facebook and Twitter. They range from expressions of bitter disappointment to manifestations of sheer hate.

Foster's film challenges common-sense notions of what an adaptation might be, both for those who still believe in fidelity and those who do not. Although it maintains the title and the general plot of the zombie outbreak, Foster's film represents a totally new narrative, to which it brings not only some of the thematic constants established by Romero, but also some polemical aspects of the zombie genre, such as the "athlete undead"—running zombies, totally enraged, building an intertextual bridge from *28 Days Later*, Danny Boyle's forerunner of that strain of living dead, and Zack Snyder's 2004 *Dawn of the Dead*.

The Internet has also played an important role in the dissemination of zombie literary narratives. Many texts, either novels or short stories, have come to light first in blogs and then as printed books. Texts that adapt Romero's rules include Rhiannon Frater's trilogy *As the World Dies* (2011a, 2011b, 2012), with its feminine perspective, J. L. Bourne's trilogy *Day by Day Armageddon* (2009, 2010, 2012), in which an author who is a Navy officer in real life uses the recurrent zompoc literary form of the diary, and the series of six *Autumn* novels David Moody began in 2001, which are notable for relying on much less gore and much more tension. According to Flint, Moody's "descriptions of buildings besieged by an endless army of the dead are genuinely unnerving" (167).

Zombie texts have broken the boundaries of the English-speaking world to infect countries like Spain and Brazil. In the hands of Manel Loureiro (the 2010 trilogy *Apocalipsis Z*) and Carlos Sisí (*Los Caminantes*, 2009–14), the infection leaves the streets of Spanish cities to spread to other countries, including the United States. And in *Terra Morta* (*Dead Land*, 2012), by the Brazilian Tiago Toy, the outbreak begins (where else?) in the laboratories of a state university.

The international dissemination of zombie adaptations is not a recent phenomenon. From the first remakes by Italian studios to more recent productions, such as the outstanding Australian short film *Cargo* (2013), directed by Ben Howling and Yoland Ramke, zombie adaptations are not restricted to the United States. Writing in 2009, Flint presents an excellent map of European zombie films, though productions like the French *La horde* (2009) and the German *Rammbock—Berlin Undead* (2010) have belied his prediction that "[i]t is unlikely that the current revival of interest in the living dead will be reflected in European cinema" (127).

Even the ivory towers of Western literary canon have been overrun by the living dead. In *Pride and Prejudice and Zombies* (2009), Seth Grahame-Smith adds martial arts and the presence of the undead to the original text of Jane Austen's novel. The basic plot is maintained, although relocated to an alternate universe in which the undead are a troublesome and deadly plague. In 2010, Steve Hockensmith published a prequel, *Pride and Prejudice and Zombies: Dawn of the Dreadfuls*, showing how the heroine, Elizabeth Bennet, becomes a skilled killer of zombies, referred to as "dreadfuls," and a sequel, *Pride and Prejudice and Zombies: Dreadfully Even After*, followed in 2011. The first in the series was disseminated even further through a graphic novel, an interactive version, and Burr Steers's 2016 feature film.

MUTATIONS AND FRANCHISES

Other adaptations generated by Romero's films include videogames and graphic narratives. Nearly two hundred videogames can be considered as collaborating in the construction of the great narrative of the zombie apocalypse, even as they depart from the basic rules established by Romero's films. Among them are *Dead Rising, Dead Island, Left 4 Dead*, and even an adaptation of Romero's fourth zombie film, entitled *Land of the Dead: Road to Fiddler's Green* (2005). Especially relevant to investigations in adaptation studies is the *Resident Evil* series, which began in 1996. The first game in the franchise quoted scenes directly from *Night of the Living Dead*: hands forcing their way through boarded windows, a music box, doors to be opened, and the fear of what is behind them. In *Night of the Living Dead*, the intense and dramatic music is interrupted when there is a passage from one room to the other, a pattern repeated in *Resident Evil*.

The series achieved levels of commercial success "that most moviemakers would envy—not only a slew of sequels and spin-offs, but feature films, novels, comic books, toys and beyond" (Flint 171). The novelizations and novels generated within the *Resident Evil* franchise offer an intriguing case for the study of adaptations, since, unlike what happens among the offspring of *Star Wars* (1977), conflict often arises between the plots developed for sequels. In Joe Schreiber's 2009 *Star Wars* novel *Death Troopers*, a zombie infestation occurs in an imperial prison barge that turns most inmates into undead who hunt a small group of survivors. One might say that this adaptation, which expands the transmedia narrative of zombie apocalypse still further, provides the best of both worlds.

As a new mutation in the epidemic adaptations of the franchise, the first film adapting the game, which appeared in 2002 (Figure 21.2), incorporates many of the emblematic

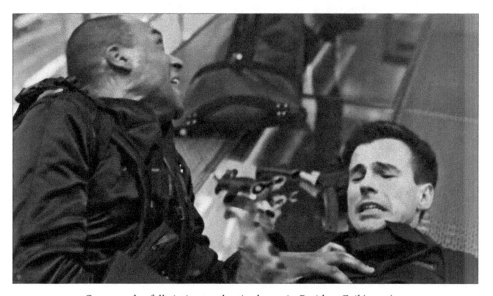

FIGURE 21.2 Commandos fall victim to adaptive lasers in *Resident Evil* (2002).

traits of video games, many of them derived from cinematic language itself, such as bird's-eye perspective for some of the scenes. In more recent films, zombies become sparser as the plots focus on other narrative elements deemed more adequate to a profusion of scenes depicting martial arts movements in bullet-time. Nevertheless, although the *Resident Evil* films taking off from the eponymous videogames have become an almost independent set of narratives, they are still a remarkable example of how intertextuality, through a continuous process of explicit citations, is basal to the adaptive process.

A good illustration is the famous "laser corridor" sequence in the first film, released in 2002, in which a group of commandos locked in a corridor is decimated by a laser defense system that adapts itself to the position of the people trapped there. The sequence is reproduced in the videogame *Resident Evil 4* (2005), enhancing the involvement of players and spectators in the narrative and their intertextual experience.

The same can be said about *The Walking Dead*, a comic book series written by Robert Kirkman, who engages in dialogue not only with Romero's zombie films but also with more recent productions, such as *28 Days Later*. Begun in 2003, and reaching more than 150 issues, *The Walking Dead* was adapted in 2010 as a television series (Figure 21.3), a format oddly appropriate to the episodic nature of the adapted text.

And the dissemination continues. Kirkman and Jay Bonansinga have published six *Walking Dead* novels. Their storyline deals with the origins and fate of one of the most hated and adored figures in all zompoc fandom, the Governor. The series also generated five videogames, four based on the comic books and one whose protagonist is Daryl, a character created exclusively for the TV series, who quickly became an audience favorite.

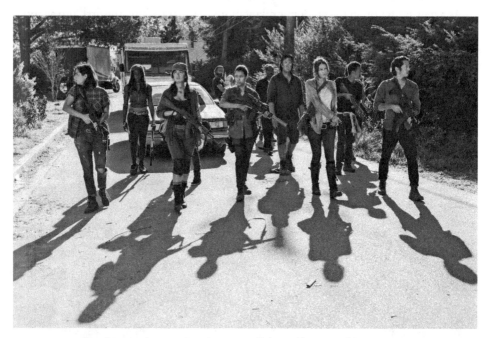

FIGURE 21.3 Zombies on the march in Season 5 of *The Walking Dead* (AMC).

Again, with *The Walking Dead*, we have not only the dissemination of zompoc narratives through at least four vectors of adaptation (film → graphic novel → TV series; film → graphic novel → novel; film → graphic novel → videogame; film → graphic novel → TV series), but also the expansion of the multiple narrative possibilities of an already very rich storyline. And these vectors do not even include the *Walking Dead* card game, dice game, and two board games released by Cryptozoic Entertainment, whose expansions include events of Season 3 and provide players with the opportunity to play as zombies ("Games"). One recent development involves so-called "webisodes" accessible only through the official website of the series (and later as part of the extras in the DVD version). Webisodes are short chapters showing other characters who do not appear in the main storyline. They raise a question whose implications make it central to all adaptive franchises: How many interesting narratives of survivors can we have in a planet dominated by zombies? The first webisode, for instance, shows how a woman caught in the middle of the chaos resulting from the outbreak becomes a zombie who is killed by the protagonist of the TV series. The episodic structure of this narrative clearly reflects the structure of the graphic narrative that originated it. So far, there are four sets of webisodes, each one exploring a particular aspect of life during the zombie apocalypse, with enough direct intertexts with the main narrative to partially satisfy the narrative hunger of the TV series audience.

The focus on the undead rather than the survivors marks a fundamental change in zombie narratives. In fact, we could say that each "walker" is an adaptation, an entity that becomes itself a new narrative. This possibility is exactly what makes zombie texts an enormous transmedial narrative, since every zombie (and every character) represents a potential new adaptation that can either reproduce the basic textual stratum that forms zompoc stories in any medium, or enhance and amplify them to an almost infinite number of narratives in several textual architectures.

The huge success of the TV series *The Walking Dead* breached the barricades against zombies on the small screen. At least two other series adapted and enhanced the narrative universe of the zombie apocalypse, the French *Les revenants* (2012) and the British *In the Flesh* (2013). The *Revenants* series adapts a 2004 French film directed by Robin Campillo; *In the Flesh* is a nominal original created by Dominic Mitchell.

Although *In the Flesh* presents an ambiance closer to most zompoc texts, showing the aftermath of a zombie war won by humans, and *Les revenants* deals with the sudden return to life of dead people who are not particularly interested in eating the living, both series bring new complexities to the landscape of the zombie narratives. They range far beyond the basic survival theme of early zombie narratives to ask, Can the dead be reintegrated to the world of the living? Do they have rights? Can they return to their previous work positions? In the case of *Le revenants*, film and series, it is not clear whether the "returned" can accurately be called zombies, since they have little in common with the creatures created by Romero. The film's opening scene shows a multitude emerging from a graveyard, mostly older people, but also some children and middle-aged women and men. The image subverts the traditional horde of zombies shuffling their way through an avenue, a paradigmatic scene in most zombie films. The undead in

Les revenants are not covered in gore. They do not carry their intestines around or hunger for human flesh. They are clean, intelligent, and far from those imbecilic creatures who are "incapable of making plans, coordinating their attacks or learning from their mistakes" (Paffenroth 6). Indeed, this seems to be a trend in the expansion of narratives of the undead, as shown by the American television series *Resurrection* (2013–15), an adaptation of Jason Mott's 2013 novel *The Returned*, which shares a perspective with the French series. However, in the end all these texts have a common denominator with Romero's films and other zombie narratives: their attempt to answer the basic question, What do we do with them?

The impact of zombie apocalypse narratives in our culture is so strong that the undead have jumped over the walls separating fiction and reality to become part of everyday real life through textual adaptation. The American Centers for Disease Control and Prevention, a public health institute linked to the Department of Health and Human Services, has issued a graphic novel, "Preparedness 101: Zombie Pandemic," stressing the importance of being prepared for an emergency and including even a "Preparedness Checklist, so that readers can get their family, workplace, or school ready before disaster strikes" ("Zombie Novella"). Needless to say, some of the items listed, such as "copies of personal documents" and "extra cash," would be useless in a real zombie outbreak. Nevertheless, the graphic novella can easily be read as an adaptation of Romero's films, whose references to the hexalogy include the pivotal role of the press in the initial moments of the disaster (as in *Dawn of the Dead*) and a metalinguistic use of dreams (as in the last scene of *Day of the Dead*).

Kyle William Bishop has noted that while creatures like ghosts, werewolves, vampires, and re-animated corpses have their origins linked to some folkloric or literary narrative, zombie narratives are primordially presented through the screen. Almost all vampire movies are indebted in varying degrees to the work of Bram Stoker. Tales of re-animation invoke an intertextual dialogue with Mary Shelley's *Frankenstein*. But zombies have no basal written narrative that establishes or describes their thematic and formal elements (12–13).

Instead, the adapted text for the zombie apocalypse narratives is the six films by Romero. Every text created after that, in whatever medium, is fundamentally an adaptation. Especially in the case of the texts in zombie fiction, they are the result of an inversion of the conventional vector of literature to film. To embrace this inversion and the myriad possibilities it unleashes within the set of the existing textual architectures means the extension and transformation of the very concept of adaptation. This transformation involves both a greater inclusion of non-canonical texts and their various textual architectures and a greater willingness to reorient our analyses and discussions. It also poses the important challenge of developing specific analytical tools to deal with the formal specificities presented by the adaptation of those non-canonical texts, with the essential accompanying new terminology.

The inversion of vectors in adaptations is also a way to restore to life texts that, on occasion or for some audiences, might be dead. It is a path to perceiving that adaptations ultimately and paradoxically involve repetition and transformation, maintenance

and change, in an endless network that barely sates our hunger for them. The various processes of adaptation become different modes of contagion in which narratives endlessly multiply in ways that will never be stopped by anything as simple as a shot to the head.

Works Cited

Adams, John Joseph, ed. *The Living Dead 2*. San Francisco: Night Shade, 2010. Print.

Allen, Graham. *Intertextuality*. London: Routledge, 2000. Print.

Becker, Robin. *Brains: A Zombie Memoir*. New York: HarperCollins, 2010. Print.

Bishop, Kyle William. *American Zombie Gothic: The Rise and Fall (and Rise) of the Walking Dead in Popular Culture*. Jefferson: McFarland, 2010. Print.

Bourne, J. L. *Day by Day Armageddon*. New York: Pocket, 2009. Print.

———. *Day by Day Armageddon: Beyond Exile*. New York: Gallery, 2010. Print.

———. *Day by Day Armageddon: Shattered Hourglass*. New York: Gallery, 2012. Print.

Brooks, Max. *World War Z: An Oral History of the Zombie War*. New York: Three Rivers, 2003. Print.

Cargo. Dir. Ben Howling and Yoland Ramke. Perf. Andy Rodoreda, Alison Gallagher. Atlantis, 2013. Film.

Dawn of the Dead. Dir. George A. Romero. Perf. David Emge, Ken Foree. United Film, 1979. Film.

Dawn of the Dead. Dir. Zack Snyder. Perf. Sarah Polley, Ving Rhames. Universal, 2004. Film.

Day of the Dead. Dir. George A. Romero. Perf. Lori Cardille, Terry Alexander, Joe Pilato. United Film, 1985. Film.

Dead Island. Deep Silver. 2011. Videogame.

Dead Rising. Capcom. 2006. Videogame.

Diary of the Dead. Dir. George A. Romero. Perf. Shawn Roberts, Joshua Close. Third Rail, 2008. Film.

"Dread Central." Web. 1 July 2014.

Fallows, Tom, and Curtis Owen. *George C. Romero*. Harpenden: Pocket Essentials, 2008. Print.

Flint, David. *Zombie Holocaust: How the Living Dead Devoured Pop Culture*. London: Plexus, 2009. Print.

Frater, Rhiannon. *Fighting to Survive: As the World Dies, Book 2*. 2008; rpt. New York: Tor, 2011a. Print.

———. *The First Days: As the World Dies, Book 1*. 2008; rpt. New York: Tor, 2011b. Print.

———. *Siege: As the World Dies, Book 3*. 2009; rpt. New York: Tor, 2012. Print.

"Games." Cryptozoic Entertainment. Web. 29 July 2015.

Genette, Gérard. *Palimpsests: Literature in the Second Degree*. Trans. Channa Newman and Claude Doubinsky. Lincoln: U of Nebraska P, 1997. Print.

Golden, Christopher, ed. *The New Dead: A Zombie Anthology*. New York: St. Martin's Griffin, 2010. Print.

Harvey, Ben. *Night of the Living Dead*. London: Palgrave Macmillan, 2008. Print.

Hutcheon, Linda, with Siobhan O'Flynn. *A Theory of Adaptation*. 2nd ed. New York: Routledge, 2013. Print.

In the Flesh. Created and written by Dominic Mitchell. Perf. Luke Newberry, Harriet Cains. BBC Three, 2013–14. Television.

Jenkins, Henry. *Convergence Culture: Where Old and New Media Collide.* New York: New York UP, 2006. Print.

——. "Transmedia Storytelling." *MIT Technology Review.* 15 Jan. 2003. Web. 10 June 2014.

Keene, Brian. *The Rising.* New York: Leisure, 2003. Print.

Kirkman, Robert et al. *The Walking Dead: Compendium One.* Berkeley: Image, 2009. Print.

Kirkman, Robert, and Jay Bonansinga. *The Walking Dead: The Rise of the Governor.* New York: St. Martin's, 2011. Print.

Land of the Dead. Dir. George A. Romero. Perf. Simon Baker, John Leguizamo. Universal, 2005. Film.

Land of the Dead: Road to Fiddler's Green. Xbox/Microsoft, 2005. Videogame.

Left 4 Dead. Valve Corporation. 2008. Videogame.

Les revenants. Dir. Robin Campillo. Perf. Géraldine Pailhas, Jonathan Zaccaï. France 3 Cinéma, 2004. Film.

Les revenants. Created by Carlton Cruse. Perf. Kevin Alejandro, Agnes Bruckner. A&E, 2012. Television.

Loureiro, Manel. *Apocalipsis Z.* Barcelona: Plaza e Janés, 2010. Print.

Moody, David. *Autumn.* New York: Thomas Dunne, 2010. Print.

Mott, Jason. *The Returned.* New York: Harlequin MIRA, 2013. Print.

Night of the Living Dead. Dir. George A. Romero. Perf. Duane Jones, Judith O'Dea. Image Ten, 1968. Film.

Night of the Living Dead. Dir. Tom Savini. Perf. Tony Todd, Patricia Talman. Columbia, 1990. Film.

Paffenroth, Kim. *Gospel of the Living Dead: George Romero's Visions of Hell on Earth.* Waco: Baylor UP, 2006. Print.

Resident Evil. Capcom. 1996. Videogame.

Resident Evil 4. Capcom. 2005. Videogame.

Resident Evil. Dir. Paul W. S. Anderson. Perf. Mila Jovovich, Michelle Rodriguez. Sony, 2002. Film.

Resurrection. Created by Aaron Zelman. Perf. Mark Hildreth, Samaire Armstrong. ABC, 2013–15. Television.

Romero, George A., and Susanna Sparrow. *Dawn of the Dead.* New York: St. Martin's, 1978. Print.

Russo, John. *Night of the Living Dead.* New York: Warner, 1974. Print.

Sanders, Julie. *Adaptation and Appropriation.* London: Routledge, 2006. Print.

Schreiber, Joe. *Death Troopers.* New York: DelRey, 2009. Print.

Sisi, Carlos. *Los Caminantes.* Palma de Mallorca: Dolmen Editorial, 2009. Print.

Skipp, John, and Craig Spector. *Book of the Dead.* New York: Bantam, 1989. Print.

——. *Still Dead.* Shingleton: Mark V. Ziesing, 1992. Print.

Stam, Robert. "Beyond Fidelity: The Dialogics of Adaptation". *Film Adaptation.* ed James Naremore. New Brunswick: Rutgers UP, 2000. 54–76. Print.

Survival of the Dead. Dir. George A. Romero. Perf. Alan Van Sprang, Kenneth Welsh. Magnet, 2009. Film.

28 Days Later. Dir. Danny Boyle. Perf. Cillian Murphy, Naomie Harris. Twentieth Century Fox, 2002. Film.

Toy, Tiago. *Terra Morta.* São Paulo: Draco, 2011. Print.

Vuckovic, Jovanka. *Zombies: An Illustrated History of the Undead.* New York: St. Martin's Griffin, 2011. Print.

The Walking Dead. Created by Frank Darabont. Perf. Andrew Lincoln, Chandler Riggs. American Movie Classics, 2010—. Television.

Wetmore, Kevin J., Jr. *Back from the Dead: Remakes of the Romero Zombie Films as Markers of Their Times.* Jefferson: McFarland, 2011. Print.

Zombi 2. Dir. Lucio Fulci. Perf. Tisa Farrow, Ian McCulloch. Variety, 1979. Film.

"Zombie Novella." Centers for Disease Control and Prevention: Office of Public Health Preparedness and Response. Web. 13 June 2014.

THE HISTORY OF HONG KONG COMICS IN FILM ADAPTATIONS

An Accidental Legacy

WENDY SIUYI WONG

THROUGHOUT Hong Kong's film history, locally created comic books and characters have been adapted into movies, just as in Hollywood. These locally produced comics, known as *manhua*, are considered lowbrow reading materials for the masses. Manhua production first reached its peak in the 1950s, rising and falling in popularity in cycles over subsequent years, then entered a continuous downward trend beginning in the mid-1990s (Wong, "Manhua" 45–46). Popular Hong Kong manhua titles were once widely circulated in Chinese diaspora communities across Southeast Asia and all over the world. Likewise, Hong Kong cinema once enjoyed greater penetration and influence overseas before the start of its decline in the late 1990s. This essay sees manhua movie adaptations as outstanding examples of Hong Kong's original, authentic culture and asserts that they represent a legacy of Hong Kong popular culture in Asia. While once strong representatives of the cultural identity of Hong Kong, these two mediums are now both at risk of vanishing market shares and influence.

Manhua was a tool of socialization in the 1950s, when immigrants and newborn baby boomers made up the majority of Hong Kong's population. The 1960s were a period caught between the past and the present, with both the baby boomers and their parents adapting to their new lives in Hong Kong. Unlike the manhua and movies of previous decades, manhua and film adaptations of manhua in the 1960s increasingly depicted contemporary Hong Kong scenery. Manhua of the following two decades, the 1970s and 1980s, began to treat Hong Kong as a permanent space, a place for both generations to call home. During these two decades, the identity of Hong Kong began to emerge, along with the diversification of manhua and film genres. Income and class polarization grew, along with the expansion of Hong Kong's economy and the political changes that

occurred during the transitional period of 1997. These changes produced a new genre of entertainment, depicting the sub-cultural lives of gangsters—first in manhua, then in movies. This essay concludes with a discussion of *McMug Comics*, the so-called Hello Kitty of Hong Kong, created by Alice Mak Ga-bik and Brian Tse Lap-man and adapted to multiple media—print manhua, film, and other spin-off products—with its influence reaching far beyond Hong Kong.

MANHUA AND MOVIES AS TOOLS
OF SOCIALIZATION

Hong Kong was a British colony from 1841 to 1997, following the defeat of the Qing Government in the First Anglo-Chinese War (1839–42), also known as The First Opium War. Prior to the communist takeover in 1949, China was Hong Kong's primary supplier of everyday necessities, and residents were free to cross the border without formal documents. When daily interactions with China, especially reading materials and products of popular culture, were cut off in the 1950s, Hong Kong's people were forced to produce their own. The reappearance of newspapers was one of the first signs of the return to normalcy after the war. Four-panel manhua strips, written in colloquial Cantonese Chinese and focused on daily life, became popular entertainment.

The population of Hong Kong in 1945 was 500,000, but by 1950, that number had skyrocketed to 2.36 million, due to the influx of people from China and the postwar baby boom. Among the new arrivals in Hong Kong were skilled manhua artists like Yuan Bou-wan, Lui Yu-tin, and Wong Chak, all of whom had enjoyed publication in various major newspapers in Guangzhou or other cities in China before the war. These artists continued their work in Hong Kong, creating newspaper manhua strips that were collected and printed as individual comic books. These manhua titles were very popular and frequently were made into movies. *Kiddy Cheung* (1947), created by Hong Kong–born artist Yuan Bou-wan (1922–95), was adapted into the film *The Kid* in 1950. Yuan created his famous character before the war for a Guangzhou-based newspaper and continued publishing the series in a Hong Kong newspaper after the war, using the character to critique the unjustness of adult society (Wong, *Hong Kong Comics* 4). Work opportunities were scarce at the time. Many children had lost one or both parents during the war. But in general people were optimistic about the future, and both manhua and movies reflected these hopes, as well as traditional Chinese values.

One of Hong Kong's most prominent directors, Feng Feng, directed *The Kid*, which starred nine-year-old Bruce Lee as Kiddy Cheung. Having lost his parents in the war, the character lives a bare-bones lifestyle with his uncle and young cousins, a realistic depiction of life for many children at that time. The nonexistent social safety net and insufficient and unaffordable educational opportunities made it likely that the oldest children in households with several young children would have to sacrifice their educational

opportunities for their younger siblings. School-age children often valued earning money to support their families above going to school, becoming street kids before they were old enough to work.

The Kid reflects the social problem of young children failing to complete their education, instead being recruited by gangsters to engage in criminal activities. Tempted by the easy money and apparent prestige of the gangster lifestyle, Kiddy Cheung is on the verge of quitting school to begin a life of crime. In one scene, Cheung visits his uncle in his manhua rental booth after running away from home with cash he has earned through criminal activity. His uncle, played by Yi Qui-shui, lectures him about how bad it is to be a gangster, turns him away, and refuses to accept his money. The speech by the straight-arrow uncle reflects the traditional Chinese value of hard work and earning an honest living. It communicates and upholds a core value through the mass communication medium of cinema. Luckily, at the end of the movie, his uncle helps Kiddy Cheung realize the error of his ways before it is too late.

Movies produced in Hong Kong in the 1950s and 1960s were not designed solely as entertainment, but were usually imbued with traditional Chinese values. *The Kid* is clearly intended as a socializing tool. Although Hong Kong was a British colony, its society was still very much dominated by traditional Chinese values at that time. Manhua production during this period is a mix of Shanghai's manhua style and images of Chinese characters.

In 1946, the Guangzhou newspaper *Chum Daily* first published the manhua *Wu Long Wong* (1946) by Lui Yu-tin (1927–2008), one of the most popular serial manhua stories in southern China after the war. This manhua was collected and published in serial form, with several issues sometimes released in a single month. Outside Guangzhou, the manhua could also be purchased in Hong Kong and Macau. After China changed to a communist regime, *Wu Long Wong* continued publication in the Hong Kong newspaper *Chung Sing Daily*, where the manhua strips became the newspaper's main attraction.

So popular was this manhua title that it hit the silver screen in 1960 with no less than three comedic films revolving around the main character, Wu Lung Wong. The movies were *Siu Po-po Pokes Fun at the King of Blunders*, *Silly Wong Growing Rich* (Figure 22.1), and *Much Ado about Nothing*. All three shared the same lead, the prominent comedian Leung Sing-bo, and the same director, Chu Kei. Like many movies in this period, these titles often showed average people's struggles to achieve better lives while modeling correct values for society.

In the first movie, *Siu Po-po Pokes Fun at the King of Blunders*, Wu Long Wong is a rich man with a fancy car living in a mansion among economically average people, like the young girl Po-po, played by Feng Po-po, the gifted child actor known as Hong Kong's Shirley Temple. One day, Wu's wife drives the car past Po-po's house and splashes dirty water onto Po-po, her mother, and their freshly washed laundry. The outraged little Po-po and her mother demand that Wu and his wife apologize and compensate them for the loss. Instead, Wu and his wife refuse and look down on Po-po and her mother because they are poor. To get revenge on the couple, Po-po and her friend puncture the tires of their car behind their backs and then tease them about having bad luck with flat

FIGURE 22.1 *Silly Wong Growing Rich* (1960).

tires. Little stories like this continue throughout the movie, but Wu and his wife eventually realize that being rude is wrong and that all people are equal. The movie has a happy conclusion, with the couple living in harmony next to people from a different class, and everyone getting along.

Although the *Wu Long Wong* series does not preach explicit social messages like *The Kid*, it promotes fairness, equality, and social harmony. Lacking overt societal criticism, this light-hearted comedy series was intended for all ages, with a majority of the audience made up of children. By 1961, the majority of Hong Kong's population of three million was children under fifteen. This young majority created a ready market for children's manhua and for movies that modeled correct social values for the young population.

Between Past and Present

Beginning in the 1960s, Hong Kong society and culture entered a new phase after experiencing the Korean War, the US trade embargo of China, influences from the Cultural Revolution, and the watershed Riots of 1967. Ackbar Abbas identifies these changes as challenges to Hong Kong people's understanding of their "way of life," which often

resulted in "a radical change of paradigms, a half-conscious shift of experiential grids" (276). Popular manhua during this period—*Wu Long Wong* (1946), *Uncle Choi* (1958), and *Old Master Q* (1962)—were examples of paradigm shifts away from drawing experience from the past toward a new phase, focused on the power of local customs and local knowledge to create a sense of belonging.

The parents of baby boomers moved from China to Hong Kong after the war, leaving their pasts behind and facing uncertainty ahead. Their experiences in China became a transition or temporal past, with the past short-lived compared to the unknown future. The imagery and stories of *Wu Long Wong, Uncle Choi*, and *Old Master Q* embed memories of the past and represent a paradigmatic mix of the honored past and an uncertain present. The *Wu Long Wong* and *Uncle Choi* movies reflect the values and experiences of the past, while *Old Master Q* films project stories of everyday life in present-day Hong Kong, although the present may be an unstable transitional period requiring people to move to another place to enjoy long-term political stability.

Uncle Choi (1958), by Hui Guan-man (1930–2007), was another popular manhua for children, first released in 1958 and later made into movies. The first one, entitled *How Cai Shu Subdued the Tyrant* (1962), starred Chou Tat-wah, Hong Kong's most prominent action star of the time. This black-and-white film was a big hit with the fans (mostly children) of both manhua and movies because of the story's action and adventure elements. Both the manhua and the movie drew upon the wartime experiences of their parents' generation but added touches of contemporary life. While parents watched this movie in the context of their memories, children enjoyed its action and adventure elements while simultaneously sharing their parents' wartime experiences. The movie audience's background may be a key reason for the success of this manhua title and its film adaptation. Unlike Wu Long Wong and Old Master Q, Uncle Choi was an anti-war hero in an anti-Japanese war story. He dressed in modern clothing rather than traditional Chinese costumes and was constantly involved in action and adventures. This title was a number-one bestseller during its first few years in print and maintained its popularity until the mid-1970s. The decline of manhua titles drawing upon past influences from the mainland gave rise to the next big hits. In 1991, a now-grown childhood fan of this title, the renowned film director Tsui Hark, made this manhua into a movie called *Uncle Choi, The Raid*. However, society and audiences had changed a great deal, and this film was less well received than manhua adaptations of the 1960s.

The next big hit, drawn in a style similar to that of *Wu Lung Wong*, was Wang Chak's *Old Master Q*, which first appeared in 1962. The best known of all classic comical manhua characters, *Old Master Q* soon enjoyed a second life in film adaptations. Unlike the adventures of *Wu Lung Wong* and *Uncle Choi, Old Master Q* movies were often filmed on location in the heart of Hong Kong, accurately portraying where the audience lived. The artist (born Wong Kai-hei, also known as Alfonso Wong) moved to Hong Kong in 1960, worked for a French Catholic missionary, then later became the art editor for the Catholic children's magazine *Le Feng (Ngokfung Bo)*. In 1962, he created *Old Master Q* as a four- or six-frame manhua strip with little dialogue but content designed to appeal to

all ages, first appearing in newspapers and magazines, then published as a serial title two years after. The characters' expressive faces and vivid actions made *Old Master Q* a favorite among readers. This humorous cartoon has been published continuously ever since then, earning a place in history as the longest-lived Chinese manhua.

Old Master Q and his supporting characters Mr. Chun and Big Dumb have inspired several live-action and animated movies over the past four decades. In the black-and-white-film era, the first *Old Master Q* movie was produced in 1965. Altogether, three movies were produced during the 1960s. Like the manhua, the black-and-white *Old Master Q* movies were lighthearted comedies under the direction of Chan Lit-ban. The actors dressed like the characters in the manhua, and the movies were named after the printed cartoon. The storyline, set in contemporaneous Hong Kong, revolved around the everyday lives of the three main characters.

The third black-and-white film, *How Master Cute Thrice Saved the Idiot Ming* (1966), shows Master Q and Big Dumb chasing after their friend, Idiot Ming, who is trying to commit suicide because he suspects that his wife has cheated on him. After failed attempts at suicide in the city and condemnation from the crowds because his acts have endangered public safety, Ming finally reaches a cliff and is ready to jump. Luckily, Master Q and Big Dumb save him and convince him to learn the truth before killing himself. As usual, the movie has a happy ending. Unlike Wu Long Wong's *Siu Po-po Pokes Fun at the King of Blunders* (1960), this movie focuses on personal problems, rather than preaching traditional Chinese values. In another departure, it was shot on location around the city of Hong Kong, not filmed in a nondescript studio. Movies in the mid-1960s began shifting from tools of socialization to depictions of contemporary reality, celebrating Hong Kong as the audience's permanent new home and the basis of reality. This movie, set in the cityscape of Hong Kong and showing increasing concern for personal problems, is an indicator of the paradigm shift and self-understanding of everyday life that Abbas describes.

The comedic approach continued in three movies in the 1970s, two of them produced by the Shaw Brothers, featuring more depictions of everyday life in Hong Kong. Shaw Brothers Productions' 1976 hit, *Mr. Funny Bone*, was based on a series of realistic experiences in Hong Kong, including riding on a bus, eating dim sum in a restaurant, and being robbed in the park. Each scene reflected the lives of average people living in Hong Kong in the 1970s. Throughout this movie, images of Hong Kong and its national identity are clearer, more specific, and more contemporary than in the previous era. However, as society became more modern and most people donned contemporary clothing, the traditional Chinese images of main characters Master Q and Big Dumb became steadily less convincing.

Old Master Q was better received in a series of animated adaptations released in 1981 (Figure 22.2) and later made into a three-part series. Their release, the first feature-length animation produced in Hong Kong, marked the first time that a manhua title was adapted to animation. This animated *Old Master Q* series successfully updated the images of the characters while at the same time preserving the spirit of the original manhua.

FIGURE 22.2 *Old Master Q* (1981).

ESTABLISHING THE PERMANENT SPACE
AND DIVERSIFICATION OF CULTURE

Following two transitional decades moving away from the experiences and memories of the war in China, the 1970s saw the emergence of Hong Kong as a permanent space that inspired a sense of home, rather than a temporary experience for characters and filmgoers on their way elsewhere. After the Riots of 1967, those immigrants who had fled China as refugees settled in, along with the first generation born in the city. Together they established Hong Kong as their permanent home in the 1970s and 1980s. While the society continued to change, this time its younger generation had little previous experience or memories of the mainland. Observing how the city adapted to each challenge, Abbas describes its strategies as "Zelig-like and without full understanding, to the new situation. At one level, it might be possible to describe the shift in terms of a movement from trade to manufacturing, and then to service and finance. But the cultural and affective readjustments which necessarily accompany these shifts are much harder to gauge, and these too have important political and historical implications" (276).

The manhua *Siu Lau-man*, created by artist Wong Yuk-long in 1970, is an example of these political and historical shifts. It represents both the end of traditional Chinese influence, brought by the parents' generation, and the formal beginning of Hong Kong's independent identity and image. Politically, manhua titles drew a clear line, distancing Hong Kong from mainland China and its association with old images like *Old Master Q* and the communist present.

The classic Hong Kong manhua *Siu Lau-man* (*Little Rascal*, 1970–75), later renamed *Lung Fu Mun* (*Tiger Dragon Gate*, 1975–2000), was a significant indicator of popular culture, reflecting and representing the lives of people growing up in public housing estates, some of them first-generation Hong Kong citizens (Wong, "Manhua" 41). Although *Siu Lau-man* was drawn in black and white, it abounded in depictions of violence, including graphic images of blood and guts, and foul language. The original manhua *Siu Lau-man* created the action genre in 1970 and caught the "kung fu fever" fad created by Bruce Lee's movies. Lee's big film hits—*The Big Boss* (1971), *Fists of Fury* (1972), and *The Way of the Dragon* (1972)—were a boon for Wong's manhua. Episodes produced during this period often borrowed from the fame of Bruce Lee and kung fu.

Wong captured his readers' attention with images of public housing estates, factories, and the red light districts of Hong Kong, creating a sense of identity and belonging through storylines not so different from traditional Chinese swordplay stories emphasizing righteousness. As the kung fu craze crested in the 1970s with Bruce Lee, this genre became "a cultural imaginary consecrated in Hong Kong cinema" and "was constituted in a flux of nationalism during the historical process whereby China catches up with modernity" (Li 516). A few years later, in response to public criticism of the manhua's violent scenes, the artist changed its name to a milder one and relocated its action from Hong Kong to Japan.

Siu Lau-man's success is an extension of audiences' acceptance of *guzhungpian* (costume drama). Throughout the history of postwar Cantonese cinema in Hong Kong, the three chief paradigms of *guzhungpian* were the martial arts picture, swordplay, and kung fu features (Tan 171). *Siu Lau-man* is a printed, frame-by-frame version of sequential pictorials depicting a series of fighting actions. Although Wong set the story in contemporary Hong Kong rather than presenting something he "found spatially in China and temporally in a past" (Tan 328), readers were already familiar with this genre.

Lung Fu Mun (The Dragon and the Tiger Kids) was made into a movie in 1979, a year after Jackie Chan's hit movie *Drunken Master* (1978). For the first time, Wong Yuk-long funded the film's production himself. Although the movie included all the lead characters from the popular manhua, it was a box office failure, perhaps because no real actors could match the characters in readers' imaginations, or perhaps because movie regulations forbade depictions of the extreme violence found in the manhua. If "Hong Kong cinema has taught us another way to understand authenticity," as Chu Yiu-wai points out (15), the uniqueness of the *Lung Fu Mun* manhua was authentic enough for its readers—though this particular movie adaptation was not.

Despite the failure of the *Lung Fu Mun* movie, locally produced manhua had reached a peak by the 1980s, presenting Hong Kong as a permanent space, a true home to the people living there. *Lung Fu Mun* secured a loyal readership and continued publication until 2000; it was picked up and made into another movie in 2006. This movie adaptation, *Lung Fu Mun (Dragon Tiger Gate)*, starring Donnie Yen, retained only a few of the original characters and the brief plot outline from the original manhua. These changes, along with the use of computerized special effects, resulted in a film quite different from the straightforward line drawings of the original 1970s manhua.

If *Lu Fu Mun* represented the establishment of Hong Kong as a permanent space and as mainstream culture, then the work of Lee Chi-tat, a self-employed artist, offered readers an alternative that enriched the subculture. The manhua titled *Black Mask* (1992) revolved around a skilled martial artist living in a big city as an ordinary citizen by day and a masked hero at night. This six-issue, *Batman*-like manhua was set in an unknown city just like its American counterpart, symbolizing Hong Kong's development into an international city. In 1996 it was made into a film starring martial arts phenomenon Jet Li.

Action manhua titles adapted to film rarely captured the flavor of the original manhua. After decades of reading manhua and watching movies, readers and audiences demanded quality and variety. Ma Wai-shing's *Chung-wah Ying-hung (Chinese Hero: Tales of the Blood Sword)* (1984) is a great example of the high narrative and visual standards that manhua attained at its peak. This title was originally released in 1980 in *Golden Daily*, one of the manhua newspapers owned by Wong Yuk-long, then as a supplement to another Wong work, *Drunken Master*. Its first issue, as an independent title published in 1982, sold approximately 45,000 copies.

The manhua industry reached its peak in the mid-1980s, when Wong Yuk-long dominated and monopolized the market after buying out most of his competitors, including Seunggoon Siubo. In 1986, Wong's company, Yuk-long Group (later renamed CultureCom Holdings Limited), was listed on the stock market. But the stock market crash of 1987, the departures of key artists Ma and Seunggoon, and some fraudulent

accounting practices left Wong's company in serious trouble. Wong was sentenced to four years in prison in early 1991. Although he was released in 1993, Wong never regained his monopoly control of Hong Kong's manhua industry.

Aside from the difficulties that Wong and his company faced, the manhua industry seemed to be freed from the homogenization imposed by the major genre of fighting. Local production continued to flourish, with diversification into new genres such as gambling, romance, ghost stories, gangsters, martial arts sagas, and independent manhua. New drawing and plotting techniques and diverse subjects appeared, even as Hong Kong neared the scheduled 1997 return to Chinese sovereignty. Uncertainty over the city's economic future helped fuel an increase in vice in the early 1990s.

The Hong Kong movie industry also reached its peak in the 1990s. In 1994, Feng Chiming's manhua title *Dagger, Sword, Laugh* was made into a movie, *Three Swordsmen*, starring Andy Lau Tak-wah and Brigitte Lin Chin-hsia, and directed by Wong Tai-lai. This movie, a fad swordplay-genre film featuring two popular stars, does not emphasize manhua adaptation as its main attraction. However, when Ma's *Chung-wah Ying-hung* was made into a 1999 movie of the same title, *Chung-wah Ying-hung* (*A Man Called Hero*) (Figure 22.3) it drew the public's immediate attention. In this movie, great effort was made to retain the flavor of the original print manhua while experimenting with composition and camera angles. The film starred Hong Kong idols Eken Yee-kin Cheng as Wah Ying-hung and Nicholas Tse as his son, Wah Kin-hung.

Another important manhua series by Ma Wai-shing, *Fung Wan* (*Wind and Cloud*), later renamed *Tin Ha Pictorial* (1989) and published by his own company, Jonesky Publishing, was also made into a series of movies, the first in 1998. *The Storm Riders*, directed by Andrew Lau Wai-keung, cast star idols Eken Cheng Yee-kin and Aaron Kwok Fu-shing. Its 2009 sequel, *The Storm Warriors*, kept the same stars but used a different directorial team, the Pang Brothers (Danny Pang Phat and Oxide Pang Chun).

Eken Cheng was the most popular star of adaptation movies during this period. He was also cast in lead roles for two other major Hong Kong manhua movie adaptations: the *Young and Dangerous* series, and the *Feel 100%* series. The *Young and Dangerous* series is based on the original manhua *Gu-waak Zai* (*Teddy Boy*), with story and script by Ow Man (born Man Kai-ming), first published in 1992. This manhua series has continued publication to this day. The *Feel 100%* series is based on the manhua by Lau Wan-kit. The appearance of these two movie adaptations demonstrated a paradigm shift in Hong Kong's manhua industry and reflected societal changes and the diversification of culture in the early 1990s.

INTERROGATIONS OF NEW CULTURE

Margaret Thatcher's visit to China in 1982 brought more changes to Hong Kong. Abbas observed in the 1990s, "Hong Kong 'culture' now means more than just a culture produced in Hong Kong (like clothing with a 'made in Hong Kong' label); it means a culture that interrogates the very nature of Hong Kong and explores the possibility of its

FIGURE 22.3 *A Man Called Hero* (1999).

redefinition" (286). Although the identity of Hong Kong was established and diversified in popular culture within action-genre manhua and movies in the 1980s, the culture continued to evolve, along with changes in society. One of these interrogations involved the creation of a new manhua genre, later known as the *Gu-waak Zai* (*Teddy Boy*) series, which developed into a distinctive film genre.

The Gu-waak Zai series, together with *Portland Street* and *Red Light District*, published in 1992, initiated a new genre of triad gangster fighting (Wong, *Hong Kong Comics* 129). Other manhua artists also began producing titles in this genre, which depicted violence in a new way suggestive of gangster activities. The government responded by amending the indecent publication laws, requiring that these "adult" materials be sold in sealed packaging and labeled with a warning. The rise of this genre reflected the rise of societal polarization in the 1990s (Wong, *Hong Kong Comics* 101).

After three decades of unauthorized Japanese manga production in Hong Kong, Japanese publishers finally began licensing Chinese-language manga in the early 1990s. Within a short time, Chinese-language Japanese manga had garnered a majority share of Hong Kong's manhua market. As Hong Kong's population continued to grow and to become more educated, the greater varieties of genres and the higher qualities of plot and comic arts of Japanese manga titles made them the preferred choice of most readers.

However, Japanese manga was less appealing to those readers who, unable to endure the keen competition and rigorous academic standards of Hong Kong's education system, left school early. Sociologists found that societal polarization had become more serious, as indicated in the 1991 census data, and had not improved much by 2001. For instance, there were 87 moderate-poverty neighborhoods in the 1991 census, and 102 in 2001 (Delang and Ho 137).

One phenomenon related to these statistics involved young students quitting school. By quitting school around grade eight or nine, these young and mostly male readers often ended up working in low-end jobs or dabbling in crime, along the way becoming the main consumers of gangster manhua and movies. The gangster's day typically starts late at night and lasts until three or four o'clock in the morning, with many gangsters or young boys on the verge of criminality hanging around downtown or in the seedier parts of town, waiting for something to happen.

To reach likely readers, newly issued weekly or biweekly gangster manhua titles are usually available for sale in newspaper kiosks after 10:00 p.m. This genre of manhua contains the violent graphics and storylines that appeal to this segment of the population. Unlike Japanese paperback manga, which are thick in size, printed in black and white, and written in formal Chinese, these locally produced manhua are 32-page full-color publications that glorify gangster life, violence, and vice. By folding these thin local manhua in half vertically, readers can fit them into their back pockets to carry around. Reading locally produced gangster and fighting genre manhua has become a powerful subculture in Hong Kong. So when *Gu-waak Zai* was adapted for the movies, it became an overnight box office sensation.

As triad studies expert T. Wing Lo observes, "Since the 1990s, triad societies have been undergoing a gradual process of disorganization. Incidents of internal conflict and

clashes between gangs have increased. Gang cohesiveness and members' loyalty and righteousness have begun to diminish" (Lo 852). The creation of *Gu-waak Zai* on paper provided the script to promote gangster heroism as the righteous way to uphold justice in the triad. Then the silver screen provided an excellent venue for the story's visualization. Both the manhua and the movie adaptation show their media reflecting reality. Unlike *The Kid*, the 1950s movie adapted from the manhua *Kiddy Cheung*, this newly emergent genre did not preach the traditional Chinese values of hard work and making an honest living. Rather, the series did not condemn vice or the gangster lifestyle as Kiddy Cheung's uncle did, thus reflecting society's changed values.

The first *Gu-waak Zai* movie adaptation was released in 1996 under the same Chinese title, *Gu-waak Zai* (*Young and Dangerous*). It was directed by Andrew Lau and starred Eken Cheng in the lead role as Chan Ho-nam. This adaptation was based in part on the original and used most of the characters from the original manhua. The opening scene shows a group of young boys living in public housing who lack parental supervision and have flunked out of school. The boys eventually join the triad, and the *Young and Dangerous* series focuses on their careers of crime within the triad.

Triads commonly perform "protection" services, run enterprises, and sometimes "even team up or cooperate with illegal entrepreneurs to run the business" (Lo 852), as audiences can readily find in this series. The plot, based on members of triad societies, provides an excellent source of inspiration for the audience, since it is possible for a young member like Chan Ho-nam, the lead character, to work his way up the career ladder, much as he might in a big corporation. By following the story as it develops, readers and audience members who live in poverty and have little hope of achieving success in a typical career are invited to identify with Chan Ho-nam and to project their imagination into the series, either on paper or onscreen.

Following the box-office success of the first movie, *Young and Dangerous*, two sequels, *Young and Dangerous II* and *Young and Dangerous III*, were produced immediately and released the same year. In 1998, *'97 Young and Dangerous IV* and *Young and Dangerous V* were released, together with two movies featuring characters originally from the *Young and Dangerous* series: *Portland Street Blues* and *Young and Dangerous: The Prequel*. By the late 1990s, Hong Kong's movie industry and the overall economy were in a downturn, and only a limited number of movies were being produced. In 1999, only one movie in the *Young and Dangerous* series was produced, and just two more in 2000.

Between 1996 and 2008, at least thirty-three movies were produced in Hong Kong using the title *Young and Dangerous* or featuring characters developed from the original print manhua. This explosion of gangster movies, which made it seem that the gangster genre was Hong Kong's signature, drew media criticism. Although the gangster manhua and movie phenomenon presented a realistic reflection of one aspect of society and created a unique identity and genre for Hong Kong manhua and movies, it has also indirectly hindered the development and diversification of manhua and movies in Hong Kong. The *Young and Dangerous* series faded away with the downturn in the Hong Kong movie industry in the 2000s.

For manhua readers who were not interested in the gangster or fighting genres but still enjoyed reading local-themed manhua, Lau Wan-kit's *Feel 100%* (1992–2007) offered an

alternative. This romance manhua was inspired by a Japanese manga, Saimon Fumi's *Tokyo Love Story*, and was adapted into a movie of the same title in 1996. Directed by Joe Ma Wai-ho and starring idols Eken Cheng and Sammi Cheng Sau-man, the movie focuses on the romances of young, middle-class people in Hong Kong, with appearances by manhua characters including Jerry, Hui Lok, and Cherie. After the movie's success at the box office, a sequel was made the same year with a different cast, and two other movies based on the same series appeared in 2001 and 2003. These manhua titles and movies were seen as an alternative to the gangster genre for readers who enjoyed the flavor of locally produced manhua but preferred themes that are more wholesome. These series reflected society's growing affluence and the lives of Hong Kong's large middle class, much as the *Young and Dangerous* series reflected the lives of a marginalized segment of society.

IMPLICIT IDENTITY BEYOND WORDS

Although Chinese-language Japanese manga were popular among readers who shared cultural proximity in the 1990s and early 2000s, something was still missing in translation, leaving middle-class readers not completely satisfied. During the 1990s, Hong Kong society was searching for and debating the island's national identity (Lee 499). Not surprisingly, *McMug Comics*, imbued with strong Hong Kong characteristics and local flavor, gradually became a household name, finding a formula that spoke to the audience. Abbas notes that "Hong Kong has always seemed to be a special enough place which only required finding the right formula for it to work. The preferred formula used to be 'a policy of laissez-faire'; now it is 'one country, two systems.' However, there are many indications that these formulae cannot address the complexities and historical specificity of place, which remain within the tacit" (277).

McMug Comics, with art by Alice Mak and text by Brian Tse, was originally intended for children but became popular with readers of all ages. This title was first released in *Little Ming Pao Weekly*, a supplement to one of Hong Kong's main entertainment magazines, *Ming Pao Weekly*. By this time, the percentage of children in Hong Kong had begun to decline as society grew more affluent. The main character of *McMug Comics* is a cute pig named McMug. The manhua lacks a clear narrative plot but is instead scripted with childish nonsense dialogue. Educated readers were drawn to the cartoon because of its satire and commentary on culture, society, everyday life, and even the politics of Hong Kong. The subtle satire and underlying commentary are so specific to Hong Kong that they are often impossible to render in any other language or context. The rise of this manhua reflected society's renegotiation of its previous identity, established through action and gangster genre cultures, creating a space for a more educated audience.

Since its first appearance in 1988, new characters have been developed from the comics, and various licensed products have made the characters highly visible in the marketplace. From 2002 to 2009, three animated movies were produced with McDull, the hero of the comics, in the lead role. *My Life as McDull* (2002) (Figure 22.4), the first feature

原著故事：麥家碧 謝立文

my life as mcdull

麥兜故事

《2002 年香港電影金像獎「最佳原創音樂大獎」》《金馬獎「最佳動畫片」》
《法國安錫國際動畫電影節「最佳動畫電影」》
《蒙特利爾國際兒童電影展評審團特別獎》《香港電影評論學會「推薦電影」》
《第七屆金紫荊獎「十大華語片」》
《香港國際電影節「國際影評人聯盟獎」》

FIGURE 22.4 *My Life as McDull* (2002).

based on this manhua, introduced this key series character. McDull is a comical pig who lives with his mother in Sham Shui Po, an old district of Hong Kong with an aging population. Unlike other children's comics and movies, the creator does not give him a perfect family; instead, McDull's father has run off and his mother is raising him as a single parent. Together with his mother, he lives in the sometimes harsh real world, dealing daily with pressure and competition. Fortunately, McDull fulfills his mother's wish by growing up to be a successful adult.

The first McDull movie was produced on a small budget at a low point in Hong Kong's movie market, during the dawn of the SARS outbreak in 2003. Nevertheless, director Toe Yuen Kin-to, formerly an independent animator, was passionately committed to the project despite the tight budget. He successfully adapted the title into a feature-length animated film, using computer-generated three-dimensional graphics to depict the city scene where the story takes place, while keeping the two-dimensional hand-drawn style of the original manhua. His hard work was rewarded when the film won numerous international awards, such as the Grand Prix in France's Annecy International Film Festival.

This film was made strictly for a local audience who could appreciate the insiders' satire and humor. Audiences of all ages enjoyed *My Life as McDull* because they could easily relate the story's scenes and scenarios to their own life experiences in Hong Kong. McDull's animated career was extended in *Prince de la Bun* (2004) and *McDull Kungfu Ding Ding Dong* (2009). Unlike the first two *McMug* movies, *McDull Kungfu* was made with Chinese markets in mind. The Hong Kong movie industry at that stage faced the forces of nationalization and global capitalism (Pang 414). Perhaps because of its Japanese co-producer, this movie's dialogue and cultural imagery are less obviously "Hong Kong" than the first two.

McDull is almost like the *Hello Kitty* of Hong Kong, with licensed merchandise and endorsements in various media and promotions. Both the print manhua and animation circulate throughout the Greater China region, although the humor and satire embedded in the work do not always translate completely from one culture to another. As a culturally coded medium, manhua requires internal knowledge of its culture of origin for its full appreciation.

CONCLUSION

The success of locally produced movie adaptations of manhua depends on their responsiveness to changes in demography and society overall. It is foreseeable that "Hong Kong's colonial experience will likely be in the long run an ephemeral episode in its history" (Chun 452). After 1997, both the Hong Kong manhua and movie industries faced tremendous challenges. As Pang indicates, Hong Kong's movie industry has experienced a serious decline since 1997, forcing the industry to look toward a new direction,

branding itself through its association with general mainland Chinese movies, putting the cultural identity of Hong Kong's movies at risk of vanishing (Pang 413).

Hong Kong's manhua and animation market is currently dominated by Japanese products which pose stiff competition for increasingly scarce locally produced material. The success of the McMug comics and animation, however, has proven that if an adaptation is able to link the bonding experience of the original manhua title with the extended imaginative possibilities of movies, it will be more likely to succeed in a keenly competitive market.

In the current age of diversification and globalization, many comic titles have moved not just into movies but also to new media such as games, licensed by-products, and versions for the Internet and smart phone. Although this survey does not consider genres beyond the big screen, they are equally important to study, for they too reflect changes in consumption patterns and reading and entertainment habits. To continue building upon the successes of local work and to compete effectively with other imported cultural products in a globalized world, it is necessary for local producers of cultural products to consider embedding local flavor within their work, while at the same time shaping it to appeal to other audiences so that it can be exported beyond China and Taiwan.

WORKS CITED

Abbas, Ackbar. "Hong Kong: Other Histories, Other Politics." 1997. Rpt. in Cheung and Chu 273–96. Print.

Cheung, Esther M.K., and Chu Yi-wai, eds. *Between Home and World: A Reader in Hong Kong Cinema*. Hong Kong: Oxford UP, 2004. Print.

Chu, Yiu-wai. "Introduction: Globalization and Hong Kong Film Industry." Cheung and Chu 2–15. Print.

Chun, Allen. "Colonial 'Govern-Mentality' in Transition: Hong Kong as Imperial Object and Subject." *Cultural Studies* 14.3/4 (2000): 430–61. Print.

Delang, Claudio O., and Ho Cheuk Lung. "Public Housing and Poverty Concentration in Urban Neighbourhoods: The Case of Hong Kong in the 1990s." *Urban Studies* 47.7 (2010): 1391–1413. Print.

Lee, Ou-fan Leo. "Postscript: Hong Kong—A Reflective Overview." *Postcolonial Studies* 10.4 (2007): 499–509. Print.

Li, Siu Leung. "Kung Fu: Negotiating Nationalism and Modernity." *Cultural Studies* 15.3/4 (2001): 515–42. Print.

Lo, T. Wing. "Beyond Social Capital: Triad Organized Crime in Hong Kong and China." *British Journal of Criminology* 50 (2010): 851–72. Print.

Pang, Laikwan. "Postcolonial Hong Kong Cinema: Utilitarianism and (Trans)local." *Postcolonial Studies* 10.4 (2007): 413–30. Print.

Tan, See-kam. "Chinese Diasporic Imaginations in Hong Kong Films: Sincist Belligerence and Melancholia." Cheung and Chu 147–76. Print.

Wong, Wendy Siuyi. "Manhua: The Evolution of Hong Kong Cartoons and Comics." *Journal of Popular Culture* 35.4 (2002): 25–47. Print.

———. *Hong Kong Comics: A History of Manhua*. New York: Princeton Architectural P, 2002. Print.

FILMOGRAPHY

Year	Original Manhua Title	Art/Script	Adapted Film Title	Theatrical Run (year/month/day)	Director	Cast
1947	Kiddy Cheung	Yuan Bou-wan (1922–95)	The Kid	1950/05/31	Feng Feng	Bruce Lee
1946	Wu Long Wong	Lui Yu-tin (1927–2008)	Much Ado about Nothing	1960/06/15	Chu Kei	Leung Sing-bo, Law Yim-hing
			Silly Wong Growing Rich	1960/07/20	Chu Kei	Leung Sing-bo, Tam Lan-hing
			Siu Po-po Pokes Fun at the King of Blunders	1960/12/15	Chu Kei	Leung Sing-bo, Feng Bo-bo
1962	Old Master Q	Wong Chak (1924–)	Master Q and Da Fanshu	1965/05/10	Chan Lit-ban	Ko Lo-cheun, Aai Dung-gwa Cheung Ching
			How Master Q Thrice Saved the Idiot Ming	1966/07/13	Chan Lit-ban	Same as above
			Master Q	1966/08/03	Chan Lit-ban	Same as above
			Old Master Q	1975/03/08	Lee Tit, King Weng	Leung Tin, Betty Ting Pei
			Mr Funny Bone	1976/10/02	Kuei Chih-hung	Wang Sha, Li Ching
			Mr Funny Bone Strikes Again	1978/11/18	Wong Fung	Wang Sha, Aai Dung-gwa
			Old Master Q	1981/07/16	Woo Shu-yue	Animation
			Old Master Q Part II	1982/07/10	Woo Shu-yue, Wong Chak	Animation
			Old Master Q Part III	1983/08/04	Toshiyuki Honda, Choi Ming-yum	Animation
			Old Master Q 2001	2001/04/05	Yau Lai-to	Nicholas Tse, Cecilia Cheung

(Continued)

Year	Original Manhua Title	Art/Script	Adapted Film Title	Theatrical Run (year/month/day)	Director	Cast
1958	Uncle Choi	Hu Guan-man (1930–2007)	Master Q: Incredible Pet Detective	2003/12/20	To Kwok-wai	Animation
			Old Master Q and Little Ocean Tiger	2011/01/27	Hiroshi Fukutomi, Wong Chak	Animation
			How Cai Shu Subdued the Tyrant	1991/03/28	Ching Siu-tung, Tsui Hark	Dean Shek Tin, Tony Leung Ka-fai, Tso Tat-wah
			The Raid	1962/05/15	Wong Fung	
1970	Siu Lau-man (Little Rascal, renamed as Lung Fu Man in 1975)	Wong Yuk-long (1950–)	The Dragon and the Tiger Kids	1979/07/05	Wong Yuk-long, Liu Jun-guk	Meng Yuen-man, Mang Hoi, Pai Piao
			Dragon Tiger Gate	2006/07/27	Yip Wai-shun	Nicholas Tse, Donnie Yen, Shawn Yu Man-lok
1984	Chung-wah Ying-hung (Chinese Hero: Tales of the Blood Sword)	Ma Wing-shing (1961–)	A Man Called Hero	1999/07/17	Andrew Lau Wai-keung	Ekin Cheng Yee-kin, Nicholas Tse, Shu Qi
1988	Dagger, Sword, Laugh	Art: Feng Chi-ming (1957–) /Script: Lau Din-kin	The Three Swordsmen	1994/08/25	Taylor Wong Tai-loi	Andy Lau Tak-wah, Brigitte Lin Ching-hsia

1989	Fung Wan (Wind and Cloud, later Tin Ha Pictorial)	Ma Wing-shing (1961–)	The Storm Riders	1998/07/18	Andrew Lau Wai-keung	Ekin Cheng Yee-kin, Aaron Kwok Fu-sing
			The Storm Warriors	2009/12/10	Danny Pang-phat, Oxide Pang-chun	Ekin Cheng Yee-kin, Aaron Kwok Fu-sing, Nicholas Tse
1992	Black Mask	Lee Chi-tat (1965–)	Black Mask	1996/11/09	Lee Yan-gong	Jet Li Lian-jie, Lau Ching-wan
			Black Mask II: City of Masks	2003/01/09	Tsui Hark	Andy On Chi-kit, Tobin Bell
1992	Gu-waak Zai (Teddy Boy)	Script: Ow Man (1961–)	Young and Dangerous	1995/01/25	Andrew Lau Wai-keung	Ekin Cheng Yee-kin, Jordan Chan Siu-chun
			Young and Dangerous II	1996/03/30	Andrew Lau Wai-keung	Ekin Cheng Yee-kin, Jordan Chan Siu-chun
			Young and Dangerous III	1996/06/29	Andrew Lau Wai-keung	Ekin Cheng Yee-kin, Jordan Chan Siu-chun
			Young and Dangerous IV	1997/03/28	Andrew Lau Wai-keung	Ekin Cheng Yee-kin, Jordan Chan Siu-chun
			Young and Dangerous V Portland Street Blues	1998/01/24 1998/02/21	Andrew Lau Wai-keung Raymond Yip Wai-man	Ekin Cheng Yee-kin, Shu Qi Sandra Ng Kwun-yu, Kristy Yeung Kung-yu
			Young and Dangerous: The Prequel Born to be King	1998/06/05 2000/07/21	Andrew Lau Wai-keung Andrew Lau Wai-keung	Nicholas Tse, Sam Lee Chan-sam Ekin Cheng Yee-kin, Jordan Chan Siu-chun, Shu Qi
			Young and Dangerous: Reload	2013/01/30	Daniel Chan Yee-heng	Law Chung-him, Oscar Leung

(Continued)

Year	Original Manhua Title	Art/Script	Adapted Film Title	Theatrical Run (year/month/day)	Director	Cast
1996	Feel 100%	Lau Wan-kit (1966–)	Feel 100%	1996/02/20	Joe Ma Wai-ho	Ekin Cheng Yee-kin, Eric Kot Man-fai
			Feel 100%, Once More	1996/12/21	Joe Ma Wai-ho	Ekin Cheng Yee-kin, Sammi Cheng Sau-man
			Feel 100% II	2001/03/17	Joe Ma Wai-ho	Eason Chan Yik-sun, Joey Yung Tso-vi
			Feel 100% 2003	2003/05/15	Chung Shu-kai	Shawn Yu Man-lok, Cyrus Wong Ka-ming
1988	McMug Comics	Art: Alice Mak Ga-bik; Script: Brian Tse Lap-man	My Life as McDull	2001/12/15	Toe Yuen Kin-to	Animation
			McDull, Prince de la Bun	2004/06/24	Toe Yuen Kin-to	Animation
			McDull, the Alumni	2006/01/26	Samson Chiu Leung-chun	Ronald Cheng Chung-kei, Anthony Wong Chau-sang
			McDull Kung Fu Ding Ding Dong	2009/07/24	Brian Tse Lap-man	Animation
			McDull, Pork of Music	2012/07/10	Brian Tse Lap-man	Animation
			McDull: Me and My Mum	2014/10/01	Brian Tse Lap-man	Animation

Source: HKMDB (Hong Kong Movies Data Base; hkmdb.com).

ROADS NOT TAKEN IN HOLLYWOOD'S COMIC BOOK MOVIE INDUSTRY

Popeye, Dick Tracy, *and* Hulk

DAN HASSLER-FOREST

IN the twenty-first century, superhero movies have become Hollywood's bread and butter. The comic book adaptations that started off in the 1940s as B-movie serials and appeared in the 1960s and 1970s as campy television shows have developed into one of the defining genres of the post-classical blockbuster era. The emergence of popular film adaptations of comic book characters across this period can be charted in three successive waves, each spearheaded by a massively popular high-concept event film: first *Superman* in 1978, followed by three sequels and the spin-off *Supergirl* (1984); then *Batman* in 1989, also followed by three sequels; and finally *Spider-Man* in 2002, followed thus far by two sequels, a franchise reboot, and what has been an unrelenting deluge of movies, TV series, video games, and novels derived from superhero comics. From the perspective of a historical period in which longtime rivals Marvel (now owned by Disney) and DC Comics (a Time Warner subsidiary) have developed elaborate cinematic universes that spawn not one but several tentpole pictures each year, it seems clear that the superhero genre has become a reliable formula within the US film industry. It has in fact become customary for each new release to be greeted by a succession of critical essays and think-pieces bemoaning the superhero's continued hegemony over the global box office, while documenting the notion that these films have become increasingly formulaic and predictable (see Bordwell, "Superheroes").

Although I would not suggest that all contemporary superhero movies are identical, a dominant aesthetic has clearly emerged within this multi-billion-dollar entertainment empire. For instance, the "gritty, realistic" approach associated with Christopher Nolan's popular Batman trilogy now informs most DC Comics film and television projects, while the Silver Age–inspired self-deprecating humor and ironic banter established in

Spider-Man and *Iron Man* ground the Marvel Cinematic Universe. Both of these highly lucrative enterprises have developed into serialized narratives that now follow a logic more similar to television production than the traditional film industry: executives like Kevin Feige, president of Marvel Studios, hire directors with an established style or track record to handle a particular installment, while ensuring from a corporate level that a strong degree of aesthetic consistency and narrative coherence with other franchise entries is maintained (Johnson, *Media Franchising* 87–92).

The traditional Frankfurt School perspective, which still informs many critical ideas about Hollywood as part of a larger culture industry, views these films as generic products assembled in an artificial and entirely calculated fashion. But these genres and their associated styles and conventions emerge out of creative experimentation, happenstance, and the perceived reciprocity between certain films' financial success and popular taste as an expression of some nebulous zeitgeist. The dominant aesthetic that has emerged results not only from the adoption of a popular film's style as a formula or template to be reproduced with minor variations. It is also, and crucially, shaped by ambitious experiments that were perceived upon their release as failures: films appearing in the wake of blockbuster successes that opened up a window for new creative work but subsequently came to be viewed as examples of how *not* to adapt comic books in cinema.

This essay will discuss three of these unpopular comic book movies. Each represents a provocative approach to comic book adaptation that has come to stand as a road not taken by the superhero genre: their failure to become the cultural phenomena that their context demanded effectively foreclosed the adaptive strategies these films explored. In addition, these case studies each foreground different creative strategies that open up under-explored questions of comics-to-film adaptation. They involve not only the reciprocal relationship between the two media's formal features, but also the complex issues of authorship, production, reception, and advertising that inform both media in different ways. My approach is informed by what can be described as a "media-archaeological" approach, a kind of "excavation" that blends analysis into media history as it was with reflections on what media history might have been (Huhtamo 303). As a result of this approach, I hope to shed new light on the dynamic relationship between comics and post-classical Hollywood.

The first of the three paradigmatic failures that make up this excavation is *Popeye*, the 1980 film directed by Robert Altman that appeared as Hollywood was transitioning from the 1970s age of "Movie Brats" to the blockbuster era of conglomeration and increased corporate control. The second is *Dick Tracy*, produced and directed by Warren Beatty in 1990, following the previous year's blockbuster success of *Batman*. And the third is Ang Lee's *Hulk*, released by Universal Pictures in 2003 in the wake of *Spider-Man*'s record-breaking success in 2002. While one might speculate about various fascinating "what if" scenarios showing how the genre's history could have been different if any one of these films had been a great deal more successful, such hypotheses are impossible to validate and ultimately irrelevant. But these unusual case studies do offer insight into the trial-and-error process of popular entertainment franchises and film genres as

active processes (Altman 54–59) and the unpredictable way in which media history is defined as much by its failures as by its triumphs.

POPEYE: TWO-DIMENSIONAL AUTEURISM

When *Superman* became one of the biggest commercial hits of the newly arrived post-classical film era, it also marked the arrival in Hollywood of a new kind of adaptation. Unlike earlier 1970s film hits like *The Godfather* (1972) and *Jaws* (1975), *Superman* wasn't based on a single identifiable text or narrative. Instead, it gave new form to a pop-cultural icon that had gone through diverse incarnations over the preceding four decades. Nor were these versions limited to a single medium. While the figure of Superman is obviously associated most strongly with the comic books in which he first appeared, he had been featured prominently on the radio and in film within the first three years after his debut and had successfully migrated to television almost as soon as this new medium was introduced. With so many versions of the character constituting a Superman palimpsest, questions of authorship, originality, and fidelity are obviously complicated by decades of reciprocal adaptation across texts, as well as across media (see Brooker 56).

Like *Star Wars*, the massively influential 1977 hit that consolidated the New Hollywood blockbuster paradigm established by *Jaws* (Elsaesser 191–94), *Superman* exuded a comic book sensibility that resulted from its own hybrid nature. The entire production was geared toward the establishment of an audiovisual experience that would appeal to a contemporary audience, reintroducing a fundamentally nostalgic figure into the newly developing *dispositif* of Hollywood's blockbuster-era "Cinema of Attractions" (Kessler 57). The film's writers and producers sought to appeal to a large mainstream audience for whom Superman most likely wasn't a part of daily life, but rather a dimly remembered childhood memory: the pre-credits sequence spells out all too clearly the film's nostalgia for a more innocent age of childish popular entertainments.

Director Richard Donner's film brought the character to life on the screen by giving this famously flat character new kinds of dimensionality, most noticeably in the film's impressive use of visual effects. While the comic book page's static images and the occasional flying sequences in the 1950s TV show were both obviously two-dimensional (though in different ways), the complex optical composite shots in *Superman* gave the worlds of Krypton and Metropolis astonishing visual depth. At the same time, Mario Puzo's coauthored screenplay constructed the character's narrative arc around a conventional Oedipal trajectory that gave the superhero a newfound psychological complexity. Although the resulting film will hardly be viewed as a profound character study, *Superman* emphasized its own status as a movie event by adapting its source material to the kind of dramatic realism that fit Hollywood's popular mold. Its enormous success suggested that post-classical cinema and comic books seemed made for each

other: besides the general comic book sensibility of films like *Star Wars*, a crop of more literal comic book adaptations seemed inevitable in its wake.

The first comic book movies to follow *Superman* both arrived in December 1980, when *Flash Gordon* and *Popeye* opened within weeks of each other. But while the former film was—unfairly and inaccurately—described by many reviewers as a poorly executed *Star Wars* imitation, *Popeye* was something of a novelty. Unlike *Superman*, it involved no high-profile stunt casting. The leading roles went to untested television actor Robin Williams and character actress Shelley Duvall, while the rest of the cast was made up of faces that would be unfamiliar to the movie-going public. Like many other comic book characters, Popeye had for years been a pop-cultural icon whose familiarity was based at least as much on his appearances in other media as on his comic strip origins. And although he had been a regular presence in newspaper comic strips since 1929, audiences were at least as likely to know him from the Fleischer brothers' popular animated films or from the many television cartoons that were produced from 1960 onward.

The film production had first come into being when producer Robert Evans, having lost a bidding war for the film rights to the Broadway musical *Annie* (another classic comic strip adapted for an audiovisual medium), reached somewhat desperately for a similar property to which Paramount already owned the rights. Popeye emerged as a viable basis for a Hollywood musical, and after several years of development, it went into production in early 1980 for a Christmas release. The participation of director Robert Altman and cartoonist Jules Feiffer, who had by that time already spent several years developing the screenplay, set it apart from *Superman* and *Flash Gordon*. Feiffer and Altman's work fused 1970s cinematic auteurism with blockbuster-era production values, resulting in a whimsical and quixotic diegetic world played out on the largest possible canvas.

The creation of this world took an approach that was the opposite of *Superman*'s expansive production, which ranged from the remote planet of Krypton via the cornfields of Kansas to contemporary Metropolis. Instead, *Popeye*'s setting was limited to the imaginary village of Sweethaven, which was constructed as an elaborate set on the coast of Malta. Within this stylized but highly detailed visual environment, the film introduces familiar characters that are ostentatiously two-dimensional. Where *Superman* had constructed its comic book world on the basis of the "reality effect," an aesthetic choice that grounds the diegetic world in our understanding of our experience of daily reality, the highly artificial caricatures that populate Sweethaven rely much more heavily on the "fiction effect," allowing the artificial to become "a primary focus of the narrative" (Affron 39).

This distinction is especially relevant to the realm of comic book adaptations because comics and cartoons are ontologically grounded by a "comic aesthetic" that is "a move away from the potential 'realism' of cinema, and towards abstraction and excess" (Cohen 21). *Superman*'s production team had gone out of its way to approximate as closely as possible this reality effect, an ambition that is illustrated most clearly by the film poster's famous tagline, "You'll believe a man can fly!" *Popeye*, through its setting in an unfamiliar and clearly constructed environment, alienates the audience from cinema's more

traditional realism by insistently foregrounding its artificial nature. This internally coherent but quite alien diegetic world is inhabited by three-dimensional human actors doing their utmost to transform themselves into two-dimensional cartoon characters, as per director Robert Altman's instructions: "So I would say to [an actor], 'You can only show two dimensions. You cannot show any depth of character whatsoever—so how do you want to walk?' And we would work it out so that each person had their own way to walk or would look or sing a certain way. I figured that if you were to stand everyone up on the hill, then from miles away you could tell who each character was by their silhouette" (qtd. in Thompson 120–21).

This approach creates unusual and unique effects that explore the tension between these two media. For example, when Bluto comes face-to-face with his fiancée Olive Oyl in the company of his romantic rival Popeye and the baby Swee'pea, his explosive rage is expressed not through Method acting, but by literal steam coming out of his ears—a familiar visual metaphor in comic books and cartoons that acts as conventional shorthand for intense anger. Adding further to the striking stylization of the scene, a point-of-view shot demonstrates that Bluto is literally seeing red with rage, as we switch to a point-of-view shot in which the other three characters stare back at him dressed in shades of red, while the walls around them have also momentarily changed color (Figure 23.1). Monochromatic moments like this serve to underline even further the cartoonish nature of the diegetic world, foregrounding its constructed nature and thereby its predominant fiction effect.

While Altman's use of an immersive and realistically detailed environment might seem to point toward the kind of realist aesthetic employed by the same director in his similarly designed masterpiece *McCabe and Mrs. Miller* (1971), the effect in *Popeye* is not that of a fully realized and three-dimensional narrative world. Instead, it draws on the archetypal comic book tension between a "deep," richly detailed environment and "flat," two-dimensional characters. Comic book theorist Scott McCloud describes this

FIGURE 23.1 The cartoonish two-dimensionality of Robert Altman's *Popeye* (1980).

specific tension between seemingly opposite aesthetic registers in terms of its unusual potential for audience identification. His cognitive theory of comic book style proposes that readers more easily identify with characters that are visually abstract or "iconic," while photorealistic figures tend to create distance and to be perceived by readers as "other" (McCloud 24–45). McCloud uses Hergé's Tintin as an example of an iconic character surrounded by a highly realistic background, a combination that "allows readers to *mask* themselves in a character and safely enter a sensually stimulating world" (43).

In film, a similar effect is most easily achieved in animation, the most obvious example being the Disney studio's classical style in films like *Pinocchio* (1940). In this film, the overwhelmingly detailed backdrops and the use of Ub Iwerks's legendary multiplane camera open up a realistic diegetic world with texture and depth, which is populated at the same time by highly iconic and unrealistic cartoon characters. But in live-action filmmaking, the indexical nature of photochemical cinematography makes it more difficult to create this kind of masking, as human actors in principle have the same degree of aesthetic detail, texture, and photorealism as their surroundings. *Popeye* is one of the most provocative examples of live-action cinema attempting to remediate a key feature of comic books, making every effort to reduce its human avatars to two-dimensional vessels for comic strip characters that function as the kind of "visual stereotypes" on which comic books have traditionally thrived (Eisner 18–20).

Part of this remarkable tension between a textured, fully realized diegetic world and wholly unrealistic, iconic characters results from Feiffer and Altman's explicit fidelity to one particular incarnation of the Popeye franchise. E. C. Segar's comic strip *Thimble Theatre*, in which the character was first introduced in 1929, had a distinctive visual style and created an eccentric, surreal world in which Popeye and the Oyl family's adventures played out across daily three-panel black-and-white strips and Sunday's full-page color mini-narratives. For Altman and Feiffer, the idea from the start was "to do more of the early Segar thing than the cartoons through which most of the public knew Popeye" (Altman, qtd. in Anderson 120), with a strong emphasis on Segar's obsession with modern bureaucracy, and with costumes that were "very faithful to the way the characters looked in the comic strip" (121).

After a notoriously difficult location shoot full of much-publicized personal conflicts, weather calamities, substance abuse, and budget overruns, the end result, which premiered as a holiday family musical in 1980, was released to poor reviews and abundant "bad buzz" (Morris). And while BoxOfficeMojo.com reports that its domestic gross alone returned nearly twice the film's estimated $25 million budget, *Popeye*'s failure to connect to the popular imagination has nevertheless led to its general perception as a flop. With even a sequel like *Superman II* raking in well over $100 million, a high-concept comic book film that didn't break box office records clearly didn't provide a template worth repeating. *Popeye*'s fate, taken together with *Flash Gordon*'s even less spectacular earnings, made it clear that such costly comic book adaptations remained risky propositions for the corporate executives increasingly making the decisions at Hollywood's rapidly diversifying film studios.

DICK TRACY: REMEDIATING
THE COMIC BOOK FRAME

While the Superman film franchise slowly petered out, few other literal comic book adaptations featured prominently in the developing culture of blockbusters and high-profile sequels as "consolidated entertainment" (Maltby 22) in the 1980s. The most successful and influential productions of this era, like the *Star Wars* trilogy and the Indiana Jones series, embraced a style of pop-cultural pastiche that many people associated with comics. But hardly any of them were actually based on existing comic book characters. And given the notable lack of critical or commercial success for the occasional high-profile comic book adaptation (most memorably the critical and commercial fiasco of *Howard the Duck* in 1986), film studios in the 1980s tended to focus on serialized entertainment franchises based on original properties like *Ghostbusters* (1984), *Gremlins* (1984), *Beverly Hills Cop* (1984), and *Back to the Future* (1985).

Toward the end of this decade of corporate mergers, buyouts, and takeovers, however, changes in the comic book industry and the composition of its readership led the newly merged global media conglomerate Time Warner to invest in a comic book franchise. Time Warner subsidiary DC Comics had found great success publishing graphic novels—"literary" comic books like Frank Miller's *Batman: The Dark Knight Returns* (1986) and Alan Moore and Dave Gibbons's *Watchmen* (1986)—which had revived adult interest in what had by this time become a niche medium. As a direct result, the decision was made to develop a blockbuster film around the comic book character Batman, which could be used as a central brand to unite products across Time Warner's diverse publishing channels: music, film, television, comics, novels, toys, and fashion. The media conglomerate's plan to use the *Batman* film as the tentpole for countless branded products was so successful that the ubiquitous black-on-gold logo became much more than just a movie poster: it was the signifier for "participation in a particular cultural moment" (Pearson and Uricchio 183).

Batman's impact as a successful example of "corporate synergy" was followed the next year by *Dick Tracy*, Warren Beatty's long-gestating adaptation of another comic book character dating back to the 1930s. While the production had been green-lit in 1988, the ambitious marketing and merchandising campaign surrounding it was designed entirely to replicate the previous year's Bat-success, with the film's already staggering $47 million production budget overshadowed by the $54 million advertising campaign that introduced it. With the minimalist design of its one-sheet publicity posters mimicking *Batman*'s iconic logo, composer Danny Elfman penning another rousing orchestral score, a tie-in pop album by Madonna resembling the previous year's Prince record, and toys and T-shirts galore, nearly every published review made the connection to the previous year's game-changing blockbuster: "'Tracy' has carbon-copied almost everything from last year's 'Batman'" (Howe).

Even apart from the fact that *Dick Tracy* made less than half the amount *Batman* had earned at the box office, the two films also represent quite distinct approaches to comic book film adaptation. While Burton's film featured striking production design that resonated with comics' representation of urban fantasy, it otherwise followed mostly in *Superman*'s tracks by combining an imaginary story-world with a reality effect that grounds characters, setting, and narrative in the conventions of classical Hollywood film style. In the same ways as *Star Wars*, superhero films like *Superman* and *Batman* strove to present their fantasy worlds as immersive and credible environments, with little interest in the formal conventions of comics.

In this sense, *Dick Tracy* operates in a substantially different register from those other comic book movies. At nearly every level, Beatty's film eschews Hollywood's conventions of transparent realism, opting instead for a conspicuously stylized take that enters into dialogue with the comic book form from which it has been adapted. As in *Popeye*, this stylization is not achieved through the slavish visual fidelity to the original artwork exhibited by later films like *Sin City* (2005), *300* (2006), and *Watchmen* (2009). What *Dick Tracy* achieves instead is a productive negotiation of some of the comic book medium's specific formal characteristics, further hybridizing the already famously impure forms of cinema and comic books.

The most striking way in which *Dick Tracy* references its comic book origins is in its use of color. The film's celebrated production design, with a limited palette of gaudy colors employed not just for the characters' costumes, but for vehicles, props, and entire sets, is easily the film's most-discussed feature. While this unconventional use of color already vividly establishes the film's fiction effect, the impact of the film's radical comic book aesthetic is achieved in concert with the film's editing patterns and, even more crucially, its use of framing. As Michael Cohen demonstrates in his analysis of the film, *Dick Tracy* uses several unusual strategies of framing and mise-en-scene that illustrate the way it moves "away from the language of 'cinema' towards the language of 'comics' in which the spatial arrangement articulates the narrative" (34). While the images in the film are not exact duplicates of existing comic book panels, their framing and organization reproduces and incorporates comics' semiotics. Throughout the film, we encounter stylistic devices that are rare in post-classical Hollywood cinema, such as the use of deep focus (including the repeated use of the notoriously distracting split diopter lens), a largely static camera, montage sequences that move the narrative forward through the equivalent of sequential images, and conspicuous framing that mimics the shape and function of comic book panels within the cinema frame.

This approach is illustrated clearly by a short sequence early in the film, when detective Dick Tracy is called away from his visit to the opera to investigate a crime in progress. Establishing a form of mise-en-scene that will dominate the film, the characters and location are introduced in a single over-the-shoulder close-up: both Dick Tracy and Tess Truehart are visible in profile as they turn toward each other, while the colorful but blatantly artificial backdrop of the opera stage is in clear focus in the far background (Figure 23.2). Upon Tracy's return shortly thereafter, the shot is replicated perfectly, the later scene's altered stage backdrop the only visual element of the shot that has changed

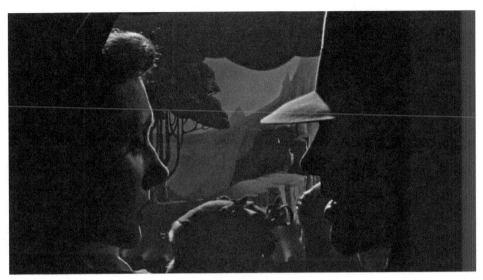

FIGURE 23.2 Dick Tracy and Tess Truehart framed in profile during a self-reflexively theatrical performance at the opera.

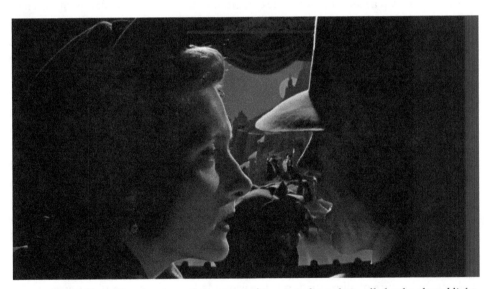

FIGURE 23.3 Upon Tracy's return, the passage of time is indicated visually by the altered lighting and backdrop.

(Figure 23.3). In addition to offering a subtly self-reflexive comment on the film's already obvious degree of theatrical artifice, the sequence of shots communicates the passage of time not through the traditional cinematic techniques of dissolves or continuity editing, but by the swift juxtaposition of shots in which small changes in otherwise identical images lead the viewer to infer meaning.

While the short duration of the entire sequence would in most cases signify a similarly short onscreen duration with minimal elisions, the film here calls upon the audience's ability to fill the gap between two similar shots in a way that resembles what McCloud calls the process of "closure," a formal technique he describes as the most fundamental to comics or "sequential art." In order to construct a meaningful narrative out of a sequence of comic book panels, readers must continuously suture the gaps, or gutters, in between successive images. This activity underlies McCloud's main argument concerning the emphatically *active* nature of comic book readership, as he seeks to reposition comics as a legitimate and diverse medium, rather than a fundamentally immature and degenerate form of children's literature. By incorporating formal strategies and forms of staging, framing, and narration that are clearly derived from the comic book medium, *Dick Tracy* provides a provocative and challenging experiment with comics-to-film adaptation. As an adaptation of material from another medium, the film moves far beyond the common strategy of simply viewing comic book characters as a form of recognizable intellectual property that is wholly transformed to fit the dominant style of Hollywood film.

Several more detailed examples of the ways in which *Dick Tracy* organizes its comic book aesthetic have already been provided by Michael Cohen's rewarding close analysis of the film, which argues that this style constitutes "an aesthetic translation of the characteristics and conventions from the comic medium by using the stylistic and functional equivalents in cinema" (36). But although Cohen's work illuminates several key aspects in which *Dick Tracy* enters into a productive dialogue with comic book aesthetics, he leaves some crucial questions about the effects of these decisions under-explored. For while one can identify certain formal characteristics that are more or less typical for the dominant style in any given medium, both cinema and comics are highly diverse and flexible media in a constant state of mutual transformation. This makes it difficult to assign absolute qualities to either without falling into the trap of media-essentialism.

A helpful perspective is offered by Jay David Bolter and Richard Grusin's concept of remediation, which focuses on the ways in which media respond continuously to each other in a never-ending process of reciprocal adaptation. The central tension that informs this process is between what Bolter and Grusin call "immediacy" and "hypermediacy." Immediacy indicates the perception of transparent mediation, or the point at which a set of arbitrary but historically specific conventions become all but unnoticeable to the audience. Hypermediacy, on the other hand, signals the opposite, as the constructed nature of all mediation is foregrounded, often through the co-presence of multiple media forms or traditions within a single frame. The (double) logic of remediation is therefore defined as a dialectical form in which both immediacy and hypermediacy offer different kinds of pleasure that are opposites without being mutually exclusive: immediacy represents a desire to erase all signs of mediation and immerse oneself in the text, while media-saturated hypermediacy invites us "to take pleasure in the act of mediation" (Bolter and Grusin 14).

The dialectical nature of this logic makes it more helpful than the previously discussed binary separation between the fiction effect and the reality effect. Although the

distinction between the two suggests a similar type of effect, they do not function as polar opposites, nor can they be isolated from their historical context. But even more especially in the context of cross-media adaptation, the concept of remediation relates both effects to the relationship *between* media conventions. This helps explain why films like *Superman*, *Batman*, and *Star Wars*, each of which is set in blatantly unrealistic diegetic worlds full of fantastical characters and events, can be experienced predominantly in terms of transparency and immediacy. At the other end of the scale, the logic of hypermediacy can be readily identified in *Popeye* and *Dick Tracy*. These films remediate the characteristics and conventions primarily associated with comics in unfamiliar ways, thus creating a dominant effect of hypermediacy.

This double logic also helps us better understand how the remediation of comics' formal characteristics within the cinematic frame doesn't automatically reproduce the same narrative or aesthetic effect. Instead, we can often identify what Kamilla Elliott has described as the "ventriloquist" effect, as the comic book source is taken over wholesale by its cinematic adaptation (143). In *Popeye*, for instance, the effect of seeing human actors performing in a way intended to mimic the two-dimensional caricatures of comic strips is clearly quite different from viewing drawings (either still images or animated cartoons) that are truly iconic. By the same token, the effect of working with a limited but remarkably garish color palette on the cinema screen is difficult to compare with the way in which American comics were historically limited in the range of available colors in print. Instead, *Dick Tracy*'s excessive use of saturated colors seems to function as an intertextual reference to the history of the medium, while at the same time evoking Hollywood's classical age of lushly saturated Technicolor cinematography.

HULK: FRACTURING THE SCREEN

Bolter and Grusin's logic of remediation, which constitutes a general theory of the structural interdependence of (visual) media, offers a refreshing perspective on the nature of media change that can itself be transhistorical by always foregrounding specific historical media transformations. But the work itself emerged in the context of digital media's emergence, and the book's subtitle, *Understanding New Media*, illustrates its focus on digitization and media convergence.

As had happened before, with the commercial success of *Superman* in 1978 and that of *Batman* in 1989, the door was opened in the early twenty-first century to further large-scale experiments with comic book movies, especially those based on superhero characters. Ailing comic book publisher Marvel, having gone through bankruptcy in 1996, concluded that the only way forward was by moving its characters from comic books to other, more popular media. Acknowledging that comic books had become an insufficiently profitable medium, Marvel concluded that its "primary product was no longer printed volumes of superhero adventures, but the intellectual property of the superhero itself" (Johnson, "Marvel's Mutation" 72). Marvel therefore strategically developed the

licensing of its characters to film studios, following the modest initial success of *Blade* in 1998 and *X-Men* in 2000 with the smash hit *Spider-Man* in 2002 (Rauscher 26).

Like *Popeye* and *Dick Tracy, Hulk* also had its own long and complex development history. But it was advertised, reviewed, and broadly received as the successor to the previous year's phenomenally popular *Spider-Man*, with which it did appear to have many things in common: it marked the blockbuster debut of one of Marvel's most iconic superheroes; it provided an origin story that introduced a new audience to the franchise's main characters; it made innovative use of groundbreaking computer-generated visual effects; and it was directed by a maverick auteur with established credentials in both independent and art house cinema and Hollywood genre films. From a marketing perspective, the objective with *Hulk* was once again to appeal to a much larger mainstream audience that extended far beyond the limited readership of comic books and that might respond to the film in the same way that general audiences had embraced *Superman, Batman*, and *Spider-Man* before it.

However, Ang Lee's adaptation of comics' green monster, itself an atomic-age adaptation of Robert Louis Stevenson's 1886 novella *Strange Case of Dr. Jekyll and Mr. Hyde*, was a much more radical formal experiment than any previous comic book movie to emerge in the context of the post-classical Hollywood blockbuster. Where Altman's *Popeye* had remediated comics' formal strategy of masking and *Dick Tracy* had adapted framing and coloring conventions to the cinematic image, *Hulk* attempted to incorporate comic books' panel arrangements by making innovative use of digital editing and compositing techniques.

Whatever their differences, all definitions of the comics medium emphasize the centrality of "juxtaposed images in deliberate sequence" (McCloud 9). In its traditional printed form and in most digital distribution formats, this juxtaposition results in the medium's characteristic page design, made up of multiple panels. One of the most intriguing paradoxes of comic books is the way this representational form relates to questions of temporality. For although the reader's eyes may read the panels in the intended sequence, multiple studies have shown that the surrounding visual/temporal landscape is taken in as well (Szczepaniak 92). By navigating back and forth not only between individual images, but between the larger frame of the page layout and the smaller frames contained therein, readers infer meaning on the basis of both the implied causal relationship between sequences of panels and possible differences in scale, variations in borders, differences in panel arrangement, and other aspects of page design.

The most striking aspect of *Hulk* as an adaptation of superhero comics is its remediation of paneling by complex split-screen arrangements. As a formal technique in narrative film, split-screen has most commonly been used to represent simultaneous action from multiple angles, for instance by visualizing both parties engaged in a telephone conversation, or to build suspense by giving the audience access to two different points of view at the same time. But apart from the established use of this technique for phone conversations and the recognizable stylistic tics of idiosyncratic auteurs like Brian De Palma, the use of split-screen has been rare since the late 1970s, especially in the context of post-classical Hollywood blockbuster cinema.

Hulk went into production just as new digital tools were rapidly replacing traditional photographic visual effects in Hollywood film production and were becoming the norm for film editing and compositing. Tools like Avid's digital film editing suite and the Cineon compositing tool made it possible for filmmakers to explore new narrative techniques, often by adapting conventions from other visual media. Although the medium's transition from analog to digital had the potential to transform cinema's visual style and narrative technique radically, the dominant aesthetics remained largely unchanged. Digital technology was used to create spectacular effects like the liquid-metal shape-shifter in *Terminator 2: Judgment Day* (1991) and Spider-Man's dizzying web-slinging chases through Manhattan. But given the range of options offered by the new tools for editing and compositing, the Hollywood blockbuster offered primarily what David Bordwell has described as an "intensified" version of classical Hollywood film style ("Intensified Continuity" 24–25).

In his attempt to adapt superhero comics to the realm of digital cinema, Ang Lee and the rest of his creative team extended post-classical Hollywood's narrative vocabulary by exploring a much wider range of editing options, including the use of complex split-screen compositions (Figure 23.4). The simultaneous presence of up to five different frames on the screen contributes to what Lee in his DVD commentary describes as a "comic-booky" effect, visually evoking the paneled page design of superhero comics. But even though the intermedial reference to comics' "spatio-topia or *mise-en-page*" (Ecke 17) seems obvious, the effect is also clearly different from that of navigating comic book panels on the page. Since the complex split-screen compositions featured throughout *Hulk* generally present multiple perspectives on simultaneous actions, they demand from the viewer a heightened engagement with what may appear to be an overload of visual information.

FIGURE 23.4 A complex split-screen composition in Ang Lee's *Hulk* (2003).

The overload itself is heightened by the fact that the multiple frames making up the split-screen composition are rarely static, as they have appeared in symmetrical half-screen arrangements in such popular films as *Carrie* (1976) and *Kill Bill Vol. 1* (2003). Instead, the dynamic split-screen panel arrangements in *Hulk* typically move in and out of the frame, creating a visual environment that "employs split screens to *express meanings* that are more closely related to those expressed by multi-panel layouts in comics than with the uses of split screen conventionalized in film" (Bateman and Veloso 137). The primary effect of this ongoing visual reference to the aesthetics of another narrative medium is clearly that of hypermediacy: the film frame no longer appears to the viewer as a transparent window onto an internally coherent and self-sustaining diegetic world, but as an interface in which competing and dynamic visual elements jostle for attention.

This strategy doesn't reproduce the effect of the comics page because the "panels" on the screen don't represent sequential moments, but rather multiple perspectives on simultaneous action. What it emphasizes is the relational nature of comic book panel layouts, which can similarly derive meaning as much from the organization of space as from the linear progression of causal narrative from panel to panel. By breaking up the transparent film screen into dynamic and unpredictable arrangements of multiple kinds of visual information (including diagrams, blueprints, microscopic close-ups, and so on), the film's visual design owes as much to the overwhelming visual logic of computer screens and digital culture as it does to the multiple panels of the comic book page. As in *Dick Tracy*, the remediation of formal conventions from comics simultaneously thus transforms these features into something quite different.

Unlike *Dick Tracy*, however, *Hulk* also constitutes an attempt to bring remarkable thematic depth and psychological realism to this superhero adaptation. The main contradiction in Lee's film is therefore not between the three-dimensional photographic world and a two-dimensional comic book aesthetic that seeks to contain it. Instead, the primary tension here is between the remediation of comic book page layouts, which can produce the distancing effect of hypermediacy, and the film's immersive and fully realized narrative world. True to Lee's auteurist motifs, *Hulk*'s depiction of the film's dramatic conflict is presented as a critical interrogation of family ideology, "of the lies that are often used to keep the family intact" (De Kloet 129). The film's aesthetic break from the conventions of the post-classical Hollywood blockbuster is thus compounded by its thematic separation from the typical Oedipal trajectory of the superhero for whom the (absent) father represents the Freudian ego ideal (see Hassler-Forest 48–57; Reynolds 60–66).

This combination of a comic book aesthetic with Lee's ambitious auteurist approach to the film's content led most critics to dismiss *Hulk* summarily upon its release, nearly all of them mentioning both what they call the film's "humorless" approach to its source material and its distracting use of elaborate split-screen compositions. The review in *Entertainment Weekly*, typical of the general critical response, complains that the film "divides the screen, self-consciously and to no added effect, like a comic-book page of multiple images" (Schwarzbaum). Especially interesting in these reviews is the repeated claim of aesthetic gratuitousness. When considered alongside Schwarzbaum's criticism that *Hulk* leaves "little unanalyzed space for fun," the hostility that has enveloped Lee's

film vividly illustrates the limitations that have continued to restrain the superhero film genre for so many years.

The first of these limitations is the unspoken demand that the films' relationship to comic books be one in which the characters and narratives are fully absorbed by Hollywood cinema, while comic books' formal features are either ignored or in a few cases reduced to the occasional iconic image reproduced in one of the film's shots. Formally audacious experiments with the adaptation of comics in the film medium like *Popeye, Dick Tracy,* and *Hulk* are not unique. *Scott Pilgrim vs. The World* (2010), for instance, combines audiovisual references to videogames with the formal features of comics, such as the constant interplay between words and images on the screen. But these three films offer provocative alternatives that appeared at what in hindsight have been pivotal moments in the genre's history.

The second limitation is historical rather than theoretical. The contradiction between these films' formal audacity and their status as mainstream entertainment products has stranded them in a critical no-man's-land: too big to be perceived as cult texts, but not successful enough to become popular classics. Each straddles the boundary between what many perceive to be mutually exclusive categories: the artificially created Hollywood blockbuster and the authentically expressive auteurist art film. Their contradictory nature can be summed up by the fact that they are ultimately an insufficiently popular form of popular culture. And yet their existence demonstrates that explorations of the relationship between these two media can teach us a great deal about the possibilities and limitations of comic book movies and the way they are perceived by critics and audiences.

Looking back on them from a context in which global superhero franchises have established a remarkably stable aesthetic vocabulary, from DC's Christopher Nolan–inspired gritty realism to Disney's more brightly lit and colorful Marvel Cinematic Universe, these three films demonstrate the untapped potential of comic book adaptation. By adapting and remediating features such as masking, paneling, and page layout on the cinema screen, each one shows how incorporating specific aesthetic features produces new and under-explored effects that occupy a middle ground between art house cinema and post-classical Hollywood.

Works Cited

Affron, Charles, and Mirella Jona Affron. *Sets in Motion: Art Direction and Film Narrative.* New Brunswick: Rutgers UP, 1995. Print.

Altman, Rick. *Film/Genre.* London: British Film Institute, 1999. Print.

Bateman, John A., and Francisco O. D. Veloso. "The Semiotic Resources of Comics in Movie Adaptation: Ang Lee's Hulk (2003) as a Case Study." *Studies in Comics* 4.1 (2013): 135–57. Print.

Batman. Dir. Tim Burton. Perf. Michael Keaton, Jack Nicholson. Warner Bros., 1989. Film.

Berninger, Mark, Jochen Ecke, and Gideon Haberkorn. *Comics as a Nexus of Cultures: Essays on the Interplay of Media, Disciplines and International Perspectives.* Jefferson: McFarland, 2010. Print.

Bolter, Jay David, and Richard Grusin. *Remediation: Understanding New Media*. Cambridge: MIT P, 2000. Print.

Bordwell, David. "Intensified Continuity: Visual Style in Contemporary American Film." *Film Quarterly* 55.3 (2002): 16–28. Print.

———. "Superheroes for Sale." *Observations on Film Art*. 16 Aug. 2008. Web. 9 Dec. 2014.

Brooker, Will. *Hunting the Dark Knight: Twenty-First Century Batman*. London: I. B. Tauris, 2012. Print.

Cohen, Michael. "*Dick Tracy*: In Pursuit of a Comic Book Aesthetic." Gordon, Jancovich, and McAllister 13–36.

De Kloet, Jeroen. "Saved by Betrayal? Ang Lee's Translations of 'Chinese' Family." *Shooting the Family: Transnational Media and Intercultural Values*. Ed. Patricia Pisters and Wim Staat. Amsterdam: Amsterdam UP, 2005. 117–32. Print.

Dick Tracy. Dir. Warren Beatty. Perf. Warren Beatty, Al Pacino. Touchstone, 1990. Film.

Ecke, Jochen. "Spatializing the Movie Screen: How Mainstream Cinema Is Catching Up on the Formal Potentialities of the Comic Book Page." Berninger, Ecke, and Haberkorn 7–20.

Eisner, Will. *Graphic Storytelling and Visual Narrative*. Tamarac: Poorhouse, 1996. Print.

Elliott, Kamilla. *Rethinking the Novel/Film Debate*. Cambridge: Cambridge UP, 2003. Print.

Elsaesser, Thomas. "Specularity and Engulfment: Francis Ford Coppola and *Bram Stoker's Dracula*." Neale and Smith 191–208.

Flash Gordon. Dir. Mike Hodges. Perf. Sam J. Jones, Melody Anderson. Starling, 1980. Film.

Gomery, Douglas. "Hollywood Corporate Business Practice and Periodizing Contemporary Film History." Neale and Smith 47–57.

Gordon, Ian, Mark Jancovich, and Matthew P. McAllister, eds. *Film and Comic Books*. Jackson: UP of Mississippi, 2007. Print.

Hassler-Forest, Dan. *Capitalist Superheroes: Caped Crusaders in the Neoliberal Age*. Winchester: Zero, 2011.

Howe, Desson. "*Dick Tracy*." *Washington Post*. 15 June 1990. Web. 9 Dec. 2014.

Huhtamo, Erkki. "From Kaleidoscomaniac to Cybernerd: Notes towards an Archaeology of Media." *Electronic Literature: Technology and Visual Representation*. Ed. Tim Druckery. London: Aperture, 1996. 297–303. Print.

Hulk. Dir. Ang Lee. Perf. Eric Bana, Jennifer Connelly. Universal, 2003. Film.

Johnson, Derek. *Media Franchising: Creative License and Collaboration in the Culture Industries*. New York: New York UP, 2013. Print.

———. "Will the Real Wolverine Please Stand Up? Marvel's Mutation from Monthlies to Movies." Gordon, Jancovich, and McAllister 64–85.

Kessler, Frank. "The Cinema of Attractions as *Dispositif*." *The Cinema of Attractions Reloaded*. Ed. Wanda Strauven. Amsterdam: Amsterdam UP, 2006. 57–69.

Maltby, Richard. "'Nobody Knows Everything': Post-classical Historiographies and Consolidated Entertainment." Neale and Smith 21–44.

McCloud, Scott. *Understanding Comics: The Invisible Art*. New York: HarperCollins, 1994. Print.

Morris, Jon. "Robert Altman's *Popeye*." *The High Hat*. Web. 2 Dec. 2014.

Neale, Steve, and Murray Smith, eds. *Contemporary Hollywood Cinema*. New York: Routledge, 1998. Print.

Pearson, Roberta E., and William Uricchio. "I'm Not Fooled by That Cheap Disguise." *The Many Lives of the Batman*. Ed. Roberta E. Pearson and William Uricchio. New York: Routledge, 1991. 182–213. Print.

Popeye. Dir. Robert Altman. Perf. Robin Williams, Shelley Duvall. Paramount/Disney, 1980. Film.

Rauscher, Andreas. "The Marvel Universe on Screen: A New Wave of Superhero Movies?" Berninger, Ecke, and Haberkorn 21–32.

Reynolds, Richard. *Super Heroes: A Modern Mythology*. Jackson: UP of Mississippi, 1992. Print.

Schwarzbaum, Lisa. "*The Hulk*" [*sic*]. *Entertainment Weekly*. Time Inc. Network, 11 Aug. 2005. Web. 9 Dec. 2014.

Scott Pilgrim vs. The World. Dir. Edgar Wright. Perf. Michael Cera, Alison Pill. Universal, 2010. Film.

Spider-Man. Dir. Sam Raimi. Perf. Tobey Maguire, Kirsten Dunst. Columbia, 2002. Film.

Superman. Dir. Richard Donner. Perf. Christopher Reeve, Margot Kidder. Warner Bros., 1978. Film.

Superman II. Dir. Richard Lester. Perf. Christopher Reeve, Margot Kidder. Warner Bros., 1980. Film.

Szczepaniak, Angela. "Brick by Brick: Chris Ware's Architecture of the Page." *The Rise and Reason of Comics and Graphic Literature: Critical Essays on the Form*. Ed. Joyce Goggin and Dan Hassler-Forest. Jefferson: McFarland, 2010. 87–101. Print.

Thompson, David, ed. *Altman on Altman*. London: Faber and Faber, 2011. Print.

CHAPTER 24

ADAPTATION XXX

I. Q. HUNTER

ADAPTATION in a loose sense has long been one of the strategies of both softcore "sexploitation" and hardcore pornographic films. Introducing explicit material or emphasizing sex in an adaptation is not, of course, necessarily the mark of pornography. Sexually explicit content appears, in the name of realism and psychological truth, in all forms of cinema, including the most prestigious art house films, from Pasolini's *Salò, or the 120 Days of Sodom* (1975) to Lars Von Trier's *Nymphomaniac: Volumes I and II* (2013). There are certainly film versions of erotic or pornographic novels that engage in standard means of adaptation but with material that poses specific issues of censorable representation, especially properties recognized as erotic classics, whose adaptation may generate scandals key to their commercial prospects: *Lolita* (1962), *Tropic of Cancer* (1970), *Emmanuelle* (1974), *Story of O* (1976), *Fifty Shades of Grey* (2015), and the numerous filmed versions of Sade, such as *Salò* and *Cruel Passion* (1976). How these films represent and foreground sex will depend on their genre and market as well as the vagaries of censorship. This essay, however, deals with another and more transgressive kind of erotic adaptation. Such films add sexually explicit content to versions of preexisting material that are not obviously erotic, exploiting them usually for niche softcore or hardcore markets. These adaptations are better understood as *parody*, which is how they are generally constrained to present themselves in order to evade charges of plagiarism. Their satirical purpose can be traced back to the erotic philosophical novels of eighteenth-century France, when Sade divulged the suppressed or disavowed erotic component of Richardson, even though pornography as a discursive category did not yet exist (Darnton). Erotic parodies go back to the sexploitation films of the 1960s, but the "hardcore version" is now one of the most high-profile subgenres of an industry struggling to produce distinctive downloads and DVDs that can compete with free Internet pornography on "tube sites." Most pornographic versions are not adaptations of books, but rather unlicensed remakes of films within industry-standard pornographic tropes, though some are dramatizations of real or scurrilously imagined sexual events in the lives of historical figures like *Caligula* (1980) and *Who's Nailing Paylin?* [sic] (2008). While many pornographic versions share little with their sources other than a pun on

titles, others are sustained spoofs, such as *A Clockwork Orgy* (1995), a hardcore reimagining of *A Clockwork Orange* (1971), and *Spider-Man XXX: A Porn Parody* (2011), whose homages to the characters and scenarios of specific films expect to be recognized.

This essay, setting the history of the erotic or pornographic adaptation/parody in an historical context, will focus on examples of commercially produced American sexploitation and pornographic films, with some discussion of British and continental European films. These are commercially released and mostly heterosexually orientated full-length films, though since the 1980s pornographic films have mostly existed on video and online. Because issues of authorship and aesthetics seem largely beside the point, the focus of this essay will be historical and descriptive, with particular attention to how the question of what counts as erotic and pornographic is historically bounded and discursively shifts over time. An important context is that pornography might be regarded not only as underground but as "the Other Hollywood"—a parody itself of the mainstream, with its own roster and economy of stars, auteurs, subgenres, awards, and so on that occasionally overlap with Hollywood's (Hines; Simpson).

It might be objected that such pornographic films should not be regarded as adaptations, both because the relationship to the original is one of opportunistic parasitism rather than intensive textual reworking, and on ethical grounds: the films go well beyond betraying their sources, as adaptations are frequently accused of doing, and aim to defile them. They are nevertheless adaptations in that they have a stated and recognized relationship with a preexisting text, albeit one unregulated by copyright. Like more conventional adaptations, they present themselves within a discursive category of dependent texts understood by the audience and promoted in the film's ancillary materials and paratexts, and they reuse material with a degree of cultural recognition that can be profitably remediated. They certainly *exploit* the source texts, but the commercial rather than aesthetic incentive to repeat material is hardly unique to pornography. Adaptation itself can be seen as a mode of exploitation (Hunter, *Cult Film as a Guide to Life* 77–96). Mainstream film production has always worked within an economy of standardization through repetition and remaking.

Even so, the status of pornographic adaptation is unique. It is true that shifting textual material from genre to genre is a familiar mode of adaptation—Western versions of *King Lear*, for example, or musical or *film noir* versions. As David Bordwell has said, "we can usefully understand any plot as a composite of possibilities that surface in other plots. . . . [A]ny narrative we encounter in the mass-market cinema (and probably in other forms of filmmaking) is part of an ecosystem, a realm offering niches for many varieties—including hybrids." Explicit sex can be found in conventional novel-to-film adaptations like *Devil in the Flesh* (1986), in much the same way that explicit sex scenes can appear in literary novels like *Crash* (1973) and *American Psycho* (1991), without requiring their exile to the erotica section of the bookshop. But relocating material, as porn versions do, into *pornography* is arguably something else entirely. Although pornography is an unstable discursive category, it denotes a separate and wholly toxic sphere so far as visual material is concerned. Its specific physical dislocation (top shelf, sex shops, sex cinemas, NSFW porn sites) is crucial to its identification as tolerated but ethically

fraught material whose primary purpose is the extra-aesthetic one of sexual arousal. Arousal may well be a by-product or incidental attraction of other forms of adaptation, but it is fundamental to pornography and seals its pariah status as the lowest of all cultural forms. Pornographic adaptations like *Extra Terrestrian: Die Ausserirdische* (1996), a German film, also known as *E.T. Porn Home* and *E.T.: The Vagina*, about an alien who lands in Victorian times, or *E.T. XXX: A DreamZone Parody* (2013), have a different intent from the remake of *The Postman Always Rings Twice* (1981), which is sexually graphic in order to adapt more honestly the erotic realities hinted at in James M. Cain's novel and left offscreen in the 1946 *film noir* version. The remake of *The Postman Always Rings Twice* might be said to aim at a fidelity to its material beyond what even Cain's novel could express. Sex scenes involving the beguiling alien of Spielberg's 1982 classic, however, introduce a radical dissonance with the original film, whose effect is not only comic but aggressively tasteless: in *E.T. XXX: A DreamZone Parody*, for example, the alien sprouts a long green penis that is fellated and ejaculates.

There is, arguably, however, a wider purpose of fidelity through "pornification" that is perhaps not so very different from that of *The Postman Always Rings Twice*, focusing on sexual possibilities left unsaid and unsayable in the original but, given pornography's insistence on the latent sexual fantasies in any scenario, not entirely impossible; extra-terrestrials presumably reproduce somehow, and there is no diegetic proof that E.T. entirely lacks sex organs and erotic intention. Showing fictional characters having sex pays homage to their potential as objects of sexual fantasy and also fills in the gaps, as it were, single-mindedly subsuming all human motivation to the pursuit of erotic pleasure and orgiastic utopianism: "Porn parody films highlight an undercurrent of sexuality within all mainstream texts by providing negotiated readings of mainstream media" (Booth 8). A further link to older traditions of the erotic is the mechanistic view of Nature expressed in pornography, whose truth, seemingly confirmed by Darwin and Freud, is to insist on the primacy of the body and its unruly demands and to create what Steven Marcus, writing in the 1960s about Victorian erotica, called a "pornotopia" or fantasy space of erotic potential in which sex is the sole impulse and source of power (Marcus). There is consequently an element of satirical debunking in all pornography, at once Bakhtinian in representing the return of repressed bodily desires that threaten to overturn civilization, and crudely misogynistic and even misanthropic in identifying humans with their sexual selves. In dragging their sources down the cultural scale, pornographic parodies can be seen as an extreme instance of the abusive havoc and vulgarization that film adaptations are habitually accused of inflicting on their innocent originals (the oft-noted sexual and gendered language of adaptation is especially relevant here). For what could be more degrading than a porn version? Indeed, pornography might be seen as the perfect manifestation or allegory of the threat posed by every adaptation to the realm of cinema, with its blunt concreteness, objectification of the body, excessive corporeal effect, and voyeuristic and dissecting gaze.

This then is the challenge of understanding porn adaptations, in which the wrenching of texts from their original contexts and meanings is uniquely controversial and troubling. Of all forms of adaptation, they are the most scandalous and take the most liberties.

Sexploitation

Until the 1950s, explicit sex in cinema was either kept underground in stag films or "smokers" or was restricted to the avant-garde. Sexual content emerged in the sexploitation film, a risqué but not pornographic subgenre of exploitation cinema. Exploitation cinema as a distinct category of filmmaking in the United States involved cycles of low-budget, independently made and distributed films, produced to cash in on topical issues, new audiences, and especially the success of particular films or subgenres, from teen horror and science fiction in the 1950s to blaxploitation films in the 1970s. Often this would involve not so much adaptation as the imitation of specific films or the appropriation of their material so as to render it more sensational by adding sex and violence or to cater to specific audiences. *Blacula* (1972), for example, like other Blaxploitation films of the 1970s, reworked horror tropes to emphasize black characters and themes.

Sexploitation films were a key form of exploitation cinema (Schaefer). They began with the pseudo-documentaries of the 1930s and the nudist films of the 1950s, such as *The Garden of Eden* (1957), and were encouraged by a 1957 New York Court of Appeals decision that nudity per se was not obscene. Russ Meyer's *The Immoral Mr. Teas* (1959) is generally reckoned the first sexploitation film with a narrative. These softcore films (nudity but no explicit sexual activity) later diversified into subgenres, such as "roughies" like Meyer's *Lorna* (1964) and *Motorpsycho* (1965), "kinkies," and "ghoulies," in which sexual content was subordinated to narratives by turns violent, melodramatic, and gothic. As in exploitation generally, the logic of sexploitation was to copy other genres and reorient them around sexual spectacle. "Roughies" like *Hot Spur* (1968), *The Ramrodder* (1969), and *Linda and Abilene* (1969) were set in the Wild West, while the horror film lent itself easily to erotic content, as in "sex vampire" films like Hammer's *The Vampire Lovers* (1970), based loosely on Sheridan Le Fanu's *Carmilla*, and Jean Rollin's *The Nude Vampire* (1969). Sexploitation mostly copied other films rather than directly adapting novels, but there were exceptions that adapted classic underground erotic novels newly out of embargo in the 1960s, such as *Lady Chatterley's Lover*, novels by John Cleland and the Marquis de Sade, and Victorian classics of the kind republished by Grove Press, which created a heritage for these new films, as well as cashing in on their notoriety. A further attraction was that these novels could not be adapted within the mainstream.

David Friedman, one of the key sexploitation producers, brought out *The Lustful Turk* (1968), based on a British Victorian underground novel, about two Englishwomen abducted by an Algerian pirate while en route to India and presented as a gift to the Bey of Algiers. More characteristic, however, were spoofs on specific films that represented established genres, such as Friedman's jungle film *Trader Hornee* (1970), whose title riffed on *Trader Horn* (1931), and which was filmed for added authenticity on the Monogram-Allied Artists lot (Flint, "The Golden Age of Porn" 27). Softcore parodies like *The Erotic Adventures of Zorro* (1972) and *The Adult Version of Jekyll and Hide* [sic] (1972) continued into the 1970s, even as the market embraced hardcore. The most

famous was *Flesh Gordon* (1973), initially intended as a hardcore feature but released as an R-rated comedy. A spirit of comic realism and Freudian erotic "correction" is alive in these films, offering audiences what was implied but repressed in the originals.

Cleland's *Fanny Hill* (*Memoirs of a Woman of Pleasure*), subject to the first American obscenity case in 1821 and unpublished in the United States until 1966, after three concurrent trials that eventually went to the Supreme Court, has been adapted a number of times in the United States and Europe since the 1960s. The various iterations highlight how such material could be used differently as sexploitation evolved and finally gave way to hardcore. *Fanny Hill* was first filmed, mostly in Germany, by Russ Meyer in 1965. His version, *Fanny Hill: Memoirs of a Woman of Pleasure*, produced by Albert Zugsmith, was a softcore romp in the style of Tony Richardson's *Tom Jones* (1963), the film that became the template for costume sex films in the 1960s; indeed, advertisements heralded Meyer's film as "[a] female *Tom Jones*." It is a fairly straightforward adaptation that keeps the eighteenth-century setting and plot in which Fanny Hill, an innocent country girl, comes to London in 1748 to seek her fortune and is referred to Mrs. Maude Brown, the kind madam of an elite London brothel.

Later sexploitation versions of *Fanny Hill* strayed more significantly from the source text in order to exploit the currency of the novel. "Fanny Hill" came simply to signal sexual licentiousness, the character being relocated in place and time as a symbol of sexual availability in films such as the Friedman production, *The Notorious Daughter of Fanny Hill* (1966). In *Fanny Hill meets Dr. Erotico* (1967), Fanny returns to the castle of Lady Chatterly [*sic*], her former employer, after spending a year in a London brothel. Like Fanny, Lady Chatterly is merely a signifier of sex cast adrift from the content of Lawrence's novel and given the same mobile status as Dracula. So in this film, an erotic mashup with the world of Frankenstein, Fanny is a servant girl with whom the monster falls in love, while in *Fanny Hill Meets the Red Baron* (1968), Fanny is transported to World War I, where she serves as a nurse devoted to raising the patients' morale by joining them in a variety of sexual activities, and in *Fanny Hill Meets Lady Chatterly* [*sic*] (1967), she again settles in the castle of Lady Chatterly, now a famous courtesan.

Fanny Hill [*The Swedish Fanny Hill*] (1968), a Swedish film directed by Mac Ahlberg, is a contemporary treatment in which Fanny travels by train to the Big City (presumably Stockholm), finds herself working in a brothel, and embarks on a series of relationships before one of her lovers leaves her a fortune that enables her to live with her true love. Again, Fanny has only a name in common with Cleland's character, though she retains the characteristics of an unsophisticated virgin from the provinces. Given the impossibility at this time of showing explicit sex even in sexploitation films, there is a good deal of plot but very little erotic content beyond displays of female nudity. This was true generally of sexploitation, where "there is a great deal more explicit activity in the lesbian scenes than in the heterosexual ones, because it is much easier to fake sex between two women than between a woman and a man" (Turan and Zito 56). More contemporary-set versions made Fanny an innocent ripe for sexual initiation. Joe Sarno's American film *The Young, Erotic Fanny Hill* (1971) is actually about Fanny's close friend, Lenore, who leaves Fanny for the city, where she and her new roommates turn to modeling in the nude for employment until Fanny arrives and demonstrates

a more satisfying way of lovemaking to the three young women. *Around the World with Fanny Hill* [*Jorden runt med Fanny Hill*] (1974), directed by Ahlberg, revisits his earlier scenario of Fanny Hill in Stockholm, where she tires of being a housewife, divorces her husband, and embarks on a film career in Hollywood, Hong Kong, and Venice. These updated versions, while alluding to the harlot's progress that the novel had traced from innocence to prostitution to happy marriage, are determined by the tropes of sex films of the period: tourism, the linking of free sex with the good life, and a phallocentric interpretation of female liberation as continuous accessibility. In these later Fanny Hill films, as in the British sex comedy *Games That Lovers Play* (1970), in which Fanny Hill and Lady Chatterley also appear, any connection with conventional processes of adaptation has been severed, leaving only the character's name and its promise of picaresque sexual exploits. Fanny becomes like Emmanuelle, originally a character in the massively successful adaptation of Emmanuelle Arsan's novel, who broke free from her origins and globe-trotted in numerous sequels and Italian rip-offs from *Black Emanuelle* [*sic*] (1975) to *Emanuelle and the Last Cannibals* (1977) to *Emanuelle in America* (1977). Fanny is no longer just a servant girl, but rather an avatar of the sexual revolution and what in Britain was called "permissiveness." These soft-core films, redolent of the joys of jet-setting consumerism in the 1970s, depict carefree middle-class sexuality with sufficient élan to claim the more respectable bourgeois label of erotica. Rather than presenting themselves as adaptations of particular texts, these films adapt the more general pornographic scenario of a central female character undergoing sexual initiation and exploration—a plot line that connects them with not only eighteenth-century novels like Sade's *Justine* but Terry Southern's *Candide* parody, *Candy* (1958), and countless other pornographic novels from Jean-Baptiste de Boyer's *Thérèse philosophe* (1748) to Pauline Réage's *Story of O* (1954) and E. L. James's *Fifty Shades of Grey* (2011).

Cleland's novel has been adapted four more times since the 1970s. The different styles of adaptation embody distinct national modes of sexploitation. In the British film *Fanny Hill* (1983), the novel was adapted, quite faithfully up to a point, as a sex comedy, the key mode of British sexploitation since the late 1960s. As with other British erotic literary adaptations, such as *Mistress Pamela* (1974), based on Richardson's *Pamela*, and *The Bawdy Adventures of Tom Jones* (1975), the film centered on working-class rebellion against traditional strictures of sexual expression and took its cue from pre-Victorian literature, the 1963 film *Tom Jones*, and the *Carry On* tradition of British bawdy. *Fanny Hill* was remade again in Britain in 1995 as a straight-to-video softcore film (necessarily so: hardcore was banned in the United Kingdom until 2000), and finally in an entirely different mode as a television classic serial written by Andrew Davies, which sought to remove the novel from its pornographic context and align it with such sexually aware contemporary reinterpretations of the historical novel as the neo-Victorian *Tipping the Velvet* (2002).

The outlier among these numerous adaptations of *Fanny Hill* was *The Memoirs of Fanny Hill* [*Oh Fanny*] (1971). This American hardcore film appeared after the softcore sexploitation market, with its mild nudity and compensatory emphasis on plot and comedy, yielded to hardcore pornography. The hardcore *Fanny Hill* is barely related to the original novel and consists entirely of extended scenes of sexual activity with

minimal narrative continuity. Through these varied uses of *Fanny Hill* we can see chang-ing appropriations of a classic text—not in copyright and therefore fair game—from tit-illating softcore to hardcore version to television heritage drama.

"Golden Age" Parodies

Hardcore pornography in the United States since the stag film—the earliest existing American example seems to be *A Free Ride* (1915–17)—had developed into "beaver loops" by the late 1960s. Hardcore was to some extent legalized in the United States in 1970 after the President's Commission on Obscenity and Pornography concluded that pornography was not harmful to society, and industries sprang up in New York, San Francisco, and Los Angeles. The first hardcore films widely distributed were documen-tary compilations of stag films like Alex De Renzy's *A History of the Blue Movie* (1970) and Bill Osco's *Hollywood Blue* (1970). Documentaries and later stories with narratives were easier to defend in court because of the US Supreme Court decision in 1957 that defined obscenity as material "utterly without redeeming social importance"; they also "drew more varied audiences than the single lonely men who watched loops" (Ford 42). Following the release of the first full-length narrative film, Bill Osco and Howard Ziehm's *Mona (the Virgin Nymph)* (1970), "Much of the early days were spent deter-mining the new boundaries and pushing the envelope to see what problems would arise" (Holliday 343). The new films were in many ways similar to underground films like Warhol's *Blue Movie* (1969), Carolee Schneeman's *Fuses* (1965), Curt McDowell's *Thundercrack!* (1975), and Kurt Kren's films of the activities of the Vienna Actionists. As it first emerged from hippie culture, the porn industry was much more deliberately transgressive and politically libertarian than later commercial pornography.

The key year was 1972, which saw the release of *Deep Throat, The Devil in Miss Jones,* and *Behind the Green Door,* all of them major box office successes during the brief period of "porno chic" ended by judicial pressure in June 1973. *Mona* was one of *Variety's* fifty top-grossing films of 1971, and *Deep Throat* and *The Devil in Miss Jones* were among the ten top-grossing films of 1973. Subsequently, "pornographic features accounted for about 16 per cent of the total American box office between the years of 1972 and 1983" (Ford 92), though distribution was uneven, subject to local ordinances, and often con-trolled by the Mafia.

This period has become known as the Golden Age of pornographic cinema, when the films had narratives and were relatively ambitious, often filmed on 35mm, and shown in some mainstream cinemas (Flint, "The Golden Age of Porn"). This was at a time, too, when more mainstream releases adapted classic erotic and controversial texts. Pier Paolo Pasolini, for example, made *The Decameron* (1970), *The Canterbury Tales* (1971), and *The Arabian Nights* (1974), which themselves inspired numerous rip-offs in the Italian exploitation industry. And art cinema took on board erotic material in films like *Last Tango in Paris* (1974), *In the Realm of the Senses* (1976), *Immoral Tales* (1974), and

The Beast (1975), all of which briefly suggested imminent rapprochement between the mainstream and pornography.

Adaptation in pornography, as generally in the history of cinema, was a means of cultural legitimation. A number of hardcore versions—*Alice in Wonderland* (1976); *The Passions of Carol* (1975), based on *A Christmas Carol; Through the Looking Glass* (1976), from a Russian short story; and *Autobiography of a Flea* (1976), a version of a Victorian underground novel republished by Grove Press—drew on properties in the public domain. More often, the object of imitation was Hollywood cinema. Pornography, like sexploitation, is poised between raw spectacle and classical narrative, in which sensational "attractions" are subordinated to plot and characterization. To reach feature length and narrativize the sex scenes, hardcore films assimilated Hollywood conventions, making some claim to generic legitimacy by borrowing the conventions of classical films while maintaining the tension between fiction and staged documentary: "This bid for approbation not only upheld the filmic fourth wall, but also pillaged the plots and the iconography of established Hollywood genres, oddly enough from the western to, and more often and more appropriately, the detective film, in the quest for box office dollars" (Lorenz 353).

There were parodies and sexual versions of Hollywood genres like the Western (*A Dirty Western* [1975]) and science fiction (*Sex World* [1977], a spoof of *Westworld* [1973], and *Café Flesh* [1982], "the last great porn film to emerge before the video market changed the business forever" [Flint, *Babylon Blue* 67]), and adaptations and pastiches of specific films (*The Boys in the Sand* [1972], whose title punned on *The Boys in the Band* [1970]; *Eruption* [1977], based on *Double Indemnity* [1944]; and *Waterpower* [1976], which borrows from *Taxi Driver* [1976]). These films are certainly hardcore, but "Golden Age films are long on story because they were made for exhibition in theatres, where viewers can rarely masturbate and never fast-forward" (Ford 97). The structure of porn films has often been likened to that of the musical, with sex scenes replacing musical numbers, and indeed the two genres share parodic and utopian elements, as well as a sense of unreality combined with a documentary record of skilled performers. As Jon Lewis observes, "The end result of such an assimilation was a genre of films that was at once strangely familiar and funny. People went to see porn films to see the sex. But what they got, in addition to all that sex, was a satire of Hollywood that cleverly revealed the banality of the generic narrative form. Indeed, the sex scenes, which are connected by the stuff of conventional Hollywood narrative, rendered ridiculous the expository devices routinely employed in more mainstream films" (222).

Although the sex scenes in these films are much longer and more explicit than those in sexploitation films, they were not entirely distinct. Some films, such as *Alice in Wonderland* and *Gums* (1976), a spoof of *Jaws* (1975), were released in soft and hard versions to reach a wider audience and to tailor the films to different regional regimes of censorship and regulation.

The most critically acclaimed of Golden Age parodies was Radley Metzger's *The Opening of Misty Beethoven* (1976) (Figure 24.1), which borrowed its plot from the myth of Pygmalion via *My Fair Lady* (1964), "a well-known and even culturally respectable template for a film that is less a parody than an alternately witty, bawdy and faithful

FIGURE 24.1 Pornography meets *My Fair Lady* in the Golden Age classic *The Opening of Misty Beethoven* (1976).

incarnation of its source material" (Church 19). Metzger specialized in making upscale European erotica, using adaptation in *Therese and Isabelle* (1967) and *Camille 2000* (1969) to indicate his films' ambition, authorize the sexual liberties taken on screen, and, according to Metzger, compensate for his poor skills as a storyteller (Gorfinkel 33). Depictions of sexual behavior among the middle-class and youth cultures attempted both to record the sexual revolution and to raise the films above pornography by imitating the tropes of the art house at a time when the distinction between art house and exploitation was blurred. In Metzger's films, "narratives of erotic ennui and sexual existentialism piggyback on the fashionable pop-psychologised rhetoric of social malaise and youthful disinvestment" (Gorfinkel 32). In the mid-1970s Metzger, as Henry Paris, turned to making hardcore with *Naked Came the Stranger* (1975), a hardcore adaptation of a hoax novel, and *Misty Beethoven*. Pygmalion itself becomes a metaphor for adaptation, and for elevating the pornographic to the status of erotica (Church 20).

CONTEMPORARY XXX VERSIONS

The Golden Age ended in part because pornography moved to video, which to aficionados of the genre represented lowered ambitions and production values. Hardcore parodies nevertheless remained popular in the expanding video market of the 1980s. The number of video releases skyrocketed from 400 in 1983 to 1,500 in 1985 (Fletcher 52), featuring films like *Cagney and Stacey* (1984) and *Sheets of San Francisco* (1986). The explosion continued in the 1990s with films like *Edward Penishands* (1991)—in which

the title character's scissorhands are replaced with dildos—*The Maddams Family* (1991), *Penetrator 2: Grudge Day* (1996), *Apocalypse Climax* (1996), and many others, as documented in *Shaving Ryan's Privates* (2003). The porn parody was sufficiently established as a category to be derided in the Medveds' *Son of Golden Turkey Awards*, which listed *Lust Horizons* (1974), *The Sexorcist* (1974), *The Pink Lagoon* (1981), and *Sperms of Endearment* (1984) among "The Most Shamelessly (and Tastelessly) Derivative Title for a Pornographic Film" (181–82). The key subgeneric development of the period, however, was gonzo porn, in which narrative gave way to semi-documentary stagings of sex in which the cameraman participates and records the action, commenting on it in real time. The drift was generally away from embedding sex in developed stories and toward long scenes of sexual activity to which domestic viewers could masturbate uninterrupted by anything more than cursory narrative set-ups.

In recent years the pornographic parody, or XXX version, has achieved dominance within the porn industry (Fletcher). After the comparative lull of the 1990s, the subgenre was revived in the 2000s with X-Play's *Not the Bradys XXX* (2007) and *Not Bewitched XXX* (2008), which won Best Sex Comedy at the *Adult Video News* (AVN) Awards in 2008, and Hustler's *This Ain't the Munsters XXX* (2008) and *This Ain't Star Trek XXX* (2009). New Sensations followed with *The Office: A XXX Parody* (2009), directed by Lee Roy Myers. The AVN awards in 2014 were dominated by DVDs and downloadable content like *Breaking Bad XXX* (2013), *Not the Wizard of Oz XXX* (2013), *This Ain't Die Hard XXX* (2013), *This Ain't Star Trek 3 XXX* (2013), and *The Lone Ranger XXX* (2013), with Adrianna Luna as Tonto. Few successful films or genres have subsequently escaped spoofing or the indignity of off-color puns, including *Hairy Twatter: A Dreamzone Parody* (2012), *The Little Spermaid: A Dreamzone Parody* (2013), *Repenetrator* (2004), and *Porn of the Dead* (2006) (Steve Jones, Watson). The parodies are also retrospective—*This Isn't Dirty Harry . . . It's a XXX Spoof!* (2013), *Grease XXX: A Parody* (2013), and *Clerks: A Porn Parody* (2013), relocated to a sex shop—and embrace art house as well as cult films: *This Isn't The Grand Budapest Hotel . . . It's a XXX Spoof* (2014), *The Big Lebowski: A XXX Parody* (2011). Although often resorting to puns to acknowledge their sources, hardcore versions frequently cut to the chase by simply adding *This Is Not* or *XXX* to the title, curtly emphasizing both their subgenre and their parodic intent. As Claire Hines notes, in general "the contemporary porn industry has effectively 'skimmed,' or perhaps more fittingly 'knocked off,' the most successful features of the business model provided by studio-era Hollywood": genre, stardom, and more recently, new technological advances in computer-generated imagery (133).

Pirates (2005), a parody of *Pirates of the Caribbean: The Curse of the Black Pearl* (2003), seems to have been pivotal, not least because it was the top-grossing porn film of the year. The film's appeal for fans was assisted by web marketing and taking more care to get the details of the parody right. More generally, fan favorites such as comic book and superhero films have frequently been parodied. *Spider-Man XXX: A Porn Parody*, nominated for sixteen awards at the AVN Awards of 2012, was directed for Hustler by its parody specialist, Axel Braun, who commented: "I knew we had struck a chord when several famous comic book writers and artists, and even a much-celebrated mainstream

director, contacted me out of the blue to tell me how much they enjoyed the adult movie parody. The word was definitely out that this was worth watching. ... Even though I spoofed the iconic upside-down kiss from Raimi's first movie, I wanted to stay with and spoof the comic version, and I guess that's why adults in the comic book community responded so positively" (Trigger 2011).

Braun stressed the need to aim for some degree of fidelity, or at any rate semiotic imitation, to appeal to fans: "It's important for me to replicate their style, down to the framing, the angles—that's what gives the feel of the actual original. If you just throw a couple of wigs on people and shoot a couple of jokes, it doesn't come out the same" (Rutter 2009).

British pornographic parodies, which more often target television and reality television than films (Hunter, "Naughty Realism" 157), include *To the Manor Porn* (2002) and *Down on Abby: Tales from Bottomley Manor* (2014), which was also released in a softcore version and shown in episodes on the cable channel Television X. As the titles suggest, these are comedies whose plot maximizes the coupling possibilities of characters in an eroticized utopia. Comedy is often thought inimical to sexual arousal, but these films use it to soften the lead-up to the sex scenes and make themselves more acceptable as "couples movies." Once the sex scenes get going, however, they are not comic burlesques of pornography itself; the presentation of sexual performance is as serious as in other genres of pornography. It is within the established norms of contemporary commercial pornography that the porn version has its place as a category, sometimes apparently more upmarket and expensively produced, and with pleasures related to the process of adaptation itself. As Fletcher remarked of videos in the 1980s, "If the video box advertises a familiar title and a re-enactment of a scene from a hit film, the buyer will assume that more time and money have gone into the production" (50).

It would be inaccurate to describe these films as narratives in the same way as the 1970s films were. They follow the conventions of most pornography, which consists of rigorously schematic and self-contained scenes of particular acts or fetishes or scenarios. The appeal of these films is clearly to fantasy, whether it is imagining having sex with iconic screen characters or exploring the offscreen spaces of their sexual lives:

> Jack Lawrence, who garnered a Best Actor nomination for his performance in *Reno 911: A XXX Parody* [2010], shared his thoughts about why porn parodies are doing so well: "They are really the only things selling." He theorized that because porn parodies are fun and playful, many men feel comfortable bringing them home to watch with their wives and girlfriends. Someone else offered a different perspective: people have a connection to the television shows and movies they grew up with. "Who wouldn't want to have sex with Marcia Brady?" one female performer remarked. (Comella 65)

For example, *Official Psycho Parody* (2010) (Figure 24.2) works by (unnecessarily) filling in gaps in the narrative of Hitchcock's *Psycho* (1960), working against the classical injunction to eliminate extraneous material for the sake of character motivation and tight plotting. So instead of cutting directly from a non-sex scene based on the episode

FIGURE 24.2 Marion Crane (Sara Sloane) undresses in Norman Bates's office in *Official Psycho Parody* (2010).

in Marion Crane's workplace at the start of *Psycho*, the hardcore version introduces a lengthy three-way sex bout in the back office. In narrative terms this is redundant, especially since the characters are then dropped from the plot, but it is required by the pornographic convention that sex is always imminent, motivation is identified entirely by sexual desire, and all possible permutations should be encouraged. Elsewhere the film's comedy depends on the audience's knowledge of the original film and its narrative twists.

Norman wears high heels from the start, and his transvestism—or whatever sexual variant he represents—is taken for granted and played for laughs. So when Norman peeps covertly at Marion as she undresses, he fixes attention on her brooch ("Stunning, so sexy") rather than her naked body. Norman's love of taxidermy—"I like stuffing birds," he tells Marion, highlighting the sexual pun unquestionably implied in the original film—now includes keeping the body of Jessica, an old family maid, in his office, a motif surprisingly consistent with Hitchcock's black humor. Suspense and interest are maintained around *how* obligatory "cardinal" narrative moments, such as the shower scene, will be reworked and sex gratuitously shoehorned into them (Marion is stabbed to death in the shower with a dildo). The sex scenes generally keep to the expected formulaic transitions from fellatio to "cum shot," though there is some attention to characterization, as when Norman's submissiveness to Marion in their sex scene can be read as an index of his feminization. This is not, then, a remake in the style of Gus Van Sant's conceptual retread, *Psycho* (1998), which allegedly replicated each shot of the original but added moments of sexual knowingness, as when Norman masturbates watching Marion undress. On the other hand, it is certainly a better porn film than either version of *Psycho* and, unlike most adaptations or remakes, therefore has a specific dual

use. Like a videogame adaptation, the porn version repurposes the material into a new ludic space of fantasy; it is both parody and pornography. Yet at the same time, its appeal is much like the appeal Linda Hutcheon ascribes to other kinds of adaptation: "Part of the pleasure . . . comes simply from repetition with variation, from the comfort of ritual combined with the piquancy of surprise. Recognition and remembrance are part of the pleasure (and risk) of experiencing an adaptation; so too is change" (4).

As pornography has moved to the web, so parodies have been made specifically for online consumption. Hence the X-rated short films made by Lee Roy Myers for the porn and comedy site WoodRocket.com, which include such unlikely efforts as *The Room XXX Parody: The Bed Room* (2014), a parody of the cult film *The Room* (2003), and *SpongeKnob SquareNuts—The XXX Parody* (2013), a five-part spoof of the children's cartoon series. These, like Myers's *Game of Bones* (2014) webseries, a parody of *Games of Thrones*, are as much fan productions as pornography. According to Myers, "The way I've always approached porn is trying to find new ways to get sales through media attention and the best way to find new markets is through mainstream media. Through people picking up on a story and being freaked out or engaged by a new form of porn" (Francey).

The parodies are often detailed, funny, and irreverent, and their humor, inspired by *MAD* magazine, *Airplane!* (1980), and *Saturday Night Live* (1975–), is best enjoyed by fans of the originals who take pleasure in both the parodies' transgression and their accuracy at the level of costume, location, and dialogue. Nevertheless, as usual with porn versions, each episode works as parody only until the sex begins, with a sustained eighteen- to twenty-five-minute scene keeping strictly to the conventions of explicit genital action and maximum visibility.

These films embrace pornography's pariah status while also acknowledging its new accessibility and cultural place in a continuum of trashy popular culture that is itself increasingly sexualized. As one character says in the pre-credit sequence of episode one of *Game of Bones*, "How could anyone come up with a porn parody filthier than the show?" It is worth noting that some of the films are also available in non-sex versions and have reached well beyond the silo of pornography. The SFW version of Myers's *Simpsons* porn parody attracted three million hits in its first week on YouTube (Neuman 2011), where it participates in the contemporary frenzy of retro and cannibalization, remakes, sequels, and spin-offs. Porn parodies echo rather than subvert the mainstream, especially when set within the larger context of "pornification," a term that indicates both the drift of pornography from the cultural margins toward the mainstream and the accelerating commodification of sex in popular culture.

In their appeal to fans, these films also have some cult potential (Hunter, "A Clockwork Orgy"; Smith). Bethan Jones has shown how *The Sex Files: A Dark XXX Parody* (2009) knowingly fills in gaps in the narrative so as to appeal to the X-Philes devoted to *The X Files* TV series and thereby intersects with fan fiction produced by "shippers," fans emotionally invested in relationships real or implied in their object of fandom:

> In reading *The Sex Files* fans read via *The X-Files* and the fan fiction they are familiar with. The canon text of *The X Files*, the fan fiction texts which have arisen from it,

and *The Sex Files: A Dark XXX Parody*, each interact in specific ways and affect the viewer's understanding of each text. . . . Those shipper readings of *The X Files* have found their expression in fan fiction, with Mulder and Scully's first time being written and rewritten, interpreted and debated within *The X-Files* online communities. The porn parody thus clearly builds on both canon and fan fiction to create a film which—while still hardcore pornography—taps into shippers' needs in a way that is consistent with both the series and much fan fiction. (380)

Porn versions are therefore comparable to the most sustained contemporary acts of eroticization, "slash" fan fiction and its print spin-offs, mostly by women, within a culture of borrowing and poaching that flirts with the limits of copyright. Such erotic revisions have moved into the mainstream recently with mashups like Arielle Eckstut's *Pride and Promiscuity: The Lost Sex Scenes of Jane Austen* (2008), E. L. James's *Fifty Shades of Grey* (2012), Charlotte Brontë and Eve Sinclair's *Jane Eyre Laid Bare* (2012), and F. Scott Fitzgerald and Karena Rose's *The Great Gatsby Unbound* (2013). As Paul Booth says, "The gender roles stereotypically asserted by prototypical pornographic films are hyper-emphasized in parodies, mocking contemporary gender stereotypes through overt articulation. Women take a more central role in pornography in general, and in porn parody specifically" (10). On the other hand, while the key change made by many parodies is to replace male characters with female ones—as in *Lady Scarface* (2007) or *The Lone Ranger XXX* (2014), which makes Tonto a woman—the result is less to make the film more female-centered than to ensure that the spectacle of the sexual opening of women remains the genre's primary quest and obsession. It is arguable that whereas such porn parodies, for all their carnivalesque subversion, ultimately reinstate patriarchy, "slash fiction" (erotically charged fan fiction that is usually written by women) appropriates the material from the male gaze in order to communicate a female point of view and express more transgressive and queer fantasies.

IS PORNOGRAPHY ADAPTATION?

It is one thing to offer an overview of the pornographic version; it is quite another to make the films remotely interesting as adaptations, or even as parodies. They do not necessarily attempt to reproduce the textual qualities or experience or themes or pleasures of the original, because they are, unlike the aspirational erotica of the 1970s, emphatically pornographic texts. And it is questionable whether their audiences would care anyway. What works as pornography doesn't work consistently as adaptation, given the films' more focused and primary utility as incitements to masturbation. Use, one might say, competes with form, except in cases like *The Lustful Turk* that adapt already pornographic texts. The parody rarely interferes with the sex scenes, though these may incorporate some element of relationship with the original—as in *Official Psycho Parody*, in which Marion's seduction of Norman and domination of him indicates his feminized

submissiveness, or in *Pirates* (Hines 136), whose romantic couplings take their cue from the tone of the original film. Narrative function is to some extent no more than distraction, a "square up" frame of disavowal, a matter of product differentiation, or simply material to be fast-forwarded—in other words, filler. It is hard to determine, as Kyle Meikle points out, "how pornographic adaptations could or should be appreciated *as pornographic adaptations*: in the oscillation of the old (plot lines, characters) and the new (sex scenes, characters who are 'ready for some action'), a plenitude that produces both laughter and orgasms" (129).

This is a wider issue in discussing pornographic texts. Generally the meaning and significance of pornography has been discovered symptomatically, an individual film merely reiterating an ideology implicit in the genre's allegedly rigid codes, an ideology which, for the genre's many critics, is one-dimensionally expressive of patriarchal violence. Recent work on pornography has shifted away from such large and dismissive generalities and, rather than assuming their underlying ahistorical and politically regressive sameness, attends more to the context of porn consumption, porn's relationship with other genres, and the differences between specific texts (Attwood 2007). The same should go for XXX versions. They are certainly adaptations, though their transformative procedures more resemble those of exploitation films, parodic remakes constrained by the laws of copyright, than conventional legitimate adaptations. Even so, it is often more relevant to focus on paratextual relations—titles, DVD boxes, advertisements, trailers—than the detailed and meaningful acts of reinvention that denote adaptation proper (or improper). While the resort to parody was once an attempt at legitimation as well as burlesque, contemporary pornographic parodies use parody as a mark of distinction within a crowded market of otherwise indistinguishable products, adding a level of intertextual reference as the basis for advertising their content on DVD covers, in sex shops, and in online catalogues. As Sinclair Lewis once said, "Advertising is a valuable economic factor because it is the cheapest way of selling goods, particularly if the goods are worthless" (quoted in McGrady 110). The pattern behind the design and marketing of pornographic parodies is not so very different from the pattern behind the design and marketing of parodies such as *Scary Movie* (2000), *Epic Movie* (2007), and *The Starving Games* (2013) that seek to exploit the commercial success of mainstream films to attract viewers and to draw out, often with ribald humor, the low-brow erotic possibilities of the original films. If pornographic parodies have a single function, it is to demonstrate that anything can be sexualized and thereby to satirize the disavowal of sex in mainstream cinema.

Works Cited

Around the World with Fanny Hill. Dir. Mac Ahlberg. Perf. Shirley Corrigan, Peter Bonke. Minerva, 1974. Film.

Attwood, Feona. " 'Other' or "One of Us"?: The Porn User in Public & Academic Discourse." *Participations* 4.1 (May 2007). Web. 16 July 2015.

Booth, Paul. "Slash and Porn: Media Subversion, Hyper-articulation, and Parody." *Continuum: Journal of Media and Cultural Studies* 28.3 (2014): 1–14. Print.

Bordwell, David. "Gone Grrrl." *Observations on Film Art.* Web. 21 Oct. 2014.

Brontë, Charlotte, and Eve Sinclair. *Jane Eyre Laid Bare.* London: Pan, 2012. Print.

Church, David. "Desiring to Merge: Restoring Value in Niche-Interest Adult DVDs." *Film International* 63–64 (2013): 11–21. Print.

Comella, Lynn. "Studying Porn Cultures." *Porn Studies* 1.1–2 (2014): 64–70. Print.

Darnton, Robert. *The Forbidden Bestsellers of Pre-revolutionary France.* New York: Norton, 1995. Print.

Eckstut, Arielle. *Pride and Promiscuity: The Lost Sex Scenes of Jane Austen.* London: Canongate, 2013. Print.

Elias, James, et al., eds. *Porn 101: Eroticism, Pornography, and the First Amendment.* Amherst: Prometheus, 1999. Print.

E.T. XXX: A DreamZone Parody. Dir. Jim Powers. Perf. Capri Anderson, Alana Evans. DreamZone, 2013. Film.

Fanny Hill. Dir. Mac Ahlberg. Perf. Diana Kjær, Hans Ernback. Europa, 1968. Film.

Fanny Hill. Dir. Gerry O'Hara. Perf. Lisa Foster, Oliver Reed. Brent Walker, 1983. Film.

Fanny Hill Meets Dr. Erotico. Dir. Barry Mahon. Perf. Susan Evans, Michael R. Thomas. Barry Mahon Productions, 1967. Film.

Fanny Hill Meets Lady Chatterly. Dir. Barry Mahon. Perf. Susan Evans, Alex Keen. Barry Mahon Productions, 1967. Film.

Fanny Hill Meets the Red Baron. Dir. Barry Mahon. Perf. Susan Evans, Kristen Steen. Barry Mahon Productions, 1968. Film.

Fanny Hill: Memoirs of a Woman of Pleasure. Dir. Russ Meyer. Perf. Letícia Román, Miriam Hopkins. CCC, 1964. Film.

Fitzgerald, F. Scott, and Karena Rose. *The Great Gatsby Unbound.* London: Piatkus, 2013. Print.

Fletcher, Tony. "Tom Cruise Does Not Star in This Film." *Sky Magazine* 42 (Feb. 1990): 50–52. Print.

Flint, David. *Babylon Blue: An Illustrated History of Adult Cinema.* London: Creation, 1999. Print.

———. "The Golden Age of Porn." *Desire* 8 (1995): 26–30. Print.

Ford, Luke. *A History of X.* Amherst: Prometheus, 1999. Print.

Francey, Matthew. "Lee Roy Myers Wants to Save Porn by Destroying Your Youth." *Vice.* Web. 26 Feb. 2013.

Gorfinkel, Elena. "Radley Metzger's 'Elegant Arousal': Taste, Aesthetic Distinction and Sexploitation." *Underground U.S.A.: Filmmaking beyond the Hollywood Canon.* Ed. Xavier Mendik and Steven Jay Schneider. London: Wallflower, 2002. 26–39. Print.

Hines, Claire. "Playmates of the Caribbean: Taking Hollywood, Making Hard-Core." *Hard to Swallow: Hard-Core Pornography on Screen.* Ed. Claire Hines and Darren Kerr. London: Wallflower, 2012. 126–44. Print.

Holliday, Jim. "A History of Modern Pornographic Film and Video." Elias et al. 341–51. Print.

Hunter, I. Q. "*A Clockwork Orgy*: A User's Guide." *Peep Shows: Cult Film and the Cine-Erotic.* Ed. Xavier Mendik. London: Wallflower, 2012. 126–34. Print.

———. *Cult Film as a Guide to Life: Fandom, Adaptation and Identity.* New York and London: Bloomsbury Academic, 2016. Print.

———. "Naughty Realism: The Britishness of British Hardcore R18s." *Journal of British Cinema and Television* 11.2–3 (2014). 152–171. Print.

Hutcheon, Linda, with Siobhan O'Flynn. *A Theory of Adaptation*. 2nd ed. London: Routledge, 2013. Print.

James, E. L. *Fifty Shades of Grey*. London: Arrow, 2012. Print.

Jones, Bethan. "Slow Evolution: 'First time Fics' and *The X-Files* Porn Parody." *Journal of Adaptation in Film and Performance* 6.3 (2013): 369–85. Print.

Jones, Steve. "*Porn of the Dead*: Necrophilia, Feminism, and Gendering the Undead." *Zombies Are Us: Essays on the Humanity of the Walking Dead*. Ed. Cory Rushton and Christopher Moreman. Jefferson: McFarland, 2011. 40–60. Print.

Lewis, Jon. *Hollywood v. Hardcore: How the Struggle over Censorship Saved the Modern Film Industry*. New York: New York UP, 2002. Print.

Lorenz, Jay Kent. "Going Gonzo!: The American Flaneur, the Eastern European On/Scene, and the Pleasures of Implausibility." Elias et al. 352–58. Print.

Marcus, Steven. *The Other Victorians: A Study of Sexuality and Pornography in Mid-Nineteenth Century England*. London: Weidenfeld and Nicholson, 1964. Print.

McGrady, Mike. *Stranger Than Naked or How to Write Dirty Books for Fun and Profit*. New York: Wyden, 1970. Print.

Medved, Harry, and Michael Medved. *Son of Golden Turkey Awards*. London: Angus and Robertson, 1986. Print.

Meikle, Kyle. "Pornographic Adaptation: Parody, Fan Fiction and the Limits of Genre." *Journal of Adaptation in Film and Performance* 8.2 (2015): 123–40. Print.

The Memoirs of Fanny Hill. Dir. Morton Fishbein. Perf. Charlotte Holstein, Wilson McGaver, Terry Miller. Waggoner. 1971. Film.

Neuman, Joshua. "Lee Roy Myers: The Bastard Love Child of Mel Brooks and Linda Lovelace." *Heeb*. Web. 15 Sept. 2011.

Official Psycho Parody. Dir. Gary Orona. Perf. Sarah Vandella, Ryan McLane. Zero Tolerance, 2010. Video.

The Opening of Misty Beethoven. Dir. Radley Metzger. Perf. Constance Money, Jamie Gillis. Crescent, 1976. Film.

Rutter, Jared. "The Big New Wave of Porn Parodies." *AVN*. Web. 9 July 2009.

Schaefer, Eric. "*Bold! Daring! Shocking! True!*": A History of Exploitation Films, 1919–1959. Durham: Duke UP, 1999. Print.

The Sex Files: A Dark XXX Parody. Dir. Sam Hain. Perf. Kimberly Kane, Anthony Rosano. Digital Sin, 2009. Video.

Simpson, Nicola. "Coming Attractions: A Comparative Analysis of the Hollywood Studio System and the Porn Business." *Historical Journal of Film, Radio and Television* 24.4 (2004): 635–52. Print.

Smith, Iain R. "When Spiderman Became Spiderbabe: Pornographic Appropriation and the Political Economy of the 'Soft-Core Spoof' Genre." *Peep Shows: Cult Film and the Cine-Erotic*. Ed. Xavier Mendik. London: Wallflower, 2012. 109–18. Print.

Trigger, Jack. "ADULT FILMS: Spider-Man XXX: A Porn Parody Nominated for 16 AVN Awards." *Major Spoilers*. Web. 28 Dec. 2011.

Turan, Kenneth, and Stephen F. Zito. *Sinema: American Pornographic Films and the People Who Make Them*. New York: Praeger, 1974. Print.

Watson, Thomas J. "There's Something Rotten in the State of Texas: Genre, Adaptation and *The Texas Vibrator Massacre*." *Journal of Adaptation in Film and Performance* 6.3 (2013): 387–400. Print.

The Young, Erotic Fanny Hill. Dir. Joe Sarno. Perf. Laura Cannon, Tallie Cochrane. Joe Sarno, 1971. Film.

CHAPTER 25

VIDEOGAME ADAPTATION

KEVIN M. FLANAGAN

NARRATIVE videogames differ from media like film, novels, and radio broadcasts in their reliance on interactive input and their foregrounding of play. That said, they are among the latest in a long line of media that make and remake stories. While many different kinds of texts, from twentieth-century psalters to yesterday's Internet meme, are arguably always reliant on extant sources for their intelligibility, videogames present a special case in which older regimes of representation are remade into something apparently more dynamic. With the exception of some abstract art games, most videogames function under the logic of "remediation," a tendency within digital media to incorporate, contain, reform, and re-establish old media forms for a new cultural moment (Bolter and Grusin 339–46). *Grand Theft Auto IV* (2008), for instance, is not a game experience that was conjured out of the ether. Though the game is premised on building a criminal empire through such outré actions as carjacking, assassination, and kidnapping, it has surprising claims to realist discourse. The convincingness of its world is based on the game's ability to contain, in representative miniature, the contours of a city space (based on New York City), fashions based on popular designs, and fictional cars approximating iconic brands, as well as photographs, cinematic cut scenes, and mock web pages that are rendered through the game's graphical engine. Moreover, *Grand Theft Auto IV*, as befits a sequel, distills and responds to a series of design decisions that take previous games in the more than decade-old franchise into account. Even the production of the game thoroughly remediated the triumphs and controversies of publisher and franchise developer Rockstar Games—though, in a bit of transnational irony, the Scotland-based Rockstar North developed most of the games in this thoroughly American series (Kushner 260–65). This loop of iterated design and textual mediation was refreshed anew with *Grand Theft Auto V* (2013), the most recent in the series.

Looked at from a textual angle, the history of videogames becomes a history of adaptation. Since the early days of *Tennis for Two* (1958) and *Spacewar* (1962), videogames have looked to other textual forms, and other media histories, for their inspiration. This inspiration is not limited to in-game content, but also buttresses the technology and history of the games industry. *Spacewar*, for example, was created by MIT academics

using computers funded by and designed for US nuclear research (Flew 92–93). In the 1980s and 1990s, videogames destined for the US market were displayed at the industry electronics trade show CES (Consumer Electronics Show). Their earlier marketing and display tactics had more to do with established patterns in the electronics industry than with the cross-platform media franchising now more closely associated with the San Diego Comic Con, or with E3 (the Electronic Entertainment Expo, a videogame-centric show that launched in the mid-1990s, during a moment of industry transition).

As with feature film production, videogames are caught between being a capital-intensive profit engine within a larger media marketplace and an incubation chamber for artistic ideas about how we interact with the world. Their unsettled identity carries over to the discursive ways we talk about videogames in academic settings. Just as games themselves are suspended between the incessant drive for technological innovation and conservative market impulses that favor franchises, remaking, and transmedia adaptations, game studies as a discipline is split between ludologists, a camp committed to games as a unique medium of play, and narratologists, a group that sees games as one in a long line of media constructed around the delivery of stories (Aarseth; Juul). Although books like Ian Bogost's *Unit Operations: An Approach to Videogame Criticism* (2008) help move discussion away from an irresolvable binarism—Bogost looks at commonalities between literary analysis and the logic of computation—and toward what is now recognized as a synthetic digital humanities approach, videogames remain a somewhat unruly and disreputable object of study in the context of English departments and traditional humanities programs (ix–x). That said, videogames are attractive because of their elegant balance of representational artistry and their scientific and technological precision, however demotic their status.

Videogames engage with adaptation discourses on many levels, at different stages of their conception and reception. In this way, they recall Jack Boozer's claims about the importance of process in the study of adaptations. Just as film adaptations have different relationships and statuses vis à vis source texts at the various parts of their production—the screenplay, for instance, is a key intermediary in a narrative's movement from novel to screen—so, too, do videogames adopt differing relationships to their source materials over time (Boozer 1–3). Most obviously, videogames adapt stories and characters from sources like books, films, television shows, and comic books. In an age of conglomerated media empires and the synergistic "convergence" of cultural properties, videogames are a crucial medium for the active production of new experiences (Elkington 7).

The basic adaptation paradigm for videogames tackles a set of issues common to other kinds of transmedia transformation: the movement of textual material from one medium, platform, delivery method, time, or cultural context to another. This movement of meaning happens differently at various moments in a given game's life. The kind of adaptive work being done when a game is written and programmed based on a design team's reading of Mark Twain's *The Adventures of Tom Sawyer* (1876) is different from the kind of adaptive work that happens when players build their own map approximating California in the Campaign Editor in *Starcraft* (1998). In general, videogame adaptation presents a unique set of design and discursive challenges, since when a novel or film

is adapted into a videogame, adapters such as programmers, creative producers, and game designers must translate linear narratives or stable fictitious properties into quasi-ludic, player-controlled experiences. Moreover, as with other intermedial exchanges, the videogame adaptation process must pay particular attention to the affordances and constraints of different media. What is gained or lost in the movement of the rules, characters, and story from the outward realm of physical game world to the relative mystery of a digital space? Can a game faithfully recreate the physical experience or canonical text it is based upon? Should it try to?

Adaptation studies as a discourse can cut to the quick of some ongoing debates in the different stages of a videogame's production and reception. Videogames provide adaptation studies with a multivalent, young, and exciting object of new media study; adaptation studies provide videogames and game studies with a set of structuring questions and concerns, theoretical and practical, that are precisely about how meaning is made, remade, and experienced. To this end, I have isolated four encounters in videogame adaptation that examine a tension, point of transition, or point of comparative *frisson* that speaks to an active paradigm in adaptation studies. What follows is a survey of several videogame adaptations that cover a variety of texts, an expanded group of participants and adapters, and a range of cultural backgrounds, but always with an eye toward one of the foundational debates in games studies: the paradox of originality, whereby new experiences come from remediated and newly adapted engagements with a wider cultural sphere. This means paying attention to the narrative/play split, with a general interest in *what*, precisely, is being adapted when already existing material is turned into a videogame.

The first encounter has to do with textual analysis, focusing specifically on videogames as a way to adapt virtual worlds. This section focuses on how videogames can be analyzed as representative transmedia properties that adapt source material, whether in a traditional relationship to specific source texts or as intertextual assemblages, to fit the demands of a coherent game diegesis.

The second encounter looks at "porting," the act of adapting a game from one console or operating system to another. A common mode of adaptation in the history of videogames is the creation or modification of a game experience based on the specific technological dictates of a different "platform," which are as much the technical possibilities of a device—say, the Sega Genesis console—as the abstract creative possibilities open to or barred from such a device (Bogost and Montfort). Part of understanding videogame adaptation means understanding platform architectures, such as consoles or software suites, each with their own technological possibilities and limitations, that allow for play experiences different from those of other platforms (Schweizer 488). This section examines medium specificity and fidelity discourse as a means of scrutinizing the various textual, technological, and experiential changes brought about by porting.

The third encounter deals with the linguistic and cultural translation of games. As one would expect from a creative field whose two hotspots are Japan and the United States, a key process in videogame adaptation is localization, the process by which publishers translate aspects of a game (text, cultural citations, mythological references, even

character appearance) for specific markets (Kohler 211). Using work at the intersection of adaptation studies and translation studies, this section looks at what happens when games move around the world.

Finally, the fourth encounter deals with "modding," a type of player-centric adaptation that happens long after a game has shipped. Videogame adaptation is a process that often relies as much on players as media producers, and often happens within games themselves. Modding—player-centric modification of game assets, usually through level editing tools released with specific games—is a key component to videogame culture. Games centered on user-generated content hold playing at adaptation as an end unto itself. This section looks at modding in relation to the turn in adaptation studies toward looking at adaptation as an educational skill, a mode of literacy that values process and negotiating new encounters.

Videogame adaptation is not exhausted by these four encounters. They are fruitful points of discussion that barely scratch the surface of possible dialogues. For instance, games themselves can be programmed to adapt during play, such as those that modulate difficulty in real time based on player performance. Even *Pong* (1972) can be reprogrammed to make a two-player experience more competitive (Ibáñez and Delgado-Mata). Adaptation scholars might engage in dialogue with programmers and coders in a discussion of automated, self-generating modes of adaptation. The aesthetic relationship between cinema and videogames is fast becoming a cultural norm. In relatively early filmic attempts at videogame adaptation, the relationship between film and game was largely superficial. According to Will Brooker, "because fidelity to the original is of low priority when porting games to cinema, direct adaptations of videogames—with rare exceptions—have little in common with the aesthetics and conventions of the source material, and resemble the game primarily only in mise-en-scene and costume design" (123). *Mortal Kombat* features characters from the eponymous game and focuses on an international martial arts tournament, but basically just shows the degree to which the game franchise was a reimagining of the Bruce Lee film *Enter the Dragon* (1973), underscoring the mutual visual and narrative language of game genres and film genres.

With the expansion of the games industry and the tendency of major media producers to embrace new technologies in pursuit of new audiences, however, the relationship shifts. Videogames increasingly look to films and books for narrative material, and films and books increasingly look to videogames for aesthetic experiences and kinetic thrills (Papazian and Summers 11). *Edge of Tomorrow,* a 2014 film in which protagonist William Cage (Tom Cruise) is able to repeat the same day every time he dies, illustrates Hollywood's rare intellectualization of a videogame trope. The potential centrality of videogames to adaptation studies is closely connected to videogames' shifting historical relationship to long-standing objects of study like novels and films. Videogame adaptations have been seen as ancillary paratextual supplements to movies; a mutually constructive aesthetic sounding board for new kinds of kinetic cinema; and the slightly unsatisfying alternative to allegedly passive storytelling platforms like graphic novels. The relative novelty of videogames ensures the start of a long-standing relationship, if not an outright affair. As an expressive medium, their possibilities are only beginning to be explored.

FIRST ENCOUNTER: ADAPTING
VIRTUAL WORLDS

The basic conceit of the most popularly regarded form of videogame adaptation is the attempt to make texts of one genre in one medium playable in another genre in another medium. In other words, when a property is adapted from a fixed narrative media form like a novel or a film, game designers must do more than just move story information, characters, and approximations of visual descriptions. Whole regimes of experience can be altered. Videogames have a tradition of interactive genre types that differ immensely from those of books or movies. Genres that have developed over the past forty years in the commercial games marketplace include side-scrolling platformers (a character avatar is controlled in relation to a two-dimensional, scrolling screen, usually in avoidance of enemies and pitfalls), single-screen puzzle games (a game board is laid out, usually from a top-down perspective), first-person shooters (usually three-dimensional games that align player vision with an in-game avatar, most often with the goal of shooting targets and navigating maze-like spaces), and text-only adventure games (interactive fictions based on typed commands, perhaps the videogame genre closest to literary hypertext). Videogame adaptations frequently take a known genre and work with content from another text, in the process creating a compromise between two different traditions.

A representative film-to-game example is *Lego Lord of the Rings* (2012), an adaptation of the three *Lord of the Rings* (2001–3) films and select aspects of J. R. R. Tolkien's books (1954–55) that did not appear in Peter Jackson's films, which merges the material singularity and sense of humor of previous Lego videogames with attention to the major set pieces of the beloved stories. The game traces a narrative line from the capture and failed destruction of the One Ring of Power, through the initiation of Frodo's quest, to the widespread war between the forces of good and evil and the eventual disposal of the Ring that follow. The game features playable approximations of many of the big sequences from the epic story—the exploration of the Mines of Moria, the Battle of Helm's Deep, the ordeal at Mount Doom—and even includes content not featured in the theatrical films (for instance, players can interact with the controversial poet Tom Bombadil). Like previous Lego franchise games, *Lego Lord of the Rings* offsets the seriousness of many of its plot points with humor, especially slapstick bits such characters' being hit by objects, pratfalls, and accidental dismemberments. Yet unlike previous Lego games, which present the narratives of the franchises they adapt (*Batman, Indiana Jones, Star Wars, Harry Potter*) through mumbled speaking, *Lego Lord of the Rings* features verbatim dialogue ripped directly from the films. In this sense, *Lego Lord of the Rings* is successful according to some of the criteria important to textual fidelity, while at the same time innovative, even occasionally disruptive, toward its source's intentions and meanings. *Lego Lord of the Rings* sets Tolkien and Jackson's epic fantasy in a world that simultaneously adapts aspects of physical Lego play—the collection of specific pieces, the construction of buildings and items—and works within the confines of an already established videogame

discourse. In this way, it is both an adaptation of textual precedents and an attempt to give a digital approximation to a physical, decidedly analog form of play. *Lego Lord of the Rings* is an open world game that allows players to visit and revisit many of the locales mentioned in its sources (often in ways that go against the linear narrative thrust of these sources, where the adventurers are constantly cut off from terrain already covered), but it tempers this general experience with the more specific genre conceits of an arcade style "beat 'em up," where hordes of enemies constantly assault the players, as well as light role-playing game elements that allow some character customization. Thus, *Lego Lord of the Rings* is an adaptation constructed across genres, source texts (some of which are themselves adaptations), and media platforms to give a new experience of Middle-earth.

Comparing two or more attempts at adapting an author's work, a media franchise, or an intellectual property reveals a grand variety of possible approaches. Of the numerous games adapted from or inspired by H. P. Lovecraft, *Cthulhu Saves the World* (2010) and *Eversion* (2010) provide two satisfyingly disparate interpretations. *Cthulhu Saves the World* and *Eversion* form something of a neat comparison because they were both developed by very small independent outfits. Mark J. P. Wolf's recent work on subcreation and the transmedia practice of building experientially coherent imaginary worlds helps explain the current popularity of Lovecraftian adaptations in games, as the author left a rich legacy from which to work (25). Lovecraft wrote stories for roughly twenty years, selling them to pulp magazines but never enjoying wide recognition until well after his death. Whatever one thinks of Lovecraft's prose—stories like "The Color Out of Space" and "The Dunwich Horror" are full of inscrutable passages that seem at first deeply contradictory in their descriptions of objects and encounters—his writing can be admired for its constant attempt to build from seemingly irreconcilable discrepancies. In *Supernatural Horror in Literature*, he sketches a signpost for gauging the "emotional level" of a weird tale, the hybrid of occultish horror and sci-fi in which he preferred to work: "The one test of the really weird is simply this—whether or not there be excited in the reader a profound sense of dread, and of contact with unknown spheres and powers; a subtle attitude of awed listening, as if for the beating of black wings or the scratching of outside shapes and entities of the known universe's utmost rim" (16). The philosopher Graham Harman praises Lovecraft: "no other writer is so perplexed by the gap between objects and the power of language to describe them, or between objects and the qualities they possess" (3). Lovecraft dwells on helplessness, the unknowable, the moments where language short-circuits, and on forces that outstrip a given person's capacity for comprehension. Videogame adaptations of Lovecraft have, to varying degrees, tried to pick up on Lovecraft's ontological strangeness, often beginning with large-scale diegetic concerns. To use Wolf's terminology, Lovecraft's world, blending elements of 1920s New England, the wastes of Antarctica, and the nether regions of the Cthulhu mythos, is an ongoing subcreated world, one flexible enough to encourage new creators without the need to bow to strict continuity and canonicity. Its weirdness and nearly infinite scale are its primary attractions.

Zeboyd Games's *Cthulhu Saves the World* is a computer role-playing game deliberately styled after early entries in the popular *Dragon Quest* series, whose main narrative

conceit is that the all-powerful cosmic being Cthulhu, stripped of his powers, must journey around the world, fighting evil in the hope of liberating his powers and regaining ascendancy. The central joke is that Cthulhu, typically a godlike destroyer, must wander around, engage in mundane combat against lesser foes, recruit a party of adventurers to aid him, and inadvertently help the very people he usually annihilates. The game takes tropes familiar from countless other role-playing games and garbs them in references to Lovecraft. A player guides Cthulhu through Dunwich, Innsmouth, R'lyeh, and other iconic places. Cthulhu battles many familiar enemies, including Azathoth and Nyarlathotep (a.k.a. "the Crawling Chaos"). Even insanity, that most Lovecraftian of affective states, is herein selected from a menu. Whereas Lovecraft's stories use insanity in the context of slow degradation, often with no immediate cause, *Cthulhu Saves the World* considers insanity to be a controllable, scripted event. *Cthulhu Saves the World* is an entertaining game that is not too difficult to complete (when played in its default mode, it avoids the sense of dire impossibility common to Lovecraft stories). Ultimately, its obsession with references to Lovecraftiana overshadows its attention to the processes and emotional punctuations in Lovecraft's fiction. In place of cosmic horror, we get familiar role-playing game (RPG) trappings and almost nonstop humor. While the game arguably parodies the seriousness with which Lovecraft's fans take his writing, it does not aspire to the feeling—the uncertainty, the doubt, the creeping unease—of a Lovecraft story.

In contrast to this literal transposition of content, Zaratustra Productions' *Eversion* takes a different approach. It still maps Lovecraft onto a videogame genre—in this case, the side-scrolling platformer—but does so while adapting the affective regime of the author's work. It connects to what Ian Bogost has labeled the "Proceduralist Style," coined in response to a small class of indie art games that are more concerned with translating mechanics, experience, or even mood than with replicating textual content (that is, less what the literary text is "about" than what it "feels like") (Bogost, "Proceduralist"). *Eversion* was originally created as part of a competition on the TigSource website in which contestants created a game based around a quotation from Lovecraft's *Commonplace Book*. *Eversion* is not so much a game directly based on a Lovecraft story or Lovecraftiana as an attempt to adapt a Lovecraftian experience and mechanics. A title card with a Lovecraft quotation ("Sounds—possibly musical—heard in the night from other worlds or realms of being") maps onto the game's "evert" button, which when triggered sends the protagonist Zee Tee (the player's avatar, a kind of humanoid flower) into a parallel layer of reality. This is a central proceduralist conceit: the connection between a game's diegesis and a mechanic that, when used over the course of a game, breaks down the distance between player input and the exploration of a world. Moreover, at certain points tied to level progress and depth of eversion, the world literally begins to dissolve. A shapeless black wave consumes all visible space, eventually swallowing Zee Tee. This replicates to an astonishing degree the ontological uncertainly and sense of instability at the heart of Lovecraft's fiction. These events are still scripted, programmed to occur when players reach certain points in each level, but when encountered in the course of play, they do indeed convey a sudden realization of the world collapsing in on itself.

The proceduralist approach echoes Graham Harman's reading of Lovecraft as a writer who produces uncertainty through his carefully written non-descriptions of the strange and alien, a process that ceases to work when faced with literalization or paraphrase (244). Rather than give us knowable things or familiar references, as in *Cthulhu Saves the World*, *Eversion* uses design to prompt a briefly felt phenomenological experience of the weird. In the process, however, *Eversion* loses some of the detail and context contained by *Cthulhu Saves the World*, which so clearly and lovingly reproduces some aspects of Lovecraft. Zeboyd's approach in *Cthulhu Saves the World* seems to me to be more widely symptomatic of videogame adaptations writ large: when they pay attention to them at all, adapters often focus disproportionately on referencing textual minutiae and on generating a knowingly ironic take on their inspiration. Far less common is the path taken by *Eversion*, which appears to be a rare attempt to translate an author's ideas into a ludic mechanic, a process that seems more responsive to the possibilities of videogames as a medium. Tanya Krzywinska has noted that a third Lovecraft adaptation, the first-person survival horror game *Call of Cthulhu: Dark Corners of the Earth* (2005), strikes its own balance between Lovecraftian content and Lovecraftian moods.

SECOND ENCOUNTER: PORTING

Many videogame properties are released on several platforms simultaneously, often by the same developer and, confusingly, often with the same name. However, these games are, strictly speaking, not empirically the same. They each contain different code, and while they might use the same design assets, they are programmed according to the constraints of the console on which they are played ("porting"). A videogame port is the term used to distinguish a videogame that is created for (or "ported" to) a given platform. Videogame ports are adaptations of a sort, as they tend to depend on a canonical hypotext of a given game—either the first, or the most technically complete, or the most culturally influential—a common point of reference that becomes a determining factor in the reception of future iterations of a game (compare Genette 5). In discussions of videogame ports, fidelity remains a practical way for critics and fans of all stripes to judge the relative success of an adaptation. Take the controversial game *Mortal Kombat* (1992) as an example. When Midway decided to release ports of *Mortal Kombat* for home consoles, it essentially prompted adaptations of the game within the technological, aesthetic, and cultural constraints of each platform. A comparative analysis of ports thus lends itself to a kind of straightforward fidelity criticism. *Mortal Kombat's* standard version was its arcade release, which contains seven playable characters, has several different stages, and uses most of the vertical and horizontal space of a standard four-by-three tube television. *Mortal Kombat's* Sega Game Gear port (1993) maintains the relatively crisp, full-color graphics of the original, but has only six initial playable characters, sprites who loom larger in the frame, as well as simplified level designs. Controls are changed to accommodate the system's reduced number of buttons. The Nintendo

Game Boy, a competing portable console, received an even more stripped-down version of the game with black, white, and gray graphics and none of the gore that made the initial game infamous. The version released for the Sega Genesis (1993) has graphics that scale closer to the arcade version, contains all playable characters as well as detailed graphics, and restores the gore. According to the criteria of "layman's judgment," to use J. D. Connor's phrase, or even to the terms often favored by paid videogame reviewers, *Mortal Kombat*'s Genesis port bears the closest technological and design relationship to its hypotext of the games mentioned. In the practical discourse around games, an "arcade perfect port" is likely to sell better and earn more critical praise than one bound by too many technological changes or hardware constraints. At the same time, the culture around porting for a large chunk of videogame history has been dominated by this paradigm, which discourages change and experimentation in favor of fidelity.

In some cases, placing a non-game hypotext like a film at the center of a transmedia event simultaneously generates several different ports, whose platform specificity and different developers create entirely different games. This is arguably true for the various ports of James Cameron's film *Terminator 2* (1991). *The Terminator* universe became a transmedia experience distributed over theme park rides, comics, books, films, and, of course, games. It was a masterpiece of ancillary branding and marketing, a key survival strategy in the age of Hollywood's conglomeratization (Hillier 32). Midway's *Termintator 2: The Arcade Game* (1991) is an on-rails shooter that replicates the shooting set pieces and fetishism of weaponry so central to the film. A version of the game developed by Dementia and distributed by Ocean goes the variety route, allowing players to engage in hand-to-hand combat and vehicle chases, all while approximating the film's narrative with interstitial animated sequences that reproduce plot points. Versions of the game developed by LJN and Flying Edge opt for a similar mix. The franchise's characters were even used for IntraCorp's *Terminator 2: Judgment Day: Chess Wars* (1993), an electronic chess simulator for the DOS operating system.

This last game doubles as an example of branding, a corporate practice on the fringe of adaptation proper, an attempt to render some aspect of a franchise palatable for almost any instance in which something can be bought or sold. In one sense, branding is used primarily as an advertising tool that transposes content from one property onto another, usually with the goal of promoting a franchise or property in a superficially visual way. In this way it is arguably a kind of likeness-based appropriation. *Terminator 2: Judgment Day: Chess Wars* promotes the characters and settings of the *Terminator* franchise, but its basic play mechanisms are entirely based on chess, a public domain game with an ancient history and no obviously commercial agenda. *Terminator 2: Judgment Day: Chess Wars* is not a bad way to play chess, but as an adaptation in the *Terminator* franchise, it may fairly be judged as not engaging with the conceptual issues that make the films beloved in fandom circles (the time travel paradoxes, issues of machine and non-human affect, willingness to explore the roots of a man-made apocalypse, and so on). *Terminator: Judgment Day: Chess Wars* is closer to *Cthulhu Saves the World* than *Eversion* because it is less interested in the conceptual mechanics of its source than in scattered pieces of content.

All of these examples of ports—indeed, all of the adaptations mentioned so far in this essay, to one degree or another—raise questions about medium specificity. Kamilla Elliott points out that this concern over what specific media do well goes back at least to Vachel Lindsay's *Art of the Moving Picture* (1915) and becomes something of a founding dogma in adaptation studies in George Bluestone's *Novels into Film* (Elliott, "Theorizing Adaptations" 27; Lindsay 87; Bluestone 63–64). Games studies derives its identity from a basic claim to medium specificity, since videogames became an object of scholarly scrutiny on the assumption that they could do things that other media could not (Aarseth). Finer distinctions exist in "platform specificity," where as much attention is paid to technological affordances and constraints of specific platforms as to the aesthetic possibilities they raise. What a scholar from adaptation studies like Elliott can bring to the discussion is a loosening up of the discourse, which currently seems to favor the technological over the aesthetic. For instance, her use of "interart analogies" throughout *Rethinking the Novel/Film Debate* removes the mandate of the uniqueness of the medium by focusing on overlapping strategies, all without ignoring differences and tensions (9). To bring this perspective to bear on the *Terminator 2: Judgment Day: Chess Wars* example reframes my remarks about that game's apparent failure. Read another way, *Terminator 2: Judgment Day: Chess Wars* shows how the struggle between the rebels and the machines in Cameron's world always at some level resembled chess (both sides have expendable, as well as more powerful, flexible, and important resources). Moreover, the game's use of non-interactive battle "cut scenes" (animated cinematic events) tries to bridge the gap between film world and game world, thus allowing for a commingling of the two. Whatever the practical problems, the game weds the aspects of a tabletop board game, a film, and a videogame, as experienced on an MS-DOS PC, without necessarily prioritizing any of these media. Instead, *Terminator 2: Judgment Day: Chess Wars* combines these categories into something that inevitably exceeds the potential of its somewhat scattered parts.

THIRD ENCOUNTER: LOCALIZATION (TRANSLATION AND CULTURAL SPECIFICITY)

Despite their historical distance, adaptation studies and translation studies are now understood in increasingly common terms (Minier 15; Raw 1–19). Katja Krebs has written about the "somewhat arbitrary" distinction between the two practices, as "both translation and adaptation—as (creative) process, as product or artefact, and as academic discipline—are interdisciplinary by their very nature; both discuss phenomena of constructing cultures through acts of rewriting, and both are concerned with the collaborative nature of such acts and the subsequent critique of notions of authorship" (3). In both cases, the relationship between two texts undergoes comparative analysis in which a hypotext is rethought as it changes media or intended audience. While the

stated goal in the adaptation or translation process can be offered as an intention to be faithful to a source, a radical transformation to suit a new context can be just as valid. Videogames are produced in a worldwide marketplace, and they cross borders that are physical and cultural. Even though the historic centers of concentrated videogames production are the United States (specifically the West Coast) and Japan, games are now designed and sold the world over, with the Internet allowing for unprecedented access and cheap distribution. Despite this, there are still obstacles to international acceptance. For instance, many games made in the West do not readily translate for Arabic-speaking audiences because the text in these games was originally meant to be read left-to-right, instead of right-to-left (Campbell). In the Soviet Union, videogames from Japan and the United States were not legally available until years after their debuts elsewhere. The iconic Elektronika (1983) handheld was the Soviet Union's answer to Nintendo's Game & Watch portables, a pirated videogame system that was manufactured to suit Russian tastes: instead of featuring Mickey Mouse, like a Japanese version, the Elektronika contained a game based on the locally popular cartoon *Just You Wait!*, featuring the exploits of "a no-good wolf and a clever bunny" (Idov 130).

To localize is to both translate the onscreen language of a game and to make a property culturally relevant to a new audience. In writing about Marcus Lindblom's American localization of the game *EarthBound* (1995, Super Nintendo Entertainment System), a role-playing game with a contemporary setting called *Mother 2* in Japan, professional translator Clyde Mandelin has noted that, in addition to the accuracy and referential specificity of individual lines of written text, many changes were required to bring the game to a Western audience: the use of diegetic sounds inserted to reduce onscreen violence, the graphical changes undertaken "to avoid possible lawsuits," the changes to images or characters with built-in cultural associations, and the removal of religious references (Mandelin; Schreier). In his analysis of *EarthBound*, Mandelin even goes so far as to highlight all the moments in which the game's scatological humor was removed or displaced, a signal of differences between what Nintendo of Japan and Nintendo of the United States thought was appropriate for their respective audiences. *EarthBound* is a "good" localization in its thorough attempt to make a quirky Japanese game intelligible to American audiences who had never seen anything like it, even as it is "bad" at preserving the original game's cultural specificity. However, as an exercise in forging a creative dialogue between two cultures, the American localization of *Earthbound* is first-rate.

The localization process is a chance for publishers to curate a brand identity. In the longer history of videogames, this commonly happens when a game is remade or rebooted and, when translated, re-localized. Game remakes tend to be more directly based on their original source text than reboots. Consider the complex process that produced *Sword of Mana* (2003), a remake of the GameBoy's *Final Fantasy Adventure* (1991), for the GameBoy Advance handheld console. Released in Japan as *Seiken Densetsu, Final Fantasy Adventure*, the GameBoy game was intended to take advantage of the branding of the popular *Final Fantasy* series. Games in the series following *Final Fantasy Adventure* in Japan retained the *Seiken Densetsu* ("Legendary Sacred Sword")

name, whereas in America they received new branding under the *Mana* title, such as *Secret of Mana* (Super Nintendo Entertainment System, 1993) and *Legend of Mana* (PlayStation, 1999). When *Final Fantasy Adventure* was remade in 2003, it received the title *Sword of Mana* in the United States, effectively using the adaptive process of remaking as a strategy to exploit its brand lineage in expectation of future games in the series. This process reveals one of the central paradoxes of videogame adaptation: the constant drive for newness, even if only contextual, as born from an inevitable reliance on older experiences and sources. But it also highlights the paradox of localization: the preservation of some part of the original identity of the object, complemented by an invitation to a new audience with different cultural expectations.

Adaptation studies provides several entries into the practice of localization. Following Julie Sanders, localized videogames can be conceived as texts that have been "reinterpreted" for a new audience, both in and across familiar generic boundaries (19). In writing about intercultural adaptations as acts of cultural revision, Pascal Nicklas and Oliver Lindner talk about appropriation as the construction of a "new living organism," a "new cultural capital" that is less concerned with preservation than with revitalizing something for different markets (6). Like games studies' obsession with medium specificity, localization highlights the stakes of cultural specificity. On the one hand, almost all videogames are commodities that circulate in a global marketplace, and literacies focused on game genres often transcend national borders. On the other hand, language remains a barrier, especially for text-and-narrative-heavy genres like the role-playing games cited earlier, and even globally dominant tongues like English, Mandarin, and Spanish speak only to pockets of the world's population. In Nicklas and Lindner's model, however, localization is not a rear-guard action that provides a new market for a game after the fact. Instead, it can be thought of as a productive stage in the adaptation process in its own right, in which ideas travel and are synthesized.

FOURTH ENCOUNTER: MODDING AND USER-GENERATED ADAPTATION

Select videogames are released with the understanding that fans can adapt, add to, or alter them to their heart's content. Such modifying, or "modding," of a game is as old as the form itself. Many videogames circulated widely in the pre-commercial 1970s precisely because of their openness to the ideas of others (King and Borland, Chapter 21). Dan Pinchbeck defines modding as "creating new variations on a game by using a combination of new assets, new level designs, and alterations to a game's codebase," a gambit publishers play in pursuit of a more vibrant audience and an extended shelf life (119). *Doom* (1993) is among the most famous games to come with modding tools. Players could construct levels, add or limit items, or apply new visual "skins" for objects and monsters. The *Aliens* "total conversion" mod makes the entire game look like an

officially licensed adaptation of the film *Aliens*. Moddable games usually come with level editing tool kits and rarely require modders to have thorough programming skills.

Modding is part of a tradition of player-generated content for videogames that allows all participants to become adapters. A few games are creation engines whose main attraction is their democratizing of design. The *RPG Maker* franchise gives users a chance to build and play their own role-playing games using pre-supplied assets. Sandbox games (so called because their flexibility allows for creation and experimentation on par with a child's sandbox) like *Second Life* (2003) and *Minecraft* (2009), which feature an open world with few restrictions placed on how one plays, reward patience, curiosity, and collaborative creativity.

A sandbox game like *Minecraft* is both a tool for creating adaptations and a game in which users learn a new play style in and of itself. Even though there are few restrictions on design possibilities, players have regarded *Minecraft* as a place to recreate and reimagine previous game experiences. The video blogging team Achievement Hunter has used *Minecraft* as a platform for reconstructing the first level of *Super Mario Bros.* (1985), thereby removing it from Nintendo's proprietary Mario universe and recontextualizing it as a creative exercise (Lien). But even though the game contains an achievement system, no particular *Minecraft* experience need have specific goals. In fact, an open-world, procedurally generated game like *Minecraft* invites players to rethink the play styles associated with most games. With its emphasis on exploration and its regard of the game world as an experiential resource, *Minecraft* allows for a Freudian "polymorphous perversity" of play: a non-teleological, almost utopian experience of construction and experimentation (Childers and Hentzi).

Modding, and participatory player creation more generally, offers a useful test case for the increasing tendency within adaptation studies to regard adaptation as a process. Laurence Raw and Tony Gurr "believe that greater attention needs to be paid to the process of adaptation," with a particular focus on "how the utterances of convergence culture determine the way we think at every stage throughout our lives" (4). Raw and Gurr are concerned with the ways adaptation can become a common paradigm for twenty-first-century instruction. In this way, they point the way forward to more productive dialogue between adaptation scholars and writers on videogame literacy about the transformative potential and learning outcomes of these apparently disparate practices. For instance, James Paul Gee sees videogames as both tools for teaching thinking skills—for learning through play, interaction, and the constant encounter of new scenarios—and as the gateways for emerging areas of pedagogical study like situated cognition, literacy studies, and connectionism, or the notion of learning and interaction as pattern recognition (8). Videogames teach us to think about how to react to or participate in different situations, and moreover simulate a scaled-down thought experiment that virtualizes the variety of ways in which we experience the world. Adaptations likewise give us new perspectives on process, transformation, and the stuff of cultural creation, all while encouraging us to think comparatively and contextually about communication.

Modding and play-as-adaptation illustrate the expansive, if still under-explored, relationship between adaptation studies and videogames. As an ongoing player- and

user-centric process, moddable, player-generated game adaptations challenge the assumption that videogames are adaptations in only a limited sense. Videogames adapt, and make us into adapters, at all stages of their conception, creation, distribution, and reception. Games are adapted from hypotexts, and the transformation of textual material that results from such a movement invites close analysis. They are adapted to work on different platforms, in response to different technological and genre demands. They are adapted for different cultural situations, illustrating the tension of videogames as a global commodity and videogames as a local mode of storytelling and experience. Finally, games give players, fans, and educators the tools to engage with the apparatus of adaptation. They present a new media threshold that unites different approaches to adaptation in a relatively young, if increasingly mature, form of expression. Practically speaking, videogames are as good for adaptation studies as for humanities departments. Videogames have a contemporary relevance to culture at large and an active importance in the lives of twenty-first century students—a winning combination that promises new ways to invite young scholars into existing paradigms in the life of the mind, with the added bonus of increasing enrollments in English and modern language departments.

Acknowledgments

Thanks to Bobby Schweizer for sharing his knowledge of Lego and for commenting on an early draft of this essay.

Works Cited

Aarseth, Espen. "Computer Game Studies, Year One." *Game Studies* 1.1 (2001). Web. 29 Aug. 2014.

Aliens. Dir. James Cameron. Perf. Sigourney Weaver, Michael Biehn. Twentieth Century Fox, 1986. Film.

Bogost, Ian. *Unit Operations: An Approach to Videogame Criticism.* Cambridge: MIT P, 2008. Print.

———. "The Proceduralist Style." *Gamasutra.com.* 21 Jan 2009. Web. 4 Aug. 2014.

Bogost, Ian, and Nick Montfort. "Levels." *Platform Studies.* MIT P, n.d. Web. 30 Jul. 2014.

Bolter, Jay David, and Richard Grusin. "Remediation." *Configurations* 4.3 (1996): 311–58. Web. 1 Aug. 2014.

Boozer, Jack. "Introduction: The Screenplay and Authorship in Adaptation." *Authorship in Film Adaptation.* Ed. Jack Boozer. Austin: U of Texas P, 2008. 1–30. Print.

Bluestone, George. *Novels into Film.* Berkeley: U of California P, 1957. Print.

Brooker, Will. "Camera Eye, CG-Eye: Videogames and the Cinematic." *Cinema Journal* 48.3 (2009): 122–28. Web. 1 Aug. 2104.

Call of Cthulhu: Dark Corners of the Earth. Headfirst Productions, 2005. Videogame.

Campbell, Colin. "How Western Games Are Being 'Culturalized' for Arabic Countries." *Polygon.com.* 30 Nov. 2013. Web. 3 Aug. 2014.

Childers, Joseph, and Gary Hentzi, general eds. "Polymorphous Perversity." *The Columbia Dictionary of Modern Literary and Cultural Criticism*. New York: Columbia UP, 1995. *ProQuest*. Web. 30 Aug. 2104.

Connor, J. D. "The Persistence of Fidelity: Adaptation Studies Today." *M/C Journal* 10.2 (2007). Web. 30 Aug. 2014.

Cthulhu Saves the World. Zeboyd Games, 2010. Videogame.

Doom. Id Software, 1993. Videogame.

Earthbound. Ape/Hal Laboratory, 1995. Videogame.

Edge of Tomorrow. Dir. Doug Liman. Perf. Tom Cruise, Emily Blunt. Warner Bros., 2014. Film.

Elkington, Trevor. "Adaptation." *Encyclopedia of Video Games: The Culture, Technology, and Art of Gaming*. Vol. I. Ed. Mark J. P. Wolf. Westport: ABC-CLIO, 2012. 7–9. Print.

Elliott, Kamilla. *Rethinking the Novel/Film Debate*. New York: Cambridge UP, 2003. Print.

———. "Theorizing Adaptations/Adapting Theories." *Adaptation Studies: New Challenges, New Directions*. Ed. Jørgen Bruhn, Anne Gjelsvik, and Eirik Frisvold Hanssen. New York: Bloomsbury, 2013. 19–46. Print.

Enter the Dragon. Dir. Robert Clouse. Perf. Bruce Lee, John Saxon. Warner Bros., 1973. Film.

Eversion. Zaratustra Productions, 2010. Videogame.

Final Fantasy Adventure. Square, 1991. Videogame.

Flew, Terry. *New Media*. 4th ed. New York: Oxford UP, 2014. Print.

Gee, James Paul. *What Videogames Have to Teach Us about Learning and Literacy*. London: Palgrave, 2003. Print.

Genette, Gérard. *Palimpsests: Literature in the Second Degree*. Trans. Channa Newman and Claude Doubinsky. Lincoln: U of Nebraska P, 1997. Print.

Grand Theft Auto IV. Rockstar North, 2008. Videogame.

Grand Theft Auto V. Rockstar North, 2013. Videogame.

Harman, Graham. *Weird Realism: Lovecraft and Philosophy*. Winchester: Zero, 2012. Print.

Hillier, Jim. *The New Hollywood*. London: Continuum, 1992. Print.

Ibáñez, Jesús, and Carlos Delgado-Mata. "Adaptive Two-Player Videogames." *Expert Systems with Applications* 38.8 (2011): 9157–63. Web. 3 Aug. 2014.

Idov, Michael, ed. *Made in Russia: Unsung Icons of Soviet Design*. New York: Rizzoli, 2011. Print.

Juul, Jesper. "Games Telling Stories? A Brief Note on Games and Narratives." *Game Studies* 1.1 (2001). Web. 29 Aug. 2014.

King, Brad, and John Borland. *Dungeons and Dreamers: A Story of How Computer Games Created a Global Community*. 2nd ed. Pittsburgh: CMU/ETC P, 2014. eBook.

Kohler, Chris. *Power Up: How Japanese Video Games Gave the World an Extra Life*. Indianapolis: Brady Games, 2004. Print.

Krebs, Katja. "Introduction: Collisions, Diversions, and Meeting Points." Krebs 2013. 1–10. Print.

Krebs, Katja, ed. *Translation and Adaptation in Theatre and Film*. London: Routledge, 2013. Print.

Krzywinska, Tanya. "Reanimating H. P. Lovecraft: The Ludic Paradox of Call of Cthulhu: Dark Corners of the Earth." *Horror Video Games: Essays on the Fusion of Fear and Play*. Ed. Bernard Perron. 267–88. Print.

Kushner, David. *Jacked: The Outlaw Story of Grand Theft Auto*. Hoboken: Wiley, 2012. Print.

Lego Lord of the Rings. Traveller's Tales/Warner Brothers Interactive, 2012. Videogame.

Legend of Mana. Square, 2000. Videogame.

Lien, Tracey. "Achievement Hunter recreates *Super Mario Bros.* World 1-1 in *Minecraft*." *Polygon.com*. 28 Dec. 2012. Web. 30 Aug. 2014.

Lindsay, Vachel. *The Art of the Moving Picture*. 1915; rpt. New York: Macmillan, 1922. Print.

Lovecraft, H. P. "Commonplace Book." *Wired.com*. 4 July 2011. Web. 4 Aug. 2014.

———. *Supernatural Horror in Literature*. 1927; rpt. New York: Dover, 1973. Print.

Mandelin, Clyde. "*Earthbound/Mother 2*." *LegendsofLocalization.com*. Web. 3 Aug. 2014.

Minecraft. Mojang, 2009. Videogame.

Minier, Márta. "Definitions, Dyads, Triads and Other Points of Connection in Translation and Adaptation Discourse." Krebs 13–35. Print.

Mortal Kombat. Midway Games, 1992–93. Videogame.

Mortal Kombat. Dir. Paul W. S. Anderson. Perf. Christopher Lambert, Robin Shou. New Line, 1995. Film.

Nicklas, Pascal, and Oliver Lindner. "Adaptation and Cultural Appropriation." *Adaptation and Cultural Appropriation: Literature, Film and the Arts*. Ed. Pascal Nicklas and Oliver Lindner. Berlin: Walter de Gruyter, 2013. 1–13. Print.

Papazian, Gretchen, and Joseph Michael Sommers. "Introduction: Manifest Narrativity—Video Games, Movies, and Art and Adaptation." *Game On, Hollywood!: Essays on the Intersection of Video Games and Cinema*. Eds. Gretchen Papazian and Joseph Michael Sommers. 7–18. Print.

Pinchbeck, Dan. *Doom: Scarydarkfast*. Landmark Video Games. Ann Arbor: U of Michigan P, 2013. Print.

Pong. Atari, 1972. Videogame.

"Porting (Concept)." *GiantBomb.com*. Web. 20 Aug 2014.

Raw, Laurence. "Identifying Common Ground." *Translation, Adaptation, and Transformation*. Ed. Laurence Raw. New York: Continuum, 2012. 1–20. Print.

Raw, Laurence, and Tony Gurr. *Adaptation Studies and Learning: New Frontiers*. Lanham: Scarecrow, 2013. Print.

Sanders, Julie. *Adaptation and Appropriation*. London: Routledge, 2007. Print.

Schreier, Jason. "The Man Who Wrote *Earthbound*." *Joystiq.com*. 23 Aug. 2013. Web. 3 Aug. 2014.

Schweizer, Bobby. "Platforms." *Encyclopedia of Video Games: The Culture, Technology, and Art of Gaming*. Vol. II. Ed. Mark J. P. Wolf. Westport: ABC-CLIO, 2012. 488–89. Print.

Second Life. Linden Lab, 2003. Videogame.

Secret of Mana. Square, 1993. Videogame.

Spacewar. Massachusetts Institute of Technology, 1962. Videogame.

Starcraft. Blizzard Entertainment, 1998. Videogame.

Super Mario Bros. Nintendo, 1985. Videogame.

Sword of Mana. Square Enix, 2003. Videogame.

Tennis for Two. Brookhaven National Laboratory, 1958. Videogame.

Terminator 2: Judgment Day. Dir. James Cameron. Perf. Arnold Schwarzenegger, Linda Hamilton. TriStar, 1991. Film.

Terminator 2: Judgment Day. Ocean Games, 1991. Videogame.

Terminator 2: Judgment Day: The Arcade Game. Midway Games, 1991. Videogame.

Terminator 2: Judgment Day: Chess Wars. IntraCorp. 1993. Videogame.

Tolkien, J. R. R. *Lord of the Rings*. 1954–55. Rpt. New York: Mariner, 2003. Print.

Twain, Mark. *The Adventures of Tom Sawyer*. 1876. Rpt. New York: Dover, 1998. Print.

Wolf, Mark J. P. *Building Imaginary Worlds: The Theory and History of Subcreation*. New York: Routledge, 2013. Print.

PART V

ADAPTATION AND INTERTEXTUALITY

CHAPTER 26

EKPHRASIS
AND ADAPTATION

CLAUS CLÜVER

THEORISTS of intermediality, many of whom are German scholars, tend to place relations among media into three (not mutually exclusive) categories: media combination (*Medienkombination*), intermedial reference (*Intermediale Bezüge*), and intermedial transposition or transformation (*Medienwechsel*, change of media). Lists of instances of the last category frequently include, among others, illustration, transposition into instrumental music or dance, adaptation, and ekphrasis. Irina Rajewsky is among those who consider intermedial transposition a "genetic" category: at the end of the process there will be a new "medial configuration" belonging exclusively to one medium (which may be a plurimedial medium, such as opera or radio or film) but referring by many different means to the configuration in the source medium (Rajewsky 55–56). While this may be correct with regard to program music based on verbal texts or pictures, to most illustrations, and to ballets based on fairy tales or other narratives, it is a questionable position to hold when it comes to all instances of ekphrasis; more important, it is untenable with regard to any kind of adaptation from any medium to any other. In fact, this appears to be the criterion that distinguishes adaptation from all other forms of intermedial transposition. When it designates a process, "adaptation" may be a genetic term; when it designates the result of that process, "adaptation" names a special configuration in a new medium that incorporates significant elements of the source medium.

Adaptation is a process that may involve many different media, both as source and as target media. A musical composition may be adapted to the demands of a film. I have elsewhere discussed Robert Indiana's adaptation of the design of the word "LOVE" executed in his two-dimensional multicolored oil painting to the requirements of a large three-dimensional steel sculpture, which even allows viewers to walk around the word (Figure 26.1; see Clüver, "Inter textus" 32–35). Since this essay will investigate the affinities and distinctions between adaptation and ekphrasis, a genre of verbal representations of configurations in visual media, I will focus my discussion of adaptation on processes involving the verbal medium either as source or as target medium.

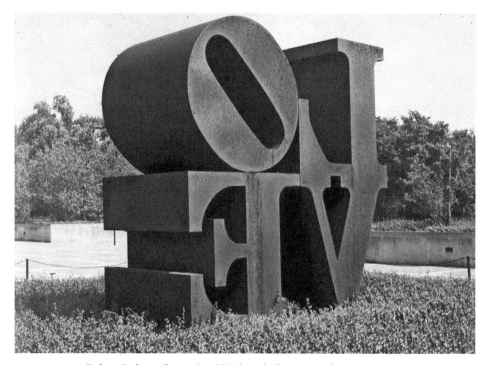

FIGURE 26.1 Robert Indiana (b. 1928), *LOVE* (1970). Cor-ten steel, 144 × 144 × 72 in.

Indianapolis Museum of Art. Photo: Claus Clüver.

Ekphrasis has a history dating back to rhetorical practices in antiquity. The term resurfaced in academic discourse in 1955, when Leo Spitzer offered a new reading of John Keats's canonical "Ode on a Grecian Urn" (Spitzer 72). Jean Hagstrum discussed it in 1958 in *The Sister Arts* (Hagstrum 18 n34). Since then it has become a much visited topic among scholars interested in what came to be called the "*ut pictura poesis*" discourse, which has generated several monographs and essay collections and has spread from analyses of poems on pictures and other works of art, the traditional focus, to considerations of ekphrastic passages in verbal narratives and their functions, to the ekphrastic nature of non-literary texts, as well as to investigations into the roots of the term in the theory and practice of classical rhetoric (cf. Clüver, "Quotation"). Besides painting, the objects represented have included other forms of visual art, such as Keats's urn and, in the most frequently cited example from classical epic poetry, the shield of Achilles described in the *Iliad*. Interest in the topic continues unabated, but the questions asked have changed to some extent. A 2013 conference in Hull was dedicated to developing "a more reciprocal model" of ekphrasis "that involves a dialogue or 'encounter' between visual and textual cultures" (Meek and Kennedy). Primarily in France, but also in Germany, the discussion has also begun to include reflections on the effects of ekphrastic representations on the recipient that have led to the construction of a new concept, the "iconotext," most recently advanced by Liliane Louvel in *Le tiers pictural* (see also Louvel, *Poetics*). The present discussion will forgo any critical analysis of

this concept and any consideration of its application, in modified form, to adaptation studies.

For a long time, discussions of ekphrasis approached poetry and painting as "sister arts," often invoking the statement attributed to Simonides of Ceos that painting is silent poetry and poetry painting that speaks; but their relation has also been considered, following Leonardo da Vinci, as a "*paragone*" concerning the superiority of one art over the others in their capacity to represent material reality. Murray Krieger concluded his historical and theoretical survey in *Ekphrasis: The Illusion of the Natural Sign* by adding his own twist to the old *paragone*: he suggested that the major motivation for ekphrastic practices is the writer's attempt to outdo pictorial representation by incorporating, as it were, the visual in the verbal text and adding those qualities that are more easily achieved by words than by painting. The view that ekphrastic practices are primarily motivated by a rivalry of writers with visual artists was also held by James A. W. Heffernan and W. J. T. Mitchell, both of whom summarized ekphrasis as "the verbal representation of visual representation" (Heffernan 3; Mitchell 152) and thus confirmed the conventional restriction to issues of representation. This catchy phrase implicitly opened up the category of ekphrastic texts beyond the literary.

In my 1995 essay "Ekphrasis Reconsidered," I questioned that restriction in view of the many twentieth-century verbal representations, in poetry or prose, of abstract and non-representational paintings and sculptures. I wondered why our contemporary concept of ekphrasis should exclude these as objects, almost a century after such forms of visual art-making had begun to be a significant part even of mainstream visual culture in the West. Likewise, I failed to see why the numerous poems on architectural objects, whose function is not the representation of aspects of material reality, should not be accepted as ekphrastic texts.

I used the volume of poems on sculptures, paintings, cathedrals, photographs, and other visual configurations called *Metamorfoses* (1963) by the Portuguese poet Jorge de Sena to make this point. I also used *Arte de Música* (1968), his companion volume of poems on musical compositions, at times involving their performance, to argue that in their manner of representation, poetic form and style, voice, and function, these two parallel projects were alike. I consequently proposed to establish "ekprasis" as an overarching concept and offered a very different formulation for the second part of Heffernan's phrase, while retaining the first: "the verbal representation of a real or fictitious text composed in a non-verbal sign system or medium" ("Ekphrasis Reconsidered" 26).

Two decades later, I do not think that the attempt to establish "ekphrasis" as an umbrella term for all comparable verbal representations is practicable or even helpful, especially since it would call for some qualifying term or phrase for each individual genre. It is best to continue understanding ekphrasis as one of the genres of descriptive verbal representation, alongside representations of configurations in music, dance, film, and other media. Rainer Maria Rilke's "Archaïscher Torso Apollos" and also his "Römische Fontäne" are thus ekphrastic poems, but not his "Spanische Tänzerin," a verbal representation of dance. I have also observed that it can be confusing to call

all medial configurations "texts" (in the semiotic sense of "complex signs"). And since "visual medium" might be taken to include film or television, it should be modified as "non-kinetic." So I will rephrase my condensed definition: "*Ekphrasis is the verbal representation of real or fictive configurations composed in a non-kinetic visual medium.*"

Each component of this phrase requires an explanation, although here it can only be brief and focused on the major elements:

- "Verbal representation" refers to any kind of text composed in the verbal medium, orally or in writing, including not only texts that we read as "literary," but also texts written or presented by art historians, critics, or art gallery docents, published in exhibition or auction catalogues, history books, or newspapers, broadcast on radio and television, or found in artists' journals or correspondence.
- "Representation" denotes a descriptive function in ekphrasis. It must involve some process of intersemiotic or intermedial transposition. References by title alone ("Picasso's *Ma jolie*") or such simple phrases as "Dürer's self-portraits" or "an Impressionist landscape" should by themselves not be considered ekphrastic representations.
- Medial configurations are objects that can be intermedially transposed, or "transmediated," as Linda Hutcheon has put it (11). Portraits can; faces can*not*.
- Visual configurations represented ekphrastically, including three-dimensional ones such as sculptures, need not be figurative representations. It is theoretically untenable to accept the description of an early landscape by Mondrian as ekphrastic but not the verbal representation of his non-figurative *Victory Boogie-Woogie*.
- Verbal representations of cathedrals or bridges or other architectural structures *when viewed as meaningful configurations* are ekphrases. There is a genre of *Architekturgedichte* (poems on architecture), most of which, like many (but by no means all) *Bildgedichte* (poems on pictures), are ekphrastic.
- "Non-kinetic" excludes configurations in (usually performative and plurimedial) media such as film and television. It does not exclude mobile sculptures or assemblages with mobile elements.
- The objects of verbal representation can be real or fictive. If the latter (usually in a "literary" text), readers will use the details of the verbal representation to construct a mental image by relating these to comparable real configurations known to them. John Hollander has proposed the term "notional ekphrasis" ("Poetics" 299) for representations not only of fictive images, but also of lost or unknown works; but by itself, "notional" does not make this more inclusive range explicit. It concerns mostly older ekphrastic texts, among them the oldest known examples of the poetic genre, the *Eikones* of Philostratus the Elder: sixty-four poems on paintings that may have actually existed but are known only by their descriptions (see also Lund).
- Since the question of determining and distinguishing visual media (usually by the technical media involved) may be complicated, it seems advisable to speak of intermedial *or intersemiotic* transposition, indicating the semiotic concern with sign systems and their codes and conventions.

Verbal representations of configurations in other media (such as music, dance, and film) that are the results of *Medienwechsel* are covered by most of the points made in the preceding, though a few of these will have to be modified. All such representations should be basically descriptive if they are to be seen as parallels to ekphrasis.

As I remarked earlier, configurations in nonverbal media can in turn represent one or more configurations in another medium, including the verbal. The musical genre of symphonic poems can represent known verbal narratives or pictures at an exhibition; films may show (and make us hear) "Mozart" composing his *Requiem* or "van Gogh" painting his *Crows over Wheatfield*. These are somewhat analogous phenomena to ekphrasis but are not covered by that concept or label. The Greek verb ἐκφράζειν refers to a verbal activity. For etymological and historical reasons, but also as a practical matter, such terms as "musical ekphrasis" or "filmic (cinematic) ekphrasis" should not be admitted: if used broadly to designate any kind of intermedial transposition, the term "ekphrasis" will become redundant and useless.

The observation that intermedial or intersemiotic transposition is a process that results in configurations belonging solely to a single medium and only referring in different ways to the medium from which they were transposed is for the most part plausible. Modest Mussorgsky's musical *Pictures at an Exhibition* are solely music; except in its title, Charles Demuth's painting *I Saw the Figure Five in Gold* contains no text of the William Carlos Williams poem of which it is a close translation (see Clüver, "Transposition" 79–83); a ballet choreographed and performed to a composition by Bach resembles an illustration placed side by side with the text it illustrates, although it would not be performed without the music. With the exception of a few concrete poems, intermedia texts whose visual layout may reflect visual aspects of the source to which they refer, ekphrastic poems or prose passages are strictly verbal texts. But adaptations result in configurations from which the material aspects or other properties of the source text have not been entirely eliminated.

My goal here is not to present a full-fledged theory of adaptation, or even of ekphrasis, but rather to make a distinction between ekphrasis and adaptation as different forms of intermedial transposition involving words. Adaptation is more difficult to define than ekphrasis. We speak of adaptation when a narrative is turned into a play or a movie, or a play into an opera. Stories can be transposed into comic strips, and fairy tales into ballets; but in these two instances neither the process nor the end results are alike. In what sense are they both adaptations? Is a *tableau vivant* representing a painting an adaptation of the pictorial image to a performance medium, or is it the equivalent of ekphrasis involving two nonverbal media? Can a musical setting of a lyric poem be considered an adaptation of the lyrics to the medium of music? What is the relation of an opera libretto to its literary source and to the opera as performed? Is the use of a preexisting composition in an advertisement on television or radio an instance of adaptation? How does this process compare to the adaptation of a Shakespearean play to the Kabuki stage?

In what follows I rely on observations I have made over the years in a number of studies devoted to questions of intermediality. I still uphold the idea I formulated in 1992: "The term [adaptation] seems best used to cover the process (and its results) of

adjusting a specific source text to the requirements and possibilities of another medium in such a way that parts of it are retained and incorporated in the resultant new text [medial configuration]" ("Interarts Studies" 507). But I would now enlarge this formulation to include the adaptation of genres, the imitation in a different medium of formal features or compositional strategies employed in specific configurations, as well as the idea of intramedial adaptation. And, contrary to the use of "ekphrasis," it makes perfect sense to speak of cinematic or musical or operatic adaptation.

While adaptation processes may involve many different media as both source and target media, a very frequently encountered phenomenon is the adaptation of verbal, mostly literary, texts to the demands of other media and of the conventions governing their use. For the most part, verbal texts are adapted to plurimedial media such as the theater, the opera, film, radio, television, or to comic strips, a mixed-media genre. Their transposition into digital media may often be a case of remediation, to which I will briefly refer later. Relatively scarce, however, is the adaptation of nonverbal texts into a purely verbal genre; more often, we may encounter verbal imitations of formal, structural, or compositional strategies or devices employed in a nonverbal medium. Ekphrasis, on the other hand, is concerned exclusively with describing visual configurations.

A prime example of the classical type of ekphrasis is John Hollander's sonnet "Edward Hopper's Seven A.M. (1948)." Its title names the title of the painting it verbalizes (Figure 26.2), and also the painter and even the year of its creation. Every detail of the scene it evokes can be traced back to Hopper's depiction of a scene that looks convincingly like a scene one might have encountered in the phenomenal world, though a rather strange one.

> Edward Hopper's Seven A.M. (1948)
> The morning seems to have no light to spare
> For these close, silent, neighboring, dark trees,
> But too much brightness, in low-lying glare,
> For middling truths, such as whose premises
> These are, and why just here, and what we might
> Expect to make of a shop-window shelf
> Displaying last year's styles of dark and light?
> Here at this moment, morning is most itself,
> Before the geometric shadows, more
> Substantial almost than what casts them, pale
> Into whatever later light will be.
> What happens here? What is the sort of store
> Whose windows frame such generality?
> Meaning is up for grabs, but not for sale. (*Tesserae* 10)[1]

We hear a voice that offers a particular reading of the painting. We might not have phrased it in the same way, but we can accept it and may be surprised by the neat play of words at the end—a device that does not seem to have its equivalent in the painting, but may make us decide that the depiction confirms the conclusion. In fact, the poem invites

constant confirmation of all of its details. It works entirely within its own medium but is not self-contained. The reader is likely to go constantly back and forth between the poem and either a reproduction or a mental recollection of the work. Moreover, the voice we hear, which we identify as the poet's, may also be heard as that of the painter coming across the actual scene. This sonnet is not exactly a speaking picture, but the poet has lent his voice to the painter, who has supposedly represented what he has seen.

This transposition can indeed be read as an intermedial *translation*. Like any translation, it is an interpretation of the original text. It is also the result of necessary choices, some of them imposed by the sonnet form, as well as by the differences between the media. The poem cannot suggest the painting's texture and Hopper's individual style of representation, nor does it permit us to form any mental picture of the actual objects depicted in the painting. It indicates the lighting, but it has no colors. The choice of a strictly observed but skillfully manipulated sonnet form may be taken to be an equivalent to Hopper's formal choices in his own medium—but that is the reader's decision. The text highlights some of the features represented in the painting and makes us see, down to its final verse, what we may not have been aware of; but in its total dependence on the visual image, it does not seem to proclaim any superiority of the verbal over the visual medium. And while it may enrich our own interpretation, it will also direct and thus limit it.

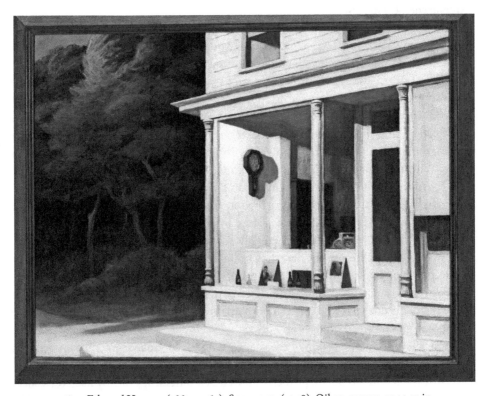

FIGURE 26.2 Edward Hopper (1882–1967), *Seven a.m.* (1948). Oil on canvas, 30 × 40 in.

Hollander's poem can be read as a translation exactly because the voice we hear may also be the painter's, but it is not a good example of the difference (and possibly the *paragone*) between depiction and description. Ekphrastic texts representing visual representations may just describe objects in the phenomenal world that are depicted in the graphic work, but they must indicate by some means that they are indeed representing a representation, that what they describe is a portrait and not just a face.

If read as a translation, the poem is an extreme case of a large poetic genre called in German *Bildgedicht*, covering poems about pictures and other works of visual art as well as about their makers and their making and other related issues. Many contain at best ekphrastic passages; some are not ekphrastic at all. In his extensive work on the genre, Gisbert Kranz has also developed a theory of the *Bildgedicht*; but since it is not really an ekphrastic genre, his various categories are only of restricted value for our topic (cf. Clüver, "Transposition" 57–58). Rather than offering here a system of ekphrastic categories, which others have attempted from various angles, I will only point out that, unless an ekphrastic text is received as a *translation* of its visual source, fidelity is not a critical issue in dealing with such verbal representations, which may be more interesting in what they distort, add, or omit, and which may range from parody (e.g., X. J. Kennedy's "Nude Descending a Staircase"; cf. Clüver, "Painting" 23, 25) to vehicles for an aesthetic credo (e.g., Keats's "Urn," Mallarmé's "Sainte," Rilke's "Archaïscher Torso Apollos").

The situation is different with a text the Swiss-Bolivian poet Eugen Gomringer wrote to accompany a set of twelve "teilkreis-projektionen" (projections of circle segments) contained in a square black box that was produced in 1977 by the Swiss artist and graphic designer Marcel Wyss. Each projection is impressed on a loose sheet of handmade paper. When opened to the left, the lid attached to the box receives the turned-over sheet from the stack in the box on the right, so that the viewer sees the back of the previous sheet side by side with the front of the next one. Every sheet shows four quarters of a circular form of the same overall diameter, with a smooth surface pressed into the rough paper. With the broadest segment at bottom left, the breadth of each segment to the right is reduced by half. Their position remains unchanged in all variations. What does change is their inward or outward orientation. The ways in which each circle segment faces either outward or inward create raised interior shapes with a rough surface that are different in each sheet. Unnumbered, the sheets can be arranged in any sequence. An extreme case is the variant that shows all segments with their round edges pointing inside. Its opposite is the variation forming a closed circle, where the round outside ("aussenrund") encloses a round inside ("innenrund"), except that the different breadth of the segments does not result in a smooth internal round shape, like the outside of the circular form. Once turned over and placed in the lid of the box on the left, the backs of the sheets show an inversion of the shapes, with the circular segments appearing as raised shapes with a smooth surface.

Gomringer's untitled poem, printed in lower-case letters, appears by itself on a sheet that precedes the twelve with the variations of circle segments. Visually, it forms a column; more precisely, it consists of a wider column formed by the alternating nouns

"aussenrund" (outsideround) and "innenrund" (insideround) and a narrower one con-
stituted by six short words, each placed between the two nouns.

<div align="center">

aussenrund

ist

innenrund

wie

aussenrund

auch

innenrund

durch

aussenrund

von

innenrund

zu

aussenrund

zu

innenrund

von

aussenrund

durch

innenrund

auch

aussenrund

wie

innenrund

ist

aussenrund

gomringer[2]

</div>

This internal column grows from three to five letters, then shrinks via three to two, and
then returns in reverse sequence to the initial noun. Arranged vertically, the text is cir-
cular in its structure. The reference to a circular shape is also established semantically
by the word "round." The text begins with a series of equations by means of "is," "as,"
and "also" ("aussenrund *ist* innenrund *wie* aussenrund *auch* innenrund") and then
describes, by means of three prepositions and their reversal, a dynamic process ending
again in stasis. It refers to abstract forms lacking any context. If encountered in isolation,
it would be received as a minimalist verbal structure built according to clear rules, visu-
ally, auditorily, and rhythmically self-sufficient. But it follows a leaf with the title that
announces variations of "teilkreis-projektionen." Consequently, the text is understood
as serving as a preparation for the visual experience, and the "round" of the nouns as
a reference to the geometric shapes that are to follow. The alternating repetition of the
nouns connected by the twelve changing short words anticipates on the verbal level the
twelve visual variations announced by the title.

Gomringer's poem is a verbal representation of Marcel Wyss's specific visual project that uses nonrepresentational forms according to the aesthetic of the Swiss Concrete artists around Max Bill. The text implies a "viewer's gaze," as Hollander has called it, at configurations that do not. It does not represent a specific variation; but it also does not refer to the collective body of works created by a visual artist in a particular phase of his production, as does this poem by Carlos Drummond de Andrade (1902–1987), published posthumously:

> Quadro I (Mondrian)
>
> Universo passado a limpo.
> Linhas tortas ou sensuais desaparecem.
> A cor, fruto de algebra, perdura.
> (Literal translation: Picture I (Mondrian). The universe made clean. /
> Crooked or sensuous lines disappear. / Color, the fruit of algebra, endures.[3]
> From "Arte em exposição" [Art on Exhibit], in Farewell, 1996.)

Drummond's poem is an effective verbalization of Mondrian's work during the final decades of his career, the paintings in which the materials have been reduced to a few straight horizontal and vertical black lines and usually one or two of the primary colors, carefully placed as if by calculation against a clear background. There is no visual reference to any detail of the extra-pictorial phenomenal world. The poem is as reduced in its materials as the paintings to which it refers by the collective title "Picture I (Mondrian)," which could designate any of the painter's works of the 1930s and early 1940s. But the poem's first line states in a highly condensed form that this art has a connection to the phenomenal world: it is an art of utmost abstraction, unlike the nonrepresentational art of the Swiss. The final two lines allude to this connection by naming lines that are no longer present and "color" that "endures." Abstraction results from viewing, and Drummond's contemplation of Mondrian's paintings implies such a view by the artist. But as I have shown elsewhere, that is about as close as such ekphrastic efforts can come (see Clüver, "Painting" 33). Gomringer's poem is an exception, and even it cannot get beyond representing the basic concept of the twelve variations. It is also unusual in being tied, with a specific function, to the place of its publication. Interestingly, when Gomringer included the text in the 1995 edition of his collected poems as "mandala für marcel wyss" (vom rand 151), he gave it a circular form, which referred to the original context but could not possibly have been used there.

My description of Gomringer's poem is a verbal representation of a verbal text and thus does not qualify as an ekphrasis. But my description of Marcel Wyss's project is a verbal representation of a real set of configurations in a visual medium. It is not a literary text, but it is undoubtedly an intermedial transposition, although it would hardly be read as a translation, as the three poems I have presented might possibly be read. The passage about Wyss is as factual as possible, intended to give the reader unfamiliar with the visual project a clear mental image—without suggesting any manner to interpret

it. Its function is here to stand in for the absent visual configurations, but it could also appear in a presentation of both the images and the poem, alongside the description of the poem itself, to aid in the reception of both kinds of text. My description of the poem inevitably has tinges of an interpretation, of the suggestion of a meaning it assumes when related to the visual project it accompanies.

All verbal texts discussed so far exhibit a particular quality that in ancient rhetoric was called ἐνάργεια (*enargeia*), in Latin *perspicuitas*, usually rendered in German as *Anschaulichkeit*, a term difficult to translate because the usual "clear and distinct" does not render the visual implication of the German *anschaulich*. To sustain "ekphrasis" as a critically viable term within the comprehensive category of intermedial reference, *enargeia* should remain an essential property in its definition. It is exhibited in even as short a text as Drummond's poem, given its subject, but is lacking from "Picasso's *Ma jolie*" and other forms of brief or vague quotations and allusions. That is what I argued against Tamar Yacobi's more inclusive position (see Yacobi), although my suggestion to substitute "verbalization" for "verbal representation" now seems impractical (see Clüver, "Quotation").

Art historians and critics deal with works that actually exist. Their descriptions display changing ideas about their own role and function in society and about changing tastes in critical styles. They invite comparisons with literary ekphrases of the same works. They can also document how the approaches of generations of viewers, including writers, may have been shaped by varying modes of the contemporary critical or art-historical discourse, and even how a critic's interpretive phrases can find their way into an ekphrastic poem, as I have shown in looking at Anne Sexton's "The Starry Night" ("Transposition" 62–68).

Literary narratives present fictive visual images at least as frequently as existing ones, and they do so in a great variety of ways and for many different functions and effects determined by the nature of the narrative. They occur as ekphrastic passages in prose narratives and in such forms as Robert Browning's rhymed "dramatic monologues." Like ekphrastic poems, they may embellish or subvert the visual texts and are not bound by rules of fidelity. In one of Browning's monologues we hear a duke describe a portrait of his "last duchess" commissioned and controlled by him, which he uses to present mental images of both her and himself. These images are intended to impress, but the poem leads the reader to construct images of both the duke and his last duchess that are quite contrary to those the duke intends. "Fra Lippo Lippi" is another of Browning's monologues, in this case attributed to the real artist, offering a self-portrait with references to his paintings. The description of an artist and his work is a common narrative practice. In Franz Kafka's *Der Prozess*, the painter Tintorello's portraits of the judges, executed as commissioned, convey a haunting sense of the nature of the courts that are conducting K.'s trial. But the work, real or fictive, of actual painters, from Brueghel to Matisse, is likewise a favorite topic of ekphrastic representations in narratives, many of them dealing with the lives of the artists. They continue a long line of *Künstlerromane* reaching back into the eighteenth century, many of which are traditionally presented as a subgenre of the *Bildungsroman*, the "novel of education." The ekphrastic passages are frequently given to viewers who have some connection to the works observed.

But ekphrastic passages are found in many other literary narratives. To cite just one example: Alain Robbe-Grillet's early work as a writer is characterized by overly detailed descriptions that entail the act of careful, if not obsessive, observation. Most of these, like the description of a banana plantation in *La jalousie* (1957), are not ekphrastic. In *Dans le labyrinthe* (1959), Robbe-Grillet has an elusive narrator begin by meticulously describing a fictitious etching; but then the narrative voice introduces color and finally movement into the scene, from which an action begins, returning in the end to the same still image. The same process is later repeated with the photograph of a soldier seen on a wall. These are not arbitrary events, but the identity of the perceiving consciousness and its relationship to the central figure of a soldier, who may be the figure in the photograph or may be hallucinating while observing the pictures on the wall, is never made clear.

Ekphrasis in whatever form is a mode of description. Adaptation is too variegated a procedure of *Medienwechsel* for the results to constitute a genre, even when restricted to the verbal medium. It does not operate in the descriptive mode, although some adaptations may contain descriptions. In the present context, I shall first look at transpositions of verbal texts into other media and then at verbal adaptations of configurations composed in nonverbal media. A clear-cut case is the rendition of a verbal narrative in the mixed medium of the comic book. Much discussed because, in the eyes of most critics, unexpectedly successful, is Stéphane Heuet's *bande dessinée* version of Proust's *À la recherche du temps perdu*. France Lemoine entitled her recent essay "The Representation of the Ineffable: Proust in Images." There is plenty of verbal text in the first person, direct quotations or close circumscriptions of Proust's; and there are visual representations of persons, places, situations, and narrative sequences, including the representation of a text such as this: "but then the memory (not yet of the place where I was, but of some of those where I had lived and where I could have been)" (Heuet 3; cf. Lemoine 137), rendered by a panel showing a pair of large eyes within a confusion of interiors. Verbal descriptions have been rendered by visual depictions, with the inevitable addition of all that is left undetailed in the text, in ways that the reader of Proust is expected to find acceptable.

The comic book is a mixed medium because its visual and verbal components are separable but not coherent or self-sufficient when separated (cf. Clüver, "Introduction" 505). Other such mixed-media genres are *livres d'artiste* and many children's books. Representations of verbal texts by purely visual means are grouped as visual illustrations, which are usually not considered adaptations. Otherwise, the visual is normally part of adaptations of verbal narratives to performance-oriented media, most of which are plurimedial. There usually is a verbal text on which the performances are based (play script with stage directions, libretto, film script, radio play script), which may be in turn compared to its literary source text as an instance of intramedial adaptation. The examination of an opera libretto as such requires analyzing it in connection to the music as well as to the entire panoply of operatic theater; if it has been adapted from a play and the object of study is its relation to its source or the mode of adaptation, it is

important to remember that both play and libretto are verbal texts that draw on codes and conventions not only of a literary system, but also of different systems of stage representation. The final performed configuration will usually contain dialogue fragments from the narrative source, though these are often reformulated. But it is best to think of the shared and transposed elements, such as plot, action, characters, and settings, as transmedial elements realized and shaped according to the possibilities and limitations of each medium (and its constituent media)—according to (or subverting) contemporary aesthetic conventions and often with changed thematic or ideological orientations. Fidelity to the source text can be a concern motivating the adapting team, but is not a critical consideration: for the critic, changes and transformations should be of equal if not greater interest.

These transmedial elements are somewhat like the graphic design concept that Robert Indiana adapted from its realization as the painting *LOVE* to the stainless steel sculpture. But each of these elements can be subject to change and transformation. Depending on the degree and nature of such changes, we may conceive of the new configuration as "based on" and finally "inspired by," rather than "adapted from." This distinction may apply especially to transpositions of verbal narratives to a medium such as the dance, which substitutes an entirely different sign system in order to denote, very roughly speaking, the same object. (Dance usually involves music, of course, which may be either specially composed for the occasion or preexistent and made to function in a new context, with a change of "meaning.") But while a text that has been translated from one verbal language into another usually does not require knowledge of the original in order to be understood, the programmatic aspects of dance based on verbal narrative, when indicated by a title, frequently presuppose an audience's familiarity with the plot and the major characters, though not necessarily with their verbalization in any particular version (e.g., of fairy tales or mythological stories). Receiving this kind of dance, or more precisely, receiving it as a transcreation of a verbal narrative, thus requires processing signs created by bodies in motion, mostly along with musical signs, and relating these to a recollected version of that narrative as story or play. A ballet based on an unmodified Bach composition is not an adaptation; but George Balanchine's *The Steadfast Tin Solder*, with its title referring to a fairy tale by Hans Christian Andersen, choreographed to music by George Bizet, certainly is.

It also seems appropriate to speak of the adaptation of a Western play to the modern Kabuki stage, although from a different viewpoint one might consider this a particularly complicated case of "transculturation," a concept that has become central to much contemporary translation theory. But in the context of intermedial studies the examination of this kind of adaptation, which again involves the adjustment of transmedial elements, does not appear to be substantially different from studying the adaptation of a play to the operatic stage.

Using the concept of transmedial elements realized in different media, it is possible to ask whether paintings or sculptures based on mythological, religious, or historical subjects or even illustrations of novels or play texts might not be considered adaptations.

This question also arises with regard to program music that refers to a verbal narrative by title (and at times by printed programs). It lacks the kind of signs to the crucial transmedial elements that dance can provide. But it can create its own narrative and dramatic moments as well as motifs representing characters, as Hector Berlioz did with the *idée fixe* in his *Symphonie fantastique*, although it seems more appropriate to think of the "Witches' Sabbath" in its final movement as *based on* Goethe's *Faust I* and not as *adapted from* it.

Song, words set to music and performed by one or more voices, usually accompanied by musical instruments performing a score, is an adaptation of these words to a new medium, even if the words printed in the score are the same as when printed separately. Words sung are not the same as words recited, and their meaning is changed.

Ekphrasis is the descriptive transposition of visual configurations into words. As we have seen, such configurations can also be transposed into other media. Siglind Bruhn has studied such transpositions into music under the label "musical ekphrasis" (see Bruhn), a label she has since withdrawn. Inspired by her usage, Laura Mareike Sager has written a doctoral dissertation that offers a broad extension of my own definition of 1998, proposing to redefine ekphrasis as "the verbalization, quotation, or dramatization of real or fictitious texts composed in another sign system" (Sager 15). This makes verbalization only one of the possibilities of ekphrastic intermedial transposition, which she calls, with Bruhn, "transmedialization" (Sager 16), and includes all adaptations of verbal texts to stage, screen, or radio. Adaptation is not even considered as a different kind of transposition, and "ekphrasis" becomes a broad label equivalent to "transmedialization." But Sager makes some insightful comparisons between verbal narratives that significantly feature ekphrases and their filmic adaptations. Moreover, she reminds us that films can contain dialogue with ekphrastic passages. She also points out that paintings, graphic works, and sculptures can be shown in films either directly or as imitations, or as *tableaux vivants*. But she does not notice that paintings shown in films are remediated images that often function differently in their new contexts, or that a camera moving over a painting does not move the way a human eye moves. The cinematic representation of pictorial images or sculpted forms is the result of an adaptation to the new medium.

A striking example of the adaptation of a painting to the musical stage is Stephen Sondheim's *Sunday in the Park with George* (1984), based on Georges Seurat's painting *Un dimanche après-midi à l'Île de la Grande Jatte—1884*. Its plot is concerned with a fictionalized Seurat and his work on the figures in the painting, which is represented as a *tableau vivant* at the end of the first act and the beginning of the second, as well as at the end of the musical.

Turning to adaptations with the verbal as the target medium, we find that specific individual configurations transposed from a different medium are usually narratives, often films. The descriptions of movies in Manuel Puig's *La traición de Rita Hayworth* are verbal representations parallel to ekphrasis. "Novelizations," on the other hand, recast configurations in other media such as film and television and even videogames to fit the dimensions of a novel, adjusting the transmedial elements realized in the source

text to their own conventions and their objectives; if the source contained dialogue, it may be included. In the case of films, this may often involve the expansion of a film script, which may in turn have been based on a novel or short story, so that novelization becomes a case of multiple intramedial adaptation.

What happens more frequently is the adaptation by writers of formal or structural devices and of specific techniques and manners of representation developed in a non-verbal medium to the specific needs and possibilities of their texts. Thus, we have the "musicalization of fiction" (paralleled by the "musicalization of painting" at the hands of such twentieth-century artists as Kandinsky and Klee). Building on Steven P. Scher's categories, especially "Music in Literature," and such earlier studies as Calvin Brown's *Tones into Words*, Werner Wolf has developed an entire system of "intermediality" departing from this phenomenon (Wolf; see also Petermann). Being aware that its structure is based on an adaptation of the sonata form will affect a reader's engagement with Hermann Hesse's *Steppenwolf* and its many references to music. The critical discourse on the techniques and strategies of the cinema has led writers to adapt a number of them into "cinematic writing"—which must not be confused with screenwriting or the rewriting of a film as a novel (novelization). Collage and montage, developed as particular ways of image-making, have been adapted by poets and novelists for their own needs. The many attempts, some of them far-fetched, to identify Cubist literature all rely on what critics have identified as characteristic traits of Cubist painting and have found adapted in some form in a literary text. My own detailed reading of Gertrude Stein's "If I Told Him" as a transfer of the techniques used in paintings like *Ma jolie* in order to achieve, along with other means, "A Completed Portrait of Picasso" is one example claiming such an adaptation (Clüver, "Painting" 26–29). Even such titles for musical compositions as "Arabesque," "Improvisation," "Symphonic Poem," or "Sketch," popular in the nineteenth century, indicate an affinity to characteristics of particular visual or literary forms composers felt they had adapted. Finally, our critical vocabulary contains many concepts and terms that are used to discuss configurations in many or all media. Such transmedial terms (which, like "color," "rhythm," and "frame," may in fact blend literal and metaphorical applications) must not be confused with the formal concepts discussed earlier.

It has been the goal of these reflections to investigate affinities and possible distinctions we may construct between two ways of *Medienwechsel* involving the verbal medium. Both are inevitably the result of a spontaneous or deliberate interpretation. I have not established a larger theoretical framework for the forms and functions of ekphrasis, nor for the many uses of adaptation, amply explored in this Handbook. Nor have I attempted to explore the relations between adaptation and remediation, because the latter concept does not apply to, or conflict with, ekphrasis. Adaptation, like ekphrasis, is an interpretive process; remediation is not.

Ekphrasis is an enargetic representation of non-kinetic visual configurations as semiotic objects. It verbalizes perceptions of, or reactions to, characteristic features of configurations that actually exist or suggests the perceived existence of such configurations in virtual, or fictive, reality. Its materials are purely verbal. It produces a mental

image of configurations in a visual medium, making them *anschaulich* without literally showing anything. It implies a viewer's gaze at these objects; if they are the product of an encounter with the phenomenal world, it suggests the producer's way of representing that world according to the semiotic and cultural conventions of the age. Ekphrasis is a parallel procedure to verbal representations of other than non-kinetic visual media, including such a kinetic visual medium as film. As literary texts, ekphrases can be freestanding or integrated as ekphrastic passages in other texts, including plays, libretti, and film scripts.

Adaptation, when limited to processes concerning the verbal medium, is the concept covering either the transfer of verbal texts to other media or the transposition to the verbal of configurations, usually narrative, in other media. We also speak of adaptation when literary texts employ compositional, structural, or other formal procedures or patterns developed and used in a nonverbal medium according to the possibilities and limitations of the verbal and of contemporary literary conventions. Of these, transfers of verbal texts are the most frequent, especially since the verbal medium is also part of plurimedial configurations such as plays, which can be transposed into other plurimedial media such as opera or film. Their primary function is not descriptive. They recast characteristic features of a source text in accordance with the possibilities, limitations, and conventions governing the target medium. They contain medium-specific versions of transmedial elements and possibly even portions, such as dialogues, of the adapted text. Unlike ekphrasis, adaptation does not result in a new text that only *refers* back to the adapted configuration or medium. In that respect it should be seen as constituting its own large and somewhat amorphous subcategory standing apart from all the other forms of *Medienwechsel*, which end up offering no more than *intermediale Bezüge*.

NOTES

1. "Edward Hopper's Seven A.M. (1948)" from John Hollander, *Tesserae and Other Poems*, copyright © 1993 by John Hollander. Used by permission of Alfred A. Knopf, an imprint of Knopf Doubleday Publishing Group, a division of Penguin Random House LLC. All rights reserved. Any third party use of this material, outside of this publication, is prohibited. Interested parties must apply directly to Penguin Random House LLC for permission.
2. The untitled poem by Eugen Gomringer is © Eugen Gomringer, reprinted by permission of the author.
3. "Quadro I (Mondrian)" from Carlos Drummond de Andrade, *Farewell* (Rio de Janeiro: Record, 1996), p. 35, reprinted in *Poesia Completa* (Rio de Janeiro: Nova Aguilar, 2002), p. 1403, erroneously entitled "Quadro I (Mordriam)." Copyright © Graña Drummond (www.carlosdrummond.com.br). Used by permission of Agência Literária Riff, Rio de Janeiro.

WORKS CITED

Brown, Calvin. *Tones into Words: Musical Compositions as Subjects of Poetry*. Athens: U of Georgia P, 1953. Print.

Browning, Robert. "My Last Duchess," "Fra Lippo Lippi." *The Poems and Plays of Robert Browning.* Ed. Saxe Commins. New York: Modern Library, 1934. 94–95 and 209–18. Print.

Bruhn, Siglind. "A Concert of Paintings: Musical Ekphrasis in the 20th Century." *Poetics Today* 22.3 (2001): 551–605. Print.

Clüver, Claus. "Ekphrasis Reconsidered: On Verbal Representations of Non-Verbal Texts." *Interart Poetics: Essays on the Interrelations between the Arts and Media.* Ed. Ulla-Britta Lagerroth, Hans Lund, and Erik Hedling. Amsterdam: Rodopi, 1997. 19–33. Print.

———. "Inter textus/inter artes/inter media." *Komparatistik 2000/2001. Jahrbuch der Deutschen Gesellschaft für Allgemeine und Vergleichende Literaturwissenschaft.* Ed. Monika Schmitz-Emans and Uwe Lindemann. Heidelberg: Synchron, 2001. 14–50. Print.

———. "Interarts Studies: An Introduction." 1992/2000. *Media inter Media: Essays in Honor of Claus Clüver. Studies in Intermediality* 3. Ed. Stephanie A. Glaser. Amsterdam: Rodopi, 2009. 497–526. Print.

———. "On Intersemiotic Transposition." *Art and Literature* I. Ed. Wendy Steiner. *Poetics Today* 10.1 (1989): 55–90. Print.

———. "Painting Into Poetry." *Yearbook of Comparative and General Literature* 27 (1978): 19–34. Print.

———. "Quotation, Enargeia, and the Functions of Ekphrasis." *Pictures into Words: Theoretical and Descriptive Approaches to Ekphrasis.* Ed. Valerie Robillard and Els Jongeneel. Amsterdam: Free UP, 1998. 35–52. Print.

Drummond de Andrade, Carlos. "Quadro I (Mondrian)." *Farewell.* Rio de Janeiro: Record, 1996. 35. Print.

Gomringer, Eugen. "mandala für max wyss." *vom rand nach innen: die konstellationen 1951–1995.* Vol. 1. Wien: Splitter, 1995. 151. Print.

———. Untitled poem ("aussenrund"). *nichts für schnell-betrachter und bücher-blätterer: Eugen Gomringers Gemeinschaftsarbeiten mit bildenden Künstlern.* Ed. Annette Gilbert. Bielefeld: Kerber, 2015. 77. Print.

Hagstrum, Jean H. *The Sister Arts: The Tradition of Literary Pictorialism and English Poetry from Dryden to Gray.* Chicago: U of Chicago P, 1958. Print.

Heffernan, James A. W. *Museum of Words: The Poetics of Ekphrasis from Homer to Ashbery.* Chicago: U Chicago P, 1993. Print.

Hesse, Hermann. *Steppenwolf.* Trans. Basil Creighton. New York: Holt, Rinehart and Winston, 1957. Print.

Heuet, Stéphane. *Remembrance of Things Past: Combray.* Trans. Joe Johnson. New York: NBM/ComicsLit, 2001. Print.

Hollander, John. "Edward Hopper's Seven A.M. (1948)." *Tesserae.* New York: Knopf, 1993. 10. Rpt. in *The Poetry of Solitude: A Tribute to Edward Hopper.* Ed. Gail Levin. New York: Universe, 1995. 26. Print.

———. "The Poetics of Ekphrasis." *Word & Image* 4.1 (1988): 209–17. Print.

Hutcheon, Linda, with Siobhan O'Flynn. *A Theory of Adaptation.* 2nd ed. London: Routledge, 2013. Print.

Kafka, Franz. *The Trial.* Trans. Breon Mitchell. New York: Schocken, 1998. Print.

Kennedy, X. J. "Nude Descending a Staircase." *Nude Descending a Staircase: Poems, Songs, a Ballad.* Garden City: Doubleday, 1961. 69. Print.

Kranz, Gisbert. *Das Bildgedicht.* 3 vols. Köln: Böhlau. 1981–87. Print.

Krieger, Murray. *Ekphrasis: The Illusion of the Natural Sign.* Baltimore: Johns Hopkins UP, 1992. Print.

Lemoine, France. "The Representation of the Ineffable: Proust in Images." *The Imaginary: Word and Image/L'imaginaire: texte et image*. Ed. Claus Clüver, Matthijs Engelberts, and Véronique Plesch. Amsterdam: Brill-Rodopi, 2015. 131–46. Print.

Louvel, Liliane. *Le tiers pictural: Pour une critique intermédiale*. Rennes: Presses universitaires de Rennes, 2010. Print.

——. *Poetics of the Iconotext*. Ed. Karen Jacobs. Trans. Laurence Petit. Farnham: Ashgate, 2011. Print.

Lund, Hans. "Skaldic Ekphrasis in Old Norse Literature." *Making the Absent Present: Challenging Contemporary Concepts of Ekphrasis*. Ed. Heidrun Führer. Aachen: Shakerverlag. Forthcoming. Print.

Meek, Richard, and David Kennedy. Call for Papers. "Ekphrasis: From Paragone to Encounter." Department of English, University of Hull, 3–5 July 2013. Print.

Mitchell, W. J. T. "Ekphrasis and the Other." *Picture Theory: Essays on Verbal and Visual Representation*. Chicago: U Chicago P, 1994. 151–81. Print.

Petermann, Emily. *The Musical Novel: Imitation of Musical Structure, Performance, and Reception in Contemporary Fiction*. Rochester: Camden House, 2014. Print.

Puig, Manuel. *Betrayed by Rita Hayworth*. Trans. Suzanne Jill Levine. Champaign: Dalkey Archive, 2009. Print.

Rajewsky, Irina O. "Border Talks: The Problematic Status of Media Borders in the Current Debate about Intermediality." *Media Borders, Multimodality and Intermediality*. Ed. Lars Elleström. Houndmills: Palgrave Macmillan, 2010. 51–80. Print.

Robbe-Grillet, Alain. *Dans le labyrinthe*. Paris: Les Éditions de Minuit, 1959. Print.

——. *La jalousie*. Paris: Les Éditions de Minuit, 1957. Print.

Sager, Laura Mareike. "Writing and Filming the Painting: Ekphrasis in Literature and Film." Diss. University of Texas at Austin, 2006. Print.

Sena, Jorge de. *Metamorfoses, 1963; Arte de Música, 1968. Poesia II*. 2nd ed. Curated by Mécia de Sena. Lisboa: Edições 70, 1988. 51–212. Print.

Sexton, Anne. "The Starry Night." *All My Pretty Ones*. Boston: Houghton Mifflin, 1962. 9. Print.

Spitzer, Leo. "The 'Ode on a Grecian Urn,' or Content vs. Metagrammar." 1955. Rpt. in *Essays on English and American Literature*. Ed. Anna Hatcher. Princeton: Princeton UP, 1962. 67–97. Print.

Stein, Gertrude. "If I Told Him: A Completed Portrait of Picasso." *Portraits and Prayers*. New York: Random House, 1934. 21–25. Print.

Wolf, Werner. *The Musicalization of Fiction: A Study in the Theory and History of Intermediality*. Amsterdam: Rodopi, 1999. Print.

Wyss, Marcel. *teilkreiss-projektionen: zwölf variationen*. Locarno: editions lafranca, 1977. loose sheets in box.

Yacobi, Tamar. "Pictorial Models and Narrative Ekphrasis." *Poetics Today* 16 (1995): 599–649. Print.

CHAPTER 27

..

ADAPTATION
AND ILLUSTRATION
A Cross-Disciplinary Approach

..

KATE NEWELL

WITHIN the field of adaptation studies, "adaptation" has come to signify a range of media transactions. No longer limited to novel-to-film transpositions, adaptation encompasses negotiations between novels, comics, films, games, songs, animation, radio, and a host of other media vehicles. Yet within this collective advancement, few studies have considered or even mentioned illustrations in illustrated novels as adaptations. Illustrations have been identified as precursors to film adaptations, as Kamilla Elliott has observed (*Rethinking* 31–76), but are rarely theorized as adaptations in their own right. This oversight reflects a tendency Lars Elleström has noticed in academic writing to speak of intermedial phenomena in isolation. As he points out: "Most studies of illustration are performed within the context of illustration only. . . . Furthermore, most studies of adaptation prefer not to discuss anything but adaptation, which is generally understood as novel-to-film-adaptation" ("Adaptations" 114). Even the many scholars responding to Linda Hutcheon's invitation to move beyond the novel/film dyad (xiii) have seldom considered the relation between adaptation and illustration.

While discussions of illustration in adaptation studies are rare, the few instances indicate an increasingly complex view of the impact of illustrated novels on film adaptations. References to illustration in early adaptation studies tended to be dismissive. Geoffrey Wagner, for example, describes Hollywood's "least satisfactory" and "puerile" adaptations as "book illustration[s]" (222–23). More recently, however, writers like Kamilla Elliott, Judith Buchanan, and Thomas Leitch have located illustrated novels and film adaptations along a spectrum of intermedial practices. In *Rethinking the Novel/Film Debate*, Elliott demonstrates that word/image, novel/film debates are not particular to studies of film adaptation but have moorings in literary and art historical debates on the formal and aesthetic qualities of art, many of which played out in nineteenth- and early-twentieth-century conversations about the role of illustration. Buchanan and Leitch

examine methods by which film adaptations signal fidelity to a source text by approximating the composition or visual tone of its illustrations (Buchanan 22; Leitch, *Film* 181, 209; see also Newell 304–6). The insights of these writers provide a backdrop for some of the issues considered here.

This essay evolves from two related questions: Why has illustration generally not been brought under the rubric of adaptation, and why have adaptation studies and illustration studies taken largely diverging paths? To address these questions, I turn first to definitions of "adaptation" and "illustration" and argue that the functions highlighted in particular definitions have shaped the tone of the discourse on film adaptation and illustrations in novels and have contributed to the insularity of their study. Next, I point to issues common to both studies of adaptation and illustration—such as fidelity to a source text and the audience's role in interpreting and authenticating particular word-image relationships—in order to demonstrate that, despite ostensible differences, studies of film adaptation and of illustrated novels foreground similar concerns. The greater part of the essay explores three dichotomies that reveal three common misperceptions concerning adaptations and illustrations and argues that assumptions related to the capabilities and limitations of media have contributed to divisions in the study of film adaptations and illustrated novels.

Definitions of "adaptation" and "illustration" are surprisingly scarce in adaptation studies and illustration studies. As Sarah Cardwell and Thomas Leitch have pointed out, few writers actually define adaptation; instead, most describe the process by which adaptations come into being or assess the result (Cardwell 10–15; Leitch, "Adaptation" 87–89). Linda Hutcheon is one exception; she defines adaptation as "an extended, deliberate, announced revisitation of a particular work" (170). She demarcates adaptations from other sourced cultural productions that do not offer an "extended engagement" with a work. For example, "allusions to and brief echoes of other works would not qualify as extended engagements, nor do most examples of music sampling, because they recontextualize only short fragments of music" (9). Hutcheon does not mention illustration in her "continuum" of adaptations (though she does include the vaguely labeled "visual art revisitations"), and her qualifiers (e.g., "extended," "revisitation") are variable enough to include *or* exclude illustrations as adaptations (171). Illustration studies likewise offer few definitions for illustration, and those that are offered are vague, though they highlight characteristics similar to those of adaptation. Perry Nodelman describes illustration as "an art that demands the prior existence of another art"; for Alan Male, illustration is a 'working art' that visually communicates context to audience" (Nodelman 79; Male 5). In helping to determine why illustration does not count as adaptation, definitions from both camps complicate more than they clarify.

Though equally unhelpful in answering this first question, denotative definitions of "adaptation" and "illustration" are very helpful in understanding the tone of the discourse on film adaptation and illustrated novels and the insularity of their respective studies. The *Oxford English Dictionary* offers at least seven definitions for "adaptation," many of which highlight modification, as in "[t]he action or process of adapting one thing to fit with another, or suit specified conditions, esp. a new or changed

environment." Most definitions of illustration relate to clarification: "The action or fact of making clear or evident to the mind; setting forth clearly or pictorially; elucidation; explanation; exemplification" ("Adaptation"). That denotative meanings for both "adaptation" and "illustration" are process- (as opposed to result-)oriented likely contributes to the process-based approaches that Cardwell finds typical of adaptation studies (that is, approaches that highlight "the process by which an adaptation comes into being, as opposed to the 'end-product,' the adaptation itself" [11]), and, I would add, of illustration studies (approaches that highlight author-illustrator relationships and image-word dialogues).

As their definitions indicate, neither adaptation nor illustration exists without the preexistence of something else, yet the implication that adaptation *transforms* whereas illustration *explains* likely contributes to divisions in the study of film adaptations and illustrated novels. Denotative meanings manifest in various aspects of adaptation discourse, but are perhaps most evident in discussions of how a film might update or amend the message of its nominal source. As Deborah Cartmell and Imelda Whelehan declare, "At its best an adaptation on screen can re-envision a well-worn narrative for a new audience inhabiting a very different cultural environment" (*Screen* 23). Likewise, the denotative meaning of "illustration" shapes the discourse on illustrated novels, as is best exemplified in writing that treats illustration as translation. Charles Congdon, for example, asserts, "The ordinary purpose of illustration is to explain, to elucidate, to render clear what is obscure or abstruse" (484). Similarly, Frank Weitenkampf rules that "illustration must elucidate the text or adorn it; it may do both" (235). Because both film adaptations and illustrations in illustrated novels offer extended engagement with particular works and "demand the existence of another art," the studies of each are interested in issues of fidelity, intertextuality, and audience involvement. Yet the angle from which film adaptation studies and illustration studies address these issues corresponds to the function highlighted in the denotative meaning. That is, conversations about fidelity and audience in adaptation studies often evoke adaptations' transformative abilities, whereas conversations in illustration studies often evoke illustration's role as helpmate or collaborator. Conversations regarding intertexts and audience in adaptation studies often evoke environmental or ecological metaphors, whereas conversations in illustration studies favor dialogic metaphors.

Studies of film adaptations and studies of illustrations in novels both evoke issues of fidelity, largely in the course of drawing comparisons between two works. As Jørgen Bruhn, Anne Gjelsvik, and Eirik Frisvold Hanssen point out, "A central—perhaps even *the* central—question of adaptation studies has been that of fidelity" (5; see also Andrew 27; MacCabe 5; McFarlane, "It Wasn't" 164–65). Even in adaptation studies' current climate of intertextual, dialogical, and intermedial perspectives, fidelity continues to shape adaptation discourse by providing writers with a reading model to debunk and a straw man against which to pitch avowedly new approaches. Such backlash, Elliott reminds us, is not really all that new, as "fidelity has *always* been robustly challenged in adaptation studies" ("Theorizing" 24). Similarly, Lorraine Janzen Kooistra has found that in studies of illustrated novels, "the single most significant criterion for evaluation

is the image's degree of 'faithfulness' to the text" (9). Fidelity is, however, determined differently for each mode. Discussions of film adaptations might address the process by which a film transforms a work to fit "a new or changed environment," whereas discussions of illustrations might address the degree to which the image illuminates or explains the prose. For example, in her analysis of the 1992 adaptation of Virginia Woolf's *Orlando*, Sharon Ouditt concludes that Sally Potter seems to "take issue with some of the ideas (class, marriage, patrilineage) that no longer seem appropriate in the 1990s," and that she "either transposes [these points] directly, translates them into a different kind of semiotic unit, or adds to them" (156, 155). Adam Sonstegard's reading of H. W. McVickar's 1892 illustrations for Henry James's *Daisy Miller* draws attention to the method by which the images clarify the prose. On the question of how honorable are Giovanelli's intentions, Sonstegard contends, "In McVickar's iconography, the man's appearance telegraphs 'scoundrel' and confirms Daisy as a fool for trusting [him]" (70).

The denotative meanings play a similar role in shaping *infidelity* discourse. Writers on film adaptations and writers on illustrated novels have both acknowledged that fidelity-rooted comparisons become problematic when similarities and differences are used as measures of value, and have adopted (explicitly and implicitly) a lens of infidelity to view relationships between texts less narrowly (see Bruhn, Gjelsvik, and Thune 2; Elleström, "Adaptations" 115; Mitchell, *Picture* 83–107). In such studies, the merit of an adaptation or illustration is assessed in terms of its critical engagement with (rather than its transposition of) its source text. Julie Sanders notes that adaptation can be "an act of re-vision" and "is frequently involved in offering commentary on a sourcetext" (18). Brian McFarlane praises several films, among them *Chimes at Midnight* (1966), *My Own Private Idaho* (1991), *Clueless* (1995), and *Great Expectations* (1997), for their infidelity: "In each of these cases, what is offered is, in some sense, a radical re-working of the precursor text, a kind of commentary on its great antecedent, a new work" ("It Wasn't" 166). Similar language characterizes this line of argument in illustration studies. In her discussion of illustration in *Vanity Fair*, Judith L. Fisher alleges that "Thackeray's most successful illustrations, aesthetically and interpretively, do not 'illustrate' the text at all." Rather, they "create alternative story lines, presenting countervoices to Thackeray's narrations" (61; see also see Kooistra 66; J. Hillis Miller 101–3; Skilton 304; Steig 1–23). Julia Thomas likewise highlights illustrations' interpretive function: "Illustration exposes the fact that texts are never in the author's control, nor are their meanings singular or fixed: an illustration is an interpretation or 'reading' of the text, and, as such, can conflict with other readings" (14). While both writers on adaptation and writers on illustration notice and value critical exchange between the adapted and the adapting work, the former emphasize the transformative result of the transaction—the "revision," the "new"—and the latter emphasize the dialogic, "the countervoices."

Both adaptation and illustration studies have acknowledged the inherent intertextuality of all cultural productions, as well as the audience's role in making sense of adaptations and illustrations. Yet here again we see the denotative meanings of "adaptation" and "illustration" shaping the conversation. Within adaptation studies, the notion that adaptation involves the translation of a single, coherent literary text into the medium of

film has been supplanted by an intertextual focus that describes processes of adaptation in terms of ecological and environmental metaphors. Julie Sanders proposes that adaptation might be best conceptualized "in terms of intertextual webs or signifying fields" (24). In Robert Stam's oft-cited description, film adaptations "are caught up in the ongoing whirl of intertextual reference and transformation, of texts generating other texts in an endless process of recycling, transformation, and transmutation, with no clear point or origin" (66). A similar understanding of intertexts guides contemporary writing on illustration but is framed in more dialogic terms, with a specific artist drawing inspiration from specific works. As Antonella Braida and Giuliana Pieri observe, "how is a text invoked, interpreted, and used by the artist? The process is not unilateral: pictures recall texts which may in turn recall other pictures" (9; see also see Hodnett 8; Skilton 316; Small 9; and Thomas 27).

The ecological and dialogical emphases are also evident in discussions of the audience's role in making sense of a work and their ability or inability to recognize specific intertexts and other cultural markers. Christine Geraghty points out that "just as texts develop from a network of sources that have no single author, they too can have a plurality of meanings, depending on the textual skills and the contextual position of the reader" (2). Discussions of meaning-making in studies of illustrated novels also highlight plurality, but tend to frame the process in terms of a dialogue or collaboration. Lorraine Janzen Kooistra, for example, maintains, "Throughout the reading process, the reader participates in a dialogue between image and text which activates the interpretation of the book as a whole" (13). One result of the reader-response mode, David Skilton attests, is that "[t]he reader becomes in turn a producer, making a new work which stands at a remove from the first work, and itself requires reading" (303; see also Hodnett 4; Hutcheon 120–28; Nodelman 173; Sanders 22; Whelehan 15–17).

Though by no means exhaustive, this overview demonstrates that, while adaptation studies and illustration studies share common concerns regarding adapting and adapted works, their conceptualization of those concerns has taken distinct paths. To return to my earlier question of why illustration has not been theorized as a mode of adaptation, we could say that this issue is simply one of labeling. Catherine Grant asks, "How do we know when a film is an adaptation of a literary (or other) text? We know, of course, when it, and the discourses which surround it, signal this" (57). Filmmakers, studios, and writers often announce, "I'm making an adaptation of such-and-such," and the resulting product is then bought, sold, and marketed as an adaptation. By contrast, neither the process nor the product of illustration has been labeled "adaptation" at an industry or institutional level. The illustrations in illustrated novels are labeled simply "illustrations" or "book illustrations," thus reinforcing their supportive function. A larger reason that illustration has not been theorized as a mode of adaptation has to do with assumptions tied to the denotative meanings of "adaptation" and "illustration" and the ways those assumptions have shaped perceptions of media. That adaptation studies has come to recognize adaptation as an activity that extends beyond novel-to-film transpositions demonstrates not a change in media or media vehicles, but rather a change in thinking about media and media vehicles.

As inter-art forms, illustrated novels and film adaptations have both been sites of so-called media wars debating the relative values of image and prose. While studies of illustration and film adaptation have challenged media competitions within their own camps, assumptions of division still exist between camps. Three common misperceptions about the capabilities and limitations of illustration and film (both in terms of illustrated novels and film adaptation and in general) can be dramatized through three dichotomies. The first common misperception is that the most useful illustrated novels to study are nineteenth-century first editions, produced through close communication between author and artist. This misperception contributes to a divide between studies of illustration and of adaptation by associating illustrated novels with the past. In contrast, adaptation appears to be perpetually regenerative in the postmodern culture of mashups, fan edits, machinema, and other protean forms. The second common misperception is that illustrations and film adaptations have wholly dissimilar relationships to their source texts in that illustrations supplement their precursors and film adaptations replace theirs. The third common misperception is that illustrations are static and film is dynamic, and thus too different to be comparable. As I argue, these misperceptions and related media expectations contribute to the largely isolated studies of film adaptations and illustrated novels.

Most studies of illustrations in illustrated novels—within adaptation studies and elsewhere—focus on nineteenth-century first editions illustrated by well-known illustrators (e.g., Sidney Paget, John Leech, John Tenniel, E. W. Kemble), on celebrated author-illustrated editions (e.g., *Alice in Wonderland, Vanity Fair, Trilby*), or on relationships between individual authors and individual illustrators (e.g., studies by Hall, Harvey, and Steig). Such emphases have provided insight into the dynamics of image-prose dialogues and debunked notions of illustration as merely decorative. Yet they have also fostered the impression that such editions offer the most telling image-word relationships and are the most valuable to understanding a given work's larger visualization history. In locating the meaning-making activity in the two persons of author and illustrator, such studies can become moored in biographical and dyadic interpretive models and can reinforce problematic ideas regarding canonicity and authenticity. Julia Thomas contends that studies of the nineteenth-century illustrated novel "locate its meanings in its mode of production, and, in particular, the relation between the author and the artist commissioned to picture his or her texts" (12). Such methods of reading, David Skilton avers, "see[k] in the *production* of the illustrated work a validation of the verbal/visual relationship" (303). Even Kamilla Elliott, who nowhere else identifies artist or author as a locus of meaning, explains that she has selected *Vanity Fair* as a test case because "Thackeray's dual role as writer and illustrator . . . reduces the biographical variables *that must be considered* when authors and illustrators are different persons, allowing for a more intense and direct focus on prose-picture relationship" (*Rethinking* 36, emphasis added). Author/artist-centered readings have dominated studies of illustrated novels in illustration studies but need not dominate studies of illustration in adaptation studies, which has, under the influence of post-structuralism and cultural studies, sought to challenge, complicate, or refute notions that meaning can be located so narrowly, or even at all.

The range of illustrated novels published throughout the twentieth and twenty-first centuries provides fertile ground for adaptation studies, particularly regarding issues of authorship, readership, intertextuality, and cultural literacy. Close collaborations between authors and illustrators, such as those prevalent in the nineteenth century, become less common in the twentieth and twenty-first centuries, particularly in the area of adult fiction, and are impossible for reissues of nineteenth-century novels. A common practice has been to publish editions of works that were un-illustrated in their first edition with illustrations, sometimes by well-known illustrators—*Frankenstein* illustrated by Lynd Ward (1934) or Bernie Wrightson (1983), *Moby Dick* illustrated by Boardman Robinson (1942) or Barry Moser (1979). Occasionally, works that were illustrated in their first edition are reissued with non-canonical illustrations, often in association with a publisher's book club, such as the Limited Editions Club or the Heritage Club. Additionally, celebrated illustrated editions might be republished with illustrations by another celebrated illustrator, as in the example of *Adventures of Huckleberry Finn*, published in 1885 with E. W. Kemble's illustrations and in 1940 with Norman Rockwell's illustrations for the Heritage Press. The 1957 Heritage Press edition of *Final Adventures of Sherlock Holmes* includes illustrations by Frederic Dorr Steele, Sidney Paget, William H. Hyde, and George Hutchinson, and the 1974 Westvaco edition of *Daisy Miller* reprints images by James McNeill Whistler and John Singer Sargent. Leitch and Buchanan have demonstrated the value of looking at the ways in which canonical illustrations from the nineteenth century serve as source texts for film adaptations, but the value of that mode of inquiry is not specific to canonical illustrations or celebrity illustrators. *A Christmas Carol*, for example, continues to evolve and extend a network of influence across media. Just as early films drew from Leech's illustrations, P. J. Lynch's illustrations for the 2006 *A Christmas Carol* incorporate a number of high-angle and low-angle perspectives and aperture-style framings common to cinema. Looking at illustrated editions in tandem with film adaptations provides a history of how a work has been interpreted visually and allows us to discern interpretive patterns across disciplines.

Perhaps the most common illustrated editions of classic works of literature are those published by early readers series, such as Oxford Bookworms, Great Illustrated Classics, Junior Classics for Young Readers, and Classic Starts. Aimed at developing readers, these editions are most often abridgements directed at a particular literacy and skill level and are heavily illustrated by unknown or little-known illustrators with straightforward visual styles. The images convey information about character and character relationships in a manner least likely to confuse fledgling readers. For example, John Holder's illustration of Catherine Sloper for the Oxford Bookworms edition of *Washington Square*, retold by Kieran McGovern, avoids the ambiguity of appearance suggested by James (and other illustrators) and depicts her as unmistakably matronly and unattractive. In a similar manner, Sue Shields's depiction of Mr. Darcy at the Meryton ball for the Oxford Bookworms edition of *Pride and Prejudice* emphasizes his pride: he wears a smug expression, his chest and upper body appear inflated, and he is much taller than the other characters. Such editions may not garner critical or academic praise, but they, like film adaptations, serve the undeniable function of developing cultural, visual, and

lexical literacy and maintaining the vitality of the classics. As Julie Sanders notes, film adaptations can "constitute a simpler attempt to make texts 'relevant' or easily comprehensible to new audiences and readerships" (19). Similarly, in his foreword to *Gris Grimly's Frankenstein*, Bernie Wrightson reflects on the impact of his own *Frankenstein* illustrations: "I realized that I had done something much more than just decorate a favorite story: I had created a gateway into the book for the reader." He sees Grimly in a comparable position, "at the gateway, the key that unlocks the heart of the story in his hand" (xi). Film adaptations and illustrated editions can both function in this manner. More important, they can function in this manner collectively. That so many different gateways exist for a given work illuminates the range of interpretative lenses through which a work can be read and, by extension, draws attention to the fluidity of the text itself. Such plurality is less apparent when we limit our sampling to first editions, which tend to fix a work's meaning by virtue of their seeming definitiveness.

The second misperception is tied to physical differences in the relationship between illustrations and film adaptations and their source texts. An illustrated novel comprises a set number of still images that are juxtaposed against prose; film adaptations comprise a set number of moving images that stand in for the prose. These physical differences contribute to idea that illustrations supplement their source, while film adaptations replace theirs. Although "supplement" is generally used to refer to information that an illustration might add to or clarify in the prose against which it is juxtaposed, the act of juxtaposition creates flexibility in the image-prose relationship that expands the signifying value of both illustration and prose. Additionally, while film adaptations may seem to replace their sources, the presence of the source in the adaptation itself and the reading models applied to the adaptation problematize this independence.

The notion that illustration is supplemental derives from numerous sources. As we have seen, definitions of "illustration" as "the action or fact of making clear or evident" create the expectation that the illustrations in illustrated novels will supply information absent from the prose. Other factors contribute to this assumption as well: the physical reality of the printed page in which image and prose are juxtaposed, the tendency for pages containing only words to outnumber pages with illustrations, the practice of publishing editions of novels illustrated in their first editions without illustrations or with an incomplete or entirely different set of illustrations in subsequent editions, and the frequent practice of book historians discussing novels published with illustrations to ignore the illustrations or simply replace them with non-illustrated editions, as Elliott has noted (*Rethinking* 49). As Kooistra explains, traditional views of illustration hold that "[s]ince the image has no individual significance, but only gains meaning in relation to the written word, illustration can be ignored or omitted without loss" (9). Yet the relativity of the image's meaning also allows it to signify on multiple levels and in multiple contexts. The job of the illustration may be to elucidate and clarify, but what it elucidates and clarifies is determined largely by the context in which it is placed.

Though studies of illustrated novels tend to highlight the ways in which the image-word dynamic is shaped by careful counsel between illustrator, writer, and publisher, a more common situation involves a publisher needing simply to publish an edition with

images (Hodnett 10; Nodelman 40). Such necessity can result in hastily assembled editions in which illustrations and prose are imperfectly aligned. Julia Thomas, commenting on publishers' practice of recycling illustrations from various artists, notes an 1852 edition of *Uncle Tom's Cabin* in which Eva's appearance varies dramatically from illustration to illustration (28). Kooistra mentions 1860s reprints that were "cobbled together with pictures by a number of artists and engravers" (2). The 2000 Oxford Bookworms edition of *Frankenstein* uses an image from *The Cabinet of Dr. Caligari* on its cover.

The range of significations possible in illustrated editions is apparent in a comparison of a Lynd Ward woodcut included in three editions of *Frankenstein*. First appearing in Chapter 18 of the 1934 Smith and Haas edition, Ward's image depicts Victor reclining on a boat, adrift on a lake under a cloudy sky. The facing text reads: "I passed whole days on the lake alone in a little boat, watching the clouds." Victor adds that these lake sojourns "seldom failed to restore me to some degree of composure" (170). The 2000 Oxford Bookworms edition also features this illustration, but in Chapter 20, and it is aligned with the text in which Victor disposes of the body of the female creature. While the image fits into this context—Victor is still on a boat—the calm of his posture and of the water seems at odds with the task described in the prose. The 2010 Fall River Press edition also features this particular image, which it restores to Chapter 18. Here, though, the image faces the text that recounts Victor's travel arrangements to England, and the subsequent page mentions the boat ride Victor and Clerval take "from Strasbourg to Rotterdam," which also has restorative effects. Victor recalls that "I lay at the bottom of the boat, and as I gazed on the cloudless blue sky, I seemed to drink in a tranquility to which I had long been a stranger" (160). Although Ward's image depicts Victor alone and a sky far from cloudless, the placement of the image suits this context surprisingly well. This example supports the myth that illustration is supplemental because no illustration has an indelible link to a single, particular prose moment but can represent multiple moments. Yet in drawing attention to the context-specific nature of meaning, it also shows that prose is equally supplemental. The illustration may "only gai[n] meaning in relation to the written word," but the meaning of the written word is also dependent on the illustration.

If illustrations are thought to supplement their source texts, film adaptations are thought to replace theirs, as evidenced in remarks such as "I haven't read the book, but I've seen the movie," and in a 2011 poll conducted by *The Guardian*, "Do Film Adaptations Ruin the Book for You?" Yet the notion that film adaptations "replace" their sources is complicated at several turns. For example, the source's prose is not replaced so much as reconstituted in other formats within the film (e.g., screenplay, voiceover, letters). Additionally, as suggested by the bulk of fidelity-based criticism, the source text haunts the margins of the film adaptation for most viewers, whose viewing experience involves comparisons between the film they are watching and their memory of the source.

During viewing, the source's prose remains present in voiceover and dialogue, or in intertitles, characters' typed or handwritten pages, or other forms of filmed text (see Elliott, *Rethinking* 77–112). Adaptations from the silent period often included intertitles

that quoted from the adapted text, and films like *The Age of Innocence* (1993) employ a narrator who recites lines drawn or abridged from the adapted source. Another common practice is to use the book source as a framing device through an establishing shot of either the book's cover or its opening pages, as in the 1934 and 1943 adaptations of *Jane Eyre* and the 1933 adaptation of *Oliver Twist*. Another technique implies that a character is actually writing the book and that the film is the visual manifestation of that writing process. For example, *On the Road* (2012) features several shots and scenes of Sal Paradise (Sam Riley) writing "On the Road," including a scene in which he arrives at the idea to write his book on a continuous scroll, rather than individual sheets of paper. Similarly, *The Great Gatsby* (2013) incorporates a scene in which Nick Carraway (Tobey Maguire) writes down the story of Jay Gatsby as part of his rehabilitation from alcoholism. In each of these examples, the film does not replace the adapted source, but rather foregrounds the adapted source to root itself more firmly as an adaptation.

The notion that film adaptations replace their sources is also complicated by the tendency of audiences to watch film adaptations with the source in mind, as the whole of fidelity discourse demonstrates. Several writers contend that much of the pleasure of adaptation comes from such comparison (see Bruhn 82; Geraghty 5; Hutcheon 4; Sanders 9). These examples demonstrate that the supplement/replace distinction collapses fairly easily. If J. Hillis Miller is correct and the illustration "always adds something more" (102), the repeated assignment and reassignment of image and word, word and image, should yield a continual return of additions to the text at the same time that it draws attention, in a Derridean sense, to inevitable gaps and omissions in both image and prose: "But the supplement supplements. It adds only to replace. It intervenes or insinuates itself *in-the-place of*; if it fills, it is as if one fills a void. If it represents and makes an image, it is by the anterior default of a presence" (145). Likewise, film adaptations can never replace their sources, not simply because they are "haunted at all times by their adapted texts," as Hutcheon claims (6), but because adaptation is defined by its attachment to a nominal source, which becomes the source only in response to the adaptation. Simone Murray has complicated this genealogy further by drawing attention to the tendency for book publishers to anticipate and plan for adaptation "from the earliest phases of book production" (13).

The third common misperception—that illustration is static and film is dynamic—is also tied to characteristics of media. Much early writing on relationships between media focuses on differences between and capabilities of individual media, claiming, for example, that painting and film are spatial and perceptual, poetry and novels temporal and conceptual (see Bluestone 45–64; Lessing, Chapter 18; McFarlane, *Novel* 27–28). Elliott challenges such distinctions, finding many of the characteristics said to be specific to one medium in others as well (*Rethinking* 9–112). The seemingly basic claim that films are visual and novels are verbal, for example, falls apart in the face of films with intertitles or dialogue as well as illustrated novels. As Elleström points out, distinctions between static and dynamic media are really rooted in temporality—that is, whether or not their sense data alters with time ("Modalities" 19). Illustration is static: while we might find

something new in an illustration each time we return to it, the illustration itself does not change. Film, by contrast, does change. If we were to walk away from a film and return fifteen minutes later, the sense data would be different. This distinction need not confirm that illustrations and film adaptations engage in radically different relationships with their source texts, or that one is more suitably labeled "adaptation" than the other. Rather, it provides a jumping-off point for considering some ways in which illustrations and film adaptations attempt to blur and stretch the borders of their media. In looking at illustration and film less as distinct media than as comparable media vehicles, we can add to our understanding of fidelity, intertextual networks, and source relationships, other adapting activities, such as how media vehicles may adapt medial strategies not conventionally associated with them.

As has been well documented, illustrators use a range of techniques to create the impression of movement (see Eisner 25–37; Elliott 18–26; Lutman 196; Nodelman 158–92; Sullivan 12). Some, for example, might use a technique of blurring lines in an effort to convey movement, as Lawrence Beall Smith does in his *Washington Square* illustration of Catherine Sloper and Morris Townsend's first dance. Similarly, in his *Frankenstein* illustration of the Creature leaping from Mt. Montanvert, Wrightson's thin diagonal lines create the impression of movement. Illustrators can also convey movement or action by creating a series of images that depict the same subject with slight variations. Didier Mutel's depiction of Dr. Jekyll's transformation into Mr. Hyde unfolds over eight separate portraits, each of which depicts a face, each with a slightly different expression, each from a different angle. Viewed in succession, the images show a head turning from left to right and a face transforming from man to monster. Though not every detail of the transformation is depicted, readers understand that the transformation is occurring from the illustrations' compositional motion cues, and the sequence offers enough consistent information for readers to fill in the gaps.

The arrangement of image and word on the page also conveys a sense of movement. Elliott draws attention to the method by which *Vanity Fair*'s vignettes "are combinations of movement and freezing" action: "Interspersed between lines of moving prose, they at times seem to leap out from that movement, carrying with them both the mobility of the prose and their own mobile pictorial leap from it" (19). This technique is evident in McVickar's *Daisy Miller* illustration of the scene in which Winterbourne gives Randolph a lump of sugar. The placement and magnified proportions of the sugar bowl and its contents dominate the page, and the sugar cubes appear to escape the bowl, roll across the page, and divide James's text almost in half. The placement of the image disrupts the flow of the prose and brings energy and a sense of movement to the image.

Just as illustrators employ techniques to convey movement, so filmmakers employ techniques to convey stasis, most visibly through freeze-frames like the one that famously closes *The 400 Blows* (1959). Other films use freeze-frames to create the impression of paused movement, often to introduce characters or sustain action, and to allow audiences time to contemplate the image on the screen without the distraction of movement. *GoodFellas* (1990) and *Election* (1999) pair freeze-frames and voiceover commentary to provide elucidating (and often ironic) commentary on characters and

narrative events. Such moments stand out because they draw attention to the movement of cinema in their seeming absence of movement.

Filmmakers use several techniques beyond freeze-frame to slow film dramatically in order to invite extended contemplation. One example is what Mark Crispin Miller describes as the "careful painterly compositions" Stanley Kubrick uses in *Barry Lyndon* (1975), which "place us in the position of visitors to an art gallery; like art objects which 'expect' observers, they seem at first to require nothing more than cool, detached perusal." The numerous fixed long-shots and deliberate visual and narrative pacing in *Safe* give Todd Haynes's 1995 film a stillness so uncommon for the period that most reviewers comment on it in some fashion. As Janet Maslin observes, "Long shots, flat compositions and cruel fluorescent lighting create a powerfully disorienting effect." Cindy Fuchs notes that the film's closing shot, which holds steadily on Carol (Julianne Moore), "captures the stunning beauty of *Safe*, its precision and poetry in the face of all its absurdities and seeming voids. It's not an image you'll soon forget, no matter how you read it."

Illustration and film also use techniques to challenge our perception of the boundaries of their media and of their "material modality," which Elleström defines as "the latent corporeal interface of the medium" ("Modalities" 17). For both illustration and film, the interface is a flat surface, yet both can disguise this materiality by employing three-dimensional techniques, such as pop-up paper architecture and 3-D filming, that offer the illusion of a different interface and a new medial experience. The architecture of the pop-up book creates a sense of three-dimensionality and gives readers the feeling of a dynamic visual reading experience as their impression of the book and its images changes as they open a page, lift a tab, or pull a string. Readers' responses to Robert Sabuda's adaptations of previously illustrated novels—*The Wonderful Wizard of Oz* (2000), *Alice's Adventures in Wonderland: A Popup Adaptation* (2003), *Peter Pan* (2008)—highlight the dynamism of the reading experience. An Amazon.com reviewer praises a page from *Peter Pan*: "It is astonishingly beautiful to open a page and look down into the depths of a London that is alive and swirling with mystery. The clouds slowly reveal themselves as fragments of all the central characters in the book, almost as if they were actively hiding and exposing themselves in life" (Psotka). These sentiments are echoed in professional reviews of Sabuda's work. Chris Hedges, writing for the *New York Times*, notes that the "eye-popping images, which leap off the page into a child's face, are almost demeaned by the word pop-up." The pop-up book provides an interesting complication to the notion of the static illustration. Despite readers' declarations of a dynamic experience, the images themselves remain two-dimensional: color and line printed on flat surfaces. The complexity of the paper architecture creates a simulation of three-dimensional effects that is similar to the three-dimensional effect of turning a page in a conventional book, but that readers experience as novel due to their participation in the spectacle and its unfurling.

The 3-D experience offered by cinema points to some ways in which an already dynamic medium might attempt to stretch its medial borders to make itself more so— more like "real life." In reviewing Baz Luhrmann's 2013 adaptation of F. Scott Fitzgerald's

The Great Gatsby, many reviewers respond to the film in language that conveys a sense that the film exceeds its material modality. A reviewer for the *Daily Star* claims that the "colors . . . jump out of the screen" ("What's so"). Similarly, reviewer Grant Tracey praises the film as "dazzling and full of brightness. Reds, blues, and pinks create a fairytale atmosphere and a story that jumps off the screen with an intensity of feeling." Several reviewers testify that the 3-D effects gave them the experience of being in the film: "In the 3-D version, the viewer swoops and swerves through one of Gatsby's parties in a movement that combines Vincente Minnelli–style suavity with the controlled vertigo of a theme park ride" (Scott). Of course, viewers of Luhrmann's film do not actually swoop and swerve through a 1920s party, but rather remain fixed in the theater, just as they would for any other film, and the illusion to which they respond is the result of the joint efforts of the camera and projection systems, just as it would be for any other film.

The idea that illustration is static and film is dynamic might discourage us from comparing their adaptive functions on the grounds that they are too different. But when we do compare them, we see similarities in the methods by which both attempt to adapt medial effects in an effort to convey something new. While the comments on Sabuda's books and the 3-D *Great Gatsby* reveal that each offers an experience that exceeds expectations for the media, the novelty of each production is well within the norms of its medium. Instead of reading such moments as pushing the boundaries of their medium, we might say that they draw attention to the role that perception, expectation, and habit play in constructing boundaries between media and invite us to think about why, how, and whether those boundaries actually exist.

I began this essay with two guiding questions: Why has illustration not been brought under the umbrella of adaptation, and why have adaptation studies and illustration studies evolved along largely non-converging paths? The quick explanation for the insularity is disciplinary. Scholars trained in book or art history have done most of the writing on illustration, and scholars trained in literature have done most of the writing on film adaptation. Writers with historical backgrounds have tended to favor survey approaches to illustration and techniques or biographical approaches. Writers with literary backgrounds have tended to favor close reading and comparative approaches, and have contributed to the assumption that "adaptation" is synonymous with "film adaptation." While the field of adaptation studies has broadened to include a range of theoretical approaches, a survey of the titles of monographs and essay collections most commonly cited in scholarship on adaptation yields "film" and "literature" as the two most common keywords, suggesting that, in practice, adaptation is more firmly rooted in relationships between novels and films than in common practices across disciplines.

As I hope I have shown, the insularity of the study is also the result of labels we have applied to activities and assumptions that go along with those labels. Denotative meanings for the names we apply to specific media vehicles and adaptive activities guide our understanding of those vehicles and activities and, in discipline-specific application, foster a sense of separatism that, while healthy in some respects, can contribute to the installation and defense of unproductive borders. As Elleström charges, isolation among specializations interested in hybrid media productions has resulted in the

development of specialized vocabularies that grapple with similar ideas. He advises that adaptation studies would benefit from "adapt[ing] to terminology that is applicable to general intermedial notions and phenomena," and speculates that "if such a strategy were applied, not only within adaptation studies, but in all research areas that involve multiple media types, it would be possible to communicate across borders of specialization" ("Adaptations" 114). Such focus would provide a larger sense of how work has been experienced, appreciated, revised, and interpreted over time through diverse media.

Writers on adaptation understand that one of the benefits of adaptations is that they enable us to see what and how artistic and cultural productions signify in particular contexts and historical moments. Many writers have developed tropes for reading adaptation that allow for the consideration of multiple versions of a work. Sarah Cardwell recommends that we "view adaptation as the gradual development of a 'meta-text'" (25), and Linda Hutcheon proposes a continuum model, which would "offe[r] a way to think about various responses to a prior story" (172). As fulfilling as these views can be, they remain only partial if they are fixed on how a work has materialized in only one or two modes (novel and film, film and film). A cross-disciplinary approach to illustration and adaptation under the banner of intermediality would allow us to see not only how a work has been responded to, but also how that work has been shaped by its connections and collisions with different media, and how those engagements have been theorized and historicized by a range of disciplines.

WORKS CITED

"Adaptation." *OED Online*. Oxford UP, June 2015. Web. 8 Aug. 2015.

The Age of Innocence. Dir. Martin Scorsese. Perf. Daniel Day-Lewis, Michelle Pfeiffer. Columbia, 1993. Film.

Andrew, Dudley. "The Economies of Adaptation." MacCabe, Murray, and Warner 27–39. Print.

Barry Lyndon. Dir. Stanley Kubrick. Perf. Ryan O'Neal, Marisa Berenson. Peregrine, 1975. Film.

Bluestone, George. *Novels into Film: The Metamorphosis of Fiction Into Cinema*. Baltimore: Johns Hopkins UP, 1957. Print.

Braida, Antonella, and Giuliana Pieri. *Image and Word: Reflections of Art and Literature from the Middle Ages to the Present*. Oxford: European Humanities Research Centre, 2003. Print.

Bruhn, Jørgen. "Dialogizing Adaptation Studies: From One-way Transport to a Dialogic Two-way Process." Bruhn, Gjelsvik, and Hanssen 69–88. Print.

Bruhn, Jørgen, Anne Gjelsvik, and Eirik Frisvold Hanssen, eds. *Adaptation Studies: New Challenges, New Directions*. London: Bloomsbury, 2013. Print.

———. "'There and Back Again': New Challenges and New Directions in Adaptation Studies." Bruhn, Gjelsvik, and Hanssen, *Adaptation* 1–16. Print.

Bruhn, Jørgen, Anne Gjelsvik, and Henriette Thune. "Parallel Worlds of Possible Meetings in *Let the Right One In*." *Word and Image* 27.1 (Jan.–Mar. 2011): 2–14. Print.

Buchanan, Judith. "Literary Adaptation in the Silent Era." Cartmell 17–32. Print.

Cardwell, Sarah. *Adaptation Revisited: Television and the Classic Novel*. Manchester: Manchester UP, 2002. Print.

Cartmell, Deborah, ed. *A Companion to Literature, Film, and Adaptation*. Malden: Blackwell, 2012. Print.

Cartmell, Deborah, and Imelda Whelehan, eds. *Adaptations: From Text to Screen, Screen to Text*. New York: Routledge, 1999. Print.

Cartmell, Deborah, and Imelda Whelehan, eds. *The Cambridge Companion to Literature on Screen*. Cambridge: Cambridge UP, 2007. Print.

Cartmell, Deborah, and Imelda Whelehan. *Screen Adaptation: Impure Cinema*. New York: Palgrave, 2010. Print.

Congdon, Charles T. "Over-Illustration." *North American Review* 139 (1884): 480–91. *JSTOR*. Web. 24 June 2014.

Corrigan, Timothy. "Literature on Screen, a History: In the Gap." Cartmell and Whelehan, *Cambridge* 29–43. Print.

"Do Film Adaptations Ruin the Book for You?" *Guardian* 23 Mar. 2011. Web. 15 May 2014.

Eisner, Will. *Comics and Sequential Art: Principles and Practices from the Legendary Cartoonist*. New York: Norton, 2008. Print.

Election. Dir. Alexander Payne. Perf. Matthew Broderick, Reese Witherspoon. Bona Fide, 1999. Film.

Elleström, Lars. "Adaptations Within the Field of Media Transformations." Bruhn, Gjelsvik, and Hanssen 113–32.

———. "The Modalities of Media: A Model for Understanding Intermedial Relations." *Media Borders, Multimodality and Intermediality*. Ed. Lars Elleström. New York: Palgrave, 2010. 11–48. Print.

Elliott, Kamilla. *Rethinking the Novel/Film Debate*. Cambridge: Cambridge UP, 2003. Print.

———. "Theorizing Adaptations/Adapting Theories." Bruhn, Gjelsvik, and Hanssen 19–45.

Fisher, Judith L. "Image versus Text in the Illustrated Novels of William Makepeace Thackeray." *Victorian Literature and the Victorian Visual Imagination*. Ed. Carol T. Christ and John O. Jordan. Berkeley: U of California P, 1995. 60–87. Print.

The 400 Blows. Dir. François Truffaut. Perf. Jean-Pierre Leaud, Albert Rémy. Les Films du Carrosse, 1959. Film.

Fuchs, Cindy. "Safe: Todd Haynes' Film is Elusive But Hard to Forget." Rev. of *Safe*, dir. Todd Haynes. *Philadelphia City Paper*. 10–17 Aug. 1995. Web. 15 July 2014.

Geraghty, Christine. *Now a Major Motion Picture: Film Adaptations of Literature and Drama*. Lanham: Rowman and Littlefield, 2008. Print.

GoodFellas. Dir. Martin Scorsese. Perf. Robert De Niro, Ray Liotta. Warner Bros., 1990. Film.

Grant, Catherine. "Recognizing *Billy Budd* in *Beau Travail*: Epistemology and Hermeneutics of an Auteurist 'Free' Adaptation." *Screen* 43.1 (Spring 2002): 57–73. Print.

The Great Gatsby. Dir. Baz Luhrmann. Perf. Leonardo DiCaprio, Tobey Maguire. Warner Bros., 2013. Film.

Hall, N. John. *Trollope and His Illustrators*. London: Macmillan, 1980. Print.

Harvey, J. R. *Victorian Novelists and Their Illustrators*. New York: New York UP, 1971. Print.

Hedges, Chris. "Public Lives; In Him, Storyteller Meets Architect." *New York Times* 9 Dec. 2003. Web. 13 June 2014.

Hodnett, Edward. *Image and Text: Studies in the Illustration of English Literature*. Aldershot: Scolar, 1986. Print.

Holder, John, illus. *Washington Square*. By Henry James. Retold by Kieran McGovern. Oxford Bookworms Library. Oxford: Oxford UP, 2000. Print.

Hutcheon, Linda. *A Theory of Adaptation*. New York: Routledge, 2006. Print.

James, Henry. *Daisy Miller*. N.p.: Westvaco, 1974. Print.

Jane Eyre. Dir. Christy Cabanne. Perf. Virginia Bruce, Colin Clive. Monogram, 1934. Film.

Jane Eyre. Dir. Robert Stevenson. Perf. Orson Welles, Joan Fontaine. Twentieth Century–Fox, 1943. Film.

Kooistra, Lorraine Janzen. *The Artist as Critic: Bitextuality in Fin-de-Siècle Illustrated Books*. Aldershot: Scolar, 1995. Print.

Leitch, Thomas. "Adaptation and Intertextuality, or, What Isn't an Adaptation, and What Does it Matter?" Deborah Cartmell, ed., *Companion*. 87–104. Print.

———. *Film Adaptation and Its Discontents: From* Gone With the Wind *to* The Passion of the Christ. Baltimore: Johns Hopkins UP, 2007. Print.

Lessing, Gotthold Ephraim. *Laocoon: An Essay on the Limits of Painting and Poetry*. Trans. Ellen Frothingham. New York: Noonday, 1957. Print.

Lutman, Stephen. "Reading Illustrations: Pictures in *David Copperfield*." *Reading the Victorian Novel: Detail into Form*. Ed. Ian Gregor. New York: Barnes and Noble, 1980. 196–225. Print.

Lynch, P. J., illus. *A Christmas Carol*. By Charles Dickens. Somerville: Candlewick, 2006. Print.

MacCabe, Colin. "Introduction: Bazinian Adaptation: *The Butcher Boy* as Example." MacCabe, Murray, and Warner 3–25.

MacCabe, Colin, Kathleen Murray, and Rick Warner, eds. *True to the Spirit: Film Adaptation and the Question of Fidelity*. Oxford: Oxford UP, 2011. Print.

Male, Alan. *Illustration: A Theoretical and Contextual Perspective*. Lausanne: AVA, 2007. Print.

Maslin, Janet. "Life of a Hollow Woman." Rev. of *Safe*, dir. Todd Haynes. *New York Times* 23 June 1995. Web. 17 July 2015.

McFarlane, Brian. *Novel to Film: An Introduction to the Theory of Adaptation*. Oxford: Oxford UP, 1996. Print.

———. "'It Wasn't Like That in the Book.'" *Literature/Film Quarterly* 28.3 (2000): 163–69. Print.

McVickar, H. W., illus. *Daisy Miller and An International Episode*. By Henry James. New York: Harper, 1892. Print.

Miller, J. Hillis. *Illustration*. Cambridge: Harvard UP, 1992. Print.

Miller, Mark Crispin. "Barry Lyndon Reconsidered." *Georgia Review* 30.4 (1976). The Kubrick Site. Web. 17 Jul. 2014.

Mitchell, W. J. T. *Picture Theory*. Chicago: U of Chicago P, 1994. Print.

Murray, Simone. *The Adaptation Industry: The Cultural Economy of Contemporary Literary Adaptation*. New York: Routledge, 2012. Print.

Mutel, Didier, illus. *The Strange Case of Dr. Jekyll and Mr. Hyde*. By Robert Louis Stevenson. Paris: Ateliers Leblanc, 1994. Print.

Newell, Kate. "'You Don't Know about Me Without You Have Read a Book': Authenticity in Adaptations of *Adventures of Huckleberry Finn*." *Literature/Film Quarterly* 41.4 (2013): 303–16. Print.

Nodelman, Perry. *Words about Pictures: The Narrative Art of Children's Picture Books*. Athens: U of Georgia P, 1988. Print.

Oliver Twist. Dir. William J. Cowen. Perf. Dickie Moore, Irving Pichel. Monogram, 1933. Film.

On the Road. Dir. Walter Salles. Perf. Sam Riley, Garrett Hedlund. MK2, 2012. Film.

Orlando. Dir. Sally Potter. Perf. Tilda Swinton, Billy Zane. Adventure, 1992. Film.

Ouditt, Sharon. "*Orlando*: Coming across the Divide." Cartmell and Whelehan, *Adaptations* 146–56. Print.

Psotka, Joseph. "Pop-up Pantasia." Rev. of *Peter Pan*, by Robert Sabuda. Amazon. 29 Nov. 2008. Web. 17 July 2014.

Safe. Dir. Todd Haynes. Perf. Julianne Moore, Xander Berkeley. Sony Pictures Classics, 1995. Film.

Sanders, Julie. *Adaptation and Appropriation*. New York: Routledge, 2006. Print.

Schober, Regina. "Adaptation as Connection—Transmediality Reconsidered." Bruhn, Gjelsvik, and Hanssen 89–112.

Scott, A. O. "Shimmying Off the Literary Mantle: 'The Great Gatsby,' Interpreted by Baz Luhrmann." Rev. of *The Great Gatsby*, dir. Baz Luhrmann. *New York Times* 9 May 2013. Web. 1 Aug. 2014.

Skilton, David. "The Relation between Illustration and Text in the Victorian Novel: A New Perspective." *Word and Visual Imagination: Studies in the Interaction of English Literature and the Visual Arts*. Ed. Karl Josef Höltgen, Peter M. Daly, and Wolfgang Lottes. Erlangen: Universitätsbund Erlangen-Nürnberg, 1988. 303–25. Print.

Small, Jocelyn Penny. *The Parallel Worlds of Classical Art and Text*. Cambridge: Cambridge UP, 2003. Print.

Smith, Laurence Beall, illus. *Washington Square*. By Henry James. New York: Heritage, 1971. Print.

Sonstegard, Adam. "Discreetly Depicting 'an Outrage': Graphic Illustration and 'Daisy Miller''s Reputation." *Henry James Review* 29.1 (Winter 2008): 65–79. Web. *Project Muse*. 3 June 2014.

Stam, Robert. "Beyond Fidelity: The Dialogics of Adaptation." *Film Adaptation*. Ed. James Naremore. New Brunswick: Rutgers UP, 2000. 54–76. Print.

Steig, Michael. *Dickens and Phiz*. Bloomington: Indiana UP, 1978. Print.

Sullivan, Edmund J. *The Art of Illustration*. London: Chapman and Hall, 1921. Print.

Thomas, Julia. *Pictorial Victorians: The Inscription of Values in Word and Image*. Athens: Ohio UP, 2004. Print.

Tracey, Grant. "*The Great Gatsby*." Rev. of *The Great Gatsby*, dir. Baz Luhrmann. *North American Review* 298.3 (Summer 2013): 46. *Humanities Source*. Web. 5 June 2014.

Ward, Lynd, illus. *Frankenstein*. By Mary [Wollstonecraft] Shelley. Retold by Patrick Nobes. Oxford Bookworms Library. Oxford: Oxford UP, 2000. Print.

———. *Frankenstein; or the Modern Prometheus*. By Mary Wollstonecraft Shelley. New York: Harrison Smith and Robert Haas, 1934. Print.

———. *Frankenstein; or the Modern Prometheus*. By Mary Wollstonecraft Shelley. New York: Fall River, 2006. Print.

Wagner, Geoffrey Atheling. *The Novel and the Cinema*. Rutherford: Fairleigh Dickinson UP, 1975. Print.

Weitenkampf, Frank. *American Graphic Art*. New York: Henry Holt, 1912. Print.

"What's So Great about Gatsby; Riches, Glamour, and Doomed Love in the Roaring 20s." Rev. of *The Great Gatsby*, dir. Baz Luhrmann. *Daily Star* 15 May 2013: 28, 29. *Lexis Nexis Academic*. Web. 13 June 2014.

Whelehan, Imelda. "Adaptations: The Contemporary Dilemmas." Cartmell and Whelehan, *Adaptations* 3–19. Print.

Wrightson, Bernie. "Foreword." *Gris Grimly's Frankenstein*. New York: Balzer and Bray, 2013. x–xi. Print.

Wrightson, Bernie, illus. *Frankenstein; or the Modern Prometheus*. By Mary Wollstonecraft Shelley. New York: Marvel, 1983. Print.

CHAPTER 28

··

ALIGNING ADAPTATION
STUDIES WITH
TRANSLATION STUDIES

··

LAURENCE RAW

CRITICAL debate over the relationship between translation and adaptation—in disciplinary as well as practical terms—has become livelier in recent years. Lawrence Venuti's 2007 article "Adaptation, Translation, Critique" criticized Robert Stam's work on the grounds that he invoked "a dominant critical orthodoxy based on a political position ... that the [adaptation] critic applies as a standard on the assumption that the film should inscribe that and only that ideology" (28). Patrick Cattrysse has recently reworked Venuti's points in accusing theorists like Kamilla Elliott and Thomas Leitch of making "Hasty Generalizations about What Adaptation Is" by means of catch-all definitions that "embrace all past, present and future adaptations" (133). For Cattrysse, "[s]uch generalizations turn out to be false and debatable" in most cases (136). The majority of adaptation theorists assume, quite erroneously, that "there exists a homogenous set of theoretical thoughts about adaptation known to and agreed upon by everyone"—readers and learners who ultimately hold the same personal values as the theorists (136). In the introduction to a recent anthology, I addressed these criticisms by suggesting that because the relationship between translation and adaptation might be interpreted differently across the globe, we should beware of imposing absolute definitions on specific bodies of work. What might be considered a "translation" in one context might be described as an "adaptation" in another. Drawing on the work of translation studies scholar Dirk Delabatista, I suggested that any text includes three levels of "reality"—its *status* (what it is believed to be in a given community); its *origin* (where it comes from); and its *features* (as revealed through synchronic analysis). This framework can help us understand how and why translations have been distinguished from adaptations in space and time. I also proposed that translation and adaptation specialists come together and share their insights (Raw, "Translation" 12–14). Katja Krebs's recent anthology *Translation and Adaptation in Theatre and Film* (2014) was conceived with a similar

purpose in mind: to establish a series of "meeting points" or "converging agendas" that might be "disruptive, selfish and perverse yet ... [remain] central to the (re)writing, (re)construction and reception of cultural positions and ideologies," as well as prompting reconsideration of "some of the entrenched positions" that inhibit further research (Krebs 9).

Yet Cattrysse still seems dissatisfied with these attempts to negotiate between the translational and adaptive positions. In a review of my anthology, he insists there should be "a common working definition" of translation and adaptation, one that he believes can be provided through descriptive adaptation studies (DAS), based on the polysystem theory of translation studies, which he first discussed over two decades ago. He claims that "this approach was far ahead of its time, and it deserves better than to be ignored" (124). Cattrysse's proposal is not without its merits: DAS can broaden our understanding of how and why texts are transformed at different points in time. On the other hand, adaptation studies should not be treated as a subaltern discipline operating in translation studies' shadow. We should broaden our focus of interest to accommodate the work of other theorists so as to rethink the way we understand both adaptation and translation. It was this spirit of collaborative endeavor that underpinned my introduction, as well as Krebs's call for a redefinition of hitherto entrenched theoretical positions.

This essay builds on my introduction by offering further suggestions as to how such collaborations might be forged. It begins by discussing one aspect of translation and adaptation about which there is a fair degree of consensus: there exist certain texts (literary, cinematic, or otherwise) that might be deemed "untranslatable" or "unadaptable." Understanding the implications of such terms might be illuminated through DAS, but also by investigating cognitive processes. How do members of different socioeconomic communities cope with (or even adapt to) an untranslatable or unadaptable text? This form of analysis is normally conducted in monolingual or monocultural contexts. Drawing on the work of psychologists Jean Piaget, D. W. Winnicott, and Jerome Bruner, as well as more recent research into translation and cognition, I examine the ways in which linguistic, psychological, and cultural issues are intertwined in cognitive processing, and thereby address issues of ontology (the relationships between human minds and the words they inhabit) and epistemology (the workings of individual minds in their search for knowledge). This framework acknowledges the presence of variables (different people have different interpretations of the untranslatable or unadaptable) and therefore exemplifies what Liliana Coposecu defines as "discursive hybridity"— shifting modalities at the levels of "identity, modes of talk [and] socialization into communities of practice" (83). A willingness to embrace such modalities should forge a spirit of cooperation—not just involving adaptation and translation specialists, but informed more generally by a spirit of cross-disciplinary negotiation, the desire to create something new. This form of academic endeavor (acknowledging irrational or plural subjectivities) serves a noble ethical purpose by envisioning a future better than the present, based on the incorporation of multiple ideas that might identify the value of a "successful" translation or adaptation (Pym 138–39). Put more straightforwardly, cooperation can help to dispel the notion that texts are untranslatable or unadaptable and thereby

help us understand how different people behave in different situations. Such knowl-
edge can not only help us rethink the relationship between adaptation and translation,
but can create what Samuel Taylor Coleridge described long ago as a "clerisy"—a group
committed to "the advancement of knowledge, and the civilization of the community"
as well as "cultivating and enlarging the knowledge already possessed" (34).

In her recent work *Against World Literatures* (2013), Emily Apter defines the untranslat-
able as "something on the order of 'an Incredible,' an 'Incontournable,' an 'Untouchable.'
There is a quality of militant semiotic intransigence attached to the Untranslatable. . . .
This effect of the non-carry-over (of meaning) that carries over nevertheless (on the back
of grammar), or that transmits at a half-cocked semiotic angle, endows the Untranslatable
with a distinct symptomatology" (34–35). Untranslatable texts are frequently the most
popular subjects for translation as individuals engage with "the many cognitive misfits
and value clashes." This is a positive sign: the constant updating and revision of such texts
allow "literary comparatism to be more responsive to the geopolitics of literary [as well
as other] worlds" (39). Apter offers several examples of untranslatable terms, including
"cyclopedia," "peace," "sex," "gender," and "*monde.*"

The obstacles preventing meaning from being carried over from one text to another
are also outlined by Adam Mars-Jones in a piece on allegedly unadaptable books and
their film versions. They include *Ulysses, À la recherche du temps perdu, Naked Lunch,*
and Boris Vian's *L'écume des jours* (1947), adapted in 2013 by Michel Gondry and retitled
Mood Indigo in English. Mars-Jones argues that the worlds created by these literary texts
resist visual paraphrase; despite Gondry's intelligent use of "pixilation"—the technique
of stop-motion animation applied to live actors—*Mood Indigo* still seems like a series
of riffs on existing material, bearing only a tangential relationship to the source text.
Mars-Jones describes one newly created sequence—set in a lecture theater with type-
writers installed along the desktops—as "mildly insulting to the consistency and control
of Vian's writing process," even though the adaptation as a whole offers a convincing
account of fantasy, "whose nature it is to burst even when not actively popped, with hun-
ger and sickness always showing" (17–18).

To describe a text or a phrase as untranslatable or unadaptable involves certain unspo-
ken assumptions. They might be nationalistic or orientalist (an untranslatable Arabic
text cannot be rendered palatable to Western readers), or even aesthetic: Maureen Freely
offers a vivid recollection of her decision to retain untranslatable words (*börek, meyhane,
yalı*) in Turkish in her English version of Orhan Pamuk's *Kar* (*Snow*), on the assump-
tion that most English speakers in Turkey would be well acquainted with them anyway.
Once the completed text reached the publishers, the copyeditor introduced several fur-
ther alterations, including simplified versions of the Turkish words (cheese pastry, bar,
beachside house) without either Freely's or Pamuk's permission, on the grounds of com-
prehensibility for "the reader"—meaning, of course, "the western reader" (Freely 122).

The belief that literary texts are untranslatable can also be attributed to literary preju-
dice: novels like Vian's *L'écume des jours* are unique referential phenomena whose textual
specifics portray a transcending generality, inviting readers to occupy the place of those
limned in the text, to partake of the author's experiences and empathize with them and

appreciate his or her unique style (Mars-Jones 18). A cinematic version might commu-
nicate the source text's themes, but no such version could find visual equivalents for
Vian's unique writing style. Like the Turkish words retained in Freely's translation of
Kar, there are aspects of *L'écume des jours* that resist any transformative attempts.

Deconstructing untranslatability or unadaptability lends itself to DAS as defined by
Cattrysse. Looking at Freely's translation in its historical context of production involves
us in issues of politics, orientalism, and shifting sociocultural relations between East
and West, as more and more Turkish texts have been rendered into English since Pamuk
won the Nobel Prize in 2006. Freely's observations about English speakers in Turkey
knowing words such as *börek* (cheese pastry) tells us a great deal about shifting patterns
of migration over the last three decades, as Turkey has opened its borders to increasing
numbers of foreigners from the West and elsewhere. On the other hand, Freely's deter-
mination to retain Turkish words in a translated text suggests a concern that Pamuk's
source text might be "lost" when rendered in another language. This analysis shows how
"the role of individual actions and an individual's explanatory discourse [as set forth in
Freely's piece] . . . [is] neither ignored nor favored next to other sources of information"
(Cattrysse 243).

A DAS-based analysis of *L'écume des jours* raises further interesting questions about
the role of the screenwriter/director in the process of transforming Vian's source text
and the extent to which the film's construction was shaped by other concerns—for
example, the presence of Audrey Tautou in the cast, which, as Mars-Jones suggests,
prompts viewers to watch the film in the hope that it recaptures the joyous spirit of
Amélie (2001), the actress's breakthrough film. Other viewers might speculate on
whether the Vian adaptation might have been better made by someone more will-
ing to engage with the source text (Mars-Jones 18). Such investigative processes,
Cattrysse contends, render the question of untranslatability and unadaptability a non-
issue: "Since translations and adaptations exist, it must be that whatever they translated
or adapted was translatable and adaptable" (264). I would disagree on one important
count: part of the DAS process lies in deconstructing why the term "untranslatable" or
"unadaptable" was invoked in the first place. In the case of *Kar/Snow*, Freely uses it as a
means of resisting the simplifying (or westernizing) process of retranslation imposed
on her by the copyeditor. As someone conversant in both languages, she positions her-
self as a cross-cultural speaker attempting to render Pamuk's idiosyncratic syntax into
effective English. Mars-Jones's reference to "unadaptable" texts is equally ideologi-
cally positioned because it implies the existence of a canon of modernist literature that
resists cinematic transformation. This construction places the West at the center of the
cultural universe—especially those representatives (modernist authors) with the talent
to write in a consciously unadaptable style.

Ideology likewise determines the ways in which texts are deemed "untranslatable"
and "unacceptable" in contemporary Turkey. Alper Kumcu notes that state authorities
have not always been willing to embrace the notion of multilingualism; hence texts pub-
lished in other languages spoken in the country—Kurdish and Armenian—often receive
limited distribution and remain untranslated, so that they languish in comparative

obscurity. Although the state's promotion of Turkish as the only legitimate language of communication contravenes EU guidelines, it nonetheless fulfills as an effective purpose of sustaining national unity (83–84).

DAS looks at explanations beyond the level of individual agency while eschewing the kind of value judgments that deem one text to be superior to another. This method of analysis can help us understand how the outwardly negative terms "untranslatable" and "unadaptable" are periodically invoked by writers seeking to validate their particular ideological positions. DAS also has the virtue of looking at texts from an intertextual perspective, replacing the single source with a multiple source model.

There are other ways in which we can interpret the relationship between translation and adaptation that extend far beyond the DAS framework. Suzanne Göpferich and her collaborators recently conducted a series of "exploratory analyses" of how individuals view the act of translation, using five tyro students in translation studies and five professionals as focus groups. The results proved that the better translators were on the whole more imaginatively creative, although the professionals tended to "make fewer errors, have fewer problems ... [and] proceed in a strategic manner" (76–77). Nonetheless, if learners were given sufficient support by their teachers to facilitate their tasks, they could not only "make more reflective decisions" but establish "alternative paths of thinking that improve their associative competence" (Göpferich et. al. 76–78).

These observations provide a fascinating elaboration of Katja Krebs's suggestion that new ways of approaching translation and adaptation might disturb "some of the entrenched positions" currently inhibiting further research. Learners have to adapt to the prevailing conventions in order to accomplish successful translations, but they possess the potential to reshape such conventions by means of a cognitive leap into the intellectual unknown. By doing so, they show how conventions—linguistic, sociological, or political—have to respond to shifts in thought and feeling. While such possibilities very much depend on the type of translation task involved, and the context in which the act of translation or adaptation takes place, Sharon O'Brien nonetheless reminds us that once the "processing at the conscious level" has been completed, the human mind can extend into hitherto undiscovered creative territory (22). This observation suggests that individual agency assumes more significance than Cattrysse would have us believe. Investigating more closely the ontology of translation and adaptation can make this point clearer. Jean Piaget's 1947 *Psychology of Intelligence* defines intelligence as "the most highly developed form of mental adaptation ... the indispensable instrument for interaction between the subject and the universe when the scope of this interaction goes beyond immediate and necessary contacts to achieve far-reaching relations" (7). Children become aware of the world around them through a transformative process from the sensorimotor (or instinctive) to the reflective (imaginative) level. This is accomplished in three stages. The information is first molded into one simultaneous whole. Then children search within themselves for an understanding of its nature. Finally, they make sense of that information, "enabling real actions affecting real entities to be extended by symbolic actions affecting symbolic representations and thus going beyond the limits of near space and time" (121). This tripartite process Piaget calls

adaptation, which can "neither be a translation or even a simple continuation of sensori-motor processes in a symbolic form" (121–22). Children learn to establish a system of relationships between themselves and the worlds they inhabit; such relationships change as they grow older. From about four to seven years old, they are preoccupied with culti-vating "an intuitive thought"; from seven through eleven, this is transformed into "con-crete operations," operational groups of thought concerning objects; and from eleven to twelve years and beyond, "formal thought is perfected and its groupings characterize the completion of reflective intelligence" (123). The adolescent never loses the power of intuitive thought, which for Piaget is "the maximum degree of adaptation" insofar as it can encourage others to make "perceptual adjustments" in their ways of thinking (129).

For Piaget, adaptation and translation comprise two strategies in children's pro-cesses of development: they translate their impressions of the world around them into familiar terms and subsequently adapt the familiar into something new—for example, concrete operations or new thought-patterns. Yet this distinction is not particularly sig-nificant: what matters more is that Piaget offers a credible model for understanding how individuals make sense of the world, and how adaptation and translation are intrinsic to that process. Through Piaget we can better comprehend how learners possess the capac-ity to transform the criteria that determine how they should produce their work, despite their palpable lack of experience.

The British psychoanalyst D. W. Winnicott's *Playing and Reality*, published twenty-four years after *The Psychology of Intelligence*, suggests that "experience" is a complex term—although children might be limited to an inexperienced worldview, they grasp very early on that "the third part of the life" of every human being, "a part that we can-not ignore, is an intermediate area of experiencing" (47). Experience connects the imagination to the outside world; it is the catalyst for everyone as they learn how to adapt to shifting circumstances. Winnicott believes that experiences change as children adapt. Individual experiences begin as formless, but through the creative power of the imagination they are transformed into building-blocks that represent the foundation of human experience (87). Winnicott stresses the importance of play in childhood and adolescence; it facilitates growth, forges group relationships, encourages communi-cation, and provides a means to link individuals to their communities (58). Playing is not just a leisure-time activity, an alternative to the real business of work or school; it is "always a creative experience, and it is an experience in the space-time continuum, a basic form of living" (64). Through play, children not only refine experiences, but acquire a more sophisticated capacity to manipulate "external phenomena in the service of the dream and invest . . . chosen external phenomena with dream meaning and feel-ing" (70). They subsequently adapt this dream through the act of shared playing, thereby transforming the cultural experiences of themselves as well as their fellow group mem-bers. If we extend Winnicott's suggestions still further, it is perfectly feasible to argue that Göpferich et al.'s translation studies learners are "playing" as they draw on their experiences of the source texts to establish alternative ways of thinking.

The ontology of adaptation and translation based on this model posits a direct link between language, communication, and psychology: individuals cannot transform

anything until they have mentally adjusted to new experiences. Rather than establishing a common definition of adaptation or translation, Winnicott's ideas suggest that, as the word "creativity" implies, people adjust to their environment in different ways. This construction situates individual perception as the major subject for analysis because it is the principal process by which we make sense of objects "by direct and immediate contact" and thereby acquire "the final equilibrium reached in the development of intelligence" (Piaget 53).

To construct an epistemology of adaptation and translation based on this framework, I draw on the work of Jerome Bruner, whose *Making Stories* (2002) is founded on the belief that play encourages children to "enter the world of narrative [and storytelling] early. They develop expectations about how the world should be [and experience] things that ... surprise" (31–32). The process of acclimatization to such experiences can be termed "adaptation." As we grow older, we become aware of "unspoken, implicit cultural models of what selfhood might be"—models that have been established and refined by the cultures we inhabit (65). While such models are not set in stone—we all have the capacity to change them—they shape the narratives we construct about ourselves to such an extent that we often express ourselves in terms of what we think others expect us to be like: "In this process, selfhood becomes *res publica*, even when talking to ourselves" (66). We have a responsibility to relate to a world of others—friends and family, institutions, the past, reference-groups (78). Perhaps paradoxically, Bruner proposes that while our lived cultures guide us toward "the familiar and the possible," we continually insist on constructing self-narratives to define ourselves, to represent "those deviations from the expected state of things that characterize living in a human culture. . . . [This process] is irresistible as a way of making sense of human interaction" (83). Our entire life is marked by a series of struggles between the desire to define ourselves and the desire to respect the definitions of others. The vitality of cultures lies in this dialectic, the need for individuals and the societies they inhabit to come to terms with contending views and clashing narratives. Both individuals and their societies must acquire the ability to *adapt* or *translate* (the processes are regarded as interchangeable in this model). Sometimes individuals alter their behavior; on other occasions their cultures modify their ideologies: "If a culture is to survive, it needs means for dealing with the conflicts of interest inherent in communal living" (92).

Bruner's ideas substantiate the notion that anyone can contribute to the process of rethinking currently prevailing ideas of translation, adaptation, or any other transformative act. Nothing can be deemed untranslatable or unadaptable unless specific institutions choose to impose such notions for ideological purposes. Bruner also demonstrates how any act of cognitive processing involves cultural as well as linguistic and communicative issues, a dimension as important in monolingual or monocultural as in cross-cultural settings. Bruner's model, placing the individual at the center, inevitably favors plurality over consensus. Edda Weigand suggests that differentiation and hybridity influence every human act, even among individuals inhabiting the same local cultures: "Living with uncertainty . . . requires us to orient ourselves according to principles of probability. Even if there are rules, in the end they can be broken or changed."

Conventions are there to be challenged, subverted, or rethought: "We look for particular conditions and proceed from standard cases to individual cases" (47).

It might appear that the preceding discussion, drawn largely from the work of psychoanalysts and psychologists with only a passing interest in the humanities (although Bruner does relate narrative self-making to the act of writing fiction), has little application to the process of adapting texts to film. I would beg to differ. In a recent essay on Anthony Drazan's film version of David Rabe's Broadway hit *Hurlyburly* (1998) (Figures 28.1 and 28.2), I argued that our understanding of the two central characters, played by Kevin Spacey and Sean Penn, depends on the actors' ability to create a cascade of images, both mental and visual, that "draw on sensory, affective and explicit memory, and to connect this [knowledge] with a detailed kinaesthetic score that supports the body-mapping of these images" (Raw, "Actor" 224). The actors respond not only to the screenplay but to one another; they engage in continual processes of adaptation and translation as they accommodate themselves to new surroundings and new experiences.

Every gesture and vocal inflection has been "conceived as responses to the action of the moment, rather than any predetermined view of the roles they play" (234). Watching them onscreen is like witnessing young children making sense of new phenomena by drawing on their creative faculties.

Screenwriters have to remain adaptable, not only in their approaches to textual transformation, but in their professional lives as well. Carol Wolper recommends that any aspiring scribe "learn how to adapt and follow through," seek out new opportunities, try new methods, and take note of peer advice: "You don't have to agree with everything they say . . . but if they feel they are talking in vain, they'll move on" (7, 14). Such suggestions evoke Bruner's observations about the importance of revising self-narratives in line with prevailing conventions. Wolper emphasizes the importance of cultivating new

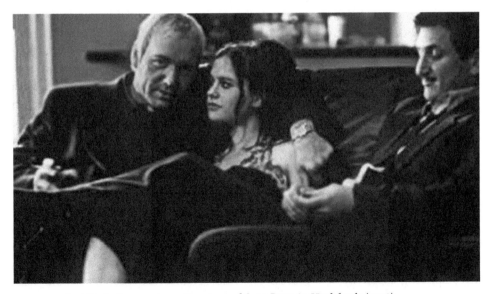

FIGURE 28.1 Kevin Spacey, Anna Paquin, and Sean Penn in *Hurlyburly* (1998).

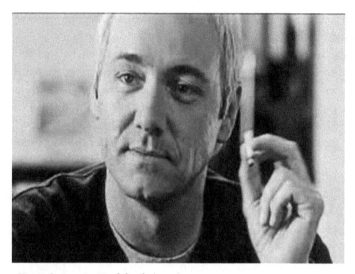

FIGURE 28.2 Kevin Spacey in *Hurlyburly* (1998).

ideas through adaptation: "The brain can be re-tooled. Old habits don't have to die pain-fully. It's amazing how an addiction to freedom and working for yourself can cure you of attachment" (27). To acquire the ability to adapt and possibly change the way the act of screenwriting is viewed is a tantalizing prospect that can help individuals "take stock of all the things . . . [they] have going as a way of reconnecting to the foundation of . . . self-esteem" (42). For Wolper, the adaptive act, conceived in terms similar to those proposed by Piaget and Winnicott, represents "FREEDOM and inspiration" (60).

This cognitive approach to adaptation and translation might seem unsatisfactorily imprecise because it makes no attempt to differentiate the two processes. If we view adaptation and translation as transformative acts involving individuals as well as the communities they inhabit, however, then it follows that any definition of either term would be perpetually subject to renegotiation. They are not untranslatable or unadapt-able, as Emily Apter would have us believe, but their meanings are fluid, subject to change in cross-cultural as well as monolingual contexts. They also promote what Thomas Leitch has described as an "active literacy" that focuses on questions like "What should reading [or translating or adapting] be for?" and encourages individuals to begin acts of rewriting that can "inspire storytellers and analysts alike to their own productive and inevitable rewriting" (20–21).

How can the cognitive approach reshape the way we undertake adaptation or translation studies? To answer this question, I turn to *Adaptivity as a Transformative Disposition for Learning in the 21st Century* (2014), a collection of position papers concentrating largely on education in Singapore and the surrounding territories that attempts to redefine educational practices at the secondary and tertiary levels. The editors take up and extend Leitch's concept of active literacy into a blueprint for reform, encompassing adaptivity as a process epistemology involving individuals and com-munities and adaptivity and learning as transformative dispositions. Such notions are

especially significant in Singapore, a small nation-state aspiring to global orientation. The Ministry of Education has sponsored several initiatives designed to encourage educators to experiment with alternative pedagogies and offering different pathways to learners with diverse abilities (Hung, Lim, and Lee viii). In "An Ecological Perspective on Scaling: Balancing Structural and Individual Adaptivities," Shu-Shing Lee and a group of collaborators construct an ecological model of learning that permits innovation to spread, grow, and sustain itself over time and space. Its foundations involve sowing the seeds of intellectual and personal growth through the provision of communication resources while promoting "people capacity development" (292), more precisely defined as enabling learners to contemplate the possibilities of innovation and adapting or translating them to a variety of contexts. While individual opinions are valued, such seeds will "spread" (296) and "grow" (297) only through group interactions: learners and educators alike have to cultivate their abilities of negotiation and decision-making. The educator's task also involves the "grafting" (299) of new material into the learning context and subsequently disseminating it across classrooms, schools, and system-wide settings.

Once these adaptive seeds have been sown, they need to be harvested and refined across a wide catchment area. This can be accomplished only through sharing, whether online or through publications, workshops, and symposiums. The sharing process should be dialogical in order to promote further experimentation and a refining of existing initiatives. Harvesting and distribution lead to the creation of new communities of practice dedicated to innovation, respecting individuals yet recognizing the power of group intervention (Lee et al. 278–317).

In their conclusion, the editors suggest that the ecological model leads to the creation of "adaptive experts" who "rise above their routine expertise to demonstrate flexible and adaptive performances in different and unique situations" (318). They constantly search for "out-of-the-box" solutions to problems both practical and intellectual, while courageously venturing into unknown theoretical territory without feeling unduly at risk: "They try to make their tacit assumptions explicit and experiment with new possibilities" (321). Following Bruner, the editors do not separate individuals from their communities: adaptation and translation evolve from the dialectics between the two. Communities dedicated to transformation are termed "micro-cultures." If such cultures can be established in schools, in regions, and ultimately countrywide, then educators and learners can discover tangible ways in which learning will improve without radically redefining their curricula (337). Micro-cultures create "tipping-points," the stimuli that produce "eco-cultural change" (342) and that engender a new understanding of what education involves (Hung et al., "Conclusion" 347).

This ecological model of learning could promote similar innovation in adaptation and translation studies. Part of the groundwork for this innovation is the acknowledgment that teaching and research are not separate activities, but that both are essential aspects of academic practice. Tony Gurr and I suggested recently that in some contexts there has been a "divorce of pedagogy from subject-matter specialties: educators spend most of their time engaged on individual research projects and use the lecture [or seminar] as

the quickest and most convenient mode of dealing with content delivery duties" (Raw and Gurr 60). The polemicist Larry Cuban believes that this is the inevitable outcome of "the deeply revered university norm of faculty autonomy," in which individual departments have for all intents and purposes been left to their own devices (53). While this might be too much of a sweeping generalization (some institutions have adopted flexible and innovative teaching methods[1]), more work needs to be done in the areas of discussion-based teaching, problem-solving, and metacognition—developing learners' abilities to reflect on how they are adapting to new material and how other strategies might suit them better (Bok 189–90). Forming research communities in which educators and learners collaborate in developing new ideas might be one way to address this issue. Learners can be given a series of questions to answer in groups, while the educator listens to discussions and engages with the groups as needed. The focus should be on developing twenty-first-century learning abilities like resilience and openness through discussion by making all participants more aware of their existing capabilities and more resourceful in developing these capabilities further. They should learn to reflect on what they value, what they know, what they do with what they know, and how they might improve themselves (Raw and Gurr 61).

This form of learning encourages educators and learners to reflect on what received notions of translation and adaptation involve, to develop new approaches that shift away from current paradigms like those shaped by literary or media studies, and to move into hitherto undiscovered areas like those set forth by Piaget and Winnicott. Such initiatives can help to sow the seeds of future research concerning their introduction into different academic and educational cultures and the cultivation of the kinds of abilities associated with twenty-first-century learning at the heart of similar initiatives in Singapore. By encouraging individual scholars, educators, and learners to cultivate what Piaget would call their own adaptive or translational strategies, we can establish new theoretical possibilities—outside-the-box solutions to such issues as the role of translation theory in adaptation studies and the role of adaptation theory in translation studies. Through group interaction, we can negotiate and refine our ideas by setting aside the confrontational model of academic practice that underpins Cattrysse's *Descriptive Adaptation Studies*, which dismisses certain theorists' work as "hasty," and construct in its place a collaborative environment dedicated to experiment and innovation. This might seem idealistic, but the success of the recent initiatives in Singapore set forth in *Adaptivity as a Transformative Disposition* emphasizes the potential of communities to redefine the educational and theoretical agenda in different subject areas.[2]

These communities do not reject existing bodies of knowledge—there is still a place for Cattrysse's DAS approach—but subject them to extensive scrutiny as a basis for establishing new areas of research. In the fields of adaptation and translation studies, several questions along these lines invite a closer look. How does the significance of individual transformations alter the way in which DAS views the dialectic between the individual and society? Do we need to forge new micro-cultures based on the psychological models put forth by Bruner, in which individuals and societies perpetually adapt their beliefs? What is the role of experience in reshaping our theoretical knowledge of

translation and adaptation? And, following Winnicott, what justification might there be in describing the adaptive work we accomplish in higher education as "playful"?

These micro-cultures need not be confined to translation or adaptation studies specialists. The ecological model of educational practice has for some time formed the basis of ecocriticism, which is principally concerned with the relationship between texts and the natural or physical environment. Do men write differently about nature than women? In what ways has literacy affected humankind's relationship to the natural? Questions like these form a cornerstone of the ecocritic's work. Adaptation and translation specialists could draw on these insights to form new constructions of Leitch's theory of "active literacy" by reflecting on whether it is an intellectual concept that demands a rethinking of individuals' relationship to their environment. Should we adapt or translate the ways we think about nature? And should a preoccupation with the natural world and our place within it reshape the way we think about adapted or translated texts?[3] Such questions might seem far-fetched, even irrelevant to the kind of textual analysis that currently forms the cornerstone of most theoretical approaches. But if we reflect on adaptation and translation in the Piagetian sense as a process of adjusting to our environment, then ecocriticism should become an essential component of our theoretical agenda.

Following the suggestions proposed by the Singapore educationalists, such collaborations might begin by sowing the seeds of new intellectual ventures, looking for radical solutions to familiar issues. Earlier in this essay I looked at Apter's notion of the untranslatable. One of the examples she discusses at length is the word *monde* (175–90). Perhaps we could reconstruct the term from an ecological rather than a linguistic perspective. This would not entail an analysis of biblical and Enlightenment notions, but would encompass humankind's relationship to the natural world. We might reflect on whether the word has been constructed as a means to render the inexpressible expressible. If this is the case, what do such strategies tell us about our concept of literacy based on our relationship to the environment, and how this concept might have changed (or not changed) over time? Whatever conclusions might be reached, it is clear that *monde* has been translated in numerous idiosyncratic ways.

The significance of such collaborations extends far beyond the disciplinary spheres of literature, film, adaptation, and translation. Jonathan Bate suggests that Coleridgean clerisies dedicated to the advancement of the humanities are intrinsic to the contemporary knowledge economy in bringing together "past, present and future, in yoking inheritance to aspiration and tradition to innovation, and in maintaining the understanding of 'those rights' and 'correspondent duties' that . . . can play a major role in 'securing' . . . that 'character of general civilization'" (12). More recently, Fred Inglis has argued that the only means by which academics can "speak the truth about the future of their respective disciplines, as well as broadening the areas of research," is to form collaborations that "reshape our commonality . . . and reject the fatuous insistence that universities should compete in all their business, as though our common pursuit of those much diminished treasures—truth, goodness, beauty—were not the noblest vocation a man or woman could follow." Group solidarity not only provides a stable environment

in which individuals can flourish, but offers a means by which academics can resist the commercialization of their institutions and point them instead toward the kind of innovative research pioneered by their colleagues in Singapore.

In some contexts, the movement toward collaboration is already in full swing. Susan Bassnett suggests that the transdisciplinary initiatives commonplace in the sciences could soon become more widespread in translation studies. Already "there is some very exciting thinking . . . coming from people who might not necessarily define themselves as Translation Studies scholars, from classicists, comparative literature, world literature, or globalization studies" (11). She believes that collaborations should neither be monolingual nor focused on one specific subject area. Translation studies has split into several areas: linguistic, technological, sociological, philosophical. If adaptation studies can do the same by accommodating the insights of Piaget, Winnicott, and Bruner, then it can trace a similar path. Future collaboration between the two disciplines should be fruitful so long as academics, educators, and learners are prepared to take risks, even in today's business-obsessed educational environment (13).

Collaborative micro-cultures not only broaden our academic, cultural, and pedagogical understanding, but also give us the opportunity to follow the kind of intellectual journey traced by Maureen Freely as a writer/translator: "It has given me a chance to stand outside my own world, to be on the receiving end as the ivory towers decide who . . . should be read, and how. If I have the confidence to assert that translators [or adapters] are best placed to make these practices visible, it is because I have changed my understanding of what it means to be a translator. Our work may begin on the page, but it rarely lets us stay there. It sends us out into the world. . . . We are witnesses, with tales to tell" (125–26). If adaptation and translation studies specialists can collaborate to produce more witnesses, then the future of both disciplines as cornerstones of the humanities agenda seems assured. The next few years should prove fascinating for everyone involved.

NOTES

1. Derek Bok cites one initiative in the United States in which professors have been encouraged to teach courses by diminishing the number of lectures while employing technology to allow more problem-solving through the use of collaborating groups, with graduate student tutors helping when students get stuck (195). The two volumes of essays edited by Cutchins, Raw, and Welsh offer a series of case studies from colleagues worldwide recounting the ways they adopted innovative methods to teaching adaptation, with specific reference to film and theater studies.
2. The significance of such approaches for the future of higher education globally cannot be overestimated. Bok emphasizes how "more active and collaborative methods of teaching" that mesh with educators' own research agendas not only motivate learners but help to reduce dropout rates, and argues that other territories need to keep up with recent initiatives in Australia, New Zealand, and Singapore in order to maintain high standards of education and publication (223–24).

3. Such questions have already been addressed by certain ecocritics. In "Loving Ourselves Best of All: Ecocriticism and the Adapted Mind," Nancy Easterlin suggests that ecocriticism requires a theoretical foundation grounded in a knowledge of evolutionary and related areas of psychology, especially Darwinian theories of adaptation.

Works Cited

Amélie. Dir. Jean-Pierre Jeunet. Perf. Audrey Tautou, Mathieu Kassowitz. Union Générale Cinématographique, 2001. Film.

Apter, Emily. *Against World Literature: On the Politics of Untranslatability.* London: Verso, 2013. Print.

Bassnett, Susan. "Translation and Interdisciplinarity: An Interview with Laurence Raw." *Journal of American Studies of Turkey* 39 (Spring 2014): 5–15. Print.

Bate, Jonathan. "Introduction." *The Public Value of the Humanities.* Ed. Jonathan Bate. London: Bloomsbury Academic, 2011. 1–17. Print.

Bok, Derek. *Higher Education in America.* Princeton: Princeton UP, 2013. Print.

Bruner, Jerome. *Making Stories: Law, Literature, Life.* Cambridge: Harvard UP, 2002. Print.

Cattrysse, Patrick. *Descriptive Adaptation Studies: Epistemological and Methodological Issues.* Antwerp: Garant, 2014. Print.

———. "Review: *Translation, Adaptation and Transformation." Journal of Adaptation in Film and Performance* 7.1 (2014): 121–24. Print.

Coleridge, Samuel Taylor. *On the Constitution of Church and State.* 1829. Ed. John Barrell. London: Dent, 1972. Print.

Coposecu, Liliana. "Discursive Hybridity at Work." *Professional Communication across Language and Cultures.* Ed. Stanca Măda and Răzvan Săffoiu. Amsterdam: Benjamins, 2012. 83–102. Print.

Cuban, Larry. *How Scholars Trumped Teachers: Change without Reform in University Curriculum, Teaching and Research.* Stanford: Stanford UP, 1999. Print.

Cutchins, Dennis, Laurence Raw, and James M. Welsh, eds. *The Pedagogy of Adaptation.* Lanham: Scarecrow, 2010. Print.

———, eds. *Redefining Adaptation Studies.* Lanham: Scarecrow, 2010. Print.

Easterlin, Nancy. "Loving Ourselves Best of All: Ecocriticism and the Adapted Mind." *Mosaic* 37.3 (2004): 1–18. Print.

Freely, Maureen. "Misreading Orhan Pamuk." *Translation: Translators on their Work and What It Means.* Ed. Esther Allen and Susan Bernofsky. New York: Columbia UP, 2013. 117–27. Print.

Göpferich, Suzanne, Gerrit Bayer-Hohenwarter, Frederike Prassl, and Johanna Stadlober. "Exploring Translation Competence Acquisition: Criteria of Analysis Put to the Test." *Cognitive Explorations of Translation.* Ed. Sharon O'Brien. London: Continuum, 2011. 57–86. Print.

Hung, David, Kenneth Y. T. Lim, and Shu-Shing Lee, eds. *Adaptivity as a Transformative Disposition for Learning in the 21st Century.* Singapore: Springer Science and Business Media, 2014. E-book.

Hung, David, Kenneth Y. T. Lim, and Shu-Shing Lee. "Conclusion." Hung, Lim, and Lee 323–47. E-book.

———. "Series Editors' Foreword." Hung, Lim, and Lee ii–xi. E-book.

Inglis, Fred. "Today's Intellectuals: Too Obedient?" *Times Higher Education Supplement*, 28 Aug. 2014. Web. 2 Sept. 2014.

Krebs, Katja. "Introduction: Collusions, Diversions and Meeting Points." *Translation and Adaptation in Theatre and Film*. Ed. Katja Krebs. New York: Routledge, 2014. 1–13. Print.

Kumcu, Alper. "Translational and Transnational (Hi)Story: [The] Role of Translation and Interpreting in the Course of Turkish Republic Accession to [the] European Union." *Role of Translation in Nation Building*. Ed. Ravi Kumar. New Delhi: Modlingua, 2012. 73–87. Print.

Lee, Shu-Shing, David Hung, Laik Woon Teh, Yew Meng Kwan, Swathi Vishnumahanti, Ambar Widiastuti. "An Ecological Perspective on Scaling: Balancing Structural and Individual Adaptivities." Hung, Lim, and Lee 278–317. E-book.

Leitch, Thomas. *Film Adaptation and Its Discontents: From* Gone with the Wind *to* The Passion of the Christ. Baltimore: Johns Hopkins UP, 2007. Print.

Mars-Jones, Adam. "Bubbles Burst." *Times Literary Supplement* 5810 (8 Aug. 2014): 17–18. Print.

Mood Indigo/ L'écume des jours. Dir. Michel Gondry. Perf. Romain Duris, Audrey Tautou. Studio Canal, 2013. Film.

Naked Lunch. Dir. David Cronenberg. Perf. Peter Weller, Judy Davis. Twentieth Century Fox, 1991. Film.

O'Brien, Sharon. "Introduction." *Cognitive Explorations of Translation*. Ed. Sharon O'Brien. London: Continuum, 2011. 1–15. Print.

Pamuk, Orhan. *Kar*. İstanbul: İletişim Yayınları, 2002. Print.

———. *Snow*. Trans. Maureen Freely. New York: Knopf, 2004. Print.

Piaget, Jean. *The Psychology of Intelligence*. Trans. Malcolm Piercy and D. E. Berlyne. 1947. Rpt. Totowa: Littlefield Adams, 1976. Print.

Pym, Anthony. *On Translator Ethics*. Trans. Heike Walker. Amsterdam: Benjamins, 2012. Print.

Raw, Laurence. "Actor, Image, Action: Anthony Drazan's *Hurlyburly* (1998)." *Modern American Drama on Screen*. Ed. William Robert Bray and R. Barton Palmer. Cambridge: Cambridge UP. 2013. 220–38. Print.

———. "Introduction: Identifying Common Ground." *Translation, Adaptation and Transformation*. Ed. Laurence Raw. London: Continuum, 2012. 1–21. Print.

Raw, Laurence, and Tony Gurr. *Adaptation Studies and Learning: New Frontiers*. Lanham: Scarecrow, 2013. Print.

Ulysses. Dir. Joseph Strick. Perf. Barbara Jefford, Milo O'Shea. British Lion, 1967. Film.

Venuti, Lawrence. "Adaptation, Translation, Critique." *Journal of Visual Culture* 6.1 (2007): 25–44. Print.

Weigand, Edda. "Professional Action Games: Theory and Practice." *Professional Communication across Languages and Cultures*. Ed. Stanca Măda and Răzvan Săftoiu. Amsterdam: Benjamins, 2012. 43–61. Print.

Winnicott, D. W. *Playing and Reality*. 1971. Abingdon: Routledge Classics, 2005. E-Book.

Wolper, Carol. *Adapt or Wait Tables: A Freelancer's Guide*. Los Angeles: Rare Bird, 2013. E-book.

CHAPTER 29

ADAPTATION AND INTERMEDIALITY

LARS ELLESTRÖM

THE overarching aim of this essay is to investigate the relation between the two research fields of adaptation and intermediality and to demonstrate why, to my mind, adaptation studies is in dire need of a broad intermedial research context and well-developed intermedial concepts.

I start with an examination of the three words in my title. What is *intermediality*? What is *adaptation*? How should adaptation *and* intermediality be understood? I do not believe that the relation between adaptation and intermediality is a relation between two equal parts; it is rather a relation of subordination. Most theoretical and practical issues that are closely knit to adaptation are part of the broader scholarly field of intermediality.

After these fundamental preliminaries, I present a list of ten more or less explicit and more or less acknowledged ways of delimiting the notion of adaptation within the broader field of intermediality. These borders of adaptation, sometimes only implied and sometimes, importantly, contested by researchers, are surveyed and each one briefly scrutinized. The goal is to pinpoint border zones of adaptation that are only partly recognized as such by adaptation scholars. While the presented list is not complete, I try to cover the most pertinent issues regarding the limits of adaptation and hence adaptation studies. My main points in this section of the essay are that failing to reflect on these borders ignores relevant neighbor disciplines, and that insufficient attention to related theoretical fields severely reduces the possibility for adaptation studies to produce research that is relevant for a broader range of phenomena and a broader field of scholars.

In the final section of the essay, I return to the core issues of intermedial research, and hence of adaptation studies, and summarize some vital notions that are helpful for investigating essential similarities and differences among media and for capturing the material and semiotic conditions for adaptation. Whereas these notions are well-suited for analyzing adaptation processes, whether adaptation is understood in narrower or broader ways, they are designed for investigating intermedial relations at large, thus placing adaptation in a wider-ranging context of media interrelations.

THE RELATION BETWEEN ADAPTATION
AND INTERMEDIALITY

Putting two concepts or research fields together in a linguistic construction is easy. Understanding and describing their interrelations may be trickier, and suggestions are bound to be debatable. As a devoted intermedial researcher much interested in adaptation studies, however, I find the relation between adaptation and intermediality relatively clear-cut.

What Is Intermediality?

Media may be understood as communicative tools; they are intermediate entities that make connection between two or more minds possible. If used unspecified in the following, the term *media* refers broadly to both single media products and media types. All media are multimodal and intermedial in the sense that they are composed of multiple basic features and are fully understood only in relation to other kinds of media, with which they share basic features. Briefly put, intermediality is (the study of) specific relations among dissimilar media products and general relations among different media types. Werner Wolf, one of the leading intermediality researchers, defines *intermediality* as a relation "between conventionally distinct media of expression or communication: this relation consists in a verifiable, or at least convincingly identifiable, direct or indirect participation of two or more media in the signification of a human artefact" (37). Not all intermediality scholars share exactly the same concepts and goals, of course; the view presented here concerns intermediality geared to semiotics rather than, say, cultural studies. For me, intermediality can plainly be described as an approach that highlights media differences—and hence media similarities—and their constitutive role for meaning-making within communication. I further suggest that theoretical studies of intermediality are roughly divided between two main perspectives (Elleström, *Media Transformation* 3–4).

The first is a synchronic perspective: How can different kinds of media be understood, analyzed, and compared in terms of the combination and integration of fundamental media traits? This viewpoint emphasizes an understanding of media as coexisting media products, media types, and media traits.

The second is a diachronic perspective: How can the transfer and transformation of media characteristics be comprehended and described adequately? This viewpoint emphasizes an understanding of media that includes a temporal gap among media products, media types, and media traits—either an actual gap in terms of different times of genesis or a gap in the sense that the perceiver construes the import of a medium on the basis of previously known media. This goes beyond the general field of media history, that is, the study of how media types evolved and were transformed throughout the

centuries. We find the latter sense of a diachronic perspective on media in, for instance, Irina Rajewsky (46–47).

Media characteristics is a term that I use to denote all sorts of media traits associated with both form and content: structures, stories, rhythms, compositions, contrasts, themes, motifs, characters, ideas, events, moods, and so forth. All the things that can be represented by a medium, in the broad sense of being made present to the perceiver's mind, are media characteristics; these characteristics are more or less transmedial, meaning that they can be more or less successfully transferred among different kinds of media (Elleström, *Media Transformation* 39–45).

Regarding the diachronic perspective, I find it imperative to keep an emphasis on both the notion of transfer, indicating that identifiable traits are actually relocated among media (the story and characters of a comic strip can be clearly recognized in a movie), and the notion of transformation, stressing that transfers among different media nevertheless always entail changes (the story in the movie cannot possibly be identical to the one in the comic strip). For the sake of brevity, however, I refer to this perspective simply as *media transformation*.

Hence, whereas intermediality broadly includes all sorts of relations among different kinds of media, transmediality more narrowly includes intermedial relations that are characterized by actual or potential transfers. The issues to be discussed in what follows might thus be termed both intermedial and transmedial.

What Is Adaptation?

For me, it is more difficult to define adaptation than intermediality. Of course, I have a reasonably good idea of it, but lack professional motivation to circumscribe it in a more precise way. Hence I see it as my task to highlight the ways adaptation could be defined in narrower or broader ways, rather than to actually define it myself.

Nevertheless, I do have a few quite stern suggestions regarding adaptation in relation to intermediality. Adaptation, understood as a media phenomenon and not as adjustment or acclimatization of just about anything, is no doubt a kind of media transformation. Furthermore, it is a specific kind of media transformation. I find it convenient and theoretically motivated to distinguish between two kinds of media transformation that should be understood as two analytical categories, rather than two object types. The first is *transmediation*: repeated (although certainly not identical) representation of media characteristics by another medium, such as a television program featuring the same characters and themes as a children's book or being narratively structured as a classical drama. The second is *media representation*: representation of another kind of medium, such as a review that describes a dance performance or refers to music; a medium, which is something that represents, becomes represented itself. Whereas transmediation is about "picking out" elements from a medium and using them in a new way in another medium, media representation is about "pointing to" a medium from the viewpoint of another medium. In other words, whereas in transmediation the "frame" is not included

in the transfer from one medium to another, it is in the case of media representation. While these two types of media transformation overlap in practice, of course, it is convenient to distinguish them theoretically, as they emphasize two different ways of transferring media characteristics among dissimilar media (Elleström, "Adaptation"; *Media Transformation* 11–35).

The most well-known example of media representation within the artistic domain is ekphrasis, typically a poem representing a painting. Ekphrases are generally understood to refer directly to their represented objects (the ekphrastic poem may use words such as "painting" or "image" and phrases such as "to the left" or "in the middle of the picture"). The most well-known example of transmediation within the artistic domain is adaptation, typically a movie transmediating a novel. Outside the credits, the adapting movie does not typically refer to the adapted novel (for instance, the characters do not say that "we are now close to the end of the novel"); it rather uses the characteristics of the novel in a new way. Apart from these established types of media transformation and media transformation research, there is a broad range of other transmedial research issues without recognized names. The popular notion of remediation is no doubt closely related to the issue of media transformation, even though Bolter and Grusin, for example, do not properly delineate it from an intermedial point of view.

Adaptation is thus a sort of transmediation: a medium represents again, but in a different way, some characteristics that have already been represented by another kind of medium. This is as far as I want to go in the direction of defining adaptation. Since no one has ever, to the best of my knowledge, circumscribed adaptation in terms of media representation, I do not find this delimitation very controversial. Adaptation is no doubt commonly understood as the transfer of media characteristics from one medium to another, but not as media representation. A medium that adapts another medium does not represent that other medium; it represents its characteristics in a new way. For instance, a movie representing a theater performance (a movie that includes the performance of theater in its plot) is not normally called an adaptation; however, a movie whose plot closely resembles that of a theatrical play is generally believed to be an adaptation.

I am not the only one who hesitates to delimit the notion of adaptation beyond this point. Although condensed and detailed definitions of complex phenomena may be useless and even misleading, it is surprising to note the lack of efforts to actually define the phenomenon and research area of adaptation beyond the fundamental idea that it involves some sort of transfer among different media (sometimes adaptation is actually understood also as transfer among similar media, which makes it an intramedial as well as an intermedial phenomenon). Browsing the research, one finds an abundance of case studies, many research summaries, and (during the last decades) an increasing number of entirely warranted critical discussions of inadequate theory and worked-out concepts. Furthermore, there are many suggestions about what adaptation studies should do instead of carrying on with run-of-the-mill analyses of similarities and differences between films and their literary sources. However, elaborated definitions regarding the essence and the borders of the field are largely missing. The research field seems to have

grown organically from a pragmatic and certainly legitimate starting point: the existence of a huge number of movies based on novels and plays.

Although it is not my aim to define adaptation, the following section of this essay will try to demonstrate that it is vital to scrutinize the border zones of adaptation. I will leave it to others with a greater incentive to demarcate adaptation studies as a separate field of media transformation studies to decide where the fences, if any, should be placed.

What *Is* Adaptation *and* Intermediality?

It should be clear by now why I think that adaptation and intermediality are not two equal parts that can either be joined or exist in conflict with each other. The undisputed fact that adaptation concerns the transfer of media traits from one medium to another medium is the most fundamental feature of adaptation, I argue, which makes it part of the broad field of transmediality and the even broader field of intermediality. Most theoretical and practical issues discussed under the heading of adaptation are hence subordinated to intermedial research questions. Please note that I say *most* theoretical and practical issues; there are certainly relevant issues for adaptation studies that are not, as such, intermedial, but rather, say, historical, sociological, or aesthetic. By the same token, intermedial studies in general is also preferably combined with various other research areas depending on the basic research questions. However, adaptation studies that disregard the fundamental condition of media transformation are arguably not really adaptation studies.

THE BORDERS OF ADAPTATION STUDIES: TEN ASSUMPTIONS

While I have already stated that adaptation is a kind of transmediation, several questions regarding its scope remain to be answered. Regardless of how adaptation has been delimited, it has only covered bits and pieces of the area of transmediation. This is a predicament. The problem is that many research objects, issues, and viewpoints are left out of focus. As a result, it has been difficult to construct comprehensive adaptation theories whose results can be generalized beyond the field itself.

I will here briefly scrutinize ten border zones of adaptation that I have identified on the basis of a critical study of adaptation research. These border zones will be indicated by means of ten more or less explicit or accepted assumptions about the limits of adaptation. I do not regard these assumptions as fallacies; my errand is to pinpoint border zones, not to suggest expanded borders for adaptation studies. The first assumption concerns the overarching question of whether adaptation concerns only specific media products or also media types in general. The second to fifth assumptions all

involve questions of which sorts of media should be dealt with: Assisting or only self-reliant media? Non-artistic or only artistic media? Casual or only premeditated media? Furthermore: if only self-reliant, artistic, and premeditated media are relevant objects of investigation, should relations among all kinds of media that fulfill these conditions be dealt with, or only relations between literature or theater and film? The sixth assumption is about what nature the transmediated characteristics have: Should adaptation be understood as transfer of all sorts of media characteristics, or only narrative traits? The seventh to tenth assumptions all have to do with what kinds of relations there are among the media involved. Can adaptation be understood as transfer of media characteristics from several media, or is it restricted to a single source medium? Can it be conceived as transfer of parts of media, or should only complete media be considered? May indirect transfers also be considered? Is adaptation always a one-directional transfer?

Whereas several of these issues are explicitly and, in the case of a few of them, even extensively discussed in existing adaptation research, others are only implied or even absent (and it would no doubt be possible to add further assumptions to my list). By the same token, several of the assumptions are contested, whereas others are defended or silently accepted. The following overview supplies a selection of references that I hope to be representative and reasonably just.

1. Adaptation is a transfer of media characteristics among media products, not qualified media. The first and perhaps most all-embracing assumption concerns the nature of the media involved in adaptation: Are they specific creations or rather clusters of media, or, in other words, are they media products or qualified media? I use the term *qualified media* to denote media types (both artistic and non-artistic) that are historically and communicatively situated, indicating that their properties differ depending on parameters such as time, culture, aesthetic preferences, and available technologies. Qualified media include types such as music, motion pictures, radio programs, and news articles. A qualified medium is constituted by a cluster of individual media products (Elleström, "Modalities" 24–27). The question for adaptation studies is whether adaptation should be understood as the transfer of media characteristics among particular media products or among qualified media.

It is clear that most researchers tacitly assume that in adaptation, both source medium and target medium are media products. Although many film adaptation studies are combined or integrated with investigations of general literature-film relations, these relations, including transfers of characteristics among different qualified media, are not called adaptation. However, when investigating individual examples of work-to-work adaptations, distinguishing clearly among general characteristics of qualified media and properties that belong to a certain media product is obviously not possible: many of the characteristics of, for instance, a particular novel are characteristics of novels or even written literature in general.

A few adaptation researchers have pointed out the consequences of this assumption. Patrick Cattrysse notes that the sources of a film adaptation may be manifold; they are not only literary and not necessarily specific media products. American *films noirs*, for

instance, adapted not only literary works but also features of "German Expressionism of the 1920s as well as American contemporary photography, drawing and painting" ("Film [Adaptation]" 61). A decade later, Kamilla Elliott more emphatically points out that the field that she prefers to refer to as adaptation does not always consider common media traits (*Rethinking* 113–32). To use my terminology, Elliott argues that the notion of adaptation should include the transmediation of both media products and qualified media. However, the assumption that adaptation is the transfer of media characteristics among media products, not qualified media, is still a cornerstone of adaptation studies.

2. Adaptation is a transfer of media characteristics among self-reliant media, not assisting media. The second assumption is that adaptation involves only media that are independently distributed and appreciated as finished works in their own right, not media that are assisting in the process of media production. This means that qualified media such as scores, scripts, and libretti, designed to be transmediated and having qualities that make them less fit to be appreciated by non-specialists, are not treated as source media for adaptation. Jack Boozer, who argues for a focus on the screenplay in film adaptation, suggests an explanation of why this is not standard procedure: "a work of fiction or drama typically has a single author and a readily consumable existence in published form, just as an adapted film can be recognized as a finished entity on screen. The adapted screenplay, however, has had no comparable existence as a finished artifact for public consumption (with the exception of published transcripts)" (2).

Of course, all adaptation scholars are well aware of the existence of assisting media such as screenplays and libretti; the point is that they are generally not considered to be sources for adaptation. While adaptation research often discusses assisting media, it is normally implied, rather than openly stated, that they are not really source media. But several researchers, including Boozer and Thomas Leitch ("Twelve Fallacies" 150), have challenged this assumption. Robert Stam states, briefly and paradoxically, that "[e]ven non-adaptation fiction films adapt a script" ("Introduction" 45). Furthermore, Anna Sofia Rossholm examines an assisting media type that has not received much attention—the artist's notebook—in a study that treats director Ingmar Bergman's notebooks as sources for adaptation ("Auto-Adaptation").

Because there is no such thing as a definite and indisputable source medium, I think that few adaptation scholars would dispute the possibility of treating assisting media as source media. The choice of examined source medium is a choice guided by critical attention and an appreciation of relevance. Nevertheless, so far there has been no turn of the tide; the study of self-reliant media as source media still clearly dominates the field.

3. Adaptation is a transfer of media characteristics among artistic media, not non-artistic media. The third assumption seems to be implicitly embraced by most adaptation scholars within the humanities. Adaptation studies have devoted themselves wholly to investigating how media characteristics are transferred among media that include or have strong connections to artistic media. This is the case also for explorations of adaptation of history. To the best of my knowledge, no one has ever contested the notion that

adaptation is an artistic process (although it is often recognized that the term *adaptation* also refers to notions such as the adaptation of species in natural surroundings, notions that may be relevant for comparison with artistic adaptation). On the other hand, it has not been defended either, as it is an assumption that is not explicitly stated. It should be noted, though, that the range of artistic works dealt with by adaptation scholars has expanded. In an influential collection of adaptation essays from the late 1990s, editors Deborah Cartmell and Imelda Whelehan included studies of popular culture (172–225), opening the gates for research on adaptation among a wide range of popular culture products. Popular culture, however, also consists of artistic media, whether one finds the aesthetic level high or low. Non-artistic media such as news reports and advertisements (also potentially aesthetic; there is no definite border between artistic and non-artistic, of course) are still waiting to be embraced, or even noticed, by adaptation studies.

4. Adaptation is a transfer of media characteristics among premeditated media, not casual media. A fourth assumption seems to be tacitly embraced by all adaptation scholars. The notion that adaptation involves premeditated media—media that are planned, designed, and carefully worked out—is taken for granted. It is neither overtly declared nor contested. Casual media types such as ordinary speech, gestures, and email messages are excluded by default. Whereas this may be said to be a consequence of non-artistic media being avoided, casual media are one step further away from standard adaptation studies, so to speak: even if non-artistic media were to be included in the research field, that would certainly not automatically lead to an inclusion of casual media.

Although I am not aware of any attempts to expand adaptation studies to the domain of casual media, Francesco Casetti takes a step in that direction when he suggests "regarding audiovisual and literary texts as one would regard conversations, newspaper reports, public speeches, research reports, stories and anecdotes" (82). In other words, he argues that non-artistic and casual media should be part of the field of reference in adaptation research in order to level the media hierarchy. However, we are still waiting for someone to suggest that adaptation studies should investigate the transfer of characteristics among casual media. Such an investigation would constitute a major expansion within the area of transmediation. Whereas an inclusion of both non-artistic and casual media would no doubt be a key shift of focus for adaptation studies, it would also mean that the fundamental material and mental conditions for transfer of characteristics among dissimilar media could be investigated on the basis of a broader and more varied empirical material.

5. Adaptation is a transfer of media characteristics from literature or theater to film, not among other qualified media. Given that the empirical material for adaptation studies does not include assisting, non-artistic, and casual media, it is also generally assumed that adaptation involves the transfer of media characteristics from literature or theater to film, rather than among other media types. For many, novel-to-film adaptations are the archetypical adaptations. However, it has always been taken for granted that short

stories and plays may be source media for adaptation as well as novels. The earliest stud-ies of film adaptation investigate adaptations from stage plays, and film adaptations of Shakespeare are a classical locus for adaptation studies.

Nevertheless, a further expansion of source media types and an adding of various target media types have clearly been on their way for some decades. The narrow scope of films adapting literature and theater has been openly and even forcefully contested by several researchers, many of them influential. Discussing adaptation in the context of interpretation theory, Dudley Andrew argues in 1984 that adaptation is certainly broader than novel-to-film relations (96–106). Andrew later suggests that adaptation might include the notion of film adapting history rather than other media ("Adapting Cinema to History"; cf. Geraghty 167–91). In a way, this would move adaptation studies beyond the range of intermediality, if it were not for the fact that history always reaches us in mediated forms.

Adaptation research beyond the literature or theater-to-film formula has appeared in various forms. There have been investigations of adaptation from film to novel, from comics to film, and from novel to cartoon to film (Cartmell and Whelehan); from novel to opera (Halliwell); from oral narratives to film (Cham); from drama to sym-phony, from drama to opera, from novel to song, from novel to film to opera, and from music to novel (Urrows); from graphic novel to film and from film to digital cinema (Constandinides); and so forth (see also, for instance, Elliott, *Rethinking*; Hutcheon; and Leitch, *Film Adaptation*). Nonetheless, the implicit literature- or theater-to-film formula continues to have a firm grip on adaptation studies. There are still many sorts of transmediation among premeditated, artistic, and self-reliant media that are not usually counted as adaptation—for instance, the declamation of written poetry and other kinds of transmediation between written and spoken verbal texts (but see Groensteen 276–77).

6. Adaptation is a transfer of narrative traits, not other media characteristics. The sixth assumption concerns the nature of transmediated characteristics. It is often, perhaps almost always, implied that adaptation involves the transfer of narrative traits, not other media characteristics—unless they are accompanied by a transfer of narrative charac-teristics. Sometimes this assumption is made explicit. Although Linda Hutcheon inves-tigated a wide range of artistic media in *A Theory of Adaptation* (2006), for instance, her study was overtly limited to the adaptation of stories.

Stories, however, are not the only things that can be transferred among dissimilar media. My technical term for more or less transmedial traits is *compound media charac-teristics*, which should be understood as cognitive entities represented by media (*Media Transformation* 39–45). Virtually endless numbers of compound media characteris-tics are available for transfer among dissimilar media—for adaptation, if one wishes. However important, narration is only one such compound media characteristic, or rather one such constellation of media characteristics. It is well-known within adapta-tion studies that narratives consist of many elements that are intricately related to each other. In an elementary manner, the form-content dichotomy may help us understand

what is actually transferred when narratives are transformed from one kind of medium to another. On the one hand, plots and stories (the series of events as they unfold in the temporal decoding of a media product, and the series of events as they are perceived to be related to each other in the represented, virtual world) are two types of narrative sequential structures that are transferred among media. Additionally, the storyworld, which includes an elaborate virtual space, may be at least partly transferred among dissimilar media. In addition, parts of narratives—such as relations among particular characters or other figurations—may be transferred; clearly, relations among entities of this type are formal narrative features. On the other hand, many features in narratives are perceived as entities. Hutcheon lists a number of elements of a story that are certainly compound media characteristics and may be understood as transmedial narrative content, such as characters, motivations, consequences, events, symbols, and themes (10).

Whereas narration is traditionally associated with literature and motion pictures, it has increasingly gained the status of a fundamental cognitive notion during the last few decades. Transferring narratives and narrative traits among other media types is also possible. Marie-Laure Ryan, among others, has investigated this phenomenon and has explored what she calls "transmedial narratology" (35). Yet these new developments have not been picked up by adaptation scholars to any great extent.

My main point here, however, is that the notion of narrative reaches far—especially if perceived as a fundamentally transmedial characteristic—but not far enough if one aims at a more complete understanding of what kind of media characteristics may be transferred among dissimilar media. Adaptation scholars acknowledge this limitation from time to time, as when they observe that adaptation involves a transfer of "the spirit" of the source (see Elliott, *Rethinking* 136–43). For instance, Micael M. Clarke argues that in spite of conspicuous deviations from the narrative, Mira Nair's film adaptation of the novel *Vanity Fair* "captures the essentials of Thackeray's vision: his social critique, his feminist sympathies, and his dark satire on British imperialism" (39).

I conclude that it is not uncommon to include media characteristics that do not have very much to do with narrative in discussions of adaptation. The assumption that adaptation involves only the transfer of narratives is more often contested than explicitly formulated and defended. However, there is a palpable lack of elaborated discussion and conceptualization regarding the central question of what, apart from narrative, is actually transferred among media in adaptations. Whereas there are plenty of rewarding investigations of the narrative capacities of literature and film, respectively, other media types and other kinds of compound media characteristics are not nearly as well scrutinized.

7. Adaptation is a transfer of media characteristics from one medium to another, not from several media. It is now time to investigate how adaptation has been delimited within the area of transmediation regarding different kinds of relation among source and target media. The seventh assumption is that adaptation involves only one source medium. However, specific transfers of media characteristics may also be understood as

parts of more far-reaching and complex networks involving many media. Several source media products or source media types may be transformed into one target media product or media type, and one and the same source media product or source media type may be transformed into several target media products or target media types. Whereas it has always been taken for granted that a source may be adapted several times, few adaptation scholars consider that the process of adaptation may include several sources. However, the assumption that adaptation involves only one source has been contested by a handful of scholars. More than two decades ago, Cattrysse unambiguously argued for the notion that adaptation often entangles several source media ("Film [Adaptation]"; "The Unbearable Lightness of Being"). The tenth of Leitch's "Twelve Fallacies in Contemporary Adaptation Theory" is that *"[a]daptations are adapting exactly one text apiece"* (164–65). Other scholars have argued for the advantages of including several sources in investigations of adaptation (see Lev; Schober; compare Hutcheon xiii).

It is furthermore evidently the case that a medium acting as the target in one specific case of media transformation may be viewed as the source of yet another target. In the end, most media products, and also qualified media, may well be knitted together in a huge and ever-unfinished web of media transformations.

8. Adaptation is a transfer of media characteristics among complete media, not parts of media. The eighth assumption is that both sources and targets should be considered in their entirety, not piecemeal. Although this is tacitly understood as the norm, I think that few would defend it at any length. Nobody denies that adaptation necessarily involves deviations from the source, which means that the source cannot in any absolute sense be transferred completely. It is furthermore common to consider only parts of the source medium, the target medium, or both. Nevertheless, a majority of adaptation investigations focus on whole media products rather than fragments. The idea of adapting a qualified medium in its entirety, however, is clearly absurd.

This is not a major issue in adaptation studies, and it is rarely brought to the surface of discussions (but see Schober 89). Yet it is certainly relevant to determine the position of adaptation studies in relation to the many research areas within the humanities that deal not with comparisons of complete media products but rather with general comparisons of ideas, approaches, styles, themes, motifs, and structures in various media products and qualified media.

9. Adaptation is a direct, not an indirect, transfer of media characteristics among media. This ninth assumption is related but not identical to the second assumption that adaptation involves only self-reliant and not assisting works. At issue here, however, are not the sorts of media but the kinds of relations among media that are involved in adaptation. Whereas the second assumption excludes assisting media, the ninth assumption excludes intermediate media. Hence, according to the ninth assumption, adaptation is normally understood as (or at least investigated as) a direct transfer of characteristics from a source to a target, without considering potential intermediate media that may be either assisting or self-reliant, finished works in their own right.

This assumption is something of a paradox, as it is no doubt normal procedure to think and analyze in terms of transfer from novel to film, for instance, despite the well-known fact that virtually all novel-to-film adaptations are based on scripts that are based on novels, short stories, plays, and so forth (see Leitch, "Twelve Fallacies" 154). Not unexpectedly, then, the implied idea that it is not the business of adaptation studies to deal with intermediate media has been contested by several scholars. Pedro Javier Pardo García, situating his arguments within the general frame of intertextual theory, observes that it is sometimes so difficult to recognize unambiguous sources and targets that it may be unavoidable to consider intermediate media products when investigating adaptation processes. Examining Kenneth Branagh's film adaptation *Mary Shelley's Frankenstein*, he focuses on intermediate stages of myth, versions in various media types, and stories liberated from their first source: Mary Shelley's novel ("Beyond Adaptation"; cf. Cattrysse, "Film [Adaptation]" and *Descriptive* 259–61). Walter Bernhart, writing about the musical adaptation of literature in Kate Bush's song "Wuthering Heights," which refers to events in Emily Brontë's novel *Wuthering Heights*, has emphasized that thinking of adaptation "in terms of a direct transposition from one medium into another" may be difficult (25). Considering intermediate stages between what is construed as source and target is sometimes necessary, he argues, though these stages may be difficult to pinpoint because they involve networks of transfers.

10. Adaptation is a transfer of media characteristics in one direction only, not two. The tenth and last assumption that I have highlighted is based on the notion that the transfer of media characteristics from a source medium to a target medium is the core of transmediation and hence of adaptation. From a practical point of view, it is clear that no source media products are materially modified when they are adapted, and in that sense the assumption that adaptation involves one-way traffic is self-evidently true and certainly explicitly stated numerous times. From a hermeneutical viewpoint, however, it may be equally true that adaptation involves a two-way transfer of certain media characteristics. Even if one identifies a definite source media product that actually precedes the target media product, the source may be said to be affected by the target for anyone who understands the old media product differently in light of the new media product.

In a sense, then, some media characteristics may be understood to be transferred from a new media product to an old media product. Similarly, the understanding of an old qualified medium may be modified by a new qualified medium that is comprehended to be based on the old one. From a hermeneutical perspective, the source may become the target, opening the door for scholars to contest the view that adaptation goes in one direction only. Thierry Groensteen points out that the target medium may retroactively affect the perception and appreciation of the source medium (277). Elliott notes that adaptation is "mutual and reciprocal inverse transformation that nevertheless restores neither [the film nor the novel] to its original place" (*Rethinking* 229; cf. García Landa, "Adaptation, Appropriation, Retroaction"). Jørgen Bruhn, under the influence of Mikhail Bakhtin, has advocated a dialogic view of adaptation ("Dialogizing"; Bruhn, Gjelsvik, and Thune, "Possible Worlds"). In a recent article, Elliott discusses various

ways of contesting the assumption that adaptation is one-way transfer ("Theorizing Adaptations" 25).

MEDIA DIFFERENCES

I am not arguing either for or against an expansion of the notion of adaptation in opposition to the ten assumptions surveyed in the preceding section of this essay. It is not my business here to delineate the field of adaptation studies. What I do argue is that if the ten border zones are simply ignored, adaptation studies misses the opportunity for valuable theoretical cross-fertilization both within and outside the field of intermediality. As we can see, many of the border zones have already been investigated to some extent, while others have been more seriously neglected.

Considering and debating the border zones that connect adaptation to relevant neighbor disciplines, however, would be of little help without a concise understanding of the fundamental features of media. Adaptation is a kind of transmediation that is characterized by a transfer of compound media characteristics among dissimilar media, and in the end media transformation is governed by fundamental pre-semiotic and semiotic media similarities and differences. Obviously, no adaptation would be needed if there were no differences to overcome. Again, it must be emphasized that whereas any transfer of media characteristics between two different media types inevitably brings about transformation, a transfer of recognizable characteristics *is* possible; media characteristics are more or less transmedial, an observation constantly verified empirically as people observe similarities among different sorts of media, even if not every observer agrees on what these similarities are.

There are numerous top-down investigations of media differences, starting with accounts of two qualified media like written literature and film, that are fraught with assumptions about how these media types are or should be delineated. But the issue of fundamental media differences and similarities has not, to the best of my knowledge, been thoroughly investigated, though it has not passed unnoticed by adaptation scholars. Brian McFarlane approaches the issue when he distinguishes "transfer" from "adaptation proper" and argues that, although transfer is "the process whereby certain narrative elements of novels are revealed as amenable to display in film," adaptation proper is "the process by which other novelistic elements must find quite different equivalences in the film medium, when such equivalences are sought or are available at all" (13). Elements that are "not tied to one or other semiotic system" are transferable; elements that are "closely tied to the semiotic system in which they are manifested" must be adapted (20). This distinction usefully highlights the difference between more and less transmedial characteristics or elements and emphasizes that adapted elements are "closely tied" to a specific "semiotic system." Although this statement is to the point, the properties of semiotic systems must be investigated in greater detail beyond McFarlane's linguistically colored notion of "enunciation" to reach an understanding of the "equivalences" among semiotic systems.

Other researchers who have moved toward the basic and decisive differences between media types include Thierry Groensteen, who argues that any media change necessarily affects the manner in which the new medium represents (275), and André Gaudreault and Philippe Marion, who claim that "any process of adaptation has to take into account the kinds of 'incarnations' inherent in this encounter in terms of the materiality of media" (61)—a statement I would urge is valid for the field of media transformation at large.

However, these observations have a rather preliminary nature. I have therefore developed a somewhat more detailed bottom-up account of fundamental media similarities and differences, starting not with media types and their interrelations but with the smallest units of material and mental media properties. In a research paper on intermediality and multimodality at large, I have presented what I call the four modalities of media: the material, the sensorial, the spatiotemporal, and the semiotic ("Modalities" 17–24). The first three modalities, which are pre-semiotic, should be understood as media properties that precede interpretation but are bound to become involved eventually in the semiotic domain. A modality should be understood as a category of related media characteristics that is basic in the sense that all media can be described in terms of all four modalities. All individual media products, and all conceptions of qualified media, may be understood as specific combinations or types of combinations of modes of the four modalities—in other words, unions of particular traits belonging to the four modalities. A particular media product must be realized through at least one material mode (as, say, a solid or non-solid object), at least one sensorial mode (as, for instance, visual or auditory, or both), at least one spatiotemporal mode (as spatial or temporal, or both), and at least one semiotic mode (as mainly iconic, indexical, or symbolic). Though they are far from covering all media features, these four modalities form a skeleton on which all media are built. In *Media Transformation*, I use this theoretical framework to analyze media transformation, including transmediation and media representation.

On the basis of such a bottom-up understanding of media interrelations, I conclude that written literature and film are essentially dissimilar. There are also essential differences between written literature and oral literature, which means that more careful analyses of media transformations must uphold this important distinction (in adaptation studies "literature" almost always implicitly refers to written literature). Many researchers load their revolvers when hearing the word *essential*. But there are many kinds of essences, and not all of them are social constructions. Essential similarities and dissimilarities among media consist of basic pre-semiotic and semiotic features. For instance, the qualified medium of film is now understood by most people in most cultures to be a combination of visual, predominantly iconic signs (images) mediated on a flat surface and sound in the form of both icons (as music), indexes (sounds that are contiguously related to events in the film), and symbols (as speech), all expected to develop in a temporal dimension. The combination of these features is no doubt a historically determined social construction of what we call the medium of film, but given these qualifications of the medium, it has a certain essence. Because qualified media are

cultural conceptions that are created, perceived, and defined by human minds, there are no media types "as such" and therefore no independent essences of qualified media "as such"; however, once we agree that, for pragmatic reasons, it is meaningful to say that there are dissimilar media types, essential pre-semiotic and semiotic traits are inscribed into these conventionally defined qualified media. It would be nonsensical to argue that a static collection of visual symbols (letters and words) mediated, for instance, by a book actually constituted a film. This is because there are essential dissimilarities on a basic level between our conceptions of written literature and film. One hundred years ago the two qualified media were construed slightly differently, which means that, at that time, the essential dissimilarities between what was then called written literature and film were slightly different; the same terms were used to refer to somewhat different media notions.

These dissimilarities are of a different nature than those allegedly essential media properties that Leitch—correctly, I think—judges to be "functions of their historical moments and not of the media themselves" ("Twelve Fallacies" 153). Leitch argues against Seymour Chatman's "essentialist view that novels and films are suited to fundamentally different tasks—in Chatman's view, assertion and depiction respectively" (151; cf. Chatman). Adaptation studies of media similarities and dissimilarities in this broad sense, often focusing on historical, aesthetic, and normative ideas of how media types (should) differ, have long been popular, from George Bluestone (1–64) onward.

My emphasis here on media dissimilarities has little to do with this tradition of comparing two qualified media and judging what is suitable or not for them on the basis of "their historical moments and not of the media themselves"; however, I do find it vital to underscore that there are material, sensorial, spatiotemporal, and fundamental semiotic differences among "media themselves" in the sense that socially constructed and culturally qualified media types are constructed on a basis of fundamental material and mental capacities of media products and their perceivers. Although these capacities partly differ among media types, they also overlap to different degrees.

Despite essential pre-semiotic and semiotic dissimilarities among media, a transfer of media characteristics over modal borders is often possible. As our brains have cross-modal abilities—they can make meaningful transmissions between, say, visual and auditory information, or spatial and temporal forms of presentation—many media characteristics are actually transmedial. In brief: the fact that there are fundamental or even essential media dissimilarities does not preclude shared representational capacities (to various degrees) or the transfer of media characteristics among dissimilar media (to certain extents). Over thirty years ago, Andrew noted that in order to explain how different sign systems can represent entities that are approximately the same (such as narratives), "one must presume that the global signified of the original is separable from its text" (*Concepts* 101). This is no doubt true: represented objects are, in the end, cognitive entities in our minds, and these entities may be made present by different kinds of signs—although media differences will always ensure that they are not completely similar when represented again by another kind of medium.

Conclusion

Intermedial research investigates all kinds of interrelations among dissimilar media. As the core of adaptation consists of the transfer of media traits from one media product to another, different one, adaptation studies are part of intermedial studies at large. More precisely, adaptation involves a diachronic rather than a synchronic view of intermedial relations. Hence it is part of what might be called media transformation. However, in contrast to a phenomenon such as ekphrasis, which is defined as a media product representing another kind of media product, adaptation has never been circumscribed in terms of media representation. Adaptation must be understood as a target media product *representing again* certain characteristics of a source media product. A typical film adaptation, for instance, does not represent its source novel—it is not a film about a novel; rather, it represents the story, characters, and so forth that were earlier represented by the novel. I call this kind of media transformation *transmediation*.

I have tried to demonstrate that adaptation, although it undoubtedly belongs to the area of transmediation, is not clearly delimited within this intermedial space. Although this is not necessarily a problem in itself, it may indeed become an obstacle if it results in neglect of the border zones of adaptation. Ignoring relevant neighbor disciplines leads to theoretical inbreeding and conceptual isolation. My list of ten more or less overt and more or less recognized ways of delimiting the notion of adaptation within the broader field of intermediality is intended to highlight research areas and research question that may prove to be fruitful in future efforts to strengthen the conceptual framework of adaptation studies. Some of these empirical and theoretical border zones, as I have shown, are already under exploration; others largely remain virgin territory.

But investigating the intermedial border zones linking adaptation to pertinent neighbor disciplines will be of little help unless the fundamental features of media are considered properly. A research discipline devoted to relations among dissimilar media—more precisely, to the transfer of characteristics among dissimilar media—cannot escape thorough investigations of fundamental material and mental conditions for media differences and similarities. I therefore suggest working with intermedial notions that cover both pre-semiotic and semiotic stages of meaning creation—notions applicable to all kinds of media, not only written literature and film.

Works Cited

Andrew, Dudley. "Adapting Cinema to History: A Revolution in the Making." Stam and Raengo, *Companion* 189–204. Print.

———. *Concepts in Film Theory*. New York: Oxford UP, 1984. Print.

Aragay, Mireia, ed. *Books in Motion: Adaptation, Intertextuality, Authorship*. Amsterdam: Rodopi, 2005.

Bernhart, Walter. "From Novel to Song via Myth: *Wuthering Heights* as a Case of Popular Intermedial Adaptation." Urrows 13–27. Print.

Bluestone, George. *Novels into Film.* Baltimore: Johns Hopkins UP, 1957. Print.

Bolter, Jay David, and Richard Grusin. *Remediation: Understanding New Media.* Cambridge: MIT P, 1999. Print.

Boozer, Jack. "Introduction: The Screenplay and Authorship in Adaptation." *Authorship in Film Adaptation.* Ed. Jack Boozer. Austin: U of Texas P, 2008. 1–30. Print.

Bruhn, Jørgen. "Dialogizing Adaptation Studies: From One-Way Transport to a Dialogic Two-Way Process." Bruhn, Gjelsvik, and Hanssen 69–88. Print.

Bruhn, Jørgen, Anne Gjelsvik, and Eirik Frisvold Hanssen, eds. *Adaptation Studies: New Challenges, New Directions.* London: Bloomsbury, 2013. Print.

Bruhn, Jørgen, Anne Gjelsvik, and Henriette Thune. "Parallel Worlds of Possible Meetings in *Let the Right One In*." *Word and Image* 27 (2011): 2–14. Print.

Cartmell, Deborah, and Imelda Whelehan, eds. *Adaptations: From Text to Screen, Screen to Text.* London: Routledge, 1999. Print.

Casetti, Franco. "Adaptation and Mis-Adaptations: Film, Literature, and Social Discourses." Trans. Alessandra Raengo. Stam and Raengo, *Companion* 81–91. Print.

Cattrysse, Patrick. *Descriptive Adaptation Studies: Epistemological and Methodological Issues.* Antwerp: Garant, 2014. Print.

———. "Film (Adaptation) as Translation: Some Methodological Proposals." *Target* 4 (1992): 53–70. Print.

———. "The Unbearable Lightness of Being: Film Adaptation Seen from a Different Perspective." *Literature/Film Quarterly* 25 (1997): 222–30. Print.

Cham, Mbye. "Oral Traditions, Literature, and Cinema in Africa." Stam and Raengo, *Literature* 295–312. Print.

Chatman, Seymour. "What Novels Can Do That Films Can't (and Vice Versa)." *Critical Inquiry* 7 (1980): 121–40. Print.

Clarke, Micael M. "Celluloid Satire, or the Moviemaker as Moralist: Mira Nair's Adaptation of Thackeray's *Vanity Fair*." *In/Fidelity: Essays on Film Adaptation.* Ed. David L. Kranz and Nancy C. Mellerski. Newcastle: Cambridge Scholars P, 2008. 38–59. Print.

Constandinides, Costas. *From Film Adaptation to Post-Celluloid Adaptation: Rethinking the Transition of Popular Narratives and Characters across Old and New Media.* New York: Continuum, 2010. Print.

Elleström, Lars. "Adaptation within the Field of Media Transformations." Bruhn, Gjelsvik, and Hanssen 113–32. Print.

———. *Media Transformation: The Transfer of Media Characteristics among Media.* Basingstoke: Palgrave Macmillan, 2014. Print.

———. "The Modalities of Media: A Model for Understanding Intermedial Relations." *Media Borders, Multimodality and Intermediality.* Ed. Lars Elleström. Basingstoke: Palgrave Macmillan, 2010. 11–48. Print.

Elliott, Kamilla. *Rethinking the Novel/Film Debate.* Cambridge: Cambridge UP, 2003. Print.

———. "Theorizing Adaptations/Adapting Theories." Bruhn, Gjelsvik, and Hanssen 19–45. Print.

García Landa, José Angel. "Adaptation, Appropriation, Retroaction: Symbolic Interaction with *Henry V*." Aragay 181–99. Print.

Gaudreault, André, and Philippe Marion. "Transécriture and Narrative Mediatics: The Stakes of Intermediality." Trans. Robert Stam. Stam and Raengo, *Companion* 58–70. Print.

Geraghty, Christine. *Now a Major Motion Picture: Film Adaptations of Literature and Drama.* Lanham: Rowman and Littlefield, 2008. Print.

Groensteen, Thierry. "Le processus adaptatif (Tentative de récapitulation raisonnée)." *La transécriture: Pour une théorie de l'adaptation.* Ed. André Gaudreault and Thierry Groensteen. Québec: Nota Bene, 1998. 273–77. Print.

Halliwell, Michael. *Opera and the Novel: The Case of Henry James.* Ed. Walter Bernhart. Amsterdam: Rodopi, 2004. Print.

Hutcheon, Linda, with Siobhan O'Flynn. *A Theory of Adaptation.* 2nd ed. New York: Routledge, 2013. Print.

Leitch, Thomas. *Film Adaptation and Its Discontents: From* Gone with the Wind *to* The Passion of the Christ. Baltimore: Johns Hopkins UP, 2007. Print.

———. "Twelve Fallacies in Contemporary Adaptation Theory." *Criticism* 45 (2003): 149–71. Print.

Lev, Peter. "The Future of Adaptation Studies." *The Literature/Film Reader: Issues of Adaptation.* Ed. James M. Welsh and Peter Lev. Lanham: Scarecrow, 2007. 335–38. Print.

McFarlane, Brian. *Novel to Film: An Introduction to the Theory of Adaptation.* Oxford: Clarendon, 1996. Print.

Pardo García, Pedro Javier. "Beyond Adaptation: Frankenstein's Postmodern Progeny." Aragay 223–42. Print.

Rajewsky, Irina O. "Intermediality, Intertextuality, and Remediation: A Literary Perspective on Intermediality." *Intermédialités* 6 (2005): 43–64. Print.

Rossholm, Anna Sofia. "Auto-Adaptation and the Movement of Writing across Media: Ingmar Bergman's Notebooks." Bruhn, Gjelsvik, and Hanssen 203–22. Print.

Ryan, Marie-Laure. "Introduction." *Narrative across Media: The Languages of Storytelling.* Ed. Marie-Laure Ryan. 1–40. Lincoln: U of Nebraska P, 2004. 1–40. Print.

Schober, Regina. "Adaptation as Connection: Transmediality Reconsidered." Bruhn, Gjelsvik, and Hanssen 89–112. Print.

Stam, Robert. "Introduction: The Theory and Practice of Adaptation." Stam and Raengo, *Literature* 1–52. Print.

Stam, Robert, and Alessandra Raengo, eds. *A Companion to Literature and Film.* Malden: Blackwell, 2004. Print.

———, eds. *Literature and Film: A Guide to the Theory and Practice of Film Adaptation.* Oxford: Blackwell, 2005. Print.

Urrows, David Francis, ed. *Essays on Word/Music Adaptation and on Surveying the Field.* Amsterdam: Rodopi, 2008. Print.

Wolf, Werner. *The Musicalization of Fiction: A Study in the Theory and History of Intermediality.* Amsterdam: Rodopi, 1999. Print.

TRANSMEDIA STORYTELLING AS NARRATIVE PRACTICE

MARIE-LAURE RYAN

POPULAR culture is so efficient at promoting itself (an important reason that it is popular) that anybody who is not a hermit will have heard of narrative systems that stretch over multiple installments and media. The prototype is *Star Wars*: there were first three movies, then six, now there will be nine; there are novels, comics, computer games, online worlds, action figures, T-shirts and costumes for kids, not to mention over 40,000 pieces of fan fiction on fanfiction.net. After *Star Wars* came *Lord of the Rings*, *Harry Potter*, and *The Matrix*. Now *Millenium Trilogy*, *Twilight Saga*, and *The Hunger Games* are sending tentacles that reach beyond their original realization as novels. Even *Fifty Shades of Grey*, which began as fan fiction responding to the *Twilight Saga*, has emancipated itself to become the center of its own storyworld. It seems that every time a narrative "goes viral," it engenders transmedia activity.

This has led to a new concept in popular culture studies: transmedia storytelling. The expansion of storytelling across multiple media is being hailed by its proponents as the narrative form of the (digital) future, just as in the 1990s, hypertext fiction was regarded as the future of narrative. It would be pointless to deny the existence of transmedia franchises built around cult narratives. But the phenomenon labeled transmedia storytelling opens many theoretical, more particularly narratological and pragmatic, questions.

TRANSMEDIA STORYTELLING VERSUS ADAPTATION

Should transmedia storytelling be regarded as a species of adaptation? Linda Hutcheon and Siobhan O'Flynn think so. The second edition of *A Theory of Adaptation* (2013) ends with a detailed epilogue, written by O'Flynn, that discusses many of the ways in which stories can be expanded from traditional to digital media. Hutcheon and O'Flynn take

a very broad view of adaptation, a view that encompasses "recreations, remakes, reme-
diations, revisions, parodies, reinventions, reinterpretations, expansions, and exten-
sions" (181). This conception is so broad that it covers both adaptation as the retelling
of known stories in different media and a process that Richard Saint-Gelais calls trans-
fictionality: the sharing of elements, mostly characters, but also imaginary locations,
events, and entire fictional worlds, by two or more works of fiction. Transfictionality is
particularly popular in postmodern literature (cf. Lubomír Doležel's concept of "post-
modern rewrite") because it involves an implicit reflection on the nature of fictionality,
but it is as old as print literature. One of the first examples of the process is the sequel to
the adventures of Don Quixote, published in 1614 by Alonso Fernández de Avallaneda.
Transfictionality relies on three fundamental operations: (1) extension, which adds
new stories to the fictional world while respecting the facts established in the original;
(2) modification, which changes the plot of the original narrative, for instance by giving
it a different ending; and (3) transposition, which "preserves the design and the main
story ... but locates it in a different temporal or spatial setting" (Doležel 206). If we
regard adaptation as a change of milieu that forces an organism, a person, or a story to
adapt to new circumstances, then the third of these operations presents some similarity
to the retelling of a story in a different medium: in one case the characters and the plot
must be adapted to a new environment; in another the story must be adapted to new
semiotic resources. Transposition therefore represents the intersection of adaptation
and transfictionality. But the first two operations, expansion and modification, do not
involve any kind of adaptation. Whereas adaptation tries to preserve the story but some-
times changes the world, transfictionality tends to preserve the world, either in part or
in whole, but to change the story, or to add more stories to the world.

Hutcheon and O'Flynn's inclusion of extension, reinterpretation, and reinvention in
the list quoted earlier implies that they regard transfictionality as a species of adaptation.
By contrast, the Producers Guild of America, clearly intent on distinguishing transme-
dia storytelling from adaptation, insists on at least three storylines rather than the two
needed for adaptation, though they are silent on the status of a narrative adapted from
novel to film and from film to musical:

> A Transmedia Narrative project or franchise must consist of three (or more) nar-
> rative storylines existing within the same fictional universe on any of the following
> platforms: Film, Television, Short Film, Broadband, Publishing, Comics, Animation,
> Mobile, Special Venues, DVD/Blu-ray/CD-ROM, Narrative Commercial and
> Marketing roll-outs, and other technologies that may or may not currently exist. These
> narrative extensions are NOT the same as repurposing material from one platform to
> be cut or repurposed to different platforms. (qtd. in Hutcheon and O'Flynn 181)

Henry Jenkins, the principal theorist and advocate of transmedia storytelling, also
makes a sharp distinction between adaptation and transmedia. Jenkins associates
transmedia storytelling with what I call transfictionality: "And for many of us, a sim-
ple adaptation may be 'transmedia,' but it is not 'transmedia storytelling' because it is

simply re-presenting an existing story rather than expanding and annotating the fictional world" ("The Aesthetics of Transmedia").

Jenkins's conception of transmedia storytelling prioritizes the world over the story. Plot-preserving adaptations are certainly an important part of transmedia franchises. For instance, the *Harry Potter* and *Lord of the Rings* movies retell the novels in the film medium, and they are sufficiently faithful to the original to offer an entry point into the "system" as efficient as the novels. But a narrative cluster consisting exclusively of a novel and of its cinematic adaptation does not constitute a case of transmedia storytelling, nor must a transmedia story system include adaptations in the narrow sense of retelling a story in a different medium. We will see in the following two examples of transmedia story systems that do not include this kind of adaptation: *The Matrix* and *Alpha 0.7*.

If transmedia is a new form of storytelling, then, it should be more than adaptation, a time-honored practice; it should tell new stories or provide new information about a familiar storyworld, as does the equally time-honored practice of transfictionality; and it should use multiple media to do so. It should therefore hybridize the inherent transmediality of adaptation with the inherent world-expanding capacity of transfictionality. In Jenkins's conception, this hybridization should not be a haphazard accumulation of documents by various authors around a common storyworld. Instead, it should rely on a controlled process: "Transmedia storytelling represents a process where integral elements of a fiction get *dispersed systematically across multiple delivery channels* for the purpose of creating *a unified and coordinated entertainment experience*. Ideally each medium makes its own *unique contribution* to the unfolding of the story" ("Transmedia Storytelling 101," italics in original).

The trademark of this definition is its implicit reliance on a top-down, deliberate distribution of narrative content across various media platforms. The label transmedia *storytelling* suggests that this content forms a story, which means a self-contained type of meaning that follows a temporal arc, leading from an initial state to a complication and resolution. This arc is what Aristotle had in mind when he described stories as having a beginning, middle, and end. But story arcs do not lend themselves easily to fragmentation and dispersion into multiple documents. Imagine how annoying it would be to read the beginning of a story in a novel, then to have to go to a movie theater to get the next episode, then to have to buy a comic book, and finally to have to play a computer game in order to find out how it ends. Transmedia can avoid this pitfall by telling a variety of autonomous stories or episodes, held together by the fact that they take place in the same storyworld. People are willing to look for information across multiple platforms because they are so in love with a given storyworld that they cannot get enough information about it. Only the most dedicated problem-solvers enjoy the game of putting a story together like a jigsaw puzzle out of elements deliberately dispersed across multiple documents. In the majority of cases, transmedia storytelling satisfies the encyclopedist's passion for acquiring more and more knowledge about a world, or the collector's passion for acquiring more and more objects related to this world, or even the cult member's passion for sharing with others an object of worship, rather than the detective's passion for reconstructing a story out of disseminated facts.

Top-Down versus
Bottom-Up Development

As we have already seen, Jenkins's definition of transmedia storytelling presupposes a top-down planning process that distributes narrative information into multiple documents, so that users will have to consume many of these documents for *a unified and coordinated entertainment experience*. Yet in practice, most franchises grow from the bottom up, through a process of aggregation that adds more and more documents to a storyworld that has already achieved popularity and coherence independently of any transmedia buildup. This bottom-up process will, however, be followed by top-down development when media conglomerates adopt a best-seller and build around it a systematic advertising campaign that covers many platforms. Transmedia projects that are conceived top-down from the very beginning are the exception rather than the rule. Two of them will serve as examples for the discussion to come.

The Matrix, a franchise that Jenkins (2006) has studied in great detail, is the epitome of a top-down approach to transmedia storytelling. The three films, released in 1999 and 2003, were accompanied by short anime films, comics, and computer games that had been specially commissioned by the authors of the films, Lilly and Lana Wachowski. The design philosophy of the Wachowskis cultivates the desire to look beyond the films, especially when it comes to the relation between the films and the computer game. For instance, in the film *The Matrix Reloaded*, the heroes succeed in their final mission because a character named Niobe and her team manage to cut down the electrical power that feeds the machines. This event, which is necessary to the logic of the plot, is not shown in the film, but it is one of the tasks that the player must complete in the game. Earlier in *The Matrix Reloaded*, the main character, Neo, encounters a new character named the Kid who wants to join in Neo's fight against the machines. From their dialogue, one can conclude that they already know each other. The story of their first meeting is not shown in the film, but it is the subject matter of one of the anime shorts, *Kid's Story*. In both of these examples, the film shows an event that can be explained only through a backstory presented in another document.

A second example of transmedia storytelling conceived top-down is the German television project *Alpha 0.7: Der Feind in dir* (The Enemy Within), which was produced in 2010 by the German TV chain Südwest Rundfunk (Ryan, "Transmedia"). *Alpha 0.7* consists of a main document—a television miniseries that ran in six weekly installments of thirty minutes—a collection of satellite documents available on the Internet, and a series of radio shows that presented a sequel to the miniseries.

Alpha 0.7 tells a story situated in Germany in the year 2017. In this world, a company named Protecta plans to introduce security systems that will employ brain-scanning technology. When an individual develops the kinds of thoughts that could lead to violent crime, his thinking will be changed by implanting a chip in his brain, and he will be

turned into a harmless person. The planned system will ensure near-total security for German citizens, but it will violate the individual's right to privacy.

The plot of the miniseries concerns Johanna, a young woman who is hired by Protecta as a test subject—the seventh such subject, as the title *Alpha 0.7* suggests; all the others have mysteriously disappeared or committed suicide. The company implants a chip in Johanna's brain, unbeknownst to her, in order to control her behavior. Meanwhile, an underground movement called Apollo fights to maintain freedom of thought. In the course of·the plot, Johanna escapes from Protecta, makes contact with Apollo, and has the chip removed. Then she is captured again, the chip is put back in, and so on, in a series of reversals typical of the thriller genre. In the last episode, she is freed from Protecta, but she is wanted by the police for a murder she attempted when she was under the control of Protecta. Her adventures as a fugitive are the subject matter of the radio show.

Alpha 0.7 uses television and radio to tell the story, but it also uses a website to provide supplementary documents about the storyworld. For instance, there is a fictional blog maintained by Apollo that discusses the ethical dilemma of imposing security on the population at the cost of privacy. There is a website on which Protecta presents itself to the public as a benefactor of humankind. This positive image is reinforced by a television spot in which a convicted rapist praises the brain-controlling system of Protecta for turning him into a law-abiding citizen and saving him from a life in jail. Then there is the blog of Johanna, who describes the day-by-day changes that are taking place in her mind and her fear that she is suffering from a mental disease. There is also a fictional television news spot that reports the disappearance of a character named Stefan Hartmann, who was Alpha 0.1, and a web page that contains the links on Hartmann's computer. The user is invited to visit these links in order to solve the mystery of Hartmann's disappearance, but the clues do not lead anywhere. The production team had planned an Alternate Reality game as one of the transmedia documents whose theme would most likely have been the story of Stefan Hartmann, but nothing came out of this idea because the project ran out of funds. Finally, there are links to a number of real-world documents, such as the website of Homeland Security, describing a project about "hostile intent detection" and websites that describe recent achievements in brain science, which is getting ever closer to reading minds. The nonfictional documents exist independently of the story, but their reference is redirected from the real world to the storyworld.

RELATIONS BETWEEN DOCUMENTS

We have seen that transfictionality rests on three types of relations. Of these three, expansion is by far the most popular in transmedia systems. Just as children hate it when parents modify their favorite bedtime stories, most fans resent changes that threaten the integrity of a treasured storyworld. A large part of fan activity, as Richard Saint-Gelais argues (423), is devoted to protecting the canon. Fan fiction admittedly contains

parodies, transpositions, even "slash fiction" (Gwenllian Jones 536–37) that alters the sexual preferences of characters, and it is the transgressive character of these contributions that make them interesting. They allow short side trips to alternate storyworlds, rather than contributing to the ongoing creation and exploration of the canonical world. But compared to expansions, they are a small minority—a minority even smaller than the number of people who produce fan fiction, compared to the number of people who consume the canonical, industry-produced documents. And the number of people who actually read fan fiction may well be even smaller than the number of people who write it.

The standard ways to expand a world are to stretch the story in length (= time) though sequels, prequels, and midquels, or to stretch it in breadth (= space) by telling the (back)story of new characters who are connected in some way to the old characters. If they were not connected, their story would constitute a "walled garden," narratively inaccessible from the stories told in the other documents, but sharing a setting with them. The result would be something like the stories in James Joyce's *Dubliners*. Yet another common device is to represent events from different points of view. For instance, in *Alpha 0.7* the main story is told from the impersonal, external point of view that is typical of film and drama (showing rather than telling), but one of the online documents associated with the television series is the diary of Johanna, in which she retells the same events from her own perspective. This diary takes advantage of the superior facility of written narrative over the medium of film when it comes to representing the mental life of characters.

Alpha 0.7 and *The Matrix* illustrate two different types of connection between the main documents and their satellites. The structure of *The Matrix* can be compared to a piece of Swiss cheese. The film presents an image of the storyworld that is full of plot holes. The function of the other documents is to fill these holes so that the user can form a more complete, more coherent mental representation of the storyworld. Conversely, the film provides information that completes the stories told by the other documents. The anime film *Kid's Story* would, for instance, be incomprehensible if the spectator did not know that what passes as reality in the world of *The Matrix* is actually a simulation created by machines in order to enslave mankind. This information is presented in the first of the three feature films. Each element of the system is itself a piece of Swiss cheese that depends on other documents for the plugging of its holes. Yet despite their logical gaps, it is very possible to enjoy the feature films on their own, because the cinematography, with its use of florid special effects and its breathlessly rapid editing of action sequences, does everything it can to turn the films into spectacle and to distract the spectator from the logical gaps of the plot.

In *Alpha 0.7* most of the satellites play a role comparable to that of description in novels. The primary narrative action is limited to the television serial and the radio play sequel, which the producers conceived as a "second season." But the online documents flesh out the storyworld by describing the social and technological environment that has evolved in Germany by the year 2017. Just as, in a novel, many people skip descriptions, in *Alpha 0.7* it is not absolutely necessary to consult the satellites, but if people limit themselves to the

television serial they will get a rather banal thriller with a poorly constructed story full of cheap plot tricks, whereas if they consult the satellites they will discover a richly imagined world that raises a vital ethical question: Which is more valuable, security or privacy? In their different ways, then, *The Matrix* and *Alpha 0.7* satisfy a principle that has been formulated by Jason Mittell for transmedia television serials, but whose relevance extends to any system with a central document: transmedia extensions "must accomplish the goal of rewarding those who consume them and not punishing those who do not" (272).

INTERACTIVITY AND USER PARTICIPATION

A widely circulated view of transmedia storytelling presents its worlds as collective creations that erase the distinction between spontaneous fan contributions and the content produced by the professionals of the entertainment industry. Top-down and bottom-up productions supposedly merge into a harmonious whole, and transmedia storytelling, we are made to believe, fulfills the dream of Roland Barthes's writerly text "to make the reader no longer a consumer, but a producer of the text" (4). This overly optimistic view needs to be damped down. First, fan contributions often rewrite the canonical stories in ways that prevent the construction of a unified world. They present what Nelson Goodman would call world versions, ways the storyworld could be, or could have been, rather than a homogeneous, logically coherent world. Second, far from mutually implying each other, participatory culture and the spreading of narratives across multiple media are really two distinct phenomena. They tend to be confused because the cult narratives that generate transmedia franchises also tend to inspire intense fan activity. Moreover, both have benefited tremendously from digital technology: fan participation, because the technology put at the disposal of the public efficient tools of creation, publication, and communication; and transmedia extension, because of the possibility to digitize "old" media and make them easily accessible. But there are genuinely transmedial projects that do not inspire fan creations, such as *Alpha 0.7*, and conversely, there are strictly book-based stories like Mark Z. Danielewski's 2000 novel *House of Leaves* that do generate world-external fan activity. It should be acknowledged, however, that a transmedia project like *Alpha 0.7* that fails to inspire fan activity is considered a popular failure, while a single-medium narrative that inspires a high level of fan participation is likely to be claimed by the entertainment industry and turned into a transmedia empire.

Although active fan participation, or interactivity, is not a defining feature of transmedia storytelling, it nevertheless plays an important role in the design of transmedia systems because of its ability to create interest in a storyworld. "Give the user something to do" is one of the most common pieces of advice given to prospective authors of transmedia narratives (Jenkins, "Seven Principles"; Phillips). This recommendation raises the question of what kind of tasks and what forms of interactivity transmedia storytelling can support without being turned into a game (for transmedia storytelling may include games, but it should not be confused with game design). Interactivity is a

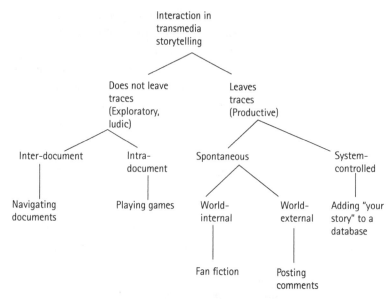

FIGURE 30.1 Types of interaction in transmedia storytelling.

broad category that needs to be subdivided if it is going to provide a useful analytical tool for transmedia systems. Figure 30.1 proposes a taxonomy of modes of interactivity and participation.

The first split is between those forms of interactivity that are purely transient and those that leave permanent traces in a system. Transient interactivity can take two forms. First, there is an external form that gives the user the freedom to make choices among documents presented by the system. It is an inherent property of digital interfaces and of transmedia storytelling, and it is not a particularly interesting phenomenon. Second, there is an internal interactivity that is inherent to some of the documents of a transmedia system. In internal interactivity, the user's mode of participation is narrowly scripted by the system. For instance, in a system that includes videogames, users are told to play the role of a certain character in the game and to pursue certain goals, but users' actions do not leave permanent traces on the system; once they have finished playing a videogame, the game world will revert to its initial state for the next player, and the game can be replayed under the same conditions. Among the forms of interactivity that create permanent, and consequently publicly available, content, we may distinguish spontaneous contributions, such as fan fiction, from system-controlled participation like a transmedia system's encouragement to users to post publicly visible comments, or to contribute their own materials about a certain topic. In these cases, top-down meets bottom-up, since the producers of the system openly invite users to create content. Although some scholars view transmedia storytelling as the possibility of co-creating or changing a story, collective creation is feasible only when the system consists of a collection of individual stories rather than a global storyline. It is always possible to add "your own story" to a narrative database that collects individual testimonies in various media,

but it would be disastrous for narrative coherence to allow fans to access and modify the documents that constitute the Mother Ship, as the central document of a transmedia system is called in the entertainment industry. The feasibility of collective storytelling has been seriously called into question by *A Million Penguins*, an experiment conducted by Penguin in 2007 in which participants could expand or modify the beginning of a story posted on a publicly accessible wiki. The project resulted in ungovernable chaos, rather than the publishable novel that Penguin had hoped to produce, and the wiki was shut down.

Despite all the talk about participatory culture, transmedia storytelling is no more hospitable to collective creation than single-medium projects because there is something about narrative form and narrative logic—let's call it teleology—that requires a top-down, controlled design.

Varieties of Transmedia

For all the attention devoted to media in scholarly discourse, an attention that reflects their importance in social life, the terms *medium* and *media* remain remarkably slippery, and there is no consensus about their definition (Ryan, "Story/World/Media"). A purely semiotic conception associates media with types of signs, such as image, sound, and language; a technological conception regards media as inventions and platforms designed for the capture and transmission of information, such as printing, photography, film, and the digital; a cultural conception, finally, regards as media (or more precisely as "the media") information channels that play a major role in influencing public opinion, such as the press, television, or the Internet. A given medium like television can belong to more than one of these categories. The list of the potential targets of the transmedia operation in the definition of the Producers Guild of America bears testimony to the fuzziness of the concept of medium: it includes forms of encoding and material supports (DVD/Blu-ray/CD-ROM, Mobile), pragmatic uses of narrative (Commercial and Marketing roll-outs), genres (short film and animation as genres of film), delivery systems (publishing, broadband), semiotically defined types of narrative (comics), technologically based media with specific semiotic properties (film, television), and types of events (special venues).

Depending on how one conceives "medium," there are a number of different types of narrative that rely on multiple media. The main differences between these various types lie in the spatial location and mode of accessibility of their components.

1. Multimodal narratives (Kress) that use various types of signs within the same physical package, especially text and image, as in comics, but also text and sound, as in books that come with a CD, or image, text, or smell, as in children's "smelly books." Film is the ultimate multimodal narrative, with its combination of moving image, spoken language, music, and occasionally text. In a genuine multimodal

narrative, none of the modes (or media, in the semiotic sense) functions independently of the others. This condition spells the difference between, say, editions that add illustrations to self-standing narrative texts and narratives that were conceived from the very beginning as text-image combinations.

2. Narratives based on a single physical support that gives access, through digital technology, to documents belonging to various semiotic media. This case is represented by augmented books like Marisha Pessl's *Night Film* (2013). By downloading a special app on a tablet computer and scanning certain pages of the book, users can unlock additional content located "in the cloud" that could not be encoded in book-supported print—for instance, the recording of the musical composition that the heroine is playing or a character's oral narration of an episode in the heroine's life not reported in the written text.

3. Narratives made accessible through the convergence of multiple technological devices. An example is the augmented reality project *Mapping Ararat*, which gives substance to the dream of Mordecai Noah, a nineteenth-century Jewish leader who wanted to create a Jewish homeland on Grand Island in upstate New York. Visitors to the project are invited on a walk through Grand Island, during which they encounter virtual images of what Ararat might have been like. The unified experience relies on the coordination of three different technologies: a smartphone that captures images of virtual buildings, an audio guide that tells the story of the buildings, and a map that locates the sites of augmentation.

4. Stories residing on a platform that gathers multiple documents representing various types of signs—text, image, moving image, and sound. This is the case of *Alpha 0.7*. Originally *Alpha 0.7* consisted of two platforms: a television serial, which constituted the Mother Ship, and a website that contained satellite documents. But as soon as the episodes of the television serial had been aired, they were uploaded to the website so that users could find everything in the same place. This type of storage encourages a thorough exploration of the storyworld, since all the documents can be easily accessed.

5. In classical cases of transmediality, such as *The Matrix* or *Star Wars*, the system consists of physical objects that are located in different places, so that users must move in space to get to them. For instance, after seeing the movie in a theater, they must go to the bookstore to buy a book or a videogame and to the toy store to buy costumes and action figures. Nowadays, almost everything can be downloaded or ordered online, so that minimal physical displacement is required, but users still need to acquire various objects, and in order to do so they must visit various sites on the Internet. The frequent result of physical dispersion, which is all but inevitable in a storyworld as heavily exploited as *Stars Wars*, is partial and incomplete exploration.

6. But there is at least one type of spatial dispersion of narrative elements that requires a complete exploration of the system: alternate reality games, or ARGs (see McGonigal). An ARG is a kind of treasure hunt in which a story must be reconstructed by following various clues. These clues can be located either in the

physical world or on the Internet, and they can involve various semiotic modes and physical supports. To reconstitute the story, players must solve riddles that yield fragments of the story or point to the next clue. Since the sequence of clues leads to the solution of a mystery, it must be followed from beginning to end, but the hunt for the story is more important than the story itself.

All these phenomena involve a story, and all of them use multiple media to reveal it. This suggests that "transmedia storytelling" is no less a fuzzy set than the concept of narrative itself (Ryan, "Toward"). The core of the set is represented by phenomena 4 and 5, while the other phenomena are marginal members.

TRANSMEDIA: ADVERTISING, STORYTELLING, OR WORLD BUILDING?

Many of the phenomena regarded as instances of transmedia storytelling are more or less disguised forms of product placement. The extensions of *Alpha 0.7* promote, for instance, all three of the branches of Südwest Rundfunk: television through the Mother Ship, Internet through the website, and radio through the radio plays. Many of the non-fictional documents referred to on the website are themselves radio programs that have been aired by Südwest Rundfunk. In *Alpha 0.7* the advertising function blends seamlessly with the narrative function, since the promoted documents truly flesh out the storyworld, but in many cases so-called transmedia storytelling is nothing more than blatant multi-platform advertising. When Steven Spielberg's 2001 movie *A.I.* was advertised with an ARG called *The Beast*, this was not transmedia storytelling, because there was next to no narrative connection between *The Beast* and the movie. Similarly, when Campfire advertised the television series *Game of Thrones* (2011–) through puzzles distributed over the Internet, this was a way to generate hype about the show, but it was not transmedia storytelling, because the puzzles did not contribute useful information to the storyworld of the television series, and the "reward" for solving the puzzles was not additional content, but a mere sneak preview of the show (Klastrup and Tosca). And when German soccer fans gathered in July 2014 on Unter den Linden in Berlin with *Star Wars* light sabers to watch their team play in the World Cup on a giant screen, or when the following month the Colorado Rockies organized a *Star Wars*–themed baseball game, inviting fans to wear *Star Wars* costumes and blaring *Star Wars* music, this was not storytelling, but exploiting the popularity of a storyworld for other purposes while creating publicity for the *Star Wars* franchise.

In the Facebook post "Transmedia Is a Lie," Brian Clark of GMD studios (a company that describes itself as "innovation lab") observes that there has been no great transmedia hit. By transmedia hit one must understand top-down, deliberately planned transmedia projects, rather than franchises exploiting an independently successful novel or

film. The closest to a great transmedia success is *The Matrix*, but the franchise owes its popularity to the films, not to the transmedia extensions, of which the general public is largely unaware. What does this failure to produce a great hit tell us about transmedia as a narrative form?

Film scholar David Bordwell has challenged the storytelling ability of transmedia franchises. On his blog, Bordwell reacts to the following claim by the filmmaker Lance Weiler: "Instead of creating a script, with its genre formulas and three-act layout, the filmmaker should generate a bible, which plots an ensemble of characters and events that spills across film, websites, mobile communication, Twitter, gaming, and other platforms. The filmmaker designs 'timelines, interaction trees, and flow charts' as well as 'story bridges that provide seamless flow across devices and screens'" ("Culture Hackers"). In this new conception of filmmaking, the role of the director is to be some kind of orchestra conductor who coordinates the various media involved in the project through bridges and timelines to ensure a global coherence.

As a film scholar, Bordwell is particularly interested in the narrative poetics of Hollywood film, which rests on the notion of a narrative arc leading from exposition to complication to climax to resolution. This aesthetic, borrowed from drama, is widely regarded as Aristotelian. Bordwell's concept of narrativity is also inspired by Meir Sternberg, who writes: "I define narrativity as the play of suspense/curiosity/surprise between represented and communicative time. . . . Along the same functional lines, I define narrative as a discourse where such play dominates" (529).

For Bordwell, following Sternberg, narration is an essentially temporal phenomenon leading to certain effects, and the distribution of narrative content into multiple documents across different media can only be detrimental to these effects:

> In between opening and closing, the order in which we get story information is crucial to our experience of the *storyworld*. Suspense, curiosity, surprise, and concern for characters—all are created by the sequencing of story action programmed into the movie. . . . Facing multiple points of access, no two consumers are likely to encounter story information in the same order. If I start a novel at chapter one, and you start it at chapter ten, we simply haven't experienced the art work the same way. ("Now Leaving from Platform 1")

In other words, transmedia storytelling suffers from the same deficiency as hypertext fiction, a narrative form that never really took off outside the niche audience of academia: neither can control what the user knows at a certain moment, or manage effects that rely on a strategic release of information.

In answer to Bordwell's objections, Jenkins argues in "The Aesthetics of Transmedia" that "not every fictional work should become a transmedia franchise." There are indeed other types of narratives than the Aristotelian plot favored by Hollywood, and the key to transmedia storytelling is to find the right type. What is this type? A narrative consists of a spatial component, the storyworld, and of a temporal component, the story or plot. In some narratives the world is subordinated to the plot; it is the environment that sustains

the characters (and which the characters modify through their actions). In other narratives, the plot is subordinated to the world; it functions as a path that takes the user through the world and reveals its landscapes. Plot-centered narratives include jokes, tragedies, and this story proposed by E. M. Forster as an example of plot: "The king died, and then the queen died of grief" (87). World-centered narratives, by contrast, include science-fiction and fantastic tales—the genres that have inspired the largest and the most popular transmedia franchises.

Successful plots make us want to speed up time in order to find out how the story ends. But successful worlds make us want to slow down time in order to linger longer in them. The more we are immersed in a storyworld, the more we dread the moment when we will be expelled from it. The desire we may develop for other stories taking place in a given storyworld can be explained by the fact that once we have invested the cognitive effort necessary to its mental construction, we would much rather go back to a familiar world than learn or construct a new one from scratch. The more a storyworld departs from the real world, the greater the cognitive effort needed to imagine it. This may explain why fantastic and science-fiction worlds tend to generate more transmedia activity than realistic, everyday worlds. Since it takes a greater effort to construct these worlds, we want a return on our cognitive investment, and this return takes the form of spin-offs that provide an easy access to the storyworld.

Conclusion

Does transmedia storytelling, like so many advertising campaigns, create artificial needs, or does it answer legitimate aspirations? It cultivates an addiction to storyworlds that translates into an insatiable urge to consume not only documents that expand the world, but also non-media objects such as T-shirts, costumes, and action figures that demonstrate brand loyalty (Scolari) and integrate the user in a fan community. But if transmedia storytelling succeeds in creating this addiction, it is because it responds to a basic need of the imagination, the need to inhabit storyworlds and return to them over and over again, not to relive the same experience, but to make new discoveries. Literary theory, with its emphasis on "textuality" (that is, a web of signifiers) and its long-standing contempt for the notion of "content" (a notion more commonly embraced by today's entertainment industry) has been slow to recognize this need for immersion as legitimate. But it is now making up for lost time through its recent attention to the concept of storyworld (Herman; Ryan and Thon) and to the process of world creation (Wolf). By exploiting the unique affordances of various media, transmedia storytelling should provide a richer sensory and cerebral experience of storyworlds than single-medium narratives. In practice, however, it rarely rises above the colonization of multiple information channels for the promotion of a Mother Ship, usually a movie or television show. There should be a difference between media *saturation* as a form of marketing and transmedia *storytelling* as a form of narrative art. The former is widely represented; for the latter to

become reality, media colonization should be replaced by media collaboration, or media convergence, to use an oft-quoted phrase popularized by Jenkins. Much remains to be done to make this collaboration narratively efficient.

WORKS CITED

A.I. Artificial Intelligence. Dir. Steven Spielberg. Perf. Haley Joel Osment, Jude Law. Warner Bros., 2001. Film.

Alpha 0.7. Dir. Marc Rensing. Perf. Victoria Mayer, Oliver Stritzel. Südwestrundfunk, 14 Nov.–18 Dec. 2010. Web. 31 July 2014.

Alpha 0.7—Der Feind in dir. Südwest Rundfunk, 2010. Radio.

Alpha 0.7—Der Feind in dir. Südwest Rundfunk, 2010. Television.

Aristotle. *Poetics.* Trans. Malcolm Heath. London: Penguin, 1996.

Barthes, Roland. *S/Z.* Trans. Richard Miller. New York: Farrar, Strauss and Giroux, 1974. Print.

The Beast. Dir. Sean Stewart and Elan Lee. Microsoft, 2001. Alternate reality game.

Bordwell, David. "Now Leaving from Platform 1." *Observations on Film Art.* Web. 31 July 2014.

Clark, Brian. "Transmedia Is a Lie." Facebook. Web. 31 July 2014.

Danielewski, Mark Z. *House of Leaves.* New York: Pantheon, 2000. Print.

Doležel, Lubomír. *Heterocosmica: Fiction and Possible Worlds.* Baltimore: Johns Hopkins UP, 1998. Print.

Forster, E. M. *Aspects of the Novel.* 1927. Rpt. Harmondsworth: Penguin, 1990. Print.

Game of Thrones. HBO, 2011–. Television.

Goodman, Nelson. *Ways of Worldmaking.* Indianapolis: Hackett, 1978. Print.

Gwenllian Jones, Sara. "Slash Fiction." *The Routledge Encyclopedia of Narrative Theory.* Ed. David Herman, Manfred Jahn, and Marie-Laure Ryan. London: Routledge, 2005. 536–37. Print.

Herman, David. *Basic Elements of Narrative.* Malden: Wiley-Blackwell, 2009. Print.

Hutcheon, Linda, with Siobhan O'Flynn. *A Theory of Adaptation.* 2nd ed. London: Routledge, 2013. Print.

Jenkins, Henry. "The Aesthetics of Transmedia. Response to David Bordwell." Web. 31 July 2014.

———. *Convergence Culture: Where Old and New Media Collide.* New York: New York UP, 2006. Print.

———. "The Revenge of the Origami Unicorn: Seven Principles of Transmedia Storytelling." Web. 31 July 2014.

———. "Transmedia Storytelling 101." *Confessions of an Aca-Fan.* Web. 31 July 2014.

Joyce, James. *Dubliners.* 1914. Rpt. New York: Bantam, 1990. Print.

Kid's Story. Dir. Shinishiro Watanabe. Perf. Clayton Watson, Keanu Reeves. Studio 4°C, 2003. Film.

Klastrup, Lisbeth, and Susana Tosca. "*Games of Thrones*: Transmedial Worlds, Fandom, and Social Gaming." Ryan and Thon 296–314. Print.

Kress, Gunther. *Multimodality: A Social Semiotics Approach to Contemporary Communications.* London: Routledge, 2010. Print.

"The Maester's Path Project: Trailer for HBO's *Game of Thrones*." Campfire, 2011. Web. 31 July 2014.

Mapping Ararat: An Imaginary Jewish Homeland Project. Web. 31 July 2014.

The Matrix. Dir. Lilly and Lana Wachowski. Perf. Keanu Reeves, Laurence Fishburne. Warner Bros., 1999. Film.

The Matrix Reloaded. Dir. Lilly and Lana Wachowski. Perf. Keanu Reeves, Laurence Fishburne. Warner Bros., 2003. Film.

McGonigal, Jane. *Reality Is Broken*. London: Penguin, 2011. Print.

Mittell, Jason. "Strategies of Storytelling on Transmedia Television." Ryan and Thon 253–77. Print.

Pessl, Marisha. *Night Film*. New York: Random House, 2013. Print and Web.

Phillips, Andrea. *A Creator's Guide to Transmedia Storytelling*. New York: McGraw-Hill, 2012. Print.

Ryan, Marie-Laure. "Story/Worlds/Media: Tuning the Instruments of a Media-Conscious Narratology." Ryan and Thon 25–49. Print.

———. "Toward a Definition of Narrative." *The Cambridge Companion to Narrative*. Ed. David Herman. Cambridge: Cambridge UP, 2007. 22–35. Print.

———. "Transmedia Storytelling and Transfictionality." *Poetics Today* 34.3 (2013): 361–88. Print.

Ryan, Marie-Laure, and Jan-Noël Thon, eds. *Storyworlds across Media*. Lincoln: U of Nebraska P, 2014. Print.

Saint-Gelais, Richard. *Fictions transfuges: La transfictionnalité et ses enjeux*. Paris: Seuil, 2011. Print.

Scolari, Carlos Alberto. "Transmedia Storytelling: Implicit Consumers, Narrative Worlds, and Branding in Contemporary Media Production." *International Journal of Communication* 3 (2009): 586–606. Print.

Star Wars. Dir. George Lucas. Perf. Mark Hamill, Harrison Ford. Twentieth Century–Fox, 1977. Film.

Sternberg, Meir. "Telling in Time (II): Chronology, Teleology, and Narrativity." *Poetics Today* 13 (1992): 463–541. Print.

Weiler, Lance. "Culture Hackers: Lance Weiler Explains Why Film Makers Should Expand Their Films into a 'Storyworld.'" Web. 31 July 2014.

Wolf, Mark J. P. *Building Imaginary Worlds: The Theory and History of Subcreation*. London: Routledge, 2012. Print.

ADAPTATION AND INTERACTIVITY

KYLE MEIKLE

THE second edition of Linda Hutcheon's *A Theory of Adaptation* (2013) concludes with an epilogue in which Siobhan O'Flynn considers "how adaptation is perceived and practiced" following "the emergence of new platforms, modes of interaction, and the changing production design of entertainment properties" (179) since the book was first published in 2006. Citing "the rise of the social web with the increasing popularity of participatory media, blogs, and wikis, the increase in smart mobile devices that support these interactions, the viral dissemination of DIY content online through platforms such as YouTube, Facebook and Twitter, and the revolution of touch-screen interfaces" (179), O'Flynn argues that participatory culture expands both the range and the nature—the quantity and the quality—of the "modes of interaction" available to audiences. O'Flynn echoes Hutcheon's own prefatory suggestion that the "continuum of adaptive relations . . . can and should be rethought and retheorized in the light of the new media," since, "[f]or better or for worse, the new media are participatory media" (xx, xxvi). Here Hutcheon herself echoes Henry Jenkins, who argues in *Convergence Culture*: "The term *participatory culture* contrasts with older notions of passive media spectatorship" (3). Glancing back to the novel/film paradigm of adaptation studies yore, Hutcheon says, "It is not that reading a print book and watching a film are not active, even immersive, processes," but that in convergence culture, the "verbal transitivity of showing and telling [has] to be replaced by the prepositional engagement of the 'with' that signals something as physical and kinetic as it is cognitive and emotional" (xx). For Hutcheon, adaptation culture is transitive, convergence culture interactive; adaptation culture revolves around objects, convergence culture around subjects. Hutcheon wonders whether the "coexistence of the new and the old, the digital and the analogue" portends a shift in "degree or, more radically, of kind" (xix), but she and O'Flynn tend toward the latter opinion.

Consider the particular touch-screen technology O'Flynn turns to in the final third of her epilogue: the iPad, whose "touch screen, gyroscope, video and audio support make it an extremely rich platform for adapting children's books, which can be easily

oriented towards exploratory play and educational learning or edutainment. The best adaptations often combine much-beloved illustrations with dynamic interaction and audio elements, including voice-over Read to Me modes, clickable words triggering the reading of that word or sentence, and Easter Egg sounds to be discovered" (201). Even if Trilogy Studios' 2011 iBook adaptation of Crockett Johnson's *Harold and the Purple Crayon* "remains very close to the 1955 original," for instance, it "engages the reader/player in a different way" (202). Its illustrations "are designed to invite interactivity by having elements appear in half-opacity and sometimes as unfinished, signaling the opportunity to complete the image.... [S]wiping reveals stars and a tinkling sound, and tapping sends the stars shooting off the edge of the screen with a swooshing sound. The app also includes a 'Read to Me' mode, a 'Read Alone' mode, and portions of the audio are often delayed, waiting to be triggered by touch-screen interactivity" (202). In such iBook adaptations, "pre-existing stories, either in text alone or as illustrated texts, remain close to the originating work and the innovation in adaptation occurs in the innovations in form and interactivity" (202). For O'Flynn, Trilogy Studios' *Harold and the Purple Crayon* works differently than, say, the seven-minute animated adaptation of Johnson's book produced by Brandon Films in 1959 and later distributed by Weston Woods Studios—and that difference is a difference of kind ("a different way," an "innovation") rather than degree.

While O'Flynn contends that the "transcoding process" of new media adaptations brings much to bear upon Hutcheon's closing question of "What Is Not an Adaptation?" (181), the case of *Harold and the Purple Crayon* raises a related question: What is not new? That is, the innovations in Trilogy Studios' iBook seem somewhat less innovative if we speculate on the original book's uses, or the book's original uses. A September 2011 "Tech Report" on the *Harold* adaptation alludes to those uses even as it overwrites them. The clip begins with reporter Rich DeMuro explaining, "Reading has never been more engaging or interactive thanks to the iPad. There are two types of books making their way to the device: Those that replicate the printed page and others that let your child become a part of the story." DeMuro clearly sees the *Harold* adaptation as falling into the second category, but a subsequent scene finds him holding a print copy of Johnson's book as he explains that it "came out in 1955, and I can guarantee you a lot of kids took their purple crayon to these pages. On the iPad edition, it's totally welcomed." Cut to an unidentified developer who says that "what that really allows the kid to do is engage on a new level that's far greater than they could ever do with a print book." DeMuro implicitly dismisses the interactivity of a child using a crayon to scribble on *Harold*'s pages as unwelcome, just as O'Flynn implicitly dismisses the interactivity of parents reading aloud to—or *with*—their children when she frames the iBook's "Read to Me" mode as innovative. A text like Trilogy Studios' *Harold* doesn't so much innovate new modes of interactivity as it does make explicit the modes of interactivity that were in place all along. Indeed, both the report and O'Flynn willfully ignore any number of old(er) media texts that engage kids and invite interactivity: Choose Your Own Adventure books, coloring books, pop-up books, puzzle books, Play-A-Sound books, Read-Along Books and Records—some of which are adaptations, some of which are not.

And there's the rub—or the swipe, if you like. By privileging participation in the ways they do, Hutcheon and O'Flynn stress what's new in new media, rather than what's new in adaptation. Never mind how the iBook *Harold* works as an iBook; how does it work as an adaptation? In extolling new media, Hutcheon and O'Flynn run the risk of resurrecting the very binarism from which adaptation scholars have retreated in recent years. As Kamilla Elliott argues in her essential polemic *Rethinking the Novel/Film Debate*, many adaptation scholars have long upheld a false opposition between words and images as "absolutely different semiotic systems of film and language" (Andrew, qtd. in Elliott 1), even as those same scholars sought to reconcile novels and films as "sister arts sharing formal techniques, audiences, values, sources, archetypes, narrative strategies, and contexts" (Elliott 1). This paradoxical approach to adaptation has meant that "even though analogical rhetoric pervades the novel/film debate, categorical approaches have dominated its theorization" (11). Such a model follows Seymour Chatman's famous claim that novels can do things that films can't (and vice versa)—that is, while critics may locate analogous operations in novels and films, the two media remain categorically distinct. As Elliott avers in her subsequent discussion of silent film intertitles, illustrated novels, and pictorial initials, such categorical distinctions are less stable than adaptation scholars might assume. Instead, she proposes a more fluid and reciprocal looking glass analogy of adaptation that makes "each art the modifying adjective of the other" and creates a "mutual and inherent rather than a hierarchical and averse dynamic" (210–11).

This looking glass analogy would seem perfectly suited to the texts of convergence culture (e.g., the iPad *Harold*), which collapse categorical distinctions between the verbal, visual, auditory, and other channels. As O'Flynn herself says, the "fusion of different media" in iBooks "raises the question of whether the categorization via older models of siloed or distinct production industries (games vs. films vs. books) is still relevant, particularly in terms of how a work makes meaning as an adaptation" (205–6). But O'Flynn focuses far more on how new media make meaning as new media than on how adaptations make meaning as adaptations within the context of those new media. She maintains distinct categories of reception, even as she questions distinct categories of production. In O'Flynn and Hutcheon's account of participatory culture, the hierarchical and averse dynamic of novel/film simply gives way to the hierarchical and averse dynamic of old/new media; old and new media represent not only absolutely different productive or semiotic systems, but different cognitive and kinetic systems as well. Hutcheon and O'Flynn conflate film and novel as passive old media that show and tell, and set them against the more active, participatory new media of social networks, videogames, and websites that we interact with. Convergence culture threatens to multiply the objects of adaptation study without multiplying its methodologies.

Yet Jenkins himself defines participation as "[t]he forms of audience engagement that are shaped by cultural and social protocols rather than by the technology itself" (331). Perhaps Hutcheon and O'Flynn mistake participatory media for participatory culture. Michael Ryan Moore argues, "Within the new media environment, adaptation becomes a strategy of participation" (183). But adaptation has always been a strategy of participation, a system as cognitive and kinetic as it is semiotic. Adaptation scholars just haven't

framed it as such, opting for formal, cultural, and industrial accounts of the phenomenon instead. Rather than asking what's new in new media, scholars could ask what's old in adaptations—that is, how adaptations themselves are and always have been interactive. Different kinds of media invite different degrees of interaction, but so do different kinds of texts; mysteries involve different modes of interactivity than do comedies, or slashers, or pornography. What sorts of invitations do adaptations, as a particular kind of text, extend to their audiences? Attending to that question would mean considering not (or not only) what new media can do that old media can't, but, more pressingly, what adaptations can do that other texts can't—itself a variation of Hutcheon's closing question of what isn't an adaptation. Adaptation scholars could set adaptations' modes of interaction against or alongside old and new media's.

This focus on adaptation, rather than media, as a categorical distinction may lead to an understanding of adaptation itself as a medium, or adaptations as media. It may lead adaptation scholars to better articulate the *procedural rhetoric* of adaptations, in a phrase that Ian Bogost draws from the affordances of videogames, but one that encompasses "any medium—computational or not—that accomplishes its inscription via processes" (46). In this study of adaptation, the processes and protocols of new media would give way to the processes and protocols of adaptation—how, why, where, when, what, and for whom adaptation functions. This approach offers an obvious advantage to adaptation scholars insofar as it argues for the singularity of adaptation, rather than the singularity of new media, in the context of convergence culture. As Jenkins says, "Convergence does not occur through media appliances, however sophisticated they may become. Convergence occurs within the brains of individual consumers and through their social interactions with others" (3). Convergence does not occur through the iPad, but within the brain and body of its offscreen user. Before we get to convergence, we may very well ask: How does adaptation occur within the brains and bodies of individual consumers and through their interactions (social or otherwise) with others?

Adaptation scholars have long concerned themselves with the exchange value of adaptations, with equivalencies between telling and showing, between literature and film, between source texts and adaptations—hence the field's history of invectives against fidelity discourse. Asking how adaptation occurs within the brains and bodies of individual consumers could shift scholarly focus from the exchange value of adaptations to their use value, from the forms of adaptation to its functions. As Lev Manovich observes,

> The history of art is not only about the stylistic innovation, the struggle to represent reality, human fate, the relationship between society and the individual, and so on— it is also the history of new information interfaces developed by artists, and the new information behaviors developed by users. When Giotto and Eisenstein developed new ways to organize information in space and in time, their viewers also had to develop the appropriate ways of navigating these new information structures—just as today every new major release of a new version of familiar software requires us to modify information behaviors we developed in using a previous version. (39)

This history of art, which Manovich parallels with a "gradual shift in attention from the author to the text and then to the reader" in cultural criticism (40), hints at adaptation's functionalities. The history of adaptation, after all, is one in which audiences have had to adapt to "new information interfaces developed by artists," to navigate "new information structures," to modify their behaviors as novels are updated into plays, or plays are updated into films, or films are updated into videogames. For what is every adaptation that follows from an earlier source, if not an update? At a minimum, Hutcheon and O'Flynn offer adaptation scholars a renewed interest in the listeners, players, readers, and viewers—in short, the users—of adaptations. Adaptation is an operating system (Adaptation OS) through which those users develop new ways of organizing information across various media, texts, and user interfaces. And only greater attention to the ways that adaptation operates within and outside convergence culture can answer Hutcheon's question of whether adaptation scholars are facing a "transitional time" or a "totally new world" (xix), an entirely new operating system (Convergence OS) or an update of the old (Adaptation OS X). The operating system of adaptation predates convergence culture, even while the range of its programmers has expanded in recent years. Rethinking the difference between old and new media as one of degree, not kind, leaves scholars better positioned to rethink the difference between adaptation and other intertextual and transmedia practices as one of kind, not degree.

So what types of interaction do adaptations invite that other texts do not? What are adaptation's particular protocols and commands? Hutcheon and O'Flynn not only offer us the impetus to ask these questions in the first place; they also gesture to the most logical first place to begin answering them. O'Flynn's focus on children's books like *Harold and the Purple Crayon* in her epilogue is far from incidental, since children's books (and adaptations thereof) constitute a disproportionate share of convergence culture: the myriad film franchises based on comics and young adult properties; the growing popularity of digital and analogue games, many of which are adaptations (a phenomenon Paul Booth explores at length in *Game Play*); and the growing demand for texts like adult coloring books (e.g., Johanna Basford's best-selling *Enchanted Forest* and *Secret Garden*), some of which, like Fred Armisen, Carrie Brownstein, and Jonathan Krisel's *The Portlandia Activity Book*, are film or television tie-ins. More important, though, children's texts tend to stress interactivity in ways that other texts do not. Children's texts are frequently as "physical and kinetic" as they are "cognitive and emotional." If, as Hutcheon suggests, "adaptive play" is one of the hallmarks of convergence culture (xix), then the adaptation of children's texts presses the question of what adaptations can do that other texts cannot by foregrounding interactivity.

And *Harold and the Purple Crayon*, a picture book that invites as much interactivity as its iPad adaptation, presses that question through its protagonist. Harold is a boy who creates his world using just a crayon, journeying down "a straight long path" before he draws a shortcut to "where a forest ought to be"; "a very small forest, with just one tree in it," which "turned out to be an apple tree"; a "frightening dragon" to guard the apple tree; an ocean (inadvertently, after the dragon he's drawn causes his hand to shake); a boat; a beach; a picnic of "nine kinds of pie that Harold liked best"; a "very hungry moose and

a deserving porcupine to finish it up"; a mountain from which to spot "the window of his bedroom," since "he ought to be getting to bed"; a hot air balloon (after he falls off the half-drawn mountain); a house where his window "ought to be" but isn't; a building "full of windows"; "lots of buildings full of windows"; "a whole city full of windows"; a policeman to point the way home; and then, finally, a frame around the moon that's been following him from the first page ("He remembered where his bedroom window was, when there was a moon. It was always right around the moon"). As in the iPad *Harold*, Johnson's drawings are often arrested, "unfinished," signaling not "the opportunity to complete the image," as O'Flynn has it, but *an* opportunity to complete the image. In this respect, the print *Harold* may even be less restrictive than its digital counterpart. Harold often draws his world—his apple tree or his boat or his balloon—line by line over the course of several pages, offering his young readers the opportunity to complete or copy his illustrations. But there's no need for those readers to color inside the lines, as Harold himself doesn't. *Harold and the Purple Crayon* is all about what "ought to be"—that is, the prescribed lines that Harold may or may not follow—and what isn't always. Harold ultimately realizes that the various frames he's trying to replicate, literalized in "the window of his bedroom," don't matter so much as the framer, the user, the person who possesses the purple crayon. What "ought to be" becomes what is.

It's little wonder, then, that so many of *Harold*'s adaptations offer audiences their own purple crayons, sometimes literally so. A 2012 production of Don Darryl Rivera's musical *Harold and the Purple Crayon* at the Chicago Children's Theatre, for instance, included "audience-participation" segments; *Chicago Tribune* critic Chris Jones notes that everyone in the theater got a purple crayon "and the chance to draw on the walls." The DVD release of HBO's 2002 animated series *Harold and the Purple Crayon*, meanwhile, includes a sixteen-page "Activity Booklet" as an insert. "Now it's your turn," reads the script on the cover, with a picture of Harold proffering the purple crayon to the reader. The booklet features coloring, maze, matching, and connect-the-dots activities corresponding to different episodes, culminating in four largely blank pages with the heading "CREATE YOUR OWN WORLD." And in 2001, Briarpatch released a *Harold and the Purple Crayon* card game adaptation that came with a dry erase board and purple marker ("Let's help Harold draw a brand new adventure. On your turn take a card, draw the object and use it in a story"). These adaptations extend the interactivity of the book at least as much as the iPad *Harold*, which is no longer active, let alone interactive. At the end of 2014, users on Trilogy Studios' Facebook page complained that the book had disappeared from their iPads, with one speculating that the company may be defunct; HarperCollins subsequently published a non-app, eBook version of *Harold* in the fall of 2015. In inviting interactivity, these digital and analogue adaptations reframe the experience of reading *Harold and the Purple Crayon* as much as they reframe the story itself. Adaptation—not new media or old—becomes the purple crayon that colors what ought to be for its audiences.

Indeed, *Harold and the Purple Crayon*'s language of what "ought to be" or not to be applies as much to adaptation as to interactivity. What are consumers and producers of adaptations if not users who weigh what "ought to be" against what isn't, couldn't, or shouldn't be? Hutcheon says that to experience an adaptation *as an adaptation*, "we need

to recognize it as such and to know its adapted text, thus allowing the latter to oscillate in our memories with what we are experiencing" (120–21). In her appraisal of new media, Hutcheon seems to overlook this fundamental mode of interaction. As Thomas Leitch counters in his review of *A Theory of Adaptation*'s second edition, every adaptation is interactive because "[r]ecognizing and experiencing any adaptation as an adaptation already involves a higher order of intertextual activity on the part of both texts and their readers than inhabiting a single receptive framework, even if that were possible" (158). Harold himself inhabits multiple productive and receptive frameworks in Johnson's story, and *Harold and the Purple Crayon*'s adaptations, whose knowing audiences range from the playwrights and producers who restage the story to the young and old readers who take their own crayons to its pages, literalize those different frameworks. Hutcheon tries to divide interactivity along the lines of the cognitive and the emotional, which belong to the old media, and the physical and the kinetic, which belong the new, but Johnson's story and its adaptations suggest that these categories are less mutually exclusive than she maintains. Medium specificity is merely one framework through which adaptation operates, as intramedial adaptations (like abridged classics for children) attest. Cutting across the new/old media divide, we could seek to identify *Harold and the Purple Crayon*'s modes of interaction, *Harold and the Purple Crayon*'s adaptations' modes of interaction, and, finally, adaptations' modes of interaction.

All in all, however, *Harold*'s intertextual sprawl is more modest than that of most children's texts in convergence culture. In order to get at the question of what adaptations may do that other texts may not—in cognitive, emotional, kinetic, and physical terms— we'll have to abandon Harold's self-drawn boat for a no less imaginary or individual vessel, one named for its adolescent captain: Max's *MAX*, from Maurice Sendak's 1963 picture book *Where the Wild Things Are*. Sendak was a protégé of Johnson's, and his children's classic (declared the best picture book of all time in a 2012 *School Library Journal* survey that placed *Harold* sixteenth ["SLJ's Top 100"]) bears passing resemblance to its predecessor. Like Harold, Max sets off on a journey from his bedroom, only to end up on an island populated by creatures of his making—the moose and porcupine in Harold's case, the eponymous wild things in Max's—and Max, like Harold, yearns to find his way back home. Max has "made mischief of one kind" (nailing a chain of kerchiefs to the wall to hang a tent) "and another" (chasing the family dog with a fork), so his mother banishes him to his room, where a forest grows and an ocean "tumble[s] by" with a "private boat." Max sails to the island where the wild things are and becomes the king of things— "the most wild thing of all"—and he follows his mother's lead by sending the wild things "off to bed without their supper" after a "wild rumpus." In repose, though, Max longs to be "where someone loved him best of all," and so he returns home, where he finds his "still hot" supper waiting for him in his room. If *Harold and the Purple Crayon* offers an image of adaptation, with its protagonist struggling to sketch people, places, and things as they "ought to be," then *Where the Wild Things Are* offers an image of convergence, with its protagonist struggling to contain the multitudes of the Wild Things. Both boys end up in bed at story's end, Harold's purple crayon dropping to the floor, Max's scepter and crown back on the island, waiting for others to take them up.

And others did. *Where the Wild Things Are*, like *Harold and the Purple Crayon*, was adapted into an animated short in the years following its publication—by Gene Deitch in 1973, for the same studio that distributed the *Harold* film—but in the mid-1990s, Sendak and producer John Carls (the latter of whom would later go on to develop the iPad *Harold*) courted music video whiz kid Spike Jonze to direct a live-action adaptation of Johnson's book. The project fell through, but Sendak took to Jonze, whom he later enlisted to helm a big screen adaptation of *Where the Wild Things Are* instead. Jonze began work on the project soon after the release of his and Charlie Kaufman's 2002 feature *Adaptation.*, a deconstruction of novel-to-film adaptation that blooms from Susan Orlean's *The Orchid Thief*, and production continued on and off from 2006 to 2008, amidst Warner Bros.' concerns over the movie's "darker-than-expected, adult tone" (Brodesser-akner). The film, released in 2009, was every bit as adult and dark as Jonze and Sendak intended it to be. In a *Dazed* interview from that year, the director recalls that the author said early on, "I don't want a faithful adaptation, I want somebody to take this and make it their own. And if you're gonna do this, it needs to be personal and it needs to be dangerous" ("RIP"). Those two adjectives could hardly describe Sendak's original picture book better, since its "destructive fantasies" were decried by psychologist Bruno Bettelheim before it was even published (qtd. in Shafer). John Cech writes that *Where the Wild Things Are*, upon its publication, "crossed a number of unmarked but nevertheless carefully tended boundaries. Most strikingly, it broke a taboo against the expression of the powerful emotions of childhood—whether they were explosions of anger or sudden journeys into fantasy—that were normally kept far away from the pages of the picture book" (110). This emotional excess may be why, "[e]ven though some of his readers may not be able to recall Sendak's name or even the title of the book, they vividly and instantly remember the story and the effects it had and continues to have on them" (114). Readers remember the book's "effects" as well as its story. Jonze explains his own relationship to the book in similar terms, describing his mother reading Sendak's story to him as "hypnotic. Just totally engrossing. Not even wanting to be Max, but just in *being* Max" (Heath). He told *Urban Outfitters'* Molly Young that his "motivation for the film was just loving what it stirred up in me, connecting to what I felt as a kid." Jonze remembers *Where the Wild Things Are* in terms of interactivity, in terms of what the story did to him and how it made him feel. And in adapting *Where the Wild Things Are*, Jonze seeks to replicate the experience of reading the story as much as the story itself. Adaptations of canonical children's texts like *Where the Wild Things Are* and *Harold and the Purple Crayon* may foreground the observation, dating back to George Bluestone, that every adaptation is only ever an adaptation of an ideation, a remembrance of a text, rather than the text itself, since they're aimed as much at adults who used to be kids as at kids themselves. What Jonze adapts is not Sendak's book but "a kind of paraphrase of the [book]" (Bluestone 62) recalled from childhood. Jonze wants the adaptation to do the same things that the book did when he was a kid.

So what does Jonze's *Where the Wild Things Are* do as an adaptation? In a rudimentary sense, it leads to more doing. Perhaps more so than other texts, adaptations beget adaptations, and Jonze's film inspired a pack of tie-in texts across old and new media

more motley than the wild things themselves, aimed at old and new audiences. Most of those texts announce themselves *as adaptations*, based (variously) on Jonze's film, Jonze and Dave Eggers's screenplay, Sendak's picture book, or some combination thereof. Old media adaptations include *The Wild Things*, a novel by Eggers aimed at young adults ("ADAPTED FROM THE ILLUSTRATED BOOK 'WHERE THE WILD THINGS ARE' by MAU-RICE SENDAK AND BASED ON THE SCREENPLAY 'WHERE THE WILD THINGS ARE' *co-written by D.E. and* SPIKE JONZE"); *Where the Wild Things Are: The Movie Storybook* ("Based on the screenplay by Spike Jonze and Dave Eggers. . . . Based on the book by Maurice Sendak. . . . Adapted by Barb Bersche and Michelle Quint"), which expands Sendak's sentences and replaces his illustrations with stills from the film for younger readers; a *Where the Wild Things Are Puzzle Book* ("Based on the Motion Picture," with its author, Alice Cameron, unlisted), bulkier but briefer than the storybook; a *Coloring and Creativity Book* ("Written by Sadie Chesterfield. . . . Based on the Screenplay by Spike Jonze & Dave Eggers. . . . Adapted from the book by Maurice Sendak. . . . Illustrated by Carolina Farias") that comes with a set of crayons; and *Heads On and We Shoot*, an extensive making-of book from Eggers's McSweeney's imprint. Somewhere between the old media and the new there's the film's soundtrack from Karen O and the Kids, executive-produced by Jonze himself and available in both analogue (vinyl) and digital (CD, MP3) formats. More firmly falling on the side of the new, there's the film's website, with its games ("Dirt Clod War," "Wild Thing Scramble"), video clips, downloads (wallpapers, buddy icons, screensavers, posters) and streaming clips from the soundtrack; a Tamagotchi-like iPhone app called "Wild Things," in which users interact with Carol, the main Wild Thing, and have access to more videos, posters, music, and so on; *We Love You So*, a blog spearheaded by Jonze that ran from April 2009 through June 2010, "established to help shed some light on many of the small influences that converged to make this massive project a reality," and featuring posts on "Design," "Art," "Photography," "Music," "Skateboarding," "television," "toys," "web," and "video"; and *Where the Wild Things Are* for the Wii, PS3, Xbox 360, and Nintendo DS. Falling somewhat outside the borders of the old or the new in this matrix of "tie-intertextuality," as Elliott has called such configurations in an essay of the same name (194), is Urban Outfitters' line of *Where the Wild Things Are* apparel, ornaments, and furniture meant to "celebrate the movie and its magical story" ("Where the Wild Things Are") and Opening Ceremony's high fashion line "inspired by [Jonze's] new film adaptation of Maurice Sendak's treasured book, *Where the Wild Things Are*," including such items as an adult-sized "Max Suit" for $610 and a "max lined parka" (blurb: "keep your inner wild thing tame") for $895. Much as the wild things converge in the individual consumer of Max ("I'LL EAT YOU UP!" he threatens at one point), these *Wild Thing*s converge in the brains and bodies of their own individual consumers, young and old alike.

Like *Harold*'s reframings on stage and screen, these adaptations challenge the distinction that Hutcheon and O'Flynn maintain between old and new media's modes of interaction. The movie storybook, for instance, implicitly encourages parents to read aloud to or along with the three- to seven-year-old children for whom the text is intended. The *Coloring and Creativity Book* includes an activity that asks its users to articulate

how one of the wild things feels by writing an adjective under various illustrations of its face (they're given a head start with a pair of faces labeled "sad" and "happy"). The puzzle adaptation asks its user to reconstruct images from the film, each matched by narration on the opposing page. And the videogame adaptation begins with a tutorial on how to control Max as he commands the wild things (press LB to Rumpus, press RB to Roar). The game even includes an insert that touts Max's continuing adventures "in three exciting . . . movie tie-in books!" In this foursome, one mode of interaction supplements another. These various *Wild Things* suggest that adaptations extend, rather than restrict, modes of interaction for their audiences, whether moving from old media to new or vice versa. And as adaptations of an overly affective story, they also suggest that Hutcheon's own foursome, the "physical and kinetic" and the "cognitive and emotional," converge on the mode of adaptation itself. Carl Plantinga writes that " 'affect' is a broader category than 'emotion.' Affects are any felt bodily state, including a wide range of phenomena, including emotions, moods, reflex actions, autonomic responses, mirror reflexes, desires, pleasures, etc." (87). Jonze is just another user for whom adaptation is as experiential as it is textual, as intensive as it is interpretive. As Plantinga says, "emotions are intimately tied to cognitions, and for this reason affective experience, meaning, and interpretation are firmly intertwined" (86). Adaptations make us think and feel (literally, metaphorically) in ways that other texts do not.

Two *Wild Things* intertexts that precede even Jonze's film speak to adaptation's distinction. The first is a 1988 episode of *thirtysomething* titled "What Forest Is This," for which *Where the Wild Things Are* serves as inspiration. The episode revolves around Ethan, a young boy whose parents have split and whose father has just moved out (leaving him in a phallogo-centrifugal household much like the fatherless Max's). Ethan begins having nightmares about a monster deep in the woods whom he must eventually confront and befriend. Since Ethan's father used to tell him the story about the monster before he went to bed, his mother Nancy's version is incomplete. "He—he thinks that there is this monster in his closet," she explains to a friend, "and what am I supposed to tell him? It's not there? It is there. It just moved from our bedroom to his." In one scene, she attempts to get the whole story from Ethan, who sits behind the greenish glow of a computer, typing furiously as he plays a game. Nancy looks at a picture Ethan has painted of the monster—itself an obvious homage to Sendak's—and says, "You know, it is really funny, but I have been thinking about that story all day. Y'know, the one about the prince?" Ethan remains silent. Nancy positions herself behind the computer, in Ethan's line of sight. "Alright, um, I know there was a prince," she says, "and I know there was this kingdom that was in trouble because something was gone, I mean, something that the people really needed, and the only one that could help them was, um, this prince, and he had to go into the woods, I—I know that. And he had to go into the woods, and there was this monster there. But what I don't know is what was missing. What did he have to go and find?" Nancy suggests that "it was a rose" ("It was not," Ethan replies) or that it was "magic broccoli" ("Please," sighs Ethan). "You're so dumb," he says. "It was the sun." The sun was missing, much as both the sun and son are missing in Max's nighttime excursion in *Where the Wild Things Are*. Indeed, the opening of Jonze's film finds Max listening to his science

teacher explain that the sun is dying; he later freaks out Carol, the head wild thing, with this fact, setting up their final confrontation and Max's departure from the land of wild things. Throughout the episode, we get film adaptations of Ethan's story; he eventually confronts the monster, who is styled after his drawing, and they become friends.

Contrast this scene from *thirtysomething* with a similar scene from Jonze's film, in which Max overhears his (single) mother take a stressful work call at home. "Can you tell me exactly what Mr. Lasseter didn't like about the report?" she pleads with the person on the other end of the line as she sits in front of a computer. "I cannot afford to lose this." Max lies down next to the desk and tugs on the toe of his mother's pantyhose. "I could use a story," she says after she gets off the phone. Jonze alternates between high angle shots of Max and low angle shots of his mother. "Uh, um, sure," Max says. "There were some buildings. There were these really tall buildings, and they could walk. Then there were some vampires." Jonze shows Max's mother transcribing the story. "And one of the vampires bit the tallest building and his fangs broke off. Then all his other teeth fell out. Then he started crying. And then all the other vampires said 'Why are you crying? Aren't those just your baby teeth?' And, uh, he said, 'No, those are my grown-up teeth.' And the vampires knew that he couldn't be a vampire anymore, so they left him. The end." An activity in the tie-in *Coloring and Creativity Book* asks users to "[i]llustrate [Max's] story" in a series of blank, captioned boxes ("There were some buildings . . .", "They could walk," "Then there were some vampires")—to adapt those captions into images, as it were.

In *thirtysomething* and Jonze's *Where the Wild Things Are*, Ethan and Max narrate their own versions of Sendak's story in a manner reminiscent of Harold's. And in both cases, they narrate their stories to address fraught emotional situations: Ethan's turmoil over his parents' separation in *thirtysomething*, Max's mother's work-related stress in *Where the Wild Things Are*. In the former case, new media (i.e., the computer) impede this process; in the latter case, new media speed it. In both cases, though, adaptation becomes a system for expressing particular emotions. "I could use a story," Max's mother says. Adaptation becomes an affective framework for parent and child, producer and consumer, programmer and user—a reframing through which they work out their emotions—not unlike Jonze's own approach to *Where the Wild Things Are*. Leitch has argued that "every adaptation is occasional rather than expressive" ("How to Teach" 11), but some adaptations may be as expressive as they are occasional; indeed, their emotional expression may be the occasion. For Sarah Annunziato, Jonze's film "serves as a manual for young people that instructs them on how they might learn to cope with difficult situations in their personal lives" (259–60). Adaptation becomes manual: a practical thing, a tactile thing.

The second intertext—Susan Kilpatrick's *A Guide for Using* Where the Wild Things Are *in the Classroom*, originally published in 1994 but reprinted in 2009 to coincide with the release of Jonze's film—even more pointedly answers the question of what adaptations do by highlighting their participatory nature. Kilpatrick begins the guide, which is "*Based on the novel [sic] written by Maurice Sendak*," by announcing: "A good book can touch the lives of children like a good friend. The pictures, words, and characters can inspire young minds as they turn to literary treasures for companionship, recreation, comfort, and guidance" (3). None of the four possible uses Kilpatrick offers for children's

literature is immediately tied to interpretation. The guide's tear-out pages emphasize its tactile, physical, use-driven nature; these activities are meant to be replicated, adapted, and adopted by their users.

Those activities serve both as adaptations in themselves and as prompts for further adaptation. In the "Story Ladder" exercise, students are encouraged to cut out five "sentence blocks" (e.g., "A forest grew in his room. There were trees and vines"; "Max sailed away to where the wild things are") and arrange them in the correct order (24). In "Story Scenes from *Where the Wild Things Are*," students match the same "sentence blocks" to single words that emphasize those sentences' role in the story (e.g., "Forest": "A forest grew in Max's bedroom" [21]). In the "Wild Things Booklet" exercise, students copy sentences from a chalkboard (e.g., "Wild things roll their eyes") and then "illustrate that page to match what the sentence says," ending up with a complete book that they should read "to a grownup and/or student partner" (25).

Other activities revolve around restaging *Where the Wild Things Are*. Kilpatrick provides "Suggestions for Presenting Reader's Theater," in which "dialogue may be read verbatim from the book just as the author has written it, or an elaboration may be written by the performing students. Sound effects and dramatic voices can make these much like radio plays" (44). She encourages students to "hold up pictures they have created to go with the story or poem," further emphasizing her call to adaptation. Kilpatrick also provides a "Reader's Theater Script" (45), which already expands the character list to Pete (who "just would not behave") and his brother Joey. Instead of a rumpus, the "Strange Beasts" ask for a "big parade" (45). The performance ends with a recital of "Max Was a Wild Thing," a poem by Kilpatrick (18), and M. E. Hicks's song "The King of the Wild Things" (43). A "Stick Puppet Theaters" prompt suggests "[l]et[ting] students experiment with the puppets while telling the story in their own words or reading from the book" and letting students "hold up the stick puppet that represents who or what might have said it" (20), an activity based on students' recall of *Where the Wild Things Are*. And the *Guide* even includes "Wild Things Recipes" (42) for Max's Sailboat (made of tuna, mayo, English muffins and cheese squares), Wild Things Cookies (decorated with cream cheese, peanut butter, frosting, and candies to resemble Wild Things faces), and Wild Things Punch (a mix of Sprite and fruit juice). These are adaptations of a different sort, to be sure, but adaptations nonetheless.

If the *thirtysomething* scene emphasizes the affective work of adaptations, Kilpatrick's book indicates their cognitive work. Adaptation, not apps or videogames or websites, becomes the participatory medium, the operating system. Kilpatrick's book is not simply a guide for using *Where the Wild Things Are*, but a guide for using adaptations themselves, or adaptation itself. *A Guide to Using* Where the Wild Things Are *in the Classroom* provides the source code for Adaptation OS. As the second half of Kilpatrick's title implies, adaptations can do things "*in the Classroom*" that other texts cannot. Leitch has long advocated a turn from literature to literacy in adaptation studies, advancing the proposition that "all critical reading"—as well as all writing—"is rewriting" ("How to Teach" 10). Kilpatrick reminds us that adaptations are pivotal not only in classrooms where they may be offered as substitutes for canonical novels or singular interpretations

thereof, but in any classroom, where the incessant processes of rereading and rewriting are intertwined. As Kilpatrick's *Guide* attests, rereading is fundamental. In at least one sense, then, Adaptation OS is educational software.

But adaptation's program extends to other senses as well. Kilpatrick's *Guide*, with its emphasis on making and doing, attests to how the cognitive work of adaptations frequently encompasses other kinds of play. Elliott argues for a more cognitive approach to adaptation in the closing pages of *Rethinking the Novel/Film Debate*, since "cognitive linguistics and neuropsychology . . . have largely eroded the categorical differences between mental and perceptual images prevalent" in previous adaptation study (221). The notion that "[v]erbalizing and visualizing . . . prove to be connected rather than opposed cognitive processes" (222) would suggest that the rhetoric surrounding adaptations is more medium-specific than their actual reception—an important point for adaptationists working in convergence culture. The cognition of adaptations extends beyond their form to their content: How do audiences receive adaptations differently from other texts? This intertextual play can, of course, be seen as its own form of participation, and adaptation scholars stand to gain much by applying the game theories of new media studies to adaptations themselves. Consider the playful nature of another bedtime retelling of *Where the Wild Things Are*: BoyCrush's *Where the Wild Twinks Are: A XXX Parody*, a hardcore gay rewriting of Sendak's story described by the studio as revolving around Max, "a young, blonde heart-throb whos [*sic*] sexually repressed home life causes some heavy tension with his step-dad," and whose "life gets flipped upside down when four adorable, furry creatures capture him & start the biggest fuckfest of his life" ("Where the Wild Twinks Are"). A pornographic adaptation like *Where the Wild Twinks Are*—featuring Max in a wolfish white suit and crown—invites simultaneous cognitive and kinetic responses from its audience in ways that other texts do not.

Adaptation OS invokes emotion, cognition, and kinetics, but it also invokes a sense of the physical. Adaptations attune audiences to materiality in ways that other texts do not. In the Urban Outfitters interview, Jonze explained that he "wanted it to feel like Max was really there with . . . these creatures—and that you could touch them and feel them" (Young), a sentiment carried over into the costumes sold by Opening Ceremony. Jonze initially wanted all-material (i.e., puppet) Wild Things for his film; budget constraints forced him to complement his live-action puppets with digital effects. Like Kilpatrick's Wild Things recipes, this fact reminds us that every adaptation involves nonhuman actors and actants, ingredients and raw materials turned into something else. Under the source code of Adaptation OS lies the motherboard.

In a recent essay not on what adaptations do, but on "Doing Adaptation," Elliott describes the student projects produced in her literature and film courses that go "beyond the verbal and rational to nonverbal and nonrational adaptations of all kinds in all media," including "layer cakes about book chapters," "tactile interactive projects about audience response," and "music about critical theory" (75, 77). This "creative-critical work," as she calls it (75), sounds none too far removed from Jonze's puppets, or BoyCrush's pornographic parody, or Kilpatrick's lessons, all of which stress the nonverbal, nonrational, and sometimes nonhuman work involved in adaptation. Adaptations

teach and titillate and materialize in ways that other texts do not. Adaptations structure a unique series of interactivities between subjects and objects, old materials and new, old media and new. Elliott's students may engage different objects, different materials, and different media, but they always work "with" adaptation—a physical, kinetic, cognitive, and emotional mode of interaction that possesses all the promise of a purple crayon.

Works Cited

Annunziato, Sarah. "A Child's Eye View of *Where the Wild Things Are*: Lessons from Spike Jonze's Film Adaptation of Maurice Sendak's Picture Book." *Journal of Children and Media* 8.3 (2014): 253–66. Print.

Armisen, Fred, Carrie Brownstein, and Jonathan Kreisel. *The Portlandia Activity Book.* San Francisco: McSweeney's, 2014. Print.

Basford, Johanna. *Enchanted Forest: An Inky Quest and Colouring Book.* London: Laurence King, 2015. Print.

——. *Secret Garden: An Inky Treasure Hunt and Colouring Book.* London: Laurence King, 2013. Print.

Bersche, Barb, and Michelle Quint. *Where the Wild Things Are: The Movie Storybook.* HarperFestival–HarperCollins: New York, 2009. Print.

Bluestone, George. *Novels into Film.* Baltimore: Johns Hopkins UP, 1957. Print.

Bogost, Ian. *Persuasive Games: The Expressive Power of Videogames.* Cambridge: MIT P, 2007. Print.

Booth, Paul. *Game Play: Paratextuality in Contemporary Board Games.* London: Bloomsbury, 2015. Print.

Brodesser-akner, Claude. "Marketing 'Where the Wild Things Are' Won't Be Child's Play." *Advertising Age.* 14 May 2009. Web. 2 June 2015.

Cameron, Alice. *Where the Wild Things Are: Puzzle Book.* HarperFestival–HarperCollins: New York, 2009. Print.

Cech, John. "Max, Wild Things, and the Shadows of Childhood." *Angels and Wild Things: The Archetypal Poetics of Maurice Sendak.* University Park: Pennsylvania State UP, 1995. 109–42. Print.

Chesterfield, Sadie, and Carolina Farias. *Where the Wild Things Are: Coloring and Creativity Book.* HarperFestival–HarperCollins: New York, 2009. Print.

Eggers, Dave. *The Wild Things.* San Francisco: McSweeney's, 2009. Print.

Elliott, Kamilla. "Doing Adaptation: The Adaptation as Critic." *Teaching Adaptations.* Ed. Deborah Cartmell and Imelda Whelehan. Palgrave Macmillan: New York, 2014. 71–86. Print.

——. *Rethinking the Novel/Film Debate.* Cambridge: Cambridge UP, 2003. Print.

——. "Tie-Intertextuality, or, Intertextuality as Incorporation in the Tie-in Merchandise to Disney's *Alice in Wonderland* (2010)." *Adaptation* 7.2 (2014): 191–211. Print.

Harold and the Purple Crayon. Dir. David Piel. Perf. Norman Rose. Brandon Films, 1959. Film.

Harold and the Purple Crayon Game. Millburn: Briarpatch, 2001. Board game.

Harold and the Purple Crayon: The Complete Series. Perf. Sharon Stone, Connor Matheus. Sony Pictures, 2004. DVD.

Heads On and We Shoot: The Making of Where the Wild Things Are. San Francisco: McSweeney's, 2009. Print.

Heath, Chris. "Spike Jonze Will Eat You Up." *GQ.* 14 Sept. 2009. Web. 25 May 2015.

Hutcheon, Linda, with Siobhan O'Flynn. *A Theory of Adaptation*. 2nd ed. New York: Routledge, 2013. Print.

Jenkins, Henry. *Convergence Culture: Where Old and New Media Collide*. New York: New York UP, 2006. Print.

Jonze, Spike. "Wild Things." *Urban Outfitters*. 18 Sept. 2009. Web. 10 Oct. 2010.

Johnson, Crockett. *Harold and the Purple Crayon*. New York: HarperCollins, 1955. Print.

Jones, Chris. "Oh Harold, we never get to know you." *Chicago Tribune*. 14 Oct. 2012. Web. 28 May 2015.

Karen O and the Kids. *Where the Wild Things Are: Motion Picture Soundtrack*. DGC/Interscope, 29 Sept. 2009. CD/MP3/Vinyl.

Kilpatrick, Susan. *A Guide for Using* Where the Wild Things Are *in the Classroom*. Westminster: Teacher Created Resources, 1994. Print.

Leitch, Thomas. "How to Teach Film Adaptations, and Why." *The Pedagogy of Adaptation*. Ed. Dennis Cutchins, Laurence Raw, and James M. Welsh. Lanham: Scarecrow, 2010. 1–20. Print.

———. "New! Expanded! Unimproved!" Rev. of *A Theory of Adaptation,* by Linda Hutcheon, with Siobhan O'Flynn, 2nd ed. *Literature/Film Quarterly* 41.2 (2013): 157–60. Print.

Manovich, Lev. "Postmedia Aesthetics." *Transmedia Frictions: The Digital, the Arts, and the Humanities*. Ed. Marsha Kinder and Tara McPherson. Oakland: U of California P, 2014. 34–44. Print.

Moore, Ryan Michael. "Adaptation and New Media." *Adaptation* 3.2 (2010): 179–92. Print.

Plantinga, Carl. "Emotion and Affect." *The Routledge Companion to Philosophy and Film*. Ed. Paisley Livingston and Carl Plantinga. London: Routledge, 2009. 86–96. Print.

"RIP Maurice Sendak: 2009 Interview by Spike Jonze." *Dazed*. Dazed Digital, 2012. Web. 6 Apr. 2015.

Sendak, Maurice. *Where the Wild Things Are*. New York: HarperCollins, 1963. Print.

Shafer, Jack. "Maurice Sendak's Thin Skin." *Slate*. The Slate Group, 15 Oct. 2009. Web. 9 Apr. 2015.

"SLJ's Top 100 Picture Books." *School Library Journal*. 6 July 2012. Web. 9 April 2015.

TrilogyTouch. "Trilogy Studios Reinvents Harold and the Purple Crayon for iPad and Other Mobile Platforms." *YouTube*. 14 Sept. 2011. Web. 26 May 2015.

"Trilogy Studios." *Facebook*. N.d. Web. 26 May 2015.

We Love You So. 2009–10. Web. 29 August 2015.

Where the Wild Things Are. Dir. Spike Jonze. Perf. Max Records, James Gandolfini. Warner Bros., 2009. DVD.

Where the Wild Things Are. Burbank: WB Games, 2009. Videogame.

"Where the Wild Things Are." *Facebook*. Urban Outfitters, 17 Sept. 2009. Web. 10 Oct. 2010.

"Where the Wild Things Are x Opening Ceremony Max Lined Parka." *Opening Ceremony*. N.d. Web. 10 Oct. 2010.

Where the Wild Things Are—Warner Bros. Warner Bros, 2009. Web. 29 August 2015.

Where the Wild Twinks Are: A XXX Parody. Dir. Andy Kay. Perf. Benjamin Riley, Jason Valencia. BoyCrush, 2013. DVD.

"Where the Wild Twinks Are: A XXX Parody." *BoyCrush Store*. 31 Oct. 2013. Web. 29 Aug. 2015.

"Whose Forest Is This?" *thirtysomething*. Writ. Kathleen Tolan and Richard Kramer. Dir. Peter Horton. MGM, 1988. MPEG-4 video file.

Wild Things. Warner Bros. Entertainment, 6 Oct. 2009. Mobile app.

Young, Molly. "Call of the Wild." *Urban Outfitters*. 18 Sept. 2009. Web. 25 May 2015.

PART VI

··

ADAPTATION
ACROSS DISCIPLINES

··

CHAPTER 32

···

POLITICS AND ADAPTATION

The Case of Jan Hus

···

PETR BUBENÍČEK

There are as many versions of the (now so very distant) period of the Hussite movement as there are historians.

—František Šmahel (1993)

Today, Jan Hus would be a leader of a political party and his platform would not be a pulpit but Lucerna Palace or Wenceslas Square. And we can be sure that his political party would be very close to us, communists.

—Zdeněk Nejedlý (1946)

The history of the Hussite movement was deliberately misinterpreted by the bourgeois historians in order to cover up the fact that it really was a radical socialist movement, posing as a religious one, which in the Middle Ages was clearly unavoidable.

—Antonín Malina, in a review of the film *Jan Hus* (1955)

THE history of the nationalized film industry in post–World War II Czechoslovakia offers many examples of the relationship between adaptation practice and the political establishment of that time. This essay will analyze the shifting relationships between politics and adaptation in Czechoslovakia in the late 1940s and early 1950s. After the February coup of 1948, the Communist Party of Czechoslovakia became the ruling party. The party leaders used Stalinist social mechanisms to implement economic and political measures aimed at opposing their ideological enemies. The citizens were intimidated by means of organized violence, and the free society was systematically torn apart. The tools used by the communists in their endeavor included not only political repression, but also literary and film art to promote the new regime. It was deemed necessary to complement the idea of the common enemy by a complex ideological myth. Constructing the tenets of socialist art to support the Marxist-Leninist ideology, the

new regime reappropriated events and figures of the Czech past, as well as works of art, for the aesthetic and moral education of citizens.

In order to understand the social and political struggles that were involved in forming the film adaptations created in this period, we must first understand those who represented the subject matter of these educational reappropriations, as well as those who authored the adaptations and their ideological templates. These include Jan Hus (c. 1370–1415), priest and theorist of ecclesiastical Reformation; Jan Žižka of Trocnov (c. 1360–1424), general and Hussite leader; František Palacký (1798–1876), historian and politician who served as the design engineer of the Czech national myth; Alois Jirásek (1851–1930), novelist and proponent of Palacký's concept of history; Tomáš G. Masaryk (1850–1937), philosopher, sociologist, and first president of the Czechoslovak Republic; Zdeněk Nejedlý (1878–1962), musicologist, politician, and minister of culture and education in the period of the harshest Stalinism (1948–53); and film director Otakar Vávra (1911–2011), the author of the Hussite Trilogy: *Jan Hus* (1954), *Jan Žižka* (1955), and *Against All* (1956).

WHO WAS JAN HUS?

Jan Hus can be viewed as either a historical or a theological figure. Modern-day historians attempting to reinterpret him as a historical figure have questioned interpretations from historians of the time of the Czech national revival of the nineteenth century to the period of the Czechoslovak Republic and finally to communist Czechoslovakia. Setting aside confessional and national conflicts as well as social illusions, these historians focus on the study of the man's work, his society, and his world in an attempt to determine Jan Hus's identity as a thinker and theologian of the time, rather than as a religious martyr.

The spiritual situation in Europe at the beginning of the fifteenth century was so bleak that it became a breeding ground for several new movements. In the Czech lands, these included the teachings of religious reformer Konrad von Waldhausen, one of the first predecessors of Hus, Jan Milíč of Kroměříž, Matěj of Janov, and the evangelist and monastic movements. The church was experiencing a profound crisis, marked most notably by a period of schism when both Gregory XII (in Rome) and Benedict XIII (in Avignon) claimed the papacy, a conflict the Catholic Church tried to rectify by electing Alexander V as Pope in 1409.

This triple papacy was clearly unacceptable from both a theological and a societal point of view. The moral decay of the Church was most visible in simony, the practice of selling church offices and roles, which provoked the most vigorous protests from reformers. The Church in the Czech lands possessed many estates—according to some records, up to a third of all land—and received a considerable portion of its income through the activities of the mendicant orders (cf. Šmahel, "Husitská revoluce [1419–1471]" 117–18).

We will probably never know for certain who Jan Hus was; there is too little evidence for that. We do know that he came from a poor family and first chose to study theology primarily to have a chance at a more comfortable existence (Čornej, *Velké* 87; Molnár, *Na rozhraní* 326). One year after being ordained, Hus was charged with management of the Bethlehem Chapel in Prague's Old Town, where for the following ten years he would deliver daily sermons castigating the vices of both secular and ecclesiastic authorities. He took part in educational activities, teaching at the University in Prague, where he served as dean and rector. In addition to teaching, he also penned several treatises, most of them religious, in both Czech and Latin.

Until 1408 Hus enjoyed the protection of Archbishop Zbyněk Zajíc of Hazmburk. When he began to criticize the archbishop, he was forced to seek protection at the royal court. Four years later, however, he came into conflict with King Václav IV himself because he objected to selling indulgences (Šmahel, *Husitská revoluce* 265–66). When he was excommunicated from the Church, he decided to leave Prague, which had also been threatened with a similar interdiction on the entire city. For some time after his departure, Hus remained active in the country. In late 1414 he received an invitation to attend the Council of Constance, which was convened by Sigismund of Hungary to put an end to the papal schism and rectify the situation within the Church. Hus left for Constance, hoping that he would be given a chance to defend his ideas, but upon his arrival he was imprisoned, and, having refused to recant his doctrines, he was sentenced to be burned at the stake for heresy. The sentence was executed on 6 July 1415 (Šmahel, "Husitská revoluce [1419–1471]" 120). After Hus's execution, the people of the Czech Kingdom revolted on a mass scale.[1]

Hus and other preachers clearly brought out the desire for change in the masses. Since Hus was active in the early fifteenth century, a hundred years before Martin Luther and Jan Calvinus presented their reformative doctrines, the question remains whether he is more aptly regarded as a precursor of reformation or a reformer himself (cf. Hudson). Amedeo Molnár believes that the first reformation of the Catholic Church took place in the Czech lands and was followed by another in Germany and Switzerland ("Husovo místo" 6). The standard histories see Hussitism as an effort to rectify the Church's legitimacy and moral integrity. Molnár's view is supported by the fact that in the teachings of Hus and his precursors we can find views that re-emerge in Luther—for example, the rule of *lex Christi*, the obligatory norm with biblical roots that lays down rules for the life of every Christian. According to this rule, if a priest lives in sin, he ceases to be a priest, and the same rule extends to the Pope himself. Another example is the need to return to the Church as it was laid out by Christ and his apostles, without any of the political, organizational, and legal formulas on which it later came to depend (see Nechutová 52–54).

However his contemporaries saw Hus, Europe did not accept the Czech demands, and the so-called Hussite Revolution began in 1419. The Hussite community, led by Jan Žižka of Trocnov, formed a major military power that defeated five crusades the Pope proclaimed against them over the following sixteen years (in 1420, 1421, 1422, 1427, and 1431) and was not crushed until the Battle of Lipany on 30 May 1434.

One of Jan Hus's treatises, "Contra Iohannem Stokes," offers a self-portrait based on a critique of Dominican licentiate and Cambridge University master John Stokes, whom Hus attacks for having insulted the Kingdom of Bohemia and the University in Prague. Constructing a threefold identity, Hus identifies himself as the most humble of all priests, a Czech national loyal to the Czech king, and finally as *alumnus et magister bakalarius alme universitatis*. The text thus serves as a defense of the university's and the Kingdom's reputation and presents an image of Hus as a representative of academia and a preacher (Hus, *Contra Iohannem Stokes* 57–70).

Hus appealed against his 1412 excommunication directly to Christ and not to the church officials. Czech historian of law Jiří Kejř understands this appeal not only as a reaction to unfavorable news, but also as a theological manifesto. In this single action, Hus managed to express his mistrust of the Church jurisdiction and instead placed his trust in Christ as the one true judge of all things (Kejř 98–99). The medieval concept of the Church was, however, strongly institutionalized, and the Pope represented its supreme earthly authority. Hus's rebellion against a hierarchy based on canonical law put him in an unfavorable position. Had he consulted contemporary lawyers (for example, his own lawyer, Jan of Jesenice), they would certainly have recommended a more cautious approach, because from a legal point of view Hus's actions were not defensible. Even if he could pray to Christ, the only earthly authority with whom he could deal was the Pope. The fragments of the Constance protocols testify that Hus's insistence on this point hurt his own position, which many of the cardinals considered to be risible. Jiří Kejř notes that although the Constance judges admitted some testimony that later proved false and ascribed to Hus opinions that he did not in fact hold, they still proceeded within the confines of the law (205). From the point of view of canonical legal norms, there was no judicial error during the process, and Hus was therefore convicted justly (211). As Kejř points out, the moral and theological status of the case is an entirely different question (212).

Modern commentators have reached no consensus on the originality of Hus's teachings. Modern historians regard him as a theologian and religious exponent, but modern theologians believe that he borrowed most of his ideas from John Wycliff and conclude that his own texts do not yield any new systematic theological observations. Hus seemed to handpick the most critical and moralistic aspects from the reformist and scholastic tradition. One final issue that film adaptations of Hus's life make especially urgent concerns the social aspects of Hus's teachings. While modern historians do not deny that these aspects were part of Hus's teachings (or at least that they can be deduced from those teachings), they do not see Hus as a fighter for social truth or justice in the way the Marxists did (see Mezník; Molnár, *Na rozhraní*; Šmahel, *Husitská revoluce 2*).

CHANGING IMAGES OF HUSSITISM

The reappropriation of Hussitism became noticeable in the Czech culture as early as the late eighteenth century. The anti-reformists regarded both Hus and Jan Žižka as villains, and Žižka was depicted as a pathological psychopath and a violent criminal in the sixteenth century. When Kaspar Royko (1744–1819), a professor of religious history at the University of Prague, published the Constance Council files, the ideological question became an issue of academic interpretation, and the problem of sources was established as the key aspect of the debate. Literary fiction sank its teeth into Hussitism when poet and Czech national revivalist Antonín Jaroslav Puchmajer dedicated one of his three patriotic odes to Jan Žižka. The poem was regarded as one of the highest achievements of contemporary literature. The ode's elaborate structure has made it prized as one of the most complex poetic forms, often praising or glorifying abstract qualities such as heroism, beauty, wisdom, and individuals representing these qualities. Puchmajer's *Óda na Jana Žižku z Trocnova* [*Ode Upon Jan Žižka of Trocnov*, 1802] reversed these conventions by focusing on a known criminal. The poem began a new era of Žižka's restoration, closely related to the rise of nationalism fueled by the Napoleonic Wars and supported by the Austrian government, which needed a strong image of a popular military leader to provide a morale boost for the army against the French.

In the nineteenth century the Czech nation, like other small nations in Europe, went through a period of national revival whose anti-German and anti-Catholic character gave Hussitism an important position in Czech patriots' fight against Germanization and the Catholic Church, two major tools of the ruling Habsburg dynasty. František Palacký, a prominent Czech historian, significantly shaped the debate of Hussitism and its cultural heritage. In his extensive work *Dějiny národu českého v Čechách a v Moravě* (*The History of the Czech Nation in Bohemia and Moravia*, 1848–1876), he emphasized the period of the Hussite wars, basing his account on the romantic myth of a nation rebelling against its usurpers and his extensive research in the libraries and archives of Europe's noble families.

In the introduction to his study of this period, Palacký writes: "The Hussite leaders did not fight for glory or riches, for power or throne; they were always willing to sacrifice their own property as well as lives for the ideas, for the sacred cause of their conscience and their nation" (171; my translations throughout). Such a positive evaluation coming from a respected historian and the future "Father of the Nation" ensured that from now on, the period of Hussitism would be regarded as the defining moment in Czech history. Hussite doctrines, considered by the previous generations and even some of Palacký's colleagues as a deplorable excess of religious fanaticism, became unexpectedly useful during the Czech national revival of the nineteenth century. As historian Petr Čornej observes, "The Czech national society, which was formed on the basis of ethnicity, found in Hussitism an analogy to the processes which it was going through itself. From this point of view Palacký was a true founder of the Hussite myth which

proved exceptionally vital in its many modifications and political actualizations even if it is a mere echo for us today" ("Boží bojovníci").

Palacký saw Hussitism as a last stronghold of the democratic nature of the Old Slavonic people, a kind of liberal and social-democratic utopia (the state is disrupted, and the people have absolute freedom of speech, with no one to persecute or rule them). He also believed that Hussitism was a sign of democratic spirit, itself a characteristic feature of Slavic people. The limited reach of the ideas expressed in Palacký's histories at the time of their publication at first kept them from widespread popularity. They did not gain more influence until the 1860s,[2] when non-Catholics were granted equal rights to Catholics *de jure*. In the course of the following decades, many works of literary fiction focused on the period of Hussitism and its ideals. One of the most prolific and prominent authors of the period, Alois Jirásek, devoted several of his historical novels and plays to Hussitism, establishing it as a one of the ideological cornerstones of the Czech national discourse.

Apart from literary fiction, one other element played an important role in the process of making the nationalist ideals available to the masses. These were the so-called camp movements, which started in 1868 as a reaction of the Czech people when Austria ignored their constitutional demands in the Austro-Hungarian Compromise of 1867. The movements began as pilgrimages to important sites of Czech national history. Thousands of people would journey to a place of a memorable battle. Together they would reminisce about important figures of the Hussite movement, and their leaders would formulate and disseminate their political demands. The extraordinary atmosphere of these gatherings had a strong impact on the generation of young artists—Jirásek, historical novelist Svatopluk Čech, poet Jaroslav Vrchlický, and painter Mikoláš Aleš—who participated in them and would later use their experience as an inspiration in their art. A view of the Hussite leaders as admirable heroes who "had morally pure rural origins, promoted democratic ideals, expressed interest in social issues, had a deep mistrust in nobility, and were able to unite against their arch-enemies, who were often much stronger than them" (Čornej, "Boží bojovníci") was slowly becoming a prevalent image in the eyes of the masses.

Hussitism remained a key part of the political historical myth even after the birth of Czechoslovakia in 1918 because the new republic was based on the platform of reformation and the Hussite movement. Drawing on Palacký, the first president, Tomáš G. Masaryk, saw Hussitism as a manifestation of the nation's search for its identity. The central terms in this search were for Masaryk truth and humanity; the former even found its way onto the presidential banner in the phrase "Truth prevails," a motto picked up by Václav Havel in 1989. In this period, the Hus myth plays a significant role in forming the identity of the Czech nation, though in an entirely new form. Masaryk reappropriates Hus as a historical figure, interpreting him in a philosophical context and emphasizing the role of the Hussite movement in the development of the "meaning of the Czech history" (Masaryk 248–52). Although the accentuation of truth is based on authentic texts of Jan Hus ("truth prevails above anything else"), it is questionable whether we can think of the "ideal of humanity" in the sense in which Masaryk understands it to be relevant

when we talk about the "truth of Christ" in the medieval sense and the appeal to moral-ity that represents the only way to redemptiion.

After the February coup of 1948, the communists soon began to reappropriate literary works related to the Czech national revival and national mythology. During this process, they removed other semantic layers of the works, especially those linking these works to the German cultural context. Thus a new canon was formed in which some authors were marginalized or erased. Instead of crediting the ideas of the revival movement to the small group of intellectuals living mostly in cities, the communist ideologues systemati-cally built an image of poor godforsaken patriots fighting for the Czech national culture in remote villages, thus subordinating the role of the urban intellectuals to the myth of the oppressed proletariat.

A prominent force in this devaluation of the Hussite ideal was Zdeněk Nejedlý, a con-troversial figure of the official Czech culture of the late 1940s and early 1950s. Originally a musicologist, Nejedlý published a 1905 monograph titled *Dějiny husitského zpěvu v Čechách* (*History of Hussite Singing in Bohemia*) that helped establish him as associate professor at Charles University, where he founded the Department of Musicology and became its first professor in 1919. Jiří Křesťan notes that "in the late 1910s Nejedlý leaves the historical research of the Hussite period never to come back. From now on he is only interested in the era from the point of view of journalism or propaganda" (67). During the years of Czechoslovakia, his views became closer to those of left-wing politicians, and he joined a number of political associations, mostly of far-left intellectuals. He spent World War II in the Soviet Union, where he joined the Czechoslovak Communist Party. Upon his return to Czechoslovakia, he soon became one of the prominent figures of the Czech political and cultural scene, becoming the first minister of culture and educa-tion of the Czechoslovak Socialist Republic in 1948. In his prewar musicologist works, Nejedlý had regarded Hussitism as a complex social process and had emphasized its democratic principles. After 1948, however, he saw its primary purpose as a means of legitimizing the new order of things, highlighting its revolutionary strength. In his ide-ology, the widely accepted authority of Hus's historical figure became a vehicle of the tradition to which the modern-day communists were the rightful successors:

> In its immediate historical sense the Hussite revolution was a revolution against the feudalism and its main representative—the papal court. But more importantly and generally speaking it was a fight of the oppressed against their oppressors, a fight against an old, evil world order for a new, better one—and the same fight we are fighting today, only in different forms. This is why it is only right to call the Hussites' movement revolution and not a mere revolt, because it reversed the very order of the society and changed the very core of the nation. (Nejedlý, *Komunisté* 22)

Although previous ideological systems had projected their own principles onto the Hussite movement, the communists, led by Nejedlý, turned out to be the most radi-cal, determined, and systematic group of their reappropriating efforts. In the spirit of Stalinist dogmatism, the communist ideologues reinterpreted Hussitism so that Jan Hus

ceased to be a primarily religious reformer of the late Middle Ages and became a spiritual leader of the proletariat, suffering under the heavy hand of feudal authorities. All religious aspects of Hussitism that could have been removed were removed, and those that could not be—those directly related to God—were passed off as a mere expression of contemporary social problems.

"Comrade" Jirásek

The literary work of Alois Jirásek (1851–1930)—including the play *Jan Hus* (1911), which became the source of Vávra's eponymous film adaptation—represented the peak of a leading tendency of Czech culture and identity in the nineteenth century. Jirásek's historical novels provided an answer to the question of the Czech national identity, which he, like Palacký, saw in the historical tradition. Unlike every other Czech writer, Jirásek treated this theme extensively, systematically, and within the context of a popular genre. No other contemporary Czech novelist produced mass-friendly fiction that dealt at the same time with Czech history in its entirety, from its mythical beginnings to the revival movement. Jirásek's writings about Hussitism covered the whole period, from its roots to its victorious battles to its defeat.

After Czechoslovakia was established in 1918, Jirásek's position became unshakable, not only because his work was so widely popular, but also because in 1917 he had signed the Manifesto of Czech Writers, a politically significant document demanding self-identification of the Czech nation, and because after the birth of the republic he became an official icon of his time (Janáčková 8). This position became even more cemented by the artist's death in 1930; Jirásek's funeral was one of the last national funerals typical of the Austro-Hungarian Empire. His literary work was published throughout the duration of the Czechoslovak republic and quickly became an important part of the literary canon.

After 1948, Jirásek's image underwent an ideological transformation that enlisted the author to serve a new cultural and political concept. These changes had already begun during the 1920s and 1930s, when Jirásek's image was aligned more closely with the military traditions of the young Czechoslovakia. But this realignment represented only a partial shift, since the Hussite myth was regarded as a public good. In the communist period, the understanding of both Hussitism and Jirásek changed more dramatically. Members of the establishment now saw the author as a progressive writer and the popularizer of the Hussite movement. Not all communists were Jirásek enthusiasts. For some, he represented subversive tendencies that had survived from prewar Czechoslovakia. Nevertheless, Zdeněk Nejedlý managed to establish Jirásek as the leading author of the new canon, and in 1948 launched a "Jirásek initiative."[3] The project's goal was to publish all of the author's literary texts and to build a Jirásek museum in the Renaissance villa Letohrádek Hvězda. The editor-in-chief of the collected works was Nejedlý himself, whose post–World War II editorial practice could hardly be called academic. The

ideological forewords with which Nejedlý equipped the texts show clearly that the main goal of the project was to gain control over the interpretation of Czech history and cultural heritage. The aim of this reinterpretation of Jirásek's texts to ensure a single correct reading of Czech history is clear from the words of Klement Gottwald, the first president of communist Czechoslovakia: "Let us make sure that the people continue to draw from the great and beautiful works of Jirásek strength, courage and fighting spirit in their construction of socialism in our homeland as well as in the global battle of peace which our Hussite republic is fighting alongside all the other progressive powers of the world led by the Great Soviet Union" (Gottwald 86). Thus nationalized, Jirásek became the chief proponent of progressive art thanks to the determined efforts of Zdeněk Nejedlý (Šámal). This ideological manipulation was normative; Nejedlý no longer acted as a university professor at this point, but rather as the executor of the communist cultural ideology.

THE FILMMAKING SCENE

The adaptation process of the Hussite Trilogy began not in the film studios or a screenwriter's office but in the minds of the members of the establishment. Thanks to their monopoly over political power, film as art became a tool of propaganda, aimed at educating the masses in the spirit of Marxism-Leninism. The communist politicians of the early 1950s decided which themes and interpretative approaches were suitable and which were not. Institutionalized control over the film industry, norm-making, strict censorship, and the personal motivation of the comrades at all levels of the political hierarchy defined the professional environment of the directors. Film projects begun after 1948 had to comply with the cultural policies of communist doctrine and follow its political directives. One of the major requirements was that the adaptation highlight the political and national class struggle. According the principles established by Klement Gottwald, Zdeněk Nejedlý, and the resolutions of the Central Committee of the Communist Party of Czechoslovakia, film was meant to celebrate the tradition of Hussitism and its impact on contemporary Czech society (cf. Kratochvíl, "O dramaturgických").

The ways contemporaneous politics interfered with film production are aptly illustrated by an adaptation handbook penned by Zdeněk Nejedlý in 1949. In this volume, *Film and Work of Alois Jirásek*, he discusses the issues of adapting fiction to film, reporting that he has been inspired to write it after a lengthy debate with filmmakers. Nejedlý argues that the ideas behind new films based on the works of Jirásek and other progressive authors must be directed toward political goals. He emphasizes the responsibility of the workers in the nationalized film industry who are in charge of the ideological aspect of the adaptations. Further on, he formulates three directives that establish a strict aesthetic and political framework for any future adaptations. Adapters should not attempt to improve Jirásek or other writers, modify their source texts, or use any film devices to

distort the integrity of the text: "[I]f [the screenwriter or the director] treats a literary subject, it has to strictly adhere to the same structure as the literary work or a work of art in general, just like anything that wishes to be called *a work*" (Nejedlý, *Z české* 457). The objective is to showcase the virtues of the original text and to recreate the *image* found especially in the work of Jirásek. The author had contemplated a career as a painter in his youth, and according to Nejedlý his novels display a visual approach to literature. Nejedlý also emphasizes the importance of *ideas*. Filmmakers should adhere to the idea of "Czech identity," which Nejedlý contrasts with cosmopolitanism and a bourgeois degeneracy devoid of all patriotism. Adaptations that follow these two principles will instill in the masses the willingness to work for the nation's good. Nejedlý's last directive concerns *progressiveness*. Filmmakers should draw from Jirásek the meaning of the Czech history, fulfilled by the socialist revolution, and thematize the progressive efforts leading to communism. The main historical era representing this progressiveness was the period of Hussitism. Regarding Jirásek's texts as so much raw material, Nejedlý found in them a suitable template to represent the revolutionary fight at its most intense: "[I]f a film wishes to capture Jirásek's art with which he pitches progress against reactionism, it has to set these two against each other with the same degree of clarity which can be found in Jirásek" (Nejedlý, *Z české* 457).

The final form of an adaptation was also influenced by the organization of its production. After World War II, new political circumstances led to profound changes in the structures enabling the production and creation in Czechoslovak cinema. In 1945, following a decree of president Edvard Beneš, film production and distribution were nationalized. After the political coup of February 1948, the communist government seized control over officially distributed art and imposed strict censorship on it. Government control over the ideological aspect of the new films, in which communist politicians saw a powerful propaganda tool, was implemented by the establishment of the Czechoslovak National Film industry on 13 April 1948. This final step in the centralizing of the film industry that had begun immediately after the end of World War II represented a radical material transformation of film production in Czechoslovakia. These efforts culminated in 1953 with a conflict between the filmmakers and the ideologues and a new period of gradual decentralization (Szczepanik 94).

The leading power sought to keep the situation under control by installing communist functionaries in decision-making positions in the nationalized cinema. These people were often ignorant of the complexity of film industry and creative work. The role of the screenwriter and the director also changed:

> Numerous committees were there to crush the individual filmmakers; their superiority of power enabled them to decide what was right and wrong, what must be changed in order to succeed. The author was relegated to the role of an artisan whose only task was to perform and the work—which had been commissioned by the establishment anyway—was "assembled" not only by at least partially qualified members of the Central Dramaturgical Office but also by complete dilettantes from the central Film Committee. Bureaucratization of the creative process thus reached its peak in the years following the February coup of 1948. (Klimeeš 138)

Jan Hus, the Revolutionary

Otakar Vávra (1911–2011) is one of the most controversial figures in recent Czech culture. He has been ridiculed for being able to make films under any and all political regimes, yet he is fondly remembered as the director of several brilliant and timeless films and a source of inspiration for younger filmmakers like Jiří Menzel, Věra Chytilová, and Emir Kusturica (see Blažejovský). Forced to prove his political engagement in order to be allowed to continue making films after February 1948, he succeeded in doing exactly that with the Hussite Trilogy.

Jan Hus (1954), the first installment of the trilogy, represents the practice of the cultural politics in Czechoslovakia in its early years after the February coup. More specifically, it shows the influence decisions of the communist officials had over the screenwriters and filmmakers of the time. The authors of the script, Vávra and Miloš Václav Kratochvíl, used Jirásek's historical drama *Jan Hus* as the basis for the film. But the play was not the only source of their inspiration. Kratochvíl, a novelist and historian, had written two novels after 1948 (*Master Jan Hus* and *The Torch*) that dramatized the fate of Jan Hus and complied with the structural and thematic rules of social realism. Both these texts played an important role in the process of the adaptation of Jirásek's play. The basic plot and some lines were chosen from Jirásek's play because of their ideological suitability; Kratochvíl's texts were used to emphasize the motif of the working masses and revolution. The screenwriters came up with a story set in the year 1412, when John XXIII, one of three claimants to the papacy, announces the sale of indulgences. Hus's preaching against indulgence selling and sacrilege in the Bethlehem Chapel provokes a rebellious mood among the people. Three journeymen are arrested for preventing a priest from selling indulgences and are beheaded, despite the officials' assurances to Hus. Pope John excommunicates Hus, who leaves the city and continues preaching in small villages. Later, he travels to Constance, where he is arrested in spite of the safe conduct granted to him by the Emperor Sigismund. He appears before the Council, but the fanatical prelates do not let him defend himself. Refusing to recant, he is condemned and burned at the stake. The film ends with a scene in the Bethlehem Chapel, where his last words are read aloud and Jan Žižka swears to stay true to his master's teachings.

The screenwriters made a conscious effort to satisfy the political requirements, to bring ideological elements into the new work, and to emphasize contexts consistent with communism. There was, however, an inherent conflict in the medieval theme: it was impossible to evade the religious issues and the related terms (faith, legitimacy, the kingdom of God). The solution the filmmakers present reflects their attempt to placate a political establishment determined to prescribe only one possible reading of history. At the beginning of the film, the movie camera shows four sheets of paper covered in writing that offers a straightforward interpretative key based on Marxist premises:

> At the turn of the 15th century the Kingdom of Bohemia was one of the most powerful countries in Europe. The riches of the Church, the nobility, and the German

merchants came from the sweat and blood of the subjects, who were getting poorer and poorer.

That was when the reformers began to criticize the lavishness of the masters and rich citizens and above all demanded rectification of the Church, which had surrendered to vice, greed, and power.

The efforts of these reformers reached the peak in the teachings of Jan Hus, who could fight against the feudal oppression only through religious forms. And so, calling for the victory of the divine truth, he demanded a just social order.

Jan Hus spoke to all social classes, which is why his teachings became the ideological premise of the Hussite movement—the mightiest revolutionary fight in world history till that time.

This introductory text and the Hussite singing make it clear that the authors of the adaptation complied with the ideas of the early 1950s, adapted the film to the ideological norms, and transformed Jirásek's play into an agitprop piece. Despite acknowledging the impossibility of sidestepping the religious theme, they still follow Zdeněk Nejedlý's interpretation of the movement's history, which claims that medieval society was headed in the direction of revolution, even if it had no term for such a thing. According to the film, the religious upheaval of the Middle Ages was simply a different term for what was really social revolution. Even before the film was released in cinemas in 1954, the filmmakers also issued statements framing the film's Hussistism as proto-revolution. In a feature about the scripts of the Hussite trilogy, M. V. Kratochvíl called Hus "the first great ideologist of his time" (Kratochvíl, "O scénářích" 14). In another article, he noted that it was necessary to moderate the religious vocabulary of the characters "so that the modern audience are not confused and distracted from the true essence of the Hussite movement and its goals" (Kratochvíl, "O dramaturgických" 437). Actor Zdeněk Štěpánek, who played Hus in the first film and Jan Žižka in the other two parts of the trilogy, highlighted the need to depict Hus as a "passionate fighter for truth, justice and the human right, a strong, fair, unyielding man who was fully aware of the consequences of his struggle" ("Zdeněk Štěpánek" 10).

The inherent contradiction of the leading elements in the adaptation process is well documented by the final assessment and approval of the film before its release. In his memoirs, Otakar Vávra recalls the atmosphere of the film's screening before a political committee:

> The rough cut of the film had to be approved by the Minister of Culture Václav Kopecký during the screening of the film at the Ministry headquarters. The room was packed with people—all members of the Central Committee of the Communist Party of Czechoslovakia were there as well as party historians, ideologists, and God knows who else. When the screening was over, the room went completely quiet. One of the party historians put up his hand and said: "Comrades, we must decide whether more damage will be caused if we release the film or not." I felt downright disgraced. Then Minister Kopecký spoke: "Jesus Christ, people, what have you done! You made Hus look like a priest!" . . . Then he got angry: "He keeps talking about God's

truth! And he is looking up to the heavens! . . . But what is God's truth? Nonsense! Whose truth? Is comrade Kratochvíl by any chance a protestant? Hus was supposed to say: 'Truth of the people!' " Then they came up with some other comments, and Kopecký told me to think it over. The film was not approved that night. (Vávra 192)

Despite the film's wholesale revision of Hus and Hussitism, it nevertheless did not reflect enough of the revolutionary traditions of the nation and the class awareness of the people to warrant approval. Kopecký's position within the Party was so solid that it was necessary to incorporate the views he had expressed during the screening. The film was approved only after the final scene was reshot to show Jan Hus dying at the stake without looking up, now announcing: "I wanted a just system for the people. And for the truth I have been teaching and preaching I will gladly die."

Not even this ahistorical nonsense could change the fact that Hus remained a priest in the film—at least formally, as attested by his priestly attire and his preaching in the Bethlehem Chapel and the villages. The ideological mission of the film was thus accomplished by its eventual compliance with Nejedlý's idea that Hus's religious dispute merely disguises his true goal of social revolution. To highlight this hidden objective, the characters representing the sympathetic side of the Church—preachers of similar views based on characters from Jirásek and Kratochvíl—were removed from the film, leaving the noble character of Hus standing in sharp contrast to all the other representatives of the Church, who preyed on the poor and powerless. The political views of the filmmakers were further illustrated by the added caricature of a greedy priest. The priest sells indulgences to enrich himself, steals from the poor, and excommunicates Hus. Other Church representatives are portrayed in a highly theatrical manner that presents them as avaricious, self-indulgent, and lazy, opposed only by Hus's exceptional moral character.

This polarity is further illustrated by the relationship between Hus and his former friend Štěpán Páleč. In one of the first scenes of the film, the two university officials engage in a dispute that ends with Hus standing up for the poor people, represented by the simple inhabitants of the city of Prague, while Páleč sides with the intellectual elite and the lay and church establishment. The ideological groundwork of medieval society is thus established early on, encouraging the audience to sympathize with the hero who promotes their own interests. Later, Páleč fails as both a friend and a human being when he supports the death sentence for Hus at the Council of Constance. The educational function Nejedlý had sought for cinematic art was thus achieved by this black-and-white polarizing of the leading characters. Most historians and theologians share the view that the historical figure of Jan Hus was never known for setting the people against the Church, but rather for demanding the Church's redress of its ills and failings. According to them, his main goal was to save the people from sin. Even if we can detect overtones of the teaching of Christ in Hus, siding with the poor and powerless, few historians outside the communist camp have seen him as a rebel set on stirring up the people. Even Nejedlý himself must have suspected that Hus was

sober and realistic, interested in religious activity. For the new world order, however, it was necessary to reappropriate his image and to portray him as a revolutionary fighter.

Compared to the historical sources and Jirásek's play, in the film Hus is a schematic character lacking any psychological depth. He is never shaken by doubts or fear. If there are any moments of sadness, they do not reflect his inner state, but rather his response to other people's actions. Shocked by the deaths of the three journeymen, he grieves over their dead bodies but promptly identifies them as the first victims of the forthcoming fight, igniting the revolutionary torch. This presentation is fundamentally different from the spiritual and aesthetic pattern in Jirásek's play, which envisions Hus following the archetypal path of Christ's suffering. Sitting in the prison in Constance, Jirásek's Hus contemplates his fate: "It is hard not to feel woeful, when even the bravest of men was saddened after the Last Supper when he said: 'My soul is sorrowful even unto death'" (139). The authors of the film script made a conscious effort to downplay the individual dimension of Hus's life and, in compliance with the optimism of radical socialism, dropped all motifs of doubt or hesitation. It is hardly surprising that the authors cut a potentially disturbing scene from Jirásek's play in which Hus is approached by a woman with a dead baby in her arms. She tells Hus that because of his conflict with the Church, no religious ceremonies can be held in the city, so her baby has died without having been christened, and now its soul will have to stay forever in Limbo. Hus tries in vain to placate her, appealing to God's love and grace, but the woman is adamant in her wrath: "Who roused him [the Antichrist]? (To Hus). It was you—you sent him to plague us, it is because of you that people are dying without sacrament. Woe unto you, for our souls, for my poor, unchristened child" (77). Such a scene could not possibly have been deemed suitable by the authors of the adaptation because the ideological character of the story would have been disrupted by the interpersonal conflict of two characters the audience could sympathize with. By contrast, Jirásek's play does not offer any solution to this conflict, but leaves it to the audience to make up their own minds.

The ideological reappropriation of Jirásek's drama was underlined by portraying the masses as an embodiment of the highest moral and social ideals. The image of people as a homogenous revolutionary mass is completely absent from Jirásek's play. In the film, however, the masses are repeatedly emphasized. Jirásek's play starts with a conversation among several of Hus's opponents, discussing how to silence the preacher; the film opens with a scene at a great building site where one of the workers collapses under a heavy burden and dies of exhaustion. Soon the greedy priest arrives, offers sacraments for payment, and steals an axe from another worker, depriving him of the ability to earn a living for his family. The adaptation emphasizes the motif of the Church and feudal power suppressing the needs of the people as a principal storyline. Under the influence of Hus's teachings, the people become emancipated and turn into an active mass. Even minor individual characters representing the mass (workers, poor women, old men) embody this moral and ideological progress. Thus the goal Hus urges in the film is to strive for a new, just social system, not the Kingdom of God.

Post Scriptum: New and Improved Hus?

The summer of 2015 marked the six hundredth anniversary of Jan Hus's martyrdom. The commemorating events—books, conferences, exhibitions—included the première of *Jan Hus* (2015), a three-part television film directed by Jiří Svoboda. It is an adaptation of a book written by Eva Kantůrková that was first published through samizdat in 1988 and whose official version came only two years after the Gentle Revolution in 1991. The new adaptation disrupts the previous image of Jan Hus because it portrays him as a more ordinary figure, a priest who cares first and foremost for his flock of believers. This new version of the story replaces the revolutionary Hus with a character who is primarily a theologian and a driven reformer. The film emphasizes Hus's written works and notes how he is viewed by several contemporary thinkers. It emphasizes some familial ties that help establish Hus as a human being, rather than a religious or socialist icon. Though this contemporary view of the past may seem more neutral than the one formed during the communist regime, it nevertheless does not represent the only true and complete tale, which in fact cannot be achieved at all. Since no biographer, historian, playwright, novelist, or filmmaker can escape formative ideological entanglements, none of them can see the real Jan Hus. There are only different interpretations, stemming from specific social and cultural contexts. What we do have left are Hus's works and the path they present us with: "[S]eek the truth, listen to it, . . . hold it close and defend it till the end" (Hus, *Výklad na vieru* 69).

Notes

1. The dynamics of the Hussite movement have been described by Czech philosopher Erazim Kohák: "Common people fighting together for a common cause resulted not only in expanding of the active radius of the country, but also in a rapid growth of use of the Czech language at the expense of both Latin, spoken in the academy, and German, spoken in the towns. Defending the chalice on the battlefields birthed a community which was bound together by a sense of belonging, born out of the memory of the victories over the Crusaders, a common language as well as a mission to defend the faith represented by the sign of chalice. It is not without reason that some Czech historians believe that during this period the nucleus of the Czech nation was formed" (62).

2. In fiction, the theme of Hussitism appears as early as the Czech national revival and also in German-language texts like Maißner's epos *Žižka* (1846). The German historical novels of Karl Herloßsohn (1804–49), which were very popular in the Czech lands even before their translation into Czech, also played an important role in forming a positive image of Hussitism.

3. Jirásek's literary work was also utilized for the so-called "Badge of Julius Fučík." Anyone who wished to earn this badge had to read a selection of ideologically appropriate novels. Jirásek's novel *Proti všem* [*Against All*] thus found itself in the company of political texts on Stalin and Lenin. Its primary function was to strengthen the minds of new socialist youth.

Works Cited

Against All. Dir. Otakar Vávra. Perf. Zdeněk Štěpánek, Gustav Hilmar. Československý státní film, 1958. Film.

Blažejovský, Jaromír. *Dobové tance kolem života a díla Otakara Vávry.* Web. 2 Sept. 2014.

Čornej, Petr. *Boží bojovníci: Dva vzorce husitského mýtu.* Web. 7 Aug. 2014.

———. *Velké dějiny zemí Koruny české.* V: 1402–1437. Prague: Paseka, 2010. Print.

Gottwald, Klement. *Klement Gottwald 1951–1953.* Prague: Státní nakladatelství politické literatury, 1953. Print.

Hudson, Anne. *The Premature Reformation: Wycliffite Texts and Lollard History.* Oxford: Oxford UP, 1988. Print.

Hus, Jan. "Contra Iohannem Stokes." *Polemica.* Prague: Academia, 1990. 57–70. Print.

———. "Výklad na vieru." *Opera omnia 1, výklady.* Ed. Jiří Daňhelka. Prague: Academia, 1975. Print.

Janáčková, Jaroslava. *Alois Jirásek.* Prague: Melantrich, 1987. Print.

Jan Hus. Dir. Otakar Vávra. Perf. Zdeněk Štěpánek, Karel Höger. Československý státní film, 1954. Film.

Jan Žižka. Dir. Otakar Vávra. Perf. Zdeněk Štěpánek, František Horák. Československý státní film, 1957. Film.

Jirásek, Alois. *Jan Hus.* Prague: Otto, 1911. Print.

Kantůrková, Eva. *Jan Hus.* Prague: Melantrich, 1991. Print.

Kejř, Jiří. *Husův proces.* Prague: Vyšehrad, 2000. Print.

Klimeš, Ivan. "Za vizí centrálního řízení filmové tvorby." *Iluminace* 12.4 (2000): 135–39. Print.

Kohák, Erazim. "V záři (a stínu) kalicha." *Domov a dálava.* Prague: Filosofia, 2010. Print.

Kratochvíl, Miloš Václav. "O dramaturgických problémech při psaní Husitské trilogie." *Film a doba* 4.2 (1953): 433–38. Print.

———. "O scénářích Husitské trilogie." *Filmové informace* 50.4 (1953): 13–14. Print.

Křesťan, Jiří. *Zdeněk Nejedlý: politik a vědec v osamění.* Prague: Paseka, 2012. Print.

Masaryk, T. G. "Přednášky profesora T.G. Masaryka." *Ideály humanitní: 1901–1903.* Prague: Ústav T.G. Masaryka, 2011. 241–306. Print.

Mezník, Jaroslav. *Lucemburská Morava: 1310–1423.* Prague: Nakladatelství Lidové noviny, 1999. Print.

Molnár, Amedeo. "Husovo místo v evropské reformaci." *Československý časopis historický* 1.14 (1966): 1–14. Print.

———. *Na rozhraní věků: cesty reformace.* Prague: Kalich, 2007. Print.

Nechutová, Jana. "Husovo učení a Lutherova reformace." *Teologická reflexe* 1.7 (2001): 48–57. Print.

Nejedlý, Zdeněk. *Komunisté—dědici velkých tradic českého národa.* Prague: Sekretariát ÚV KSČ, 1946. Print.

———. *Z české literatury a kultury: (1860–1960).* Prague: Československý spisovatel, 1973. Print.

Palacký, František. *Dějiny národu českého III.* Prague: Odeon, 1968. Print.

Petráň, Josef, et al. *Dějiny Československa 1: do roku 1648.* Prague: Státní pedagogické nakladatelství, 1990. Print.

Šámal, Petr. "Znárodněný klasik. Jiráskovská akce jako prostředek legitimizace komunistické vlády." *Zrození mýtu: dva životy husitské epochy.* Ed. Robert Novotný et al. Prague: Paseka, 2011. 457–72. Print.

Šmahel, František. "Husitská revoluce (1419–1471)." *Dějiny českých zemí*. Ed. Jaroslav Pánek et al. Prague: Karolinum, 2008. Print.

———. *Husitská revoluce 1: Doba vymknutá z kloubů*. Prague: Karolinum, 1995. Print.

———. *Husitská revoluce 2: Kořeny české reformace*. Prague: Karolinum, 1996. Print.

Szczepanik, Petr. "Machři a diletanti. Základní jednotky filmové praxe v době reorganizací a politických zvratů 1945 až 1962." *Naplánovaná kinematografie: český filmový průmysl 1945 až 1960*. Ed. Pavel Skopal. Prague: Academia, 2012. 27–101. Print.

Vávra, Otakar. *Podivný život režiséra: obrazy vzpomínek*. Prague: Prostor, 1996. Print.

"Zdeněk Štěpánek o svých úlohách v Husitské trilogii." *Filmové informace* 13.5 (1954): 10–11. Print.

..

ADAPTATION AND HISTORY

..

DEFNE ERSIN TUTAN

WHEN we attempt to answer the question "What is history?," E. H. Carr suggests, in his highly praised assessment of history and historiography, that "our answer, consciously or unconsciously, reflects our position in time, and forms part of our answer to the broader question what view we take of the society in which we live" (8). Carr regards the present age as "the most historically-minded of all ages," as "[m]odern man is to an unprecedented degree self-conscious and therefore conscious of history" (134). In the words of Eric Hobsbawm, this increasing self-consciousness coincides with "the rapid historicization of the social sciences themselves. For want of any help from academic historiography, these have increasingly begun to improvise their own—applying their own characteristic procedures to the study of the past" (282–83). Today we may easily argue that historians are not as innocent as they used to be thought, that they do not objectively record or compile facts for the aim of creating a universal history—indeed that historians are not the sole authorities in the writing of history to begin with. Hence we have histories in the plural; we frequently speak of alternative histories battling against History with a capital H; we see novelists posing as historians and historians as novelists—all of which indicate that our fascination with the debate over history has not been in the least exhausted.

Where do debates about history intersect with the notion of adaptation? Having thus far produced its most fruitful work in exploring the relation between literature and film, studies in adaptation should by no means be considered limited to this paradigm. Indeed, every version of history should be regarded as a rewriting, essentially an adaptation, since the historian adapts the material she or he has at hand into a pre-planned scheme to meet a certain end. "An adaptation, like the work it adapts," Linda Hutcheon argues, "is always framed in a context—a time and a place, a society and a culture; it does not exist in a vacuum" (*Theory* 142). As she also acknowledges, this is not "a radical, new insight" ("Pastime" 71). In the early twentieth century, Carl Becker claimed that "[t]he 'facts' of history do not exist for any historian until he creates them, and into every fact that he creates some part of his individual experience must enter" ("Detachment" 12). Hutcheon concludes from this claim that "representations of the past are selected to

signify whatever the historian intends" ("Pastime" 71). It is precisely these intentions that shape the textual construct we call *history*. As Hutcheon notes, postmodernism has laid bare the assertion that "storytellers can certainly silence, exclude, and absent certain past events—and people—but it also suggests that historians have done the same" ("Pastime" 56). In this respect, the parallelism between history and fiction and between the historian and the storyteller becomes obvious.

To this end, this essay argues that all historical representations are radically adaptive and that the ways in which these alternative representations are conceived and perceived tell us more about the present than about the past they refer to. As Arthur Asa Berger puts it in explaining Mikhail Bakhtin's dialogism: "First, there is the past, which has an impact on our ideas and what we create. Second, there is the future and the responses we anticipate from our audience (real or imagined), which affect what we do. . . . Texts, then, are suspended between the past and the future" (35–36). Hence it is through the present that the past and the future remain in a constant dialogue, demonstrating the inescapably contemporaneous character of history.

In his Presidential Address at the American Historical Association in 1931, Becker introduces Mr. Everyman, a regular citizen, who serves as his own historian. He starts out by justifying why Mr. Everyman needs to have some knowledge of history, "the memory of things said and done" ("Everyman" 235–36), without which he cannot sustain his life either at the present or in the future: "it is impossible to divorce history from life" (242). Accordingly, in order to make sense of his present and move on to his future, Mr. Everyman needs his past—a past that is his own "imaginative creation, a personal possession which . . . [he] fashions out of his individual experience, adapts to his practical or emotional needs, and adorns as well as may be to suit his aesthetic tastes," thereby creating his own history ("Everyman" 243). This process of writing history starts out with the selection of relevant facts, without the awareness of personal bias included in this selection. Mr. Everyman embodies "the freedom of the creative artist," blending "fact and fancy" as he sees fit, indifferent as to whether his history is true ("Everyman" 245). In this context, history is judged solely by its utilitarian function in orienting us in life, thereby connecting the past, the present, and the future.

According to Becker, the historian's purpose is "to reconstruct, and by imaginative insight and aesthetic understanding make live again, that pattern of events occurring in distant places and times. . . . Whether the events composing the patterns are true or false, objectively considered, need not concern him" ("Historiography" 76). What he calls reconstruction is, for Stuart Hughes, interpretation. Hughes acknowledges the courage of Becker as the first man to "confess the total relativity of historical judgments" (14). In *History as Art and as Science*, Hughes categorizes historians, starting with the nineteenth-century school of historical writing, under four titles chronologically— idealist historians, positivist historians, neoidealist historians, and neopositivist historians—and concludes that it was through the neoidealist historians' approach that "historical understanding" began to be regarded "a subjective process—a mighty effort to recall to life what is irrevocably over and done with" (10). However hard he tries, it is impossible for Hughes's historian to act as "a contemporary of the events he describes,"

for he knows what has happened since then, and his apprehension is conditioned by the outcome rather than the process (12). Similarly, Becker fervently argues in many of his essays that the historian can never detach himself from either his own personality or the milieu of his age. He asserts that facts do not lead to concepts, but that concepts determine facts ("Detachment" 24). In other words, the historian's end justifies his means: he selects the supporting material that will prove his argument.

Hughes's historian enacts the same phenomenon in the structuring of his narrative. For Hughes, the writing of history is closer in methodology to the writing of a novel or play in which there appears "a leading character whose point of view is dominant—who might as well be the 'I' by whom the story is told. . . . [This] situation is not so very different from that of the historian who frankly fits his material into a scheme that he himself has composed. . . . However he chooses to proceed, he—the historian—is the one who is directing the show" (71, 76). This position is endorsed by E. H. Carr's advice to "[s]tudy the historian before [we] study the facts" (23), for "[n]o document can tell us more than what the author of the document thought" (16).

These complementary, often overlapping perspectives make it clear that the subjective nature of history has long been under scrutiny by critics as well as historians, in an effort to disrupt the belief in a singular, never-changing version of history. Despite these efforts, students of history have often maintained their belief in the singular version, and postmodern critics have felt free to revisit the challenges involved in the conception and reception of history. As postmodernism has forcefully asserted, history exists "always within textual boundaries"; history is thus "also fictional, also a set of 'alternative worlds'" (Waugh 106). Inevitably, "history itself depends on conventions of narrative, language, and ideology in order to present an account of 'what really happened'" (Mazurek, qtd. in Hutcheon, "Pastime" 61). So the writing of history involves the same process as the writing of fiction, resulting in "history as text, history as personal reconstruction" (Waugh 107). This approach repeats Becker's reconstruction hypothesis, embraces Hughes's interpretation argument, and acknowledges Carr's assertions. Viewed in this light, adapting history implies that history is fiction and fiction history. As we move beyond the discrimination between factual and fictional history, the focus shifts to the processes employed in adapting historical material, shaped by extra-textual factors, whether political, social, or cultural.

In his Foreword to our co-edited volume, *The Adaptation of History: Essays on Ways of Telling the Past*, the late James M. Welsh divides history into three general phases: "(1) Pre-Modern History or Mythic History (as practiced by Homer . . .); (2) Modern History, treating the 'facts' objectively as 'evidence', a 'scientific' approach . . . ; and (3) Post-Modern History, moving away from the 'scientific' evaluation of 'factual' matters back towards the Truth of the Mythic" (5). According to Welsh, the historian functions as the mythmaker in the latter category, emphasizing the "'story' of 'history'" (5). In his words, "Modernist historians would of course object to his making things up, of being 'inaccurate' and inventing characters; but the distinctions that apply here are not so much between 'fact' and 'fiction' as between 'fact' and 'truth' and between 'fiction' and 'truth'" (5). Alun Munslow's name for Welsh's modernist historians is "conventional

historians." He suggests that all among them—"even those who argue they are self-conscious about what they are doing—remain locked into the epistemic oxymoron that they can 'tell the truth about history'" (34). Instead, he proposes "experimental history," which he describes as the space in which we explore "how to 'tell the past' in genres that reflect upon the needs of representation. . . . History henceforth speaks in new ways" (193). For Munslow, the story of what really happened cannot be subjectively retrieved in any single shape or form. As postmodernism has constantly argued, all representations—and those who represent them—are inevitably discursive, undermining any attempts to impose any monolithic notions on them. More important, however, postmodernism tries to engage the reader in a self-critical re-evaluation process:

> In challenging the seamless quality of the history/fiction (or world/art) join implied by realist narrative, postmodern fiction does not, however, disconnect itself from history or the world. It foregrounds and thus contests the conventionality and unacknowledged ideology of that assumption of seamlessness and asks its readers to question the processes by which we represent our selves and our world to ourselves and to become aware of the means by which we *make* sense of and *construct* order out of experience in our particular culture. We cannot avoid representation. (Hutcheon, *Politics* 53–54)

In other words, while watching a historical film, reading a historical novel, or studying a history textbook, for that matter, we cannot avoid the sense of personal engagement, not only looking at the ways in which the author or authors re/construct historical material, but also making comparisons between the representation and our own experience. As we try to come to terms with the present and the future, we are obliged to come to terms with the past. As Catherine Bernard says, "one should not overlook the inherently political—and ambiguously humanist—stance of writers trying to make sense of the present by reassessing our cultural modes of processing the past and our situation within a historical and cultural continuum" (136). It is by way of our negotiation with the past that we reclaim the present and move on to the future.

When we embrace such an approach toward the adapted versions of history—or more notably toward history as adaptation—why is it that we are so uncomfortable? The true reason might be, as the female protagonist of J. M. Coetzee's *Foe* (1986) says, that "what we accept in life we cannot accept in history"—that is, lies and fabrications (qtd. in Hutcheon, "Pastime" 57). Marianne Holdzkom suggests that "[a]dapting history is an uncomfortable business. . . . Many historians demand the kind of accuracy from films that one finds in a history textbook" (433). Underlying this observation are two problematic assumptions: that historians are the ultimate authorities on the subject of history, and that the accuracy of history textbooks' versions of the past renders those textbooks the only reliable sources. Robert A. Rosenstone states that it is time we stopped "expecting films to do what (we imagine) books do. . . . Like written histories, films are not mirrors that show some vanished reality, but constructions, works whose rules of engagement with the traces of the past are necessarily different from those of

written history" (37). But this position is uncomfortable for Holdzkom, for she "does not excuse filmmakers who rewrite history for their own purposes" (433).

Hence there appears to be an enduring contradiction between the theoretical approaches put forth by distinguished scholars who challenge the myth of the omniscient, objective, and authoritarian history and the popular reactions to such history. To put it differently, the perspectives of Becker, Hughes, Carr, Hutcheon, Waugh, and many others appeal to the scrutiny of academic readers, but fall short in addressing the common concerns of popular readers and audiences of history. Two exemplary cases offer practical demonstrations of how this is so: the ways in which audiences have perceived *The Tudors* and *Magnificent Century*.

According to Ranjani Mazumdar, "History and memory are always embroiled in a unique relationship. Television . . . is one of the most powerful sites for the articulation of memory within the public sphere," and television series enable "the production of history as collective memory" (325). At the same time, televised versions of adapted history are the most frequently and publicly contested.

The Tudors, which the American cable channel Showtime broadcast from 2007 through 2010, presented itself as a historical television series (Figure 33.1). The English screenwriter Michael Hirst, who created the series, noted, "Showtime commissioned me to write an entertainment, a soap opera, and not history. . . . And we wanted people to

FIGURE 33.1 *The Tudors*. Season 1, Episode 1.

watch it" (qtd. in Gates). Following this brief, Hirst renounced all claims to the responsi-
bilities of a historian in order to fulfill his responsibilities as an entertainer.

Taking its name from one of the two most significant dynasties in English history,
The Tudors is based on the reign of King Henry VIII. Yet the publicity it received in
the media made it sound like a tabloid exposé: "Countless affairs, a handful of wives,
a few beheadings, a rift with the church that changed England's religious landscape
forever—*The Tudors* explores the turbulent years of King Henry VIII's nearly 40-year
reign. Testosterone is oozing, bosoms are heaving. . . . Make way for *The Tudors*. History
class was never like this!" (Crichlow). On 23 March 2008, *New York Times* defined the
series as a "primitively sensual period drama . . . [that] critics could take or leave, but
many viewers are eating up" (Gates). Only five days later, another review concluded that
the series "fails to live up to the great long-form dramas cable television has produced
largely because it radically reduces the era's thematic conflicts to simplistic struggles
over personal and erotic power" (Bellafante).

Following these brief reviews, experts in the field—historians, of course—studied the
degree to which the series had departed from agreed-upon facts and had distorted his-
tory, scene by scene, episode by episode. Some argued that the characters "wore cos-
tumes from the later Elizabethan era and travelled in Victorian carriages" (Hough).
Yet the fundamental problems did not arise from either the costumes or the décor. For
Dr. David Starkey, a specialist in the Tudor period, "it was a disgrace that the BBC had
'squandered' public money on a historical drama" which he called "gratuitously awful"
and claimed "had been deliberately 'dubbed down' to appeal to an American audience"
(qtd. in Hough). In contrast, while claiming *The Tudors* to be "historically inaccurate,"
Dr. Tracy Borman, a leading historian and an expert on the Tudor dynasty, admitted
that she found herself "becoming strangely addicted" to the program, although she
had been determined at first to loathe it (qtd. in Hough). She regarded the cast to be
"unfeasibly beautiful," the costumes "dodgy," and the storylines "improbable," but still
praised the series for having "undoubtedly stimulated interest in British history" (qtd.
in Hough). Her mild approval, however, comes with a condition: "Television dramas,
films and novels can inspire an abiding passion for their subject. . . . Provided that they
encourage people to find out what 'really' happened, rather than being treated as reliable
historical sources in their own right, then they can and should be respected as a force to
be reckoned with in the world of history" (qtd. in Hough).

According to Borman, fictional treatments of history are not only unreliable but also
unimportant, except for leading people to find the truth of the matter. Apparently she
still believes in the rather utopian idea that what *really* happened in history can some-
how be retrieved objectively. Many sources indicate that the English audiences criti-
cized the depiction of Henry VIII as a hedonistic womanizer, and that they believed this
distortion was introduced to attract a specifically American audience.

Only four months later, the series arrived in Turkey and was aired on CNBC-e. The
Turkish audience, apparently more distant from English history and thus personally
detached from it, did not dwell on the distortions, but considered the series to be his-
torically accurate instead. Aydın Sevinç, a blogger for *Milliyet* newspaper, claims that the

series is based on historical facts and data and takes the form of an entertaining course in history. He recommends this "cinematic feast" to anyone who wants to be informed about the history of both Britain and all of Europe (Sevinç; my translation, as are all the following). Although many Turkish viewers have focused on how handsome Henry VIII is, reviews never mention how handsome Jonathan Rhys Myers is; rather, they equate the historical figure with the performer playing him, adopting the Henry VIII character on television as the real Henry VIII. A majority of those who share their opinions on *Uludağ Sözlük*, a website especially popular among the young, refer to Henry VIII's gorgeously handsome appearance and his exaggerated sexuality. Instead of criticizing the hedonistic depiction of the king, these commentators refer to the fact that *The Tudors* links a nation's fate to the question of whether the king could have a son, and therefore liken Henry VIII to sultans from their own Turkish history. One such commentator draws a clear parallelism between the age of the Tudors and that of Suleiman the First in their representational forms (*Uludağ Sözlük*).

What does *The Tudors* signify for the larger issue of adapting history? First, it constitutes a good example of how any product of culture fabricating material based on history is evaluated according to the criterion of truthful depiction of historical facts. Unless it directs individuals toward historical truth—a truth by definition singular—and toward motivating them to learn and respect that truth, it is not worthy of attention; popularizing history in this manner is worthless unless it serves such a holy mission. Second, and perhaps more interesting, the more distant the audience is from the history in question, or the more independent from it, the milder the objections to the adapted history. In other words, detachment renders the debates over fidelity to the source material insignificant. What happens, then, when a historical character to whom the Turkish audience is nationally attached is depicted as equally hedonistic? Are the results any different?

Magnificent Century (Figure 33.2) is the most expensive project in Turkish television history, with a budget of 3.5 billion Turkish Liras (approximately US$1.5 million). The first episode of this historical television series was broadcast on 5 January 2011 on Turkey's Show TV; the series still continues on a different channel. Dealing principally with the life of Suleiman the First (also known as Suleiman the Magnificent), the longest reigning and the most highly respected sultan of the Ottoman Empire, *Magnificent Century* not only won millions of fans instantly, but also stirred serious controversy among various circles, including complaints that within three weeks surpassed the total number of those that had been made in 2010 to the Radio and Television Supreme Council. The complainants expressed discomfort with the disrespectful and hedonistic portrayal of a historically significant character and the way historical facts had been twisted into fictions. Based on Article 4 of the Law numbered 3984, the Council then warned the director general of Show TV for "not demonstrating the required sensibility about the privacy of a personage that made history" ("RTÜK"). Nothing that the several historians appointed to evaluate the historical accuracy of the script, the costumes, and the décor did could forestall these protests. Many political parties and members of parliament filed suits against the series, and Recep Tayyip Erdoğan, then prime minister and now president of Turkey, stated his discomfort:

FIGURE 33.2 *Magnificent Century.* Season 2, Episode 39.

> We go wherever our ancestors went on horseback; we are also interested in the same
> places, but these, I believe, get to know those ancestors through the television screen,
> as in the documentary *Magnificent Century*. We do not have such ancestors. That
> is not how we remember Kanuni [Suleiman]. . . . Thirty years of his life he spent on
> horseback, not at the palace, as in this series. . . . I denounce both the producers of
> the series and the channel owners on behalf of my fellow citizens. We are awaiting the
> judicial branch to decide on the necessary sentence. ("Başbakan")

The term "these" apparently refers to the Turkish audience, even though this form of
address would be inappropriate in Turkish. More to the point, *Magnificent Century*
does not present itself as a documentary at all. Neither does it contest any authoritative
national memory of Suleiman, as he no longer exists outside historical adaptations. It is
clear that the root of the problem here is the way in which Suleiman is depicted, just as
in the case of *The Tudors*. Apparently the Turkish audience, which could remain rela-
tively indifferent to the depiction of Henry VIII because of their distance from his his-
torical world and his historical memory, cannot remain at ease when the same process is
applied to a character in whom they are more deeply invested. To this end, the audiences
of historical adaptations cannot be detached viewers, just as it is impossible for histori-
ans themselves to be detached.

 Erhan Afyoncu, the history advisor of the *Magnificent Century*, stated in an interview
that he knew such a series would stir such reactions

> because we treat figures of government in history as prophets. That is why creating
> a historical series is very difficult in Turkey. Still, however, I did not want to stand
> aside while such a series was being created. I have the historian's responsibility. . . .
> Calling such efforts a "cheap copy" is rude. . . . We attribute sacredness to history and

treat it through our present value judgments. Ottoman history is so majestic that it crushes us; we regard it as unapproachable. That is why Ottoman history is made into a taboo. ("Muhteşem")

One might agree with Afyoncu's approach, adding only that the difficulties media productions have in dealing with history are hardly restricted to Turkey; such productions have raised problems all around the globe.

Critics of both *The Tudors* and *Magnificent Century* ignore the fact that both series are fictional constructs. Yet history, which we prefer to regard as so far beyond question that challenging it would be taboo, is also fictional in its textual qualities. As Hutcheon argues, "to re-write or to re-present the past in fiction and in history is, in both cases, to open it up to the present, to prevent it from being conclusive or teleological" ("Pastime" 59). Historical representations illuminate not the past that they set out to discover, but the very present in which they are embedded. Treated as such, neither *The Tudors* nor *Magnificent Century* sheds light on the past; they do not necessarily tell us anything new. On the contrary, they illuminate the present, providing an idea of where *we* stand. As Hayden White would argue, "every representation of the past has specifiable ideological implications" (qtd. in Hutcheon, "Pastime" 69). These cases show in practice what has been discussed in theory: that there remains no difference between factual and fictional history, or history and adaptation, as they are essentially one and the same.

As these two cases have made clear, history as adaptation includes two levels of analysis. One level concerns the way history is conceived. Whether in the form of a history book, novel, film, or television series, history is textual, and therefore inevitably fictional. As Robert Stam claims in his "Foreword" to *The Theme of Cultural Adaptation in American History, Literature, and Film*, "adaptation is an active process of mediation, whereby a creative agent (a writer, a director, a spectator) turns one thing into another through a kind of interlocutory interaction. . . . Rather than be faithful to these preexisting texts, [adaptations] can aggressively take ownership of them through audacious infidelities, by rewriting them" (i–ii). History involves a constant process of rewriting, whereby the material gets readapted in each and every version.

This view of the conception of history has been more widely accepted than that of the second level, which concerns the reception process. The way recent audiences have received history as adaptation demonstrates more resistance to changing conceptions of history. Audiences prefer their well-established notions of history to remain unchallenged so that their everyday beliefs remain intact. As Rachel Carroll observes,

> All adaptations express or address a desire to return to an "original" textual encounter; as such, adaptations are perhaps symptomatic of a cultural compulsion to repeat. The motivations informing the production and consumption of adaptations may seem intent on replication but, . . . every "return" is inevitably transformative of its object—whether that object be the original text or the memory of its first encounter. A film or television adaptation of a prior cultural text—no matter how "faithful" in intention or aesthetic—is inevitably an *interpretation* of that text: to this extent, every adaptation is an instance of textual *infidelity*. (1)

Hence there exist no possible options for fidelity in the case of history as adaptation.

"In every age," Becker argues, history will be "taken to be a story of actual events from which a significant meaning may be derived" by some circles, and "in every age the illusion" will be that "the present version is valid because the related facts are true, whereas former versions are invalid because [they are] based upon inaccurate or inadequate facts" ("Everyman" 248). For this reason, everyone will keep writing history anew and adaptations will continue to unfold endlessly.

In the Museum of Anatolian Civilizations in Ankara, there is an inner courtyard where long wall reliefs are displayed. From the late Hittite period, from Charchemish 920–900 B.C., there are four consecutive reliefs depicting the war between the Hittites and the Egyptians. The Hittite figures are atop a chariot, crushing the Egyptians underneath the wheels. The guides in the museum are quick to provide the information that another set of the exact same wall reliefs is also on display in the Cairo museum, with one minute detail changed: the Egyptians are atop the chariot, crushing the Hittites underneath. The reliefs could be regarded as yet another example of how history has always been adaptive in its nature, whether twenty-first-century critics like it or not. Only if we embrace each alternative historical representation, each rewriting, as adaptation can we liberate history from monopoly and treat it democratically. This would mark a radical departure, motivated by the multi/cross/inter-disciplinary initiative defining adaptation studies.

WORKS CITED

"Başbakan Erdoğan'dan Muhteşem Yüzyıl'a Ağır Eleştiri." *Hürriyet*. 25 Nov. 2012. Web. 1 Aug. 2014.

Becker, Carl. "Detachment and the Writing of History." 1910. Becker, *Detachment*. 3–28. Print.

———. *Detachment and the Writing of History: Essays and Letters of Carl L. Becker*. Ed. Phil L. Snyder. Ithaca: Cornell UP, 1958. Print.

———. "Everyman His Own Historian." *Everyman His Own Historian: Essays on History and Politics*. 1935. Chicago: Quadrangle, 1966. 233–255. Print.

———. "What Is Historiography?" 1938. Becker, *Detachment*. 65–78. Print.

Bellafante, Ginia. "Nasty, but Not So Brutish and Short." *New York Times*. 28 Mar. 2008. Web. 1 Aug. 2014.

Berger, Arthur Asa. *Cultural Criticism: A Primer of Key Concepts*. Thousand Oaks: Sage, 1995. Print.

Bernard, Catherine. "Coming to Terms with the Present: The Paradoxical Truth Claims of British Postmodernism." *European Journal of English Studies* 1.2 (1997): 135–38. Print.

Carr, E. H. *What Is History?* 2nd ed. Ed. R. W. Davies. London: Penguin, 1990. Print.

Carroll, Rachel. "Introduction: Textual Infidelities." *Adaptation in Contemporary Culture: Textual Infidelities*. Ed. Rachel Carroll. London: Continuum, 2009. 1–7. Print.

Crichlow, Lenora. "The Tudors: About the Show." *BBC America*. Web. 1 Aug. 2014.

Gates, Anita. "The Royal Life (Some Facts Altered)." *New York Times*. 23 Mar. 2008. Web. 1 Aug. 2014.

Hobsbawm, E. J. "Karl Marx's Contribution to Historiography." *Ideology in Social Science: Readings in Critical Social Theory*. Ed. Robin Blackburn. Suffolk: Fontana/Collins, 1972. 265–84. Print.

Holdzkom, Marianne. "An Inconvenient Founding Father: Adapting John Adams for Popular Culture." Raw, Tunç, and Büken. 421–35. Print.

Hough, Andrew. "BBC Period Show, The Tudors, Is 'Historically Inaccurate,' Leading Historian Says." *Telegraph*. 10 Aug. 2009. Web. 1 Aug. 2014.

Hughes, Stuart H. *History as Art and as Science: Twin Vistas on the Past.* New York: Harper and Row, 1964. Print.

Hutcheon, Linda. "The Pastime of Past Time: Fiction, History, Historiographic Metafiction." *Postmodern Genres.* Ed. Marjorie Perloff. Norman: U of Oklahoma P, 1989. 54–74. Print.

———. *The Politics of Postmodernism.* London: Routledge, 1993. Print.

———. *A Theory of Adaptation.* New York: Routledge, 2006. Print.

Magnificent Century [*Muhteşem Yüzyıl*]. Dir. Taylan Biraderler. Perf. Halit Ergenç, Nebahat Çehre. 2011. Pegasus Film, 2013. DVD.

Mazumdar, Ranjani. "Memory and History in the Politics of Adaptation: Revisiting the Partition of India in *Tamas.*" *Literature and Film: A Guide to the Theory and Practice of Film Adaptation.* Ed. Robert Stam and Alessandra Raengo. Malden: Blackwell, 2005. 313–30. Print.

"Muhteşem Yüzyıl'ın Tarih Danışmanı Eleştiriler İçin Ne Dedi?" *Turktime.* 10 Jan. 2011. Web. 1 Aug. 2014.

Munslow, Alun. *The Future of History.* Basingstoke: Palgrave Macmillan, 2010. Print.

Raw, Laurence, Tanfer Emin Tunç, and Gülriz Büken, eds. *The Theme of Cultural Adaptation in American History, Literature, and Film.* New York: Edwin Mellen, 2009. Print.

Rosenstone, Robert A. *History on Film/Film on History.* Harlow: Pearson Longman, 2006. Print.

"RTÜK Muhteşem Yüzyıl'ı Uyardı." *CNN Turk.* 12 Jan. 2011. Web. 22 July 2015.

Sevinç, Aydın. "İşte Yılın Dizisi: The Tudors." *Milliyet.* 22 Sep. 2007. Web. 8 Oct. 2015.

Stam, Robert. "Foreword." Raw, Tunç, and Büken. i–iii. Print.

The Tudors. Dir. Ciaran Donnelly. Perf. Jonathan Rhys Meyers, Sam Neill. 2007. Sony Pictures Home Entertainment, 2009. DVD.

Uludağ Sözlük. Web. 10 Oct. 2015.

Waugh, Patricia. *Metafiction: The Theory and Practice of Self-Conscious Fiction.* London: Methuen, 1984.

Welsh, James M. "Foreword: Adapting Cinema + History (= Cinematic History?)." *The Adaptation of History: Essays on Ways of Telling the Past.* Ed. Laurence Raw and Defne Ersin Tutan. Jefferson: McFarland, 2013. 1–6. Print.

MAKING ADAPTATION STUDIES ADAPTIVE

BRIAN BOYD

ADAPTATION means one thing in the humanities and another in the sciences. Or does it? In adaptation studies, it means the transformation of an artwork into another form for a different audience. In evolutionary biology, it means the transformation of ancestral features of an organism into new functions that increase the organism's chances of flourishing in a given environment (more than the alternatives thus far available).

The differences seem slight. No wonder that, especially since the 2002 release of the film *Adaptation.*, adaptation studies has regularly invoked biological adaptation as an uncertain shadow or, more confidently, as a powerful ally (Bortolotti and Hutcheon). Nevertheless, adaptation studies has much more to learn from evolutionary approaches to literature and art, sometimes called adaptationist literary studies (Boyd, *On the Origin; Why Lyrics Last*; Boyd, Carroll and Gottschall; Carroll, *Evolution; Reading*; Gottschall; Gottschall and Wilson).

Taking an evolutionary perspective allows us to recognize the true breadth that adaptation studies can have, enables a theory of cultural creation that affords full scope for both individual agency and social and historical context, and solves adaptation studies' perennial problem of "fidelity discourse" (is this adaptation faithful to its source?), not by dismissing it, but by setting it within the lusher landscape of what we could call "fertility discourse."

BUILDING ON WHAT CAME BEFORE

Linda Hutcheon famously ends *A Theory of Adaptation*: "In the workings of the human imagination, adaptation is the norm, not the exception" (177). Even she does not go

far enough. All invention, whether in nature or art, in society or science, adapts prior design:

> Unlike other species, we can imitate closely and therefore follow established forms. Crucially, we *need* to imitate in order to innovate. Building on what came before underlies all creativity, in biology and culture. Starting again from scratch wastes too much accumulated effort: far better to recombine existing design successes. Even adopting a high mutation rate, changing many features at once, would rapidly dismantle successful design. (Boyd, *On the Origin* 122)

Ontogenically, we humans learn, much more than any other species, through imitation and adaptation. Children around the world master narrative through hearing stories from their elders and through pretend play (Berman and Slobin). Others richly scaffold our development. Biologist and anthropologist Sarah Hrdy identifies cooperative breeding as a key factor in allowing our ancestors to rear offspring with richer brains and richer behavioral repertoires. Philosopher of biology Kim Sterelny shows how we became "evolved apprentices," reliably acquiring skills and knowledge across multiple generations.

Children begin by telling stories not in the adult way, but in pretend play that adapts what they have heard to their own capacities and interests. They particularly favor what biologists call "superstimuli" like dragons or dinosaurs, or what evolutionary cognitive anthropologists define as "minimally counterintuitive" beings—witches, fairies, Spider-Man, or the local sprites or djinns of their culture—that have long had such a hold on human imaginations (Atran 103–7). Or they adapt simple "scripts," routine actions and reactions of everyday life, involving animals, humans, or other agents. Hutcheon defines adaptation as repetition with variation (8, 175–77). Children in their pretend play take simpler forms of what they see or hear around them and vary them endlessly as they master patterns of action and interaction (Sawyer).

Phylogenically, too, stories told by adults have immemorially been adapted for the occasion and the means available. Only relatively recently have some societies invented writing and then printing presses and the Internet to make it possible to fix and spread stories in authorial and canonical forms, whoever and wherever audiences might be. Parents telling stories to children, adults around the campfire, bards addressing a community or a court, and societies of all kinds staging rituals have adapted and still adapt their stories—not just what they say, but how they say it, the degree of enactment, and the use of props, costumes, or accompaniment—to the composition and response of their audiences. Unless we are bores and drones, we know from our own oral storytelling that we have to shape our stories for our listeners. And even when we report from our own direct experience, we have to adapt, turning perception, interpretation, and recollection into words and story.

Just as life adapts previously successful design at all sorts of levels, from genes to societies, so does art. In literature, writers adapt everything from previous modes, genres, and plots to structures, character types, and characters, and even images, phrases, and words. Just as live species try to adapt to different circumstances, so do artists adapt

existing art to their own preferences, skills, and tools and to their sense of the preferences and skills of the audiences they aim to engage.

ADAPTING THE TROY STORY

Any complex form of recent life has become what it is by making many adjustments to prior forms. Likewise, any recent work of art depends on a vast history of art, on the long human proclivity to engage in art, and on the particular resources of a particular art and its forms within a certain lineage.

The first great masterpieces of story, *The Iliad* and *The Odyssey*, emerged from the traditional matter of Troy. In all likelihood, Homer filled in rather spare narrative material and shaped it uniquely, adapting it by enormous expansion, reflection, and rearrangement in order to earn both repeat invitations to the courts of his time and a reputation that would last far beyond his time (Boyd, *On the Origin* 221; de Jong 215). Within *The Odyssey*, Homer shows Odysseus himself wildly adapting his own account of his past for the Phaiakians, for Eumaeus, for Telemachus, for the suitors, and for Penelope, altering his identity, character, and history to suit the audience and occasion.

Each of the Greek tragedians—Aeschylus, Sophocles, and Euripides—adapted the matter of Troy, along with other legendary cycles, to reflect their own individual visions, according to the technical means of the theater available to them. Centuries later, Virgil ambitiously conflated *The Odyssey* and *The Iliad* to shape *The Aeneid*, a story of wandering followed by a story of war, drawing on Greece's cultural capital for the sake of Rome's, and on Homer's reputation for the sake of his own. More than a millennium later, Dante developed his descent into the Inferno not only from Christian teachings but also from the descent into the underworld in *The Odyssey* and *The Aeneid*.

Only once did Shakespeare base an entire play on the matter of Troy. In *Troilus and Cressida*, he drew on Homer as reworked by Virgil and Ovid and recently translated by Chapman, and on Chaucer's version of Boccaccio's elaboration of Benoît de Sainte-Maure's addition to the Troilus of the Greek epic cycles. His play's unusually Latinate language and savagely ironic mode have made many think he adapted it for performance at the Inns of Court, although evidence for that is lacking. Three centuries later, James Joyce, partly moved by Charles Lamb's children's adaptation *The Adventures of Ulysses*, himself adapted *The Odyssey*, episode for episode, into novel form, compacting ten years of wanderings around the Mediterranean into one day in Dublin. In the course of his own *Ulysses* he also adapted, among many others, *Hamlet*; *The Lake*, by George Moore, Ireland's foremost novelist before Joyce (Boyd, "Plain"); the mode, scope, and characters of his own stories in *Dubliners* (Wright); and an incident from his own life.

All these writers, even Homer, adapted previous stories about Troy, in whole or in part, for their own purposes. The unquestionable creativity of many of the greatest storytellers in the Western tradition depended, in their greatest work, on prior stories. They drew on adaptations of adaptations, on particular stories, and on the development of

story traditions, techniques, and tastes. They often added further novelty by grafting one or more additional preexisting stories onto still older stock. They adapted their stories, in their form and vision, to their own times—Greece emerging from the Dark Ages, Athens in its heyday, imperial Rome, fourteenth-century Florence, Elizabethan London, modernist Europe—but they also adapted them to last.

Problems and Solutions

If adaptation within literature extends processes active throughout adaptation within life, three principles at work throughout life, or emerging as cognition evolves, raise and answer key questions about literary adaptation: problem-solving, costs and benefits, and attention.

Problems emerge with life, as Karl Popper declares in *All Life Is Problem-Solving*. Adaptations in biology are solutions, physiological or behavioral, to particular problems of survival or reproduction within a particular range of environmental conditions. In nature, the redeployment of preexisting design offers the necessary basis for new adaptation: that is why we share so much of our DNA with chimpanzees or even daffodils. The preexisting design must itself be adaptive, or the genetic repertoire of a species would not be available for further modification. But if a new modification *is* adaptive, if it solves a problem better than the organism's previous repertoire and therefore spreads through the population, the fact that it offers a solution automatically creates a new problem: at the very least, how best to benefit from this new solution. An incremental improvement in vision, say, or an expansion of preferences into a new niche, will create new pressures on behavior, body, and mind to make more of the new capacity or the new environment.

In the same way, in literature and the other arts, new solutions generate new problems. In composing *The History of Henry the Fourth*, Shakespeare created Falstaff to solve structural problems in adapting to the stage Holinshed's chronicle and the colorful legends of wild Prince Hal. But the huge success of Falstaff created a new problem: how to capitalize further on that success and the expectations it had generated. To solve that problem, Shakespeare composed *The Second Part of Henry the Fourth*—a complex, highly constrained redevelopment of the givens of the previous play in the light of what had already happened there to Henry IV, Hal, and Falstaff—and *The Merry Wives of Windsor*—a free comedic extravaganza that needed only Falstaff's large presence and nothing of the historical situation or the constraints of consistency with the history plays—before writing *The Life of Henry the Fifth*.

In nature, the redeployment of existing design can take many forms: genetic mutation, direct gene transfer (in bacteria), endosymbiosis (the formation of eukaryotic cells, cells with nuclei, from prokaryotic or unnucleated cells, through assimilation and cooperation), epigenesis (the modification of gene expression by the environment), sexual recombination, and hybridization. Science keeps discovering new ways nature has found to adapt existing design—most recently, bacteria's capacity to soak up the genetic remains even of long-dead organisms (Overballe-Petersen et al.). Another powerful

way species with flexible behavior redeploy existing solutions is social learning, whether chimpanzees are mastering the art of cracking nuts or children the local language.

There are many contested evolutionary models of cultural transmission. Evolutionary theorist Richard Dawkins's analysis of "memes," which Bortolotti and Hutcheon accept as a homology—a complete functional equivalent—to genes, stresses that the meme as cultural replicator, like the gene as biological replicator, replicates to its own benefit, not necessarily to that of the organism that incorporates it. For Dawkins, religions are prime instances of memes reproducing for their own benefit, not for that of the humans who take them up. Evolutionary anthropologist Dan Sperber counterproposes an epidemiological rather than a genetic model: an epidemiology of representations whose key feature is the different susceptibility of different individuals or populations to the more or less "viral" elements of culture. Evolutionary anthropologists Peter Richerson and Richard Boyd stress the power of gene-culture co-evolution. Evolutionary psychologist Steven Pinker rejects the notion of memes, because they ignore the minds that shape culture, the very causal factors that design things to appeal to or impose on other human minds (165). Systems biologists have recently offered a powerful challenge to a gene-centered view of biology, emphasizing the incapacity of genes to operate except within the functioning of an organism interacting actively with its environment (Noble, *Music*; "Physiology"). This critique would also challenge the applicability of the meme, modeled on the gene, to culture.

Whatever evolutionary models ultimately prove most productive in helping to explain culture, all models agree that in biology, successful new elements build on (*adapt*) existing design in order to solve new problems (to become *adaptive*). In thereby creating new opportunities, they pose the additional problem of how to make more of the new adaptations. Evolution requires a degree of fidelity, or existing design would be lost. But if there were only fidelity, life would have evolved no further than the first self-replicating organism—which would not have been in a position to solve the new problems generated by its own successful self-replication. Rather, the process of biological adaptation forgoes exact fidelity to solve new problems, but in doing so, necessarily creates new problems that invite new solutions. The process is fertile, rather than merely faithful. Adaptation in art follows the same pattern: redeploying existing design to create new solutions that by their very existence introduce new problems from which further new solutions may emerge.

PROBLEMS, SOLUTIONS, INTENTIONS

In a world where problems and solutions matter, we have evolved to become very good at reading the behavioral solutions others adopt to cope with the problems they face. Social species in particular become skilled at reading others of their kind in terms of intentions, in terms of the solutions they seek to the problems they recognize. In this way, members of social species can learn by recognizing how others have solved problems that might also apply to them. Even chimpanzees and infants can analyze simple actions of others in

terms of problems and purposeful solutions (Premack and Premack). We uniquely ultra-social humans naturally understand human actions within stories in the same way, in terms of characters' attempted solutions to the problems they confront.

Storytelling, of course, is one kind of human action, and just as we can understand other actions in terms of problems and solutions, we can also understand storytellers' choices in their narrative acts in terms of the problems they seek to solve in telling their stories. A good audience can enjoy not only the clash of characters' attempted solutions to their problems, but also the storytellers' problems and solutions in inventing, shaping, and arranging their narratives.

When we approach literature or other arts through adaptation, however, we can focus more sharply than usual on the available partial solutions that artists have adapted, on the new problems they have posed themselves—in the case of storytellers, through adapting existing generic models and specific story templates—and on the new problems their solutions may have generated. No wonder that Hutcheon selects the successive problems of a series of writers and composers, adapting a true story of Carmelite nuns facing the guillotine just before the end of the Reign of Terror, in order to reassert the need to factor intention into understanding works of art (95–105), or that Thomas Leitch frequently resorts to a problem-solution model in comparing and contrasting the different responses of adapters to what might superficially seem like similar kinds of adaptation.

Costs and Benefits

A problem-solution model needs to incorporate costs as well as benefits. Nature automatically tracks the benefits of possible solutions against their costs, in terms of survival and reproduction rates. A mutation whose costs exceed its benefits will be swiftly eliminated. An evolutionary route that might ultimately have led to an adaptive peak of greater benefits than costs would remain unattainable if it could be reached only by way of a valley of intermediate steps where costs exceeded benefits. Since evolution moves only a step at a time, a species cannot reach better adaptations through worse options than it currently has.

Sociality has evolved in many distinct lineages because it can offer less costly solutions to common problems—like finding food, or avoiding becoming food for others—so long as the savings outweigh added costs, such as the risk that groups may deplete resources faster or attract more predators. Social animals regularly reduce their own costs by leveraging the discoveries of others, in the human case even building on solutions discovered generations ago.

In artistic adaptation, as in other social and cultural behavior, costs and benefits play a key role. Creating novel design is costly in terms of search time, effort, and the frequent failure to earn the positive response of attention and interest that reward artists in terms of improved status and resources. Adapting ready-made design massively reduces search costs, even for the most creative, and promises greater benefits if a

generic form or a particular template has already proved it can attract an audience. Even Shakespeare, the most inventive of writers, adapts the conventions of his time (regularly enriching them at all points), from blank verse to genres like comedy, tragedy, and history. Following the norms of his time, he adapts specific stories and characters from chronicles, prose and verse tales, and pre-existing plays, concentrating, extrapolating, duplicating, or inverting what he finds through the device of multiple plots, itself an established theatrical practice of his time.

ATTENTION

Art needs to earn and hold attention, or it dies of failure to engage the audiences who might have profited from it and to reward the artists who have labored to create it (Boyd, *On the Origin* 99–112, 215–54). Attention is a very limited resource: even human working memory can grasp only four or five chunks of information at any moment (Bor). Any attention we give to a work of art must compete with the attention we could pay to real-world pressures, or to competing demands on our optional time, like play or other art. Even in the free time that modern human ecological dominance makes possible, we face this problem: How do I make the fullest use of my disposable time? How do I maximize benefits and reduce costs?

Not that we make conscious cost-benefit analyses. Evolution generated emotions as a way of motivating animals toward beneficial and away from costly behaviors. This, incidentally, is a major reason I have argued for art—which can cost huge amounts of time, energy, and other resources—as an evolutionary adaptation. If engagement in art did not yield benefits, nature would have eliminated it from the human dispositional repertoire (Boyd, *On the Origin* 83–84).

Our individual motivation to spend time engaged with this or that work of art will depend on our assessment—in terms of our emotions, interest, arousal, boredom, or confusion—of its benefits to *us*. In our species, where we learn most of what we know from others, a quick prior measure of our own likely interest will be a work's capacity to earn the attention of others, whether in terms of sheer numbers, or the niches we belong to, or the experts we trust most.

Artists face different problems from audiences. In order to earn attention through their next work, and to reduce costs while creating it, they almost invariably adapt previously successful modes of earning attention within art. Minds welcome familiarity and find too much novelty disconcerting and demanding. On the other hand, neural tissue automatically diminishes its response to a repeated or prolonged stimulus. Minds need novelty (Martindale). Artists will therefore likely adopt proven ways of earning attention, in modes, genres, forms (sonnets, ballads) and even particular stories, characters, casts, or types (Achilles, Sherlock, or Batman; the woman perilously pursued in eighteenth-century fiction; recyclable contemporary figures like James Bond or Norman Bates; vampires, zombies, or post-apocalyptic survivalists). But they will not

merely repeat; they will adapt. As they capitalize on salient routes to attention, they also lower comprehension costs for their audiences, while sharpening audience alertness to divergences from well-defined expectations.

QUESTIONS

Several clusters of questions arise from this analysis of adaptations. If we accept a wide scope for adaptation in science and in art, does *everything* become an adaptation, so that "adaptation" as a term in literary studies loses its specificity and value? No, I suggest. Viewing literature and other arts in terms of adaptation allows us to see works better in terms of the problems that the adopter of a prior mode or adapter of a specific pre-text seeks to solve. Does the adapter pose the problems well, and are they fruitful problems to try to solve? Does the adaptation solve them well? Does it have viability and resonance beyond its immediate purpose? Is it fertile enough to provoke others into adaptations of their own?

The resemblance between biological and artistic adaptations suggests another set of questions. Does an artistic adaptation adapt for flexibility, for viability within a wide range of environments, in the manner of flight or intelligence, or for a very local set of conditions, in the manner of pandas feeding on bamboo leaves, or koalas on eucalyptus leaves? What does an adaptation adapt for: a large audience or a niche, a monoculture or a cross-cultural audience, short-term or long-term success? Should we evaluate these different purposes, or should we avoid evaluation and treat them perfectly neutrally, or should we carefully discriminate their different effects? In nature, some species adapt for low investment and rapid short-term saturation (mayflies, daisies), others for high investment and long growth (elephants, sequoias). Biologically, it makes little sense to say that one strategy is superior to another. At one level high-investment humans may dominate the ecosphere, but at another microbes vastly outdo us in number, mass, and range; without our microbiomes we could not survive, but microbes will almost certainly outlive us. The nineteenth-century notion of evolution as a ladder of ascent leading up to *Homo sapiens* has been rightly discarded: evolution is a tangled bush, not a steeply conical tree with us at the crown. But is it merely elitist or parochial and self-serving to value human lives as something uniquely special, or to find elephants more valuable than *E. coli*?

Turning to artistic adaptation, how do we assess an adapter's decision to aim at the widest or the most exacting audience, at the trade-off between breadth of readership (the Classics Illustrated *Odyssey*, or Charles Lamb's *Adventures of Ulysses*) and artistic depth (James Joyce's *Ulysses*)? Do we simply appraise the terms of the trade-off, assessing what has been forfeited for what has been gained, or should we evaluate it? Should we remember that in their day Shakespeare and Dickens aimed at both wide audiences and discriminating ones, and at audiences both in and beyond their time and place? Or that Joyce's fascination with Odysseus began with his reading of Lamb's *Adventures of Ulysses*—that there might not have been the expansive adaptation without the simplifying one? Perhaps we need to keep in mind the ratio of cost to benefit: for many authors and audiences, this must matter more than simply maximizing benefit, because not all can afford the high cost

of *maximum* benefit, in a human world with varying capacities and interests and divisions of labor. As the biological analogies suggest, there could be many different scales to apply, depending on what questions we wish to ask, and there may always be a danger that if experts ask the questions, they will answer in a way that privileges expertise.

An evolutionary and cognitive perspective may offer answers to a different set of questions. Why has adaptation studies focused so often on adaptations of literature to film when, as in nature, adaptations can operate in so many directions? To the obvious historical answer—that adaptation studies started in literature departments as film was rising to academic notice—we can add that film reduces attention costs (on average, reading a novel imposes much higher costs in time, focus, and solitude than viewing a feature film), and therefore has a different cultural capital (wide current popularity, rather than the historical esteem of the few older novels that do continue to be read).

Furthermore, we have always adapted experience into words in recounting the day's actualities or conjuring up the night's possibilities. Literature adapts in the same way, but in drama, and even more in film, we seem to be re-presented with experience. In film we encounter prefocused experience, rapidly divulged, and offering superstimuli like spectacular scenes or events, or close-ups of faces disclosing emotions deftly evoked by talented actors. As a species, we have naturally adapted experiences or inventions into words in order to relay them, but the new power of film seems to allow us to encounter others' experience by circumventing verbal report. That explains film's immediacy and impact and its often low costs for viewers. Yet to present that simulacrum of concentrated, intensified, and accessible experience, film requires elaborate preparation that the naïve viewer may not recognize and that the expert needs to explain.

In explaining the difference between literature and film, the literary expert, used to the sophisticated ways we adapt outer and inner experience in words, may see the adaptations of verbal narrative into feature films mostly in terms of losses, despite the gain of immediacy. Which brings us to the recurrent question, or the bugbear, of adaptation theorists: Why does the field keep returning to the question of the fidelity with which adaptations embody the original?

FIDELITY AND FERTILITY: LIFE AND ART

Again, the analogy with biological adaptation may help clarify these questions. Biologists identify evolutionary adaptations in terms of their function, the problems that they solve in a species. In assessing artistic adaptations, we need to have a similarly clear sense of the problem facing the adapter—and the adapter's sense of the problem, which may not be the same—and of the solution the adaptation presents.

Biological adaptation involves both fidelity and fertility. To be an adaptation, a biological feature must establish itself across the species and must be reliably passed down to subsequent generations: it must be reproduced with fidelity. But to be adaptive, to have solved a new problem, or an old one better, it must have improved in some way on some prior state of the species. Adaptation looks two ways, toward retention or fidelity

and toward innovation or fertility. Fidelity alone is not enough. As we have seen, evolution would have stopped if there were only exact fidelity in reproduction; the first arrangement of organic material capable of self-replication would have replicated until problems caused by its very proliferation eliminated this first form of life. From its first emergence, life has needed to be able to engender new adaptations to solve new problems. Only that way could it reach the stage where there are creatures like us who can ask questions about life, evolution, and adaptation.

Adaptations emerge especially through mutations. Major mutations are usually unviable and therefore quickly eliminated, but inheritance does not require near-absolute fidelity. Indeed, recent work in systems biology shows that minor mutations occur all the time, still code for the necessary proteins, and are easily accommodated by a robustly interconnected organic system. But the accumulation of these minor mutations can prepare additional options for more substantial change, under new pressures acting on a still viable but now more flexible genetic repertoire. Still-functioning combinations can approach a threshold where a new adaptation requires only minor additional steps (Wagner).

Something similar occurs in artistic adaptation. Artistic systems are robust enough to sustain themselves with minor changes, and may be more viable in new contexts for having these changes. Shakespeare revised *Hamlet* and *King Lear* by cutting hundreds of lines from his original texts to provide more theatrically effective versions. Although these cuts change characterization and emphasis, each play remains essentially the same, yet each version is fitter for a different environment, page or stage.

In biology, reasonably faithful inheritance of species characteristics is necessary for viable offspring, just as an accurate rendering of the text is necessary for a new edition, an audiobook, or a translation. Vladimir Nabokov was within his rights to have the first Swedish translation of *Lolita*—half the length of the original, thanks to the excision of the least erotic parts—burned by the publishers (Schiff 240–41).

But fidelity is not enough. When a bird or insect is blown or a mammal swept to a new environment, it can cope only by adapting its behavior. It must select, for instance, from the different food sources now available: retaining an exact commitment to old preferences would be fatal. Nabokov, asked about adapting novel into film, answered, "A completely faithful cinema reproduction of a novel would mean filming one after another all its printed pages turned by an invisible hand at the rate of a three-minute pause each, soundlessly and without any vignettes, for the benefit of those too lazy to open a tangible book" (Interview with Goldschlager). That would be both a faithful and a fatal adaptation: it would never be born in the new ecosystem of cinema, nor could it survive there if it were.

Fidelity and Fertility: Artistic Adaptations

While artistic adaptations always need to reach independent viability, the adapter's problem situation may be conceived of as lying closer to either the fidelity or the fertility end of the adaptive spectrum.

Adapters who aim at fidelity may see their problem in terms of service to the source, like conservationists hoping to ensure the persistence of a species by introducing it to a new environment. Or they may seek to leverage the source's established cultural capital or recent success by becoming its accredited representative in another medium, like an entrepreneur introducing a profitable crop or domesticated animal into a new territory. Adapters who aim closer to fertility will take advantage of the lower invention costs possible by borrowing rich existing design and need have no sense of responsibility to their source, except on their own terms. They are closer to the long-term course of evolution, thoroughly transforming options to explore new possibilities.

If an adapter aims at fidelity, we should ask why; how has fidelity been sought; and how does the adaptation achieve this goal? While fidelity should not be seen as the only aim of adaptation, neither should it be dismissed as servile. Andrew Davies's 1995 and 1996 BBC adaptations of *Pride and Prejudice* and *Emma* aimed to be self-sufficient surrogates for some of the pleasures of reading Austen (reduced cost for a large share of the benefit, and therefore wider audiences) and a route back to the original (for those prepared to pay greater costs—but already lowered, if they now know the characters and story—for greater benefit). To return to the earlier analogy, the BBC was adapting a profitable resource to a larger territory. The Inuit makers of *Atanarjuat: The Fast Runner* (2001), on the other hand, were more like conservationists. They gathered and honed a network of ancient Inuktitut oral narrative into a tight-knit story that would introduce half-alienated young Inuit to their cultural heritage and the traditional practices of their forebears, and introduce a worldwide audience to a rich, uniquely Inuit, but also universal story in a way that helped preserve the mores, the achievements, and the language of Inuktitut (Angilirq et al.).

We can ask, what target audience does an adaptation aim at, and does it hit that target? What audience range does the adaptation aim at, in terms of time (does it target the immediate present, or a more lasting audience?), space (a local or an international audience?), class (a highly educated or a broader audience?), and age (all ages, or a particular niche?)? When adaptation constitutes an act of homage, the source has presumably made much of its medium; is the adaptation true to *its* medium, as Raúl Ruíz's *Le temps retrouvé* is in finding filmic equivalents for Proust's drifting subjectivities? Does it have interpretive depth in exemplifying or distilling the original, or does it banalize the original to make it acceptable to conventions in another format that the source author challenged in the original (as most literate Russians will concur that Chaikovsky has banalized Pushkin's *Eugene Onegin*, or most readers will find Ridley Scott's *Blade Runner* has diluted Philip K. Dick's *Do Androids Dream of Electric Sheep?*)? Have the problems the adaptation sought to address been profound or shallow, freely determined or narrowly constrained, as when James Harris and Stanley Kubrick invited Nabokov to adapt *Lolita* to the screen, asking him "to appease the watchdogs and moral shepherds of American cinema" by ending the film with Lolita and Humbert married, with an adult relative on hand to bless the union (Boyd, *Vladimir Nabokov* 386–87)?

In choosing as their core aim not fidelity to the source but fertility, adapters can pose themselves two distinct options: an active engagement with the source, to be appreciated by those of their audience who happen to know it, or relative detachment from the source.

In the former case, we can assess the result in terms of its originality and energy, as in *West Side Story's* adaptation of *Romeo and Juliet* from play to musical, past to 1957 present, aristocratic family feuds to New York ethnic gang warfare; or its vitality for a particular moment, as in *William Shakespeare's Romeo + Juliet* (1996), with its startling switches from Verona to Verona Beach, and Shakespeare's day to the 1990s, even as it retains the playwright's language and story; or its bold transposition into seemingly remote modern terms, as *Clueless* (1995) transforms the English country gentry of *Emma* to a Beverly Hills high school in the 1990s. Or we can examine the degree to which the adapter challenges the received interpretations or even the assumptions or omissions of the source: Peter Brook presenting *King Lear* on stage and screen as twentieth-century not in setting but in harrowing spirit, Jean Rhys challenging *Jane Eyre* in the feminist, postcolonialist 1966 prequel *Wide Sargasso Sea*. Some will update, revivify, echo, and challenge their original all at once, as Joyce does in adapting Odysseus from hero to humble and humiliated everyman, from avenger to forgiver, announcing and obscuring his novel's relation to Homer at the same time.

Darwin prepared readers of *On the Origin of Species* for his theory of natural selection by first analyzing the artificial selection of pigeon breeders and the remarkable transformations they had wrought, in many different directions, on the familiar ancestor stock. Those artistic adapters who invite audiences to recognize their reconfigurations of their initial model offer something analogous: we know the source and can be fascinated at a new form derived from it. But other adapters work more like evolution on the long scale, transforming material utterly, with little concern for the starting point, as evolution has transformed creatures no bigger than dogs into blue whales, or dinosaurs into hummingbirds. The greatest artists transform the most. Homer turns a bare outline of Odysseus's delayed return home to a Penelope beset by suitors into the complexly structured narrative of *The Odyssey*. Shakespeare ignores chronology, the proportions of history, and the cast of real historical actors to restructure events from Holinshed into *King John*. Hitchcock famously claimed to read the sources for his film once before acting on that mere prompt to devise his own movie (Leitch 238). Each of these artists simply turns the raw material into what might work best for an ambitious epic, an engaging history play, or a gripping murder film. We do not need to read these works "*as adaptations*," in Hutcheon's terms (xvi–xvii, 79–111), but we *can* read them, where the various sources can be identified, in terms of the precise problem situation the adapter faces, given this source material, the generic and modal practices of the time, and artists' desire to build on reputations earned by previous work without merely repeating earlier successes (Boyd, *On the Origin*, 215–54, 321–57; "On the Origins," 108–10; *Why Lyrics Last*, 64–101).

Nabokov's *Ada*

Let us turn to two artists who consciously adapt material meta-adaptively and in ways that explore the fidelity-fertility range. Nabokov had resisted Harris and Kubrick's invitation to adapt *Lolita* when they seemed more interested in appeasing the Hays

code than reflecting his novel, but he changed his mind after their position softened. He volunteered for the screenplay once he suddenly realized a way to reflect a key element of the novel, the insistent presence of the long-unidentified Quilty, by beginning the film with Humbert's murder of Quilty. Living for six months not far from Sunset Boulevard, Nabokov wrote a six-hour screenplay in a spirit of exuberant inventiveness, constructing new scenes and characters to fashion "a vivacious variant of an old novel" (Nabokov, *Lolita* xii). When Kubrick insisted that the screenplay be shortened, Nabokov compressed it to half the length, but once he handed in the revised version, Harris and Kubrick thoroughly revamped it in strict secrecy (*Lolita*; Boyd, *Vladimir Nabokov*). The next novel Nabokov wrote after his 1962 viewing of the film's premiere, *Ada*, reflected his experience of *Lolita*'s adaptation as well as his involvement in a controversy caused by his advocating, demonstrating, and defending uncompromising literalism in his 1964 translation of Pushkin's *Eugene Onegin*.

Ada opens with a parodically garbled mistranslation of the famous opening sentence of *Anna Karenina*, and in doing so echoes the way Pushkin opens *Eugene Onegin* with a reworking of a famous line from earlier Russian poetry. The novel's second chapter shows Marina and Demon (the parents of the hero and heroine, Van and Ada) when they first become lovers, as Marina acts in a play that grotesquely garbles *Eugene Onegin*—a stinging criticism of the Chaikovsky opera adaptation, and of distortedly derivative adaptation in general, that also targets Robert Lowell's "Adaptations," as he called them, of Osip Mandelstam's poetry, in which Lowell was often led astray by absurd misconstructions of the Russian. "'Adapted' to what?" Nabokov asked of Lowell's adaptations: "To the needs of an idiot audience? . . . But one's audience is the most gifted and varied in the world" ("On Adaptation" 283). When Van and Ada meet for a second summer together at Ardis, Ada's family's estate (Van has been brought up as her cousin and Marina's nephew), her governess, now a celebrated author, has to tolerate the wild caprices of the adaptation of her novel into a Hollywood script:

> "Incidentally," observed Marina, "I hope dear Ida will not object to our making him not only a poet, but a ballet dancer. Pedro could do that beautifully, but he can't be made to recite French poetry."
> "If she protests," said Vronsky, "she can go and stick a telegraph pole—where it belongs." (201)

Van himself writes a science fiction novel, *Letters from Terra*, ignored for fifty years but then made into a film that reverses many of the results of the scrupulous research behind his novel—and which, in a bizarre irony, thereby gets closer to the truth. Ada has a small part in a film, *Don Juan's Last Fling*, which preposterously fuses the Don Juan legend (especially as deployed in Pushkin's *The Stone Guest*) with *Don Quixote*, not to mention elements of the Lolita story, as written by Osberg, an anagram of "Borges," on the Antiterra on which the novel is set.

Here and in other ways Nabokov's satire and parody seem to insist on fidelity in translation and adaptation. Yet he insists even more on the role that imaginative transformation of earlier art plays in creativity. He echoes Tolstoy in the opening and at the close

of the novel because *Ada* relocates the nineteenth-century novel, with its aristocratic country estates and grand picnics, into the twentieth century, for comic destabilizing effect: sexual frankness, cars, swimming pools, and Hollywood all appear in 1884 and 1888. Nabokov can do this because he also adapts science fiction, in a comically retro, proto-steampunk fashion (hydraulic telephones, an alternative earth with a counterfactual version of earth history), reminding us that what we think of as a quintessentially twentieth-century mode has its roots in nineteenth-century writers like Jules Verne and H. G. Wells, both directly evoked in *Ada*.

Ada records obsessive love as seen through the prism of memory. No surprise, then, that it pointedly echoes *À la recherche du temps perdu*. In Proust, Swann's love for Odette prominently prefigures the main story, Marcel's love for Albertine a generation later. Nabokov adapts and tightens that structure, compacting Proustian languor into demonic haste, in the love of Demon for Marina in a three-chapter prologue to the novel prefiguring their children's torrid, lifelong love. Within that, he also adapts, compacts, and compounds Proustian crossovers between visual art and his characters' lives (see especially Boyd, *Ada*Online, 13.01–14.05n.)

Ada depends on a deeper ekphrasis. In the structure of his novel, Nabokov explicitly echoes Bosch's *Garden of Earthly Delights*, with its tripartite division into Paradise, the Garden of Earthly Delights, and Hell. Van and Ada as they fall in love—a pointedly fortunate and Edenic fall—in Ardis the First, in 1884, seem at times, in the intensity of their focus, the lone humans in their sexualized private paradise. They resume their ardent affair in Ardis the Second in 1888, now all too conscious that others around them are also sexually active and sexually interested in them, in a narrative version of the overcrowded and hyperactive sex in Bosch's central panel. Then, after Van's self-expulsion from Ardis, in the remainder of the novel, we find ourselves in the hell of the consequences of their "passionate pump-joy exertions" (286).

For Nabokov, art should be exact: hence his predilection for literal translation and close transposition into other arts, when fidelity counts. But he also emphasizes that newer art should recognize how much it owes to older art, which it can nevertheless adapt, transform, and critique as freely as it likes.

Natural adaptation, too, plays a key role in *Ada*. Darwin rightly saw orchids, the most prolific of plant groups, as a supreme example of adaptation. Ada is a passionate orchid collector and orchid artist, who "might choose, for instance, an insect-mimicking orchid which she would proceed to enlarge with remarkable skill. Or else she combined one species with another (unrecorded but possible), introducing odd little changes and twists that seemed almost morbid in so young a girl so nakedly dressed" (99). She intercrosses orchids, as if in echo of Darwin's *On the Various Contrivances by which British and Foreign Orchids are Fertilised by Insects, and on the Good Effects of Intercrossing*. Her great-grandfather is named Erasmus Veen, after Darwin's grandfather, Erasmus Darwin, whose *The Loves of the Plants* (1791) insisted that sexual reproduction "was at the heart of evolutionary change and progress, in humans as well as plants" (Wikipedia, s.v. "The Botanic Garden"). Darwin himself believed that "living things produced by cross-pollination always prevail

over self-pollinated ones in the contest for existence because their offspring have new genetic mixtures" (Orlean 53). While Ada paints a variant on *Ophrys veenae*, a species Nabokov has plausibly invented within a real genus famous for pseudo-copulation, Van, very early in their relationship, bends closely over her, touching her, inhaling her, before rushing off to masturbate. Van and Ada are brother and sister, but because of the entangled relationships closer to the trunk of their family tree, they are also "putative first cousins (since Aqua and Marina are sisters), putative second cousins (since Demon and Dan are first cousins) and putative and real third cousins (since Demon and Dan are second cousins to Marina and Aqua)" (Boyd, *Ada*Online, n. to Family Tree, Pt. 1 Ch. 1). Darwin, like many in the European gentry and nobility, also had a tangled family tree, a fact that troubled the great theorist of biological inheritance. Van and Ada are lovers over an eighty-year span, but they are infertile.

In Proust, Swann and Odette use the phrase *faire cattleya* as a private code for "making love," after the Cattleya corsage Odette wore when they first made physical contact. Unhappy with the late-1960s imagery on the cover of the first American paperback of the novel, Nabokov drew for Penguin a design that they adopted with little change: a single Cattleya orchid (Figure 34.1a and b). Nabokov, who had studied the evolution of the lycaenids, the butterfly family in which he became the world authority in the 1940s

FIGURE 34.1A AND B Nabokov's drawing of a Cattleya orchid (a), and the cover of the 1970 Penguin paperback reprint of *Ada* based on that drawing (b).

FIGURE 34.1A AND B Continued.

(Johnson and Coates), has Ada breed caterpillars, including "the noble larva of the Cattleya Hawkmoth (mauve shades of Monsieur Proust), a seven-inch-long colossus, flesh colored, with turquoise arabesques" (56). He interbreeds art and nature, art and art, as Ada interbreeds real and imagined orchids. But Ada and Van remain dangerously, unhealthily, even disastrously self-involved. Not only infertile in themselves, they kill by their carelessness the half-sister who brings new blood into their hothouse family. *Ada*'s complex and multiple adaptations and hybridizations of art and nature, of page, stage, screen, and painting, suggest that the more exactly you know your world, or the world of art, the more you can transform it as you wish. The more you learn to go beyond yourself, the freer you are to find yourself and the more fecund you can be.

KAUFMAN'S *ADAPTATION*

Ada's orchids lead to Charlie Kaufman's screenplay adapting Susan Orlean's *The Orchid Thief* (1999), which itself evokes Darwin on orchid adaptations. Spike Jonze's 2002 film from Kaufman's script, *Adaptation.* (Figure 34.2), by now a staple text for adaptation studies, resembles *Ada* not only in spotlighting orchids but also in being meta-adaptational and in addressing both fidelity within adaptation and the creative fertility to be found in building on prior design but moving beyond fidelity.

In real life, Kaufman, having been paid to adapt *The Orchid Thief*, found himself with writer's block because he could not see how to adapt the book—part pen-portrait of orchid thief John Laroche; part memoir of Orlean's relationship to his colorful personality, to Florida, and to orchid lore and orchid obsession; part historical and scientific essay on orchids and orchid theft—into a workable screenplay. Ironically, Kaufman's solution to the problem of the screenplay and the problem of fidelity came by abandoning fact and jumping into fiction. After introducing a version of himself as Charlie Kaufman, would-be adapter of *The Orchid Thief*, in the throes of writer's block, he invents an identical-twin brother with none of Charlie's scruples in life or art. Donald Kaufman's intervention in Charlie's life, like his suggestions for Hollywoodizing the screenplay, turns their lives, and their relation to Laroche and Orlean, into a Hollywood adventure story in the Florida swamps, precisely the kind of outcome the character Charlie Kaufman dreads. The invention of Donald and his desire to find a Hollywood sex-drugs-guns story in the relationship of Laroche and Orlean fly in the face of fidelity.

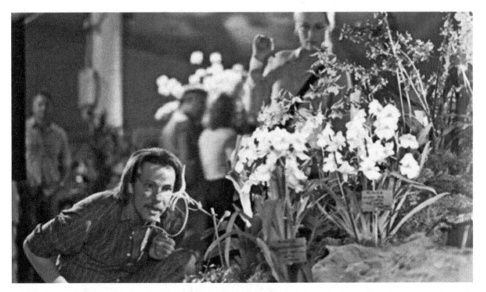

FIGURE 34.2 Chris Cooper as orchid thief John Laroche in Spike Jonze's *Adaptation.* (2002), from Charlie Kaufman's screenplay adaptation of Susan Orlean's *The Orchid Thief* (1999).

But as Orlean comments, the real Kaufman's screenplay "has ended up not being a literal adaptation of my book, but a spiritual one" (Kaufman ix). After all, it presents almost literal images of Laroche, Orlean, orchids, and Laroche's orchid lore, introduces substantial quotations directly from Orlean's book, acknowledges the difficulties her idiosyncratically mixed-form and non-narratively-driven work poses, and presents its own wild mix of forms. Introducing fat, diffident, self-conscious Charlie Kaufman into the script provides a perfect foil to set off lean Laroche's untrammeled confidence and energy. In the contrast between Charlie and Donald, Kaufman also limns the contradictory sides of Laroche's personality that fascinate Orlean: the intellectual versus the huckster, the moralist versus the exploiter, the committed obsessive versus the serial opportunist. Kaufman adopts a perennial device of narrative, character contrast, to adapt *The Orchid Thief* precisely by forgoing fidelity. Even the ironic presentation of the book's wisdom, Hollywood style, in the closing minutes, after Charlie Kaufman's denunciation of glib Hollywood resolutions, echoes Orlean's ironic circling around her own motivations, her tentative conclusions, and her explicit anxieties about her book's clashing of genres.

By exploring the comic impasse of Charlie Kaufman's writer's block and the comic betrayal of his scruples and his source in the Hollywood-chase ending, the real Kaufman unexpectedly breeds something utterly new out of *The Orchid Thief.* He draws attention to his source and respects it in its own right, while also turning it into a Hollywood movie and a critique of Hollywood formulas that trusts in its audience to go beyond any obvious genre, as Orlean has boldly done in her own book. *The Orchid Thief* circles around singularity (Laroche, the ghost orchid) and replication (Laroche's dreams of endlessly replicating the ghost orchid). *Adaptation.* replicates parts of *The Orchid Thief* and honors its singularity by engendering its own. Paradoxically, Kaufman's emphasis on adaptation as a source of creativity, rather than as an example only of fidelity, is faithful to Laroche's emphasis, and Orlean's, and nature's, and art's.

WORKS CITED

Adaptation. Dir. Spike Jonze. Perf. Nicolas Cage, Meryl Streep. Columbia, 2002. Film.

Angilirq, Paul Apak, et al. *Atanarjuat: The Fast Runner: Inspired by a Traditional Legend of Igloolik.* Toronto: Coach House/Isuma, 2002. Print.

Atanarjuat: The Fast Runner. Dir. Zacharias Kunuk. Perf. Natar Ungalaaq, Sylvia Ivalu. Odeon, 2001. Film.

Atran, Scott. *In Gods We Trust: The Evolutionary Landscape of Religion.* New York: Oxford UP, 2002. Print.

Berman, Ruth A., and Dan Isaac Slobin. *Relating Events in Narrative: A Crosslinguistic Developmental Study.* Hillsdale: Erlbaum, 1994. Print.

Blade Runner. Dir. Ridley Scott. Perf. Harrison Ford, Rutger Hauer. Warner Bros., 1982. Film.

Bor, Daniel. *The Ravenous Brain: How the New Science of Consciousness Explains Our Insatiable Search for Meaning.* New York: Basic, 2012. Print.

Bortolotti, Gary R., and Linda Hutcheon. "On the Origin of Adaptations: Rethinking Fidelity Discourse and 'Success'—Biologically." *New Literary History* 38 (2007): 443–58. Print.

"The Botanic Garden." Wikipedia. Web. 27 Dec. 2014.

Boyd, Brian. *AdaOnline*. Web. 27 Dec. 2014.

——. *On the Origin of Stories: Evolution, Cognition, and Fiction*. Cambridge: Belknap/Harvard UP, 2009. Print.

——. "On the Origins of Comics: New York Double-Take." *Evolutionary Review: Art, Science, Culture* 1 (2010): 97–111. Print.

——. "A Plain Clothes Priest." *James Joyce Quarterly* 15.2 (1978): 176–79. Print.

——. *Vladimir Nabokov: The American Years*. Princeton: Princeton UP, 1991. Print.

——. *Why Lyrics Last: Evolution, Cognition, and Shakespeare's Sonnets*. Cambridge: Harvard UP, 2012. Print.

Boyd, Brian, Joseph Carroll, and Jonathan Gottschall, eds. *Evolution, Literature, and Film: A Reader*. New York: Columbia UP, 2010. Print.

Carroll, Joseph. *Evolution and Literary Theory*. Columbia: U of Missouri P, 1995. Print.

——. *Reading Human Nature*. Albany: State U of New York P, 2011. Print.

Clueless. Dir. Amy Heckerling. Perf. Alicia Silverstone, Stacey Dash. Paramount, 1995. Film.

Darwin, Charles. *The Annotated Origin: A Facsimile of the First Edition of On the Origin of Species*. Ed. James T. Costa. Cambridge: Harvard UP, 2011 [1859]. Print.

——. *On the Various Contrivances by which British and Foreign Orchids are Fertilised by Insects, and on the Good Effects of Intercrossing*. London: John Murray, 1862. Print.

Dawkins, Richard. *The Selfish Gene*. 2nd ed. Oxford: Oxford UP, 1989. Print.

de Jong, Irene. *A Narratological Commentary on the Odyssey*. Cambridge: Cambridge UP, 2001. Print.

Emma. Dir. Diarmuid Lawrence. Perf. Kate Beckinsale, Mark Strong. BBC, 1996. Television.

Gottschall, Jonathan. *The Storytelling Animal: How Stories Make Us Human*. New York: Houghton Mifflin Harcourt, 2013. Print.

Gottschall, Jonathan, and David Sloan Wilson, eds. *The Literary Animal*. Evanston: Northwestern UP, 2005. Print.

Hrdy, Sarah Blaffer. *Mothers and Others: The Evolutionary Origins of Mutual Understanding*. Cambridge: Belknap/Harvard UP, 2009. Print.

Hutcheon, Linda, with Siobhan O'Flynn. *A Theory of Adaptation*. 2nd ed. London: Routledge, 2013. Print.

Johnson, Kurt, and Steven Coates. *Nabokov's Blues: The Scientific Odyssey of a Literary Genius*. Cambridge: Zoland, 1999. Print.

Kaufman, Charlie. *Adaptation: The Shooting Script*. New York: Newmarket, 2002. Print.

King Lear. Dir. Peter Brook. Perf. Paul Scofield, Diana Rigg. Royal Shakespeare Company, 1962. Play.

King Lear. Dir. Peter Brook. Perf. Paul Scofield, Jack McGowran. Filmways, 1971. Film.

Leitch, Thomas. *Film Adaptation and Its Discontents: From* Gone with the Wind *to* The Passion of the Christ. Baltimore: Johns Hopkins UP, 2007. Print.

Martindale, Colin. *The Clockwork Muse: The Predictability of Artistic Change*. New York: Basic, 1990. Print.

Nabokov, Vladimir. *Ada or Ardor: A Family Chronicle*. New York: McGraw-Hill, 1969. Print.

——. *Eugene Onegin*, by Aleksandr Pushkin. Trans. with commentary. 4 vols. New York: Bollingen, 1964. Print.

——. Interview with Seth Goldschlager. Unpublished [1972]. Vladimir Nabokov Archives, Berg Collection, New York Public Library. TS.

———. *Lolita: A Screenplay*. New York: McGraw-Hill, 1974. Print.

———. "On Adaptation." 1969. Rpt. in Nabokov, *Strong Opinions*. New York: McGraw-Hill, 1972. 280–83. Print.

Noble, Denis. *The Music of Life: Biology beyond Genes*. Oxford: Oxford UP, 2006. Print.

———. "Physiology Is Rocking the Foundations of Evolutionary Biology." *Experimental Physiology* 98.8 (2013): 1235–43. Print.

Orlean, Susan. *The Orchid Thief: A True Story of Beauty and Obsession*. London: Heinemann, 1999. Print.

Overballe-Petersen, Søren, et al. "Bacterial Natural Transformation by Highly Fragmented and Damaged DNA." *PNAS* 110.49 (3 Dec. 2013): 19860–65. Print.

Pinker, Steven. "Toward a Consilient Study of Literature." *Philosophy and Literature* 31 (2007): 162–78. Print.

Premack, David, and Ann James Premack. *Original Intelligence: Unlocking the Mystery of Who We Are*. New York: McGraw-Hill, 2003. Print.

Popper, Karl R. *All Life Is Problem-Solving*. London: Routledge, 1999. Print.

Pride and Prejudice. Dir. Simon Langton. Perf. Jennifer Ehle, Colin Firth. BBC, 1995. Television.

Richerson, Peter J., and Robert Boyd. *Not by Genes Alone: How Culture Transformed Human Evolution*. Chicago: U of Chicago P, 2005. Print.

Rhys, Jean. *Wide Sargasso Sea*. London: André Deutsch, 1966. Print.

Sawyer, R. Keith. *Pretend Play as Improvisation: Conversation in the Preschool Classroom*. Mahwah: Erlbaum, 1997. Print.

Schiff, Stacy. *Véra (Mrs. Vladimir Nabokov)*. New York: Random House, 1999. Print.

Sperber, Dan. *Explaining Culture: A Naturalistic Approach*. Oxford: Blackwell, 1996. Print.

Sterelny, Kim. *The Evolved Apprentice: How Evolution Made Humans Unique*. Cambridge MIT P, 2012. Print.

Le temps retrouvé. Dir. Raúl Ruíz. Perf. Catherine Deneuve, Emmanuelle Béart. Gemini, 1999. Film.

Wagner, Andreas. *The Arrival of the Fittest: Solving Evolution's Greatest Puzzle*. New York: Penguin, 2014. Print.

William Shakespeare's Romeo + Juliet. Dir. Baz Luhrmann. Perf. Leonardo DiCaprio, Claire Danes. Twentieth Century Fox, 1996. Film.

Wright, David G. *Dubliners and Ulysses: Bonds of Character*. Novi Ligure: Edizioni Joker, 2013. Print.

CHAPTER 35

···

THE AURA OF AGAINNESS

Performing Adaptation

···

NICO DICECCO

On 26 January 2013, I saw a Vancouver performance of *Testament* by German theater company She She Pop. *Testament*, which is based on Shakespeare's *King Lear*, sees the actors share the stage with their actual fathers in what becomes a public negotiation of their intertwined histories and futures, their inheritances, and their misunderstandings of one another. This play does not feature any characters named King Lear or Cordelia (the actors use their real names); dialogue from the Shakespearean text is used, but sparingly; and the narrative progress of the play, if you could say it has a narrative at all, only parallels the act and scene structure of *Lear* in a rough sense (e.g., by finding compelling analogues for the 100 knights, the storm, and so on). The points of connection that do exist between *Testament* and the Shakespearean text are made most clear because of a flip chart that stands stage left, affixed to which is a scroll containing a German translation of *King Lear*. The chart is recorded by a digital camera, and a projection of that camera's feed appears on a large screen, also stage left. As *Testament* progresses, the actors manually turn the scroll, underlining or striking through those parts of the play that they select, amend, and omit.

On 24 June 2015, I saw a performance of *King Lear* as part of the annual Bard on the Beach festival in Vancouver. Very little of Shakespeare's text was cut or altered in this performance. The central conflict of the play followed from the conflict between the characters named King Lear and Cordelia (all actors adopted character names from *Lear*); the dialogue was entirely written by Shakespeare; and the narrative adhered to the act and scene structure of the Shakespearean text—or at least that's how it seemed to me on 24 June, though I did not have a printed copy of *Lear* with me in the theater.

It is uncontroversial to refer to both of the preceding works as performances, but to call either of them adaptations raises some puzzling challenges. To be sure, familiarity with Shakespeare's text conditioned and enriched the experience of both performances for me. But is that enough to constitute adaptation? Two questions come immediately

to mind. Since drama so often depends on a transition from written text to live perfor-
mance, is every staging of a play an adaptation? And is a work like *Testament* really an
adaptation, given how little of Shakespeare's text gets produced "as written"? Perhaps
neither of them is an adaptation, with *Testament* being too radical a departure from the
original and Bard on the Beach's version of *Lear* adhering too closely—closely enough,
we might say, that it simply *is* Shakespeare's *King Lear*, an authentic instance of the origi-
nal meant-to-be-performed work. Here the taxonomical tradition in adaptation studies
rears its head: How much formal repetition is too little or too much for a theatrical work
to be an adaptation? Do certain kinds of repetition count more than others? Do the for-
mal markers of adaptation remain constant across media, so that a theatrical adaptation
of a written play follows the same rules for inclusion under the umbrella of adaptation as
other cross-media pairings?

I do not think that these questions will ever have satisfactory answers. Indeed, I think
that asking them in the first place presumes and sustains a problematic model of adap-
tation. I do not merely reject taxonomical approaches, which have already been suf-
ficiently lambasted in recent years. Rather, I suggest that the taxonomical impulse in
adaptation studies itself stems from a much more ingrained obsession with form: the
notion that certain kinds of texts "are" adaptations and others are not, and that the field
should treat those kinds of cultural products as its basic organizing principle. In other
words, we tend to believe that adaptation studies is the study of works that *are* adapta-
tions; thus phrased, it is a fairly intuitive assumption. As Linda Hutcheon points out,
however, the term "adaptation" is used not only to refer to the kinds of products that
"are" adaptations, but also to two processes: production and reception (xiv). The prob-
lem, as I see it, is that we tend to define the processes of adaptation from a standpoint
that privileges the products. We consider the production process to be an authentic
instance of adaptation only when it results in the *kind* of text that "is" an adaptation.
Similarly, for reception to be a process of adaptation, we presuppose that the cultural
objects being received *are already* adaptations. In both cases, the live and embodied
aspects of adaptive process are subordinated to the material works that can be organized
and catalogued under the label of adaptation.

The two contrasting *Lear* performances described here, and the questions that bubble
up when we attempt to determine their status as adaptations, help to demonstrate where
the organizational logic of the product-oriented model breaks down. Performance is
well suited for this purpose, since "the stage" has a way of troubling the apparent onto-
logical stability of "the page." However intuitive the product-oriented approach might
initially seem, its privileging of form and physical material as the primary sites where
one might locate a work's meaning and value as adaptation depends on what some per-
formance studies scholars call the "logic of the archive." Building on Derrida's work in
"Archive Fever," Rebecca Schneider explains: "The archive is built on 'house arrest'—the
solidification of value in ontology as retroactively secured in document, object, record.
This retroaction is nevertheless a valorization of regular, necessary loss on (performa-
tive) display—with the document, the object, and the record being situated as survivor
of time" (103).

In this sense of "house arrest," I see a way to explain the entrenchment of product-oriented models of adaptation. The retroactivity Schneider mentions is especially evocative, suggesting that the logic of the archive ascribes value as inherent to its materials only *after* the fact of their being the things that happened to make it—which is to say, make it past both quotidian processes of destruction and the authorizing forces that consecrate material for inclusion in the archive. Moreover, this "making it past" can also be understood as a *making past*, a generation of anteriority that manifests as a search for origins. Carolyn Steedman's engagement with "Archive Fever" offers further insight: "Derrida had long seen in Freudian psycho-analysis a desire to recover moments of inception, beginnings and origins which—in a deluded way—we think might be some kind of truth, and in 'Archive Fever,' desire for the archive is presented as part of the desire to find, or locate, or possess that moment of origin, as the beginning of things" (3).

A reception model based on the interpretation of works that *are already* adaptations gives expression to this search for origins, a desire for the "truth" of a work to be locatable within the apparent ontological stability of physical material. Accordingly, even as the field of adaptation studies moves away from hierarchical models of source and target (as it has been doing for well over a decade), there are ways in which the template of "origin" and "derivative" is nevertheless still enacted through evaluative processes that locate the meaning of adaptation itself as inherent to those objects that "are" adaptations.

In pursuit of an alternative to the archival logic of product-oriented approaches to adaptation, this essay explores the possibility of studying reception as adaptation. In other words, I ask what it would mean if the "adaptation" in adaptation studies did not refer to what certain cultural objects *are*, but rather to what certain audiences *do* (in a live and embodied sense) when they engage with the relationship between a work and its precursor(s). Rather than approaching adaptation primarily as a product and secondarily as two processes, I suggest that product and process alike depend crucially on performance. The identification of texts across a gap of intermedial difference can thereby be framed in line with Elin Diamond's suggestion that "performance is always a doing and a thing done" (1). Adaptation requires the "doing" of a certain attentiveness to intertextual similarity, and it results in the "thing done" of adaptive materiality.

In product-oriented models, the "thing done" is most often presumed to be a physical, archivable "thing"—as distinct from "thing done," meaning an "action that was carried out"—so a performative model requires an understanding of materiality that is capacious in its parameters. Toward a performative notion of materiality, and subsequently a performative model of adaptation, I begin what follows with a consideration of aura. As Walter Benjamin describes it in "The Work of Art in the Age of Mechanical Reproduction," the aura is a quality stemming from a work of art's "presence in time and space, its unique existence at the place where it happens to be" (220). At a glance, this might seem to be a product-oriented view of the relationship between art and authenticity, but it nevertheless opens up a fruitful avenue of inquiry for adaptation studies. I have already indicated that I do not think questions like "What is an adaptation?" and "How much formal similarity is enough to count as adaptation?" will ever have satisfying

answers. Given the emphasis Benjamin places on space and time, perhaps there is more to be gained by asking, "*When* is adaptation?" and "*Where* do adaptive acts take place?" Where a product-oriented model would locate the "unique presence in space and time" of adaptation squarely within the physical form of the adaptation-as-material-thing, thinking carefully about the "doings" of adaptive acts leads me to suggest that adaptations are never strictly isolatable to the spaces and times they appear to occupy.

Linda Hutcheon has already considered the relationship between aura and adaptation. In claiming that adaptation "has its own aura," she references Benjamin's definition, cited earlier, which stresses that aura depends on a unique spatiotemporal presence. Hutcheon then adds, "I take such a position as axiomatic, but not as my theoretical focus" (6). Hutcheon takes her position for granted because, throughout Benjamin's essay, his concept of aura is bound up with the autonomy of an artwork. Indeed, Benjamin clearly articulates the stakes of aura when he writes: "The presence of the original is the prerequisite to the concept of authenticity. . . . The whole sphere of authenticity is outside technical—and, of course, not only technical—reproducibility" (220). The connection between the authenticity of an artwork and the "presence" of an original raises an obvious challenge for a product-oriented model of adaptation—especially a model premised on linear transfer—because such a framework implies that an adaptation originates with its precursor text. If an adaptation is inauthentic by virtue of its derivation from and reliance on a previous artwork, its unoriginality is the reason for its lack of autonomy as a work of art. Throughout her study, however, Hutcheon makes a strong case for the originality of adaptations, stressing the point that "an adaptation is a derivation that is not derivative—a work that is second without being secondary" (9). Adaptations are authentic, for Hutcheon, because they are original works on their own terms; they are not mere copies, "in any mode of reproduction, mechanical or otherwise," so much as repetitions "without replication" (173). This observation that adaptations are non-identical with their sources leads Hutcheon to conclude that the aura is not degraded through the process of adaptation, since the work of art is not literally copied. Accordingly, the palimpsestic doubleness that marks one of the central pleasures of adaptation (33, 116, 122) is not at odds with the singular identity of specific adaptations as works of art. In this view, adaptations do not destroy the aura of an original but "carry that aura with them" (4).

Perhaps the central unaddressed problem in Hutcheon's discussion of aura is that often adaptations are indeed copies in mechanical or digital modes of production, at least to the extent that any film or any printed book or any MP3 is a copy. Precisely because adaptations move through the circuits of industrial production in the same way that ostensibly non-adaptive works do, they are subject to Benjamin's critique regarding products "designed for reproducibility" (224). Pointing out that an adaptation is by necessity not "the same," in a technical sense, as the text it adapts does nothing to address the fact that many of the adaptations that audiences get to see are in actuality reproductions. The initial product of the adapter—the manuscripts, the film reels, the videos— might have the status of being materials that the artist worked with in the process of production, so we could say that those have the "unique presence" to which Benjamin

refers. Regardless, these precise materials are not the ones that most audiences will see, read, or hear. The situation for the majority of audiences of adaptations, particularly in the novel/film paradigm, has rather more in common with what Benjamin indicates when he writes, "From a photographic negative, for example, one can make any number of prints; to ask for the 'authentic' print makes no sense" (224). Accordingly, the issue of authenticity with respect to adaptations produced in industrial systems premised on mass circulation is more complicated than Hutcheon lets on. It does not make sense to ask which copy of an adaptation is "authentic," unless it is an adaptation that, from its first moments of production, is not "designed for reproducibility." It does not ultimately matter, from this perspective, whether or not the process of adaptation itself has any effect on the aura of a work of art; its status as an industrial reproduction degrades the aura nonetheless.

Much to her credit, Hutcheon is interested in offering "generalizable insights into theoretical issues" (xv). When she uses the term "adaptation," she does not necessarily mean to reference only those media that operate in the mode of mass industrial reproduction. Moreover, the broader claim that Hutcheon uses "aura" to bolster is not something I see as problematic; adaptations are not inherently any less "original" or "authentic" than any other work of art produced by the same technical means. The dissonance between Hutcheon's discussion of aura and Benjamin's, however, raises the question of whether there is a productive sense of aura in Hutcheon, in Benjamin, or in a synthesis of the two perspectives, that goes beyond the defense of autonomy in adaptation, and that helps to elucidate adaptation as a phenomenon in more general terms.

Consider the following statement of Benjamin's: "By making many reproductions it [the technique of mechanical reproduction] substitutes a plurality of copies for a unique existence. And in permitting the reproduction to meet the beholder or listener in his own particular situation, it reactivates the object reproduced" (221). Although Benjamin is talking about precisely the condition that "withers" the aura, the situation he describes shares much with another important concept in Hutcheon's theory. In describing the paired notions of the "knowing audience" and "oscillation," Hutcheon writes, "If we do not know that what we are experiencing actually *is* an adaptation or if we are not familiar with the particular work that it adapts, we simply experience the adaptation as we would any other work. To experience it *as an adaptation*, however, as we have seen, we need to recognize it as such and to know its adapted text, thus allowing the latter to oscillate in our memories with what we are experiencing" (120–21, emphasis in original). It is a stone's throw from the oscillation here discussed to the situation Benjamin describes when he writes that "it reactivates the object reproduced." In both cases, there is a noetic return to an object that does not need to be physically present with the beholder or listener or audience at the time of oscillation or reactivation.

An example is helpful here. Sitting in the audience at Bard on the Beach's *King Lear* (Figure 35.1), listening to Benedict Campbell as Lear ask Cordelia, "What can you say to draw a third more opulent than your sisters?" I overheard the person beside me anticipate the next line of the play. "Nothing," she whispered to her friend, to which the friend responded, "Shhh," at precisely the moment that Andrea Rankin as Cordelia said,

FIGURE 35.1 Andrea Rankin and Benedict Campbell in *King Lear* (Bard on the Beach, 2015).
Photo: David Blue.

"Nothing." Admittedly, I too was anticipating Cordelia's line, albeit silently, and I glared sidelong in displeasure that my experience of Rankin's delivery was interrupted by the participation of my neighbors. Beyond illustrating my crotchetiness as a theatergoer, however, this moment offers an apt demonstration of the live performance of oscillation. The noetic "reactivation" of Cordelia's line was not only evinced by our anticipation of it; my neighbor's need to express the line audibly conveys just how active, how felt and embodied the process of oscillation can be.

Further, that this oscillation was both anticipatory and recollective goes to show that, as will become increasingly clear, this noetic return is crucial to the messy temporality of adaptation. For now, I want to note that what changes between Benjamin's discussion of the aura and the situation created by the "plurality of copies" is that the "unique existence" most pertinent is not that of the auratic object but that of the audience in its "particular situation." If Hutcheon is right to home in on the aspect of an adaptation's aura that involves some unique presence in time and space, then perhaps it is possible to locate the spatiotemporally unique circumstance in the process of oscillation, in the "live" or real-time constitution of the adaptation *as such*.

In her discussion of attention and materiality, N. Katherine Hayles observes,

> On the level of conscious thought, attention comes into play as a focusing action that codetermines what we call materiality. That is, attention selects from the vast (essentially infinite) repertoire of physical attributes some characteristics for notice, and

they in turn constitute an object's materiality. Materiality, like the object itself, is not a pre-given entity but rather a dynamic process that changes as the focus of attention shifts. (14)

Materiality for Hayles is not pre-given, but produced through live, embodied encounters with objects. Going forward, I use the term "attendance" as a shorthand reference for the state of "being there" in time and space that is pertinent both to the aura of works of art and to the "reactivation" of artistic objects by way of their copies. This shorthand use of the term "attendance" is particularly valuable for discussing adaptations because it operates at the intersection of reception and materiality.

The idea that the object itself is not a pre-given entity offers a way to complicate the present discussion of aura and to consider the importance of the live act of material constitution as bound up in a certain kind of auratic generation, whether an artistic object is an original or a copy. With the non-reproducible works of art to which Benjamin refers, the aura is inseparable from the specific object, as with the patina that forms on a bronze statue, which is chemically unique to that particular statue (220). "Attendance" suggests that we would need to select the characteristics of the patina from a vast "repertoire of physical attributes" in order for the aura to which it attests to be materially apparent. Considered from this perspective, the aura is part of the object, and its chemical specificity is no less relevant to its uniqueness in space and time, but its significance as aura comes into being at "the place where it happens to be" through attendance.

It is a noteworthy coincidence that Hayles, in the excerpt quoted earlier, refers to selection from the "repertoire" of physical attributes. One of the quagmires of thinking about attention, materiality, and performance in the ways that I am suggesting is that it can be tempting to think about live performance as essentially ephemeral, and so opposed to materiality and mediation. Challenging this essentialist binary by highlighting two divergent historical practices of evaluating knowledge and cultural transmission, which she terms the "archive" and the "repertoire," Diana Taylor writes, "The repertoire requires presence: people participate in the production and reproduction of knowledge by 'being there,' being a part of the transmission. As opposed to the supposedly stable objects in the archive, the actions that are the repertoire do not remain the same. The repertoire both keeps and transforms choreographies of meaning" (20). I would add that paying attention is itself an action "that does not remain the same," necessarily live in its performance and crucial to the retention and transformation of "choreographies of meaning." Such is the case for the selfsame reason that objects are not pre-given entities; dynamic shifts in focus are an inevitable component of repertory knowledge production, reproduction, and transmission. We might be tempted to undervalue the role of attendance in the constitution of adaptations as such, because it is a form of knowledge transmission that stands in contrast to the archival logic of the ostensibly durable and tangible. The repertoire, however, offers a way to re-evaluate the issue of auratic generation in terms that treat the reception of adaptations both as materially significant and as spatiotemporally unique live events.

My suggestion has much in common with Philip Auslander's argument that in rock music, "[t]he aura is located in a dialectical relation between two cultural objects—the recording and the live performance—rather than perceived as a property inherent in a single object, and it is from this relation of mutuality that both objects derive their authenticity" (85). The aura of rock music, for Auslander, is not a pre-given entity, locatable in either a recording or a live performance, but something that is generated at the intersection of the two. When we attend (and attend to) an adaptation *as such*, we select from the vast repertoire of formal markers that we can identify with a precursor text; in doing so, we constitute the materiality of the adaptation in a way that depends on the dialectical relation between two cultural objects.

The role of formal markers in this dialectical process is why, even though I have suggested that formal definitions of adaptation are inadequate, I would not go so far as to claim that form is irrelevant to the way adaptations get identified with precursor texts. I would merely add that the audience plays an active and constitutive role in *performing* that identification. Indeed, the formalist methods of Brian McFarlane and others become valuable tool sets for identifying some of the attributes that make up the repertoire we might use to perform identification. So, too, do our routes of access—the spaces in which embodied audiences encounter and constitute adaptations—provide part of the context that "conditions meaning" as we attend to adapted text and adaptation alike (Hutcheon 145). A knowing audience is necessary for an adaptation to function qua adaptation, but not every audience knows precisely the same things, and what they happen to know about a precursor text changes the way they attend (to) the adaptation. Moreover, it is not simply the case that every formal component potentially relevant to the dialectical relationship between an adaptation and its source(s) exists on a flat or neutral plane for every audience. Robert Stam's argument that fidelity gives expression to the disappointment we feel when an adaptation fails to live up to our expectations does more than point to the moralistic and subjective nature of fidelity criticism (54). It subtly highlights the important way in which different audiences have different expectations about what an adaptation ought to repeat, which is another way of acknowledging that what we prioritize in a source changes how we constitute the adaptation. Different prioritizations of adapted texts produce materially different adaptations.

This auratic generation of adaptive materiality stands in contrast with other instances of textual interpretation in general because the formal and contextual pieces must be in place for the audience to understand the present-tense attendance to a cultural object in terms of its againness: its dialectical relationship with a past-tense attendance to a cultural object. My use of the word "againness" is inspired in part by Rebecca Schneider's handling of the term: "It can be argued that any time-based art encounters its most interesting aspect in the fold: the double, the second, the clone, the uncanny, the *againness* of (re)enactment" (6, emphasis in original). If my argument rests crucially on the recognition that the reception of adaptations is a live act, then againness helps to get at the temporal component of this encounter. Adaptation, too, is time-based, even if it is not reducible to a singular art form or medium. Diana Taylor, however, uses the term "againness" to get at a slightly different sense, stressing the way that the repertoire

depends on presence in space and the various means by which it resists easy notions of disappearance: "Multiple forms of embodied acts are always present, though in a constant state of againness. They reconstitute themselves, transmitting communal memories, histories, and values from one group/generation to the next" (21). If attendance is the live and embodied act of being present to pay attention, Schneider and Taylor help to reveal the spatiotemporal quality of attending to repetition as such. What marks adaptation as different from the repetitions to which they refer ultimately comes down to the various contextual, discursive, formal, and social "frames" that lead an audience to mark an instance of repetition *as adaptation*. Some of the "frames" that provoke the constitution of an adaptation have to do with formal qualities that a given audience has prioritized in a past-tense encounter with the adapted text (e.g., Cordelia's "Nothing"). This process of prioritization, however, means that the formal components that foster adaptive identification are only as good as the embodied knowledge of those that can identify them as markers of adaptation.

Although there are many potential attributes that can foster trans-textual identification—titles, designs, names, character traits, plot patterns, phrasings, settings, gestures, marketing materials—the category of adaptation itself must also be part of the audience's embodied knowledge for the repetition to be identified as a special case of intertextual againness. In other words, what is at stake in the aura of againness is only partially about autonomy, the capacity of adaptations to succeed as stand-alone works of art; also of concern is whether or not something is considered an authentic adaptation. One of the reasons formal/ontological models of adaptation have remained dominant in adaptation studies is that they seem to offer a clear solution to the problem of inclusiveness, which is the objection that if everything is an adaptation in one way or another, then the term ceases to be meaningful. Hence Hutcheon responds to the idea that adaptation might include "any act of alteration" to cultural works by arguing that "from a pragmatic point of view, such a vast definition would clearly make adaptation rather difficult to theorize" (9). Deborah Cartmell and Imelda Whelehan are even more restrictive than Hutcheon: "Naturally the further one moves from locating the heart of adaptation studies as residing on the literary/screen nexus, the more boundless and indefinable the area becomes" (12). Understood as a linear process of transfer, adaptation offers a formally stable guideline for categorical inclusion and exclusion; those texts that were not transferred, in whole or in part, from some precursor text do not qualify as authentic adaptations.

For Auslander, authenticity in rock music ideology is also about inclusion and exclusion (67); authenticity is the guiding principle for rock fans to lean on when distinguishing between rock and pop (69). As with the tendency to locate adaptation within forms or objects, authenticity in rock ideology is often perceived as something contained in the music. Auslander argues against this tendency, stating that authenticity "is an effect not just of the music itself but also of prior musical and extra-musical knowledge and beliefs" (66). So too, I have been arguing, is the constitution of an adaptation an effect of both the text itself and prior textual, intertextual, and extra-textual knowledge and beliefs.

The extra-textual belief that an adaptation is an intentional repetition of a precursor work carries a particular discursive force, depending on the context that fosters that belief. The announcement (in a list of film credits, an interview with an adapter, an official press release, a marketing blurb) that a work is an adaptation is extremely effective at fostering the performance of identification precisely because of the way it discursively authorizes the work of art as an authentic repetition. Less official contexts of authorization—for example, speculation in an online message board—will of course carry less force, but may nonetheless play a role in the aura of againness. In short, those attributes that might mark an adaptation as deliberate and announced (to use the terms Hutcheon employs in defining adaptation) are not necessary for a work of art to function as an adaptation, but their contribution to the aura of againness is substantial.

What comes to be accepted as authentic adaptation has more to do with authorization by interpretive communities than it does with the physical or formal attributes of specific cultural objects. Here I draw on the position that Margaret Kidnie articulates in *Shakespeare and the Problem of Adaptation* regarding the discursive constitution of dramatic (particularly Shakespearean) works of art:

> The pragmatic truth of the dramatic work of art—what is considered essential to an accurate, faithful, or authentic reproduction on the stage or page—is thus continually produced among communities of users through assertion and dissension, not legislated once and for all through an appeal to an objective external authority. . . . Arguments about whether or not forms of corruption or adaptation are taking place are a sign of competing sides vying for the power to define, for the moment, that cultural construction that will "count" or be valued as authentic Shakespeare—and the more canonical the work, the more hotly disputed is the debate about its authentic instances. (31)

The label of adaptation, in other words, is something that interpretive communities offer up when they perceive that a production of Shakespeare strays too far from the original. In turn, designating works as too different from Shakespeare to count has the correlated effect of producing the ostensibly authentic Shakespearean work, not as a materially or ontologically fixed product, but as a limited moment of discursive consensus about what the authentically Shakespearean does or does not look like.

Throughout Kidnie's analysis, however, adaptation is primarily understood as the problematic other against which the authentic work of Shakespeare is constituted. The correlative that my discussion points to is that adaptation is not limited to the role of a corrupt supplement to an authentic work, a point that becomes clearer when we briefly move away from Shakespeare as the case study. As Kidnie suggests at the end of the passage just quoted, the relative canonicity of the work in question alters the stakes of the debate. I would go further: the Western cultural investment in representations of Shakespeare makes debates over its authentic instances of a different order than those over whether or not, for example, *21 Jump Street* (2012) is actually an adaptation (or a remake, reboot, or sequel). Moreover, the sheer frequency and variety of

both productions and so-called adaptations of Shakespeare also make it a different kind of case. When there is only one data point, one instance of adaptation, concerns over authenticity are just discussions about fidelity, more or less reducible to the question, "Does it represent those attributes that I value and prioritize [read: desire] in the source?" Finally, as noted earlier, just as authentic Shakespeare comes into being by way of debate about its deviant instantiations, so too does authentic adaptation develop as a discursive effect (in part) because those selfsame debates inevitably stake claims about what does or does not count as adaptation. Because the scope of her project is limited by her investment in Shakespeare, Kidnie stops short of making the more inclusive theoretical point: the broader phenomenon of adaptation shifts in meaning over time as communities participate in debates over whether certain works are adaptations, originals, parodies, sequels, remakes, and so on. In short, narratives of taxonomic stability are the discursive effect of ongoing debates and acts of authorization that continually (re)produce the category of authentic adaptation.

Drama presents a distinct challenge to formal/ontological models of adaptation because the test of authenticity appears to operate according to different rules from those best suited to the novel/film paradigm. As I noted at the outset of this essay, it sometimes appears that every staging of a play could be considered an adaptation. David McCandless and Martin Puchner both consider this problem at some length, but Kidnie summarizes its crux especially well:

> If the identity of drama is not constructed as bridging two distinct media, and what is essential to the work is limited to its text(s), then distinctions between drama and forms of literature such as the novel disappear. . . . If this logic is pursued, performance of literary drama becomes *by definition* adaptation: a stage performance of *King Lear* is no more the work of art than a stage performance of *Bleak House* since both adapt the conditions of one medium (literature) to another (performance arts). . . . The prior unspoken assumption that leads to an understanding of theatrical productions as "necessarily adaptations" is the identification of the work of art with one idealized text, rather than with its (many) texts and performances. (21–22, emphasis in original)

If the written text is treated as the work of art, then all of its stagings are adaptations into a performative mode, and if all stagings are adaptations, then we are once again back at the problem of inclusiveness. At this juncture, the formal/ontological model of adaptation begins to eat its own tail. As W. B. Worthen's history of certain page/stage debates and deconstruction of text/performance dichotomies demonstrates, the central importance of both page and stage in histories of drama creates a situation in which either every staging is an adaptation or different definitions of adaptation are required for each intermedial pairing.

Though Kidnie does not cite Diana Taylor or Rebecca Schneider, her argument draws attention to the pitfalls of treating the logic of the archive as the interpretive default. The notion of "one idealized text," even in its diction, reveals a bias in favor of the written document. Within adaptation studies, we can see this bias manifest in statements

like Brian McFarlane's explanation of his reasons for not studying theatrical adaptations: "That [novel and film] both exist as texts, as documents, in the way that a stage performance does not, means that both are amenable to close, sustained study" (202). What McFarlane has in mind when he discusses "close, sustained study" presupposes that repertory knowledge is either not transmissible or that its transmissions are not valuable. Approaching this notion in light of Taylor's and Schneider's ideas, it becomes clearer that since the orthodox linear transfer model rests on archival logic, it struggles to offer insights generalizable to both the novel/film paradigm and the text/performance context.

As a counterpoint to the dilemma that orthodox models of adaptation find themselves in regarding the question of dramatic adaptation, it is helpful to recognize the ways that adaptation occurs, to quote Schneider on the temporality of theater, "in the 'meantime'—in between possibly errant acts and possibly errant words—not only, that is, in some sacrosanct text, but in the temporal balancing acts of encounter with that text" (88). In her reading of *Hamlet*, from which she borrows the phrase "in the meantime" (3.2.44), Schneider is careful to note that Shakespeare does not set up an easy opposition between stage and page in which the "text on the page is authentic and fixed while performance is shifty and mobile" (87). Hamlet is rather more concerned to use the live performance as a record of his father's murder, in a move that aptly demonstrates how the apparently tidy distinction between the "live" and the "recorded" is more vexed than it seems (89). It is not the case that the written version of the speech Hamlet inserts into *The Murder of Gonzago* is the authentic work by virtue of its apparent durability or of its preceding the live performance in front of the king. The work—meaning both the artwork and the work that Hamlet attempts to *do*—exists in the uneasy relation between the murder that was performed, its written and staged versions, and the encounter of Claudius with that intertextual predicament.

This latter point is crucial for thinking about the relationship between the meantime of theater and the aura of againstness. The live performance of *The Mousetrap* is a record intended to prompt recognition, and so "catch the conscience of the king" (2.2.617). According to a product-oriented model of adaptation, we could argue that Hamlet's play-within-a-play is not only a historical record but also an adaptation to the stage of a historical act. A performative model, however, would set aside this interest in categorical questions—is it actually an adaptation if the source is a historical record? Would it be more appropriate to call it a theatricalization of history? What term best suits the specific ontology of this intertextual pairing?—in order to focus on the work of recognition upon which Hamlet's plot depends. Crucial to *The Mousetrap* is the circumstance of the audience; it is not strictly the same play for Ophelia or Polonius as it is for Claudius, who is a "knowing audience" of the murder that Hamlet's play adapts. This is not to level all interpretations as equally valid or equally significant, which is the anxiety that surrounds the problem of inclusiveness. The adaptation that Claudius constitutes is more pertinent, in this instance, because he is the mouse that Hamlet seeks to trap. The authentic work is located not so much in any of its particular instantiations as in the effect—the performed work—of the interaction between cultural objects and participants.

The aura of againness, given that it exists in the meantime of adaptation, substantially complicates any straightforward notion of the place and time where a given adaptation "happens to be." Rather, adaptation works *as such* precisely because it is never entirely present with itself. For an adaptation to become itself, an audience must "be there" with it, attending to its againness, identifying it with a precursor text, bringing to bear the influence of formal, discursive, and categorical markers that frame the adaptation *as such*. The catch is that, by virtue of attending the adaptation, one must not be attending the text it adapts. In a certain sense, to paraphrase what Peggy Phelan says of performance, adaptation's being becomes itself through disappearance (146). At the very least, attending an adaptation depends on the disappearance of its adapted text—not, of course, a permanent disappearance, but a materially significant one nonetheless.

I would even go so far as to suggest that adaptation depends on a principle of non-simultaneity. The closest to simultaneity one might get with respect to the coextensive reception of adaptation and adapted text is side-by-side comparison—but comparison requires an interval. In an effort to fill out the various Venn diagrams that are so often the stock-in-trade of adaptation studies methodology, I have spent countless hours shifting my attention back and forth between adaptations and their sources. I remember watching Zak Snyder's 2009 film adaptation of *Watchmen* with Alan Moore's 1987 graphic novel in one hand and a remote control in the other. I had already seen Snyder's film once, but I watched it again in order to perform a closer comparison with Moore's graphic novel. I would watch a portion of the film, pause it, compare it with the comic, note visual and textual similarities or differences, unpause the film, and continue the process. Although the amount of time that elapsed between my attending to the graphic novel and my attending to the film was minimal, I could not attend to both simultaneously—that is, despite being present with both works in the time and space of my living room, I could pay attention to only one at a time. The analysis I produced was detailed and rigorous, attuned to both the broad similarities and differences between texts and to subtle rephrasing and graphical resonances and dissonances. But this analysis was also quite distinct from my initial encounter with Snyder's film, which occurred years after I had last read Moore's comic—and that first experience of *Watchmen* as an adaptation was far more impressionistic and emotionally charged. In both cases there was an interval between attending to each text, but the nature of that interval substantially altered the process of oscillation.

Although during the side-by-side comparison of *Watchmen* my body as a whole was in the same room with both works at the same time, there was a more limited ocular and noetic presence that could not be split between the two works. In any given moment, I was physically looking at either one text or the other, and thinking about one, the other, or their relationship. This latter observation—that I was sometimes noetically present with the relationship between an adaptation and its adapted text—is less a counterpoint to the principle of non-simultaneity than it is an indication of the material basis for the aura of againness. In other words, attending to the relationship between texts is not the same as attending to both texts simultaneously. To build on what I suggested earlier about the meantime of adaptation, we might say that it requires attending to a third

text that is not reducible to but emerges as a gestalt effect out of the interaction between juxtaposed wholes, like a moiré or interference pattern. One cannot see both the discrete arrangements of lines and the moiré effect at the same time. Insofar as perceiving the interaction between adaptation and adapted text requires its own instance of paying attention, the aura of againness has its own materiality, in Hayles's sense of that term. Accordingly, unlike the aura that Benjamin discusses, the aura Hutcheon takes as axiomatic for her theory of adaptation, what makes the aura of adaptation spatiotemporally unique, is that it stems from its momentary disappearance from the place it happens to be, in order that the attendee might perform the identification of a text with a precursor. For this crucial reason, the constitution of adaptations is a retroactive process; after the fact of constitution, the adaptation will have always been one.

I conclude by returning to the two performances that I opened with and the question of their status as adaptations. What a performative model of adaptation makes clear is that although both *Testament* and Bard on the Beach's *King Lear* worked with their Shakespearean precursor in distinct ways, both could become adaptations only through the audience's performance of identification. Putting this performative model to use requires critics to shake off their comfortable reliance on the logic of the archive—to think of adaptations less as "works" fixed in their physical forms and more as an active engagement with what Schneider calls "remains." She writes, "If the past is never over, or never completed, 'remains' might be understood not solely as object or document material, but also the immaterial labor of bodies engaged in and with that incomplete past" (33). An adapted text, as archival object *and* as embodied memory, is precisely the sort of "incomplete past" to which Schneider refers. Effectively, this is to say that all texts remain for the potential future of their "reactivation" through adaptation. And this is also to say that, even if adaptations do not strictly carry their auras with them, the aura of againness nevertheless remains.

Works Cited

Auslander, Philip. *Liveness: Performance in a Mediatized Culture*. London: Routledge, 1999. Print.

Benjamin, Walter. "The Work of Art in the Age of Mechanical Reproduction." 1936. *Illuminations: Essays and Reflections*. Trans. Harry Zohn. Ed. Hannah Arendt. New York: Schocken, 1968. Print.

Cartmell, Deborah, and Imelda Whelehan. *Screen Adaptation: Impure Cinema*. Basingstoke: Palgrave Macmillan, 2010. Print.

Diamond, Elin. "Introduction." *Performance and Cultural Politics*. Ed. Elin Diamond. London: Routledge, 1996. Print.

Hayles, Katherine N. *How We Think: Digital Media and Contemporary Technogenesis*. Chicago: U of Chicago P, 2012. Print.

Hutcheon, Linda, with Siobhan O'Flynn. *A Theory of Adaptation*. 2nd ed. New York: Routledge, 2013. Print.

Kidnie, Margaret J. *Shakespeare and the Problem of Adaptation*. New York: Taylor and Francis, 2008. Print.

King Lear. By Bard on the Beach and Theater Calgary. Dir. Dennis Garnhum. BMO Mainstage Theater, Vancouver. 24 June 2015. Performance.

McCandless, David. *Gender and Performance in Shakespeare's Problem Comedies.* Bloomington: Indiana UP, 1997. Print.

McFarlane, Brian. *Novel to Film: An Introduction to the Theory of Adaptation.* Oxford: Clarendon, 1996. Print.

Moore, Alan. *Watchmen.* New York: Warner, 1987. Print.

Phelan, Peggy. *Unmarked: The Politics of Performance.* New York: Routledge, 1993. Print.

Puchner, Martin. "Drama and Performance: Toward a Theory of Adaptation." *Common Knowledge* 17.2 (2011): 292–305. Web.

Schneider, Rebecca. *Performing Remains: Art and War in Times of Theatrical Reenactment.* New York: Routledge, 2011. Print.

Shakespeare, William. *Hamlet.* Ed. Sylvan Barnet. New York: Signet Classics, 1963. Print.

——. *King Lear.* Ed. Russell Fraser. New York: Signet Classics, 1963. Print.

Stam, Robert. "Beyond Fidelity: The Dialogics of Adaptation." *Film Adaptation.* Ed. James Naremore. New Brunswick: Rutgers UP, 2000. 54–78. Print.

Steedman, Carolyn. *Dust: The Archive and Cultural History.* New Brunswick: Rutgers UP, 2002. Print.

Taylor, Diana. *The Archive and The Repertoire: Performing Cultural Memory in the Americas.* Durham: Duke UP, 2003. Print.

Testament. By She She Pop. Perf. Sebastian and Joachim Bark, Fanni and Peter Halmburger, Ilia and Theo Papatheodorou, and Lisa Lucassen. Fei and Milton Wong Experimental Theater, Vancouver. 26 Jan. 2013. Performance.

Watchmen. Dir. Zak Snyder. Perf. Jackie Earle Haley, Patrick Wilson. Warner Bros., 2009. Film.

Worthen, W. B. "Disciplines of the Text: Sites of Performance." *The Performance Studies Reader.* Ed. Henry Bial. 2nd ed. New York: Routledge, 2007. Print.

PART VII

PROFESSING ADAPTATION

CHAPTER 36

TEACHING ADAPTATION

MARTY GOULD

MANY teachers of literature are looking for alternatives to the use of film as a treat for rewarding students for making it all the way to the end of a long novel, as a review of a text the class has just finished reading and discussing, or as a bit of respite between encounters with difficult texts (Krueger and Christel 68; Phillips 21).[1] Tired of reactionary complaints that the film is not like the book, these teachers seek ideas for putting adaptations to work in delivering the core learning objectives of their courses. But though they may want to use film as an instructional ingredient, rather than merely icing on a pedagogical cake already mixed, baked, and consumed, they may not be sure how to do it: lacking reliable recipes and new techniques, teachers often stick to more familiar fare. Other obstacles abound in the form of colleagues, administrators, and even students who cannot understand why any instructor would waste valuable class time on light, non-literary, pop-cultural fluff. Adaptation, for these folks, is nothing but empty calories that will spoil the appetite for—and perhaps even the ability to digest—a more substantive and intellectually nutritious literary diet.

Those who teach (or want to teach) with adaptation are likely to ask (or be asked) eleven core questions:

1. Why *must* we engage with adaptation in the classroom?
2. How do we justify to colleagues, administrators, and parents the use of adaptation in the study of literature?
3. How can we use adaptations to promote the higher-level aims of English study?
4. How can (will) adaptation transform the focus of English and the humanities in ways that reflect our modern mediated culture?
5. How do we explain to students what adaptation is (and isn't)?
6. How do we handle the persistent and dreaded fidelity issue?
7. Which specific tools do our students need in order to read, think, and write about adaptation in intellectually productive ways?
8. How can we use adaptations to unlock literature in new ways?
9. How can we use adaptations to make our students better readers and writers?

10. How can we transform adaptation theory into specific pedagogical practices?

11. How can we use adaptation in assessing student learning?

There are obviously points of overlap in the way the questions are phrased, and their answers inevitably engage with intersecting issues. This essay seeks to answer these questions by exploring the current field of adaptation studies as it relates to pedagogical practice. Because I don't assume an audience of already onboard adaptation enthusiasts or experienced practitioners, I begin with the why (questions 1–4) and end with the how (questions 5–11).

Adaptation and the Aims of Literary Study

Any syllabus worth its salt grounds its core learning objectives in a fully considered sense of relevance and purpose. Perhaps more to the point, instructors commonly find that they need to defend their adaptation-based courses to administrators, colleagues, and parents who, not well versed in adaptation studies, raise disapproving eyebrows at course content that seems intellectually and culturally suspect. There are many ways of responding to these challenges, but the various reasons one might offer generally fall into three broad areas:

1. Adaptation is directly relevant to the central, traditional concerns of English studies.
2. Our students already are and will continue to be consumers and producers of adaptations.
3. Adaptation introduces the ideas, perspectives, and skills our students require to succeed in the twenty-first century.

Put more simply, adaptation reflects what English has always been about, and at the same time adaptation beckons toward an entirely new model of English studies.

As a form of critical engagement with literature, adaptation can function like a scholarly essay, but with the advantage of being more accessible than most published scholarship; adaptations can effectively communicate to our students the scholarly ideas about texts we would like to introduce in our courses (Cutchins, "Why" 88, 90). Additionally, in studying adaptations, our students learn to consider the processes of (re)mediation, the ways in which different representational technologies function to render the same ideas (Bolter and Grusin). On a more abstract level, guided engagement with adaptation leads students to think critically about "books as a cultural form, authorship as a conceptual category, and reading as a collective experience" (Carroll, "Coming" 136).

The study of adaptations can also help to frame for our students the relevance of literary study. When they consider how and why certain texts are adapted in particular ways at particular times for particular audiences and via particular media, students are required to read closely and to think about how and why it is that we continue to read texts written a century or more ago (Sanders 19). Interpreting and keeping in circulation the literature that seems to speak most profoundly to the human condition or to issues that persist across time and cultural boundaries, adaptations remind our students that culture matters, that literature and art help us to understand ourselves and our world.

Under increasing pressure to defend their fields of study, many humanists invoke Pierre Bourdieu's concept of cultural capital: in order to succeed socially, our students need a body of literary knowledge that will enable them to participate in certain cultural conversations, a knowledge that acts as a badge confirming their membership in educated, elite society. Adaptations play a key role in the circulation of cultural capital, reviving and circulating texts, in various guises, across cultural and historical moments. And those texts that are thus circulated are the very texts we consider most culturally valuable. Adaptation, as Julie Sanders says, "is a veritable marker of canonical status: citation infers authority" (9). Even in cases in which the adaptive relationship is hostile or subversive, the fact that the originary text is available for reconstruction, that it constitutes broadly recognizable material, and that it appears worth reproducing or subverting attests to its culturally central position: adaptability indicates cultural significance or relevance (Cardwell 69; Sanders 97–98).

John Bryant argues that adaptation is essential to cultural and literary studies (110). Although he uses Herman Melville's *Typee* as his primary example, he poses a series of questions that can be usefully deployed in classroom encounters with any originary text/adaptation pairing: "How does the nature of the cultural revision differ from authorial and editorial revision? Who are the agents of adaptation and for whom do they speak? How can adaptation be used to measure a culture?" (109). We can, Bryant says, use adaptations to measure the evolution of cultural forms and social norms over time. Through the study of adaptation, our students will think about the processes of cultural evolution, becoming critically aware of how (and why) literary texts have spoken to different social readerships and cultural moments in different ways.

INTERTEXTUAL READING, MUTIMODAL PRODUCTION, AND COMPARATIVE ANALYSIS

Even when adaptation isn't a formal component of the curriculum, its shadow looms over the English classroom. Alongside the books we assign, our students' backpacks are stuffed with a nebulous knowledge of those texts absorbed through prior—usually uninformed—encounters with adaptations. Their initial reading of any text is shaped by what the adaptation industry has already told them about what the text is about,

what its chief interests and pleasures are, and what it "means" (Hutcheon, "In Defence" par. 14–25; Venuti 30). Because our students by nature read intertextually and comparatively, we ought to make more sustained efforts to teach them to engage with adaptations critically so that they may discuss the relationship between originary text and adaptation intelligently.

When it comes to contemporary works, it is increasingly difficult to segregate literature and film into separate courses. In *The Adaptation Industry*, Simone Murray explains the "phenomenon of twin-track authorship, whereby a writer works simultaneously on book and screenplay versions of a story with the intention of pursuing whichever is contracted first, and then converting the cultural and financial capital secured in one industry into enhanced bargaining power in the other" (42). Given the role of multiple-track authorship and cross-format leveraging strategies, creative writing programs would be well-advised to require their students to gain skills in writing in multiple genres, not to mention taking courses on adaptation.[2] Familiarity with the dynamics of adaptation and cross-modal translation equips our students with the critical skills they need to function in a modern world characterized by multimodal deliveries of reconstituted content (Damrosch).

Indeed, given modern multimodal publishing practices and a multimedial cultural landscape, ignoring adaptation in the classroom and failing to teach our students to analyze and create new media may constitute pedagogical malpractice (Reiss and Young 166–67). As Jerome McGann explains, literacy signifies the ability to "decipher, judge, and use many different kinds of texts" (127). Training our students to read actively, intertextually, and comparatively turns them into critical, questioning readers, rather than passive consumers of text, in whatever form it takes. For this reason, many critics have made strong cases for the importance of making adaptation a central component of English studies. Laurence Raw and Tony Gurr, for example, contend that studying the process of adaptation develops specific twenty-first-century skills: communication, social interaction, and aesthetic engagement (5). Raw and Gurr join a growing chorus of critics like Thomas Leitch who contend not simply that adaptations are appropriate in English study, but that they are *essential* to the English curriculum. These arguments are part of conversations about what departments of English actually do, what skills they impart to their students, and what their larger purpose might be (Leitch, "How" 1–2). These are issues that adaptation studies can help us address by fostering intertextual reading, multimedia analysis, and cross-cultural translation.

Modern digital culture, as Nathaniel Córdova explains, has utterly transformed traditional notions of texts, reading, and communication. Texts are created and circulated within discursive networks, where they are fragmented, rearranged, and joined with other texts (144, 152–53). Given such a cultural environment, it is necessary, as Sarah Cardwell argues, to replace the linear model of adaptation that relates each iteration directly (and solely) to its originary text with a networked model that reflects a genetic form of adaptation (67–68). In place of a "centre-based conceptualisation of adaptation," Cardwell proposes an approach that sees all adaptations working together with the originary text to create what she terms the "meta-text": the "ever-changing,

ever-developing" story that is within but not solely constituted in the originary text (14). Rather than tracing a singular, linear movement from antecedent originary text to individual adaptation, we ought to cast the net broadly to capture all of the texts the originary text has incorporated into itself and the various articulations it has generated in its turn. Such an approach foregrounds the dynamic processes that sustain literary production and reminds us that literary representation and meaning are not fixed but evolving. Translating theory into pedagogical practice, we can build our courses around the study of not singular texts, but what we might call "adaptive clusters" or "textual instances," a multimodal constellation of books, poems, films, images, and variously mediated forms of adaptation that surround and inform an originary text. While literature remains at the heart of what we teach, our sense of "text" as a singular, fixed object is entirely reshaped by the recontextualizing apparatus that adaptation studies provides.

Hillel Schwartz and Marcus Boon argue for the importance of teaching adaptations as expressions of natural human impulses and ubiquitous cultural practices (Schwartz 302–4; Boon 6–7). Boon traces the origins of the word "copy" to the Latin *copia*, meaning "abundance, plenty, multitude" (41–49). This reconnection of an idea that has come to signify slavish imitation, duplicity, and theft to its linguistic and cultural roots reintroduces an exciting generative element into the discussion of textual mimesis. From this perspective, the re-representation of an existing literary text does not diminish but multiplies it, extending the text's cultural reach by generating more instances of it. Getting our students to accept the legitimacy of literary adaptations may be as simple as adjusting their attitudes toward mimesis, attitudes that have particular cultural histories themselves, as Boon and Schwartz point out. Introducing adaptations into the classroom may open new and productive conversations about linguistic imitation, literary borrowing, and creative originality. And these conversations ultimately return our students to some of English study's core concerns: creation, authorship, revision, citation, and plagiarism.

In *The Fluid Text*, John Bryant reminds us that all literary texts "exist in more than one version, either in early manuscript forms, subsequent print editions, or even adaptations in other media with or without the author's consent" (1). Adaptation stands alongside revision and publication as a key element in the (re)shaping of a literary text. Two compelling conclusions may be drawn from this observation. The first is that the full history of a literary text must necessarily trace its development through multiple forms from manuscript to adaptation; adaptations should therefore be given due attention alongside the writing and publication history of any text we teach (Bryant 4). The second is that bringing adaptations into the classroom conversation can be an effective tool for giving our students an understanding of textual fluidity: an awareness that literary texts have histories; that writing is a process of creation, revision, and re-creation; that editors, readers, critics, and adapters all play legitimate roles in the ongoing developmental story of a text's writing and reception. What is perhaps most exciting in Bryant's vision of the fluid text is the bold notion that we can only truly know a text when we know more (certainly it would be impossible to know *all*) of its versions, from its early author's notes and manuscripts to its

publication history, including its reappearance in other cultural and historical contexts, its citation by other texts, and its transformation into other textual or visual media. Adaptations don't lead us or our students away from the texts we teach; they lead us to the very heart of the textual condition, to an understanding of literary texts as points of intersection for multiple, evolving creative forces.

Once our students understand creative agency as dispersed across individual, institutional, and cultural actors and recognize that texts exist in multiple variations, the very concept of authorship and the retrievability of an author's intent become much less certain (Cardwell 24–25). The seemingly simple notion of a single, static "source" text becomes complicated as students learn to trace the elaborate webs of influence, citation, borrowing, revision, and interpretation that surround any literary text (Sherry 103). In this way, adaptation disrupts a straightforward teleology of one text giving rise to another, replacing the Romantic idea of the author as uninfluenced creative genius with a richer understanding of writers and texts in perpetual constitutive conversation (Sanders 10, 38). To challenge notions of fidelity and complicate ideas about authorship and intentionality, Jamie Sherry recommends the study of screenplays, which are often the creations of multiple (not always credited) authors, exist in several versions, and serve as material for translation into another medium, film (91–92).

Unfortunately, adaptations can reinforce our students' commitments to naïve notions of textual authorship and intentionality. As Sarah Cardwell notes, students often assume that "an adapter's intentions ought to be synonymous with those of the source text's author," and that assumption quietly reinscribes authorial intent as critical trump card (21–23). Linda Cahir addresses this issue by providing her students with an "aesthetic rubric" that focuses their attention on the degree to which a given film achieves independent artistic quality while conveying its creators' own interpretive vision of its source text (263). Cardwell and Cahir remind us of the importance of teaching an adaptation as its own independent entity while also exploring its connections with its literary parent. Cahir employs the image of the diptych to illustrate how two canvases can be appreciated individually yet acquire an enhanced value when they are set side by side and allowed to illuminate one another (Cahir 98–99).

REFOCUSING READING
AND ENHANCING WRITING SKILLS

Adaptations can serve specific practical functions in the classroom. When students are exposed to a film adaptation before they read the text from which it was drawn, they are able to approach the text as more familiar terrain. In the case of texts with convoluted plots or difficult language, this film-first approach can help students move past their struggles with basic comprehension, readying them for more sophisticated levels of analysis. Coupled with carefully designed film viewing exercises or guides, this

approach can develop active reading and higher-order critical thinking skills (Krueger and Christel 55–88).

While they can help introduce new texts to our students, adaptations can also be useful in rendering opaque texts that might seem to our students so familiar as to be transparent. The shifting of presentational mode from novel to film or story to play can be a highly effective tool for defamiliarizing a text for students. Seeing the-same-with-a-difference can prompt thinking about how form, medium, and genre work and why they matter (Dziedzic 69). It can invite our students to think about visual elements and language, about the defining features of a text, about narrative perspective and thematic focus, and how all of these things contribute to effect and meaning. Comparative analysis of adaptation can help our students learn to read "in a more contextual manner," with greater attention to how texts and films are put together and how they work (Cutchins, "Why" 93). Such a perspective requires students to become more fully aware of themselves as culturally constructed readers positioned within specific historical, social, and personal frameworks.

Integrating English's two halves—reading and writing—the study of adaptation trains students how to read as writers (Leitch, *Film* 19). As William Kist has explained, new media, especially film, can develop students' close-reading skills—skills that are transferable to print texts. Linda Cahir has similarly proposed that paying attention to the parallel elements of film and literature can help students become better viewers, readers, and writers. Cahir likens the individual cinematic frame to the word, a sequenced shot to the sentence, and groups of shots to the paragraph. Lighting is likened to textual tone, and camera angles to narrative point of view (46–71). These equivalencies suggest ways in which film can be used to teach both reading and writing skills, as film viewing becomes a lesson in how language works and how smaller elements contribute to larger cinematic and textual effects.

Adaptation serves the literacy objectives of the Common Core curricular standards that have been adopted by forty-three US states. Take, for example, the English Language Arts guidelines: it is easy to see how exploring adaptations as artistic or interpretive expressions can prompt students to think about how "an author's choices" concerning form, structure, setting, and characterization generate meaning and "aesthetic impact" (CCSS.ELA–Literacy.RL.11–12.3 and 11–12.5). Adaptations remind students that all novels, plays, and films arise from a series of authorial choices, and they highlight the presence and significance of particular authorial choices in both originary and adapted texts.

Moreover, beginning in grade 8, the Common Core "English Language Arts: Literacy" standards specifically call for students to engage with texts across different versions or media. In grades 9 and 10, students are to "analyze the representation of a subject or a key scene in two different artistic mediums, including what is emphasized or absent in each treatment" and to "analyze how an author draws on and transforms source material in a specific work" (CCSS.ELA–Literacy.RL.9–10.7 and 9–10.9). College-bound students in grades 11 and 12 should be able to evaluate how different recorded or performed versions of plays, poems, or novels "interpret the source text"

(CCSS.ELA–Literacy.RL.11–12.7). These are learning objectives specific to the study of adaptation, and they are at the very center of the secondary educational framework in place across the United States.[3] All of this means that for high school teachers, adaptations are already a part of the Core curriculum; for college instructors, our students most likely have had some sort of structured engagement with adaptation before they arrive in our classrooms.

CREATIVE ENGAGEMENT AND PRODUCTIVE OUTCOMES

We have traced how adaptations serve the traditional objectives of English studies, while also transforming the field in ways that make it better suited for preparing students for the twenty-first century. This latter move requires the abandonment of the traditional methods of integrating adaptation within the literature classroom, which normally consists of "a series of one-on-one comparisons between classic novels or plays or stories and their adaptations" (Leitch, "How" 12). Such a structure can simply reinforce the cultural status of the originary text, turning the course into a survey of the "greatest hits" of literature, padded with some of their more notable adaptations. In place of this structure, Leitch calls for courses that are much more centrally occupied with adaptation. Such a course might begin by teaching students what adaptation is and how prevalent a practice it is. Students would see "adaptations as necessary, contingent, and incessant rewritings," as unavoidable forms of textual engagement (13–14). While the first half of the course would foreground comparative analyses of adapted and originary texts, in the second half of the course students would move toward the production of their own adaptations, versions that reflect their analyses of an originary text. By the end of the course, students would be working collaboratively to translate an adapted screenplay into a video. The end goal is to position students as creators, rather than mere analyzers, of literature (15).

A course so oriented toward creative composition and the production of original adaptations attends to the higher cognitive processes as defined by the revised Bloom's taxonomy. Collaboratively crafted in 1956 by a group of educational psychologists led by Benjamin Bloom, the taxonomy classifies cognitive skills and places them into a hierarchy of increasing intellectual difficulty. In Bloom's original taxonomy, "evaluation"—generally expressed in the argumentative essay—stood at the apex of student achievement. When the taxonomy was revised in 2001, evaluation was usurped by the more dynamic and comprehensively integrative act of creation (Anderson et al.; Krathwohl). Accordingly, we can help our students develop higher-order cognitive skills by scaffolding assignments that guide them from comprehension and comparison of originary texts and their corresponding adaptations to the creation of their own original work of adaptation, which reflects their highest-order critical thinking skills.

Defining Terms and Discussing Fidelity

Because adaptation study as it is currently conceived may be new to our students, teachers who wish to tap into the pedagogical potential of literary adaptations may need to outline some preliminary boundaries and define some heuristic terms. They should be prepared to provide a clear definition of what adaptation is, with an understanding that students' ability to engage with adaptation will largely be determined by this definition. A set of terms taken from criticism may also help students talk about literature in relation to adaptation in informed and specific ways.

Fortunately, critics have provided definitions in abundance. Julie Sanders offers several synonyms, the connotations of which students might productively debate: "version, variation, interpretation, continuation, transformation, imitation, pastiche, parody, forgery, travesty, transposition, revaluation, revision, rewriting, echo" (18). Perhaps the most useful definitions call our attention to adaptation as act rather than as object (Bryant 94; Cartmell, "Foreword" viii). Emphasizing adaptation's fundamentally transformative nature, Sanders calls adaptation "an act of re-vision in itself" (19). The two key components of this characterization are the propositions that adaptations reflect critical interpretations of the source text and that adaptations must always involve an alteration of the originary text (thus challenging students' reliance on fidelity criticism). These ideas are echoed in Marcus Boon's sense of adaptation as repetition with a difference, or as Linda Hutcheon formulates it, as "repetition without replication" (Boon 91; Hutcheon, *Theory* 7).

Students may initially cling to much more restrictive definitions that rigidly separate "legitimate" forms of adaptation from other forms of intertextuality.[4] In this way, they are much like those modern critics who, as Leitch notes, express a desire to distinguish between adaptation and not-adaptation, even when they themselves seem unable to locate the fine line ("Adaptation" 89). Teachers should interrogate those desires and consider what is at stake in defining our terms. What do we lose when we think of adaptation as a very tightly delimited category of intertextual revisitation? What new instructional opportunities or interpretive insights might be gained by investing the term with a more broadly inclusive flexibility? For these reasons, it may be wise to introduce adaptation to our students in its most commodious form, as a term that can stretch to incorporate a wide range of acts of transfer, translation, revision, and revisitation. Such a capacious definition allows instructors to subject a diverse array of representational reiterations to adaptive analysis. When it comes to discussion of adaptation, flexibility may be the key for fostering new and creative thinking (Leitch, "Adaptation" 103).

In addition to the parameters of study, critics like Cutchins, Raw, and Welsh insist on the importance of providing students with "a usable taxonomy, a language that will allow them to recognize, abstract, and make sense of what they encounter within and between these texts. The language of film and adaptation will also allow them to communicate what they have understood to wider audiences" (*Pedagogy* xvi). Of course, when

it comes to taxonomical schema, modern adaptation theory offers a bewildering multitude of options. While some critics may embrace the broad critical access made possible by "the plurality and fluidity of many adaptation taxonomies and theories," many teachers, like Mary Snyder, may find that their students are confused by the competing terms and parameters available (Hayton 123; Snyder 16). Finding much of the scholarly material too advanced for her introductory students, Snyder created her own set of five analytical methods that her students could use in exploring literature-to-film adaptations (199–200). The irony of solving the problem of too many analytical frameworks by creating yet another set of categories seems lost on Snyder, but her basic point is well taken: teachers may need to filter and bring some sense of order to this ever-expanding series of taxonomical systems to save their students from groping about in the dark.

Although "usable taxonomies" can provide our students with critical concepts, analytical methods, and the language for communicating their ideas about adaptations, the dizzying variety of available systems and their abstract complexity can overwhelm students, thwart critical inquiry, and restrain discussion. Whether it be Geoffrey Wagner's transposition, commentary, and analogy; Dudley Andrew's borrowing, intersection, and transformation; Linda Cahir's four modes of stage-to-screen translation; Richard Hand's "Five Creative Strategies of Adaptation"; or Kamilla Elliott's six-point scheme (to name but a few of the taxonomies in circulation), every system of categorization forecloses discussion by predetermining one's critical approach. Label an adaptation a "commentary," for example, and what follows can only be a discussion of that adaptation as commentary, to the exclusion of other potential approaches and interpretations (Cardwell 61–62). While systems of categorization can provide students with a vocabulary for talking about what an adaptation does and how (and why) it does it, they can also serve as an all too convenient set of pigeonholes into which students can insert an adaptation, which then ceases to be an object of open critical inquiry.

While critics insist that it is not—or at least should no longer be—necessary to preface every treatment of adaptation by dethroning the old fidelity model, when it comes to using adaptation in the classroom, it may remain a necessary first step. Until we have done our jobs and raised new generations well versed in more modern approaches, we must recognize that our classrooms are filled with students who will not merely assume but insist that absolute fidelity to an originary text is not only possible, but is in fact the highest level of achievement and the basis for any evaluation of the adaptive effort. Administrators, colleagues, and parents likewise hold these outmoded ideas and may require exposure to more current notions of adaptation in order to win their support for what may otherwise seem to them to be a violation of sound pedagogical practice or a massive waste of instructional resources and class time.

Given how eager our students are to dismiss all adaptations as unacceptably unfaithful to their source texts (which are often deemed dull and overly long), a unit (or course) on adaptation will almost inevitably begin with some discussion of the problems and limitations of fidelity-based criticism. The fidelity standard encourages the substitution of qualitative evaluation for critical analysis. Students often struggle to move beyond a deeply held belief that a faithful adaptation is a good adaptation, and this commitment

to assessing an adaptation's quality can impede their ability to identify or critically ana-lyze the adaptation's unique artistic features, its creative reworking of its source materi-als, or its interpretive aims. Teachers can counter this impulse toward "making polarized value judgments" about adaptations by reminding students that they are to engage with adaptations as they would any literary work, and that critical inquiry is not about deter-mining quality but "about analysing process, ideology, and methodology" (Sanders 20). In short, we must position adaptations as objects of objective critical analysis by remov-ing evaluation and qualitative comparison from the equation (Leitch, *Film* 16). We can also make critical commentary and interpretive intervention more central by teach-ing adaptation as action and process rather than merely as outcome or product (Raw, "Paragogy" 31).

One solution, then, is to remove fidelity from the discussion entirely. Another solu-tion is to invert the hierarchy of values, so that our students come to appreciate textual *infidelity* as a mark of artistic achievement. If we can get students to understand that adaptation, by its very definition, requires alteration and adjustment, they may begin to not only accept but embrace infidelity as the indication of an adapter's interpretive intervention in the source text, akin to the fingerprints that can be traced in clay that has been molded and shaped into a new form (Carroll, *Adaptation* 1). From this per-spective, points of departure from an originary text can be seen as marks of interpre-tive insight or creative expression, sites for rich critical discussion of both the originary text and its adaptation. To help students understand that interpretive adaptation neces-sitates textual infidelity, that adaption requires departure from as much—if not more than—adherence to its originary text (which is, after all, a point of origin and not of destination), it may be best to employ distinctly *un*faithful adaptations in the classroom, pairing texts with adaptations that bear more distant relationships to their literary par-ents (Cahir 101). In this way, students can begin to appreciate that repetition without replication offers fertile fields for critical exploration.

CRITICAL THINKING
AND COMPARATIVE ANALYSIS

The determination to slay the fidelity dragon once and for all has led some scholars to argue that comparison/contrast activities encourage description in place of analysis and reinforce "the traditional hierarchies between the source text and the adaptation copy" (Hudelet 42). However, as Peter Clandfield notes, "[w]hile fidelity, or lack thereof, to a source is a limiting criterion for detailed appraisals of adaptations, simply asserting the outdatedness and irrelevance of all varieties of fidelity is just as limiting as a strategy for teaching adaptations" (141). Once we train our students to avoid using comparisons as bases for simple descriptive or qualitative assessments of an adaptation, as Suzanne Diamond explains, we can teach them how to use comparison in the service of more

complex analysis that takes into account "culture, psychology, history, politics, and the function of remembering" (98). Comparison is a natural and potentially productive approach to adaptation study, and we would do well to temper the reactive move against fidelity-based approaches (Snyder 208). We can rehabilitate comparison as an analytical tool in the classroom by decoupling it from qualitative judgment and redirecting it toward more objective critical ends.

There are four critical questions we can ask students to help them move from simple comparison to meaningful comparative analysis:

1. Why are those points of continuity or divergence significant?
2. What do they reveal about how the originary text works to produce its effects and meanings?
3. What do they reveal about how the adaptation works to produce its effects and meanings?
4. Are those points at which the adaptation appears to diverge from its source text really points of difference, or are there ways of reading those elements as consistent with a certain reading of the source text?

This set of questions reframes and repurposes our students' innate inclinations toward fidelity-based comparative analysis. But in place of a qualitative assessment that has as its end goal the privileging of either originary or adapted text, these questions direct students to consider changes to be choices that are made to accommodate a new representational mode, to fit a specific context, to communicate a particular interpretation, or to generate a new message (McKinnon).[5] These are not questions that lead students to the conclusion that an adaptation is "better or worse" than its originary text, but rather to find ways of explaining why the adapter has made certain decisions in rendering the adaptation (Venuti 38–39). The questions form the basis of additional inquiries into historical and cultural contexts, generic conventions and devices, and the issue of an adaptation's status as independent art object.

Active Literacy, Remediation, and Creative Engagement

When we focus our students' attention on adaptation as a process, we help them understand that verbal and visual communication necessitates multiply contingent decisions involving audience, medium, and message, and this perspective should make them more aware of the relationship between form and content in their own writing. Lessons on adaptation connect interpretation with communication, with a particular emphasis on the process of revision. Calling attention to the notes, diagrams, and annotations that lie behind every "linear, script-based argumentative essay," an adaptation-centered

perspective can provide students with "*a more nuanced* awareness of the various choices they make throughout the process of accomplishing the work and the effect those choices might have on others" (Shipka 75–76).

Given this natural synergy, it is not surprising that composition has become the centerpiece of much recent critical work on adaptation pedagogy. Challenging traditional views of an English curriculum built around what students read, Leitch argues, "We end up teaching our students *books* instead of teaching them *how to do things with books* because our college English curriculum is designed around literature at the expense of the active, writerly engagement, the sense of performance and play, the unquenchable sense of agency even in the presence of canonical works, that we call literacy" (*Film* 14). Donna Reiss and Art Young agree: "Literature classes have not always given students the opportunity to be writers as well as readers of the very genres they are studying" (167). A balanced adaptation-oriented pedagogy corrects this problem by attending to students as both consumers and producers of texts and media.

Adaptations can function pedagogically not merely as objects of study but as assessable products. Students might, for instance, be given the option of adapting their written analyses to a visual or multimedia format (Reiss and Young 165). A multimedia essay that puts image, sound, and motion to work in service of effective argumentation and analysis requires students to consider the most effective, most interesting ways to express their ideas, and this in turn encourages sustained original, creative thinking (Ellis 38). Such an approach to composition embraces the essay as an exploratory form, a field for discovery rather than a forum for communicating a fully processed argument. Emphasizing process thus provides us with a view of our students' minds at work (Ellis 50).

Remediation activities offer "learning by doing" opportunities for students to explore different ways of communicating their ideas (Cutchins, Raw, and Welsh, *Pedagogy* xv–xvi; Reiss and Young 167–71). Adaptive assignments foster what Leitch calls "active literacy" by recasting revision and creation as acts of reading and interpretation, reinscribing the deep connections between reading and writing (Leitch, "How" 10). Such activities can realign English studies with active analytical and creative engagement with literature rather than the passive consumption of reified canonical texts, a realignment that redefines literacy itself (Leitch, *Film* 10–11). Creative-critical assignments further reinforce the kinds of lessons on adaptation suggested by Mary Snyder's *Analyzing Literature-to-Film Adaptation*, one of the few studies of adaptation written from a practitioner's perspective, by giving students an adapter's awareness of the complexities of interpretive representation and the impossibility of strict fidelity to an originary text (see also Elliott, "Doing" 76–77).

In place of a traditional essay, the creation of some form of adaptation can demonstrate a student's higher-order reading and thinking skills as well as a deeper understanding of the originary text. Active adapting also provides hands-on experience with the methods, aims, and challenges of adaptation as process. By not only studying but also producing adaptations, students can gain complex insight into "the industries and aesthetics of adaptation . . . [and] the complex relationships of texts that surround and

exert various forces on remediation" (Sherry 91–92, 102–3). Students may, for example, produce their own short films, adapting a selected scene from the text by adjusting its characters, point of view, setting, or focus. These short (three-minute) productions provide evidence of close reading—they demonstrate how well students understand the ways particular elements contribute to the larger whole—but they also can serve as visual arguments. Published on the web, these short films can provide points of contact with students in other classrooms and other schools, who may comment upon or explain how their counterparts' films have engaged with the originary text. In this way, adaptation can provide multiple opportunities for the collaborative, transdisciplinary engagement appropriate to twenty-first-century learning (Raw and Gurr 5, 13–29).[6]

Teachers can assess these creative products (retold story, scripted dramatic scene, performance, film or media presentation) according to a rubric keyed to the demonstration of (1) comprehension and critical interpretation of the originary text and (2) awareness and deployment of relevant adaptive theories and strategies. A good adaptation is one that demonstrates a complex, nuanced understanding of the source text, reflects prevailing critical interpretations of that text (discovered through traditional library research), and offers a new vision of it. Though the rubric should place some value on aesthetics, it is perhaps more important that the student's creative work reflect a complex and nuanced understanding of adaptation as an interpretive and creative process and an act of mediated communication (Sherry 87–88).

Teachers shouldn't be afraid to let their students take the lead when it comes to crafting multimedia projects. Our students often possess greater skills in using new media than we do. It makes sense to allow them opportunities to introduce us to new technologies as they explore innovative ways to express their mastery of the core course concepts and texts (Reiss and Young 165). At the same time, we should keep in mind that an assignment needn't be an elaborate production or require knowledge of, or access to, new media. A more modest—but equally effective—assignment might be the pitching of an idea for an adaptation (Krueger and Christel 124–26). As Cutchins, Raw, and Welsh explain, it isn't necessary to have students actually create films, since "[t]hey will be forced to make many of the same decisions screenwriters, directors, and producers make when asked to simply produce a script, a treatment, and a fairly detailed storyboard" (*Pedagogy* xvi). Storyboarding allows students to visually represent a narrative as a precursor to a fully digital storytelling project (Córdova). Students will need to dig deeply into a source text in order to find justification for their adaptations. This sort of creative exercise can teach students that just as a single text can generate multiple interpretations, those interpretations can be expressed in different ways and in various forms (Berger 31–43). Key to these creative adaptation assignments is the inclusion of a short reflective exercise, in which "students articulate their choices of topics, words, and media so that they recognize the relationship between their rhetorical purposes and their productions" (Reiss and Young 166). Students should be able not only to explain their adaptive strategies and their production process but also "to interpret their [own] work critically, engaging with other criticism and theory about the works they adapt" (Elliott, "Doing" 78).

CHALLENGES AND RESOURCES

Adaptations can do many remarkable things for our students, but they can also pose many challenges to be overcome in the classroom. Chief among these challenges is the pesky problem of time. How does one shoehorn a second (or third or fourth) version of a text into an already overcrowded syllabus? Which other texts will have to be jettisoned in order to make space for the various adaptations of the originary text that has been chosen? But this curricular exchange isn't all about loss, for there is much to be gained in structuring a course around textual revisitations. When they encounter the same text in different guises, students see the text with remarkable clarity. Nor does it have to be an all-or-nothing proposition. As John Golden points out, in place of a full-length film, students can watch brief (less than fifteen-minute) clips that raise the issues and invite them to hone the skills we would most like them to focus on (xv). Showing several different approaches to filming a single scene can highlight a range of issues from point of view and symbolism to cultural codes, the conventions of genre and the differences among media (Hayton 129). If the adaptation is of a long novel, a few carefully excerpted pages may be more than enough to illustrate the adapter's methods and aims or to show students alternatives to the messages or representational strategies of the text. Following Golden's advice to read film first, these excerpts can be worked through closely in class before students are sent home to engage the originary text on their own. Encountering an adaptation before its originary text provides them with a familiar framework for scaffolding new information (Dial-Driver, Emmons, and Ford 67–68).

Of course, we must think about what we need to give to our students in the way of tools, terms, and techniques for reading (or viewing) and assessing adaptations. This is an issue of particular importance if the adaptation in question is a film. Though they have plenty of experience watching films, most students have received little or no instruction on how film works or how to view it with an informed, analytical eye. Teachers might consult any number of introductory film studies texts in preparing viewing guides for their students. Most of these books seem more oriented toward courses strictly on film rather than courses that use film in the service of literary study, but there are several welcome exceptions: Ellen Krueger and Mary T. Christel's *Seeing and Believing: How to Teach Media Literacy in the English Classroom*, John Golden's *Reading in the Dark*, and Mary Ellen Dakin's *Reading Shakespeare Film First*. These last two are NCTE publications aimed at junior high and high school teachers, yet their focus on film as a tool for literary study makes their material adaptable for use in the study of literature at any level.

Teachers new to moving images will find a helpful introduction in Krueger and Christel's *Seeing and Believing*. In Chapter 4, Christel offers a quick and accessible runthrough of some basic film terminology; from basic camera shots to lighting terms, the chapter covers the essential ways in which cinema represents movement, conveys narrative perspective, and establishes visual motifs (40–54). Visual glossaries and captioned

examples of camerawork abound on YouTube, a fantastic free resource that offers not only a dazzling range of material for viewing, but also a site for students to upload their own creative visual work.

Students may need special guidance to properly view a film *as an adaptation*, with a focus on how the film reads and represents a text they are studying. They may need structured viewing guides that highlight or pose questions about particular elements we want them to focus on in each scene (Golden 36–95). Prompted to think about how specific techniques and elements are used to translate the text into a motion picture, students will be primed to view and discuss the film as an interpretive rendering of or a critical response to the source text.

When we bring adaptations into our classrooms, we introduce an element that necessarily changes the direction and pacing of the course. When an originary text appears on a syllabus accompanied by one or more of its latter-day adaptations (or perhaps its own textual forebears), it invites our students to linger. We spend more time in the company of fewer texts, replacing the mad dash through the forest of frantic and futile comprehensive coverage—where the primary course goal is introducing students to as many new texts as we can cram into the semester—with a focus on multimedia literacy and multiply engaged analysis.

For twenty-first-century students, immersed in a hyperlinked world, reading is intertextual, and communication is multiply mediated (Hudelet 41). For these students, the insights and skills that adaptation studies provides are particularly relevant. Adaptation draws attention to the modern (inter)textual condition, in which all texts are fragmented, borrowed, and in communication with other texts across various media. At the same time, adaptation makes our students more aware of the cultural and historical forces that shape all writers, texts, and readers (Cobb 20). By engaging adaption in our classrooms, we provide our students with critical perspectives and skills that are not only relevant but necessary to full participation in our contemporary cultural landscape.

NOTES

1. The general assumption is usually that adaptation = film. Disrupting this inaccurate equation is another task to add to the list of issues to be addressed in the classroom. Much of the pedagogical work that has been published similarly assumes a novel-to-film paradigm. In the current essay, I consider adaptations in all forms and across all media.

2. Murray's focus on the role of money and markets within the adaptation industry offers another point for pedagogical engagement, for it reminds us that understanding how and why texts are adapted requires sociological study and an understanding of production and distribution practices (186–87).

3. Although direct student engagement with adaptation is included within the Common Core, the way in which it is outlined in the standards is less than satisfying. It is described in one standard as a fairly straightforward compare/contrast activity, in which students note similarities and differences across media. Literacy objectives RL.9–10.9 and RL.11–12.7 are better crafted to deliver a meaningful engagement with adaptation, as students analyze "how an

author draws on and transforms source material" and evaluate "how each version interprets its source text." The potential of the latter objective is somewhat restricted by the suggestion that the adaptation be faithful rendering, such as a performance of a play.

4. Julie Sanders distinguishes between the two terms in her title *Adaptation and Appropriation* on the basis of the degree to which the original text is commented upon, altered, or interpreted. Phyllis Frus and Christy Williams distinguish between an adaptation, which remains close to an originary text, and a "transformation," which reimagines or changes the source text and "works independently of its source" (3).

5. Shelley Cobb proposes that courses organized around periods of cinema history (as opposed to traditional literary periods) can highlight adaptations as products of particular historical, industrial, social, and political forces (19).

6. US Common Core "Production and Distribution of Writing" guidelines (CCSS.ELA–Literacy.W.9–10.6) for grades 7–12 call for students to work individually and collaboratively to produce "writing products" that take advantage of technology's capacity to link to other information and to display information flexibly and dynamically." Students should be able to use technology to enhance and publish their work and to collaborate with others.

Works Cited

Anderson, L. W., et al. *A Taxonomy for Learning, Teaching, and Assessing: A Revision of Bloom's Taxonomy of Educational Objectives.* New York: Longman, 2001. Print.

Andrew, Dudley. "Adaptation." 1984. Rpt. *Film Adaptation.* Ed. James Naremore. New Brunswick: Rutgers UP, 2000. 28–37. Print.

Berger, Richard. " 'Never Seek to Tell Thy Love': E-Adapting Blake in the Classroom." Cutchins, Raw, and Welsh, *Redefining* 31–44. Print.

Bolter, Jay David, and Richard Grusin. *Remediation: Understanding New Media.* Cambridge: MIT P, 2000. Print.

Boon, Marcus. *In Praise of Copying.* Cambridge: Harvard UP, 2010. Print.

Bowen, Tracey, and Carl Whithaus, eds. *Multimodal Literacies and Emerging Genres.* Pittsburgh: U of Pittsburgh P, 2013. Print.

Bryant, John. *The Fluid Text: A Theory of Revision and Editing for Book and Screen.* Ann Arbor: U of Michigan P, 2002. Print.

Cahir, Linda Costanzo. *Literature into Film: Theory and Practical Approaches.* Jefferson: McFarland, 2006. Print.

Cardwell, Sarah. *Adaptation Revisited: Television and the Classic Novel.* Manchester: Manchester UP, 2002. Print.

Carroll, Rachel, ed. *Adaptation in Contemporary Culture: Textual Infidelities.* London: Continuum, 2009. Print.

———. "Coming Soon . . . Teaching the Contemporaneous Adaptation." Cartmell and Whelehan, *Teaching* 135–56. Print.

Cartmell, Deborah. "Foreword." Cutchins, Raw, and Welsh, *Redefining* vii–viii. Print.

Cartmell, Deborah, and Imelda Whelehan, eds. *Teaching Adaptations.* New York: Palgrave, 2014.

Clandfield, Peter. "Teaching Adaptation, Adapting Teaching, and Ghosts of Fidelity." Cutchins, Raw, and Welsh, *Pedagogy* 139–56. Print.

Cobb, Shelley. "Canons, Critical Approaches, and Contexts." Cartmell and Whelehan, *Teaching* 11–25. Print.

Common Core State Standards Initiative. National Governors Association Center for Best Practices and Council of Chief State School Officers. Web. 1 Aug. 2015.

Córdova, Nathaniel. "Invention, Ethos, and New Media in the Rhetoric Classroom: The Storyboard as Exemplary Genre." Bowen and Whithaus 143–63. Print.

Cutchins, Dennis, Laurence Raw, and James M. Welsh, eds. *The Pedagogy of Adaptation.* Lanham: Scarecrow, 2010. Print.

Cutchins, Dennis, Laurence Raw, and James M. Welsh, eds. *Redefining Adaptation Studies.* Lanham: Scarecrow, 2010. Print.

Cutchins, Dennis. "Why Adaptations Matter to Your Literature Students." Cutchins, Raw, and Welsh, *Pedagogy* 87–96. Print.

Dakin, Mary Ellen. *Reading Shakespeare Film First.* Urbana: NCTE, 2012. Print.

Damrosch, David. "World Literature in a Postliterary Age." *Modern Language Quarterly* 74.2 (June 2013): 151–70. Print.

Dial-Driver, Emily, Sally Emmons, and Jim Ford, eds. *Fantasy Media in the Classroom: Essays on Teaching with Film, Television, Literature, Graphic Novels and Video Games.* Jefferson: McFarland, 2012. Print.

Diamond, Suzanne. "Whose Life Is It, Anyway? Adaptation, Collective Memory, and (Auto) Biographical Processes." Cutchins, Raw, and Welsh, *Redefining* 95–110. Print.

Dziedzic, Benjamin. "When Multigenre Meets Multimedia: Reading Films to Understand Books." *English Journal* 92.2 (Nov. 2002): 69–75. Print.

Elliott, Kamilla. "Doing Adaptation: The Adaptation as Critic." Cartmell and Whelehan, *Teaching* 71–86. Print.

———. *Rethinking the Novel/Film Debate.* Cambridge: Cambridge UP, 2003. Print.

Ellis, Erik. "Back to the Future? The Pedagogical Promise of the (Mulitmedia) Essay." Bowen and Whithaus 37–72. Print.

Frus, Phyllis, and Christy Williams. "Introduction: Making the Case for Transformation." *Beyond Adaptation: Essays on Radical Transformations of Original Works.* Ed. Phyllis Frus and Christy Williams. Jefferson: McFarland, 2010. 1–18. Print.

Golden, John. *Reading in the Dark: Using Film as a Tool in the English Classroom.* Urbana: National Council of Teachers of English, 2001. Print.

Hand, Richard J. "'It Must All Change Now': Victor Hugo's Lucretia Borgia and Adaptation." Cutchins, Raw, and Welsh, *Redefining* 17–30. Print.

Hayton, Natalie. "'Adapting' from School to University: Adaptations in the Transition." Cartmell and Whelehan, *Teaching* 120–34. Print.

Hudelet, Ariane. "Avoiding 'Compare and Contrast': Applied Theory as a Way to Circumvent the 'Fidelity Issue.'" Cartmell and Whelehan, *Teaching* 41–55. Print.

Hutcheon, Linda. *A Theory of Adaptation.* New York: Routledge, 2006. Print.

———. "In Defence of Literary Adaptation as Cultural Study." *Media/Culture* 10.2 (May 2007). Web. 12 Feb. 2011.

Kist, William. "New Literacies and the Common Core." *Educational Leadership* 70.6 (March 2013): 38–43. Print.

Krathwohl, D. R. "A Revision of Bloom's Taxonomy: An Overview." *Theory into Practice* 41.2 (2002): 212–18. Print.

Krueger, Ellen, and Mary Christel. *Seeing and Believing: How to Teach Media Literacy in the English Classroom.* Portsmouth: Heinemann, 2001. Print.

Leitch, Thomas. "Adaptation and Intertextuality, or, What Isn't an Adaptation, and What Does It Matter?" *A Companion to Literature, Film, and Adaptation.* Ed. Deborah Cartmell. Chichester: Wiley Blackwell, 2014. 87–104. Print.

———. *Film Adaptation and Its Discontents: From* Gone with the Wind *to* The Passion of the Christ. Baltimore: Johns Hopkins UP, 2007. Print.

———. "How to Teach Film Adaptations, and Why." Cutchins, Raw, and Welsh, *Pedagogy* 1–20. Print.

McGann, Jerome. *The Textual Condition.* Princeton: Princeton UP, 1991. Print.

McKinnon, James. "Creative Copying?: The Pedagogy of Adaptation." *Canadian Theatre Review* 147 (Summer 2011): 55–60. Print.

Murray, Simone. *The Adaptation Industry: The Cultural Economy of Contemporary Literary Adaptation.* New York: Routledge, 2012. Print.

Phillips, Nathan. "Frankenstein's Monstrous Influences: Investigating Film Adaptations in Secondary Schools." Cutchins, Raw, and Welsh, *Pedagogy* 35–52. Print.

Raw, Laurence. "The Paragogy of Adaptation in an EFL Context." Cartmell and Whelehan, *Teaching* 26–40. Print.

Raw, Laurence, and Tony Gurr. *Adaptation Studies and Learning: New Frontiers.* Lanham: Scarecrow, 2013. Print.

Reiss, Donna, and Art Young. "Multimodal Composing, Appropriation, Remediation, and Reflection: Writing, Literature, and Media." Bowen and Whithaus 164–82. Print.

Sanders, Julie. *Adaptation and Appropriation.* New York: Routledge, 2006. Print.

Schwartz, Hillel. *The Culture of the Copy: Striking Likenesses, Unreasonable Facsimiles.* New York: Zone, 1998. Print.

Sherry, Jamie. "Teaching Adapting Screenwriters: Adaptation Theory through Creative Practice." Cartmell and Whelehan, *Teaching* 87–105. Print.

Shipka, Jody. "Including, but Not Limited to, the Digital: Composing Multimedia Texts." Bowen and Whithaus 73–89. Print.

Snyder, Mary H. *Analyzing Literature-to-Film Adaptations: A Novelist's Exploration and Guide.* London: Continuum, 2011. Print.

Venuti, Lawrence. "Adaptation, Translation, Critique." *Journal of Visual Culture* 6.1 (2007): 25–43. Print.

Wagner, Geoffrey. *The Novel and the Cinema.* Rutherford: Farleigh Dickinson UP, 1975.

CHAPTER 37

...

ADAPTATION AND REVISION

...

KEITH WILHITE

To begin. To begin. How to start.

—Charlie Kaufman, *Adaptation.* (2002)

Reworking familiar materials is standard artistic practice. And much as many creative artists transform prior texts into new works of their own, so, too, academics often rewrite the approaches of thinkers who have influenced them.

—Joseph Harris, *Rewriting: How to Do Things with Texts* (2006)

DURING the 2010–11 academic year, I offered a first-year seminar in Duke University's Thompson Writing Program entitled "Remakes and Adaptations: Rewriting across the Genres." As I prepped for the course, I debated whether to include the brilliant film *Adaptation.*, written by Charlie Kaufman and directed by Spike Jonze. I know. In retrospect the question should only have been: How could you not? Weighing the standard, anti-cerebral viewing habits of eighteen-year-olds, I suppose I fretted over the film's accessibility and appeal to university students. But a more substantive dilemma also drove my equivocation. I was preparing to teach not a course on film, literature, and adaptation studies, but a first-year *writing* seminar. In other words, the real question was how to make *Adaptation.* a generative context for thinking about the formal and conceptual work that academics perform.

The more time I spent with Kaufman and Jonze's film, however, the more it seemed to provide a framework for the ideas that would guide our inquiry. As Robert Stam notes, *Adaptation.* "foregrounds the process of writing. We see Susan Orlean at her computer, surrounded by the various sources—encyclopedias, botanical books, histories—that feed into her own text. And we see Charles Kaufman, trying to adapt her book, panicked and sweating before the blank computer screen. Film, we are reminded, is a form of writing that borrows from other forms of writing" ("Introduction" 1). Through these moments of intertextuality, the film poses questions about the nature of authorship, originality, fidelity, and genre—concerns that belong equally to the fields of academic

writing and adaptation studies. Yet, as Stam suggests, *Adaptation.* also makes visible the specific practice of writing as an exercise in the meaningful remaking of previous material. Elaborating on this point, Devin Harner claims "that the two texts [*Adaptation.* and Orlean's *The Orchid Thief*] are dependent on each other, not to make meaning, but to make *further* meaning" (33). This idea of two (or more) texts working in concert "to make further meaning" also strikes me as an apt analogy for academic writing and, moreover, informs the kind of work I want my students doing in all my courses.

If *Adaptation.* highlighted a number of the seminar's key thematic concerns, then Joseph Harris's *Rewriting: How to Do Things with Texts* provided an essential guide to the practice of academic writing. In scholarly contexts, writers constantly draw on, respond to, and rework the texts of other writers. Harris sees this practice as the indispensable element of academic writing: "whatever else they may do, intellectuals almost always write *in response* to the work of others" (1). In college-level writing, citing and documenting the work of experts marks the most familiar instance of this response, but over the course of the semester, we also identified and practiced the more nuanced ways that writers "rewrite" the work of other writers through a process of intellectual and artistic response. In short, the seminar invited students to adapt the practices of academic writing, as described by Harris, to our inquiry into adaptation studies.

The complementary ideas of writing "in response to" in order "to make further meaning" constitute the essential juncture between these two fields of study. As Nicolas Cage, playing the onscreen Charlie Kaufman, sits before his typewriter and mumbles, "To begin. To begin. How to start," he restages a scenario familiar to new and veteran writers alike. One way to break through this impasse is to reframe the question for students. Rather than ask, "What do you have to say about a particular idea or topic?" students might begin with a question that emphasizes the process of interpretation and response: "What have others had to say about this subject, and how might you respond to them?" The process begins with responsive reading. Students mark phrases that strike them as potentially significant, provocative, or confusing, look for patterns of repetition or contradictions in the text, and annotate as they read. (This is not so different from what they see the onscreen Kaufman doing with *The Orchid Thief*.) In this way, students embark upon writing as a process that responds to previous texts, takes ideas in new directions, and generates further meaning.

My purpose, though, is not to describe my seminar, but rather to explore the relations between adaptation studies and academic writing. Although that course will provide a historical context for this discussion—and I often frame my remarks in terms of pedagogical practice—I want to examine modes of adaptation and the concepts and questions shared between these two fields. Moreover, I want to reflect on how my thinking about adaptation, writing, and revision has evolved, as well as how I invite students to contemplate their own work and—a term I will explain later—the "afterlife" of writing. What does it mean to author a text? What role does the reader play? What distinguishes original work from merely derivative repetition? Where does one draw the line between creative borrowing and plagiarism? How does the process of interpretation and revision enhance, rather than diminish or undermine, an anterior text? For students to engage productively

with such abstract questions, it helps to establish key terms and practices that allow them to navigate more complex levels of thinking and writing. For first-year college writers, especially those in the humanities, Harris's *Rewriting* provides a useful road map. Harris examines "academic writing as a social practice, as a set of strategies that intellectuals put to use in working with texts," but he also sets out "to describe some of its key moves with a useful specificity" (3). Those "key moves" provide his book's structure: "Coming to Terms"; "Forwarding"; "Countering"; "Taking an Approach"; and "Revising."

At a basic level, I use these interrelated moves in my writing courses to scaffold a series of essay assignments that build toward more substantial writing projects. But in the "Remakes and Adaptations" seminar, I also wanted to explore more substantive links between these strategies and the thematic concerns of adaptation studies. At first glance, the correspondence between the process of adaptation and the successive revisions that writers make to improve their own texts is obvious. Yet at its core, as Harris argues, the practice of academic writing is fundamentally intertextual. In other words, I wanted our seminar to examine the practices of writing and revision through the formal and conceptual transformations that take place in adaptations. To do so, I organized the course, as I have this essay, around a set of shared terms and conceptual links that I want to test and explore here. If I have a working argument, it is this: adaptation provides a theoretical framework through which students can question seemingly established writing categories, such as author, reader, text, plagiarism, and revision. At a practical level, however, the process of adaptation also clarifies the practical moves we ask students to perform through reading, interpretation, writing, and rewriting in the belief that successive revisions elucidate ideas and create new meaning.

AUTHOR-TEXT-READER

What work does an author perform? What counts as a text? What is the role and responsibility of the reader? In my experience, students usually agree on a couple of things: a text should articulate the views of its author, and our job, as readers, is to come to an understanding of the writer's perspective (whether to agree or disagree with it, or simply to gather new information). That description may hold true for an academic essay like this one, but even in a scholarly context, asking students to examine their assumptions about the relationship among author, text, and reader can help them begin to understand their roles in a disciplinary or discourse community.

Roland Barthes's "The Death of the Author" provides a useful entrée—a challenging text, to be sure, but one that a little advance prep can open up for students in meaningful ways.[1] In that essay, Barthes contends that "a text's unity lies not in its origin but in its destination" (148). He debunks the author as the originator of a meaning to be "*deciphered*" (147) and "restore[s] the place of the reader" as the true site of writing (143).[2] In this sense, "The Death of the Author" advocates for a "writerly" mode of reading in which we read for the allusive, intertextual fabric of the text. To read in a writerly mode

is to understand the text as "a multi-dimensional space in which a variety of writings, none of them original, blend and clash" (Barthes, "Death" 146). One way to make this "multi-dimensional space" evident to students is to highlight the citations and end-notes that often fade into the background when they read scholarly writing. Barthes's own essay is also laden with more subtle allusions to Mallarmé, Valéry, Proust, Brecht, and Balzac. At a higher level, however, reading in a writerly mode requires students to set aside assumptions about authorial intention, to focus on the multiple, even contra-dictory meanings carried through the language of the text, and to imagine how their response in effect constructs that text.

As I understand it, then, this kind of reading offers a common ground for both aca-demic writing and adaptation studies. Reading in a writerly mode demystifies the notion of the author as virtuoso who creates, *ex nihilo*, a singular meaning. Each interpretation or adaptation serves as an act of "disentanglement" to generate new writing, new works of art, new meanings (Barthes, "Death" 147). In *The Pleasure of the Text*, Barthes writes, "*Text* means *Tissue*; but whereas hitherto we have always taken this tissue as a product, a ready-made veil, behind which lies, more or less hidden, meaning (truth), we are now emphasizing, in the tissue, the generative idea that the text is made, is worked out in a perpetual interweaving; lost in this tissue—this texture—the subject unmakes himself" (64). Barthes's project suggests that intellectual and artistic texts are always performa-tive works in progress, open to new interventions that renew a text from one reading (or viewing) to the next.

This abstract discussion lends itself to more practical analogies between writing and the process of adaptation. For Harris, a text is "an artifact that holds meaning for some readers, viewers, or listeners. A book (or other piece of writing) is a text, but so are movies, plays, songs, paintings, sculptures, photographs, cartoons, videos, billboards, advertisements, web pages, and the like. . . . [T]exts are objects that have been made and designed—*artifacts* that can in some way be shelved, filed, or stored and then retrieved and reexamined" (11). After reading Barthes, this description of a text may seem refresh-ingly clear, but the underlying ideas emerge from a Barthesian mode of thinking. Harris's text may not "unmake" its authorial subject, but note that "readers, viewers, or listeners" occupy the place where that "meaning" gets disentangled. Like Barthes, Harris is interested in destinations.

Contemporary adaptation studies shares a similar impulse to de-emphasize ori-gins. Stam lists "reading, rewriting, critique, [and] translation" among the "archive of tropes and concepts" that adaptation theory has accrued ("Introduction" 25). These terms reflect a shared vocabulary between adaptation theory and academic writing that privileges interpretive acts of reading over fidelity to authorial intent. Elsewhere Stam writes, "An author's expressed intentions are not necessarily relevant, since literary crit-ics warn us away from the 'intentional fallacy,' urging us to 'trust the tale not the teller.' . . . Authors are sometimes not even aware of their own deepest intentions" ("Beyond Fidelity" 57). Harris articulates similar sentiments when discussing "strategies for *com-ing to terms* with complex texts, for re-presenting the work of others in ways that are both fair to them and useful to your own aims in writing" (5). While the note on fairness

implies a kind of fidelity to an author's purpose, Harris is quick to remind readers, "Of course, any text you write will also hint at possibilities of meaning you had not considered, imply or suggest things you had not planned. A text always says both less and more than its writer intends" (17). What I like here is the crossover Harris creates between a text, more generally, that "always says both less and more than its writer intends" and the texts that "you [that is, the student]" will write. This moment serves as a kind of pivot between the more abstruse notions of author, text, and reader that Barthes unpacks and the practical concerns of a writing seminar. In part, successful writing—like successful adaptation—requires not only generous and interpretive approaches to the work of other writers and artists, but also becoming a strong reader (critic, translator, rewriter) of one's own texts in the name of generating new ideas or interpretations.

Plagiarism

At what point does the "clash" of unoriginal writing drift from celebratory collage into intellectual theft? According to the *MLA Handbook for Writers*, "Plagiarism involves two kinds of wrongs. Using another person's ideas, information, or expressions without acknowledging that person's work constitutes intellectual theft. Passing off another person's ideas, information, or expressions as your own to get a better grade or gain some other advantage constitutes fraud. Plagiarism is sometimes a moral and ethical offense rather than a legal one since some instances of plagiarism fall outside the scope of copyright infringement, a legal offense" (52). For the past several years, whether teaching a writing seminar or a literature course, I have included some version of that passage on my syllabus. I supplement it with what I hope is more nuanced language about research and responsible advocacy, but the paragraph always ends the same: "The penalty for plagiarism is failure of the assignment and, possibly, the course." Every institution where I have taught requires faculty members to include some statement identifying their policy. We've conceded that plagiarism remains an unfortunate reality of higher education, regardless of how stridently we discourage the practice through assignment design and classroom pedagogy.

In "The Ecstasy of Influence: A Plagiarism," Jonathan Lethem writes, "The kernel, the soul—let us go further and say the substance, the bulk, the actual and valuable material of all human utterances—is plagiarism" (68). Or, rather, it would be more proper to say that Lethem has cribbed those words from Mark Twain's consoling letter to Helen Keller, who had been accused of plagiarism. You learn this if you read the "Key: I Is Another" at the end of Lethem's essay. "This key to the preceding essay," he writes, "names the source of every line I stole, warped, and cobbled together as I 'wrote' (except, alas, those sources I forgot along the way)" (68). Even this wave at documentation offers only tongue-in-cheek respect to the mantra that "responsible writers compose their work with great care," citing all the "ideas, facts, and words" they have borrowed (*MLA Handbook* 52). Lethem's writing subject occupies, as Barthes would say, "a zero degree"

where he can never know the extent to which his writing has repurposed the language of another (*Pleasure* 35).

Somewhere between the MLA prohibition and Lethem's unabashed celebration, the discussion of plagiarism and academic writing became more than boilerplate language for the syllabus in my "Remakes and Adaptations" seminar. Lethem's essay provides an excellent resource for a writing course, whether or not the ostensible field of inquiry is adaptation studies.[3] The text perfectly weds form and content: it is a "collage text," a formal experiment in selecting and adapting previous texts that explores the historic and, arguably, necessary links between writing and plagiarism. The essay offers an even richer field of debate linking academic writing and adaptation to issues in art, property, economics, fair use, and legality. Cultural artifacts, as Lethem notes, circulate within two "economies": a "market economy" and a "*gift economy*" (65). He borrows that idea from Lawrence Lessig, a leading scholar on copyright law and intellectual property. In almost every way, "The Ecstasy of Influence" embodies Lessig's claim that "[w]e live in a 'cut and paste' culture enabled by technology" (105). Lessig argues that "to call a copyright a 'property' right is a bit misleading, for the property of copyright is an odd kind of property" (83). The art world—in which an often ineffable creative process and a concrete creative product coexist—occupies a kind of parallel realm in which the belief that "ideas released to the world are free" inevitably confronts the discourse of copyright law (84). As Lessig remarks, "Here the law says you can't take my idea or expression without my permission: The law turns the intangible into property" (84). Even the MLA definition, with its "sometimes" and "some instances," suggests that in the transformation from the intangible to the tangible, plagiarism troubles the line between "moral and ethical offense" and "legal" violation.

In his *New Yorker* essay "Something Borrowed," Malcolm Gladwell describes his own experiences with that nebulous realm. The playwright Bryony Lavery lifted prose from a *New Yorker* profile he had written in 1997. Entitled "Damaged," that piece detailed the work of Dorothy Lewis, a psychiatrist who studies serial killers. For her play *Frozen*, Lavery copied some "six hundred and seventy-five words" to develop the life and work of her central character, a psychiatrist who studies serial killers, a woman who shares more than a passing resemblance to Dorothy Lewis ("Borrowed"). In "Something Borrowed," Gladwell examines the creative and legal space where questions of authorship and originality give way to intellectual property. As a culture, we have decided that a certain amount of borrowing, even theft, is both acceptable and necessary to the creative process. Gladwell draws numerous examples from the world of music to show how commonplace such thievery is. Plagiarism, however, carries a different weight and stigma. "The ethical rules that govern when it's acceptable for one writer to copy another are even more extreme than the most extreme position of the intellectual-property crowd," Gladwell writes. "[W]hen it comes to literature, we have somehow decided that copying is *never* acceptable."

Considering our culture's romantic vision of the solitary author, conjuring brilliance from the void, perhaps creative writing is particularly susceptible to the notion of the originating talent. Yet, as Gladwell argues, "[t]he final dishonesty of the plagiarism

fundamentalists is to encourage us to pretend that [the] chains of influence and evolution do not exist, and that a writer's words have a virgin birth and a eternal life." Lethem, embracing the "ecstasy" of the influences he echoes, makes a similar case: "Finding one's voice isn't just an emptying and purifying oneself of the words of others but an adopting and embracing of filiations, communities, and discourses" (61). The central issue, it seems, depends on a more nuanced understanding of plagiarism, one that makes for a dynamic discussion of adaptation, originality, and academic writing along lines that have little to do with fidelity and everything to do with the transformative and interpretive properties of art and intellect.

Early in "Something Borrowed," Gladwell writes, "Words belong to the person who wrote them. There are few simpler ethical notions than this one, particularly as society directs more and more energy and resources toward the creation of intellectual property." He offers here a real-world premise for the kind of indignation invoked by the MLA editors for willful plagiarists. "Once detected," the *MLA Handbook* notes, "plagiarism in a work provokes skepticism and even outrage among readers, whose trust in the author has been broken" (53). The rest of Gladwell's essay, however, offers a careful recalibration of the seemingly obvious point that words have a kind of direct provenance. While he knows he has every right to feel upset, what he experiences is something more generous and generative: "instead of feeling that my words had been taken from me, I felt that they had become part of some grander cause" ("Borrowed"). In short, Lavery's play transformed Gladwell's mundane if well-written descriptions of psychiatric phenomena into art.

This insight leads to the most compelling idea to emerge from Gladwell's piece, especially in regard to adaptation and writing as processes of response that create new works and further meaning. He draws a distinction between "borrowing that is transformative and borrowing that is merely derivative." This, for me, is the key moment and an accessible context for talking to college-level writers about plagiarism. Although Lethem's essay, once students catch on to his project, leads to spirited debates about the originality—even legitimacy—of plagiarism, pastiche, and collage as art forms, I still would not permit them to submit an academic essay that contains plagiarized passages. While less innovative, Gladwell's distinction between transformative and derivative borrowing perfectly anticipates the kernel of Lethem's text and, moreover, helps students think about the kind of work they should strive to do through their research and writing. Borrowing that is merely derivative adds nothing to our understanding of a text, film, culture, or the human condition; it offers meaningless repetition. As Lethem claims, "the primary motivation for participating in the world of culture in the first place [is] to make the world larger" (65). In the context of academic writing, I ask my students to borrow from their research in order to support and advance their own lines of inquiry, but the express goal is always to add something to the conversation, to try to articulate an interesting perspective that enlarges our understanding of a concept or text.

The language of "derivative" and "transformative" can lead to more productive conversations with students about writing and originality than stern warnings about plagiarism. In my experience, malicious plagiarism is the province of a small faction of

students. The more pressing questions for most young writers include the following: What do I do with my research? How do I express my own ideas on a topic? What does it mean to write a "creative" academic essay? Discussing plagiarism in the context of adaptation studies clarifies academic writing as a practice that reframes and revises anterior texts and, as a result, gives students a more useful vocabulary for thinking about "second use" and transformative borrowing as imaginative forms of scholarly expression. Lethem's and Gladwell's essays offer opportunities to contemplate key writing concepts, such as "authorship," "text," and "originality," but they also provide an occasion to think more broadly about how writing makes meaning in our culture, either by elucidating complex issues, unsettling recalcitrant viewpoints, or presenting an unexpected perspective. In "The Ecstasy of Influence," Lethem writes, "The world of art and culture is a vast commons, . . . The closest resemblance is to the commons of a *language*: altered by every contributor, expanded by even the most passive users. That a language is a commons doesn't mean that the community owns it; rather it belongs *between* people, possessed by no one, not even by society as a whole" (66). Meaning emerges through that dialogic response—between people, between texts. Like adaptations, academic writing is responsive writing that strives "to make the world larger."

THE ORIGINAL

If plagiarism is the "soul" of human expression, and if a text is "a multi-dimensional space in which a variety of writings, none of them original, blend and clash" (Barthes, "Death" 146), then what counts as an original idea? Is originality the province of the writer or the reader/listener/viewer? And, perhaps most pressing to college students, what would it mean to write an "original work of scholarship"? Adaptation studies can help students rethink concepts of originality and determine what constitutes an original text in ways that will bear upon the kind of writing they do as novice scholars.

For starters, it is useful to note that the fetish of the original is relatively recent. In *A Theory of Adaptation*, Linda Hutcheon argues, "[i]t is the (post-) Romantic valuing of the original creation and of the originating creative genius that is clearly one source of the denigration of adapters and adaptations. Yet this negative view is actually a late addition to Western culture's long and happy history of borrowing and stealing or, more accurately, sharing stories" (3–4). Not only does Hutcheon remove the mantle from "the originating creative genius" in Western culture, but she also gives the lie to our supposed lack of interest in secondary or derivative works. "If adaptations are . . . such inferior and secondary creations," she asks, "why then are they so omnipresent in our culture and, indeed, increasing steadily in numbers?" (4). She provides evidence from Oscar- and Emmy-winning movies that suggests a vested cultural interest in acts of creative repetition. The answer, according to Hutcheon, lies in "repetition with variation, from the comfort of ritual combined with the piquancy of surprise. Recognition and remembrance are part of the pleasure (and risk) of experiencing an adaptation" (4).

I would make a similar case for the role of writing more broadly, especially in fields that deal with critical interpretations of cultural texts (art, film, literature, photography). At its best, such writing offers "repetition with variation," not simply by summarizing or tweaking what has already been said—a diminished form of critique—but by linking the reader's recognition of the text with a new interpretation or unique perspective that flirts with both "pleasure" and "risk," either by enhancing the reader's understanding of a film or novel, or by unsettling the sometimes troubling political assumptions that inform a work and its reception. That, however, can be a difficult sell to college writers wading into intellectual debates for the first time. In that regard, I prefer Hutcheon's definition of adaptations as both a product and a process. Adaptations are, on one hand, "a *formal entity*" that can be examined and subjected to analysis. On the other hand, as Hutcheon continues, we should also consider adaptation as "*a process of creation,*" and a "*process of reception*" (7–8)—a move that again brings origins and destinations into meaningful dialogue. Hutcheon reads adaptation through "modes of engagement—telling, showing, and interacting with stories" (27)—as well as processes of creation, reception, and "cultural transmission" (32).

If convincing students of the "pleasure" and "risk" of academic writing is a bridge too far, they are more receptive to thinking of their intellectual work in the terms of process and product. I will speak to this more fully in the conclusion, but submitting work to repeated revision with a purpose—a peer-reviewed first draft leads to an instructor-reviewed second draft and culminates in a final, graded draft—enacts the fluidity between process and product, subjecting a previously "complete" piece to further review and rewriting. In the mode of adaptation that Hutcheon limns, writers and filmmakers negotiate meaning through the processes of creation and reception. In this model, an emphasis on "modes of engagement" and response replaces obsessions over origin or originality. While I would not expect a first-year student writer to generate an "original" argument about, say, *The Awakening*, I would expect her to read and respond to what she sees in Chopin's novel, as well as what other writers have written about the text. Over the course of multiple drafts, I would also expect two things to occur. First, the student should improve upon her initial thinking and her original response to the text. Second, the question of originality should give way to a more sophisticated understanding of how writers contribute to ongoing disciplinary discussions through a process of repetition and variation that, in the best cases, leads to a more capacious understanding of a text, a historical context, a culture, or individual lives.

Covers and Reproductions

A useful way to help students think about their work as writers is through cover songs and other artifacts that remake cultural texts. Cover songs represent a unique, if narrow, form of adaptation since, even if they shift genre (R&B to rock 'n'roll), they stay in the same medium—music—and thus distinguish themselves from more traditional

literature-to-film adaptations. But precisely for this reason, cover songs and similar reproductions make a perfect analogy for academic writing as a process of revising and reworking both others' writing and one's own. Moreover, as texts that respond to and transform previous artifacts, cover songs and revised drafts epitomize Hutcheon's definition of adaptation as "a work that is second without being secondary" (9).

As Harris shows, the cover song also illustrates the concept of "rewriting." He notes, "The cover song, in which one musician reinterprets a song associated with another, is a staple of rock and roll. And what you listen for in a good cover is not an imitation of the original, . . . but a new rendering of it" (75). Don Cusic similarly defines a cover song as "one that has been recorded before" but that offers a unique interpretation (174). "A cover song," he continues, "allows new interpretations, new voices, and new audiences to rediscover [the original]" (176). Despite often writing in a defensive mode, Cusic makes a convincing case for the cover song as fertile ground for questions about originality that also lend themselves to adaptation and academic writing. According to Cusic, if we move past the stigma of inauthenticity or illegitimacy attached to artists who do not write their own music (172, 176), we can read cover songs for what they are, namely "a history lesson for a new, young audience who never heard the original" (174). Similar references to "inauthenticity" also haunt adaptations, but I am more intrigued here by the "history lesson." In the same way that a film adaptation might introduce an audience to a previously unknown novel and its attendant historical and cultural context, the cover is a mode of intertextuality and a critical reading of sorts that can draw attention to and elucidate an earlier version of the song. The vital element is the "new rendering."

Cover songs that switch or alter point of view along gender lines work especially well in the classroom to trigger the cultural transmission of new meaning. Harris mentions Aretha Franklin's feminist remake of Otis Redding's "Respect" (75). Big Mama Thornton's bluesy 1952 "Hound Dog" and Elvis's 1956 rock 'n' roll rendition provide material for a complementary discussion. The traditional folk song "House of the Rising Sun" (or "Rising Sun Blues"), made famous by The Animals in 1964, has inspired multiple variations. The Animals sing their version from the perspective of a young man brought low by a life of "sin and misery in the 'House of the Rising Sun.'" Joan Baez's and Bob Dylan's versions, from 1960 and 1962, respectively, both take the point of view of a young woman who, "led astray" by "a rambler," has been brought to "ruin" at the infamous brothel. Although these three renditions are contemporaneous, they raise (or obfuscate) different issues regarding gender, region, economic class, sex, and victimization in 1960s American culture. (Dylan's version offers an additional challenge for students tempted to limit the song's meaning to the performer's gender identity.)

In my "Remakes and Adaptations" seminar, our most productive discussions addressed Dynamite Hack's 2000 cover of NWA's "Boyz-n-the-Hood" (1987). Mickey Hess has written an insightful account of what it means for a white indie-rock band to cover a song by black rap artists from South Central Los Angeles and, in the process, not only provides a specific context for debates about originality and legitimacy, but also updates the often exploitative historical relationship between African-American

musical artists and the white singers and musicians who adapt their work. Hess writes, "Instead of presenting themselves as hip hop outsiders in a hip hop world, Hack's video self-representation shows the band living a privileged white lifestyle, totally isolated from the black inner-city life associated with NWA" (185). Tellingly, it is not the cover alone that achieves this, but rather the multimodal adaptation of the song as music video, which translates what might be considered mere parody into the framework for a critique of white privilege. This assortment of texts provides a perfect occasion for students to explore how interpretations and ideas proliferate across multiple modes of adaptation in which NWA's song, Hack's cover, the music video, and Hess's essay all play a role in uncovering further layers of meaning.[4]

Recalling the process and product of adaptation that Hutcheon describes, cover songs also serve as an ideal metaphor for the revising process: variation matters more than fidelity. Among scholars of adaptation theory, Stam has led the way in interrogating fidelity as the standard measure for judging adaptations. He considers fidelity an "inadequate trope" for the discussion of adaptation, offering instead "translation" ("Beyond Fidelity" 62)—translation, I take it, specifically as Walter Benjamin defines the term: "It is the task of the translator to release in his own language that pure language which is under the spell of another, to liberate the language imprisoned in a work in his re-creation of that work" (80). This relates to my perhaps generous notion of academic writing in terms of "repetition with variation" that flirts with both the pleasure of new insights and the risk of unsettling cherished convictions. Benjamin writes that "a translation issues from the original—not so much from its life as from its afterlife" (71). Writing about a text need not be a derivative art form, any more than a cover song is. In Benjamin's mode of thinking, writing and revision partake in the "afterlife" of the artwork and serve "to shine upon the original all the more fully" (79).

Although I've focused primarily on cover songs as exemplary adaptations here, my students also had a rare opportunity to consider this afterlife and how it applies to their work as academic writers. During the 2010–11 academic year, the Nasher Museum of Art at Duke University featured an exhibit entitled *The Record: Contemporary Art and Vinyl* (26 Aug. 2010–6 Feb. 2011). As the press release notes, the exhibit "explore[s] the culture of vinyl records within the history of contemporary art. Bringing together artists from around the world who have worked with records as their subject or medium, this groundbreaking exhibition examines the record's transformative power from the 1960s to the present" (*The Record*). The exhibit offered a case study for thinking through theoretical inquiries pertaining to adaptation and considering how artists repurpose and transform existing cultural artifacts. In "The Work of Art in the Age of Mechanical Reproduction," Benjamin examines the loss of "authenticity" and the "aura" through technological effects in the modern age, specifically through cinema and photography. The "authenticity" of the original, he writes, has to do with "its presence in time and space, its unique existence at the place where it happens to be" (220). *The Record* featured works by over forty artists that challenged students to rethink this argument and to contemplate how the "aura" can be remade or reconstituted across time—or, as Hutcheon

claims, how "adaptations are never simply reproductions that lose the Benjaminian aura. Rather, they carry that aura with them" (4).

This claim is illuminated by the provocative work of Dario Robleto from *The Record*. Robleto crafted his art objects from hand-ground and melted vinyl records and then reintroduced his art back into everyday consumer society. Consider Robleto's loquaciously titled "There's an Old Flame Burning in Your Eyes, or, Why Honky Tonk Love Is the Saddest Kind of Love" (1998) (Figure 37.1).

At first glance, one sees an ordinary box of matches, but as the plaque explains: "Vinyl records by Patsy Cline, Conway Twitty, Hank Williams, Tammy Wynette, and others were ground into powder, then melted and coated onto the head of each match. Boxes of these altered matches were laid on bars in several honkytonks around town, waiting for their chance to go out in flames" (*The Record*). At the risk of sounding esoteric, these matches encode silent quotations from a past cultural moment; they spark allusive flames. Robleto plays with multiple meanings of "second use" in his piece "Sometimes Billie Is All That Holds Me Together" (1998) (Figure 37.2).[5] The plaque reads: "Several new buttons were crafted from melted Billie Holiday records to replace missing buttons on found, abandoned, or thrift store clothing. After the discarded clothing was made whole again, it was redonated to the thrift stores or placed back where it was originally found" (*The Record*).[6]

The genius of these pieces resides in the way they conscript an unwitting "audience" to participate in and, in a way, complete the artistic remake—striking the match, buttoning the shirt. In the context of the exhibit, however, the way meaning emerges in these works also makes Robleto's art unique for a discussion of adaptation and writing. Robleto transforms artifacts to create a new object, but a significant portion of that new

FIGURE 37.1 Dario Robleto, "There's an Old Flame Burning in Your Eyes, or, Why Honky Tonk Love Is the Saddest Kind of Love" (1998).

Photo: Seale Studio, San Antonio.

FIGURE 37.2 Dario Robleto, "Sometimes Billie Is All That Holds Me Together" (1998).

Photo: Seale Studio, San Antonio.

object's impact evolves through the intertextual correspondence between the object and the exhibit plaque. The artifact and its explanatory text work together to make further meaning from a seemingly ordinary book of matches or pile of buttons. Robleto's cultural objects celebrate the afterlife of artwork and, as such, they reconstitute the aura by way of Benjamin's notion of translation. More pragmatically, however, the conversation between object and plaque gives students an accessible analogy for the intertextuality of adaptation and academic writing.

REVISION AND THE AFTERLIFE OF WRITING

I'd like to conclude by focusing on how adaptation, as both process and product, lends itself to discussions of revision in a writing seminar. In *Adaptation.*, as he tries, imperfectly, to articulate his vision for Orlean's *The Orchid Thief*, the onscreen Kaufman says, "It's great, sprawling *New Yorker* stuff, and I'd want to remain true to that. You know? I'd want to let the movie exist, rather than be artificially plot driven" (Kaufman 5). Kaufman confronts the more traditional struggle of how to "remain true" to the anterior text, and in part, the film explores how the process of writing frustrates that initial desire. Adaptation imagined as translation clarifies why "the transfer can never be total," why the process must "pursu[e] its own course according to the laws of fidelity in the freedom of linguistic flux" (Benjamin 75, 80). As Hutcheon suggests, "Just as there is no such thing as a literal translation, there can be no literal adaptation" (16). This is the difficult, at times mysterious work that *Adaptation.* dramatizes.

In academic writing, the question of "fidelity" resonates differently. The idea of representing the words and ideas of others in good faith—not taking words out of context or misrepresenting ideas for one's own gain—is a basic disciplinary shibboleth. Mere accuracy, though, does not take one very far, for writers must adapt those words and ideas to their own unique lines of thinking. Hence a prescription that perhaps more accurately links the task of the writer to the adapter-as-translator is "fidelity in the freedom of linguistic flux." Yet for me, the most interesting link between adaptation-as-translation and academic writing hinges on the question of fidelity as it pertains to the revising process. We might think of it in terms of remaining faithful to one's own purpose as a writer, even as one comes to terms with the difficult task of allowing subsequent revisions to pursue their own paths, which may be quite different from that of the original draft.

For as much as my writing and literature courses focus on how students can respond to, repurpose, and rewrite the words and ideas of others to compose interesting intellectual projects, I also invite students to adapt these strategies to their own writing. In his call to shake off the onus of fidelity, Stam urges critics to attend to the "dialogic responses" that adaptations perform: the "readings, critiques, interpretations, and rewritings of prior material" ("Beyond Fidelity" 76). While the projects that students write depend on precisely this kind of dialogic engagement with their research, this approach can also help them to view their own earlier drafts, or "prior material," in this critical, self-examining light.

In my "Remakes and Adaptations" seminar, the students and I spent a good percentage of our time thinking about the "afterlife" of their writing, both within the course and after the course. The latter sense might include the public life of essays that students publish, either in on-campus journals or other venues, but a stronger link can be forged between adaptation and transference. First-year writing seminars should introduce students to the intellectual life of college-level thinking and writing, but a fifteen-week course cannot give students the facility to navigate the demands of every discourse community they will encounter. In that sense, the afterlife of the seminar requires students—ideally with faculty support—to adapt and revise the skills and strategies they have learned to new contexts.

For my purposes here, and in keeping with how my own thinking about writing and revision has evolved, the afterlife of writing within the course remains more pertinent. I structure my writing seminars around two sequences of short essay assignments that culminate in a major project. Over the course of four or five weeks, students write three short essays (750–1000 words each), either in response to course readings or, in some cases, readings in conjunction with on-campus archival work. These short essays are "low-stakes" assignments: a chance for students to think through complex ideas and practice Harris's writing moves. Then, over the course of the following two or three weeks, students select one of those short essays and develop it into a more substantial writing project (1800–2000 words). To be clear, the point is not for the students simply to "add on to" the end of the earlier essay. Rather, I ask students to reimagine a more expansive line of inquiry, one that would require them not simply to refine what they had previously written, but to bring in new texts and ideas,

experiment with new lines of inquiry and, as a result, reconsider, reshape, and revise their arguments and analyses.

It can be a tough sell. Students who take the better part of a week (or even just a sleepless night) to write an essay often submit that draft convinced their work is done. Even if they know in advance that further writing awaits them, they remain committed at a deeper level to their own "intentional fallacy": the belief that they knew exactly what they wanted to say and, indeed, have already said it. Adaptation, with its emphasis on modes of intertextuality and repetition-with-a-difference, can help to unsettle that conviction. As I have argued here, adaptations and academic writing are responses to anterior texts in the name of generating new ideas, further meaning. The student-writer must become a critical reader and translator of her own ideas, but the work of revision is also a dialogic process—between student-writer and instructor and between student-writer and her peers—to uncover these possible meanings and to hone ideas and interpretations across earlier and later drafts.

While student-writers typically begin with a purpose—one often imposed by an assignment prompt—a working project is not the same as its realization. Getting students to begin writing before they know exactly where they will end up is the first step in undermining fidelity to what may be only a promising, inchoate idea. As Harris suggests, "The value of writing an early draft of an essay can sometimes lie in the chance it gives you to think your way through to the point, sometimes at the very end of your draft, where you've finally figured out what [it] is you want to say" (114). In this way, the revising process functions as a meaning-making intervention in one's own work, a process that shares in the vocabulary of adaptation: reading, rewriting, critique, translation, and interpretation. As suggested earlier, the revising process exemplifies Hutcheon's definition of adaptation as "a work that is second without being secondary" (9). More important, for me, adaptation and the afterlife of writing have influenced the way I discuss revising practices with my students, regardless of the course content. Whether teaching first-year writing or an upper-level literature seminar, I encourage students to cultivate responsive reading practices, and I try—through assignments, workshops, conferences, and written feedback—to help them become strong readers of their own work, to recognize the strengths and deficits in their own writing.

Ultimately, writing, like adaptation, is about choices. Stam writes, "Filmmaking generally, and adaptation in particular, involves thousands of choices" ("Introduction" 17). Writing involves a similar series of choices, and the revising process requires writers to select from an array of options. The student-writer must often sort through feedback from her peers and instructor, and these comments will pertain to different iterations of ideas at various stages of the project. In the end, the decision belongs to the writer, who must take ownership of those choices. Adaptation studies can help students comprehend this aspect of academic writing and reimagine their responsibilities as contributors to ongoing scholarly conversations. At its best, like the process of adaptation, writing offers discerning judgments, responds to and enriches our understanding of previous texts, and leaves the door open to further lines of inquiry.

Notes

1. For example, if before you assign the essay you spend part of a class period crafting definitions of "author," "text," and "reader" with your students, you have a ready-made prompt: "Identify three passages in which Barthes's text affirms your understanding of these key terms and three passages that challenge you to think about these terms in new ways." This gives them a way into the text and a starting point for the next class discussion.

2. Admittedly, Barthes also vacates this locus: "Yet this destination cannot any longer be personal: the reader is without history, biography, psychology; he is simply that *someone* who holds together in a single field all the traces by which the written text is constituted" (148).

3. For a brief discussion of how Lethem's essay treads the increasingly hazy "line between originality and compilation" in contemporary Web 2.0 culture, see Leitch 64–65. For an example of how to invite student-writers to "work in the mode of Jonathan Lethem" and compose "plagiarisms" of their own, see Harris, "Authorizing Plagiarism."

4. From a pedagogical perspective, Hess's article also usefully demonstrates the intertextual practice of academic writing, especially the way he plays sources off one another as he wends his way through difficult issues pertaining to originality, parody, and appropriation (see 183 and 187). In this way, the article makes a good case study for the writerly mode of reading I mentioned earlier, asking students to mark the passages Hess cites and to explain how he uses the ideas of other writers to develop his own line of argument.

5. My sincere thanks to Dario Robleto and Inman Gallery in Houston, TX, for permission to include these images. Thanks also to Lori Cassady, Assistant Director and Archivist at Inman Gallery, for facilitating my request.

6. These descriptions can be found on the artist page for Dario Robleto on *The Record* website <http://nasher.duke.edu/therecord/robleto-dario.php>.

Works Cited

Adaptation. Dir. Spike Jonze. Perf. Nicolas Cage, Meryl Streep. Columbia, 2002. DVD.

Barthes, Roland. "The Death of the Author." *Image–Music–Text*. Trans. Stephen Heath. New York: Hill and Wang, 1977. 142–48. Print.

———. *The Pleasure of the Text*. Trans. Richard Miller. New York: Farrar, Straus and Giroux, 1975. Print.

Benjamin, Walter. *Illuminations: Essays and Reflections*. Trans. Harry Zohn. Ed. Hannah Arendt. New York: Schocken, 2007. Print.

Cusic, Don. "In Defense of Cover Songs." *Popular Music and Society* 28.2 (2005): 171–77. Print.

Gladwell, Malcolm. "Something Borrowed." *New Yorker* 22 Nov. 2004. Web. 16 June 2014.

Harner, Devin. "*Adaptation, The Orchid Thief*, and the Subversion of Hollywood Conventions." *Beyond Adaptation: Essays on Radical Transformations of Original Works*. Ed. Phyllis Frus and Christy Williams. Jefferson: McFarland, 2010. 31–41. Print.

Harris, Joseph. "Authorizing Plagiarism." *Authorship Contested: Cultural Challenges to the Authentic, Autonomous Author*. Ed. Amy E. Robillard and Ron Fortune. New York: Routledge, 2015. 192–205. Print.

———. *Rewriting: How to Do Things with Texts*. Logan: Utah State UP, 2006. Print.

Hess, Mickey. "'Don't Quote Me, Boy': Dynamite Hack Covers NWA's 'Boyz-n-the-Hood.'" *Popular Music and Society* 28.2 (2005): 179–91. Print.

Hutcheon, Linda, with Siobhan O'Flynn. *A Theory of Adaptation*. 2nd ed. New York: Routledge, 2013. Print.

Kaufman, Charlie. *Adaptation: The Shooting Script*. New York: Newmarket, 2002. Print.

Leitch, Thomas. *Wikipedia U: Knowledge, Authority, and Liberal Education in the Digital Age*. Baltimore: Johns Hopkins UP, 2014.

Lethem, Jonathan. "The Ecstasy of Influence: A Plagiarism." *Harper's* Feb. 2007: 59–71. Print.

Lessig, Lawrence. *Free Culture: How Big Media Uses Technology and the Law to Lock Down Culture and Control Creativity*. New York: Penguin, 2004. Print.

MLA Handbook for Writers of Research Papers. 7th ed. New York: MLA, 2009. Print.

The Record: Contemporary Art and Vinyl. Organized by the Nasher Museum of Art at Duke University. 26 Aug. 2010–6 Feb. 2011. Web. 2 July 2014.

Stam, Robert. "Beyond Fidelity: The Dialogics of Adaptation." *Film Adaptation*. Ed. James Naremore. New Brunswick: Rutgers UP, 2000. 54–76. Print.

———. "Introduction: The Theory and Practice of Adaptation." *Literature and Film: A Guide to the Theory and Practice of Film Adaptation*. Ed. Robert Stam and Alessandra Raengo. Malden: Blackwell, 2005. 1–52. Print.

CHAPTER 38

..

HOW TO WRITE
ADAPTATION HISTORY

..

PETER LEV

THE history of Hollywood adaptations has not yet been written. There are hundreds of books and thousands of articles about film adaptations of novels and plays, but only a tiny percentage consider adaptation from a historical perspective. The two leading histories of Hollywood screenwriting, Tom Stempel's *FrameWork* and Marc Norman's *What Happens Next*, lack an index entry for the concept "adaptation," though Norman's book does discuss the 2002 film *Adaptation*. A typical article on film adaptation compares a novel and a film, or a play and a film, and books on adaptation just multiply the examples. Some of the more interesting works on this subject consider all the adaptations of a particular author's work—for example, Bruce Kawin's *Faulkner and Film*—but these are historical only within a very limited scope (how Faulkner has been adapted over time). A broader national cinema or international cinema context for adaptation history has been neglected.

How did the discipline, or subdiscipline, of adaptation studies become so ahistorical? The simple explanation is that the individuals who write about film adaptations usually come from literature departments, and they are primarily interested in a certain literary author or a set of canonical texts. So adaptations can be used as a way to explore Shakespeare, or Faulkner, or Virginia Woolf. There are a few additional benefits to this approach: first, one can begin to explore film language as well as written language; second, work on adaptation can potentially reach a larger audience than purely literary journal articles; third, it may be that standards of methodology and research are less rigorous in adaptation studies than in other branches of the humanities, because the field is relatively new. Scholars of adaptation are free to follow their passions in film and literary studies without constraint from well-established academic disciplines.

This explanation, however, is not entirely satisfactory. Although books and articles on adaptation may once have been written by literature professors with little knowledge of film studies, many graduate programs in literature and related disciplines currently provide a solid grounding in film history and theory. In addition, a number of writers

on adaptation have academic degrees in film studies and teach in film rather than litera-
ture departments. Even if this were not the case, one would expect humanities scholars
to have an appreciation of history and historiography. Why then are adaptation books
and articles so ahistorical, and why has no one tackled a history of Hollywood adapta-
tions? My more nuanced explanation would be that exploring the history of adaptations
is for various reasons difficult and time-consuming. Adaptation is clearly a process (of
translating a source text to a finished film), but that process is highly complex. To write
a history of adaptations in a given period and place, one would need to know how sto-
ries were chosen, how they were adapted for the screen, and who had an influence on
the final product. This would be a lot of work even for one film; it is far easier to avoid
production history and simply compare the source text and the finished film. Doing
a large-scale comparative analysis—several studios, many films—would be extremely
time-consuming. Also, an account of how stories were chosen and shaped in Hollywood
requires access to primary source documents such as studio records, script drafts, and
correspondence. These are unevenly available in research library special collections
(however, for Hollywood in the period 1930–1960, enough is available to provide a rea-
sonable picture of Hollywood filmmaking methods). Going through the primary source
materials would be time-consuming and often expensive, requiring substantial travel.
But since scholars have embraced archival research in many humanities disciplines, it's
surprising that they have not studied the history of adaptations.

A couple of well-known theories might also be discouraging adaptation scholars
from taking a historical approach. The auteur theory of film suggests that the director
is or should be the creative force beyond the movie, and therefore the director's artistic
personality is the key consideration in film history. Those who subscribe to this theory
have little reason to study production history, because subscribers know in advance that
the director is creatively in charge. The source text becomes unimportant in relation to
the director's shaping of the material. A curious alternative to the auteur theory appears
in Marc Norman's *What Happens Next*, which is concerned with the screenwriter—or
after 1960 the screenwriter-director—as the shaping force in Hollywood films. Norman
is not much interested in source texts, either. Another theory inhospitable to adaptation
history is intertextuality, as proposed by Mikhail Bakhtin and applied to film studies
by Robert Stam. Briefly, this theory proposes that a complex narrative such as a novel
(studied by Bakhtin) or a film (studied by Stam) combines many borrowings and influ-
ences, so that it is far too simple to speak of a unitary source text. This is a useful idea
that should not be taken to extremes. Yes, it is true that any film absorbs a number of
influences related to period, genre, creative personnel, formal strategies, and so on.
However, in many cases the source text (credited by the film, with rights purchased by
the production company) has a significant influence on the final product, and there-
fore should be studied in relation to the production process. Intertextuality can add to
an analysis of adaptation—for example, it is easy to see the Howard Hawks–Humphrey
Bogart–Lauren Bacall film *To Have and Have Not* (1944) as heavily influenced by the
earlier Bogart film *Casablanca* (1943), as well as by Hemingway's novel *To Have and
Have Not* (Schatz 425). But there are only a few cases in which the source text is more or

less irrelevant—for example, the film *Rebel Without a Cause* (1955), which supposedly used only the title of a nonfiction book about juvenile delinquency.

Dudley Andrew's *Mists of Regret*, an excellent cultural history of French film of the 1930s, does provide a precedent for what an American adaptation history could be. Andrew uses both statistics and qualitative analysis to show that French film changed from an emphasis on theatrical adaptations in the early 1930s to a concentration on novelistic adaptations later in the decade. For theatrical influence, he highlights not only such theater and film directors as Marcel Pagnol and Sacha Guitry, but also the presentation of musical, theater, and vaudeville performances in many 1930s films. For the move to more novelistic films, he talks about several intertwined factors, including novelists like André Gide and Roger Martin du Gard who were highly interested in film; the office formed by the publisher Gaston Gallimard to encourage novel-to-film adaptations; the influence of Emile Zola and of American realists such as James M. Cain; and the novelistic styles of certain filmmakers (115–72). A great strength of Andrew's book is his understanding of French film within the cultural and intellectual history of the period; he shows that artistic styles are influenced by a wide variety of cultural institutions, and that cross-media connections happen via these institutions. Not everything in Andrew's book is applicable to American cinema, for two reasons. First, the US film industry in the 1930s and 1940s operated on a larger scale and was far more commercialized than the French industry. Second, filmmaking in Hollywood developed in relative isolation from the cultural center of New York, and unlike their French counterparts, Hollywood filmmakers often drew on traditional models (Victorian novels, Broadway musicals, early twentieth-century realist theater) rather than contemporary trends. Nevertheless, *Mists of Regret* is a high-quality work that should inspire future ventures in US adaptation history.

Other scholars have given us a theory and a method for adaptation history but not a finished product. Linda Hutcheon's *A Theory of Adaptation* looks at the perplexing question of authorship in the section entitled "Who?" She concludes that authorship depends on both the medium and the specific project, but in film adaptation the crucial adapters are usually the screenwriter and the director (85). Note that the screenwriter, often excluded from auteurist criticism, is explicitly included by Hutcheon. She also examines the question of "Why" stories are adapted (how decisions are made about which stories to adapt), but her ideas here, like Andrew's, are not entirely applicable to the highly commercial Hollywood context. Using as her example a historical incident of Carmelite nuns executed during the French Revolution and adapted by such major figures as novelist Georges Bernanos and composer François Poulenc, Hutcheon proposes that stories are chosen based on deeply felt affinities between adapter and source text (108–9). Though this could happen in Hollywood under the studio system (approximately 1930–1960), in many cases stories were chosen according to their commercial potential and then were assigned to scriptwriters and directors.

Thomas Schatz's *The Genius of the System* (1988) pioneered the use of archival research to provide a sophisticated look at how Hollywood film production actually worked. Through alternating chapters on MGM, Universal, Warner Bros., and David O. Selznick's varied career, Schatz presents a large sample, though not a complete history,

of Hollywood from about 1930 to 1960. By delving into studio records, he is able to give detailed examples of how films developed via institutional hierarchies and collaborations between individuals. Schatz, like Hutcheon, argues for the collective authorship of movies, but to Hutcheon's creative dyad of screenwriter and director Schatz adds the creative producer. Irving Thalberg is presented as the key individual at MGM, Hollywood's leading studio of the 1930s, the producer who closely guided that studio's most important productions. By following story conference records for the film *Grand Hotel*, for example, Schatz is able to show how much Thalberg influenced that production (108–20). Though Schatz is not so interested in source texts, he does describe a fascinating moment when Thalberg and director Edmund Goulding sit down with the play script of *Grand Hotel* and go over that script in specific detail (111). Following Schatz's lead, an adaptation scholar could research play script, story conferences, film script drafts, editing notes, preview records, and so on to create an in-depth account of the adaptation of *Grand Hotel*. Some of this work has already been done in an article by Robert Spadoni that quotes extensively from story conference transcripts.

Simone Murray has recently contributed a cross-media, sociological analysis of contemporary adaptations in her book *The Adaptation Industry*. She finds that in the current world of media convergence the author, the book, the literary agent, and the screenwriter are part of a complex, interlinked network of production and publicity. Murray's book tells us a great deal about current practice—how an intellectual property contract is written, how a literary star author is publicized—but it is only intermittently historical. She is interested in the history of the book and the history of certain ideas (e.g., Barthes and Foucault's "death of the author" versus the auteur theory), but not in the history of the Hollywood studio system. She mentions only briefly the fact that current Hollywood works on a freelance system that is far different from the earlier "studio-system production line" (141). A researcher focused on earlier periods could emulate Murray's sociological perspective, but her specific findings would not be so helpful.

Despite the excellent work by Andrew, Hutcheon, Schatz, and Murray, a great deal remains to be done before we have an adaptation history of Hollywood film, or even one period of Hollywood film. We need to know how stories were chosen and how they were shaped by screenwriters, directors, producers, and other collaborators during the production process. And we need to do enough primary source research to be able to generalize about the history of a studio, or a few studios, or the entire industry. This essay will limit itself to Hollywood in the 1930s, but the principles suggested here should apply to any period.

How Stories Were Chosen

The eight largest Hollywood studios (MGM, Paramount, Twentieth Century–Fox, Warner Bros., RKO, Columbia, Universal, United Artists) all aspired to release about

fifty films per year, or one per week, except for United Artists. This created an urgent and continuing need for story material. In response, each studio had a department devoted to finding and summarizing stories, typically called the story department. The best published accounts of a story department come from Samuel Marx, who headed that department at MGM in the 1930s. Marx and his assistant Kate Corbaley supervised about a dozen "readers," who read and summarized plays, novels, short stories, and other potential sources. According to Marx, his department covered about 20,000 story properties in a year, or 400 per week. This was the Los Angeles–based story department, but MGM had a New York–based operation as well. Marx himself went back and forth frequently from Los Angeles to New York to keep in touch with Broadway theater and New York publishing houses. When the MGM story department found promising material, it was presented to Louis B. Mayer, Irving Thalberg, and the studio's producers by Kate Corbaley, who was a gifted oral story-teller. Producers learned to pay attention to Corbaley's recounting of a story when it diverged from the original. At one point Thalberg told producer Bernie Hyman, who was struggling with an adaptation, "Shoot the story Kate told!" (Marx, "Looking" 26). Marx, as story department head, also had some responsibility to assign screenwrit-ers to projects and supervise their work, though Thalberg had final authority on this matter.

What stories were story departments choosing, and how did they choose? Samuel Marx wrote about these questions in an article from 1937 and a book published fifty years later. Primary source research would be needed to provide a more complete pic-ture; the place to start would be the Paramount production records at the Margaret Herrick Library, Academy of Motion Picture Arts and Sciences. But we can also look at more accessible data and chart how many adaptations and what kinds of adaptations were made each year during the 1930s. Dudley Andrew reported such figures for French cinema by counting different types of adaptations for 1933 and relying on the refer-ence work *La cinématographie française* for 1937 (150). I have not found readily avail-able statistics for American film, but it is possible to count. The key resource here is *The American Film Institute Catalog of Motion Pictures Produced in the United States: Feature Films 1931–1940*.

In two volumes and more than 2,500 pages, the *AFI Catalog* provides basic informa-tion about every US-made feature film produced between 1931 and 1940. For all credited adaptations the source is listed, whether that source is a play, a novel, a short story, or something else. Very occasionally an obvious source is not listed. For example, a film entitled *The Divine Comedy* does not credit Dante's poem, though the catalog entry describes a relationship between film and poem. Aside from this bizarre exception, I counted all films with a listed source as adaptations, and all films without a source as originals. For films that are part of a series, the *AFI Catalog* does not always provide source information. In a few cases I could not tell if a film was an adaptation or an origi-nal, so I omitted it from the count. But these few omissions should not substantially affect the percentages of adaptations and originals I discovered.

Note that "original" is narrowly defined, and that non-adaptations are in most cases highly formulaic, for example low-budget Westerns, comedies, and crime films. Almost all films from low-budget studios such as Republic, Monogram, Producers Releasing Corporation, and even smaller companies were originals, and many such films reached only small audiences. Therefore, I limited myself to counting only the releases of the eight major studios, and even there I found that Columbia and Universal (both low-budget specialists) had many more originals than adaptations; however, Columbia and Universal remained in the mix. I still would have had thousands of films to count, so I limited this project to a sample: all the major studio entries from "A" to "D," or more than 20% of the 2,509 pages devoted to film entries. The results (Table 38.1) should be fairly close in representing the total mix of adaptations and originals in Hollywood of the 1930s.

Table 38.1 Adaptations versus Originals from *AFI Catalog 1931–1940*, Entries for "A" through "D"

		Total	Percentage
1931	Plays	12	17
	Novels	19	27
	Short stories	5	7
	Originals	34	49
1932	Plays	21	34
	Novels	14	23
	Short stories	0	0
	Originals	27	44
1933	Plays	16	22
	Novels	15	21
	Short stories	7	10
	Originals	35	48
1934	Plays	15	21
	Novels	22	31
	Short stories	3	4
	Originals	32	44
1935	Plays	10	12
	Novels	24	30
	Short stories	9	11
	Originals	38	47
1936	Plays	2	3
	Novels	18	26
	Short stories	11	16
	Originals	39	56

(Continued)

Table 38.1 Continued

		Total	Percentage
1937	Plays	12	16
	Novels	11	14
	Short stories	5	7
	Originals	48	63
1938	Plays	10	14
	Novels	13	18
	Short stories	2	3
	Originals	46	65
1939	Plays	10	16
	Novels	19	31
	Short stories	4	6
	Originals	29	47
1940	Plays	13	19
	Novels	14	20
	Short stories	2	3
	Originals	41	59

Additionally, the sample includes eight films based on comic strips, five based on films (generally remakes of foreign films), and one each based on an opera, operetta, radio drama, nonfiction articles (*Confessions of a Nazi Spy*, 1939), and legends (*The Adventures of Robin Hood*, 1938). If these were added to the chart, the percentage of adaptations would increase slightly. Note that a few films credit both a play and a novel as sources; in this case, I counted the first credited source only.

What can we learn from these figures? First of all, the eight major studios made a tremendous number of films between 1931 and 1940: more than 3,500. Among these films, there were many adaptations of plays and novels and not so many adaptations of short stories. The percentage of originals in a given year ranged from 44% in 1932 and 1934 to 65% in 1938. The ratio between play and novel adaptations varied tremendously from year to year, but there does seem to be some drop-off in play adaptations in the second half of the decade. More striking is the increase in the percentage of originals versus adaptations, beginning in 1936. We can highlight these changes by comparing 1931–1935 to 1936–1940 (Table 38.2).

Based on these figures, it would be hard to posit a golden age for play adaptations in 1931–1935 and then a golden age of novel adaptations in the second half of the decade. Instead, novelistic adaptations were more numerous than theatrical adaptations for both half-decades, and though the gap in percentages grew a bit in 1936–1940, this difference is probably not significant. But what explains the larger percentage of originals in 1936–1940? Film historian Tino Balio has documented what happened at one studio,

Table 38.2 Adaptations versus Originals, 1931–1935
and 1936–1940

	Plays	Novels	Originals
1931–1935	21%	26%	46%
1936–1940	13%	21%	57%

Warner Bros. In 1934, studio president Harry Warner put a cap on the yearly funds available to buy movie rights for novels and plays, thus reducing the percentage of adaptations in the studio's output. This economy move, in place until 1941, put greater emphasis on original scripts by the studio's staff writers (99–100). Balio does not indicate whether other studios followed Harry Warner's lead.

As mentioned earlier, the process of going through several hundred film descriptions from the *AFI Catalog* for 1931–1940 suggests that lower-budget films from Columbia, Universal, and even the five largest studios—MGM, Paramount, Fox, Warner Bros., RKO—were very likely to be originals, whereas higher-budget films were likely to be adaptations. For example, at Twentieth Century–Fox in the second half of the decade, films supervised by Sol Wurtzel, the head of the "B" picture unit, were almost always originals, whereas films supervised by Darryl Zanuck, the head of production in charge of the "A" pictures, were usually adaptations. If adaptations were indeed the higher budget and more prestigious products of the 1930s, then it would be useful to know the percentage of novel, play, and story adaptations in relation to the prestige films of the decade. Academy Award nominations for "Outstanding Picture," 1930–31 to 1940, provide a rough way to measure the extent to which Hollywood's most lauded films were adaptations. The measurement is rough because of the subjectivity and film industry politics involved in how Academy members voted. In addition, the number of films nominated for "Outstanding Picture" varied considerably from year to year: five films were nominated in 1930–31, but this number rose to twelve films in 1934.

If we compile a chart of adaptations versus originals using data from the Academy of Motion Picture Arts and Sciences website (oscars.org) and the Internet Movie Database (imdb.com), the figures look somewhat different from those derived from the AFI Catalog (Table 38.3).

Looking once again at half-decades and percentages, we arrive at the figures shown in Table 38.4.

Charting the films nominated for Outstanding Picture confirms the idea that prestige pictures were more likely to be adaptations than originals. In comparison to our sample of all major studio films produced in 1931–1940, which showed originals comprising about 50% of the total, the percentage of originals nominated for Outstanding Picture was only 19% in 1931–1935 and 27% in 1936–1940. The percentage of both plays and novels was higher in films nominated for Outstanding Picture than in the general sample, and in both 1931–1935 and 1936–1940 novels comprised a higher percentage than

Table 38.3 Adaptations versus Originals, Films Nominated for Outstanding
Picture, 1931–1940

	Plays	Novels	Stories	Originals	Other
1930–1931	1	2	2	0	0
1931–1932	3	2	2	1	0
1932–1933	2	4	1	3	0
1934	3	3	1	3	2
1935	3	7	1	1	0
1936	1	3	2	4	0
1937	3	3	1	2	1
1938	3	1	1	4	1
1939	1	5	2	1	0
1940	3	5	2	0	0

Table 38.4 Adaptations versus Originals, Films Nominated for
Outstanding Picture, 1931–1935 and 1936–1940

	Plays	Novels	Originals
1931–1935	26%	38%	19%
1936–1940	22%	35%	27%

plays. However, breaking down the year-by-year accounts of Academy nominees, we find that the greater representation of novels over plays is primarily a function of two Award years, 1935 and 1939. Theatrical adaptations were nominated almost as frequently as novel adaptations in 1931–1934, and exactly as frequently in 1936–1938. In his 1937 article, Samuel Marx wrote that plays were the most desirable form of film material because plays, like film scripts, were mostly dialogue. Plays, therefore, commanded the highest prices (27). Marx went on to say, "Plays have lately become the bulk of material purchased for the screen" (27), a statement that does not seem to be true for the Hollywood studios in general but may have been true for MGM. At any rate, Andrew's discussion concerning France in the 1930s of a period dominated by play adaptations followed by a period dominated by novel adaptations does not match the statistics for prestige pictures in the United States. There may be subtle variations between which type of adaptation was favored in which year or years, but the Hollywood studios made numerous theatrical and novelistic adaptations throughout the 1930s.

The Academy Award charts show a rise in originals in the latter half of the 1930s, but this change may be primarily due to a limited definition of adaptation. Tino Balio, quoting the trade paper *Motion Picture Herald* from 1936, lists four main types of prestige pictures: "nineteenth century European literature"; "Shakespearean plays"; "best-selling

novels and hit Broadway plays"; and "biographical and historical subjects" (179–80). The first three categories would be listed in the *AFI Catalog* as adaptations, but the biographies and historical works might or might not be classified as adaptations. For example, *The Story of Louis Pasteur* (1935) credits no written source and is therefore an original, whereas *The Life of Emile Zola* (1936) credits a non-fiction book and therefore in my typology would be an "other" adaptation (not a play, novel, or short story). If we removed biographies and historical works from the "original" category, then adaptations would be even more preeminent among the prestige films of the 1930s.

How Stories Were Adapted

Story properties were usually acquired for specific production projects, rather than on the general principle that "this is a good story, we might use it someday." Studio executives often approved buying the rights for a novel, play, or story because they had a cast and/or a director in mind. Or a producer or director would indicate the desire to film a certain story, and the studio would then acquire the rights. In some cases, actors brought story material to the studios even in the 1930s, long before independent production companies headed by actors or directors became the norm. For example, Katharine Hepburn chose her own material at MGM in the late 1930s and early 1940s (Schatz 363–64). Writers generally did not control what stories they would work on unless they had pitched an original to the studio. Since studio films in the 1930s were always team projects, a key question for Hollywood adaptation studies is how much influence a screenwriter or screenwriters had on the story, structure, characters, and tone of an adapted film.

One popular image of how film adaptation works is that the screenwriter sits down with a book or play and over weeks or months crafts a production-ready script. This does in fact happen, but the process is far from solitary. Via story conferences, various higher-ups, including the producer, the director, and perhaps the head of production counsel the writer on what should go into the script. It is a team job, and the writer is not the team leader. Samuel Marx reported that sometimes the writer would not even be invited to a story conference because important decisions could be made without him or her (Marx, "Looking" 23). Darryl Zanuck, more judicious, wrote in a memo to William Wyler and Philip Dunne that he saw a film as a collaboration belonging one-third to the writer, one-third to the director, and one-third to himself as creative producer (Lev 46). That sounds reasonable, except that Zanuck was talking about *How Green Was My Valley* (1941), the adaptation of a novel by Richard Llewellyn, and Zanuck gave zero credit to the author of the source text.

In the transformation of a novel or play to film, it was often the writer and only the writer who paid attention to the source text. Nunnally Johnson, perhaps the top writer at Zanuck's studio, Twentieth Century–Fox, deflected attention from his own achievement as screenwriter of *The Grapes of Wrath* by saying the film owed a great deal to novelist John Steinbeck (Froug 239). Playwright and screenwriter Sidney Howard, in an article

about the screenwriter's craft, discussed a hypothetical adaptation of a Sinclair Lewis novel. The most eye-catching point of this supposedly conjectural example (Howard had already adapted two Sinclair Lewis novels) was Howard's comment that the producer and the director probably had not read the novel at all, whereas the writer would have thoroughly read and reread it. Howard described the first story conference as the moment that "he [the writer] tells the producer and director the story of the picture" (35). Interestingly, both Johnson and Howard talked about screenwriting as a trade rather than an artistic endeavor, with Johnson comparing his adaptation work to the craft of a "cabinetmaker" (Froug 245). The more cynical Howard described screenwriting as "adaptation hack-writing, cut to the dimensions of the director's demands," and added, "The screen does not yet ask of its writers much more than technical ingenuity" (32). Nevertheless, any account of the process of adaptation must start with the screenwriter's work.

Let me depart briefly from the 1930s to recount my experience of going through multiple script drafts to analyze the adaptation of *Cleopatra* (1963). This film was, of course, a legendarily extravagant and poorly managed production. Omitting the several script drafts for the first, canceled version of this *Cleopatra*, starring Elizabeth Taylor and directed by Rouben Mamoulian, there are still well over a thousand script pages for the second version, again starring Taylor but directed by Joseph L. Mankiewicz. For the second version Nunnally Johnson, Laurence Durrell, Sidney Buchman, Ranald MacDougall, and Mankiewicz himself wrote script pages. Buchman, MacDougall, and Mankiewicz received screen credit, but the shooting script seems to be almost entirely Mankiewicz's work. MacDougall and Buchman were supposed to help with structure, and perhaps they did. Nunnally Johnson wrote a witty partial script in the style of Cecil B. DeMille's *Cleopatra* (1934); it was not used at all, but would interest scholars researching Johnson's career. Durrell wrote only a few scenes, and his main innovation was presenting the reactions of Rome's ordinary citizens to Cleopatra's parade (a bit of Durrell's emphasis on ordinary people may survive in the final film). So Mankiewicz was the primary screenwriter, the person who absorbed the story as told by Plutarch, Suetonius, Appian, and the modern author C. M. Franzero, and then turned it into a screenplay.

Going through the script drafts produced a number of insights on the production process and the finished film, including the following:

1. Mankiewicz stayed fairly close to Plutarch, whom he acknowledged in interviews as the main historical source of the movie.
2. Though Mankiewicz enormously admired Shakespeare, he tried not to borrow or duplicate scenes from Shakespeare's *Julius Caesar* or *Antony and Cleopatra*. For example, the death of Julius Caesar, which Mankiewicz had already filmed in his adaptation of the play *Julius Caesar* in 1953, is presented in *Cleopatra* only via a brief montage.
3. Mankiewicz wrote a very long final draft script, more than 300 pages, and therefore Twentieth Century–Fox should not have been surprised that the director's cut of the film was five and a half hours long—but Fox was surprised and appalled.

4. When Fox cut the film to four hours for release, Mankiewicz and some of the actors protested that their creative work had been compromised and a masterpiece had been destroyed. Looking at script drafts, I found no potential masterpiece, but the character of Octavian (played by Roddy McDowall) did lose some important scenes from script to film.

5. The final script draft gives only minimal indications of the battle scenes, even though *Cleopatra* was supposed to be an epic spectacle. The studio tried to fix this by re-scripting and re-shooting after the director's cut, but without much success.

Reading the many script drafts confirms the tremendous waste of *Cleopatra*'s production, including the waste of fine scenes written by Johnson and Durrell. It also provides a greater understanding of the sources and the priorities of writer-director Mankiewicz (Lev 243–50, 253–55). Without this kind of primary source research, which is very much the exception in adaptation studies, our field is missing a vital tool.

The process of adaptation is not complete with the screenwriter's work. It is next transformed by the director and the actors, along with a number of other talented contributors (the cinematographer, art director, editor, composer, and so on). But here we encounter a methodological problem: How does one discuss the director as adapter when he or she may not have even read the source text? The answer is fairly straightforward. The director is not trying to duplicate the source text; he or she is trying to make an audience-pleasing movie. If the source text is well-loved and reasonably close fidelity is desired, an activist producer like Irving Thalberg or David O. Selznick may monitor the production. In other cases, the director may be responding to the source text only as refracted by the screenplay. In the film version of *The Grapes of Wrath*, director John Ford basically shot Nunnally Johnson's script, which had been influenced by producer/head of production Darryl Zanuck. Yet Ford, cinematographer Gregg Toland, and actors including Henry Fonda, John Carradine, and Jane Darwell also added a great deal to the film: realism, lyricism, respect for the poor families fleeing the dustbowl. John Steinbeck, author of the source text, admired the film and recognized that it was distinct from his novel, though certainly related. He described the film as "a hard, straight picture . . . in fact, with the descriptive matter removed, it is a harsher thing than the book, by far" (Lev 61). Steinbeck attributed the authorship of the film to Zanuck, rather than to Nunnally Johnson or John Ford; in a complex collaboration, it is not a bad idea to look to the person at the top. Nevertheless, we, as historians and critics, should also examine the screenwriter, the director, and other creative participants as shapers of the film.

TOWARD ADAPTATION HISTORY

What would a thoughtful and reasonably thorough adaptation history look like? It would obviously need an organizing principle that allowed for coverage of many films. One approach would be organization by source text, meaning that in a study of English

novels-to-films all the adaptations of Dickens would be covered, along with adaptations of Fielding, Austen, Hardy, and others. This approach has the value of building on what has already been done, but the emphasis on source texts probably precludes attention to who made adaptations, under what circumstances, and with what results. Organization by source text would lead to a very fragmented history. More promising to me would be an emphasis on adaptations in relation to production history. A complete international history of adaptation based on production history and primary sources would probably be far too ambitious, but one could start with a national cinema in a defined period, a studio such as Warner Bros., or a film movement such as the French New Wave. A study of one individual, even a much-discussed writer-director, strikes me as too isolating, too much a monograph rather than an expansive history.

How should adaptation history relate to the literary and cinematic canons? Articles and books on adaptation have generally adhered to both canons, and especially to the literature that is frequently taught in college and secondary school classrooms. For example, the journal *Adaptation* describes itself in a subtitle as *The Journal of Literature on Screen*, thus prioritizing literature. An article by Carolin Overhoff Ferreira in *Adaptation* that departs from canonical sources specifically places the word "non-canonical" in the title, perhaps as a warning to readers. *Literature/Film Quarterly* gives equal weight to literature and film in the journal title—indeed, the cover graphic could also be read as "Film/Literature Quarterly"—but it too puts great emphasis on the literary canon, especially in its yearly issues on "Shakespeare and Film." Both journals only occasionally publish articles involving source texts from humbler media such as comic books. By contrast, the volume in which this essay appears includes essays on comic books, videogames, and other kinds of sources and adaptations. It seems to me that an adaptation history of Hollywood would need to consider whatever source texts are being adapted in a particular period. So for the 1930s Charles Dickens and Somerset Maugham would need to be included, but also Dashiell Hammett, W. R. Burnett, and the playwright Aurania Rouverol, whose 1928 play *Skidding* initiated the Andy Hardy franchise.

Adaptation history focused on an individual Hollywood studio would seem to be a fruitful avenue of study, for here we find an organization and a well-defined system of production, and therefore the chance to discover how story properties were chosen, who did what in preparing an adaptation, and whether the studio specialized in certain cycles or genres of adaptation. Some recent case studies have been done on how the studios handled adaptation in the 1930s. Despite its promise, this work still has problems, including limited primary source research, neglect of the screenwriter, and little or no attention to adaptation as a process. Leslie Kreiner Wilson's article on *Dinner at Eight* does focus on a screenwriter, Frances Marion, but approaches her work through published sources (by Marion and others) rather than archival material. Wilson mentions that adaptation at MGM should be analyzed as "first and foremost a *business*" (373); that this point needs to be made emphasizes adaptation studies' lack of historical and economic grounding. Wilson's article describes tensions between Mayer, Thalberg, and Selznick at MGM, but has little to say about what Selznick, the producer, contributed to *Dinner at Eight*. Wilson's most valuable research involves censorship. Here she delves

into primary sources to show how the script changed in relation to both US and British censorship concerns (376–80). As her article demonstrates, Hollywood's internal censors were often part of the authorship of a film.

Patrick Faubert's essay on *Anthony Adverse* presents a sophisticated theoretical framework for case studies but is disappointing on the process of adaptation. He develops a framework for describing adaptation via "appropriation, intertextuality and authorship" (182), not claiming to originate any of these ideas. "Appropriation" proposes that an adaptation uses a source text to respond to a new social-cultural environment, thus becoming a work distinct from the source text. Faubert then discusses the adaptation of *Anthony Adverse* as a response to the Great Depression specifically tailored for US audiences. Faubert has done no primary source research as far as I can tell, depending heavily instead on Nick Roddick's *A New Deal in Entertainment: Warner Brothers in the 1930s*. His description of the "three authorial figures" for the film *Anthony Adverse* is intriguing for both inclusions and omissions. To Faubert, the authors involved are Hervey Allen, the novelist and a big part of the publicity for the film; stars Fredric March and Olivia de Havilland; and the Warner Bros. studio itself (191–93). These are all helpful choices, with the star images of March and de Havilland and the corporate strategy and "house style" of Warners definitely contributing to the film. But what about the screenwriters, the director, and the producers? What was the process within Warner Bros. that transformed a wildly popular novel into a prestige film? Faubert provides a good deal of context but is strangely mute about the process of adaptation.

The most ambitious recent study of Hollywood adaptations in the 1930s is Guerric DeBona's book *Film Adaptation in the Hollywood Studio Era* (2010), which includes case studies of *David Copperfield* (1935), Orson Welles's unproduced *Heart of Darkness*, and *The Long Voyage Home* (1940). DeBona often takes a simplistic view of film authorship: Selznick is the unique adapter of *David Copperfield*, and *The Long Voyage Home* shows director John Ford adapting plays by his friend Eugene O'Neill. Other contributors like George Cukor (director of *David Copperfield*) and Dudley Nichols (screenwriter of *The Long Voyage Home*) are barely mentioned. DeBona's Great Man approach to authorship better fits the *Heart of Darkness* script because Welles was writer, director, and originator of the project. In addition, the film was never made, so there is no need to describe complicated teamwork during production. Like Wilson and Faubert, DeBona has useful things to say about the social and cultural context of the three projects. For example, he describes how Charles Dickens was widely read in US schools in the 1930s, thus creating a large potential audience for Dickens adaptations (41, 47–50). On the whole, however, DeBona has done little primary source research. The Welles chapter benefits from quotations from the *Heart of Darkness* script, which for many years was available only in a few archives but is now accessible online. There is also one citation from an RKO memo on conflicts between Welles and the studio involving budget. The *David Copperfield* chapter includes one citation from archival material as well, this one on art direction and costumes. Like the Wilson and Faubert case studies, DeBona's chapters on *David Copperfield* and *The Long Voyage Home* could benefit from more research on the process of adaptation within a particular studio.

INTERTEXTUALITY

Intertextuality poses questions about the possibility of adaptation history and the idea of adaptation itself. If any text is a tissue of intertexts, then instead of adaptations we should be talking about an endless pattern of diverse and hybrid but related texts. Such a pattern would rely to some extent on a given audience's subjectivity and experiences, and could extend the pattern freely in time, so that when we see Ward Bond in *The Grapes of Wrath* we would connect his performance not only to earlier films, but to Ward Bond performances that he had not yet given in 1940. Robert Stam, the leading exponent of intertextuality in adaptation studies, is a virtuosic critic with an impish sense of humor; Bakhtinian intertextuality lends itself to both virtuosity and humor. In *Literature through Film: Realism, Magic and the Art of Adaptation* (2005), Stam argues strenuously against fidelity criticism and the bromide that "the novel was better than the film," then spends five chapters subordinating film adaptations to key moments in the history of the novel. His key moments or tendencies are *Don Quixote, Robinson Crusoe,* Henry Fielding's reflexive novels (*Joseph Andrews* and *Tom Jones*), *Madame Bovary,* and *Notes from Underground,* and in each case he develops intertextual strings of novels and films connected to these tendencies. In Chapter 6, Stam reverses himself and discusses the French New Wave as an autonomous movement related to various literary tendencies but not subordinated to them. At the center of the New Wave chapter is an intertextual adaptation study of Jean-Luc Godard's *Contempt.* In the concluding Chapter 7, Stam turns to South American magical realism and finds a few adaptations like *Macunaima* and *Erendira* that are different but of approximately the same quality as the source novels.

Stam's book is excellent criticism, but is it a model for adaptation history? Well, not exactly. It lacks the consistency and the interest in process that I would expect of an adaptation history. Stam's focus wanders a bit. His five key moments in the history of the novel eventually morph into two conflicting traditions, the parodic, self-reflexive hybridity of Cervantes versus the realist tradition of Defoe. Then, since he doesn't like either the prose style or the Eurocentric ideas of *Robinson Crusoe,* the book morphs again into a broad study of the Cervantic and Rabelaisian tradition of reflexivity and the carnivalesque. The way Stam uses adaptations is also problematic because the best or most characteristic adaptations do not necessarily develop around a few literary masterpieces. For example, a study limited to the various adaptations of *Madame Bovary* would not be presenting peaks of adaptation history. The string of adaptations based on a single work is similar to the conventional, *Faulkner and Film* approach discussed at the beginning of this essay, and leads to a narrow conception of adaptation history dominated by the literary canon. To be fair, Stam does sometimes make conceptual leaps away from this approach, as when a discussion of unreliable narration in *Notes from Underground* leads him to consider the unreliable narration of *Lolita* and its adaptations. Stam also tells us that Orson Welles was "[a]rguably one of the most 'Cervantic' of directors" (44),

and elaborates on this theme for a few paragraphs before analyzing Welles's unfinished adaptation of *Don Quixote*.

As to the process of adaptation, Stam, like many scholars of adaptation history, is not particularly interested in the economic side of filmmaking or the subtleties of cinema authorship. He does reference this material on occasion, most strikingly in relation to Godard's conflicts with his producers during the production of *Contempt*. Here the production situation is also part of the film's diegesis (*Contempt* is about making a film, with conflicts between screenwriter, director, and producer), and Stam describes the self-reflexive slipping of levels (284–94). Stam also occasionally talks about censorship—for example, the limits on Kubrick's version of *Lolita* (230–31). He is generally content with individual authorship of a film, accepting the French New Wave idea of the director as author. Since he writes mainly about non-Hollywood art films, this decision is often not as problematic as it might be, though it would be helpful to hear about production conditions and film authorship in Latin American films. The more profound challenge to authorship in Stam's work is the notion of a free-flowing intertextuality, spanning continents and centuries, but in most of the sections on specific adaptations I find a strange disjunction. On the one hand, relationships between source text and adapted text are presented in a fairly conventional way. On the other hand, Stam, following Bakhtin, delights in presenting culture as transgressive, heteroglossic, and carnivalesque.

Though Stam describes his work as a history (1), he might also accept the label "hyper-textual cornucopia" (37), a phrase he uses to describe the many adaptations of *Don Quixote*. The explosive abundance of his cornucopia does not completely mesh with history because it goes back and forth in time and strongly reflects the critic's subjectivity. Stam describes the organizational principle of his study as largely aesthetic, though he does not categorize aesthetic trends in the manner of André Bazin; instead, he presents his passion for the parodic, self-reflexive mode of literature and film. So this is a loosely organized, imperfect book; it is also, in its originality and passion, an important book for any student of literature and film.

CONCLUSION

Adaptation studies in general is flourishing in the twenty-first century, but we know surprisingly little about the history of Hollywood adaptations. Despite the high-quality graduate schools, peer-reviewed journals, and scholarly books associated with adaptations, one would search in vain for an adaptation history based on primary source research. Adaptation scholars have not felt the need to explore via studio records how adaptations were made at MGM, Paramount, and Warner Bros. Simone Murray's work on the adaptation industry has yet to be extended to a historical view of Hollywood. Dudley Andrew's *Mists of Regret* has no close analogue in American film history, and Thomas Schatz's pioneering work on the US studio system has been largely ignored by adaptation studies. We do not even have a good sense of

what primary sources are available. Adaptation scholars need to learn that the David O. Selznick collection is at the University of Texas and the Warner Bros. Archives are at the University of Southern California, and that research on Selznick or Warners should consult those collections.

Some years ago the field of film studies experienced a "historical turn." Scholars gradually abandoned post-structuralism, which had dominated the 1970s and early 1980s, to look at questions that Lacan and Derrida could not answer: Who made the movies, and how, and why, and for whom? Film historians like David Bordwell, Janet Staiger, and Kristin Thompson (*The Classical Hollywood Cinema*, 1985), Douglas Gomery (*The Hollywood Studio System*, 1986), and Thomas Schatz led the way to a more pragmatic understanding of Hollywood film production. I hope that the same turn toward history and empiricism will eventually come to adaptation studies. We have had a very good theoretical discussion of film adaptations led by Linda Hutcheon, Thomas Leitch, Robert Stam, and others—a discussion more open and less doctrinaire than the 1970s post-structuralism referenced earlier. Now we need to get our hands dirty and see how adaptations were actually shaped, in Hollywood and around the world.

Works Cited

Andrew, Dudley. *Mists of Regret: Culture and Sensibility in Classic French Film*. Princeton: Princeton UP, 1995.

The American Film Institute Catalog of Motion Pictures Produced in the United States. Vol. F3, *Feature Films, 1931–1940*. Berkeley: U of California P, 1993.

Balio, Tino. *Grand Design: Hollywood as a Modern Business Enterprise, 1930–1939. History of the American Cinema*, vol. 5. Ed. Charles Harpole. Berkeley: U of California P, 1995.

Bordwell, David, Janet Staiger, and Kristin Thompson. *The Classical Hollywood Cinema: Film Style and Mode of Production to 1960*. New York: Columbia UP, 1985.

Cleopatra. Dir. Joseph L. Mankiewicz. Perf. Elizabeth Taylor, Richard Burton. Twentieth Century–Fox, 1963.

DeBona, Guerric. *Film Adaptation in the Hollywood Studio Era*. Urbana: U of Illinois P, 2010.

Faubert, Patrick. "'Perfect Picture Material': Anthony Adverse and the Future of Adaptation Theory." *Adaptation* 4.2 (2011): 180–98.

Ferreira, Carolin Overhoff. "Non-inscription and Dictatorship in Non-Canonical Adaptations— *A Bee in the Rain* (1972) and *The Dauphin* (2001) by Fernando Lopes." *Adaptation* 3.2 (2010): 112–31.

Froug, William. *The Screenwriter Looks at the Screenwriter*. New York: Dell, 1972.

Howard, Sidney. "The Story Gets a Treatment." Naumberg 32–52.

Hutcheon, Linda, with Siobhan O'Flynn. *A Theory of Adaptation*. 2nd ed. London: Routledge, 2013.

Gomery, Douglas. *The Hollywood Studio System*. New York: St. Martin's, 1986.

Kawin, Bruce. *Faulkner and Film*. New York: Ungar, 1977.

Lev, Peter. *Twentieth Century–Fox: The Zanuck-Skouras Years, 1935–1965*. Austin: U of Texas P, 2013.

Marx, Samuel. *A Gaudy Spree*. New York: Franklin Watts, 1987.

———. "Looking for a Story." Naumberg 16–31.

Murray, Simone. *The Adaptation Industry: The Cultural Economy of Contemporary Literary Adaptation*. New York: Routledge, 2012.

Naumberg, Nancy, ed. *We Make the Movies*. New York: Norton, 1937.

Norman, Marc. *What Happens Next: A History of American Screenwriting*. New York: Three Rivers, 2007.

Roddick, Nick. *A New Deal in Entertainment: Warner Brothers in the 1930s*. London: BFI, 1983.

Schatz, Thomas. *The Genius of the System: Hollywood Filmmaking in the Studio Era*. New York: Pantheon, 1988.

Spadoni, Robert. "Geniuses of the Systems: Authorship and Evidence in Classical Hollywood Cinema." *Film History* 7.4 (1995): 362–85.

Stam, Robert. *Literature through Film: Realism, Magic, and the Art of Adaptation*. Malden: Blackwell, 2005.

Stempel, Tom. *Frame/Work: A History of Screenwriting in the American Film*. New York: Continuum, 1988.

Wilson, Leslie Kreiner. "Frances Marion, Studio Politics, Film Censorship, and the Box Office: Or, the Business of Adapting *Dinner at Eight* at MGM, 1933." *Literature/Film Quarterly* 42.1 (2014): 373–85.

ADAPTATION THEORY AND ADAPTATION SCHOLARSHIP

KAMILLA ELLIOTT

IN 2003, Thomas Leitch published a critique of adaptation scholarship, entitled "Twelve Fallacies in Adaptation Studies." The first fallacy, that "there is such a thing as contemporary adaptation theory," leads to eleven others, critiquing either adaptation studies' adherence to fallacious theoretical tenets or its failure to adopt credible ones (149). Leitch's fallacies build on Robert B. Ray's critique of "The Field of 'Literature and Film'" (2000), then the main locus of adaptation studies, an essay similarly describing adaptation scholarship as "ultimately antitheoretical," "thoroughly discredited," and "irrelevant" (45–6). For Ray, adaptation scholarship floundered and was justly marginalized by film studies because it lacked "a presiding poetics" (44) and had failed to embrace the theoretical turn in the humanities—that is, the shift from humanist, formalist, aesthetic scholarship focused on high-art, canonical works and their civilizing properties to scholarship informed by Marxist, post-structuralist, and postmodern studies of all manner of works and from objectivist, historical, existential, and Freudian theories to abstract philosophical, New Historical, phenomenological, and Lacanian theories. Leitch and Ray, together with Robert Stam and others in James Naremore's influential volume *Film Adaptation* (2000), proposed replacing New Criticism, aesthetic formalism, and simple comparative criticism with a democratizing Barthesean intertextuality, a Derridean deconstruction of originals and copies, Bakhtinian dialogic exchanges, Kristevan post-structuralist intertextuality, and a Foucaultian demystification of the author to revivify adaptation scholarship.

By 2000, British scholars Deborah Cartmell and Imelda Whelehan had co-edited six essay collections that also found literature, film, and adaptation scholarship to require retheorization. Cartmell, Whelehan, and associates were less concerned with updating formal and textual theories than with revolutionizing cultural adaptation studies.

Contending that the humanist politics and high art elitism that accompany aesthetic formalist and New Critical adaptation studies foster oppressive social, political, cultural, media, academic, and disciplinary hierarchies, they championed postmodern cultural theories and radical politics to redress these political and cultural inequities. Calling for academic attention to low and popular culture, with a focus on adaptations' reception rather than their creation, and for feminist, postcolonial, queer, Marxist, and other radical political readings of adaptations, they worked to radicalize humanist aesthetic discourses regarding the civilizing and elevating properties of elite art.

In the 1990s, Australian and Western European scholars such as Brian McFarlane and Patrick Cattrysse condemned adaptation scholarship for its impressionistic, subjective value judgments, advocating their replacement with empirical, descriptive, systematic theories. McFarlane recommended structuralist narratology "to replace the reliance on one's subjective response to the two texts as a basis for establishing similarities and differences between them" (195); Cattrysse proposed polysystems translation theory to create "a coherent and systematic theory of film adaptation" ("Film [Adapation]" 55).

Since 2003, a sizable proportion of adaptation scholars have brought these and other new theories to bear on adaptations. Yet scholars continue to charge that the field is theoretically lacking and behindhand:

> Even a casual observer of the field of adaptation studies would perceive that the field is suffering from intellectual dolours. (Murray, "Materializing" 4)

> [A]daptation theory has progressed very little since the 1950s. (Albrecht-Crane and Cutchins 11)

> Adaptation studies, rather like Don Quixote, continue to fight the day before yesterday's battles. (MacCabe, "Introduction" 7)

> We [need] to steer away from the ... delimiting preoccupations and presuppositions, the deeply ingrained attitudes and agendas historically informing adaptation studies. (Hodgkins 2)

> [M]ost of the problems that were raised in adaptation studies in the 1990s (if not before) still await a solution today. (Cattrysse, *Descriptive* 14)

Scholars now find fault with the progressive theories championed by scholars at the turn of the century. John Hodgkins recommends newer theories; Simone Murray suggests abandoning humanities theories and turning to social science ones; Colin MacCabe and Patrick Cattrysse recommend a return to earlier theories rejected by the theoretical turn. Although they disagree on particular theories, all of these scholars agree that adaptation scholarship languishes because of its adherence to the wrong theories and that adopting the right theories will revive it.

The theoretical diagnoses and prescriptions—get rid of those theories, adapt adaptation studies to these theories—have persisted for over a century now, regardless of what the theories are, across diametrically opposed as well as compatible theories. If at the dawn of the twenty-first century, adaptation studies was denounced as a last bastion of reactionary cultural and political conservatism, elitist and impressionistic

high-art aestheticism, and intellectually, aesthetically, and spiritually empty empiricism, it was equally censured in prior decades for violating the very theories that it was now charged with favoring: categorical medium specificity, New Critical organic unity, aesthetic formalism, Romantic originality, logocentrism, and high-art humanism. Back in 1957, rather than challenge medium specificity theory, an entrenched cardinal tenet of humanities criticism in his day, George Bluestone called for an end to the academic study and cultural practice of adaptation. Bluestone, hailed as the father of contemporary adaptation studies, actually wrote his book to finish them off. The so-called birth of the field, then, was an attempted abortion of it. That Bluestone objected not only to the *study* but also to the *practice* of literary film adaptation underscores how profoundly anti-adaptation (not just anti-adaptation *studies*) medium specificity theory is. Subsequent theories have continued to oppose adaptation, as I have argued elsewhere (Elliott, *Rethinking*, "Theorizing," "Rethinking").

This essay contends that the problems of adaptation scholarship derive not so much from sheer scholarly incompetence or a particular set of theories requiring replacement by other theories, but from a dysfunctional relationship between adaptation and theorization more generally. It is not new theory that we need, or more theories, or a more rigorous application of the theories we already have, but rather a fundamental rethinking of the relationship between adaptation and theorization. Since this rethinking must await the parameters of a larger research project, this essay considers more narrowly some of the difficulties that adaptation's dysfunctional relationship with theorization has created for adaptation scholarship.

The first thing to underscore is that, instead of tackling adaptation's dysfunctional relationship with theorization of all kinds, we charge adaptation scholars past and present with theoretical incorrectness, ineptitude, and lack. No field in which I have worked is more critical—indeed, contemptuous—of fellow scholars (see Elliott, "Theorizing," for examples). We blame each other for engaging the wrong theories and for failing to make adaptations conform to the right theories—or indeed, any theories at all. We argue that the problems of adaptation scholarship lie with scholars alone. The field, many have stated or implied, attracts weak scholars who cannot find publication opportunities elsewhere. Certainly there are weak scholars in adaptation studies, as there are in any field; yet the field has equally attracted internationally renowned scholars who made their reputations in other fields, most of whom have struggled to garner as much respect for their work on adaptation as they have for their scholarship on other subjects. Fredric Jameson, Linda Hutcheon, Robert Stam, Dudley Andrew, Seymour Chatman, François Truffaut, André Bazin, and Béla Balázs, to name only a few, have all undertaken adaptation scholarship. Their struggles to be heard or their failure to receive the same accolades here as elsewhere attest to the especial difficulties of theorizing adaptations. Bazin's 1948 essay on adaptation was neglected and not translated into English until the late 1990s because it challenged the mainstream theories of his day; Andrew's call for adaptation studies to take a sociological turn in 1980 was not heeded until decades later. Both Hutcheon and Jameson have been less well received in adaptation studies than elsewhere; both have been critiqued for theoretical hybridity. Hutcheon arranges her postmodern, pastiched theory of adaptation under traditional empirical questions,

satisfying neither postmodern nor empirical critics; Jameson's essay on adaptation has been critiqued for its odd brew of high art humanism and Marxism. Other respected scholars have had to go beyond their usual theoretical suspects and methodologies to address adaptation. After championing intertextuality in 2003, Leitch found it inadequate to theorize adaptations in 2012. Yet these theoretical hybridities and other departures from conventional theoretical methodologies by no means represent scholarly failures; rather, they indicate the ways in which adaptations demand that theories adapt to them, something that the field's best scholars understand.

While I could multiply these examples, it is more important in the space allotted here to consider briefly some of the reasons for adaptation and theorization's dysfunctional relationship. Adaptation and theorization are similar and yet inimical, overlapping and yet irreconcilable processes: they vie to rework whatever they touch in their own images. Theorization is more constrained than adaptation. To theorize something is to conform it to a set of tenets, beliefs, and ideas; to adapt something is to modify it to suit a new set of conditions. Theory wants to be the only set of conditions to which adaptations adapt; yet adaptations adapt to a host of other things as well—and this interferes with their theorization.

More specifically, traditional theorization seeks to define, taxonomize, and devise principles to account for its subject matter in all times and all places; adaptations inherently resist such theorization because they cross every border and line seeking to define and categorize them. They are never fixed: even after their production, they continue to assume new identities in new contexts of consumption and re-adaptation. But it is not solely traditional theorization that they oppose: they are at odds with trans-theoretical principles in the humanities that favor abstraction over concretism as indicative of higher intellect. As concrete cultural practices, they refuse to consistently conform to ideological and idealistic theories. They are theoretically promiscuous, as likely to violate aesthetic principles, religious doctrines, moral values, political tenets, and systems as to support them. Their claims to resemblance offend the humanities' transtheoretical favoring of difference, whether in the form of Romantic originality, aesthetic formalist medium specificity, New Critical organic unity, postmodern hybridity and diversity, radical identity politics, post-structuralist *différance*, Marxist dialectics, Bakhtinian dialogics, or psychoanalytic othering. Even as they participate in structures and systems, adaptations work to dismantle them, including those structures and systems we call humanities theories.

Because adaptations resist theorization of all kinds, theorization of all kinds is, to varying degrees, anti-adaptation, regularly subjugating adaptations to tenets that distort and delimit them, disciplining them, and making them and their scholarship appear dull, obvious, banal, gauche, clichéd, and unfashionable. Adaptations, we know, can be quite the reverse: scintillating, surprising, immensely creative, subtle, innovative, and absolutely cutting edge. So can adaptation scholarship.

Unlike the novel/film rivalry, which I found in 2003 to be a reciprocal and inverse process growing out of older interart rivalries concerning words and images, the relationship between theorization and adaptation is not a reciprocal, mutual, inverse one.

Unlike novels and films—which were at the turn of the twenty-first century roughly equivalent cultural, aesthetic, semiotic, and political productions—theorization and adaptation, for all their similarities, are set in an unquestioned hierarchical relationship in academia. It is the task of scholars to theorize adaptations, not to adapt theories to and through adaptations. Theories seek to colonize and conform adaptation to their tenets and conscript them for wars with other theories. Even politically and philosophically radical theories are conservative in their relations to adaptations, disciplining and punishing them whenever they stray from their tenets.

THEORIZE, DISCIPLINE, AND PUNISH: (CON)SCRIPTING ADAPTATIONS

Theories and their accompanying methodologies do not come from God or from a position of ultimate truth or right; they develop within academic disciplines. Adaptations and adaptation studies are disciplinary bastards, simultaneously no discipline's children and every discipline's children, belonging to none, yet claimed by all. Their position as everybody's child allows for their universal theoretical use and abuse; their position as nobody's child allows for their universal neglect and marginalization. Like an abused and neglected child, adaptation studies has been blamed for its own theoretical abuse and marginalization by the very theories and disciplines that abuse and marginalize it—and, like so many abused children, we have theoretically abused each other.

In addition to chastising adaptations for disciplinary violations, disciplines war over adaptation's theoretical custody. Literary scholars treat adaptations in ways that favor literature as secondary sources or as literary criticism that informs literary questions and valorizes literary culture. Conversely, film scholars view adaptations as primary sources—"films in their own right"—independent of pre-texts for informing film questions and valorizing film culture. Other arts and media disciplines do similarly. Transdisciplinary theories, whether semiotics, narratology, aesthetics, cultural studies, politics, or sociology, use adaptations to support their theories, denying, denigrating, and ignoring aspects of adaptations that lie outside their theoretical purview.

Adaptation scholars do likewise, scripting and conscripting adaptations to wage theoretical wars. In the twentieth century, when adaptation studies was chiefly focused on literature and film, adaptations were regularly theoretical fodder in disciplinary and media wars for academic and cultural ascendancy, as I have argued elsewhere (*Rethinking*). But the focus of my earlier scholarship, I now believe, rested too much on adaptations' conscription and scripting in *disciplinary* wars and not enough on their uses in *theoretical* wars.

For most of the twentieth century, adaptations were conscripted to prove theories applied to arts, media, representations, and culture. From Vachel Lindsay in 1915 to

Seymour Chatman in 1980 and beyond, adaptations were denigrated to exalt Romantic theories of originality and aesthetic formalist theories of art, particularly medium specificity theory; they were mocked as semiotic impossibilities when they dared to challenge structuralism, and were castigated for their representational failings by both aesthetic formalists and their cultural studies opponents (Elliott, "Rethinking"). And when adaptations' challenges to older theories were considered, they continued to serve as ca(n) non fodder for theoretical wars. Adaptations are still used to prove new theories, to revive old ones, to contest aesthetic and political values, and to support some modes of epistemology over others. While this is the case with almost any cultural material, it is particularly egregious that adaptations should be thus co-opted by theories that denigrate or fail to theorize and explicate them *as adaptations*.

Instead of seeking to understand adaptations on their own terms, we apply theories devised for other subjects in other fields and disciplines to adaptations and then wonder why we have so much trouble theorizing them. While adaptations participate in many disciplines, these theories were developed to address things that are not necessarily adaptations—books, films, arts, and media generally; signs, narratives, translation, aesthetics, cultures, societies, industries, politics, economics, history, psychology, philosophy, and more. None was tailor-made for adaptations. Adaptations are not reducible to any of these theories, nor will applying every possible available theory to adaptations produce a theory of adaptation.

While I now believe that impasses between adaptation and theorization are largely responsible for the difficulties besieging adaptation studies, its scholars, myself included, have been complicit with theories in failing adaptations and adaptation studies. The remainder of this essay examines some of the fallout for adaptation scholarship of seeking (and failing) to conform adaptations to theories of all kinds. These include tensions between theoretical progressivism and theoretical nostalgia, theoretical sprawl, failures in citation, mythological histories of the field, and trans-theoretical field myths.

THEORETICAL PROGRESSIVISM VERSUS THEORETICAL NOSTALGIA

> A novel, alternative approach is needed, yet inspiration can be found in some of the oldest ideas.
>
> —Sarah Cardwell (73)

As we have seen, the failure of new theories to resolve the problems of adaptation scholarship has led some scholars to return to older theories in order to ponder what theoretically viable babies may have been thrown out with the bathwater dumped by the theoretical turn. Yet the nostalgic theoretical turn in adaptation studies is accompanied by a continued championing of newer theories (e.g., Hodgkins; Murray, *Industry*; Saint

Jacques), producing a Janus-faced field. In 1996, John O. Thompson declared older theories "unfashionable because, to put it quickly and roughly, they are pre-Derridean and pre-postmodern." This progressivist view paradoxically adopts the very legalistic, moralistic, hierarchical language he condemns when used by proponents of older theories: "The older positions stand convicted of being both dogmatic and elitist, as well as naïve" (11).

Since 1996, as newer theories have failed to resolve the theoretical problems of adaptation studies, scholars have been returning to older theories. Theoretical nostalgia takes various forms, from the reiterations of those who never abandoned older theories seeking to reinstate them (Cahir, Welsh), to the championing of theories contemporaneous with but rejected by the theoretical turn (Cattrysse), to the updating of older theories so that they incorporate aspects of the theoretical turn (Krebs), to the revisiting of older adaptation theorists whose writings were ignored because they bucked the mainstream theories of their day (Andrew, Naremore, Corrigan).

André Bazin is the key figure of this last form of theoretical nostalgia, resurrected in film as well as adaptation studies. For some, the return to Bazin in adaptation studies marks a rejection of theoretical progressivism and a dissatisfaction with newer theories. His work enables Colin MacCabe to return to adaptation studies' concern with the "original" debunked by Thompson (noted earlier), serving as valorized and valorizing *theoretical* original for this endeavor ("Bazin was the first to identify" [MacCabe 8]). For others, Bazin serves as a forefather in a lineage of theoretical progress that they have carried further. While Cartmell and Whelehan call Bazin a rare "champion of adaptation in the 1950s," they critique him for "sometimes employ[ing] a language that is adaptation studies' own worst enemy" (*Screen Adaptation* 34, 131). For these scholars, Bazin requires the further progress of postmodern cultural studies and progressive political theory.

Bazin is not the only theorist to resurface in twenty-first-century literature, film, and adaptation studies. Dudley Andrew's 1980 essay "Adaptation" has been reprinted in Naremore's essay collection and both editions of Timothy Corrigan's reader. That reader has itself achieved classic status in just twelve years, its second edition advertised as a "new edition of this classic book" ("Film and Literature"). In 2012, Routledge reissued Linda Hutcheon's *A Theory of Adaptation*, its unchanged text (apart from a new preface and epilogue) indicating its classic status. In 2013, Routledge went further, announcing five "Classic Texts on Film and Literature You Need in Your Library," "previously out-of-print ... works originally published between 1968 and 1993, an unmissable collection for students and teachers of film and literature, that would be an asset to any library."

Joining and widening the backward glance in 2012, Rainer Emig urged adaptation scholars to return to the theoretical humanities classics of the late twentieth century—works by canonical theorists, including Derrida, Foucault, Butler, Bhaba, Baudrillard, Kristeva, and Lyotard. It could be argued that even turn-of-the-twenty-first-century progressivists were promoting classical theories pioneered decades earlier.

Such complicities combine with oppositions between theoretical progressivism and theoretical nostalgia to create a reciprocal, inverse mirror dynamic, in which the nostalgic is figured as progressive and the progressive as nostalgic. In a 2010 conference paper, Corrigan articulated one side of that looking glass when he argued, "We need

to encourage the refractive spread of adaptation studies where evolutionary progress can also be a return to positions that we may have archived too quickly—from Vachel Lindsay and Béla Balázs to Bazin and Bellour and well beyond." In 2011, MacCabe articulated the other side when he cast theoretical progressivism as nostalgic. Arguing that Jean-Luc Godard had toppled the hierarchy that set literature above film fifty years ago, he complained that cultural studies scholars still protesting the priority of literature over film are fighting superannuated battles (7–8).

Beyond such reciprocal inversions, theoretical progressivism and theoretical nostalgia are more unilaterally agreed upon as discourses of theoretical failure. Theoretical progressivism decrees the failure of old theories; theoretical nostalgia, the failure of new ones. Together, they point to the long-standing failure of theories to account satisfactorily for adaptations.

Theoretical Sprawl

Dissatisfaction with the theories already applied to adaptation studies and disappointment with the failure of new theories to account for adaptations have led to theoretical sprawl, as scholars seek additional theories to account for adaptations. Theories proliferate in adaptation studies not only because adaptations inhabit so many fields, each with its own theories and methodologies, and not only because older theories remain alongside newer ones, but also because postmodern cultural theories have been democratizing adaptation studies and expanding the range of media that scholars are expected to address. In 2006, Hutcheon threw adaptation studies open beyond its usual suspects of literature, film, theater, and television to include theme park rides, tie-in merchandise, fan fiction, videogames, art installations, mashups, YouTube compilations, and more. The field continues to expand with each emerging technology and each new mode of remediating existing media. Because adaptation studies, unlike other fields, is not typically divided into historical periods, adaptation scholars are implicitly expected to know more than scholars in single discipline fields. The prevalence of interhistorical and intercultural adaptations expands the materials adaptation scholars are expected to master.

Theoretical tenets and theoretical disagreements have been major contributors to theoretical sprawl. While some still seek to overthrow prior theories when they present new ones, thereby diminishing the number of theories applied to adaptations (Murray, Cattrysse), others present new approaches as add-ons to prior theories, methods, and questions (Hodgkins). Postmodern theories, which mandate a democratic, global inclusivity, combine with the totalizing ambitions of traditional theory to require attention to a panoply of issues. Scholars must not only know the canonical works of literature and film that appeal to high art aestheticians, but also those that enter the mass culture that attracts the attention of cultural studies. They must study adaptations not only as aesthetic productions, but also as industrial products, and examine their consumption and interpretations in various historical, cultural, contextual, ideological,

political, economic, local, and global contexts. They must understand them not only as objective constructs, but also as creative and subjective processes; they must consider the unconscious as well as the deliberate aspects of their production and consumption, and their collective as well as individual dimensions. Adaptation scholars must attend to their forms: not only to their semiotics, genre, narratives, and textualities, but also to their intersemiotics, generic shifts, narrative exchanges, intertextualities, and interme-dialities. The intertextual, intermedial, and polysystems theories that have replaced one-to-one translation models produce longer genealogies, wider webs, and more numerous interchanges for adaptations, which scholars are also expected to know and master. The field must encompass not only adaptations' participation in formal systems, but also their functions in cultural systems, their role as mediators of value, taste, ethics, and judgment: their beliefs and ideologies, their aesthetics, their politics, their morals, their profits.

Scholars who define theorization as a totalizing, universal system that can account for adaptations in all times and places despair of theorizing such a large field. Heidi Peeters remarks, "somewhat disappointingly, [Hutcheon's] *A Theory of Adaptation* does not offer the Grand Theory we might have been hoping for . . . there are no great answers in this publication, no paradigm shifts in conceptualizing adaptations." Yet fellow post-modern scholars Cartmell and Whelehan are equally critical, arguing that Hutcheon's "book point[s] to the conclusion that there cannot be, as the title promises, *a* theory of adaptation" (*Screen Adaptation* 56, emphasis in original).

Those who define theorization as a list of principles guaranteed to produce aestheti-cally "good" adaptations equally despair of theorizing adaptation studies in the wake of theoretical sprawl: "the number of variables involved in any adaptation from the linguis-tic form of the novel or short story to a film's matters of expression approach [*sic*] infin-ity. . . . There are thus no models of how to adapt in this volume" (MacCabe 8). Cattrysse is more hopeful, recommending polysystems theory, which can expand to include new systems as needed. Yet his exclusion of so many aspects of adaptations, his discount-ing of other epistemologies, and his dismissive misreadings of prior scholarship (at 35–36, for example, he charges Whelehan with holding the views she has spent a lifetime opposing), unfortunately makes his theory, which does contribute valuable elements to adaptation studies, unlikely to garner the support of most adaptation scholars.

Theoretical sprawl has further exacerbated some of the problems with adapta-tion scholarship identified by Ray in 2000. Ray was confident that bringing the theo-retical turn to bear on adaptation studies would redress the scattered and unfocused case study structure of adaptation scholarship that prevailed under aesthetic formal-ism and New Criticism—the "endless series of twenty-page articles" addressing a sin-gle text adapted to a single film (44–45). But the postmodern cultural studies theories that arose to oppose aesthetic formalism have not only continued to address isolated local examples of adaptation, they have further justified and reified this kind of schol-arship as ideal. Postmodern theories resist master narratives and champion hybridity, pluralism, and diversity focused on the local and particular. This extends to the use of theories. Cartmell and Whelehan affirm "the excitement of encountering in every site

of adaptation an entirely new set of relations which allows us to draw promiscuously on theoretical tendencies in film and literary studies" (*Screen Adaptation* 22). Brett Westbrook, too, recommends a "glorious plurality" of diverse (even dissonant) theories, calling critics to "choose from a candy store of available approaches: semiotics, feminist criticism, Russian Formalism, media studies—the whole menu" (43–44). As aesthetic formalist and postmodern cultural theories dominate the field today, edited collections and journal articles continue to comprise the majority of the field's publications. It is also striking that a majority of its monographs, including those by scholars who are neither aesthetic formalists nor postmodern cultural scholars, also unfold as series of disparate case studies (e.g., Leitch, *Film Adaptation*; Geraghty, *Now a Major*; Hunter, *English Filming*).

FAILURES IN CITATION

Theoretically validated theoretical sprawl has led to theoretically validated failures in citation that further undermine the perception of adaptation scholarship. No other field in which I have published suffers from such pronounced, extensive lapses in citation by scholars at every level. In other fields, press and journal reviewers have required me to read, cite, debate, and engage with every major (often every minor) publication on my subject. Such rigor is rare in adaptation studies. I have seen scholars at all levels ignore, dismiss, reduce, and even falsify the work of rivals. I have found new scholars claiming to revolutionize the field who do not cite even the minimum amount of prior work in the field required of any first-year PhD student. I have seen prominent scholars entering adaptation studies without having bothered to conduct similar basic research. I have discovered scholars making a case for a book that needs to be written by hiding or distorting the work of prior scholars they have clearly read and dismissed in their book proposals; in many instances, presses have believed these scholars and have published their books. It is my conviction that these practices of obscuring, reducing, and distorting prior work have made adaptation scholarship appear to be much poorer and thinner than it actually is. These practices have created a relentless cycle in which new scholars reading only the most recent work in the field believe that prior adaptation scholarship is not worth reading. As a result, misperceptions of the field are perpetuated without evidence.

Of course, there are other reasons that citation is especially problematic in adaptation studies. Its size, scope, interdisciplinary range, and fragmentation by numerous academic disciplines, as well as its numerous theoretical debates, render surveying and summarizing the field a formidable task. But even when the field was small, Greg Jenkins finds that Roy Madsen does not credit George Bluestone for ideas lifted from him wholesale, and that Bluestone does not credit Gilbert Seldes. Nor, I find, does Seldes cite Vachel Lindsay, who made almost identical arguments two decades earlier regarding medium specificity. Lindsay does not cite the scholars who pioneered the theories

he propounds, although he was not himself an academic, subject to the conventions of scholarly citation. The reasons for these lapses in citation appear to be theoretical ones. Formal scholars do not cite prior scholars, it seems, because they believe tenets such as medium specificity to be essential, universal, self-evident truths rather than discursive constructions created by scholars and open to debate. Scholars who adhere to medium specificity in the twenty-first century continue to project this impression—rarely, if ever, engaging the arguments against it made by Leitch and myself in 2003. More generally, aesthetic formalism, which tends to be a theory of taste, appreciation, and pleasure in particular materials in the present moment, is rarely concerned with chronologies of a field or building on prior theories. Its consideration of the past tends to be limited to classics and aesthetic influences rather than prior scholarship.

Postmodern scholars do not always cite their sources either—again, perhaps on theoretical grounds. Postmodern cultural studies and sociology are primarily concerned with the local and the contemporary, rather than with tracing histories of cultural theory or studying older cultures and contexts. Moreover, postmodern theory contends that every work, fictive or critical, is always already an adaptation or pastiche of earlier discourses and representations and (somewhat paradoxically) simply the view of the person writing. As a result, postmodern and sociological scholars see no need to position themselves in a lineage beginning with Gilbert Seldes's assault on high art and championing of low art in 1924 in relation to adaptation or to consider how their work builds on and departs from Lester Asheim's 1951 sociological study of the adaptation industry and audience culture. Instead, they predicate their scholarship on attacks against aesthetic formalism (Cartmell and Whelehan) or textual studies (Murray). Likewise, contemporary theorists of media convergence never mention Claude-Edmonde Magny's 1948 argument regarding the convergence of literature and film, since it is based in narrative and stylistic arguments, rather than studies of late capitalism and globalization. Perhaps scholars promoting post-structuralist intertextuality in adaptation studies do not mention prior critics who rejected translation models (Mitry) and advocated intertextual ones (Cohen) because few heeded these earlier works and the problems they described remain. Yet such policies and practices mean that new works often begin the field again at square one, instead of building on prior work, making the field appear to be more elementary than its actual history attests.

It may be that we do not cite prior studies because we have not read them. Lack of research and reading may not, however, represent indolence or arrogance; they may also be products of theoretical positions. When theorists dismiss older theories as narrow, wrong, or outmoded, theoretical progressivism becomes a justification for not even *reading* older work. But when progressivists dismiss older works without having read them on the basis of dismissals by fellow progressivists, this can result in serious misreadings diametrically opposed to the actual positions of prior scholars. Even when progressivists agree with prior work, their belief that they have improved or integrated it into their own work implies that older work can be dispensed with, having evolved.

Equally, when older theorists dismiss progressive theories as wrong-headed, this too becomes grounds for not even *reading* such scholarship, instead reductively dismissing

opposing views, as Cartmell and Whelehan, Murray, MacCabe, and Cattrysse all join in doing, sometimes at each other's expense. (see Elliott, "Theorizing," "Rethinking"). Failing to engage opposing views with accurate, detailed argumentation further contributes to the perception that adaptation scholarship is thin and weak. Moreover, when the repetition of identical arguments replaces full responses to counterarguments, creeds and dogmas displace scholarship. As the field becomes more polarized and scholars treat only the work of those with whom they agree with seriousness and respect, reductive treatments of other viewpoints make adaptation scholarship appear to be much weaker than it actually is. When outsiders read only summaries of the field by both camps, if they pay any attention to adaptation studies at all, they are likely to perceive that adaptation scholarship is poor and unconvincing across the board.

Another theoretical trend that masks strong prior adaptation scholarship is a tendency for scholars to cite theorists rather than fellow scholars. Although Stam reiterates one of Joy Gould Boyum's arguments almost verbatim, he credits a theorist, rather than Boyum, with the idea:

> [A]n adaptation will be considered faithful to the extent that its interpretation remains consistent with those put forth by the interpretive community. (Boyum 77).

> [W]hen critics refer to the "spirit" or "essence" of a literary text what they usually mean is the critical consensus within an "interpretive community" (Stanley Fish) about the meaning of the work. (Stam, "Introduction" 15)

While this practice is accepted in the humanities, since Boyum herself cites Louise M. Rosenblatt for her reader response theory (xi), such displacements of adaptation critics and their sources from the lineage of adaptation studies contribute to the diminution of adaptation scholarship and the elevation of already celebrated theorists on the shoulders of buried adaptation scholars and, indeed, female theorists.

For all our discourses of deconstructing cultural, disciplinary, and media hierarchies and canons, adaptation scholars too often maintain theoretical hierarchies and canons at the expense of our field and its scholarship, being quick to credit canonical theorists and slow to credit fellow scholars. In a field such as ours, devoted to the study of how texts and media rework other texts and media, it is particularly egregious when we fail to acknowledge our own reworkings of prior texts or to indicate how we are adapting prior adaptation scholarship.

MYTHOLOGICAL FIELD HISTORIES
AND TRANSTHEORETICAL FIELD MYTHS

Failures in citation have contributed to mythological field histories that consolidate adaptation scholarship in ways that make it appear far more obtuse, backward, and

unintelligent than it actually is. No field in which I have worked so persistently fore-grounds its weakest scholarship in summaries of the field, minimizes or omits its strongest works, and invents myths to make prior scholarship appear to be weaker than it is. Prior to the theoretical turn in adaptation studies, overviews of the field included progressive scholarship from the 1970s to the early 1990s. Greg Jenkins's 1997 summary contains scholars who opposed medium specificity (Orr), promoted intertextuality (Cohen), championed reader response over author intent (Boyum), and advocated a Marxist, historical treatment of adaptations (Larsson). By contrast, twenty-first-century scholars who claim to be revolutionizing the field omit these scholars from their over-views (Aragay's summary is a notable exception). By contrast, summaries of the field in books *not* claiming to revolutionize it continue to include earlier progressive scholar-ship (e.g., Niemeyer, Donaldson-Evans). This contrast reflects poorly on the scholarship that is more centrally deemed to be "adaptation studies."

New scholars and outsiders tend to turn to the most recent publications to glean their overviews of a field; they rarely conduct independent research to test field overviews, so these misleading and partial histories of the field continue. While summaries of the field cannot be expected to go into extreme depth and detail or to include every scholar who has ever weighed in, summaries of adaptation studies lack the copious bibliographies contained in other field introductions that allow scholars to engage in further reading. Hutcheon's extensive and impressive book-length study of adaptation is undoubtedly the best and the most comprehensive in addressing prior adaptation scholarship to date, but it is erratic in its citation. Hutcheon does not credit Sarah Cardwell for pioneering a key distinction between adaptation as product and adaptation as process, which means that readers like Rainer Emig credit Hutcheon with the innovation and are not directed to Cardwell's work to expand their knowledge of this aspect of the field. Similarly, although Hutcheon includes my account of Martin Meisel's pioneering research on Victorian adaptation almost verbatim, not citing his work means that scholars who want to study these trends in more detail are not directed to this deeper body of work on the subject.[1] When leading scholars (e.g., Cartmell and Whelehan, *Screen Adaptation*; Geraghty; MacCabe, "Introduction") subsequently refuse to summarize the field, they imply that it has been sufficiently and accurately represented in prior summaries, with the result that errors and lapses in citation in prior summaries continue to misrepresent "adaptation studies" to outsiders and newcomers. (Cartmell subsequently published an overview of adaptation studies in 2012.)

When failures in citation join the failure of theories to account for adaptations, field myths arise and are perpetuated. Nowhere is this more apparent than in adaptation studies' myth of fidelity, upon which so many scholars have staked their claims to theo-retical innovation and revolution. In most cases, theoretical innovation and revolution are overstated, and new scholars, while protesting against fidelity in adaptation studies, merely proclaim their fidelity and conformity to the theoretical humanities mainstream.

The myth that adaptation scholarship has been chiefly and culpably concerned with absolute fidelity of the adapting text to the adapted text up until right now, at the time of this writing, is palpably a myth because there is no evidence to support this in actual

adaptation scholarship. It is one thing to claim that some adaptation scholars have recommended degrees of fidelity in adaptation. Yet even these discourses are placed in the service of condemning absolute fidelity and championing some degree of infidelity (Elliott, *Rethinking* 128–29). Certainly, some literary scholars condemn film adaptations for not living up to cherished canonical texts (see, for example, most of the essays in Peary and Shatzkin); scholars seeking to revive aesthetic formalism have recommended a modified fidelity of style (MacCabe); some pedagogical books recommend translation approaches to adaptation (Cahir; Desmond and Hawkes). Yet not even the most conservative of publications insists upon absolute fidelity in adaptation in the way that so many critics claim all or most scholars before them have. Even in the years 1909–77, when one would expect to find ample evidence of fidelity criticism, a count of entries in Jeffrey Egan Welch's annotated bibliography of literature and film studies indicates that publications advocating fidelity and opposing infidelity comprise a minority of adaptation scholarship; many more promote *in*fidelity than fidelity or are entirely unconcerned with the subject. Moreover, it is ludicrous and embarrassing to adaptation scholarship for anyone after 1910 to claim to be the first to substantially challenge fidelity in adaptation.

Why then does this myth persist? The fidelity myth is central to adaptation studies as a myth of theoretical faith-keeping. Its constant, transtheoretical repetition as claim to originality in adaptation scholarship is a means of returning to theoretical origins of all kinds to pledge theoretical fidelity. The absolute fidelity myth is a unifying force in adaptation studies; it is the straw villain that offends every humanities theory from medium specificity to post-structuralist difference, from dialogics to dialectics, from Romantic originality to postmodern hybridity, from New Critical organic unity to radical political dissent.

We know that fidelity is a field myth because, quite strikingly, most critics asserting it offer no citation or evidence for it. Those who do tend to cite prior opponents of the myth, most commonly Robert Stam ("Beyond"), who himself cites *no one*. Some fidelity myth proponents (e.g., Cartmell and Whelehan, *Adaptations* 203; Leitch, "Twelve Fallacies") cite media reviewers, audiences, and adaptation practitioners rather than scholars. Even as they rightly demonstrate the formidable cultural power of fidelity imperatives, presenting the opinions of non-academics as the views of most adaptation scholars unfortunately denigrates adaptation scholarship.

Others erroneously assert that formal critics such as George Bluestone, Geoffrey Wagner, and Brian McFarlane championed fidelity and opposed infidelity in adaptation, when in fact they did *the reverse*. Bluestone considers fidelity to be "unhelpful," "blurring the mutational process," and contends that a quest for fidelity indicates a "lack of awareness . . . that changes are *inevitable*" (5, emphasis in original). He conducted his series of comparative case studies in order to demonstrate *the folly of fidelity in adaptation*, palpably declaring in his conclusion that it is "impossible to effect a 'faithful' rendition" and calling for filmmakers to therefore abandon literary adaptation entirely (113). Bluestone opposed fidelity in adaptation to keep faith with the theory of medium specificity: the belief that each medium represents certain things best, based on its properties, and should therefore not seek to represent what other arts can represent better, according

to their inherent and essential traits. Geoffrey Wagner has also been misread as "obsessively concerned with defending adaptations of any sort from the charge of infidelity" (Aragay 16), even though his hierarchical taxonomy of adaptation types values the most unfaithful adaptations the most highly and the most faithful the least. Brian McFarlane, too, has been charged with engaging "a kind of fidelity criticism" (Mayer 4), even though he clearly states that "the fidelity approach seems a doomed enterprise and fidelity criticism unilluminating" (19). While both Bluestone and McFarlane demonstrate the limitations of fidelity in their case studies, neither champions fidelity. These and other readings have seeped from scholarship into teaching guides, inculcating information into the next generation of adaptation scholars, reinforcing my earlier argument that refusals to understand, let alone engage, opposing theories seriously have damaged perceptions of adaptation scholarship. Contemporary cultural scholars wrongly assume that formal scholars must support fidelity along with all the conservative political values they are charged with holding, even though many aesthetic formalists are left-wing politically. As a result, radical political scholars claiming to be the first to challenge fidelity in adaptation fail to grasp that the medium specificity theory to which aesthetic formalism, New Criticism, and structuralist narratology pledge allegiance is as dedicated to infidelity as their own theories. They further confuse comparative criticism with fidelity criticism, failing to understand that comparative criticism more often aims to establish the *differences* between adapting and adapted works than their similarities.

In the final analysis, the myth of fidelity in adaptation studies masks adaptation scholarship's obsession with forcing adaptations and their scholarship to be faithful to *theories*. The anti-fidelity protest in adaptation studies has been used consistently and paradoxically to promote fidelity to all manner of theoretical positions. Observing that adaptation studies "all seem to have one fundamental starting point, namely the denunciation of the notion of fidelity to the original text" (216), Frederic Jameson remarks, "The scarecrow of fidelity is then a reminder to keep faith with some Lacanian gap or rift within this equally split subject with is the object of adaptation studies; it stages a well-nigh Derridean vigilance to the multiple forms difference takes in the object of such studies and insists on fidelity to the difference rather than to this or that ideology of the original" (213). Although he does not include Romantic originality, medium specificity, aesthetic formalism, New Criticism, or structuralist semiotics in his list, "the scarecrow of fidelity" has been invoked "to keep faith with" these theories as well.

We need to turn our attention from critiquing a mythical insistence upon fidelity of adapting media to adapted media to consider the way in which we maintain fidelity to theories that dismiss, other, constrain, denigrate, and fail to explicate adaptations. Adaptation studies faces too many difficulties from external marginalization and the application of theories that oppose adaptations on aesthetic, semiotic, political, and philosophical grounds to warrant the feuds and disservices we do to each other's scholarship internally. It is not more rigorous theorization we need if such rigor intensifies theoretical abuses of adaptations and their scholarship; it is more rigorous scholarship that does justice to the work done by prior and contemporaneous scholars—a refusal to falsify, obscure, or misrepresent the good scholarship that has already been conducted

in our field; a commitment to debating our disagreements with rigor; rigorous refereeing standards among those who publish in adaptation studies to redress lapses and errors in citation and slay field myths; a keener awareness of the real threats to adaptations and their scholarship; and the courage to challenge the theories that have failed and abused adaptations.

NOTE

1. Here are the two passages:

> In his massive and impressive account of Victorian interart exchanges, Martin Meisel documents the pervasive practice of adaptation: poems, novels, plays, paintings, operas, songs, dances, tableaux, and tableaux vivants adapted to each other, in every direction and back again. (Elliott, *Rethinking* 162)

> The Victorians had a habit of adapting just about everything—and in just about every possible direction; the stories of poems, novels, plays, operas, paintings, songs, dances, and tableaux vivants were constantly being adapted from one medium to another and then back again. (Hutcheon xiii)

WORKS CITED

Albrecht-Crane, Christa, and Dennis Cutchins, eds. *Adaptation Studies: New Approaches*. Rutherford: Fairleigh Dickinson UP, 2010. Print.

——. "Introduction: New Beginnings for Adaptation Studies." Albrecht-Crane and Cutchins 11–22. Print.

Andrew, Dudley. "Adaptation." *Concepts in Film Theory*. New York: Oxford UP, 1984. 96–106. [First published as "The Well-Worn Muse: Adaptation in Film History and Theory." *Narrative Strategies: Original Essays in Film and Prose Fiction*. Ed. Syndy M. Conger and Janet R. Welsch. Macomb: Western Illinois UP, 1980. 9–17.] Print.

Aragay, Mireia. "Introduction: Reflection to Refraction: Adaptation Studies Then and Now." *Books in Motion: Adaptation, Intertextuality, Authorship*. Ed. Mireia Aragay. Amsterdam: Rodopi, 2005. 11–36. Print.

Asheim, Lester. "From Book to Film: Mass Appeals." *Hollywood Quarterly* 5.4 (Summer 1951): 334–49. Print.

——. "From Book to Film: Simplification." *Hollywood Quarterly* 5.3 (Spring 1951): 289–304. Print.

——. "From Book to Film: Summary." *Quarterly of Film, Radio, and Television* 6.3 (Spring 1952): 258–73. Print.

——. "From Book to Film: The Note of Affirmation." *Quarterly of Film, Radio, and Television* 6.1 (Autumn 1951): 54–68. Print.

Balázs, Béla. *Béla Balázs: Early Film Theory:* Visible Man *and* The Spirit of Film. Ed. and trans. Erica Carter and Rodney Livingstone. Oxford: Berghahn, 2010. Print.

Bazin, André. "Adaptation, or the Cinema as Digest." Trans. Alain Pierre. 1948. Naremore 19–27. Print.

Beja, Morris. *Film and Literature*. New York: Longman, 1976. Print.

Bluestone, George. *Novels into Film*. Berkeley: U of California P, 1957. Print.

Boyum, Joy Gould. *Double Exposure: Fiction into Film*. New York: Plume, 1985. Print.

Cahir, Linda Costanzo. *Literature into Film: Theory and Practical Approaches*. Jefferson: McFarland, 2006. Print.

Cardwell, Sarah. *Adaptation Revisited: Television and the Classic Novel*. Manchester: Manchester UP, 2002. Print.

Cartmell, Deborah, ed. *A Companion to Literature, Film, and Adaptation*. Oxford: Wiley-Blackwell, 2012. Print.

———. "100+ Years of Adaptations." Cartmell, *Companion* 1–13. Print.

Cartmell, Deborah, and Imelda Whelehan. *Adaptations: From Text to Screen, Screen to Text*. London: Routledge, 1999.

———. *Screen Adaptation: Impure Cinema*. New York: Palgrave Macmillan, 2010. Print.

Cartmell, Deborah, I. Q. Hunter, Heidi Kaye, and Imelda Whelehan, eds. *Alien Identities: Exploring Differences in Film and Fiction*. London: Pluto, 1999. Print.

———, eds. *Classics in Film and Fiction*. London: Pluto, 2000. Print.

———, eds. *Pulping Fictions: Consuming Culture across the Literature/Media Divide*. London: Pluto, 1996. Print.

———, eds. *Sisterhoods across the Literature/Media Divide*. London: Pluto, 1998. Print.

———, eds. *Trash Aesthetics: Popular Culture and Its Audience*. London: Pluto, 1997. Print.

Cattrysse, Patrick. *Descriptive Adaptation Studies: Epistemological and Methodological Issues*. Antwerp: Garant, 2014. Print.

———. "Film (Adaptation) as Translation: Some Methodological Proposals." *Target* 4.1 (1992): 53–70. Print.

Chatman, Seymour. "What Novels Can Do That Films Can't and Vice Versa." *Critical Inquiry* 7 (1980): 121–40. Print.

Cohen, Keith. *Film and Fiction: The Dynamics of Exchange*. New Haven: Yale UP, 1979. Print.

Corrigan, Timothy. "Adaptations, Refractions, and Obstructions: The Prophecies of André Bazin." Presented at the SCMS Conference, Los Angeles, March 2010. Conference paper.

———. *Film and Literature: An Introduction and Reader*. 2nd ed. London: Routledge, 2011. Print.

Desmond, John M., and Peter J. Hawkes. *Adaptation: Studying Film and Literature*. New York: McGraw-Hill, 2006. Print.

Donaldson-Evans, Mary. *Madame Bovary at the Movies: Adaptation, Ideology, Context*. Amsterdam: Rodopi, 2009. Print.

Elliott, Kamilla. "Rethinking Formal-Cultural and Textual-Contextual Divides in Adaptation Studies." *Literature/Film Quarterly* 42.3 (Oct. 2014): 576–93. Print.

———. *Rethinking the Novel/Film Debate*. Cambridge: Cambridge UP, 2003. Print.

———. "Screened Writers." Cartmell, *Companion* 179–97. Print.

———. "Theorizing Adaptations/Adapting Theories." *Adaptation Studies: New Challenges, New Directions*. Ed. Jørgen Bruhn, Anne Gjelsvik, and Eirik Frisvold Hanssen. London: Bloomsbury, 2013. 19–45. Print.

Emig, Rainer. "Adaptation in Theory." *Adaptation and Cultural Appropriation: Literature, Film, and the Arts*. Ed. Pascal Nicklas and Oliver Lindner. Literature, Film, and the Arts, Spectrum Literature Series No. 27. Berlin: Walter de Gruyter, 2012. 14–24. Print.

"Film and Literature: An Introduction and Reader, 2nd edition." Routledge Books. Web. 9 July 2015.

Geraghty, Christine. *Bleak House*. London: British Film Institute, 2012.

————. *Now a Major Motion Picture: Film Adaptations of Literature and Drama*. Lanham: Rowman and Littlefield, 2008. Print.

Hodgkins, John. *The Drift: Affect, Adaptation and New Perspectives on Fidelity*. London: Bloomsbury, 2013. Print.

Hunter, Jefferson. *English Filming, English Writing*. Bloomington: Indiana UP, 2010. Print.

Hutcheon, Linda, with Siobhan O'Flynn. *A Theory of Adaptation*. 2nd ed. London: Routledge, 2013.

Jameson, Fredric. "Afterword: Adaptation as a Philosophical Problem." MacCabe, Warner, and Murray 215–33. Print.

Jenkins, Greg. *Stanley Kubrick and the Art of Adaptation: Three Novels, Three Films*. Jefferson: McFarland, 1997. Print.

Krebs, Katja. "Translation and Adaptation: Two Sides of an Ideological Coin?" *Translation, Adaptation and Transformation*. Ed. Laurence Raw. New York: Continuum, 2012. 42–53. Print.

Larsson, Donald F. "Novel into Film: Some Preliminary Reconsiderations." *Transformations in Literature and Film*. Ed. Leon Golden. Tallahassee: UP of Florida, 1982. 69–83. Print.

Leitch, Thomas. "Adaptation and Intertextuality, or, What Isn't an Adaptation, and What Does It Matter?" Cartmell, *Companion* 87–104. Print.

————. *Film Adaptation and Its Discontents: From* Gone with the Wind *to* The Passion of the Christ. Baltimore: Johns Hopkins UP, 2007. Print.

————. "Twelve Fallacies in Contemporary Adaptation Theory." *Criticism* 45.2 (Spring 2003): 149–71. Print.

Lindsay, Vachel. *The Art of the Moving Picture*. New York: Macmillan, 1915. Print.

MacCabe, Colin. "Introduction. Bazinian Adaptation: *The Butcher Boy* as Example." MacCabe, Warner, and Murray 3–25. Print.

MacCabe, Colin, Rick Warner, and Kathleen Murray, eds. *True to the Spirit: Film Adaptation and the Question of Fidelity*. Oxford: Oxford UP, 2011. Print.

Madsen, Roy Paul. *The Impact of Film: How Ideas Are Communicated through Cinema and Television*. New York: Macmillan, 1973. Print.

Magny, Claude Edmonde. *L'age du roman Americain*. Paris: Seuil, 1948. [*The Age of the American Novel: The Film Aesthetic of Fiction between the Two Wars*. Trans. Eleanor Hochman. New York: Frederick Ungar, 1972.] Print.

Mayer, Robert. "Introduction: Is There a Text in the Screening Room?" *Eighteenth-Century Fiction on Screen*. Ed. Robert Mayer. Cambridge: Cambridge UP, 2002. 1–15.

McFarlane, Brian. *Novel to Film: An Introduction to the Theory of Adaptation*. Oxford: Clarendon, 1996. Print.

Mitry, Jean. "Remarks on the Problem of Adaptation." *Midwest Modern Language Association Bulletin* 4.1 (1971): 1–9. Print.

Murray, Simone. *The Adaptation Industry: The Cultural Economy of Contemporary Literary Adaptation*. London: Routledge, 2012. Print.

————. "Materializing Adaptation Theory: The Adaptation Industry." *Literature/Film Quarterly* 36.1 (2008): 4–20. Print.

Naremore, James, ed. *Film Adaptation*. New Brunswick: Rutgers UP, 2000. Print.

Niemeyer, Paul J. *Seeing Hardy: Film and Television Adaptations of the Fiction of Thomas Hardy*. Jefferson: McFarland, 2003. Print.

Orr, Christopher. "Adaptation: A Review." ["The Discourse on Adaptation."] *Wide Angle* 6.2 1984: 72–76. Print.

Peary, Gerald, and Roger Shatzkin, eds. *The Modern American Novel and the Movies*. New York: Ungar, 1978.

Peeters, Heidi. Review of Linda Hutcheon, *A Theory of Adaptation*. *Image and Narrative: Online Magazine of the Visual Narrative*. Issue 16: *House/Text/Narrative*. Feb. 2007. Web. 16 Mar. 2010.

Ray, Robert B. "The Field of 'Literature and Film.'" Naremore 38–53. Print.

Routledge. "Classic Texts on Film and Literature You Need in Your Library." Email advertisement. 20 June 2013.

Saint Jacques, Jillian, ed. *Adaptation Theories*. Maastricht: Jan Van Eyck Academie, 2011. Print.

Seldes, Gilbert. *The Seven Lively Arts*. New York: Harper, 1924. Print.

Stam, Robert. "Beyond Fidelity: The Dialogics of Adaptation." Naremore 54–76. Print.

———. "Introduction: The Theory and Practice of Adaptation." *Literature and Film: A Guide to the Theory and Practice of Film Adaptation*. Ed. Robert Stam and Alessandra Raengo. London: Blackwell, 2005. 1–52. Print.

Thompson, John O. "'Vanishing' Worlds: Film Adaptation and the Mystery of the Original." Cartmell et al., *Pulping Fictions* 11–28. Print.

Truffaut, François. "A Certain Tendency of the French Cinema." 1954; rpt. in *Movies and Methods*. Ed. Bill Nichols. Vol. 1. Berkeley: U of California P, 1976. 224–35. Print.

Wagner, Geoffrey. "Three Modes of Adaptation." *The Novel and the Cinema*. Rutherford: Farleigh Dickinson UP, 1975. 219–31. Print.

Welch, Jeffrey Egan. *Literature and Film: An Annotated Bibliography, 1909–1977*. New York: Garland, 1981. Print.

Welsh, James M. "Foreword." Cahir 1–5. Print.

Westbrook, Brett. "Being Adaptation: The Resistance to Theory." Albrecht-Crane and Cutchins. 25–45. Print.

CHAPTER 40

AGAINST CONCLUSIONS

Petit Theories and Adaptation Studies

THOMAS LEITCH

As my wife and I were sitting down to lunch with two friends some time ago, one of them asked me, "Are you a theorypod?" I was taken aback by the word, which was unfamiliar to me, and before I could answer, the other friend said, "Oh, no, he's not. Tom does things with movies and other real stuff." In the conversation that followed, they explained the meaning of "theorypod" by saying that they might just as well have used words like "theorist" or "devotee of theory" instead. But they didn't dispel my discomfort at the prospect of being labeled a theorypod, or for that matter a theorist—or indeed at being labeled *not* a theorypod. I realized, moreover, that despite the confusion initially introduced by the novel term, I would have been just as unpleasantly stumped if I'd had to choose between calling myself a theorist and calling myself not a theorist, especially if the grounds for being not a theorist were that I did "things with movies and other real stuff." Nor did I seek some compromise position in the middle that would allow me to call myself sort of a theorist and sort of a non-theorist, or someone who used theory without being a theorist. What really made me uncomfortable was the way the question was raised, as if some useful purpose were to be served by dividing the world into theorypods and everyone else, no matter which side received the more favorable rating.

Since I've often told my students that I look forward to living in a world, or at least teaching a curriculum, in which courses in literary studies aren't divided into theory and literature proper—a field and a curriculum in which we all sometimes think like theorists without making a point of identifying ourselves as theorists—I wondered after this conversation whether I'd been dreaming of what David Bordwell and Noël Carroll might call a post-theory world, but then decided that I hadn't. After all, I certainly didn't believe we'd arrived at a world that had left theory behind. Nor would I want to live in such a world. I do agree with Bordwell and Carroll, however, that the fields of literary and especially cinema studies would fare better if they weren't kept so firmly under the sway of one single reigning theoretical paradigm at a time. And I agree with them that "[w]hat we call Theory is an abstract body of thought which came into prominence in

Anglo-American film studies during the 1970s. The most famous avatar of Theory was that aggregate of doctrines derived from Lacanian psychoanalysis, Structuralist semiotics, Post-Structuralist literary theory, and variants of Althusserian Marxism. Here, unabashedly, was Grand Theory—perhaps the first that cinema studies has ever had" (Bordwell and Carroll, "Introduction" xiii). When cinema studies came of age in the academy, it was under the aegis of what Bordwell and Carroll and many others have called Grand Theory. The sporadic pilgrimages I've made to the annual conference of the Society for Cinema and Media Studies over the years have persuaded me that although fashions in Grand Theory have changed from structuralist semiotics to Marxist post-structuralism to feminist apparatus theory to a rediscovery of André Bazin and Gilles Deleuze, what hasn't changed is the commitment to an orthodoxy driven by allegiance to a single presiding theory.

Like Bordwell and Carroll, I'd like to see a world in which the orthodoxy that sustains Grand Theory gives way to a wider profusion of theories. I'm highly sympathetic to Bordwell's argument that *"You do not need a Big Theory of Everything to do enlightening work in a field of study"* (29). Unlike Bordwell and Carroll, though, I'm not seeking a fundamental reorientation of theory from psychoanalytic to what they call constructivist theories that emphasize consciously created contexts, intentionality, and hermeneutics. What I'd like to see is not only different theories, but different ways of thinking about theory, doing theory, and being a theorist that don't require both theorypods and non-theorypods to present their documents at the border. In particular, I'd dissent from Carroll's perfectly reasonable summary of the use of theory, which I would have accepted without qualification ten years ago: "Theories are framed in specific historical contexts of research for the purpose of answering certain questions, and the relative strengths of theories are assayed by comparing the answers they afford to the answers proposed by alternative theories" (56). Carroll's position is sound, I think, but it doesn't go far enough along the road André Gide marks out: *"Toute théorie n'est bonne que se elle permet non le repos main le plus grand travail. Toute théorie n'est bonne qu'à condition de s'en server pour passer outre"* (661). No theory is good, that is, unless it permits, not rest, but the greatest work. No theory is good except on the condition that it is used to go beyond. Like Gide, I've come to believe that the value of theories doesn't reside in the answers they provide, however compelling those answers are, but in their invitation to go beyond those answers. So I'd like to propose, not a new theory of textual and intertextual studies, but a new way, which is really a very old way, of thinking about the way theory might operate most usefully in the field of adaptation studies.

My discussion so far has focused on the place of theory in cinema studies because I think that discipline's history has been most decisively shaped by the intervention of Grand Theory in the ways Bordwell and Carroll identify. So I find it thoroughly logical that Kamilla Elliott's recent attacks on the uncritical application of Grand Theory to adaptation studies have taken as their target precisely the Grand Theory most closely identified with cinema studies. My own interest might be said to focus on adaptation as oscillation, the movement that Jørgen Bruhn, Anne Gjelsvik, and Eirik Frisvold

Hanssen, taking a leaf from J. R. R. Tolkien, have described as "there and back again" (1). The Introduction to their recent collection *Adaptation Studies: New Challenges, New Directions* identifies three such bases for oscillation: the movement back and forth between adaptation and "origin and authorship," which "are less obvious categories than one might think"; the movement between archives dedicated to preserving and performances dedicated to "telling, or retelling a story, passing it on," which "can be considered valuable, or even a gift"; and the challenges and opportunities raised by "a meeting of media, such as the representation of Bilbo's book" in Peter Jackson's film adaptation of *Lord of the Rings* (2). The whole process of adaptation might be described as an oscillation between celebrating hypotexts as honored sources and celebrating hypertexts as adaptive renewals—both of these impulses essential to an ecology of textual studies. The most obvious sign of this oscillation is the impulse that has moved several critics of adaptation to propose tripartite systems that acknowledge different but equally tenable attitudes that adaptations can take toward the texts they adapt: Geoffrey Wagner's transposition, commentary, and analogy (222, 223, 227); Dudley Andrew's borrowing, intersecting, and transforming (98–104); John M. Desmond and Peter Hawkes's close, loose, and intermediate adaptations (3); and Linda Costanzo Cahir's literal, traditional, and radical adaptations (17). More recently, Simone Murray and Kamilla Elliott have identified the oscillation between readings of particular adaptations and the general theories drawn from them or imposed on them as the founding move in adaptation studies, with both theorists and interpreters constantly warning of each other's excesses. This oscillation is hardly limited to adaptation studies, but recent debates within the field supply particularly useful examples.

Murray's monograph *The Adaptation Industry* provides two such illuminating illustrations in the form of case studies. Although Murray's opening chapter dismisses the kind of comparative textual analysis fostered by case studies of novels and their film adaptations operating "under the aegis of long-dominant formalist and textual analysis traditions" (16), she twice indulges in case studies of her own. The first time is when she examines adaptations of novels that have won the Man Booker Prize: "The current chapter includes, in spite of the book's Introduction abjuring such a methodology, some brief textual analysis of Booker film adaptations, not as cinematic close-reading for its own sake, but to investigate what these screen texts reveal about the adaptation industry from which they emerge" (106). The second is when she finds it necessary to discuss Stephen Daldry's 2008 film adaptation of Bernhard Schlink's 1995 novel *The Reader* in greater detail than she usually allows herself: "Such a choice, late in the present volume, might look like a reversion to adaptation studies' wearyingly familiar methodology of the case study, and hence contradict my Introduction's exasperation at the ubiquity of this practice. In fact, it is not any exceptionalism of *The Reader* (scholars' usual reason for selecting a case study) that motivates this choice but rather its very typicality" (178). Both times, Murray excuses her apparent inconsistency with her own methodology by noting that her close readings differ from other commentators' close readings because they are undertaken not for their own sake but for the sake of the larger economic forces they illuminate.

There is no need for Murray to be so defensive, since she does not indulge in nearly enough close textual analysis of either Booker film adaptations or *The Reader* to constitute one of the case studies she so clearly abhors; if she had not taken the trouble to rationalize these two sections, I never would have noticed that they were case studies, because, like nearly everything else in Murray's book, they are studies of paradigmatic adaptation situations, not of the textual features of particular books or their film adaptations. But that description applies just as clearly to Christine Geraghty's case studies in *Now a Major Motion Picture* as it does to Murray's—a similarity that Murray prefers to overlook, but one that Geraghty's own framing of her case studies makes clear:

> This book does not comment on the faithfulness or otherwise of the adaptations it looks at and does not take comparison with the source as its main method. . . . Instead, the analysis focuses on the films and television programs themselves: examining how the fact of adaptation is referred to or used in the text; looking at how such references interact with other factors such as genre, editing, or acting; looking at the reviewing context, which often provides the framework for treating a film as an adaptation; and assessing the critical debates that have been generated by particular adaptations. (5)

Although Geraghty's indication that she "does not expect [her examples] to be representative" (5) seems to support Murray's claim that her case studies are different because they *are* representative, typicality rather than exceptionalism has been a guiding principle for single-authored collections of adaptation case studies from George Bluestone to Brian McFarlane to Guerric DeBona.

In short, Murray the economic theorist is not nearly as different as she would like to believe from lowly analysts like Bluestone, McFarlane, DeBona, and Geraghty, who largely choose their examples for their typicality and make claims about them that range far beyond mere interpretation and comparative evaluation. Whether the rule is typicality or exceptionalism, however, it would be as hard to find an adaptation scholar whose writing in the past twenty years has focused on what Murray calls "cinematic close-reading for its own sake" as it would be to find a recent adaptation scholar who has focused on adaptation theory for its own sake. Readings and theories in adaptation studies aim to enrich each other, as inductive and deductive approaches to scholarship in the humanities do generally. On the whole, the activities of adaptation scholars cannot be divided neatly into textual and contextual study, or interpretation and generalization, or theory and practice—except of course when it suits us, or someone else, to claim that they can.

Deploring the fact that although "aesthetic formalism's affinities with postmodern culturalism offer the potential for bridging formal-cultural rifts, their political polarities have prevented any bridges from being substantially forged," Elliott has recommended "hybrid methodologies that integrate formal and cultural and textual and contextual factors . . . a formal culturalism, a cultural formalism, a textual contextualism, a contextual textualism" and has concluded, "If our current theories cannot adequately account

for adaptations, then we need to get rid of them and develop new ones" ("Rethinking" 584, 585, 588). While strongly endorsing Elliott's call for hybrid methodologies, I'd suggest that what adaptation scholars most need is not new theories, but new attitudes toward theories.

It's in this context that I'd raise a fundamental question: When we teach adaptation, or for that matter anything at all, in programs of literary or cinema or textual or intertextual studies, what do we most want our students to learn? Several goals come to mind. Most teachers will offer their students the powerful lure of greater aesthetic appreciation that will allow them to value *Bleak House* or Charles Dickens or the Victorian novel generally more highly, both as a supplementary corrective to the relatively parochial tastes, nurtured by contemporary popular culture, with which students first arrive in their classes, and as a demonstration that other writers and characters in other cultural and historical moments, perhaps thinking and feeling very much as students do themselves, have expressed themselves in unfamiliar ways that could well extend the students' own expressive powers. Partly for these reasons, partly out of an abiding reverence for a shared past, teachers who use adaptation in the classroom will try to impart a deeper, richer, more comprehensive sense of the literary and cultural history revealed by comparing adapted texts to their adaptations in order to emphasize both the importance of historical perspectives in illuminating problems and challenges that might otherwise seem unique to the present and the irreducible otherness of the past as an exemplar of all the other figures and voices that students will encounter outside the classroom—figures and voices better met with solicitude and a desire for greater understanding than with blank resistance or bafflement. Teachers of literary or cinema studies will be especially interested in giving their students both the tools and the critical disposition they need to analyze texts closely and critically by developing more specific ideas about how texts work and why—a pragmatic set of skills bound to become even more crucial when the students encounter texts that they have not already studied under expert direction. Many teachers will want their students to come away from their courses with a definite sense of why some past texts have endured the cultural oblivion that has buried so many of the others, whether that sense ends up being rooted in aesthetics (if only the best texts survive, what consecrates them as the best?), economics (why does the marketplace favor the texts it does and not their competitors?), or politics (why do the institutions that select some texts rather than others function in the ways they do?). Whatever their own practices and prejudices, most teachers will be powerfully motivated to help their students develop a greater ability to formulate and articulate original responses to all manner of texts and other cultural phenomena, whatever forms those responses may take.

I'd be hard-pressed to divide these goals, and the practices that foster them, between theory and interpretation. In fact, I think this rather modest range of goals suggests that the situation is more complicated than the opposition between theory and interpretation acknowledges. Giving due weight to both sides of the debate between theory and interpretation suggests that there are in fact more than two sides. It has merely suited some of us, and probably all of us from time to time, to recast this cornucopia as a duality.

But to stick for the moment to the duality: I've looked at criticism from both sides now, and if I were forced to choose between readings and theories as if they divided the field of textual studies as mutually exclusive competitors, I'd come down on the side of theory because as a teacher, I've come to realize that I'm more inclined to use particular examples in the service of general ideas or operations than the other way around. When I've taught *Middlemarch* or *Hedda Gabler* or *Citizen Kane*, my focus has been predominantly textual, and I love the feeling I get when I see students respond to the greatness of Eliot or Ibsen or Orson Welles by indicating that they too get it. I don't have to explain why audiences in bygone days (which interestingly always seem more remote from the present in the comparatively short history of cinema studies than in the much more venerable canon of literary studies) found these works exciting because the students themselves share that excitement. I'm less interested in getting my students to respond to *Middlemarch* and *Hedda Gabler* and *Citizen Kane* as great works of fiction or drama or cinema than as exemplary texts the students can use to sharpen critical skills that will help them respond to a wide range of plays and movies and other texts that I don't happen to be teaching them. Even though I know that theory and practice are interdependent, my deepest loyalty isn't to interpreting individual texts, but in using those texts as provocations to more general discussion, and ultimately to a more critical literacy. So if I were forced to choose between them, I'd advocate for the primacy of theory over interpretation in the study of adaptation. The theory I advocate isn't identified with any particular theoretical school or position—certainly not with Grand Theory. Instead I'd prefer to call it *petit theory*, not because its claims are any more modest, but because it proceeds in what I like to think of as more modest ways. Petit theory, as its name implies, is defined specifically in contradistinction to Grand Theory, and I like to think that committing petit theory is a misdemeanor that wouldn't be punished by such a long prison term as perpetrating Grand Theory.

In the United States, the arrival of Grand Theory dates from the October 1966 Johns Hopkins symposium on structuralism, where Jacques Derrida delivered "Structure, Sign, and Play in the Discourse of the Human Sciences." This year marks the golden anniversary of Grand Theory in the United States. Instead of a party and a birthday cake, however, there's continued widespread, albeit low-level, suspicion, often hostility, to the totalizing ambitions of Grand Theory. This suspicion is voiced by everyone from Kamilla Elliott to the friends who wondered whether I was a theorypod. So maybe it's time, not to return to the days before Grand Theory, but to move forward to embrace, or more accurately to deploy, petit theory.

What makes petit theory petit, or petty, is that it operates not as a series of dogmas or organizing principles, still less as a set of solutions to consensual problems, but as a series of working hypotheses. I'm aware that my emphasis on the provisional, contingent, hypothetical valence of theory is very much at odds not only with the way theory is viewed today by both its adherents and its opponents, but also with the relevant definition of theory given by the *Oxford English Dictionary*: "4. A scheme or system of ideas or statements held as an explanation or account of a group of facts of phenomena; a hypothesis that has been confirmed or established by observation or

experiment, and is propounded or accepted as accounting for the known facts; a state-ment of what are held to be the general laws, principles, or causes of something known or observed" ("Theory"). This definition, which is consistent with Noël Carroll's understanding of theory, is applicable to every theory in the humanities *if and only if you happen to accept that theory*—that is, is you're part of what Stanley Fish calls some interpretive community, like an undergraduate classroom or the Society for Cinema and Media Studies, that inhabits a given theory so completely that it accepts its hypotheses as explanations.

The alternative definition I'd suggest owes less to Carroll's understanding of the-ory as explanation than to an older understanding that the *OED* attaches, not to the English word *theory*, but to its ancestor, the Greek word *theōria*, in an etymological note appended to its entry for "theory": "A looking at, viewing, contemplation, speculation, theory" ("Theory"). Considered on these terms, theories are provisional and contingent. Theories are working hypotheses that might be true and might not. We adopt them not because we're convinced that they're true but because they help us think better. In Gide's terms, the whole point of petit theory, or more precisely of petit theories, is that using them encourages us to go beyond them. My reference to petit *theories* rather than Grand Theory, or even petit theory, shifts deliberately from the singular to the plural to indicate the difference between a world, or an interpretive community, under the sway of a single consensual theory and a community in which multiple, often competing theories are constantly subject to debate because the currency of those theories is up for grabs. In such a world, it makes sense to speak of the theories of global warming, of evolution, of gravity. You might be so accustomed to accept these theories' explanatory power than you regard them as gospel, but as disputants are always entitled to point out, they're only theories.

Replacing Grand Theory with petit theories, which demand not our allegiance but only our thoughtful consideration, can make us more receptive to several recommen-dations for the conduct of theory in general, and adaptation theory in particular. The first is that we focus on asking questions instead of making assertions. Although it is widely acknowledged that the most productive assertions in the humanities are those that foster productive debates, surprisingly few theorists have taken the next logi-cal step and argued that the most directly productive critical interventions are those that take the form of questions themselves. Instead of handing down dicta, I'd sug-gest, we should focus on raising questions, not as a necessary means toward the end of generating answers, but as a desirable end in themselves. Our goal should not be to answer these questions definitively. That practice would be deeply anti-scholarly, for the even the most timeless wisdom enshrined in the ivory tower does not take the form of definitive answers to questions. Scholarly disciplines and scholarly life may be instituted by consensus, but they are fed daily by debate. So the point of every question should be to raise better questions, which will in turn help to raise still better questions.

In practice this amounts to a recommendation for a soft Hegelianism. This critical method is not to be identified with Hegel's, still less with Marx's, deterministic view of

history, but with an open-ended dialectic in which the constant clash between theses and their antitheses and the new syntheses that arise from each clash and provoke in turn new clashes sometimes leads to breakthroughs, sometimes to stale repetitions, sometimes to dead ends. And indeed, as soon as we think about theory dialectically, we realize that doing theory—the activity of theorizing—finds its place within a much older, pre-Hegelian practice of Socratic dialectic, which depends on asking and answering questions, and then using the answers to ask better questions.

A second recommendation follows from this first one. Instead of attempting to map problems and fields visually by fixing them in graphic space, I'd recommend narrativizing them in time, contextualizing them by telling their stories. This is one area—in Elliott's terms, one methodology—in which adaptation studies ought to be leading the way, however short it may sometimes fall of its promise, because both adaptations themselves and adaptation theory, especially as it's practiced in the English-speaking world, emphasize temporal, narrative models over spatial models of exposition and analysis. When you think about it, of course, it's equally true that this is how Grand Theory works, or at least how it used to work: by deconstructing theories of origins as inadequate and narrativizing problems and debates like the search for origins instead. A widely remarked irony of Grand Theory is that it began precisely as a series of destabilizing questions, not a program of totalizing answers. As Grand Theory became more grand, it became notoriously more doctrinaire in its quest for certain kinds of power eerily reminiscent of the pursuits of power its exponents had so ruthlessly exposed in earlier schools of thought. But this temptation to move from searching questions to dogmatic answers is equally a danger for all theory, not just Grand Theory, and indeed for critical methodologies like literary history and New Criticism that didn't originally set themselves up as theory but were adopted, or co-opted, as heuristic methodologies by theorists and classroom teachers until they became critical orthodoxies uncritically inhabited by teachers and their unwary students. So it's a temptation that can't be avoided or resolved by adopting whatever critical or theoretical position is currently fashionable; it can only be resisted, over and over again, by theorists who are determined not to turn into demagogues.

One way for theorists to resist the temptation to freeze their enabling questions into stifling dogmas has been proposed by Stanley Fish, who urges us to reject the "model of *demonstration* in which interpretations are either confirmed or disconfirmed by facts that are independently specified" and embrace instead "a model of *persuasion* in which the facts that one cites are available only because an interpretation (at least in its general and broad outlines) has already been assumed" (365). I'd go further and argue that instead of seeking to demonstrate or even to persuade, we should place our arguments for what we perceive as opposed positions or viewpoints in broader, more chastening contexts by transcending them in the manner described by Kenneth Burke, who defines transcendence as "the adoption of another point of view from which they cease to be opposites" (336). Attempting to transcend their differences instead of attempting to resolve them by demonstration or persuasion would invite disputants who find themselves arguing with each other to rise above their differences by asking, for example,

"Why are we arguing? What's at stake in our argument? What are the implications of our disagreement? Whose interests are best served by defining the argument in the ways in which it seems to present itself to us? What can we learn from it? What can we do about it? Would it be better to resolve it, to leave it unresolved, or to change the subject?" The goal in each case should be not so much to resolve conflicts, but rather to reframe them more helpfully and illuminatingly—to use them instead of remaining committed to them.

The questions I've been suggesting may seem to recast theorists as psychotherapists who respond to every proposition with another maddeningly open-ended question like "Why do you say that?" or "How do you feel about that?" And indeed I'd recommend that instead of professing the correctness of definitive answers, teachers should focus more on caring therapeutically—not simply for the well-being of our students or our disputants, but for that of our discipline, our profession, our place in the larger social culture, and any other areas of shared concern as well. Under this aegis, every course we offer in adaptation, whatever its locus or critical orientation, could fairly be called "The Care and Feeding of (Inter)textual Studies."

If we follow Bordwell and Carroll, who suggest that "[w]hat is coming after Theory is not another Theory but Theories and the activity of theorizing" ("Introduction" xiv), then this prescription exhorts us to shift the locus of critical theory—or, as I'd prefer to call it, of theorizing—from scholarly journals to classrooms, where, despite the inevitable power differentials, which of course play out in the journals as well, our primary concern isn't to be right as individuals, but to foster the care and feeding of ourselves as a scholarly community and of our discipline. What I propose, in short, is a return-with-a-difference to Socratic dialogue—what Linda Hutcheon might call a "repetition without replication" of the strategies Socrates shares with all adapters (7)—not just of the kinds of leading questions teachers have asked students from time immemorial, but a genuine ongoing dialogue in which every participant is assumed to have some contribution to make, even if not all those contributions turn out to be equally valuable. Socratic dialogue provides both the ideal rhetorical form and the ideal situation or occasion for scholarly inquiry. And it incidentally provides a surprisingly definite answer to the question I asked earlier. What do we most want our students to learn? Over and above all the eminently worthy goals I sketched out earlier, one additional goal stands out: the mastery of dialectical argument. Suspicious as I am of definite answers, I find this one irresistible, not only because it emphasizes the ability to engage in logical reasoning with others as the single most desirable outcome of liberal education, but because it properly restores the relation between teachers and students to the center of theory and criticism.

Since I've been largely considering theory in general, I'd like to close by indicating some particular questions I'd like to see adaptation scholars take up and debate with their students and among themselves—even, or especially, if they don't provide definitive answers to them. One of these questions has already been foundational to the field. What is the relation between adaptations and other kinds of intertexts, and why do we draw the lines between them as we do? Or, to put this question in different terms: What is the relation between the process of adapting and other textual practices?

To this foundational question I would add at least one other that I've raised before but haven't been able to answer. Why are some hypotexts labeled texts and others labeled contexts, and whose interests are suited by making these distinctions as we make them? Some years ago, I ended an essay by asking, "What is the difference between texts and contexts?" and, after noting that film adaptations of *The Killers* offered fundamental challenges to what I took to be the received wisdom on this subject, asked "why such a fallacious distinction has remained so ubiquitous" (40, 41). Even my conclusion that some contexts get promoted to texts because they are "treated as a text by somebody" (42) raises more questions than it answers about who has the power to frame contexts as texts, and why some contexts but not others are chosen to be framed in this way. Kathleen Murray has acutely described Howard Hawks's *To Have and Have Not* (1944) in terms of a "systemic and reciprocal practice of creation" that invokes such a wide range of texts and contexts that the film "needs to be thought of as a Warners picture, a Hawks film, a Hemingway adaptation, a Faulkner screenplay, a response to *Casablanca*, and a Bogart/Bacall vehicle simultaneously" (110, 111). On the whole, however, the question of how and why texts differ from contexts has never caught on in the field, but it continues to provoke me, though so far not to a satisfactory answer.

Another question, which would seem to be even more foundational, is raised by Kyle Meikle in his contribution to the present volume: What can adaptations do better than other texts? What can they do that other texts can't? Although, or because, Meikle's answer is provisional and incomplete, adaptation scholars are indebted to him for raising so explicitly a question the field had been remarkably successful in ignoring. At least two other questions that follow from this one—What does labeling and reading a text as an adaptation allow it to do that other readings don't? And to what does the label of adaptation commit that text and its analysts?—seem eminently worth pursuing.

A final group of questions arising from my own classroom teaching is a series of meta-questions that have less to do with adaptation as such than what I've called the care and feeding of adaptation studies. What do the different groups of people who want to talk about adaptation most want to talk about, and why? What makes them interested in adaptation in the first place? How can we encourage them to talk most productively to each other? At any given moment, what do people think is most appropriate to say about adaptation, and what we can we learn from their preferences?

My peroration takes the form of a request. I'd ask every adaptation scholar and every teacher who has any interest in adaptation to begin adapting to a newly normative mode of asking questions, and to do everything possible to help students make the same kind of adaptation, proceeding from introductory questions to ever better questions about reading and writing and themselves and the world, scaffolding those questions so that they lead constantly to more searching questions—and throwing off as desirable by-products the occasional declaration and adaptation—while constantly resisting the temptation to freeze their ideas into dogmas. And just in case this charge leaves you wondering what you can possibly talk about in class in between those moments of passionate engagement with your material that will produce the most telling debates, I'd offer another aphorism from Gide, which offers both an amusingly reductive way to

think about theory and a deeply provocative way to think about both theorizing and adapting: *"Toutes choses sont dites déjà; mais comme personne n'écoute, il faut toujours recommencer"* (Robidoux 104). Everything has already been said; but since no one was listening, everything must be said again.

WORKS CITED

Andrew, Dudley. *Concepts in Film Theory.* New York: Oxford UP, 1984. Print.

Bluestone, George. *Novels into Film.* Baltimore: Johns Hopkins UP, 1957. Print.

Bordwell, David. "Contemporary Film Studies and the Vicissitudes of Grand Theory." Bordwell and Carroll 3–36. Print.

Bordwell, David, and Noël Carroll. "Introduction." Bordwell and Carroll xiii–xvii. Print.

Bordwell, David, and Noël Carroll, eds. *Post-Theory: Reconstructing Film Studies.* Madison: U of Wisconsin P, 1996. Print.

Bruhn, Jørgen, Anne Gjelsvik, and Eirik Frisvold Hanssen, eds. *Adaptation Studies: New Challenges, New Directions.* London: Bloomsbury, 2013. Print.

Bruhn, Jørgen, Anne Gjelsvik, and Eirik Frisvold Hanssen. "'There and Back Again': New Challenges and New Directions in Adaptation Studies." Bruhn, Gjelsvik, and Hanssen 1–16. Print.

Burke, Kenneth. *Attitudes toward History.* 3rd ed. Berkeley: U of California P, 1984. Print.

Cahir, Linda Costanzo. *Literature into Film: Theory and Practical Approaches.* Jefferson: McFarland, 2006. Print.

Carroll, Noël. "Prospects for Film Theory: A Personal Assessment." Bordwell and Carroll 37–68. Print.

DeBona, Guerric. *Film Adaptation in the Hollywood Studio Era.* Urbana: U of Illinois P, 2010. Print.

Derrida, Jacques. "Structure, Sign, and Play in the Discourse of the Human Sciences." *Writing and Difference.* Trans. Alan Bass. Chicago: U of Chicago P, 1978. 278–93. Print.

Desmond, John M., and Peter Hawkes. *Adaptation: Studying Film and Literature.* New York: McGraw-Hill, 2005. Print.

Elliott, Kamilla. "Rethinking Formal-Cultural and Textual-Contextual Divides in Adaptation Studies." *Literature/Film Quarterly* 42.4 (2014): 576–93. Print.

———. "Theorizing Adaptations/Adapting Theories." Bruhn, Gjelsvik, and Hanssen 19–45. Print.

Fish, Stanley. *Is There a Text in This Class? The Authority of Interpretive Communities.* Cambridge: Harvard UP, 1980. Print.

Geraghty, Christine. *Now a Major Motion Picture: Film Adaptations of Literature and Drama.* Lanham: Rowman and Littlefield, 2008. Print.

Gide, André. *Journal 1889–1939.* Paris: Gallimard, 1948. Print.

Hutcheon, Linda, with Siobhan O'Flynn. *A Theory of Adaptation.* 2nd ed. New York: Routledge, 2013. Print.

Leitch, Thomas. "The Texts Behind *The Killers.*" *Twentieth-Century American Fiction on Screen.* Ed. R. Barton Palmer. Cambridge: Cambridge UP, 2007. 26–44. Print.

McFarlane, Brian. *Novel to Film: An Introduction to the Theory of Adaptation.* Oxford: Clarendon, 1996. Print.

Murray, Kathleen. "*To Have and Have Not*: An Adaptive System." *True to the Spirit: Film Adaptation and the Question of Fidelity.* Ed. Colin MacCabe, Kathleen Murray, and Rick Warner. New York: Oxford UP, 2011. 91–113.

Murray, Simone. *The Adaptation Industry: The Cultural Economy of Contemporary Literary Adaptation.* New York: Routledge, 2012. Print.

Robidoux, Réjean. *Le traité du Narcisse (Théorie du symbole) d'André Gide.* Ottawa: Éditions de l'Université d'Ottawa, 1978. Print.

"Theory." *The Compact Edition of the Oxford English Dictionary.* 2 vols. New York: Oxford UP, 1971. Print.

Wagner, Geoffrey. *The Novel and the Cinema.* Rutherford: Fairleigh Dickinson UP, 1975. Print.

INDEX

Print sources are followed by the names of authors or editors, comics by the date of their first appearance, films by the names of directors, if known, and release dates. Page numbers followed by italicized letters indicate *figures* or *tables*.